THE YALE DICTIONARY OF
ART AND ARTISTS

THE YALE
DICTIONARY OF

ART AND ARTISTS

Erika Langmuir and Norbert Lynton

Yale University Press
New Haven and London

Some entries from this book previously appeared in *The Pan Art
Dictionary 1300–1800*

Typeset in Ehrhardt in Hong Kong
Printed in the United States of America

Library of Congress Cataloging-in-Publication Data
Langmuir, Erika.
Yale Dictionary of Art and Artists / Erika Langmuir and Norbert
Lynton.
 p. cm.
ISBN 0-300-06458-6 (paper)
 0-300-08702-0 (cloth)
1. Art–Dictionaries. 2. Artists–Dictionaries
I. Langmuir, Erika. II. Lynton, Norbert. III. Title
N33.L353 2000
703–dc21 00-025800

A catalogue record for this book is available from the British Library.

The paper in this book meets the guidelines for permanence and durability
of the Committee on Production Guidelines for Book Longevity of the
Council on Library Resources.

10 9 8 7 6 5 4 3 2 1

PREFACE

The purpose of this dictionary is twofold: to act as a reference book for travellers and gallery visitors, and also to provide at-home information to students of western art history and general readers interested in the subject. To these ends, entries vary between the cursory and the encyclopedic: major artists and artists whose careers or talents have recently been reassessed, or who seem to the authors to merit reassessment, are given the fuller treatment. Examples include Dutch seventeenth-century history painters, whose work, highly praised by contemporaries, has recently come to be studied again after two centuries of neglect (see, e.g. Sandrart). The length of the entries certainly relates to our sense of the subjects' importance but it also may be influenced by the quantity of information about them and its relevance to an appreciation of their work. In the case of Picasso, for example, it seems imperative to refer to his wives and partners even in what has to be a sketchy, though relatively exhaustive, survey of his long career. In the case of another artist, this kind of detail would be of little value. Also, we have tried to go beyond historical information to indicate what characterizes an artist's work and attracts our interest to it – in other words what justifies his or her status and inclusion. Thus there are personal factors at work and no apology is made for these. Some element of first-hand knowledge seemed essential, and this, in conjunction with the practical limits that had to be set for this publication, has meant that we have not covered everything readers would have a right to find treated in a larger volume, or a series.

Entries include painters, sculptors, printmakers, etc., but not architects, except those who also practised as one or more of the above, and the specialized field of Byzantine art has not been included, although a number of western-influenced eastern-european artists are. The period covered runs from 1300 to the present day, but again there are exceptions. There are, for example, entries on antique sculptures that influenced later art. There is an infinity of artists that could, perhaps should, be included. There are many more topics and terms that might be discussed. Style and group names have multiplied alarmingly during the last hundred years, but only those 'isms' that have proved their staying power and remain in general use are accounted for here. Stylistic, technical and other art-historical terms are included where standard dictionary entries were felt to be inadequate. The aim has been to provide a glossary to more specialized art-historical literature, such as exhibition catalogues or scholarly monographs, rather than to be exhaustive. The

choice of terms defined has been dictated mainly by our experience as university teachers of art history, explaining to students the past meaning of such terms as 'decorum' or 'Fancy Picture', the significance of style labels such as 'Gothic' and 'classicizing', as well as the more obvious technical aspects of, say, 'fresco' or 'grisaille' painting.

This dictionary cannot claim to be exhaustive at any point, most obviously so when we come to recent decades. A profusion of art is being produced and there are many opportunities for contact with it through exhibitions, books and the media. Whom and what to include and how much space to allocate to each entry required endless decisions and these decisions may appear arbitrary to the reader, though they were not to the authors. One question considered was whether readers were likely to need information about a specific artist. The book is not a means of promoting little-known artists, living or dead, who deserve better; neither is it the place to follow an inclination to register an occasional feeling that certain artists have had more attention than they merited by omitting them altogether. If some artists' work is being hotly promoted by the commercial galleries and bandied about by the media, a reader might want to look them up. But readers may note a cooler or a warmer tone in different entries: this book is the work of two writers, not a committee or a machine.

It has been decided to make value judgements explicit, but, at the same time, to try to differentiate clearly between the judgements of contemporaries, posterity, the general public and specialists, and to alert readers to differences of opinion where those exist and seem to matter. Finally, we have not shied from recording our own opinions in longer entries, thinking it better to allow these open expression rather than have them creeping in by the back door of supposed objectivity.

Vague but extreme notions of individuality and uniqueness bedevil people's understanding of what art is and how it is made; here we can work against that a little. Yet, at any rate some of the shorter entries imitate what time may show to have been a destructive habit of the modern age: that of attending to artists' early years at the expense of the later, in the belief that it was in their youth that they made their mark and laid claim to a place in history. This has indeed often been the case: innovation, often the work of someone's twenties or thirties, has called for more notice than subsequent production, however appealing. It would certainly be easy to let this work grow in future editions, not only because of the daily increment of names, terms and topics that is the history of art in modern times.

Cross-referencing between entries, indicated by asterisks (*) or (*see also...*) has been copious, partly to encourage browsing but mainly from a

desire to demonstrate the intricate web of relationships that make up the history of art. It is a fact that professional artists actively seek out the influence of other artist as well as passively absorbing the influence of their teachers or local schools. The names most frequently referred to – Leonardo da Vinci, Michelangelo, Rubens, Courbet, Picasso and a few others – really do identify the lodestars of western art.

Museum, Church and other institutional references are normally listed not in alphabetical order, but, depending on the entry, according to the importance of their holdings of works by the artist or in chronological order as this applies to their holdings of works by the artist under whose name they appear. Anonymous private collections are only mentioned where a major, or important, portion of the artist's work is held in such collections. References have been abbreviated only slightly, either by dropping such words as 'Museum' or 'Gallery' – as is 'New York, Metropolitan' for 'New York, Metropolitan Museum of Art' – of the name, where only one museum or gallery exists in the locality listed: 'Bergamo, Accademia' for 'Bergamo, Accademia Carrara' and 'private collection' is shortened to 'pc'. Churches are normally listed only under the short name of their titular saint 'Rome, S. Ignazio', not 'Rome, church of S. Ignazio Loyola'. The local name of the saint or church is usually given, except where familiarity with the English name makes such consistency undesirable for the English-speaking reader. Thus references are to 'Vatican, St Peter's' or 'Rome, St John Lateran' rather than 'Vatican, S. Pietro', or 'Rome, S. Giovanni in Laterano'. By extension, there are references to 'Venice, Doge's Palace', 'Pavia, Charterhouse', 'Dijon, Charterhouse'.

Discrepancies in dates between this volume and other publications reflect either scholarly debate in the face of inadequate documentation, or new certitudes recently published. Differences in the spelling of names normally reflect contemporary variations in orthography. The currently preferred form has generally been adopted; occasionally, however, the most familiar English form of the foreign name has been used. Thus while Jan van Eyck is listed as 'Eyck, Jan van', the reader will find Charles I's favoured painter under 'Van Dyck, Sir Anthony'. De Kooning is always referred to thus, and therefore he will be found under 'D'; other names including 'de' and its variants will be found under the initial letter of the next part of their names. Vincent van Gogh is to be found under 'G' but Van Doesburg is under 'V'. In the case of many compound names cross-references are given, but readers are asked to look under possible variants.

On a few occasions we have moderated the English spelling of an artist's name; on others the temptation has been resisted. Thus 'Malevich' is now

common (though 'Malievich' would get us closer to the Russian pronuncia-
tion), replacing the German form 'Malewitsch', but 'Jawlensky' is still
written thus, and consequently often pronounced 'jaw-lensky': here 'Yavlen-
sky' is used, with a cross-reference under 'J' lest he be lost from sight.

Artists' dates are normally given in the form '1450–1527', where '1450' is
the date of birth and '1527' of death. The form '*c*.1450–1527', indicates a
date of birth around 1450; '1450/51–1527' greater precision. An entry such
as 'active (or recorded) 1480–1527' means that the artist was working in 1480
at an age not now known and died in 1527, while 'active (or recorded) 1480
to 1527' means that neither the year of birth nor death is now known. A vari-
ation might be '1450–after 1527', indicating that the artist was not necessar-
ily active until 1527 but is recorded in some form of documentation until
that date.

Any work such as this relies on the primary research and survey compi-
lations of others. To all these we give humble and grateful thanks. Every
effort has been made to seek out up-to-date sources and to eliminate errors
where these have crept into the literature, but anyone who has undertaken a
similar task will know that such effort can never wholly succeed. The users
for whom this dictionary is mainly intended should find it adequately reli-
able; any specialists who may come upon it are asked for tolerance – and to
communicate errors of fact, new findings or differences of opinion to the
authors.

A

Aachen, Hans von (1552–1615) German painter from Cologne; trained in the Netherlands. While working in Florence, he recommended himself to the Emperor Rudolf II in Prague by sending him a portrait of the sculptor Giovanni *Bologna. In 1597 he became official portraitist to Rudolf. On Rudolf's death in 1612 he remained in the service of the Emperor Matthias. He is now chiefly remembered for his religious, mythological and *allegorical works, in a sophisticated *Mannerist style akin to *Spranger's, and, through prints, nearly as influential (Munich, Alte Pinakothek; Budapest, Museum; *see also* Savery; Arcimboldo).

Aaltonen, Wäinö (1894–1966) Finnish sculptor, born near Turku. Deaf from an early age, he studied in his home town. The civil war of 1918 brought commissions for memorials and drew attention to his capacity for monumental sculpture. His most prestigious work is the allegorical group he made for the new parliament, opened in 1931. Eminent Finns are recorded in his portrait busts. There is an Aaltonen museum in Turku.

Abakanowicz, Magdalena (1930–) Polish sculptor, trained in Sopot and Warsaw; professor since 1979 at Poznań Art College. She specialized in fabricating woven sculpture, making thread from fibre and weaving or moulding dramatic forms, *abstract at first, then also *figurative. She has gained many Polish and European awards and exhibited widely, representing Poland at the 1980 Venice *Biennale.

Abate, Nicolò dell' (1512–71) Painter from Modena, now chiefly remembered as the third Italian founder of the School of Fontainebleau (*see* Rosso; Primaticcio; *also* Cellini). Nicolò's career before his voyage to France in 1552 is also of interest, however. A specialist in decorative *fresco

cycles throughout the Modenese and in Bologna (from *c.*1548), he executed the fullest 16th-century pictorial recensions of Virgil's *Aeneid* (*c.*1540, now Modena, Galleria; *Story of Camilla, Aeneid* book xi, *c.*1550–52, Bologna, Palazzo Poggi), of the *Roman Histories* of Appian (1546, Modena, Palazzo Comunale), of Livy (*Tarquin* cycle, *c.*1548–50, Bologna, Palazzo Torfanini, destroyed), and of Ariosto's *Orlando Furioso* (*c.*1548–50, now Bologna, Pinacoteca), which were based whenever possible on book illustrations and prints after, for example, *Giulio Romano and *Raphael. His decorative friezes influenced the early work of the *Carracci in Bolognese palaces, and although he worked largely as an executant of Primaticcio's designs at Fontainebleau, his taste for Northern Italian *illusionism (*see* Mantegna, Correggio) helped to transform the latter's designs for the Galerie d'Ulysse. His eclectic style, formed on Correggio and *Parmigianino, but on Netherlandish landscape (*see* Patinir) and *Dosso as well, also helped to soften and enliven the colder *Mannerism of Primaticcio (e.g. *Salle de Bal*). His predilection for narratives set in landscape found an independent outlet at the French court (*Aristeus and Eurydice*, London, National, and *Rape of Proserpine*, Paris, Louvre) and anticipates the French *Rococo. The same may be said for his depictions of aristocratic pastimes – in which he is also an unrivalled recorder of fashionable dress (*Sala dei Concerti*, Bologna, Palazzo Poggi; drawings, Düsseldorf, Kunstmuseum; Florence, Uffizi; Paris, Louvre; Cambridge, Fitzwilliam). The canon of his portraits has never been fully established, and some of his work in this genre has been attributed to Parmigianino. A great deal of his work in France, for the court and other patrons, has been lost, although much is recorded in drawings. He was assisted in his last project, the decorations for the festive entry of Charles IX to Paris, 1571, by his son Giulio-Camillo dell' Abate.

Aberli, Ludwig (1723–86) Pioneering Swiss landscape painter and draftsman, born in Winterthur but active mainly in Bern. Unlike Caspar *Wolf, he specialized in serene views of Swiss lakes, and was fascinated by medieval ruins (Bern, Kunstmuseum; Zofingen, Stadtbibliothek).

Abildgaard, Nicolai Abraham (1743–1809) The most prominent Danish *Neoclassical painter, and the last to devote himself entirely to *History painting; his work stands in contrast with the intimate *Realism of his immediate successors (*see*, e.g. *Eckersberg, *Juel, *Købke). As court artist, he was also an influential designer of architecture, furniture, theatrical costumes, etc. After training at the *Academy in Copenhagen in the 1760s, Abildgaard spent the years 1772–7 on a scholarship in Rome, inspired mainly by ancient sculpture and *Michelangelo. He became friends with the sculptor *Sergel, and through him met *Fuseli, whose interests he shared. Abildgaard's principal work in Rome was the ambitious and *expressive *Wounded Philoctetes* (Copenhagen, Statens Museum, which has the leading collection of the artist's work), but as well as illustrating Homer he also drew on Shakespeare and Nordic and Celtic myth. Back in Copenhagen in 1778 he received his greatest commission, a series of huge paintings on the history of the ruling dynasty for the royal palace, Christianborg; he had completed ten when the project was abandoned in the 1790s. Only three survived the fire of 1794; the others are known through sketches. Among Abildgaard's students at the Copenhagen Academy – where he was appointed Professor in 1778 – were *Carstens, the sculptor *Thorvaldsen, who assisted him in the decoration of Amalienborg palace, and Eckersberg, who rejected most of his teacher's ideals.

abstract art Art that does not represent aspects of the visible world; also referred to as non-objective, non-representational and non-*figurative art. All art requires some degree of abstraction. Naturalistic art (*see* *Realism) can come close to deceiving us, as in *trompe l'oeil painting, but even the art based on close observation of nature has required some factual and aesthetic deviations from physical truth in order to become an art object. It was when aesthetic organization and expression were given priority over what the *academies taught as artistic verisimilitude, during the last twenty years of the 19th century, notably in *Post-Impressionism, that abandoning academic norms and everyman's apprehension of reality could become programmatic. The *Cubism of *Braque and *Picasso included many works that in their titles refer to a figure or still-life subject which the viewer might fail to find in the work. Such paintings or drawings imply a process of abstraction, that is of departure from representational legibility, but by 1912–13 some painters, including Picasso, were producing pictures that appear to be wholly abstract – they do not allude to objects in the real world. Thus they broke the chain of principle which had obtained in western art since ancient time, whereby art's first duty was to provide a recognizable scene or object, however much varied by the demands of style or medium.

The decorative arts had always been free of this principle; in some cultures indeed – notably Jewish and Islamic – the representation of living beings was forbidden, and thus ornamental designs were developed that made sophisticated use of patterns and of line and colour, including script. In the West, the emergence of abstract art was preceded by a period when ornamental design, influenced both by the anti-naturalism of *Post-Impressionism and by close study of natural forms, played so prominent a role as to close the gap between fine and decorative art: this was the period of *Art Nouveau, which also saw theoretical analysis of the affective properties of forms and colours. In the foundation text of abstract painting, *Kandinsky's *On the Spiritual in Art*, some theoretical prehistory and experiential justification is offered for the analysis of, especially, colour's expressive functions, but his recommendation of abstract art as the way into a more profoundly spiritual art, away from the materialistic focus of almost all 19th-century art, was accompanied by both a surprising recognition and a warning.

One was that innocent, faithfully representational art would also lead in this direction – Kandinsky was thinking of Henri *Rousseau as well as of folk traditions – while the other warned that serious art must not be led by the desire for abstraction into becoming mere decoration. This delayed his own move into full abstraction, while he seeded paintings that appeared to be free-hand, musically expressive compositions of abstract forms and colours with little scenes developed in his own earlier pictures: mountains, citadels, figures on horseback or in boats, and so forth, to hold and guide viewers' attention to their religious meaning. Kandinsky was a Russian then working in Germany. Another Russian, *Malevich, working mostly in Moscow, in 1915 exhibited paintings which presented flat shapes in single colours on rectangular canvases of a modest size. At times he referred to the first of these as *icons, and there can be no doubt that he intended them to be seen as religious images of a new sort, representing his shareable vision of the cosmos as a transcendental realm towards which western mysticism (especially in America, Germany and Russia) was directing attention. In so far as his paintings were offered as representations, even though not of our natural world, it could be argued, they are not abstract. Subsequently they have been spoken of as the beginnings of geometrical abstract art, since they were principally of geometrical forms in colour on a white ground, yet this is misleading too. The painting Malevich himself presented as the key work in the new idiom, known as his *Black Square* – a single black form centred on a square white ground – is, in Russian, a 'four-cornered' thing and was plainly painted to be neither a square nor any other neat geometrical forms. Malevich's disciples, *Lissitzky and *Rodchenko, used clear geometrical forms in their compositions, but these too referred to cosmic experiences and aspirations. In Paris, Robert *Delaunay made paintings in 1912–13 in which colour seemed to dominate over forms that could be firm or soft; these forms were mostly circles and parts of circles and some of the titles he used referred to the sun and the moon, again,

that is, to worlds other than this Earth, and it may be significant that his wife, Sonia, was born and grew up in Russia and until 1914 remained in touch with artistic developments there.

This suggests that the move towards and into abstract art came from a need to make art capable once again of dealing with elevated themes, after a century during which art seemed to have descended into triviality or to honouring routine representations of serious subjects. The literature (more than the art) of *Symbolism had similarly sought to give fresh significance to religious themes, but it had also placed emphasis, notably in the work of Mallarmé, on purification, that is, the economical use and cleansing of the means of each art form in order to release the resonances inherent in them but covered over by centuries of elaboration. This too led to work with sacred subject-matter, and it was in this spirit that Maurice *Denis in 1890 wrote that a picture was, first and foremost, a 'flat surface covered with colours arranged in a certain order'. Often quoted as a statement on behalf of abstract painting, Denis's words were intended to give priority to aesthetic formulation over naturalism and to flatness seen as natural to painting and thus expressing a moral truth. A statement often quoted twenty or so years later was that of Plato, who, in 4th-century BC Greece, had Socrates commending as 'eternally and absolutely beautiful' two- and three-dimensional forms produced by mathematics and machinery. This unambiguously referred to non-representational forms and implied non-expressive purposes, and so it served the champions of a modern art not derived by abstraction from seen objects, an art which honoured and sometimes imitated the forms and products of modern technology and that started not from nature but from such a manmade base as mathematics. While *Dadaists used references to machinery as a way of mocking humanity, abstract artists who worked with strictly geometrical forms could quote Plato on the unconditional beauty of their work. Those who used materials and sometimes processes belonging to technology, initially the *Constructivist artists of early Soviet Russia, could also claim to be reaching out to the socially

necessary world of industry and even to be contributing to it.

The meeting of Russian Suprematist and Constructivist ideas and art (principally in the person of Lissitzky) with the principles and practice of the *De Stijl group (Van *Doesburg) in 1920s Germany produced an *Elementarist trend that affected all progressive design practice in central Europe and subsequently abroad, which, partly through the presence of *Moholy Nagy, flourished at the *Bauhaus from 1923 on. Just as the emergence of the Dutch De Stijl group, in 1917, had been an idealistic riposte to the bloodiest of wars being pursued in Flanders, so Elementarism answered Dadaism's accusation that art had failed, and would always fail, in so far as it did not prevent that war. Clear geometrical design, devoid of individualist expression and pursued in the name of functionalism (though rarely justifiable in terms of function: its products were thought to *look* functional), would serve the real world and everyone in it, while also providing models of a perfect manmade future. This double aspiration – as opposed to the modern dynamics the Italian *Futurists tried to bring into their art – powered a broad geometrical-abstract movement that centred on Paris at the end of the 1920s with the *Cercle et Carré group and its successor, the even more international *Abstraction-Création group.

By this time, however, a free-form and intensely personally expressive form of abstract painting had emerged in *Surrealism with the art of *Miró, as well as a semi-abstract kind of imagery in the fantasy art of other Surrealists such as *Tanguy. Moreover, *Klee, even before he taught beside Kandinsky at the Bauhaus, had developed a programme of free, instinctual invention which took major impulses from the materials employed and the marks made and developed an abstract composition or a partly representational image from these seeds. Thus he explored a vast range of forms and colours without adhering to either side of the abstract *versus* figurative divide which had become explicit from the very start, and established what he called his generative process as an increasingly influential principle in modern art.

Similarly the sculptor *Brancusi, working in Paris, had made much simplified figurative sculpture that spoke of stone and chisels as well as of humanity and had gone on to use simplified forms, as of birds and fishes, to develop a sophisticated three-dimensional art that belonged to nature more than to technology but spoke eloquently of the timeless shaping spirit of humanity. *Arp made paintings and sculpture that also, though in a more playful spirit, look abstract while feeling natural. *Mondrian, the most persuasive and enduring of the great pioneers of abstraction, working in a geometrical manner, cared little for geometry or the forms of machinery as such, but patiently developed his style as a counter statement to civilization's confusion and emotionalism: the issue for him was one not of forms and colours but of the relationship of these to each other and to the surface on which they are displayed.

As all expectation of even a vestige of representation fades from art, it becomes possible to speak of a picture or sculpture as an object existing in its own right, a human invention; though it seems likely that the choices involved in producing such objects will always reflect values implanted in us by the forms of the world around us. Turning to mathematical forms and to such devices as random numbers can serve to reduce this influence, and in 1930 Van Doesburg initiated the term *concrete art for such wholly abstract work. Max *Bill adopted the term for exhibitions he organized during and after the Second World War, and was himself an outstanding concrete artist, together with another Swiss, Richard *Lohse.

Sculptors, inheriting a long tradition of an art dealing almost exclusively with the human image, were slow to essay complete abstraction. Still-life sculptures were made from 1912 on by Picasso, *Boccioni, *Magnelli and others; constructivists assembled materials in abstract and quasi-abstract compositions from 1914, and from about 1920 these tended to be related to architectural rather than to natural forms. Surrealists, partly inspired by tribal sculpture, assembled strange objects with or without figurative connota-

tions. It was *Moore and *Hepworth, who, in the 1930s, made wholly abstract sculpture, he only intermittently, always drawn back to the figure, she more consistently, at first as almost geometrical solids that may have been inspired by Brancusi but were not abstracted from living forms, and then in larger wood carvings and bronzes that bore connotations of ancient standing stones and of the sea. At this time, *Calder, close to the Surrealists in Paris, began to make his *mobiles that may evoke nature (leaves in a breeze, fishes in water) but rarely imitate natural forms.

During the 1940s and 50s, *Abstract Expressionism emerged in the USA and also its European counterpart under various names including *Art informel. Both sprang from pre-war developments in geometrical and non-geometrical painting, drawing on earlier abstraction as well as on Surrealism, but insisting on personal modes of expression as opposed to Concrete art's impersonal voice, and requiring each artist to establish a hallmark idiom in a rule-less and apparently limitless field of production. Sculpture as well as painting took renewed energy from these movements, not least because of their reliance on the expressive potential of diverse materials. David *Smith and Anthony *Caro emerged as dominant figures in a new vein of abstract, constructed and coloured metal sculpture that exercised great influence and bore diverse fruit as younger sculptors brought in new materials (e.g. resin with glass fibre) and thus also new forms. A figurative element is sometimes discernible in post-war abstract art but was not its aim; the interesting point is that no guilt now attached to incorporating such references in work considered abstract. Since then the abstract/figurative opposition has become uninteresting and less noticeable, similarly the geometrical/free-form division within abstraction, as barriers have been transgressed or marriages across them have been entered into. *Conceptual art may deliver its ideas in abstract or figurative terms. When it employs emphatically real objects, as in the work of Damien *Hirst, it demonstrates that even the old assumption, that art must always involve a degree of abstraction, no longer holds.

Abstract Expressionism Most widely used name for a movement, in painting first and mainly, which emerged in New York from 1943 and became prominent in the 1950s. The name signals aims and processes rather than a style. Its progenitors' work was linked by an emphasis on the process as generating the work by externalizing feelings through action. There was otherwise no evident unison in the work of the painters that drew attention to the movement. *Pollock, *De Kooning, *Rothko, *Gottlieb, *Kline, *Still, *Newman and others explored paths suggested by European art, notably by *Surrealism and *Expressionism, sharpened by the presence in America of European artists such as *Ernst and *Miró and supported by New York's collections of European art, notably those of the Museum of Modern Art and the Museum of Non-Objective Art (now the Solomon R. Guggenheim Museum). The late canvases of *Monet, certain paintings of *Matisse, and especially the expressive *abstract work of *Kandinsky presented unexplored possibilities. Impulses to large-scale, rhetorical art came from the Mexican muralists, *Orozco especially. Further impetus came from the dominant role the Second World War gave to the USA and New York's awareness of European developments in psychology and philosophy, especially Existentialism, complemented in some cases by an answering input from Eastern thought such as Zen Buddhism. The movement in time acquired something like national backing. Lavish exhibitions and publications, financed by public and private patronage, gave the New American Painting (as it was sometimes called) a dominant place in western art in the 1950s and 60s. The paintings of Pollock, in particular, suggested that Kandinsky's art had been directed to Surrealist ends of deep self-reflection. There was talk of Abstract Surrealism, of art as self-exploration, profound enough to contact the archetypal imagery described by the psychologist Jung. The large scale on which Pollock and others worked demanded exceptional physical activity and this was at times seen as central, with the painting surface as the arena within which the artist performs. The

term Action Painting drew attention to this. Pollock's mid-1940s paintings were generally made by dripping and trickling paint on to canvas spread out on the floor. Pools and waving lines of paint hint at space and time and present extremes of openness and closure. Photographs of him thus at work were received as a declaration of the new art's essence.

This remained in dispute though its meaning was soon established: it was venturing into the unknown, in art and within oneself, and thus resisting the loss of individuality forced by mass society yet connecting with humanity at basic levels. Success related to finding a process leading to an identifiable result. Pollock became famous for his skeins of paint, Kline for broad, calligraphic brushstrokes, Rothko for suave veils of colour hovering mysteriously on vertical canvases, Still for opaque surfaces with torn edges that revealed contrasting colours behind them, Gottlieb for juxtaposed explosive and rounded forms, etc. On the West Coast *Tobey painted with lines of (typically) white paint that looked like abstract writing and hinted at the East. Thus the new art transcended the technical as well as the stylistic limits of western art.

In sending this art out to big international events and as grand touring exhibitions, promoting it verbally as a matter of national pride, and then also finding a positive response to it abroad, America celebrated a form of world ascendancy. A well-known history of the movement, by Irving Sandler (1970), was entitled The Triumph of American Painting. Reactions against it, attempted by a younger generation from the late 1950s on (notably *Johns, *Rauschenberg and then the *Pop artists), were at first received as violence against an elevated art. Similarly, individual efforts among prominent Abstract Expressionists, tiring of the movement's rhetoric, to reclaim freedom of expression attracted fierce criticism, as in the cases of De Kooning and *Guston.

Abstraction-Création Multinational group formed in Paris in 1931 by Jean *Helion, August *Herbin and Georges *Vantongerloo and others, in succession to

*Cercle et Carré, to promote a wide range of *abstract art at a time when governments in Germany, Italy and Russia were suppressing it. The group organized exhibitions and published an annual magazine from 1932 to 1936.

Academy By the late 18th century, many European artists perfected their training in specialized art schools – academies – the majority of which were subsidized by governments and held a monopoly of public exhibitions of art (the London Royal Academy was a notable exception). The academies superseded, but did not entirely replace, the earlier system of craft training through apprenticeship to a master licensed by a guild.

Typically, academic art training was founded on *classicizing theories of art. Perhaps the clearest exposition of these are the Discourses of Sir Joshua *Reynolds, the first President of the London Royal Academy (1769–90). In practice, students began with drawing: first from prints or drawings after ancient Graeco–Roman sculpture or the works of Italian *Renaissance masters such as *Michelangelo and *Raphael; later, after plaster casts or originals of antique statuary, and finally from specially posed nude life models. Only after several years' training in drawing were students allowed to paint, that is, to use colour. The academies enforced a rigid hierarchy of the *genres, allotting prizes, such as scholarships for study in Italy, only to those who proved themselves in the 'highest' genre, *History painting. These provisions caused much discontent among practising artists, and are basic to the revolts which undermined the academies almost from their inception.

The first academies, however, were not of this kind. So-called after the original location of Plato's school of philosophy in ancient Athens, the earliest modern academies date from the revival of Platonism in 15th-century Italy. They consisted of small debating societies meeting to discuss philosophical topics. The most influential of them was sponsored by Lorenzo de'*Medici in the 1470s. By 1600, academies of various disciplines had proliferated throughout Italy and even north of the Alps. The word

'academy' was also used as a Latin synonym for the vernacular 'university'.

Despite several engravings, by or after *Leonardo da Vinci, bearing the inscription *Academia Leonardi Vinci*, there is no evidence that Leonardo founded an academy of art – although he may have given his name to a scientific academy. It is difficult to date or place precisely the first art academies (Florence in the 1490s? Rome *c*.1530?), but it is probable that they, too, began as informal discussion and drawing groups, whether in connection with Lorenzo de'Medici's collection of ancient sculpture, in the studio of the sculptor Baccio *Bandinelli, or elsewhere.

The first modern art academy – one which was both sponsored by a ruler and undertook to educate young artists – was the Accademia del *Disegno founded in Florence in 1562 by the artist-courtier Giorgio *Vasari under the aegis of the Grand Duke Cosimo I de'Medici. Its foundation was facilitated by the fact that in Florence sculptors and painters did not belong to the same guilds, and were not in the majority within the guilds to which they belonged. A benevolent society or confraternity of artists, the Company of St Luke, already existed, probably since the 14th century.

By claiming for painting and sculpture a common source in theory (*disegno*), the Florence academy strove to gain for the visual arts the standing of a liberal art such as poetry, to differentiate artists from craftsmen and to enlist them in the ranks of the professions. All later art academies have been motivated by a similar desire to raise the status of artists. For his part, the newly invested Grand Duke Cosimo sought to harness artistic production in Florence to legitimize and publicize his dynastic aspirations.

Similar factors played a part in the foundation of the second important Italian art academy, the Academy of St Luke in Rome, sponsored by the pope. After abortive beginnings, it was effectively initiated in 1593, under the presidency of the painter Federico *Zuccaro.

Because of opposition by more powerful local painters' guilds, the spread of art academies throughout Italy was slow.

Throughout the 17th century, in centres outside Florence and Rome, they retained the character of private study groups, admitting both professional artists and connoisseurs. A crucial development, however, was the importance accorded to drawing from life (including from unposed models), notably in the academy at Bologna instituted by the *Carracci.

Art academies of this unofficial type also migrated north of the Alps through artists returning home from Italy. The first seems to have been established in Haarlem by Karel van *Mander, 1583; the earliest in Germany by Joachim von *Sandrart, in 1674/5 at Nuremberg. The guilds, however, continued to legislate for the arts in the Netherlands until the second half of the 17th century, and in German states until the early 18th century.

The first official art academy in northern Europe was founded in Paris in 1648, through the efforts of the painter *Lebrun. Although its rules depended on those of the academies of Florence and Rome, the French Royal Academy, under the protection of Colbert, the minister of Louis XIV, far outstripped its Italian models in efficacy. It held a monopoly of hiring models for life-drawings, as well as of public exhibitions. It opened branches in provincial cities. It disbursed scholarships for study at the French Academy in Rome, and became the model for all the other royal and imperial academies of northern Europe, with the exception of the London Royal Academy, founded in 1768. Through its profitable exhibitions, this English institution, despite its royal charter, maintained both economic and political independence. A Polish academy was projected in the 1690s; the Berlin Academy was established in 1697; the Vienna Academy in 1705 (re-established 1726); that of St Petersburg in 1724; of Stockholm in 1735; at Copenhagen, 1738; at Madrid, 1752. Lesser academies were also founded in the 18th century throughout the German principalities, Italian and Swiss cities, and the municipalities of the Netherlands. The Royal Academy of Mexico was opened in 1785; the first official American Academy of the Fine Arts in Philadelphia in 1805.

Once the classical tradition academies were charged with upholding lost its centrality in the 19th century, academies were split by radical dissent and attempted reform and break-away groups (see *Secession) formed alternative structures. Those who defended the great tradition tended to debase it through repetition and by misapplying honoured formulae to mean occasions. Many compromised between upholding the ideals they represented and satisfying middle-brow tastes for commercial success.

Independent academies and art schools sprang up in many forms. An artist might set up a studio school for selected pupils, in imitation of the system used at the Ecoles des Beaux-Arts, the official art schools of France. Open studios were set up without masters, such as the Académie Suisse in Paris, set up by a former model, to provide a convivial workplace, or for particular groups as in the cases of the Académies Scandinave and Wassilief, used mostly by young Scandinavian and Russian artists. Among the best remembered schools were those where, inside or outside the official system, masters encouraged free development, as in the case of *Carrière's academy and *Moreau's studio in the Paris Ecole des Beaux Arts. Some later private academies became important to history, among them the Subjects of the Artists school set up in New York in 1948 by *Rothko, *Motherwell and others. Official academies survive, reformed to accommodate modern developments; in Russia, political change caused the closing of the imperial academy and its replacement with a new, equally official institute.

Rejecting the methods and principles imparted by systematic training seemed the essential step towards maturity for many a modern artist, but the 20th century saw the creation of art schools committed to modern aims and methods, often linked to modern design training. The most famous of these was the German *Bauhaus (1919–32). Today art is taught in a range of institutions, some of them within a national or local system, some within independent universities, many smaller ones private and associated with particular artists. As long as individualism and instinctive creation are accorded priority in art theory, some doubt must attach to the validity of art training. At the same time, the value of centres where aspiring artists can work and debate in a context of shared experience, information and facilities cannot be questioned.

Action Painting A term introduced into art writing by the American poet and critic Harold Rosenberg in his essay 'The American Action Painters', published in *Art News* (New York) in 1952. He did not name individual painters, but he was referring primarily to *Pollock, who was known to be painting on the floor, moving around his canvas and dribbling and splashing paint from a brush, stick or can, and *De Kooning, then painting his Woman series, who had been working on vertical canvases with or without a figurative theme but with energetic and often broad brushtrokes. Rosenberg wrote that some painters were now using the canvas 'as an arena in which to act', the work being a vestigial record of the action. The painter no longer approached his easel with an image in his mind; he went up to it with material in his hand to do something to that other material in front of him. The image would be the result of this encounter.'

'Action Painting' was at first widely used in discussions of what was also called *Abstract Expressionism, because it pointed to a dramatically new process when identified with Pollock's technique, and thus could be received as a recipe and a challenge. On both sides of the Atlantic, and also in Japan, painters sought additional ways of propelling paint on to surfaces and improvising marks with and in them. In so far as it involved emphatic, expressive marks, whether made with the brush or by some other means, the French term *Tachism was widely used for the parallel European phenomenon.

Adam, Lambert-Sigisbert (1700–59) and his brother **Nicolas-Sébastien** (1705–78) French neo-*Baroque sculptors, much influenced by the work of *Bernini which they studied whilst at the French *Academy in Rome, where Lambert-Sigisbert defeated *Bouchardon in the competition for the Trevi fountain.

Although this commission eventually went to an Italian architect, the elder Adam gained many others, including a relief for the Corsini chapel, St John Lateran. After their return to France the brothers mainly practised as a team employed by the court on large-scale decorative sculpture, of which the best-known is the *Neptune and Amphitrite* on the Bassin de Neptune, Versailles (other works St Cloud; Paris, Louvre; Versailles, chapel; St Petersburg, Hermitage). Less successful in portraiture, Lambert-Sigisbert executed a bust of *Louis XIV as Apollo* on speculation, but the work was rejected (terracotta version, London, V&A). Nicolas-Sébastien's outstanding independent work is the tomb of Queen Catharina Opalinska, 1749, Nancy, Notre-Dame de Bon Secours.

Natives of Lorraine, the Adams came from a long line of sculptors and bronze founders in Nancy. A third brother, **François-Gérard** (1710–61) became court sculptor to Frederick the Great at Potsdam. They were the maternal uncles of *Clodion.

Adami, Valerio (1935–) Italian painter associated with *Pop art. His work is remarkable for often nightmarish qualities. It combines elements of *abstract and *figurative art, presenting them in a plain, didactic manner suggestive of diagrams and comic strip.

Adler, Yankel (1895–1949) Polish painter who worked in Germany and Paris before emigrating to Britain in 1939 and settling in London in 1943. His style, a form of expressive *figurative art indebted to Picasso, was influential in the 1940s and 50s.

Aelst, Willem van (1627–c.83) Much-travelled, influential Dutch painter of flower pieces, whose asymmetric compositions and novel colour range anticipate *Rococo design. Born in Delft, he spent 1645–9 in France and later became court painter to Ferdinand II de'*Medici in Florence, returning to settle in Amsterdam in 1657. Two of his best-known followers are Rachel *Ruysch and Jan van *Huysum. There are works by him in The Hague, Mauritshuis; Karlsruhe, Kunstsammlungen; Oxford, Ashmolean; etc.

aerial perspective *See under* perspective.

Aeropittura An Italian art tendency, dedicated to celebrating mechanical flight (the term denotes air + painting), announced by a manifesto in 1929. It emerged under the aegis of *Marinetti and in the context of *Futurism, gaining some international standing through exhibitions in Paris (1932) and Berlin (1934). Dottori and Fillia were its best-known adherents. Marinetti's death (1944) precipitated its decline.

Aerts, Hendrick *See under* Steenwijk, Hendrick van.

Aertsen, Pieter (1508–75) Amsterdam painter, a member of the guild in Antwerp from 1535 to before 1557. He was a pioneer of independent *still life and *genre (e.g. *Farmer's Wife*, 1543, Lille, Musée; *Peasants' Feast*, 1550, Vienna, Kunsthistorisches; *Farmer's Table*, Antwerp, Mayer van den Bergh; *Egg-Dance*, 1557, Amsterdam, Rijksmuseum; *Peasant's Kitchen*, Copenhagen, Museum; *Pancake Bakery*, c.1560, Rotterdam, Boijmans Van Beuningen). These paintings are the direct forerunners of the 17th-century kitchen and market scenes of the Flemish artists *Snyders and *Fyt, and the northern Italian Vincenzo *Campi and Bartolomeo *Passarotti. The pictures for which Aertsen is best remembered today, however, are works which are symbolic inversions of religious scenes. In these, monumental yet naturalistic (*see under* realism) secular elements are featured in the foreground, and the religious motif is relegated to a small area in the background. Thus the famous *Butcher's shop* (1551, Uppsala, University) virtually occludes the Flight into Egypt; the biblical story of *Jesus in the House of Martha and Mary* justifies the lavish display of foodstuffs and kitchen implements (Rotterdam, Boijmans Van Beuningen; Vienna, Kunsthistorisches). This 'inversion' of religious theme and genre influenced – through engraved

versions – the youthful *bodegónes* of *Velázquez.

Aertsen's numerous altarpieces were largely destroyed in Iconoclastic Riots (*see under* icon). Only fragments and smaller devotional panels have survived (e.g. Antwerp, Museum). Portraits by him are recorded, but none is known. His son, Pieter Pietersz. (*c.*1543–1603) continued to paint portraits and *history pictures.

Aertsen's Italianate modelling and brushwork, as well as his dramatic monumentality and sense of movement, even in still-life, anticipate the work of *Rubens. His nephew-in-law, Joachim Beuckelaer (*c.*1535–*c.*75) was trained by him and painted the same themes in much the same technique; some problems of attribution remain between the two artists. The best-known works attributable to Beuckelaer are in Cologne, Wallraf-Richartz; Brussels, Musées; Antwerp, Museum.

Affetti *See under* expression.

Afro (1912–76) Working name of Afro *Basaldella, Italian painter and brother of Mirko. He was one of the best-known Italian *abstract painters, winning the first prize for Italian painting at the Venice *Biennale in 1956 with his vigorous and colourful works.

Agam, Yaacov (1928–) Israeli artist who studied under *Ardon in Jerusalem and *Itten in Zurich, and settled in Paris in 1951. He developed a form of *kinetic art, reliefs whose *abstract forms appear to change as the viewer moves past them. He also experimented with adjustable sculptures and with light environments. In 1974 a major retrospective was shown in Paris, Düsseldorf, Amsterdam and Tel Aviv.

Agar, Eileen (1904–91) British artist, prominent among those who formed British *Surrealism in the mid-1930s. Her work is marked by a cheerfulness rare in the movement, and some of her best pieces are assembled objects or trophies.

Agostino di Duccio (1418–81) Sculptor who left Florence as a mercenary

soldier on his father's death in 1433 and was trained elsewhere. He worked mainly in Modena; Venice; Perugia; Bologna, and, above all, Rimini, where he executed some of the reliefs in the Tempio Malatestiano (*see* Matteo de'Pasti; Alberti; Piero della Francesca). In 1463 he returned to Florence, where he began to work on the gigantic block of marble later used by *Michelangelo for the *David*.

Agucchi, Monsignor Giovanni Battista (1570–1632) Bolognese cleric and art theoretician. As secretary to the papal nephew Cardinal Pietro *Aldobrandini (1592–1605), then as Secretary of State to the Bolognese Pope Gregory XV *Ludovisi (1621–1623), he was able to influence patronage in Rome. His influential *classical theory of art, the *Trattato della Pittura*, rejects both *Mannerism, based on an inborn idea of beauty in the artist's mind, as advocated by Federico *Zuccaro, and the uncritical naturalism attributed to *Caravaggio and his followers (*see also* realism, disegno), in favour of a selective approach by which nature is embellished and idealized (*see also* Idealization). Such an approach was exemplified, according to him, in the work of the Bolognese Annibale *Carracci and his pupils, notably Agucchi's friend *Domenichino.

Aikman, William (1682–1731) Distinguished, albeit monotonous, Scottish portrait painter. He was the son of the laird of Cairney, but he sold the family estate to travel abroad. He studied under *Medina, but later spent several years in Rome and visited Constantinople. After *Kneller's death in 1723 he migrated from Scotland to London, where he had connections in literary circles. He is reckoned, with *Richardson, to be the best portraitist of the generation following Kneller's. There are works by him in Edinburgh, Scottish NPG, and in many Scottish collections.

Aix Annunciation, Master of the (active *c.*1445) Now-unknown painter named after the *triptych of the *Annunciation* painted for St-Sauveur de la Madelaine,

Aix-en-Provence, commissioned in 1442 and completed in 1445 (central panel, Aix, St-Sauveur; right wing, Brussels, Musées; left wing, Rotterdam, Boijmans Van Beuningen and Amsterdam, Rijksmuseum). It is the earliest masterpiece of painting in Provence after the decline occasioned by the departure of the papal court from Avignon in 1377; the artist demonstrates a knowledge of Netherlandish painting (in particular *Campin) and of the Burgundian sculpture of *Sluter.

AKhRR Acronym formed of the initial letters of the Association of Artists of Revolutionary Russia, formed in 1922 to support *realism as the true idiom for Soviet art and to supply images of the birth and growth of the new state and celebrate the work of factories, shipyards, farms etc. AKhRR, in offering this alternative to modern tendencies, prepared the ground for the *Socialist Realism that became obligatory in 1932.

alabaster A fine-grained, easily worked stone, either an opaque or translucent form of gypsum, normally white, or a translucent calcite, which may be banded like marble. The Italian town of Volterra, in Tuscany, has long been a centre of alabaster carving; its museum Guarnacci contains a vast collection of Etruscan alabaster cinerary urns from the 6th to the 1st century BC. Extensive alabaster beds were also found in the English Midlands; from the late Middle Ages until the Reformation, small *retables carved from English alabaster were exported throughout Europe (London, V&A; Nottingham, Castle). The stone continued to be employed for funerary effigies until the 18th century, although by c.1600 the tomb-making industry had moved to the fringes of the City of London, and employed mainly immigrants from the Low Countries.

Albani, Francesco (1578–1660) Bolognese painter, a pupil first of *Calvaert, then of the *Carracci. He followed Annibale Carracci to Rome shortly after 1600, carrying out his designs for frescos in S. Giacomo degli Spagnuoli, 1602–7. In 1609

he painted decorative frescos in the Palazzo Giustiniani (now Odescalchi) and c.1616 in the Palazzo Verospi (now Credito Italiano) where his growing fascination with *Raphael is noticeable. In 1616 he returned to Bologna, where his lyrical and rather slight talent was at its best in representations of myth and allegory in landscape, of which the most notable is the series of the *Four Elements* (1626–8, Turin, Pinacoteca). In his later years he became increasingly involved in the theoretical defence of *Classicism.

Albers, Josef (1888–1976) German-American painter, trained in Berlin and Munich before he enrolled at the *Bauhaus in 1920. His chosen craft was stained glass. In 1925 he was one of the former students appointed to the Dessau faculty; he taught and worked in a range of design activities, including typography and furniture. His preferences matched perfectly the recommended Bauhaus style of the later 1920s for exact and succinct forms. In 1933 he took up a teaching post at *Black Mountain College, North Carolina, USA, remaining there until 1949 but giving courses also at Harvard University Graduate School of Design. From 1950 to 1958 he was chairman of Yale University Department of Architecture and Design. His glass panels and paintings were much exhibited in the USA from 1936 on. In 1956 he had a retrospective at Yale and in the 1960s his work was often seen on both sides of the Atlantic. His art and teaching were rooted in the analysis of space, form and colour as visual phenomena. He worked as an *Elementarist yet his exploration of the visual intricacies of line constructions and colour relationships, and hence his exploitations of the visual drama offered by the simplest arrangements, gave his work a personal, expressive note. The general aim of all his work was to awaken mankind's capacity to see intensely. It is brilliantly served by his linear lithographs and his famous series of paintings *Homage to the Square*, begun in 1950. *Interaction of Color* (1963) is a didactic demonstration of how colour experience is conditioned by context. He also wrote statements as succinct and pointed poems; their essential message is

that *constructive art and intuition are partners.

Alberti, Leon Battista (1404–72) Italian humanist; professional papal secretary, amateur antiquarian, architect and artist. His importance for the history of art resides primarily in his authorship of the influential treatise *On Painting* (Latin version, *De Pictura*, 1435; Italian version, *Della Pittura*, 1436), circulated in manuscript until the 16th century when it was first printed.

The illegitimate scion of a Florentine family in exile from their native city state, Alberti first entered Florence in 1434. *On Painting* prescribes artistic ideals which in effect record those of the Florentine New Style as evolved by *Donatello, *Masaccio, *Ghiberti and *Brunelleschi, to whom the Italian version is dedicated. Alberti describes *istoria* (*see under* genres) as the greatest work of the painter, and advocates a method of constructing single-vanishing-point *perspective. The treatise was almost certainly directly influential on *Leonardo da Vinci, and on certain non-Florentine artists, notably *Mantegna. The author was also acquainted with *Piero della Francesca, whose architectural backgrounds reflect Alberti's views on this subject, as advocated in the treatise *On Architecture* (*De re aedificatoria*, 1452), and demonstrated in a few buildings erected or restructured to Alberti's designs in Rimini, Florence and Mantua. A treatise in the Tuscan vernacular, *On the Family*, 1433–4, continued to be plagiarized until the mid-18th century and still makes excellent reading for anyone interested in the social thought of Renaissance Florence.

Albertinelli, Mariotto (1474–1515) Florentine painter, long-time associate of Fra *Bartolommeo and his business partner from 1509–12. They had both studied under Cosimo *Rosselli. Although generally influenced by Bartolommeo (e.g. *Visitation*, 1503, Florence, Uffizi), Albertinelli clung longer to a 15th-century style (*Crucifixion*, 1506, Val d'Ema, Charterhouse). Occasionally, however, he surpassed his friend in dramatic power (*Annunciation*, 1510, Florence, Accademia). Weary,

according to *Vasari, of the 'sophistry and brainrackings' of painting, Albertinelli 'retired for many months' in 1513 (not, as is often asserted, permanently) to run an inn. There are works by him in Rome, Borghese; Harewood House, Yorks; London, Courtauld.

Albright, Ivan Le Lorraine (1897–1983) American painter, trained first in architecture. During the First World War, in the army, he drew detailed medical illustrations. Later he studied painting at Nantes and in Chicago, Philadelphia and New York. His paintings reflect his skill as a meticulous draftsman turned to ends that go beyond reportage, developing a *realism of hypnotic power. Detail becomes dominant, oppressive. Some of his paintings express a claustrophobia associated with fear of death.

Aldegrever, Heinrich (1502–c.55) Accomplished German draftsman and engraver (*see under* intaglio), a brittle imitator of Dürer, specializing in tiny highly finished prints mainly of religious and *allegorical subjects.

Aldobrandini Italian family of Florentine origins. **Ippolito Aldobrandini** (1536–1605) was elected Pope in 1592, under the name of Clement VIII. Of the Pope's nephews, the most influential was Cardinal **Pietro Aldobrandini** (d.1621), owner of the ancient wall painting, the **Aldobrandini Wedding*, and patron of *Domenichino and Annibale *Carracci – probably through his secretary, *Agucchi. When Ferrara was taken over by Clement VIII in 1598, it was Cardinal Aldobrandini who – looting the *Este art treasures – brought back to Rome *Titian's *Worship of Venus*, *The Andrians* and *Bacchus and Ariadne*, which later helped to lay the foundations for a wholly new artistic style (*see for example* Poussin). Cardinal Pietro Aldobrandini's paintings were inherited by his brother, Cardinal **Ippolito Aldobrandini** (d.1638) and in turn by his niece, Olimpia, wife of Camillo *Pamphili, through whom many found their way into the Pamphili collection, now housed in the Galleria Doria-Pamphili, Rome.

Aldobrandini Wedding Ancient Roman wall painting depicting preparations for a wedding, it was discovered in Rome in 1605–6 and removed to the garden of Cardinal Pietro Aldobrandini's villa; in 1818 it was acquired for the Vatican Museum where it is now exhibited. It was the object of numerous copies, *engravings and commentaries, and influenced 17th-century *classicizing painters such as *Poussin.

Alechinsky, Pierre (1927–) Belgian painter, for a time a member of the *Cobra group. In 1951 he settled in Paris. About this time he developed an interest in Japanese calligraphy, travelled to the Far East and made a film on the subject. His paintings formed part of *Art informel yet were never wholly *abstract, incorporating *figurative references, sometimes mythical. In a movement inclined to solemnity his work stands out for its lively, at times witty, character.

Algardi, Alessandro (1598–1654) Sculptor born and trained in Bologna, mainly known for his activity in Rome (from 1625) where he became the only rival of Gian Lorenzo *Bernini. A more reticent, less *expressive sculptor than Bernini, he also lacked the latter's gifts as courtier and salesman. Nonetheless he was a highly original artist, combining lyricism, vitality and an unaffected naturalism (see under realism) in his portraits with elegance and fantasy in his decorative work; younger contemporaries preferred him to Bernini as a teacher. Overshadowed after his premature death by the long-lived *Baroque master, he regained influence with the *Neoclassical sculptors of the 18th century (e.g. Edmé *Bouchardon).

Since Bologna lacked natural sculpting stone, he spent his formative years modelling clay. This, and the influence on him of his first teacher, the painter Lodovico *Carracci, were responsible for his highly developed pictorial sense: he created the relief altarpiece, a pictorial sculptural type which was to become a major art form for the next hundred years. His immense relief of the *Encounter of St Leo the Great and Attila the Hun* for the altar of St Leo in St

Peter's, Vatican (1643–53) was unprecedented in scale and prominence of location, and, despite lacking dramatic tension, it remained for centuries the exemplar of a sculpted *istoria* (see under genres). His portrait busts, which span almost the length of Algardi's Roman career (e.g. Rome, various churches, Palazzo Odescalchi, Doria; Milan, Poldi Pezzoli; Berlin, Staatliche; Manchester, Gallery; St Petersburg, Hermitage; London, V&A; etc.) focus on individual physiognomy and personality rather than on social status. In contrast to Bernini's mature and late portraits, they are undemonstratively meditative. Yet Algardi, too, pioneered new bust types: one, unprecedented in a secular context, in which both hands are shown as the sitter turns the pages of a book (London, V&A); another, in which the sitter interrupts his reading of a prayer book to turn, hand on heart, to the altar of his funerary chapel (Rome, S. Maria del Popolo), inspired Bernini's more flamboyant bust of Gabriele Fonseca. And perhaps no contemporary sculptor rivalled Algardi's delicate touch in the carving of certain textural effects, such as the gauzy material of a widow's veil (e.g. Rome, Doria).

After the death of Lodovico Carracci in 1619 Algardi left Bologna and was employed by the Duke of Mantua to carve ivory and produce small models for metalwork. It is with such work, and with the restoration of antiques, that Algardi first earned his living in Rome (e.g. *Urn of St Ignatius Loyola*, 1629, Rome, Gesù; drawing, St Petersburg, Hermitage; supports for the Borghese Table, 1634, pc). In Mantua, Algardi also studied the decorative stucco work of *Primaticcio, which influenced his later ornamental stuccoes in the Villa Doria Pamphili, constructed under Algardi's direction largely as a showcase for decorative sculpture encasing antique reliefs and sarcophagus fronts (1645–6). Its owner, Prince Camillo *Pamphili, nephew of Pope Innocent X, was Algardi's most important patron after his uncle's accession in 1644.

Algardi's first public commission in Rome, obtained for him by *Domenichino, was for large stucco statues of saints for the Bandini chapel, S. Silvestro al Quirinale (1629). From the mid-1630s he received

commissions also for large-scale sculpture in marble: the tomb of Pope Leo XI (1634–40, Vatican, St Peter's); the altar group of the *Beheading of St Paul* (1634–44, Bologna, S. Paolo Maggiore) and a statue of *St Philip Neri with an Angel* (1635–8, Rome, S. Maria in Valicella, sacristy). But his position as the second foremost sculptor in Rome was not assured until the accession of Pope Innocent X and the temporary fall from favour of Bernini.

Algardi also executed the bronze statue of *Pope Innocent X* (1647–50, Rome, Palazzo dei Conservatori) which, despite an accident in the casting, rivals the painted portrait by *Velázquez; the fountain of St Damasus (1645–7, Vatican, courtyard of S. Damaso) now much damaged; and the high relief altar for Camillo Pamphili's church of S. Nicola da Tolentino (1651), which constitutes a critique of Bernini's altar of St Teresa in the Cornaro chapel. He probably also provided designs for the stucco reliefs in St John Lateran (*c*.1648).

Many small bronze and silver objects, figurated or purely ornamental, by or after Algardi may also be found in private and public collections. His moulds and models continued to be used after his death, and innumerable copies in gesso were made, as well as casts in wax for study by other sculptors.

Algarotti, Francesco (1712–64) Cosmopolitan and prolific Venetian writer on painting and other subjects, collector and art dealer. Through his friendships in Paris, London, Dresden and Berlin, and his purchases of Venetian paintings – on behalf of such clients as Frederick the Great of Prussia (from whom he received the title of Count) – he both assisted the spread of Venetian culture and influenced the practice of contemporary Venetian art. Although he was an early advocate of *Neoclassicism, he praised his friend, the great *Rococo painter *Tiepolo for his imagination, and assisted him with commissions, as he did most of the other leading painters of Venice (*see* e.g. *Piazzetta, *Pittoni, *Zuccarelli, *Carriera), choosing subjects most appropriate to the painter in question, and persuading *Canaletto to paint *capricci, which he

considered more dignified than the merely topographical *vedute, and for which he himself selected the buildings to be juxtaposed. Algarotti's treatises and correspondence are our most important sources of information on Venetian 18th-century artists, although – like most of his contemporaries – he mentions neither the *Guardi brothers nor Pietro *Longhi.

Alkmaar, Master of (active 1504 to *c*.1520) Unknown Dutch painter of the *Seven Works of Mercy*, dated 1504, from St Lawrence in Alkmaar, now in the Rijksmuseum, Amsterdam, in which Christ appears among the unfortunates who receive charity in carefully detailed scenes of contemporary urban life. He is sometimes identified with Cornelis Buys, recorded as a painter in Alkmaar between 1516 and 1519, and the brother, according to Van *Mander, of Jacob van *Oostsanen.

all'antica (Italian, in the ancient mode) A term used most often with reference to works of *Renaissance art, to signify dependence on motifs or stylistic elements derived from the art of Graeco–Roman antiquity: '*all'antica* ornament', 'nudity *all'antica*', etc. It is not precisely synonymous with *classical or classicizing: it does not differentiate between periods of ancient art and aesthetic ideals; an image *all'antica* may depict archeological motifs in a non-classical style. Alternatively, a classicizing image may include few, or no, *all'antica* motifs.

alla prima (Italian, from *prima*, first, early) A method, practicable only in oils, of painting directly on the support without elaborate preliminary studies to establish composition, pose, tonality. Changes are incorporated into the paint layers, and are revealed through x-rays. As the top layers become translucent with age, such changes may become visible to the naked eye (*pentimenti*). Painting *alla prima* tends to preclude learned perspectival representations or other sophisticated compositions; it generally implies dependence on the model, and relies for its effects on subtle adjustments of colour areas and/or spontaneity of colour application.

Allegory A *genre equally important
in literature and the visual arts. The word
is adapted from a Greek and Latin root
meaning 'speaking otherwise than one
seems to speak'. Probably the greatest stim-
ulus to the use of allegory in the visual arts
is the fact that Indo-European languages
do not distinguish, in gender, declension
etc., the words for abstract notions from
other nouns. This linguistic characteristic
favours *personification*, as when we say that
'time flies', 'love is blind', 'the cruel hand
of fate'. Visual allegory, however, also relies
on *simile*, as in someone 'being steady as a
rock', and *metaphor*, as in 'the ship of state'.
Because of its close relationship to
language, allegory, like *history painting, is
one of the prime means through which
artists, in their perennial struggle to raise
themselves above craftsmen and other pur-
veyors of luxury goods, have claimed parity
with poets, scholars and orators – learned
professionals who stir the hearts and minds
of others to some higher purpose. It is used
to expand and enrich the significance of
the 'lower' genres, especially portraits
(precisely through the use of such attrib-
utes as 'steady' rocks and 'clinging' ivy),
but also landscape and still life. Much of
the imagery of allegory has drawn on
ancient literature, notably Graeco-Roman
myth, often interpreted allegorically even
in antiquity, and the related but distinct
traditions of astrology. Thus Mercury,
the swift messenger of the gods, can also
appear in his role of planetary protector of
scholars, merchants or artisans; Venus,
goddess of love and beauty, can signify
lust or, conversely, a humanizing and
civilizing influence. Other allegorical
figures frequently found in art are drawn
from ancient history – ancient rulers or
heroes may exemplify magnanimity, justice,
loyal heroism or clemency on the basis, for
instance, of anecdotes narrated by the 1st-
century Greek biographer Plutarch – the
Bible, or post-antique literature, such as
Petrarch's allegorical poems, the *Triumphs*
of 1304–74. While the appearance or iden-
tity of many personifications and exem-
plars, notably those of the virtues and vices,
the liberal arts, the seasons or months of
the year, was codified in the Middle Ages,
numerous others were added in the Renais-

sance when more ancient texts were redis-
covered and studied. Personifications of
cities, nation states, empires and continents
were also devised or standardized for use in
overtly political contexts – perhaps the only
form of allegorical imagery still flourishing.
By the end of the 16th century a number
of handbooks describing the appearance
and attributes of abstract notions of all
kinds had been compiled specifically for the
use of artists. The most important, Ripa's
Iconologia of 1593, many times amplified,
translated and republished, remained in
use throughout the 18th century. Although
persuasive allegorical works continued to
be produced in this period, by the Venetian
decorative history painter *Tiepolo, for
example, many artists of the second rank
prided themselves on inventing new
personifications, or combining old ones in
new ways, expending much ingenuity on
pictures whose messages, when decoded,
proved conventional or banal: 'Truth is the
Daughter of Time', 'Time and Old Age
destroy Beauty'.

Despite the beauty and vividness of the
many medieval and Renaissance allegorical
works in painting and sculpture, and
the vigour of late examples such as
*Delacroix's *Greece on the Ruins of Misso-
longhi* of 1826 or *Liberty Leading the People*
of 1830, or even *Picasso's 1936 *Guernica* –
as much personally devised allegory as
history painting – the greatest age of alle-
gory is surely the 17th century. In the mag-
nificent decorative ensembles and single
works of *Rubens, *Pietro da Cortona,
*Bernini and their contemporaries, viewers
could see flesh-and-blood personifications
and pagan deities walk the earth or soar the
skies, breathing the same air and bathed by
the same light as saints, monarchs and
people rather like ourselves, ennobled
by their presence. Although Dutch moral-
izing genre of the same period, in the work
of *Jan Steen for example, may not be
strictly speaking allegory, it shares many of
its intentions and devices.

The decline of allegory, at least in its
overt form, in our own time has many and
complex causes, but must be related to the
general decline of *Classical education,
and the prevalent view that literary values
are inimical to the visual arts. It persists,

however, in the applied arts of stamps, coins and medals, and in marketing: many company emblems employ, or refer to, allegorical figures, including those borrowed from pagan mythology.

Allegri, Antonio *See* Correggio, Antonio Allegri.

Allori, Alessandro (1535–1607) and his son **Cristofano** (1577–1621) – also called *Bronzino after his father's uncle and teacher – were Florentine painters. Alessandro was a *Mannerist who combined the influence of Bronzino with that of *Michelangelo, whose work he studied in Rome in the late 1550s (Florence, Palazzo Vecchio, S. Maria Novella, SS. Annunziata; Rome, Doria; etc.). Cristofano reacted against his father's style, siding with the 'reformist' painters *Santi di Tito and *Cigoli to evolve a more painterly and *naturalistic idiom. He was a striking portraitist (e.g. Oxford, Ashmolean) and his ability to represent subtle and complex emotional states is exemplified in his celebrated *Judith with the Head of Holofernes* (1613, Coll. HM the Queen; later version, Florence, Pitti), long considered to be the masterpiece of Florentine 17th-century art. There are other works by him in Florence, Pitti, Casa Buonarotti; Pistoia, S. Domenico; Belfast, Museum; etc.

Alma-Tadema, Lawrence (1836–1912) Dutch-born British painter. He was trained in Belgium and came to England in 1865 when his detailed, archeologically exact and entirely pleasurable scenes of society life among the ancient Romans proved to find a ready market. Where others felt they had to impress the world with their high-minded *History paintings, he offered *genre scenes making no intellectual demands, working them with great compositional skill and delicacy of tone and surface. He was rewarded for his success with a knighthood and the highest honour the British monarch can bestow, the Order of Merit.

altarpiece A painting or relief (or a combination of the two) set above and

behind the altar table. Its original purpose was to provide a backdrop for the elevation of the Eucharist during mass, introduced into the liturgy in 1215, when the Lateran Council decreed that Christ is physically present in the consecrated Host and wine (doctrine of transubstantiation). All altarpieces by definition include eucharistic imagery referring to Christ's saving body. They may also depict the patron saint or saints of the person, family or institution who commissioned them; the saint to whom the altar is dedicated, and the titular saint of the church in which it is situated; regional or national patron saints; portraits or heraldic emblems of the donors, and references to particular circumstances which led to their being commissioned. *See also* dossal, retable, polyptych, sacra conversazione.

Altdorfer, Albrecht (*c*.1480–1538) Painter and printmaker, perhaps trained as an illuminator by his (probable) father Ulrich Altdorfer. He was the most consistent exponent of the *'Danube school' style, whose main characteristics are the importance of landscape as an *expressive element even in religious scenes, and a poetic feeling for nature (*see also* Jörg Breu, Lucas Cranach, Wolf Huber).

His work is rooted in the calligraphic ornament of Late *Gothic, and in its *naturalism and emotionality. Although he borrowed motifs from Venetian and other Italian art, he remained indifferent to the *classicism of the Italian *Renaissance and to the new pictorial problems of *perspective, proportion and anatomical correctness (in contrast to his contemporary, *Dürer). The drawings, prints and paintings of the Danube school, and of Altdorfer in particular, provided German-speaking humanists with an attractive alternative to Italianate rationality: a supposed revival of the pantheistic native sensibilities of ancient Germanic tribes.

Most of Altdorfer's life was spent in Regensburg, where he achieved both financial success and influence. He was on the town council in 1519 when the entire Jewish community of nearly 600 was expelled within four days, and the syna-

gogue demolished – an event which Altdorfer celebrated (as the inscriptions make plain) with two etchings of the building's porch and interior. He was also a prime mover of the profitable cult of an image of the Virgin which was promoted on the site, designing the cult badge, painting the banner, and making several woodcuts relating to the pilgrimage. He was still a council member – having refused an invitation to become mayor – when the city adopted Lutheranism in 1533.

His earliest known works are drawings and prints, and the early paintings, such as the first dated picture, the *Satyr Family* of 1507 (Berlin, Staatliche), are small in scale. Natural forms provide the dramatic content, the human figure virtually submerged in luxuriant northern forest vegetation (e.g. *St George in a Wood*, 1510, Munich, Alte Pinakothek) or dramatic light effects (*Nativity*, c.1515, Berlin, Staatliche). At this time Altdorfer also produced independent drawings, intended for collectors.

From c.1510 he began to receive commissions for altarpieces, adopting a somewhat larger scale and more monumental figure style, although natural forms still dominate. The major works of this type were executed from c.1518 for the monastery of St Florian near Linz; there are also panels from a dismembered altarpiece of c.1520 in Florence, Uffizi, and Nuremberg, Museum. He continued, however, to paint *cabinet pictures, including pure landscapes with no human figures, and landscapes with architectural fantasies, of which details were derived from engravings after the Italian architect *Bramante (*Danube Landscape*, c.1522–5; *Susannah in the Bath*, 1526; both Munich, Alte Pinakothek). Altdorfer's most celebrated painting, the *Victory of Alexander over Darius* (1529, Munich, Alte Pinakothek), was a commission from Duke Wilhelm IV of Bavaria, one of a series of famous battles which also comprised pictures by Hans *Burgkmair and Jörg *Breu the Elder. On a panel less than 1.5 m tall, it is one of the most grandiose compositions in Western art. The impossibly high and distant viewpoint suggests that the battle is seen as only God and eternity could view it.

Erhard Altdorfer (recorded 1506–61) was his brother's pupil but may also have been influenced by the other masters of the Danube style c.1500, Lucas Cranach and Jörg Breu. Although he never achieved Albrecht's greatness, he became, in 1512, court painter and architect to the Duke of Mecklenburg at Schwerin, where he is documented until 1561. He made 85 woodcuts for the Lower German Bible printed at Lübeck in 1533.

Altichiero (recorded between 1369 and 1384) Italian painter, probably from Zevio near Verona. He introduced the International *Gothic style to Verona (Palazzo del Governo; S. Anastasia), but is best known for his *frescos in Padua (Basilica di S. Antonio, Chapel of S. Felice, completed 1379, and – in collaboration with the otherwise-unknown Paduan artist Avanzo – Oratory of S. Giorgio, c.1377–84). Altichiero's Paduan works are the first major development anywhere in Italy of the *realism of *Giotto.

Altman, Nathan (1889–1970) Russian painter. He studied in Odessa and during 1907–12 in Paris at the *Académie Wassilief. Back in Russia he joined the Union of Youth society. After the Revolution he taught in Petrograd's new Free Studios and was a member of the art board of the Commissariat of Enlightenment. In 1918 he decorated Uritsky Square in Petrograd for the first anniversary of the Revolution, cladding the lower part of Alexander's Column with large *Suprematist shapes. His paintings of the time have the same declaratory character: *Lissitzky called them 'poster paintings'. In 1921 he designed the décor for Mayakovsky's play *Mystery-bouffe*. Apart from a second period in Paris, 1929–35, Altman remained in Petrograd/Leningrad for the rest of his life.

Altobello Melone (active c.1508–35) Italian painter, perhaps a pupil of *Romanino. From 1517 he continued the *fresco series in Cremona cathedral begun

by Boccaccio *Boccaccino, and influenced those painted from 1519 by Romanino himself. His style is highly expressive (*see* expression), borrowing lyrical Venetian elements from Giovanni *Bellini but also a spikier and more calligraphic approach influenced by the prints of *Dürer. There are easel paintings by him in Milan, Brera; London, National; Washington, National; etc.

Alvarez y Cubero, José (1768–1827) Spanish sculptor who worked mostly in Rome where he became *Canova's disciple and friend, adopting his *Neoclassical style and principles so wholeheartedly that he is sometimes called 'the Spanish Canova'. Spanish sculptors adopted Neoclassicism for some time thanks to his example, and in 1826 he was appointed director of the Madrid *Academy.

Amadeo, Giovanni Antonio (1447– 1522) The leading Lombard sculptor, architect and engineer of the second half of the 15th century. The architectural and sculptural style for which he is best known, relying on brilliant *polychromy, a profusion of decorative carving, and formed through contact with the International *Gothic sculpture of Milan and his native Pavia, is best exemplified on the façade and the tombs of the Colleoni chapel, Bergamo, executed during 1470–6. Here he introduced *classical motifs within a mannered Gothic whole. He worked originally as a modeller of terracotta, later as a marble carver in the cloisters of the Charterhouse at Pavia (1466–70). In 1474 he undertook joint responsibility for the façade of the charterhouse, and for a series of tombs for Cremona cathedral (1481–4). Around 1500 his style underwent yet a further change under the impact of Gian Cristoforo *Romano's classicism. The new manner is evident in Amadeo's harmonious *Tomb of S. Lanfranco* (S. Lanfranco outside Pavia) and in a relief for the Carmine, Pavia. In the last 20 years of his life Amadeo was mainly active as an architect and engineer on the cathedrals of Pavia and Milan, having resigned his directorship of the Charter-

house façade sculpture in 1499, in favour of Benedetto *Briosco.

Aman-Jean, Edmond (1860–1936) French painter who in the 1880s shared *Seurat's studio but was himself a *Symbolist. In 1884 he helped *Puvis de Chavannes execute his large painting *The Sacred Grove*. His own work included portraits of Symbolist writers he knew well, such as Mallarmé and Verlaine, but is characterized by suave pictures of pensive young women, stimulated by *Pre-Raphaelitism. Visits to Italy, partly for health reasons, led him to brighten his colours and to paint in a manner closer to *Bonnard's.

Amberger, Christoph (*c.*1505–61/2) A pupil of Hans *Burgkmair, Amberger was an outstanding portrait painter in Augsburg, the most cosmopolitan German city of the Renaissance and a dissemination point for Italianate artistic ideals. Even before his meeting with *Titian in 1548, his works demonstrate Venetian influences (Birmingham, Barber; Berlin, Staatliche, Museen; Brunswick, Herzog Anton Ulrich; Stuttgart, Staatsgalerie; Vienna, Kunsthistorisches).

Ambrogio, Giovanni, Evangelista and **Cristoforo** *See* under Predis.

American Abstract Artists, A.A.A. An association of *abstract artists active mainly in New York, though not all were of American nationality. It was formed in 1936 to provide a link between abstract artists, to show their work and to lead the public to an understanding of it. Some members belonged also to the *Abstraction-Création group of Paris. As emigration brought leading artists from Europe, the group became even more international and more significant. Early members included *Albers, *Reinhardt, *De Kooning, David *Smith and *Lassaw. With the rise of *Abstract Expressionism, the A.A.A.'s work was done, but it lived on as a group and grew substantially in the 1950s.

Amigoni, Jacopo (1682–1752) Born in Naples and already schooled in the

manner of *Solimena upon his arrival in Venice, Amigoni is nonetheless classed as a Venetian painter. The main influences on him are Luca *Giordano and Sebastiano *Ricci. Like them, he became a peripatetic artist, spending 10 years in Bavaria (1717–27), where his fresco cycles at Schleissheim, Nymphenburg and Ottobeuren influenced Bavarian *Rococo, and the next 10 (1729–39) in England; his best surviving decorative work is at Moor Park, where he succeeded *Thornhill. In England he was forced to diversify into portraiture, which he enlivened through luminous colour schemes and the introduction of playful *putti. During 1740–7 he was once again in Venice, painting mainly mythological scenes for the private market. In 1747 he left Italy for ever, to become Court Painter in Madrid. His late style degenerated into a rather lifeless, *classicizing form of *Rococo.

Amman, Jost (1539–91) Swiss printmaker; he settled in Nuremberg in 1561, where he became the most prolific book illustrator of his time. His woodcuts and engravings (*see under* relief, intaglio prints respectively) are more important as historical documents than as works of art; the *Panoplia, or Book of Trades* of 1568, for example, is a major source of knowledge of the procedures of 16th-century northern European crafts, including of course printmaking itself.

Ammanati, Bartolomeo (1511–92) Outstanding Tuscan-born *Mannerist sculptor and architect, active in Florence, Urbino, Venice – where he was strongly influenced by Jacopo *Sansovino – Padua and Rome. At the end of his life he was much affected by the Counter-Reformatory ideas of the Jesuits, and in two famous letters, one to the Florentine *Academy (1582) and one to the Grand-Duke Ferdinand I de'*Medici (c.1590), he pleaded against the representation of the nude and begged that those already extant in Florence, whether by himself or others, be covered up or removed. His best-known works as a sculptor are the Del Monte monuments in Rome, S. Pietro in Montorio (1550–3), begun originally under the

direction of *Vasari and with the advice of *Michelangelo, and the Fountain of Neptune on the Piazza della Signoria, Florence (1560–75; *see also* Montorsoli).

amorino, pl. *amorini* *See under putto.*

Amsterdam Cabinet, Master of the *See* Housebook Master.

Anamorphic, anamorphosis A type of *perspective in which the viewpoint is placed far outside the image to the side. Viewed from the front in the normal way, the motif is so elongated as to be unrecognizable; it is visible only when viewed from the side of the image or reflected on a metal cylinder. The principle of anamorphic design was first exemplified in a woodcut of c.1531–4 by Erhard Schön. It was used by Hans *Holbein the Younger for a distorted skull in his portrait of *The Ambassadors* (1533, London, National). The anonymous portrait of *Edward VI* (1546, London, NPG) is also an anamorphosis.

Ancheta, Juan de (c.1530–88) Basque sculptor, influenced by *Michelangelo. He is thought to have studied in Italy, although in Spain he was the best pupil of *Juni. His most successful altar is at Jaca Cathedral, 1575–8.

Andachtsbild (pl. *andachtsbilder*; German, devotional image) A small-scale religious image for private devotion, intended to arouse meditation. The term is most frequently applied to the intimate and *expressive half-length portrait *icons produced in northern Europe in the late Middle Ages, sometimes as symbolic representations of mysteries of the Christian faith. Thus the figure of Christ as the Man of Sorrows, abstracted from the narrative of the Passion, symbolizes the mystery of the Eucharist.

Andre, Carl (1935–) American sculptor whose early work showed the influence of *Brancusi. Working for the Pennsylvania Railroad planted the idea of using standard elements which led to such works as the row of 139 firebricks shown at the 'Primary Structures' exhibition in New

York in 1966. A smaller group of bricks, bought in 1972 by the Tate Gallery in London, served as a pretext for an art scandal in the British press. Since the 1960s Andre has exhibited all over the western world; his work is associated with the idea of exploring propositions inherent in repeating a chosen seminal element.

Andrea da Firenze, Andrea Bonaiuti

(active c.1343–77) Florentine painter, famous for the *fresco decoration of the chapter house of the Dominican friary of S. Maria Novella in Florence, begun in 1365. It is the most complete visual statement of Dominican doctrine, and the boldest assertion of the primacy of the Dominican Order and its saints – Thomas Aquinas and Peter Martyr in particular – in upholding the Church and showing the way to Salvation. The intellectual and abstract nature of the decoration is made clear in its schematic composition, arbitrary changes of scale and an extensive use of *allegory. *Realism is, however, deployed in vivid details, such as the piebald 'dogs of the Lord', the *domini canes* or Dominicans, hounding the wolves of heresy. The Universal Church is symbolized through an image of Florence cathedral, complete with the huge dome projected in 1368 but not built until 1436, under *Brunelleschi. Since 1540, when Eleonora di Toledo, wife of Cosimo de'Medici, chose it for the church of her Spanish entourage, the chapter house has been known, confusingly, as the Spanish Chapel.

Andrea del Castagno (c.1419–57)

Precocious and influential Florentine painter from the mountain village of Castagno. An outstanding draftsman, he was praised by contemporaries and also *Vasari for his *expressive line and his mastery of relief and *perspective, specifically *foreshortenings of human figures rather than the depiction of deep space. Vasari's accusation that Castagno murdered his friend *Domenico Veneziano has been disproved: the latter survived him by some years.

Possibly trained by an itinerant follower of *Masaccio, Andrea moved to Florence c.1437–8. His first metropolitan commission (destroyed) to paint the conspirators in the Albizzi rebellion hanging by one leg on the façade of the Bargello – a work which earned him the unwelcome nickname of *Andrea* (or *Andreino*, 'little Andrew') *degli Impicchati*, 'of the hanged men'. He executed his first surviving dated work 1442–4, the *frescos of the apse vault, Venice, S. Zaccaria, S. Tarasio chapel, whose standing saints show his study of *Donatello's prophets on the bell tower of Florence cathedral. By 1444 he had also furnished designs for the mosaic of the *Death of the Virgin* for the Mascoli chapel, S. Marco, which was to influence *Mantegna. Back in Florence in the same year, he designed one of the circular stained-glass windows in the drum of the cathedral dome (*Lamentation*); his only *sacra conversazione*, the *Madonna di Casa Pazzi*, (Florence, Pitti) also dates from c.1444. Its colour is indebted to Domenico Veneziano, working at about this time on the important, now lost, fresco cycle of the *Life of the Virgin* in S. Egidio at the hospital of S. Maria Nuova, which was completed by Andrea in 1451–3 with the scene of the *Death of the Virgin* (also lost). Andrea's most mature surviving ensemble, *The Last Supper*, with, above, the *Resurrection*, *Crucifixion* and *Entombment*, was executed in 1447 in the then-refectory of the convent of S. Apollonia, Florence. In 1449–51 Andrea decorated a room in the Villa Carducci outside Florence with a series of *Famous Men and Women* (detached frescos, now Florence, Uffizi), single figures from Florentine and world history, painted as if standing in shallow niches seen from below. The *Assumption* of 1449–50 for the Florentine church of S. Miniato fra le Torri is now in Berlin, Staatliche. Two chapels in SS. Annunziata, newly remodelled by *Michelozzo, were furnished with *fresco altarpieces by Andrea c.1453: *St Julian with the Saviour* (Da Gagliani chapel) and the famous *Trinity with Sts Jerome, Paula and Eustochium* (Corboli chapel) with its drastically foreshortened crucified Christ, whose awkward lower limbs were later concealed by the artist with flaming seraphim painted *a secco* (*see* secco). In 1454 Andrea was probably in Rome, designing and perhaps executing some of the illusionistic archi-

tectonic decoration of the Bibliotheca Graeca in the Vatican. His last work, the equestrian monument in fresco of Nicolò da Tolentino, emulating that of Hawkwood by *Uccello, was painted in Florence cathedral in 1456; the wiry and energetic figure in fictive marble demonstrates the abiding influence of Donatello. In addition to newly uncovered *sinopie* (*see under* fresco) there are drawings by Andrea in e.g. Düsseldorf, Kunstmuseum; Vienna, Albertina; Cambridge, MA, Fogg.

Andrea del Sarto (1486–1530) The leading painter in Florence from *c.*1510. Influenced by Fra *Bartolommeo (whom he displaced in importance both as executant and teacher), *Leonardo, *Michelangelo, *Raphael, contemporary Northern prints (*Dürer, Lucas van *Leyden), and by 15th-century Florentine tradition, he evolved a complex but harmonious individual style combining firm draftsmanship with energetic and *expressive colour, naturalism (*see under* realism) with *idealization, spontaneity and sketchiness of brushwork side by side with a high finish. He rethought the work of Leonardo, adapting the latter's *sfumato* and complexities of pose whilst rejecting his monochrome *chiaroscuro for a form of chromatic modelling (*see under* colour). Just as his colour range is warmer and more varied than Leonardo's, so the address of his painted figures to the viewer is more direct and less enigmatic, albeit almost equally poetic. A measure of Andrea's success is that he was both a principal source of the development of Florentine *Mannerism (*see* Pontormo, Rosso) and an inspiration to the anti-Mannerist reformers at the end of the century (*see* e.g. Cristofano Allori, Santi di Tito). He is among the most copied of Tuscan artists.

The son of a tailor, he was first apprenticed to a goldsmith, then trained as a painter under *Piero di Cosimo and **Raffaellino del Garbo** (1466–1524). His earliest important independent works were *frescos painted in the entrance cloister of SS. Annunziata, four scenes from the *Life of S. Filippo Benizzi*, 1509–10; *Procession of the Magi*, 1511; *Birth of the Virgin*, 1513–14. This last, Andrea's first mature statement,

is a critique in 16th-century idiom of *Ghirlandaio's treatment of the subject in S. Maria Novella (*c.*1485–90).

Also begun in 1514 but worked on at intervals until 1526 was a series of frescos in *grisaille in the Chiostro dello Scalzo. Two scenes were painted during Andrea's absence in 1518–19 by *Franciabigio. The subject of the series is the life of St John. Despite their pale monochrome, which varies from a golden warmth to cooler greener hues, the scenes are vibrant with light and colour, and are among the most important High *Renaissance works in Florence.

Other outstanding frescos by Andrea are the unfinished *Tribute to Caesar* (*c.*1521), completed in 1582 by Alessandro Allori, which is part of the propagandistic Medicean decoration of the salone in the villa at Poggio a Caiano (*see also* Pontormo, Franciabigio); the *Madonna del Sacco* above a door of the Great Cloister of SS. Annunziata (1525), a famous composition which inspired a painting by *Poussin; and the less well-known, because for a long time inaccessible, *Last Supper* in the refectory of the ex-convent of S. Salvi (1526–7).

His most famous easel painting is the altarpiece of the *Madonna of the Harpies* (1517, Florence, Uffizi). Other altarpieces and smaller devotional works in oils on panel are found in Florence, Pitti, Uffizi; St Petersburg, Hermitage; London, National, Wallace; Madrid, Prado; Paris, Louvre; Rome, Borghese; Vienna, Kunsthistorisches; Washington, National. Although he mainly painted religious subjects, a few portraits are also known (Berlin, Staatliche; London, National; Edinburgh, National; Chicago, Institute). In 1513 Andrea, along with the younger Pontormo and Rosso, designed the decorations for the carnival floats of the Medicean confraternities (allegorical scenes, Florence, Uffizi), and in 1515, in tandem with his friend and associate the sculptor Jacopo *Sansovino, he executed decorations for the festival entry into Florence of Pope Leo X de'Medici. A more unusual commission (1515) was the furniture and panelling decoration for the nuptial chamber of Pier Francesco Borgherini, illustrating the Old Testament

story of Joseph, in which Andrea and
*Granacci were the senior painters and
the younger Pontormo and Francesco
Bacchiacca (1494–1577) also participated
(decoration dispersed; panels by these
artists respectively Florence, Pitti, Uffizi,
Palazzo Davanzati; Rome, Borghese and
London, National).
Andrea worked in France 1518/19 in the
service of King Francis I. He broke his
contract, according to *Vasari, because
he missed his wife. Whether the story is
true or not, it points to a quality in the
man which is consonant with his work.
Vasari discerned in him 'a certain timidity
of spirit' and the lack 'of ornaments,
grandeur, and copiousness' which pre-
vented him from achieving in painting
something 'truly divine'. And it is true
that, despite his Medicean commissions,
Andrea the tailor's son worked mostly for
the Florentine bourgeoisie, for confrater-
nities of small merchants and artisans,
religious communities, and a few art-loving
merchant collectors.

Andrea di Bartolo *See under* Bartolo
di Fredi.

Andrea di Lione (1610–85) Neapo-
litan painter, pupil of *Falcone and like him
celebrated for battle scenes, although he
also executed bucolic and pastoral subjects
influenced by *Castiglione. There are
works by him in Naples, Capodimonte;
Madrid, Prado; Vienna, Kunsthistorisches;
New York, Metropolitan; etc.

Andrews, Michael (1928–95) British
painter, trained at the Slade School of Art
and noted for delicate representational art
derived from direct observation and from
echoing photographs and sometimes
others' paintings. Some of his work reflects
on contemporary social life, some on
nature's space and light. In both, intensely
recalled visual experience provides the
essential stimulus.

Angelico, Fra or **Beato** (1395/1400–55)
Influential and much loved Tuscan painter;
the nickname 'Angelic' was given to him
posthumously. Born Guido di Pietro, he
took the name Giovanni upon entering the

Dominican order in Fiesole *c*.1418–21;
*Vasari calls him Fra Giovanni da Fiesole.
Already trained as a painter and minia-
turist before becoming a friar, he continued
to practise his art mainly in the service of
his order. After the mid-1430s his work
shows mastery of the new style initiated
by *Masaccio, translated, however, into a
different *expressive idiom: tender, medi-
tative, delicately luminous. Depending on
the function and location for which they
were executed, his paintings range from the
austere (e.g. *frescos of S. Marco, *see below*)
to the richly decorative (e.g. frescos of
Chapel of Pope Nicolas V, *see below*). In the
latter he continued to use gold-leaf orna-
ment and complex colour harmonies in the
manner of *Gentile da Fabriano, active in
Florence in 1422–5.
Fra Angelico's earliest known works,
the triptychs (*see under* polyptych) for S.
Domenico, Fiesole (*c*.1424/5, reworked
c.1505 by Lorenzo di Credi to form a
single-field, *Renaissance *sacra conver-
sazione*) and for Florence, S. Pietro Martire
(1428–9, now Florence, S. Marco) show the
influence both of Gentile and *Ghiberti.
Soon after (*c*.1430), his study of Masaccio
becomes evident in greater spatial clarity
and simplification of volume (e.g. *Madonna
and Child*, S. Marco; *Madonna and
Child with Twelve Angels*, Frankfurt,
Kunstinstitut). His first mature painting,
which gave rise to innumerable variants
and adaptations, was the altarpiece of the
Annunciation of *c*.1432/3 now at Cortona,
Museo. The panels of the *predella include
some of the most magical evocations of the
Tuscan landscape ever painted.
Fra Angelico's artistic status was con-
firmed with the commission in 1432 from
the Linendrapers' Guild for an enormous
image of the Virgin and Child on panel in
a shuttered tabernacle, with Sts John the
Baptist and John the Evangelist on the
inside of the shutters, and Sts Peter and
Mark on the outside (1433–5, S. Marco).
The marble tabernacle was furnished by
Ghiberti's workshop, and the sculptor may
have aided the painter-friar with designs for
the over-life-size figures, which are analo-
gous to his own statues for the Or San
Michele, and larger than any contemporary
Florentine works on panel.

From *c*.1437–45 and 1450–*c*.2 Fra Angelico was occupied with the altarpiece and frescos for S. Marco in Florence, one of the most extensive Dominican pictorial ensembles ever executed. Sadly, the condition of the altarpiece, and the dispersal of its predella (Munich, Alte Pinakothek; Paris, Louvre) make it difficult to appreciate either its original splendour or novelty (1438–40, S. Marco). Features of it were imitated by *Ghirlandaio, *Baldovinetti, and others. Of the remaining frescos, the mystical *Crucifixion with Saints* of the chapter room of the priory (1441–2) is undoubtedly the most solemn painting by Fra Angelico. In addition to this and other frescos on the ground floor he designed all the paintings in the upstairs corridor and in the friars' individual cells. They represent scenes from the life of Christ and the Virgin, not as realistic narratives, but as subjects for meditation.

Something of the style of the S. Marco altarpiece may be seen in the other great panel painting of *c*.1440–5, the *Deposition* for the Strozzi chapel in S. Trinità (now S. Marco, pinnacles of *Gothic frame by *Lorenzo Monaco).

In 1445 Fra Angelico was summoned to Rome by Pope Eugene IV. His only surviving work in the Vatican was painted, however, for Eugene's successor, Nicolas V, in 1447–8; after a brief period at Orvieto, 1447, he was back in Florence in 1450. The frescos of Nicolas's small chapel, representing six scenes from the *Life of St Stephen* and five from the *Life of St Lawrence*, are the most complex of his works, showing his study of Roman architecture and his fruitful experiments with various methods of dividing up the narrative fields. Benozzo *Gozzoli was the chief assistant on this and the Orvieto project.

On his death in 1455, Fra Angelico was the most prized painter in Florence. Both *Piero della Francesca and *Domenico Veneziano probably spent time in his studio in the 1430s; Ghirlandaio, Baldovinetti profited from his example; *Verrocchio came under his spell. No other artist, however, achieved quite the same blend of new science with popular appeal, spirituality with charm – the qualities which make

him even today one of the most widely reproduced, if not well-understood, Italian artists.

Angerstein, John Julius (1735–1823) Financier, philanthropist and collector, born in St Petersburg. His collection, sold after his death, formed the nucleus of the National Gallery, London.

Anguier, François (*c*.1604–69) and **Michel** (*c*.1613–86) French sculptors, brothers, born in Normandy. François is said to have worked in his youth in Abbeville, Paris, and England; Michel moved to Paris *c*.1627. Both remained independent of the dominant *Sarrazin studio. They went together to Rome about 1641 and are said to have both worked with *Algardi, François, however, returning home in 1643. Michel, who remained in Rome until 1651, is well-documented as a pupil and later an assistant in Algardi's studio; he was employed at St Peter's and St John Lateran, where he made stucco reliefs in an *expressive style which shows no dependence on Algardi. On his return to France, Michel assisted François on the Montmorency tomb at Moulins, Chapel of the Lycée, 1649–52, which introduced a tame version of the Roman *Baroque style to France. François continued to receive commissions for similar tombs (Paris, Louvre; Versailles). Michel, far more successful, turned to *classicism both in his lectures at the Royal *Academy and his work (stucco decoration, rooms of the Queen Mother, Anne of Austria, Louvre Palace; reliefs, Paris, Val-de-Grâce; sculptural group of the *Nativity* for the high altar of the same church, now Paris, St. Roch; *Amphitrite*, Paris, Louvre). His only important official commission after 166? was the decoration of the Porte St Den? 1674, severely classical high reliefs remi? cent of those on ancient Roman triun? arches.

Anguissola, Sofonisba (15? The most celebrated of a fami? painters' – the others being? Elena, Lucia, Europa and? Born in Cremona, she w? by Bernardino *Campi, ?

(*c*.1495–1575). In 1559 she was invited by Philip II to the court of Spain, where she was a maid of honour to the Queen and executed many portraits in the *realistic north Italian mode of *Moroni. Most were destroyed in the fire of 1604 at the Pardo palace. There are a number of self-portraits by her (e.g. Naples, Capodimonte) and she may have invented an early form of *Conversation Piece, consisting of half-length portrait figures relating to each other in a *genre situation, such as playing chess (e.g. 1555, Poznań, Museum). She returned to Italy in 1580, settling in Genoa in 1584 and then moving to Palermo with her second husband. *Van Dyck drew her on his Italian visit (1624, 'Italian Sketchbook', London, British), recording her conversation and advice; his painting of her is now lost.

Annigoni, Pietro (1910–88) Italian painter, admired for his portraits in a style that – like Dalí's – derives from the careful naturalism of *early Renaissance painting but also veers into a grandiosity not attempted before the 19th century and in the 20th welcomed by totalitarian leaders. The former is well represented in his first portrait of Queen Elizabeth II (1954–5, London, Fishmongers' Company), the second in his later portrait of her (1969; London, NPG). He has also painted other members of the British royal family and important persons including President John F. Kennedy. In Italy he has also painted church frescos and rather ponderous allegorical scenes, but it is in the humbler role of portraitist that he has achieved fame.

Anselmi, Michelangelo (*c*.1492–1554/6) Northern Italian painter. Born in Tuscany of a Parmesan family, he returned to Parma by 1520. Between 1522 and 1527 his work was wholly indebted to *Correggio (*frescos, Parma, S. Giovanni Evangelista); after 1527, perhaps as a result of a visit to Siena, it was influenced by the *Mannerist forms of *Sodoma and *Beccafumi (Parma, cathedral; Galleria), and from 1530 by *Parmigianino (Reggio Emilia, S. Prospero; frescos, in collaboration with *Rondani, Parma, Oratorio della 'oncezione). Anselmi was commissioned,

in 1541–2, to complete the decoration of the church of the Steccata in Parma which Parmigianino had left unfinished (apse, inner portal).

Antelami, Benedetto (recorded from 1178–*c*.1230) The most notable Italian sculptor before Nicola *Pisano (but see also Bonnanno of Pisa; Nicolò; Wiligelmo). He executed the famous relief of the *Deposition of Christ from the Cross* and the bishop's throne in Parma Cathedral, and is responsible for the extensive sculptural decoration of Parma Baptistery, with its widely influential statues of the Labours of the Months.

antependium A low rectangular panel used to decorate the front of the altar table. Antependia are among the earliest (12th century) post-antique panel paintings in the Latin West.

Anthonisz., Cornelis (*c*.1499-shortly after 1556) Dutch painter, printmaker and cartographer, born and active in Amsterdam. He is best remembered for his group portraits of civic guards, to which he introduced the motif of the banquet, adding focus and liveliness to an essentially static type of painting akin to the school photograph (*'The Brass Penny Banquet' of the Amsterdam Civic Guard*, 1533, Amsterdam, Historisch).

Anti-Art Term brought into use in the 1950s for works of art and tendencies intended, or apparently intended, to reject the accepted values and purposes of art by subverting them and proposing alternative strategies. *Dada was the first instance of such a movement and it was in discussing Dadaism that the term gained currency. It has subsequently been associated also with such movements as *Conceptual art and *Performance art.

'Antico', Pier Jacopo Alari Bonacolsi, called (*c*.1460–1528) Italian goldsmith and sculptor from Mantua, where he created a new type of bronze statuette, the 'sculptural counterpart of *Mantegna's paintings', more archeologically correct and more technically accomplished than

anywhere else in Italy (*see also* Bertoldo), although less expressive than *Riccio's brilliant Paduan improvisations on antique themes. Many were small versions of ancient Roman statues, among them the *Spinario, the *Apollo Belvedere and the *Marcus Aurelius. Antico's earliest surviving bronzes were medals and a famous classicizing vase celebrating the marriage in 1479 of Gian Francesco Gonzaga, the younger brother of Federico Gonzaga, Marquess of Mantua. After Federico's death in 1484 Antico entered the service of Gian Francesco in his castle of Bozzolo. From 1501 he made statuettes, some of them in gold and silver, for Isabella d'Este, advised her on the acquisition of antique sculptures and restored them for her. Antico evolved a sophisticated method of casting which allowed for exact replication of his models, and was to be equalled only later, in the studio of Giovanni *Bologna. The greatest single concentration of his works is now in Vienna, Kunsthistorisches.

antitype *See* typology.

Antolínez, José Claudio (1635–75) Spanish painter, active in Madrid. A brilliant colourist, he specialized in painting the Immaculate Conception – a third of the 70-odd known works by him, dating from 1658 to 1673, are on this theme – and the Ecstasy of St Mary Magdalen (Madrid, Prado; Barcelona, Museum). An exceptional *genre picture is *The Poor Painter's Drummer* (*c.*1670, Schleissheim), whose subject is derived from engravings after Annibale *Carracci and whose motif of a view through open doors is taken from *Velázquez's *Las Meninas*. He emulated the latter again in the group portrait of the *Danish Minister Lerse and Family* of 1662 (Copenhagen, Museum) which also includes a self portrait. His arrogance led to his early death after a duel.

Antonello da Messina (*c.*1430–79) Outstanding, if ill-documented, painter from Messina in Sicily. His mature works combine an Italian sense of volumetric structure with Netherlandish technique, notably in the treatment of light, and

*iconography (e.g. bust-length *Ecce Homo*, New York, Metropolitan; Genoa, Spinola; *Salvator Mundi*, 1475, and *St Jerome in his Study*, both London, National). He was prized as a master of the small bust-length portrait in the Netherlandish mode (New York, Metropolitan; Philadelphia, Museum; Berlin, Staatliche; Washington, National; Paris, Louvre; Madrid, Thyssen-Bornemisza Coll; Rome, Borghese; Turin, Museo). Exceptionally, he was able to work both on the monumental scale of large altarpieces (*Polyptych of St Gregory*, 1473, Messina, Museo; S. Cassiano altarpiece, see below) and, for private collectors on a minute scale approaching that of miniatures (e.g. *St Jerome*, London, National). Although his portraits have the finesse of surface texture associated with Netherlandish art, certain small-scale works (e.g. *Crucifixion*, London, National) have such breadth of form that they appear grandly monumental; all, even the *Ecce Homo*, avoid the extremes of pathos characteristic of much northern art for a meditative, *classical restraint.

An independent master in Messina by 1457, Antonello is said to have been apprenticed in Naples to Colantonio, an able imitator of Netherlandish painting (e.g. *St Jerome in his Study*, Naples, Capodimonte). Since original works by Jan van *Eyck and Rogier van der *Weyden, as well as by their Burgundian, Provençal and Spanish followers, were available for study in Naples, scholars have abandoned earlier hypotheses of a trip to the Netherlands, although a voyage to central and northern Italy during 1465–71, when Antonello could have absorbed the influence of *Piero della Francesca and *Mantegna, is still thought likely. A stay in Venice 1475–6 is well documented. Of his major Venetian commissions, an altarpiece for S. Cassiano, only fragments remain (Vienna, Kunsthistorisches). Other works from this period are the *St Sebastian*, now in Dresden, Gemäldegalerie, once the wing of a triptych (*see under* polyptych) and the small *Crucifixion* now in Antwerp, Museum. A close interaction between Antonello and Giovanni *Bellini is universally acknowledged, although scholars disagree as to which artist most influenced the other.

Antonello's son **Jacobello da Messina**, first recorded in his father's will in 1479, was his chief assistant and completed works left unfinished at his death. His only secure independent work is the *Madonna and Child*, 1480, Bergamo, Accademia.

Antoniazzo Romano (active 1460–1508/12) The most notable native-born painter working in Rome in the late 15th century; his direct, ingenuous figure style was influenced by that of the 'foreigners' with whom he worked: *Ghirlandaio, *Perugino, *Melozzo da Forlì, yet remains recognizably individual. When painting on panel he sometimes deploys his *Renaissance figures against an old-fashioned gold *ground. There are works by him in many Roman churches, e.g. S. Antonio dei Portoghesi; S. Croce in Gerusalemme; S. Maria della Consolazione; S. Maria sopra Minerva; Sant'Onofrio; etc.

Antonio and Giovanni d'Enrico *See under* Tanzio da Varallo.

Antonio Lombardo *See under* Pietro Solari.

Apollinaire, Guillaume (1880–1918) Poet and the most influential Parisian art critic of the early 20th century. Eager to recognize talent and significance in new art and artists, he was never a sure guide to quality or to the essence of a development. Yet his enthusiasm endeared him to artists. He praised the worthy and the unworthy alike, but no art event escaped his eye and pen. His reviews appeared in a number of periodicals and he wrote many catalogue texts. In a lecture of 1912 he announced the birth of *Orphism. His 1913 booklet, *The Cubist Painters – Aesthetic Meditations*, combines an account of diverse forms of Cubism, not altogether sensible, with wider-ranging comments on art. He became an ally of the Italian *Futurists. He produced some graphic poems in which the text, with or without lines, makes an image reflecting its meaning. A collection of these *calligrammes* was published in 1914 under the title *Et moi aussi je suis peintre* (*And I Too Am a Painter*). In describing his own play *The Breasts of Tiresias* (1917) as 'surrealist'

he provided a name for *Surrealism, born seven years later.

Apollo Belvedere A Roman marble copy of a Greek bronze original, this statue was held up as a model of the *classical ideal (*see also* idealization) and of male beauty for nearly 400 years since 1523, when it was first displayed in the Belvedere court at the Vatican; it had probably been discovered around 1500. Innumerable casts and copies in various media were made of it, and in the 18th century its elongated proportions were praised for contributing to the awe-inspiring character appropriate to a god. *Reynolds adapted its pose for the portrait of Commodore Keppel which made his fame (Greenwich, Maritime). The American Benjamin *West fostered the legend of the 'purity' of Greek art, exclaiming on his arrival in Rome in 1760: 'My God, how like it is to a young Mohawk warrior!' and this supposed similarity with a 'noble savage' was copiously celebrated. *Winckelmann devoted to it one of his famously extravagant passages in the *History of Ancient Art*; it inspired the great German poet Schiller (1759–1805) to write that no mere 'son of the earth' could describe 'this celestial mixture of accessibility and severity, benevolence and gravity, majesty and mildness'. *Mengs was one of the first to question its status as a Greek original, noting that it was made of Italian marble; its reputation has steadily diminished since the end of the 19th century. Along with other famous antique works of sculpture (*see Belvedere Torso, Laocoön, Spinario*) the *Apollo Belvedere* was removed to France after Napoleon's conquest of Italy in 1798, and returned to the Vatican, where it remains, in 1815.

Appel, Karel (1921–) Dutch painter, born and trained in Amsterdam. He was a founder member of the *Cobra group in 1948, and in 1949 he helped organize an exhibition of international *avant-garde artists at Amsterdam's Stedelijk Museum. About this time he was exhibiting in Paris as well as around Northern Europe, and in 1950 he decided to settle in Paris where he was seen as a leading painter

of *Art informel. Since then there have
been many exhibitions and awards, as
well as commissions for murals and other
forms of large-scale public art (tapestries,
stained glass). The vigour of his art attracts
attention: strong, contrasting colours
applied with apparent vehemence, at times
presenting roughly delineated creatures
derived from Norse mythology.

Apt, Ulrich the Elder (*c.*1460–1532)
German painter active in Augsburg, where
he worked both in *fresco (Augsburg,
cathedral; town hall) and on panel. His
most important painting is a two-winged
altarpiece of the *Adoration of the Christ
Child by the Shepherds and the Magi* for the
church of the Holy Cross in Augsburg
(1510, now divided between Paris, Louvre
and Karlsruhe, Kunsthalle), which
includes portraits of the officers of the
weavers' guild. He was the teacher of his
three sons, who carried on his style in his
workshop, and of Jörg *Breu the Elder.

aquatint A specialized form of
etching (*see under* intaglio), developed in
the 18th century. Rosin dissolved in spirits
of wine was poured over a clean metal plate.
In drying, the rosin collected into little
lumps with the plate exposed in a fine
system of irregular lines between them.
These lines could then be etched or
'stopped out', providing a soft tone, which
could then be accented with line etching.

Arakawa, Shusaku (1936–)
Japanese artist who helped to found a neo-
*Dada group in Tokyo in 1958 and became
known for aggressive *anti-art works sati-
rizing society and its values. In 1961 he
moved to New York where he developed
a series of paintings he called 'diagrams'.
These involved first the vacant silhouettes
of familiar objects, absent yet insistently
present, and then the substitution of words
for things. Thus he tests the aesthetic as
well as the communicative context of visual
stimuli and the imagination.

Archipenko, Alexander (1887–1964)
American sculptor of Russian origin, a
pioneer of modern sculpture. He began to
study painting and sculpture at the Kiev

Academy in 1902, but was expelled in 1905
for criticizing his teachers. He worked in
Moscow, exhibiting there 1906–8, then
moved to Paris. From 1910 on he exhibited
frequently in Paris where he was asso-
ciated with the *Cubist circle; he also had
exhibitions at the Folkwang Museum in
Hagen (1912) and the *Sturm gallery in
Berlin (1913). *Apollinaire recommended
his sculpture as being 'the most abstract,
most symbolic, newest forms' and having
a 'sacred character'. It was figurative
but marked by contrasts of swelling and
hollow forms. From 1912 he experimented
with assembled sculptures, incorporat-
ing a variety of materials and combined
painting and sculptural elements to
produce *Sculpto-peintures*. After the First
World War he toured Europe with an exhi-
bition and in 1921 settled in Berlin where
he opened an art school. The same year he
exhibited in Potsdam, at the Sturm gallery
and in New York. In 1923 he emigrated to
the USA where he taught and developed
his sculpture. He became a US citizen in
1928. His work generally lost its formal
brilliance but he did not cease to experi-
ment with processes and materials,
including forms of translucent plastic,
lit internally.

architectonic Having architectural
qualities. When used in writings on art, the
word may mean that a painting or sculpture
depicts architecture or is used in an archi-
tectural setting, but it may also signify
architecture-like compositional stability
and weight, a reliance on vertical and
horizontal accents.

Arcimboldo, Giuseppe (1527–93)
Milanese painter, designer of stained glass
and tapestries. From 1562 until 1587 he
served as court painter at the Habsburg
imperial court in Prague. He is now
remembered almost exclusively for his
grotesque allegorical or symbolic figures,
some of them are personifications of,
e.g. *The Elements* or *The Seasons* (Vienna,
Kunsthistorisches), others actual portraits,
all ingeniously composed from still-life
elements: e.g. *The Cook*, portrayed in frying
pans, roast meats and sausages; *Rudolph II
as Vertumnus*, the god of horticulture,

assembled out of fruit, flowers and corn (both Stockholm, Museum).

Ardon, Mordecai (1896–1992) Israeli painter of Polish origin, born Max Bronstein, student at the *Bauhaus in 1920–5 and at the Munich Academy, and for a time assistant at *Itten's school in Berlin. In 1933 he emigrated to Israel. He taught at the Bezalel Art School in Jerusalem as professor and subsequently director. In 1952 he became artistic advisor to the Ministry of Education and Culture. In 1963 he received the Israel Prize. His paintings and works in other media incorporate Jewish themes and images but also belong, through their rich colour, near-*abstraction and emotive programmes, to the international *Art informel of the 1950s and 1960s.

Arellano, Juan de (1614–76) The leading Spanish flower painter of the 17th century, influenced by the flower pieces of Daniel *Seghers, which were extremely popular in court circles in Madrid (Madrid, Prado). Arellano also trained his son, the flower painter **José de Arellano**, but his most gifted pupil was Bartolome *Peréz de la Dehesa.

Aretino, Pietro *See under* Dolce, Lodovico.

Arman (1928–) French artist who adopted a misprinted version of his name, Armand Fernandez. From 1955 he essayed a variety of *Anti-art techniques, starting with random printings with rubber stamps and going on to assembling collected objects. His *poubelles* (dustbins) display rubbish in glass boxes; his *accumulations* are assemblages of things in boxes or cast in transparent plastic; his *colères* (fits of rage) are displays of smashed objects. In the polite setting of galleries these take on the allure of tactical naughtiness. In the 1960s his work attracted attention and rewards and was widely exhibited in Europe and the USA.

armature A rigid framework or skeleton around which a clay, plaster or wax sculpture is modelled; a similar structure used in *cire-perdue metal casting; the metal framework of stained-glass windows.

Armitage, Kenneth (1916–) British sculptor, trained in Leeds and London. He exhibited widely in the 1950s when his bronzes of single figures and of groups, generalized but eloquently human, were seen as reflecting Cold War anxieties. Their humour tended to be overlooked, as was his formal inventiveness; both continued into his larger sculptures of the 1960s and after.

Armory Show Familiar name of the International Exhibition of Modern Art shown at the 69th Regiment Armory, New York, in February–March 1913 and then in Chicago and Boston. Three-quarters of the exhibition was of American art, selected by a committee under William *Glackens, but it amounted to about 1600 exhibits and included a large section of modern art from Europe, selected by Walt Kuhn and Arthur B. Davies. Kuhn visited the Cologne Sonderbund exhibition and booked much of that for New York; together he and Davies had viewed the new art of Paris as well as *Impressionist, *Post-Impressionist and *Symbolist artists. They brought a too-generous group of 38 paintings by Augustus *John from London, but no German *Expressionists or Italian *Futurists. Sculpture was represented more thinly yet tellingly by such key figures as *Rodin and *Brancusi.

There were over half a million visitors and the press covered it energetically. Parts of it were treated as a scandal and a joke, yet the exhibition forced some awareness of modern art on a wide public and helped major institutions to accept at least its forerunners: e.g. the Metropolitan Museum in New York bought its first *Cézanne there. It also seeded new ambitions in an American art world that had become isolationist.

Arnolfo di Cambio (recorded from 1265–c.1302) One of the three leading sculptors of late 13th-century Italy. Like his one-time master Nicola *Pisano, he combined a knowledge of antique models with that of contemporary *Gothic developments. Some of his sculptural works rely

primarily on architectural forms (altar canopies, 1285, Rome, S. Paolo fuori le mura; 1293, S. Cecilia in Trastevere), and he is thought also to have been the architect of the churches of the Badia and S. Croce in Florence, and the first chief architect of Florence Cathedral, for the façade of which he executed a sculptural complex of figures and reliefs (c.1300, Florence, Opera del Duomo). From c.1277, Arnolfo was working for the Angevin court in Rome (*Charles of Anjou*, Rome, Palazzo dei Conservatori) and probably through connections at court he won commissions for the tombs of Cardinal de Braye (d.1282, Orvieto, S. Domenico) and Cardinal Annibaldi della Molara (d.1276, Rome, St John Lateran). The de Braye wall tomb is the key monument for our understanding of Arnolfo as a sculptor; much altered, it is nonetheless remarkable both for the naturalism (*see under* realism) of the effigy and for its influential *iconography of Death and Salvation.

Arp, Hans or **Jean** (1887–1966) Painter and sculptor, born in Strasbourg when Alsace was part of Germany, and active in Germany and Switzerland at various times, yet generally seen as part of the story of modern art in France. He studied art in Weimar and in Paris. In 1912 he was in Munich, in touch with the *Blaue Reiter group; in 1913 his work was included in a survey of recent art at the *Sturm gallery in Berlin. In 1914 he was in Paris but the outbreak of war sent him to Zurich. There he and his future wife Sophie *Taeuber worked with the *Dada group. Arp was exploring *anti-art ideas such as invoking chance as a factor in *abstract *collages. In 1919–20 he collaborated in Cologne with *Ernst and *Baargeld in their *Dada campaign. He also spent some days in Berlin where he made contact with *Lissitzky.

Arp's collages used geometrical forms; in painted wood reliefs he used soft, organic forms suggestive of living nature. He explored geometrical abstraction (*see also* De *Stijl) but also biomorphic forms with their suggestiveness and invitation to humour. Thus he combined directions normally seen as opposites, *Elementarism and

*Surrealism. In 1925 he contributed to the first Surrealist exhibition in Paris; in 1930 he became a member of *Cercle et Carré and in 1931 helped to found *Abstraction-Création. In 1927–8 he worked with Sophie and Van *Doesburg on the interiors of the Aubette Café in Strasbourg: their contributions were geometrical whereas he used large organic forms in strong colours. In 1926 the Arps had settled at Meudon, a Paris suburb, which became their main home for the rest of their lives. In the 1920s most of Arp's work had been painted wood reliefs. From about 1930 it was mainly free-standing sculpture, some of it on a monumental scale. In all this he conveyed creativity as a benign activity, an ineluctable form of human fruitfulness. From 1920 on he published poetry in French and in German, sometimes accompanied by his own woodcuts.

Arpino, Giuseppe Cesari (usually called by his papal title, **Cavaliere d'Arpino**) (1568–1640) The favourite painter of Pope Clement VIII, he specialized in decorative cycles for high-ranking ecclesiastics and Roman princes (1589–91, Naples, S. Martino; 1589, Rome, Loggia Orsini; 1591/2, S. Luigi de'Francesi, Contarelli chapel, vault; 1592, S. Prassede, Capella Olgiati; 1591–1636, Palazzo dei Conservatori). He also designed the mosaics for the dome of St Peter's 1603–12. His style is usually classed as Late *Mannerism, and is marked by clarity and sobriety; his recollections of *Raphael are unrefreshed by studies from nature. Around 1590 he employed *Caravaggio as a fruit and flower specialist.

arriccio *See under* fresco.

Art brut French term meaning raw art, coined by *Dubuffet for 'works executed by people free of artistic culture'. He collected such works from 1945 on and formed a Compagnie d'Art Brut with *Breton and others. The collection, of several thousand items, was displayed in Paris in 1967 and donated to the city of Lausanne; it has been shown at the Château de Beaulieu there since 1976. A form of indigenous primitive art, it is mostly the

work of the mentally sick, expressing obsessions directly, unmitigated by artistic values.

Art informel French term, meaning formless art, used for a movement in European painting and sometimes sculpture which, emerging in the later 1940s, paralleled American *Abstract Expressionism. Other names used for it, sometimes for particular forms of it, are *Tachism and Art autre (alternative art). Artists for whose work these terms were first used include *Burri, *Fautrier, *Mathieu and *Tàpies. As they suggest, total *abstraction was not an essential aspect but rather an expressive, sometimes turbulent use of paints and other materials, producing poignant images that could be read as a response to the recent war and a protest against the Cold War with its threat of even greater destruction.

Art nouveau French for 'new art', referring to developments principally in design and the applied arts seen throughout fashionable Europe and America from 1880, characterized by shapes and patterns derived from organic structures and at times from simple geometrical forms. In Germany this tendency was called *Jugendstil*, from the journal *Jugend* (youth) founded in Munich in 1896; in Austria it was associated with some of the Secession artists and called *Sezessionstil*; in Italy it was known as *lo stile Liberty* after the London store; in Spain, where Barcelona was a particular centre for it, they called it *Arte joven*, young art. It was also known as Modern style, e.g. in Russia.
The French term was first used to draw attention to art standing outside artistic conventions, but its general application was to design. It signalled not only the rejection of historical styles but also a desire to bring all design into one idiom. Some artists were of especial importance: the Belgian *Van de Velde is an oustanding instance of a painter becoming a designer to reform design. Some Art nouveau designers systematically studied the affective properties of shapes, colours, visual rhythm, etc., and led artists to give similar consideration to the effect of their images. Much Art nouveau design

was rich and sensuous and aimed at a well-to-do clientele; some, especially that pioneered by the Scot Charles Rennie Mackintosh and the Austrian Joseph Hoffmann, implied a wider public with simpler tastes. Out of the second strand was born the reaction against Art nouveau which began before 1914. The emergence of *abstract art may have been stimulated, certainly was aided, by this movement.

Arte povera Italian term ('poor' or 'impoverished art') coined by the critic Germano Celant to indicate a tendency he discerned in 1967 and presented in an exhibition in Turin in 1970. The artists he saw as representatives of 'poor art' belonged to several countries and are associated also with other movements and activities such as *earthworks and *Conceptual art, under wide discussion in those years. Using valueless raw materials, such as soil, Arte povera endeavoured to elude the commercialism of art and its segregation as an exclusive activity.

Arthois, Jacques d' (1613–86) Flemish landscape painter, active in Brussels, where he trained many pupils, and ran a large workshop which included his brother Nicolas and his son Jean-Baptiste, whose work is scarcely distinguishable from his. He specialized in large decorative woodland scenes, many with biblical subjects – such pictures were often intended for the choirs of *Gothic churches (e.g. Brussels, Ste Gudule). There are works by him in Brussels, Musées Royaux; Madrid, Prado; Frankfurt, Städelsches; Aschaffenburg, etc.

Arts and Crafts movement A British movement in design and decorative art, deriving its name from the Arts and Crafts Exhibition Society founded in 1888, and of wide influence on both sides of the Atlantic both in its promotion of styles and methods and in some of its socio-political attitudes. Its leader and guide was William *Morris; behind him stood the architect A.W.N. Pugin and John *Ruskin, the art historian and critic who was himself led into political criticism by his urge to understand art and design and to work for their

improvement. They looked to the Middle Ages and rural traditions to promote the moral and aesthetic virtues of craft work over industrial production; the use of machinery became one of the problems Morris and his successors had to contend with, and by accepting the machine as a tool they were able to be influential in the 20th-century, e.g. on the *Bauhaus. But the movement also embraced other views and influences, notably that of Christopher Dresser who studied Japanese design traditions in Japan, lectured on the subject in America, and made his designs mostly for machine production. The two idioms, that derived from English craft traditions and that taking on aspects of Oriental art and design, met in *Art Nouveau and thus contributed to modern developments in art. By this time the British movement had spawned American groups and individual designers and craftsmen of much the same persuasion. For example, the founding of the Art Workers' Guild in London in 1884 was followed a year later by the founding, in Providence, Rhode Island, of the American Art Workers' Guild.

Arundel, Thomas Howard, 2nd Earl of (1586–1646) Leading figure at the court of King Charles I of England; with his wife, Aletheia Talbot (d.1654), daughter of the wealthy 7th Earl of Shrewsbury, he was the founder of modern collecting in England. A learned man, he was a devoted lover of books and manuscripts as well as of *classical sculpture and of paintings. In these his taste ran from a passionate interest in *Holbein the Younger – whose peerless *Christina of Denmark, Duchess of Milan* now in the National Gallery, London, he had inherited with other portraits by the artist – to *Titian, *Veronese, and lesser 16th-century Venetian masters. He also commissioned works from *Rubens and *Van Dyck, both of whom painted his portrait, as did *Hollar, whom he brought to England, and *Mytens. In 1613–15 the Arundels travelled through Italy with Inigo *Jones, visiting every major art centre and carrying out archeological investigations in Rome. In the following year, Lady Arundel's father having died, they were able to begin

collecting in earnest, employing ambassadors as agents, and, later, training the family's tutor, the Reverend William Petty, to act as a private agent. Petty was sent to Constantinople in 1624 and spent three years there acquiring antiquities for the Earl. In poor health and in increasingly dire financial straits in the 1630s, Arundel formed a commercial company to colonize and exploit Madagascar, but the scheme came to nothing, and after a brief spell leading Royalist troops against the Covenanters, he virtually retired from public life. Much of the Arundels' great collection preceded them in flight to Antwerp; it began to be broken up in a piecemeal way after the death of the Earl in Parma, where he had gone after separating from his wife, and trickled away after Lady Arundel's death – the last items going to auction in London in the 1720s. Many of the antique sculptures from the collection are now in the Ashmolean Museum, Oxford, while paintings can be found in most of the major European galleries.

Asam, Cosmas Damian (1686–1739) and his brother **Egid Quirin** (1692–1750) Influential Bavarian *Rococo artists specializing in ecclesiastical buildings. Cosmas Damian was primarily a *fresco painter, Egid Quirin a sculptor in stucco and wood. Both practised as architects, to create spectacular *illusionistic church interiors akin to stage designs and popular miracle plays, in which all the arts contributed equally to the dramatic total effect. Sons of the painter **Hans Georg Asam** of Tegernsee, they were sent by a patron to Rome in 1711. Having absorbed the ideals of the Roman *Baroque (*see* especially Bernini, Gaulli, Pozzo) they reinterpreted them in a lighter and even more vivid way throughout the German principalities and in Switzerland and Bohemia. Their greatest achievement is the church of St John Nepomuk, Munich (1733–46) endowed by Egid Quirin and built, together with a priest's house, next to his own residence. The brothers designed the entire building as a symbol of artistic creation in the service of God, but included also figures from *classical mythology. Cosmas Damian also executed secular frescos at Mannheim (1729–30; destroyed

in World War Two) and Alteglofsheim (1730), drawing together the Italian tradition of *Correggio and *Pietro da Cortona and the Flemish manner of *Rubens for his own version of mythological subjects.

Ashcan The Ashcan school was a group of Philadelphia painters, headed by Robert *Henri. Returning from Europe in 1891, stirred by the realistic and socially committed art of *Goya, *Manet, *Daumier and others, Henri became the centre of a group who used art to report on the world outside the studio. About 1900 they moved to New York where they were known as the New York Realists and identified with social reformism because of their subjects, not merely urban scenes but scenes of slum overcrowding and ethnic ghettos. Their pictures were generally picturesque, but some of the growing group, e.g. *Sloan and Stuart *Davis, did illustrations for left-wing journals that were outspokenly critical. During the years up to the First World War many young artists picked up this realistic idiom and sometimes also the radical thrust, including *Dove, *Kuhn, *Hopper and *Epstein. The Ashcan school helped American art to discover an identity and engage with modern times.

Aspertini, Amico (1474–1552) Eccentric Bolognese painter and sculptor, now best known for his eclectic *fresco cycle in Lucca, S. Frediano, 1507–9. He was in Rome in 1500–3 and again in 1532–4 and 1535–40, when he produced two important sketchbooks of drawings after the antique, which are among the fullest records of ancient works of art known in the *Renaissance (London, British).

Asselijn or **Asselyn, Jan** (c.1615–52) Dutch painter, best known today for his heroic painting of the *Threatened Swan* defending its nest against a dog (Amsterdam, Rijksmuseum), which at a later date was transformed, with the aid of an inscription, into a political allegory. Asselijn began as a painter of battle scenes; he painted a few exquisite Dutch winter landscapes (e.g. Paris, Coll. F. Lugt) but the majority of his work consists of

Italianate harbour scenes and landscapes (Amsterdam, Rijksmuseum; Barnsley, Museum; Woburn Abbey; etc.). Of these, the most remarkable are his panoramic views (Vienna, Akademie). He was in Rome between 1635 and 1644; he married in Lyon in 1644, and worked in the Hôtel Lambert in Paris in 1646. He was back in Amsterdam in 1647; in 1648, *Rembrandt executed a portrait etching of him.

Assemblage A term invented by *Dubuffet in the early 1950s for works made of bits of things, two-dimensional (i.e. *collages becoming the entire work) and three-dimensional. An exhibition at the Museum of Modern Art, New York, in 1961, 'The Art of Assemblage', brought together a wide range of pictorial and sculptural art to which the term could be applied and thus gave it wide currency.

Ast, Balthazar van der (1593/4–1657) Dutch flower painter, brother-in-law and pupil of Ambrosius *Bosschaert the Elder; he was in turn the teacher of Jan Davidsz. de *Heem. Ast continued Bosschaert's precisely descriptive style and carefully balanced compositions; his paintings, however, became gradually larger and more complex, often including rare and exotic flowers, fruits, insects and shells; he also painted *still lifes made up of only shells. In 1619 he left Middelburg to move to Utrecht, and in 1632 he settled in Delft; he was immensely influential on the development of flower and fruit painting in each of these cities. There are works by him in Rotterdam, Boijmans Van Boyningen; Dessau, Staatliche; Pasadena, Norton Simon; private collections.

Atkinson, Conrad (1940–) British artist, trained in Carlisle and Liverpool and at the Royal Academy Schools in London. He became prominent in the 1970s as a *Conceptual artist dedicated to commenting on social issues through his art by methods akin to those of investigative journalism.

Atkinson, Lawrence (1873–1931) British artist, a member of the *Vorticist group. He had studied music and was self-

taught in art. He produced *abstract paintings, usually of rising geometrical structures. Then he turned to abstract and near-abstract carvings. With one of them, *Bird*, he won the Grand Prix at the 1921 Milan Exhibition.

Atkinson, Terry (1939–) British artist, one of the founders of Art and Language and author of several texts published by its press in the late 1960s and early 1970s. Atkinson became known as a trenchant *Conceptual artist. The message of his art is stated in the title of a lecture he gave in 1984, 'Gramsci says: "the crisis consists precisely in the fact that the old is dying and the new cannot be born; in this interregnum a great variety of morbid symptoms appears".' Later paintings have the character of snapshots. Their titles point to their content, e.g. a series called *Art for the Bunker* (1983–5) comments with an innocent air on nuclear armaments and their threat to humanity.

Atlan, Jean-Michel (1913–60) French painter, born in Algeria, who began to exhibit in 1944 and then again, after ten years without showing, in 1956. His paintings were seen as major contributions to *Art informel; he said they were instinctive, coming out of the need for rhythmical expression. Characteristic Atlans are of strong, mostly flat forms, often with dark outlines – signs on the canvas that can suggest large hieroglyphs.

Atlas *See under* caryatid.

Audran, Claude III *See under* Watteau, Jean-Antoine.

Audubon, John James (1785–1851) French–American artist, born in Haiti and trained in painting briefly in the studio of J.-L. *David. He visited America in 1803 and settled there in 1806. He painted portraits but his chief interest was in recording wildlife and around 1820 he began to make drawings of North American birds. In 1826 he went to Britain to find backing and to have his watercolours turned into aquatint engravings, coloured by hand. *The Birds of America* appeared in four volumes during 1827–38 and contains 435 plates. He returned to America in 1831 and with his two sons prepared *The Viviparous Quadrupeds of North America*, published in two volumes in 1845 and 1848.

Auerbach, Frank (1931–) British painter, a refugee from Germany in 1939, who studied painting at St Martin's School of Art and the Royal College of Art and then attached himself to *Bomberg whose influence has remained dominant in his work. This is *figurative but can often seem *abstract on account of its concentration on structural gestures made with brush and paint to capture the visual character or presence of models or sitters and at times of familiar London townscapes. His range of subjects has remained limited; his mode of expression has developed in terms of densities and of colour; his association with key figures in the history of art, notably *Rembrandt, has become clearer over the years. He has exhibited regularly since 1956 and had a major retrospective in London (Hayward Gallery) in 1978.

Autodestructive art Works of art whose disintegration is their content and message have been produced in the West (and in countries under western influence, such as Japan) since at least the 1960s. They should be distinguished from works created to be temporary (ephemeral celebratory works, sand paintings for an American Indian ritual, *Performance art etc.) whose passing is incidental to their purpose. Gustav *Metzger's paintings done in acid on nylon, *Latham's towers of burning books, *Tinguely's self-demolishing machine *Homage to New York* all speak of quietus. There have been many other such works, done to assert art's freedom from commerce and also from its old association with grace and with reassuring permanence.

Automatism *Romanticism suggested that the unconscious contributes significantly to artistic creation. The search for automatism in modern art was stimulated by Freud's enrolment of free association in psychoanalysis. The poets *Breton and Soupault experimented with automatically produced texts in 1919, and Breton's

Surrealist Manifesto of 1924 gave priority to 'pure psychic automatism' as *Surrealism's preferred means of circumventing inner censorship. Pure automatism may not be achievable. The Surrealists and their successors employed a variety of means to minimize control, such as alcohol and drugs, as well as processes to which chance contributed significantly.

Auverra, Johann Wolfgang von der (1708–56) German sculptor. From 1730 to 1736 he worked in Vienna; in 1736 he became Court sculptor in Würzburg (decoration of Würzburg Residenz; altars and pulpits for many churches in Würzburg and Franconia).

Avant garde (from the French for vanguard) Just as the word 'revolution' was adopted after the French Revolution for abrupt changes in cultural as well as other human affairs, 'avant garde' came in both to suggest that progressive artists could scout out the territory ahead in search of new styles and of themes of greater importance than the establishment permitted, and to undermine that establishment. *Romanticism had claimed that 'poets are the unacknowledged legislators of the world' (Shelley, 1821), implying confrontation with all authority, especially that of the institutions formed long ago to legislate in the arts. Victor Hugo's victory, in 1830, over ancient literary and dramatic conventions was hailed as successful revolt against all restrictions on creative freedom. In 1845 a French book on the social role of art and artists argued that art's mission was to guide the human race and that therefore, to know 'whether an artist truly belongs to the avant garde, you have to know where humanity is going', associating the arts with ideology. In the visual arts enmity became open when, in 1850 and 1851, with Europe's political revolutions of 1848 a vivid memory, the London press savaged pictures by the three young *Pre-Raphaelites, shown at the Royal Academy, as blasphemous and subversive. *Ruskin came to their defence in 1851, the first great champion of an avant-garde cause. In 1855, *Courbet, finding his best canvases excluded from the art section of the Paris

World Exhibition, built himself a gallery nearby and labelled it *Realism; Champfleury was Courbet's champion. By the time the *Impressionists borrowed a photographer's studio to exhibit together, in 1874, the battlelines were clear: on one side the *academies as citadels of time-honoured values, successive avant-garde movements on the other. The Russian revolutionary Bakunin published an anarchist periodical entitled *L'Avant-garde* in 1878, linking the term to political radicalism and turning some progressive writers etc. against its use for artistic matters. But it soon came to be used more for these than for politics, signalling new creative ideas and individuals but associating these with an anarchistic, anti-bourgeois ideology. It only remained for their succession to speed up and diversify, so that quite soon yesterday's avant garde could become the target of today's. Movements promising radical innovation followed hard upon each other's heels from the 1890s on and rarely lasted long after their launching and initial propaganda. For a time, Paris was both the main stronghold of convention and the nursery of avant-garde groups, events and institutions, but many cities in Europe and America saw similar developments and, in so far as these were responding to Paris, a diminishing time-lag. From the 1960s on, with the promotion of *Post-Modernism as a broad and vague movement countering *Modernism's supposed dogmaticism and narrowness, the term and notion 'avant garde' was derided and declared obsolete. Pluralism was now the theoretical position, not backing this or that innovation. Moreover it seemed improper for avant gardes to be paraded in triumph through the journals and museums when there remained no powerful enemies to make war on – the media being hungry for controversy. Artists and critics rarely use the term now, though the practices by which earlier avant gardes outflanked and out-sloganed each other have not noticeably changed. Innovation now receives a welcome that brings it closer to fashion than ever before, since a quick turn-around is assumed and all attention focuses on it. Though it seems good to drop warlike terms for developments in art, hostilities between contending movements and

their supporters have sharpened and become continuous and global as the financial stakes have risen.

Avanzo *See under* Altichiero.

Aved, Jacques-André-Joseph-Camelot (1702–66) French portraitist, who trained under a French engraver in Amsterdam and went on to paint with the sober naturalism (*see under* realism) associated with the Dutch school. He came to Paris in 1721, and his best-known work is the portrait of *Mme Crozat* (1741, Montpellier, Musée; others, Cleveland, Ohio, Museum; Versailles). A friend of *Chardin, he is thought to have provoked the latter to begin painting *genre pictures in the 1730s.

Avercamp, Hendrick (1585–1634) A pioneer of the *realistic Dutch landscape, who was called 'the Mute of Kampen' because of his disability. He specialized in winter scenes of outdoor sport and leisure (Bergen, Museum; London, National; Toledo, Ohio, Museum; etc.). His nephew, **Barent Avercamp** (1621/3–79), closely imitated his manner in the early years of his career.

Averlino, Antonio *See* Filarete.

Avery, Milton (1893–1965) American painter, largely self-taught. He combined an apparently naïve style with a *Matisse-inspired deployment of often suave, strangely luminous colours applied in flat areas. His emphasis on visual sophistication within simplicity, and his drawing attention to Matisse as a major modern master, made him a formative influence upon the more meditative members of the *Abstract Expressionist movement and upon the painters associated with *Post-Painterly Abstraction. In return, their renown reflected back on him, bringing him to international fame in the last fifteen years of his life.

Ayres, Gillian (1930–) British painter, trained at Camberwell School of Art in London. She showed in the Situation exhibitions of 1960–1 and subsequently became well known for large *abstract paintings, lyrical and dramatic, mostly characterized by surfaces of rich, even scintillating colours, stimulated by a wide range of visual material.

Ayrton, Michael (1921–75) British painter, sculptor and writer, associated with *Neo-Romanticism because of the emotive and disturbing character of his vision, though in many respects he could be seen as a modern *Mannerist. Intensely literate and steeped in the classics, Ayrton frequently represented *classical myths (Icarus, the Minotaur). Admiration for his work came largely from scholarly friends. The Tate Gallery, London, has several examples of his work.

B

Baader, Johannes (1875–1956) German professional architect and amateur propagandist for a post-Christian world religion. From 1918 he was prominent in the Berlin *Dada group, and noted for his public protests against the new republican government and the established church. His disruptive actions continued until about 1925 when he returned to his career as architect.

Baargeld, Johannes Theodor (?–1927) pseudonym of Alfred Grünewald: *Bargeld* is German for 'cash', or 'ready money'. Son of a wealthy banker, Baargeld published a Communist broadsheet in post-1918 Cologne, during the years of the British occupation. The authorities vetoed it after five issues. He then turned to *Dadaism, founding a Cologne Dada Group with his friend Max *Ernst and collaborating with him, and with *Arp who came to Cologne for a few weeks in 1920, on publishing a Dada journal and presenting a Dada exhibition, promptly closed by the police. Some Dada works were created jointly by him and Ernst. The following year Baargeld ceased all artistic activity.

Baburen, Dirck van (*c.*1590/5–1624) One of the group of painters known as the Utrecht Caravaggisti (*see also* Honthorst; Terbrugghen). He left for Rome probably in 1612, returning to Utrecht in 1621. His most important Roman commission was the decoration, with another Dutch painter, David de Haen (*d.*1622), of a chapel in S. Pietro in Montorio. Back home, he was more at ease with *genre subjects; like Terbrugghen, he combined earlier Netherlandish motifs with *Caravaggesque effects of illumination. *Vermeer may have owned his picture of *The Procuress* (1622, Boston, MFA), which appears in the background of two of his own paintings, and his yellow, sky-blue and white colour harmonies may also have influenced the Delft artist. There are paintings by Baburen in Utrecht, Museum.

Bacchiacca, Francesco Ubertini, called *See under* Andrea del Sarto.

Baciccia or Baciccio *See* Gaulli, Giovan Battista.

Backer, Jacob Adriaensz. (1608–51) Dutch portraitist and *history painter, influenced by *Rembrandt but almost certainly not his pupil; later works show him turning to the new, Italianate *classical style. There are civic and militia group portraits, as well as individual likenesses, in Amsterdam, Historisch, Rijksmuseum; The Hague, Mauritshuis. His nephew and probable pupil, **Adriaen Backer** (1630/2–84) was also a successful portraitist.

Backhuysen or Backhuyzen, Ludolf *See* Bakhuizen, Ludolf.

Backoffen, Hans (active *c.*1500–19) German late *Gothic sculptor, documented in Mainz, for whose cathedral he executed the stone monuments of the Archbishops Johann von Liebenstein (about 1500) and Uriel von Gemmingen (about 1514–19). He was the appointed sculptor of the latter's successor, Albrecht von Brandenburg, and some scholars find an affinity to the style of von Brandenburg's appointed painter, *Grünewald. Some middle-Rhenish wooden sculptures are also sometimes attributed to him (e.g. Frankfurt, Liebighaus).

Baço, Jaime (1413–61) Hispano-Flemish painter (*see also* Bermejo, Dalmau) working in Valencia; only one surviving work is known, an altarpiece of 1460 in Cati near Valencia. He was employed at the Aragonese court of Naples between *c.*1442 and 1451.

Bacon, Francis (1909–92) Born in Dublin of English parents, Bacon became one of the most admired, exhibited and debated modern painters around the world.

He had no art training, but worked in London first as an interior designer. His painter friend Roy de Maistre gave him some instruction and in 1933 and 1934 Bacon showed a few paintings, attracting some notice with them, including that of Herbert *Read. It was not until the 1940s that he gave painting priority, and in 1945 he showed three paintings, including the triptych *Three Studies for Figures at the Base of a Crucifixion* (1944; London, Tate). In 1946 he was included in an exhibition presented by UNESCO; in 1948 the Museum of Modern Art, New York, bought its first Bacon, in 1949 he had his first solo show in London and his first solo show outside London took place in New York in 1953. Since then, his fame has risen steadily, making him the foremost British painter this century and an exemplary explorer of the human image in painting during decades when *abstraction and then *Conceptual art appeared to be dominant.

Bacon's repertoire of figures drew on observation of friends and his gay lovers but was often more directly supplied by photographs than sitters and sometimes by other photographic material, such as Muybridge's studies of human and animal movement, by film stills and reproductions of famous paintings, and by medical records of malformations and wounds. He also developed a repertoire of pictorial situations, sometimes involving vertical lines that seem to cage his figures, sometimes a circus-like arena in which his pictorial drama is enacted, sometimes a suggestion of an interior, with doors and doorknobs, a w.c. or basin, or a bed suggestive both of battlefields and an operating table. These, plus curtaining and other properties, provide his staging for sexual and other intimate events, at other times for human presences some of which are portraits, all dramatic, even melodramatic, none of them joyful. Slippery, pulled paints are used for faces and figures; fine, firm surfaces of immaculate paint in sometimes shocking colours form the stage-set, and much of the frisson offered by his paintings comes from this confrontation. In some works a splash of white, often on the figure looks like an ejaculation and serves like a signature and a dismissal. Some of his most important paintings are, again, triptychs, inevitably evoking *altarpieces in their form but also, in their dispositions and sometimes their references, asserting links to the tradition of eloquent religious painting from the 16th century on.

The English critic David Sylvester, who knew him well, interviewed Bacon several times from 1962; these have been published from 1975 on, providing important insights into an art whose first effect is often to shock and distance the viewer. Sexual urges and recollections, veiled by alcohol or other drugs, are often his subject matter and seem to condition his vision of human beings even in portraits, so that Bacon may be seen as a latter-day *Expressionist benefiting from effects introduced into painting by the *Surrealists. What the interviews make clear is that he was also one of the most intelligent and thoughtful of painters, deeply aware of age-old questions of what is reality and what is appearance and how appearance is to be achieved and made significant in art. He was consciously aiming at a new kind of figurative narration, in tune with modern filmic imagery as well as the decades of international and civil war, of persecutions and massacres, through which he lived.

All art centres have had their major Bacon exhibitions at various times, but perhaps the most telling was the Bacon exhibition prepared by Sylvester for Venice and shown during the 1993 *Biennale in the Museo Correr. The Bacon paintings looked at home in the city of *Titian and *Tintoretto, where painterly, dramatic painting was born. In 1997–8 a group of drawings surfaced and some have been exhibited. There is debate whether these are by the artist or, if they are, whether he considered them exhibitable. They are certainly slight and cursory, but they add to one's conviction that for him artistic experience and constructive working were at least as important as the seedy lifestyle that provided many of his subjects.

Bacon, John (1740–99) English sculptor, self-trained after going to work at the age of 14 in a porcelain factory. Technically very efficient, he invented a superior *pointing machine, by means of which a

block of marble could be rough-hewn in half the time previously taken; it was used not only in his studio but by many others in England and abroad, particularly in France. His largest work was the Chatham monument, Westminster Abbey (1779–83).

Bacon, Sir Nathaniel (1585–1627) Outstanding English gentleman-amateur painter, perhaps taught in Utrecht by *Terbrugghen. He worked for family and friends in his East Anglian country house, with frequent trips to the Low Countries, and is the only English artist of this period known to have painted over-life-size kitchen and market scenes with lavish *still-life components, in the manner – though not in the style – of *Snyders (three of ten recorded in his wife's will survive: two at Gorhambury, Herts. and one in London, Tate). He is also the author of the earliest autonomous landscape painting by an English-born artist, a small oil on copper now in Oxford, Ashmolean, as well as numerous highly accomplished self portraits (Gorhambury), and was praised by professional painters for inventing a new yellow pigment.

Badalocchio, Sisto Rosa, called (1585–after 1621?) Italian painter and engraver from Parma, a pupil of the *Carracci in Bologna. After the death of Agostino Carracci in 1602 he and *Lanfranco went to Rome to join Annibale Carracci to whom they dedicated, in 1606–7, a volume of engravings after *Raphael. Badalocchio became one of Annibale's chief assistants until the latter's death in 1609, when he returned to Parma. He was active again in Rome on several occasions, and is also documented in Reggio Emilia in 1618. He is best known for a series of poetic nocturnal paintings of the Entombment of Christ, probably based on a composition by Ludovico Carracci (Oxford, Christ Church) and a prototype painting by Annibale (Rome, Doria-Pamphili) and extant in many versions of different sizes and on different supports, canvas and copper (Rome, Pal. Patrizi; Naples, Capodimonte; London, National; Dulwich, Gallery etc.).

Badger, Joseph (1708–65) Colonial American portrait painter, working in his native Boston where he succeeded *Smibert (New Haven, Yale University; see also Robert Feke, John Greenwood).

Badile, Antonio See under Veronese.

Baen, Jan de (1633–1702) Fashionable Dutch portrait painter. A native of Haarlem, he studied under Jacob *Backer in Amsterdam, but chose to abandon the latter's Rembrandtesque manner (see Rembrandt) for the elegant international style of Anthony *Van Dyck. He became the leading portraitist in court circles in The Hague, second only to Caspar *Netscher, and worked also for Charles II of England and for Friedrich Wilhelm, elector of Brandenburg, who tried in vain to lure him to Berlin. He also executed a few institutional group portraits (Amsterdam, Rijksmuseum; Hoorn, Westfries).

Baertling, Olle (1911–81) Swedish painter and sculptor, active mainly in Stockholm. His early work was *Expressionist but tended towards *abstraction and became wholly abstract when he visited Paris in 1948, studied with Léger and *Lhote and came under the influence of *Mondrian. He is best remembered for his paintings of straight-edged interlocking forms, often sharply pointed and in bright colours, producing a firm and energetic visual surface without, it would seem, any emotional message beyond that of dynamism. From the 1950s on he also made welded steel sculptures, using similar forms and with similar colours added to them.

Baglione, Giovanni (c.1573–1644) Roman painter, best remembered as the implacable enemy of *Caravaggio and the author of the Vite de' Pittori, scultori et architetti, Dal Pontificato di Gregorio XIII dal 1572 in fino a' tempi di Papa Urbano Ottavo nel 1642, (1642) probably the most reliable source for the biographies of late 16th- and early 17th-century Roman artists. He also wrote a guide to Roman churches, Le Nuove Chiese di Roma (1639). The son of a Florentine resident of Rome, Baglione first painted in a Late *Mannerist

idiom influenced by the followers of *Barocci (1589, frescos in the Vatican Library and the Scala Santa). Around 1600, however, his style changed radically under the influence of Caravaggio, which did not, however, prevent Caravaggio and his friends, notably the architect Onorio Longhi and the painter Orazio *Gentileschi, from circulating long and coarse derisory poems about him and his work. In 1603 Baglione brought a suit for defamation of character against them, claiming that Caravaggio was jealous of him because he, Baglione, had received a commission for an *Ascension of Christ* in the church of the Gesù. Baglione was strongly criticized for a painting of *Divine Love subduing Earthly Love* (now Berlin, Staatliche) executed shortly before the trial to rival a *Victorious Earthly Love* by Caravaggio; significantly, the picture was once attributed to Caravaggio himself. (A later version is now in Rome, Galleria Nazionale.) During the pontificate of Paul V Baglione received numerous commissions in Rome and in the papal states in Umbria and the Marches. In these years Caravaggio's influence diminished, to be replaced by that of Annibale *Carracci and his Bolognese followers (*Rinaldo and Armida*, Rome, Pal. Rospigliosi). In the early 1620s Baglione worked for the ducal court in Mantua; his Roman works of this decade are influenced by *Guercino (*St Sebastian*, 1624, S. Maria dell'Orto). Vacillating between progressive trends, he absorbed none of them fully; the quality of his work declined rapidly after about 1630.

Baillairgé, François (1759–1830) French-Canadian wood sculptor and painter, born in Quebec. He studied in Paris in 1778–81. His first commission on his return to Quebec was the decoration of the cathedral. With his brother **Florent** (1761–1812) and son **Thomas** (1792–1859) and other members of his family he carved decorations for many Canadian churches (Neuville; St Joachim). There are sculpted figures by him in Ottawa, National; Detroit, Institute of Art. François was the drawing teacher of the painter-surveyor **Joseph Bouchette** (1774–1841), whose topographical sketches of Canadian

scenery were engraved and published as books in 1815 and 1832.

Bailly, David (1584–1657) Leiden portrait painter, credited, on insufficient evidence, with the invention of the *vanitas* *still-life, of which his pupil Harmen van *Steenwijck was the leading exponent. His 1651 *Portrait of a Young Painter* (which may be a disguised self-portrait in youth and middle age) presents, however, a virtually complete catalogue of *vanitas* motifs (Leiden, Lakenhal).

Baily, Edward Hodges (1788–1867) English sculptor who worked in *Flaxman's studio, trained at the Royal Academy Schools and had a successful career as sculptor and designer. Many of his works are tombs and monuments, and portrait busts (some of the latter are in the National Portrait Gallery, London); his public works include the figure of Nelson high above London's Trafalgar Square and the statues on the National Gallery on the north side of the square. He also carved *history subjects, among them *Eve at the Fountain* (1822; Bristol) and *Eve Listening to the Voice* (1842; London, Bethnal Green).

Baj, Enrico (1924–) Italian painter, trained in Milan at the Accademia di Brera. He became known in the late 1950s for his series of pictorial manikins constructed out of a variety of materials, at once humorous and disturbing and implying mockery of the highflown rhetoric of *Art informel.

Bakhuizen, Ludolf (1630/1–1708) He signed his name also Backhuyzen and Backhuysen. Leading, if slightly monotonous, Dutch marine painter. Portraits and a few religious and *genre scenes, *landscapes and town views by him are also known, as are a number of etchings. Born in East Friesland, he came in about 1650 to Amsterdam, where he was to spend the rest of his life, and where he first worked as a merchant's clerk and calligrapher, before turning to making pen drawings of shipping. He learned painting from Allart van *Everdingen and also from Hendrick

*Dubbels, whose influence is clear in his early works. His mature seascapes show the influence of the younger Van de *Velde, especially the storm scenes; after the two Van de Veldes went to England in 1672 he became the most renowned marine painter in Holland and one of the most successful artists of his time, patronized by Peter the Great of Russia and various German princes. There are works by the prolific Bakhuizen in many public and private collections, including Amsterdam, Rijksmuseum, Historisch; Leipzig, Museum; London, National; etc.

Bakhuyzen, Hedrikus van de Sande (1795–1860) Dutch landscape painter, a forerunner of the *Hague School.

Bakst, Léon (1866–1924) Adopted name of Lev Rozenberg. Russian painter, illustrator and stage designer, best known in the West for the designs he made for Diaghilev's Russian Ballet. He studied art in St Petersburg and, during repeated travels, in Paris in the 1890s. He was one of the founders of the *World of Art group and journal in 1899, contributing paintings to its exhibitions and illustrations and covers for its magazine, *Mir Iskusstva*, as well as others. In 1906 he installed Diaghilev's exhibition of Russian art at the *Salon d'Automne. In these and other ways, including involvement in many exhibitions in Russian and in western Europe, Bakst was an international figure and from 1910 lived mainly in Paris. His work is in many styles, benefiting from the *fin de siècle*'s interest in exotic as well as period styles. Among the many designs he made for the Russian Ballet, during 1909–22, those for *Schéhérazade* (1910), *L'Après-midi d'un Faune* (costumes, 1912), *Le Légende de Joseph* (costumes, 1914) and *La Belle au Bois Dormant* (1921) are the most famous. He made designs also for many other productions and for ballet and drama productions by other companies, at times making a marked impact on fashion. The Bakhrushin Theatre Museum in Moscow has the best collection of his designs.

Baldacchino Italian word, anglicized to baldachin or baldaquin, originally meaning 'brocade', from the Italian Baldacco, 'Baghdad', noted for its brocade cloth. The term came to be used for the fringed canopy, or cloth of honour, carried in procession over the Eucharist or some other holy object, and affixed over a bedhead, throne or altar. The cloth canopy over the altar of a Christian church was soon replaced by a permanent structure in stone or metal, also called a *ciborium. *Bernini's enormous *bronze baldacchino over the altar of St Peter's, Vatican, is the most famous as well as the largest. Its much imitated twisted columns were inspired by the Early Christian stone columns surviving from the original 4th-century basilica erected by Constantine the Great.

Baldessari, John (1931–) American *Conceptual artist working mainly with texts, photographs, films and videos. His verbal and visual parables are frequently ironic in spirit.

Baldinucci, Filippo (1625–96) Florentine amateur draftsman and writer on art, author of the massive *Notizie de'professori del *disegno da *Cimabue in qua . . .*, 1681–1728 (the posthumous publication of the 3rd, 5th and 6th volumes from Baldinucci's manuscript notes was the work of one of his sons). This encyclopedia of artists' biographies was intended by the author and by his original patron, Cardinal Prince Leopoldo de'*Medici (1617–75), to substantiate the claim of Tuscan artistic primacy made over a century before by *Vasari in his *Lives of the Artists*, and to bring the latter up to date – i.e. 1670. Baldinucci, a depressive with an unfulfilled religious vocation, a largely self-taught scholar of straitened means, was by profession a bookkeeper, although also the friend of many leading Florentine artists (e.g. Carlo *Dolci, *Sustermans) and a member of Leopoldo's commission for the purchase of works of art. After the Cardinal's death he had a difficult struggle to realise his great project, receiving scant support from Leopoldo's nephew, Grand Duke Cosimo III. Nonetheless, his work is one of our most important sources for the lives of contemporary and late 16th-century artists. His great antagonist was the Bolognese art

historian *Malvasia, who naturally sought to validate his native tradition in its own terms rather than from a Florentine perspective.

Baldovinetti, Alesso (*c*.1425–99) Florentine painter, designer of stained-glass windows, mosaics and tarsias. His style was formed on that of *Domenico Veneziano, whose now lost frescos in Florence, S. Egidio, he completed in 1461. His best-known independent work is the fresco of the *Nativity*, 1460–2, in the entrance courtyard of SS. Annunziata, with an expansive and detailed landscape studied, at least in part, after nature (*see also* Andrea del Sarto; Franciabigio; Pontormo; Rosso). He also collaborated on the chapel of the Cardinal of Portugal in S. Miniato (1466–73; *see also* Antonio Rossellino; Pollaiuolo; Luca della Robbia) for which he painted the *Annunciation*. In 1483 he was appointed curator and restorer of the mosaics in Florence Baptistery. There are panel paintings by him in Paris, Louvre; London, National; Florence, Uffizi; etc.

Balduccio, Giovanni di (recorded from 1315 to 1349) Italian sculptor from Pisa, recorded working under *Tino da Camaino. He settled in Milan *c*.1334, where he introduced the Pisan style (Milan, St Estorgio).

Baldung, Hans (called **Grien**) (1484/5–1545) Draftsman, printmaker, book illustrator, designer of stained glass and painter, trained in *Dürer's workshop in Nuremberg *c*.1503–5. Born into an academic family in Schwäbisch Gmund, Baldung spent most of his working life in Strasbourg, although he lived also in Halle, where in 1507 he painted two altarpieces – now in Berlin, Staatliche and Nuremberg, Museum – and in Freiburg, 1512–17. The most outstanding and influential follower of Dürer, he nonetheless did not share the latter's rational humanism and is the German artist most closely identified with northern mysticism. Many of his prints and paintings express to an extraordinary degree the period's ambivalence towards sensuality: woodcuts of witches and witches' sabbaths, with their emphasis on the female nude, and small *cabinet pictures on the theme of Death and the Woman, of which the most famous and arresting is the panel of *c*.1517 in Basel, Kunstmuseum, depicting a fully *classical nude horribly embraced by a half skeletal, half-cadaverous Death (other paintings on this subject, from 1509 onwards, Vienna, Kunsthistorisches; Florence, Uffizi). Three woodcuts of wild horses in the forest (1534) are almost certainly meant to allude to man's bestial passions, and Baldung's most famous print, the woodcut of *The Bewitched Groom* (1544) combines the themes of horse and witchcraft to mysteriously powerful effect, aided by Italianate *perspective.

In addition to altarpieces (the most important of which, based on Dürer's *Heller Altarpiece*, was painted in 1512–16 for the cathedral of Freiburg im Breisgau) and collectors' pictures, Baldung also painted masterly portraits, notably during his stay in Freiburg (e.g. Munich, Alte Pinakothek; Berlin, Staatliche; Vienna, Kunsthistorisches). In his later years, he was increasingly influenced by *Grünewald (e.g. *Magdalen*, 1539, Darmstadt, Landesmuseum).

Balen, Hendrick van (1575–1632) *See under* Van Dyck, Sir Anthony.

Balestra, Antonio (1666–1740) Italian painter and printmaker from Verona, where he returned to settle permanently in 1718. He is important for his *classicizing, anti-*Baroque and anti-*Rococo influence on the local school (where his leading pupil and successor was **Giovanni Bettino Cignaroli**, 1706–70), and more generally throughout the Veneto. The fundamental experience in the formation of his own style was his period in *Maratta's studio in Rome, from 1691 to before 1697. A trip to Lombardy and Emilia in 1700 resulted in a fruitful admixture of elements from *Correggio. There are paintings by Balestra in churches in Verona and Venice (e.g. Verona, Scalzi; Venice, S. Zaccaria) in palaces (e.g. Macerata, Castel San Pietro; Pommersfelden, castle) and public collections (e.g. Norfolk, Virginia, Chrysler) and drawings in various

public and private collections (e.g. Milan, Ambrosiana; Washington, National). In the early 1720s he also became increasingly involved in book illustration (e.g. preparatory drawings, Parma, Biblioteca Palatina).

Baljeu, Joost (1925–) Dutch artist, trained in Amsterdam as a designer. He became prominent after the Second World War as the leader of a *Constructivist revival in the Netherlands. His work is mostly in three dimensions, partly in response to *Biederman. He was founder and editor of the journal *Structure* (1958+) and author of a book on Van *Doesburg (1974).

Ball, Hugo (1886–1927) German writer who founded the *Cabaret Voltaire in Zurich in 1916. A pacifist, he had crossed into Switzerland at the outset of the 1914–18 war. He and the artists and writers that gathered around him initiated the *Dada movement. Poor health forced him to leave Zurich before the end of 1916. His account of these years was published in 1927 as *Die Flucht aus der Zeit* (Flight from Time).

Balla, Giacomo (1871–1958) Italian painter associated with the *Futurist movement, born in Turin but from 1893 working in Rome. His early paintings use the *divisionist method, learned from Italian practitioners and reinforced by a visit to Paris in 1900. *Boccioni and *Severini studied under him when he adapted this method to everyday urban subjects symbolic of social issues. They persuaded him to join the Futurist group of painters in 1910. His *Dynamism of a Dog on a Leash* (1912; Buffalo, Albright-Knox) represents movement as revealed by photography. He spent part of 1912–13 in Düsseldorf, exploring the representation of motion in *figurative (e.g. motorcars, birds in flight) and in *abstract terms (geometrical patterns suggesting shimmering light by the interaction of juxtaposed colours). In 1914 he painted a series of cosmic images of the movement of planets in spiralling and arching forms and contrasts of colour and tone. Balla was also interested in interior and stage design, as well as typography and

other design areas. Working in Rome he became the centre of a local Futurist group and was a mentor to the second Futurist wave that formed in Italy after the First World War.

Balten, Pieter *See under* Bruegel.

Balthus (1908–) Professional name of Balthasar Klossowski de Rola, French painter, born in Paris, the son of a Polish painter and descendant of minor aristocrats. Guided by *Derain and others, Balthus became a sophisticated painter of semi-naïve street scenes and of dreamlike visions of interiors with figures marked by psychological tension and at times sexual abandon. His appeal to repressed memories and wishes is sharpened by a style that combines *Neoclassical economy of form with Oriental refinement and ornament. His work was praised by the *Surrealists but he worked in seclusion until the later 1960s, since when he has been hailed as a master of *figurative painting, at once succinct and exotic.

Bambino Vispo, Master of the *See under* Starnina, Gherardo.

Bambocciate, Bambocci, Bamboccio *See under* Laer, Pieter van.

Banco, Nanni di *See* Nanni di Banco.

Bandinelli, Baccio (1493–1560) Ambitious but neurotic and technically deficient Florentine sculptor, who was an early (1530s) proponent of *academic training. A protégé of the *Medici from their return to power in 1512, he became, in all but name, court sculptor to Cosimo I after *Michelangelo's final departure from Florence in 1534. His monumental *Hercules and Cacus* of the same year (Florence, Piazza della Signoria) designed as a pendant to Michelangelo's *David* was deservedly criticized, not least by Bandinelli's bitter rival *Cellini. Trained by his father as a goldsmith and inlay expert, Bandinelli was apprenticed to *Rustici, but, despite his ability to attract major monumental sculpture commissions (e.g. tombs of Popes Leo

X and Clement VII de'Medici, 1536, Rome, S. Maria sopra Minerva; monument of Giovanni dalle Bande Nere, 1540, for Florence, S. Lorenzo, now Piazza S. Lorenzo) remained most successful working on a small scale (Florence, Bargello) and as a draftsman and carver in relief. The latter skill was acquired during his stay at Loreto under Andrea *Sansovino (1517–19); although he abandoned the reliefs he had been working on before they were finished – as he was to abandon many statues – his later reliefs for the balustrade of the choir of Florence cathedral (1547–55) are generally adjudged to be his best work. Others in the same series were executed by his pupil Giovanni *Bandini. Temperamentally and technically ill-equipped to produce naturalistic (*see under* realism) and *expressive statues in the Florentine tradition, Bandinelli was able, however, to copy well from the antique (*Orpheus*, dependent on the *Apollo Belvedere*, 1519, Florence, Palazzo Medici; copy of *Laocoön*, 1520–5, Florence, Uffizi). His *Dead Christ supported by Nicodemus*, 1554–9, for his tomb in SS. Annunziata in Florence (begun after his model by his son Clemente Bandinelli (1534–54) before the latter's departure for Rome) was the sculptor's final act of rivalry with Michelangelo, who was then carving a Pietà for his own funerary monument. As ambitious socially as he was artistically, Bandinelli forged a noble pedigree for himself and successfully negotiated to be made a Knight of St James, *c*.1529; he describes his intrigues in his *Memoriale*, along with *Cellini's autobiography and *Vasari's *Lives* an important document for the history of 16th-century art.

Bandini, Giovanni (1540–99) Florentine sculptor, a pupil of Baccio *Bandinelli, after whose death he completed the choir screen for Florence cathedral, 1572, for which work he became known as Giovanni dell'Opera ('Opera del Duomo', cathedral workshop). Ironically, in view of his master's long rivalry with *Michelangelo, he participated in the decorations for the latter's funeral, and was entrusted with the figure of *Architecture* on Michelangelo's tomb in S. Croce,

Florence (set in place 1574; terracotta model, London, Soane). He also contributed a bronze figure to the decoration of Francesco de'*Medici's *Studiolo* in the Palazzo Vecchio, under the overall direction of *Vasari (1573). From 1582 he worked for the Duke of Urbino (*Pietà*, 1585–6, Urbino, cathedral; portrait statue, 1587, now Venice, Doge's Palace courtyard). In 1595 he returned to Tuscany to execute Ferdinand I de'Medici's statue for the monument at Livorno (*see also* Pietro Tacca). There are also reliefs by Bandini in the Gaddi chapel, Florence, S. Maria Novella (1576–7); in these as in his portrait sculpture he followed the rather tight, generalized style of Bandinelli

Banks, Thomas (1735–1805) British sculptor, amongst the first to work in the *Neoclassical style. The son of a steward to the Duke of Beaufort, he was first influenced by William *Kent. Although ill-educated and inarticulate, he aimed 'to bring poetry to the aid of all his compositions'. During the 1760s he won prizes for classical reliefs, and in 1772 he went to Italy on a Royal *Academy travelling studentship. In his seven years in Rome he became friends with *Sergel and *Fuseli, and came under the influence of J. J. *Winckelmann. Upon his return to England in 1779 Banks could find little patronage; he attempted to settle in St Petersburg (1781–2) where the Empress Catherine bought his much-admired *Cupid*, now lost. In 1786 he was elected to the Royal Academy, and continued working mainly on funerary monuments and busts; little of his 'poetic' sculpture remains. There are works in London (Westminster Abbey, V&A, St Paul's, NPG, Soane, Royal Academy), in Stowe Park, Stratford-upon-Avon, and elsewhere. His best-known monument, to Penelope Boothby (1793), is in Ashbourne, Derbyshire.

Bannard, Walter Darby (1931–) American painter who became known in the mid-1960s as a contributor to the succinct mode of *Post-Painterly Abstraction. His paintings are noted for their concentration and refinement.

Baranoff-Rossiné, Vladimir (1888–1942) Russian artist, trained as a painter in Odessa and at the St Petersburg Academy. He worked as a sculptor in Paris from 1910 to 1916, influenced by Cubism, *Boccioni and *Archipenko, making and exhibiting sculptures assembled out of many materials and *kinetic sculptures. Back in Russia he produced *abstract paintings and constructed sculptures. After the 1917 Revolution he was given a teaching post in the new art workshops and a place on the Commissariat of Enlightenment's fine art board. His best-known work is a sculpture suggestive of a standing figure but otherwise an *abstract assembly of partly painted wood elements enriched with crushed egg shells: *Symphony No.1* (1913; New York, MoMA). In 1925 he emigrated to Paris where he worked until deported by the Germans in 1942.

Barbari, Jacopo de' (*c.*1440–before 1516) Printmaker and painter from Venice; after 1500 he worked at courts in Germany and the Netherlands, although he may have revisited Venice in 1508/9. Little is known of his background or training; it has been suggested that he was a well-born amateur who entered Alvise *Vivarini's studio in the 1490s. The first dated work attributed to him is the famous large *woodcut in six blocks, the *Bird's-eye View of Venice*, 1497–1500. Early engravings (*see* intaglio) show the influence of Vivarini and *Mantegna; some were copied by *Dürer. Later prints adopt German techniques evolved by *Schongauer and Dürer. Amongst the few painting by Jacopo known today is the famous **trompe l'œil* *still-life, one of the earliest known, of the *Dead Bird* (Munich, Alte Pinakothek). Other works in paint are in Berlin, Staatliche; Dresden, Gemäldegalerie; London, National; Paris, Louvre; Philadelphia, Johnson Coll.

Barberini Italian family, of Florentine merchant stock, renowned for their patronage in 17th-century Rome, which effectively began in 1623 when Cardinal **Maffeo Barberini** (1568–1644) was elected pope, taking the name of Urban

VIII. As the great patron of *Bernini, Urban VIII is associated with the *Baroque embellishments of Rome and especially of St Peter's – such as the immense *baldacchino*, for which the ancient Roman Pantheon was despoiled of its bronze – giving rise to the pasquinade (*see under* Pasquino): *Quod non fecerunt barbari, fecerunt Barberini* (what the barbarians did not do, the Barberini did). But other members of the family, elevated by Urban to the cardinalate, also patronized the *classical current of 17th-century art: **Antonio Barberini**, Urban's younger brother, employed *Reni and *Domenichino as well as *Pietro da Cortona and *Lanfranco; the Pope's learned nephew, **Francesco Barberini**, commissioned paintings from *Poussin (*see also* Cassiano dal Pozzo, Francesco's secretary); Francesco's brother, the younger **Antonio Barberini**, was Andrea *Sacchi's benefactor. The Barberini palace in Rome is now the seat of the Galleria Nazionale, and the work of most of these artists can be seen there, particularly in the famous decoration of the ceilings.

Barberini Faun Famous Late Antique statue, much esteemed in the 17th century; perhaps a marble copy of a bronze original, representing a satyr sprawling in sleep. It is said to have been discovered during work in 1624 on the Castel Sant'Angelo, once the tomb of the Roman emperor Hadrian, and is first recorded in 1628, in a receipt for the first of its many restorations. It belonged at this date to Cardinal Francesco *Barberini, nephew of Pope Urban VIII, the great patron of *Bernini, but there seems to be no truth in the tradition that the latter was involved in its restoration (the statue's right leg was truncated at the thigh, the left leg was in fragments, the left arm and the seated figure's base were missing). The *Faun* remained in the Palazzo Barberini until, in 1814, it was finally sold under duress to Crown Prince Ludwig of Bavaria; a ban on its export was only lifted in 1819, and the statue reached Munich in 1820; it is now in the Glyptothek.

Barbieri, Giovanni Francesco *See* Guercino.

Barbizon School Name given to a loose association of landscape painters centred on the hamlet of Barbizon on the edge of the Forest of Fontainebleau. Easily reached from Paris, the Forest, favourite hunting ground of François I when residing at Fontainebleau, was still considered wild and mysterious and its villagers primitive. *Corot was one of the first painters to choose to paint there but it was Theodore *Rousseau who settled in Barbizon in 1836 and became something of a leader to those who followed him. By 1840 a train from Paris took travellers within an hour's carriage ride of the Forest; in 1849 it reached Fontainebleau and opened the area to weekend trippers. J.F.*Millet settled in Barbizon that year. The Barbizon painters retained their links with Paris. They were never part of the life of the Forest though their work tended to be associated with honouring the simplicity and dignity of the peasants and thus seen as a political as well as artistic challenge to academic traditions. Foreign artists as well as French came in increasing numbers for short and long visits from the 1850s on, including a number of Americans, such as William Morris Hunt who became a disciple of Millet and made his work popular in the USA, the German *Liebermann and the Hungarian *Munkacsy. With growing popularity Barbizon lost its character and the Forest much of its attraction to serious artists, especially after the death of Millet in 1875.

The Forest of Fontainebleau had in some measure replaced the Roman Campagna as a desirable site for drawing and painting amid nature. The later 19th century was to see several other rural areas discovered and then promoted as artists' colonies, among them, most notably southern Brittany, with Pont Aven and Le Pouldu as centres, and, outside France, Skagen (Denmark), Worpswede and Neu-Dachau (Germany), and Cornwall, with Newlyn and then St Ives as centres, in England.

Barendsz., Dirck (1534–1592) Dutch painter, the first to introduce an Italianate *Renaissance style and outlook to the art of the northern Netherlands (but *see also* the earliest Flemish 'Romanist'

Gossaert). In his early twenties Barendsz. went to Venice and studied with *Titian, returning *c.*1562 to his native Amsterdam, where he became known not only as a painter but also as a man of letters, scholar, and musician. There are works by or attributed to him in Amsterdam, Rijksmuseum, Historisch; Gouda, Municipal; London, National.

Barlach, Ernst (1870–1938) North-German sculptor, born in Holstein, trained in Hamburg and Dresden. Following a visit to Russia, moved by the earthy simplicity and piety of the Russian peasant, he devoted his art to making images of figures visualized in a semi-medieval style, expressing alienation from the modern world and mankind's need of God. His forms suggest the broad planes of late medieval wood carving, most clearly so in his own wood carvings but also in the sculptures he modelled for bronze casting. In 1910 he settled at Güstrow, near Rostock on the Baltic. In 1912 he published his first drama *The Dead Day*, with 27 *lithographic illustrations. This drew attention to him as part of the emerging *Expressionist movement in literature and art; other dramas and lithographic suites followed. He served in the German army 1914–16. Fame and popularity came in the post-war years when Barlach executed a series of war memorials, received the Kleist Prize (1924), published his autobiography (1928) and was honoured with a retrospective by the Berlin Academy (1930). In 1934 a large exhibition was shown in Bern; the same year saw the removal of his war memorial from Magdeburg Cathedral in response to the church council's demands (it was stored in the Berlin National Gallery). His play *The Real Sedemonds* had its première in 1935 with great success but further performances were vetoed by the local authority. The Berlin Academy wanted to show a group of his works as part of its 1936 jubilee exhibition but their removal was ordered before the opening. In 1937 many of his public works were removed or destroyed and 381 Barlachs were taken from public collections; some of them toured as *'Degenerate Art'. His studio in Güstrow is now a Barlach Museum. A private collection

forms the basis of another, the Barlach House in Hamburg.

Barlow, Francis (1620s–1704) English painter and etcher specializing in lovingly observed pictures of birds and animals; he has also been called 'the real father of British sporting painting' for his hunting pictures (*see also* Wooton, Tillemans). There are works by him at Ham House, Surrey; Parham, Sussex; Onslow coll.

Barna da Siena (active early 1350s) A follower of *Duccio, only slightly influenced by the intervening generation of painters, primarily *Simone Martini. His *fresco cycle of the *Life of Christ* (San Gimignano, Collegiata) is notable for the intellectual rigour of its arrangement and its transcendental emotionality. (*See also* Bartolo di Fredi.) There are panel paintings in New York, Frick and Boston, MFA.

Barna[ba] da Modena (active 1361–83) Prolific Italian painter, from a Milanese family settled in Modena; influenced by Bolognese and Sienese masters (*see* Vitale da Bologna; Duccio). He was mainly active in Genoa, where around 1370–77 he executed two *polyptychs for the cathedral of Murcia, Spain (now in the cathedral museum). A small portable altarpiece (London, National) is thought to have been painted for the same patron, Juana Manuel, queen of Castile. From 1379 he spent some time in Pisa. There are other signed and dated panel paintings, polyptychs and fragments from polyptychs in many collections and some churches, including Genoa, S. Bartolomeo del Fossato; Frankfurt, Städelsches; Indianapolis, Art Inst.; etc.

Barocci, Federico (*c*.1535–1612) Eclectic but highly individual painter of Urbino. His refined and emotional fusion of Venetian *colore* with Central Italian *disegno*, most dependent on the earlier example of *Correggio, anticipated and influenced the *Carracci and led the transition from Late *Mannerism to the *Baroque. Through his many altarpieces,

commissioned from as far afield as Genoa, Tuscany, Umbria and Rome, he affected many artists throughout Italy. The sincerity and lyrical pathos of his idiom perfectly expressed Counter-Reformation sensibility; his altarpiece of *The Visitation* (1583–6; Rome, S. Maria in Valicella) is the only painting known to have been admired by St Philip Neri, founder of the Oratorians, who was once found in mystical ecstasy in front of it.

Formative influences on Barocci were his study of High *Renaissance works in the collection of the Duke of Urbino, notably those by *Titian and *Raphael, and his visit to Rome in the mid-1550s, where he became friends with Taddeo *Zuccaro and studied the *frescos of the Vatican. A subsequent visit, 1560–3, ended tragically with his being allegedly poisoned by a rival. After his return to Urbino he virtually ceased to paint for four years, and remained an invalid for the rest of his life. By *c*.1567, however, with the *Madonna of S. Simone* (Urbino, Galleria) he had somehow found his Corregesque idiom – by what precise means is not known, since he apparently never visited Parma. His subsequent series of great altarpieces includes the *Deposition* (1567–9, Perugia, cathedral); *Il Perdono* (early 1570s, Urbino, S. Francesco); the *Madonna del Popolo*, painted in 1575–9 for the Misericordia of Arezzo (now Florence, Uffizi); the *Calling of St Andrew* (1580–3, Brussels, Musée); the *Annunciation* (1582–4, Vatican, Pinacoteca); the *Circumcision* (1590, Paris, Louvre); the *Last Supper* (late 1590s, Urbino, cathedral); *Crucifixion* (1596, Genoa, cathedral). Other works are dispersed in many public collections, as are Barocci's wonderfully colouristic chalk drawings, part of his meticulous preparation after the life for his painted works. The subtle diversity of colour, the linear rhythms and the exquisite sentiment – sometimes falling into sentimentality – of his late paintings, such as the *Beata Michelina* (1606, Vatican, Pinacoteca) anticipate the *Rococo as much as the earlier works pointed the way to the *Baroque.

Baronzio, Giovanni (active from *c*.1340–1362) Italian painter working in Rimini

and nearby centres, chiefly remarkable for the narrative inventiveness of his religious scenes (Urbino, Galleria, *polyptych signed and dated 1345; etc.).

Baroque, baroque A stylistic term employed in its neutral sense for art, architecture, music and even literature of the 17th century. It may derive from *barocco*, as used for irregular or misshapen pearls. Originally a derogatory term, meaning a departure from the norms of *classicism, in its lower-case form it may still be used, not only in the arts, to denote something exaggerated, overblown, capricious.

In art, Baroque is associated with a large scale; sweeping diagonal movement; a tendency to break away from the picture plane both in depth and towards the viewer; forms flowing and swirling one into the other (as opposed to the clearly delimited forms of classicizing art); colourism (*see under* disegno) and *illusionism. Although international – and indeed, through *Caravaggio and the Baroque painter *par excellence* *Rubens, deeply marked by the art of northern Europe – Baroque signifies a deliberate rejection of the hermetic complexities of pan-European court *Mannerism in favour of a return to the values of Italian *Renaissance art. What might have been a more or less purely artistic development, however, found enthusiastic support from institutions and individuals throughout European society. Spurred by the fear of religious and political fragmentation, the need to assert ever more absolute power, or in defence against such power, 17th-century patrons welcomed, in some cases demanded, a more universal, expressive (*see under* expression) and persuasive visual language, capable of reaching spectators of all classes. Baroque is thus associated with the 'higher' *genres – history painting (or sculpture in the same epic mode), *allegory, and portraiture – traditional in public or princely venues.

Although the illusionistic figurative decoration of domes was (after a medieval prelude in baptisteries and oratories) a 15th and 16th-century development, (notably by Italian artists such as *Melozzo da Forlì, *Michelangelo, *Correggio, *Pordenone, *Giulio Romano, *Vasari and *Veronese), it reached an exuberant apogee in Baroque art, beginning early in the 17th century with Annibale *Carracci's 'critique' of Michelangelo in the sculpture gallery of the Farnese Palace in Rome. Aurora's horse-drawn chariot glides above the viewer's head in the Ludovisi's summer house painted by *Guercino, a protégé of Annibale's cousin Ludovico. *Lanfranco, another Carracci follower, brought to Rome the whirling apparitions of Correggio's Parma domes, nearly a hundred years after Correggio's death. *Rubens's ceilings for the Whitehall Banqueting House, London, and the new Jesuit church in Antwerp adapted Italian models of the previous century to trans-Alpine locations and the new demands of, respectively, monarchist propaganda and Counter-Reformation doctrine. Back in Rome, *Pietro da Cortona satisfied both aims in the *Gran Salone* in the *Barberini palace, which simultaneously celebrates the triumph of Pope Urban VIII Barberini with that of Catholic orthodoxy. Influenced by Pietro da Cortona, *Luca Giordano executed the only flamboyantly Baroque ceiling of Florence, in the Palazzo Medici-Riccardi, before moving on to Spain, where he decorated acres of royal and church ceilings. *Gaulli and, under his influence, *Andrea Pozzo painted soaring apotheoses of Jesuit saints and missions on the ceilings of the new Jesuit churches of Rome; in 1703 Pozzo was to bring their innovations to Vienna.

Gaulli's and Pozzo's ceilings, and Roman Baroque of the second half of the century in general, abolished the traditional boundaries between the arts, and between art and reality, in order to stimulate in the viewer a heightened emotional state, analogous to those saintly raptures which are so often the subject depicted. The man who first created, then influenced, such hypnotic effects was the sculptor and architect Gian Lorenzo *Bernini; *see* this entry for an account of the Cornaro chapel, an especially conspicuous example of a unified environment created around the representation of a Counter-Reformation saint, Teresa of Avila, in ecstasy.

Baroque portraiture, whether with the aid of overt allegory or without, is dramatic, at times bombastic, and manipulative

of the spectator. The formal 'portrait of status' often 'locates' the viewer below the sitter to stress the latter's superiority: Charles I, in *Van Dyck's equestrian portrait of him, is viewed from stirrup-height, while the Stuart brothers look on us *de haut en bas* (both London, National). Van Dyck learned the device from Rubens, and it is used by portraitists as diverse as *Philippe de Champaigne and *Rembrandt. More characteristic of the latter, however, especially in his self portraits, is to break through the picture plane, maximizing the illusion of intimacy between viewer and sitter. *Chiaroscuro is one of Rembrandt's favourite devices in both portraits and narrative scenes; indeed, he gives his group portraits the semblance of history paintings – a development of great importance to the evolution of portraiture (*see for example* Reynolds).

While art historians speak of Baroque landscape and Baroque still life, and even of Baroque genre, these categories seem to fall less readily under the style label, albeit sharing some of the technical characteristics outlined at the beginning of this entry. Unhappily, scholars have also coined the term 'Baroque Classicism', to include such 17th-century artists as *Poussin.

Barra, Didier (*c*.1590–after 1652) Born in Metz, he is recorded in Naples from 1631, painting poetical yet accurate panoramic views of the city based on contemporary maps. Under the name Monsù (a corruption of Monsieur) Desiderio, his identity has until recently been merged with that of another painter from Metz, François de *Nomé.

Barrera, Francisco (1595–after 1657) Spanish painter, working in Madrid, specializing in seasonal still lifes with spectacular displays of foodstuffs, some including figures and comparable to those of Vincenzo *Campi in northern Italy (Seville, Museo).

Barret, George the Elder (1732?–84) Irish landscape painter and engraver who settled in England in 1762 and became a founder-member of the Royal *Academy, specializing in topographic views of *picturesque locations on private estates. He was the financially successful rival of the far-more talented Richard *Wilson, who described his landscapes as 'spinach and eggs'. His best works remain in the family collections of his most notable patrons, the dukes of Portland and Buccleuch; also, e.g., Wilton, Pembroke coll. His son, **George Barret the Younger** (*d*.1842) was a landscape watercolourist.

Barry, James (1741–1806) Irish-born painter of huge talent, a fiery and unbalanced temperament, and the overwhelming ambition to succeed as a painter of heroic subjects. Brought by Edmund Burke to London in 1764, he was introduced to *Reynolds, who encouraged him. Still financed by Burke, he studied in Italy from 1766 to 1771, schooling himself in the manner of *Michelangelo. He was made Associate to the Royal *Academy in 1772, and Academician in 1773; after a disagreement in 1776 over his *Death of Wolfe*, a critique of *West's famous picture of 1771, he never exhibited at the Academy again. His major works are the enormous canvases representing *The Progress of Human Culture* painted in 1777–83 to decorate the Great Room of the Society of Arts; but his portraits in the elevated style advocated by Reynolds are more consistently successful (e.g. *Hugh, Duke of Northumberland, c*.1784, Syon House). Embittered by lack of patronage for his narrative extravaganzas, Barry, who in 1782 became Professor of Painting at the Academy, took to abusing his fellow Academicians from the lecture podium. He was turned out of the Academy in 1799, and died deranged and in poverty. There are works by him in Dublin, National; London, Tate; Manchester, City; Bologna, Pinacoteca; Sheffield, Galleries; etc.

Bartholdi, Frederic Auguste (1834–1904) French sculptor, born in Colmar, who studied sculpture in Paris after trying his hand at architecture and painting. He became known after his bronze statue of General Rapp, commissioned by his native city, was exhibited in 1855. He visited Egypt in 1856 and 1869 (the year the Suez Canal was opened), and was seized with the

ambition of creating a great Suez monument, a lighthouse to compete with the legendary marvels of ancient times, the Colossus of Rhodes and the Pharos of Alexandria. He fought in the Franco-Prussian war of 1870–1, thereafter taking especial interest in making war memorials and also exploring themes relating to Franco-American relations. His statue of Lafayette was shown in Paris in 1873 and erected in Union Square, New York, in 1876. He started work on a monumental statue for the USA in 1870. In 1875 he made the definitive model for *Liberty Enlightening the World*, the engineer Eiffel supplying the wrought-iron pylon that sustains the Statue of Liberty's many stone slabs. US Congress accepted the French gift in 1877 and the statue was shipped over, erected on Bedloe's Island, New York, and ceremoniously unveiled in 1886, big and famous enough to serve as an eighth Wonder of the World.

Bartolo di Fredi (documented 1353 to 1397) Sienese painter dependent on designs by the *Lorenzetti and Simone *Martini, which he transforms, however, by bold simplifications of natural appearances, harshness of colour and increased emotionalism. He executed an Old Testament cycle of frescos in the Collegiata in San Gimignano (*see also* Barna da Siena); and works on panel, including an *Adoration of the Magi* in Siena, Pinacoteca. He was the father of the painter Andrea di Bartolo (*c.*1370–1428) with whom he collaborated on an altarpiece for Siena Cathedral, now lost. An altarpiece by Andrea is in Siena, Pinacoteca.

Bartolommeo or **Baccio della Porta**; called **Fra Bartolommeo** (1472–1517) Florentine painter, a Dominican friar from 1500. A pupil of Cosimo *Rosselli, later associated with the workshop of *Ghirlandaio, he gradually freed himself from their pedestrian *realism, adopting, *c.*1499, the pictorial principles of *Leonardo da Vinci (*Last Judgement*, now Florence, S. Marco), and becoming the chief protagonist in Florence of the transition to the High *Renaissance style. More accessible than Leonardo or *Michelan-

gelo, and more attuned to local traditions than *Raphael, he had a decisive influence on younger Florentine artists, notably *Andrea del Sarto who displaced him as 'head' of the Florentine school after *c.*1514.

A supporter of Savonarola, Bartolommeo entered the Dominican order as a consequence of a vow made during the storming of San Marco in 1498, when Savonarola was taken prisoner. He resumed painting (*c.*1503–4), only at his superiors' insistence and in the service of the order, running the San Marco workshop as Fra *Angelico had before him. During 1509–12 he was in official partnership with his former fellow pupil, Mariotto *Albertinelli. By 1503–4, with Leonardo's temporary return to Florence, he had recent examples of his manner to hand. In 1508 he spent April–November in a Dominican house in Venice, where he studied the work of Giovanni *Bellini. Three important paintings of 1509 attempt to reconcile Leonardesque and Venetian modes: *Madonna with Six Saints* (Florence, S. Marco); *God the Father with the Magdalen and St Catherine of Siena* (Lucca, Pinacoteca); *Madonna with Sts Stephen and John the Baptist* (Lucca, cathedral). This last also demonstrates the influence of Raphael's *Madonna del Baldacchino*, although earlier Raphael had, in some lesser details, been indebted to him. The mature altarpieces, and the most *classicizing, date from 1511–12: *Marriage of St Catherine* (Paris, Louvre); the unfinished *St Anne* (Florence, S. Marco); a second *Marriage of St Catherine* (Florence, Accademia); *Virgin in Glory* (Besançon, cathedral).

In 1514, concerned to see the latest developments of the art of Michelangelo and Raphael, Fra Bartolommeo visited Rome. What he saw there discouraged him, according to *Vasari, and he returned to Florence, troubled by his own inability to paint 'nudes', or, more accurately, figures in dramatic action. Ill-digested Roman borrowings can be found in the *Madonna of Misericord* (1515, Lucca, Pinacoteca) and *St Mark Evangelist* (*c.*1514, Florence, Pitti). A more successful synthesis is achieved in his last great altar, the *Salvator Mundi* (1516, Florence, Pitti).

Bartolommeo Veneto (active 1502–46) Ill-documented northern Italian painter. Despite his appellation, 'the Venetian', he was probably born in Cremona in Lombardy; his earliest-known work, the *Madonna Dona delle Rose* (Venice, pc) is dated 1502 and signed '*Bartolamio mezo venizian e mezo cremonese*' – '. . . half Venetian and half Cremonese'. On another *Madonna* (formerly Bologna, pc) dated 1509, he professed himself to be 'a pupil of Gentile [*Bellini]', but the greatest influence on his early, mainly devotional paintings is that of Gentile's younger and more gifted brother, Giovanni Bellini. An early portrait of a woman (London, National) was perhaps executed in Ferrara, where he may be identified with an artist who worked for Lucrezia Borgia. His later pictures are all fashionable portraits, painted probably after his return to Lombardy. He may have been employed in Bergamo and Milan; the latest-known work, dated 1546, depicts a member of a noble Brescian family, Ludovico Martinengo (London, National).

Bartolozzi, Francesco (1728–1815) Italian *mezzotint engraver, born in Florence; he trained there and in Venice, where he became the supreme master of book decoration and reproductive engraving. He was invited to settle in England in 1764 by the librarian of George III, and engraved the *Guercino drawings at Windsor, and later *Holbein's portraits of the court of Henry VIII. His luminous stipple engravings after the designs of Giovanni Battista *Cipriani, whom he had known in Florence, and Angelica *Kauffmann were mainly responsible for these artists' popularity. In 1768 he was one of the founder-members of the Royal *Academy. Implicated in the financial ruin of his son, he moved to Lisbon in 1801, to become director of the Academy of Fine Arts; his mezzotints in the softly diffused 'English style' caused a profound change in the pictorial manner of *Sequeira among other Portuguese artists.

Barye, Antoine-Louis (1796–1875) French sculptor, son of a Paris silversmith. His training was in fine metal relief work but he became known as an ambitious sculptor of animals – often wild animals, demonstrating natural energies and violence. He studied drawing briefly under *Gros and was influenced by *Delacroix; he also developed his close knowledge of animal anatomy and motion from life. His subjects drew the disdain of those looking for ennobling content, and at times he used mythological themes to give his work the status of *History, but it was his ability to combine *naturalistic accounts with *Romantic feeling that brought him substantial success from the 1830s. In 1854 he was made professor of zoological drawing at Paris's Natural History Museum.

Basaiti, Marco (c.1470–1530) Venetian painter, probably of Greek origin. From the mid-1490s he was an assistant in the studio of Alvise *Vivarini, whose altarpiece in Venice, S. Maria Gloriosa dei Frari, he completed in 1503–5. He became a weak imitator of Giovanni *Bellini. His best-known work is the large and picturesque *Calling of the Sons of Zebedee* (1510, Venice, Accademia); other works London, National; Vaduz, Liechtenstein Coll.

Basaldella, Dino (1909–77) and **Mirko** (1910–69) Italian sculptors, brothers of the painter *Afro. Makers of dramatic forms, mostly *abstract, in metal, cast and wrought, they were part of a lively movement in Italian sculpture that was seen and collected internationally during the 1950s and 60s.

Baschenis, Evaristo (1617–77) One of the most original *still-life painters of the 17th century. Ordained as a priest at an early age, he lived all his life in his native Lombard town of Bergamo; by 1675, however, his works had entered princely collections in Rome, Florence, Venice and Turin. Although stylistically dependent on *Caravaggio, Baschenis invented a new type of still life, composed almost entirely of musical instruments. Without any overt *vanitas* (*see under* still life) symbolism, these images conjure up melancholy associations. Perhaps late in life he also executed a few 'kitchen pieces' of poultry and fruit. Repetitions and variants of

Baschenis's prototypes were produced in quantity by his studio; his manner was also closely imitated by his pupil **Bartolomeo Bettera** (*c*.1639–after 1687) and by the latter's son, **Bonaventura Bettera** (*c*.1663–after 1718) and by many other, anonymous, local painters, with increasing loss of quality.

Baselitz, Georg (1938–) German painter and sculptor, prominent among the new German *Expressionists. He lived, studied and worked in East Germany until the 1950s when he settled in West Berlin and evolved his own figurative idiom, distant both from western *abstraction and from the Social *Realism demanded in East Gemany. He became known in the early 1960s with paintings and his *Pandemonium Manifestos*, uncouth and challenging. His figure subjects imply significance but deny their heroic character with fragmentation, wild brushwork and other devices such as, from 1969 on, being painted upside down. Professor at the Karlsruhe Academy from 1977, he has also taught in Berlin. Since 1980 he has added sculpture to his production, roughly carving and painting figures one of which, making the Nazi salute but fallen on to its back, was his contribution to the 1980 Venice Biennale.

Baskin, Leonard (1922–) American sculptor and printmaker, using a personal, partly *Expressionist style for tragic figure subjects.

Basquiat, Jean-Michel (1960–1988) Afro-Caribbean-American painter, noticed first as a graffiti artist, who was taken up by the galleries in New York and became a commercial success, partly on account of his exuberant imagery and vehement mode of painting, and partly on account of *Warhol's support and occasional collaboration. His early death from drugs added to his fame. A film about him was made by *Schnabel in 1996.

Bassa, Ferrer (recorded 1324–48) Catalan painter and manuscript illuminator, the first Spanish artist known to have worked in the Italian style derived from

contemporary Florentine and Sienese art (*see* e.g. Giotto, Duccio, Simone Martini). He had probably studied in Italy. He received commissions from Alfonso IV, King of Aragon, and his successor Pedro IV, but his only secure extant works are the *frescos in the Chapel of San Miguel in the Franciscan convent of Pedralbes, near Barcelona, 1345–6. He died while working on an altar for the Franciscan priory, Valencia.

Bassano or **Bassani** A family of painters of the Venetian school, so-called after their native town of Bassano; their family name was dal Ponte. The best-known is **Jacopo Bassano** (*c*.1510–92), who during 1545–60 was one of the most influential painters in the Veneto, apart from *Titian, combining a highly elaborate *Mannerist style with *realistic details, some of them adapted from northern prints by, e.g. *Dürer, and others observed directly from nature. First trained by his father, **Francesco dal Ponte the Elder** (*c*.1470/80–*c*.1540), he was then taught by Bonifazio de'Pitati in Venice. Jacopo's sons – **Francesco the Younger** (1549–92), **Giovanni Battista** (1553–1613), **Leandro** (1557–1622) and **Gerolamo** (1556–1621) – staffed the workshop which came to specialize in the bucolic *genre paintings, often with biblical subjects, evolved by him in the 1550s. In 1579 Francesco, the most talented, moved to Venice where he received state commissions for the Doge's Palace as well as specializing in genre nocturnes in a style more realistic than his father's.

Jacopo evolved an especially sumptuous colour range (*see also* Tintoretto), although later works show a falling-off in quality, partly because of the substantial contribution of his shop, and partly his gradual loss of sight. There are important works by him in Bassano, Museo and in galleries in Italy and abroad.

Bassen, Bartholomeus van (recorded 1613–52) Dutch painter and architect, perhaps born in Flanders. He is recorded in Delft from 1613 to 1622, then moved to The Hague, where between 1639 and 1650 he was municipal architect; the Nieuwe

Kerk, built 1649–56, is in part based on his designs (view of the exterior, The Hague, Gemeentemuseum) and he built a palace for the exiled 'Winter' King and Queen of Bohemia (Coll. H.M. the Queen). He specialized in imaginary views of church interiors and palaces, often with architectural or sculptural details based on reality. There is no evidence that he went to Italy or England, as has been suggested, although he painted several Italian church interiors, in particular that of St Peter's in Rome (e.g. Prague, Narodni). The figures in some of his pictures are by other painters, such as Esaias van de *Velde, in The Hague since 1618, and Frans *Francken II of Antwerp. There are paintings by Bassen in other private and public collections, including London, National; Budapest, Szepmuveszeti.

Bastiani, Lazzaro *See under* Carpaccio, Vittore.

Bastien-Lepage, Jules (1848–84) French painter, mainly of rural *genre scenes and of portraits, influenced both by *Barbizon *naturalism and by the *Impressionists. His skills, inclination to sentimental subjects and avoidance of extreme Impressionist dissolution of forms brought him success and exceptionally wide influence, in France but also abroad, especially in Britain, Scandinavia and the USA.

Bateau-Lavoir A building in the Montmartre district of Paris, converted into studios, nicknamed by the poet Max Jacob after the laundry boats moored on the Seine. From about 1904 it was occupied by such key figures of the *avant garde as van *Dongen, *Picasso and *Braque and by writers such as Jacob himself and Pierre Reverdy. Its historical interest declined after 1912 when Picasso and others moved out of Montmartre.

Batoni, Pompeo Girolamo (1708–87) Italian painter who drew from the antique and copied *Raphael, and whose *classicizing style influenced *Mengs and Gavin *Hamilton. Born at Lucca, he settled in 1728 in Rome, where he painted altarpieces for churches and grand decorative schemes

(notably in the Villa Borghese, Palazzo Colonna and the Casino Benedict XIV). He is chiefly known today for his portraits of European nobles and Englishmen on the *Grand Tour, usually posed in front of architectural ruins or with other examples of ancient art (Brunswick, Museum; Florence, Moderna, Uffizi, Pitti; London, NPG, V&A; Milan, Brera; etc.).

Battistello *See* Caracciolo, Giovanni Battista.

Batz, Alexandre de (*d.* 1759) French-born New Orleans architect and watercolour painter of the life of the Louisiana Indians.

Bauchant, André (1873–1958) French *naïve painter, a market-gardener who at the age of 45 turned his hobby into a full-time occupation. In 1928 his work was shown alongside that of four other naïve painters (Henri *Rousseau, Bombois, Vivin and *Séraphine) as 'Painters of the Sacré Coeur' and Diaghilev commissioned him the décor for the ballet *Apollon Musagête*. In 1949, a large retrospective in Paris showed the range of his work: still lifes and landscapes, but also *History paintings from the bible and other texts.

Baudelaire, Charles (1821–67) French poet and critic. A troubled childhood led to a dissolute lifestyle and his recommendation of an unconventional aesthetic rooted in contemporary urban life. His first published work was art criticism, *Le Salon de 1845*, followed by further essays on the *Salons and in 1859 by *The Painter of Modern Life*, principally on the work of *Guys. He championed *Delacroix against the defenders of *classicism; *Manet was his immediate disciple but many artists were influenced by his call for an art concerned with the present. Baudelaire saw modernity as the necessary complement to ideals of permanence and timelessness: our present world, he asserted, has its own beauty and its own heroism, associated not with idealization but with fragmentation, with sin rather than morality. Such convictions led him from a position close to utilitarianism to an

aesthetic of *purism according to which art is justified by its own qualities, not by answering external needs and ideals. His sonnet 'Correspondences' celebrates the way in which stimuli affecting one of our senses can arouse reactions in another, as when sounds or smells evoke colours, and invites artists of all sorts to explore this enriched response. Such interaction of the senses, implying also a productive alliance between distinct art forms and their processes, was of great concern around 1900 and is invoked directly in *Orphism and *Futurism.

Baudoin, Pierre-Antoine (1723–69) French *Rococo painter in *gouache, the pupil and son-in-law of *Boucher. He executed illustrations for the bible, and a series on the Life of the Virgin, but is best remembered for his much-engraved (*see under* intaglio) erotic *genre scenes.

Baugin (active before 1630–mid-1600s) The most remarkable French 17th-century painter of *still life, working in Paris; almost certainly not identical with Lubin *Baugin. He is known for three modest but strikingly poetic pictures (*Books and Paper by Candlelight*, Rome, Spada, depicting a letter addressed to *'Baugin peintre'*; *The Five Senses*; *Dessert with Wafers*, Paris, Louvre). These are notable for geometrically rigorous and subtle compositions, built up of simple forms representing a small selection of familiar objects seen from a high viewpoint above a table, with minute attention to surface detail. His work is closer to that of contemporary Spanish still-life painters, such as *Sánchez Cotán, than to Dutch and Flemish practitioners.

Baugin, Lubin (*c.*1612–63) French painter of religious pictures born at Pithiviers. He was nicknamed *'Le Petit Guide'*, 'Little Guido', because his large-scale canvases for Parisian churches and congregations emulated the compositions and colour range of Guido *Reni. He also specialized in small-scale panel paintings of Holy Families for collectors, and these reflect the influence of 16th-century painters of the School of Fontainebleau, *Primaticcio, *Rosso Fiorentino, as well as of *Correggio and *Parmigianino, whose works Baugin may have seen at first hand during a trip to Italy around 1645–50. Some canvases remain in Parisian churches, but most were seized during the French Revolution; many were lost and are known only through engravings, others have been scattered to provincial museums throughout France. Small panels are still to be found in private collections; also London, National.

Bauhaus The German art and design school formed and for some years directed by the architect Walter Gropius in Weimar and Dessau. No other modern art and design school has been more discussed, yet little that can be said about it in broad terms remains true upon closer inspection: the world changed during its 14 years' existence, the institution itself changed, and the individuals and ideas guidings its work changed and developed.

The school opened in 1919 under the state of Thuringia as a combination of the Weimar art academy and the design school directed before 1914 by *Van de Velde. Gropius added architecture to the programme and, in the proclamation published for the Bauhaus's opening, emphasized the importance of the crafts as the basis for the crowning and integrating activity of building. The Bauhaus was divided into workshops, rather than studios or departments, led by technical instructors and aesthetic instructors. The latter in every case was an artist. Thus the sculptor Gerhard Marcks and painters such as *Feininger, *Itten, *Schlemmer and *Klee came to the Bauhaus, to be followed by *Kandinsky. A preliminary 'Basic Course', initiated by Itten, gave students a broad experience with materials and in art and design practices before they specialized to work in a chosen craft. By 1923 this seemed old-fashioned and remote from commercial realities. The Bauhaus needed funds urgently, and Gropius called for the design of utilitarian objects for manufacture under licence, to bring royalties to the school; the crafts now served for making the prototypes to be offered to industry. Painting and sculpture, and also graphic art, had a marginal place in all this yet artists still

dominated. Klee, Kandinsky and Schlemmer contributed lecture courses on art theory, but art instruction was occasional and sometimes private rather than a major offering. Itten, who refused to think in industrial terms, was replaced in 1923 by *Moholy-Nagy, for five years the busiest and most influential teacher there. He reformed the Basic Course and the work of the metal and glass workshops, demonstrated the importance of photography and turned the graphic workshop into a typography studio.

Political pressure forced the Weimar Bauhaus to close in 1925. Gropius accepted the invitation of the mayor of Dessau to reopen the school, in premises to be designed by himself and furnished with Bauhaus-designed objects. The Dessau Bauhaus opened in 1926 with several of its earlier faculty present but now complemented by some of their former students, such as *Bayer, Marcel Breuer (subsequently a noted architect) and *Albers, whose training enabled them as instructors to combine the aesthetic and the technical functions. Bauhaus light fittings, furniture and wallpaper had a marked commercial success.

Gropius resigned the directorship in 1928 and was succeeded by the architect Hannes Meyer, brought in the previous year to head a newly formed architecture workshop. Meyer's Marxism led him to emphasize practical and psycho-social instruction at the expense of aesthetics; in expectation of this Moholy-Nagy and some of his colleagues also left. In 1930, after political disagreements with the Dessau authorities, Meyer was replaced by the architect Mies van der Rohe. The Bauhaus continued as a design school only, and as such it moved to Berlin in 1932. There it closed in 1933, under attack from the Nazis.

Though art work was never central to the Bauhaus, artists played major formative and theoretical roles there, at least until 1928. Among the most influential productions of the Bauhaus were the 14 'Bauhaus Books' produced by Moholy-Nagy under Gropius's supervising editorship, presenting cardinal texts of modern art and design: writings by Van *Doesburg, *Malevich, Kandinsky, Klee, Moholy-Nagy himself,

etc. These exercised a wide influence on art and art teaching in the 1930s and subsequently, guaranteeing the Bauhaus a key role in modern art history. Moholy-Nagy opened a New Bauhaus in Chicago, Gropius taught architecture at Harvard and Albers taught at *Black Mountain College and at Yale. The former Bauhaus student Max *Bill directed a Design School at Ulm from 1950 as a new Bauhaus, while Bauhaus methods, notably the idea of a basic course for all beginners, were being echoed around the world.

Baumeister, Willi (1889–1955) German painter, born and trained in Stuttgart under *Hölzel and in the company of *Schlemmer. He visited Paris and Switzerland before serving in the German army in 1914–18. His mature work begins in 1919 with his 'Wall Pictures', their mural character enhanced by low relief formed with sand and putty. At first these were mostly *abstract; by the mid-1920s, through contact with *Purism and *Léger, they incorporated popular motifs and themes, e.g. sportsmen. He was active also as a designer and it was as professor of typography that he taught in Frankfurt from 1928 until he was dismissed in 1933. He returned to Stuttgart, working as a typographer but painting in secret, linking abstract painting with archetypal signs. During the Second World War he wrote *The Unknown in Art*, published in 1947 in support of the renewed German interest in abstract art. In 1946 he was appointed professor at the Stuttgart Academy and remained there until his death.

Baumgarten, Lothar (1944–) German *Conceptual artist who uses anthropological material for art works in the form of books, installations and photographs, setting tribal culture against modern postcolonial reality, as in his 1993 exhibition at the Guggenheim Museum in New York where he inscribed the names of America's native societies on the sides of the spiral ramp and questioned the present ownership of their lands.

Bawden, Edward (1903–89) British painter and graphic artist, who trained and

later taught at the Royal College of Art in London while working as a commercial artist. During 1940–4 he worked in France and the Middle East as an official British war artist. His graphic work, full of energy and humour, explored many media and processes; he was also a fine watercolour painter and ceramicist. He is particularly remembered for a series of murals painted during the 1950s and 60s, and for book illustrations, including those done for the *Oxford Illustrated Old Testament* and the Folio Society's *Gulliver's Travels to Lilliput*.

Bayer, Herbert (1900–85) Painter, graphic artist and designer of Austrian origin. He studied architecture first but was a student at the *Bauhaus 1921–3 and joined its faculty as graphic designer 1926–8. He then worked in advertising in Berlin, also painting and making *Surrealist photographs. He moved to New York in 1938 and worked again as a designer while also producing paintings and sculptures. Bayer organized two great Bauhaus exhibitions, that at MoMA, New York, in 1938, and that which toured the world in 1967–71 from Stuttgart.

Bayeu y Subias, Francisco (1734–95) Although today overshadowed by his brother-in-law, Francisco *Goya, and hardly known outside Spain, Bayeu was the most successful Spanish painter of the later 18th century. A native of Zaragoza, where he trained and for whose basilica of El Pilar he was to execute four ceiling frescos (*in situ*; sketches, Zaragoza, Diocesan), Bayeu became a protégé of the court painter *Mengs. In 1764 he painted one of his most important commissions, *Olympus: The Fall of the Giants*, a ceiling fresco for the Royal Palace in Madrid. Although the fresco closely follows the composition of the final oil sketch (Madrid, Prado), they differ considerably in style: where the sketch is free, with loose, painterly brushwork in the manner of *Giaquinto, the fresco is sober and powerful, with clearly delineated figures, showing the *classicizing influence of Mengs. This stylistic difference between oil sketches and large-scale works was to persist throughout Bayeu's career. In 1777

he was appointed director of the royal tapestry factory, able to secure work for Goya and for his own younger brother, the painter **Ramón Bayeu y Subias** (1746–93) whose tapestry cartoons are his main achievements. In 1788 Francisco Bayeu was made director of painting at the Royal *Academy of San Fernando and court painter to Charles IV. There are also important frescos in the cloister of Toledo cathedral; altarpieces in Madrid churches; sketches for tapestry cartoons in Madrid, Prado, and other small easel paintings and oil sketches in Zaragoza, Bellas Artes; London, National; Dallas, Southern Methodist University, Meadows.

Bazaine, Jean (1904–75) French painter, trained in sculpture, largely self-taught as painter. He achieved notice as an expressive painter and also designer of stained glass (church at Assy, 1944–6). He was known internationally as a major contributor to *Art informel.

Bazille, Frédéric (1841–70) French painter, associated with the beginnings of *Impressionism through his friendship with *Monet, *Renoir and *Sisley. He painted out-of-doors alongside them but inclined to studio-based figure subjects as in the large *Artist's Family* (1867–8; Paris, Orsay).

Baziotes, William (1912–63) American painter, prominent in what became the *New York School. *Motherwell was a close friend in the 1940s and both used *automatist methods drived from *Surrealism. In Baziotes's case these led to a wide range of *abstract and semi-abstract imagery, mostly executed in a careful, traditional manner.

Bazzani, Giuseppe (1690–1769) Italian painter from Mantua. Like *Magnasco, whose work he knew, a painter of the fantastic and the grotesque, master of the rapid, nervous brush-stroke and of magic light effects (e.g. Columbia, Missouri, University). While Bazzani had few imitators in Italy, his influence has been discerned in the work of the Austrian decorative painter *Maulbertsch.

Beale, Mary (née Cradock) (1632–99) The daughter of a Suffolk clergyman, Mrs Beale became known in London as a prolific portrait painter in the manner of *Lely; many of her sitters were clerics. Transcripts of her husband's diaries (1671–81) record about 140 portraits completed in six years, of which a number have been identified; of her work before 1671 we know nothing. She often painted heads framed in fictive stone ovals adorned with fruit in stone.

Beardsley, Aubrey (1872–98) English illustrator and writer who, in a short career dogged by ill-health, produced a large body of graphic work and exercised a remarkable influence. His early illustrations to *Morte d'Arthur* (1893) are indebted to William *Morris and to *Burne-Jones, but he soon developed his sophisticated, characteristic style of flat black solids and hard straight and sinuous lines, perfect for reproduction and based on a variety of ancient and recent, European and Oriental models. His first major works were illustrations for *The Yellow Book* and for Oscar Wilde's play *Salome* (1894). Much else followed, some of it privately printed because obscene, some of it reprinted in expurgated editions, e.g. his *Story of Venus and Tannhauser* (1907), written in adroitly stilted prose. His illustrations affected *Art nouveau art and design and are associated with late nineteenth-century European decadence; its harsh confrontation of black and white may also have aided the *Modernist revolt against Art nouveau.

Beato Angelico *See* Angelico, Fra or Beato.

Beaucourt, François (1740–94) Canadian painter of portraits and religious subjects, born near Montreal. Between 1773 and 1786 he travelled in Europe as far as Russia, and settled for a while in Paris, where he was influenced by *Fragonard. His father **Paul Beaucourt** (1700–56) went to New France with the French colonial infantry in 1720; leaving the service around 1741 he became a naïf painter in Quebec.

Beaugrant, Guyot de (recorded 1526–51) Sculptor from Lorraine, working in the Netherlands until 1533–5, when he settled in Bilbao. He is the chief sculptor of the lavishly ornamental chimneypiece in the Franc, at Bruges, commissioned by the Regent of the Netherlands Margaret of Austria in 1529 to celebrate the Peace of Cambrai and completed 1531. The design was furnished by Lancelot *Blondeel.

Beaumont, Claudio Francesco (1694–1766) Italian painter from Turin, the leading decorative artist of the 18th century in Piedmont, working in what has been called the Franco-Italian *Rococo style. During 1723–31 he was living in Rome, and may have influenced *Boucher during the latter's stay at the French *Academy there. From 1731 Beaumont was court painter to the Savoy, the royal family of Piedmont (Turin, Palazzo Reale).

Beaumont, Sir George Howland (1753–1827) English collector, art patron and amateur painter, one of the chief proponents of an English national gallery of Old Master paintings – in 1823 he promised his own collection to the nation, provided that a suitable building could be found for its proper display and conservation (*see also* John Julius Angerstein). He owned some of the finest works in the present National Gallery, London, including *Rubens's *Autumn Landscape with a View of Het Steen*, *Canaletto's *'The Stonemason's Yard'* and *Claude's *Hagar and the Angel*. The latter, with Beaumont's watercolours by *Girtin, is said to have first provided *Constable with 'pictures that he could rely on as guides to the study of nature'.

Beauneveu, André (active *c*.1360–1401) Flemish sculptor and illuminator, probably from Valenciennes. He was one of the most innovative and influential *Gothic artists working in France, active in Paris as sculptor to King Charles V (St-Denis, royal tombs) and from *c*.1380 at the court of the Duke of Berry in Bourges. Here he painted 24 pioneering illuminations of prophets and apostles, naturalistic (*see under* realism) and sculptural, for the duke's famous *Psalter*, *c*.1380–5 (Paris, Bibliothèque

Nationale). From 1392 he was at work as a sculptor on the Sainte Chapelle at Bourges, which was to contain the duke's funerary monument. Only fragments remain of this once-brilliant enterprise (now Bourges, Cathedral, Musée). Although not as monumental as the work of *Sluter, Beauneveu's sculpture demonstrates the penetrating individualism of facial features characteristic of late 14th-century Flemish art. His assistant and successor at the court of Bourges, Jean de Cambrai (d.1438), continued this tradition in his effigies of the Duke of Berry and his wife (now Bourges, Cathedral; also a *Virgin and Child*, Marcoussis, Célestins).

Beccafumi, Domenico (c.1484–1551) With *Sodoma, the leading Sienese painter of the late 16th century, although a more intelligent, sensitive and consistent artist. Labelled a *Mannerist, he can now be seen to have assimilated Florentine, Umbrian and Roman influences into a Sienese idiom traceable back to the *Gothic art of *Duccio. All of Beccafumi's work, despite internal evolution and change, combines calligraphic line and rhythmic contours with intense colourism (*see under* disegno). Probably more than any other artist of his time he exploits *contre-jour* and lighting effects, as in the great nocturnal *Birth of the Virgin* altarpiece, c.1543, now in Siena Pinacoteca. Bare-limbed trees, as if in filigree against the sky, are almost a trademark (e.g. *Stigmatization of St Catherine*, c.1514–15, Siena, Pinacoteca; *St Paul* altarpiece, c.1515, Siena, Opera del Duomo; *Nativity*, c.1524, Siena, S. Martino; etc.).

An early trip to Rome, c.1511, has been postulated, followed by another and more decisive visit c.1519, when he was able to study virtually all of *Raphael's Roman paintings, and a third in 1541. During 1519–24, and intermittently throughout the rest of his life, he was employed designing episodes of biblical history inlaid in the pavement of Siena cathedral. These were to be his most *classicizing works. A number of major altarpieces remain in Siena. In 1538–9 he executed large panels for the apse of Pisa cathedral. His important Sienese *frescos maintain the intensity of

colour of his panel pictures, most notably the ceiling in the Sala del Concistoro of the Palazzo Publico, commissioned in 1529 but executed mainly c.1535. It demonstrates also Beccafumi's ability to improvise on *all'antica motifs, especially in architecture, and his grasp of the principles of *perspective. Eight bronze angels on *Peruzzi's high altar in Siena cathedral were modelled by Beccafumi in the last three years of his life.

Becerra, Gaspar (c.1520–1570) Influential Spanish sculptor and painter. He was trained in Rome under *Michelangelo and *Vasari. His main work in Spain, where he returned in 1557, is the high altar in Astorga Cathedral, 1558–60. In 1563 he became court painter to Philip II, when he began the mythological ceiling paintings in the palace of El Pardo, near Madrid.

Beckmann, Max (1884–1950) German painter, born in Leipzig and trained at the Weimar Academy. He spent part of 1903–4 in Paris studying modern and medieval painting. He had one-man shows in Frankfurt in 1911, Magdeburg in 1912 and Berlin in 1913. In 1914 he joined up as a medical orderly but was discharged in 1915 after a breakdown. He was appointed to teach at the Städel School in Frankfurt in 1925 and became a professor in 1929. In 1925 he had exhibitions in Frankfurt, Zurich and Berlin.

Before 1914 he had produced *History paintings as well as naturalistic street scenes and portraits. The war experience moved him closer to a form of *Expressionism in a series of religious and contemporary scenes in which *realism is modified by a late medieval expressive distortion of forms and space. *The Night* (1918–19, Düsseldorf, Kunstsammlung Nordrhein-Westfalen) reports on the butchery which accompanied the birth of the Weimar Republic but is also a symbolic statement that refers us to religious paintings of about 1500 as much as to modern Germany. Similarly based paintings followed, some more symbolic, some more realistic, and in 1925 Beckmann's work was included in the *Neue Sachlichkeit

exhibition. By the end of the 1920s his work was well known in Central Europe and in New York. He was dismissed from his post in 1933 by the Nazi regime; over 500 of his works were removed from public collections and ten of these were toured in the *Degenerate Art exhibition. He left Germany in 1937 and settled in Amsterdam.

In 1938 his work was included in a London exhibition; Beckmann visited London and spoke in the exhibition on his ideas on painting (*Meine Theorie der Malerei*). He lived and painted in the Netherlands throughout the war. In 1947 he emigrated to America and was appointed to the School of Fine Arts, Washington University, St Louis. In 1948 a travelling exhibition of his work was launched at the City Art Museum there. He subsequently taught and lectured at a number of institutions in the USA. In 1950 he was awarded the First Prize for Painting at the Venice *Biennale.

Beckmann's art is epic, dealing with great human themes; it is also a personal response to daily life and to contemporary themes; it depends on a private, unexplained repertoire of characters and symbolic objects. He developed for himself a grand theatrical manner combining traditional and modern elements. His paintings are grave assertions of the human spirit in the face of oppression. He himself spoke of them in contradictory terms, as 'my own sloughed-off skin' and as 'a game of hiding oneself' (*Diaries*, 8 September 1940 and 31 July 1944).

Bedford Hours, Master of the; also called Bedford Master (active *c.*1405/10–after 1424) *Illuminator, or several illuminators, working in Paris, named after the *Bedford Book of Hours* begun in 1424 for John of Lancaster, Duke of Bedford, Regent of France from 1422 to 1435 (now London, British Library); he, or they, also illustrated the *Bedford Breviary* (Paris, Bibliothèque Nationale) and other manuscripts with increasingly richly ornamented margins. The Bedford Master or his workshop collaborated with the *Boucicaut Master and the Master of the *Rohan Hours.

Bedoli, Girolamo Mazzola (*c.*1500/5–69) Italian *Mannerist painter from Parma. A fellow-pupil of *Parmigianino's in the shop of the latter's uncles. After Parmigianino's death he added his family name, Mazzola, to his own. There are works by him in Naples, Capodimonte; Parma, Gallery; S. Sepolcro; Cathedral; Steccata.

Beechey, Sir William (1753–1839) English painter, a pupil of *Zoffany and the chief rival of *Hoppner. A conscientious but dull portraitist, he was appointed Portrait Painter to Queen Charlotte in 1793 (Windsor Castle, Coll. H.M. The Queen; London, NPG; etc.).

Beerstra[a]ten, Jan Abrahamsz. (1622–66) Dutch painter of topographical views of towns and castles throughout Holland, often depicted as winter scenes. He also executed imaginary seaports and a few sea-battles (Amsterdam, Rijksmuseum; etc.).

Beert, Osias (*c.*1580–1624) Leading painter in the first generation of Flemish *still-life specialists, active in Antwerp; his style was overtaken by that of artists in *Rubens's circle, notably *Snyders. In his carefully detailed 'spread tables', clarity of form and exact description are more important than atmosphere. He was apparently the first Flemish painter to include Chinese porcelain in his pictures. Some of his pictures have a moralizing biblical scene in the background. There are works in Antwerp, Museum; Berlin, Staatliche; Madrid, Prado.

Bega, Cornelis *See under* Ostade, Adriaen and Isaack van.

Beggarstaff Brothers, or **J. & W. Beggarstaff** Pseudonyms used by William *Nicholson and his brother-in-law James Pryde as poster artists in the 1890s. It was a commission for a poster for E.G. *Craig's London production of *Hamlet* that decided them to work as partners and they had some success with other posters for various occasions and products. Nicholson was undoubtedly the creative

partner, Pryde the agent, and Nicholson went on to develop a substantial solo career as printmaker and painter. With their radical use of simplified silhouettes and flat colours, the Beggarstaff posters were a major contribution to international *Art nouveau yet retained a marked English flavour.

Beham, Hans Sebald (1500–50) and **Bart[h]el** (1502–40) Nuremberg painters and printmakers. Both brothers trained under *Dürer, and both were expelled from Nuremberg in 1525, along with Georg *Pencz, for anarchism and atheism – although the sentence was revoked in the same year.

Bartel is the more major artist, notable for portraits, many of which employ Italianate formats, such as the half-length or knee-length (e.g. New York, Metropolitan; Liechtenstein, Schloss Vaduz; Madrid, Thyssen; Vienna, Kunsthistorisches; Munich, Alte Pinakothek; Ottawa, National). His best-known print was an allegory of the equality of all humankind in death. He died on a trip to Italy, having been court artist to the Duke of Bavaria at Munich and Landshut from 1530.

The elder brother, usually called Sebald, was an etcher, engraver (*see under* intaglio), designer for stained glass and woodcuts and a painter of miniatures. No easel pictures are known to have been painted by him, although he executed a table top, now in Paris, Louvre. He was one of the most prolific graphic artists of the time, producing popular prints, often tiny in size, in huge editions. He specialized in *genre subjects and topical events, but borrowed also from Italian engravings by *Mantegna, *Pollaiuolo, Marcantonio Raimondi (*see under* Raphael). After relinquishing his Nuremberg citizenship in 1535, he settled in Frankfurt, where he continued his association with book production.

Bell, Graham (1910–43) British painter, born in South Africa. His art and writings in the 1930s argued for a *realism reflecting contemporary life. In 1937 he helped found the *Euston Road School in London where he taught during 1938–9.

Bell, Vanessa (1879–1961) British painter, older sister of the writer Virginia Woolf and wife of the art critic Clive Bell, with whom and others (notably Roger *Fry and Duncan *Grant) she formed the core of the *Bloomsbury Group. She studied painting at the Royal Academy Schools but responded to what she saw of French painting since *Impressionism in the first *Post-Impressionist exhibition, and subsequently also in Paris, with bold paintings and decorative work (for the *Omega Workshops) which make her a British *avant-garde artist during c.1912 to c.1920 (the dates of her work are often uncertain). *Matisse was a major influence but she also ventured briefly into abstract painting by means of collage. She was closely associated with Grant who from 1916 shared her house in Sussex, Charleston Farmhouse. They sometimes painted the same subjects and from the 1920s on they both worked in a friendly, gently painterly manner derived from Impressionism and *Fauvism. Their art had its admirers during the 1920s and 30s; after the Second World War it seemed too agreeable and uncontroversial to be in favour. At Charleston they decorated walls and furniture with *figurative and *abstract designs; these in addition to their modest collection of art, often the work of their friends, make Charleston the essential shrine of Bloomsbury art. Her son and Clive's, **Quentin Bell** (1910–96), became a greatly admired writer and lecturer on art and was himself a busy painter, sculptor and ceramicist.

Bella, Stefano della (1610–64) One of the greatest Italian etchers (*see under* intaglio), influenced first by *Callot, later by *Rembrandt and the Dutch landscapists. Born in Florence, he was a pupil of Callot's teacher Remigio Cantagallina (c.1582–?1635) and became a protégé of the Medici. Around 1638 he went to Rome, and between 1639–50 worked for French publishers in Paris. In 1650 he returned to Florence. A prolific artist, he made over a thousand etchings, many concerned with various aspects of popular life, and influenced Italian *genre painting as well as other printmakers.

Bellange, Jacques (recorded 1600–17) Painter, etcher (*see under* intaglio) and designer of stage scenery and theatrical machinery, active with Jacques *Callot and the painter Claude Deruet (*d.*1660), at the court of the Duke of Lorraine at Nancy. An internationally famous Lorraine Late *Mannerist artist. His highly individual style, now known mainly through prints, was formed on the etchings of *Parmigianino and the engravings (*see under* intaglio) of German masters such as *Schongauer and *Dürer, and Flemish masters such as *Goltzius. These disparate sources were welded into a sophisticated idiom in which extreme figure elongation, complex poses, unusual viewpoints and spatial ambiguity serve the end of religious mystical *expressivity (e.g. etchings of *The Three Maries, The Annunciation, Carrying of the Cross*, etc.; drawings, various museums including St Petersburg, Hermitage; paintings of the *Virgin Annunciate* and the *Archangel Gabriel*, Karlsruhe, Kunsthalle). In addition to his major works on religious subjects, Bellange also executed a number of *genre compositions (e.g. etching of the *Hurdy-Gurdy Player*) which stress ugliness and deformity as intensely as the religious works stress elegance and beauty.

Bellano, Bartolommeo (*c.*1440–96/7) Italian sculptor, the son of a Paduan goldsmith and a member of *Donatello's workshop in Padua, going with him to Florence in 1453. He appears to have worked on the bronze reliefs of the pulpits in Florence, San Lorenzo just before, or just after, Donatello's death in 1466. By 1468 he was again in Padua (Eremitani, monument of Raimondo Solimani; etc.). In the 1470s he worked in Venice; visiting the Sultan Mehmet II with Gentile *Bellini in 1479–80. Thereafter he was continuously employed in Padua (S. Antonio, bronze reliefs for choir screen, now set in the interior of the choir; S. Maria dei Servi, De Castro monument; S. Francesco, Roccabonella monument, finished after Bellano's death by *Riccio, who was said to have been his pupil). In addition he made a number of influential bronze statuettes (Philadelphia, Museum; Paris, Louvre; etc.).

Bellany, John (1942–) Scottish painter who became known in the 1970s for his dramatic compositions of symbolical figures and objects but in the 1980s, after coming close to death and major surgery, turned to lighter, more lyrical themes and methods, painting actual and symbolical characters, and often himself, in luminous paints and watercolours.

Bellechose, Henri *See* Malouel, Jean.

Bellegambe, Jean (*c.*1468/70–1534/6) Netherlandish painter, the leading artist of his time in Douais. Although from about 1525 he adopted elements of the new Italianate manner introduced in Antwerp by Quentin *Metsys, mainly in landscape and ornamental details, his style remained more generally faithful to that of Rogier van der *Weyden, relying on elongated figures, refined colour contrasts and much use of gold leaf. He seems to have worked entirely for monastic establishments. His greatest work is the *Credo* *polyptych now in Douai, Charterhouse museum, which can be compared in ambition if not in achievement with Jan van *Eyck's *Adoration of the Lamb* altar in Ghent; other paintings in New York, Metropolitan; Warsaw, National; Paris, Louvre; Berlin, Staatliche; etc.

Belling, Rudolf (1886–1972) German sculptor associated with the *Sturm circle and the *Novembergruppe. Stimulated by *Cubism and *Archipenko, he represented humanity in mechanistic terms. The Nazis declared his work *degenerate and he left Germany and taught at Istanbul Academy, returning home when the Second World War had ended.

Bellini, Jacopo (before 1400–70/1) and his sons **Gentile** (1429–1507) and **Giovanni** (*c.*1431/2–1516) The leading dynasty of Venetian painters (*see also* Vivarini), they exemplify the transition from *Gothic to High *Renaissance styles in Venetian art. The most important was Giovanni; *see below*.

Jacopo Bellini was a pupil of *Gentile da Fabriano, whom he may have followed to Florence in 1422. Virtually nothing of his

painted work remains; we may assume that, at least early on, it shared Gentile's International Gothic style. Jacopo was the author, however, of two important volumes of drawings, the largest extant collection by any single Italian artist of the period and by any Venetian artist (London, British, on paper; Paris, Louvre, on vellum). Gentile was to present the notebook now in Paris to Sultan Mehmet II in 1479 (*see below*). The drawings demonstrate Jacopo's interest in narrative and in *perspective, including the single-vanishing-point type developed in Florence (*see under* Alberti). It is difficult to assess either the originality or the degree of influence of these drawings in the absence of secure dating. If compiled early in Jacopo's career their emphasis on landscape or architectural settings and on imaginative motifs *all'antica* might be assumed to have influenced Jacopo's son-in-law from 1453, Andrea *Mantegna. If, however, the notebooks date from the 1450s, they must reflect the younger man's influence on Jacopo. In either case, they prefigure later Venetian developments.

Gentile Bellini's career, like that of his brother, began in their father's workshop. A solid, meticulous, if prosaic draftsman, he continued to head the family firm, specializing in official portraiture, large-scale commissions from the Venetian state and from the *scuole* – the charitable confraternities of Venice. In 1474 he was appointed to the team refurbishing the Greater Council Hall in the Doge's Palace (this series of paintings, to which Giovanni later also contributed, were lost in the fire of 1577; *see also* Carpaccio). His *teleri* – large narrative paintings on canvas – for the Scuole di S. Giovanni Evangelista, 1496–1500, and di S. Marco are now in Venice, Accademia and in Milan, Brera, respectively. (The latter was finished by Giovanni.) In 1479–81 Gentile was despatched by the Venetian government to Istanbul, where he worked as an artist in the service of Sultan Mehmet II, whose portrait, a badly damaged original by Gentile or a variant or copy, is now in London, National. (Other portraits, mainly bust-length profiles in the older Venetian tradition, are in Venice, Accademia; Boston, MFA; etc.). In 1469 Gentile was knighted by the German Emperor Frederick III; a portrait has been postulated, although none is known or recorded.

The most gifted and the most influential of the family was Giovanni Bellini. Although the greater part of his work was conservative in content – altarpieces and Madonna and Child pictures for private devotion, a few portraits – it is he who inaugurated the High Renaissance in Venetian art. This he achieved through a highly personal synthesis of Tuscan and Tuscan-influenced pictorial construction, based on geometric calculation, with Netherlandish optical empiricism (*see* Jan van Eyck). When, *c.*1475, and perhaps through the agency of *Antonello da Messina, he mastered the Netherlandish technique of oil painting in glazes (*see under* colour) he was able to represent mathematically measurable space and volumes as if suffused with light (*Coronation of the Virgin, c.*1475, Pesaro, Museo. This is Bellini's first painting in oils, in which the influence of *Piero della Francesca has also been discerned). Even in Bellini's earlier works in tempera (e.g. *St Vincent Ferrer Polyptych*, 1464, Venice, SS. Giovanni e Paolo; *Pietà with the Virgin and St John, c.*1470, Milan, Brera) light served as a unifying principle – not only through its optical effects, but also *expressively and symbolically. The clearest expression of Bellini's symbolism of light may be found in his *St Francis* (after 1475, New York, Frick), where sunlight recalls both Francis's hymn to 'Brother Sun' and his receiving the stigmata of Christ.

Giovanni's paintings are distinguished also by a new method of colour perspective. He eschews the aerial perspective of *Leonardo da Vinci, by which colours lose their separate identity and intensity with distance, fading to a pale blue at the horizon. Instead, he suggests recession by alternating 'wedges' of light and dark colour from foreground to background – a development of great importance for later painters of landscape (e.g. *Poussin) as it has the virtue of preserving the colouristic unity of the picture without sacrificing three-dimensionality (*see especially* the *Baptism of Christ*, 1501, Vicenza, S. Corona).

Giovanni Bellini transmitted his mature achievements to his pupils, *Giorgione and *Titian, and they in turn affected him. Although a sincerely pious Christian, late in life he painted a few pagan subjects. The *Feast of the Gods* for Alfonso d'Este (1514, Washington, National) was later partly modified by Titian, to harmonize with his own more unbuttoned mythologies for the same room. But the *Venus, or Lady at her Toilet* (1515, Vienna, Kunsthistorisches), one of Bellini's very rare nudes, is sensuous without a hint of eroticism.

Giovanni's early works demonstrate the influence on him both of his father and of his brother-in-law Mantegna, although his derivations from the latter may be seen also to be 'arguments'. This dialogue is especially noticeable in the two *Agony in the Garden* paintings, one by each artist, now in London, National. Mantegna's influence is noticeable in the linear outlines, hard-edged drapery folds and glossy tight curls, as well as in the figure canon and foreshortenings. After his assimilation of Antonello's more atmospheric manner, Bellini returned briefly to Mantegna. It has been suggested, plausibly, that he wished to recapture the crisp detail of his early work, and combine it with his new-found monumentality. Such a synthesis is indeed visible in many of his finest paintings, e.g. the great altarpieces and votive pictures of the 1480s (*Doge Agostino Barbarigo before the Virgin*, 1488, Murano, S. Pietro Martire; the first extant work by him painted on canvas).

Giovanni's many Madonna and Child pictures adapt Byzantine *icon conventions. Some of the most beautiful may be found in Venice, Accademia; Bergamo, Accademia; London, National; Milan, Brera.

Of his altarpieces, many of the most famous remain *in situ* in Venetian churches; others may be found in the Accademia.

Bellmer, Hans (1902–75) German-Polish, later French artist, first drawn to art by seeing the work of *Böcklin, *Beardsley and other *fin de siècle* artists and by contact with *Grosz and *Dix in Berlin where he worked on advertising graphics. He abandoned 'useful' work in 1933 with fascism's

rise to power and fashioned his first *Doll*, a female articulated puppet in plaster. This and further puppets, at once naturalistic in their elements but distorted in their assembly and explored in photography and very elegant drawings and etchings, served as objects and images burdened with his sexual memories and fantasies. Innocence and violent eroticism re-enforce each other in them. He left Nazi Germany in 1938 and was well received in Paris by the Surrealist circle. In 1939 he was interned; subsequently he worked with the French Resistance. His work was not widely known until his retrospective exhibition, shown in Paris in 1971.

Bellori, Giovanni Pietro (1615–96) Roman collector, antiquarian and seminal writer on art. He was the great Italian advocate of Nicolas *Poussin, and championed Annibale *Carracci against *Caravaggio. His encyclopedia of contemporary artists' lives, *Le Vite de' pittori, scultori et achitetti moderni . . .*, 1672, is one of our best sources for the lives of these and other 17th-century artists working in Rome. Its preface, *Idea of the Painter, of the Sculptor and of the Architect*, originally delivered as a lecture to the *Academy of Saint Luke in Rome, was a cogent manifesto of *classical ideals (*see also* idealization), inspiring the teachings of the French Royal Academy and generations of art theoreticians – he was the most important, albeit unacknowledged, influence on *Winckelmann.

Bellotto, Bernardo (he signed himself also Bellotto de Canaletto, and is still known in Poland as Canaletto) (1720–80) Nephew and one-time assistant of Antonio *Canaletto, from whom he learned the use of the *camera obscura. He soon abandoned the 'sunlit' palette of his uncle's studio for a colder, more intense colour key, culminating in the famous 'moonlight' colours of his Warsaw paintings. Unable to break Canaletto's monopoly of Venetian *vedute, Bellotto, after some years' activity in various centres of central and northern Italy, left the peninsula to become court painter in Dresden (1747–56). Later he worked also in Vienna and Munich. The final 13 years of his life saw him employed

at the court of the last King of Poland, Stanislas Poniatowski. His most interesting works are his *vedute* of Warsaw. The topographical precision of these enabled them to be used in the exact reconstruction of the city after the Second World War. The greater part of Bellotto's work is to be found in the museums of Dresden and Warsaw, but there are examples in many collections in Europe, Britain and the United States.

Bellows, George Wesley (1882–1925) American painter who studied under *Henri and *Sloan and became a second-generation member of the *Ashcan School. Success came soon: in 1909 he was elected Associate of the National Academy (the youngest ever to have this honour) and in 1913 became a full academician. His vigorous, unflinching but mostly cheerful urban *genre scenes drew wide interest, meeting a concern for social issues that faded after the First World War.

Belvedere Torso One of the most celebrated, most often reproduced, imitated, adapted fragments of ancient marble sculpture, signed in Greek 'Apollonius, son of Nestor, Athenian' (but *see also Laocoön; Apollo Belvedere; Barberini Faun; Borghese Warrior; Farnese Bull; Farnese Hercules; Pasquino*). Nothing is known of the sculptor; the statue is thought to date from the 1st century BC but to reflect a conception of the 3rd century BC. First recorded in the collection of a noble Roman cardinal in the early 1430s, it has been in the Vatican since 1506/7 (except for 1798–1815, which it spent in France as one of the trophies of Napoleon's Italian campaign; *see also* Spinario) and is named after the statue court of the Belvedere where it was first displayed. The torso is that of a powerfully athletic male nude (the head, arms and lower legs are missing) seated on an animal skin, probably that of a lion, and may have represented the mythical hero Hercules. Its extreme *contrapposto* means that from certain viewpoints the small of the figure's back is visible at the same time as its abdomen – a distortion criticized by *Alberti in the 15th century as lacking in *decorum, but much admired by

*Michelangelo some hundred years later. The *Torso*'s great fame among connoisseurs and artists dates precisely from when the *Renaissance master professed his admiration for it; it is the basis of any number of his painted and sculpted figures, supine as well as seated. The remarkable fact that it was left unrestored may originate in Michelangelo's recommendation, or simply in its being so closely identified with Michelangelo, who left so many of his own works incomplete.

Belvedere, Andrea (*c.*1652–1732) Man of letters and playwright, the foremost flower painter in Naples in the late 17th century. He created a naturalistic style (*see under* realism) which also contained refined *Rococo elements (Naples, Capodimonte; Museo di S. Martino; Florence, Pitti; Stibbert). From 1694 to 1700 Belvedere worked in Spain; on his return to Naples he gave up painting, and the last years of his life were devoted to the theatre.

Benbridge, Henry (1743–1812) Philadelphia-born American portrait painter and miniaturist. In 1764 he trained with *Mengs and *Batoni in Rome, where James Boswell commissioned from him a full-length likeness of the Corsican patriot, General Pascal Paoli, widely acclaimed when it was exhibited in London in 1769. The following year Benbridge returned to Philadelphia where he married the miniaturist Letitia Sage. During the War of Independence Benbridge became the most respected portrait painter in South Carolina and Virginia.

Bencovich, Federico (1677–1753) Venetian painter and printmaker of Dalmatian origin. He trained in Bologna, first with *Cignani, whom he followed to Forlì, then with G.M. *Crespi at the same time as *Piazzetta, whose style was to influence him after their return together to Venice in 1710–11. He became a friend of Rosalba *Carriera. Although there are works by him in Venice (altarpiece, S. Sebastiano) he was successful and influential mainly north of the Alps (e.g. for the Prince-Bishop of Bamberg at Pommersfelden). He worked in Vienna 1716–20, and from 1733 onwards he

was there as court painter of the Vice-Chancellor of the German Empire and Bishop of Bamberg and Würzburg (his decorations for the Bishop's Palace at Würzburg were substituted by *Tiepolo's a few years later). In 1743 he retired to Gorizia where he was in the service of the Counts Attemps until his death. His dramatic *chiaroscuro effects influenced the young Tiepolo and Austrian painters like *Maulbertsch.

Benedetto da Majano or **Maiano** (1442–97) Florentine sculptor closely associated throughout his career with his architect and sculptor brother **Giuliano** (1432–90) and with the painter Domenico *Ghirlandaio. His other brother, **Giovanni**, was active in England where he is recorded from 1521 to 1536 (Hampton Court Palace; London, St Paul's). Benedetto's fastidious carving style is highly pictorial, and he is the first *Renaissance sculptor known to have relied extensively on terracotta models, a number of which survive. His masterpiece is the pulpit in S. Croce, Florence, with its poetic invocation of landscape in the scenes from the *Life of St Francis*. He also carved a bust of the rich merchant who commissioned the pulpit, Pietro Mellini (1474, Florence, Bargello). Another authenticated bust is that of Filippo Strozzi (before 1491, Paris, Louvre). His free-standing statue of *St Sebastian* in the Misericordia, Florence, has been said to look forward to the tensions of 16th-century *Mannerist sculpture.

Bening or **Benninck, Alexander** (*d*.1519) and his son **Simon** (*c*.1483–1561) Netherlandish manuscript illuminators. In 1469 Alexander Bening was master miniaturist in the guild at Ghent, where he died. He is sometimes identified with the Master of *Mary of Burgundy. Simon Bening is the outstanding artist of the last generation of illuminators. He settled in Bruges, where he worked in the *naturalistic, atmospheric style developed by the Master of Mary of Burgundy. He is the illuminator of the famous *Grimani Breviary* now in Venice, Marciana Library, and the *Hennessy Hours* (Brussels, Bibliothèque Royale; *see also* Books of Hours; Limbourg Brothers).

Simon Bening was the father of **Levina Teerlinc** (*c*.1510/20–1576) who entered the service of Henry VIII of England as a painter, and is recorded as a 'gentlewoman' and court miniaturist in the reigns his successors Edward VI, Mary, and Elizabeth I.

Benois (Benua), Alexandre (1870–1960) Russian painter and writer, born into a St Petersburg family of mixed German, French and Italian origins. He met Diaghilev in 1890 and joined him in founding the *World of Art group and journal. His interest in the history of Russian art was demonstrated in articles and a book (1902). He worked for the Russian Ballet, designing several productions including *Les Sylphides* (1909) and *Petrushka* (1911). He reviewed exhibitions and could not but be antagonistic to the *avant garde who attacked the traditions he valued. After the 1917 Revolution he was made curator of the Hermitage, the former imperial collection. In 1928 he emigrated to Paris where he continued to write and design sets and costumes.

Benson, Ambrosius *See under* David, Gerard.

Bentame *See* Schildersbent.

Benton, Thomas Hart (1889–1975) American painter who spent 1908–12 in Paris and then became part of the *Stieglitz circle in New York. About 1920 he turned away from *avant-garde interests, to paint American life in the South and Midwest in *genre paintings. He began his first mural cycle that year, exhibiting sections of it in New York in 1923 and 25. He had studied his subjects on the ground but also immersed himself in Italian *Mannerism, and from these sources developed a kind of *Social Realism which he promoted vehemently in words and paintings, celebrating rural life and mocking cities. During the 1930s, a tendency known as 'regionalism' (reporting on the American scene) rose in popularity and Benton's fame rose with it, bringing commissions such as that for the *America Today* series in the New School of Social Research, New York. He taught at

the Arts Students League, New York, during 1926–34, when one of his students was Jackson *Pollock. In 1937 he published his autobiography. His reputation remained firm; in 1961–2 he painted a mural in the Harry S. Truman Memorial Library, Independence, MO.

Bentvueghels *See* Schildersbent.

Benvenuto di Giovanni *See under* Vecchietta.

Béothy, Etienne (1897–1962) Hungarian-French sculptor who studied in Budapest before settling in Paris. In 1931 he was a founding member of *Abstraction-Création. His work at this time was the sculptural realization of mathematical formulae. He wrote of their relation to art in *The Golden Section* (1939).

Bérain, Jean (1640–1711) French decorative artist and engraver (*see* intaglio) specializing in designs of arabesques, other motifs for wall and ceiling panels, tapestries and architectural ornaments. He was mainly influenced by *Lebrun, whose decorative inventions he developed in a lighter and more fantastical vein anticipating the *Rococo. From 1682 until his death he was designer of the private apartments of King Louis XIV (*Dessinateur de la Chambre et du Cabinet du Roi*). His designs were widely propagated through his and others' engravings.

Bérard, Christian (1902–49) French painter and stage and film designer who, under the influence of the poet Jean Cocteau, became a theatrical designer admired for his elegant fantasy.

Berchem, Nicolaes or **Claes** (1620–83) Prolific Dutch Italianate painter and etcher, born in Haarlem, the son of the great *still-life painter Pieter *Claesz. He popularized pictures of Italian pastoral and arcadian scenes, and is one of the precursors of the *Rococo style (Amsterdam, Rijksmuseum; Hanover, Landesgalerie; St Petersburg, Hermitage; London, National, Wallace; Munich, Gemäldesammlungen; etc.). He also executed mythological and biblical

scenes (The Hague, Mauritshuis; Bristol, Museum; Paris, Louvre; etc.) and an *Allegory of Amsterdam* (Amsterdam, Historisch); views of harbours (Leipzig, Museum); winter scenes (Haarlem, Hals); in fact, nearly every *genre with the exception of still life. He also painted figures in other artists' landscapes, especially for his friend Jacob van *Ruisdael and for *Hobbema, and collaborated on a painting with *Dou (Amsterdam, Rijksmuseum). He is said to have been in Italy from 1642 to c.1645, but it is unlikely that he actually made the journey at this time, although he probably travelled there in 1653/4. Recorded in Amsterdam in 1660 and 1667, he had settled there permanently by 1680. A popular and highly paid artist, he left some 800 paintings, 500 drawings, and over 50 etchings (*see under* intaglio).

Berckheyde, Gerrit (1638–98) and **Job** (1630–93) Among the earliest Dutch specialists of townscape. Gerrit, probably a pupil of his elder brother Job, is the better known of the two, although Job was more versatile. After travelling in Germany in their youth, they returned to their native Haarlem, painting small pictures of the city's streets, squares and canals, as well as a few landscapes and church and shop interiors (e.g. London, National; Haarlem, Hals; Douai, Musée; The Hague, Mauritshuis).

Berczy, William von Moll (1749–1813) Painter of pastel and oil portraits in Canada – chiefly Montreal but also Toronto and Quebec – from about 1805. He was born in Saxony, the son of a German ambassador later stationed in Vienna, and studied at Leipzig University. During 1785–90 he was in Italy studying art with his wife, a Swiss painter, then came to London, where he probably met *Zoffany. In 1792 he emigrated to the United States; he moved to Canada in 1795, turning to painting when his financial and land dealings involved him in difficulties. His son and daughter were also watercolour and miniature painters.

Berg, Claus (before 1485–after 1532) Outstanding albeit ill-documented Late

*Gothic German wood sculptor from Lübeck. He may have trained with Veit *Stoss. He was active in Denmark between 1504 and 1532; there are works by him in Odensee (huge carved altar in the parish church), Sorö, Vindinge; his masterpiece is the series of eleven powerfully energetic apostles in Güstrow cathedral, which adapt Stoss's drapery style, conceived in limewood, to the more resistant material of oak.

Bergmüller, Johann Georg (1688–1762) Influential German painter, etcher (*see* intaglio) and publisher in Augsburg, a pupil of Johann Andreas *Wolff in Munich, after which he was in Rome with Carlo *Maratta. He settled in Augsburg in 1712, becoming Catholic Principal of the Art *Academy in 1730. From 1739 he was Court Painter to the Prince Bishop of Augsburg; with the help of a large workshop he painted numerous portraits, altarpieces, *fresco façades and church decorations in Augsburg (cathedral, Pollheimer Chapel; Kreuzkirche; St Anna; various religious orders), Bavaria, the Tyrol and Swabia. He is the teacher of the following generation of Augsburg painters, notably *Holzer and *Göz.

Bergognone or **Borgognone, Ambrogio di Stefano da Fossano**, called (active 1481–1523?) Italian painter active in Milan and for several years at the Charterhouse of Pavia (an altarpiece from which is now in London, National, along with several other works). His style derives chiefly from *Foppa. His brother **Bernardino** (active between 1492 and 1523) is known to have assisted him in Pavia and in Lodi (Milan, Brera).

Berlewi, Henryk (1894–1967) Polish painter, trained in Warsaw, Antwerp and Paris. In Warsaw he was part of a *Futurist group, then met *Lissitzky and followed him to Berlin, making contact with *Moholy-Nagy and Van *Doesburg. He conceived the *abstract idiom he named *Mécano-facture*, characterized by precise elements, some of them suggesting technology. He published his theories in Warsaw in 1924 and exhibited at the

*Sturm Gallery. In 1926 he returned to *figurative painting. In 1928 he settled in Paris. During his last years he turned again to *Mécano-facture*.

Berlinghieri Dynasty of Italian painters from Lucca active in the 13th century, among the earliest to have signed their works: a *Crucifix* in Lucca (Gallery) signed 'Berlingeri' is usually identified with the founder, **Berlinghiero Berlinghieri**. The famous and influential gabled panel of *St Francis and Scenes from his Life* was signed by his son, **Bonaventura**, and dated 1235, a mere nine years after the saint's death, and is the earliest surviving dated *dossal.

Berman, Eugene (1899–1972) Russian painter and theatre designer who settled in Paris in 1918 and was associated with a tendency labelled *Neo-Romanticism which mingled the softer aspects of *Surrealism with suavely decorative methods. In 1937 he emigrated to the USA where the fantasy element in his art became more marked.

Bermejo, Bartolomé (active 1474– after 1498) A native of Córdoba, he has been called the best artist in Spain before 1500. Unlike most of the other Hispano-Flemish painters (*see* Luis Dalmau, Jaime Baço) he may actually have trained in the Netherlands, although his greatest work, the dramatic *Pietà* in Barcelona Cathedral, also shows signs of northern Italian influence. There are other paintings by him in Madrid, Prado; Boston, Gardner; London, National.

Bernaerts, Nicasius *See under* Desportes, Alexandre-François.

Bernard, Emile (1868–1941) French painter. He met Van *Gogh and *Toulouse-Lautrec while studying at the Académie Cormon in Paris, and then worked with *Gauguin at Pont Aven. He developed a *Synthetist manner in 1887–8, picturing Breton life in flat, simplified forms with dark outlines, which Gauguin adopted in 1888. They both showed in the Paris

Synthetist exhibition in 1889 and Bernard became associated with the *Nabis and the Rose + Croix group in the 1890s. In 1890 his desire to reform art as a vehicle for religious experience led him to found the journal *La Rénovation esthétique*. In 1893 he published letters he had received from Van Gogh. In 1904–6 he paid visits to Cézanne and published accounts of their conversations and, in 1907, some of the letters Cézanne had written him.

Bernini, Pietro (1562–1629) and his celebrated son **Gian Lorenzo** (1598–1680) Sculptors, active mainly in Rome. Gian Lorenzo Bernini, important also as an architect (e.g. Rome, S. Andrea al Quirinale; Vatican colonnade), playwright and stage designer, is virtually synonymous with the High *Baroque style (*see also* Rubens). Pietro Bernini, best known to contemporaries for his exceptional technical facility, has been variously categorized as a Late *Mannerist, an *expressive Mannerist, and a proto-Baroque sculptor. Born near, and trained in, Florence, he sought advancement first in Rome, then, in 1584, in Naples, where Gian Lorenzo was born. The family moved to Rome in 1605/6. Pietro is the author of one of the city's best-loved landmarks, the *Fontana della Barcaccia* (1637–9) – a fountain in the form of one of the barges which then navigated the Tiber – at the foot of the Spanish steps. It has been said that Pietro handed on to Gian Lorenzo his technical facility, an empirical approach to style, and an 'emotive attitude to sculpture' best demonstrated in the remarkable range of transient emotions portrayed in his marble relief of the *Assumption of the Virgin* (1606–10, Rome, S. Maria Maggiore) inspired by the painter Lodovico *Carracci.

Gian Lorenzo Bernini, a child prodigy, continued to grow in artistic stature throughout his life and to work into extreme old age. Not an introspective or intellectual genius like his great predecessors *Donatello, *Leonardo and *Michelangelo, he must be identified with those orthodox beliefs and aspirations of triumphant Catholicism and of secular absolutism for which he found such compelling visual embodiments. For this reason, his reputation – as he himself predicted – waned after his death, and has never been high in non-Catholic countries. Recent scholarship, however, has restored him to his rightful place as one of the 'great image-makers of all time'. His work sometimes reaches out to crowds but more typically seeks to affect the individual viewer. In the most famous example, the Cornaro chapel (1645–52, Rome, S. Maria della Vittoria), architecture, painting, sculpture – in variously coloured marbles and gilt wood – and carefully adjusted natural light are combined so as to reveal, as in a vision, the ecstatic vision of St Teresa of Avila. Art historians have termed this Baroque effect the 'double vision': the saint's mystical experience of the divine is made the subject of the viewer's mystical experience of the work of art. Where *Renaissance artists expended their skills – notably in *perspective – to make of the spectator an 'eye-witness' of objectively 'real' events, Bernini draws the viewer into an enlarged sphere of subjectivity.

Trained in his father's workshop, Gian Lorenzo was early put to the study of the antique, profiting from Pietro Bernini's access to the Vatican collections. His earliest surviving work, variously dated 1609, 1612 or 1615, the *Goat Amalthea nursing the Infant Jupiter* (Rome, Borghese) evokes Hellenistic sculpture. At the same time he executed portraits (Rome, S. Giovanni dei Fiorentini, S. Prassede, S. Maria sopra Minerva) and religious statuary (Florence, Contini-Bonacossi Coll.; Madrid, Thyssen). Drawn through his father into the circle of papal patronage (portrait bust of Pope Paul V, *c.*1618, Rome, Borghese) the youthful prodigy attracted above all the patronage of a great collector, the pope's nephew, Cardinal Scipione *Borghese (portrait bust, two versions, 1632, Borghese). It was for Scipione that he carved the three great works which crown his early development: *Pluto and Persephone* (1621–2), *Apollo and Daphne* (1622–5) and *David* (1623; all Borghese), which were influenced by contemporary painting, especially that of the recently deceased Annibale *Carracci, his rival *Caravaggio, and Guido *Reni.

In 1623 the elevation to the papacy of another early patron, Cardinal Maffeo *Barberini (Urban VIII, 1623–44) ended Bernini's career as a purveyor of collectors' sculpture. The new pope employed him extensively on the decoration of St Peter's. The great bronze baldacchino, a canopy over the site of St Peter's grave under the dome (1624–33) is a hybrid of sculpture and architecture and mediates between the human scale and the gigantic proportions of St Peter's. Bernini's plans for the piers supporting the dome included four colossal statues; he himself carved the Longinus (1632–8; see also Mochi; Quesnoy). He executed the marble and bronze tomb of Urban VIII in 1628–47; like his other mature works, it is a sculpted theatrical event, in which even the allegorical figures play a lively part, and a skeletal Death draws our fearful attention to the sarcophagus below. The concept is recast more dramatically and sombrely in the much later tomb of Pope Alexander VII in St Peter's (1671–8). Of Bernini's several other monuments for the Vatican church, mention must be made of the Cathedra Petri, 1657–66, the throne of St Peter as Vicar of Christ, which completes the symbolic and visual task of the baldacchino by closing off our view of the apse.

Bernini's portraits of the 1630s revolutionized sculptural practice in their pictorial representation of transient attitudes; when working from life, he sketched his sitter carrying on his daily routine. From this period date the busts of Scipione Borghese already mentioned; the likeness of Bernini's mistress, Costanza Buonarelli (c.1636, Florence, Bargello), which in intimacy and immediacy anticipates *Rococo sculpture; a bust of King Charles I, now lost, after the triple portrait by *Van Dyck, and the flamboyant portrait of the young Englishman who brought it to Rome, Thomas Baker, completed by an assistant (c.1637, London, V&A).

In the 1640s Bernini worked more as a designer than an executant, beginning the great series of figurative fountains which changed the face of Rome, notably the Triton fountain for Urban VIII (1642–3, Piazza Barberini) and the strikingly theatrical Four Rivers fountain (1648–51, Piazza

Navone) for Innocent X. Innocent X's successor, Pope Alexander VII (1655–67) proved to be one of Bernini's most generous patrons; among his commissions were the Cathedra Petri discussed above and the Scala Regia, the 'royal staircase' of the Vatican palace (1663–6) down which the pope was carried in his ceremonial chair and which provided Bernini with the occasion to execute one of his only two equestrian statues, Constantine (compl. 1670). In 1665 Bernini visited France, but his grandiose plans for the façade of the Louvre palace were not accepted. Although his bust of Louis XIV (1665, Versailles) was appreciated, the equestrian statue of the King (completed 1677), a masterpiece of absolutist propaganda, was recarved to represent a Roman hero.

In the last phase of Bernini's career he designed, for Pope Clement IX, the Angels on the bridge over the Tiber leading to the papal fortress of Sant'Angelo (autograph Angel with the Superscription, 1670, Rome, S. Andrea delle Fratte). The visionary bust of Gabriele Fonseca, Pope Innocent X's physician, in his funerary chapel in S. Lorenzo in Lucina (c.1668) marks the apogee of Bernini's expressive portraiture, almost to the point of caricature (but see Algardi) and the altar monument of the Blessed Lodovica Albertoni (1671–4, Rome, S. Francesco a Ripa) takes up again themes of the Cornaro chapel in an even more vehemently emotional form. Where the youthful Bernini had revelled in the virtuoso carving of varying textures – as in the Scipione Borghese commissions – the old sculptor put his formidable technique entirely in the service of fervent spirituality. In an age of increasing doubt, he died affirming, in his art as, paradoxically for so accomplished a courtier, in his private life, the certainty of individual salvation to the point of mysticism.

Bernini's son, Domenico, wrote a life of his father published in 1713. His most outstanding follower was not a relation, however, but Antonio Raggi (1624–1686), originally a pupil of Algardi.

Berrettini, Pietro See Pietro da Cortona.

Berri, or Berry, Jean, Duke of (1340–1416) Youngest brother of Charles V of France, known for his lavish patronage and his collection of illuminated manuscripts. *See* under Books of Hours, Limbourg Brothers.

Berrío, Gaspar Miguel *See under* Holguín, Melchor Pérez.

Berruguete, Pedro (*d.*1504) **and Alonso** (*c.*1488–1561) Pedro Berruguete has been identified with 'Pietro Spagnuolo', Peter the Spaniard, who was the assistant of *Joos van Ghent in the ducal palace of Urbino, 1477. First-hand experience of both Netherlandish and Italian art is indeed suggested by the works he completed after his return to Spain by 1483, when he settled in Toledo to engage on a series of *retables.

Pedro's eldest son, Alonso, was the most important sculptor in 16th-century Spain. In Florence by *c.*1504, he studied the early work of *Michelangelo and participated in a contest of wax models after the ancient group of the *Laocoön*. He returned to Spain *c.*1517 (*Resurrection*, *c.*1517, alabaster relief, Valencia, cathedral). In 1518 he became court painter at Vallodolid but was prevented by illness from following Charles V to Germany in 1520. Henceforth, although receiving benefices and eventually ennoblement, he worked only for royal ministers and high-ranking churchmen. Through his activity, the centre of Spanish sculpture shifted from Burgos to Vallodolid. He executed a number of complex sculpted altars (now Vallodolid, Museum; Santiago, Cáceres; Salamanca, Irish college; etc.) and carved 36 walnut choir stalls, surmounted by 35 alabaster figures, for Toledo Cathedral (1539–43). Even when *polychromed, Berruguete's work is never naturalistic (*see under* realism). His is an *expressive form of *Mannerism, animated by recollections of Florentine sculpture – not only by the youthful Michelangelo, but also by *Donatello – unrefreshed by study from the life, but made more strident by a Spanish form of religious intensity. His carving in relief can be refined and delicate, but his figure style is characterized by dislocated, angular outlines and elongated proportions. Although

he had many pupils, notably Francisco Giralte and Isidro de Villoldo, his style never really became popular in Spain. *See also* Vigarny, Felipe.

Bertoia, Giacomo Zanguidi, called (1544–74) Italian *Mannerist painter. He has been called a 'posthumous *alter ego*' of *Parmigianino (*d.*1540) assuming his style at will, but with greater fantasy, in decorative *fresco cycles at Parma (Palazzo del Giardino, Sala del Bacio, also fragments of another room, now in the Gallery). Trained in Bologna, Bertoia could, however, work in a more sober *classicizing style, as he did in the Oratorio del Gonfalone in Rome (1568–9 and 1572) and in the vast scheme of mural decorations in the Farnese palace at Caprarola, where he first collaborated with, then replaced, Federico *Zuccaro.

Bertoldo di Giovanni (*c.*1420–91) Bronze sculptor, trained by *Donatello and employed on the latter's unfinished pulpits in S. Lorenzo, Florence; possibly responsible for the design as well as the casting of the *Entombment* relief and parts of the frieze. In his last years he was in charge of the collection of antiquities of Lorenzo the Magnificent de'*Medici, and is reputed to have been *Michelangelo's master from *c.*1489. For the Medici he also made bronze statuettes (Florence, Bargello; Vienna, Kunsthistorisches) and a bronze relief (Florence, Bargello) reconstructing, or improvising upon, antique prototypes.

Bertos, Francesco (recorded 1693–1738) Sculptor active in Rome and Venice; he may have been of Spanish birth. His mainly secular works in marble and bronze, including a number of allegorical (*see* allegory) pyramidal groups, both on a large and small scale, enjoyed great popularity among the foreign, particularly British, visitors (Los Angeles, Getty; Padua, Antoniano).

Bertram, Master (documented 1367–1414/15) German painter, also known as Bertram of Minden after his birthplace in nearby Birde, Westphalia. He was the leading artist of his day in Hamburg, where he ran a workshop producing painted and

sculpted altarpieces, such as his famous altar for St Peter, now in Hamburg, Kunsthalle (*Grabow Altarpiece*, 1379).

Beschey, Balthasar *See under* Lens, Andreas Cornelis.

Bettera, Bartolomeo and **Bonaventura** *See under* Baschenis, Evaristo.

Bettes, John the Elder (active *c.*1531–1570) and his son **John Bettes the Younger** (d.1616) The least shadowy members of an ill-documented dynasty of English painters. John Bettes the Elder was a portraitist and miniaturist, first recorded as carrying out decorative work for Henry VIII at Whitehall Palace, London, in 1531–3. He may also have executed woodcuts (*see* relief prints). His only securely known painting is the portrait of an *Unknown Man in a Black Cap*, dated 1545 (London, Tate), which is close both in technique and style to *Holbein, Bettes's probable master. John Bettes the Younger was a pupil of Nicholas *Hilliard.

Beuckelaer, Joachim *See under* Aertsen, Pieter.

Beuys, Joseph (1921–1986) German sculptor, *Conceptual and *Performance artist, who, through his art, his didactic events and his teaching, became one of the most influential figures in western art in the 1970s, and 80s. He engaged art both in personal expression, referring often to his war experience of being shot down as a Luftwaffe pilot over the Crimea and kept alive by Tartar nomads who covered him in lard and rolled him in felt, and in politics, notably the blind and oppressive forces operating in modern democracies, not only but especially in western Germany. Science too, he argued, was out of touch with human needs, and his work embodied much alchemical and mystical symbolism while addressing itself to contemporary issues. His hat, hiding his head injuries, and huntsman's waistcoat, comprised his professional uniform; his earnestness, sometimes fierceness, masked humour and charm.

Born and brought up a Roman Catholic in north-west Germany, Beuys was drawn to the arts but thought of becoming a pediatrician. War intervened. During his experience in the Russian steppes he kept notes and made simple drawings of people and life around him. Further war service and injuries followed. In 1946 he returned to his parents' home in Kleve and began to study sculpture, before moving to the Düsseldorf Academy, while also pursuing scientific and literary interests and philosophy, including the teachings of Rudolf Steiner, the writings of James Joyce, drawn by their 'spiritual and mythological' content, and *Leonardo, drawn by his versatility and experimental method. Around 1950 he began to exhibit sculpture, figurative and *abstract and made in a variety of materials. In 1953 he had his first solo exhibition, in the house of friends in Kranenburg who were also his first significant collectors. A physical and spiritual crisis in the mid-50s, partly relieved by farm work, was followed by stronger convictions and confidence. Art, he decided, needed greatly to extend its frontiers in order to compensate for science's narrow specialization and in order to regain art's original shamanistic, healing power and social centrality.

In 1961 he was appointed professor of monumental sculpture in the Düsseldorf Academy. In 1962 he was one of the first members of the international *Fluxus movement with its public events and anti-individualistic emphasis, staging at the Academy a Fluxus event in 1963. But he was opposed to the tendency of Fluxus and other *Neo-Dadaist actions to be provocative; he sought to generate constructive energies, not shock. He performed his *Siberian Symphony, 1st Movement* on this occasion with the help of a grand piano, a blackboard and a dead hare. In 1963 he also made his first lard-and-felt sculptures and installations. In 1964 he participated in a 'Festival of New Art' in Aachen and in the third Dokumenta exhibition at Kassel. In 1965 he performed, at the opening of his exhibition in the Schmela Gallery, Düsseldorf, 'How to Explain Paintings to a Dead Hare', carrying the corpse around the show and speaking to it, his head covered with honey and gold leaf. From this time on

Beuys's performances included a growing element of lecturing and discussion, with writing and drawing on blackboards. He was exhibiting and performing frequently, especially in Germany, the Netherlands and Belgium, and in 1967 helped found a German Student Party. His fervour drew Academy and other students to him; this led to protests against him within the Academy and, in 1969, to the closing of the Academy by the police to prevent a student event taking place. Beuys was now wholly at odds with officialdom, and demonstrated this in 1971 when he accepted into his class 142 students refused admission to the Academy on the instructions of the Minister of Education. A similar event in 1972 led to Beuys's dismissal from the Academy by order of the Minister. He continued to teach, but also developed plans for a 'Free International College for Creativity and Interdisciplinary Research'; in 1974 he and the writer Heinrich Böll founded such a 'Free College' in Düsseldorf. That year Beuys performed in Britain and New York. His New York action *I like America and America Likes Me* involved his sharing a gallery space with a coyote for three days. A subsequent London action *Direction of Energies to a New Society*, given at the Institute of Contemporary Arts and repeated in 1975 in New York, involved various props including 100 blackboards written and drawn upon, all acquired by the National Gallery in Berlin in 1976. At this time he began to be given honours by various German cities, not without opposition, and in 1979 he was given back his studios in the Düsseldorf Academy and the title of professor though without his contract being renewned and thus without pay.

Beuys's continuing campaign to increase awarenes of art as essential creative thought and action, and to fuse it with politics, was fed by such sometimes offensive, sometimes defensive actions taken around him, while he continued to perform and show, including his exhibition at the fifteenth *Bienal of São Paulo, representing Western Germany, while also having his first full retrospective, at the Guggenheim Museum, New York. Handicapped only by uncertain health, Beuys continued to teach, perform and make assemblages and installations,

both against and with the art market, with himself as a key presence in his work. This emphasis was often at the heart of attacks upon him, sometimes because of the Christ-like image he adopted for some occasions. His death has focused attention on his sculpture and drawings. They can be seen in museums around the world, e.g. in the Pompidou Centre, Paris. They have remarkable symbolical force without ever yielding their content to full analytical justification.

Bevan, Robert (1865–1925) British painter who in the 1890s studied in Paris and spent some time at Pont-Aven where he met *Gauguin. He was a founding member of the *Camden Town Group in London in 1911 and of the London Group in 1913. Having worked in a modified *divisionist manner, he firmed and flattened his style in the *Nabi manner, painting landscapes and scenes of town and country life. His pen and ink drawings show a Van *Gogh-like touch. The Tate Gallery, London, has the best collection of his work.

Bewick, Thomas (1753–1828) British wood-engraver (*see* intaglio), working mostly in Newcastle-upon-Tyne where his father owned a colliery. He worked for an engraver mainly of ornamental silver before specializing in wood-engraving. He wrote and illustrated two books valued for their accuracy as well as the beauty and sometimes moralizing humour of their major illustrations and vignettes: *A General History of Quadrupeds* (1797) and *A History of British Birds* (two vols, 1797 and 1804). He wrote an autobiography (*A Memoir of Thomas Bewick*, 1862) that reinforces the impression given by his art, of a strong, modest, moral individual with exceptional powers of observation but also of compelling, economical design. The poet William Wordsworth praised him in a poem published in *Lyrical Ballads* (1798); later *Ruskin praised Bewick's 'magnificent artistic power, the flawless virtue, veracity, tenderness, the infinite humour of the man', regretting only that, not being an educated gentleman, Bewick could not command more elevated subjects and exhibited some of that 'love of

ugliness which is in the English soul'. In fact, Bewick had had no art training other than that got from drawing for his own satisfaction and seeing around him the signboards of inns and shops. His literary style suggests wide reading combined with his characteristic feelings for directness.

Beyeren or **Beijeren, Abraham van** (1620/1–90) Dutch painter, the most important *still-life specialist in The Hague, although he also worked in other cities in Holland. He is perhaps best remembered for his fish still lifes (e.g. Oxford, Ashmolean), but he also painted remarkable *pronkstilleven* and *vanitas* pictures, flower pieces and river views (The Hague, Mauritshuis; Worcester, MA, Museum; etc.). Incomprehensibly, his still lifes found few purchasers in his lifetime.

Bibiena Influential family of Italian *quadratura* (*see* illusionism) specialists, stage designers, inventors, theatre architects and draftsmen of scenographic fantasies, whose real name was Galli; they were called Bibiena after their place of origin in Tuscany. The most important were the brothers **Ferdinando** (1657–1743) and **Francesco** (1659–1739), pupils of *Cignani in Bologna, and Ferdinando's sons **Giuseppe** (1696–1757) and **Antonio** (1700–74). Ferdinando spent 28 years in Parma as painter and architect before transferring in the same capacity to the imperial court at Vienna, 1708. His important treatise, *L'architettura civile . . .* , 1711, introduced the new device of two-vanishing-point or diagonal *perspective, which revolutionized the *Baroque stage and decisively influenced the draftsmanship of *Piranesi. Francesco is known primarily as a theatre architect. Giuseppe, famed for opera sets, also published a collection of designs, the *Architetture e Prospettive*, 1740, which was the model for Piranesi's first publication and was influential on the great visionary artist in other ways (e.g. drawing, London, British, formerly attributed to Piranesi). Antonio practised both as a theatre architect and as a painter of *illusionist frescos (Vienna; Pressburg; etc.).

Biederman, Charles (1906–) American artist who studied at the Art Institute of Chicago in 1926–9 and made *abstract paintings and constructions. After some months in Paris in 1936–7 he studied linguistics under Alfred Korzybski and adapted his teachings to his own methods. He wrote a major treatise, *Art as the Evolution of Visual Knowledge* (1948), arguing the necessity for art to abandon all illusionism, even of space, and thus to become three-dimensional. The characteristic Biederman works of the later years are reliefs made up of rectilinear geometrical units, most recently finely assembled metal elements sprayed with colour. Further books, *Letters on the New Art* (1951) and *The New Cézanne* (1958), develop his argument in support of what he called 'Constructionism' (*see* Constructivism) and prove its roots in nature, not mathematics or engineering. He lives and works in the woods outside Minneapolis. It was in the Minneapolis Institute of Arts that he had a major retrospective in 1976 and that is where his work is best seen.

Biedermeier An early 19th-century style, in painting and domestic design, developed in Austria and Germany and named after a figure in a satirical review of the time. In German *bieder* means honest but commonplace, *meier* a (dairy) farmer and by implication a useful but unpretentious fellow. In painting this was associated with placing detailed *naturalism above all concerns for idealization, fictional subjects however elevated, or stylization; in design it meant homely, solid furniture and interiors, a utilitarian verson of *Neoclassical simplicity. *Waldmüller was the outstanding practitioner and promoter of this kind of naturalistic painting and it found adherents. Denmark had a phase of Biedermeier painting associated primarily with the work of *Købke and partly with his teacher, *Eckersberg.

Bierstadt, Albert (1830–1902) German-born American painter of landscapes, trained at the Düsseldorf Academy. He returned to America in 1857 after travels in Germany and Italy, and painted European subjects before turning to

grandiose representations of the American West, e.g. *The Rocky Mountains* (1863; New York, Metropolitan), which had a great success when exhibited in 1864. He was highly regarded in Europe and was accorded the Légion d'Honneur when he showed a vast Rocky Mountains landscape at the Paris Salon in 1869. He is now regarded as a mayor figure in the *Luminist movement in American painting and photography.

Bigarny, Biguerny, Felipe *See* Vigarny, Felipe.

Bigot, Trophime (1579–after 1605) and his son of the same name (recorded between 1620 and 1634) Recently rediscovered French painters from Provence. Trophime Bigot the Elder was born in Arles and went to Italy in the last years of the 16th century, returning to France where he executed altarpieces in and around Aix-en-Provence. His son, documented in Rome before his return home in 1634, studied the work of *Honthorst, and produced candlelit nocturnal pictures once grouped under the name of the 'Candlelight Master' (e.g. Oxford, Ashmolean).

Bijlert or **Bylert, Jan van** (*c.*1603–71) Dutch painter from Utrecht, the son of a glass-painter, Harmen van Bijlert, who was also his first teacher. Like the better-known 'Utrecht Caravaggisti' (*see* Terbrugghen, Honthorst, Baburen) Bijlert studied with *Bloemart and in 1621 made the pilgrimage to Rome; his first paintings after his return to Holland in 1624 contain direct borrowings from the work of *Caravaggio. The strong light effects disappear from his later works, as he came under the influence of Honthorst and Terbrugghen. He painted religious, mythological and Arcadian subjects and *genre, including half-figures on the scale of life, and, particularly in his later years, many portraits. There are works by him in Utrecht, Centraal; London, National; Belfast, Ulster.

Bilibin, Ivan (1876–1942) Russian painter, member of the *World of Art and famous for his illustrations and theatre

design, from 1899 steeped in folk art, often having Slav legends for their subjects but at the same time exhibiting *Art nouveau stylistic priorities in their emphasis on decorative flatness of image and colour. He studied under *Repin and himself taught until 1917. In 1920 he emigrated to Egypt and then, in 1925, to Paris. In 1936 he returned to the Soviet Union and was professor of Graphic art at the Leningrad Academy until he died during the siege of the city. Among his finest works are his images for Pushkin's *The Golden Cockerel* (1907) and the sets and costumes he made for Rimsky-Korsakov's opera version of the same text (1909). The Tretyakov Gallery in Moscow and the Russian Museum in St Petersburg have examples of his work; the Bakhrushin Theatre Museum in Moscow and the Ashmolean Museum, Oxford, have much of his work for the stage.

Bilivert or **Biliverti, Giovanni** (1576–1644) Florentine painter, the son of a Dutch goldsmith from Maastricht, Giacomo di Giovanni Bylevelt, who probably settled in Florence shortly before his son's birth. He studied with *Cigoli, and followed him to Rome in 1604; his style of the following decades is indebted to both Cigoli and *Caravaggio (Florence, S. Croce; Pitti; Casa Buonarroti; London, National; Pisa, Cathedral). In the 1630s, he began to emulate the *sfumato of *Furini.

Bill, Max (1908–94) Swiss artist and designer, trained in Zurich and during 1927–9 at the *Bauhaus, subsequently working mainly in Zurich. He was a member of *Abstraction-Création 1932–6, and became prominent as an *abstract painter and (from 1933) sculptor, basing two- and three-dimensional works on simple formal or mathematical propositions. Following Van *Doesburg, he called this art *concrete: it is not abstracted from anything. In 1944 he organized in Basel the first international exhibition of concrete art and began to teach at the Zurich School of Applied Art. In 1950 he conceived, and in 1951 became the first director of, the High School of Design in Ulm, seen as

successor to the *Bauhaus; he took charge of the departments of architecture and industrial design until 1956. He had always travelled extensively, forming alliances with like-minded artists and designers. From the 1950s on this activity increased, as did his publishing of major texts by himself and others (e.g. *Kandinsky's chief writings and texts by *Vantongerloo). In 1960 in Zurich he organized the exhibition 'Concrete Art: 50 Years of Development'. His paintings and sculptures have become known internationally since his first one-man show in Zurich in 1945.

Bingham, George Caleb (1811–79) American painter, especially admired for his pictures of life on and around the river Missouri, done mostly during 1845–55. He had studied theology and law, and joinery and sign-painting, before a short period at the Pennsylvania Academy in 1838. He then worked mainly in Washington as a painter of portraits before returning to Missouri and finding his characteristic subjects, such as *Fur Traders descending the Missouri* (1845, New York, Metropolitan), and the almost hypnotic stillness and clarity that makes his realism dreamlike. Subsequent studies in Düsseldorf made his *realism more international, in a post-*Barbizon manner, and more self-conscious.

Bird, Francis (1667–1731) English sculptor, the first to receive extensive training in Flanders and Rome, c.1678–c.1689, he made a second journey to Rome c.1695, and probably a third in 1711. He worked for *Gibbons, then for *Cibber; his reputation as an independent sculptor dates only from after 1700. There are funerary monuments by him in London, at Westminster Abbey and St Paul's; and a *Conversion of St Paul* on the west pediment of St Paul's, as well as monuments in the provinces (Isleworth, Middlesex; Tissington, Derbyshire; Oxford; etc.). He became one of the directors of *Kneller's *Academy; in the last decade of his life, when he had virtually ceased to practise sculpture, he ran a business as an importer of Italian marbles.

Bissier, Julius (1893–1965) German painter who worked first in a *Neue Sach-

lichkeit *realistic manner until, in the late 1920s, he became interested in Chinese calligraphy and Eastern mysticism. From this time on he worked mainly on paper in watercolours or tempera, making delicate *abstract or simplified still-life images. In 1957 he left Germany to live at Ascona in southern Switzerland, a friend of *Tobey and of Ben *Nicholson. His international reputation soared from 1958 when a Bissier retrospective toured Europe from the Kestner Society in Hanover. The Kunstsammlung Nordrhein-Westfalen, Düsseldorf, is rich in his work.

Bissière, Roger (1888–1964) French painter who became known as part of the *Art informel movement in the 1950s with his free but gentle *abstract compositions.

bistre A transparent water-soluble cool brown *pigment made by boiling the soot of wood, used as a wash in pen-and-ink drawings and watercolours. The word is first recorded in 18th-century France, but the pigment was in use earlier, by *Claude and *Rembrandt among others.

Black Mountain College A college for advanced study in the arts, established in North Carolina in 1933. *Albers taught there and shaped its programme. This benefited from visits, long and short, by major artists, writers, composers, dancers etc., especially to the summer schools from 1944 on. These visitors included *Léger, *De Kooning and *Motherwell, the composer Cage and the dancer-choreographer Merce Cunningham. *Rauschenberg and other significant artists were students at the College, but it is for its staff and visitors (who indeed included former students) and their adventurous ideas and methods that it is famous.

Blackburn, Joseph (c.1700–63) English-born colonial American painter, who from 1755 succeeded John *Greenwood as the most fashionable portraitist in Boston, working in a debased English *Rococo style (Boston, MFA). He influenced the far greater *Copley.

Blake, Peter (1932–) British painter, one of the older contributors to the *Pop art movement, contributing images from the world of film and pop stars, and then also wrestlers, music-hall artists and occasionally figures from folk legends, in a manner that at first adapted fairground and common advertising styles and then tended towards *Pre-Raphaelitism. In 1995–6 he was Associate Artist at the National Gallery, London, working with scenes and subjects he studied in its collection.

Blake, William (1757–1827) English poet, painter, illustrator and printmaker, an outstanding figure in what later became known as *Romanticism, now renowned for his visionary work in words and images and for his opposition to the academic priorities of his time, particularly those taught by *Reynolds. The son of a London hosier, he attended a drawing school at the age of ten but also studied prints and plaster casts to acquire the language of high art. Working for an engraver from 1772, his main task was to draw the Gothic tombs of Westminster Abbey. In 1779 he began to study in the Royal Academy Schools and soon after to exhibit watercolours on historical and biblical subjects in Royal Academy exhibitions. Through artist friends such as *Flaxman and *Fuseli, Blake became part of a circle of educated people who helped to publish his early poems. He also associated with politically progressive men and women such Tom Paine, William Godwin and Mary Wollstonecraft.

He developed a method of making line prints with added colour that he used to accompany some of his own writings: he published his *Songs of Innocence* (1789) and *Songs of Experience* (1794), with handwritten text and handcoloured illustrations, done by a process he called 'illuminated printing'. Reading the mystical writings of Swedenborg, Böhme and others and fusing their teaching with his understanding of Christianity and of the revolutionary propositions debated in his country and put into practice across the Channel, he developed his own religious and philosophical system, expounded and illuminated in books such as *The Book of Thel* (1789), *America; A Prophecy* (1793), *Urizen* and

Europe: A Prophecy (1794), all published by himself in this manner. Between 1800 and 1816 he produced a great number of watercolours illustrating parts of the bible and of Milton. He also developed his own version of the medieval technique of *tempera painting as a means of making large, independent prints on biblical, Shakespearian and other subjects, taking only three or four prints from tempera on board and then adding line and colour by means of ink and watercolours. These impressed no-one when he exhibited the results in 1809. The painter *Linnell, who with *Palmer and others formed part of a circle of young artists about him, known as the 'Ancients', commissioned drawings for the *Book of Job* (1821–6) and watercolours for Dante's *Divine Comedy* (1824–7).

Thought eccentric, even mad, because of his fierce and at times inelegant variations on formal themes derived from ancient art, from his especial hero *Michelangelo whose work he knew from *engravings, and from medieval and sometimes Eastern art, partly because of his singular rhetoric and elaborate private symbolism, most of all for his compulsion to teach the world anew about good and evil, Blake was largely forgotten until *Rossetti and other *Pre-Raphaelites recognized in him an inspired, inspiring rebel. It is in the 20th century that he was hailed as a genius and a soothsayer, a forerunner of 'flower-power' and other campaigns for an alternative society based on primitive principles close to human physical and spiritual needs. His example has influenced several British artists, especially in the *Neo-Romantic phase, and has also powered modern English poetry. He claimed to be guided by supernatural forces in his life and work; two hundred years later his work, though still in many respects obscure as well as forceful, seems prophetic in its social and primitive religious pronouncements. The Tate Gallery and the British Museum in London own many of his finest works; high quality facsimiles of his images, with and without texts, have been published since the 1920s.

Blanchard, Jacques (1600–38) One of the leading French painters of the reign

of Louis XIII, born in Paris. In 1624 he travelled to Rome, and lived in Venice 1626–8, where his style was strongly influenced by *Veronese. In 1628 he was employed in Turin by the Duke of Savoy; he returned to Paris in the same year. From 1634 he was entrusted with a number of decorative projects, first in the hôtel de Bullion, then, in 1636, in the palace of the Louvre. He painted numerous portraits, religious and mythological subjects. His later works show close affinities with Simon *Vouet and Laurent de *La Hyre. (London, Courtauld; New York, Metropolitan; Paris, Louvre, Notre Dame.)

Blanchard, Maria (1881–1932) French painter of Spanish origin and partly French and Polish parentage, who visited Paris from 1906 and settled there in 1916. She worked in a *Cubist idiom for a time before developing a more personal and poetic manner for subjects drawn from contemporary life.

Blaue Reiter, Der (The Blue Rider) A loose association of artists centred on the *Blaue Reiter Almanac* (1912, two printings), its creators *Kandinsky and *Marc in Munich and the two exhibitions they presented in 1911 and 1913 in Munich and toured in Germany. Their own work and that of *Klee, *Yavlensky, *Münter and other friends was prominent in the exhibitions, which included also art from Paris (e.g. *Rousseau, Robert *Delaunay) and Russia (David *Burliuk). The theme of the text and illustrations in the almanac (intended as first of a series) was that true art had always had a spiritual content which transcended questions of style and representation, and that modern times were witnessing the abandoning of a materialistic and individualistic emphasis, brought in by the *Renaissance and oppressively dominant in 19th-century art, in favour of a return to spiritual values and less egocentric concerns, including the collaboration of several art forms in *Gesamtkunstwerke. Conventionally seen as part of German *Expressionism, the activities of the Blaue Reiter were essentially international in aim and spirit.

Blechen, Karl (1798–1840) German painter, mainly of landscapes, working under the influence of *Friedrich and then, after a visit to Italy in 1828, also of *Corot, moderating his detailed representations to bring in more air and light in a *Romantic spirit.

Biennial art exhibitions The city of Venice in 1895 founded the 'Venice Biennale' as a (nominally) regular event, every two years, bringing the best contemporary art from all around the world to the Giardini Pubblici (Public Gardens), for summertime display in international and national pavilions. It continues to the present day, though war and other obstacles have broken into the two-yearly rhythm. Committees, both national and international, select the artists to be represented; others international committees award prizes of varying sorts, official ones and other sponsored by major collectors. The exhibitions have grown considerably over the years, swelling from hundreds of exhibits to thousands, though numbers have shrunk recently because many recent exhibits have been installations occupying whole pavilions or large parts of them. On the other hand, a sub-section of the Venice Biennale, the Aperto (Open), has been added to show a wide selection of younger artists' work. On the whole, the Venice Biennales, formed to bring together the best work of the time, and thus from the start dedicated to the most admired artists of the day – many of whom we would not give much attention to now – and slow to recognize the contributions of *Modernist masters until they had achieved world-wide fame, became a means of giving international status to relatively new art as well as celebrating well-established individual artists, and has now focused more exclusively on the newly fashionable, though the main pavilion, in the control of the central committee has at times included important exhibition on aspects of earlier modern art. The city of São Paulo, in Brazil, has hosted its 'Bienal' since 1951, presenting international exhibitions on a smaller scale. The Paris Biennale des Jeunes was started in 1959 to show work by young artists (under 30). Other centres have at times organized

other exhibitions of art or design following a different tempo, such as the Triennales of Milan and Delhi. Print Biennales were frequent in several cities around the world during the 1970s and 80s.

Bles, Herri or **Hendrick met de** (known in Italy as **Enrico da Dinant** or **Civetta**) (1480?/c.1510?–50?) Ill-documented Flemish follower of *Patinir. He may be identical with the latter's nephew Henry Patenier, who became a master in Antwerp in 1535. He travelled in Italy, and probably spent some time in Ferrara, where his landscapes, more complex and more crowded with detail than those of Patinir, influenced local artists, notably *Dosso Dossi. His best-known picture, *The Copper Mine*, has been in Florence, Uffizi, since 1603. There are works also in Vienna, Kunsthistorisches; Piacenza, Galleria; Pisa, Museo; etc.

Blessed Clare, Master of the (active mid-14th century) Italian painter active in Rimini, named after a panel showing the vision of the Blessed Clare of Rimini, now London, National (other fragments from the same altarpiece, Florida, Coral Gables, Lowe; a nearly identical altarpiece now Ajaccio, Fesch). He may also have been the author of *frescos in Ferrara.

block-book A kind of picture book developed in the mid-15th century in which the whole page is virtually taken up with a woodcut illustration (*see* relief printing) interspersed, as it were, with words, and both image and text are cut out of the same woodblock. The earliest known dated block-books postdate printing with moveable type and separate woodcut illustrations. Although the format was used only for a few titles of a popular didactic/devotional kind – such as the so-called *Bible of the Poor* – many such volumes were produced into the 16th century in Germany and the Netherlands.

Blocklandt; Anthonie van Montfoort, called (1534–83) Dutch painter, the founder of Utrecht *Mannerism. A student of Frans *Floris in Antwerp, he

travelled to Rome in 1572. By 1577 he had returned to Utrecht, where he specialized in altarpieces, most of which were destroyed by Calvinist iconoclasts (*see under* icon). He was the teacher of *Bloemaert, *Wtewael and others. His compositions, disseminated through engravings (*see under* intaglio), influenced some of the greatest Spanish painters, including *El Greco, Morales (*see under* Valdés Leal) and even *Velázquez. He was the teacher of Cornelius *Ketel.

Bloemaert, Abraham (1564–1651) Utrecht *Mannerist painter. Like his compatriot *Wtewael, he must have absorbed elements of this artificial style during a voyage to France, 1580–3; from 1591–3 he was in Amsterdam, where he encountered the work of Haarlem Mannerists (*see* Goltzius, Van Mander, Cornelis van Haarlem). Unlike Wtewael, he abandoned Mannerist complexity c.1600, when he adopted a more 'sober', *classicizing mode. His importance derives in great part from his having taught virtually all the Utrecht painters of his day, including *Honthorst and *Terbrugghen. After 1620 he was himself influenced by Honthorst's adaptation of the style of *Caravaggio. His son, **Frederick Bloemaert** (after 1610–after 1669), engraved his father's *Foundations of the Art of Drawing*, which continued to be used in the training of Dutch artists until the 19th century. There are works by Bloemaert in most continental collections; in London, Ham House, and in some collections in the USA (Toledo, Ohio). Another son, **Hendrick Bloemaert** (1601–72) painted mainly *History pictures (*see under* genres) in small format (Utrecht, Museum).

Bloemen, Jan Frans van, called Orizzonte (1662–1748/9) and his brother **Pieter van Bloemen** (1657–1720) Flemish painters of Italian landscapes and *genre scenes, resident in Rome. Orizzonte (Italian for 'horizon') executed *classical landscapes in the manner of Gaspar *Dughet (Rome, Palazzo Corsini; Madrid, Prado). Pieter van Bloemen painted views of the Forum and the Campagna, but also Italianate genre scenes or *bambocciate* (*see under*

Laer, Pieter van), which, however, unlike the freer and more comical ones of Italo-Dutch painters, tend to a certain monumentality and pathos (e.g. Rome, Galleria Nazionale). He sometimes borrowed compositions from *Wouwerman.

Blondeel, Lancelot (1498–1561) Inventive Netherlandish painter and designer working in Bruges, where he joined the painters' guild in 1519, and often worked in collaboration with sculptors and architects (see *Beaugrant, Guyot de). He painted ephemeral decorations on canvas for public festivals, (*see* Provost, Jan) or religious subjects on canvas for banners to be carried in procession (present altarpiece in Bruges, St Salvator). His luxuriantly ornate Italianate *Renaissance architectural enframements almost swamp even his religious works (Bruges, St Jacob, triptych of Sts Cosmas and Damian; Tournai, Cathedral). In 1550 he and Jan van *Scorel were called upon to repaint portions of Jan van *Eyck's *Ghent Altarpiece* after it had been damaged in cleaning.

Bloomsbury Group A gathering of English writers, critics and artists, linked by friendship and family and sexual relationships and by common interests and through its productions and activities. Its name derives from the London district where the writer Virginia Woolf and her husband Leonard, the critic Clive Bell, and Virginia's sister, the painter Vanessa *Bell, had houses. Charleston Farm House, in Sussex, was Vanessa Bell's chief residence for some years, shared with Duncan *Grant. The group did not act publicly as a group, but gave general support to its members' work and careers, using what intellectual and social powers it had to advance. Its influence was most marked during the 1920s and '30s. In art matters it promoted in Britain the art and methods of the *Post-Impressionists and then also of *Fauvism. At other times they opted for a more purely decorative idiom and, through the *Omega Workshop particularly, encouraged the painting of furniture and making of rugs and textiles, in a modern idioms, figurative or *abstract. Interest in the leading members continues to this day, partly because of qualities as creative individuals, partly because of their characters and mobile interrelationships. The group was the subject of a major retrospective at the Tate Gallery, London, in 1999.

Blue Four (Blaue Vier) Name devised in 1924 by Galka Scheyer, collector and dealer, in order to promote the work of three of the *Blaue Reiter painters in America: *Kandinsky, *Klee and *Yavlensky, to whom she added *Feininger who at that time taught at the *Bauhaus together with the first two. Her large collection of their work is now in the Norton Simon Museum in Pasadena.

Blue Rider *See* Blaue Reiter, Der.

Blue Rose, The A group of up to sixteen Russian painters who were in many instances former students of *Borisov-Musatov, exhibited together under this name in Moscow in 1907 and subsequently in the Golden Fleece exhibitions organized under the aegis of the journal of that name, published 1906–9. Its work is best described as a particularly poetic *Symbolist development, with colour and sensitive brushwork used to deliver semi-visionary subjects, not wholly unlike some *Nabi work of the 1890s. The most admired painter in the group was Pavel Kuznetsov. After 1910, inspired by the example of *Gauguin, he travelled in Asia and reported on what he saw in sonorous, simplified landscapes and *genre scenes. Petrov-Vodkin was another member of the group.

Blume, Peter (1906–92) Russian-born American painter. He came to the USA in 1911 and subsequently studied at the Art Students League in New York. His early paintings were mostly still lifes that combined characteristics of *Purism and *Precisionism. From 1930 on he used his Precisionist methods for *Surrealist paintings that soon dealt with political themes, warning against totalitarianism. He painted murals for the *Public Works of Art Project. Later he painted in a more tightly *naturalistic idiom and also, from 1972, made small figure bronzes.

Boccaccino, Boccaccio (before 1465–1525) and his son **Camillo Boccaccino** (*c.*1501–1546) Eclectic Italian painters. Formed in Ferrara and influenced there by Lorenzo *Costa and Ercole Roberti, then in Venice where he came under the spell of Giovanni *Bellini, Boccaccino returned after 1505 to his father's native city of Cremona to become its leading painter (but *see also* Campi dynasty). He also showed a special sympathy for German and Netherlandish prints (*see* Dürer; Lucas van Leyden), and transmitted this web of influences to younger Cremonese artists. His major works are *frescos in Cremona Cathedral, 1506; 1514–18 (*see also* Altobello Melone). There are also devotional easel paintings by him (e.g. Venice, Accademia). His son Camillo, on the other hand, after a stay in Parma, 1522 to 1524, looked to the example of *Correggio and *Parmigianino; a trip to Venice around 1525 added the influence of *Titian. From these sources, and under the impact of *Romanino's and *Pordenone's vigorous frescos in Cremona Cathedral, Camillo Boccaccino forged a highly personal *Mannerist style (Prague, Gallery; Piacenza, S. Vincenzo; Milan, Brera; *frescos, Cremona, S. Sigismondo; Cremona, Museum).

Boccioni, Umberto (1882–1916) Italian painter and sculptor, prominent among the Italian *Futurists. He had his art training mostly in Rome where he met *Severini. Together they attached themselves to *Balla from whom they learned *divisionism; in other respects Boccioni's early work suggests the influence of *Symbolism. In 1906 he visited Paris; in 1907 he settled in Milan. He met *Marinetti late in 1909 or early in 1910 and signed, and largely wrote, the *Manifesto of Futurist Painters* and *Futurist Painting: the Technical Manifesto*, published in February 1910. In his new paintings he attempted to synthesize the complex of visual and memory imagery triggered by everyday urban experience. A visit to Paris late in 1911, with *Carrà and *Russolo, gave him direct contact with *Cubism and led him to rework some of his paintings for the first Paris showing of Futurist art in February 1912. His triptych *States of Mind: The Farewells*,

Those Who Stay, Those Who Go (1911–12; New York, MoMA), picturing the sensations evoked by railway travel, dominated that exhibition and remains his finest work.

While in Paris Boccioni was seized with the idea of developing sculpture to a comparable point of modernity, encouraged by the example of *Picasso and *Archipenko. He published his *Technical Manifesto of Futurist Sculpture* that April, calling for the use of disparate materials of many sorts to achieve the interpenetration of fragments of reality that experience demanded. He had a solo exhibition of sculpture in Paris in 1913. Most of the works, made largely of plaster, are lost (a few are known from photographs) but bronze casts of two of them exist: *Development of a Bottle in Space (Still Life)* and *Unique Forms of Continuity in Space*, the latter a striding figure abstracted to enhance its dynamism and Nietzschean heroism. In 1914 he gave an account of his work and thought in *Futurist Painting and Sculpture*. He was involved in politics, agitating for Italy's entry to the war, but also found himself reconsidering his art. He served in the war alongside some of his Futurist colleagues and during leaves explored a more stable representation of forms in a post-*Cézanne manner. He died after an accidental fall from a horse.

Bock, Tobias *See* Pock, Tobias.

Böcklin, Arnold (1827–1901) Swiss-German painter, born in Basel and trained principally in Düsseldorf. He travelled widely. In Paris, in 1848, he was thrilled by *Couture's *The Romans of the Decadence* (Paris, Orsay) and frightened by revolution. In 1850–7 he was in Rome, and from that time on he worked mainly in Italy, with periods in Munich and Zurich and some months in France during the Franco-Prussian War. His first paintings were landscapes: classical southern scenes, openly nostalgic. Soon he peopled them with fauns and nymphs, Pan and centaurs, ancient symbols of nature's power. For years he endured poverty. Commissions repeatedly came to nothing because of his reluctance to adapt his vision to others' expectations. Illness and death haunted him: friends and several of his children died. The Böcklins

were besieged by cholera in Rome in 1854–5 and Munich in 1873–4; he himself suffered major illnesses. Yet his output was large, and from the later 1850s on it was unmistakably his own, though varied in theme and style.

His most famous work, *The Island of the Dead* (five versions, 1880 and after), heavy with foreboding, is not typical except in that it joined *naturalism to fantasy. More normal are his scenes of dryads, mermaids and mermen, frolicking erotically. Death too is often his theme: murder, primitive violence, war. His last paintings include two treatments of war in terms of the Apocalypse. He was admired as a painter of ideas (*Gedankenmaler*) at a time when much new art merely described; this places him with *Symbolism. After his death he was attacked for his literary content; in 1905 the critic Julius *Meier-Graefe accused him and his admirers of demonstrating German cultural coarseness. Outside Germany, painters like de *Chirico and subsequently the *Surrealists valued his art for its abundant irrationality.

Bodegón *See under* still life.

Body art A tendency that became known, and at times was notorious, in the 1960s as a development out of *Conceptual and *performance art, involving the use of the artist's body as form and medium. Sometimes presented via video or in photographs (with or without added marks), often as a public enactment, Body art often presents the body as humanity oppressed and victimized and has involved mutilation and even death.

body-colour A colour which has 'body', as opposed to a tint or wash; that is, watercolour made opaque by the addition of white. *See also* gouache.

Boilly, Louis-Léopold (1761–1845) French painter of small-scale portraits, group portraits and *genre scenes, meticulously and wittily depicting contemporary physiognomy, dress and customs in the manner of *Ter Borch or *Metsu in 17th-century Holland. He was also a printmaker, and occasionally painted *trompe l'oeil

monochrome pictures to look like prints (London, National). Boilly's still-delicate *realism, carefully documented through studies from life – and in particular his famous series of popular satirical prints, the *Grimaces* (1823–8) – inspired the young Honoré *Daumier, and paved the way for later 19th-century *social realism. Born near Lille (whose museum, thanks in part to the donation of his son Julien Boilly, has an excellent collection of his works) he arrived in Paris in 1785, but did not exhibit at the Salon until 1791. He was denounced by *Wicar before the Société Republicaine des Arts, the revolutionary artists' grouping, in 1794 for the obscenity of his paintings and prints, and supposedly to demonstrate his Republican credentials Boilly embarked on one of his most ambitious works, the crowd scene of *The Triumph of Marat* (Lille, Musée). *The Studio of *Isabey* is a *conversation piece combining a score or more portraits of contemporary artists (Paris, Louvre, 1798; individual oil sketches, Lille, Musée). In a similar vein are the *Sculptor's Studio: Family Group* (Paris, Arts Décoratifs, 1804) showing the sculptor *Houdon, his family and the casts of his numerous sculpted portraits, and the 1810 painting of artists admiring the reception at the Louvre of *David's picture of Napoleon's coronation (now New York, Wrightsman coll.).

Boizot, Simon-Louis (1743–1809) French sculptor, a pupil of *Slodtz. In 1774 he became director of the sculpture studio at Sèvres, the royal porcelain factory, and his most attractive work is on a small scale, although he also executed busts for Queen Marie-Antoinette and a statue of the dramatist Racine for the theatre of the Comédie Française (*in situ*; other works Paris, Louvre).

Bol, Ferdinand (1616–80) One of *Rembrandt's most productive pupils, probably the teacher of Godfrey *Kneller. Early in his career he imitated Rembrandt's *chiaroscuro, but from the 1640s he turned to the lighter, brighter manner derived from *Van Dyck. He became a fashionable portraitist (e.g. *Admiral de Ruyter*, 1667, The Hague, Mauritshuis) and was also in

demand as a painter of allegories and history pictures (*see under* genres) for public buildings (e.g. *The Intrepidity of Fabritius in the Camp of King Pyrrhus*, 1656, Amsterdam Town Hall, now Royal Palace). After his second marriage in 1669 to the widow of a wealthy merchant, Bol ceased painting, and lived as a patrician.

Bol, Hans *See under* Hoefnagel, Georg.

Boldini, Giovanni (1842–1931) Italian-French painter who had fashionable success with his lively, apparently improvisatory portraits of elegant ladies and male personalities, finding a seductive balance between the freshness of *Impressionist painting and the lighthearted delicacies of *Rococo art. He was a member of the *Macchiaiuoli, but in 1869 he followed an invitation to England where he was received by aristocratic society and adopted as its favourite portraitist. In 1872 he moved to Paris, but went on major travels again in 1880: to England, America, Austria and Germany. After that he settled in Paris, a prominent figure in upper-class French cultural life and much despised by successive *avant-gardes.

bole An iron-oxide-containing greasy clay, usually of a strong reddish-brown colour. It was used as the underlayer for gold leaf, providing a smooth cushioned surface against which the gold leaf could be burnished, and imparting to it the warm rich colour of solid gold. This was considered necessary because gold leaf is so thin that it is translucent; if laid directly over white *gesso, it would appear a cool, slightly green colour.

Bolgi, Andrea (1605–56) Italian sculptor from Carrara. He was a pupil of Pietro *Tacca in Florence; in 1626 he settled in Rome where he became an assistant to *Bernini, who recommended him for one of the gigantic statues in the crossing of St Peter's. Bolgi's *St Helena* (1629–39) is a boringly precise work, responsive to the *classicizing current prevailing in Rome in the 1630s. He also executed portrait busts. Before 1653 Bolgi settled in Naples, where

some of his work shows an attempt to emulate Bernini's vigorous *Baroque style of the mid-century.

Bologna, Giovanni; also called **Giambologna** (1529–1608) Born in Douai as Jean Boulogne, he trained from *c*.1544 in the workshop of the Italianate Flemish sculptor Jacques Dubroeucq, and became the most influential Italian sculptor of the second half of the century, the historical link between *Michelangelo and *Bernini. His characteristic style, *Mannerist in its sinuous and complex elegance, became widely available throughout Europe with the bronze or silver statuettes sent by his Medici patrons as diplomatic gifts to courts in Italy and across the Alps, and was propagated also through his many transalpine students and assistants (*see* e.g. Adriaen de Vries). It is perhaps less well known that the same artist executed sober and unmannered portraits (e.g. bust of Cosimo I, late 1550s, Florence, Uffizi) and religious works (e.g. Genoa, S. Francesco di Castelleto, now university chapel and Aula Magna), and naturalistic (*see under* realism) sculptures of animals and birds (Florence, Bargello; Berlin, Staatliche).

Having set out, *c*.1550, on a study trip to Rome, where he met the aged Michelangelo, Giambologna was induced on his way home to settle in Florence. By 1560 he had attracted the favour of Francesco de'*Medici and was competing for the commission of a statue of Neptune as centrepiece to a fountain for the Piazza della Signoria. Although he lost the commission to *Ammanati, his full-scale clay model won him renown. A series of large multi-figured marble groups was commissioned from him by Francesco: *Samson and Philistine*, *c*.1560–2 (London, V&A), *Florence Triumphant over Pisa*, *c*.1564 (Florence, Bargello) and the *Rape of a Sabine Woman*, 1580s (Florence, Loggia dei Lanzi). These address a problem perennial in Florentine sculpture since *Donatello: how to unite several figures in a single-action group, successful from different viewpoints. The *Rape of a Sabine* realizes an obsession long held by Michelangelo but never executed by him in stone: uniting three figures in a single spiral composition. The sculptural

problem had preceded the choice of a spe-
cific narrative subject, which was identified
subsequently by a bronze relief added to the
base.

Between working on the first two marble
groups for Francesco, Giambologna
received the commission (1563) for the
bronze figures of a *Fountain of Neptune* for
Bologna. During his stay there he produced
the earliest version of the famous bronze
Flying Mercury (Bologna, Museo). A
slightly later version was sent as a diplo-
matic gift by Cosimo I de'Medici to the
Emperor Maximilian II in 1565 (Vienna,
Kunsthistorisches). A third variant, *c.*1578,
is in Naples, Capodimonte; it established
the form in which the *Mercury* was later
reproduced on a small scale in the work-
shop. Finally, the nearly life-size version
now in Florence, Bargello, was cast in the
1590s.

Giambologna's monument to Cosimo I
(1587–99, Florence, Piazza della Signoria),
the first equestrian statue in Florence, was
the fruit of studies for a sculpture of a
pacing horse begun early in the sculptor's
career; this work (and the bas-relief showing
the rider on a rearing horse) demonstrates
his interest in *Leonardo's studies for the
never-cast Sforza and Trivulzio monu-
ments. *Cosimo I on horseback* itself spawned
a series of commissions completed by
assistants largely after Giambologna's
models (*Ferdinando I de'Medici*, 1601–7/8,
Florence, Piazza SS. Annunziata; *Henry IV
of France*, *c.*1600–10/14, formerly Paris,
Pont-Neuf, destroyed 1792, fragments in
Louvre; *Philip III of Spain*, 1606–16,
Madrid, Plaza de Oriente). The chief assis-
tants associated with these workshop
projects were Pietro *Tacca, who succeeded
Giambologna as granducal sculptor,
Antonio *Susini and Pietro *Francavilla.
The shop also produced many statuettes of
horses and mounted riders (e.g. Dijon,
Musée; Kassel, Schlöss), which became
archetypal symbols of monarchic authority
throughout Europe, and were widely
imitated.

With the succession in 1587 of Ferdi-
nando I de'Medici, the protoindustrial
organization of the workshop was com-
pleted through the provision of a foundry,
extensive storage space and even dormitory

rooms for assistants, technicians and
labourers, all geared to the manufacture
of granducal monuments and small-
scale diplomatic gifts. Division of labour
increasingly pertained, and the master's
models were reused for many cast examples
of variable quality. From the 1590s,
Giambologna's participation was virtually
limited to the creation of wax sketches and
clay models, and, in his last years, to an
advisory role only – as in the project of the
three pairs of bronze doors for the west
façade of Pisa Cathedral, *c.*1600.

In addition to the works already
mentioned, the best-known statuette types
originating in Giambologna's workshop
include the *Woman bathing* and the *Venus
Urania* (signed versions Vienna, Kunsthis-
torisches); *Apollo* (best version Florence,
Palazzo Vecchio *studiolo*); *Mars*; various
figures in mythological guise of *Morgante*,
the court dwarf of Cosimo I, (Florence,
Bargello; Paris, Louvre; London, V&A);
Nessus and Deianira; the *Labours of
Hercules*; and the *genre subjects of the
Bird-catcher, *Bag-piper* and *Peasant resting
on his staff*, which wittily combine rustic
northern European themes with poses
drawn from antique Roman sculpture.

Bolotowsky, Ilya (1907–81) Ameri-
can artist of Russian origin, also playwright
and filmmaker. He came to the USA in
1923. In the 1930s he worked for the
Public Works of Art scheme and strove
to radicalize his work through study of
the *Mondrians, *Mirós, *Picassos etc. in
New York. In 1936 he was one of the
founders of *American Abstract Artists.
After 1944 he modelled himself more
directly on Mondrian, adopting his
emphasis on verticals and horizontals and
his use of diamond-shaped canvases. In
1946–8 he taught at *Black Mountain
College (one of many teaching posts he
filled until 1976), developing his work
further, into other formats and into three
dimensions. A major retrospective of his
work was shown at the Guggenheim
Museum, New York, and the National
Collection, Washington, in 1974.

Bolswert, Schelte à (*c.*1586–1659) and
his elder brother, **Boetius à Bolswert**

(*c.*1580–1633) Dutch-born reproductive engravers (*see* intaglio prints, reproductive prints). After his brother's death in 1633, Schelte left Holland to work for *Rubens in Antwerp. Reproducing more of his paintings than any other engraver, and carrying on long after the master's death, he was especially important in disseminating knowledge of Rubens's work, and many of his prints record the appearance of paintings now lost. His technique was particularly suited to translating Rubens's pictorial style into another medium; he may himself have drawn some of the 'inter pretative' drawings, intended for engravers, from the pictures (the drawing for his famous print after Rubens, *Moses and the Brazen Serpent*, is now in the Louvre, Paris). He is best remembered, however, for his engravings after Rubens's landscapes. Boetius à Bolswert worked until 1618 in Holland, where he reproduced paintings by *Bloemart, *Vinckboons and *Miereveld. Between 1618 and 1627 he was in Brussels; from 1628 he too moved to Antwerp, and executed engravings after Rubens, the most celebrated after the *Coup de Lance*. Among the other engravers working under Rubens's supervision to reproduce his paintings the chief were **Lucas Vorsterman** (1595–1675), who also engraved a collection of *Van Dyck's portraits, the *Iconography*, and **Paul Pontius** (1603–58).

Boltanski, Christian (1944–) French artist, known for his installations of sets of photographs, sometimes with lights to enhance their solemn resonance. He became known in Europe around 1970 and in the USA from 1973 on, through solo exhibitions and appearances in major collective shows such as the 1975 Venice Biennale.

Boltraffio or **Beltraffio, Giovanni Antonio** (*c.*1466/7–1516) Italian painter, *Leonardo da Vinci's principal pupil in Milan; he was working independently by 1498. Several altarpieces, and some independent portraits, are known by him (Milan, Brera; Berlin, Staatliche; Paris, Louvre; Budapest, Szepmuvesti Museum; London, National); there is also a group of pictures, among them a poetical *Narcissus*

(London, National), variously attributed to him or to a painter close to him.

Bombelli, Sebastiano (1635–*c.*1716) Venetian portrait painter. He specialized in the *Baroque full-length life-size portrait of status, but combined it with a more intimate treatment of the face, learned during his training in Bologna and Florence (Venice, Querini-Stampalia; Palazzo Ducale). He was the teacher of Giuseppe *Ghislandi, better known as Fra Galgario.

Bomberg, David (1890–1957) British painter, son of Polish immigrants. He studied art in evening classes and at the Slade School of Art. Like Wyndham *Lewis and others he was drawn to *Cubism and to *Futurism. In 1913 he contributed to the 'Cubist Room' section of an exhibition in Brighton. During 1914–15 he exhibited repeatedly with the *Vorticists. His paintings of this period were *classical in construction and close to complete *abstraction of a geometrical sort. He served in the First World War, and sought to develop a monumental and generalized but at the same time legible idiom for representations of army life. This effort climaxed negatively when his painting *Sappers at War*, completed in 1918 for the Canadian War Records Office, was rejected; a second version, less forceful, was accepted in 1919 and is now in the National Gallery of Canada, Ottawa.

This rejection and other events led him to reconsider his aims. He spent 1923–7 in Palestine, and in 1928 showed in London some of the vivid landscapes he had painted there. In 1929 he spent six months in Spain, at Toledo; during 1934–5 he was in Spain for 18 months, mostly at Cuenca and Ronda. The paintings he brought back are again principally landscapes, experienced as light and colour. He was developing a form of objective *Expressionism rooted in his sensory apprehension of the world, delivered in paint and structural gesture and thus identifying the subject with his experience of it. He had so little success with this work that at times he ceased painting altogether. In 1945 he began to teach at the Borough Polytechnic at Dagenham, London, developing in his students his

intense method of drawing and painting.
Some of them formed a Borough Group;
during 1947–55 they exhibited together as
that and as the Borough Bottega. In 1954
he attempted to set up a painting school in
Ronda; it failed. In May 1957 he became ill,
and died soon after in London.

His fame has risen sharply since the
1960s. A memorial exhibition toured
Britain in 1958. In 1967 a retrospective was
shown in London at the Tate Gallery and
toured to other centres. The Tate Gallery
has the fullest collection of his early and
later work.

Bombois, Camille (1883–1970)
French *naïve painter, who, after many
other jobs, took night work in Paris in order
to have more time for art. His work became
known to the Paris art world in the 1920s
and are admired for their vividness.

Bonacolsi, Pier Jacopo Alari *See*
'Antico'.

Bonaiuti, Andrea *See* Andrea da
Firenze.

Bonazza, Giovanni (active between 1695
and 1730) and his sons, **Antonio**
(1698–1763), **Francesco** (recorded 1732)
and **Tomaso** (*d.* 1775) Family of
sculptors from Padua, active there (e.g. S.
Maria dei Servi) and in Venice (all three
collaborated on the decoration of the
chapel of the Rosary, SS. Giovanni e Paolo,
1732; Giovanni is also the author of the
two little red marble lions on the Piazzetta
dei Leoncini, north of St Mark's) as
well as in minor centres of the Veneto. The
best known is Antonio, who executed
marble statues for churches in and around
Padua, Vicenza, Chioggia but is best
remembered for the vivid garden figures
dressed in contemporary costume in the
Villa Widmann at Bagnoli di Sopra, near
Padua, designed in a light-hearted and real-
istic *Rococo style, which inevitably recall
the great Venetian comic playwright, Carlo
Goldoni, who was a frequent guest at
the villa.

Bondol or **Bandol, Boudolf, Jean** (active
1368–81) Flemish miniaturist, also
called Hennequin de Bruges, active in
Paris, where he was painter to Charles V
and ran a large workshop. His famous
dedication miniature in a manuscript of
an historiated bible (now The Hague,
Meermanno-Westreenianum) not only
shows unusually realistic (*see under* realism)
portraits of the king and the bible's
donor, but also demonstrates Bondol's
grasp of single-vanishing-point *perspec-
tive. Bondol's naturalism was tempered in
the celebrated *Apocalypse* tapestries he
designed in 1375–9 for the king's brother,
Louis of Anjou (now Angers, Musée), for
which he used as a model a *Gothic manu-
script in the king's collection.

Bonfigli, Benedetto (active 1445–96)
Painter from Perugia, influenced by
Benozzo *Gozzoli, and unresponsive to the
change in style introduced in the 1480s by
*Perugino. He was at work in the Vatican
in 1450. A series of *frescos by him in the
Prior's Chapel of the Town Hall at Perugia
was begun in or after 1454 and left incom-
plete at his death; there are also paint-
ings by him in Perugia, S. Domenico;
Pinacoteca.

Bonheur, Rosa (1822–99) French
painter, principally of animals. She exhib-
ited regularly in the *Salon, until 1855
when *The Horse Fair* (1853; New York,
Metropolitan) was bought for touring and
engraving. Many other such purchases
followed. She achieved a substantial inter-
national reputation with her work and her
persona as an independent female profes-
sional and was the first woman artist to be
awarded the Légion d'Honneur (*chevalier*
1865, *officier* 1894). She established a
menagerie of animals and lived her later life
in a fine château outside Fontainebleau,
now a Bonheur museum.

Bonifazio di Pitati, also called **Bonifazio
Veronese** (1487–1553) Italian painter
from Verona who settled in Venice. His ear-
liest work was modelled on that of *Palma
Vecchio (e.g. *Sacre Conversazioni* now in
Venice, Accademia, and London, National)
but the uneven quality of his later produc-
tion is probably due to his keeping an
abnormally large studio which produced

many routine works, including painted panels for furniture (London, National).

Bonington, Richard Parkes (1802–1828) English painter who worked mostly in France. He moved to France with his parents in 1817 and had his first art instruction from a French disciple of *Girtin. Soon he went to Paris to study briefly in the Ecole des Beaux-Arts and in the studio of *Gros; an introduction to *Delacroix led to close friendship. Bonington's early work was almost exclusively in watercolours, scarcely used in France at this time, and his subjects were primarily *naturalistic landscapes, in search of which he travelled in northern France. Sketches made on his travels in the summer were worked up into exhibitable pictures in the winter. He sent some of them to the Paris Salon in 1822, 1824 and 1827, showing in 1824 as one of a number of English painters including *Constable and honoured with them as landscapists of a new sort.

In 1825 Bonington visited England and Scotland, partly in the company of Delacroix. On their return to Paris he worked for some time in Delacroix's studio. In 1826 he visited Italy, notably Venice which he loved for its architecture and associations. He was now painting more in oils and his subjects were *History subjects and town scenes. That year he contracted tuberculosis. He was well enough in 1827 to visit London in search of dealers; in 1828 he came again, this time in search of a cure, but died soon after his arrival.

Bonington's role as mediator between English and French painting was of great historical importance, mainly in bringing the medium of watercolour to French attention, mostly for fresh and transient landscape painting. His oil painting was relatively heavy to begin with but took on some of the delicacy and luminosity of watercolours subsequently. Partly under the influence of Delacroix, but inspired also by Walter Scott and Byron, he might have developed an outstanding career as a *History painter had he not died at the age of 25.

Bonnard, Pierre (1867–1947) French painter. He studied at the Ecole des Beaux-

Arts and at the Académie Julian. In the 1890s he was one of the *Nabis, developing methods taken from *Gauguin and from other anti-*naturalistic modes of art and applying them particularly to decorative painting, theatre décor and posters. Like *Vuillard, he also developed a partly *Impressionistic style for domestic scenes integrating pattern and colour with acute accounts of persons, spaces and sometimes artificial light. This has led to his being seen as a late Impressionist. In his mature work he reveals himself a *Post-Impressionist, using the light-conveying colours of Impressionism – and sometimes also unrealistic colours – as a means of poetic expression. This can be observed best in his long series of paintings of nudes. From the 1890s on he lived with the model Marthe Boursin (whom he married in 1925), a slim woman obsessed with personal hygiene. Bonnard did many drawings and paintings of the naked Marthe glimpsed through doorways and in mirrors. Their unreality becomes apparent when it is noticed that she does not age as the decades pass. He painted mostly from memory, away from the motif, and his work is introspective and symbolical. Most poignant are the self-portraits in which the painter-observer recorded his perplexities in poignant colours.

He worked in and near Paris and in the south of France. He had one-man shows in Paris from 1904 on and was included in many shows of French art put on outside France. In 1924 there was a large retrospective exhibition in Paris. In 1928 he had a one-man show in New York, and from that time on his work was known and admired on both sides of the Atlantic. There were major memorial exhibitions in 1947–8. By this time he had fallen out of art world favour: his subjects and resplendant colours seemed luxurious to the post-war world. Matisse defended his friend's work and Bonnard is now recognized as a great colourist and a constructor of subtle compositions in which meaning is delivered through apparently transparent, ordinary subjects.

Bono da Ferrara (active 1442–61) Italian painter, probably a pupil of

*Pisanello. He is recorded working for the Cathedral of Siena, at the court of Ferrara, and in Padua, where his name was inscribed on one of the *frescos (destroyed in World War II) in the chapel of the Eremitani painted by *Mantegna and others, reflecting the style of *Squarcione and of *Piero della Francesca, who was in Padua about 1450. An earlier panel painting is in London, National.

Bonsignori or **Monsignori, Francesco** (c. 1460–1519) Italian painter from Verona, where there are a number of altarpieces by him (e.g. Castelvecchio; SS. Nazaro e Celso; S. Fermo Maggiore; S. Bernardino). From about 1490 he was active at the Gonzaga court in Mantua, and his style became dependent on the Gonzagas' favourite painter *Mantegna. Bonsignori, a profoundly devout man, is said to have refused the profane commissions requested of him by the Marchese Francesco (he did however paint portraits, e.g. London, National). His best-known altarpiece was commissioned by Isabella d'Este in veneration of a holy Mantuan nun, the Blessed Osanna Andreasi (now Palazzo Ducale; portrait drawing of Isabella as donor, London, British Museum).

Bontemps, Pierre (c. 1505/10–68) French sculptor, a sophisticated decorative artist, influenced by *Primaticcio and *Rosso at Fontainebleau, where he is first recorded in 1536 and where from 1540 he also made casts from moulds after antique Roman sculptures. He is the only sculptor of note among the contemporaries of Jean *Goujon in Paris, and is the most important French carver of tombs around 1550 (collaboration with the architect Philibert de l'Orme on the tomb of Francis I at St-Denis; urn-monument for the heart of Francis I, also at St-Denis; tomb of Charles de Maigny; Paris, Louvre). There seems also to be a connection between England and the workshop of Bontemps in the tomb of Sir Philip and Sir Thomas Hoby at Bisham, Berkshire.

Bonvicino or **Buonvicino, Alessandro** *See* Moretto.

Books of hours In the Late Middle Ages, the most important religious books in use by the laity, especially popular in northern Europe. They included the Psalms, prayers to the Virgin, and a church calendar, and were written partly in the vernacular and partly in Latin. Because manuscript Books of Hours were richly illuminated, they were extremely important in the evolution of northern European painting, especially in the development of certain *genre subjects included in the Labours of the Months (*see* e.g. Bruegel, Pieter the Elder). Particularly famous for their illustrations are the five Books of Hours executed for the Duke of Berry in the late 14th century (now Paris, Bibliothèque Nationale and Louvre; Brussels, Bibliothèque Royale; Turin, Museo; Chantilly, Condé; *see also* Limbourg Brothers; Jan van Eyck; Bening, Alexander and Siman).

Bor, Paulus (c. 1660–69) Italianate Dutch painter of religious and mythological subjects and portraits; a founder member of the *Schildersbent during his stay in Rome 1623–6. After his return to Holland he worked in his native Amersfoort near Utrecht (Utrecht, Centraal) participating also in the decoration of the royal palaces at Honselaersdijk and Rijkswick (destroyed) and the Huis ten Bosch. He was profoundly influenced by *Caravaggio's Italian follower Orazio *Gentileschi and the Utrecht Caravaggesque painters, *Terbrugghen, *Honthorst, *Baburen.

Borch, Gerard Ter *See* Ter Borch.

Bordone, Paris (1500–71) Painter from Treviso; a pupil of *Titian from c. 1518. He died one of the most famous artists in Venice; before then, however, he had travelled widely – to Crema in Lombardy 1525–6; to France in 1538 or 1559 or both; to Augsberg c. 1540 and Milan soon after; and to his native Treviso 1557–8. Around 1533–5 he painted a *telero* for the Scuolo di S. Marco in Venice (*see under* Carpaccio) now in Venice, Accademia, which shows his preference for architectural settings. He was an accomplished portraitist (e.g. London, National; Vienna,

Kunsthistorisches; Chatsworth), but was perhaps best known for his mythological, biblical and allegorical *cabinet pictures (e.g. Berlin, Staatliche; Cologne, Wallraf-Richartz; Hamburg, Kunsthalle; St Petersburg, Hermitage). His mature style was influenced by the *Mannerism of the School of Fontainebleau (*see* e.g. Primaticcio.)

Borduas, Paul Emile (1905–60) Canadian painter who, after being influenced by *Surrealism, became prominent in a Canadian *Abstract Expressionist movement, alongside *Riopelle, using *automatism and working his paint into animated and colourful surfaces. In the 1950s he lived partly in New York and Paris, where he died.

Borghese Italian family of Sienese origin which came into prominence as patrons of art with the elevation of **Camillo Borghese** (1552–1621) to the papacy, under the name of Paul V. The Pope and his nephew, Cardinal **Scipione Borghese** (1576–1633) spent spectacular sums on palaces, churches, chapels (notably the Pope's memorial chapel in S. Maria Maggiore in Rome) and fountains. They acquired notable picture collections – not always by legitimate means. Early paintings by *Caravaggio were obtained for the rapacious Scipione by being confiscated from the Cavaliere d'*Arpino, ostensibly *in lieu* of unpaid taxes; *Raphael's *Deposition* was stolen on the cardinal's orders from the Baglioni family chapel in Perugia; *Domenichino was imprisoned for daring to deliver a painting coveted by him to its original commissioner. Scipione Borghese was, however, an early and appreciative patron of the young *Bernini, who executed a wonderful 'speaking' likeness of him in two versions; he commissioned *Reni's ceiling *fresco of *Aurora*, and many other works by Bolognese painters. His Roman villa housed a gallery of modern and *Renaissance paintings, and antique as well as modern sculpture (*see also Borghese Warrior, Hermaphrodite*). The collection was added to in the 18th century with, among other pieces, antique statues excavated by Gavin *Hamilton. Prince **Camillo**

Borghese (1775–1832) married Pauline Bonaparte, Napoleon's sister, in 1803 (*Canova sculpted her as Venus). He ceded the Borghese collection to his brother-in-law for the Musée Napoleon; part of it was later reclaimed, to be sold – with the park and the Casino Borghese in which it is housed – to the Italian state in 1902.

Borghese Warrior, sometimes called *Borghese Gladiator* Ancient marble statue, signed in Greek 'Agasias, son of Dositheos, Ephesian', and generally considered to be copy of a 4th century BC original. It was found in 1611 in Nettuno, near Anzio, and was acquired by Cardinal Borghese, the early patron of *Bernini, whose youthful *David* was inspired by it. In 1807 it was purchased by Napoleon, brother-in-law of Prince Camillo Borghese. As a 'marvel of anatomy' it continued to be studied by artists and art students after it had entered the Musée Napoleon (later the Louvre) in 1811. A beautiful sheet of studies by *Degas (Williamstown, MA, Clark Art Institute) records its continuing relevance in the 19th century.

Borglum, Gutzon (1867–1941) American sculptor who specialized in colossal portraits made by drilling and dynamiting rock faces. His best known work is the array of heads of Washington, Jefferson, Lincoln and Theodore Roosevelt on Mount Rushmore in South Dakota, begun in 1930 and finished after his death by his son Lincoln.

Borgognone, Ambrogio *See* Bergognone.

Borgognone, Il *See* Courtois, Guillaume, Jacques.

Borgoña, Juan de (*c.*1470–*c.*1536) Spanish painter, active in Toledo from 1495; from 1509 to 1511, in the chapter house of Toledo Cathedral, he painted the only great *fresco ensemble of the Spanish *Renaissance. He or his family came from Burgundy, although his style owes more to Italian than to Northern European masters; it is thought that he studied in Florence with *Ghirlandaio.

Borisov-Musatov, Viktor (1870–1905) Russian painter born in Saratov where he began to study art, moving on to Moscow in 1890 and the St Petersburg Academy in 1891. A period in Paris in 1895–8 and visits to Munich strengthened his knowledge of, particularly, *Puvis and *Gauguin, from whom he learnt to simplify his compositions. His characteristic work consists of landscapes and garden scenes with elegant figures, nostalgic visions, usually in pale colours, rather than *realistic accounts. The Tretyakov Gallery in Moscow and the Russiam Museum, St Petersburg have some of his work, also the Museum in Saratov.

Borman, Jan the Elder (recorded 1479–93) and his sons, **Pasquier Borman** and **Jan Borman the Younger** (recorded from 1499 to 1522) Late *Gothic sculptors working in Brussels. Jan Borman the Elder ran a large workshop specializing in carved altarpieces, of which the greatest is the St George altar for Louvain, 1493 (Brussels, Musées Royaux; attributed works in Diest, St Sulpice; Boendael, St Adrian). His sons succeeded him in running the workshop, mass producing altars for the Netherlands and Sweden (Güstrow, Cathedral; Brussels, Musée Communal, Musées Royaux; Liège, Saint-Denis).

Borrassà, Louis (active 1388–*c*.1425) Spanish painter working in Catalonia in an International *Gothic style showing Sienese influence. Several documented *retables by him survive (e.g. Tarrasa, S. Maria, 1411; *Sta Clara Altar*, 1412–15, now Barcelona, Vich).

Bortoloni, Mattia (1695–1750) Northern Italian painter, trained in Venice with *Balestra and active mainly in Lombardy and Piedmont – his dome *frescos in the Sanctuary at Vicoforte di Mondovi, 1745–50, are reputed to be the largest in the world. His first major work, however, was the decoration in 1716 of the great architect Palladio's Villa Cornaro at Piombino Dese on the Venetian mainland, influenced by the *classicizing style of the French painter active in Venice, Louis *Dorigny.

Bosboom, Johannes (1817–91) Dutch painter of the *Hague School who came to specialize in church interiors and travelled widely in western Europe in search of good subjects, later also occasional synagogues and cloisters as well as seaside subjects.

Bosch, Hieronymus (first recorded 1474–1516) His family name was van Aken, suggesting origins in the German town of Aachen; the name by which he is known refers to the Dutch town of 's-Hertogenbosch, where he was born (presumably *c*.1450), lived and worked. Bosch is celebrated for panel pictures, both large and small, fantastically peopled with a nightmare world of shifting forms and inconsistent scale, elegantly painted with sometimes lurid colour effects. The effects of metamorphosis – beings changing from one order of existence to another – recall those of *Gothic manuscript decorations or Italian *grotesques, but are far more gruesome and threatening. The meticulous techniques of oil painting in translucent layers or glazes (*see under* colour) evolved by Jan van Eyck are utilized by Bosch to give a semblance of reality to his creations, deployed within landscapes that stretch as far as the eye can see, or across night scenes fitfully illuminated by the fires of Hell or Armaggedon.

Fanciful theories have grown up around these paintings in the 20th century, from psychoanalytical explanations to hypotheses of Bosch's allegiance to magic, alchemy or a secret heretical sect. But it can be demonstrated that these pictures were designed to impart quite orthodox moral and spiritual truths, and that their monstrous visual imagery often simply translates into pictorial form verbal puns and metaphors, the linguistic imagery of proverbs, sermons and popular devotional literature. It is probable that Bosch's most dreamlike allegories (such as the large *triptychs of the *Garden of Earthly Delights* and the *Haywain*, both Madrid, Prado, the latter in another version in the Escorial) were painted for lay patrons – Burgundian nobles at the courts of Brussels and Malines – who delighted in intricately crafted and refined works of art and craft, but required also a moralizing

message. His equally nightmarish, but more conventional *Last Judgement* triptych, now in Vienna, Akademie, may have been an actual altarpiece, or intended for an institution such as a hospital, like Rogier van der *Weyden's *Last Judgement* in Beaune, Hôtel-Dieu.

Bosch's pictorial inventions spawned innumerable successors, among them Pieter *Brueghel's painted allegories and the prints after them; his influence can be traced through the 17th century.

We should be aware, however, that these paintings do not represent Bosch's entire *oeuvre*, which included striking but less enigmatic representations of human folly (e.g. the early *Tabletop of the Seven Deadly Sins and the Last Four Things*, Madrid, Prado) and, in well over half of his extant pictures, traditional Christian subjects, especially episodes of the Passion of Christ (e.g. Brussels, Musées; Ghent, Musée; Berlin, Staatliche; etc.).

Boschini, Marco (1613–78) Venetian painter, printmaker and cartographer, mainly remembered as a writer on art. His *Carta del Navegar Pittoresco*, 1660, a 'Navigation chart of painting', is a 'dialogue' in verse praising the glories of Venetian painting from Giovanni *Bellini to *Veronese and *Tintoretto, and championing its contemporary followers, colourists (*see under disegno*) like *Rubens and *Velázquez. For Boschini, painting is autonomous; freeing itself from aesthetic canons, it becomes 'an example to nature'; through colour, the authentic painter 'forms without form'.

Boshier, Derek (1937–) British painter. A student at the Royal College of Art, London, alongside *Hockney, *Kitaj and other British *Pop artists, Boshier became known for paintings adapting advertisement and comic strip methods to make critical political and social points. He did not stay with the Pop idiom but moved on to *abstract painting and then to making sculptures and collages, often incorporating photography, again with political meaning. In the 1980s he was professor of painting at the University of Houston in Texas before returning to Britain and to painting.

Bosschaert, Ambrosius the Elder (1573–1621) Antwerp-born founder of a dynasty of Dutch fruit and flower painters. He specialized in bright, evenly lit symmetrical bouquets of individually portrayed blooms, assembled from independent studies made at different times of year, set in arched windows opening on distant landscapes, and flanked by insects and sea shells (The Hague, Mauritshuis; etc.). His three sons, **Ambrosius the Younger** (1609–45), **Johannes** (1610/11–?) and **Abraham** (1612/13–43) continued in the same tradition. He was also the teacher of his brother-in-law, Balthazar van der *Ast.

Bosse, Abraham (1602–76) French engraver, best known for his naturalistic depictions of the daily life of the well-to-do bourgeoisie, whether in series depicting contemporary life (*Marriage in Town; Marriage in the Country*, both 1633) or in illustrations of religious texts in modern dress (*Wise and Foolish Virgins, c.*1635); when he introduces aristocratic figures, as in the *The French Nobility in Church*, they are usually slightly caricatured. Bosse's *realism and *Caravaggesque lighting have been compared to those of Louis *Le Nain. He taught *perspective at the *Academy from its foundation, 1648, until he was expelled in 1661 for disagreeing with *Lebrun's *classicizing dogmas, and also wrote treatises. His *Sentimens* of 1649 include the earliest printed reference to *Poussin's landscape paintings.

Botero, Fernando (1932–) Columbian painter, since 1960 working in Paris and New York. Trained at the Madrid Academy, he has worked in Columbia and Mexico, becoming known for domestic and social scenes characterized by gentle colours and extravagantly rounded forms of his figures. The effect is both amusing and disturbing, the generosity of his forms soon suggesting cupidity and exclusiveness. Some of his figures have recently been repeated as bronze sculptures.

Both, Andries (*c.*1612–41) and his better-known brother **Jan** (1615/18–52) Italianate Dutch painters; Jan was the most

gifted member of the second generation of landscape specialists in this mode, and Andries executed outdoor *genre subjects in the manner of Pieter van *Laer. He is supposed also to have painted the figures in his brother's landscapes, but no collaborative painting has been identified with any certainty, except possibly the *Capriccio with Figures in the Forum Romanum (Amsterdam, Rijksmuseum). Born in Utrecht, both brothers studied with *Bloemaert before leaving for Rome, where Andries arrived c.1632 and was joined by Jan c.1637. During his stay in Italy (to 1641) Jan evolved an original and influential vision of the Roman Campagna as a setting for modern idylls: artists sketching (Amsterdam, Rijksmuseum), peasants on the road (Indianapolis, Museum) or watering their flocks (London, National) etc. His landscape style combines realistic detail with a refined sense of composition and an all-pervading golden sunlight akin to that of *Claude. After Andries's accidental death by drowning in Venice, Jan returned to Utrecht where he inspired even artists who had not been to Italy to paint Italianate landscapes and Dutch landscapes bathed in the atmosphere of the Campagna (see especially Cuyp). There are drawings by Andries Both in Leiden, University; London, Witt.

bottega Italian for shop or workshop; often used in English to denote the workshops of Italian artists.

Botticelli, Sandro (1444/5–1510) Florentine painter, probably a pupil of Filippo *Lippi, and teacher of the latter's son Filippino Lippi. Between the departure from Florence of *Leonardo da Vinci, then *Pollaiuolo and *Verrocchio (c.1482, 1484 and 1485 respectively) and the death of Lorenzo de *Medici in 1492, he was the most sought after and widely imitated artist in the city, especially for the Madonna and Child pictures which he and his workshop turned out in great numbers (e.g. Florence, Uffizi; Berlin, Staatliche; London, National). Like other successful Florentine painters of the time he also executed altarpieces and church *frescos (see below); portraits (e.g. London, National, V&A;

Washington, National; Florence, Pitti, Uffizi) a few *cassone and wall-panelling paintings (Madrid, Prado; Bergamo, Accademia; Boston, Gardner; London, National; Dresden, Kunstsammlungen; New York, Metropolitan). His first documented work was an allegorical figure for the Mercanzia, a guild commercial court (Fortitude, 1470, Florence, Uffizi). His fame today, however, rests largely on his authorship of a very few pictures of an unprecedented kind: the first post-antique mythological paintings on the scale of life. The Primavera, c.1478; Pallas and the Centaur, c.1482 and the Birth of Venus, c.1485–6 (all Florence, Uffizi) adopt the large size and moral seriousness of altar paintings, albeit their pictorial treatment betrays their private and decorative nature. Both the Primavera and the Birth of Venus resemble, especially in the backgrounds and in the relationship of figures to backgrounds, the late medieval Flemish tapestries so popular in Florence at the time. And although Botticelli based some of his mythological personages on *classical sources, he did not disguise his preference for the sinuous International *Gothic ideal of feminine beauty.

The erotic painting called Mars and Venus (after 1485, London, National) may not, in fact, represent a mythological theme. Probably part of the decoration of a bed, it must, however, have some nuptial relevance.

Less well known are the fresco fragments from the Villa Lemmi near Florence (c.1483, now Paris, Louvre) probably representing a newly married couple being introduced to the Arts and Sciences and welcomed by the Graces.

However interesting to the modern viewer, these exceptional private commissions would not have been viewed at the time as important in comparison with Botticelli's participation in 1481–2 in the mural decoration of the Sistine chapel in Rome (see also *Perugino, *Ghirlandaio, Cosimo *Roselli). Botticelli executed three large narrative frescos; two depicting stories of the Life of Moses from the Old Testament and one representing both an Old Testament blood sacrifice and the Temptation of Christ from the New

Testament. Here he demonstrates his particular gift for the clear visual exposition of narrative and of theological subtleties, evident in the major altarpieces produced on his return to Florence. In the earliest of these, the *S. Barnaba* altar (Uffizi), the emaciated figure of St John the Baptist recalls *Donatello. By the end of the decade, and through the 1490s, this harsh angularity, reminiscent also of Netherlandish and German art, spread to all of Botticelli's painted protagonists (e.g. two versions of the *Lamentation*, Munich, Alte Pinakothek; Milan, Poldi Pezzoli). In no other picture is this archaicizing mode more evident than in the small so-called *Mystic Nativity* (1501, London, National), where, as in medieval art, the scale of the figures varies in accordance with their religious significance. We know that Botticelli's brother was a follower of Savonarola, the Dominican friar who ruled Florence as a theocracy after the death of Lorenzo de'Medici until his execution in 1498. Although there is no evidence that Botticelli himself was a champion of the friar, the Greek inscription on this personal work, and the deeply felt fervour of all the late paintings, bespeak his increasing involvement in the secular and religious perturbations of the time.

Botticelli, in some ways so responsive to Florentine tradition, was in other ways untypical. He never shared the Early *Renaissance interest in *perspective, the study of anatomy, or even, paradoxically, classical antiquity. Although capable of *realism in details, he was more interested in decorative or expressive values, and he eschewed tonal painting and *chiaroscuro to the end of his life. While continuing to be respected in Florence, he fell out of favour as a painter, to be rediscovered by the general public only after 1850, partly through the interest of the English *Pre-Raphaelite Brotherhood.

Botticini, Francesco (*c.*1446–97) Eclectic yet humdrum Italian painter. His only documented work is a tabernacle at Empoli, near Florence, commissioned in 1484 and finished after Francesco's death by his son Raffaello, 1504. Around this work others have been assembled by modern art historians, who do not always agree on the attribution (Berlin, Staatliche; Paris, Musée André; London, National).

Bouchardon, Edmé (1698–1762) French sculptor, internationally famous in his day for reacting against the pictorial and *expressive idiom of *Baroque and *Rococo sculpture (*see* especially Jean-Baptiste Lemoyne, the brothers Adam and Guillaume Coustou the Elder, briefly Bouchardon's teacher). Trained by his father, the provincial sculptor and architect **Jean-Baptiste Bouchardon** (1667–1742), he was highly proficient technically, imposing an icy high finish on his works. Always based on intensive study from life, these sometimes imitate closely the sculpture of *Classical antiquity (bust of *Philipp Stosch*, 1727, Berlin, Staatliche), and at other times strive for a calmly dignified naturalism (*see under* realism) (bust of *Pope Clement XII*, 1730, Florence, Corsini Coll.). Bouchardon's attempt to ally realism with classicism within a single work (*Cupid making himself a bow from the club of Hercules*, *c.*1750, Paris, Louvre) not only did not find favour at the French court, where the statue was criticized for 'turning Cupid into a street-porter', but proved an embarrassment in the making: when the eminently respectable Bouchardon sought an adolescent model amongst youths bathing in the Seine, he was reported to the police for soliciting.

Bouchardon spent 1723–32 in Rome as a pensioner of the French *Academy. Already famous and much in demand, he reluctantly obeyed a summons to return to France, where, despite the enthusiasm of an influential group of connoisseurs, he would not receive a major commission for five years. Finally, in 1739, he was able to design for the city of Paris a work of the type which had eluded him in Rome, where his project for the Trevi fountain had been rejected (*see also* Lambert-Sigisbert Adam). The fountain of the rue de Grenelle, combining sculpture with architecture, is his one extant public monument. His huge equestrian statue of Louis XV, commissioned by the city authorities for the place Louis Quinze in Paris in 1749, was completed only after the sculptor's death

by his nominee *Pigalle (destroyed in the French Revolution).

Boucher, François (1703–70) Protégé of Mme de Pompadour and the leading French painter of the early–mid-18th century. In contrast to his contemporary *Chardin, he was the consummate *Rococo decorator, and the greatest exponent of fashionable *mythologie galante* – a decorative composition devoid of drama in which the mythological theme is an excuse for erotic display of the female nude, a type of painting which Boucher executed with wit and charm (outstanding examples, Stockholm, Museum; Paris, Louvre, Cognaq Jay). But he practised all the *genres with the exception of serious history painting and the lowly still life: altarpieces (e.g. Lyon, Musée); modern *Conversation Pieces (Louvre); portraits, quasi-official such as those of Mme de Pompadour (e.g. Munich, Alte Pinakothek; London, V&A) or the affectionately ironic, intimate one of his wife (New York, Frick) or the vigorously realistic one of the baby Duke of Montpensier (Waddesdon Manor); decorative pastoral or rustic genre and landscape (e.g. Barnard Castle; London, Kenwood); hunting scenes inspired by *Rubens (Amiens, Musée); stage designs for the Opera; tapestry designs for the factories of Beauvais and the Gobelins (one of the two large mythologies now in London, Wallace, was begun as a *grisaille* tapestry cartoon (*see under* fresco) for the Gobelins; *see also* Oudry).

A brilliant draughtsman, the son of a minor painter who apprenticed him briefly to François *Lemoyne, Boucher early practised as a book illustrator and by *c.*1722 was one of the engravers (*see under* intaglio) reproducing *Watteau's *oeuvre* for publication. He has been called Watteau's greatest posthumous pupil. Other major influences – besides Rubens and, at second-hand, *Correggio – were the so-called 'little masters' of the Dutch and Flemish school, such as the Italo-Dutch *Berchem, by whom he owned a painting. From 1727–31 he was in Italy with *Natoire and Carle van *Loo, but not a full pensioner of the French *Academy in Rome. It is often said that he admired *Tiepolo, although it is uncertain

what paintings by him he could have seen; in any case, his style owes little to large-scale Italian decoration with its *illusionistic *perspectival effects. In 1765, he was made Director of the Academy and *Premier Peintre du Roi*, although he was already ill and his powers failing. By the 1760s royal taste, to which Boucher remained faithful, was being challenged, and the artist was publicly criticized for not painting works capable of elevating private morality and public virtue. He was the teacher of *Fragonard and *Baudoin.

Bouchette, Joseph *See under* Baillairge, François.

Boucicaut Master (active *c.*1405–15) French painter of manuscript illuminations, named after his most sumptuous work, the *Book of Hours of Jean le Meingre, Maréchal de Boucicaut* (Paris, Jacquemart-André), probably begun in 1409. Although working in the International *Gothic style of the *Limbourg brothers, he avoided their marked Italianisms, and went beyond them in achieving true aerial *perspective, anticipating the later perspectives of Early Netherlandish panel painting (*see especially* Jan van *Eyck). For this reason he has sometimes been identified with an illuminator from Bruges known to have been working in Paris about 1400, Jacques Coene, but there is no evidence for this identification. Other works by the Boucicaut Master include a Book of Hours now in Oxford, Bodleian, 1407; two Books of Hours now in Paris, Bibliothèque Nationale, one of them for the Limbourgs' patron the Duke of *Berry; the *Dialogues de Pierre Salmon*, Geneva, Bibliothèque, *c.*1410–15; a Book of Hours *c.*1415, Paris, Bibliothèque Mazarine.

Boudin, Eugène (1824–98) French painter, working at Le Havre and among those who painted out-of-doors. His method and his marine subjects influenced the young *Monet. The quality of light and air in Boudin's paintings heralds *Impressionism, and he participated in the first Impressionist exhibition of 1874. Honfleur, where he was born, has a Boudin Museum.

Bouguereau, Adolphe-William (1825–1905) French painter, representative and champion of entrenched academicism, and admired in his lifetime and again now for figures – mainly female – of unreal perfection and coyness, and religious as well as mythological subjects, painted with all possible smoothness. *Matisse studied under him briefly; it is assumed (probably wrongly) that he despised his master, often represented as the outstanding instance of academic pretentiousness of his time.

Boullongne, Louis de, the Elder (1609–74) and his sons, **Bon de Boullongne** (1649–1717) and **Louis de Boullongne the Younger** (1654–1733) Wealthy and successful French painters, specialists in decorative *History painting, both ecclesiastical and mythological. Louis the Elder combined the tradition of *Poussin with that of *Vouet. Bon and Louis de Boullongne the Younger, pupils of their father, also studied in Bologna and Rome; they brought back to France the delicate and graceful *classicism of *Albani, setting the tone in their secular works for the *mythologies galantes* of *Boucher. In addition to secular decorative schemes (e.g. Rambouillet, Château), they collaborated with Antoine and Noel *Coypel on the last major cycles of ecclesiastical mural and ceiling decorations commissioned in the reign of Louis XIV, in the Royal Chapel at Versailles and at Saint-Louis-des-Invalides, Paris (sketch by Louis the Younger, Indiana, Notre-Dame University, Snite Museum). Louis the Younger became Director of the Royal *Academy in 1722, was ennobled in 1724, and became Premier Peintre du Roy in 1725 (other works by him in various French provincial museums, including those at Arras and Tours).

Boulogne, Jean *See* Bologna, Giovanni.

Boulogne, Madeleine (1646–1710) French painter of decorative *still lifes, received in the *Academy in 1669. She is mainly remembered for the decorative overdoors representing trophies of arms and armour painted for the royal apartments at Versailles (Versailles, Musée) and the Tuileries.

Bourdelle, Emile-Antoine (1861–1929) French sculptor, trained in Toulouse and at the Ecole des Beaux-Arts in Paris. He was *Rodin's chief assistant for many years, but developed a personal style, more primitive and rhythmic than Rodin's and echoing Romanesque and archaic *classical forms. Some of his best work was commissioned for architectural settings, e.g. his reliefs for the Théâtre des Champs-Elysées (1912; architect Auguste Perret). The Musée Bourdelle in Paris has a wide-ranging collection.

Bourdichon, Jean *See under* Fouquet, Jean.

Bourdon, Sébastien (1616–71) Eclectic and derivative, albeit highly successful French painter, whose best and most personal works, executed in Paris after 1663, translate the *classicism of *Poussin into a more elegant and cooler idiom (e.g. *Holy Family*, before 1670, Kent, Saltwood). Born at Montpellier, he moved in 1623 to Paris and in 1630 to Bordeaux. From 1634–7 he worked in Rome, imitating the work of the *bamboccianti* (*see under* Laer) and of *Castiglione. In 1637 he returned to Paris via Venice; his major works of the 1640s adopt Venetian colourism (*see under disegno*) and *Baroque compositions (e.g. Louvre). In 1652 he was invited by Queen Christina to be court painter in Sweden; in this capacity he executed only portraits (e.g. Stockholm, Museum; Madrid, Prado) and after Christina's abdication and his return to Paris in 1654 he continued successfully to practise as a portraitist. Simultaneously, however, he also painted altarpieces chastened by the growing influence on him of *Poussin (e.g. Montpellier, Musée; Madrid, Prado; Paris, Louvre). Around 1659 he went to Montpellier, where he painted a large *Fall of Simon Magus* for the cathedral in the same style, a series of tapestry cartoons (*see under* fresco) and seven increasingly Poussinesque canvases of the *Acts of Mercy* (Sarasota, Florida, Museum). He was driven back to Paris in

1663 by the violent jealousy of local painters.

Bourgeois, Louise (1911–) French-American sculptor, born in Paris and trained as painter. In 1938 she moved to New York and turned to making sculpture in the 1940s, working first in painted wood. Subsequently she has worked in many materials, modelling and carving and also making *installations. This recent work carries sexual themes, sometimes in a context of sleaze, sometimes with ebullience. In 1992 the French pavilion at the Venice Biennale hosted a major solo exhibition of her work.

Bouts, Dieric, Dirk or **Thierry** (1420s–75) Haarlem-born Netherlandish painter, active mainly in Louvain, where he became official town painter in 1468. Influenced by Rogier van der *Weyden and Jan van *Eyck, perhaps through the agency of Petrus *Christus, he ran a large and active workshop whose output in turn influenced many northern European, especially German, artists. His sons **Dieric Bouts the Younger** (1448–91) and **Aelbrecht Bouts** (c.1455/60–1549) assisted him in the shop, and problems of attribution have arisen in relation to their output and to documentary records. His mature work is characterized by rationally organized space, whether landscape or architecture, depicted from a high viewpoint and with single-vanishing-point *perspective. Against such backgrounds, increasingly elongated figures are deployed in stiff and solemn poses. His best-known work is the *Last Supper Altarpiece*, 1464-7, Louvain, St Pierre; in 1468 he was commissioned for four panels on the subject of justice for the Town Hall of Louvain, of which only one was fully completed before his death, and the second finished by an unknown painter (now Brussels, Musées). These narratives of the *Justice of Emperor Otto III*, 1470–5, are perhaps the most important large-scale, secular narrative works of the period in northern Europe. Bouts also painted striking portraits (e.g. New York, Metropolitan; London, National) and is the author of a rare work on linen, the *Entombment*, c.1455–60 (London, National). There are

other devotional works by him in Granada, Capilla Real; Madrid, Prado; Lille, Musée; etc.

Bowyer, Robert *See under* Boydell, John.

Boyd, Arthur (1920–) Australian painter, graphic artist and potter, largely self-taught. From *Impressionist landscapes he moved towards aspects of *Expressionism and *Surrealism to develop a dramatic and personal vision peopled with mythical figures and beasts enacting religious and sexual events. In 1959 he settled in London which has remained his base though he travels widely.

Boydell, John (1719–1804) English engraver, print dealer and publisher; alderman and in 1790 Lord Mayor of London. Boydell was important for his own engravings of English and Welsh views and his international trade in landscape prints after *Vernet and *Wilson, but became celebrated above all for the Shakespeare Gallery, which opened in a purpose-built edifice in Pall Mall in 1789 to acclaim from Burke (*see under* Sublime) and the Royal *Academy. With this venture, begun in 1786, Boydell hoped to encourage the rise of a 'great national school of *History painting'. Having learned from *Hogarth that History pictures could be made to pay by selling engravings after them, he commissioned over 150 pictures illustrating Shakespeare's plays from over thirty painters – most importantly *Northcote and *Opie, but including also *Fuseli, *Kauffmann, *Reynolds and *Romney – which were reproduced as engraved illustrations to a nine-volume edition of Shakespeare published in 1802, and issued separately in folio form in 1803. Although some painters followed the conventions of History painting in the Grand Manner derived from the Italian *Renaissance, most of the contributors to Boydell's Shakespeare Gallery looked to contemporary theatre, introducing melodramatic poses and spurious 'period' costume. The collection was to be left to the nation, but Boydell's heavy losses in the French wars forced its sale by lottery shortly after his

death. Boydell's Shakespeare Gallery was emulated by other entrepreneurs, of whom the chief was Robert Bowyer. He inaugurated a Historic Gallery, also in Pall Mall, containing over a hundred paintings of scenes from British history, mainly from the Middle Ages and the Tudor and Stuart periods. These were engraved to illustrate an edition of Hume issued between 1793 and 1806, and were commissioned from many of the same painters who had worked for Boydell, including also *Hamilton, *West and de *Loutherbourg.

Boyle, Mark (1935–) also **Boyle Family** Scottish artist and his family. In the 1950s and 60s Boyle, working with Joan Hills, made many kinds of art, including *Performance art and dramatic light projections for music (working, for example, with Jimi Hendrix). In 1969 they began their *Journey to the Surface of the Earth*, a long programme of making exact relief representations of spots on the globe selected randomly by others throwing darts at a map. The work continues, together with microscopic studies of body surfaces. The *naturalism of the work fascinates, but the work also has a monumental grandeur that impresses while questioning art's role and relationship to nature. As their children, Georgia and Sebastian, have worked more significantly with their parents, the family collaboration has been recognized in the attribution of authorship.

Boys, Thomas Shotter (1804–74) British artist specializing in urban landscapes in watercolours and in colour *lithographs which he pioneered in England.

bozzetto Italian word for an early small-scale sketch or model for a larger work. It is used in English mainly to describe sculptural models in wax or clay; *see also* modello.

Bracquemond, Félix (1883–1914) French artist, close to *Manet, valued for his revival of *engraving as a creative medium as opposed to a means of multiplying the images of others.

Braij or **Bray, Salomon** (1596–1664) and **Jan de** (*c.*1627–97) Dutch artists, father and son. Salomon was born in Amsterdam, moving while young to Haarlem, where he studied with *Cornelis van Haarlem and *Goltzius. He practised both as an architect and a painter. In the 1630s he painted a number of Old Testament narrative compositions with half-length figures (e.g. Los Angeles, Getty) influenced by, among others, *Lievens; after *c.*1640 he turned to *classicizing compositions with full-length figures (e.g. his contributions to the decoration of the Huis ten Bosch). He died of the plague, preceded by his wife and four of their children. One of the surviving sons, Jan, is well known as a *History painter (e.g. Haarlem, Town Hall) and portraitist, especially of *portraits historiés* (e.g. Louisville, Kentucky; Rotterdam, Boijmans-Van Beuningen).

Bramante, Donato (1444–1514) The great Italian architect of the High *Renaissance, celebrated above all for his 1506 design of new St Peter's in Rome. Like *Raphael, Bramante was born in Urbino, and trained there, possibly under *Piero della Francesca. He is first documented painting *fresco decorations in Bergamo in 1477. In 1480 he settled in Milan at the court of Ludovico *Sforza. His early architectural style is evident in the Milanese church of S. Maria presso S. Satiro, 1478. The famous *trompe l'oeil* chancel in this church relies on a pictorial single-vanishing-point *perspective to give the illusion of spatial recession to a relief only a few inches deep; Bramante's mastery of perspective profoundly influenced his pupil or follower *Bramantino. With Ludovico's defeat by the French in 1499, Bramante, like Leonardo, left Milan. There is no evidence that he was active as a painter in Rome, although he is said to have designed the grandiose architecture of Raphael's *School of Athens* in the Stanza della Segnatura in the Vatican palace.

Bramantino; Bartolommeo Suardi, called (*c.*1465–1530) Milanese painter, probably trained by the architect *Bramante who also practised as a painter in Milan. From his native Urbino,

Bramante imparted to his pupil the tradition of *Piero della Francesca, of highly structured but immobile compositions. This mode Bramantino infused with Lombard *realism and *expressivity (e.g. Milan, Ambrosiana; Madrid, Thyssen; London, National). After a visit to Rome, 1508–9, Bramantino was ready to accept the influence of *Leonardo da Vinci, evident in the greater monumentality of his best works from c.1510–20 (e.g. Milan, Brera).

Bramer, Leonard or **Leonaert** (1596–1674) Painter from Delft, in his lifetime the city's most celebrated artist and, after his long study trip through France and Italy, 1614–27/8, the only Dutch painter to specialize in large-scale *frescos (which he undertook to restore during his life, and all of which deteriorated after his death). He also executed monumental mural and ceiling decorations in oils on canvas (Delft, Prinsenhof, main hall, 1667–9). In Venice Bramer seems to have been decisively influenced by Domenico *Fetti; he is now best remembered for evocative small nocturnal scenes, fitfully illuminated, with figures looming out of the darkness in the manner of Fetti (e.g. The Hague, Bredius; Bordeaux, Musée). Bramer knew *Vermeer, for he sprang to the younger artist's defence when his future mother-in-law refused to let her daughter marry him; it has been suggested that he, rather than *Fabritius, may have been Vermeer's teacher.

Brancusi, Constantin (1876–1957) Romanian-French sculptor who grew up in a peasant community and received a sculptor's training in Romania before going to Paris, where he developed idiosyncratically to become one of the most original, persuasive and influential sculptors in the history of art. The traditional forms and methods of woodworking he absorbed in the county of Gorj, where timber was made into houses and their ornamentation, furniture and utensils, and monuments such as the shaped columns with which graves were marked, contrasted fully with the academic training he received in Craiova and at Bucharest's National School of Fine Arts where he gained prizes for sculpture 'after the antique' and 'from life',

and his life-sized flayed male nude was purchased by the Ministry of Education as a teaching aid in medical schools. In May 1904 he left Bucharest for Paris. He said he walked most of the way, via Vienna, Munich, Zurich and Basel, arriving on July 14. He studied at the Ecole des Beaux-Arts 1905–7, financed by a grant from Romania and help from friends as well as dishwashing, and began to exhibit works in plaster at the *Salon d'Automne. *Rodin noticed his work and took him on as an assistant, but the young foreigner abandoned this promising position after only one month to find and follow his own path and to develop other contacts and friendships, which soon included *Matisse, *Léger and *Modigliani.

Still in 1907 he modelled a kneeling figure, The Prayer (Bucharest, NMA) in a simplified idiom distinct from Rodin's, and then made his first direct carving, i.e. without a preparatory maquette, turning a 28 cm-high block of sandstone into half-figures, male and female, in a tight embrace: The Kiss (1908; Craiova, MA). Self-evidently an answer to Rodin's famous The Kiss and to his many sculptures of lovers, this work announces, in *primitive forms asserting the initial block and in their chaste expressiveness, a wholly new kind of sculpture, detached from the western *classical tradition of *idealized *naturalism and from the 19th century's taste for sweet eroticism. In 1908 Brancusi was a guest at the banquet *Picasso organized for Rousseau, evidence of his recognition among the international *avant garde of Paris. A full-length version of The Kiss was set up on the grave of a Romanian girl in Montparnasse Cemetery in 1911, his first public sculpture. Brancusi had already influenced quite profoundly the work of his friend *Modigliani; *Lehmbruck visited him repeatedly in 1910; in 1912 *Epstein, *Freundlich and *Boccioni came to his studio. In 1912 also he began to sell work to the American collector Agnes Meyer and was selected by Arthur B. *Davies and Walter Pach to show in the *Armory Show in New York. By this time Brancusi sent fairly regularly to the Paris Salons and sometimes also to Romania, but his best patrons were American.

The five Brancusis shown at the Armory Show in 1913 created almost as much scandal as did *Duchamp's painting. Three of his sculptures were shown in London at the 1913 Salon of the Allied Artists Association; Roger *Fry wrote of them as being 'the most remarkable in the show' and two were bought. *The First Step* (1913–14; destroyed, head only in Paris) was his first sculpture carved in wood, responding both to the forms of a young child and to African tribal sculpture. By this time he had widened his range as a carver, making also elegantly smooth and abstracted heads, e.g. *Sleeping Muse I* (marble, 1909–10; Washington, Hirschhorn), and as a modeller, sometimes adapting carved forms, as in *Sleeping Muse* (polished bronze, 1910; Paris) and the almost featureless *Prometheus* (polished bronze, 1911; Paris; cement version, Cambridge, Kettle's Yard).

He had also found significant themes that would occupy him continually, notably that of the Maiastra of Romanian legend, the bird of salvation traditionally placed over tombs. His first *Maiastra*, in marble, he set upon a limestone base of blocks and roughly carved caryatids, together forming a quasi-religious monument (completed 1912; New York, MoMA). The American photographer Edward Steichen bought a bronze version of the bird in 1913 and Brancusi set it up in Steichen's garden on a tall pier, Romanian-fashion (1912, bronze bird and roughly carved capital; London, Tate). In 1914 he had his first solo exhibition: at Steichen's suggestion Alfred *Stieglitz showed eight Brancusis at his Photo-Secession Gallery in New York. Some of these were bought by eminent collectors including John Quinn who became his chief patron. From this time on Brancusi's work, still highly controversial, was better known in the US than in Paris. Impatient at the efforts of professional photographers, Brancusi in 1914 began to take his own photographs and to make these into significant, often markedly poetic, statements about his work. Similarly, his successive Paris studios, in which he lived, unmarried but by no means celibate, among primordial-looking tools and great blocks of stone and old tree trunks, some of which he shaped and used as furniture, others as sculptural bases (some alternated as bases and independent sculptures), became a magical place for work and for talking about art with this guru-like semi-peasant, as well as for riotous dinner parties and artistic dancing, e.g. to the *Gymnopédies* composed by his friend Satie. The studio has been recreated as far as possible (Paris). Brancusi was enriching his native spirituality by studying Oriental mysticism, and was increasingly concerned about the resonance of his work and thus also about the way it was shown. Hence the attention he gave to bases of varying sorts for his sculptures. In 1922 there comes the first mention (in a letter from Steichen to Quinn) of his desire to build 'a temple'.

In 1917 or 18 he cut his first *Endless Column* in old oak (203 cm high; New York, MoMA), a sequence of rhomboids, their sides subtly curved. He was to make several, of varying heights and proportions. They were to him archetypal forms full of symbolical reference, from the *axis mundi*, the world's axis on which Earth turns according to many cultures, to the tree of life, the pillar supporting the firmament, and the ladder to paradise, as well as the funerary columns of his youth; it is also a rhythmic structure in which some see the pulse of copulation. We almost forget that it is also a radical *modernist concept: wholly *abstract, machine-like in its repetition of one form, yet depending for its effect on variations of form and proportion.

From this time on his work can be seen as of two basic sorts: the elegant forms, never wholly abstract, he carved in fine marbles and subsequently varied as bronzes, and the often rougher, even aggressive though occasionally delicate, carvings he made in a variety of woods. One would think them opposites; to him they were complementary as activities and objects, and he often used carvings of the second sort as bases for the first. Certain forms and themes recur in this category. The abstracted heads culminate in long ovoid carvings of the 1920s, two entitled *Sculpture for the Blind* (marble, Philadelphia MA; alabaster, Paris), another entitled *Beginning of the World* (Dallas, MA), developed also as a bronze (Paris). The birds

begin to soar with *Yellow Bird* (1919; New Haven, Yale) and are called *Bird in Space* when they take on a slimmer and even more abstract form; the first of these is in white marble (1923; pc) and many others follow up to 1941, in diverse marbles and in polished bronze and becoming taller and sleeker. Three were intended for a 'Temple of Love' which he designed for the Maharajah of Indore (India), and which would also contain a pool and his tall timber sculpture, muscular but dignified, alternatively entitled *Spirit of the Buddha* and *King of Kings* (c.1938; New York, Guggenheim). Other creatures provided motifs for quasi-abstract sculptures, carved and modelled. In 1922 he carved a marble *Fish* (Philadelphia MA); a much larger *Fish* in grey marble completed this series in 1930 (New York, MoMA); between the two comes a bronze version. All of these are set up to pivot over a circular base; in the case of the smaller ones this is mirror glass or highly polished metal, so that the almost blade-like fish seems to float effortlessly. *The Miracle* (about 1932, New York, Guggenheim, and 1943, Paris), the abstracted and slimmed-down form of an alert seal, is said to relate to a young woman's sudden recovery from deep sorrow by going swimming but also to suggest the transformation of seals as they move from land into water. Meanwhile he was creating ever new sculptures in wood.

In 1935 Brancusi accepted a commission for a memorial to those who died during the First World War in defending the Romanian town of Tîrgu Jiu, close to where he was born. He at once worked on a vast *Endless Column*, to be constructed of cast metal forms threaded onto a steel shaft and sprayed with a golden alloy. He added the *Gate of the Kiss*, a massive stone gateway, for once firmly geometrical but with the lines of his second *The Kiss* making an incised pattern on the beam, and the form of his first *The Kiss*, simplified, shaping the piers. He also added the *Table of Silence*, of two broad stone drums and twelve circular stools around it. As installed in 1937, square stools both sides of an avenue link this to the *Gate* which leads on to the open space in which the *Endless Column* rises to the sky. The mathematical proportions of each element were calculated and interrelated, but the formal austerity of every part (the *Gate* could well be a riposte to Rodin's *Gate of Hell*) enhances the romance and mystery of the whole. It is said that local people half expected a Maiastra to settle on top of the *Column* and add its blessing.

Brancusi's work displays dualities from which its enduring energies spring. Peasant/urban would describe one: energetic timber carvings full of symbolism and the subtlest shaping and polishing through which materiality is lessened almost to the point of transparency. Modernity/timelessness, while similar, draws attention to Brancusi's awareness of technology, as manifested in the propellor to which Duchamp drew his attention at an aeronautics show in 1912, and of enduring global symbolism. His early and shocking insistence on what seemed like skill-less carving of stone and wood was received by others as a modernist principle of Truth to Materials, but though the character of his materials is always expressed in the forms he used, he did not limit himself in carving and never subscribed to any confining principle or 'ism', insisting only that his intention was to create an art of 'pure joy'. Thus he remained outside the stream of movements which promoted Modernism to the world (though Van *Doesburg enrolled him as member of *De Stijl), while being seen as the profoundest sculptor of modern times.

The National Museum in Bucharest and the Fine Art Museum of Craiova have some important early Brancusis, and there are major concentrations of his work in the Museum of Modern Art, New York, and the Philadelphia Museum of Art, as well as in the Musée National d'Art Moderne at the Pompidou Centre in Paris (to which 'Paris' refers, above).

Brandl, Brandel or **Prantl, Johann Peter** (1668–1735) Bohemian painter, one of the great masters of Bohemian *Baroque, born and trained in Prague but influenced by Venetian and Flemish works in the royal collections. He was Court Painter to successive rulers, and was also frequently employed by convents and

churches. There are pictures by him in Prague, National; Hradni; Duchcov Castle; and in numerous churches in Prague, e.g. Brevnov Abbey, St Margaret; St Clement; St Ursula.

Brangwyn, Frank (1867–1956) British painter, born in Bruges but living mostly in England from 1877 though working also in Bruges. He worked for a while under William *Morris and developed outstanding skills as a designer and painter of large decorative murals, such as the vivid and optimistic cycle (1924–30) on the British Empire, commmissioned for the House of Lords in Westminster but relegated to the Guildhall in Swansea. His easel paintings varied greatly in manner, from dark, overly dramatic scenes to lively *naturalism. His gifts were remarkable and his fame and activity were international, but his reputation dipped after his death. Brangwyn Museums are in Bruges, Belgium, and at Orange, France.

Braque, Georges (1882–1963) French painter, associated with *Picasso in the creation of *Cubism. Born near Paris, Braque grew up in Le Havre where he attended evening classes in drawing and was apprenticed to a painter-decorator, the profession also of his father and grandfather. From 1900 he was in Paris, pursuing both this and training as an artist, setting up in 1904 in his own studio in Montmartre. He knew *Dufy and *Friesz from Le Havre. Thrilled with seeing the *Fauve display in the 1905 Salon d'Automne, he adopted a Fauve manner and showed with his friends in 1906 and 1907, when *Kahnweiler bought work from him and put him under contract. That October Braque saw the Cézanne memorial display at the Salon d'Automne and November/December he visited Picasso's studio and saw his *Demoiselles d'Avignon* and work in progress. He abandoned Fauvism. His *Large Nude* (spring 1908; Paris, pc) shows his response to both influences but he subsequently concentrated on landscape and still life. When Kahnweiler exhibited some Braque landscapes in November 1908, a critic commented on his reducing 'everything ... to geometrical schemes, to cubes'.

Their volumetric ambiguity was not noticed. This became more patent in landscapes and still lifes done in 1909. By the end of that year Braque was fragmenting objects and introducing transparent, unstable planes, thus challenging the tradition of pictorial representation, as in *Violin and Palette* (autumn 1909, New York, Guggenheim). Still lifes done that winter (e.g. *Mandola*, London, Tate) are almost indecipherable, thanks to fractured forms amid planes that give setting and space equal presence. Picasso, in almost daily contact with Braque, was adapting Braque's method to mostly figure subjects, but in 1910 they came abreast, frequently taking seated figures with musical instruments as their titular subjects. Their paintings of this time can be difficult to distinguish, though Braque's tend to be more clearly structured and more *classical, and to show a more sensuous use of paint. Steeped in the tradition of French decorative painting, Braque sometimes used oval formats in and after 1910, as did Picasso from 1911. In 1911 both men began to introduce lettering into their compositions, as on labels, newspapers and posters, but in other respects their paintings became almost abstract, with only occasional hints of the presence of objects.

Both now used larger, clearer forms in their pictures, reduced their spatial complexity, but in other respects they diverged. Braque introduced cut paper forms to define his subjects' settings. Both made three-dimensional paper constructions but Braque's are lost and did not lead to sculpture. By 1913 Braque was annotating with charcoal lines and shading paper elements, abstract in form, to give them still-life significance; the elements, *collaged on to canvas or paper, are clearly upon it, so that pictorial space now reads as in front of the picture plane, not behind it. His paintings of this time are more colourful than before and incorporate patches of visual texture (e.g. dots) and physical texture when he mixed sand into his paint. He was working with great freedom when war came and he was sent to the front in November 1914.

He was wounded, convalesced slowly and began painting again in 1917. At first the

new work varied between a simplified, almost heraldic kind of Cubism and a freer idiom, richer in colour and in the enjoyment of paint. Still life continued as his preferred subject, but a kind of controlled opulence, sometimes including Cubist devices, sometimes more intent on fluent, interlocking forms, replaced any sense of a limited enquiry. Line became more important for him, often echoing rather than outlining forms. He had made etchings in his Cubist days; in 1931 he made images of figures from Greek mythology by scratching lines into plaster, long curling lines that gradually come to suggest a figure and its attributes. Similar lines are found in still lifes of the 1930s and in his landscapes (he owned a summer house near Dieppe from 1929 on).

His first major retrospective was shown in Basel in 1933. It enhanced his international status without making him a star in France. His art, after the war especially, has a private and gently poetic character best appreciated by fellow painters, though he is now seen retrospectively as a great modern master. In the later 1930s he introduced figures into his interiors, varying his accounts from free, rhythmic drawing to naturalistic details. A 1939 still-life painting he called *Studio* (USA, private collection), a decentralized composition including a bird in flight, initiated a series of *Studio* paintings that climaxed in the 1950s and in a series of Bird images, some of them done as decorative panels, e.g. for the Louvre Museum in 1952–3. His major exhibitions continued to be outside France (e.g. USA 1939, Amsterdam and Brussels 1945, Venice Biennale (first prize for painting) 1948, New York and Cleveland 1949, Switzerland 1953, Edinburgh and London 1956) but his stock rose in France through his connection with Galerie Maeght from 1947 and in 1962 he had a prestigious solo show in the Louvre.

Bratby, John (1922–92) British painter, associated with the *Kitchen Sink school of the 1950s, owing to his forceful paintings and drawings of domestic interiors and portraits, done in bright colours and strong lines. In his later work portraits and landscapes have been more dominant.

Braun, Mathias Bernhard (1684–1738) The foremost Czech *Baroque sculptor, born in the Tyrol but settled in Prague from 1711. Although he is best-known for his stone carving, he also worked in wood (e.g. Prague, St Clement). He contributed the best statue, that of *St Luitgard*, to the 'avenue of statues' on Charles Bridge in Prague; equally expressive (*see under* expression) sculptures from the plague column in Teplice have been removed to the Prague National Gallery's collections at Duchcov Castle, as has the newly restored *Christ upon the Cross* from Horni Slavkov; other works, Prague, Hradni Gallery; Clam-Gallas Palace; Vrtba Palace. The largest collection of his sculpture is, however, at the hospital church at Kuks, for whose gardens Braun and his workshop executed numerous allegorical figures.

Brauner, Victor (1903–66) *Surrealist painter of Romanian origins, who worked principally in Paris but with intervals in Bucharest. He came to Surrealism in 1933 through contact with *Tanguy and exhibited in Paris in 1934 and in Bucharest in 1935. From 1947 on his work was seen in New York galleries.

Bray, Salomon and **Jan de** *See* Braij, Salomon and Jan de.

'Breakfast Piece' *See under* Heda, Willem Claesz., and Claes, Pieter.

Breenbergh, Bartholomeus (*c.*1599–1655/9) A leading member of the first generation of Italianate Dutch painters. A native of Deventer, he was in Amsterdam before 1619 and lived in Italy from 1619 to 29. His pen-and-wash drawings of the Roman Campagna anticipate those by *Claude (Oxford, Christ Church); his painting style was much influenced by *Elsheimer, and, to a lesser extent, Paul *Bril. After his return to Amsterdam his work becomes extremely eclectic. He also etched (*see under* intaglio). There are works by him in Amsterdam, Rijksmuseum; Berlin, Staatliche; Dulwich, Gallery; London, National; Los Angeles, Getty; etc.

Bregno, Andrea (1418–1506) Lombard-born sculptor. Arriving in Rome in the 1460s, he became the most popular sculptor in the city, through the precision of his decorative carving, inspired by *classical motifs. Many Roman churches contain altars and wall monuments by him and his shop. He sometimes worked in collaboration, for example with *Mino da Fiesole at SS. Apostoli. As his fame spread, he was commissioned to execute the Piccolomini altar for Siena cathedral (1418–5), to which *Michelangelo later contributed four statuettes (1501–4). His style was carried back to northern Italy by his pupil Gian Cristoforo, called Romano, the son of *Isaia da Pisa.

Bregno, Antonio (recorded from 1425– after 1457) Ill-documented Lombard sculptor from Como active in Venice. He was the principal sculptor of the transitional period between Bartolommeo *Buon and Antonio *Rizzo and Pietro Lombardo (*see* Pietro Solari). He probably worked as a member of Buon's studio on the Porta della Carta of the Doge's palace, and in collaboration with Rizzo on the Arco Foscari. His work on these projects has been identified on the basis of the attribution to him of the monument of Francesco Foscari in S. Maria dei Frari, influenced by Florentine sculptors active in Venice, notably Pietro di Niccolo *Lamberti.

Breitner, Georg (1857–1923) Dutch painter. He was trained in The Hague, Paris and Amsterdam, was in Paris during 1884 and worked in Amsterdam from 1886 on. Under French influence his naturalistic paintings took on *Impressionist and *Post-Impressionist qualities, with colour and paint itself enlivening subjects mostly drawn from daily life. The Gemeentemuseum in The Hague and the Rijksmuseum in Amsterdam have substantial collections of his work.

Brekelenkam, Quiringh (*c*.1620–67/8) Dutch painter, active in Leiden from 1648. He specialized in scenes from the lives of artisans and small shopkeepers and their families, emphasizing the virtues of parental instruction, diligent labour and domesticity. Thirteen variations on the theme of a tailor's shop are recorded (e.g. Amsterdam, Rijksmuseum; London, National; Philadelphia, Museum; Bonn, Museum; Worcester, MA, Museum) and half a dozen of men or women spinning (notably Philadelphia, Museum; New York, Metropolitan; Amsterdam, Rijksmuseum). There are also paintings in Leiden, Museum.

Bresdin, Rodolphe (1822–85) French printmaker with a particular interest in the prints of *Dürer and his time and a taste for macabre and melancholic, quasi-religious themes. His work was not widely admired but Huysmans referred to it in his novel *A Rebours* and *Redon was influenced by its mood and by Bresdin's use of *lithography.

Breton, André (1896–1966) French poet, founder and chief theoretician of *Surrealism. He wrote the Surrealist Manifesto (1924) and in *Surrealism and Painting* (1928) made his case for including visual art in a movement others thought reserved to literature. Surrealism was to him an assertion of the liberty of the imagination, and he tried to rule the movement in order to keep its production pure. He particularly admired the early work of *De Chirico and subsequently *Picasso, welcomed the art of *Ernst and *Miró and later brought other artists into the movement, but fell out, for example, with *Dalí over his political attitudes and extravagant behaviour.

Breton, Jules (1824–1906) French painter, born into the rustic world of Brittany but trained as artist in Antwerp and Paris. The 1848 revolution confirmed his sympathy for the lower classes and especially for peasants. Many of his paintings show these at home and at work in a naturalistic idiom close to that of the *Barbizon painters. Sometimes he charged his scenes with symbolical content or with biblical solemnity. For this reason he has been charged with sentimentality by admirers of the *Impressionists' concentration on effects of light, but Van *Gogh admired him for his humanity and Breton was a

sensitive and gifted handler of paint, colour and tones. His work was of wide influence outside France, notably in Scandinavia and the USA.

Brett, John (1830–1902) English landscape painter who became a member of the *Pre-Raphaelite circle and was influenced by *Ruskin's writings to develop a highly detailed presentation of nature. Ruskin gave high praise to his *The Stonebreaker* (1857–8; Liverpool, Walker) and encouraged him to give similar care to such landscape as the Val d'Aosta which Brett did indeed paint in 1858 under Ruskin's guidance. Its cold, photographic detail drew criticism but Ruskin bought the picture and kept it in his drawing-room (London, pc). Brett's later work was softer and is generally felt to be of less interest.

Breu, Jörg the Elder (*c.*1475/6–1537) Painter and designer of stained glass and woodcuts. He is best-known as the founder of the so-called 'Danube school' (*see also* Lucas Cranach the Elder, Albrecht Altdorfer, Wolf Huber). During his *Wanderjahre* in Austria, *c.*1500–2, he evolved a type of altarpiece in which directly observed landscape and landscape motifs were a major, and emotionally *expressive, adjunct to narrative, even in scenes of the Passion (Zwettl, parish church; Herzogenburg, collegiate buildings; Nuremberg, Museum; Melk, abbey). From 1502 until his death, Breu worked at Augsburg, where he had been apprenticed to Ulrich *Apt the Elder. He increasingly made use of Italianate *Renaissance motifs, some derived directly from Italian masters of the 15th century, others adopted after *Dürer, and others still from the Augsburg artist *Burgkmair.

In addition to the works cited, there are paintings by Jörg Breu in Augsburg, St Anna; Munich, Alte Pinakothek; Dresden, Gemäldegalerie; Aufhausen, parish church. He contributed to the drawings for the Emperor Maximilian I's prayer book (*see* Dürer), and made 18 woodcuts (*see under* relief prints) of the investiture of Ferdinand I in 1530.

Breu's son, **Jörg Breu the Younger** (after 1510–47) was his pupil. After *Wanderjahre* which took him as far abroad as Venice, he was registered as a master painter in Augsburg in 1534. He seems to have specialized in large-scale, *classicizing decoration (New York, Metropolitan).

Nicolas Breu (recorded in Austria 1524–33) was the younger brother of Jörg Breu the Elder and his pupil at Augsburg. He has been tentatively identified with the so-called Historia Master, also known as the Master of Pulkau, active from *c.*1508, and included in the 'Danube School' through his mastery of, and emphasis on, landscape. He is the author of the altarpiece in the parish church, Pulkau (*c.*1518–22), and of the illustrations to Grünpeck's text of the *Historia Friderici et Maximiliani*, *c.*1514–15 (Vienna, Staatsarchiv). There is a *Nativity* by this artist in Chicago, Institute.

Breughel *See* Bruegel, Brueghel.

Bril[l], Paul (1554–1626) and his older brother **Matthew** (1550–83) Born in Antwerp, they played a key role in the evolution of landscape painting in Italy, assimilating Flemish modes to the new *classicizing style of the *Carracci school. This development culminated in the grand landscapes of *Poussin and *Claude, whose teacher, Tassi, may have been taught by Paul Bril.

Matthew was already an established landscape specialist, working in the Vatican, when his brother joined him in the mid-1570s. Paul is first recorded in the *Academy of St Luke in 1582. At Matthew's premature death he succeeded him in papal service (*frescos, 1589, Vatican, Scala Santa). It is generally accepted that he was active in Naples as well as Rome, leaving many easel paintings in the city; a leading share of the influential landscape and *grotesque frescos in the Ospedale degli Incurabili can be attributed to him. There are small-scale landscape canvases and paintings on copper by him in most of the main galleries in Europe.

Briosco, Andrea *See* Riccio.

Briosco, Benedetto (active 1483–1506) Lombard sculptor, probably trained in the

workshops of Milan cathedral (*St Agnes*, completed 1491, Milan, Museo del Duomo). He collaborated with Gian Cristoforo Romano (*see under* Isaia da Pisa), adopting his *NeoClassical style, on the Visconti monument in the Charterhouse of Pavia in the 1490s, and with *Amadeo, whom he converted to the new manner, at Pavia, S. Lanfranco, *c.*1498. When Amadeo left his directorship of the façade sculpture at the Charterhouse to become chief architect of Milan cathedral, Briosco was left in charge, being confirmed as sculptor-in-chief in 1501 (reliefs of the portal).

Broadsheets Single-leaf prints popular in Germany in the 16th century, normally incorporating a woodcut image (*see* relief prints) and text on some newsworthy, satirical or moralizing topic.

Broederlam, Melchior (recorded 1378–99) Innovatory Netherlandish painter from Ypres, who entered the service of Philip the Bold, Duke of Burgundy in 1378. His only known surviving works are the famous painted exteriors (1394–9) of the two wings of a sculptural altarpiece for the Carthusian monastery at Champmol (*see also* Sluter, Claus; Malouel, Jean), now in Dijon, Musée. Representing the *Annunciation and Visitation* and the *Presentation at the Temple and Flight into Egypt* in irregularly shaped pictorial fields, they combine forceful Netherlandish *realism with courtly Italianate traits – the latter perhaps the result of direct acquaintance with *Bartolo di Fredi's 1388 panels of the Life of the Virgin in Siena – and are among the earliest examples of the International *Gothic style more often associated with manuscript illumination (*see* Limbourg brothers).

Brokof[f] Family of *Bohemian sculptors, active in Prague. Johann Brokoff (1652–1718) was born in Hungary and settled in Prague in 1675. He was the teacher of his sons, **Michael Josef** and **Ferdinand Maximilian Brokoff** (1688–1731), the most important *Baroque sculptor in Bohemia after Mathias Bernhard *Braun. All three contributed several works to the 'avenue of statues' on Charles

Bridge in Prague. Among other outstanding works in Prague by Ferdinand Maximilian Brokoff are the portal and façade sculpture of the Morzin Palace; the sculptural decoration of the staircase of the Troja Palace, and the tomb of Count Mitrowitz in St Jacob.

Bronze A hard, water-resistant alloy of copper and smaller proportions of tin, and sometimes zinc or lead. Its surface colour changes according to its composition, and with exposure to the atmosphere or deliberately applied chemicals (*see* patina); it can also be chased and polished. Bronze was first made in the Middle East about 4500 BC. Ancient Greece and Rome had a long-lasting tradition of monumental bronze sculpture hollow-cast in the *cire-perdue technique, which survived into the early Middle Ages, but was virtually forgotten in Western Europe until its tentative revival in the 14th century. Church bells and small figures were solid-cast, but the cost and weight of the metal made this technique prohibitive for large-scale work. The lightness of hollow-cast bronze, combined with the material's high tensile strength, also allows greater formal freedom in the design of cantilevered elements such as projecting limbs, rearing horses, etc. The first *Renaissance monumental bronze statues were executed by *Ghiberti for the Or San Michele in Florence. Bronze has since then remained a favoured medium for public sculpture, although decried by the champions of direct carving and 'truth to materials'. See also *marble.

Bronzino, Agnolo (1503–72) Florentine painter, one of the greatest portraitists of the 16th century and an outstanding exponent of *Mannerism in religious art. After training with Raffaellino del Garbo (*d.*1527) he became the pupil and quasi-adoptive son of *Pontormo. Although he modelled his style on Pontormo's, the resemblance is superficial. Pontormo distorts the human form for the sake of emotional communicativeness and for him, as for *Michelangelo, aesthetic beauty is symbolic of spiritual values. For Bronzino, style itself is a value: the poignancy of his

best work is due to an abnegation of feeling. This is nowhere more apparent than in the *Allegory of Illicit Love* (*c.*1545, London, National) in which erotic passion and its consequences (including syphilis) are elaborated into patterns of crystalline grace. This tendency of Bronzino's work predates, but must have been reinforced by, his service at the autocratic court of Cosimo I de'Medici.

Bronzino's independent career began with a period in Pesaro, 1530–2, where he executed his earliest known portrait (*Guidobaldo, Duke of Urbino*, Florence, Uffizi). From then on he was to remain mainly in Florence, with trips to Rome recorded during 1546–8. His portraits vary with functional requirements. Where the sitters seem to demand it, their icy refinement is very great (e.g. *Ugolino Martelli*, *c.*1536, Berlin, Staatliche; *Bartolommeo Panciatichi* and his wife *Lucrezia*, pendants, both *c.*1540, Florence, Uffizi; *Laura Battiferri Ammanati*, 1555–60, Palazzo Vecchio). On the other hand, the dynastic portrait of Cosimo's wife and his heir – from which copies and variants were to be produced – is boldly direct (*Eleonora di Toledo and her son*, *c.*1545, Florence, Uffizi). In the images of the Medici children, notably of the teething two-year-old *Giovanni* (1545, Uffizi) a sympathetic *realism seems to exclude style altogether. In 1541 Bronzino began the *fresco decoration of Eleonora's private chapel in Florence, Palazzo Vecchio, his first large-scale religious work, in which naturalistic proportions and *classical features are conjoined with decorative pattern and colour. An even more extreme example of Mannerist composition is provided in the 1565–9 fresco of the *Martyrdom of St Lawrence* in the side aisle of S. Lorenzo (where Pontormo had been painting the choir before his death in 1557). Here the figures strike poses, Michelangelesque but flattened to rhyme with the wall surface and robbed of tragic import, in an *all'antica* architectural setting complementing and extending Brunelleschi's architecture. Large altarpieces were painted by Bronzino for Eleonora's chapel (1545, now Besançon, Musée; replica *in situ*, 1553); for SS. Annunziata (1552); S. Croce (1552, now Museo di

S. Croce), the latter in a style whose rhetorical clarity announces the Catholic Reformation. An analogous sentiment may be found in certain late portraits, such as the *Widow with a statuette of Michelangelo's Rachel* (*c.*1555–60, Florence, Uffizi).

Bronzino died in the house of the family of his favourite pupil, *Allori, who adopted his name.

Broodthaers, Marcel (1924–79) Belgian artist and writer, who became known as a *Conceptual artist of exceptional wit and imagination in the late 1960s. At that time he was living in London. The Tate Gallery there showed a major retrospective, also shown in Cologne, in 1980.

Brooking, Charles (1723–59) English marine painter, potentially the ablest follower of Willem van de *Velde the Younger (*see also* Monamy, Peter; Scott, Samuel; Woodcock, Robert). His knowledge of shipping and the sea is said to have been derived from an apprenticeship at the dockyards in Deptford. His few surviving paintings are poetic in tone and equally accomplished in representing rough or calm seas (Greenwich, Maritime).

Brouwer, Adriaen (*c.*1605–38) The most pictorially refined painter of low-life subjects (*see under* genres), many of them rowdy peasant tavern scenes. According to literary sources, he himself frequented port houses, paying his bills with sketches, and despised the hypocrisy and pretensions of 'respectable' society. Brouwer reconciled the sense of drama and the strictly geometric compositions of the art of his native Flanders with the painterly, tonal treatment characteristic of Dutch art, having worked from *c.*1624 to *c.*1631 in Holland, mainly in Haarlem where he came into contact with Frans *Hals.

Brouwer's first teacher was his father, a specialist in tapestry cartoons, but his earliest known work is indebted to Pieter *Bruegel the Elder, founder of the category of peasant subjects. After his return to Flanders (he became master of the Antwerp Painters' Guild in 1631/2) the vivid local colours and rigidly planar compositions of his first manner gave way

to a subtler, more atmospheric treatment. Continuous space is suggested through a predominant use of translucent greys and browns, with a focal accent in a single colour: red or green, gold or blue. In the last years of his life he painted some landscapes, idyllic in mood albeit realistic in subject (Berlin, Staatliche). Both *Rembrandt and *Rubens avidly collected Brouwer's work, and he influenced Adriaen van *Ostade and Jan *Steen, among others (Frankfurt, Kunstinstitut; Munich, Gemäldesammlungen; Philadelphia, Museum; etc.).

Brown, Ford Madox (1821–93) British painter, born in Calais, trained in Antwerp and from 1840 living in Paris where he painted *History subjects in a *Romantic mode as well as portraits. In 1844 he moved to London, to enter (unsuccessfully) the competition for frescos in the new Houses of Parliament. A journey via Basel and Florence to Rome, in 1845–6, brought him into close contact with the *Nazarene painters and led him to embark on a large triptych in their manner, celebrating English poets. Never completed, it was exhibited in London early in 1848 and seen by *Rossetti who became Brown's pupil and brought him into the *Pre-Raphaelite circle without Brown ever becoming a full member of it. Brown was influenced by Pre-Raphaelite *naturalism, which he turned into something close to *realism in his emphasis on inartistic detail as well as verisimilitude, as in *Jesus Washing Peter's Feet* (1852–6; London, Tate) and *Work* (1852–63; Manchester City). The latter, large and representing in detail a particular spot in North London closely observed under daylight, records also the appearance and actions of different classes of people, labourers, a beggar, indolent people of means, etc. Thus he intended to stimulate consideration of questions of social justice in the spirit of Thomas Carlyle, who appears in the picture beside his disciple, the Rev. F.D. Maurice, founder of the Christian Socialist Party. In *The Last of England* (1855; Birmingham City) he summarized in almost documentary fashion the plight of those forced to leave their country to seek their livelihood in distant lands. Closer to the Pre-Raphaelite

manner, he painted in 1878–93 twelve historical frescos for Manchester Town Hall, in marked contrast to the fresh, in spirit almost *Impressionist landscapes he painted out of doors for his private pleasure. He never met with success, not least because *Ruskin ignored him and because Brown treated the Royal *Academy as his enemy and took the then unusual step of organizing exhibitions for himself. His work is best seen in the Tate Gallery, London, and in Manchester City Art Gallery.

Brown, Mather (1761–1831) American painter, most of whose career from the 1780s was spent in England, where he studied with Benjamin *West. He achieved popularity with small-scale full-length portraits (London, NPG; Washington, NPG).

Bruce, Patrick (1880–1937) American painter who studied under *Henri and, in Paris from 1907, under *Matisse. He worked with *Delaunay in 1912–14 and, in collaboration with *Macdonald-Wright and *Russell, developed a Delaunay-inspired art which they named *Synchromism. In the 1920s he turned to painting still lifes in terms of defined geometrical forms. Lack of success led him to destroy much of his work and himself.

Brücke, Die (The Bridge) Name chosen in 1905 for a German artists' group in Dresden by four former architecture students: *Kirchner, *Heckel, *Schmidt-Rottluff and Fritz Bleyl (who left after a few months). Their 1906 statement invited as members young artists everywhere who felt committed to a personal rather than a conventional art. They made direct approaches to a few German and foreign individuals. Among the foreigners who became more or less nominal members were *Amiet, *Gallen-Kallela and Van *Dongen; among the Germans *Nolde (who joined briefly), *Pechstein and *Müller. Their only programme was to vivify art visually and emotionally. From a rough *Impressionism they moved on to a muscular, bright and brusque kind of painting stimulated by *Gauguin and Van

*Gogh, by *primitive artefacts and by German *Renaissance art, with themselves and their doings as preferred subjects: around 1910–11 the three core members shared a style celebrating physical existence through strong colours and rough brushwork. Shown in Dresden, their work shocked many but also attracted a circle of lay members rewarded for their financial support with annual folders of prints, mostly vivid woodcuts. Die Brücke is honoured as the first *Expressionist group, but its early work lacks the intense personal vision and the element of protest against social restraints that mark Expressionist poetry and drama from about 1910. In 1911 they moved to Berlin and for a time were part of the New *Secession group there. As Brücke they contributed to the second *Blaue Reiter and to the *Sonderbund exhibitions in 1912, but thereafter the group dissolved.

Bruegel, Brueghel A dynasty of Flemish artists, of whom the most original and influential was **Pieter Bruegel the Elder** (c.1524/30–69), followed by his younger son, **Jan Brueghel**, nicknamed Velvet Brueghel (1568–1625). Pieter's elder son, **Pieter Bruegel the Younger**, nicknamed Hell Bruegel (1564–1638), mostly produced innumerable variations on his father's *genre scenes and landscapes. This tradition was continued by his son and pupil **Pieter Bruegel III**. The son of Jan Brueghel, **Jan Brueghel II** (1601–78) was, in his turn, a careful imitator of his father's work.

Pieter Bruegel the Elder is chiefly remembered for his *landscapes and his scenes of peasant life. It was formerly thought that he had been a peasant himself, catering to the coarse humour of other rustics. This was emphatically not the case. Between 1555 and 1563, the prints issued after his drawings by the publisher and engraver Hieronymus *Cock must have been popular with the general public. When, c.1560, Bruegel began to paint the pictures for which he was to become famous, however, he found his patrons amongst the leading intellectuals and rich bankers of Antwerp and shortly after amongst members of the court in Brussels. At least

10 of Bruegel's paintings entered the collection of the Emperor Rudolph II (now Vienna, Kunsthistorisches). What little we know of the artist suggests that he was an educated man well able to associate with his distinguished clients, perhaps in the *rederijker kamers*, or chambers of rhetoric, central to festive and literary life in Netherlandish cities. The farces and allegorical plays and processions presented by these societies are reflected in many of Bruegel's paintings. The humour in his work was like the humour of *rederijker* performances: that of a townsman laughing at, not with, the antics of peasants, but also that of a moralist showing up the follies of humankind in general. At the same time, like any educated townsman of his day, he would have viewed the land and those who tilled it as the source of his country's wealth and the index of its well-being, not only in economic terms but also in relation to the forces of nature. It is the richness of all these references, as well as Bruegel's visual mastery, which made him so influential on later northern artists, for example *Rubens in the 17th century.

Bruegel drew heavily both on the traditions of early Netherlandish art and, in his mature works, on Italian *Renaissance masters. Although we now view these two modes as separate and antithetical, they were not seen as such in the Habsburg dominions which looked in two directions at once: inwards to the heyday of the native art of Burgundy, and across the Alps, to the new Italian art.

Bruegel was probably trained by Pieter *Coecke van Aelst, although he may have been a landscape specialist in Coecke's workshop. After a brief spell in Malines following Coecke's death in 1550, he moved to Antwerp, leaving almost immediately for southern Europe. His itinerary can be reconstructed through a painting (*View of the Bay of Naples*, c.1552, Rome, Doria) and many drawings made on his travels, which included Rome and Sicily. Unlike other northern artists, he recorded no works of art while in Italy, only views of cities and landscapes. Perhaps the most important immediate result of his travel sketches are the views of Alpine scenery published as a set of 12 prints, the *Large Landscapes*, after Bruegel's return to Antwerp in 1555. The

high viewpoint of these panoramic scenes was to recur in subsequent paintings (e.g. *Parable of the Sower*, 1557, San Diego, CA; *Hunters in the Snow*, 1565, Vienna, Kunsthistorisches).

Bruegel was now retained by Coecke to produce designs for engravings in the style of Hieronymus *Bosch. Nearly 40 drawings were produced by Bruegel between 1555 and 63: moralizing allegories, such as the series of the *Seven Deadly Sins*; illustrations of Netherlandish proverbs, such as *Big Fish Eat the Little Fish*. In the *Seven Virtues* series, c.1559/60, Bruegel freed himself from dependence on Bosch's demonic imagery to draw more heavily on examples from daily life.

The earliest known independent paintings by Bruegel also date from 1559/60 and bear a close relationship to the popular engravings designed for Coecke: *Netherlandish Proverbs* or *The Blue Cloak* (1559, Berlin-Dahlem, Museen); *The Battle between Carnival and Lent* (1559, Vienna, Kunsthistorisches); *Children's Games* (1560, Vienna, as above).

Three original paintings recreating Bosch's nightmarish vision were executed shortly after: the *Fall of the Rebel Angels* (1562, Brussels, Musées); *Dulle Griet* (c.1562–4, Antwerp, van der Bergh) and *The Triumph of Death* (c.1562–4, Madrid, Prado).

In 1563 Bruegel moved to Brussels. Presumably in response to aristocratic collector patrons, he now began to paint religious subjects, incorporating both archaic motifs derived from Rogier van der *Weyden and Italian Renaissance models (e.g. *Christ carrying the Cross*, 1564, Vienna, Kunsthistorisches; *Adoration of the Magi*, 1564, London, National; *Christ and the Woman taken in Adultery*, 1565, London, Courtauld). Two important Italian sources were *Michelangelo's *Bruges Madonna*, in Bruges since 1506, and *Raphael's tapestry cartoons, in Brussels since 1517.

Bruegel's study of Raphael now helped to unify the structure of his small biblical narratives of many figures in landscape (*Massacre of the Innocents*, c.1566, Vienna, Kunsthistorisches; *Census at Bethlehem*, 1566, Brussels, Musées; *Sermon of St John the Baptist*, 1566, Budapest, Museum). It

also underpins the large-scale compositions of his last years, paradoxically some of his most Flemish in content (*Peasant Kermis* and *Peasant Wedding Feast*, both c.1567/8, Vienna, Kunsthistorisches; *Parable of the Blind*, 1568, Naples, Capodimonte; the *Peasant and the Nest Robber*, 1568, Vienna, as above).

Mention must also be made of the cycle of the months which Bruegel painted in 1565 as domestic decoration for the wealthy Antwerp banker and royal official, Niclaes Jonghelinck. Only five panels are known, and it is not certain that a full 12 were painted (three panels, Vienna, Kunsthistorisches; one, Prague, Museum; and one New York, Metropolitan). The decoration is ultimately dependent on early Burgundian and Netherlandish calendar illuminations in *Books of Hours. But in several of the panels Bruegel has combined the homely details of Flemish peasant life with the mountain panoramas of his Alpine sketches. The paintings subordinate the world of humankind to the majestic cycles of nature.

Few of Bruegel's immediate followers appreciated the monumentality of his late works. Pieter Bruegel the Younger was born only five years before his father's death, long after Bruegel's large-scale compositions had been sold. His knowledge of his father's work was thus drawn mainly from prints and from imitators, such as Pieter Balten (1525–98), Hendrick and Maerten van Cleef (d.1589 and 1581 respectively), Gillis Mostaert (d.1598) and Jacob Grimmer (d.1590), naturally attracted to the most popular *genre scenes. Throughout his life he painted variations on his father's work as reflected in these derivations; his nickname 'Hell' refers to his pictures of the underworld with Bosch-like devils and torments. He was the master of Frans *Snyders.

Jan Brueghel became a major artist in his own right, albeit very much a painter of *cabinet pictures. His earliest work, like his elder brother's, repeats variations on his father's paintings, although in a delicate miniaturist technique, said to have been taught him by his maternal grandmother, Marie Verhulst. About 1589 Jan Brueghel went to Italy; in Rome 1593–5 he met

Cardinal Federigo Borromini, Archbishop of Milan from 1595, who became his great patron. Jan painted for him small, even tiny pictures, combining exquisitely painted naturalistic (*see under* realism) details in highly decorative and artificial compositions, such as the four allegorical pictures of the *Elements* (after 1608, Milan, Ambrosiana and Paris, Louvre) and the *Five Senses* (Madrid, Prado). Jan's small landscapes, too, were magical vistas of woodlands and open glades, like miniature versions of the woodland scenes of Gillis van *Conixloo, who may have taught him (e.g. 1607, St Petersburg, Hermitage). His masterpiece in this genre is considered to be the *Continence of Scipio* (1609, Munich, Gemäldesammlungen). Finally, Brueghel became a specialist also of flower pieces, sometimes combined with precious jewels and other manufactured accessories. His ability to reproduce the varieties of texture earned him the nickname 'Velvet'. Working from nature, he collected flowering plants from spring through summer, and painted landscapes the rest of the year.

Brueghel often collaborated with other artists. His most famous collaboration was with the youthful *Rubens, who also looked after his Italian correspondence. Rubens provided the figures of Adam and Eve in Brueghel's *Garden of Eden* (The Hague, Mauritshuis) and the 'pictures' in the *'Madonna and Child' wreathed with garlands of flowers* of which Brueghel painted several versions (e.g. Madrid, Prado).

Devalued in our day, partly through the many imitations by his son, Jan Brueghel II and other pupils, Jan Brueghel's work was immensely prized by many aristocratic collectors throughout Europe. They admired his meticulous technique; the subtle interplay between naturalism and artifice, the copiousness within a small compass of his precious little pictures, executed, as Cardinal Borromeo wrote, 'with extreme strength and care', an art simultaneously 'great and delicate'.

Bruges Passion Scenes, Master of the, also called Bruges Master of 1500 (active early 16th century) Netherlandish painter named after an altarpiece in Bruges,

Cathedral, which includes borrowings from German engravings (*see under* intaglio prints). Other works, London, National.

Brugghen, Henrick Ter See Terbrugghen.

Brunelleschi, Filippo (1377–1446) Best-known as the greatest architect of the Early *Renaissance, this Florentine artist matriculated as a goldsmith and practised also as a sculptor in silver, bronze and wood, designing for marble and perhaps terracotta. He is important, too, in the history of figurative art for his studies in *perspective, and for inspiring, and perhaps designing, the perspectivized architectural framework of *Masaccio's *fresco of the *Trinity*. This entry is limited to outlining Brunelleschi's figurative work, although the reader should recall his most important and famous achievement, the huge cupola of Florence cathedral.

The most significant figurative work by Brunelleschi is the bronze relief of the *Sacrifice of Isaac* now in Florence, Bargello, made in 1401–2 for the competition, won by *Ghiberti, for the second set of doors of Florence baptistry. The relief demonstrates Brunelleschi's absorption of the antique, his bias towards *realism, and the way both are combined in a composition dominated by clear geometric forms. It is technically less accomplished than Ghiberti's competition panel, which was lighter, cast in a single piece, whereas Brunelleschi's consists of a base with soldered relief sections. The technique relates it to the silver altar of St James in the cathedral at Pistoia, for which Brunelleschi had executed reliefs and statuettes, 1399–1400.

The other important sculpture, not documented but generally attributed to Brunelleschi, is the wooden figure of the crucified Christ, Florence, S. Maria Novella. Whether or not inspired by rivalry with *Donatello, as the sources report, the work recalls Brunelleschi's relationship with the younger sculptor – with whom he may have visited Rome to study antique remains sometime after 1402, or, as is more probable, who came to visit Brunelleschi during the latter's stay in Rome *c.*1413–15.

Brunelleschi did not carve in stone but

several works – a lavabo in the sacristy of Florence cathedral, the pulpit in S. Maria Novella, the tomb and altar in the Old Sacristy, S. Lorenzo – were executed by his disciple, adopted son and 'sculptural amanuensis', **Buggiano** (1412–62), after designs and wooden models by Brunelleschi.

Brunswick Monogrammist, also called Master of the Brunswick Monogram (active c.1520 to 1540) Netherlandish painter, named after a picture in Brunswick (Anton-Ulrich) of the *Parable of the Great Supper* according to Luke 14:15–24; the monogram with which it is signed has not been deciphered. About half of the dozen or so of the Monogrammist's small paintings are religious (e.g. *Ecce Homo*, Amsterdam, Rijksmuseum; *Sacrifice of Isaac*, Paris, Louvre), most of the others are multi-figured brothel scenes or outdoor scenes of lovers (Brunswick, Anton-Ulrich). This artist is an important pioneer of *genre painting, whose ability to integrate figures in landscape also make him/her an important precursor of Pieter *Bruegel. The Monogrammist is sometimes identified with Jan Sanders van *Hemessen or his daughter Katharina.

Brusasorci, Domenico Riccio, called (c.1516–67) Italian painter active in Verona. His style mid-century was influenced by the *Mannerism of Giulio *Romano in Mantua and *Parmigianino in Parma (*frescos, 1551, Trento, Municipio). In the fresco decoration of the Bishop's Palace in Verona, 1556, however, which anticipates Paolo *Veronese at the Villa Maser by framing landscape views in illusionist architecture (*see under* illusionism) this mannerist elegance is tempered under the influence of the *realism of *Moretto in Brescia. Only at the end of his career did Brusasorci, an almost exact contemporary of Paolo Veronese's master Antonio Badile, succumb to the triumphant Venetian style of Verona's famous expatriate artist (altarpiece, Verona, S. Pietro Martire, 1566).

Brustolon, Andrea (1662–1732) Sculptor and woodcarver from Belluno

in the Dolomites, trained in Venice in the workshop of the Genoese sculptor Filippo *Parodi; in 1679 he went to Rome for about a year. He returned definitively to Belluno in 1695, and worked mainly for ecclesiastical patrons throughout the mountainous area of the Dolomites (e.g. Pieve di Zoldo, S. Floriano, altar of the Poor Souls). His most celebrated work, however, was a 40-piece suite of armchairs and stands for Chinese porcelain, executed over some 24 years and exuberantly carved with allegorical figures (*see* allegory) and 'Nubian slaves' ornamented with ivory and mother-of-pearl (Venice, Ca'Rezzonico).

Bruyn, Bartel the Elder (1493–1555) German painter, active in Cologne, where he brought to an end the *Gothic tradition of *Lochner by introducing Italianate-Flemish *Renaissance forms, and founded an important school of portraiture. He was a relation, and perhaps a pupil, of Jan *Joest of Kalkar, whose influence is visible in one of his earliest dated works, the nocturnal *Nativity* of 1516 now in Frankfurt, Städelsches Kunstinstitut. By 1522–5 (Essen Minster, wings of high altar), Bruyn had become dependent on Joos van *Cleve, until in about 1530 he succumbed to the even more markedly Italianate styles of Jan van *Scorel and *Heemskerck (Xantend, St Victor; Nuremberg, Germanisches). Bruyn's best works are his portraits (Cologne, Wallraf-Richartz; Nuremberg, Germanisches). His son **Bartel** (or Bartolomaus) **Bruyn the Younger** (recorded 1550–1606) inherited both his clientele and his style (Bonn, Rheinisches); another son, **Arnt** (d.1535) was also a painter.

Bryullov (Brullov), Karl (1799–1852) Russian painter, son of an Italian ornamental sculptor working in Russia. Trained at the St Petersburg Academy and awarded a major prize, he travelled through Germany to Rome where he worked at various times and in the years 1830–3 painted his most famous picture, a large, highly theatrical and relentlessly detailed picture of *The Last Days of Pompeii* (St Petersburg, Russian), indebted to *Michelangelo, *Raphael and *Poussin and presaging Hollywood. He made paintings

for St Isaak Cathedral in St Petersburg but was also sought after as a society portrait painter. His brother **Alexander** (1798–1877) worked mainly as an architect but was also active as a portraitist; Alexander's son **Pavel** (Paul) (1840–1914) became a landscape painter after studying in Paris, exhibiting with the *Wanderers whom he formally joined in 1873.

Brzeska *See* **Gaudier-Brzeska**

Buffalmacco, Buonamico di Cristofano, called (d. after 1351?) Italian painter known only from literary references: he is mentioned as a great master comparable to *Giotto by the 14th-century Florentine writers Boccaccio and Sacchetti; around 1447 in *Ghiberti's *Commentari*, and in 1550/68 in *Vasari's *Lives*... Vasari claims there are works by him 'dispersed throughout Tuscany', but none of the works he discusses survives. Probably both Ghiberti and Vasari, activated by Florentine patriotism, base their texts on the earlier literary tradition. Attempts to connect Buffalmacco with either the frescos in the cemetary at Pisa usually attributed to *Traini, or with the unknown Master of *St Cecilia have not been convincing.

Buffet, Bernard (1928–99) French painter who studied at the Paris Ecole des Beaux-Arts and achieved early fame and wealth thanks to his large output of instantly recognizable pictures – large and small portraits, still lifes, townscapes, historical and religious subjects – all done in one manner. This is primarily graphic, with spiky thick and thin lines in black paint describing motifs in a magazine-illustrational manner and colour added as infill. The immediate effect can be austere and dramatic, and certainly Buffet's quick fame depended on impatience with the post-1945 dominance of emotional *abstract painting: here was *figurative art that was easily read as well as apparently emotional. Buffet stayed with this manner throughout his career, which ended with incapacitating illness and suicide, but French critical opinion turned against him. He showed new work with great frequency, and made designs for the Paris Opéra, but since the 1960s his patrons and his fame have been primarily outside France, especially in Japan where there are two Buffet museums.

Buggiano *See under* Brunelleschi.

Buon, Giovanni (*c.*1355–*c.*1443) and his son, **Bartolommeo** (*c.*1374–1464/7) The leading Venetian sculptors from 1392 until Bartolommeo's death. They were employed jointly on the Ca d'Oro (1422–34); the tympanum lunette over the entrance to the Scuola di San Marco (1437), and the Porta della Carta of the Doge's Palace (1438–42). A relief by Bartolommeo for the Guild of the Misericordia in Venice (1441–5) is in London, V&A.

Buonconsiglio, Giovanni *See* Marescalco.

Buontalenti, Bernardo (1536–1608) Versatile, inventive and technically skilled Florentine *Mannerist architect, civil engineer, fireworks specialist and designer in the service of the Medici Grand Dukes. Many drawings by him remain for goldsmith's work such as reliquaries and vases, for cabinet makers, and above all for theatrical scenery and costumes used in spectacles which he himself produced and directed, most notably in 1589 (Florence, Uffizi; London, V&A). The few works of sculpture actually executed by him were influenced by *Michelangelo (*Crucifix*, Florence, S. Maria Maddalena dei Pazzi; portrait bust of Duke Cosimo I, Opificio delle Pietre Dure), although his greatest talent was for ornamental detail.

Buonvicino, or **Bonvicino, Alessandro** *See* Moretto.

Burchfield, Charles (1893–1967) American painter, trained at the Cleveland School of Art 1912–16. War interrupted his career; afterwards he worked until 1929 as a wallpaper designer. Driven by obsessions, Burchfield in his early paintings and watercolours presented symbols of anxiety and melancholy through the objects depicted. Subsequently his work became more intensely descriptive yet still tended to depressing and at times sinister subjects

and moods. After about 1940 he returned to his symbolical vein, with nature's forces as his dominant subject.

Buren, Daniel (1938–) French artist who limited his idiom to a pattern of vertical parallel stripes or bands of white and one colour, often printed on fabric. This, displayed on gallery walls or the outsides of museums, or in other public spaces such as the courtyard of the Palais Royal in Paris (1986), represents a challenge to the uniqueness and value of art objects.

Burgin, Victor (1941–) British artist, trained as painter but in the later 1960s one of the first *Conceptual artists. His work has a pronounced socio-political message which he states and develops by appropriating commercial images and adding texts that challenge consumer-orientated readings of them.

Burgkmair, Hans (1473–1531) Outstanding German painter, engraver (*see under* intaglio) and designer of woodcuts (*see under* relief prints), active in Augsburg, where he occupied a position analogous to that of *Dürer in Nuremberg, acting as a conduit of Italian *Renaissance developments. The son of the painter **Thoman Burgkmair** (*d*.1523), he may also have worked under *Schongauer in Colmar in the 1490s. A trip to northern Italy is probable before 1498, when he returned to Augsburg and married the sister of Hans *Holbein the Elder, and he almost certainly visited Milan and Venice *c*.1505 and the Netherlands before 1510. His paintings after 1505 show increasingly his study of Venetian colour and monumental figure types indebted to *Leonardo and *Michelangelo. In addition to altarpieces (e.g. *St John Altarpiece*, 1518; *Crucifixion Triptych*, 1519, both Munich, Alte Pinakothek) and smaller devotional paintings (e.g. *Madonna and Child*, 1509; 1510, both Nuremberg, Museum; *Mystic Marriage of St Catherine*, Hanover, Landesgalerie), he executed many portraits (e.g. Karlsruhe, Kunsthalle; Augsburg, Museum; Cologne, Wallraf-Richartz; Vienna, Kunsthistorisches). In 1529 he was commissioned to paint one of a series of ancient battle scenes for Duke William IV of Bavaria (*Battle of Cannae*, Munich, Alte Pinakothek; *see also* Altdorfer). From 1510 he was employed on woodcuts for the Emperor Maximilian, including some for the *Triumphal Arch*, when he came into contact with Dürer, who made a portrait drawing of him. He was the teacher of Christoph *Amberger.

Burke, Edmund *See under* Sublime.

Burliuk, David (1882–1967) and **Vladimir** (1886–1916) Russian artists, brothers of the painter and poet Nikolai (1890–1920). David was the most brilliant and the most active. He studied art in Russia, at the Kazan and Odessa art schools and in Munich and Paris. This wide-ranging start was reinforced by his involvement in Russian *Futurism in Moscow and St Petersburg, and he saw himself as a rebel against artistic conventions and stimulator of innovation. He proclaimed *Mayakovsky's genius as poet before the young man knew he was a poet at all. On the estate managed by their father, in southern Russia close to the Black Sea, the Burliuks initiated a *primitivist movement which became part of Russian Futurism. David's and Vladimir's paintings combined primitivist modes with *Cubist simplifications. They organized exhibitions and debates and were involved in producing Futurist manifestos and miscellanies. David was also associated with the 1912 *Blaue Reiter exhibition and contributed to its almanac, travelling to Munich and then on to France and Italy. In St Petersburg, in November 1912, he lectured on 'What is Cubism?' That December, he produced with Mayakovsky and others the Futurist booklet, *A Slap in the Face of Public Taste*. In 1913–14 he toured Russian cities with Mayakovsky to preach and demonstrate Futurism. He left Russia in 1920, going to China, Japan and, in 1922, the USA where he opened a gallery and edited the journal *Color Rhyme*.

Burne-Jones, Edward (1833–1898) English painter, who turned to art from studies for the Church through meeting William *Morris in Oxford in 1855. With

*Rossetti he worked under Morris to paint frescos in the Oxford Union Debating Room in 1857. He lived and worked with Morris until 1859 when Burne-Jones toured Italy. In 1862 a second visit, in the company of *Ruskin, implanted in him a passion for the art of *Botticelli and *Mantegna which served well his desire to convey symbolical narratives and unspecific visions. Many of these were exhibited in the Grosvenor Gallery, London in 1877–87, and subsequently in other London galleries, and attracted a great deal of notice. For a time an associate member of the Royal Academy, he disliked showing his work in mixed exhibitions and resigned in 1893. Knowledge of his work in Paris and Brussels soon brought him international fame, and he exercised a major influence on *Symbolist painting and on the development of *Art nouveau. He was knighted in 1894 and given many foreign honours. London's Tate Gallery owns some of his best paintings.

Burra, Edward (1905–76) British painter, known mainly for his watercolour and gouache paintings and drawings. His early work, fed on film, travel, bars and theatres as well as on art, was principally social satire and shows his enthusiasm for *Grosz. His first one-man show was in 1929. In 1932 he designed the decor and costumes for Ashton's ballet *Rio Grande*. He contributed to the *Unit One exhibition in 1934 and the International Surrealist Exhibition in 1936. Under the impact of political events and of a variety of influences, including those of *Picasso, *Ernst, *Goya and *Bosch, his art became more grotesque. Even his later landscapes and other relatively objective paintings feel ominous: generally his art tended to the dramatic and the macabre. There were retrospectives in London in 1973 and 1985.

Burri, Alberto (1915–95) Italian painter who began to paint as a prisoner of war in Texas in 1945 after serving as a doctor in the Italian army. His pictures are made of materials chosen, joined and in part painted to convey the carnage wrought by war: ripped and stitched sacking, bandages, red paint, holes, charred wood,

distressed and rusting metal, torn and burnt plastic sheets. The results are richly evocative. Though they were intended to oppose the decorative tendencies of post-war abstraction, Burri's works became precious art objects sought by collectors and museums in the 1950s and 60s. He began to exhibit in Italy immediately after the war and in the USA in the mid-50s as well as in group exhibitions around Europe.

Bury, Pol (1922–) French artist whose early paintings were close to *Surrealism. He allied himself to *Cobra and other groups but in 1953 turned to making *kinetic sculptures, the first of them manipulated by the viewer but soon incorporating electric motors. He developed a series of reliefs and freestanding structures with surreptitiously moving erectile elements, humorous and a little disturbing.

Busch, Wilhelm (1832–1908) German painter mostly of landscape, working in Munich from 1854, best known for humorous illustrated narrative poems, deft in verse and image, the most famous of which is the story of the wicked doings of *Max and Moritz* (1865).

Bush, Jack (1909–77) Canadian painter, who turned from landscape painting to *abstraction under the influence of *Borduas. In the 1950s he was a frequent visitor to New York, attracted by *Abstract Expressionism. His mature work is characterized by compositions deploying broad bands of delicate colour, weightless, expansive and benign, close in design and spirit to *Post-Painterly Abstraction. A proficient jazz pianist, he brought to painting something of the improvisatory but controlled spirit of jazz. Known in Canada in the 1950s, he exhibited frequently in New York and London from the early 1960s on.

Bushnell, John (c.1630–1701) English sculptor who spent 10 years on the Continent – he is recorded working on a funerary monument in Venice in 1663 – returning to England in the late 1660s. The first English artist to show first-hand knowledge of *Baroque sculpture,

he executed several important public commissions, for Temple Bar and the Royal Exchange (London, Old Bailey) and some funerary monuments (London, Fulham Parish Church; Sussex, Ashburnham) but his mental instability prevented further commissions; he died insane.

Butinone, Bernardino (active 1484–1507) Italian painter from Treviglio in Lombardy, influenced first by *Mantegna, later by *Foppa. The two most important works associated with him, an altarpiece at Treviglio and *frescos in Milan, S. Pietro in Gessate, were painted in collaboration with Bernardo Zenale.

Butler, Lady Elizabeth (1846–1933) British painter who achieved great popularity as well as professional praise for her military scenes portraying, she said, not the 'glory of war' but 'its pathos and heroism'. Her detailed naturalism now seems merely filmic. In patriotic Victorian Britain her success – not least as a woman artist dealing with masculine prowess – was remarkable. Queen Victoria bought a scene from the Crimean War when it was acclaimed at the 1874 exhibition of the Royal Academy (on loan to Camberley Staff College in Surrey); her most famous painting is *Scotland for Ever!*, a scene from the Battle of Waterloo, painted in 1881 (Leeds City) and much reproduced in engravings.

Butler, Reg (1913–81) British sculptor. Butler worked as an architect, then also as an engineer and blacksmith, before turning to sculpture in 1944. He had his first solo exhibition at the Hanover Gallery in London in 1949, and in 1952 his work was included in a group show of new British sculpture at the Venice Biennale. In 1953 he won the first prize in a London international competition for a monument to the Unknown Political Prisoner. The model, a vertical structure of welded rods with three little cast figures at its base, should have, but never did, become a vast construction, possibly on the cliffs of Dover. Butler at this time made sculpture combining welded elements with modelled figures, but subsequently he celebrated

his fascination with the female figure in plastic sculptures that seem vividly naturalistic in form and colouring yet reveal themselves as explorations of distortion and exaggeration.

Buys, Cornelis *See under* Jan van Scorel.

Buyster, Philippe van *See under* Sarrrazin, Jacques.

Buytewech, Willem (*c.*1591–1624) Nicknamed 'Geestige Willem' ('witty Willem'). Dutch draftsman and etcher (*see under* intaglio) as well as painter. He is credited with having established an important *genre category: the banquet scene in an interior, usually called the 'Merry Company'. Its origins can be traced to biblical illustrations of the *Parable of The Prodigal Son, Mankind before the Flood, Mankind awaiting the Last Judgement*, as well as representations of the pagan *Feast of the Gods* (e.g. *Merry Company, c.*1617–20, Rotterdam, Boijmans-Van Beuningen). Buytewech was a decisive influence on the work of Frans Hals's brother Dirck, as well as that of Hendrick Gerritsz. *Pot (*c.*1585–1657) and **Isack Elyas** (active *c.*1620–30).

Bylert, Jan van *See* Bijlert, Jan van.

Byzantine art In 330 the administrative centre of the Roman Empire was moved by the Emperor Constantine from Rome and the Latin-speaking West to the old Greek city of Byzantium, shortly to be renamed Constantinople – 'City of Constantine'. The split between the Western and Eastern Empires became permanent in 395 when each adopted a separate ruler. While the West sank into anarchy and economic collapse, and, from the 5th century, invasions by 'barbarian' peoples from northern Europe, the Roman Empire survived in unbroken continuity in its Byzantine guise in the predominantly Greek-speaking provinces of the East, until the capture of Constantinople by the Turks in 1453. Byzantine art is the conscious heir of a Graeco-Roman tradition stubbornly maintained, already frozen and formulaic

in the 3rd century; its production was originally dependent on Imperial patronage, and it tends to reflect the sophistication and hierarchic solemnity of the court. Secondly, because of the adoption of Christianity as the state religion, it is in its major manifestations a predominantly religious art. Under the impact of Greek philosophy and metaphysics, it became increasingly transcendent (*see also under* Idealization): seeking beauty through mathematical principles, and above all in light as embodied in colour and the lustre of gold. Although Byzantine artists produced artefacts in all media from metal through ivory to manuscript illumination and paintings on panel (*see also* icon) and in *fresco, their grandest and most typical achievements were the mosaics clothing the walls of churches with colourful and gleaming processions and scenes from the Gospels, arranged according to the feasts of the liturgical year, so that the church building itself became an emblem of heaven and earth. (Because many provinces of the Italian peninsula were under Byzantine rule in the Middle Ages, such mosaics can be found on Italian soil as well as in the East; Byzantine craftsmen were also called to execute mosaics in, for example, Venice and even Florence. Byzantine art, although decried by Western artists such as *Vasari as clumsy, stereotypic and unrealistic, transmitted to the West many of the schemata of ancient art; much Christian imagery, including some of the most tender and eloquent groupings of the Virgin and Child; refined notions of colour, line and form (*see* e.g. Duccio). Its influence on Western European art is incalculable – as it was decisive on the art of Eastern Europe.

C

Cabanel, Alexandre (1823–89) French painter, admired in his time for laboriously painted and tasteful *History and *allegorical paintings, many of them commissioned by the state. His sweetly seductive *Birth of Venus* (1863; Paris, Louvre) is often contrasted as an example of academic style with *Manet's exactly contemporary *Olympia*.

Cabaret Voltaire Founded by the German writer Hugo *Ball in Zurich in February 1916, above a dairy in the Spiegelgasse, the Cabaret Voltaire was modelled on Berlin's intellectual cabarets. It was intended to provide income, and also to give voice, to individuals opposed to the First World War. It offered conventional and unconventional entertainment – poetry, music, dancing, displays of *avantgarde art. When Richard Huelsenbeck arrived, in March, its offerings became sharper in tone and style. Early in 1917 it transferred to the more prestigious Bahnhofstrasse as the Galerie *Dada.

Cabinet pictures From 'cabinet', a small room, private apartment or boudoir. Small-scale highly finished paintings designed to appeal to private collectors.

Cadmus, Paul (1904–) American painter, son of commercial artists. He studied in New York and worked in advertising. From 1933 on he worked for the *Federal Art Project. His paintings, often illustrating in *Renaissance detail and his precise technique themes of youthful lust and isolation, have a dreamlike atmosphere though their themes are so *realistic, and so he has been seen as a *Magic Realist of the American school.

Caffiéri, Jean-Jacques (1725–92) Virtuoso French sculptor, best known for his portrait busts; member of a Neapolitan dynasty of sculptors and bronze-founders brought to France in the 17th century by Cardinal Mazarin. His grandfather,

Philippe, had been Sculptor of the King under Louis XIV; his father and first teacher, Jacques, was employed by the Royal Office of Works and executed some portraits in bronze. Jean-Jacques, later trained by Jean-Baptiste *Lemoyne, worked chiefly in marble. Having won first prize at the French Royal *Academy, he spent the years 1749 to 1753 in Rome, where he was mainly influenced by Italian *Baroque works (stucco group of the Trinity above the high altar, San Luigi dei Francesi). Although he received a number of commissions from the Crown and Madame du Barry, mistress of Louis XV, on his return to France (portrait bust of du Barry, St Petersburg, Hermitage), his most successful works were the busts of great dramatists for the Comédie Française, Paris. Other sculptures, Paris, Louvre; Dijon, Musée; Waddesdon Manor.

Caillebotte, Gustave (1848–94) French painter and patron, associated with *Impressionism and for some time remembered mainly for his support of his painter friends and for the collection of their work he bequeathed to France. But he was an interesting painter in his own right. He studied under the *Salon painter Bonnat, and his early paintings are adaptations of his *naturalism to themes that warrant the label *realism. A major example, *Floorscrapers* (1875; Paris, Orsay), was rejected from the 1875 Salon. Instead he showed it and other works in the second Impressionist Exhibition, 1876, and until 1882 he showed there repeatedly, sometimes taking charge of the organizing and generally helping with time and money. His naturalism and realism took on a more evidently Impressionist, less personal, quality in the later 1870s when he turned to views of Paris streets and of boating and bathing; he went on painting domestic interiors with and without narrative implications which, when included in his posthumous show, may have drawn the attention of *Bonnard and *Vuillard. A few of his paintings were

shown in the United States in 1886 and in Brussels in 1888. His reputation as a painter has soared recently as closer study of his work revealed particular methods of surface organization and spatial construction.

Calder, Alexander (1898–1976) American sculptor who turned to art from engineering in his mid-20s and enrolled at the Art Students' League, New York. In 1926–7 he was in Paris and subsequently divided his time between France and the USA. He made witty one-line drawings of people and animals and applied this skill to making creatures from wire and string. Under the influence of *Mondrian, *Miró and other Paris *abstract artists he began in 1930 to make static sculptures which *Arp called 'stabiles' to distinguish them from *kinetic works baptised 'mobiles' by *Duchamp. It was as a kinetic sculptor that he made his name – first hand-operated and motorized sculptures performing a limited series of movements, then hanging or standing mobiles operated by air currents and thus more various in their actions. Made usually of metal rods and cut metal shapes, they and their titles often refer us to natural things though the colours he gave them tended to be clear and strong. He did many *gouaches in his last years, akin to the mobiles in form and colour. He was a member of *Abstraction-Création and exhibited very widely in the 1930s and after, and was commissioned to make major sculptures for public places. Major restrospectives began with one in New York in 1943.

Caliari, Paolo *See* Veronese.

Callot, Jacques (1592–1635) One of the greatest and most influential etchers (*see under* intaglio); a pioneer both in technique and in subject matter in which he combined Italian and northern European traditions. His prints are notable for the marshalling of innumerable small figures into coherent patterns. Until *c.*1621 his love for the grotesque was expressed with wit and fantasy; after that time his tone became increasingly serious, and his last great

work, the series of the *Grandes Misères de la Guerre*, 1633, foreshadows the grim horrors of *Goya's *Disasters of War*.

Born in Nancy, Callot was apprenticed to a goldsmith. During 1608–11 he went to Rome, where he learnt line engraving and copied compositions by *Mannerist painters. In 1611 he moved to Florence, becoming a pupil of **Remigio Cantagallina** (*c.*1582–1635?) and a protégé of Cosimo II de'*Medici. He achieved great success with prints of public festivities, grotesque beggars, hunchbacks and characters from the *commedia dell'arte*. After the death of Cosimo Callot returned to Nancy, where he became one of the leading figures in the artistic life of Lorraine. Probably under the impact of the religious revival current there (*see also* Bellange, Georges de La Tour) his work became more serious and deeply felt, notably in religious works such as the series of the *Great Passion*, 1625. He also turned to pure landscape, in the manner of *Bruegel. In 1625 he was called to Brussels to collect material for his huge *Siege of Breda* – later to be drawn upon by *Velázquez for the background to his painting of the same name – and in 1629 to Paris to illustrate the captures of La Rochelle and the island of Ré by the royal forces. Details from these siege compositions were to be reused in the *Grandes Misères de la Guerre* already mentioned, alluding to the invasion of Lorraine by the French in 1633.

Calvaert, Denijs or **Denys** (*c.*1540–1619) Antwerp-born *Mannerist painter. He went to Italy *c.*1562, settling in Bologna *c.*1574. A comparatively mediocre follower of *Parmigianino, he became nonetheless an important influence in his own right, as the first teacher of *Reni, *Albani and *Domenichino, who, together with the *Carracci, founded the famous school of Bologna and, through their later activity in Rome, 'reformed' Italian art by counteracting the naturalism (*see under* realism) and *tenebrism of *Caravaggio and his followers. There are paintings by Calvaert in Bolognese churches (e.g. Sta Maria della Vita) in Parma, Pinacoteca, and Rome, Pallavicini.

camaïeu *See under* grisaille.

Camargo, Sergio de (1930–)
Brazilian sculptor who studied with Lucio
*Fontana in Buenos Aires and was influ-
enced by *Arp and *Brancusi on visits to
Paris. In 1961 he settled there. The charac-
teristic Camargo is a wood relief formed by
close-packed sections of cylinders pro-
truding at random angles, all painted white
and thus particularly responsive to light.

Cambiaso, Luca (1527–85) The only
outstanding native Genoese painter of the
16th century. Eclectic and prolific, he was
trained by his father **Giovanni Cambiaso**
(*c*.1495–*c*.1579), but formed through study
of the Genoese works of Perino del *Vaga,
*Giulio Romano and *Pordenone, and
perhaps also through a visit to Rome before
1544. He executed extensive *fresco
decorations in and around Genoa (Doria
Palace, now Prefettura, 1544; S. Matteo,
before 1559; Genoa-Turalba, Villa Imperi-
ale, *c*.1565; Palazzo Meridiana, 1565; S.
Lorenzo, 1569) and numerous altarpieces
(S. Bartolommeo degli Armeni; Montalto
Ligure, S. Giovanni Battista). By 1570 he
abandoned his earlier ingenious *Manner-
ist style for a sober, pious Counter-
Reformation naturalism (*see under* realism;
e.g. S. Giorgio), which became an almost
affected folk-like simplicity in his work at
the Escorial for King Philip II of Spain
from 1583 (*see also* Federico Zuccaro, Bar-
tolomé Carducho, Pellegrino Tibaldi). In
addition to large- and small-scale religious
works, however, he executed some quasi-
erotic mythological pictures (e.g. *Venus and
Amor*, Chicago, Institute) and, like his Cre-
monese contemporary Antonio *Campi,
produced some striking nocturnes.

Camden Town Group English
painters' group formed in 1911, linked by
admiration for *Post-Impressionism and
*Sickert. Its members included *Gore
(president), *Ginner, Augustus *John,
*Gilman, Wyndham *Lewis, Robert
*Bevan, Lucien *Pissarro, Henry *Lamb
and Sickert himself. There were three
group exhibitions in London in 1911–12;
then the group merged with others to
form the London Group. It had stood
for the representations of daily reality
enhanced by organized colour and formal
dispositions.

camera obscura, camera ottica A
mechanical device developed in the 16th
century as short-cut to two-dimensional
representation of three-dimensional reality.
A series of adjustable lenses and mirrors
in a darkened space or box project on to a
screen, canvas or piece of paper the scene
in front of the lens. *Canaletto is known to
have used a portable device of this type for
his panoramic views, and it was employed,
although to different ends, by Dutch artists
of the Delft school, notably Carel *Fabri-
tius and *Vermeer. *See also* Boccaccino.

Campagnola, Domenico (*c*.1500–
after 1552) and his adoptive father
Giulio Campagnola (*c*.1482–*c*.1515/18)
Venetian draftsmen, printmakers and
painters. Giulio Campagnola was also a
musician and well-versed in *Classical lan-
guages. Born in Padua, he may have trained
with *Mantegna at the court of Mantua:
some of his early engravings (*see under*
intaglio) may have been executed after
Mantegna's designs; others copy directly
from *Dürer. He is however chiefly known
for a group of poetic landscape prints and
drawings after, or in the manner of, *Gior-
gione and the young *Titian, which use a
characteristic dotted technique to soften
contours and suggest atmosphere. No
painting has been securely attributed to
him. Son of a German artisan, Domenico
was trained, as well as adopted, by Giulio.
He became proficient in both engraving
and woodcutting (*see under* relief prints),
quite exceptionally cutting many of his own
woodblocks. He also became famous for
his landscape drawings, which he sold as
finished compositions. An eclectic artist
copying from many different sources
including the antique, he even passed off
a group of his own drawings as *Titian's
preparatory designs for woodcuts. He
settled in Padua around 1520, and became
the city's busiest painter (e.g. *frescos,
Scuola di S. Antonio; S. Giustina; Palazzo
Dusoni; Museo Civico).

Campaña, Pedro de (1503–*c.*1580)
Eclectic Flemish painter, sculptor, and
architect mainly active in Spain. Born in
Brussels as Pieter Kempeneer, he settled in
Seville from 1537 to 1562, after some seven
years in Italy. His work combines Flemish
*realism with Italian influences, drawing
both on the *classicism of *Raphael and the
*Mannerist *expressionism of *Tintoretto
(Seville, Cathedral; Santa Ana; Montpel-
lier, Museum). In 1563 he returned to
Spanish Flanders to manage a tapestry
works for the Duke of Alba.

Campen, Jacob van (1595–1657)
The most distinguished Dutch architect,
from an accomplished and wealthy family.
Like Inigo *Jones in England, he introduced
*Palladio's *Classical style to the archi-
tecture of Holland (Amsterdam, Burgher
Orphanage, Municipal Theatre, Royal
Palace, now Town Hall; The Hague,
Mauritshuis) and was also an important
champion of classicizing *History painting,
trained in the studio of Frans de *Grebber
in Haarlem and spending some years in Italy
between 1615 and 1621. As supervisor of
the Stadtholder's building schemes in the
1640s, he planned, participated in, and
commissioned from others the important
*allegorical decorations of the Oranjezaal
in the Huis ten Bosch near The Hague,
(*see also* Solomon de *Braij; Caesar Boëtius
van *Everdingen; *Honthorst; *Jordaens).
Except for his work on the Oranjezaal,
few paintings by van Campen are known,
although a large mythological canvas, *Argus
Lulled to Sleep by Hermes*, was discovered
recently and is now in The Hague, Maurit-
shuis. His knowledge of *perspective and
the methods of architectural surveyors are
thought to have influenced *Saenredam,
whose portrait he drew (London, British).

Campi Dynasty of painters from
Cremona, mainly active there and in Milan.
The best known are the three sons of
Galeazzo Campi: Giulio (after 1500–72)
and his younger (half?) brothers and pupils,
Antonio (1520/5–87) and **Vincenzo**
(1530/5–91). A distant relation,
Bernardino Campi (1522–91) also
studied under Giulio and became the first
teacher of Sofonisba *Anguissola.

Giulio Campi was an eclectic painter of
altarpieces and church *frescos (Cremona,
S. Abbondio, S. Agata, S. Sigismondo,
S. Margherita, cathedral; Milan, Brera).
Antonio Campi, like Giulio a painter of
religious subjects, began, as early as 1567
(Cremona, Museo), to specialize in noct-
urnal scenes (notably Milan, S. Paolo, 1581;
S. Angelo, 1584). Painted for Milanese
churches just before and during *Cara-
vaggio's apprenticeship in Milan, they are
thought to have influenced the younger
man's *tenebrist manner, first apparent in
Caravaggio's paintings for chapels rather
than in his earlier *genre pictures.
Vincenzo Campi is best remembered for
his large *still-life with *genre paintings,
which are among the earliest of their type
in Italy (Milan, Brera). Painted in the mid-
1570s, they were influenced by the works
of *Aertsen and Beuckelaer in the Farnese
collection in Parma, where Vincenzo was
active at the time. Vincenzo's market scenes
are the immediate antecedents of similar
paintings by *Passarotti and Annibale
*Carracci.

Campin, Robert (*c.*1375–1444) One
of the great pioneers of Netherlandish art,
now frequently identified with the *Master
of Flémalle. He was the leading painter in
Tournai from *c.*1410 until his death; Rogier
van der *Weyden and Jacques *Daret were
among his many pupils. Despite biograph-
ical data, none of his paintings is docu-
mented and the work discussed below has
been attributed to him by deductions from
style and by comparison with other artists
as well as from the scant recorded infor-
mation. Campin/the Master of Flémalle
introduced to panel painting the monu-
mentality of form and dramatic inten-
sity already achieved in Netherlandish/
Burgundian sculpture (*see* Claus Sluter). In
addition, he is credited with originating
that system of 'disguised symbolism' which
came to characterize Netherlandish art
(*see* Jan van Eyck) and its successors,
notably Dutch 17th-century painting. By
portraying religious events as taking place
in the convincingly represented actual envi-
ronment of the Netherlandish bourgeoisie,
Campin/Flémalle fostered a deliberate
ambiguity. A round form silhouetting the

Virgin's head simultaneously represents a firescreen and a halo (*Virgin and Child before a Firescreen*, *c*.1428, London, National). The well-appointed room in which the *Annunciation* is enacted in a famous *triptych (*Mérode Altarpiece*, *c*.1426, New York, Metropolitan, Cloisters) contains a water basin and towel against the wall, and a white lily in a jug on the table. Previous knowledge of Marian symbolism, as formulated in theological and mystical texts and in church liturgy, and pictured in earlier paintings, enables us to 'read' at least one of these objects, the lily, as a precise reference to the purity of the Virgin, and to infer a similar significance for the others. In other words, the viewer is invited to scan the whole painting for religious significance, and by extension the entire world of appearances, so cunningly imitated here in the new technique of oil painting. This is a precise pictorial parallel to contemporary Netherlandish religious mysticism, increasingly propounded among the laity.

Campin may have been born in Valenciennes, but his career is entirely documented in the city of Tournai, where he held administrative posts devolving from his deanship of the painters' guild from 1423. His prestige as an artist may be gauged from the fact that when, in 1432, he was charged with leading a dissolute life, and sentenced to a year's exile and a penitential pilgrimage, the sentence was commuted to a fine through the intervention of Jacqueline of Bavaria, daughter of the Count of Holland. The earliest extant painting attributed to him (as the Master of Flémalle) is the *Entombment Triptych* of *c*.1415–20 (London, Courtauld), where a new, forthright bourgeois *realism makes its first appearance. A slightly later fragment from an altarpiece depicting the *Life of St Joseph* (*c*.1420, Madrid, Prado) shows the beginnings of the use of 'disguised symbolism'.

The artistic identity of the 'Master of Flémalle' has been reconstructed around three large panels, *c*.1430–4, now in Frankfurt, Kunstinstitut, wrongly said to have been painted for an abbey or castle of Flémalle. A stylistically related fragment of an altarwing representing either the *Repentant* or the *Unrepentant Thief*, *c*.1428–

30, is in the same museum. All are monumental, individually characterized and dramatic. Two portraits in London, National, are widely attributed to the same artist and his shop.

The reader should be aware that although a wide consensus has been reached about the attributions and identification proposed in this entry, there is still a large measure of uncertainty about the relationship between Flémalle/Campin/ the young Rogier van der Weyden and the *oeuvre* here described.

Canaletto; Giovanni Antonio Canal, called (1697–1768) Venetian *vedute painter working largely for the English market and mainly resident in England 1746–55. He trained first as a scene painter under his father Bernardo Canal, and worked with his father and brother Cristoforo in theatres in Venice and Rome, 1719–20. Little is known of his training in easel painting, although he must have studied the work of older *vedutisti* such as *Van Wittel (Vanvitelli) and *Carlevaris. Canaletto's early pictures for local patrons are carefully, but freely, painted and based on individual studies. They include his masterpiece, *The Stone Mason's Yard* (1725/6, London, National). He soon discovered, however, that the mass production of pictures of celebrated sights for tourists paid better than the painting of individual masterpieces. He therefore streamlined his technique, trained a studio of assistants, one of whom was his nephew Bernardo *Bellotto, and turned out a steady stream of formulaic, brightly lit pictures, based on a repertoire of drawings (many of them now in the Accademia, Venice) from panoramas projected in a *camera obscura. His connections with English tourists, strengthened by an association with the famous collector, later British consul to Venice, Joseph Smith, led him to follow his clients to England when the 1741 War of the Austrian Succession made travel on the Continent hazardous. But, after a promising start, his English paintings disappointed, and they, and his later Venetian works, show a marked decline from his former achievements. Nonetheless, in 1763, after two unsuccessful earlier attempts,

Canaletto was finally elected to the Venetian *Academy. While few major paintings remain in Italy, there are innumerable pictures by him in England (Royal Coll. and private colls.; London, National, Wallace) and many in the USA and on the Continent. Canaletto's luminous etchings (*see under* intaglio) are also to be found in many collections and printrooms, including Venice, Correr.

'Candlelight Master' *See* Bigot, Trophime.

Cano, Alonso (1610–67) Outstanding Spanish painter, draftsman, sculptor and architect active at Granada, Seville, Madrid, Valencia and Malaga; the son of a joiner and *retable designer who taught him the rudiments of architecture and sculpture. Born in Granada he lived in Seville 1614–38, where he was apprenticed for a time to *Pacheco and perhaps also to *Montañés, whose close follower he became. Cano's art belies his violent character and the melodramatic events of his life (*see below*). His paintings from the mid-1620s to *c.*1635 follow *Zurbarán in severity and *tenebrism (e.g. Seville, Museo), but after this early period he began to employ lighter colours and a looser brush (e.g. London, Wallace) culminating in the luminous and serene *classicizing works executed in Madrid *c.*1640–51, and in Granada in 1652–67 (e.g. *St Isidore's Miracle of the Well*, 1645–6, now Madrid, Prado, seven *Mysteries of the Virgin*, 1652–5, Granada, cathedral; *Virgin and Child*, *c.*1659/64, Guadalajara, Museo; other late works, Madrid, Prado, Academy; and Granada, Museo). His major sculptural work dates from his periods in Seville (high altar at Lebrija, S. María, 1629–31) and Granada, where he established the fashion for small *polychrome wood statuettes. Nothing remains of his sculpture from the Madrid period.

Quarrelsome and jealous, Cano left Seville under a cloud, having spent part of 1636 in jail for debt, and having wounded a colleague in a duel in 1637. Possibly through the intervention of *Velázquez, who had also been in Pacheco's studio, he received an invitation to the court at Madrid. But in 1644 his young wife, whom he had married in 1631 when she was 12, was found dead with 15 stab wounds, and the artist was arrested and tortured – although, by royal command, his right arm and hand were spared. Set free, he fled to Valencia, before returning secretly to Madrid. He was finally ordained a subdeacon and appointed a canon of Granada cathedral.

Canogar, Rafael (1934–) Spanish painter, member of the El Paso group with Feito and *Saura, dedicated to expressive *abstract art and to opposition to the fascist régime of Franco.

Canova, Antonio (1757–1822) Italian sculptor, a dominant figure in Western art in his day. Born near Venice, he settled in Rome in 1781 where he soon belonged to an international group of *Neoclassical artists intent on revolutionary change. Public commissions showed him chastening his originally lively, *naturalistic style in search of the beauty afforded by clear forms and the harmony of lines and relationships recommended by *Winckelmann. Sculpture made for Popes Clement XIII and XIV established his fame and led to commissions from European and American patrons. He travelled occasionally but claimed he could work only in Rome. He received many papal and foreign honours, and was known to be friendly and supportive to young colleagues. In 1810 he was elected president of the *Academy of St Luke, and its president in perpetuity in 1814.

His work ranged from portrait busts to large heroic groups (the sculptural equivalent of *History paintings); his style allowed for a range from delicate lyricism, as in *Cupid and Psyche* (1787–3; Paris, Louvre) *The Three Graces* (1812–14; London, V&A, and Edinburgh, Scottish NG) to enduring gravity and concentrated symbolism, as in his *Monument to the Archduchess Maria Christina* (1798–1805; Vienna, Augustinerkirche), described by a contemporary as 'a scene from Sophocles, executed in that era', and Canova's variant of a tomb he had designed for *Titian. Canova was judged to have outdone the

ancients in his work, and thus contributed to the ending of the long tradition whereby the antique had for centuries been thought superior to anything modern. In his concentration on form and all-round viewpoints he prepared the ground for the revitalization of sculpture in the later 19th century by *Carpeaux, *Hildebrand, *Rodin and others, but the wave of *Romanticism, rising as he died, made his immediate successors regard his work as *academic and dry.

Cantagallina, Remigio *See under* Bella, Stefano della, and Callot, Jacques.

canvas A heavy durable cloth originally made from hemp or jute and used for sails and tents; it can also be woven from linen or cotton, and is the principal material on which oil paintings are executed. Pictures on cloth, produced throughout Europe in the 14th and 15th centuries for carrying as standards in processions were normally painted in *size on linen canvas; they were highly perishable and are now very rare (*see*, e.g. *Bouts). The use of oils on canvas seems to have been pioneered in late 15th-century Venice. Oils on canvas now replaced damp-sensitive *fresco for the large narrative scenes commissioned by the Venetian *Scuole* (*see*, e.g. *Carpaccio, Gentile *Bellini). These wall-paintings were not intended to be portable, but by the 16th century canvas had made possible the 'mail-order' practice of, e.g. *Titian. Unlike size, oil paints are not intended to stain the cloth support but to remain on its surface; to this end canvas is primed with a non-absorbent layer. At first, the chalky white *gesso used on panels was also employed on canvas; soon, painters switched to oil-based white or coloured primers, less liable to crack when the canvas is rolled for transport and considerably less labour-intensive. There are various methods of making canvas taut for painting and for display; the wooden frame used is known as a stretcher.

Čapek, Josef (1887–1945) Czech painter, brother of the writer Karel (1890–1938) some of whose books he illustrated. In 1911–12 he was a member of

an avant-garde group combining *Cubist fragmentation with *Expressionist warmth, but soon he was concentrating on the *abstracting and emblematic tendency in Cubism in order to reach a basic, urban but *primitive synthesis in paintings and in graphic work. In the 1920s he gave priority to social themes in his work. Unlike Karel, he experienced the Second World War under the German occupation. He died in Belsen concentration camp.

Cappelle, Jan van de (*c*.1624–79) Marine painter of the *classic phase of Dutch art (*see also* Aelbert Cuyp). He specialized in early morning or evening scenes in harbours or the mouths of rivers with ships at anchor. He also painted winter landscapes. Van de Cappelle ran his family's prosperous dye-works and his fortune enabled him to accumulate one of the greatest art collections of the time, including more than 500 drawings by *Rembrandt, as well as quantities of works by other seascape painters. There are works by him in most important collections.

Capriccio (Italian, whim, fancy) The Italian 18th-century imaginary, fantastical landscape, pioneered by *Magnasco and Marco *Ricci. Its greatest exponent was *Guardi. But the genre has clear affinities also with Salvator *Rosa's scenes of brigands and witchcraft, François de *Nomé's ('Monsù Desiderio') architectural fantasies, the imaginary compilations of actual ruins by *Pannini, and *Piranesi's romanticized archaeological etchings. The term is sometimes used for any or all of these.

Caracciolo, Giovanni Battista, called **Battistello** (1578–1635) Neapolitan painter, one of the greatest followers of *Caravaggio, although unlike the latter he worked in *fresco as well as in oils. First trained in the *Mannerist tradition of the Cavaliere d'*Arpino, Caracciolo became converted to Caravaggio's *tenebrist *naturalism on the Lombard artist's first stay in Naples in 1606; (Naples, S. Maria della Stella, Church of the Pio Monte della Misericordia; etc.). In 1614 Caracciolo went to Rome, where he saw the work of Annibale *Carracci in the Farnese Gallery;

next he travelled to Florence (Pitti), where he probably met *Allori, and Artemisia *Gentileschi. Finally he went on to Genoa, where in 1618 he executed decorative frescos; he returned to Naples by the end of that year. In this late phase his Caravaggism was superseded by a more *classicizing *Baroque style indebted to *Lanfranco (S. Martino; S. Diego all'Ospedaletto). A pendentive he painted in 1623 in the Cappella del Tesoro in Naples Cathedral was later destroyed to make way for *Domenichino, whose work influenced Caracciolo's later easel paintings and frescos, in which the drawing is given more prominence, and rhetorical effects accentuated (frescos in Oratorio dei Nobili, Gesù Nuovo; Palazzo Reale).

Caravaggesque *See* Caravaggio.

Caravaggio, Michelangelo Merisi da (1571/2–1610) Called Caravaggio after his birthplace near Milan, he is the prototype of the turbulent Bohemian artist, his explosive personality helping to obscure the traditional elements of his painting. It is now obvious, however, that from *c.*1599 he drew on High *Renaissance and even antique models, and that his *decorum-defying naturalism (*see under* realism) derived from Flemish art mediated through Veneto-Lombard painting of the early 16th century (*see* Lotto, Moretto, Romanino, Savoldo). Caravaggio's influence was indeed greatest on artists in areas of Flemish artistic ascendancy, notably Naples, Spain and the Netherlands. Except, perhaps, in Naples, *caravaggismo* characteristically combines subjects and compositions of Caravaggio's youthful works (half-length figures set in shallow space, prominent *still-life elements) with the *tenebrism of his later production.

Caravaggio was apprenticed in 1584 to Simone Peterzano, a Milanese painter in oils and fresco. Whether from inadequate training or aesthetic preference, Caravaggio confined himself to painting in oils, in a narrow range of earth colours, even in his large-scale Roman chapel decorations (S. Luigi dei Francesi, Contarelli chapel, 1598/9; S. Maria del Popolo, Cerasi chapel, 1601). These works, despite being in oils on

canvas, require to be viewed *in situ* and not as portable easel paintings.

His earliest years in Rome, from *c.*1588, are shrouded in uncertainty but were undoubtedly difficult. He was employed for a time in the workshop of Giuseppe d'*Arpino as a fruit and flower specialist, although it is not clear whether he ever produced independent *still lifes without accompanying figures. The only one known, a *Basket of Fruit* (Milan, Ambrosiana) may have been painted as a trial piece, since the background was added later.

In the 1590s Caravaggio found patrons among art-collecting high-ranking ecclesiastics. For Monsignor Petrignani he painted a lyrical *Rest on the Flight to Egypt* indebted to Lotto, and a full-length *Repentant Magdalen* (both Rome, Doria). But most of the pictures painted before 1598, including those executed in the household of Caravaggio's important patron, Cardinal Francesco María del Monte (1545–1626), are of secular subjects. They combine half-length figures of androgynous youths (many of them Caravaggio himself reflected in a mirror) with *illusionistic still lifes (*Boy with fruit*, Rome, Borghese; *Lute-Player*, St Petersburg, Hermitage). Some allude playfully to the antique (*Bacchus*, Florence, Uffizi). All may embody poetical, emblematic and allegorical conceits (as is obviously true of the *Concert of Youths*, or *Musica*, New York, Metropolitan). There are some low-life subjects (*Fortune-teller*, Paris, Louvre) and some studies of expression (*Boy bitten by a Lizard*, London, National).

Probably through the intervention of Cardinal del Monte, Caravaggio received his first monumental commission for the altarpiece and lateral paintings of the Contarelli chapel (*Calling of St Matthew, Martyrdom of St Matthew*, 1598/9; *St Matthew writing his Gospel*, first version formerly Berlin, Kaiser Friedrich, destroyed, second version *in situ*). Working directly on the canvas (*see alla prima*) Caravaggio had to make many, and radical, changes to the composition of the *Martyrdom*. The first altarpiece was rejected; the second one was completed in 1602. In these works were find Caravaggio's earliest use of tenebrism; strong contrasts of dark and light are

employed to render relief, to harmonize with the restricted source of light in the chapel and to illustrate the spiritual significance of the scenes. A second monumental commission followed for the Cerasi chapel (lateral paintings, *Martyrdom of St Peter*, *Conversion of St Paul*, 1601). The low-life naturalism of these scenes dismayed lower clergy, the general public, and some theoreticians of art, but found favour with upper clergy and connoisseurs. Despite controversy, Caravaggio was awarded commissions for altarpieces (*Deposition*, 1602, Vatican, Pinacoteca; *Madonna di Loreto*, 1604, S. Agostino; *Madonna del Serpe*, 1605, Borghese; *Madonna of the Rosary*, 1605?, Vienna, Kunsthistorisches; *Death of the Virgin*, 1605/6, Paris, Louvre).

In May 1606 Caravaggio killed his opponent in a duel following a brawl over a game of tennis. Severely wounded himself, he fled Rome, and after some months resumed his career as a painter of monumental devotional works in Naples (*Flagellation of Christ*, S. Domenico Maggiore; *Seven Works of Mercy*, 1607, S. Maria della Misericordia). In 1608 he went to Malta (portrait of Alof de Wignacourt, Paris, Louvre; *Beheading of St John*, Valletta, cathedral) where he was received into the Order of St John. Imprudently quarrelling with a superior, he was imprisoned. His escape was followed by a year (1608–9) of itinerant painting in Sicily (Syracuse, Messina, Palermo). These late pictures, hastily executed, are now in poor condition. They show increased pathos: light now flickers over figures reduced in scale, revealing and suggesting expression more than form.

Returning to Naples, Caravaggio was set upon by hired thugs and disfigured. He continued to paint after his convalescence (*Crucifixion of St Andrew*, Cleveland, Ohio, Museum). Expecting a papal pardon for the homicide of 1606, he set sail from Naples in June 1610, only to be arrested, mistakenly, at Port' Ercole. Released, he set out after the boat which was carrying all his belongings, and died, at Port' Ercole, of a malignant fever. Ironically his pardon had been granted shortly before.

Caravaggio's *oeuvre*, from the suave homoerotic paintings of the 1580s through

the tragic visions of 1606–10, is distinguished by its directness of address to the viewer, accomplished in his youth through mastery of close-range illusionism (*Supper at Emmaus*, London, National), later through selective social realism and the expressive manipulation of light. These qualities may compensate for his shortcomings in the composition of large-scale narrative, but do not disguise them. Caravaggio's dependence on the model, his method of painting *alla prima*, caused him to be classified as a *colourist, despite the restricted range of colours he employed (*see also disegno*).

Carducho, Bartolomé (*c.*1560–1608) and his brother **Vincencio** or **Vicente** (1576–1638) Florentine-born painters working in Spain from 1585, when Bartolommeo Carducci (as he was known) accompanied his master Federico *Zuccaro to the Escorial, bringing with him his nine-year-old brother. After Federico's abrupt dismissal in 1588, Bartolomé remained in Spain and in 1598 was appointed court painter to Philip III. With Vincencio's assistance he worked, in oils and *fresco, on the decoration of royal residences at Segovia, Valladolid, the Escorial and the Prado, evolving further the simple, *realistic style employed at the Escorial in the 1580s and 1590s by *Tibaldi and Luca *Cambiaso. There are works by Bartolomé in Madrid, Prado, Colegio de S. Marca; Lisbon, Museu, Escorial.

Vincencio became one of the most prolific Spanish painters and draftsmen, the bitter but unsuccessful rival at court of *Velázquez. In addition to the innumerable works he executed for religious foundations all over Spain he wrote a famous treatise, *Diálogos de la pintura, su defensa, origen, essensia, definición, modos y diferencias*, Madrid, 1633. These *Dialogues on Painting* castigated the 'disregard of beauty' and naturalism (*see under* realism) of *Caravaggio and his followers, thus indirectly indicting Velázquez, and defended the moral purpose of art and the *decorum required of religious painting. As a painter, Vincencio Carducho is probably best appreciated through his vivid oil sketches, 22 of which survive, for a series of Carthusian scenes

for El Paular near Segovia (20 in Florence, coll. Contini-Bonacossi; one in Edinburgh, National; one in London, pc).

Cariani, Giovanni Busi, called (*c.*1485–after 1547) Innovative Italian painter, probably born in the region of Bergamo but active mainly in Venice, where he is recorded from 1509 in the workshop of Giovanni *Bellini and the circle of *Giorgione. These influences are evident in his early works (*The Concert*, Warsaw, Museum; *The Lutenist*, Strasbourg, Museum). A visit to Bergamo in 1517, however, acquainted him with the styles of *Lotto, in the city since 1512, and *Romanino, at that time employed in nearby Cremona; he seems also to have known the Brescian *Savoldo. Cariani's mature work combines a Venetian sense of colour (*see under* disegno) with Lombard *realism, sometimes foreshadowing *Caravaggio (e.g. Lugano, Heinemann). In addition to Giorgionesque pastorals, *allegories, altarpieces and pictures for domestic devotion, he executed remarkable portraits, some of which show a knowledge of German art (e.g. *Woman of Nuremberg*, Vienna, Kunsthistorisches). There are other works by Cariani in Bergamo, Carrara, Cathedral; Milan, Brera; Ambrosiana; Ottawa, National Gall. of Canada; Rome, Pal. Barberini; Borghese; London, National; etc.

caricature (Italian *caricatura* or *ritratto caricato*, loaded – that is, exaggerated – portrait, from *caricare*, to load) Strictly speaking, not any comical, grotesque or satirical figure drawing or representation (such as the 'grotesque heads' of *Leonardo or the satirical tax collectors and money changers painted by *Marinus van Reymerswaele), but a likeness which deliberately brings to light and exaggerates the faults and weaknesses of an individual for purposes of mockery. The caricature portrait was invented at the end of the 16th century in the studio of the *Carracci. The sculptor *Bernini was a famous early practitioner, and the genre had a great vogue in 18th-century England, where not only *Hogarth but even *Reynolds painted caricature *Conversation Pieces (the latter, it is true,

only during his study trip in Italy). *Rowlandson and *Gillray are the best-known English caricaturists. Theoreticians of art took the genre very seriously, as the 'low' counterpart to 'high' academic portraiture. Where the *classicizing academic portraitist stripped off all 'accidental' features to reveal the noble essence of the sitter (*see also* Academy; idealization), the caricaturist unmasked the petty self concealed by social conventions and pretensions.

Carlevarijs or **Carlevaris, Luca** (1663–1730) Painter, etcher and mathematician; born at Udine but active in Venice; the first recorder of Venetian scenes as advertisements of the Serene Republic's splendours. This aim was expressly announced on the title page of his series of *vedute* etchings (*see under* intaglio), 1703 (preparatory drawings, London, British). A number of his paintings depict receptions or regattas in honour of foreign kings and ambassadors, and were produced for foreign participants in these events (e.g. St Petersburg, Hermitage; Copenhagen, Fredericksborg; Birmingham, Gallery; Dresden, Gemäldegalerie). *Canaletto was to re-use his compositions in similar scenes. Carlevarijs's paintings are few; a sketchbook, in oils, of studies of figures – more lively than his finished works – is in London, V&A.

Carlone, Carloni Northern Italian dynasty of sculptors and decorative *fresco painters, largely active in Genoa; the best-known are the sculptor **Taddeo Carloni** (1543–1613, Genoa, Pal. Doria, *Neptune Fountain*); the brothers **Giovanni Andrea** (1590–1630) and **Giovanni Battista** (1592–1677) Carlone, fresco painters (Genoa, Gesù, S. Siro, Annunziata; etc.). Giovanni Battista's son Andrea (1639–1697) worked in *Maratta's studio in Rome (Rome, Pal. Altieri) and brought back to Genoa a fluid manner indebted to *Pietro da Cortona. The versatile decorative painter **Carlo Innocenzo Carloni** (1686–1775) worked throughout Lombardy and in Vienna, Prague and Southern Germany.

Caro, Anthony (1924–) British sculptor, born in London, who took a

degree in engineering before studying art at the Royal Academy Schools. He worked for some months as assistant to Henry *Moore and taught from 1952 at St Martin's School of Art, London. In the late 1950s he made heavy modelled figures in reaction against the stylizations of older contemporaries. A visit to the USA in 1959, and contact with *Post-Painterly Abstraction and with the sculptor David *Smith, led Caro to abandon *figuration and construct abstract sculptures out of steel girders and sheet, welded and bolted together and sometimes painted. He exhibited single pieces in London in 1960–1 and in 1963 he had an extensive one-man show at the Whitechapel Art Gallery which demonstrated that the negatives of not-modelling and not-figures had opened up for him a wide range of expressive possibilities. Placing his sculpture on the floor, not on a base, gave it a particular immediacy. He has pursued ever new formal discoveries. Like Moore, he has served as a model of professionalism through a combination of energetic work and a productive relationship the international art world. His success has been remarkable. 1964–5 saw one-man shows in New York, Washington DC and London; many others have followed. Caro's fame and activity have become global and the range of his work has widened astonishingly. He has made small 'table sculptures', large sculptural towers that are almost architecture and multi-part sculptures commenting on conflict and death in modern forms and major religious art of the past from *Giotto to *Rodin.

Caron, Antoine (early 1520s–c.1600) French *Mannerist painter and draftsman, first recorded working under *Primaticcio before 1500, later painter to Queen Catherine de'*Medici and closely connected with the Catholic League. Only one painting by him is known to represent a traditional religious subject (*Resurrection*, Beauvais, Musée); the remaining works – easel paintings, drawings for tapestries and engravings – fall into three main categories: allegorical subjects, recalling the famous festivities of the Valois court (e.g. *Histoire d'Artémise*, drawings); massacres, alluding to the contemporary Wars of Religion (e.g.

Massacres under the Triumvirate, 1566, Paris, Louvre) and fantastical or occult subjects (e.g. *Augustus and the Sibyl*, Paris, Louvre).

Carpaccio, Vittore (1460/5–1525/6) Venetian painter, a specialist in *teleri*, the large narrative paintings on canvas which adorned the *scuole* – charitable confraternities characteristic of Venice (Scuole di S. Giovanni Evangelista, 1494; di S. Orsola, 1495–1500, both now Venice, Accademia; di S. Giorgio degli Schiavoni, 1502, in the *scuola* building but not in the room for which they were painted; degli Albanesi, c.1504, now Venice, Ca d'Oro, Galleria Giorgio Franchetti, and Museo Correr; di S. Stefano, c.1511–20, dispersed amongst many museums including Milan, Brera). He was also employed in the Doge's Palace. While Carpaccio may have trained under the *teleri* specialist Lazzaro Bastiani (c.1425–1512), he was more indebted to Gentile and Giovanni *Bellini.

Although he was unable to come to terms with the innovations of *Giorgione and *Titian after c.1507, Carpaccio's colourful, detailed 'inventory style' is superior to that of the other *teleri* painters, not only because of his response to light but also through his unerring feeling for interval and his fertile invention. He also executed a few altarpieces (Venice, Accademia, S. Domenico) and some portraits (Venice, Correr). Many of his drawings have been preserved (e.g. London, British; Paris, Lugt Coll.; Oxford, Christ Church).

Carpaccio's workshop included his son **Benedetto** (recorded 1530–45). The family name in Venetian dialect was Scarpazza; Carpaccio is the Italian form of the Latin Carpathius with which Vittore signed several of his works, and only came into use in the 17th century.

Carpeaux, Jean-Baptiste (1827–75) French sculptor, born at Valenciennes, son of a railway worker, trained by *Rude in the Ecole des Beaux-Arts. He was soon supporting himself with commissions, some of them for the town of Valenciennes. In 1854 he won the Rome prize; he went to Rome in 1856 and worked there intermittently until 1862, primarily on his first major piece, *Ugolino and his Sons* (1857–61). For

this he chose an awesome theme from Dante's *Inferno*, developing it as a free-standing group (he had first thought of a relief) and pushing its drama to the point of repulsiveness. Its *realism drew criticism when the work was shown in Paris in 1862 yet a bronze cast was bought by the state and placed in the Tuileries Gardens; he gave another to Valenciennes.

His power as a sculptor brought recognition from those not frightened by the dramatic strength of his art, and he began to receive commissions, e.g. for portrait busts and for tomb sculptures, from Paris society and the imperial family, as well as public commissions e.g. for reliefs for the exterior of the Louvre. He was awarded the Légion d'Honneur in 1866, and commissioned to make one of four groups for the front of the new Opéra. The group, *La Danse* (1869), caused a scandal because of its erotic, bacchanalian message and was vandalized in protest. He was in London in 1871, mixing with other French artists but also making contacts which led to English commissions then and later. With his brothers he ran a large Paris studio, which saw to the commercial development of his work through casts and variants and facilitated projects such as the large and complex *The Four Corners of the World supporting the Globe*. In his last years problems in the studio and in his marriage produced crises which led him to deny paternity both of some of the sculptures and of his wife's children. He went on working and tried to start a second studio. Deeply impressed by the art of *Michelangelo and *Raphael and marked by the dramatic realism of Rude, Carpeaux made sculpture that rarely aimed at grace or nobility but spoke through the vigour of its forms as well as his chosen themes and types. Now overshadowed by *Rodin's, it warrants greater fame. It is best seen in the Musée d'Orsay, Paris.

Carr, Emily (1871–1945) Canadian painter, working mainly in British Columbia and specializing in landscape. Working in isolation, she developed an intense view of nature which gave her work *Expressionist qualities and owes something to *Fauvism and later derived some formal characteristics from her contemporaries working in and around Toronto, known as the Group of Seven. Her autobiographical writings have contributed to her high national status.

Carrà, Carlo (1881–1966) Italian painter, prominent in the *Futurist movement, co-creator of *Pittura metafisica and subsequently a tradition-based *realist of great power. He was trained at the Milan Academy where he met *Boccioni. In 1910 he joined him and others in signing the two manifestos of Futurist painting. His personal manifesto of 1913 called for paintings delivering 'the plastic equivalents of sounds, noises and smells' of urban life. His first Futurist paintings were street scenes involving the spectator in impersonal dramas. In late 1911 he went with Boccioni and *Russolo to Paris to confront *Cubism. The work he showed in the 1912 Paris exhibition displays its impact: of the group, Carrà embraced Cubism most wholeheartedly. His work changed in 1914 when he gave priority to working with *collage and incorporating words in the Futurist exclamatory and onomatopoeic way. He eagerly served in the Italian army in 1915–16. In an army hospital in Ferrara he met de *Chirico and together they launched *Pittura metafisica. His early regard for *Giotto, *Uccello and other *Renaissance masters, never quite forgotten, became patent around 1919: Carrà now worked in a national idiom rooted in the early Renaissance and in antiquity, and was recognized as a major Italian artist. He published a number of books: Futurist texts (1915) and books on his life and his art (1945, 1962) among them. Milan commemorated him with a retrospective in 1967–8.

Carracci, Agostino (1557–1602), his brother **Annibale** (1560–1609) and their cousin **Lodovico** (1555–1619) Bolognese artists, because of whom Bologna assumed a leading role in Italian art in the 1590s. This was due not only to their individual and collaborative efforts as painters and (Agostino) engraver. They became famous teachers (of, e.g. *Reni; *Albani; *Lanfranco; *Domenichino) and, *c.*1582, founders of an art *Academy where artists

met to draw after the live model – an important feature of the Carracci's own practice – and discuss theoretical problems. In a lighter vein, they investigated problems of visual representation through pictorial guessing games and *caricature. The questions debated in the Carracci Academy echoed wider concerns: in 1582 the Archbishop of Bologna, Gabriele Palleotti, published a treatise calling for the reform of religious painting in accordance with the exhortations of the Council of Trent. In many respects these Counter-Reformatory precepts were a return to *Renaissance artistic ideals. The Carracci, and more specifically Annibale in his Roman works, 1595–1605, came to be seen as having rescued the great traditions of Italian art from the twin evils of *Mannerism and unbridled *realism (see Caravaggio).

The Carracci's much debated eclecticism was facilitated by Bologna's situation within the artistic map of Italy. A northern city, it looked simultaneously to Lombardy, the Veneto, across the Alps and to central Italy. In nearby Parma, the great *Correggio had already integrated the legacy of *Leonardo's Lombard sojourn (Milan, 1482–1500) with Venetian colourism (see under disegno). Before seeking out Correggio's own works, c.1585, Annibale had come under his indirect influence through the Urbino painter *Barocci, after whom Agostino executed reproductive engravings, 1582. But the warm and sensuous Venetian Renaissance idiom also survived undiluted and at first hand in the work of *Veronese. It was again Agostino, as a result of a trip to Venice in 1582 to make prints after Veronese's paintings, who first awakened the other Carracci's interest in this master (Madonna and Child, 1586, Parma, Galleria). Netherlandish *genre painting was collected throughout the region; the Farnese collection in Parma had an important group of pictures by Beuckelaer (see under Aertsen), and these works had, from c.1575, inspired local imitators, notably Vincenzo *Campi in Cremona and Bartolomeo *Passarotti (d.1592), a leading painter in Bologna in whose studio Agostino and Annibale spent some time c.1577–8. Annibale followed Passarotti in the painting of genre (Butcher's Shop,

c.1582/3, Oxford, Christ Church; Bean Eater, c.1583/4, Rome, Colonna). Unlike Passarotti's coarsely comical low-life pictures, however, his works in this mode treat their subjects with dignity. When, however, Annibale employed a similarly forthright manner in his earliest known dated religious painting, the altarpiece of the Crucifixion (1583, Bologna, S. Maria della Carità), Passarotti and other artists of the older generation were shocked. For such public paintings, Passarotti and his contemporaries employed a different style: the more highly *idealizing and artificial central Italian *Mannerism absorbed through study in Rome or Florence. The antagonism caused by his breach of stylistic *decorum may have alerted Annibale to the originality of this approach to the painting of istoria (see under genres); nevertheless, he henceforth tempered his naturalistic style through adopting a Correggesque mode (e.g. Baptism of Christ, 1585, Bologna, S. Gregorio).

Lodovico's painting in these early years was very different, more Mannerist and elegant, the brushwork more polished (e.g. Annunciation, c.1585, Bologna, Pinacoteca), perhaps contradicting the assertion of early biographers that he trained his cousins. Agostino practised mainly as an engraver, and as such was in the 1580s the most successful of the three Carracci. By 1580, however, the young artists had opened a joint workshop, albeit continuing also to work independently. They received their first collaborative commission c.1583: two mythological *fresco friezes for the newly constructed Palazzo Fava, Bologna (Jason and the Argonauts; Europa) followed in 1586 by a third (episodes from the Aeneid). Narrative friezes had been popularized in Bologna a generation earlier by *Nicolò dell'Abate and Pellegrino *Tibaldi. Borrowing motifs from the former, and the latter's Michelangelesque monumentality, the Carracci succeeded in improving on their predecessors. In 1589/90 they executed their collaborative masterpiece: the frieze of the Founding of Rome in the Palazzo Magnani, which in many details anticipates Annibale's Roman frescos. There followed the less extensive collaborative decoration of three rooms in the

Palazzo Sampieri, $c.1593/4$, after which, in $1594/5$, with Annibale's departure for Rome, the joint Bologna workshop split up. Agostino was to follow his brother in 1597.

During these formative years Lodovico's independent production began to diverge even more markedly from Annibale's. Like his younger cousin, he too looked to Correggio and the Venetians. But *Tintoretto proved to be a more lasting influence on him than Veronese. From $c.1587$ he began to employ brushstrokes and light and shade more *expressively, to convey emotion and a sense of mystery rather than to clarify form. The important paintings of these years are a series of five great *Baroque altarpieces, $1587–94/5$, now in Bologna, Pinacoteca, including his masterpiece, the *Preaching of St John* (1592); a *Holy Family with St Francis* of 1591 (Cento, Museo) and the *St Hyacinth* of 1594 (Paris, Louvre). After his cousins' departure from Bologna, Lodovico continued to teach, and greatly influenced many younger artists, notably Lanfranco and *Guercino; *see also* Algardi. After $c.1600$, however, his own work deteriorated, although the better pictures of this period still demonstrate his power to represent mystical and ecstatic experience (e.g. 1608–10, Bologna, Pinacoteca; S. Domenico).

Agostino, whilst predominantly a graphic artist and the moving spirit in the Carracci Academy, also executed several independent easel paintings between 1584 and 1593. In addition to the Dresden altarpiece already mentioned, there are pictures by him in Bologna, S. Maria della Pioggia; Vienna, Kunsthistorisches; Parma, Pinacoteca. His masterpiece is the much admired *Last Communion of St Jerome* ($c.1592/3$, Bologna, Pinacoteca), which marries Venetian colourism to a rigorously stable architectonic structure. Agostino, an intelligent man of wide culture, was through his work as a reproductive engraver familiar with a wide range of Renaissance paintings. It may have been he who first influenced Annibale to take a stand in opposition to Lodovico's emotionalism, opening Annibale's eyes to Raphael as he had done to Correggio and the Venetians. Annibale's *Sacra conversazione* (1593, Bologna, Pinacoteca) echoes the

structure of Agostino's *St Jerome*. In Rome, Agostino assisted Annibale in the Farnese palace gallery; after difficulties in collaboration, he left $c.1599$. From 1600 until his death he worked for the Farnese in Parma, where he left incompleted frescos in the Palazzo del Giardino. His son and assistant **Antonio** ($c.1589–1618$) then joined Annibale in Rome, where he remained more or less continuously, assisting Reni in the Chapel of the Quirinale, 1610; there are frescos by him in several Roman churches.

Annibale's work developed from the genre and genre-like paintings of the early 1580s through Correggesque and Venetianizing altarpieces and a more classicizing synthesis of 1593. Through such works his reputation grew, but it was almost certainly the Carracci workshop's success in the Palazzo Magnani which impelled Odoardo *Farnese of Parma to invite all or some of the family to help decorate the new Farnese palace in Rome. In the event, Agostino and Annibale arrived on a preliminary visit but only Annibale remained. The first task brought to completion by him was the ceiling decoration of the small *Camerino* used by Odoardo as his study (original centrepiece, *Choice of Hercules*, now Naples, Capodimonte). Although influenced by Central Italian Renaissance forms, the *Camerino* decoration relates more closely to Annibale's recent Bolognese work than to his Roman environment, unlike his major work for the Farnese, and the culmination of his career: the fresco decoration of the vault of the Farnese palace gallery, $c.1597–1600$. This key document in the history of European art is today little known by the wider public, due to its virtual inaccessibility in what is now the French embassy in Rome. Annibale's solution brilliantly resolved the *iconographic challenge: the gallery was to house the great Farnese collection of ancient sculpture; he created on the vault a 'picture gallery' of mythological scenes. More importantly, he revived on the gallery ceiling Michelangelo's architectonic scheme for the Sistine chapel ceiling, ridding it of its illogical shifts in scale and viewpoint and its spatial ambiguities. In so doing Annibale provided the 17th century with the major alternative

to the *illusionistic 'open' ceiling – the two traditions being merged in *Pietro da Cortona's great fresco in the Palazzo Barberini. Furthermore, in executing the Gallery decoration, Annibale once more adjusted his pictorial style: modelling himself on Michelangelo, on Raphael's Villa Farnesina *Psyche* paintings and on ancient sculpture, but without losing either his northern naturalism or his vibrant Venetian colourism, he forged a new style which underpins all of the classical revival of the 17th century. Basing every figure on studies after the live model, he reformulated in vigorous and convincing form an ideal vision of humankind.

While the gallery, true to the overall theme of its mythological scenes – 'Love conquers all' – is joyous in feeling, Annibale also created deeply felt, tragic religious paintings. Perhaps the most important is the *Pietà* (c.1599/1600, Naples, Capodimonte), but other such works, all influential, are now in London, National; Paris, Louvre; St Petersburg, Hermitage; Vienna, Kunsthistorisches. In 1600–1 he competed directly with his 'rival', the 'arch-naturalist' Caravaggio, in the altarpiece of the *Assumption of the Virgin* for the Cerasi chapel, S. Maria del Popolo, for which Caravaggio executed the side paintings.

Landscape painting, while a small part of Annibale's output, was another of his fundamental contributions to the history of Western art. He created the 'ideal landscape' (between 1598 and 1601; Rome, Doria; Grenoble, Musée), in which a monumental, classical vision of nature, on the moderate scale of the landscapes of northern artists such as Paul *Bril, provides the setting for mythological or religious narrative. His pupils Albani and Domenichino carried on this genre of painting, which in turn directly influenced the ideal or heroic landscapes of *Poussin and *Claude.

Annibale's last years were darkened by depressive mental illness, precipitated by Cardinal Farnese's miserly payment for his labours in the Farnese gallery, and his sense of humiliation as a retainer in the Cardinal's household. Despite the affectionate concern and care of his devoted pupils, he painted little after 1605, although he executed some etchings c.1606.

Carreño de Miranda, Juan (1614–85) The most important Spanish *Baroque court painter after *Velázquez. A nobleman by birth and a favourite of Queen Mariana, who ruled for her young son Charles II after the death of Philip IV in 1665, he painted elegant, but generally severe, portraits of members of the court (Madrid, Prado) as well as religious scenes in oils (Madrid, Hospital of Third Order; Courson, near Arpajon, Castle; Paris, Louvre; Barnard Castle, Bowes) and *fresco (Toledo, Cathedral; Madrid, royal palace; various churches).

Carriera, Rosalba (1675–1757) Internationally celebrated Venetian pastellist, specializing in bust-length, single-figure *Fancy Pictures and portraits. Although her work now appears insipid and flimsy, its historical interest is considerable. The earliest *Rococo portraitist, Carriera initiated a new type of likeness, seemingly intimate yet flattering. The Fancy Pictures of girls impersonating the *Arts*, the *Seasons* or the *Elements* (e.g. Washington, National) anticipate *Greuze. She was also capable, as in her self-portraits, of objective observation (e.g. Royal Coll. Windsor Castle). Her popularity was greatest among foreign tourists to Venice, notably the English, who first discovered her, and the French, whose admiration for her work was tinged with gallantry. She spent a triumphant year in Paris, 1720–1, executing, among innumerable others, two pastels of the young Louis XV and being made a member of the Royal *Academy. In 1730 she travelled also to Vienna. The rest of her working life was spent in Venice, although she catered to a large mail-order clientele: Augustus III, Elector of Saxony and King of Poland, assembled the greatest collection of her work in Dresden (Gemäldegalerie). *Pellegrini, married to one of her sisters, acted virtually as her agent in England. Her influence was formative on Maurice-Quentin de *Latour and *Liotard and she had a number of Italian imitators, including her sister Giovanna.

Carriera's career was cut short by blindness in 1745 and she died in isolation, but not forgotten by her foreign admirers. There are works by her in many public and

private collections beside the ones already mentioned, including Venice, Accademia, Ca'Rezzonico; Wolterton Hall.

Carrière, Eugène (1849–1906) French painter, associated with *Symbolism. He was trained in Strasbourg and Paris and became known for his fine mind and sensitive feelings and for the particular character of his paintings. These presented familiar domestic themes (e.g. Mother and Child) in paintings tending towards monochrome and giving a strong impression of atmosphere or mood, of deep, mysterious space and of physically insubstantial figures within it. The state bought his *Sick Child* (1884; Paris, Orsay) which, in subject and manner, may have inspired a sculpture by *Rosso. He was also a fine portraitist, again setting tonal *naturalism above any decorative or constructive use of colour. He was thus marginal to the activity of the *Symbolists, proposing a simple, not very imaginative response to the question of what a painting was capable of representing; he shunned the emphasis on colour and clear design which marked the *avant garde of his time. Among his pupils, though only for short time, was *Matisse; it may be that his succinct yet atmospheric forms influenced *Brancusi. The fullest collection of his work is in the Musée d'Orsay, Paris.

Carrington, Leonora (1917–) British painter and writer who studied art in Florence, Paris and London and became associated with the Paris *Surrealists in the later 1930s. She settled in Mexico and developed in her art a fantasy world of insect-like figures.

Carstens, Asmus Jacob (1754–98) Grandiose German *NeoClassical draftsman and painter, affected by the writings of *Winckelmann and as influential on German *Romantic artists (*see especially under* Nazarenes) as he was on other northern champions of classicism, notably *Thorvaldsen. His most admired works, exhibited in Rome in 1795, were drawings and studies for paintings, and he never executed the heroic mural 'as large as *Michelangelo's *Last Judgment*' with which he hoped to achieve immortality.

He studied briefly at the Copenhagen *Academy, refusing to copy directly from antique casts as recommended by his teacher *Abildgaard, preferring instead to rely on memory and imagination. He set out for Rome in 1783 at his own expense, but running out of funds only got as far as Mantua, where he was deeply impressed by *Giulio Romano's *frescos. In 1788 he succeeded in being appointed teacher at the Berlin Academy. In 1792, with support from the Prussian State, he fulfilled his ambition to go to Rome, where he died. Like *Flaxman and *Canova, also in Rome in the 1790s, Carstens showed in his last years a growing respect for archaic Greek art. There are drawings by him in Weimar, Staatliche; Hamburg, Kunsthalle; Copenhagen, Thorvaldsen Museum; Schweinfurt, Schäfer Coll.

Cartoon *See under* fresco.

Carucci, Jacopo *See* Pontormo.

Carus, Carl Gustav (1789–1869) German art theorist and occasional painter, trained as a doctor of medicine. An early enthusiasm for art, especially landscape painting, brought him under *Friedrich's influence for a while and he wrote in praise of landscape painting when *Neoclassical theories treated it as a minor art form. In 1831 he published *Letters about Landscape Painting*. His own paintings are at times severe, at times sentimental, but took on a firmer, more progressive mode when he visited Italy. In 1867 he published his *Observations and Thoughts on selected Paintings in the Dresden Gallery*.

Caryatid Column sculpted in the form of a draped female figure, supporting an architectural feature on her head. The Greek word was first applied to the priestesses of Artemis at Caryae, a village in Laconia. The male equivalent is called a telamon, bearer, or – if carved to suggest that it is straining to support a great weight – an atlas, in memory of the mythical Titan compelled to carry the sky on his shoulders.

Casein A protein, precipitated from milk by the action of rennet, and the basis

of cheese. Mixed with pigments, it produces matt, powdery opaque colours, formerly used for painting *a *secco*, and still occasionally employed in interior decorating.

Casorati, Felice (1883–1963) Italian painter, a member of Valori Plastici in the 1920s when he painted strange, metaphysical scenes in a mannered style. Later he developed an abstract idiom of graphic signs.

Cassatt, Mary (1845–1926) American painter who grew up and lived mainly in Europe and was trained in Paris. In the 1870s she came under the influence of *Degas who brought her into the *Impressionist circle. She exhibited with them, 1877–81 and 1886. She sent work for exhibition in America but was little noticed until, in 1893, she painted a mural, *The Modern Woman*, for the International Exposition in Chicago (not extant). Many of her paintings are of women, often mothers and children. Her position in Paris ennabled her to help American collectors make bold and advantageous purchases, notably the Havemeyers whose outstanding collection of French 19th-century painting went to the Metropolitan Museum in New York.

Cassone (pl. *cassoni*; Italian, large chest) In the Renaissance these were used for storing household items and clothes, and in the 15th century were often decorated with painted scenes from ancient history and mythology, the Old Testament, and contemporary writers such as Boccaccio. Especially elaborate were marriage *cassoni*. The only fully preserved *cassone* from the 15th century is the Trebizond cassone (*c*.1475, New York, Metropolitan) but *cassone* panels or reconstituted chests can be found in many museums. Since the same painters who decorated *cassoni* were also responsible for the decoration of bed-heads and footboards, the tops of benchbacks and wainscoting (*spalliere*) it is not always possible to tell the original location of a detached panel exhibited as an easel painting – especially since many such panels share an elongated format. The word *cassone* has thus come to

signify this type of decorative domestic painting in general.

While specialist workshops were responsible for the greater part of the production of *cassoni* and *deschi da parto* (*see under desco da parto*), they could also be commissioned from well-known artists; *Uccello, *Botticelli, *Piero di Cosimo are among those known to have engaged in such work. Painted *cassoni* tended to be replaced, from the last decade of the 15th century, by unpainted elaborately carved chests, and the importance of painted *spalliere* seems to date from that time. *See also* the Borgherini decoration *under* Andrea del Sarto, Granacci, Pontormo.

Castagno, Andrea del *See* Andrea del Castagno.

Castiglione, Giovanni Benedetto (called Grechetto) (1609–63/5) Versatile artist, born and trained in Genoa, equally at home on an intimate scale and in monumental works, in rustic *genre and in the grand manner. He completed his training with Sinibaldo Scorza (1589–1631), an Italian specialist of the Flemish animal and *still-life genre, at the same time passionately studying the Genoese work of *Rubens and *Van Dyck. He was also the first Italian to discover the etchings (*see under* intaglio) of *Rembrandt (*c*.1630), which remained an inspiration for the rest of his life. Documented in Rome from 1632–4, Castiglione came there under the influence of *Poussin – translating the latter's *classical landscapes into a more *realistic form – as well as of the great exponents of *Baroque decoration, *Bernini and *Pietro da Cortona. From 1634 he spent some time in Naples, in turn influencing indigenous painters. In the 1630s he invented the monotype technique – a single print made from an unincised copper plate painted in oils or printer's ink – and began to execute fluid brush drawings in oils on paper. Back in Genoa in 1645 he completed monumental Baroque works (S. Maria della Cella, S. Giacomo della Marina); slightly later he treated allegorical and philosophical subjects (etching, *The Genius of Castiglione*, 1648). In 1648 he was appointed court painter in Mantua, where his work contin-

ued to evolve in new directions; at the end of his life he painted ecstatic compositions reminiscent of Bernini's. There are drawings, etchings and monotypes in the Royal Collection (Windsor) and paintings in various galleries, including Birmingham.

Castillo, Antonio del (1616–68) Eclectic and versatile Spanish painter from Cordova, the best-known member of a dynasty which included his father Agustín and his uncle Juan (1584–1640; pupil of *Zurbarán and teacher of *Murillo), both of whom taught him. Antonio in turn was the teacher of *Valdés Leal. His finest works are 6 scenes from the Old Testament Life of Joseph (Madrid, Prado) skilfully blended with landscapes derived from engravings (*see under* intaglio) after *Bloemaert, but many paintings by him have been attributed at various times to *Velázquez, Zurbarán, Ribera and others.

Catena, Vincenzo (*c.*1480–1531) Venetian painter, follower of Giovanni *Bellini, first mentioned in an inscription of 1506 on the back of *Giorgione's *Laura* in Vienna, where he is referred to as Giorgione's 'partner'. Catena was a wealthy man and moved in humanist circles in Venice; it may be that Giorgione chose to associate himself with him for this reason. His own work shows Giorgione's influence only some years after the latter's death (*Martyrdom of St Christina*, by 1520, Venice, S. Maria Mater; *Adoration of the Shepherds*, New York, Metropolitan; *Portrait of Giangiorgio Trissino*, *c.*1527, Paris, Louvre; *A Warrior adoring the Virgin and Child*, London, National). Other paintings in Vienna, Kunsthistorisches.

Catlin, George (1796–1872) American lawyer who, self-taught, became a portrait painter and in the 1830s lived among and painted portraits of Native Americans. Finding little market for these works, he showed them in England and France, an 'Indian Gallery' of 507 portraits that was well received there.

Caulfield, Patrick (1936–) British painter of the *Pop art generation. His work, first seen in 1964, takes prosaic

subjects and dead-pan line and colour from the language of advertising and cheap illustrations, finding in them intensity and humour, which he has more recently compounded by bringing in also the apparently naturalistic imagery of advertising photography.

Cavaliere d'Arpino *See* Arpino, Giuseppe Cesari.

Cavallini, Pietro (Pietro dei Cerroni) (recorded Rome 1273, Naples 1308) Founder of a Roman school of painting which fused antique, Early Christian, *Byzantine and, to a lesser extent, *Gothic elements to create a new style notable for its soft modelling and relative naturalism (*see under* realism). Like the sculptor *Arnolfo di Cambio, Cavallini was employed by Charles of Anjou in Rome; he may have worked alongside Arnolfo, restoring and repainting the Early Christian cycle in S. Paolo fuori le mura (*c.*1285, destroyed 1823) and painting the *frescos of S. Cecilia in Trastevere (*c.*1293, partially destroyed) while Arnolfo was erecting the altar canopies of these churches. Cavallini also designed the mosaics in S. Maria in Trastevere, and he, or members of his workshop, may have painted the frescos in Naples, S. Maria Donna Regina. Through the Florentine painter *Cimabue, recorded in Rome in 1272, the influence of Cavallini was transmitted to *Giotto.

Cavallino, Bernardo (1616–*c.*1656) Individualistic Neapolitan painter specializing in refined small-scale, *History pictures for collectors that balance *naturalism with courtly elegance, and are distinguished by the complex play of light and vivid colouring. His only dated painting is the large *St Cecilia in Ecstasy*, 1645, one of his very rare works painted for a public location – the high altar of a church in Naples – and now in Florence, Palazzo Vecchio. Various influences, of artists whose pictures were known in Naples, have been discerned in his work: *Rubens and *Van Dyck, *Sweerts's version of *bambocciate*, *Castiglione and *Poussin are the chief among them. There are paintings by Cavallino in Naples, Capodimonte;

Florence, Uffizi; Brunswick, Herzog Anton Ulrich; Birmingham, Barber Inst.; Cleveland, Ohio, Museum; etc.

Cellini, Benvenuto (1500–71) Florentine goldsmith and sculptor. Thanks to his candid, if not always literally truthful, autobiography (1558–62, published only in the 18th century) he is now one of the best-understood personalities of his time; his two technical treatises, 1565, provide invaluable information about the ideals and procedures of Italian *Mannerist sculpture. He was the implacable critic and rival of the more *academic *Bandinelli. Although his first piece of large-scale sculpture was not executed until 1543–4 (bronze relief of the *Nymph of Fontainebleau*, now Paris, Louvre) and all of his work is characterized by a goldsmith's striving for refined decorative effects, he sought always, in both small objects and large statues, that liveliness which had been a feature of the Florentine sculptural tradition since *Donatello. Cellini moved to Rome in 1519 and until 1540 was mostly active in that city as a coin designer and medallist, jeweller and seal-maker (Florence, Bargello; Milan, Gabinetto Numismatico; Mantua, Curia Vescovile; Turin, Gabinetto Numismatico; Vienna, Kupferstichkabinett; London, V&A; etc.). According to his memoirs, he participated as a gunner in the defence of the papal fortress of Castel Sant'Angelo during the Sack of Rome, 1527; he also spent some agonized time as a prisoner in the fortress dungeons, 1539. From 1540–5 he worked in France for Francis I, for whom he completed the celebrated gold-and-enamel salt cellar begun for Ippolito d'*Este (Vienna, Kunsthistoriches). It combines, in miniature, the elegance of the School of Fontainebleau (*see* Primaticcio) with the monumentality of figural poses derived from *Michelangelo. Returning to Florence in 1545, he received the commission from Cosimo I de'*Medici for the bronze *Perseus*, as a pendant to Donatello's *Judith and Holofernes* and in full view of Michelangelo's *David* and Bandinelli's despised *Hercules and Cacus* (Florence, Loggia dei Lanzi; wax and bronze models, Florence, Bargello). He also executed the boldly *expressive over-life-size bust of Cosimo (Florence, Bargello). His talent for capturing a 'speaking likeness' in the precious and durable medium of bronze is shown to even better advantage in the bust of Bindo Altoviti (*c.*1550, Boston, Gardner). But he was able also to carve marble with sensitivity (*Apollo and Hyacinth*, 1546, *Narcissus*, 1547–8, both Florence, Bargello); his most technically accomplished work in that medium is the white-and-black marble *Crucifix*, 1556–62, originally intended for his own tomb (now Spain, Escorial), and derived from a vision of 16 years before in the dungeons of the Castel Sant'Angelo.

There is a tragic element in Cellini's life and art: although dependent throughout most of his career on princely patrons, he lacked a courtier's servile instincts and was several times imprisoned; at the same time, his sincere artistic aspirations, and his most personal creative impulses, were shaped – as they are in the *Crucifix* – into coldly elegant, courtly forms. It is these tensions that make the *Autobiography* such compelling reading even for non-art historians.

Cennini, Cennino *See under* Gaddi, Agnolo.

Ceracchi, or **Cirachi, Giuseppe** (1751–1801) Peripatetic sculptor, born in Rome. He specialized in portraits and in decorative sculpture. In England *c.*1773, he executed decorations for Robert Adam and William Chambers; during 1776–9 he exhibited at the Royal *Academy. After travels to Vienna, and in Italy and Prussia, he went to America, where during 1790–5 he made many portrait busts, including those of Jefferson and Washington. Returning to Europe imbued with revolutionary ardour, he made his way to Paris hoping for great commissions. In 1800 he was implicated in a plot to assassinate Napoleon, then First Consul, and went to the guillotine – dressed as a Roman Emperor, in a chariot of his own design. There are works by him in London (Somerset House, British, Royal Academy) and elsewhere.

Cerano; Giovanni Battista Crespi, called (*c.*1575–1632) With Giulio

Cesare *Procaccini and *Morazzone, one of the three foremost painters in Milan in the early 1600s; a protégé of Cardinal Federico Borromeo and one of the leading artists of the Italian Counter-Reformation. He was also a sculptor, architect, engraver (*see under* intaglio) and writer. His eclectic but always *expressive style had local roots – notably the *realism of the Lombard Sacri Monti (*see* Sacro Monte) – but was affected also by *Barocci and Roman *Mannerism, with which Cerano became acquainted during a visit to Rome in the late 1590s. After his return to Milan, he participated in the city's two most important artistic commissions of 1601–10: the decoration of the side aisles of S. Maria presso S. Celso and the so-called Quadroni of S. Carlo Borromeo. For the former he executed both vault *frescoes and stucco sculptures. The Quadroni are huge paintings, nearly 5 m × 6 m in glue size on canvas, illustrating the life and miracles of Carlo Borromeo, and part of a propaganda campaign mounted in Milan to obtain his canonization (1610). Cerano completed two Quadroni in 1602, a further two in 1603, and six in 1610 – more than any other artist working on this project (Milan, cathedral). Where the earlier scenes still employ Mannerist conventions, the latter are remarkably direct and intensely dramatic.

In 1621 Federico Borromeo appointed Cerano director of the painting section of the new *Academy he founded in Milan according to the regulations of the *Carracci Academy in Bologna. From 1629 to 1631 Cerano served as master of works on Milan cathedral, with special responsibility for the sculptural decoration. His designs, executed in marble by others, are in the cathedral museum. Other works by Cerano are in churches throughout Milan, and galleries in Italy and elsewhere. The Brera in Milan also has a *Martyrdom of SS. Ruffina and Seconda* executed jointly in the early 1620s by Cerano, Morazzone and Giulio Cesare Procaccini – whence its more usual name of the '*Tre Mani*', 'the three-hander'.

Cercle et Carré A group and a journal founded in Paris in 1929 by the critic Michel Seuphor and Joaquín *Torres-García to promote a wide range of *abstract art. In 1931 it was succeeded by *Abstraction-Création.

Cerquozzi, Michelangelo *See under* Laer, Pieter van.

Ceruti, Giacomo (1698–1767) Milanese-born painter active in Brescia *c.*1721–35, and from *c.*1736 commuting between Venice, Padua and Piacenza. A prolific portraitist of the local aristocracy in the Bergamasque tradition of *Moroni (Bergamo, Accademia; *see also* Ghislandi), he came to specialize in stark, dark-hued representations of beggars and vagabonds, poor peasants and the urban proletariat, which earned him the nickname of Pitocchetto, 'Little Beggar' (e.g. Brescia, Pinacoteca). They have been compared with analogous paintings by *Le Nain and Georges de *La Tour, although no direct relationship has been established. Ceruti borrowed figures, poses and whole background settings from the prints of Jacques *Callot and, especially after 1740, from engravings after pastoral scenes by Abraham *Bloemaert.

César (César Baldaccini) (1921–) French sculptor of Italian descent who received a solid academic training in Marseille and Paris, but in 1947 began to construct iron sculptures and in the 1950s became known for his *amalgames*, sculptures assembled from rubbish. More notorious and successful still were his *compressions dirigées*, cars crushed in hydraulic presses and selected by him for exhibition. His best-known work is the dramatically enlarged male thumb, in bronze (1963).

Cesare da Sesto (*c.*1477–1523) Italian painter, active mainly in Milan (Castello Sforzesco; Scotti Coll.). Some of his works show a considerable debt to *Leonardo da Vinci (copy of the latter's *Leda and the Swan*, Wiltshire, Wilton House); later paintings are indebted to *Raphael, probably after a visit to Rome, Naples (*Adoration of the Magi*, Capodimonte) and Sicily *c.*1515–20. Other paintings, *Salome*, Vienna, Kunsthistorisches; studio variant, London, National; drawings, Windsor, Royal Library; etc.

Cesari, Giuseppe *See* Arpino.

Céspedes, Pablo de (*c.*1538–1608)
The most Italianized Spanish painter of
his time in Andalusia, sculptor, architect,
writer on art; clergyman, humanist scholar
and poet. He painted in Rome from 1559 to
1566 (Sta Trinità dei Monti) and remained
in Italy until 1577. He lived afterwards
mainly in Cordova (*Last Supper*, Cathe-
dral), returning at least once to Rome. He
idolized *Michelangelo and *Raphael, and
was a friend of the *Zuccari. Few of his
writings have survived, although one is
preserved in *Pacheco's *Arte de la Pintura*.

Cézanne, Paul (1839–1906) French
painter, a key figure among those who
experienced *Impressionism and moved
on to a more considered and constructive
art, and for several reasons seen as the
father of modern art. He was born in
Aix-en-Provence and, apart from a period
(1861–70) in Paris, lived and worked in and
near Aix in isolation. The strength and
character of his work began to be recog-
nized during his last years – he exhibited in
Vollard's gallery in 1895 – but his main
impact came after his death when two exhi-
bitions in 1907 displayed a wide range of
his work, including the large late figure
paintings. About the same time *Bernard
published some of Cézanne's letters.
 Cézanne's first paintings were scenes of
violence and sombre portraits, the former
painted loosely, the latter with the pal-
ette knife to produce a compacted colour
surface. In Paris he worked with *Pissarro
who introduced him to Impressionism.
From then on he worked almost always
from the model or the motif, returning
to the same subjects again and again to
capture more completely the complex of
his sensations, emotional as well as visual,
and construct its parallel on the canvas. He
now painted landscapes, still lifes, portraits
and occasionally also male or female nude
figures in landscape: these works, studied
from models and photographs but painted
in isolation, recall his early passionate
scenes but now shunned all hint of action,
let alone conflict, and suggest the old dream
of a Golden Age when humanity and
nature were at one.

 His mode of painting varied over
the years, from the Impressionism learnt
from Pissarro to his own characteristic
abstracted version of it – abstracted in the
sense that he simplified and concentrated
colours, regularized brushtrokes to make
them into units in a pictorial structure, and
represented shapes so as to bring out
tensions across space and on the surface of
his paintings. He spoke of wishing to make
Impressionism into an art like that of the
Old Masters, but that misses the core of his
ambition, the impossible one of serving
both the complexity of the visual world as
experience and art's call for succinct,
reconciled images. As he built with paint,
patch beside patch, many of his pictures
took on a mosaic character and his objects
a faceted look to which the *Cubists
responded. But his influence has been
various, so that *Braque and *Picasso,
*Matisse, *Duchamp, *Klee and many
others were directly in his debt, also *Male-
vich and the Russian *Constructivists,
taking from him a range of sometimes
contradictory lessons. Cézanne's work
represented a new way of considering the
relationship between the world and the
artist, embodying his experience in a third
object, the painting. Thus he could serve
the development of abstract art as well as
art rooted in painstaking observation. He
sensed that he had become 'the primitive of
a new art' before he died.
 Cézanne's father, a well-to-do bank
manager, had intended his son to follow
the same career and put him to law studies.
Cézanne's friend, the future writer Emile
Zola, encouraged his urge for self-
expression, and in 1861 Cézanne gave up
law for art, to the disapproval of his father
whose death subsequently freed him from
financial problems. His paintings having
been rejected repeatedly by the *Salon,
Cézanne showed occasionally in the Impres-
sionists' exhibitions of the 1870s and 80s
and got single paintings into the Salon of
1882 and the Paris World Fair exhibition in
1889. Few significant artists ever had less
success. In addition, Cézanne's personal life
was marked by tensions that sharpened his
sensitivity to relationships. Art was a life-
line, an area in which he could know himself,
so that his struggle to lay the foundations

of an inclusive pictorial procedure can be valued as one particular endeavour seen also in other art forms, for example in the poetry of Rilke, who was deeply influenced by Cézanne, and the prose of Kafka.

His work, having been avidly collected since his death, is found in museums and galleries all over the world. In Paris the Jeu de Paume and Musée d'Orsay offer a broad selection, but the three great *Bathers* paintings of his last years are in London (National) and Philadelphia (Museum of Art and Barnes Foundation).

Chadwick, Lynn (1914–) British sculptor who worked as architectural draftsman before turning to sculpture. His earliest works were constructions in metal and glass. His first one-man exhibition, in 1950, was of hanging and standing *mobiles employing a new technique of combining metal rod frames with artificial stone to form humanoid and animal creatures: a series of beasts, of Strangers, of Watchers, solid but in hard and jagged forms that led Herbert *Read to speak of 'the geometry of fear'. In 1956 he won the international sculpture prize at the Venice Biennale. Subsequently he fused his geometrical forms with anatomical detail to calmer, sometimes humorous effect.

Chagall, Marc (1887–1985) Russian-French painter, born into a poor Jewish family in Vitebsk. He had his first painting lessons there, trained further in St Petersburg under *Bakst and then spent 1910–14 in Paris, in touch with the *Delaunays and the *Cubists. He exhibited in Paris, Berlin and Moscow. In 1914 he had his first one-man show at the *Sturm gallery in Berlin, then travelled on to Vitebsk where he was caught by the war. In 1918 he was appointed Commissar of Art in Vitebsk where he started a new art school and a modern art museum. In 1919 *Lissitzky and *Malevich joined his art school staff; soon after, Chagall resigned its directorship. He made designs for the theatre in Vitebsk and Moscow, and taught in homes for war orphans. In 1922 he moved to Berlin where he made his first etchings; a suite *My Life* was published in 1923 (the illustrated autobiography appeared in 1930). In 1923 he

returned to Paris. He had a first Paris one-man show in 1924; one in New York in 1926. From 1941 to 48 he lived in New York. He painted and made designs for American Ballet Theatre's productions in New York and Mexico City. In 1947 he had a major exhibition in Paris; in 1949 he returned to France. The next fifteen years saw Chagall exhibiting widely and given honours and commissions for decorative paintings and stained glass windows in France, the USA, Britain, Germany, Switzerland and Israel. In 1973 he visited Russia and exhibited at the Tretyakov Museum in Moscow. The same year saw the opening of his Musée National Message Biblique in Nice.

Marc was not his given name, but Moses. The change symbolizes his urge to transcend race and nationality. His early paintings report on births and deaths, a wedding, portraits, on ordinary events experienced as great symbolical moments. In Paris he found *Fauvism and witnessed the emergence of Cubism, both suggesting new poetic means pointing away from *realism, while Cubism suggested ways of arranging compositions for decorative and symbolical purposes. *I and the Village* (1911; New York, MoMA) is a compilation, each part legible, the whole a fantasy, a large modern icon dedicated to nostalgia. His *Homage to Apollinaire* (1911–13; Eindhoven, Stedelijk Van Abbemuseum) has the character of an altarpiece. Other paintings of these years are more realistic, but all are lifted on to the plane of the imaginary. In a few of them he attempted western stylistic experiments. These ceased when he was back in Russia. His idiom became more realistic though he indicated emotion through imaginary actions such as figures floating in mid-air, heads swivelling on their necks to turn up to the skies, etc. The emotion was mostly that of love (he married in 1915) and he has ever since been praised as the painter of romantic images while his epic works have had less notice. He now used elements of *Futurism and *Suprematism to celebrate the new world promised by the Revolution and for the narratives of the Jewish people.

He returned to the West the complete painter, drawing on western and Russian, at times also Eastern, traditions, and taking his themes from all aspects of the world, from

love and flowers to the bible and the Russian Revolution. The commissions for public works in prestigious locations mark the world's willingness at times to transcend religious and national barriers: Marc/ Moses made windows for Roman Catholic cathedrals and for synagogues, and mosaics and tapestries for banks as well as for the Knesset in Jerusalem. Exhibitions of his work have been frequent and ubiquitous; reproductions of it have been bestsellers.

chalk In its best-known form, a soft fine-grained white rock consisting of nearly pure calcium carbonate, pieces of which are used for drawing. Drawing chalks are also cut from black carbonaceous shale, and a red ochre variety of haematite, called sanguine from the French for 'blood-red'. Chalks were first extensively used as a drawing medium in mid-15th-century Italy, when artists developed an interest in modelling form through *chiaroscuro: black chalk provides the darkest tone, red chalk a mid-tone, and white chalk the highlight. *See also* Clouet, Jean.

Chamberlain, John (1927–) American sculptor, trained in Chicago and influenced by David *Smith's linear constructions, but admired in the 1960s for *assemblages of parts of wrecked cars. Their message remains ambiguous but their visual impact was akin to that of *Abstract Expressionism. Subsequently he used new metal and plastics and a cooler, more impersonal idiom.

Champaigne, Philippe de (1602–74) Born in Brussels and taught in Flanders by the landscape specialist *Foucquieres, he became one of the leading painters of portraits and religious subjects in Paris, where he settled in 1621 and was appointed Painter to the Queen Mother Marie de' *Medici in 1628 (paintings for Carmelite convent, rue St Jacques, now Dijon, Musée; Grenoble, Musée) while simultaneously gaining the favour of Louis XIII (*Portrait of Louis XIII as Victor over La Rochelle*, 1628, Paris, Louvre). By 1635 he had also attracted the attention of Cardinal Richelieu (decoration of gallery at Palais Royal, now lost; series of portraits of

famous men, in collaboration with *Vouet; known mainly through engravings, one portrait, Versailles; *frescos, dome of Sorbonne; *Portrait of Richelieu*, 1635–40, London, National). The official portraits of this period, such as those mentioned above, show Champaigne's links with his fellow-Flemings *Rubens and *Van Dyck, although the handling of the draperies is more *classical, resembling that of Roman statuary. Religious works of the same years (e.g. *Adoration of the Shepherds*, c.1630, London, Wallace) also show the influence of the early Rubens, translated, however, into a more static, colder and naturalistic (*see under* realism) idiom.

The *Baroque influences, however, were rejected by Champaigne after his conversion, c.1645, to the Jansenist doctrines practised at the convent of Port Royal – a particularly severe and rational form of Catholicism. The religious paintings from the 1650s until the year of his death are increasingly static, and intense in their restrained simplicity (e.g. Paris, Louvre; Lyons, Musée; Toulouse, Musée des Augustins). The portraits of these years are even more effective and original, especially the sober half-lengths, usually depicting sitters dressed in black against a grey background and behind a stone-coloured parapet (e.g. Paris, Louvre). Champaigne's mature portrait mode also well suited the official group portraits he was three times called upon to execute (*Echevins of Paris*, e.g. version of 1648, Paris, Louvre). The masterpiece of his last period combines both portraiture and a religious theme: it is the votive picture for the cure of his daughter, a nun at Port Royal (1662, Paris, Louvre), in which the painter's daughter and the prioress who prays for her are shown full-length on the scale of life, almost at right angles to each other and nearly parallel to the picture plane, in subtlest tones of grey, cream and blacks relieved only by the red crosses on their habits. It has been called as typical of the Jansenist approach to a miraculous event as *Bernini's ecstatic *St Theresa* is of the Jesuit.

Chandler, Winthrop (1747–90) Vigorous colonial American portraitist, who

probably started as a sign painter. He worked in Connecticut, never achieving the sophistication of the Boston-bred painters such as *Feke, *Greenwood and *Copley (Ohio State Historical Society).

Chantrey, Francis Legatt (1781–1841) English sculptor of humble origins, largely self-taught. He had an early success with a portrait bust of Horne Tooke (1811; Cambridge, Fitzwilliam) shown at the Royal Academy in London in 1812. He went to Paris in 1815 and Rome in 1819, visiting *Canova and *Thorvaldsen. He had a particular skill in and sensitivity for rendering flesh in marble and liked to generalize forms in order to allow light to articulate broad, unbroken surfaces. His portraits, exceptionally gentle and human, brought him success as a sculptor of busts and funeral monuments, of which he produced a great number for both private and public places, mostly in England but including, for example, Madras Cathedral. He became an Associate of the Royal Academy in 1816 and a full member in 1818; in 1835 he was knighted. He left a large fortune to the Academy to found the Chantrey Bequest, dedicated to purchasing contemporary works of art.

Charchoune, Serge (1888–1975) Russian painter who studied art in Moscow and in Paris during 1912–14, exploring aspects of *Cubism. He spent the First World War years in Barcelona, and returned to Paris where he contributed to the *Dada movement. In 1922–3 he showed in and visited Berlin. He wrote articles for a range of journals including *Schwitters's *Merz* and Van *Doesburg's *Mecano* and from 1922 to 1949 published his own, *Transbordeur dada* (Dada Transporter). He became interested in *Purism in 1927 and developed ideas for a musical form of painting and demonstrated these in frail monochromatic *abstract paintings.

charcoal A black form of carbon made by burning wood in the absence of air. Charcoal for drawing is usually made from sticks of willow, beech or vine. Easily erased with a feather, charcoal was, by the 15th century, extensively used for working

out compositions on panel or wall; in the 16th century, cartoons (full-scale drawings) were transferred onto the support by pouncing charcoal dust through holes pricked in the paper (*see under* fresco). Charcoal underdrawings can now be made visible through the paint layers by the non-invasive technique of infra-red reflectography. Drawings in charcoal on paper are impermanent unless sprayed with a fixative, normally a resin dissolved in alcohol.

Chardin, Jean-Siméon (1699–1779) French *still-life painter, who very early in his career, and again in *c*.1730–55, turned also to *genre scenes. From 1771, failing in health and eyesight, he executed masterly portrait heads in pastel (e.g. *Self-portrait*, 1755, Paris, Louvre). Although he did not practise the *academically sanctioned 'higher *genres', he was acclaimed by critics, collectors and the wider public of his own time. He fell into disfavour with the *Neoclassicist critics of the late 18th and early 19th centuries, but was rescued from oblivion by the *Realist artists and critics of the 1840s–60s, when his works were acquired for the Louvre. He is now acknowledged to be one of the greatest French painters and one of the finest painters of the 18th century.

The son of a master-carpenter, he was apprenticed to the painter Cazes in 1718. Then, *c*.1720, he became an assistant to Noël-Nicolas *Coypel, and matriculated in the Académie de Saint-Luc, which was mainly an artisanal organization. In 1728, however, he was received at the Royal Academy as a painter 'of animals and fruits' and although, because of this lowly classification, he could not rise to the higher posts, he did hold the treasurership of the Academy and was for a long time responsible for the hanging of the pictures at its annual Salon or public exhibition. In 1757 he was granted living quarters in the Louvre.

Although in the 1720s Chardin tried to compete with the brilliant large-scale ornamental still lifes of *Oudry, he lacked Oudry's facility, especially in the painting of live animals (e.g. *Cat Stalking a Partridge and Hare left near a Tureen*, late 1720s, New York, Metropolitan; *see also* his Academy

reception pieces, *The Buffet*, and *The Skate*, both 1728, Louvre). He then turned to smaller, more unified and static compositions, for which he is best known. These can broadly be grouped as dead game; the kitchen table with copper and earthenware pots and utensils, fish, meat, vegetables and eggs, and the more refined dessert table, with fruits, wine, porcelain, glass, silver and pewter (e.g. Paris, Musée de la Chasse et la Nature; Springfield, MA, Museum; and, of course, Louvre). Unlike most Flemish and Dutch still-life painters he did not depict prepared, and abandoned, meals, rather a still moment before the preparation or the consumption of food. Working laboriously from direct observation, he evolved a complex technique involving – unusually for a still-life specialist of his period or earlier – the use of impasto. By the 1750s he had extended this to include subtle glazes, scumbling and dragging (*see under* colour). But the 'magic of his technique', as an 18th-century critic called it, which envelops forms in air and makes surfaces at once opaque, reflective and translucent, is not the only factor which makes his work so affecting. The long-meditated geometric arrangement of simple shapes, as well as the modest objects depicted, give these still-lifes a grave, even austere, moral compulsion. And when in the 1730s, perhaps in response to a friendly gibe by the portraitist *Aved, Chardin began to exhibit genre scenes, it was their moral climate, which reflected the domestic values of order, industriousness, education and affection, that probably ensured their wider popularity (e.g. Stockholm, Museum; London, National; Paris, Louvre; Ottawa, National). When these paintings were engraved, they were furnished with moralizing captions which highlight, or perhaps exaggerate, their kinship with Dutch 17th-century moralizing genre.

By the 1750s Chardin, his limited invention exhausted, was showing only replicas of his earlier figure paintings; the popularity of *Greuze's more anecdotal and more melodramatic genre may have persuaded him to cease this type of production. During the 1760s, however, after the death of Oudry, he was commissioned to return to a larger, more decorative type of still life:

Attributes of the Arts and Sciences, designed as overdoors for royal palaces (now Paris, Louvre; Jacquemart-André; pc). A variant was acquired by Catherine the Great of Russia (St Petersburg, Hermitage). This painting and a replica in Minneapolis, Institute, include the plaster model of the famous statue of *Mercury* by *Pigalle, one of the many artist-admirers of Chardin who owned examples of his work. Of Chardin's several emulators the one who came nearest to him was **Henri-Horace Roland de la Porte** (1725–93) whose work was for a long while confused with Chardin's. *See also* Anne Vallayer-Coster.

Charonton *See* Quarton, Enguerrand.

Chassériau, Théodore (1819–56) French painter of Creole origin, born in the Antilles, living in Paris from 1822 on. He worked in *Ingres's studio in the early 1830s and produced oil paintings and murals in oil on plaster (Saint-Mérri, Paris; 1842–3) that echo his master's carefully delineated art. But he also adopted *Delacroix's more painterly ways and, through an output limited by his brief career, was influential as one who bridged the chasm criticism had opened between the champions of *Romanticism and *Classicism. He painted classical scenes with archeological care but also presented Shakespearian and North African subjects, even before he visited Algiers in 1846. His pictures, seen best in the Musée d'Orsay, Paris, often combine elegance with a sultry charm.

Cheere, Sir Henry (1703–81) English mason-sculptor, a pioneer of the *Rococo style. He worked with *Scheemakers between 1729 and 1733 (e.g. monument to the 1st Duke of Ancaster, Edenham), and thereafter chiefly at Oxford University and at Westminster Abbey, which appointed him 'carver' in 1743. During the 1750s and 60s his brother **John Cheere** (1709–87) worked with him on commissions from Yorkshire families (York, City Art Gallery); he also mass-produced garden ornaments. There are four books of designs for monuments associated with the Cheere workshop in the V&A, London.

chiaroscuro (Italian, light-dark) In painting, and by extension in other media, extreme contrasts of light and dark, i.e. highlight and shadow. *Leonardo da Vinci pioneered the use of chiaroscuro to create the illusion of relief on a two-dimensional surface. He exploited the predominant dark tonality of his late paintings, however, largely for *expressive ends, and this use of chiaroscuro assumes great importance from the end of the 16th century with the work of *Caravaggio and his followers (*see also* tenebrism).

chiaroscuro prints *See* relief prints.

Chicago, Judy (1939–) American artist, born Judy Cohen in Chicago, trained at the University of California at Los Angeles. Especially interested in the roles and work of women artists, she co-founded the Feminist Art Program of California Institute of Arts in 1971 and was subsequently prominent in other feminist art developments and events. In 1973–8 she created the installation piece *The Dinner Party*, celebrating female artists and 999 'supporting' women, important figures from history; this toured internationally for some years and was widely discussed. In this work, and in her other activities, Chicago collaborated with other women, asserting the value of a feminine environment and of female mutuality in a male and competitive world. In 1975 she published an autobiography: *Through the Flower*.

Chigi Princely Italian family, comprising a pope, Alexander VII (elected 1655–d.1667) and several cardinals. **Agostino Chigi** (d.1520) became banker to the popes in Rome and a preeminent patron of the arts. He commissioned works from his Sienese compatriots *Sodoma and *Peruzzi – the latter was also the architect of Chigi's splendid suburban palace, now known as the Villa Farnesina – but is remembered principally for bringing the young *Sebastiano Veneziano to Rome, and above all as the chief non-papal employer of *Raphael, whose *Triumph of Galatea* and Loggia di Psiche adorn the Farnesina. Raphael painted the *Sibyls and Prophets* for the Chigi Chapel in Sta Maria della Pace and

designed the Chigi funerary chapel in Sta Maria del Popolo for Agostino and his brother **Sigismondo**.

Chillida, Eduardo (1924–) Spanish sculptor, well known for his wide range of *abstract work, much of it in iron or steel for large or small pieces, some of it carved from wood or from stone ranging from alabaster to granite, some pieces also in ceramic. His graphics include *collaged works in black ink on scissored paper that are in effect almost two-dimensional sculptures and have some of the presence of his work in metal. He was trained in architecture but turned to making sculpture at the end of the 1940s and had his first solo exhibition in 1954. He worked first in wrought iron, attaching himself to the Spanish tradition of decorative ironwork to which *González too had been indebted. By the end of the 1950s he had a strong international reputation, leading to commissions for large public sculptures which at times involved the sculptor's architectural skills, some of them being in concrete or built of stones. Outstanding among these are his *Combs of the Winds*, a three-part steel sculpture fixed into the rocks of Donostia Bay in his native San Sebastian (1977), and *De Musica*, a steel sculpture at the Meyerson Symphony Center, Dallas (1989). Though he has been influenced by Spanish sculpture, and also by such international figures as *Moore, *Calder and *Caro, his idiom is his own. It combines a clear sense of geometry with an ability to set forms into space, or to make within solids spaces that have an exploratory, even gestural, feeling and invite a strong emotional response. Space, air and light contribute powerfully to the character of his sculpture, also sometimes a sense of maze-like enclosure that is magnetic as well as disturbing. Chillida has had many exhibitions around the world and has received many honours and prizes. A Chillida Foundation has been set up where he lives, in Hernani near San Sebastian.

Chirico, Giorgio de (1888–1978) Italian painter born in Greece and trained first in engineering and then as a painter. He studied in Munich and in Paris. From

1915 to 1917 he was in the Italian army. In 1917 he met *Carrà in the Ferrara army hospital; together they founded *Pittura metafisica. He spent some years in the 20s and 30s in Paris; otherwise lived in Milan, Florence and Rome. He published a novel in 1929 and memoirs in 1945 and 1962.

His first allegiance as painter was with *Symbolism, especially the mysterious art of *Böcklin and *Klinger. He found a similar quality in early Renaissance painting, such as that of *Uccello and *Piero della Francesca. In 1910–11 he painted his first townscapes, made enigmatic and stage-like by simplifications, distorted *perspective and a sense of deserted spaces. These were shown in Paris in 1911. He then began to people his pictorial stages with manikins and ambiguous elements, evoking ancient myths and modern science in an atmosphere of suspended time. His stress on the poetic qualities of objects was a resource for both *Dada and *Surrealism; to *Breton he was the essential pioneer of Surrealism. De Chirico's painting, however, now tended to a more gratifying mode combining elements of *Renoir and *Rubens and direct references to the antique. The *avant garde came to despise him yet his part homage to, part parody of great traditions of art has stimulated aspects of 1980s *figurative painting.

Chodowiecki, Daniel Nikolaus (1726–80) Draftsman, painter and engraver (*see under* intaglio) from Danzig, active in Berlin. Trained as a shop assistant, he turned to miniature portraits *c.*1743, then to literary and scientific illustration and the depiction of the life of the bourgeoisie. Influenced by French *Rococo prints, notably those after *Watteau and *Chardin's genre pieces, he became one of the first German artists to work for the middle classes, independent of court employment. He championed 'natural' German bourgeois manners against the affectations of French-inspired aristocrats and parvenus. His work as a whole is a valuable source for social historians. There are drawings by him in Berlin, Kupferstichkabinett; Leipzig, Museum; Weimar, Schlossmuseum.

Christo (Christo Jaracheff) (1935–) Bulgarian sculptor, working in the USA since 1964. After training in Sofia and Vienna, Christo moved to Paris where he was associated with the Nouveaux Réalités movement. He has become famous as the artist who wraps things – shopfronts, buildings, the Australian coastline, etc. – and more recently as the man who got an orange curtain hung across a valley in California. The aesthetic of wrapping associates him with *Surrealism but his programme's core is the manipulation of officialdom and vested interest to the point where it surrenders to art as an otherwise valueless, temporary event.

Christus, or **Cristus, Petrus** (active from *c.*1442–72/3) After the death of Jan van *Eyck in 1441 he became the leading painter in Bruges. His work is slavishly dependent on Van Eyck's, except in the *Lamentation over the Dead Christ* (Brussels, Musées; New York, Metropolitan) which are indebted to Rogier van der *Weyden and Dieric *Bouts. There are paintings ascribed to him in London, National; Madrid, Prado; etc., and some signed pictures, Frankfurt, Städel. He is unlikely to have travelled to Italy, as has been suggested.

Chryssa (1933–) Greek-American sculptor, properly Chryssa Mavromichaeli, trained in Paris and in San Francisco; from 1955 resident in New York. In the early 1960s she made sculptures using *Pop motifs; then she made neon sculptures in boxes and other structures, glowing mysteriously but also turning themselves on and off.

Church, Frederic Edwin (1826–1900) American *landscape painter who studied with *Cole. In 1846 he settled in New York. His first landscapes, done in great detail, suggest the influence of *Ruskin's ideas. In 1953 he travelled to South America. Back in New York, he painted North and South American scenes on the basis of oil sketches made on his travels. *The Falls of Niagara* (1857, Washington, Corcoran) and *The Heart of the Andes* (1859, NY, Metropolitan) were greatly admired. His work became known in Europe, and during

1867–8 he travelled in Europe and the Near East making sketches and collecting souvenirs for his lavish house on the Hudson River. By the time he died, taste had moved and he was more or less forgotten.

Churriguera Dynasty of Spanish sculptors and architects, famous for their ornate style; the earliest members known were altarpiece makers on the designs of others (**José Simón**, d. 1679). After 1684 **José Benito** (1665–1725) was the head of the family, executing altarpieces in a few standard and fashionable formulas (Segovia, Cathedral, Sagrario; Salamanca, San Esteban; Madrid, San Basilio, etc.). He was the architect of the new town of Nuevo Baztán, 1709–13. His brother **Joaquín** (1674–1724) revived 16th-century *Platereque forms in his architectural designs at Salamanca (Colegio de Anaya; Colegio de Calatrava; Cathedral). Their younger brother **Alberto** (1676–1750) was the most talented member of the family but did not emerge from his brothers' shadow until after their deaths. He practised as an architect mainly in Salamanca.

Ciampelli, Agostino *See under* Santi di Tito.

Cibber, Caius Gabriel (1630–1700) Danish-born sculptor, probably trained in Rome, practising in England during the Restoration. He executed several public commissions, including the two figures of *Raving and Melancholy Madness* for the gate of Bedlam Hospital (London, V&A). He was the father of the dramatist Colley Cibber.

Ciborium Dome-lidded liturgical vessel in the shape of a wide goblet, used to hold the consecrated Host of the Eucharist; by extension, the *baldacchino over the altar in Early Christian and medieval churches. Both were decorated with eucharistic symbols.

Cignani, Carlo (1628–1719) *Classicizing Bolognese painter, a pupil of *Albani. The late works of Guido *Reni and a renewed study of *Correggio contributed to form his polished style, much

admired by contemporaries. His masterpiece was the *Assumption* in the dome of the cathedral of Forlì. He ran an active studio, and was the teacher of Marcantonio *Franceschini and the Venetian *Bencovich, as well as of his own sons, the *quadratura painter **Pompeo Cignani** (1677–1739?), and **Felice** and **Filippo Cignani**. His grandson, **Paolo** (1709–64) continued the school into the second half of the century.

Cignaroli, Giovanni Bettino *See under* Balestra, Antonio.

Il Cigoli, Ludovico Cardi, called (1559–1613) Outstanding Florentine painter and architect, a friend of the mathematician and astronomer Galileo. He first adopted the *Mannerist style of his teacher Alessandro *Allori, then changed under the influence of *Barocci to a more direct and emotionally *expressive manner; colouristically he was also indebted to the Venetians, notably *Veronese. He went to Rome in 1604, returning to Florence only for brief intervals. There are works by him in Florence, Accademia; Pitti; San Marco, Museum; Empoli, Collegiata. His largest Roman works are the *frescos in the dome of the Cappella Paolina, Sta Maria Maggiore, 1610.

Cima da Conegliano, Giovanni Battista (*c*.1459/60–1517/18) Venetian painter from Conegliano, established in Venice from before 1492 to 1516. He may have studied under Alvise *Vivarini, but was mainly influenced by *Antonello da Messina and Giovanni *Bellini. His style changed little during his career and he not only repeated entire compositions but actually re-used the same cartoons (*see under* fresco) for several works; he also ran a large studio, so that many works attributable to him are not to any great extent autograph. His earliest dated painting is a *sacra conversazione* for Vicenza, 1489 (now Vicenza, Museo Civico) other altarpieces and paintings of religious subjects Conegliano, cathedral; Venice, many churches and Accademia; Milan, Brera; London, National; Berlin, Staatliche; Washington, National; Paris, Louvre. There are also

roundels painted by Cima *c.*1500 on mythological themes, Parma, Estense, Farnese; Copenhagen, Museum; Milan, Poldi-Pezzoli; Philadelphia, Johnson coll.

Cimabue (Cenni di Pepi) (first recorded 1272–after 1302) Designated 'Florentine painter' in a Roman document of 1272, he is traditionally regarded as the teacher of *Giotto, to whom he probably transmitted the new modes of *fresco painting evolved in Rome by *Cavallini. His own sources are antique Roman and *Byzantine. Cimabue's only securely attributable and datable work is the figure of St John in the mosaic of *Christ Enthroned with the Virgin and St John* (Pisa, cathedral, 1301–2). On the basis of this documented work, he is credited also with the *Madonna of St Francis* in the lower church of S. Francesco, Assisi; the much deteriorated fresco cycle in the choir and transepts of the upper church (*c.*1280); and the grandiose panel of the *S. Trinita Madonna* (Florence, Uffizi, early 1280s), which narrowly anticipates *Duccio's *Rucellai Madonna*. Some authorities also attribute to Cimabue the design of the enormous round stained-glass window of the choir of Siena Cathedral (*c.*1287), and painted crucifixes (Arezzo, S. Domenico; Florence, S. Croce). He may in addition have participated in the mosaics for the Baptistry, Florence; his influence at any rate appears in some of the latest scenes (*c.*1325).

Cione, Jacopo and **Nardo di Orcagna, Andrea.** *See*

Cipriani, Giovanni Battista (1727–85) Florentine painter who settled in England in 1755, to become the earliest exponent of a superficial and decorative *Neoclassical style. Like Angelica *Kauffmann, he worked as a decorator in interiors designed by the Scottish architect Robert Adam. His pictures were made extremely popular through the *mezzotint engravings of *Bertolozzi.

Circignani, Nicolò *See under* Pomarancio.

Circle Book, subtitled 'International Survey of Constructive Art', edited by the

architect J. L. Martin, Ben *Nicholson and Naum *Gabo and published in London in 1937. It presented essays and illustrations showing the convergence of art with aspects of contemporary science and, by associating British artists with leading continental figures in art (*Mondrian, Gabo, etc.) and design (*Le Corbusier, Breuer, Tschichold) implied that England was becoming a centre of international *Constructive art. *Circle* was intended to appear annually but this remained the only issue.

cire-perdue French, 'lost wax'. A technique of hollow-casting traditionally used for large *bronze sculpture, known to the ancients and recovered in *Renaissance Italy. It normally consists of making a full-scale model of the statue in clay, then taking plaster casts of every part to form hollow piece-moulds. These are lined with a layer of molten wax, which when cooled is fixed with skewers to a core, until an entire wax model of the statue is created. Alternatively the wax is modelled directly over the core, but in this case only one metal cast can be made. The wax skin is sealed in a fire-proof shell. Channels are provided through which air and wax can escape, and molten metal be introduced. The whole is heated until all the wax has run out, to be replaced by molten metal, which if all goes well cools and hardens to the exact configuration of the mould. The sculpture is finished by breaking off and removing outer shell and inner core, sawing off surplus metal in the vents or runnels, polishing and chasing. The hazardous procedure is well described in several famous texts, notably by *Vasari and *Cellini. Despite his reputation as a great sculptor in bronze, *Donatello never cast his own works, but relied on the expertise of bell founders.

Ciurlionis, Mikolojus Konstantus (1875–1911) Lithuanian-Russian painter, trained as a musician and mainly self-taught as a painter. His paintings convey a mystical conception of the universe through musical structures, and refer to visionary landscapes and castles. Some appear wholly *abstract and may have stimulated *Kandinsky and other

abstract artists. A commemorative exhibition in St Petersburg was held in 1912.

Civetta *See* Bles, Henri met de.

Claesz., Pieter (1597/8–1661) Dutch *still-life specialist, born in Westphalia but working in Haarlem. Along with Willem Claesz. *Heda he is an originator of the tonal 'breakfast piece': a simple meal painted more or less at eye level in monochromatic harmonies, usually in silver tones (e.g. Rotterdam, Boijmans-Van Beuningen). He was the father of Nicolaes *Berchem.

Clark, Lygia (1920–88) Brazilian artist, trained in Rio de Janeiro and Paris. She became known in the 1960s with a sequence of manipulable sculptures in metal, then 'vestiary' sculptures to be donned like clothes, in some cases to link two or more people, and environments designed to condition the behaviour of visitors. She sought through her work to develop rituals and to sharpen human awareness to situations and conditioning while breaking down the barrier between people and the untouchable art object.

Classic, classical, Classical, classicism and classicizing The confusion surrounding the usage of these terms stems from the fact that their distinct normative, historical and descriptive connotations are combined or used interchangeably.

Classic or classical in its normative sense means 'that which sets a norm, standard or canon'. In art theory from the Middle Ages until the 19th century, this usage tended to be conflated with the historical usage, referring to Graeco-Roman antiquity. The conflation expresses the canonic role of ancient civilization in the history of Western culture. The value-free, purely historical use of the term is generally indicated by the capitalization of the first letter, as in Classical.

The descriptive use of these terms points to features thought to have originated in ancient monuments of art and architecture, notably Greek 5th-century BC works and their derivations. It denotes

rationality, the clear articulation of separate parts subsumed to the monumental effect of the whole, and an emphasis on stable vertical and horizontal axes – albeit not to the point of noticeably distorting organic forms. The presentation of a somewhat generalized physical beauty is characteristic of classical etc. art, as is lucid narrative. The term *Neoclassicism is applied to those styles, recurrent from the 18th century, which exaggerate some or all of these features and combine them with Classical motifs, as for example heroic nudity or antique dress. Neoclassicism is sometimes used pejoratively, to imply lack of spontaneity and the pedantic application of outworn rules and stereotypic forms.

A functional definition of classical has been proposed by the art historian E. H. Gombrich. In this definition, the classical or classic solution to an artistic problem reconciles the conflicting demands of representational accuracy and of compositional order, both being equally esteemed by the artist. Representational accuracy here means fidelity to appearances as defined by a single viewpoint, a particular lighting scheme, and, by implication, a single moment of viewing. Compositional order, on the other hand, signifies a pattern governed by a shaped and bounded pictorial or sculptural field. Another formulation defines classicism or the classical in art as the point of equipoise between *illusion, *expression and *idealization. All definitions include the notions of balance, harmony and closure.

Claude Gelée (called Lorraine or Le Lorrain) (1600–82) Painter born in Lorraine but active for most of his life in Rome; landscape specialist who raised the *genre from a low standing in the *academic hierarchy to a major means of artistic expression. Rooted in the landscape tradition of the northerners established in Rome, the brothers *Bril and *Elsheimer, he succeeded in giving pictorial form to the nostalgia for a lost Golden Age articulated by the Roman poet Virgil, often illustrating themes from the latter's *Aeneid* or the *Georgics*. His poetic *classicism, founded on masterly control of subtle gradations of all-enveloping light and harmonious geometric

structure, became the lens through which successive generations of artists and art-lovers viewed his preferred subjects, the landscape of the Roman Campagna and the Bay of Naples or, like Richard *Wilson, the landscape of their own countries (*see also* 'Claude glass').

Claude left Lorraine *c.*1612, first for Germany and thence to Rome, where he worked, like many Lorrainers, as a pastry cook. Employed as such in the household of Agostino Tassi (*c.*1580–1644), a land-scape and *quadratura* (*see* illusionism) painter and probable pupil of Paul Bril, Claude became his apprentice. Around 1623 he visited Naples, studying there under the little-known Flemish landscapist Goffredo Wals. In 1625–7 he was again in Nancy, but by 1628 had settled for good in Rome. Within a decade he had established his reputation as a purveyor of landscape paintings to ambassadors, cardinals and the pope. In later life he would record his com-positions in drawings, compiling the *Liber Veritatis*, or 'Book of Truth' (London, British) to guard against forgeries and imi-tations, the earliest of which can be traced to *c.*1634. These drawings were engraved in 1777 by the English printmaker Richard Earlom.

Claude's oil paintings, composed and executed in the studio, are based on the pen-and-wash sketches which he executed during constant excursions into the Roman countryside (e.g. London, British); he may also have been directly inspired by ancient Roman wall paintings. To Elsheimer's dramatic light effects he preferred more typical and serene conditions: cool early-morning light, warm evening glow or hot noonday. It is the depiction of light which gives significance and poetic *expression to his paintings, in most of which the eye is led to infinity through an atmosphere-filled space whose continuity and extent are established more by subtle changes of *colour and tone than by means of linear *perspective. In the earlier harbour scenes (e.g. *The Embarkation of St Ursula*, 1641, London, National) the sun, lying low on the horizon and by definition the lightest area of the painting, coincides with the vanishing-point. Shadows reinforce the receding lines of orthogonals, and dark tree

and architectural forms in the foreground act as *repoussoirs. In later pictures Claude abandons these devices. The disc of the sun is no longer visible and the lightest portion of the painting lies parallel with the horizon; other objects are often also disposed horizontally. Light penetrates the flickering trees, dissolves architectural forms and is reflected from rippling water.

These tendencies are reinforced in the style of the last 15 or 20 years of Claude's life, when the emphasis on open space and the view to infinity is intensified through bold compositional asymmetry and trans-parency of form (e.g. *Perseus and Medusa*, 1674, Norfolk, Holkham Hall). Colours become so cool as to be almost uniformly chalky or silvery, and all the pictorial elements seem reduced to the immateri-ality of dream (e.g. *Ascanius and the Stag*, 1682, Oxford, Ashmolean).

Claude's very large output found its way to most important aristocratic and princely collections. He is now particularly well represented in England, having become especially prized by 18th-century *Grand Tourists.

Claude glass A slightly convex black-ened mirror, an 18th-century device used to view landscape. By turning his back on the reflected scene, and looking at it in his Claude glass, the *Picturesque tourist or landscape artist saw a framed, 'composed' image in finely graduated harmonizing tones, reminiscent – at least in theory – of the landscape paintings of *Claude.

Cleef, Hendrick and **Maerten van** *See under* Bruegel.

Clerck, Hendrick de (1560/70–1629) Flemish painter, a pupil of Maerten de *Vos and court painter at Brussels to the Archdukes Ernest (from 1594) and Albert (from 1606). He remained faithful to a decorative *Mannerism until after 1625. In addition to numerous altarpieces he also painted small mythological compositions for the court, on many of which he collaborated with Jan *Brueghel (Brussels, Musées Royaux have the best selection of his paintings).

Cleve, Joos van *See* Joos van Cleve.

Cleyn, Francis (1582–1657/8) Painter, born in Rostock and trained in Rome and Venice. He became court painter to Christian IV of Denmark; a number of *History paintings survive in Danish royal palaces. In 1625 he settled in England, becoming chief designer for the Mortlake tapestry works, and executing also the three canvases of the *Story of Perseus* let (after 1654) into the ceiling of the Double Cube Room at Wilton, Wiltshire. He was the master of William *Dobson.

Clodion; Claude Michel called (1738–1814) French sculptor, best known for his inventive, delicate yet energetic terracotta statuettes of Bacchic subjects – nymphs, satyrs, playful *putti* – which were inspired as much by antique vase paintings as by Graeco-Roman statuary and domestic figurines (e.g. Waddesdon Manor; Nancy, Musée; London, Wallace, V&A). From *c*.1771–*c*.89 he was assisted, especially in turning out bronze and porcelain replicas of his terracottas, by his brothers **Sigisbert-Martial** (1727–after 85), **Sigisbert-François** (1728–1811), **Nicolas** (*b*.1733) and **Pierre-Joseph** (*b*.1737). The first of his only two commissions from the crown, a group of *Music and Poetry* in the guise of children (comm. 1773, Washington, National) was in the same style, albeit on a larger scale. With the second, however, the life-size seated *Montesquieu*, he demonstrated his capacity to carve marble in a severe monumental style (1783, Versailles). His one religious commission, a *St Cecilia* for Rouen cathedral (1775–7), shows that he had studied *Bernini and *Algardi. Associated through his earlier work mainly with *ancien régime* private collectors, who included the painter *Boucher, he astonished everyone at the post-Revolutionary Salon of 1800 by his ability to adapt to Revolutionary artistic ideals with his grimly heroic group of *The Deluge*. He was later (1805) to contribute to the decoration of the Vendôme column honouring the Napoleonic Great Army.

Born at Nancy, Clodion was the nephew of the brothers *Adam, and received his first training in Paris under his mother's eldest brother Lambert-Sigisbert Adam, 1755–9. After the latter's death he briefly entered the studio of *Pigalle, winning first prize for sculpture at the *Academy in the same year. During 1762–71 he was in Rome, first as a pensioner at the French Academy, later as a successful independent sculptor, sought after by collectors from all over Europe. Sometimes seen as the last great *Rococo sculptor, he is – like the painter *Fragonard – an artist celebrating the forces of nature. His virtual alienation from the Academy and his reliance on private clients anticipate later developments in the status and conditions of art production.

Close, Chuck (1940–) American painter, associated with *Photorealism. Having started out on his painting career as an *Abstract Expressionist, Close turned in the late 1960s to painting very large portraits by transcribing his own black-and-white photographs projected onto squared-up canvases and filling in each little square tonally using an airbrush. The portraits are mostly of his friends and usually full-face, head and shoulders only, on canvases taller than wide. In the 1970s he used colour in the photographs and in his renditions. Thus he cut out personal expression and delivered, though on an overpowering scale, images that a world used to photographs receives as entirely *realistic and 'lifelike'. Badly paralysed from 1988 on, he was able to back his will to go on working with equipment and assistance. He has changed his method: using brushes strapped to his wrist and acrylic paints, he fills in each square of his grid with ground colours and simple, free-hand forms, often bright and busy, yet still delivers a lifelike portrait to one viewing the whole picture. Thus he has switched from imitating the tonal data provided by monochrome photography to making *abstract colour compositions which produce a mimetic result, and appear to be much more fun to do.

Clouet, Jean or **Janet** (*c*.1475/80–*c*.1541) and his son, **François** (also called **Janet**) (*c*.1516/20–72) Both held the post of

chief court painter to the King of France,
Jean under Francis I (*Francis I of France*,
c.1525, Paris, Louvre; *Francis I on Horse-
back*, *c*.1525–30, Florence, Uffizi) and
François under Henry II, Francis II and
Charles IX.

Jean Clouet's origins are obscure, but he
was certainly trained in Flanders or by a
Flemish artist. First recorded at court in
1516, he became *Premier Peintre du Roi* in
1531. His famous portrait of the King now
in the Louvre (see above) shows an affinity
to *Gossart in the treatment of the body
and drapery, but is closer to the cooler
French tradition of *Fouquet in the repre-
sentation of the face.

About 130 portrait drawings in red,
white and black chalk or crayon are attrib-
uted to Jean Clouet, most of them at Chan-
tilly, Musée. Only a few painted portraits
are now known; in addition to those already
cited, the most remarkable is that of the
humanist *Guillaume Budé* (*c*.1535, New
York, Metropolitan).

François Clouet, born at Tours, was
active by 1536 and succeeded his father as
Premier Peintre upon the latter's death. He
designed the funerary decorations for the
obsequies of Francis I and in 1552 executed
the death mask of Henry II. He continued
his father's practice of chalk-drawn por-
traits, but his only signed painted portrait
(*Pierre Quthe*, 1562, Paris, Louvre) shows
the influence on him of the new inter-
national portrait style (*see*, e.g. Anthonis
Mor). The only other signed painting, the
enigmatic *Lady in her Bath* (*c*.1550, Wash-
ington, National) demonstrates her interest
in both the new Flemish painting (e.g.
*Heemskerck, *Aertsen) and Italian motifs.
On the strength of this signed work, a
mythological painting, the *Bath of Diana*
(or *Diana and Acteon*) has been attributed
to him (Rouen, Musée).

Clough, Prunella (1919–1999)
British painter, born in London and a
student (and subsequently a part-time
teacher) at Chelsea School of Art. She was
known for subtly selected and organized
pictures of workers and the environment
of work – fishermen, docks, industrial
buildings and scenery, pictured without
comment as events of visual interest.

During the 1960s she turned to paintings,
drawings and prints that appear *abstract
yet are equally rooted in observation and
permit her to make free, more poetic use of
oddities and contrasts of many sorts tran-
scribed by means of a growing range of
technical means. Her work is recognizable
thanks to its particular, sometimes quirky,
character; it does not adhere to a style or
brand-image. Her early work was well
shown in 1960 at the Whitechapel Art
Gallery in London. A selection of her
paintings done since 1970 was shown at
the Camden Art Centre, London, in 1996,
and a smaller selection, but made from
all periods of her work, was shown in
Cambridge and Sheffield in 1999–2000.

Clovio, Giulio (1498–1578) Famous
Italian miniature painter, born in Croatia.
He went to Rome in 1516 and became an
intimate of Cardinal Alessandro Farnese,
for whom he illuminated a famous and
lavish manuscript, the Farnese *Book of
Hours (1546, New York, Pierpont Morgan
Library), with motifs inspired by *Raphael
and *Michelangelo, after whose work draw-
ings by Clovio are also known (Windsor,
Royal Library). His friend El *Greco
portrayed him holding the book in a
painting now in Naples (Capodimonte).

Cobra Group formed in Paris in 1948
by *Jorn, *Appel and *Corneille,
its name an acronym of Copenhagen,
Brussels and Amsterdam. Other artists (e.g.
*Alechinsky) joined and Cobra, known
for warmly expressive work within *Art
informel, formed alliances with other
*avant-garde art groups and also essayed
socially orientated town planning.

Cochin, Charles-Nicholas the Elder
(1688–1754) French engraver (*see
under* intaglio), teacher of the far better-
known **Charles-Nicholas the Younger**
(1715–90), gifted engraver, illustrator,
influential writer on art. From the age of
24 Charles-Nicholas the Younger was
employed at court, recording ceremonies
and theatrical productions. In 1749–51 he
accompanied the Marquis de Marigny on
the Italian voyage intended to groom
the latter for the post of *Directeur des*

Bâtiments, publishing *Voyage d'Italie*, an illustrated record of the trip, in 1758. Cochin subsequently taught engraving to Marigny's sister, Mme de Pompadour, mistress of King Louis XV. Although his earlier decorative designs had exemplified the *Rococo style, he now set himself to reform such extravagances, advocating a return of French art to *classicism.

Cock, Jan Wellens de (recorded from 1503–26) and his sons **Hieronymus** (*c.*1507–70) and **Matthys** (*c.*1509–48). Flemish painters and printmakers. Jan Wellens de Cock was the earliest follower of *Bosch. Far more important than either his father or his shadowy brother Matthys, Hieronymus Cock is not only remembered for his own prints publicizing the work of the leading 'Romanist', that is, Italianate painters in the Netherlands such as *Floris and *Heemskerck, but also through his establishment in Antwerp, 'At the Sign of the Four Winds', which between *c.*1546 and 1570 was the leading print shop in the Netherlands. For it Pieter *Bruegel the Elder created many of his finest engravings (*see under* intaglio).

Cockburn, James Pattison (1778/ 9–1847) English professional soldier and topographical draftsman-painter, a pupil of Paul *Sandby at the Royal Military Academy, Woolwich. He published views of Cadiz, Gibraltar, Malta, Switzerland and Pompeii between 1810 and 1820, and views of Canada – including the Niagara Falls – in 1833.

Codazzi, Viviano (1604–70) Italian painter born in Bergamo and active in Rome and Naples. He was the foremost painter of architecture of his generation, often providing the architectural and landscape backgrounds to the paintings of others, such as Artemisia *Gentileschi and, above all, Micco *Spadaro (Naples, Museo di S. Martino; Besançon, Musée; Madrid, Prado).

Codde, Pieter (1599–1678) Dutch painter, resident of Amsterdam. A specialist of guardroom scenes (*see also* Willem Duyster) he also painted portraits and *Merry Company pictures (London, National; etc.). He was the painter commissioned to finish Frans *Hals's group portrait, the *Meagre Company* (1637, Amsterdam, Rijksmuseum).

Coecke van Aelst, Pieter (1502–50) Flemish Italianate painter, sculptor, architect, decorator, designer of prints, tapestry and stained glass; writer, translator of Latin and Italian *Renaissance texts which strongly influenced northern European architecture; court painter to the Emperor Charles V. He was the pupil of Van *Orley, and the father-in-law and teacher of *Pieter Bruegel the Elder. After a trip to Italy, he settled in Antwerp in 1527. A trip to Constantinople in 1533 resulted in an influential book, or roll, of ten woodcuts (*see under* relief prints) on the *Manners and Customs of the Turks*, published in 1553 by his widow. He may have moved to Brussels, where he died, in 1544. There are over 40 versions of his composition of the *Last Supper*, influenced by *Leonardo's mural (Belvoir Castle; Brussels, Musées Royaux; etc.).

Coello, Alonso Sánchez *See* Sánchez Coello, Alonso.

Coello, Claudio (1642–93) Spanish Late *Baroque painter of Portuguese descent, a protégé of the dowager Queen Mariana and her son Charles II, and the last great painter of the school of Madrid. His works are festive, colourful and crowded; the best known is the vast *Sagrada Forma*, or *Mass of Charles II* (1685–90), which is conceived as an *illusionistic extension of the sacristy of the Escorial – at once a devotional picture, a historical scene and a portrait gallery. He was displaced from royal favour by Luca *Giordano.

Cohen, Bernard (1933–) British painter, brother of Harold *Cohen. Trained in London, he was a member of the *Situation group and became prominent in the early 1960s as a painter of controlled geometrical *abstract paintings which soon developed quirks. There followed a long series of abstract paintings composed of a variety of motifs and

emblems deployed as modulable themes for rich, complex works. From 1987 to 2000 he was professor of Fine Art at the Slade School, London.

Cohen, Harold (1928–) British painter, brother of Bernard *Cohen. Trained in London, member of the *Situation group and noted for *abstract paintings which in the early 1960s tested the semantics of form and colour. How does art mean? Does a painting stand for something else? In 1968 he went to the University of California at San Diego as visiting professor; he has remained in California and devoted himself to collaborating with computers to produce drawings. He has developed programmes he calls AARON, neither random nor predetermined. Displays have been given in major museums and galleries in the USA and Europe, and he has lectured and written about his work on several occasions.

Colantonio *See under* Antonello da Messina.

Coldstream, William (1908–87) British painter, trained at the Slade School in London and for many years its director. He was prominent among the art administrators in Britain, directing the reorganization of advanced art and design schools in England and Wales, which in the 1960s led to growth and higher attainments. He was also an outstanding and profoundly influential painter. He worked on documentary films under John Grierson in the 1930s and subsequently used art to portray the real world. In 1938 he founded the *Euston Road School of Painting with Claude Rogers and Victor *Pasmore. He developed and refined a scanning procedure of exceptional objectivity, yet far from dispassionate. His work drew little attention from the *avant garde though it was admired by many *figurative artists. A retrospective exhibition was shown in London in 1962. Renewed attention to figurative painting in the 1980s has also led to a revaluing of his art.

Cole, Thomas (1801–48) American landscape painter, born in England, living in the USA from 1818. He studied at the Philadelphia Academy and then worked in New York, going up the Hudson River Valley to sketch landscape until he settled in Catskill village in 1836. His *Essay on American Scenery*, published that year, states his commitment to his subject and its importance to art and society; subsequent travels to Europe did not lessen this belief. Filled with convincingly represented detail, his major works – those to which he also gave priority – are epic statements about nature and divinity. Cole chose his motifs and deliberated in the studio on their presentation in order to convey his sense of the sublimity of God as echoed in the world God created. When he used landscape as the setting for religious or historical subjects, as in his *Expulsion from the Garden of Eden* (1828; Boston, MFA), the narrative element is boldly subordinated to its setting. Yet in his series of the 1830s, composite works on several canvases denoting distinct moments from a sequence, as in *The Course of Empire* (1836; New York, Historical Society) and *The Voyage of Life* (1840; Ithaca, Munson-Williams-Proctor Institute), he selects and tunes the natural settings of his didactic enactments to underline and give general validity to their moral message. His pure landscapes of that time and after show his growing sense of major forms in nature's complexity, and with that his sense of the sublime. His urge to speak of religion led him in his last years to let human action dominate some of his compositions but there was no decline in his sense of nature's vivid drama.

collage Method of making two-dimensional images, adopted by artists from 1912 on. Sticking parts of photographs and illustrations on doors and screens had been a Victorian amusement. Painters had long fastened bits of paper or cloth to their canvases to test a particular effect before painting it in. The French for 'to stick' is *coller*; collage means something made by sticking on (in sculpture *assemblage is a near equivalent).

In 1912 *Picasso made a *Still Life*, a prominent part of which was a piece of printed oilcloth representing woven cane (Paris, Musée Picasso), and *Braque began

to stick pieces of cut-out paper into his compositions: bits of newspaper, shapes cut from wallpaper and paper printed to resemble wood. Soon they were both incorporating paper objects, a packet of cigarette papers, a visiting card, etc.; this sort of collage is called *papiers collés* (glued papers). The method questioned the need for artistic skills and introduced new visual effects. Also, since these elements were laid on the canvas or even protruded from it, they emphasized the space in front of the picture, not an illusory space within it. Moreover, collage showed that art might be made by building-up, constructing, adding importantly to *Cubist methods of examining how art represents. *Apollinaire hailed it as the modern art process *par excellence*.

In the 1920s Picasso showed the *Surrealists how disturbing images of familiar objects could be, as in his *Guitar* picture (1926; Paris, Musée Picasso), consisting of string, nails, newspaper and a torn section of floor cloth. By then collage was being explored by many artists and movements, including *Futurism, *Arp and other *Dadaists, *Ernst, *Schwitters, and *Constructivism; it has remained important since, especially in recent movements such as *Abstract Expressionism and *Art informel (where the use of non-art materials led to the term matter painting), the *Nouveau Réalisme* of *Arman, *Spoerri and others, etc. Collaging photographs, i.e. photomontage, became an important means of making political caricatures for *Heartfield and others and for Surrealist photographs.

Collot, Marie-Anne *See under* Falconet.

Colombe, Michel (*c.*1430–1512) Celebrated French sculptor, viewed by some historians as the last great *Gothic master working in France, and by others as a pioneer of a new indigenous style influenced by the Italian *Renaissance but not directly dependent on Italian models. A native of Bourges, where his father Philippe Colombe worked as a sculptor, he was active at Tours from 1473. His only surviving works, however, date from the beginning of the 16th century: the double *Tomb of François II of Brittany and his wife Marguerite de Foix*, 1502–7, originally Nantes, Carmelite church, now Nantes cathedral on which he was assisted by the Italian sculptor Girolamo da Fiesole; and the altar relief of *St George and the Dragon*, 1508–9, for the chapel of the château of Gaillon, now Paris, Louvre.

Colonna, Angelo Michele (1600–87) In collaboration with **Agostino Mitelli** (1609–60), the leading specialist in *quadratura* (*see* illusionism) painting. Trained in Bologna, they virtually monopolized such commissions throughout Italy and even worked for a while in Madrid, where Mitelli died. Colonna then collaborated with Mitelli's pupil, **Giacomo Alboresi** (1632–77). There are decorations by Colonna and Mitelli in Florence, Palazzo Pitti, and other palaces in Parma, Genoa, Rome, etc., and they trained a large school in their decorative style, thus laying the foundation for its extensive 18th-century development; *see* *Mengozzi Colonna, Girolamo.

colorito (Italian, colouring) *See under* disegno.

colour There are three main properties of colour as it is employed by painters: *hue*, *tone* and *temperature*. *Hue* is that attribute by which colours are classed as red, blue, yellow, etc. *Tone* is the degree of lightness or darkness on a scale from white to black (*see also* chiaroscuro). Some colours have a wider tonal range than others: yellow, for example, is restricted to a narrow range near the white end of the scale; blue, on the other hand, ranges from the near-white of sky-blue to near black. Artists have two standard means of ascertaining, and employing, the maximum tonal range of any given pigment. The first is by a process of dilution and saturation. A blue pigment, for example, highly diluted in water, a drying oil or varnish, will leave a lighter brushmark on paper, plaster or panel than the same pigment held in suspension at the point where no more can be absorbed by the medium – that is, a saturated or fully saturated colour. The full tonal range of a

colour can also be obtained, at any desired stage of dilution, through the addition of white or black pigment, the limiting factor being the point at which the original colour changes hue. *Temperature* is relative: colours, when compared with each other, can be seen to be 'cold' or 'warm' – as in the case of a steely-blue side-by-side with orange. Effects of three-dimensional relief can be obtained by colouristic means (as opposed to linear means, as in linear *perspective) by contrasting all or some of these attributes of colour in adjacent areas. When tonal contrasts are introduced within a single contour, for example, we speak of 'shading'. But similar optical effects can be produced through contrasting hues, and especially by placing cold against warm colours. Colour 'harmonies' are created by careful juxtapositions of colours taking into account hue, tone and temperature. An artist's *palette* is not only the surface on which he lays out his paints prior to applying them; the word is also used to mean either his customary choice of colours and colour harmonies, or all the colours utilized in a particular painting.

In painters' pigments, as opposed to the colours of the spectrum, of printers' ink or photographic emulsions, there are three so-called *primary* colours: red, blue and yellow. These may occur naturally in vegetable or animal dyes or in minerals, or be synthesized chemically; they cannot, however, be obtained by mixing pigments before or after application, that is, on the palette or by successive translucent layers superimposed on the support (*glazes*). *Secondary* colours are those which may be obtained by mixing pigments of the primary colours, regardless of the fact that all, or some, may also be obtained directly from minerals or through chemical processes. Thus, as most school children know, red and blue mixed yield violet or purple; blue and yellow, green; yellow and red, orange. These relationships may be shown diagrammatically on a colour wheel or by two triangles superimposed in a star shape. It will then be seen that primary colours are placed directly opposite secondary colours: yellow is opposite violet, blue faces orange, and red, green. These colours are then described as being *complementary*: red is complementary

to green, etc. (This relationship has a physiological basis in the after-image on the retina when the eye has stared at a single colour for a considerable time.) Although the colour wheel is a modern invention, relationships of complementary colours have often been exploited in the colour harmonies of the art of the past, and are particularly associated with the painting of *Renaissance Venice and its tributaries (e.g. *Giorgione, *Veronese).

Colquhoun, Robert (1914–62) British painter, born and trained in Scotland, who with his friend *MacBryde settled in London in 1941. Their art shared some of the *Neo-Romantic qualities dominant in British art during the Second World War but took on an international tone under the influence of *Adler who brought elements of *Expressionism and 1930s *Picasso into their art. Colquhoun's best work is characterized by 'wild bodies', dark, sometimes strongly coloured figures in interiors whose forms and textures imply stress. Kilmarnock in Scotland has a Colqhoun Memorial Gallery.

Colt, Maximilian (recorded 1605–45) French mason-sculptor, working in England from about 1595. He executed the tomb of Queen Elizabeth I in Westminster Abbey, 1605, and worked on Hatfield House for the Cecil family. In 1608 he became master sculptor to James I.

Colville, Alex (1920–) Canadian painter, trained at Mount Allison University, Sackville, New Brunswick. He developed an intense *naturalism dependent on exact detail in conjunction with simplified forms and situations full of psychological and optical interest. He represented Canada at the 1966 Venice Biennale, was artist in residence at the University of California at Santa Cruz in 1967–8 and visiting artist on the Berlin Künstlerprogram in 1971.

Combine Painting Term first used by *Rauschenberg in the early 1950s for paintings consisting of a painted surface together with substantial additions of other materials or objects – an extension of *collage and akin to *assemblage.

Computer Art Since the Second World War, and with the developing interest in artificial intelligence, the processing and/or generating of art by means of computers has made remarkable strides. Key moments in this development have been the formation of Experiments in Art and Technology (EAT) in New York, 1966, the Computer Technique Group in Tokyo, 1967, and the Computer Arts Society in London, 1966. Computation, sometimes of an elaborate sort, has long been a task within art, as in calculating proportional systems and complex perspective. Since the 1950s, however, computers have become widely available and have greatly increased their capacities. They can be used as a tool for executing designs with or without colour, as for example through the Quantal Paintbox and by the use of light pens. They can also be directed to generate drawings or paintings, as in the case of Harold *Cohen's AARON programme, set up by the artist but exploiting the computer's ability to act randomly. Computers can scan images and process their lines, colours or tones, or give visual form to mathematical statements and to algorithms. Dramatic examples of these are the 'fractals' produced by artists both as visual equivalents to mathematical data and as fantastical imagery. Such images printed out in quantity enlarge the field of the *multiple. Computers can also be used to generate or develop visual material for films and videos as well as to add special effects. They can also be programmed to control the behaviour of kinetic sculpture.

Conca, Sebastiano See under Giaquinto, Corrado.

Conceptual art Art which gives priority to an idea presented by visual means that are secondary to the idea. In part a reaction against the immediacy and, some would say, the idea-lessness of *Abstract Expressionism and its European equivalents, Conceptual art emerged in the 1960s and has usually appeared cool and impersonal. All sorts of materials can serve the Conceptual artist, such as the telephone in a gallery with a notice instructing the visitor to await a call from Walter *De Maria, and Jan Dibbets's delivery of art into every viewer's home when German television broadcast material specially filmed by him. Concept art can be very elaborate, expensive to make and expensive to present; it can also be exceedingly simple and of no material value. Yet it can deliver ideas powerfully, and thus it has served as a vehicle for socio-political comment as well as a broad challenge to the tradition of the work of art as a crafted, unique object.

Concrete art Ambiguous term, used in the 19th century to stress a work's basis in reality, as in *Courbet, and by van *Doesburg in 1930 to designate a pure form of *abstract art, eschewing all lyricism and symbolism and presenting nothing in fact or in intention but itself. This served as the basis for much *Constructive art in western Europe, and the term was used by Max *Bill to include art which gives visual form to mathematical concepts. Important moments in the history of concrete art have been Bill's exhibitions 'Konkrete Kunst' in Switzerland (1944 and 1960) and one at the Galerie Drouin in Paris, 'Art Concret', in 1945.

Conder, Charles (1868–1909) British painter, who worked in Australia as a surveyor before being drawn to art. In 1890 he returned to England and moved over to Paris to study at the Académie Julian and become part of a circle of artists, including Toulouse-*Lautrec, known both for unconventional artistic talents and for their debauched lifestyle. Conder's work owes much to *Whistler's subtleties of tone and colour, and his fantasies, some of them on fans, as well as some of his landscapes and townscapes are admired still as works of great skill and a *fin de siècle* aroma.

Conegliano, Cima da See Cima da Conegliano, Giovanni Battista.

Coninxloo, Gillis van (1544–1606) The most important landscape painter to have worked in Holland in the first decade of the 17th century. A Fleming, he escaped the Spanish wars first to Frankenthal, near Frankfurt, then, in 1595, to Amsterdam. He broke with the panoramic landscape of *Patinir and *Bruegel and his late land-

scapes represent luxuriant forests seen close to at eye level, in which foreground, middleground and background are interwoven and interrelated through dramatic distribution of light and shade (Vaduz, Liechtenstein Coll.; Vienna, Kunsthistorisches; etc.). His principal followers were David *Vinckboons and Roelant *Savery (but *see also* Jan Brueghel).

Consagra, Pietro (1920–) Italian sculptor who has worked in Rome from the 1940s, associated with New Realists and other groups. In 1960 he won the international sculpture prize at the Venice Biennale: his most widely admired sculpture has been in the form of large jagged metal planes erected to overlap and form a dramatic visual event symbolic of growth and decay.

Constable, John (1776–1837) British *landscape painter, born into a family of Suffolk farmers and mill-owners and creator of a vision of rural England that since his death has come to dominate English minds. This vision was rooted in long, close, partly scientific observation and study, as in the matter of clouds, but also in his association of nature with divinity: 'on whatever object I turn my eyes, that sublime expression of the Scriptures, "I am the resurrection and the life", seems as if uttered near me.' It was mostly 'the exhilarating freshness of Spring' he chose to paint, not 'Autumnal tints' with their sense of an ending and with darker tones that pleased tastes formed on heavily varnished Old Master paintings. His innate love of drawing and painting brought him contact with local collectors such as Sir George *Beaumont, and to artists and antiquarians who could guide his first professional steps. By 1799 Constable had convinced his father that art had to be his career. He entered the Royal *Academy Schools and soon sought out London collectors who would permit him to examine their Old Master landscapes – those of *Claude, *Ruisdael and *Rubens. At the RA he had to become proficient in figure drawing, from casts of sculpture and from the living model, but it was always clear to him that landscape would be his speciality and that no-one had

attempted the *naturalistic painting of nature that he envisaged. He admired aspects of *Wilson's and *Gainsborough's landscapes, and soon recognized that his close contemporary *Turner was 'stark mad with ability', but their example encouraged him rather than closing his path. He spent his summers back in Suffolk, finding subjects he would return to many times, but he also explored the countryside around London, and in 1806 he spent some weeks in the Lake District of north-east England, making sketches and watercolours, some of which he turned into oil paintings. Mountains, however, did not please him, and generally he shunned the dramatic scenery sought by the poets and painters of *Romanticism. Suffolk continued to be his chief resource, the more so after he fell in love with Maria Bicknell, a visitor to a rectory near his home. Their union was opposed by both families, and it was not until 1816, when Constable senior died, that they married. Before this, Constable had passed through miserable periods when he was not allowed to see Maria; after she died in 1828, having given him seven children, his desolation can be read in his paintings. Between those dates they lived mostly in and on the edges of London, for example in Charlotte Street and in Hampstead, though Constable worked periodically also in other parts of southern England. The Bishop of Salisbury's nephew John Smith was to be his lifelong friend, and Constable made several visits there from 1811 on, painting a much-loved view of the Cathedral in 1823 (London, V&A). In the 1820s he repeatedly took Maria to the south coast at Brighton for the sea air and made seaside studies there. He never went abroad.

In 1819 he was elected an Associate of the Royal Academy and exhibited at the RA the first of his large landscape paintings, worked up from large oil sketches to convince academicians and their public of the seriousness of ahistorical landscape painting. His smaller paintings of scenery and his studies of clouds continue to please gallery-goers with their pre-*Impressionistic insistence on finding brushmark equivalents for the 'light – dews – breezes – bloom – and freshness' which, Constable said, had not

before him been painted properly. He, however, set great store by these large paintings, carefully composed and worked in the studio, and gave them an appearance of freshness and of the evanescence of nature which disturbed polite society but drew the praise of some fellow painters in England and in France. The third of them was the painting now known as *The Hay Wain* (London, National). Shown and quite well received in the RA in 1821, it remained unsold until a Paris dealer bought it and two smaller pictures in 1824 and put them into the Paris *Salon where they were awarded a gold medal. *Géricault had admired *The Hay Wain* in London; *Delacroix and others acclaimed it in Paris, though Constable did not enjoy the highbrow terms in which Paris critics both praised his art and found it limited. Paris had not previously encountered nature painted with such immediacy and truth, nor seen an unremarkable scene such as this presented on a large canvas to convey a sense of rural peace and contentment, and did not know how to locate such work in the academic scale of importance. Individual painters responded more easily, in Paris as in London. Delacroix claimed to have learned from Constable the use of broken colour areas, made up of touches of different shades and tones. The *Barbizon painters studied him, and decades later the *Impressionists were interested in the small touches of white and other colours he employed in his smaller paintings. In England, the rise of Impressionism coincided with and enhanced a growing interest in Constable who, it was claimed, had preceded them in all important respects and for some time blocked their reception.

In 1823 Constable had spent six weeks at Lord Beaumont's house in Leicestershire, hearing about British painters Beaumont had known in his youth, including Alexander *Cozens, and studying his Claudes, some of which he copied. He also drew the memorial Beaumont had erected to *Reynolds in his grounds, inscribed with words by Wordsworth; in 1836 he would exhibit a painting (London, National) developed from this drawing (London, V&A). Though rebelling against aspects of traditional painting, he found much to admire in the work of his predecessors. Yet

in 1824–5 he was painting a full-size sketch (London, V&A) and then one of his six-foot exhibition pieces, now known as *The Leaping Horse* (London, Royal Academy), and though the final version is less harsh than the study, both display a freedom of touch and extremes of light against dark they could not have approved. Constable knew he was disconcerting even his admirers. He wrote to his friend Fisher: 'I must go on. I imagine myself driving a nail. I have driven it some way – by persevering with this nail I may drive it home'. In 1825–6 he painted a gentler picture, containing, as he put it 'more eye-salve', i.e. more to please viewers. This is *The Cornfield* (London, National), the most reproduced and copied of all his landscapes and probably the one most firmly in people's minds as representing old England. It shows a scene that young Constable knew well from boyhood but now recreated with much conscious art, adding items he had drawn on various occasions, as well as the distant church, to ease the public's access to it. Nonetheless, the boldness of his brushwork remained a problem. Although *The Cornfield* was exhibited five times, including at the 1827 Paris Salon, it remained unsold until after his death, when subscribers, including Wordsworth, bought it for the nation. In 1827 another large painting, *The Chain Pier, Brighton* (London, Tate) was shown at the RA and drew praise from *The Times*, yet this elaborate composition, drawing on several sketches and unusually full of incident, remained unsold until 1838. Maria died of tuberculosis in November 1828. The following year Constable showed at the RA the large canvas *Hadleigh Castle* (USA, Paul Mellon coll) which expresses his unhappiness most poignantly: the unromantic ruin, a stormy sky and a general darkness dominate the scene he based on a sketch of 1814. Constable's work was, in his fifties, tending towards melancholy and to scenes of isolation. Maria's death gave edge and point to this direction.

In 1829 Constable had at last been elected a full Academician, though many of his fellow academicians were still doubtful of his work. He began that year to prepare a set of mezzotint etchings, made for him

by a young engraver, to be part-published during 1830–2 as (short title) *English Landscape*. Twenty-two plates reproduced selected Constable paintings, and his text stressed the difficulty an artist had, working 'in a sphere of his own' when 'so few appreciate any deviation from a beaten track'; time would prove the value of his work, especially his concentration on the transient truths of nature, including the dark skies and sudden gleams of light that occupied him more and more and which, he admitted privately, reflected his state of mind. *English Landscape* did not sell well. In these last years of his life, marked by his own and his children's illnesses, he taught in the life room at the Royal Academy for a while, and also, during 1833–6, gave ten lectures on landscape painting, outlining its main periods and characteristics up to but not including, his own generation. He felt it 'his *duty* . . . to *tell* the world that there is such a thing as Landscape existing with "Art"', and that landscape was now the equal of *History painting as an elevating art form. These lectures were not published and are known only from some surviving drafts and from others' reports. Among the oustanding works of his last years are two watercolours he showed at the Academy, both picturing sites once of great importance, now carrying us back 'into the obscurity of a totally unknown period', and of the greatest sublimity thanks to their physical isolation as well as their cultural remoteness. One was *The Mound of the City of Old Sarum* (1834), an ancient fortified settlement long ago fallen into ruins; the other was *Stonehenge* (1834; both London, V&A). Both are highly dramatic; the latter, setting the megaliths against nature's transient effects, is blessed by one of Constable's rainbows, signalling hope amid dejection. At the Academy he was reminded again and again how fortunate he, a mere landscape painter, was to be accorded any notice. In the year of his election (by one vote) as Academician, his exhibits had been described as being 'in execrable taste, having no resemblance to any appearance in Nature – this artist's standard of excellence'. In 1830 a critic half praised his 'powerful effects' but found them 'impaired by silly affectation, and

various clumsy attempts at singularity'.

The collections indicated have many of the best Constables. The Victoria & Albert Museum in London has a particularly large collection, notably his sketches in oils, watercolours and pencil, left to the Museum by the artist's daughter.

Constant (1920–) Dutch artist, properly Constant Nieuwenhuys, first known as a vigorous and expressive painter associated with *Cobra, but famous as a significant *Constructive artist making spatial constructions and developing a polemical project for an ideal city, 'New Babylon'.

Constructivism, Constructive Art
*Cézanne called his work 'constructions after nature', indicating its origin in scrutiny and an ordering process. This duality has been basic to all *classical art, and Cézanne spoke for a generation much of whose best art showed classical motives, e.g. *Puvis de Chavannes, *Seurat. The 20th century has witnessed an art movement in which an ordering and building process is linked to scientific interests: this and its hinterland of orderly *abstract art is often referred to as Constructivism. A distinction will here be made between the Constructivist movement proper, in 1920s Russia, and the international Constructive art movement, its offspring. Attention must also be drawn to the method of constructing (as opposed to modelling or carving) sculpture: though this method provided the path to Constructivism, most constructed sculpture has not been Constructive art.

In 1912 *Picasso made the first constructed sculpture, a *Guitar* (New York, MoMA) of wire and sheet metal. *Tatlin after 1913 gave priority to constructing reliefs, but semi or wholly abstract and from found materials. Artists around him did likewise, relishing the reality of the materials and the constructive process. Tatlin's Tower project (1920) was both a constructed symbolic object and a utilitarian one. From this and from his teaching of the 'culture of materials' stemmed the movement that named itself Constructivism. A group within the Moscow Institute for Art Research (*INKhUK),

consisting of *Rodchenko, *Stepanova and Aleksei Gan, formed in late 1920 as the First Working Group of Constructivists, was officially recognized the following year and was joined by the two *Stenbergs, *Medunetsky and Boris Ioganson. In January 1922 these four plus Rodchenko exhibited as Constructivists, declared 'art and its priests to be outlaws' and commanded 'every man . . . to take the shortest road leading to the factory . . . This road is called Constructivism.' Gan's little book *Constructivism* (1922) elaborated this: artists must participate in the new industrial culture, moving from 'laboratory work' (Constructive art as research) to 'practical activity' directly beneficial to society through industry. Rodchenko set up a special department in the Moscow art workshops (*VKhUTEMAS), from which a group of 'artist-engineers' graduated in 1929. By then the government gave its support only to *Socialist Realism. Tatlin dissociated himself from these Constructivists; he thought their understanding of materials superficial and noted their lack of spiritual aims. He attempted to find an integrated role for himself in a ceramic factory in Leningrad; its managers could see him only as a draftsman. With his students he produced prototypes for efficient and economic clothing and other necessities. Others in the early 1920s applied Constructivist methods to stage design (*Vesnin, *Popova), typography (Rodchenko, *Lissitzky) and architecture, and by these and other means propagated them in western Europe. Constructivist ideas strengthened *Elementarist tendencies there, stemming in part from *De Stijl and brought together in the work (after 1923) of the *Bauhaus and particularly of *Moholy-Nagy.

Constructivist art developed in the West principally from the example of *Gabo. In his wake, Constructive art movements developed that have continued to this day. Major artists within them include *Baljeu, *Biederman, *Lohse, Kenneth *Martin, *Schöffer. Many others produce geometrical abstract art in two and three dimensions. Cool and impersonal, Constructive art has never become popular and has seemed marginal to the history of modern art. It is a new classicism, giving visual form to many kinds of order, and thus an invaluable counter to the modern taste for stylistic change and egocentric expression. A characteristic of true Constructivist work is a sort of transparency: methods and materials openly displayed, as well as the artist's ordering role. Constructivism is a model activity, and in its enrolment of modern processes, from painting to computers, demonstrates the positive, even joyful aspect of human creativity.

contrapposto Italian for a pose evolved originally in *Classical Greek sculpture and revived in the *Renaissance (*Donatello's *St Mark*, 1411, is an early example). It is designed to lend the illusion of potential movement to a static figure, through a system of changing axes and alternating contraction and relaxation. By the 16th century the term also came to mean 'variety through contrast', and is applicable not only to a single figure but to entire compositions or even groups of works of art.

contre-jour, à (French, against daylight) In painting, the device of silhouetting figures, or other motifs, against a light background. It is an effect exploited particularly in the work of Mattia *Preti.

Conversation Piece Small-scale informal portrait group, usually of a family or a gathering of friends. It may be set indoors or out. The term is modern, but is applied to a *genre of portraiture which became especially popular in 18th-century England. *Mercier and *Devis are particularly well-known specialists, as was *Hogarth early in his career. *See also* Fancy Picture; *fête galante*.

Cooper, Samuel (1609–72) English miniature painter, the last distinguished practitioner of this technique in Britain, but *see also* Cosway, Richard. His international reputation, and his prices, rivalled those of his contemporary at the Restoration court, *Lely, many of whose sitters he also painted. Until *c.*1634 Cooper trained with his uncle, the miniaturist **John Hoskins** (*c.*1595–1665); from *c.*1634 until

1642 he travelled widely on the Continent. In the 1640s he was in demand in England for portraits both of Royalists and Parliamentarians. His miniature of Cromwell is the Protector's best-known and most distinguished likeness. Despite Cooper's service to the Commonwealth, he was appointed 'limner' or miniature painter to Charles II. Like Isaac *Oliver, and unlike *Hilliard, Cooper treated the miniature as a fully modelled painting; Evelyn records (1662) holding the candle for him, '. . . for the better finding out the shadows . . .' as he drew the King. His elder brother, Alexander, also trained by Hoskins, worked as a miniaturist in Holland and Scandinavia. He died in 1660. There are paintings by both in the Royal Collection and in London, V&A.

Coorte, Adriaen (active c.1683–1707) Dutch *still-life painter active in Middelburg. He specialized in depicting a few kinds of fruit, shells or a bunch of asparagus on a ledge against a dark background (Oxford, Ashmolean; Cambridge, Fitzwilliam).

Copley, John Singleton (1738–1815) The most distinguished of the New England portraitists (Boston, MFA; Cambridge, MA, Fogg; New Haven, Yale; New York, Metropolitan). He is now chiefly remembered for his contributions to the English school: pioneering modern-dress narratives in the Grand Manner.

Taught only by his step-father, the engraver Peter *Pelham, Copley quickly surpassed the Colonial painters who influenced him: *Smibert, *Feke, *Greenwood. In 1774 he emigrated to London, via a study tour of Italy. There he discovered 'composition' and first undertook a traditional narrative subject, The Ascension (1774, Boston, MFA). His hopes of receiving a commission for an altarpiece version were never realized; upon settling in London, his bid for membership of the Royal *Academy was made with a double portrait painted in Italy. This, like his following year's entry, The Copley Family (1776–7, Washington, National), which celebrated his reunion with his wife and children, was coolly

received. Success came with the commission from a prominent merchant and sometime Lord Mayor of London, Brook Watson, to record an accident which befell him some three decades earlier. Watson and the Shark (1778, Washington, National), is the earliest painting to employ the full panoply of history painting (see under genres), albeit in modern dress, in order to depict a private event of no historical or moral import. Copley, however, probably did not differentiate between this and the following series of paintings, in which he turned to direct competition with the Death of Wolfe by his benefactor, Benjamin *West: Death of Chatham (1779/8, London, Tate); Death of Major Peirson (1783, London, Tate); The Repulse of the Floating Batteries at Gibraltar (1791, London, Guildhall); Admiral Duncan's Victory at Camperdown (1799, Dundee, Camperdown House). These form the greatest series of modern history paintings executed in England in the 18th century; the Death of Chatham, furthermore, combines meticulous individual portraiture with dramatic narrative. Copley, having painted the picture on speculation, sold advance subscriptions to the engraving. In addition, he exhibited the work privately, in rented quarters, charging admission. By thus competing with the Academy's exhibition, he made enemies and compromised the critical reception of his later works for the next 25 years, including his only royal commission: The three Youngest Daughters of King George III (1785, Buckingham Palace on loan, National), a *Rococo composition of considerable charm. The finest of the historical works, The Death of Major Peirson, commissioned by Boydell, was likewise exhibited independently and for a fee, further alienating the Academicians; the Siege of Gibraltar, exhibited in a huge tent in a London park, shows a real falling off of Copley's powers and, despite its popular success, marks the beginning of his decline. His later years were marred by pathological enmity against West, by quarrels with patrons as well as with the Academy, and by the failure of his last royal portrait, an uncommissioned equestrian portrait of the Prince of Wales, later George IV (Boston, MFA).

Coppo di Marcovaldo (recorded 1260–76) Italian painter, born in Florence but one of the founders, along with *Guido da Siena, of the Sienese school (*Madonna del Bordone*, 1261, Siena, S. Maria dei Servi). He also worked in Pistoia (*frescos, cathedral).

Coques, Gonzales (1614/18–84) The outstanding Flemish specialist in small-scale fashionable *genre and portraiture; his *Conversation Pieces were influential on later artists. He probably lived abroad after his apprenticeship with Pieter *Bruegel III and David *Rijckaert the Younger, perhaps in Holland and England, where he would have come into contact with the work of *Van Dyck. The arrival of *Ter Borch at Antwerp c.1640 was also an influence. Coques was patronized by the Dutch House of Orange, and his work was admired by successive Governors General of the Netherlands. There are examples of his meticulously finished pictures at Kassel, Gemäldegalerie; Budapest, Museum; London, National; Antwerp, Museum. Some of his paintings were executed on copper and even silver plates, and some of the individual portraits form series of the Five Senses, in which each sitter exemplifies Taste, Hearing, Sight, Smell or Touch.

Corinth, Lovis (1858–1925) German painter, trained at Königsberg, Munich and Paris. He joined the Berlin *Secession and succeeded *Liebermann as its president. His early paintings adhered to the *realism of *Courbet and *Leibl. About 1900 his painting style lightened and freshened, while his subjects became more exclusively everyday (predominantly portraits, including many self-portraits, and landscapes): he was thus part of a German *Impressionist trend and seen as one of its leaders. He had a stroke in 1911 which left his right (and painting) arm paralysed. A year later he was back at work, drawing and painting with his left arm. The experience brought an urgent *Expressionist note into his work. Landscapes and self-portraits dominated his work now. In his last year he produced a *History painting, *Ecce Homo* (Basel, Kunstmuseum), of the scourged and crowned Christ displayed to the people

by a modern Pontius Pilate and a soldier, which in its fierceness sounds a grave note of warning. Corinth's vigorous, graceless art was always controversial but he had a successful career and found patrons among those who valued his *Impressionism (with its admission of French influence) and the energy which seemed to place him in the tradition of *Hals and *Rembrandt.

Corneille (1922–) Dutch painter, born Cornelis van Beverloo, trained in drawing in Amsterdam, self-taught as painter. In 1948 he was one of the first members of *Cobra and in 1950 moved to Paris where his expressive *abstract painting was seen as a contribution to *Art informel. The Stedelijk Museum in Amsterdam gave him a major retrospective in 1966.

Corneille de Lyon (c.1500/15–74) Netherlandish portraitist, a native of The Hague, he settled in Lyon in France before 1534, becoming court painter to the future Henry II in 1541. His speciality of small-scale, thinly painted bust-length portraits was widely imitated, creating problems of attribution (e.g. Paris, Louvre; Versailles, Musée; Blois, Musée; Dijon, Musée).

Corneille the Elder, Michel (1602–64) One of the founders of the French Royal *Academy of Painting in 1648, elected Rector in 1656. Born in Orléans, he first painted in a style influenced by Italo-Dutch artists such as *Lastman, but later studied in Paris under *Vouet, whose niece he married, and was influenced by *Poussin. His most important works were for chapels and churches in Orléans and Paris – including the Oratory of Queen Anne of Austria in the Palais Royal, c.1645, awarded in competition with the leading artists of the capital – and many were destroyed during the Revolution. He was the teacher of both his sons, **Michel Corneille the Younger** (1642–1708), who later became the most notable student of *Lebrun, and **Jean-Baptiste Corneille** (1649–95).

Cornejo, Pedro Duque *See* Duque Cornejo, Pedro.

Cornelis Cornelisz. van Haarlem (1562–1638) One of the so-called Haarlem *Mannerist painters. He was a portraitist who became friends *c*.1584 with the Italianate theoretician of art Van *Mander and the engraver *Goltzius; under their influence he produced, 1588–90, spectacular history paintings (*see under* genres) with *Michelangelesque nudes in exaggerated foreshortening (*The Dragon Devouring Cadmus's Companions*, 1588, London, National). In 1590 he was commissioned by the city to decorate the Prinsenhof, the residence of the Stadholder (1590–2; Haarlem, Hals; Amsterdam, Rijksmuseum). From 1599 he carried out several other civic commissions. Following Goltzius's example, he tempered his Mannerist exuberance after *c*.1591 to work in a blander, more *classical style.

Cornelisz. van Oostsanen, Jacob, also called **Jacob Cornelisz. van Amsterdam** (*c*.1470–1533) Dutch painter (Amsterdam, Rijksmuseum; Naples, Capodimonte) and influential designer of woodcuts (*see under* relief prints) on a new enlarged scale, some of them destined to be mounted as mural decoration. Born in Oostsanen, he worked mainly in Amsterdam, where he may have taught Jan van *Scorel.

Cornelius, Peter von (1783–1867) German painter who was trained in Düsseldorf before going to Rome in 1811. He became a leading member of the *Nazarenes, partly on account of his abilities and partly because of his conviction that art should once again attend to the highest moral and artistic ideals, expressed in high-minded subjects drawn from the Bible and from northern as well as classical mythology, and an ennobling style. He made himself an expert in *fresco painting, emulating the methods of 14th and 15th-century Italian painters and moderating his *naturalism in accord with their simplified forms and compositions, but enriching his idiom gradually with elements from the more theatrical art of *Raphael. From 1819 he worked in Munich, invited there by the Crown Prince, later King, of Bavaria, and became director of the Munich *Academy. The King of Prussia invited him to Berlin

in 1841, and he stayed there, engaged mainly on preparing cartoons for frescos for an enlarged Berlin Cathedral. His work and his enthusiasm for mural painting made him the leader of an international revival of monumental art. His advice was sought when an ambitious project for murals in the London Houses of Parliament was under consideration in 1842.

Cornell, Joseph (1903–73) American artist and film-maker who was self-taught, widely read and steeped in modern French music and art, employed in New York as a cloth salesman and from 1931 unemployed, Cornell in 1932 began to exhibit *collages and objects wholly committed to *Surrealism. Soon his production was dominated by *assemblages of old and new objects and images in glass-fronted boxes. Their appearance varies widely, from a bareness that associates them superficially with *Constructive art, to Victorian clutter. Some of their elements are common, others give evidence of Cornell's wide-ranging culture. In most of them nostalgia and freshness enhance each other to produce a sense of visionary communication. He exhibited many times from 1932 on. A major retrospective was put on by MoMA in New York in 1980–1 and shown also in Europe.

Corot, Jean-Baptist-Camille (1796–1875) French painter, most admired for his landscape paintings but at heart a *classicist. His early work comprised mainly *History subjects set in landscapes in the tradition of *Poussin. The works called 'studies' show remarkable powers of observation and organization, especially those done in Italy during 1825–8: they are mainly landscapes but also pictures of women in their regional costume, dignified and calm. He continued to produce History paintings for exhibition in the Salon but in 1838, after a second visit to Italy and travels in France, he also sent fully developed landscape paintings. In 1843 he made a third visit to Italy.

Modest, generous and sociable, Corot had many friends. His character may have helped him gain the Légion d'Honneur in 1846 and to win the sympathy of the art

critics *Baudelaire and Champfleury. Benefiting from the change of cultural tone occasioned by the 1848 revolution, he sent a landscape study of 1826 to the 1849 Salon as well as a religious painting. *Pissarro and *Monet admired his exhibited work and his growing popularity helped to draw attention to naturalism. He became a prominent member of the Salon jury and during the Franco-Prussian War donated a large sum for the defence of France. He left Paris when the Commune took power and spent his remaining years wandering about France. Many later Corots are memory pictures, bringing together remembered landscapes and figures and transforming them into suave compositions with a seductive silvery tonality. Somewhat repetitive, these damaged his reputation in the eyes of younger generations though (and because) they were collected around the world and also forged in quantity. But he also produced his more spontaneous landscapes, showing a developing sensitivity to light and to particular effects of weather, qualities of a sort the *Impressionists would seek. Occasional portraits and figure studies also continued to the end of his life, providing bases for modern explorations, such as those of *Braque. The Musée d'Orsay in Paris has the fullest collection.

Corradini, Antonio (1668–1752) Italian sculptor from Este, active in Venice from 1709/10, in Vienna between 1730 and 1740, in Rome from 1740 to 1750, and in Naples from 1750 until his death. He is mainly remembered for his many *allegorical statues of veiled women (e.g. Venice, Ca'Rezzonico; Naples, Cappella Sansevero; see also Queirolo, Sammartino). They have been called 'the bridge between the *Rococo and the *Neoclassicism of *Canova'.

Corral, Jerónimo (active 1536–c.1560) The greatest Spanish master of sculpture in stucco. His masterpiece is the Benavente chapel, Medina de Ríoseco (see also Juni), in which all surfaces are covered in *polychrome figures, enacting complex *allegories of the history of the universe. Corral's *Mannerist style may have been influenced by engravings (see under intaglio)

of the School of Fontainebleau (see Primaticcio, Rosso).

Correggio; Antonio Allegri called (c.1494–1534) One of the most eclectic yet innovative High *Renaissance painters; a precursor of the *Baroque and even anticipating *Rococo developments. Born in Correggio in northern Italy was active mainly in Parma, albeit almost certainly trained at Mantua in the workshop of either *Mantegna or Lorenzo *Costa. He is renowned chiefly for his *illusionistic vault and dome *frescos (c.1519, Parma, Camera di S. Paolo; 1520–3, S. Giovanni Evangelista; c.1525–30, cathedral; but see also Pordenone) and his dramatic yet suave altarpieces and smaller devotional works (many in Parma, Galleria, see also below). Equally important, however, is the small group of mythological and allegorical paintings for the *Gonzaga (see below). Around 1513–14 various other influences become discernible in his work. The small panel of *Christ Taking Leave of His Mother* (c.1515, London, National) is especially significant. The composition is based on a print by *Dürer, but the pictorial treatment owes its use of *sfumato to *Leonardo da Vinci – arguing perhaps for a visit by Correggio to Milan. Leonardo's facial types are especially noticeable in major later altarpieces such as the *Madonna of St Jerome* (1528, Parma, Galleria). The presence in Northern Italy by c.1514 of two famous works by *Raphael, the *Sistine Madonna* and the *St Cecilia* (Piacenza and Bologna respectively) may be reflected in Correggio's earliest altarpieces, the *Madonna of St Francis* (1515, Dresden, Gemäldegalerie) and *Four Saints* (c.1515, New York, Metropolitan). At some point in the same period he must have looked to Venice, *Giorgione in particular (*Nativity*, c.1514, Milan, Brera).

While the overall design of the vault of the Camera di S. Paolo, c.1519, painted for the mundane abbess of the convent, is indebted to Mantegna, its details are fresh. Frolicking *putti look down through openings in a leafy pergola. Lunettes in *grisaille of mythological subjects demonstrate the availability to the artist of ancient coins and medals. Although individually

their mythological content is perfectly legible, the overall *iconography has never been satisfactorily explained. Attracting less notice from scholars is the life-like illusionism of the painted swags of linen cloths holding plates, jugs and bowls, referring presumably to the Camera's function as a dining room.

A greater challenge was met in the *Vision of St John* of the cupola of S. Giovanni Evangelista, 1520–3. No domal surface of such size had been painted before, and no decoration of a dome had previously omitted any allusion to the actual architecture. Correggio has depicted heavenly light which compensates for the dome's lack of a lantern or other illumination, notionally opening up the church crossing to the miraculous vision – the steeply *foreshortened body of Christ, viewed from below by the spectator and from the cupola's rim by St John.

The much larger octagonal cupola of the cathedral amplifies and transforms this concept. Taking advantage of the natural light provided by windows in the drum, Correggio has created three zones, in keeping with the subject, the *Assumption of the Virgin Mary*. Around the cornice, which represents also the parapet of the Virgin's tomb, the Apostles gesture upward. Above them the Virgin ascends to the open heavens within a continuous spiral, which seems to depict at one and the same time cloud, angels, the Saints and Blessed. To her right Eve holds the apple of Paradise. In the dark below, on the floor of the church, the viewer stands as if within the Virgin's tomb.

These domes are the artistic time-bombs which were exploded in Rome, a century later, by *Lanfranco – the source of Baroque cupola and vault decoration. Although the *Assumption* has fared very badly in a recent restoration, its visionary impact can hardly be overstressed. Detailed figure drawings testify to Correggio's meticulous preparation from the life for the orchestration of his soaring, foreshortened figures and cloud masses.

Altarpieces, the painting of which punctuates the continuous work on the cupolas, attest to Correggio's response to *Mannerist painting of the day. Bold asymmetries

and diagonals – not only across the picture surface but also in depth – enliven even the traditional formula of the *sacra conversazione* (e.g. *Madonna of St Jerome*, as above; *Madonna of St George*, c.1530, Dresden, Gemäldegalerie).

To this compositional drama may be added the complexity of nocturnal lighting (*Adoration of the Shepherds, 'La Notte'*, c.1527–30, Dresden, Gemäldegalerie), a further example of Correggio's interest in northern European art (*see* Geertgen Tot Sint Jans).

Where in Correggio's religious works these effects express spiritual beauty, they give unsurpassed sensuality to his mythological paintings. The earliest, c.1525–5, are the *Celestial Venus or the Education of Cupid* (London, National) and *Terrestrial Venus or Jupiter and Antiope* (Paris, Louvre). Around 1530 Federico Gonzaga commissioned four pictures for a *Loves of Jupiter* series: *Danaë* (Rome, Borghese); *Leda* (Berlin-Dahlem, Museen); *Io* and *Ganymede* (both Vienna, Kunsthistorisches). Io's abandoned pose is derived from a famous *classical relief, the *Bed of Policretes* once owned by *Ghiberti, and later also copied by *Giulio Romano. An equally sensuous, if in the context discordant, note is struck in the two allegories painted in tempera c.1531 for Federico's mother, Isabella d'Este, to hang in her *studiolo* alongside *all'antica* works by Mantegna, *Perugino and Costa (*Vice, Virtue*, Paris, Louvre).

Besides Lanfranco, the chief artists directly influenced by Correggio, and who in turn spread his influence, include *Parmigianino, *Barocci and the *Carracci.

Cortese, Guglielmo and **Giacomo** *see* Courtois, Guillaume, Jacques.

Cortona, Pietro da *See* Pietro da Cortona.

Cosmati work Inlaid coloured stone and glass decoration in geometric patterns, used for church pavements, altars, tombs and pulpits. The technique was handed down from father to son in a small group of Roman stone-masons, (of whom the original family bore the name Cosmati),

surviving almost unchanged from the early 12th to the beginning of the 14th century, and can be found throughout Italy and in some northern European churches, e.g. Westminster Abbey. The Cosmati sliced through antique Roman columns to obtain the large discs of porphyry etc. which are a major feature of this type of decoration.

Cossa, Francesco (1436–78) Ferrarese painter, best known for his *frescos in the *salone* of the palazzo Schifanoia at Ferrara, depicting, like mural-sized calendar pages, the activities and zodiacal signs of the months of March, April and May, in a style indebted mainly to *Mantegna. Disappointed at the low valuation and payment for this work, Cossa abandoned the decoration in 1470 to settle in Bologna, where he executed major altarpieces (now Dresden, Gemäldegalerie; Bologna, Pinacoteca, Madonna del Baraccano), frescos (now destroyed) and designs for stained-glass windows. There are panels by him – fragments from altarpieces – in London, National; Madrid, Thyssen; etc.

Costa, Lorenzo (*c*.1460–1535) Painter from Ferrara, probably trained by Ercole Roberti (recorded during 1479–96) (but *see also* Tura, Cossa). During 1483–1506 he worked for the Bentivoglio court in Bologna, where his style was affected by the softer, more luminous manner of *Francia, himself influenced by *Perugino. From 1507 he succeeded *Mantegna as court painter for the Gonzaga at Mantua (but *see* Giulio Romano). He was prized by his contemporaries for the gracefulness and 'cosmetic softness' of his work, although in portrait busts he tried to emulate the meticulous *realism of Netherlandish artists. He has the distinction of having influenced the incomparably greater *Correggio. (London, National, Coll. HM the Queen; Paris, Louvre; Bologna, S. Giacomo Maggiore; Milan, Brera, etc.)

costruzione legittima *See* perspective.

Cosway, Richard (1742–1821) Fashionable English portraitist; a fop and a 'character', for some years an intimate of the Prince of Wales. Although he also painted in oils on the scale of life, he is best known for his elegant miniatures, which revived the popularity of this genre in Regency society (*see also* Cooper, Samuel). There are works by him in London, V&A.

Cotán, Juan Sánchez *See* Sánchez Cotán, Juan.

Cotes, Francis (1726–70) Apart from *Reynolds and *Gainsborough, the most fashionable English portraitist in the 1760s. He trained in pastels under *Knapton and began to work in oils only from *c*.1753. There are pictures by Cotes in private collections and in Edinburgh, Portrait; London, NPG, Tate, Royal Academy, Foundling Hospital; Oxford, Christ Church; etc.

Cotman, John Sell (1782–1842) British painter, mainly of watercolours, born in Norwich and prominent in the *Norwich School. Little is known of his beginnings in art, but he was working in London before the end of the century and toured Wales and Yorkshire, making watercolours and sketches, before returning to Norwich in 1806. *Greta Bridge* (1805; London, British) is a particularly admired example, being constructed of broad washes in light tones that suggest space and weather yet do so in simplified terms that maintain the transparency of the medium and the flatness of the paper. During 1810–21 he published etchings of the antiquities of Norfolk and of Normandy which were well received. He also had income from teaching in Norwich, Yarmouth and London. His style became richer and more colourful in his last decades, more like Victorian painting and less appealing to modern tastes. His sons **Miles Edmund** and **John Joseph** were also painters and members of the Norwich School.

Courbet, Gustave (1819–1877) French painter, the creator and leader of *Realism. He was born into a family of well-off landowners at Ornans, near Besançon. In 1839 he went to Paris and worked in various studios and copied in

the Louvre – Venetian, Dutch, Flemish and Spanish old masters as well as modern Frenchmen such as *Géricault and *Delacroix. He was reading *Romantic authors but painting portraits and landscapes, as well as *History subjects, that increasingly emphasized his dependence on observation of nature. In 1844 he showed for the first time at the Salon: *Self-Portrait with Black Dog* (Paris, Petit Palais). He was sympathetic to the 1848 revolution but did not join it, claiming that his fight was on the level of art and ideas. Member of a social circle that included the writers *Baudelaire, Proudhon and Champfleury, and the painters *Corot and *Daumier, he began developing the theories that were to be propagated as *Realism. The 1848 Salon was without a jury and Courbet showed ten works, including another self-portrait (1847; Stockholm, National) and a large *Walpurgis Night* in which science symbolically pursues nature – an allegorical treatment of a contemporary issue which he later overpainted. Champfleury wrote in praise of it and was to be Courbet's champion for some years.

At the Salon of 1849 he showed 7 works, including a large *genre scene *After Dinner at Ornans* (Lille, Musée), portraying his father and three friends in monumental conviviality. It was praised by Delacroix and purchased by the state. Courbet went to Ornans for some months, where he painted *The Stone-Breakers* (1849; destroyed) and *Burial at Ornans* (1849–50; Paris, Orsay), both polemical demonstrations of his principles. The *Burial*, nearly 9 metres long, is a realistic, unsentimental account of a country burial represented on the scale of a major mural. At the end of 1850 the Salon opened and he showed both works there again, to much notice but most of it critical of their social message and lack of beauty. He wrote to a paper in 1851: 'I am not only a socialist but also a democrat and a republican . . . above all I am entirely a Realist . . . because being a Realist means to be a true friend of the real truth'.

The Salon of 1854 was held back until 1855 to form part of the Paris World Exhibition. Courbet had refused an invitation to produce a major work for it unless he had freedom to paint what he liked. In the event some of his most ambitious paintings were rejected, and he set up a one-man gallery nearby to show 39 paintings, including *The Painter's Studio; a Real Allegory* (Paris, Orsay), recently completed. Six metres across, it shows Courbet at work on a landscape, watched by a nude model (truth?) and a young boy (unprejudiced appreciation?), in the company of his intellectual friends on the right and, on the left, 'the other world of trivial life, the people, misery, poverty, riches, exploited and exploiters, those who live from death'. The exhibition, under the title 'Realism' and with a polemical catalogue, did not get the attention Courbet had hoped for; it seemed that even his associates felt his exhibitionism had become excessive. The Paris press had caricatured his work on several occasions; Courbet witnessed a theatrical skit on the *Studio* that November. Increasingly he sought recognition abroad, showing his work in the Low Countries, Germany and London; in Germany especially it held the attention of like-minded painters and encouraged a realist movement: *Leibl and *Thoma of Munich were among those most impressed. He also hoped to make friends for his art with hunting scenes, perhaps in emulation of *Landseer's success with such scenes at the World Exhibition. Courbet showed the first of these at the 1857 Salon but again offended critics with another exhibit, *Young Ladies by the Seine* (Paris, Petit Palais), a rich and sensuous picture which cast doubt on the females' propriety on account of their graceless forms and positions. Champfleury wrote that Courbet was trying 'to flatter popular taste and shock people at the same time'. His hunting scenes and landscapes did now draw favourable comment and Courbet in 1861 had reason to hope for the Légion d'Honneur – a hope dashed by the Emperor's veto. In December 1860, in response to demand, he opened a short-lived studio school in which he offered bulls or horses as models and refused to teach lest he diminish anyone's individuality: nature being the only true guide. The chief work produced during a stay in Saintes, 1862–3, was *Return from the Conference*, portraying clergymen as drunks; it was rejected from

both the 1863 Salon and the Salon des Refusés because of its anti-clerical message. Champfleury too disliked the painting; Proudhon defended it in a pamphlet of 1865; the picture was subsequently destroyed by Catholic interests. In 1864 Courbet, who had previously proved he enjoyed painting nude women, sent a two-figure composition, *Venus and Psyche* (destroyed), to the Salon jury which rejected it. Little different from comparable subjects by the academic painters of the day, it was considered tasteless and indecent perhaps because Courbet's nudes have an emphatic fleshly presence.

His widening range enhanced his reputation, and it seemed that the 1866 Salon would clinch his fame, yet again he was disappointed: no Légion d'Honneur, no sale to the government. A rich Turk commissioned from him a picture in the spirit of *Venus and Psyche*. The result was *Sleep* (Paris, Petit Palais), an enticing, over life-size presentation of two naked women. In 1867 he showed four paintings in the Paris World Exhibition but again erected his own gallery nearby, displaying 137 works in it – a retrospective show which, again, did not have the success he had hoped for but did result in purchases and some respectful comments in the press. The 1869 Salon included only two Courbets, received with a mixed critical response, but the same year saw a solo show within a vast international art exhibition put on in Munich. Academic and progressive painters there enthused over his work and the King of Bavaria knighted him. He showed two seascapes at the 1870 Salon and found them lauded to the skies. Nominated for the Légion d'Honneur, he now refused it. During the Franco-Prussian War of 1870–1 he found himself appointed president of an artists' committee charged with guarding Paris's art treasures. The following April he was elected to the Paris Commune and asked to reform museums and art education. When the Commune ended that summer, he was imprisoned for his part in the destruction of the great column in the place Vendôme. He was allowed to paint and sold almost everything he produced. He was released in the spring of 1872, to find that many paintings had been stolen from him or destroyed in Paris and in Ornans. In 1873

he faced renewed prosecution and fled to Switzerland, settled near Vevey and continued to paint though his friends noticed that he was drinking too much and deteriorating in body and mind. In spite of many visits from friends, he was neither happy in exile nor willing to return to France until his liberty and property were secure. In May 1877 a judgment required him to pay a vast fine in annual instalments. Courbet made plans to begin the payments but was taken seriously ill with dropsy and died on the last day of 1877.

He considered himself a northerner, heir to the realistic traditions of Dutch 17th-century painting. He was also respectful of Spanish painting, especially *Velázquez's. He had a gift for matching nature's solids and surfaces, female flesh and dying beasts but also turf, cliffs and water, with paint. He delighted in the physical and denied the spiritual. At a time when art was still associated with lofty ideals – though success was gained more often through pretentious banalities – he asserted both the artist's personal awareness and the common experience of ordinary humanity as fit matter for grandiose works. His work is sometimes clumsy, even silly; sometimes too it is ambitious beyond belief and succeeds in its aim. Generally it celebrates the tangible world, and his example stimulated several generations of progressive painters in France and abroad. The Musée d'Orsay and the Petit Palais, Paris, have major examples of his work but his large output is spread around the world. The Musée Fabre at Montpellier holds the collection of his friend and patron, Bruyas.

Courtois, Guillaume, also called **Cortese, Guglielmo** or **Il Borgognone** (1628–79) and his elder brother **Jacques Courtois** or **Giacomo Cortese,** also called **Il Borgognone** (1621–76) Painters from Burgundy, active in Rome. Both studied with *Pietro da Cortona, and both worked under his direction on the *frescos of the great Gallery of the Quirinal Palace. Guillaume Courtois emerged as an independent painter, mainly of altarpieces, in the 1650s; he was increasingly influenced by the *classicizing manner of *Maratta. His masterpiece is the

Martyrdom of S. Andrea, *c.*1670, over the high altar of S. Andrea al Quirinale. Jacques Courtois, inspired by Pietro da Cortona's *Battle of Issus* (Rome, Capitoline) became a specialist in battle paintings along with the young Salvator *Rosa. He was the teacher of Joseph *Parrocel.

Cousin, Jean the Elder (recorded from 1526–60/1) and his son **Jean Cousin the Younger** (*c.*1522–*c.*94) Leading French painters and designers from Sens, both active mainly in Paris. Jean the Elder was one of the few important painters of his day working independently of the School of Fontainebleau (*see* Primaticcio, Nicolò dell'Abate). In Paris from *c.*1538, he gained renown – and accumulated considerable property – as a painter and designer of stained glass. Only a few extant works can now be securely attributed to him: the design of the tapestries of the life of St Mammès (1543, Langres, cathedral) and the painting *Eva Prima Pandora* (before 1538, Paris, Louvre) which show his debt to *Rosso, his knowledge of Italian engravings as well as those by *Dürer, and of *Leonardo da Vinci's use of light. Two windows in Sens cathedral are traditionally attributed to him (1530). Jean Cousin the Younger was even better known to contemporaries than his father; surviving works (*Livre de Fortune*, 1568, series of emblem drawings; engravings after his designs, notably *Brazen Serpent*, *Conversion of St Paul*; engraved illustrations to Ovid's *Metamorphoses*, 1570, and *Epistles*, 1571; stained glass windows, St Gervais; *Last Judgement*, Paris, Louvre) demonstrate his debt to Florentine *Mannerism and a Flemish figure style.

Coustou, Nicolas (1658–1733) and his brother **Guillaume the Elder** (1677–1746) French sculptors, nephews and pupils of *Coysevox, with whom they collaborated on the *Lamentation Group with Kings Louis XIII and Louis XIV* on the high altar of Notre-Dame in Paris, one of their few works still *in situ*. Like their uncle, they were active mainly for the court in decorative large-scale sculpture (e.g. *Seine and Marne*, 1712, by Nicolas, Paris, Tuileries; *Apollo*, 1713–14, by Nicolas, and

Daphne, 1713, by Guillaume, for Marly, now Paris, Tuileries; *Pediment*, 1716, by Nicolas, Rouen, Customs House) and portraiture (e.g. *Marie Leczinska as Juno*, 1726–33, by Guillaume; *Louis XV as Jupiter*, 1726–33, by Nicolas, Paris, Louvre; *Nicolas Coustou* by Guillaume, Louvre, marble version Liverpool, Walker). Both brothers spent time at the French *Academy in Rome (Nicolas from 1683–7, Guillaume at some point before 1703) where they learned as much from the *Baroque of *Bernini as from antiquity. Guillaume, however, continued to evolve from the Grand Manner to *realism (e.g. *Cardinal Dubois*, Paris, Saint-Roch) and to a proto-*romantic notion of nature, as in his masterpiece, the *Horses*, originally for the horse pond in the garden of Marly, now Paris, Place de la Concorde (models ready 1740, marble groups set up 1745).

His son, **Guillaume Coustou the Younger** (1716–77) was also a sculptor, much patronized by Louis XV's mistress Mme de Pompadour and by the king himself (e.g. Paris, Louvre; his most important work, *Monument to the Dauphin*, designed before 1767, set up posthumously, Sens, cathedral).

Couture, Thomas (1815–79) French painter, son of a master cobbler. His family moved from Senlis to Paris in 1826 and Couture worked as assistant to *Gros. He exhibited at the Salon first in 1840 and caused a great stir in 1847 by showing one of the largest and most discussed *History paintings of the century: *Romans of the Decadence* (Paris, Orsay), an elaborate scenic invention portraying men and women enjoying, and also expressing disquiet at, an orgy amid fine architecture and statues. This led to state commissions but these, owing to difficulties with the authorities, were not completed. He painted a number of *Romantic scenes and characters as well as portraits, but his career declined after the climax of 1847. His studio attracted many pupils, especially visitors from America and Germany, but also *Puvis and *Manet.

Cox, David (1783–1859) British landscape painter, born in Birmingham and

active mostly in Hereford and London. He is best known for his lively and influential watercolours. He derived some of his income from teaching and published a *Treatise on Landscape Painting and Effect in Watercolour* (1814) as well as other books. The example of *Bonnington caused him to loosen his style in and after the 1830s. His son, also called **David Cox** (1809–85), worked in his father's manner in a competent and attractive way.

Coypel Dynasty of French painters successful within the Royal *Academy and in court circles during the 17th and 18th centuries.

Noël Coypel (1628–1707), a protégé of *Lebrun, under whom he worked at Versailles and for the Gobelins, painted in a *classicizing style modelled on that of *Poussin. He was Director of the French Academy in Rome 1673–5 and of the Academy in Paris 1695. From c.1700 he was employed on the decoration of the Invalides in Paris.

His son **Antoine Coypel** (1661–1722) derives his art-historical importance from his role as one of the leading champions of the *Baroque style in the later years of the reign of Louis XIV and during the Regency (*see also* Jouvenet). He is the author of the two most completely Baroque pictorial ensembles in French art of this period: the decoration of the gallery in the Palais-Royal (1702–18; destroyed 1780s; some wall panels, sketch for ceiling, Angers, Arras, Montpellier, Musées) and the ceiling of the royal chapel at Versailles (1707–10) based on *Gaulli's scheme for the ceiling in the Gesù, Rome. A child prodigy, Antoine accompanied his father to Rome, where he was praised by *Bernini. Before returning to Paris in 1676, he spent an additional year in northern Italy, studying *Correggio, the Bolognese followers of the *Carracci, notably *Albani and his school, and the Venetians (*see*, e.g. Veronese, Titian). Received in the Academy as a history (*see under* genres) painter in 1681 (diploma piece, *The Peace of Nijmegen*, 1681, Montpellier, Musée) Antoine Coypel first oscillated between proto-*Rococo lightness derived from Albani and a more severe classicism. By the early 1690s, however, he was

converted to wholehearted admiration of *Rubens (e.g. *Democritus*, 1692, Paris, Louvre) and continued to work in an explicitly Baroque manner. He became director of the Academy in 1714; *Premier Peintre du Roi* 1716, and was ennobled in 1717.

Antoine's half-brother **Noël-Nicolas Coypel** (1690–1734), a more naturally gifted painter but a timid personality, rose more slowly in the academic hierarchy. He never went to Italy, but was influenced by Rosalba *Carriera during her visit to Paris in 1720–1 and practised sometime as a pastellist. His best surviving work is a group of mythological pictures whose translucent colour and curving rhythms prefigure the work of *Boucher (e.g. Philadelphia, Museum; Geneva, Musée). His most important work, the cupola of a chapel at St Sauveur, Paris, executed c.1730 in collaboration with the sculptor Jean-Baptiste *Lemoyne, was destroyed later in the century. Distracted by disputes with his patrons over the expense of the scheme, the painter accidentally injured his head passing through a doorway, and died as a result.

Antoine's son **Charles-Antoine Coypel** (1694–1752) was but four years younger than his uncle; he was, however, received at the Academy as early as 1715. In 1747, three years after becoming *Premier Peintre du Roi*, he was made director; under his directorship, the Academy became the scene of discussions and lectures, and he initiated a scheme of 'pre-Academic' training. In addition to the decorative history paintings (*see under* genres) in which he specialized (e.g. Paris, Louvre) Charles-Antoine also executed portraits, some in pastels; *Fancy Pictures, tapestry cartoons (*see* fresco). He wrote a good deal of art theory – including a pamphlet explaining the aims of his huge *Ecce Homo* painted in 1729 for the Oratory in Paris (destroyed) and was also a poet and a dramatist.

Coysevox, Antoine (1640–1720) French sculptor, the chief rival of *Girardon, whom he eclipsed in royal favour in the 1690s, when Louis XIV began to favour the *Baroque style over strict *classicism. Although his most original works were the

portrait busts in which he specialized late in life, and which earned him at his death the epithet of 'the *Van Dyck of sculpture' (see below), he first achieved great success with his stucco decorations at Versailles, notably the equestrian relief of Louis XIV, c.1679, Salon de la Guerre. Equally spirited were his tomb monuments at Serrant, 1680–1; Paris, St Eustache, 1685–7 and Louvre, 1689–93. He was less successful in the forecourt and garden sculpture at Versailles, where he attempted to follow the manner of Girardon and *Sarrazin.

Born at Lyons, Coysevox came to Paris in 1675 to study at the *Academy. His earliest surviving work dates from 1676 (Lyons, Musée). As early as 1680 he executed a bronze bust of Louis XIV (London, Wallace) inspired by *Bernini's bust of the king at Versailles. He continued to use the same Baroque formula for later portraits of the King and court dignitaries, but evolved a more naturalistic, intimate manner for busts of his friends and colleagues (London, Wallace; Paris, Louvre; Bibliothèque St Geneviève). The spontaneity of some of his late portraits foreshadows the work of *Houdon, and certain of his full-length statues look forward to the lightness and delicacy of the *Rococo (e.g. *Duchesse de Bourgogne as Diana*, 1710, Versailles). He was the teacher of his nephews, Nicolas and Guillaume *Coustou the Elder, with whom he collaborated on a *Lamentation Group with Kings Louis XIII and Louis XIV*, 1715, for the high altar of Notre-Dame, Paris.

Cozens, Alexander (c.1717–86) and his son **John Robert** (1752–97) English watercolourists, founders of the 'Southern School' of watercolour painting, specializing in the poetically atmospheric representation of Italian and Swiss scenery. Born in Russia, Alexander Cozens only settled in England in 1746, presumably after a stay in Rome. Through his position as drawing master at Eton, he became associated with the notable patrons Sir George Beaumont and William Beckford. He is chiefly remembered now for his *A New Method of Assisting the Invention in Drawing original compositions of Landscape*, 1785, in which he advocates the use of inkblots to suggest landscape motifs to the amateur painter. His classification of cloud formations published in the same volume influenced John *Constable. The latter was also to praise the Swiss and Italian watercolours of John Robert Cozens, recording transient phenomena of light and atmosphere and compiled during two visits to the Continent (1776–9, with Richard Payne Knight; 1781–3; with Beckford). John Robert ceased painting in 1792, due to progressive paralysis. During his last years of insanity, 1794–7, he was nursed by the amateur painter Dr Thomas Munro (1759–1833), who set a number of young watercolourists, among them *Girtin and *Turner, to copying his works.

Cragg, Tony (1949–) British sculptor, trained at the Wimbledon School of Art and the Royal College of Art in London; from 1977 resident in Wuppertal, Germany. Some of Cragg's sculpture is a kind of *assemblage and with its pronounced intellectual content has been seen as a contribution to *Conceptual art. He makes it by collecting refuse, preferably in the area where the sculpture is to be, sorting this into visual or conceptual categories and arranging it to take on significant forms. Since 1985 he has increasingly made sculptural forms, out of a variety of materials, sometimes emulating existing objects but on a larger scale, in order to bring out suggestions of content normally hidden from us. He has had many one-man shows from 1979 on all over the world, and in 1987 he represented Britain at the Venice Biennale.

Craig, Edward Gordon (1872–1966) British theatrical designer and graphic artist. He was the son of the actress Ellen Terry and became eminent internationally as a stage designer and producer. He had radical ideas on variable stage sets of movable elements, on lighting, and on depersonalized acting in which the drama becomes ritualistic and unrealistic. He worked in many European cities, including Moscow, where his *Hamlet* (1912) made a deep impression. From 1908 on he published his thoughts and designs in his own journal *The Mask*. The visual

character of his designs and his desire for an *abstracted style of production, *primitive and archaic but also signalling a new age, influenced art before and after the First World War.

Craig-Martin, Michael (1941–) British artist, born in Dublin, trained at Yale, and prominent among *Conceptual artists who shifted art's priorities in the late 1960s and 70s. His first exhibition, in 1969, was of three-dimensional objects as paradoxical as they were visually direct. He showed frequently from then on, his exhibits changing rapidly but revealing the same underlying capacity for paradox. *An oak tree* (1973) was one extreme instance: a glass of water on a glass shelf fixed high up on the wall and a printed dialogue in which the artist explains how he has transubstantiated the glass of water into an oak tree without changing its appearance. In many other works the visual element is more dominant, the dialectical one less so. Among his recent works have been linear constructions set a little in front of the wall and read as precise, plain drawings of familiar, banal objects, single or grouped.

Cranach, Lucas the Elder (1472–1553) Painter, etcher and inventor of the chiaroscuro woodcut in 1507 (*see* intaglio and relief prints); in his later years also a bookseller and printer. As court painter to the Elector of Saxony, the protector of Luther, he has been called the chief artist of the Reformation. He collaborated on woodcuts in Melanchthon's *Commentary on the Lord's Prayer*, 1527; designed Lutheran altars, and several times painted Luther's portrait. Luther stood godfather to one of his children.

Although his family name was Sunder or Muller, he is called after his birthplace, Kronach, near Bamberg, where he was probably trained by his father Hans. Around 1498 he began his *Wanderjahre*, which took him to Vienna *c.*1500 and may have included a visit to Venice.

Cranach's early works, *c.*1500–4, are formative examples of the *'Danube school' – *see also* Albrecht Altdorfer, Jörg Breu the Elder, Wolf Huber. That is, Cranach employed landscape and landscape

elements (inspired by *Dürer's prints but also observed from nature) as major formal and *expressive elements in portraits (e.g. *Dr Johannes Cuspinian, Frau Anna Cuspinian, c.*1502, Winterthur, Reinhart Coll.), in biblical scenes (e.g. *Crucifixion,* 1503, Munich, Alte Pinakothek) and in episodes from the lives of saints (e.g. *Stigmatization of St Francis, c.*1500–5, Vienna, Akademie). The naturalism (*see under* realism) and *romantic intensity of these works gave way, however, to a more ornamental and calligraphic style, which was to prove better suited to the demands made on Cranach after his appointment in 1505 as court painter to Friedrich the Wise, Elector of Saxony, at Wittenberg. A trip to the Netherlands in 1509 stimulated him into adopting Flemish pictorial modes (*Holy Kinship Altarpiece,* 1509, Frankfurt, Städel), but this stage in his working life was very brief.

As court painter, Cranach was called upon to produce innumerable portraits in many copies and variants. He seems to have been the first to evolve a new portrait type, the full-length life-size figure against a monochromatic ground, evenly lit – a secular version of full-length portrait figures in the wings of altarpieces (*Duke Henry the Pious, Duchess Catherine,* 1514, Dresden, Gemäldegalerie). In these figures the proportions of the body are elongated, the silhouette of the bulky costumes, and their elaborate inner patternings, stressed, and only the heads realistically modelled in light and shade. The same heraldic style was applied to half-length portraits (e.g. *Johann Friedrich the Magnanimous,* 1529, formerly Haarlem, Gutman) and persisted throughout Cranach's career in his effigies of princely and other public figures. Yet Cranach remained entirely capable of naturalistic and fully modelled portraiture, which he continued to employ for likenesses of private persons (e.g. *Dr Johannes Scheüring,* 1529, Brussels, Musées; *Self-Portrait,* 1550, Florence, Uffizi). The reasons for this dual stylistic modality were neither purely aesthetic preference nor a matter of *decorum – although both must have played a part. To furnish, for example, over 60 copies of portraits of the Electors required by Cranach's third princely patron at Wittenberg, Johann Friedrich,

Cranach had had to organize a large and quasi-industrial workshop. Avoiding the more personal approach characteristic of such contemporaries as Dürer, he evolved a court style readily reproducible by many hands under his supervision, without loss of quality or even visible distinction between a single 'original' and its 'copies' or 'variants'. His two sons, **Hans Cranach** (*d*.1537) and **Lucas Cranach the Younger** (1515–86) were among those painters who submerged their individual artistic personalities in this enterprise. Cranach himself drew penetrating brush sketches from the life, in *gouache on tinted paper, and these were available for use in the workshop (Reims, Museum).

In addition to portraits the Cranach shop specialized in a new kind of figure composition geared to the taste of the court. *Classical myth provided an excuse for depicting the female nude in *cabinet pictures (e.g. *Judgement of Paris*, 1530, Karlsruhe, Kunsthalle; *Three Graces*, 1535, Kansas City, Gallery; *Venus*, 1532, Frankfurt, Städel; many variants also of *Lucretia*, etc.). Despite their ostensibly antique origins, these figures are Late *Gothic in their proportions and bearing, and their beauty is more fashionable than *idealized. Cranach was not attempting, like Dürer, to discover the secret harmonies of human proportion, but appealing to the erotic fantasy of his patrons. Certain Old Testament subjects were treated in the same spirit (*Bathsheba in her bath*, 1526, Berlin, Staatliche, *Judith and Holofernes*, *c*.1530, New York, Metropolitan). Larger compositions reflect another preoccupation of the court: hunting (Vienna, Kunsthistorisches; Madrid, Prado).

Simultaneously, however, Cranach continued to paint devotional images and religious scenes, and altarpieces reflecting Lutheran theology (Gotha, Schlossmuseum; Prague, Galerie; Naumburg, St Wenzel; Hamburg, Kunsthalle). His last work, finished after Cranach's death by his son Lucas the Younger, was the *Allegory of Redemption* (1553–5, Weimar, Stadtkirche). In the central panel the artist is depicted at the foot of the cross, flanked by John the Baptist and Luther, the blood of Christ spurting directly on to his forehead – no priestly intercessor between him and Salvation. There is no artist of the 16th century in whose work the tensions and contradictions of the time are more clearly demonstrated.

Crane, Walter (1845–1915) British illustrator and painter, son of a miniaturist. Trained first by his father and then by a leading maker of woodcuts, Crane was attracted to the work of the *Pre-Raphaelites. His first success was in the design and illustration of children's books; during 1865–76 he produced two or three every year and they found admirers internationally. He also worked in several 'applied art' areas, wrote about design and was the first president of the Arts and Crafts Exhibitions Society whose first show took place in London in 1888. In 1871 and again 1888 he visited Italy and was particularly impressed with the work of *Botticelli. This, combined with his contact with *Rossetti and his circle, caused him to give more attention to painting, in tempera as well as oils, but it was his decorative work and his book illustration that are his major achievement. His graphic work was well-known throughout Europe. His books, among them *The Bases of Design* (1898) and *Line and Form* (1901) influenced developments in Britain and on the Continent. His autobiography, *An Artist's Reminiscences* (1907) is lively and indicates – as do the subjects of some of his prints – his strong socialist leanings.

Crawford, Thomas (1814–57) American sculptor, born and apprenticed in New York but from the age of twenty working in Rome. There he studied under Thorvaldsen and became a *Neoclassicist, supplying his home country with official monuments as required. Outstanding among these is the bronze *Armed Liberty* installed on the dome of the Capitol in Washington in 1863.

Crayer, Caspar de (1584–1669) Flemish painter influenced by *Rubens and *Van Dyck. There are many distinguished altarpieces by him in or from churches in Ghent and Brussels (e.g. Ghent, St Michael; Musée; Brussels, Musées

Royaux). He also executed portraits (Madrid, Prado) and *allegorical pictures, such as the eight large canvases he delivered in 1635 as decorations for the state entry into Ghent of the Cardinal Infante Ferdinand (*see also under* Rubens).

Credi, Lorenzo di (1456/7–1536) Florentine painter, pupil, then assistant of *Verrocchio, whose heir and executor he became in 1488. After 1482–3, when Verrocchio left for Venice and *Leonardo da Vinci for Milan, Lorenzo remained alone in charge of Verrocchio's Florentine workshop. Around 1485 he completed a *sacra conversazione* for Pistoia cathedral probably commissioned from Verrocchio; otherwise, he is mainly known for the many domestic Madonnas, *Adorations* and images of saints which he painted in a slick and highly coloured variant of Leonardo's style (e.g. Dresden, Kunstsammlungen; London, National; Oxford, Ashmolean; Turin, Sabauda). There are also portraits by him, including one of *Perugino, in Florence, Uffizi. Because of his technical excellence, Lorenzo was much in demand as a restorer: in 1501 he restored – i.e. modernized – an altarpiece by Fra *Angelico in Fiesole, S. Domenico; in 1524, while restoring the *condottieri* *frescos by *Uccello and *Andrea del Castagno in Florence cathedral, he added decorative borders which compromised the *illusionsim of both works. He was the teacher of Giovanni Antonio Sogliani (1492–1544).

Crespi, Daniele (*c*.1597–1630) Prolific and precocious Milanese painter; his rapid development was cut short by the plague. Crespi's style underwent many changes during his short working life – from the *Michelangelo-influenced pendentives in the dome of S. Vittore al Corpo, and the Giulio Cesare *Procaccini-derived pendentives in a chapel at S. Eustorgio, 1621, to the rugged *realism of his work from S. Protaso ad Monachos, now in Busto Arsizio, S. Giovanni, 1623, and of his organ shutters for the Church of the Passion, *c*.1623. His knowledge of central Italian *Renaissance painting, and his indebtedness to the Genoese works of *Rubens and *Van Dyck, are evident in his main work, the two great cycles of *frescos in the nave of the Charterhouse of Garegnano outside Milan, 1629. He is best remembered, however, for his celebrated *Fast – or Lenten Meal – of San Carlo Borromeo* (*c*.1628, Milan, Church of the Passion) an austere testimony to Counter-Reformation piety, and the best-known work of 17th-century Lombard art.

Crespi, Giovanni Battista *See* Cerano.

Crespi, Giuseppe Maria (called Spagnoletto) (1664–1747) The most original and distinguished Bolognese painter of his day, Crespi achieved international fame, turning down invitations to settle as a court artist in Rome, Vienna and Savoy, and maintaining a mail-order practice in intimate representations of religious scenes, contemporary *genre, portraiture and *still life. He deliberately rejected *academic teaching, instructing himself instead through the genre pictures of the *Carracci, the early work of *Guercino, and through direct contact with Sebastiano Mazzoni, to whom he owed the intense *chiaroscuro and free brushwork characteristic of his style. Supported by a sympathetic Bolognese merchant collector, he went on study trips to Modena, Parma, Pesaro, Urbino, spending considerable time in Venice; influences from most of these are evident in his work. His local reputation was fully established *c*.1693 with *frescos painted for the Palazzo Pepoli Campogrande, Bologna. From 1708, he enjoyed the enlightened patronage of Ferdinando de'*Medici for whom he executed some of his most notable works, including the autobiographical *Painter's Family* and the *Fair at Poggio a Caiano* (both, with other genre works, Florence, Uffizi). Visits to Florence in 1708 and 1709 cemented the rapport between patron and painter, but with Ferdinando's death in 1713 Crespi retreated to Bologna. His treatment of low-life subjects (e.g. *The Hamlet*, after 1710, Bologna, Pinacoteca) remains exceptional in Italian art for its sympathy towards the poor and simple; a similar approach marks his contemporary religious scenes (e.g. the series of *Seven Sacraments*, *c*.1712, Dresden,

Gemäldegalerie). Mention should be made also of his famous *trompe-l'oeil* (*see* illusionism) library cupboard doors in Bologna, Conservatorio Musicale, representing shelves with music books (*c*.1710). Although his influence in Bologna was limited, Crespi's contribution to Venetian art was considerable. His son, **Luigi Crespi** (1709–79) is better known as a biographer of contemporary Bolognese artists than as a painter; *Piazzetta and Pietro *Longhi were his pupils.

Crippa, Roberto (1921–72) Italian painter, one of the first to work in a manner equivalent to that of the American *Abstract Expressionists and French *Art informel. He made a speciality of using *collage, flat and in marked relief.

Critz, John de *See under* Gheeraerts, Marcus the Younger.

Crivelli, Carlo (*c*.1430–95) Venetian-born painter, probably trained in Padua under Squarcione (*see under* Mantegna), and active mainly in the Marche, where he was the main competitor of the *Vivarini in church *polyptychs. He is notable for his decorative, yet intensely *expressive use of line, his daring application of linear *perspective to architectural settings and of *foreshortening to individual figures, the inventiveness of detail and pose which enlivens his versions of traditional religious themes, and his brilliant, metallic colour. After centuries in provincial obscurity, he was rediscovered by 19th-century English admirers of William *Morris and the *Pre-Raphaelites; as a consequence the National Gallery in London now has the most extensive holdings of his work.

Crivelli's life is scantily documented. In 1457, in Venice, he was fined and imprisoned for six months for an adulterous liaison with the wife of a sailor, subsequently leaving the city never to return. Around 1461 he established residence in Zara, Dalmatia, becoming a citizen in 1465; by 1468, however, he was working in the Marche where he remained, mainly in Ascoli and Camerino, for the rest of his life. Possible trips to Ferrara or Tuscany have

been postulated to account for his evident familiarity with Flemish art (especially Rogier van der *Weyden), but these are undocumented. In 1490 he was knighted by the *condottiere* Ferdinand of Aragon, future king of Naples, operating in the area against papal armies. Crivelli's last known work was the altar for Fabriano, S. Francesco, 1494 (now in Milan, Brera). Other works are in galleries in Italy and abroad.

His brother, **Vittore Crivelli** (recorded *c*.1481–1501/02), was also a painter, working in the Marche in a similar style (S. Elpidio a Mare, Residenza Municipale).

Crome, John (1768–1821) British painter, one of the founders of the *Norwich School. Taught partly by an amateur and partly by studying English and Dutch painters, he was himself something of an amateur, part-time painter, working in oils, watercolour and etching. His work varied in manner, but at its best exhibits a finely controlled simplicity. He is known as 'Old Crome' to distinguish him from his son, the painter **John Crome** (1794–1842).

Cropsey, Jasper Francis (1823–1900) American painter and architect, associated as painter with the *Hudson River School. He studied in Europe in 1847–50, returning there in 1857–63 and living mainly in London. He returned to America a skilled watercolourist, in 1866 helped found the American Watercolour Society (echoing London's Watercolour Society), and became known for his fine, *naturalistic and light-filled landscapes.

Cross, Henri-Edmond (1856–1910) French painter. Born 'Delacroix', he studied art in Lille and changed the name to its English version to avoid confusion. In 1881 he moved to Paris. From 1884 on he exhibited regularly in the *Salon des Indépendants. He was of the circle of *Seurat and the *Neo-Impressionists but developed his own idioms within that method. From 1891 on he lived in the south of France, not far from his friend *Signac. A widely read and thoughtful man, Cross translated *Ruskin's *Elements of Drawing* for Signac, and pondered the problems

posed by the need for sufficient *naturalism and the demands of colour-organization. With Signac he led Neo-Impressionism into its later, much broader manner, and thus was one of the forerunners of *Fauvism as well as the Fauvists' host when they came south. The colour of his paintings became more intense as his style developed, so that 'his work stood as a hymn of praise to color and sunlight, and helped form the vision of the Mediterranean coast which is commonplace today' (Robert L. Herbert, 1968).

Crosato, Giovanni Battista (1685–1758) Venetian *Rococo painter and scenographer, best-known for his *frescos in Turin where he went in 1733 and again in 1740 (Stupinigi Castle; Villa Regina; Palazzo Reale; various churches).

Cruikshank, George (1792–1878) British artist, known principally as a caricaturist in an age that valued caricature as a means of political and social commentary. His treatment of the excesses of the Prince Regent (later George IV) and his circle led to his being bribed to moderate his lampoons. In fact he turned, as the years passed, to promoting the principle of Temperance in woodcuts. He was also a brilliant illustrator, making etchings for such contemporary books as Dickens's *Oliver Twist* and older novels such as Defoe's *Robinson Crusoe*.

Cruz-Diez, Carlos (1923–) Venezuelan painter, born and trained in Caracas, director subsequently of the art school in which he studied, and founder in 1957 of a visual design studio. His work with colour led to his becoming one of the leading *Op artists and inventor of structures by means of which colour is experienced as alive and hovering in space. Thus the series he titled *Physichromy* (1959+) uses a flat surface with narrow vertical strips attached to it: colours on the back surface, on the sides of the strips and on their edges, applied to make clear shapes when seen separately, become magical and vibrant seen together. Since 1960 he has worked in Paris, developing other colour structures, including whole environments.

Csáky, Joseph (1888–1971) Hungarian-French sculptor, trained in Budapest, living in Paris from 1908 on and a member of the *Cubist circle. He returned to Paris after the Second World War, continuing to work in a Cubist manner, composing figures of cones and cylinders; his later work, from the 1930s on, tended towards a more traditional, *Neoclassical idiom.

Cubism A, many would say *the*, key movement in modern art, in painting first and then also in sculpture, exercising a wide-ranging and sometimes radical influence over all the arts and design. It has never been defined satisfactorily: there have been many Cubisms and its initiators, *Braque and *Picasso, never explained it. Yet little that is significant in modern art since 1911 has happened without some relationship to this movement, so much so that much more recent art (*Abstract Expressionism, *Post-Painterly Abstraction etc.) has been promoted as an ultimate conquest of it.

It is said that Cubism stemmed from *Cézanne. This is true but depends on misreadings of Cézanne. The faceted appearance of some his paintings has nothing to do with geometry, and his much-quoted advice to *Bernard to 'treat nature in terms of the sphere, the cone and the cylinder' was merely standard stuff. His long, slow observation of selected motifs was no part of Cubism, which took representation as just one manipulable function among others in image-making. It is this marginalization of what had long been the prior concern of western art that made it so important.

Cubism was originated by Braque in 1908. Landscapes he painted the summer of 1908 were shown that autumn at the Galérie *Kahnweiler in Paris. The critic Vauxcelles wrote that Braque had reduced everything 'to cubes', leading others to refer to the new idiom as Cubism. These landscapes were indeed much simplified, buildings and hills being shown as semi-geometrical forms though not as solids. Braque had shrunk his colours to two groups, yellow/brown/orange and grey/green, borrowing this duality from Cézanne but also using stronger tonal contrast. That autumn he painted a *Still Life with Musical Instruments*

in which the objects, simplified and shown in browns on a green cloth, are brought to the front of what little picture space there is and allowed little volume; it resembles the decorative relief still lifes which formed part of 18th-century domestic decorative schemes. Braque and Picasso often used musical instruments in their Cubist work. In this small painting they are legible; the characteristic Cubist fragmenting and mingling of things came into Braque's work during 1909. By the end of that year he painted *Violin and Palette* (winter 1909–10; New York, Guggenheim), in which the violin is a broken, angular thing and staves lift off pages of music while the palette is hung on a nail which, with its shadow, seems to belong to old, 'real' art. Picasso's work of 1908 was still in the *primitivist manner he had embarked on in 1906, with objects presented in sculptural terms and sometimes on a monumental scale. Tone is all-important in achieving this sense of mass; his colours, like Braque's, tended to be simplified to two contrasting keys. In 1909 Picasso painted some landscapes in Spain that echo Braque's reading of Cézanne, and from this time on he developed a close interaction with his friend which Braque later described as 'two mountaineers roped together'. Picasso still asserted the palpability of his motifs whereas Braque represented them as unstable clusters of planes. Figures were now rare in Braque's work whereas Picasso did figure paintings and had models pose for them; in 1910 he did a sequence of portraits and also some of his most *abstracted figures, suggested only by planes and by linear signs often independent of the tonal structure.

Their work of 1909–11 has become known as Analytical Cubism. This suggests that they analysed the appearance of objects by showing different aspects of them as though taking successive views of them from different angles, but it is difficult to find clear instances of this. What is certain is their analytical attitude to their means. They use tilting planes, lines, areas of suave brushwork, occasional signs or hieroglyphs (e.g. the newspaper and poster lettering introduced by Braque in 1911) as distinct elements, implying a building up of the image that is *Constructive rather than

imitative. This process becames dominant in 1912 with what is known as Synthetic Cubism, represented in Picasso's constructed metal *Guitar*, his *collages and Braque's *papiers collés* (*see under* collage), as well as oil paintings. Printed oilcloth, paper printed as imitation wood panels, sections of newspaper and other extraneous materials appear in their work before the end of 1912: the forms used are larger and more stable than before and admit to being matter placed on the canvas. From this time on Braque and Picasso went their different ways. From 1913 to 1919 Cubism was still their main activity and by 1920 it had become a firm, decorative mode. This unproblematic Cubism of the years just after the First World War, especially as systematized by *Gris and *Lhote, served as the base for 1920s and 30s Art Deco. Writers on Cubism stressed its *realism. Certainly its motifs belong to the real world; still lifes dominate and generally seem devoid of symbolical content; there is a marked absence of narrative subjects. Yet if Braque's and Picasso's Cubism is to do with objects, it is even more to do with what constitutes a picture. Many of their pictures must have looked like riddles at the time. Kahnweiler is known to have mistitled some of them. During those years Braque and Picasso did not send to the *Salons and did not have one-man shows in Paris: *Kahnweiler took their work and showed samples of it in his gallery informally. *Apollinaire wrote of Cubism as a major new development and presented Picasso as its initiator and leader.

Stimulated by Cézanne and the ongoing adventures of Braque and Picasso, other painters adopted Cubism. Their interpretations varied, as well as the extent to which they could abandon their previous aims. In 1910 the critics noticed that a movement was emerging to end the rule of *Impressionism and its derivatives: they pointed to the work of *Metzinger, *Gleizes, *Le Fauconnier and others, to Cézanne's influence and to the use of geometrical forms. Some of these painters knew each other already; in any case this sort of notice gave them a group identity though they tended to operate singly and in sub-groups. By the end of 1910 the circle included also Robert

*Delaunay, *Léger, *Villon, *La Fresnaye and Lhote. Several of them arranged to be shown as a group at the Salon des Indépendants in 1911 and with this, Cubism came before the public as a new movement. Later that year, when they showed in Brussels, Apollinaire could say in the catalogue that they 'accepted the name of Cubists'.

1912–13 saw Cubism displayed all over Europe. Since it offered no agreed definition, those who responded had to find their own readings of it. These varied widely, from Cubism as a way of representing things in the stereometric terms suggested by the label, to Cubism as an attempt to break through the limitations of physical sight to express a higher consciousness of existence (Fourth Dimension). Some saw Cubism as merely shattering rational methods of representing, and rejecting all the values of art along with the skills that they required. Thus Delaunay was valued in Germany for the reconstructive spirit of his paintings of 1912–13 after his own and other Cubists' destruction of images.

A sub-group formed around Villon, *Duchamp, *Picabia and others who exhibited together in October 1912 as *Section d'Or; on this occasion Apollinaire announced the emergence of *Orphism. That December, Gleizes and Metzinger published *On Cubism*, asserting Cubism's links with the realism of *Courbet and the Cubists' freedom from any duty to imitate the visible: a painting is an independent formulation and may detach itself from any sort of representing. A quasi-Orphist group exhibited at the 1913 Salon des Indépendants, including *Kupka, *Bruce and *Macdonald-Wright. Some of their work, and by 1914 some of Léger's, was or seemed abstract, but generally Cubism adhered to signalling nameable subjects in one way or another and therefore seemed to *Mondrian and others not to follow its own logic. *Futurist painting, displayed in Paris in 1912, owed some of its methods to Cubism. Delaunay had a marked influence in Germany, notably on *Marc, *Macke and *Klee. In Prague a Cubist movement formed, while in Russia *Malevich and others spoke of Cubo-Futurism. A similar mingling of ideas operated in London where *Vorticism was offered as a response.

Futurism's busy promotion campaign spread elements of the Cubist style mingled with Futurist ideas about dynamicism and modern subjects.

Making Cubist sculpture involved decisions opposed to the spirit of Cubism. It is difficult for sculpture to suggest the dissolution of solid objects and the firming up of space. Picasso had made sculpture in 1909 which imitated his more sculptural Cubist painting; his constructed sculptures of 1912 on echo his Synthetic Cubist pictures, playing games with positive and negative forms and with modes of representation. Cubist sculpture developed as a geometricization of forms in the work of La Fresnaye, *Lipchitz, *Czáky, and others. *Duchamp-Villon was within the Cubist circle but his sculpture has little to do with Cubism. *Boccioni attempted to supply both Cubism and Futurism with sculpture; he employed bold strategies to free sculpture from visual, conceptual and material limitations. *Archipenko took up Boccioni's ideas and made sculpture with movable parts as well as works that were paintings and sculpture combined. *Laurens made reliefs and free-standing pieces that are close to the Synthetic Cubist pictures of Braque and Picasso. Sculptors had to adjust to the fact of Cubism, without being able to transfer any of its essentials to their necessarily more earth-bound art until *Gabo started to use transparent and reflecting plastic.

Cubism appeared disruptive of all artistic values at first, then revealed itself as a return to old conceptions of art as an ordering process, reconstructing the visible world to the dictates of intelligence. It could be accepted as upholding the great tradition of French classicism represented by *Poussin and *Ingres. With this emphasis on the art object as something made by humans and not needing justification in terms of the visible world, it provided a basis for abstract art. As an art of ordering, Cubism could be systematized (as in *Purism) and taught as a method, notably by Lhote; it could also serve as the enemy of *Dada and *Surrealism with their demand for disruption and/or narrative.

Cubism was received as an expression of life's fragmentation in the modern world.

Echoes of this fragmentation were attempted by poets, composers and others of many kinds, so that in Cubism art has been said to have pioneered important developments in the other arts.

Cuer d'Amour Espris, Master of the *See* René of Anjou, Master of.

Currier, Nathaniel (1813–88) American printer who, in partnership with **James Ives** (1824–95), produced thousands of lithographs illustrating contemporary life and scenery. Their business was continued by their sons until 1907.

Cuyp, Aelbert (1620–91) Dutch painter, the famous son of the portrait specialist **Jacob Gerritsz. Cuyp** (1594–1652). He is best known for the landscape paintings of his mature style, combining the 'heroic' motifs of the *classical phase of Dutch landscape (*see* Jacob van Ruisdael) with an all-pervading Italianate light (*see* Poelenburgh, Breenbergh, Jan Both). Cuyp's grandeur of composition and warmth of colour characterize both the countryside scenes with sturdy cattle, and the river scenes, whether near his native Dordrecht or on other Dutch rivers. He is particularly well-represented in English collections (e.g. London, National) and in many Continental museums, as well as in galleries in the US, including Cleveland, Museum; Indianapolis, Museum; Toledo, Ohio, Museum; Washington, National.

Czaky, Joseph (1888–1971) Hungarian-French sculptor, trained in Budapest, living in Paris from 1908 and a member of the *Cubist circle. He returned to Paris after the Second World War, continuing to work in a Cubist manner, composing figures of cones and cylinders; from the 1930s his work tended towards a more traditional, *Neoclassical idiom.

D

Dada Name given to individual and group activities signalling rejection of the cultural and political values which supported the First World War, including those of art itself. The protagonists came from diverse countries and often worked in a foreign environment, reaching out through their publications to an international readership. Dada is associated with modern art but involved many forms of expression including poetry and political action. It has been called nihilistic and anarchistic and these terms suit some of its manifestations, but in so far as these involved experiment in art, writing, etc., Dada must also be said to have been a creative, inventive tendency. Among its many antecedents were the 18th century's questioning of civilization through satire, and the promotional performances of the *Futurists. It surfaced at much the same time in America and Switzerland and soon found echoes in Berlin, Cologne, Hanover and Paris. It admitted no positive aim, but its spirit and some of its methods have lingered on and been developed in new contexts. Since the Second World War some aspects of Dada have been revived; it has certainly been studied as an honoured option in the arts. From the 1940s on, through exhibitions and publications such as *Motherwell's *The Dada Poets and Painters* (1951), awareness of Dada has given impetus to tendencies challenging art's status, sometimes labelled *anti-art.

*Duchamp's arrival in New York in 1915, and *Picabia's soon after, set off a Dada phase. *Stieglitz's circle provided support for a campaign of cultural disruption lingering on into the early 1920s. Shots in it were the journals *291* (twelve issues 1915–16), *The Blindman* (two issues 1917) and *Rongwrong* and *TNT* (one issue each, 1919), as well as Duchamp's sending of his urinal to an open exhibition as *Fountain*. Paris and New York joined in these skirmishes; with Man *Ray's move to Paris, New York to some degree returned its Dada venture to Europe.

1916 saw the birth in Zurich of the group which produced the name Dada and presented Dadaism as an anti-war and anti-civilization campaign. 'Da' means 'yes' in Russian and 'there' in German; in French 'dada' signifies 'hobbyhorse'. It is a sound made by young babies. Hugo *Ball started the *Cabaret Voltaire with the Romanian poet Tristan Tzara, the Romanian artist Janco and the French/German artist *Arp. Hülsenbeck soon joined them from Berlin. Before long they were discussing a journal to be called *Dada*; eight issues appeared 1917–21 in French and German editions. The Zurich group lost some of its key members from 1917 on, when Ball, in poor mental health, and Hülsenbeck left; Tzara's move to Paris in 1919 ended Zurich's Dada spree. Huelsenbeck returned to Berlin in 1917, bringing Dada ideas into the political fray of the capital. Germany's military collapse, revolution, the Kaiser's abdication and open conflict between left and right political factions were its setting. Collaborating with *Hausmann and *Baader, alongside a partly separate group consisting of *Grosz and *Heartfield and centred on the publishing work of Wieland Herzfelde (brother of Heartfield), they harangued Germany through words and images, and at times engaged in direct action without taking a clear political stand (although Grosz, Heartfield and Herzfelde joined the German Communist Party in December 1918). Among their productions were short-lived journals, series of polemical images, often produced by means of *collage and *photomontage, and the International Dada Fair of May 1920. Much of their effort went into attacking *Expressionism for its failure to denounce the war.

A smaller Dada movement developed in Cologne in 1919–20 through the collaboration of *Ernst, Arp and *Baargeld. One of their journals was banned by the British occupying authorities; their Dada Exhibition, held during May 1920 in the glass-roofed courtyard of a public house and entered via the men's lavatory, was closed

by the police on account of an exhibit judged pornographic but revealed to be *Dürer's print *Adam and Eve*; it soon reopened with much éclat. *Schwitters, living in Hanover, wanted to join the Berlin Dadaists in 1918 but was rejected as too unpolitical. His most Dadaist productions included the journal he published from 1923 to 32, titled *Merz* (a found syllable he used to distinguish his work from Berlin Dada). Paris had contact with Dada in New York and Zurich through the peripatetic activities of Picabia and through publications. French Dada emerged as a literary adventure. Picabia had started a journal, *391*, in Barcelona in 1917. Subsequent issues appeared in New York and Zurich, but from November 1919 until 1924 he produced it in Paris where Tzara in 1920 joined him. French poets such as *Breton and Louis Aragon, who had had pieces published in *Dada*, collaborated in the promotion of a Paris Dada movement in which Breton sought to involve the young Ernst. Differences of principle and personality soon divided Picabia and Tzara from Breton, and this led to Breton's founding, in 1924, of a distinct literary and artistic movement, *Surrealism.

Dadd, Richard (1817–86) British painter, trained at the Royal Academy Schools and making a promising beginning with more or less *academic paintings until, travelling in Europe and the Middle East, he began to show signs of madness. Back home, he murdered his father and was confined for the rest of his life in asylums. Doctors encouraged him to continue to paint. The results struck Victorians as merely mad; to modern eyes he is more than an interesting psychological phenomenon but a fine painter of intensely original imaginary subjects, close-packed with detail and in character more like a tapestry than a traditional painting. An outstanding example is *The Fairy-Feller's Master Stroke* (*c*.1855–64; London, Tate). A comprehensive exhibition of his work, shown in London (Tate) in 1974, established his standing as a precursor of *Magic Realism.

Daddi, Bernardo (recorded 1327–49/51) Florentine painter whose work fuses Florentine and Sienese traditions (*see also* Giotto, Duccio, Simone Martini, the Lorenzetti). An indifferent large-scale painter, he is notable mainly for his small portable tabernacles, a form pioneered by Duccio but popularized by Daddi to cater for the growing needs of personal devotion by the urban middle classes. The earliest known example (1335) is in the Bigallo, Florence, and one of the finest is in London (1338, Courtauld), but there are others in museums in Europe and America. All show workshop participation. *Orcagna's tabernacle in the guild church Or San Michele, Florence, enshrines a *Virgin and Child* by Daddi (*c*.1346).

Dahl, Johann Christian (1788–1857) Norwegian landscape painter who lived and worked mainly in Dresden where he was a close friend of *Friedrich and became professor at the *Academy. His subjects included Norwegian scenery which he is credited with introducing into art.

Dahl, Michael (1659–1743) Swedish portrait painter, and *Kneller's only serious rival in England. He came to London in 1682 and may have worked as an assistant in Kneller's studio. From 1685–8 he travelled on the Continent, mainly in Italy; in Rome, he painted *Queen Christina of Sweden* (1687, Grimsthorpe Castle). After his return to England he secured aristocratic and court patronage; although the latter ceased with Queen Anne's death in 1714, Dahl continued to be employed by private individuals until his retirement *c*.1740. His style was carried on for another decade by his pupil **Hans Hysing** (Huyssing), a fellow Swede (active after 1691–*d*.1753) who entered Dahl's studio *c*.1700.

Dalí, Salvador (1904–89) Spanish painter, trained at the Madrid academy. He was an early admirer of the visionary art of *Böcklin and de *Chirico and of the detailed realism of the *Pre-Raphaelites and of French painters such as *Meissonier. Having made his mark in Madrid and Barcelona exhibitions, Dalí visited Paris in 1928 where he met *Picasso and *Miró and arranged an exhibition of his

work for the following year. What he showed proved him a *Surrealist; Breton hailed Dalí's art as 'the most hallucinatory known until now' and 'a real menace'. With this and his collaboration with Luis Buñuel, the same year, on the film *Un Chien andalou*, Dalí was established as one of the artists at the centre of Surrealism. Ten years later, Breton was to denounce him as a false Surrealist, dedicated to fascism and to excessive self-presentation; neither charge seems altogether just. Dalí offended Breton and others with his immoral attitude to everything and his obsession with sex (theoretically invited by Surrealism's rejection of any moral limitations). Dalí's insistent eroticism, judged politically anti-revolutionary, was a handicap to the movement. His response to the Spanish Civil War was to express his horror at all conflict; he did not identify with either side. Breton had previously welcomed Dalí's 'paranoic-critical method' as a radical contribution. Dalí defined it as 'irrational knowledge' rooted in 'delirium of interpretation'. By simulating or encouraging in himself a hyperactivity of the imagination which found multiple readings in selected visual data, and by finding ways of presenting the viewer with these, principally through elaborate detail, in a technique he described as reactionary, Dalí was able to combine extremes of reality and unreality in one picture. He used *collage at times, and also made sculptural objects to produce similar collisions of meaning. Often he worked into his art quotations from the art of others and references to significant historical figures (e.g. Lenin, William Tell) as well as representations of Gala, his companion and muse from 1929 on. His most telling device was the exploitation of spatial immensity linked to spatial confusion such as we experience in nightmares: a vertigo of the imagination.

Included in Surrealist exhibitions in Paris and abroad, Dalí's work was much seen and reported on. In 1933 he had his first one-man show in New York; in 1934 his first in London. In 1934–5 he made his first visit to the USA. In 1936 his face (with an incipient moustache) featured on the cover of *Time* and he was the most noticed participator in the events accompanying London's International Exhibition of Surrealism. From 1940 to 1948 he lived in the USA, receiving many commissions and having several exhibitions, including a retrospective at MoMA in New York. He continued to make many visits to New York but lived near Cadaqués in Catalonia (North-East Spain).

His fame and notoriety developed monumentally on both sides of the Atlantic, with Dalí representing a form of Surrealism rejected by the Surrealists, a form of modern art rejected by many champions of modern art, and a type of enigmatic art, enticing, impossible to understand but promising sexual revelations, that appeals to a wide public. Skilled self-presentation has established him as a great personality: his books and lectures, interviews and photographs to the popular press, his shocking works of art in combination with his ever more insistently reactionary pose, have kept it before the public. His art has become more obviously academic since the 1940s while incorporating responses to *Abstract Expressionism (he admires *de Kooning almost as much as *Raphael). Among the honours he has received is Spain's Grand Cross of Isabella the Catholic. A Dalí Museum has been formed in his birth-place, Figueras; there are nothers in Cleveland, Ohio and St Petersburg, Florida. Among major exhibitions have been retrospectives in Japan (1964) and Paris (1979).

Dalle Masegne, Jacobello (*d. c.*1409) and **Pierpaolo** (*d.*1403?) Venetian sculptors, brothers, active also in Emilia (Bologna, S. Petronio; S. Francesco). The figures of saints on their choir screen for St Mark's, Venice (1394) are executed in a northern *Gothic style which had great influence on subsequent Italian sculpture.

Dalmata, Giovanni *See* Giovanni Dalmata.

Dalmau, Luis (recorded 1426–45) Catalonian painter. His *Virgin of the Councillors*, 1445, now in Barcelona, Museo de Arte de Cataluña, but painted for the chapel of the town hall, is the earliest documented work in the Hispano-Flemish

style (*see also* Baço, Bermejo). Reflecting the manner of Jan van *Eyck, this style replaced the older, Italian-based *Gothic mode of Barcelona and, although short-lived in Catalonia, became the dominant style in Castile and the interior of Spain in the second half of the 15th century. Dalmau's contact with Van Eyck dated from 1431–6, when he and a tapestry weaver were sent by the king to Flanders to study the techniques of Flemish tapestry.

Dalou, Jules (1838–1902) French sculptor, born in Paris into a working-class family. He was trained in drawing and then, at the Ecole des Beaux-Arts, in sculpture. He was critical of his training there but had some success, exhibiting at the *Salon from 1861 on and being employed on decorative sculpture for luxurious houses. Politically a radical, he was appointed a keeper of the Louvre Museum by the revolutionary Commune in 1871 and had to flee France when the Commune fell. He went to London, staying there until an amnesty made his return to France possible in 1879. He had considerable success in London, being commissioned to make portraits and monuments and exhibiting at the Royal Academy. Many of his subsequent works reflect his republicanism. They include a *Triumph of the Republic* (1879–99; Paris, Place de la Nation) and the *Tomb of Blanqui* (1885; Paris, Cemetery of Père Lachaise), and a number of studies of peasants and workers, many of them part of a projected *Monument to the Workers* which he never realized. But they also include portrait busts and figures of women reading or sewing, works illustrating middle-class domesticity with evident sympathy, as well as allegorical and mythological groups. He received official commissions in which he showed his command of conventions of conception and execution; in sculptures he made out of his own interest he idealized and at times simplified *realistic subjects to give them artistic presence, as had done *Millet in painting. Key figures of modern sculpture, such as *Maillol and *Brancusi were influenced by him. The Petit Palais, Paris, has a large collection of his works.

Dalwood, Hubert (1924–76) British sculptor, who, after war service as an engineer in the Royal Navy, studied at the Bath Academy at Corsham under *Armitage and, in the 1950s, modelled expressive figures and then *abstract reliefs and free-standing forms, cast in bronze and subsequently aluminium. From the 1960s on his work varied widely, turning both to quasi-utlitarian objects such as urns and caskets and, thanks to his travels and his growing interest in buildings and their settings in Italy and the Near East, to temples and towers, some of them combining cast elements with prefabricated columns. His work was shown at the 1962 Venice Biennale where it gained a prize. A memorial exhibition was shown in London (Hayward) and toured Britain in 1979. He executed several commissions for public sculpture at universities and other sites, in Britain and abroad.

Danby, Francis (1793–1861) Irish-born British painter who worked mainly in Bristol, London and Exmouth, in watercolours first and then primarily in finely worked oils. Their evocation of man's awe before nature marks him out as a *Romantic artist, as do his more fantastic landscapes and the large biblical scenes with which he rivalled John *Martin.

Dance, Nathaniel (1735–1811) English painter, one of the youngest founder members of the Royal *Academy. He was a pupil of *Hayman in 1753–4, after which he spent 12 years in Rome (1754–65) with his architect brother, George, working hard to become a *History painter (*Timon of Athens*, Hampton Court; *Death of Mark Antony*, Knole, Kent). He is now chiefly known for his *Conversation Pieces of English tourists in Rome – which combine the manner of Hayman with the more elegant influence of *Batoni – and the theatrical picture of *Garrick as Richard III* (Stratford-on-Avon, Corporation). He retired from painting after inheriting a fortune in 1776, and in 1790 he resigned from the Academy to become a Member of Parliament. In 1800 he was created a baronet as Sir Nathaniel Dance-Holland.

Dandini, Cesare (1596–1656), his brothers **Vincenzo** (1607–75) and **Ottaviano**, and his nephew **Pietro** (1646–1712) Florentine painters; the most important are Cesare and Pietro. Cesare Dandini's altarpieces and narrative pictures are notable for their elegantly artificial theatrality (Florence, SS. Annunziata; Copenhagen, Statens; Dublin, National). Pietro Dandini studied with his uncle Vincenzo, and travelled to Rome, Venice, Emilia and Lombardy. He returned to Florence, where he received important decorative commissions (Pitti; Villa Poggio Imperiale; Villa Petraia). He excelled at painting rich costumes, precious jewellery and metalwork.

Daniele da Volterra; Daniele Riciarelli called (c.1509–66) One of the most gifted of the Roman painters closely influenced by *Michelangelo. After the death of *Sebastiano Veneziano in 1547, he became Michelangelo's 'surrogate', not only transcribing the aged master's sculptural manner in paint (e.g. *Madonna with Sts John and Barbara*, c.1552, Siena, d'Elci Coll.) but actually working from sketches supplied by Michelangelo (e.g. *David and Goliath*, c.1555/6, Paris, Louvre). After 1556 he turned, with Michelangelo's help, to sculpture (e.g. bronze equestrian monument for Henry II of France, 1560–6; only horse cast, used in 1639 for a monument to Louis XIII, melted down in French Revolution; portrait of Michelangelo in bronze relief, Florence, Casa Buonarotti), although continuing to direct the painting activities of his workshop (1555/6–62/3, S. Pietro in Montorio, Cappella Ricci). After 1559 he accepted the task of 'veiling' in paint some of the nude figures in Michelangelo's *Last Judgement* – work which earned him the nickname of *Il Brachettone* (Big Breeches).

Born in Volterra but probably trained under *Sodoma in Siena, Daniele came to Rome c.1536, soon finding employment as an executant for *Perino del Vaga (c.1538–40, SS. Trinità, Capella Massimo, destroyed; c.1540/1–3, S. Marcello, Cappella del Crocefisso). Perino helped him to secure the commission for the *Fabius Maximus* frieze of the main salone of the Palazzo Massimi alle Colonne, the

work which established his reputation. Michelangelo's influence is clearly visible in the powerful *Deposition* of c.1545, in *fresco now transferred to canvas, all that survives of the decoration of the Cappella Orsini in SS. Trinità, 1541–8. At Perino's death in 1547 Daniele became one of the foremost decorative artists in Rome (*see also* Salviati), succeeding Perino from 1547–50 in the Sala Regia of the Vatican (*see also* the Zuccaro brothers). Other important decorative schemes in the Palazzo Farnese; 1548–53, SS. Trinità, Cappella Rovere; Vatican, Apartments of Pope Julius III; Stanza di Cleopatra; 1545, an altarpiece, now Volterra, Pinacoteca. Daniele's style, always poised between *classicism and *Mannerism, became increasingly tinged with Counter-Reformation gravity and austerity.

Danti, Vincenzo (1530–76) Perugian goldsmith and sculptor, the author of the seated bronze statue of Pope Julius III outside Perugia cathedral (1553–6). Between 1557–73 he worked mainly at the court of Cosimo I de' *Medici in Florence, publishing a celebrated treatise on human proportions, dedicated to Cosimo in 1567. His main works in Florence are the bronze group of the *Beheading of St John the Baptist* over the south door of Florence Baptistry (1569–70; *see also* Rustici, Andrea Sansovino); the marble two-figure group of *Honour Triumphant over Falsehood*, his first work in that medium (after 1561, now Florence, Bargello) and a bronze statuette of *Venus Anadyomene* for the Studiolo of Francesco de'Medici in the Palazzo Vecchio.

Danube school Not a school or movement in the modern sense. The term is applied to the work, or some of the work, of certain painters who early in the 16th century having travelled along the Danube and become fascinated by its scenery, employed landscape and landscape motifs as major formal and *expressive components of their pictures. There are some affinities between their paintings and those of the Venetian *Giorgione, although their vision became available to German-speaking humanists as a nationalistic

alternative to Italianate *classicism; in this sense it is a direct antecedent of German *Romanticism of the 19th century. *See* Albrecht Altdorfer, Jörg Breu the Elder, Lucas Cranach the Elder, Wolf Huber.

Daret, Jacques (recorded 1427–68) Netherlandish painter, apprenticed to Robert *Campin along with Rogelet de la Pasture (Rogier van der *Weyden). He continued to be heavily dependent on Campin – as is evident in his major work, the altarpiece of 1434–5 for Arras, Abbey of St Vaast, of which four panels survive (*Visitation, Adoration of the Magi*, Berlin, Staatliche; *Nativity*, Madrid, Thyssen; *Presentation in the Temple*, Paris, Petit Palais).

Daubigny, Charles-François (1817–78) French painter, close in spirit to the landscape painters of the *Barbizon school but an important impulse to the *Impressionists because of his success in transcribing effects of light and atmosphere. Some of them borrowed from him the idea of a boat converted into a floating studio. He exhibited fairly regularly at the *Salon from 1840 on and in the late 1850s was rewarded with the Légion d'Honneur and a state commission.

Daumier, Honoré (1798–1879) French artist, admired and persecuted as a political and social cartoonist, but little known in his time as a painter and sculptor though his fame grew rapidly after his death. He was born in Marseille but grew up in Paris where he got some training and practice as draftsman and then apprenticed himself to a *lithographer to learn that new technique for multiplying drawn images. The 1830 revolution encouraged publication of satirical journals, and from 1831 on Daumier supplied close on 4000 lithographs to Paris journals. In 1832–3 he was in prison as a reward for his powerful image of Louis Philippe as *Gargantua*, climax of his series of attacks against the head of state. To serve as models for his cartoons of politicians he made a series of modelled heads, personalities caught in lively caricature. As censorship became more oppressive, Daumier turned to portraying Parisian

society, with humour as well as sympathy. Lawyers, blue stockings, railway travellers, artists and others came in for affectionate, immortalizing ridicule.

It was his ambition to succeed as painter. He did not send work to the open Salon of 1848 but joined in a competition for a painting to allegorize the Republic and produced a monumental image of Charity; he was placed eleventh out of 20. *Corot, *Millet *Rousseau and others encouraged him to persevere with painting but too much of his energy went on supplying lithographs and keeping track of their subjects. He wrestled with painting in the years following 1848 and again in the early 1860s. Earlier paintings emulate the *Baroque of *Rubens and other northern painters; later works attend to contemporary life, representing ordinary people about their business and their leisure and graphic, almost filmic images of Don Quixote and Sancho Panza. His eyesight deteriorated sharply from 1873. A few friends, such as Corot, helped him in his poverty. It is likely that younger artists such as *Cézanne and perhaps Van *Gogh took an interest in his work. In 1878 he had a one-man show at the Durand-Ruel gallery. By the end of century his work was sought after enough for forgeries to be frequent.

Daumier was an outstanding draftsman, indebted to *Rembrandt and other great masters but schooled above all else by observation and the urge to capture the life of his time. No one has ever used line more expressively and his grasp of social relationships was equal to that of the most encyclopaedic narrator of his time, Balzac, who said that there was something of *Michelangelo in the artist. This at first surprising reference is well justified by some of his work, the paintings of laundresses and men on ropes and also the frieze he modelled of displaced persons as summary nude figures, dramatic and at the same time *classical, that seems to link the best of Greek sculpture, via Michelangelo, to the prisoners in Beethoven's *Fidelio* and the fugitives of modern history.

David d'Angers (1788–1856) chosen name of the French sculptor Pierre-Jean David, to distinguish him from the great

J.-L. *David whose work influenced him
and who approved of the younger artist.
Born in Angers, he was in Paris by 1808 and
in 1811 won the Prix de Rome. This took
him to Italy where he met and admired
Ingres and studied the *Neoclassicism of
*Canova and *Thorvaldsen. He visited
London in 1816 to study the sculptures
from the Parthenon known as the Elgin
Marbles. He was responsible for public
sculptures in France, including the figures
in the pediments of the Panthéon in Paris
(1837), but also made numerous portrait
medallions of his contemporaries in public
affairs and the arts.

David, Gerard (*c*.1460–1523)
Netherlandish painter, the leading artist in
Bruges after the death of Hans *Memlinc.
His work was eclectically based on the
traditions of Jan van *Eyck and Rogier van
der *Weyden, and he was the last major
painter to practise this native idiom, as
opposed to the new Italianate art being
forged in Antwerp (*see* Quentin Metsys,
probably an exact contemporary). His chief
followers, who mass-produced works in his
style, were **Adrien Isenbrandt** or **Ysen-
brandt** (*d*.1551) and the transplanted
Lombard **Ambrosius Benson** (*d*.1550),
many of whose pictures were done for
export to Italy and Spain. Forgotten for
centuries, David was rediscovered only in
the second half of the 19th century. There
are works by him in London, National;
Bruges, Musée, Paris, Louvre; Amsterdam,
Rijksmuseum; Rouen, Musée; etc.

David, Jacques-Louis (1748–1825)
Great and complex French painter. He
oscillated between *Baroque *Rubénisme* and
*classicizing *Poussinisme* (*see under* Rubens,
Poussin) and may be said to have at last
reconciled these tendencies in French art.
We can think of him as the last major 18th-
century painter or as the originator of 19th-
century art. His working life fell into
quite distinct phases: *ancien régime* artist
making a career in the Royal *Academy
and with official commissions from the
crown; ardent revolutionary and republican
supremo of the arts; hero-worshipper of,
and court artist to, Napoleon; exile and
archaicizing aesthete. Throughout – and

this is sometimes forgotten with attention
focused, as David himself wished, on the
'higher' *genre of history painting – he
remained a brilliant portraitist. In this field
David's continuing allegiance to colourism
(*see under disegno*) may be perceived even in
his sparest and most classical compositions
(outstanding portraits in Paris, Louvre;
Warsaw, National; Buffalo, New York;
Montpellier, Musée; New York, Metropol-
itan; London, National; Cambridge, MA,
Fogg; Washington, National; self-portraits,
Florence, Uffizi; Louvre).

David's widowed mother took the
drawing-mad boy to her relation *Boucher,
who recommended *Vien as a teacher.
From 1769 to 74 David competed for prizes
at the Academy, and it is instructive to look
at these early works: the *Combat of Mars
and Minerva* (1771, Louvre) which resem-
bles Boucher at his most vigorous; the
Death of Seneca (1773, Paris, Petit Palais),
whose Boucher-like passages are modified
with Baroque drama in the handling of
light and dark; *Antiochus and Stratonice*
(1774, Paris, École des Beaux-Arts), which
finally won him first prize and whose
Baroque handling is tempered with *Le
Sueur-like classicism of composition.

In 1775 Vien was appointed Director of
the French Academy in Rome and took
David there with him, 1775–80. Here,
it has rightly been said, David sought a
style: drawing constantly from the antique,
studying anatomy, but also studying
*Ribera, *Caravaggio, *Veronese and
others. He was influenced also by Gavin
*Hamilton. All these influences are appar-
ent, in various admixtures, in the works he
exhibited after his return at the Salon of
1781, and which included a Rubensian
equestrian portrait, the *Count Potocki* in
Warsaw, and an eclectic altarpiece, *St Roch
interceding with the Virgin* (1780, Marseille,
Musée) in which Caravaggio, Poussin,
*Guercino and even *Lebrun are recalled
in various details. The most prophetic of
his famous later works, however, was the
Belisarius (Lille, Musée), deeply serious,
emotionally compelling, warm in colour-
ing, but returning to the readable clarity of
Poussin and to his recreation of the world
of antiquity. Its success led directly to
the royal commission which consolidated

'David's revolution' of painting and prefigured political Revolution – although it is true that its programme was a patriotic one rather than anti-monarchic: the *Oath of the Horatii* (compl. 1784, Paris, Louvre). Believing that he could not paint a true tribute to Roman virtue in Paris, David returned for a year to work in Rome, where he finished the painting, and where his studio was stormed with admirers. Exhibited in Paris in 1785, the *Horatii* passed for 'the most beautiful picture of the century', the history painting which at last restored the French school to its 17th-century grandeur. A very model of Poussinesque rigour, the painting is also disturbingly *realistic. Its success was followed up by that of *Socrates Drinking the Hemlock* (1787, New York, Metropolitan) which sealed David's reputation as head of a new school of art spreading far beyond the borders of France.

He was, however, still far from consistent in style or temper: the *Death of Ugolino* (1786, Valence, Musée) is already *Romantic both in its subject and 'gothick' style (the theme had previously been treated by *Reynolds), and *Paris and Helen* (1788, Louvre), painted for an aristocratic private collector, comes close to the closet *Rococo *Neoclassicism of Vien. The famous *Lictors Bringing Brutus the Bodies of his Sons* (1789, Louvre), however, resembles the *Horatii* in its tragic furor, its recreation of ancient patriotic virtue at the cost of personal happiness. A commission from the crown, whose subject had been modified by David, it was exhibited six weeks after the storming of the Bastille and became closely identified with the Republican cause.

David's political activism, however, was first realized within the sphere of the Academy, when he led younger artists in demanding an exhibition for the works of his talented pupil, Jean-Germain *Drouais, who had died in Rome before receiving academic recognition. This demand for equality in accord with the Declaration of the Rights of Man led finally to the setting up of the more egalitarian *Commune des Arts* and, in 1793 at the urging of David, to the abolition of the Academy, so closely identified with the monarchy.

David's role as artistic dictator and impresario of the pageantry and rites of the Revolution is beyond the scope of this entry. As a painter, he was charged in 1790 with recording the political opening act of the Revolution, the *Tennis Court Oath* of 1789. The project was never completed, but the preliminary sketches, combining 100 protagonists in a composition of tremendous breadth, demonstrate (yet again) David's ability to combine exact observation with monumentality (Cambridge, MA, Fogg; Versailles; Paris, Louvre). Of three paintings of 'martyrs' of the Revolution only one has achieved fame: *Marat assassiné* (1793, Brussels, Musée), at once portrait and *icon, borrowing the pose of a Christ in the *Pietà – which itself goes back to ancient pagan prototypes – and combining generalized space with naturalism of detail. The *Death of Lepeletier*, destroyed, is only known through an engraving; the *Death of Bara* was never finished (Avignon, Musée).

After the execution of Robespierre, whom he had supported, and his own imprisonment during the Directory (*View of the Luxembourg*, 1794, Louvre, his only landscape, painted while in prison) David turned once again to mainly artistic problems, notably to purifying his work further in the direction of greater refinement and abstraction 'in the Greek style'. The resulting painting, emulating Hellenistic statues such as the *Apollo Belvedere* looted from Italy by Napoleon, can be called Neoclassical in its aestheticism (*Rape of the Sabines*, 1799, Paris, Louvre), although it is surpassed in frigid archaicism by a similarly motivated later canvas (*Leonidas at Thermopylae*, 1800–14, Paris, Louvre).

Under Napoleon, however, David regained both his extra-artistic motivation and his social and artistic position. An oil sketch resulting from a short sitting granted by the victorious Bonaparte was worked up into the heroic *Napoleon crossing the Alps*, 'calm on a fiery steed' (1800, Versailles). Named *Premier Peintre* under the Empire, David executed two out of four great commissions rivalling the projected *Tennis Court Oath* in scale, scope and genre. *Napoleon Crowning Josephine* or *Le Sacre*

(1805–8, Paris, Louvre) takes as its point of departure a scene from Rubens's *Marie de'Medici* cycle. *Napoleon Distributing the Eagles* (1810, Versailles) controls its crowded scene with similar recall from earlier art, including *Raphael's Stanze.

After 1816 David remained in exile in Brussels, working for private patrons. Although a few late portraits continue to demonstrate his powers, the subject paintings from this period return to the erotic Neoclassicism of his *Paris and Helen* of 1788 (e.g. *Cupid and Psyche*, 1817, Cleveland, Ohio, Museum).

David was the generous teacher of many pupils, among them the leading French painters of the first half of the 19th century (*see* e.g. Gros, Ingres).

Davie, Alan (1920–) British painter, born at Grangemouth in Scotland, trained at Edinburgh College of Art. He was prominent among European painters responding to American *Abstract Expressionism. He had admired works by *Pollock and *De Kooning in Venice in 1948. His art emulated their scale and energy and involvement with the whole surface of the picture. He developed a repertory of signs and magical symbols as points of attention whilst the paint itself (drips and runs as well as brushstrokes) and the emotional force of colour work on the beholder. His art is thus pictographic rather than either *abstract or *figurative. He exhibited widely; his first retrospective in 1958 (London, Whitechapel Art Gallery) was followed by many others in Europe, the USA and Canada. Davie was an outstanding model of the painter who creates intuitively, in close touch with his materials and with what is emerging on the canvas.

Davies, John (1946–) British sculptor trained as painter in Hull and Maidstone and as sculptor at the Slade School of Fine Art, London. His work, launched in a one-man show at the Whitechapel Art Gallery, London, in 1972, astonished with its *realism: his life-size figures, dressed in real clothes and engaged in dramatic actions, some of them masked, were disconcertingly lifelike as well as

strange. This work adhered neither to conventions of *naturalism or idealism nor to the current regard for abstract sculptural composition, but interposed something different, with magical properties. Davies has gone on to explore the area just beyond verisimilitude, making figures less lifelike and in less dramatic situations, also making heads much smaller or much larger than life-size, recently also figures, realistic in pose and silhouette but with their body surfaces rendered more schematically, on swings, ropes and ladders. In a statement he has referred to 'life's circus': he would appear to be a modern *Bruegel, describing his mankind with sympathy and not without humour. He has exhibited frequently in Britain and abroad.

Davis, Stuart (1894–1964) American painter, born in Philadelphia. He studied with *Henri in 1910–13 but rejected his emphasis on subject matter and gave up a job as magazine illustrator when ordered to bring out particular political implications in his pictures. The *Armory Show was 'the greatest shock', confronting him with *Post-Impressionism, *Fauvism and *Cubism. *Lucky Strike* (1921; New York, MoMA) is a prosaic representation of a cigarette packet. Davis used banal source material frequently, particularly urban signs and notices. In 1928–29 he was in Paris. His work took on its characteristic form soon after this: flat forms, strong colours, words and signs in hieratic script, and a rhythmical structure suggestive of jazz and of urban dynamics. In 1931 he taught at the New York Art Students' League and from 1940 at the New York School of Social Research. He had retrospective exhibitions in New York, 1945, and Minneapolis, 1957; 1965 saw a memorial exhibition at the Smithsonian Institution, Washington. In 1952 he represented the USA at the Venice Biennale. Davis offered his near-*abstract art as wholly American, more truly so than the descriptive work of the *Regionalists. He was at ease with the innovations of European contemporaries and able to develop a personal as well as fully transatlantic subject matter and idiom on that basis.

De Andrea, John (1941–) American sculptor known for his life-size *Superrealist figures, often nudes, executed in resin and glass fibres, coloured and furnished with *realistic eyes and body hair.

Decorum Suitability, fitness, propriety. These normal usages of the word are extended, in art theory modelling itself on ancient Graeco-Roman literary theory, and are elevated to a fundamental principle. Decorum governs the entire work of art, taking into account its intended location and function as well as its subject matter – from its scale, format and composition, down to details of the dress and deportment of painted or sculpted figures. In the 17th century *Poussin, in his theory of the *modes* of painting (derived from music theory) argued for the need to adjust the colour range of paintings in accord with their subject and mood; this, too, is an example of decorum.

Defrance, Léonard (1735–1805) Flemish painter from Liège. Trained in the tradition of French *Neoclassicism – reinforced by his seven years in Rome, Naples, and southern France, 1745 to 1752 – he first painted portraits, figures of saints and biblical scenes (Liège, Musée). In 1773 he discovered Dutch 17th-century *genre painting during a visit to Holland. His copies of such pictures sold readily in Paris, and shortly after he began to paint everyday scenes of his own invention, specializing in the depiction of foundries and forges in which the light effects produced by burning fires are the chief attraction (e.g. New York, Metropolitan). His work has been compared to that of *Boilly.

Degas, Edgar (1834–1917) French painter and occasional sculptor and printmaker, born in Paris into a banking family. In 1854–5 he had drawing lessons from a pupil of *Ingres who implanted a feeling for *classicism which Degas reinforced by visits to Italy, a period in the Ecole des Beaux-Arts and frequent study of the old masters in the Louvre. In 1859 he took a studio and began to produce portraits and *History paintings, culminating in his *Misfortunes of the City of Orléans* (Paris, Orsay), shown at the 1865 Salon. From the mid-1860s on he chose real-life subjects under the influence of *Manet and the future *Impressionists, contributing to their exhibitions from 1874 to 1886. Though his subjects and his involvement in the promotion of Impressionism marked him out as a member of the group, he did not embrace their priorities. He painted a few subtle landscapes, but was impatient with the doctrine that painting was to be done out-of-doors and preferably at one go. His feeling for modern subjects and for colour and texture as major factors in painting fused with convictions about the organization of images that were essentially classical while also reflecting new concepts of space and vision derived from photography and Japanese prints. In this way he was close to *Post-Impressionists such as *Cézanne, *Gauguin and *Seurat, but also to the new classicists of the 1860s and after, most notably *Puvis (who had praised the *Misfortunes of War*). Degas had already undertaken paintings of horse races, including the large and curious *Injured Jockey* (1866; Upperville, MA., Mellon coll.), a translation into contemporary and sporting terms of the wounded cavalier images of *Romanticism. But *Woman with Chrysanthemums* (1865; New York, Metropolitan) marks his embrace of modernity, a resplendent flower still life combined with a portrait. The casual composition hints at his awareness of photography but the picture also shows his mastery of colour. Other informal representations of women followed, not supporting the notion that Degas was some sort of misogynist but certainly showing him observing closely and shunning idealizing formulae. He brought similar attention to a widening range of subjects, as in *The Orchestra of the Opera* (1869), *The Ballet 'Robert le Diable'*, *The Dancing Class* (both 1872; New York, Metropolitan) and the mysterious scene of sexual tension known as 'The Rape' but titled *Interior* (1868–9; Philadelphia, McIlhenny coll.), probably illustrating a scene in a contemporary novel.

He served in the army in the 1870–1 war, at which time an eye defect became apparent. Deteriorating eyesight was to

attend his remaining years and it may be that his visit to relatives in New Orleans in 1872–3 was intended to rest his eyes. In fact, though the strong southern sunlight bothered him, he painted almost continuously there too, notably a unique, almost photographic group portrait of his relatives in their New Orleans office, *The Cotton Exchange* (1873, Pau, Museum): like some of his ballet scenes, this combines a high viewpoint with a Japanese type of perspective, describing space but giving little sense of recession. Back in Paris, he added to his repertoire laundresses at their ironing or carrying loads of washing, common sights to which he gave great dignity, as in his ongoing studies of ballet dancers on and off stage. His own skills, as draughtsman as well as painter, reached a kind of climax in the 1870s when he could paint his *Beach Scene* (*c*.1876; London, National), with its figures under a bright but cloudy sky, by posing models in the studio, or in his series of *monotypes of brothel scenes, at once witty and affectionate (*c*.1879). In 1881 he exhibited his first sculpture, *The Little Dancer of Fourteen*, a wax figure dressed in a real bodice, tutu and slippers, with a real ribbon tying back her real hair, and posed assertively rather than charmingly. Commentators were appalled by what they saw as an attack on all that made sculpture art, more specifically by a realism that belonged to waxworks. For Degas the piece was a natural development of his studies from the model, and he made many more three-dimensional works in wax or clay, mostly dancers and horses, keeping them in his studio. As his eyesight worsened and drawings became more difficult to see, he relied more on modelling. Few were aware of these works and they were not cast until after the artist's death.

In 1886 Degas showed a 'Series of women bathing, washing, drying, combing their hair or having it combed'. The writer-critic Huysmans saw in it 'the stumps of the maimed, the embrace of the prostitute, the sickening gait of the legless cripple', while *Renoir recognized it as 'a piece of the Parthenon', referring to the Greek sculptures widely acknowledged as the chief masterpieces of antiquity. The pictures were done in pastel and show naked women cleaning and tidying themselves and apparently unaware of the observer. Their realism is patent in theme and observation. The series, to which he added after 1886, reveals a further mastery of composition, colour and now more especially the texture of pastel lines deliberately interwoven. These are small works of astonishing majesty, encapsulating the artist's constructive drive as much as his remarkable power of observation.

Degas's fascination with inelegant, commonplace subjects marks him out as dramatically modern, breaking once and for all the old link between serious art and high-minded, time-honoured themes. He left over 2000 oils and pastels plus 150 sculptures. An outstanding selection, including a fine sequence of the 'Series of women bathing' etc., is in the Musée d'Orsay, Paris.

Degenerate Art The notion that art which does not adhere to conventions of subject, style and method might be the product of degenerate human beings and could infect others surfaced in the last years of the nineteenth century – in Max Nordau's *Entartung* (1893; Degeneracy) and by implication in Tolstoy's *What is Art?* (1898), the former insisting on norms of taste and meaning, the latter recommending an art detached from bourgeois ideas of pleasure and entertainment in order to communicate spiritual values. In Germany such thoughts were embraced in the name of racial purity: foreign influence was condemned by some from the 1870s on and in the present century this condemnation became more specifically directed against non-Aryan elements and against progressive artists and their supporters (critics, dealers, museum directors etc.). With the rise to power of the Nazis it became a national policy pursued with brute force. From 1933 various attempts were made to rid the German art world of its progressive and/or Jewish and/or Communist artists and teachers, often under the general label of 'cultural Bolsheviks'. In 1937 the Ministry for Enlightenment and Propaganda commissioned the painter Ziegler to extract 'German decadent art' from public collections. This was done quickly, and that

July an exhibition of Degenerate Art was opened by Hitler in Munich in a building close to the new Haus der Deutschen Kunst (House of German Art) with its display of officially approved art. About 16,000 works had been sequestered by Ziegler. From these the exhibition was formed – a haphazard and intentionally inept display given point by denunciations inscribed around the exhibits. It was very popular and toured to other German cities. Many of the works were later sold abroad; the rest were burned in Berlin in 1939. In 1943, during the German occupation of France, 500–600 works by major modern artists were similarly burned in Paris.

Degouve de Nuncques, William (1867– 1935) Belgian painter, born into a deeply cultured French family and himself studious and introspective. As a painter he was largely self-taught but was a close friend of *Toorop, sharing a studio with him in Brussels. He visited Paris and was acquainted with *Puvis, *Denis and especially *Rodin who encouraged him to work and exhibit. His early work, which often gives *naturalistic subjects a *Symbolist mysteriousness is seen as foreshadowing Belgian *Surrealism; his nocturnal townscapes certainly suggest the paradoxical day/night visions of *Magritte. His later work was more directly naturalistic and was mainly landscapes.

Deineka, Aleksandr (1899–1969) Russian painter, trained in Moscow under Favorsky in 1921–25. In 1928 he became a member of the October Group. His *Defence of Petrograd* (1927 and later versions) is a powerful image, owing something to the simplified vision of *Hodler and more to open-air re-enactments of the Revolution. He was an outstandingly gifted designer and his work maintained a vigour and freshness, as well as a pictorial strength, not found in most of the art produced after *Socialist Realism became the only approved mode.

De Kooning, Willem (1904–97) Dutch-American painter, born in Rotterdam (Netherlands), who worked in a commercial art firm and attended art evening classes before emigrating to New York in 1926. In the mid-1940s he emerged as, with *Pollock, the creator of American *Abstract Expressionism. For years he had painted figures, balancing an *Ingres-like conception of form with an anti-classical view of the painting as a dialogue between painter, materials and marks (*see* Klee). John *Graham and *Gorky guided him towards a style of spontaneity and risk. By 1945 his figures were spread across the canvas as fragments of anatomy close to *abstraction. His first solo exhibition, in 1948, was of black-on-white and white-on-black paintings, suggesting anatomies but seen principally as energetic and impassioned brushstrokes. The control and taste demanded by them has become more apparent over time.

Recognized by the end of the 1940s as a key figure in the new painting, De Kooning shocked his admirers in 1953 by showing figure paintings again, crude images of big women that marked him a traitor to the movement. Time has shown that they represent a fusion of his earlier figure painting with his more expressive manner; the humour in them is still admitted only reluctantly. From about 1955 on he also painted grandiose quasi-abstract landscape images in resonant colours. Figures and places have continued to be his themes. In 1969 he began to make figure sculptures, clay coagulations which take on great presence in bronze and, like the painted women of about 1952, hover precariously between joke and awesome monument.

The vividness and brilliant management of his work have kept it in the forefront of American art. Since the later 1950s De Kooning has been an international star, exhibiting solo and in mixed exhibitions around the world.

Delacroix, Eugène (1798–1863) French painter, controversial but also highly successful in his time, and important to later painters, notably the *Impressionists and *Post-Impressionists, and to 20th-century masters such as *Kandinsky, *Matisse and *Picasso. Born near Paris, at Charenton, into a well-to-do family (Talleyrand may have been his natural father), he received a good education and trained as

a painter under *Guérin but got more artistic motivation from his friendship with *Géricault, his contact with *Bonington and studies in the Louvre (then temporarily enriched by Napoleon's appropriations from other lands). His first exhibit at the Salon, in 1822, was also his first major work: a powerful but gloomy painting, echoing Géricault's *Raft of the Medusa* but representing an episode in Dante's *Inferno*, *The Bark of Dante*. It was praised as well as attacked; amazingly (thanks possibly to Talleyrand's influence), it was bought by the government. His *Massacre of Chios*, shown at the Salon in 1824, was closer to Géricault's masterpiece in that it represents a contemporary news item, Turks slaughtering Greeks, but it was also his first markedly personal work, loose in composition and rich in drama, visual incident and colour; its deep landscape space and broad sky, and above all the colour areas animated by mingling touches of related colours, owed something to his awareness of *Constable. This painting too was bought by the government, and in 1826 Delacroix received his first state commission, a large *History painting for the Louvre's state rooms (destroyed in 1871). The same year he did another powerful painting on a contemporary theme, the Turkish seizure of the Greek city of Missolonghi shown symbolically as a young female figure standing, half kneeling, on its ruins (Bordeaux, Musée). Byron had died at Missolonghi in 1824. The dramatic, partly erotic appeal of the picture was trumped by the even greater attractions of a painting developing the climax of a Byron play. *Death of Sardanapalus* (1827 Salon) was Delacroix's most arousing painting in theme and manner, orgiastic as well as melancholy, crowded with figures, beasts and rich objects. Its combination of wildness with strong compositional accents, of energy with gravity, is characteristic Delacroix, and it offended the establishment with its contradictions. By the late 1820s he was seen as the leader of the *Romantic faction in French art, while *Ingres was honoured as the head of contemporary *classicism. Ingres's disdain of Delacroix was open; Delacroix did not, however, accept the role thrust on him, always asserting his respect

for the classical tradition. Later, from 1855 on, *Baudelaire wrote about him as the great genius of modern art.

The liberal government in power after the 1830 revolution brought Delacroix back into official favour: his partly symbolical, partly *realistic image of the revolution, *Liberty leading the People*, was bought by the state at the 1831 Salon. In 1832 Delacroix accompanied the French ambassador to Morocco on a visit that included Tangier and Algiers and some of the cities of southern Spain. North Africa was a revelation. Delacroix saw it and its peoples as a living Homeric world, remote from the cold classicism associated with plaster casts and academic strictures. He made watercolours and filled notebooks with descriptions and sketches. *Algerian Women in their Apartment* (1834) is the finest recollection of his trip. Paintings on North African themes continue to the end of his career.

*Raphael, *Michelangelo, *Tintoretto, *Veronese, Rubens and other old masters he had long admired; as he grew older Delacroix responded increasingly to the mysteriously powerful art also of *Rembrandt, placing him even above Raphael. Thoughtful as well as passionate in his enthusiasms, he kept journals which, together with his published letters and with articles published between 1829 and 1862, form one of the great cultural documents of the century. In them, original observations on colour and on the importance of what he called 'the musical part of painting' – its sensory and emotional communication as distinct from its reporting the appearance of things – mingle with perceptive comments on the arts, society and the pressures of life. His emphasis on what was later to be developed in *abstract and semi-abstract art complemented his passion for literary and historical subjects. No other painter ranged more widely in his use of literary sources.

From 1833 on he received state commissions for decorative schemes in government buildings and libraries. He designed them and closely supervised their execution by a team of assistants. Perhaps the finest of his secular mural works is *Apollo Destroying Python* in the Louvre's Galerie d'Apollon

(1850–1), the victory of light over darkness. It admits its debt to several old masters yet has a richness of tone and colour and a fluency of composition personal to him, marking him out as a great decorative painter at a time when this kind of work attracted relatively little skill or invention. His finest religious paintings are the murals in the chapel of the Holy Angels in the Paris church of Saint-Sulpice (1854–61), where *Jacob Wrestling with the Angel* stands out as a remarkably personal work on a large scale and in a public place. Yet even more astounding than these great works are some of the small, private paintings of his last years on a variety of subjects, including a *Shipwreck of Don Juan* (after Byron, 1840), *Christ on the Sea of Galilee* (1854; Baltimore, Walters), *Hercules and Alcestis* (1862; Washington, Phillips Coll.) and *Arabs Skirmishing in the Mountains* (1862; pc) – intense pieces of pictorial poetry. In 1857 he was finally made a member of the Institute, an honour he had long desired but which traditionalists had barred.

Delacroix worked mainly in Paris. In his last years he built himself a studio off the place Furstemberg, now the Delacroix Museum. Paris's Musée d'Orsay holds some of his most famous paintings, including those to which reference has here been made without mention of their location. His drawings, condemned by contemporaries as incompetent, are now admired for their energetic encapsulation of form and movement. He loved women and had enduring relationships with a few, but he never married, perhaps because he gave priority to his work, consisting of about 900 pictures large and small.

Delaroche, Paul (1797–1856) French painter who under *Gros discovered a talent for *History painting and through this enjoyed growing success in Restoration France. Where *Delacroix was violent and shocking, Delaroche mingled *Romantic with traditional qualities and a good deal of accurate archaeological detail in scenes from medieval and subsequent history, such as *The Sons of Edward* (i.e. the sons of Edward IV of England in the Tower of London; 1830; Paris, Orsay), and *The Execution of Jane Grey* (1833; London,

National). He received the Légion d'Honneur in 1828. In 1841 he completed a large and scholarly mural in the Ecole des Beaux-Arts summarizing the history of art; a major retrospective of his work was shown there shortly after his death.

Delaunay, Robert (1885–1941) French painter, born in Paris. His early work was dependent on *Impressionism and *Neo-Impressionism; then came the impact of *Cézanne and some awareness of early *Cubism, also an impulse towards bright colour from the young Russian painter, Sonia Terk, who became his wife in 1910 (see next entry). From 1909 he was painting series – *Saint-Séverin*, *Eiffel Tower*, *The City* – in which rhythmically disrupted or patterned forms display increasingly vivid colours, the subject being abstracted to convey excitement and joy. His large *The City of Paris*, shown early in 1912, is a synthetic image in which the Eiffel Tower, a view of Paris derived from Henri *Rousseau, and figures of the Three Graces celebrate the city. That year he approached *abstraction in a long series of *Window* paintings based on a postcard view of the roofs of Paris, and then a series of *Disk* paintings in which large and small forms in sonorous colours interact to suggest movement and space: subtitles refer us to sun and moon and imply a vision of sky or cosmos. His earlier work now appeared destructive; the new was constructive, not fragmenting objects but presenting harmonies addressed, like music, directly to our senses. *Apollinaire, a close friend at this time, championed this musical art and presented Delaunay as chief of a new movement which he named *Orphism.

Delaunay had been exhibiting at *Salons and group shows. In 1912 he had his first one-man shows, in Paris and Zurich. His show in the *Sturm Gallery, Berlin, in January 1913, included a new type of Delaunay painting, *The Cardiff Team*, in which rugby players copied from a newspaper photograph are backed by the Eiffel Tower, Paris's large ferris wheel, an aeroplane and bright hoardings to make a joyful composition from topical and popular material. His *Homage to Blériot*, the pioneer

of flying (1914; Paris Pompidou) is a composite work in which colourful images of aeroplanes and the Eiffel Tower together with disks and haloes of colour speak of progress and adventure. Delaunay was attempting to reach a wider public and to this end combined *avant-garde methods with others derived from religious and folk art. His success in Paris was limited. The *Futurists, however, were stimulated by his dynamic version of *Cubism, and in Germany his paintings were admired for their lyrical, expressive character: his show in the Sturm Gallery in Berlin was followed, later the same year, by a large Robert and Sonia Delaunay section in its First German Autumn Salon. In Poland and Russia too, Delaunay's work was much noticed.

The Delaunays spent 1914–20 in Spain and Portugal. Robert now turned to more traditional subjects, still lifes, figures etc., still stressing pattern and colour. His example and presence created something of a Delaunay school in the peninsula. Back in Paris in 1920, the Delaunay home again became a centre for artists and writers. In 1925 he contributed a large painting to the international Paris Exhibition of Decorative Arts. By 1930 his work was wholly abstract, presenting colour rhythms through disks and haloes, sometimes now in low relief. During the 1930s his work became more widely known through French national and American purchases. In 1937 he directed the decoration of the aeronautics and railway pavilions at Paris's World Exhibition. His last major works, mostly vertical and diagonal stacks of disks and haloes of colour joined in a rhythmical design, are often entitled *Rhythm without End*.

Delaunay, Sonia (1885–1979) Sonia Terk, Russian-French painter, was born in the Ukraine and grew up in St Petersburg. She studied art in Karlsruhe in 1903–4 and came to Paris in 1905. She was briefly married to the German art critic Wilhelm Uhde, promoter of the *Cubists; then she met Robert *Delaunay whom she married in 1910. She encouraged Robert to develop his art; she never ceased to paint but gave some priority to applying her discoveries in

the field of colour to objects of design and use: she made a cot cover for their baby son, as well as bookbindings, and in 1913 the first 'picture-poem': Blaise Cendrars's *La Prose du Transsiberien* (The Prose of the Transsiberian [Railway]) printed in several typefaces on a sheet of paper 2 metres long with a visual soundtrack of shapes and colours. In these works she deployed elements similar to Robert's though she was readier than he to make her art completely *abstract. Her themes, where they are apparent, are earthier than his: e.g., *Electrical Prisms* (1914; Paris, Pompidou) is of disks and haloes of colour almost identical to Robert's but here suggesting street lights at night-time. She continued to make objects as well as paintings, and now also gowns and waistcoats in the Delaunay style, announced as 'simultaneist' in that the interaction of the forms and colour suggests movement in depth and on the surface (the term came from the title of a well-known treatise on colour, M.-E. Chevreul's *De la loi du contraste simultané des couleurs* (1839) translated as The Principles of Harmony and Contrast of Colours, 1872).

She received income from Russia until the Revolution. After, she promoted herself as a designer, working for the theatre in Madrid and, with Robert, for the Ballets Russes. Back in Paris she became known for textiles and carpets and dresses, and a decorated 'simultaneist' car. It was not until after Robert's death that Sonia emerged fully as painter, developing the Delaunay idiom in large, strong canvases. Since the 1940s there have been several major exhibitions of her work, with and without Robert's, in Europe and North America. She received many honours, and was the first woman whose work was shown in the Louvre during her lifetime.

Delen, Dirck van *See* Steenwijck, Hendrick van.

Delff, Willem Jacobsz. *See* Miereveld, Michiel van

Delft, Master of (active early 16th century) Now-unknown Netherlandish painter, working in Delft. His principal work, a *triptych with scenes of the

Passion of Christ (London, National), shows the New Church of Delft in the background as it appeared between 1496 and 1536.

Delvaux, Laurent (1696–1778) Flemish sculptor. Recorded in England from 1721, he worked in partnership with Peter *Scheemakers *c.*1726–8, until he left for Rome. Returning briefly to England in 1733, he then settled in Brussels, where he received a Court appointment and continued to work largely in a style inspired by *Classical antiquity (Ghent Cathedral; Brussels, Musée).

Delvaux, Paul (1897–1994) Belgian painter, trained at the Brussels Academy during 1920–24. His early paintings show him working in *Post-Impressionist and *Expressionist styles, but in 1934 he saw paintings by De *Chirico, *Magritte and *Dalí. By 1937 he was part of a Belgian circle of *Surrealists centring on Magritte, and his work was included in the 1938 Paris International Exhibition of Surrealism. He had found his personal idiom and it changed little thereafter. His pictures are painstaking accounts of melancholic, nostalgic scenes in which young women, nude or clothed, appear in suspended animation while males are rarely seen or are shown only as symbols or averted from the women who always dominate the pictorial stage. The detailed realization of every part, filmic in character, underlines the all-over unreality of each composition, designed to evoke an earlier time, perhaps drawing on memories of his first awareness of sexuality. Delvaux named the world of his imagination The Anxious City; once he had found it he never abandoned it. A Delvaux museum is at Saint-Idesbald in Belgium.

Delville, Jean (1867–1953) Belgian painter, prominent in the *Symbolist movement and organizer of an annual Idealist *Salon as well as editor of the journal, *Idealist Art*. He wrote poetry as well as philosophical and critical articles, promoting Theosophical and other esoteric ideas in Belgium. The Prix de Rome took him to Florence and Rome in 1894. During

1900–5 he taught at the Glasgow School of Art, and also, 1900–37, at the Royal *Academy in Brussels and elsewhere. After the First World War he formed a group dedicated to the decoration of public buildings, often with grandiose allegorical compositions.

De Maria, Walter (1935–) American sculptor and *Earthworks artist. Emerging as one of the *Minimalists in the early 1960s, he made works in landscape, such as his *Mile-Long Drawing*, two parallel lines inscribed in the earth of the Mojave Desert in 1968 and known to the world through photographs, and was one of the initial *Conceptual artists with an installation piece consisting of a vast quantity of earth filling a gallery up to waist-high, first in Munich (1968) and subsequently in Cologne and So-Ho, New York, where it has been since 1980 as a permanent exhibit.

Demuth, Charles (1883–1935) American painter, trained in Philadelphia. A European trip in 1907–8 included a visit to Paris; he was there again in 1912–14, studying at private academies and making contact with the *Cubists. His early work suggests the decadence and delicacy of late 19th-century European art, but by 1918 he was developing a Cubism close to the style of *Cézanne, but with ray lines as used by the *Futurists to structure his surfaces. Soon he was using the same style in an elegant way to represent buildings and other scenes in apparently cool and factual descriptions but simplified to bring out their monumentality and associations. These he sometimes stressed in his titles, as in the oil painting of grain silos, *My Egypt* (1927; New York, Whitney). Some of his paintings were emblematic, e.g. *I saw the Figure 5 in Gold* (1928; New York, Metropolitan), inspired by William Carlos Williams's poem 'The Great Figure', and forming a sort of portrait of the poet. Demuth was a member of the modern art circle around *Stieglitz and was associated with the tendency known as *Precisionism on account of the clarity of his work and his concern with the industrial world.

Denis, Maurice (1870–1943) French painter, prominent among the *Nabis as theoretician. His statement of 1890, 'Remember that a picture – before being a battle horse, a nude woman or some anecdote – is essentially a flat surface covered with colours arranged in a certain order' has often been quoted as advocating *abstract art; in fact, it asserts the two-dimensional, decorative nature of painting. Denis's own work at this time showed an allegiance to both Florentine early Renaissance art (e.g. Fra *Angelico) and to Northern late Gothic art, models for an art of clear delineation without depth and *chiaroscuro. It can also be described as a form of *Pre-Raphaelite or *Nazarene painting but without the *naturalism of the first and the self-conscious historicism of the second. He is rightly grouped with the *Symbolists: he had no interest in reproducing nature's appearances; art's function was to present ideas through visual material serving as an equivalent to the visible world. His forms tend to be flat and arranged to flow harmoniously over and beside each other: here *Gauguin was the immediate example. The paint surface is mostly delicate, the colour gently unnaturalistic, but from *Neo-Impressionism Denis learned the technique of *pointillism, using it not for accuracy but to give his colour areas vitality. Much of his work was religious, contributing to the Catholic revival of the turn of the century. He represented sacred themes in modified forms to make them apt images for modern times; he also took simple lay subjects and turned them into symbolic actions with religious implications. In 1895 and again in 1897–8 he was in Italy studying the *classical tradition. He returned convinced that painters should work with traditional care and thoughtfulness, and in subsequent writings distanced himself from modern notions of spontaneity. He also championed the art of *Cézanne, representing himself and his Nabi friends in *Homage to Cézanne* (1900; Paris, Pompidou), though his own work remained at some distance from it, being more concerned with ideas and ideals, less with capturing experiences of nature.

Denis's religiosity and controlled idiom caused him to be overshadowed by more obviously revolutionary artists. Yet the influence of Nabi art was strong and his writings lent it additional force. Also he taught from 1908 to 1919 at the Académie Ranson. He exhibited many times in group and one-man shows, and received public commissions for decorative painting well suited to his preferences: e.g. the ceiling of the new Champs-Elysées Theatre, Paris, 1912. In 1924 there was a large retrospective exhibition of his work in Paris. A number of his paintings went to Moscow and in 1909 he travelled there to meet the collector Ivan Morosov, who already owned works by Denis and other Nabis, and who wanted thirteen decorative panels for his music room. Otherwise, Denis's work was not well known outside France, though his writings commanded attention. His *Théories (1890–1910)*, subtitled 'From Symbolism and Gauguin towards a New Classical Order' appeared in 1912 and was reprinted in 1913 and 1920; his *Nouvelles théories* followed in 1922. There are also other writings: on individual artists, a history of religious art (1939) and his journals of 1884–1943 (1957–59).

Denner, Balthazar (1685–1749) German painter, originally a miniaturist. Mainly active as a portraitist, based in Hamburg but also working at the courts of Brunswick and Denmark, and between 1721 and 1727 in London, he became famous for his detailed heads of anonymous old people, such as the *Head of an Old Woman* now in Vienna, Kunsthistorisches, once a prized possession of the Emperor Charles VI.

Denny, Robyn (1930–) British painter, prominent among the *abstract painters of the *Situation group and well known subsequently for his succinct colour compositions. He exhibited frequently in Britain and America. In 1966 he was one of a small group of artists to represent Britain at the Venice Biennale. In 1973 a retrospective was shown at the Tate Gallery in London. Soon after, he moved to Los Angeles where he embarked on a new series of paintings in which a few marks, made on and into dark ground colours, produced a complexity of readings in terms of light

and space. This work continued when he moved back to London, in 1988.

Depero, Fortunato (1892–1960) Austro-Italian painter. Born in Fondo (Trento), he had Austrian citizenship but worked in Italy where he associated from 1914 on with the *Futurists. In 1915 he and *Balla issued a manifesto 'Futurist Reconstruction of the Universe'. Subsequently he was active in a second-wave Futurist movement between the two world wars.

Derain, André (1880–1954) French painter, born at Chatou, near Paris, where he received his first art instruction. In 1898 he studied at the Académie Camillo alongside *Matisse; in 1900 he met *Vlaminck and set up studio with him; in 1901 he introduced them to each other at a Van *Gogh exhibition. Military service took him away from painting during 1901–4. At this time he became interested in, and collected, African *primitive art. In 1905 he worked with Matisse at Collioure in the south of France, and, exhibiting with Matisse and others at the Salon d'Automne, became known as one of the *Fauves. His paintings at this stage were bright with colour, deriving from *Neo-Impressionism and from *Gauguin's use of heightened colour and sinuous forms. Among his most powerful Fauve works are cityscapes of London, 1905 and 1906. In 1907 he lived in Montmartre, close to the *Bateau Lavoir, in frequent contact with *Picasso and *Braque. His work at this stage could be described as monumental *Cubism, stabilized by an underlying *classicism derived from *Cézanne and *Renaissance art. By 1912 it became more openly traditional, combining aspects of early Renaissance simplicity with clarified outlines in the manner of *Ingres. A cultured man, he was seen as an acceptable modernist by the time the 1914–18 war began. Apollinaire, introducing Derain's first one-man show in 1916, stressed his search for the discipline that results in order. In 1937 Derain was one of the French artists who accepted Hitler's invitation to attend the opening of the House of German Art in Munich and to demonstrate respect for the fascist art on show there (*see* Degenerate Art).

His post-war career was distinguished and uneventful. He did the décor for Diaghilev's *La Boutique fantasque* (1919) and other ballet productions, while also painting and making fine book illustrations. At intervals Derain carved stone sculptures of a remarkably *primitive sort. His later two-dimensional work combined traditional modes with modern sketchiness attractive to those who seek academic assurances in new art. In the 1920s he became one of the best-known of modern masters, exhibiting around Europe and in the USA; in 1928 he was awarded the Carnegie prize.

Deruet, Claude　*See under* Bellange, Jacques.

Desco da parto (pl *deschi*; Italian, birth tray)　In *Renaissance Italy, 12-sided or circular trays decorated with appropriate narrative or symbolic scenes, or patterns, were given as presents to new mothers, or in anticipation of a birth. They were often the product of the same workshops that specialized in *cassone* painting, although like *cassone* or other furniture decoration, they could also be commissioned from better-known artists. Many of these trays now hang as easel paintings in museums.

Deshays, Jean-Baptiste Henri　*See under* Restout, Jean the Younger.

Desiderio da Settignano (*c.*1430–64) Florentine sculptor from the neighbouring commune of Settignano, the native town also of his teacher, Bernardo *Rossellino. Son of a stone cutter, he set up a studio in Florence with his sculptor brother **Geri** (*b.*1424) whose work remains unidentified. Desiderio enjoyed great fame in his lifetime and after his premature death for his uniquely sensitive handling of *schiacciato*, or shallow, relief in *Donatello's 'sweet' mode (as exemplified in the latter's *Pazzi Madonna*). His major works are the *Monument of Carlo Marsuppini*, former Chancellor of Florence (after 1453, Florence, S. Croce), which reinterprets Bernardo

Rossellino's monument to Marsuppini's predecessor, Bruni, in the same church, with greater emphasis on the ornament and figure sculpture, and the *Altar of the Sacrament* (*c*.1461–2, Florence, S. Lorenzo). Desiderio carved a number of Virgin and Child reliefs (Philadelphia, Museum; Turin, Pinacoteca; Florence, Bargello); stuccos after these became very popular throughout Tuscany. A number of other works, mainly reliefs, some of the young St John the Baptist and Christ Child, and portrait busts of women, have been attributed to the artist on the basis of references by *Vasari and resemblance to the major monuments (Paris, Louvre; Washington, National; Berlin, Staatliche).

Despiau, Charles (1874–1946) French sculptor who worked as *Rodin's assistant during 1907–14 but in his own work developed away from Rodin's expressive mode towards a gentle classicism. This shows especially in his figure sculptures. These were admired but his popularity stemmed primarily from his many portrait busts, *realistic but also simplified and quietly descriptive of character and life.

Desportes, Alexandre-François (1661– 1740) French painter. He began his career as a portraitist, in which capacity he spent 1695–6 at the Court of Poland. He became celebrated, however, after his return to Paris when he turned to paintings of animals: in hunting scenes, as still lifes of dead game, or in portraits of living animals – such as those commissioned by Louis XIV of his favourite dogs and menagerie animals. He was the first French artist to specialize in this genre (but *see also* his rival Oudry), which had been practised by his teacher, the Fleming **Nicasius Bernaerts** (1620–78), a pupil of *Snyders. As preparation for the landscape backgrounds of his hunting scenes Desportes made a series of direct studies in oils on paper, which anticipate the outdoor sketches of *Corot (Compiègne, Château).

Dessailiant, Michel (active 1700–1723) French-born Canadian portrait painter, active mainly in Quebec (Hôtel-Dieu) but also Montreal (1701) and Detroit (1706).

Detroy *See* Troy, de.

Deutsch, Nikolaus Manuel *See* Manuel Deutsch, Nikolaus.

Devis, Arthur (1711–87) Minor English painter rediscovered in the 20th century, the first to specialize entirely in small-scale *Conversation Pieces and equally small single full-length portraits. A pupil of *Tillemans, he may have begun as a landscape artist. By 1764 he was eclipsed by *Zoffany, and turned to painting on glass and restoring. Even in his heyday, from 1742, he was disdained by the aristocracy, but found favour with the middle classes, in whose moderately sized rooms his pictures neatly fitted, and whose belongings and pretensions he inventoried with naïve charm. There are pictures by him in London, Tate, V&A; Manchester, City Art Gallery, etc.

De Wint, Peter (1784–1849) British landscape painter, primarily in watercolours, and often of the Lincolnshire plains, for which he came to use a broad, panoramic format.

Dexel, Walter (1880–1973) German painter, who studied art history at Munich University and began painting about 1912. After 1918 he became known as an *abstract artist; in 1921–2 he was drawn towards *Constructive art by the example and polemics of Van *Doesburg. His work was condemned as *degenerate in 1935. He turned to teaching theory in Berlin and started painting again in the 1960s. There was a retrospective in Bonn in 1973.

Diaz de la Peña, Narcisse (1809–1876) French painter, son of immigrant Spaniards, born in Bordeaux. Both parents died early and Diaz became a painter in Paris only after attempting other careers, including printing and decorating ceramics. But he was drawn to art, especially the *Romanticism associated with Victor Hugo and *Delacroix, and when painter friends offered him instruction he committed himself to it, studying the old masters in the Louvre. The Salon of 1831 accepted two landscape sketches, but for a while

Diaz tried to make his name with *History paintings. He had little success with these, recognized that landscape painting was his chief interest, and left Paris for the Fontainebleau area where he associated with Théodore *Rousseau and other members of the *Barbizon School. From 1837 on he showed regularly in the Salon, pleasing critics with his vivid, light-filled forest landscapes and entertaining the public with *genre scenes fed into the same settings. These now seem rather artificial and sweet, in spite of his lively handling of the brush; *Correggio appears to have wielded a major influence on his vision here. His landscapes still stand out among Barbizon productions and encouraged other artists to combine a personal mode with close observation of nature, among them Van *Gogh.

Dibbets, Jan (1941–) Dutch *Conceptual artist, associated particularly with photographs in which he counters recession with lines and with a pioneering piece of TV art, a film of a domestic fireplace complete with a burning fire.

Dickinson, Edwin (1891–1978) American painter, who studied in New York and Provincetown, and then in Paris, 1919–20. He lived and worked mainly in Provincetown and, from 1944 on, in New York, exhibiting frequently in the USA, rarely beyond (e.g. 1968 Venice Biennale). His paintings continue 19th-century traditions of poetic *naturalism, heightened by selective attention to detail and by a dramatic use of space. His self-portraits are admired for their psychological vividness.

Dickinson, Preston (1891–1930) American painter, trained in New York and Paris. Influenced by *Cézanne and *Cubism, he returned to America to become one of the *Precisionists, creating delicate, semi-geometrical scenes out of the industrial landscape.

Diderot, Denis (1713–84) French philosopher, essayist and playwright; he became editor of the *Encyclopédie*, the main vehicle for the propagation of the liberal ideas and scientific discoveries of the Age of Reason. His importance for the history of art, however, stems primarily from his influential reviews of the official art exhibitions, the Paris *Salons of 1759–71, 1775 and 1781. In these he castigated *Rococo artifice and frivolity – attacking in particular *Boucher and *Watteau (both of whom he profoundly misunderstood, although he admitted that Boucher's art lacked 'nothing except Truth') – and advocated greater seriousness, 'Nature' and 'sensibility', the *expression of emotion and its evocation in the viewer. These criteria made him over-optimistically champion the sentimental *Greuze, but also and above all *Chardin, who for him was 'Nature itself'. At his last Salon in 1781, he praised the paintings exhibited by Jacques-Louis *David, finding them 'noble and natural'. Like *Winckelmann, Diderot called for the imitation of the antique in order to regenerate art and society, to 'attain the real simplicity of Nature' – and, like Winckelmann, he can be claimed for both *Romanticism and *Neoclassicism.

Diebenkorn, Richard (1922–93) American painter, trained at Stanford University and the University of California at Berkeley. A painter of still lifes and interiors, he developed an *Abstract Expressionist idiom under the influence of *Rothko and *Still, then also of *De Kooning whose example brought lyricism into Diebenkorn's work. In the mid-1950s he returned to *figuration, working with broad areas of colour, to form spaces into which he set simplified figures. The *Ocean Park* series (1967+) appears abstract again with its large geometrical colour areas set up like architectural elevations, yet is redolent of California's light and space and delivers particular scenes in simplified, supercharged terms. He exhibited many times in the USA, and also abroad from 1948 onwards, in group and solo exhibitions. He had retrospectives in Washington and New York in 1964 and at Balboa, California, in 1965.

Diepenbeck, Abraham van (1596–1675) Flemish painter and printmaker; he worked

as an assistant to Rubens, but is most important as a glass painter (windows in Antwerp Cathedral) and book illustrator.

Dijck, or Dyck, Floris van (1575–1651) Dutch painter, active in Haarlem where, along with the less-well documented **Nicolaes Gillis** (active *c.*1610) and **Floris van Schooten** (active by 1605), he was one of the pioneers of *still-life painting. Van Dijck entered the painters' guild in 1610 after a visit to Italy. His still lifes, like those of Gillis, represent foodstuffs and tableware arranged in the middle of a table which extends beyond the sides of the painting; they are seen from a high viewpoint, with a minimum of overlapping. It is thought that Gillis brought the motif with him from Antwerp, where Osias *Beert and Clara *Peeters specialized in it. Van Schooten went beyond Dijck and Gillis in his choice of subjects, painting kitchen pieces and market scenes, and a recently discovered *allegory of the brevity of life (Schiedam, pc) as well as his still lifes – in which his style later changed to the 'monochrome' favoured by Pieter *Claesz. and Willem Claesz. *Heda. There are pictures by Dijck, Gillis and van Schooten in Haarlem, Frans Hals Museum.

Diller, Burgoyne (1906–65) American painter who studied in his native New York. His early work echoes *Impressionism and *Cubism, but in the 1930s he became one of the USA's pioneers of geometrical *abstraction under the influence of *Mondrian. He worked on murals for the *Federal Arts Project and was a member of *American Abstract Artists. Between 1945 and 1964 he taught at Brooklyn College and the Pratt Institute. From Mondrian he developed his own compositional types. He exhibited with the *American Abstract Artists until 1940 and had many one-man shows thereafter.

Dine, Jim (1935–) American painter, born and trained in Cincinnati. He became known as one of a second wave of American *Pop artists, collaborating with *Oldenburg on *Happenings and making paintings in which banal objects (ties, washbasins etc.) were combined with painted surfaces. A delicacy in these works, for all their apparent *anti-artness, became prominent in his subsequent paintings and graphic works: subtle in technique, quietly humorous and often autobiographical. Since the 1970s the graphic artist has come to dominate the painter, and the skilled traditionalist over the neo-*Dadaist. He has had many exhibitions since 1969, in the USA and in Europe, and has divided his time between New York and London.

diptych *See under* polyptych.

disegno (Italian, drawing, design) In Renaissance art theory, the term means far more than its literal translation. *Disegno* or drawing is the principle underlying and unifying the arts of sculpture, painting and architecture. Drawing the outline of a man's shadow cast by the sun of ancient Egypt, or, in other accounts, ancient Corinth, was said in legend to have been the first artistic act. Most important, *disegno* is the intellectual component of the visual arts, which justifies their elevation from crafts to liberal arts, on a part with poetry, theology, etc.

In the more particular context of 16th- and 17th-century painting, *disegno* (identified in the first instance with Florentine art and later, in its French translation, *dessein* or *dessin*, with the Franco-Roman painter *Poussin and his emulators, the *Poussinistes*) was opposed to *colorito* (identified first with the Venetian school, notably *Giorgione and *Titian, and later, as *coloris*, with the Italianate Flemish painter *Rubens and his followers the *Rubénistes*; *see also* Roger de Piles). *Disegno* involved using drawings as the basic building blocks of a finished composition; *colorito*, by contrast, implied the direct application of colour, that is paint, to the canvas or panel. (*See also* colour.) The distinction has a philosophical dimension. An artist wedded to *disegno* (the archetypal example would be *Michelangelo), after long training in drawing from life and from artistic exemplars such as ancient sculpture, devises complex figure poses and combines them into a telling composition, not through direct observation of a model but through invention, the exercise of his imagination. *Disegno* is both

the ability to draw, which facilitates invention, and the capacity for designing the whole, which is identified with invention. It is the imaginative and intellectual end of this process which justifies both *academic practice and the academic hierarchy of the *genres. In the latter, *History painting – the genre most dependent on *disegno* – is elevated to pride of place. The revival of Platonism in the 15th century identified artistic inventions – the products of *disegno* – with Platonic Ideas, the perfect prototypes of earthly things, dwelling in the mind of God. In this view, the artist, through *disegno*, found direct access to the Divine Intellect, and his activity paralleled the creative aspect of divinity. An Aristotelian, however, would have stressed the artist's ability to generalize, to arrive at a composition through familiarity with, and a memory of, many individual examples. *Colorito*, on the other hand, entails encoding in paint the tonal and colour relationships of objects seen under particular light conditions. The composition of a picture thus cannot precede its 'adornment' with colour (as in *disegno*-led painting). It grows out of the adjustments made by the artist to the tonal and colour relationships on the canvas or panel. In theory, therefore, the *colorito* specialist remains dependent on the model throughout the process of creating a painting, constantly checking the painted relationships against those of the model. (It is this fact which accounts for 17th-century writers labelling as a champion of *colorito* an artist such as *Caravaggio, who used an extremely limited and sombre range of colours. The term, coined for the more genuinely colourful Venetian school, had become synonymous with painting *alla prima*, without preliminary drawings, and with *naturalism, which depends closely on the model.) In practice, *colorito* specialists too must have relied on their memory of visual effects; this almost certainly accounts for the anatomical inaccuracies of many figures painted by *Titian, and the relative simplicity of his compositions. In general, the subtle or brilliant effects of *colorito*, such as the depiction of light at different times of day or under different atmospheric conditions, of reflections, of textures, of mood – these effects are produced to the detriment of those complexities of structure which are the province of *disegno*. On a Platonic scale of values, *colorito* depicts transient, accidental aspects of things: the momentary effects of light, shade, colour, lustre, with their immediate appeal to the senses. *Disegno*, on the other hand, reveals the permanent, invariable qualities of matter: volume, form and hidden order. The latter are, in this view, of greater appeal to the intellect, and thus 'higher'. Certain 20th-century artists and artistic movements have revived these old quarrels under new rubrics (*see* e.g. Mondrian).

The concept of *disegno* as the origin and foundation of the visual arts can be traced back to 1354–60. In these years the Florentine humanist and poet Petrarch wrote the dialogue *Remedies Against Fortune*, in which he states that *graphis* (Latin for *disegno* or drawing) is the one common source of sculpture and painting. The idea is elaborated by many later writers on art, of whom probably the most important are *Alberti, *Ghiberti, *Vasari and Federico *Zuccaro.

'disguised symbolism' *See under* Campin, Robert.

Dismoor, Jessica (1885–1939) British painter, trained in Paris. She became a member of the London *Vorticists, joining the Rebel Art Circle and signing the manifesto in *BLAST No. 1* in 1914. She exhibited with the Vorticists in London in 1915 and in New York in 1917, and with Group X in 1920. Subsequently she became a member of the London Group (*see* Frank *Dobson), standing out there as a painter committed to total *abstraction.

Di Suvero, Mark (1933–) American sculptor of Italian origin. He studied art at the University of California and moved to New York. He became known in the late 1950s for large-scale *assembled sculptures of weathered timber, dramatic pieces, vigorous gestures that were associated with *Abstract Expressionism. An accident in 1960 led him to make smaller sculptures of steel and wood, including

table-top pieces. His large works were now made of new timber and were sparser, without losing any of their drama. The Storm King Art Center, Mountainville, New York, displays a number of his outdoor pieces.

Divisionism A method of painting in which tone is indicated through hues, which are juxtaposed unmixed. The intention is that the separate touches of colour will combine in the observer's eye and appear more lively than mixed colours. Some painters of the 18th and 19th centuries enlivened their pictures thus, notably *Constable and *Delacroix, and *Impressionism's unmixed colour marks side by side were the immediate precursor of divisionism. But the *Neo-Impressionists turned that empirical manner into a quasi-scientific process, *Seurat particularly analysing observed colours into distinct hues present in specific ratios and using *pointillism to set down each hue in the quantities required for a specific optical colour effect. His neat dots of colour also give his paintings unity of surface. *Signac and others came to abandon Seurat's scientific divisionism and to use dashes and enlarged colour patches rather than dots for their lively and expressive character. Many early 20th-century painters employed a form of divisionism, for its novel texture and/or for its ability to make forms transparent and serve the *Cubists' search for insubstantiality and the *Futurists' for movement.

Dix, Otto (1891–1969) German painter associated with the satirical wing of Germany's New *Realism in the 1920s. Of working-class origin and a trained house painter, Dix won a scholarship to the Dresden School of Art. He served as a soldier in the First World War and afterwards pictured the suffering he had witnessed. He experimented with *Cubism and *Expressionism but, needing more powerful means of expression, turned to the forms and techniques of the early *Renaissance in German art. His portrayal of modern evils in an Old Master idiom brought success and, in the 1930s, defamation and imprisonment by the Nazis. In

1945 he was again sent to war and was a prisoner of war in France. In 1925 he had contributed to the *Neue Sachlichkeit exhibition; 1927–33 he was professor of painting in Dresden; after 1946 he held professorships at Dresden and Düsseldorf and received many honours.

Dobell, William (1899–1970) Australian painter who attended evening classes in art while working as architectural assistant. A scholarship brought him to London where he won painting and drawing prizes in 1930. Then he had a year in Holland, studying *Rembrandt and Van *Gogh. In 1939 he returned to Australia where he became known through a law suit, after being awarded a prize for portraiture in 1944: it was claimed that the work was a caricature, not a portrait, but the decision was favourable. His work indeed added elements of mannerism to his underlying *realism. In 1949 and 1950 he visited New Guinea and devoted the next years to celebrating the people he saw there. He received many prizes and exhibited frequently, becoming well known also in Europe. In 1966 he received a British knighthood.

Dobson, Frank (1886–1963) British sculptor, trained in drawing and painting in Arbroath (Scotland) and London, and impressed by the *Post-Impressionism he saw in *Fry's exhibitions. After serving in the First World War he gave priority to sculpture and was one of the first in Britain to prefer direct carving to modelling maquettes and then making, or getting made, carved versions of these. He exhibited with Group X in 1920, joined the London Group in 1922 and was its president 1923–27. Like *Despiau and other sculptors of his generation, Dobson sought a *classicism simplified to bring out the character of his material and a fluidity of form that has a marked period character. The female nude was his preferred subject, but he also produced fine portraits, among them the polished brass head of Osbert Sitwell (1923; London, Tate). In the 1920s and 30s he was one of Britain's most prominent sculptors but then taste turned against his kind of art and the memorial exhibition

presented at the Tate Gallery in 1966 was not a success. He is now studied as one of the pioneers of modern sculpture in Britain.

Dobson, William (1610/11–46) English painter, pupil of Francis *Cleyn, from whom he acquired a knowledge of Italian High *Renaissance, and especially Venetian, traditions of portraiture. Nothing is known of his work before 1642, when he painted the royal entourage at Oxford. Dobson is the great portraitist of the royal cause in the Civil War (although never of the King); ironically his style owes nothing to that of *Van Dyck (d.1641), the foremost interpreter of the ideals of absolutist monarchy. Dobson is a master of the half-length or three-quarter-length portrait, and excels particularly in his few group arrangements (e.g. *Prince Rupert, Colonel William Murray and Colonel John Russell*, pc; *Sir Charles Cotterell and Nicholas Lanier*, Alnwick Castle). His handling of paint is more vigorous and impasted than Van Dyck's, and his interpretation of his sitters' personalities more robust and direct. Unlike Van Dyck's, his portraits incorporate learned symbolic allusions to the qualities and interests of his sitters (e.g. *Endymion Porter*, London, Tate).

Dobson is the only purely British painter before *Hogarth of a comparable artistic and intellectual stature to his Continental contemporaries, if we except *Hilliard, who worked in the totally different idiom of miniature painting.

Documenta Name of an exhibition series held at Kassel in West Germany at roughly four-year intervals since 1955 and dedicated to international contemporary art, displayed in substantial quantity indoors and out and recorded in massive catalogues.

Doesburg, Theo van (1883–1931) Dutch painter, architect, poet, publisher and polemicist, born Christian Kupper, who adopted the name of his stepfather when his mother remarried after the early departure of his father. Later he used pseudonyms (Aldo Camini and I.K. Bonset) to

free him to publish avant-garde verse and engage in *Dada activities. As Van Doesburg he led the De *Stijl movement. He was self-taught. In 1908 he exhibited in The Hague and by 1912 was writing about Asiatic and contemporary western art. He studied *Kandinsky's 1912 treatise and worked with the architect J.J.P. Oud on the design of a villa. In 1917 he founded the *De Stijl* journal and group.

In 1918 he was active in Paris and intermittently in Germany where he influenced the young *Bauhaus and formed allegiances with *abstract and *Constructive artists as well as with *Schwitters with whom he made a *Dada tour of Holland in 1922. He polemicized tirelessly: e.g., the journal *Mécano* (four issues, 1922–23; edited by 'I.K. Bonset') with contributions from *Arp, Tzara and *Hausmann, and his prominence in the 1922 Congress of International Progressive Artists in Düsseldorf where he, *Lissitzky and *Richter promoted a *Constructive movement. Meanwhile he painted and also, with the architect Van Eesteren, developed ideas on architecture. An exhibition he put on in Paris in 1923 juxtaposed De Stijl art with architectural designs and models. In 1924 he began to set his compositions at 45° to the vertical and horizontal axes, in search, he said, of livelier dynamics. As this indicates, he was as much concerned with visual impact as with principles. The new style served as a vivid mode of interior decoration, best seen in his work in the bar/café/cinema L'Aubette in Strasbourg (1926–8, with Arp and *Taeuber-Arp). In 1930 he published yet another journal, *L'Art concret* (one issue only). His most important text was reissued by the Bauhaus in 1925 as *Grundbegriffe der neuen gestaltenden Kunst* (translated as 'Principles of Neo-Plastic Art', using Mondrian's term *Neo-Plasticism).

Dolce, Lodovico (1508–68) Venetian writer, a friend of *Titian and of his literary apologist, Pietro Aretino (1492–1556). In 1557 he published a treatise on painting in dialogue form, *Dialogo della pittura intitolato l'Aretino*, in which Aretino – whose views it certainly reflected – is the chief interlocutor. The theme of the dialogue is that *Michelangelo (with whom

Aretino had fallen out) is not as great a master as is generally supposed; his *Last Judgment* in the Sistine chapel lacks *decorum, and he concentrates solely on the human nude, introducing irrelevant *Mannerist devices in order to demonstrate his skill. *Raphael, master of all the branches of painting, is a greater, because more balanced and graceful, artist, and Titian the greatest painter of the age because of his command of colour. Dolce's dialogue develops arguments put forward in an earlier Venetian work, Paolo Pino's *Dialogo di Pittura* published in 1548; both draw extensively on *Alberti's *Della Pittura*. Dolce's *Aretino* became influential in the *disegno/colorito* debates which re-surfaced in 17th-century France (*see also* de *Piles, *Dufresnoy).

Dolci, Carlo or **Carlino** (1616–86) Morbidly religious Florentine painter; a child prodigy whose superb, if painfully slow, technique evolved, from its initial fresh and charming naturalism (*see under* realism) (1640s), into an enamelled 'hyper-realism' (1670s). This later manner, if distasteful to most 20th-century viewers, was well-suited to the pietistic *cabinet pictures of Christ or ecstatic saints to which Dolci increasingly devoted himself and which were popular at the bigoted court of Cosimo III de'*Medici and his mother Vittoria della Rovere, as well as with English collectors. Through such single bust-length figures he exercised what has been called a 'baneful influence' on later artists such as *Greuze. Yet he remained, as he had begun at the age of 15, a superb portraitist, even on the scale of life (Florence, Pitti; Cambridge, Fitzwilliam) and in this capacity was sent, instead of the aged portrait specialist *Sustermans, to Innsbruck in 1675 to paint Claudia Felice de'Medici. His slowness of execution, mocked by Luca *Giordano upon his arrival in Florence in 1682, prevented Dolci from personally completing his many commissions, and he was assisted by his daughter **Agnese** (*d.*1689) and pupil **Onorio Marinari** (1627–1715). Dolci executed a number of large altarpieces (e.g. Florence, Pitti) and not all of his collectors' paintings are small (London, National; Munich, Alte Pinakothek; etc.).

Domela Nieuwenhuis, César (1900–) Dutch painter, born in Amsterdam. Self-taught, he began to paint in 1919. He was a member of the *Novembergruppe in Berlin, then moved to Paris where he joined the *De Stijl group. From 1927 to 1933 he worked in Berlin on pictorial low-relief constructions. In Paris from 1933 on, he was a member of *Cercle et Carré and *Abstraction-Création and a champion of *abstract *Constructive art. After his first one-man exhibition in 1924 in The Hague, his work was seen in many mixed and solo exhibitions. In 1954 he visited Brazil and had a marked impact on South American art.

Dominguez, Oscar (1906–58) Spanish painter, born in Tenerife (Canaries) where he began his career as a *Surrealist. In 1934 he moved to Paris into the Surrealist circle. He invented 'decalcomania' as a technique for producing chance forms by pressing wet paint between sheets of paper. *Breton welcomed it as an automatist method; *Ernst adopted it for some of his work. Dominguez also created memorable Surrealist objects, such as the gramophone with a woman's breast on the turntable and legs coming from its horn, shown in the 1938 International Surrealist Exhibition in Paris.

Domenichino; Domenico Zampieri called (1581–1641) One of the Bolognese pupils of the *Carracci, Domenichino became, after Annibale Carracci's death in 1609, a leading painter in Rome. His frescos of the *Scourging of St Andrew* (S. Gregorio al Celio, Oratory of St Andrew, 1608) and the *Scenes from the Life of St Cecilia* (S. Luigi de'Francesi, 1613–14) are foremost examples of the style known as Early *Baroque *Classicism which was influenced by *Raphael and the Antique. *Poussin was to be deeply impressed with these works in the 1620s, and he was also influenced by Domenichino's small landscape paintings, as was *Claude.

During 1622–8 Domenichino painted the choir and pendentives of S. Andrea della Valle, while his arch-rival, *Lanfranco, received the commission for the dome. Responding to the demands of scale and

location as much as to Lanfranco's *illusionism (derived from *Correggio's Parma domes) Domenichino here modified his former manner. The new tendency to *Baroque was further accentuated in the pendentives and dome of the Chapel of S. Gennaro of the Cathedral in Naples, for which he was commissioned in 1630. The jealous intrigues of Neapolitan painters drove him from the city back to Rome in 1634; his wife having had to remain in Naples, however, he was forced to return in 1635. In Naples, in addition to the S. Gennaro frescos, Domenichino also executed altarpieces (Naples, Cathedral; New York, Metropolitan) and the *Exequies of a Roman Emperor*, one of a series of paintings illustrating scenes from Roman antiquity, commissioned from several artists for the Palace of Buen Retiro (Madrid, Prado). A few smaller easel paintings are also known (Madrid, Academia).

Domenico del Barbiere *See* Florentin, Dominique.

Domenico di Bartolo (*c.*1400–47) Sienese painter, perhaps a pupil of Filippo *Lippi, through whom he would have come into contact with Florentine *Renaissance developments in the representation of space and volume. He was, with *Vecchietta, the most modern artist in Siena in the mid-15th century; together they painted the secular *frescos in the Pellegrinaio of the Hospital of S. Maria della Scala. The most important surviving independent work by Domenico is the *S. Giuliana *Polyptych*, now in Perugia, Galleria Nazionale; architectural details of the *predella were inspired by *Donatello's reliefs for the font of Siena Baptistery.

Domenico Veneziano (*c.*1410–61) Venetian-born Florentine painter, celebrated in his day. With the loss of most of his influential *fresco decorations in Florence and Perugia, however (*see below*), he is now known mainly for his *St Lucy* altarpiece, a *sacra conversazione* executed 1445–7 for Florence, S. Lucia de'Magnoli (now Florence, Uffizi). He has accurately been described as combining a Florentine grasp of *disegno* with a Netherlandish

feeling for light (*see*, e.g. Jan van Eyck, Rogier van der Weyden) and a north Italian sensitivity to naturalism (*see under* realism) and ornament (*see also under* International *Gothic). The master of *Piero della Francesca in 1439 and associated with him again in 1447, he is thought to have been the determining influence on Piero's light and luminous palette (*see under* colour) and his *perspectival researches. He himself probably trained under *Gentile da Fabriano in Florence and Rome 1422–7, remaining with Gentile's heir *Pisanello at St John Lateran, Rome, until *c.*1432. His earliest independent Florentine works, the so-called *Carnesecchi Tabernacle*, an outdoor fresco of which fragments now survive in London, National, and a *Madonna and Child* now in Settignano, Villa I Tatti, were painted *c.*1432–7. In the latter year he went to Perugia to paint extensive fresco decorations for the Baglioni palace (razed 1540). Between 1439 and 45 he was active mainly on frescos for S. Egidio, the chapel of the hospital of S. Maria Nuova, Florence, now destroyed (*see also* Andrea del Castagno, Alesso Baldovinetti). After the completion of the *St Lucy* altar, in 1447, he and Piero della Francesca began to paint frescos in the sacristy of S. Maria at Loreto, but soon left for fear of the plague. Two luxurious *cassoni* executed for a Florentine patron in 1447–8 are also lost. From *c.*1450–3 he was working on frescos for the Cavalcanti Chapel in Florence, S. Croce (fragments now S. Croce, Museo; detached and transferred to a portable support during *Vasari's remodelling of this church in 1560, among the earliest frescos to be so treated). Few other works are recorded in the last decade of his life, and he is documented as having died destitute. It is not, however, true as Vasari claims, that he was assassinated by Andrea del Castagno, whom he survived by several years.

Donatello (*c.*1386–1466) Florentine sculptor. His full name was Donato di Niccolò di Betto Bardi; Donatello is the nickname he used when signing his works. He was famous throughout Italy, in his native town where he received numerous illustrious public commissions from guilds and governing bodies, and, especially late in

life, private commissions from Cosimo de'*Medici. His reputation as the greatest sculptor of the Early *Renaissance has never been challenged; *Vasari calls him 'superior not only to his contemporaries but even to the artists of our own times'. No later Florentine artist, including especially *Michelangelo, escaped his influence. Probably trained as a goldsmith, he was uniquely versatile working not only in bronze, often with silvered and gilt surfaces (beginning as an assistant in *Ghiberti's first Florence baptistry doors workshop), but also in stone (starting on *Nanni di Banco's Porta della Mandorla for Florence cathedral) and later also in wood, terracotta, stucco, perhaps even glass. His versatility in media was matched by his versatility of *genres. He became an innovator in relief sculpture, carved or cast, for domestic devotional purposes as well as for public emplacements on altars, pulpits, baptismal fonts, organ lofts, in architectural ornament, on doors and tomb slabs; of the seated and standing niche statue; of the free-standing statue; of the antique-emulating nude; of multiple-figure sculptural groups; of the equestrian monument; perhaps also of the portrait bust and the bronze statuette. He was prominent in the revival of antique figurative and decorative motifs. He pioneered both single-vanishing point *perspective and *schiacciato, or shallow, carving in the relief originally beneath the statue of St George on the guild church of Or San Michele (c.1417, now Florence, Bargello). Sculptural *illusionism, in the sense of allowing for the actual viewpoint of the spectator, had engaged him as early as 1408–15 in the seated St John the Evangelist for the façade of Florence cathedral (now Florence, Museo dell'Opera del Duomo). Looking back to the *Gothic masters Nicola and Giovanni *Pisano, he outdid them in dramatic *expressivity. His unprecedented emotional range varied from the contemplative dignity of St Mark for Or San Michele, c.1411–c.15, through the virile alertness of St George, to the grave tenderness of the Pazzi Madonna relief (1420s–30s, now Berlin, Staatliche), the prophet's despair of the Zuccone from the bell tower of Florence cathedral

(c.1427–36, now Florence, Opera del Duomo), the bacchic abandon of the *putti on the organ gallery from the cathedral (1433–9, now Florence, Opera del Duomo) and the playfulness of the so-called Atys-Amorino (1430s–50s, Florence, Bargello), the penitential fervour of the wooden Magdalen (1430s–50s, Florence, Opera del Duomo), the sensuous self-absorption of the bronze David (c.1446–c.60, Bargello), to the fierce severity of the equestrian Gattamelata (c.1445–53, Padua, Piazza Sant'Antonio), the traumatized solemnity of Judith poised between the two blows which decapitate Holofernes (c.1446–c.60, now Florence, Palazzo Vecchio), the tragic hysteria of the mourners in the Lamentation relief from the pulpits in S. Lorenzo, 1460s – one of the several pulpit reliefs which, completed after Donatello's death, offer a compendium of extreme emotional states depicted with the greatest penetration and realism, even when dependent on antique prototypes. Donatello's expressivity is intimately linked with his unrivalled story-telling powers, naturally most evident in his narrative reliefs (e.g. Herod's Feast, 1423–7, Siena Baptistry, font; Altar, Padua, Sant'Antonio). But even single statues, Madonna and Child reliefs, accessory or decorative figures – such as the putti on the pediment of the Cavalcanti Annunciation, who have no head for heights (1430s, Florence, S. Croce), or the paired saints on the bronze doors of the Old Sacristy, S. Lorenzo (after 1428–c.40), who debate with varying degrees of acrimony – seem to be enacting complex and absorbing tales. The sense of an autonomous capacity for thought and action in his sculpted figures, of statues projecting a force-field of psychic energy which goes out to the viewer, rather than waiting passively to be looked at, differentiates Donatello from earlier, and most later, sculptors and gives his work its endless fascination. His technical innovations serve these dramatic ends: not only the schiacciato carving, perspective and illusionism already mentioned, but also his re-invention of *contrapposto, which frees the standing figure from static frontality.

Donatello is so quintessentially a Florentine artist that it is easy to forget how

peripatetic he was. His main periods of residence outside Florence were: 1444–53, Padua (Altar for Sant'Antonio; *Gattamelata*) *see also* Bellano Bartolommeo; 1457–9, Siena. He and his long-time partner, the architect and sculptor *Michelozzo, had a studio in Pisa, 1426–9, where they executed the tomb of Cardinal Brancaccio for shipment to Naples (Sant'Angelo a Nilo). He visited Rome with *Brunelleschi to study antique ruins (possibly *c.*1402–4, more probably 1413–15) and worked there from before 1432–3 (Tomb of Giovanni Crivelli, S. Maria in Aracoeli; Tabernacle, sacristy of St Peter's). He travelled throughout Tuscany, and was in Mantua in 1450, in Modena in 1451 in connection with uncompleted projects. Other commissions came from cities even further afield and which he did not visit. In addition to works in Florence, and the other works already cited, there are sculptures by Donatello in Venice, S. Maria dei Frari; Lille, Musée; London V&A; Pisa, Museo; Prato, Opera del Duomo; attributed works are to be found in a few other museums, notably Paris, Louvre.

Dongen, Kees van (1877–1968) Dutch painter, trained in the applied arts, who settled in Paris about 1895 and developed under the influence of *Toulouse-Lautrec and Steinlen. His first paintings were clumsy but his style lightened and in 1905 he became known as one of the *Fauves. In 1908 he accepted membership of Die *Brücke. As his work became more sophisticated his subjects became principally women – dancers, nudes and portraits. He had fashionable success but his paintings have the virtues of strong compositions and firm colour.

Donner, Georg Raphael (1693–1741) Innovative and influential Austrian sculptor. Apprenticed first to a goldsmith, later to the Venetian Giovanni Giuliani (1663–1744) during the latter's employment at Heiligenkreuz, Donner avoided the typical Austrian media of wood or stucco and worked exclusively in stone or metal. His preferred medium was lead, in which he executed both reliefs and free-standing figures. His graceful *classicizing

Italianate style marked a turning-point in Viennese art from the hitherto predominant Late *Baroque or *Rococo. He worked at Salzburg, Schloss Mirabell, 1726–7; Linz, parish church, 1727; Bratislava, cathedral, *c.*1729–35; Gurk, cathedral,1741. His greatest project was the Mehlmarkt fountain for Vienna, 1737–9 (original lead figures now Vienna, Österreichisches Barock, replaced by bronze copies, 1873). Despite his tendency to planar compositions, he employed, for this monument in the round, the spiralling figure patterns of Giovanni *Bologna.

His brother **Matthäus Donner** (1704–56) continued to transmit the elements of his art to younger Viennese artists at the *Academy school which he ran.

donor portraits A donor is someone who commissions a work of art and donates it to a church or religious foundation. Such works often include portraits of the donor or donors venerating the holy personages depicted. By extension, portraits of actual people shown in devout poses in religious images – whether donated or made for private uses – are called 'donor portraits'.

Doré, Gustave (1832–83) French artist, active as cartoonist, painter and sculptor but remembered chiefly for his book illustrations and other graphics, using classic texts such as those of Rabelais and Dante, and contemporary texts such as Balzac's, but in 1872 also at the service of humanity as the recorder of the London slums. The engraving of these images is often coarse but his rich and dramatic detail, enhanced by strong *chiaroscuro, make them impressive as well as, at times, nightmarish. Van *Gogh used some of his images for his paintings and he influenced some of the *Symbolists in their more awesome imagery.

Dorigny, Louis (1654–1742) *Classicizing French painter influenced by *Lebrun. He worked mainly in Venice and the Venetian mainland, painting *fresco decorations in churches, palaces and villas – including some for the great architect Palladio's Villa Rotonda outside Vicenza

(other works Venice, Scalzi; Gesuiti; Palazzo Zenobio; Marzana near Verona, Villa Arvedi; Padua, Palazzo Cavalli). He in turn influenced the decoration by *Bortoloni of Palladio's Villa Cornaro.

Dossal or **retable** A panel set above and behind the altar table, evolved by the late 13th century from the *antependium.

Dosso or **Dosso Dossi; Giovanni Luteri** called (*c.*1489–1542) Ferrarese court artist, influenced by *Giorgione and the young *Titian; a probable trip to Rome before 1541 has been deduced from the reminiscences of *Raphael, and to some extent *Michelangelo, present in his work from that date. He is first recorded working for Federico Gonzaga at Mantua in 1512, but from 1514 was in the service of the d'Este at Ferrara, for whom he executed religious paintings, portraits, but above all allegorical and mythological subjects and others derived from contemporary poets, especially Ariosto. It is not always easy to distinguish between these latter types, especially in his many single-figure compositions (e.g. *Melissa* or *Circe*, Rome, Borghese). Landscape settings play an important part in virtually all his works, painted with great freedom both of the brush and of colour, in rich and unexpected textures and tonalities which produce a poetic, even romantic, effect (e.g. *Adoration of the Kings*, London, National). The *Bacchanal* probably from the Camerino of Alfonso d'Este (now London, National) demonstrates his shortcomings in figure painting, but these are more easily overlooked in his small-scale *cabinet pictures or his more purely decorative work (*c.*1530, Pesaro, Villa Imperiale, Sala delle Cariatidi; 1531–2, Trento, Castel Buonconsiglio; *see also* Romanino). He was assisted by his younger brother, **Battista Dosso** (recorded 1517–48).

Dou, Gerrit (1613–75) Leiden painter, the son of a glass-maker and engraver. He was *Rembrandt's first pupil (1628–31). After Rembrandt's departure for Amsterdam, he remained in Leiden, initiating the school of Fijnschilders ('fine, or miniature, painters'), which continued

into the 19th century, specializing in minutely finished small pictures crammed with *genre and *still-life accessories. He adopted many of the subjects and compositions of Rembrandt's early period (e.g. *Portrait of Rembrandt's Mother*, Amsterdam, Rijksmuseum) reducing Rembrandt's expressive *chiaroscuro to a decorative device, as in the nocturnal scenes which he popularized. Many of his pictures should be read as emblematic metaphors of the human condition (e.g. *The Quack*, 1652, Rotterdam, Boijmans-van Beuningen).

Dove, Arthur (1880–1946) American painter, trained at Hobart College and Cornell University, graduating in 1903. Commercial work brought income without satisfaction, and in 1907 he went to Paris. The paintings he did on his return in 1909 suggest *Fauvism and the work of *Kandinsky. He titled a series of experimental studies *Abstractions*. Simplification and poetic paraphrase were his aims, and he spent his life in solitude close to nature. In 1910 he exhibited at *Stieglitz's 291 Gallery. His first one-man show there, in 1912, consisted of pastels, *The Ten Commandments*, abstracted from nature. A new phase began in 1924: *collages made from non-art materials in bold compositions indebted to Kandinsky and *Klee, and to ideas derived from science, occult thought and Theosophy. He sensed powers of intuition enabling him to see through nature to the cosmos. Some of his paintings show an energy and a willingness to speak through a few strong gestures that reverberate in American painting of the years after his death. He exhibited regularly but his refusal to espouse a movement or offer a dogma of his own made all-out success impossible. His fame is largely posthumous, stimulated by a New York retrospective in 1947.

Downman, John (*c.*1750–1824) English portraitist; he also executed small historical narrative paintings in oils. He studied with *West and visited Rome in 1774/5; after a stay in Cambridge – where he painted small half-length portraits in oils on copper – and travels round the country, he settled in London. Here he perfected a

method of taking elegant likeness in coloured chalks and reproducing them in lightly tinted watercolours, excelling especially with children and young people of fashion (London, Wallace).

drawing See under disegno.

Dreer Family of German artists, of whom the best-known is **Gabriel Dreer** (recorded 1622–after 1636), painter of altarpieces (Castle chapel of the Teutonic Knights, Kronburg) and probably designer of ecclesiastical sculpture. From 1631 he was active in the cloister church of Admont in Austria. His son **Johannes** is recorded in 1623. The painters **Hans Dreer** (recorded 1561) and **Martin Dreer** (recorded 1604) presumably belonged to the same family.

drôlerie, drollery From the French for comical picture. Most often used for the humorous or *grotesque imagery in the margins of illuminated manuscripts.

Drost, Willem See under Loth, Johann Carl.

Drouais, François-Hubert (1727–75) Successful French court portraitist, son of the painter **Hubert Drouais** (1699–1767). He studied also with Carle van *Loo and *Boucher, evolving a hard, porcelain-like style, recording faithfully details of his sitters' costume and surroundings (e.g. *Mme de Pompadour*, 1764, London, National). He inherited *Nattier's aristocratic clientele, becoming especially fashionable for his portraits of noble children dressed as gardeners or Savoyard beggars to emphasize their 'natural' or 'filial' characters (e.g. Paris, Louvre; New York, Frick). His son, **Jean-Germain Drouais** (1763–1788), became a pupil of *David and in 1784 went with him to Rome, where he died of smallpox. A brilliant artist, who copied a *Caravaggio painting as early as 1785, he became a history painter (*see under* genres) of great power; his death removed from David his greatest potential rival (Paris, St Roch, Louvre).

drypoint See under intaglio prints.

Drysdale, Russell (1912–81) Australian painter, born in England but living in Melbourne from 1923. Eye troubles, culminating in the loss of his left eye in 1935, brought out the artist in him. Periods in Europe and study in Melbourne developed his art in the direction of late *Fauvism. By 1940 he was a full-time painter, living in Sydney and picturing Australian rural subjects. In the 1950s he developed a special affection for the aborigines, finding in them a humanity lacking in city folk. Observation was inflected by a mannerism which at times gave his work *Surrealist qualities. His work was widely known in Australia in the 1940s; an exhibition in London in 1950 added to his standing and drew attention to contemporary Australian art. In 1954 he represented Australia at the Venice Biennale. A major retrospective was shown in Sydney in 1960.

Dubbels, Hendrick Jacobsz (1621–1707) Dutch marine painter, born in Amsterdam where he worked all his life; one of his pupils was Ludolf *Bakhuizen. His earliest known picture is a moonlit seascape of 1645; in addition to seascapes, he painted views on inland waters and beach scenes, and a few winter landscapes in the style of Jan van de *Cappelle.

Dubois, Ambroise (1542/3–1614) French *Mannerist painter of the so-called second school of Fontainebleau, in the service of Henry IV as the artists of the first school of Fontainebleau, *Rosso, *Primaticcio, Nicolò dell'*Abate, had been of Francis I and Henry II (*see also* Toussaint Dubreuil, Martin Fréminet). Born in Antwerp, Dubois came to France as a youth; his style is a mixture of Flemish and Italian styles largely derived from engravings (*see* intaglio). His most important work, the Gallery of Diana at Fontainebleau, was demolished in the 19th century (fragments, Fontainebleau, Galerie des Assiettes) but paintings survive from other cycles he executed in the palace (Fontainebleau, Salle Ovale; Paris, Louvre).

Dubreuil, Toussaint (1561–1602) French *Mannerist painter of the so-called

second school of Fontainebleau, in the service of Henry IV as the artists of the first school of Fontainebleau, *Rosso, *Primaticcio, Nicolò dell'*Abate, had been of Francis I and Henry II (*see also* Ambroise Dubois, Martin Fréminet). Although Dubreuil's decorations at Fontainebleau have disappeared, and his paintings in the Petite Galerie of the Louvre were destroyed by fire in 1661, many are known through copies, drawings and tapestries after his designs (painting, *A Sacrifice*, Paris, Louvre). Dubreuil's style is generally based on that of Primaticcio, but he is more restrained, and forms an important link between Fontainebleau Mannerism and the later *classicism of *Poussin.

Dubuffet, Jean (1901–1985) French artist, son of a wine merchant of Le Havre where he attended art school. In 1918 he went to Paris but stopped painting in 1924 and took charge of the family business, making art only occasionally. In 1942 he decided to give art priority, though it seemed too late for an artist's career: he would work just for himself. He exhibited his new work in Paris in 1944 and 1946, and in New York in 1947, and found himself an admired newcomer. He sold his business, painted full-time and made growing use of inartistic materials such as asphalt, broken bottles and graffiti. He collected the art of children and mental defectives and called it *Art brut. His *Corps de Dames* series of 1950–1 echoes graffiti; other figure subjects followed, also land- and townscapes. The crudeness of his work was much remarked on; more important is its delicacy and his Rabelaisian humour. Major retrospectives were shown in Paris and New York in 1960–62, and in London, Amsterdam and New York in 1966. At this time he began to work with painted polystyrene, making reliefs and free-standing objects. Commissions came for large sculpture, for stage sets and for paintings, and his work was shown around the globe (e.g. large exhibitions in Le Havre, Toronto and Tokyo 1977–8). He wrote books about Art brut and about his own work. His work says that the world is more handsome than we think and tells us to look without prejudice, like children.

Duca, Giacomo del (*c.*1520–after 1601) Sicilian sculptor and architect, an assistant to *Michelangelo in Rome. His most important independent work of sculpture is the tomb of Elena Savelli in St John Lateran, 1570, initiating a series of funerary monuments with the bust of the deceased in prayer, which became the most common type of Roman High *Baroque tomb (*see* *Bernini's *Gabriele Fonseca* of *c.*1668–75).

Duccio, Agostino di *See* Agostino di Duccio.

Duccio di Buoninsegna (first recorded 1278–*c.*1318) Sienese painter, who was one of the great innovators in Italian art, although his reputation has been overshadowed by that of his younger Florentine contemporary, *Giotto. There are two factors mainly responsible: the early development of art-historical writings in Florence, and the survival of great *fresco cycles by Giotto in their architectural settings. Duccio's masterpiece, on the other hand, the *Maestà* *polyptych for the high altar of Siena cathedral (1308–11), in tempera and gold leaf on panel, was dismembered in 1771. Although most of its fragments have been restored and assembled in the cathedral museum, others are scattered throughout galleries in America and Europe (New York, Frick; Washington, National; Fort Worth, Museum; Madrid, Thyssen; London, National). Some fragments are lost. The original effect of this most ambitious and complex of Italian altarpieces can now be reconstructed only through an effort of the imagination.

Contracts survive for three major commissions. Of these, the 1302 *Maestà* for a chapel in Siena Town Hall is lost. It was the second altarpiece known to have incorporated a *predella. The contract of 1285 with a confraternity of S. Maria Novella, Florence, is generally accepted as relating to the so-called *Rucellai Madonna* (Florence, Uffizi). This is the largest panel with a unified pictorial field to have survived from the 13th and 14th centuries. The painting combines a monumental scale with jewel-like precision and delicacy, and grandeur with emotional intimacy. Duccio

had forged a new idiom merging traditional *Byzantine schemata with a new naturalism (*see under* realism), colour with linear pattern, and surface decoration with description of form and volume.

But the achievements of the *Rucellai Madonna* are surpassed in the great Siena *Maestà* (contract of 1308). The Virgin enthroned among angels, saints and apostles figures on the main panel on the front, originally facing the lay congregation in the nave. The front predella comprised narrative scenes of the Infancy of Christ, and the front pinnacles, scenes of the Last Days of the Virgin. On the back, originally visible only to the clergy in the choir, the predella illustrated Christ's Ministry; the main panel, the fullest depiction of Christ's Passion in Italian art; the pinnacles, his miraculous Apparitions. With its 58 narrative scenes and 30 single figures in addition to the main front scene, the *Maestà* rivals any mural cycle or sculptural programme in formal and *iconographic inventiveness. It may be thought to surpass Giotto's Arena Chapel cycle not only in colouristic effects (as might be expected of a panel painting) but also in descriptive realism.

Duccio trained and influenced a notable school of Sienese painters, among them Simone *Martini and Ambrogio and Pietro *Lorenzetti, who continued and extended his researches into combining visual description with expressive subtlety and decorative splendour.

Duchamp, Marcel (1887–1968) French artist, the great challenger of conventional priorities. Grandson of a painter, he was the brother of the painters Suzanne Duchamp and *Villon and of the sculptor Raymond *Duchamp-Villon. Marcel began to paint in his teens and in 1904–5 worked at the Académie Julian in Paris. In 1906 he settled at Neuilly, close to Paris. His early work combines elements of *Cézanne and *Fauvism, but almost from the start he used symbols in his images and fragmentation to suggest the passing of time. In 1911 he made a painting for Raymond's kitchen, *Coffee Mill* (pc), describing its action as well as its form. When he sent *Nude descending a Staircase* (1912) for exhibition his *Cubist friends

asked him to reconsider it or change its title; he withdrew it. Shown in the *Armory Show in 1913, it attracted admiration and mockery. Meanwhile he studied the *Futurist exhibition in Paris and in discussions with *Apollinaire and *Picabia developed attitudes of a sort subsequently labelled *Dada.

In July and August 1912 he was in Munich, working on semi-*abstract images of metamorphosis, and collecting sketches and notes which would serve as source material for *The Large Glass*. In 1913 he mounted a bicycle wheel on a kitchen stool and called it a 'distraction' (lost); it was a forerunner of his 'readymades'. That winter he began to make full-scale drawings for *The Large Glass* and worked on *Three Standard Stoppages* (New York, MoMA), an assemblage of three-metre lengths of string glued to canvas on ruler-like strips of wood and fitted into a box; the lines of string are randomly unstraight, subverting the canonical metre defined by the French Assembly in 1799 and adopted as standard in 1889, 25 years earlier. In 1914 he issued the first 'readymade' when he bought a bottlerack and inscribed it as a work of his own, subverting notions of authenticity and invention (lost). When the war came, exempt from military service on reasons of health, Duchamp decided to go to America.

In June 1915 he disembarked in New York, a celebrity. Walter and Louise Arensberg were soon his friends and formed the largest collection of his work, now in the Philadelphia Museum of Art and including the works mentioned here without location. His friendship with Picabia deepened, he formed allegiances also with Americans such as Man *Ray, the poet William Carlos Williams and the composer Edgard Varèse, and became the centre of a Dada-minded group of New York artists. Talking and playing chess began to be dominant activities. In 1916 he joined with Arensberg and a group of artists to form the Society of Independent Artists and to plan its first exhibition under the motto 'No Jury, No Prizes, Hung in Alphabetical Order'. In 1917 he sent a urinal, signed 'R. Mutt', as *Fountain* to the first annual exhibition of this society and resigned when he found it excluded (lost).

In 1918 he completed a painting, suggestively entitled *Tu m'* (You . . . Me; New Haven, Yale University): his first painting for four years, it was also to be his last.

When the USA declared war he sailed for Buenos Aires. In June 1919 he returned to Paris, stayed with Picabia and associated with Tzara, Breton and other Dadaists. Among his works of this period is the 'rectified readymade' entitled *L.H.O.O.Q.* (in French this sounds like 'she has a hot arse'): a reproduction of the *Mona Lisa* to which he added a pencilled-in moustache, a goatee and his signature. In 1920 he returned to New York and worked with Ray on a kinetic optical construction and an experimental film. With Ray and Katherine Dreier he founded the Société Anonyme which organized shows and lectures and formed a large collection of modern art (given to Yale University AG in 1941). Before the end of 1920 Duchamp created an *alter ego* in Rrose Selavy (himself in drag) who appears in a Ray photograph and whose name (sounding like 'piss, that's life') appears henceforth as author(ess) of 'readymades' and as signatory of one of Picabia's paintings.

In January 1923 Duchamp signed *The Large Glass*; he had brought it to 'a state of incompletion'. Its proper name is *The Bride stripped bare by her Bachelors, even*; approved versions of it, by Ulf Linde and Richard *Hamilton, are in Stockholm, Moderna Museet, and London, Tate, respectively. It is a 'painting' of many materials including dust, lead foil, lead wire and drilled holes, on two panes of glass set between panes of glass – *abstract, *figurative and diagrammatic, and a compendium of his work to that date. Its meaning is still debated: alchemical symbolism, the Kabbala, chess and other games and systems are alluded to in it, and it may be that Suzanne's marriages in 1911 and 1919 were crucial to its production. In the upper half it represents the Bride, below the Bachelors, urgent but impotent and accompanied by devices that tell of their plight and curiosity. Shown at the Brooklyn Museum in 1926 and then stored, the work proved to have been smashed when it was unpacked years later. Duchamp said fate had completed it and carefully reassembled the pieces.

With that he appeared to say farewell to art. He divided his time between France and the USA, and between chess and a variety of collaborations on exhibitions, films, etc. His productions of those years include a book, with V. Halberstadt, on rare end-games in chess, and a set of photographs and notes and drawings in facsimile relating to *The Large Glass*, printed and boxed as a guide to the work (1934). In 1941 he published *Box in a Valise* as a portable Duchamp museum in the form of photographs, colour reproductions and models. Other things were done privately and without explanation, such as the relief torso and limbs of a naked woman in 1948–9, strangely distorted. It turned out to be a study for a complex work he developed in secret for 20 years, 1946–66: an *assemblage in which the female figure is observed spreadeagled, holding a little gas lamp before a landscape, clouds and a moving waterfall, through two peepholes in a pair of weather-beaten timber doors set into brickwork. Only the doors may be photographed; a personal pilgrimage is required if we wish to see more. Interpretations abound. *Given: 1. The Waterfall. 2. The Illuminating Gas* is Duchamp's second statement on the theme of longing, voyeurism and the inability to enjoy. The first was factual in its account of everything on the transparent panes, yet mysterious and obscure: here everything is quasi-*realistic and wholly illusionistic.

Probably the most radical artist of the century, Duchamp rescued art from providing visual satisfactions and returned it to older functions. Questioning ideals of creativity, he asserted parody and randomness in place of invention. Much else is signalled by his work, at the core of which may be the theme of unrequited incestuous love, associated with voyeurism, itself an allegory of art. His centrality has become apparent through major exhibitions in London (1966) and New York and Philadelphia (1973), both with important catalogues, and through many books and articles. A British film casts him as Sherlock Holmes investigating himself. The enquiry continues.

Duchamp-Villon, Raymond (1876–1918) French sculptor, brother of

*Villon and of *Duchamp. Trained first in medicine, he turned to sculpture in 1898. His early works exhibit bold simplifications that by 1912 ousted description to give priority to sculptural form. His best known work is *The Horse* (bronze; 1912–14), combining elements of *Cubism and *Futurism in a dynamic paraphrase of the energy of a horse and of mechanical power. His career was cut short by typhoid fever. A memorial exhibition was included in the 1919 Salon d'Automne.

Duck, Jacob (1600–60) Dutch painter, resident in Utrecht. He specialized in guardroom scenes (Utrecht, Museum). *See also* Willem Duyster, Pieter Codde.

Dufresnoy, Charles Alphonse (1611–68) French painter and writer on art. He spent the better part of his life, 1633 to 1656, in Italy, and combined a taste for Venetian painting with admiration for *Poussin, whose works he imitated in paintings (St Petersburg, Hermitage) and drawings (Chantilly, Musée). He is best remembered for his Latin poems in which he champions *classicism, but tentatively also sets out a defence of Venetian colourism (*see under* disegno) later taken up by De *Piles.

Dufy, Raoul (1877–1953) French painter and designer, born at Le Havre and trained in evening classes and then at the Ecole des Beaux-Arts in Paris alongside *Friesz, his friend already in Le Havre. He associated with the artists who in 1905 became the *Fauves. He had his first one-man show in 1906 and began to sell his sketchy, colourful paintings, but in 1908 he came under the influence of *Cézanne and moved close to early *Cubism in some his then relatively solemn paintings. Soon, helped by commissions from Paul Poiret for textile designs and decorative schemes, he regained the hedonistic centre of his art. From about 1920 his paintings are confections in which vivacious line vies with gay colour to please and entertain. In 1930 he won the Pittsburgh Carnegie Prize; in 1936 he had large exhibitions in New York and in London. In 1952 he won the international painting prize at the Venice Biennale.

He also worked brilliantly as a book illustrator and stage designer. His work, unconcerned with theoretical and existential questions such as cast gloom over much modern art, has lived on, thanks to countless exhibitions since his death.

Dughet, Gaspar (1615–75) He is also known as Gaspar Poussin, after his celebrated brother-in-law Nicolas *Poussin, in whose studio he trained 1630–5. From *c*.1647 he was acknowledged as the leading landscape specialist in Rome. While basing his finished paintings on intensive study from nature in the Roman Campagna, he combined in them the *picturesque style of Salvator *Rosa with the *classical ideal of landscape of Poussin and *Claude. Avidly collected by English travellers, his works influenced English 18th-century painters such as Richard *Wilson and were taken up by supporters of the Picturesque Movement as models for actual landscape gardens and parks; his style continued to be imitated by painters in Rome until well after 1700. There are many easel paintings by him in English collections, including the National, London; he also painted landscapes in *fresco (Rome, S. Martino ai Monti, Colonna, Palazzo Costaguti, Doria).

Dujardin, Karel (*c*.1622–78) Versatile Dutch painter and etcher, born in Amsterdam, where he studied with Nicolas *Berchem before leaving for Rome sometime in the 1640s. By 1650 he was again in Amsterdam, preparing to visit France; he returned to Holland in 1652–75. He died in Venice after a trip to Tangiers. Best known for his small bucolic Italianate landscapes (e.g. Cambridge, Fitzwilliam; The Hague, Mauritshuis; Paris, Coll. F. Lugt), in the years 1654–6 Dujardin also painted Dutch landscapes with animals in the manner of Paulus *Potter (Amsterdam, Rijksmuseum; London, National). In the 1660s he became fashionable with the ruling classes of Amsterdam, executing portraits in the elegant style of van der *Helst (Amsterdam, Rijksmuseum) and highly finished religious and mythological pictures (London, National; Mainz, Museum; Potsdam, Sanssouci; Sarasota, Museum).

Dumonstier or **Dumoustier** Dynasty
of French painters and draughtsmen,
now best remembered for continuing
the *Clouet tradition of chalkdrawn por-
traits. **Geoffroy Dumoustier** (recorded
1535–73), son of the illuminator Jean
Dumoustier of Rouen, became court
painter to Francis I and Henri II of France;
he worked with *Rosso at Fontainebleau
from 1537 to 1540, and was much influ-
enced by him in his designs for stained-
glass windows and engravings; he was also
an etcher (*see under* intaglio). His sons
Etienne (1540–1603) – court painter to
Henri II, Francis II, Henri III and Henri IV
– and **Pierre the Elder** (*c.*1545–1610) were
among the most distinguished followers of
Clouet; their brother **Cosme** (*c.*1550–1605)
is less well-known. Geoffroy's nephew
Daniel (1574–1646) carried on the Clouet
style of drawn portraits into the 17th
century enjoying success at court.

Dunoyer de Segonzac, André (1884–
1974) French painter whose early
paintings were *realist in the manner of
*Courbet and *Daumier. His colours
and touch then lightened under the influ-
ence of *Impressionism. This remained
his idiom, though touched by transient
influences, including those of *Cézanne
and *Cubism. His art is valued for its
freshness and grace, best seen in his
watercolours and drawings, including book
illustrations, and in his designs for the
theatre.

Dupont, Gainsborough (*c.*1754–97)
The nephew and assistant of Thomas
*Gainsborough. He engraved his uncle's
*Fancy Pictures, and probably himself
painted the small-scale 'engraver's copies'
which exist of some of them. He also
completed, in the elder Gainsborough's
style, the series of portraits of members of
Whitbread's brewery begun by his uncle.
In 1790 he began to exhibit at the Royal
*Academy.

Duque Cornejo, Pedro *See under*
Roldán, Pedro.

Duquesnoy, François *See* Quesnoy,
François du.

Dürer, Albrecht (1471–1528) The
first self-conscious artistic genius in north-
ern European art; painter, draughtsman,
printmaker in both *relief and *intaglio,
theoretician and would-be reformer of art.
Through his woodcuts and engravings,
most of them published by himself, he
became an international figure, supplying
*iconographic models to artists throughout
Europe and as far away as Persia, and
setting new standards of technical mastery.
From within his own German/Netherlan-
dish *Gothic heritage, with its interest in
the particular, he sought to learn the
general laws enshrined in Italian art: the
laws of optics, the 'rules' of ideal beauty
and harmony (*see also disegno*). His own
work ultimately succeeded in synthesizing
these two traditions, so that some of his
most detailed and 'northern' images
demonstrate his conquest of, for example,
single-vanishing point *perspective (*Nativ-
ity*, engraving 1504, with its picturesque
setting of a ruined German farmhouse) or
of the canonic proportions of man, horse,
hounds and stag (*St Eustace*, engraving
*c.*1501), or the *classical female nude (*The
Dream of the Doctor*, engraving *c.*1497/8).
Other works translate Italianate imagery
into Gothic idiom; thus the winged, nude
Fortuna (engraving 1501/02), holds a
perfect example of a German goldsmith's
chalice, and hovers over a minutely por-
trayed northern landscape; the *Centaur's
Family* (engraving, 1505) lives in a German
forest, and a northern lake is the setting of
a rape modelled on such *Classical scenes
as the *Rape of Europa*, but performed by a
marine monster with elk antlers (engraving,
*c.*1498).

Dürer was born in Nuremberg, the
second son of Albrecht Dürer the Elder, a
goldsmith from Hungary who had trained
in the Netherlands. From his father he
must have learnt draftsmanship, the use of
the burin in copper engraving, and admira-
tion for the great Netherlandish artists (*see*
Jan van Eyck, Rogier van der Weyden).
Until the age of five he lived in a house
behind that of the rich patrician Pirck-
heimer. Here were laid the foundations of
Dürer's lifelong friendship with Willibald
Pirckheimer (two portrait drawings, 1503,
Berlin, Kupferstichkabinett). Pirckheimer

was later to study law and the humanities at the universities of Padua and Pavia. It is he, the improbable humanist intimate of a Nuremberg craftsman, who was to prompt Dürer's interest in visiting Italy; who would initiate him in the classics, assist him with his treatises and suggest the iconography of his unusual secular prints, and, above all, foster and encourage his ambitions, not as a craftsman but as a creative and erudite artist in the Italian mode.

A famous drawing in silver-point, the *Self-Portrait of 1484 at the Age of Thirteen* (Vienna, Albertina) testifies as much to the efficacy of the elder Dürer's training as to young Albrecht's precocious talent and unusual self-consciousness. It was to be the first in a series of drawn and painted self-portraits, unique in the history of art before *Rembrandt (drawing, 1491/2, Erlangen, University Library; drawing, 1493, New York, Lehman Coll.; painting on parchment, 1493, Paris, Louvre; painting on panel, 1498, Madrid, Prado; painting on panel, 1500, Munich, Alte Pinakothek; drawing, c.1503, Weimar, Schlossmuseum; drawing c.1512/13, and drawing, 1522, Bremen, Kunsthalle).

In 1486 Dürer was apprenticed to Michael *Wolgemut, in whose workshop he learned painting in oils and watercolours, designing woodcuts for book illustration, and the rudiments of marketing works of art.

In the spring of 1490 began the four-year period of Dürer's *Wanderjahre*, only part of which are accounted for. He was supposed to go to Colmar to work under Martin *Schongauer; when he arrived early in 1492, Schongauer had been dead for nearly a year, and his three brothers recommended Dürer to another brother, the goldsmith Georg Schongauer who practised in Basel, one of the great centres of European book production. Here Dürer produced designs for woodcuts which transformed Basel book illustrations (e.g. frontispiece to the *Letters of St Jerome*, 1492) introducing greater spatial *realism and descriptive notation of surfaces.

In 1494 Dürer was back in Nuremberg where a marriage had been arranged for him by his father. Agnes Frey, Dürer's wife, was to sell prints for him at book fairs. The marriage, which was to remain childless, was unhappy. Dürer left his wife almost immediately on his first trip to Venice (summer 1494–spring 1495), the first German artist to seek artistic instruction in Italy rather than in the Netherlands, and one of the earliest northern European artists to encounter the Italian *Renaissance on its native soil. It is probable that at this time he also stopped at Padua, Mantua, Cremona, and visited Pirckheimer in Pavia. The main evidence for the trip consists of drawings and watercolours (Vienna, Albertina; Berlin, Kupferstichkabinett; Basel, Kunstsammlungen; Frankfurt, Städel).

After his return from Italy Dürer settled down in Nuremberg to consolidate his new-found synthesis between northern love of detail and Italianate generalization. There followed a decade of extraordinary productivity, during which he carried out numerous commissions for paintings (*Dresden Altarpiece*, Dresden, Gemäldegalerie; *Mater Dolorosa Altarpiece*, now divided between Dresden, Gemäldegalerie and Munich, Alte Pinakothek; *Paumgärtner Altarpiece*, Munich, Alte Pinakothek; *Adoration of the Magi*, Florence, Uffizi; *Jabach Altarpiece*, Frankfurt, Städel; Cologne, Museum; portrait of Frederick the Wise, Berlin, Deutsches; three portraits of members of the Tucher family, Weimar, Schlossmuseum; Kassel, Gemäldegalerie; etc.), began to print and publish his own woodcuts and engravings (of which over 60 were produced between 1495 and 1500, including the *Apocalypse* and the *Large Passion*) and continued to draw and paint in watercolours for his own delight and instruction (e.g. the *Parrot*, Milan, Ambrosiana, the *Little Hare* and *Great Piece of Turf*, Vienna, Albertina).

Dürer's prints of these years established his international fame. On his second trip to Italy, 1505–7, he was no longer an unknown young northerner but the most celebrated German artist of the age. Thus upon his arrival in Venice he secured the commission for an altarpiece in the national church of the German community, S. Bartolommeo (*The Feast of the Rose Garlands* now Prague, Rudolphinum). The *Christ among the Doctors* (Madrid, Thyssen)

is a painting also under-taken in Venice, probably for an Italian patron. While the S. Bartolommeo altarpiece paid tribute to Giovanni *Bellini, who received Dürer with friendship, the *Christ among the Doctors* reveals the influence of *Leonardo da Vinci. Several portraits were also produced during Dürer's stay in Venice (e.g. Hampton Court; Berlin, Staatliche).

Dürer relished the social position attainable by artists in Italy. In a famous letter to Pirckheimer he writes, 'How shall I long for the sun in the cold; here I am a gentleman, at home I am a parasite.'

His return to Nuremberg saw him trying to attain a similarly elevated position even in this more hostile climate. He bought a large house, wrote verse, studied languages and mathematics, and began to draft an elaborate treatise on the theory of art. He succeeded in bringing out three books: on geometry, on fortifications, and on the theory of human proportions, this last appearing posthumously. He collaborated with Pirckheimer, illustrating the latter's translation – from Greek into Latin – of a treatise on Egyptian hieroglyphics. At the same time, however, his Venetian experiences revived his gusto for painting (*Adam and Eve*, now Madrid, Prado; and three major altarpieces: *Martyrdom of the Ten Thousand*, now Vienna, Gemäldegalerie; *Heller Altarpiece*, central panel by Dürer destroyed 1729, copy by Jobst Harrich, Frankfurt, Städel; *Adoration of the Trinity* or *Landauer Altarpiece*, Vienna, Kunsthistorisches).

From about 1511 he returned also with increased energy to his graphic works, experimenting with tonal effects more than he had before the Venetian trip (woodcut *Small Passion*, 1511; *Engraved Passion*, 1513). He produced three 'master engravings' in 1513 and 1514 which are exceptionally large in size, meticulous in technique and unprecedented in their representation, by linear means alone, of pictorial effects of lustre and tonal variations (*Knight, Death and the Devil*; *St Jerome in his Study*; *Melencolia I*).

In 1512 Dürer was involved in designing the gigantic woodcut of the *Triumphal Arch*, printed from 192 blocks, for the Emperor Maximilian I, and in other projects for the Emperor, the *Triumphal Procession* and the *Prayer-Book*. These mark the so-called 'decorative' phase of his *oeuvre*, on which he turned his back after Maximilian's death in 1519 and his own conversion to Lutheranism *c*.1520. His religious beliefs did not, however, prevent him from seeking out the Emperor's successor, the ultra-Catholic Charles V, at his coronation, in order to secure the renewal of the pension granted him by Maximilian. This was the occasion of Dürer's final long excursion from Nuremberg, this time accompanied by his wife – the year-long trip through the Netherlands, as much the artist's triumphal tour, sightseeing and sketching expedition (*Silver-point sketchbook*, dispersed among print cabinets of major museums), sales round and shopping trip, as a voyage to petition a prince.

After his return from the Netherlands, already weakened by a malarial fever contracted there, Dürer resumed the production of small-scale engravings, many of them portraits in profile. His last important paintings were the monumental over-life-size panels of the *Four Apostles*, perhaps originally conceived as wings of an altarpiece which was never carried out and executed instead as independent works. They were donated by the artist to the city of Nuremberg, 1526, inscribed with texts meant to castigate both Papists and the more radical Protestants falsifying – in Dürer's view – Luther's teachings (Munich, Alte Pinakothek).

Dürer may be said to have truly brought the Italian Renaissance to northern Europe, not only in its pictorial motifs (as others were also beginning to do) but in its artistic theories and conceptions of art and the artist's role. Simultaneously, he influenced Italy, directly and through followers such as *Altdorfer – fuelling the narrative imagination even of such great masters as *Raphael – and elevated the print to a great expressive medium, unsurpassed until Rembrandt. His stress on originality of invention – made possible in this marketable commodity which required no previous commission – marks him out as perhaps the first truly 'modern' artist.

Dusart, Cornelis *See under* Ostade, Adriaen and Isaack van.

Duvet, Jean (1485–1561) French goldsmith and engraver (*see under* intaglio). He is sometimes called the Unicorn Master after his series of six prints, executed in the mid-1540s, on the medieval theme of the hunt for the unicorn – thought to be an *allegory of the virtues of Diane de Poitiers, mistress of Henry II. He was born in Langres and worked there and at Dijon; an early adherent to Calvinism, he took refuge from persecution in 1541 in Geneva. Between 1546 and 1556 he executed his most famous work, the visionary series of 24 prints of the *Apocalypse*, indebted to *Dürer, published in Lyon in the year of his death.

Duyckinck Dutch-American dynasty of artists active in New Amsterdam (New York). **Evert I** (1621–1702), a miniature painter, was born in Holland and went to America in 1638. His son **Gerrit** (1660–1710) also painted in oils (New York, Historical Society). The last member of the family of any significance was **Gerardus II** (1723–97), a great-grandson of Evert I who taught painting on glass and drawing.

Duyster, Willem (*c*.1599–1635) Dutch painter resident in Amsterdam, a specialist of small-scale guardroom scenes (Philadelphia, Museum; St Petersburg, Hermitage; London, National; Stockholm, Museum; etc.).

Dyce, William (1806–64) British painter, principally of religious and historical subjects, but also an outstanding landscapist as his poetic *Pegwell Bay* (1860; London, Tate) proves. Born in Aberdeen, trained there and in London, he worked mainly in Edinburgh until, in 1836, *Eastlake got him appointed director of the newly established Government Schools of Design in London. Dyce made two visits to Rome in the 1820s where he associated with the *Nazarenes and developed his profound knowledge of Italian *Renaissance painting. His own painting at times comes very close to both, at others exhibits a sense of time and place, as when he locates biblical subjects in *naturalistically observed scenery that is clearly of his century. His position between the Nazarenes and the much younger founders of *Pre-Raphaelitism made him a guide to the latter; he also took from them some of their methodical account of detail. His knowledge of Italian and Nazarene art also showed in his efforts to paint, and promote the painting of, *frescoes. In 1843 he was commissioned to paint frescoes in the London Houses of Parliament; similar commissions followed for Buckingham Palace and for Osborne House, the Queen's summer residence on the Isle of Wight.

Dyck, Anthony van *See* Van Dyck, Sir Anthony.

Dyck, Floris van *See* Dijck, Floris van.

Dying Gaul, Dying Gladiator *See under* Ludovisi.

Džamonja, Dušan (1928–) Croatian sculptor, known in the 1950s for spatial structures in metal, who then evolved a new form of sculpture: crystalline forms on a substantial scale, sometimes incorporating glass elements and generally covered with little spikes and coated with silvery lead.

E

E.S., Master (active from 1450 to late 1460s) Pioneering and prolific German engraver on copper plate (*see* intaglio prints) active in the upper Rhine valley, known only by the monogram which appears on 18 of some 316 works attributed to him; the earliest engravings to be so identified. He is also the first master to have dated some of his prints, notably the elaborate images of the *Einsiedeln Madonna* commissioned in 1466 by the Benedictine monastery of Einsiedeln in Switzerland to celebrate the quincentenary of its miraculous foundation. It has been suggested that this innovative printmaker – whose use of contour and hatching influenced *Mantegna, and whose figure types and narrative inventions inspired metalworkers and sculptors as well as engravers – finished his career in the employ of the monastery, and that the initials ES refer not to him but to that institution.

Eakins, Thomas (1844–1916) American painter born into a Quaker family in Philadelphia and trained at the Pennsylvania Academy. In 1866–9 he was in Paris, working under *Gérôme and others, but drawn especially to the *naturalism and *realism of the *Barbizon painters and of *Courbet and *Manet. Then he spent seven months in Spain, admiring in particular *Velázquez and *Ribera. Thereafter, sensing his preparation completed, he appears to have lost interest in European art, the first major artist to assert that progress in American art would come from staying at home.

In July 1870 he returned to Philadelphia. He painted local scenes and portraits, charged with emotional truth as well as visual fact, and became the leader of American naturalistic painting. His keen interest in science shows in *The Gross Clinic* (1875; Philadelphia, Jefferson Medical College where he had attended anatomy lectures), an updating of *Rembrandt's *Anatomy Lesson of Dr Tulp*; a later painting of a doctor at work, *The Agnew Clinic* (1889, Pennsylvania University) is less dramatic. Both pictures shocked contemporaries with their strong statement of facts.

Eakins taught at the Academy from 1876, and was made head of the painting school in 1878. He reformed teaching methods, giving priority to painting the living nude model as against drawing from plaster casts. Meeting philistine objections, notably to his allowing female students to draw the male nude, he resigned but taught in his own school and at the Arts Students League in Philadelphia.

Outdoor activities had always appealed to him, merging with his passion for optics and other scientific knowledge. A work that brings some of these interests together is *Max Schmitt in a Single Scull* (1871; New York, Metropolitan). Truth to visual appearances and painting real subjects directly experienced were the conscious basis of his work and suggest classification as a Courbet-type realist, yet he was without the Frenchman's insistent materialism. Eakins's paintings attend to space and light and communicate a sense of individual liberty. His vision called for unusual clarity, moral as well as pictorial. He insisted that representing nudes had to be occasioned by sense, not by artistic inclination, and thus he painted them infrequently: in *The Swimming Hole* (1883, Forth Worth, Kimbell), for example, and in a series of boxers painted in the 1890s. He experimented with photography and at times used photographs as data for paintings. He made a number of relief sculptures from 1882 on. In 1884 he married Susan Hannah Macdowell, who was studying painting with him and whom he encouraged to continue in her career. She was primarily a portraitist and Eakins now too gave most of his time to portraits. These are remarkable for their sense of character and social context. The Philadelphia Museum of Art has the best collection of his work.

Earl, Ralph (1751–1801) Colonial American portrait painter from Connecticut inspired by John Singleton *Copley; he also made topographical drawings at Lexington and Concord of the earliest events of the American Revolution, which were engraved. Fearing imprisonment as a pro-British spy, he fled to London in 1778, and entered the studio of Benjamin *West, where, among others, he painted his fellow-student *John Trumbull (Massachusetts, Historic Deerfield, Inc.; see also Matthew Pratt, Gilbert Stuart). He returned to America in 1785. There are works by him in New Haven, Yale University; Massachusetts, Amherst College, Smith College, Worcester, Museum. His younger brother James (1761–96) was also a painter, as was his son, Ralph E.W. Earl (c.1785–1838) who married a niece of Andrew Jackson, the future president, and came to specialize in his portrait.

Earthworks Sculpture in which land itself is given new form, therefore also known as Land Art. Exhibitions presented the concept in 1968 and '69, and no clear distinction was ever made between it and the Conceptual art to which, for example, *De Maria's *Mile Long Drawing*, two parallel lines scored in 1968 into the Nevada Desert, is held to belong. Robert Smithson's *Spiral Jetty* of 1970 is one of the first Earthworks presented as such; it has received a great deal of notice. The same year saw *Heizer completing his vast trenches forming a negative cross in the Nevada Desert. Perhaps it is the Napoleonic grandiosity of such works that had drawn criticism of them as violations of nature, but this category embraces also works that are less commanding and quite transient. In Britain Richard *Long in 1967 began his career of working with what the surface of Earth provides by walking on grass so as to leave a mark which nature would soon erase; subsequently he would clear stones, or rearrange them positively, to make a form in a distant, deserted place. These artists were very influential in making art other than as saleable art objects, but they needed to finance their projects. Fine photographs of earthworks, usually by the artists themselves, could be offered for sale as well as inform the world of what was done, and artists also found ways of bringing stones, twigs, mud etc. into the galleries and shaping them into art objects. In a period of ecological debate and awareness, as art that works with and in nature, often without disturbing an environment to any serious degree and without using up its resources, earthworks have been received as a benign corrective to sculpture's traditionally more demanding ways (e.g. in the making of large bronzes), and has also enlarged our sensibilities by means of its inventions, often of surprising delicacy.

easel painting Literally, the term applies to any picture, on panel or canvas etc. painted on an artist's easel; by extension, it is used of any portable painting larger than a miniature, as opposed to mural paintings such as *frescos.

Eastlake, Sir Charles (1793–1865) British painter, art administrator and writer. Eastlake had an early success with his topical *History painting *Napoleon on Board the Bellerophon* (1815), which enabled him to go to Rome, where he studied and worked from 1816 to 1830 and was influenced by the *Nazarenes. Elaborate history and *genre subjects, often set in Italian sites, made him popular back in England, but he saw his role increasingly as a writer and administrator. He became president of the Royal *Academy in 1850 and director of the new National Gallery (London) in 1855. Enthusiastic about and expert in early *Renaissance painting, he made some outstanding purchases of works from a period not then so greatly admired.

Eckersberg, Christoffer Wilhelm (1783–1853) Danish painter, trained in the Copenhagen *Academy under Abildgaard. During 1810–16 he worked in continental Europe, first in Paris under J.-L.*David, and then for three years in Rome. To the *Neoclassicism he learnt he joined an exceptional feeling for effects of nature, as his pictures of Rome demonstrate. Back in Copenhagen, where he was professor at the Academy from 1816, he painted historical subjects for the royal palace of Christiansborg and for some years dominated portrait

painting in which he combined keen observation with austere Neoclassical composition. In the 1820s, less engaged on portraits, he turned to marine painting, including paintings of ships. These are vivid works, as much for his compositional methods as for their conveying of light and space. He reformed the Academy's teaching, giving studies from life a new importance, also wrote textbooks on *perspective; these activities occupied much of his time. His work is best seen in the Statens Museum for Kunst in Copenhagen.

Écorché (French, flayed) A type of figure drawn or sculpted as an aid to the study of anatomy, in which muscles and tendons are shown as if the covering skin had been removed.

Edelfelt, Albert (1854–1905) Finnish painter who studied art in Helsinki, Antwerp and Paris, where he worked under *Gérôme, was close to *Bastien-Lepage and befriended younger Scandinavian painters, notably *Gallen-Kallela. He was touched by *Manet's *Impressionism, using a lighter palette than before and often working direct from nature though his finished paintings, often much larger than open-air working allowed, were much more solidly worked while retaining Impressionist brightness and informality. In the late 1880s he travelled in outlying parts of Finland and painted luminous landscapes of what he saw, expressing in them the spirit of his country. With nationalist feelings gathering in the face of Russia's imperialism, Edelfelt worked to give Finnish art its independent status in the eyes of Europe, for instance by pressing for a separate Finnish pavilion at the 1900 Paris Exposition. He also illustated patriotic poems by J. L. Runeberg and in 1904 painted murals in the University of Helsinki (destroyed in the Second World War).

Edelinck, Gerard (1640–1707) Flemish engraver (see under intaglio) active in Paris, where he specialized in reproductive prints after portraits by *Rigaud and others, although his most famous print is *The Fight for the Standard*, after *Rubens's

drawing of *Leonardo's *Battle of Anghiari*. He married the daughter of *Nanteuil.

Egell, Paul (c.1691–1752) German sculptor. He spent the years from 1716 to 1720 under *Permoser in Dresden, and then two years in Italy. In 1723 he was appointed sculptor to the Elector Palatine's court in Mannheim, where he remained for the rest of his life (decorative sculpture, Elector's palaces; altarpieces, various churches).

Egg, Augustus Leopold (1816–63) British painter, a Londoner but often abroad for the sake of his health. He painted historical and literary subjects in a firm and bright style, even before he was influenced by the Pre-Raphaelites. Like them, he at times tackled serious social themes, as in the series *Past and Present* (1858; London, Tate); at others he painted more agreeable *genre scenes, such as that of a pair of well-dressed young ladies in a railway compartment, *The Travelling Companions* (1862; Birmingham City), one of the best-loved Victorian paintings.

Eggeling, Viking (1880–1925) Swedish painter and film-maker, who settled in Paris in 1911. During the First World War he was in Switzerland where he associated with the *Dadaists and became the close friend of Hans *Richter. At this time he was making pencil compositions on paper, their geometrical and curved forms relating polyphonically like music, some in the form of horizontal scrolls to be read sequentially. He collaborated with Richter on some scroll paintings and drawings. In 1920, working in Berlin with encouragement from Van *Doesburg, he began to make short animated *abstract films, with *Diagonal Symphony* (1921–2) the first to be completed and exhibited.

Ehrenstrahl, David Klöcker (1629–98) German-born Swedish painter. In Sweden from 1652, he moved in 1661 to Stockholm, where he became court painter, earning the art-historical title of 'father of Swedish painting'. In addition to official portraits and allegorical compositions, he executed large hunting and animal scenes in

landscape, in which both landscape and animals are studied from nature. These subjects were commissioned from Ehrenstrahl by Charles XI of Sweden, and form the most original aspect of the artist's work (Stockholm, Museum).

Eight, The Group of American painters, formed in 1908 for a New York exhibition. Some of its members, *Henri, *Glackens, *Sloan among them, were urban *realists and were known also as the *Ashcan School; others, including *Prendergast and Arthur B. Davies, used gentler styles and subjects, but it was the realists who caught the attention of the press and gave the exhibition its notoriety.

Eilshemius, Louis Michel (1864–1941) American painter, trained in New York and Paris, who early on turned from *Impressionism to painting visionary subjects of his own invention in a *primitive manner. He named himself 'Mahatma' in celebration of his greatness and was offended by the world's blindness to it. *Duchamp championed him on account of the refreshing naïvety of his style, in 1920 an exhibition was arranged and some purchases were made, but in 1921 Eilshemius gave up painting and his work had no public success until the 1930s.

ekphrasis, pl. ekphrases *See under* Philostratus.

Ekster (Exter), Aleksandra (1882–1949) Russian painter, born near Kiev. From 1908 a regular visitor to Paris, she was close to the *Cubists and the Italian *Futurists and supplied Russian *avant-garde circles with information from the West. She exhibited in Russian progressive exhibitions. Her painting assimilated elements from western movements and, under the influence of Robert *Delaunay, *Malevich and *Tatlin, became *abstract in 1915. During 1916–20 she designed sets and costumes for productions in Moscow, Odessa and Kiev. In Kiev, during 1918–20, she organized a *Suprematist school in her studio, and with her students painted Suprematist decorations

on to steamers which were to carry the message of revolution and socialism around the country. From 1920 to 1924 she lived in Moscow, teaching, painting and making textile designs. In 1921 she was one of the five *Constructive artists included by *Rodchenko in the exhibition '5 × 5 = 25'. In 1923–4 she designed sets and costumes for Protozanov's film *Aelita*. In 1924 she left Russia for Paris where she taught alongside *Léger and continued to work for the stage and for films.

Elementarism A tendency in Central European *abstract art, born out of the meeting of Russian *Constructivism, in the person of *Lissitzky, and the De *Stijl movement, in the person of Van *Doesburg, in Berlin and at the Düsseldorf Congress of International Progressive Artists in 1922. A manifesto published in *De Stijl* that year announced 'elementarist art' as an art 'built up of its own elements alone' and giving 'artistic form to the elements of our world'. It was signed by *Hausmann, *Arp, Ivan Puni and *Moholy-Nagy. An article by Van Doesburg, '*Elementare Gestaltung*' (approximately, elementary form-making), appeared in the new Berlin design journal *G* in 1923, distinguishing the 'primary (elementary) means' by which art and design were now to proceed from the 'secondary (auxiliary) means' which had dominated previously with their illusionistic effects and descriptive or narrative subject matter. In 1924 van Doesburg used the term Elementarism also for a modified form of *Neo-Plasticism in which the vertical–horizontal dispositions promoted by De Stijl were replaced by compositions at 45° to the orthogonals for the sake of stronger visual dynamics.

Eliasz., Nicolaes, called **Pickenoy** (1590/91–1654/56) Dutch portrait painter, son of an Antwerp emigrant, Elias Claesz. Pickenoy. Next to Thomas de *Keyser, he was the leading portrait painter in Amsterdam before the arrival of *Rembrandt. In addition to likenesses of individuals, he executed many guild, civic-guard and regent group portraits (e.g. Amsterdam, Historisch).

Elle, Ferdinand *See under* Poussin, Nicolas.

Elsheimer, Adam (1578–1610) Short-lived but immeasurably influential painter on copper of small-scale religious works and, later in his career, poetic landscapes peopled with biblical or mythological figures. Born in Frankfurt, Germany, he trained as a figure painter but was also affected by the landscape style initiated by *Coninxloo. From 1598 to 1600 he was in Venice, where he was influenced by Hans *Rottenhammer and the works of *Titian, *Giorgione, *Tintoretto. From 1600 until his death he lived in Rome, where the landscape backgrounds in his paintings came to dominate the figures. Elsheimer's painstakingly and delicately executed works are notable for the way in which light is used to model form and express mood. He often experimented with different sources of illumination within a single scene: moonlight, firelight, the light of torches. Within its tiny compass his world is surprisingly monumental, and he is the great interpreter of a characteristically northern European nostalgia for the *Classical south, a tradition carried on subsequently by the Italianate Dutch painters (*see* e.g. Both). Working very slowly, he contracted debts which led him to be imprisoned for a time shortly before his death. From about 1604 he had rented rooms in his house to a Dutch artist, Hendrick Goudt (1580/1–1648) who may also have been his pupil, and who bought his work. Goudt's engravings after his paintings made Elsheimer's compositions available to artists in the Netherlands from as early as 1608; the dark tones, particularly of the night-time scenes, influenced *Rembrandt amongst others. *Rubens, who knew Elsheimer in Rome, is another of the great artists affected by him, as is *Claude. There are paintings by Elsheimer in Kassel, Gemäldegalerie; Cambridge, Fitzwilliam; Edinburgh, National; Florence, Uffizi; Frankfurt, Städel; The Hague, Mauritshuis; London, National, Apsley House; Munich, Alte Pinakothek; Paris, Louvre; Vienna Kunsthistorisches; etc.

Elyas, Isack *See under* Buytewech, Willem.

Emblem book An emblem is made up of three parts: picture, motto and explanatory text. Emblem books originated in Italy (*Emblemata*, 1531, Alciati) but their importance for art history largely derives from their wide currency in the Low Countries in the 17th century. Many Dutch *genre pictures derive, not from direct observation of everyday scenes, but from the illustrations in emblem books. Their contemporary significance, therefore, can best be recovered through familiarity with these publications. Heraldic emblems, often highly sophisticated, associated with noble Italian families and individuals, are called *imprese* (sing. *impresa*).

Emin, Tracey (1963–) British artist, born in London, trained as painter at the Royal College of Art, and since then active in a variety of media and art forms. Her subject-matter is blatantly autobiographical: her family, her twin brother, the abuse she suffered and her subsequent sexual history, as well as her life as artist, are recounted in images and annotated objects, including countless drawings and monoprints and her tent with appliquéed lettering, naming *Everyone I have Ever Slept With 1963–1995* (1995). Recently much of her work has been in the form of texts, handwritten, unsophisticated and misspelt; her performances sometimes centre on reading some of these texts which touch listeners because of their insistent honesty and directness. Her 1997–8 show 'Exorcism of the Last Painting I Ever Made', at the Kunstverein, Cologne, was a developing installation piece which included her clothes and bed and, at the opening, herself as well as many of her productions. She shows frequently abroad, on both sides of the Atlantic. In 1999 she was short-listed for the Tate Gallery's Turner Prize, exhibiting her *Bed*.

Empoli, Jacopo da *See* Jacopo da Empoli.

encarnado Spanish, 'flesh-coloured'. The term used in Spanish art for the *polychromy of the flesh part of wooden sculptures; the term *estofado*, 'quilted', is applied to the painting of draperies. *Encarnadores* and *estofadores* were the specialized craftsmen who executed such work – but after *c.*1600 it was sometimes done by distinguished painters, see, e.g., *Pacheco.

Engelbrechtsz. or **Engelbrechtsen, Cornelis** (1468–1533) Netherlandish painter active in Leyden, working in a mannered, ornate and *expressive Late *Gothic style (Leyden, Lakenhal; Munich, Alte Pinakothek; New York, Metropolitan). He was the teacher of *Lucas van Leyden, who influenced his later works, and of his own three sons.

engraving *See under* intaglio prints.

Ensor, James (1860–1949) Belgian painter, trained at the Brussels Academy, who worked most of his life in his native town of Ostend. His early paintings were in the tradition of northern *naturalism: townscapes and interiors in warm, low colours. His parents ran a souvenir shop and sold items that were to appear in their son's paintings: shells, fans, porcelain, carnival masks, etc. His alcoholic father died in 1887, about which time the painter's palette lightened and his art turned to a much more imaginative, even fantastic, mode – a variant of French and Belgian *Symbolism, but heralding *Expressionism and *Surrealism. One of his first major works was the large *The Entry of Christ into Brussels in 1889* (1888; Los Angeles, Getty), pictured as a carnival procession, painted crudely and in harsh colours and announcing socialism more than Christ. In other paintings he explored such imagery as grotesque masks and skeletons, by themselves and in human company. *Daumier had been an influence; now *Turner's sometimes visionary colour effects appear in a context that echoes the nightmarish images of *Bosch. It was only in his later years that his work met with recognition. The first book about him came out in 1908; his first major exhibition was in 1920, in Brussels. In 1883 he had been one of the founders of Belgium's leading contemporary art group, Les *Vingt, yet they rejected his work when it abandoned conventional means and themes. In 1929 he was made a Baron by his country.

Epstein, Jacob (1880–1959) American-British sculptor, born in New York where he began his art training, continued from 1902 on in Paris. In 1905 he moved to London. In 1907 he got his first commission, for 18 figures for the British Medical Association in London; completed in 1908, they met with loud hostility. He early developed a passion for archaic and *primitive sculpture and over the years formed an outstanding collection of, especially, African carvings. His own carvings took on a primitive character and at times represent archetypal subjects, e.g. *Maternity* (1910; Leeds City) and the tomb of Oscar Wilde (1912; Paris, Père Lachaise Cemetery) with its 'flying demon-angel'. In *Rock Drill* (1913), he mounted a totemic figure, half human, half robot, on a real drill: as an image it was as much animal and sexual as industrial, equating mechanical power and action with human energy. Exhibited in 1915, it astounded many, both for the brutality of the figure and for the use, in a work of art, of a real mechanical device. In 1916 he exhibited the upper half of the figure only, having discarded the rest and amputated part of the arms: the aggressive image had thus, under the influence of the reality of war, become an image of frailty (London Tate). Epstein early showed exceptional gifts as modeller of portraits. His first one-man show in 1927 included several of these and established him as a major portraitist. Many eminent men sat to him, among them Einstein, Tagore, T.S. Eliot and Churchill, though his portraits of women and children are the most captivating. Such works brought approval but his desire was to create 'grave' and meaningful works which would 'confront our enfeebled generation' and give man 'new hope for the future'. He produced a sequence of mighty carvings on biblical subjects – among them *Genesis* (1930; Granada Television), *Behold the Man* (1935; Coventry Cathedral), *Adam* (1939; coll. Lord Harewood) and *Jacob and the Angel* (1940; Granada Television) –

abused by many and praised by a few for their primeval vehemence. Large modelled figures, such as *Lucifer* (1945; Birmingham Museums), fared no better: offered as a gift to the Tate Gallery in London and the Fitzwilliam Museum in Cambridge, it was refused by both. Nonetheless, commissions for large sculptures were not lacking. On the day he died he completed the *Bowater House Group* in Knightsbridge, London: Pan, man, woman, child and dog appear to rush into the spaces of Hyde Park.

His controversial works and brilliant portraiture gave him a particular place among modern artists, as did his Bohemian ruggedness and his links with high society. He could not be ignored. Two volumes of autobiography (1940 and 1955) raised sympathy for his efforts. A retrospective at the Tate Gallery in 1952 was followed by an honorary doctorate from Oxford University in 1953; in 1954 he was knighted by the Queen. A commemorative exhibition was shown in Edinburgh and London in 1961, and a retrospective in Leeds and London (Whitechapel) in 1987.

Erhart, Michael (recorded 1469–after 1522) and his son **Gregor** (recorded 1494–1540) German sculptors, active in Ulm (high altar, Blaubeuren Abbey near Ulm, 1493–4), *see also* Zeitblom. Only fragments of Michael Erhart's sandstone *Mount of Olives*, erected in front of Ulm Minster, survive (1516–18, Ulm, Museum). Sometime during 1500–10 Gregor Erhart became the most prominent carver in Augsburg, associated with the painters Hans *Holbein and Hans *Burgkmair, but all the documented works are lost, and his career after 1510 has not been convincingly reconstructed.

Ermilov, Vassily Dmitrievich (1894–1968) Russian painter born in Kharkov where he received his first training before further study in Moscow where he associated with the *Futurists. In 1917, a practising *Suprematist, he returned home to teach, paint and make posters in support of the Revolution. In the 1920s and 30s he gave priority to architectural and theatre design, before returning to painting in relative obscurity.

Ernst, Max (1891–1976) German-French painter, born at Brühl near Cologne. He studied philosophy at Bonn University, taught himself to paint, and was included in the *Sturm Gallery's First German Herbstsalon in 1913. His work at this time was close to *Macke's *Delaunay-based *Expressionism. From 1914 to 1918 he was in the German army, doing occasional watercolours, arrangements of shapes and signs that suggest fantastic landscapes. With *Arp and *Baargeld he founded a *Dada group in Cologne in 1919. He paid homage to de *Chirico's work in a *lithograph series *Fiat Modes* (1919). In another series he used line blocks found at a printer's: the images are irrationally mechanistic. In another he took rubbings from the blocks. Altogether he explored areas of chance creation, most obviously so in the *assembled objects and picture-reliefs of 1919. Ernst's work of 1920 is dominated by a series of *collages: 'exploitation of the fortuitous or engineered encounter of two or more intrinsically incompatible realities on a surface which is manifestly inappropriate for the purpose – and the spark of poetry which leaps across the gap', he explained later. *Breton arranged a Paris Ernst show in 1920; Ernst titled it 'Beyond Painting'. In 1922 he obtained a French visa and at once moved to Paris, taking with him paintings in which he represented similar incompatibilities of space and object, as in *The Elephant of the Celebes* (1921, London, Tate). These were *Surrealist works before Surrealism, and he soon extended his source material by incorporating also sacred formulae, as in *Pietà, or Revolution by Night* (1923; estate of Roland Penrose). He contributed to the first Surrealist exhibition in 1925 but did not involve himself much in Surrealist events and publicity. With his *frottage drawings of 1925 he supplied a new sort of automatic creation, with little or no intervention from the censoring mind. Images from these reappear in his later work, as when paintings done in a veristic manner employ imagery found by frottage. Some images became stock characters for him: e.g. birds, ghoulish animals/figures suggesting torn bark, blossoms created by turning a colour-laden

palette knife in a broken circle. It was always the inner eye of the imagination he sought to address, and this is particularly effective in image series published like visual novels in 1929 (*La Femme* 100 *Têtes*) and 1934 (*Une semaine de bonté*), consisting of provocative pictures made by collaging illustrations. Images of cataclysm appear in his paintings from 1933 on, responding to the rise of fascism in Germany, Italy and Spain. When the 1939 war started he was interned as an enemy alien and rearrested by the Germans in 1940; he escaped and got to New York in 1941. His work was known there (a one-man show in 1931, 48 works in the MoMA show 'Fantastic Art, Dada, Surrealism' in 1936). Generally the imagery and methods of Surrealism provided important impulses in the 1940s; in particular Ernst's use of paint dripped from a swinging can may have started *Pollock on his drip technique. But the American years saw Ernst working in a variety of media and Surrealist ways, and making sculpture from casts of found objects and paintings that echo the awesome inventions of *Grünewald and *Altdorfer. After some years in Arizona, Ernst returned to France in 1949.

In 1951 his home town showed a large retrospective; in 1953 it was repeated in Knokke-le-Zoute, Belgium, and many others followed. In 1954 he was awarded the main prize for painting at the Venice Biennale. These events, and publications about him, established him as a master of imaginative art. A collection of his writings appeared in English in 1948 as *Beyond Painting*; another, in French, in 1970.

Escher, Maurits Cornelis (1898–1972) Dutch graphic artist, who explored formal metamorphoses and transformational patterns with positive–negative contrasts and impossible spatial constructions; e.g. a square staircase rising for ever without gaining height, or a building with conflicting top/bottom indications. His work lies between *Surrealism and mathematics.

Esprit Nouveau, L' Journal founded by *Ozenfant and *Le Corbusier in 1920, its name signalling the emergence of a 'new spirit' stimulated by the precision of machine production, and displaying a taste for order and clarity. The new artists, its editors claimed, are not 'special beings, superior, bizarre', but in tune with facts of modern existence, finding in it qualities of beauty akin to those we honour in the *classicism of the Greeks. The art they promoted was *Purism, but articles and illustrations by many contributors refer to a wide range of modern and old art, such as that of *Corot and *Ingres, and also to contemporary design, music, films, music hall, etc. The journal ended in 1925, the year in which Corbusier's Pavillon de l'Esprit Nouveau was part of the Paris Exhibition of Decorative Arts.

Este One of the oldest and most illustrious Italian families, the Estensi or d'Este took their name from their native town, Este, in the Veneto. They were lords of Ferrara virtually without interruption from the late 12th century until 1598, when, with the death of **Alfonso II d'Este** (ruled 1559–97) the duchy devolved to direct papal sovereignty, and some of its greatest art treasures, paintings by *Titian executed for **Alfonso I** (ruled 1505–34) were carried off to Rome (*see also under* Aldobrandini). After 1598 the Este moved their residence to Modena, under their dominion since 1288, which, together with Reggio Emilia, they held until the 19th century. Like other Italian princelings, the early Este were in effect mercenary captains; holding the balance of power on the peninsula, they became from the end of the 14th century notable patrons of letters, music, architecture and painting. **Leonello d'Este** (ruled 1441–50), pupil and patron of the famous humanist Guarino, employed *Alberti, Jacopo *Bellini, *Mantegna, *Piero della Francesca and *Pisanello, and commissioned pictures from Rogier van der *Weyden. His brother and successor **Borso d'Este** (ruled 1450–1471) made *Tura his chief court painter, and employed him, *Cossa, and Ercole de' *Roberti on the *frescos of the Palazzo Schifanoia. His successor and half-brother, **Ercole I d'Este** (ruled 1471–1505) is chiefly remembered for the model civic project of the *addizione Erculea*, designed by the Ferrarese architect Biagio Rossetti (*c.*1447–1516). Ercole's

daughter **Isabella d'Este** (1474–1539), from 1490 wife of Francesco *Gonzaga, Marquess of Mantua, became one of the greatest women patrons and collectors of all time. She secured paintings from Mantegna, *Perugino, *Costa and *Correggio for her private *studiolo*; *Leonardo da Vinci drew a portrait of her, and she was painted also by *Titian (from a portrait of *Francia) and perhaps by *Giulio Romano. With equal avidity she collected ancient gems and sculptures, and commissioned *all'antica* sculpture by *Antico; one of her greatest treasures was the equally antique-seeming *Cupid* by the young *Michelangelo. Many of her views on art and artists are documented in her letters to her sister **Beatrice d'Este** (1475–1497) who in 1491 married Ludovico *Sforza, Duke of Milan. Isabella's patronage, especially her plans for a *studiolo*, in turn inspired their younger brother Alfonso I d'Este already mentioned. In addition to Titian, Giovanni *Bellini, the court painter *Dosso and the sculptor Antonio Lombardo (*see under* Pietro Solari) decorated Alfonso's famous private retreat, the *studiolo* or *camerino* in the castle of Ferrara.

In the next century, the Este continued their collections in Modena; these are now housed in the city's Galleria Estense, along with items, notably small bronzes, salvaged from Ferrara. **Francesco I d'Este**, Duke of Modena from 1629 to 1658, commissioned portraits from *Velázquez while in Madrid in 1638 and, on the basis of painted likenesses, from *Bernini. In 1774, however, **Francesco III** sold a hundred of the best paintings in his collection to Augustus III of Saxony for his famous gallery at Dresden.

Estes, Richard (1936–) American painter who in the 1960s became known as one of the best *Photorealist or *Superrealist painters. Characteristic paintings are synthetic compositions derived from photographs, often of shop fronts, exploring the rich visual world of reflective surfaces, and external and internal spaces.

estofado *See under encarnado.*

etching *See under* intaglio prints.

Etty, William (1787–1849) British painter who, born to pious Methodists of York, was quoted as saying that 'as all human beauty was concentrated in woman, he would dedicate himself to paint her'. He had little education and a late start, working for a printer and becoming a student at the Royal *Academy Schools at the age of twenty. He studied hard, and continued to use the Schools' life room throughout his career, making painted studies (where pencil or crayon drawings were the norm) and developing a system of working up the figure rapidly from an outline to the emphatically pneumatic representation he sought. Wishing to shine as a *History painter, he chose subjects from the bible and the great poets that required prominent female nudes. Much encouraged by finding his *Pandora Crowned by the Seasons* bought by *Lawrence, president of the RA, he aimed high, spending 1822–4 in Italy, studying Venetian painting especially, and returning to tackle subjects already honoured by *Titian and *Veronese. He was, it appears, a clean-living man who never married but is said to have fallen in love with many a model, and respectful of women, but his picturing of them was openly voluptuous and met with disapproval from Victorians who welcomed similar subjects when painted by Italian Old Masters, not least, perhaps, because they would have darkened with time whereas Etty's work glowed with fresh colour. He had a reputation as a colourist in his day: in fact, he used colours firmly but without subtlety or originality. Similarly, there was nothing remarkable about his stagecraft as a painter, and his women tended to be the same version of Woman throughout, youthful and firm-bodied but of limited character. Everything else in his paintings he treated more broadly. Having worked in London, he returned to York in 1848, visiting London in 1849 when a large Etty retrospective exhibition was shown at the Society of Arts.

Euston Road School London painting school opened by *Coldstream, *Pasmore, Graham Bell and Claude Rogers in 1937 to foster a form of *naturalism, socially supportive and anti-élitist, but also

sensitive in manner and tending to ordered simplification. It closed when war intervened, but its influence was long-lived.

Everdingen, Caesar Boëtius van (1606–78) and his now-better-known younger brother, **Allart** (1621–75) Dutch painters. Atypically, Caesar Boëtius specialized in *classicizing allegorical and history paintings (*see under* genres). He was one of the nine Dutch painters active, alongside Flemish artists, in the courtly decoration of the Oranjezaal in the palace of Huis ten Bosch outside The Hague (*see also*, e.g. Jan Lievens, Honthorst, Jordaens, Thulden). Allart was a landscape painter, influenced by his probable teachers, Roelant *Savery and Pieter *Molijn, and, after 1644–5, by his voyage in Scandinavia. On his return to Haarlem he began to specialize in scenes of rocky mountains, fir forests, log cabins and waterfalls. After his move to Amsterdam in the 1650s this romantic repertoire affected the greater painter Jacob van *Ruisdael. There are works by the younger Everdingen in London, National; Leningrad, Hermitage; as well as in galleries in Holland, Germany and Denmark.

Evergood, Philip (1901–73) American painter, sent to Eton and to Cambridge by his parents, yet drawn to art. He studied in London, New York and Paris. He returned to New York in 1926 and had his first one-man show there in 1927. In 1929–31 he was again in Europe, impressed especially by El *Greco. Back in the USA he worked during 1934–8 for the *Federal Art Project painting murals in a *realistic style and with progressive social implications. His later work is more lyrical and fantastic. His talent lay principally in his disposition of line and linear forms, but in the 1950s and after he attempted also to enhance the painterly quality of his pictures.

Evesham, Epiphanius (1570–after 1633) English sculptor and painter. From 1601 to *c.*1614 he was working in Paris, although none of his works there has survived. After his return to England he made a number of distinctive tombs (signed tomb of Lord Teynham, Lynsted, Kent, *c.*1622). *Vertue called him 'that most exquisite artist'.

Eworth, Hans (active 1540–73) A native of Antwerp, he is recorded in London, 1549–73, painting mainly portraits but also mythological figures and *allegories. His style progressed from a robust *realism to ornate Elizabethan stylization. Eworth was employed by Mary Tudor (portrait, *c.*1553, Cambridge, Fitzwilliam) and later by her successor, Elizabeth I, of whom he painted the allegorical *Queen Elizabeth confounding Juno, Minerva and Venus* in 1569 (Windsor Castle). One of his best-known pictures is the allegorical portrait of Sir John Luttrell (1550, London, Courtauld).

Expression, Expressionism, Expressivity (for Expressionism as a 20th-century style, *see* next entry) A complex topic in art, expression always aims to arouse emotion in the viewer. It may do so by depicting emotion, that is, by portraying figures displaying emotions appropriate to a given situation or narrative. In Italian *Renaissance art theory, the 'motions of the soul as shown through the motions of the body' are called *affetti*. The viewer is intended to react to the portrayed *affetti* as he would to the attitudes of actors in the theatre. Then again, artists may strive to arouse emotions in the viewer not through the depiction of emotional states, but through a representation of e.g. natural phenomena which normally evoke an emotional response, such as a storm, a moonlit night, etc. Such responses are generally culturally conditioned (a sunny sky may not evoke similar emotional states in a desert Bedu and a Laplander) and the viewer's emotional response may, or may not, accord with the artist's expectations, depending on whether they share the same cultural set. Given cultural preconditioning, emotional arousal may be effected, as in music, by less concrete representational means. Thus certain ranges or combinations of colours may, or may be thought to, evoke certain ranges of emotions: 'cool' colours such as

blues, greys, greens, may calm or sadden, while 'hot' colours such as reds, oranges, yellows, may evoke joy or rage. Analogous effects may result from lines or shapes independent of colour. Even more problematic is the question of the artist's state of mind. A *Romantic definition of art supposes that the work of art allows direct access to the artist's emotions. It is improbable, however, that a painting or sculpture requiring months, even years, of work, and perhaps the intervention of assistants, should in this sense express a single predominant emotion, such as tenderness or anguish etc. A modified and more acceptable version of the Romantic theory of art describes the artist as his own first, and ideal, audience. He seeks, through various artistic strategies, to arouse *in himself* a given emotional response.

Expressionism Term applied first to the French painting that followed *Impressionism and *Post-Impressionism, then also to art produced outside France that rejected Impressionism's *naturalism, and then more specifically to such art in Central Europe and the new writing and music (subsequently also architecture and film) there. The word itself was not wholly new; in any case it proposed itself to anyone needing a term that implied anti-Impressionism. When recent Paris paintings (*Fauves, *Derain, *Braque, *Picasso) were shown in Germany in 1911 they were labelled Expressionism and critics wrote about the artists as Expressionists. The first *Sturm Gallery exhibition presented as Expressionist similar works from Paris and others by *Hodler, *Kokoschka and *Munch. Hermann Bahr's book of 1916, about recent German-language literature, was entitled *Expressionismus*, and *Walden used the same title for his 1918 polemical book on a wide range of recent art.

Expressionism, then and now, implied many things. It referred to in-turned art, drawing on the visible world but also going behind it to display the essence of experience in *abstracted formulations. Where *realistic and *naturalistic tendencies, including the academic tradition of idealised naturalism, seemed concerned with the material world, Expressionism presented itself as focusing on the spiritual, on the soul as well as on personal emotions. It has also been associated with protest – against conventions in the arts, especially those relating to taste and propriety, against moral conventions, against the class-ridden formalities of Wilhelmine Germany, against political systems created in defence of wealth and commerce.

In art, the history of Expressionism is dominated by two groups, the *Brücke group in Dresden, formed in 1905, and the *Blaue Reiter group in Munich, 1911. They span a wide range and exhibit profound differences. Where the Brücke artists used distortion to signal tensions in the artist and sharpen viewers' responses, Blaue Reiter artists typically wished to involve us in a more meditative communication. Whereas some of the Brücke artists wished to be seen as 20th-century Germans developing a truly German art in a country too long dominated by French values and manner, the Blaue Reiter circle was of its nature international, and viewed art in global, even eternal terms. Few artists found the label satisfactory. Kokoschka both rejected it and claimed to be the only true Expressionist. None wished to have his or her individuality submerged in group coherence, though the Brücke men, in their first years, were a close community. It is best to see Expressionist art as representing a cluster of trends, with each practitioner as a distinct contributor. As Expressionism met with public acceptance, its diversity became more marked. At first it drew the attention of a few supportive critics, collectors and museum directors while others campaigned against it; after 1918 it was seen as the essential modern art of Central Europe, and could claim a second generation of adherents in *Beckmann and others. Yet by this time it was under attack from the artistic left as well as from conservatives: the *Dadaists resented it as a bourgeois art form, stained with the blood of a war and invalidated by its lack of a clear, progressive political aim. *Abstract-Expressionism and its European counterparts, *Art informel etc., echoed some of its aims and methods. More recently,

Neo-Expressionism has appeared in, especially, German art, some of it repeating Expressionism's metropolitan themes and pathetic gestures.

Exter, Aleksandra *See* Ekster.

ex-voto Latin 'in accordance with a vow'. The word is normally applied to a painted image or three-dimensional figure, or object, made as an offering to God or a saint in gratitude for a personal favour or grace, or in the hope of receiving one; a church building erected for the same purpose is usually called 'votive'. Although most surviving ex-votos are examples of folk rather than 'high' art, much church plate, and some famous pictures from the *Renaissance onwards, were made as ex-votos – such as *Titian's paintings giving thanks for Jacopo Pesaro's victories against the Turks (Antwerp, Musées Royaux; Venice, Frari) or Philippe de *Champaigne's famous double portrait, inscribed as an ex-voto, for the cure of his daughter, a nun at Port Royal (Paris, Louvre).

Eyck, Jan van (active 1432–41) Netherlandish painter, internationally celebrated in his own lifetime and since as the 'inventor of oil painting'. This is not literally true, but there is no doubt that Jan – and perhaps his shadowy elder brother Hubrecht (*see below*) – brought oil painting to a dazzling degree of proficiency in the depiction of optical phenomena. Working on panel with glazes (*see under* colour), Van Eyck was able to portray a seemingly infinite variety of textures and light effects. Although he never mastered convincing linear *perspective, he evolved aerial or colour perspective, and was precocious also in achieving unity of lighting, whether in an interior (*Arnolfini Marriage*, 1434, London, National) or in an expansive landscape (*polyptych of the *Adoration of the Lamb*, 1432, Ghent, St Bavo). Despite the fact that he painted with the meticulous precision of a miniaturist, and may have begun his career as an illuminator of manuscripts (pages of *Turin Book of Hours*, *c*.1417, Turin, Museo) Van Eyck did not invariably paint small: some of the figures in the Ghent polyptych are represented on the scale of life. On whatever scale, however, it is to the convincing portrayal of the natural world, rather than to decorative or *expressive ends, that the art of Van Eyck was directed – albeit within a system of symbolism and a scale of values dictated by the church and the courtly circles who were his main employers (e.g. *The Virgin in the Church*, Berlin, Staatliche; *The Annunciation*, Washington, National; *Virgin and Child with the Chancellor Rolin*, Paris, Louvre; *Virgin and Child with Saints and a Carthusian*, New York, Frick; *Virgin and Child with Saints and Canon van der Paele*, Bruges, Musée).

Jan van Eyck's career as a painter and courtier is well documented. From 1422–4 he served John of Bavaria at The Hague. At the end of his employment he went to Bruges, but in 1425 moved to Lille, to take up his appointment as court painter and *valet de chambre* to Philip the Good, Duke of Burgundy, for whom he was also to undertake several secret diplomatic missions. Around 1430, however, he was allowed to continue as court painter – a post he was to hold in all for 16 years – while residing at Bruges and working as an ordinary master painter. It is then that he was able to paint the double portrait of the Italian merchant from Lucca, Giovanni Arnolfini, and his wife, Giovanna Cenami (*see above*), signing his name beside the mirror which reflects them and him. Quite probably, this device inspired the construction of *Velázquez's *Las Meninas* (1656), in which a mirror plays a similar role, since Van Eyck's picture was then in the Spanish royal collection. Also from the 1430s are the inscribed and dated portraits in the National, London (*Leal Souvenir*, 1432; *Man in a Turban*, perhaps a self-portrait, 1433).

Matters are quite otherwise with regard to **Hubrecht**, or **Hubert, van Eyck**. An inscription, which may be a later addition, on the frame of the Ghent polyptych identifies it as the work of Hubrecht, completed after his death by his brother Jan. If there was such a person, he is thought – from a now-lost epitaph – to have died in 1426. Attempts to differentiate the brothers' hands, and establish a body of work for Hubrecht, have not proved convincing.

Although Van Eyck's influence was incalculable, and he is in a sense the fountainhead of all naturalism (*see under* realism) in European art, his direct influence was not widespread. Petrus *Christus was his immediate follower in Bruges and may have completed a picture of his. Dieric *Bouts borrowed certain decorative elements of his style. In general, however, his example proved both too difficult and too dispassionate, and Netherlandish art moved into a more linear and more overtly emotional mode with the work of Rogier van der *Weyden.

F

Fabriano, Gentile da *See* Gentile da Fabriano.

Fabritius, Carel (1622–54) *Rembrandt's most gifted and original pupil, *c*.1641–*c*.3, the initiator of the Delft school of painting *c*.1650, and the major link between Rembrandt and the greatest Delft painter, *Vermeer. He was killed in the explosion of the Delft gunpowder magazine which destroyed a large part of the city. Fewer than a dozen paintings can be attributed securely to him. After one essay in dramatic narrative (*The Raising of Lazarus*, 1643/5, Warsaw, Muzeum) he devoted the rest of his life to portraits and figure studies (*Self-Portrait*, *c*.1645/50, Rotterdam, Boijmans Van Beuningen); *genre (*The Goldfinch*, 1654, The Hague, Mauritshuis) and *perspective scenes (*View of Delft*, 1652, London, National). Fabritius favoured Rembrandt's use of heavy, pasty paint juxtaposed with thin glazes (*see under* colour), but he replaced his teacher's warm brown tonality with cool daylight hues, and reversed Rembrandt's use of *chiaroscuro, preferring to silhouette a dark figure against a light ground.

His younger brother, **Barent** or **Barend Fabritius** (1624–73), may have studied with Rembrandt *c*.1650. His best-known work, *Self-Portrait as a Shepherd*, 1658 (Vienna, Akademie) employs his brother's style.

Fahlstrom, Oyvind (1928–76) Swedish painter, born in Brazil. He lived in Sweden from 1939, and from 1961 divided his time between New York and Stockholm. Self-taught, he began in 1952 to make composite narrative paintings and, from 1962 on, variable pictures inviting observer participation. His style was close to comic strips; his imagery hints at politics and daily life, but meaning is screened by inconsequentiality. His work was shown at the Venice Biennales of 1964 and 1966 and in a number of one-man and mixed shows, notably in New York.

Faithorne, William (1616?–91) The outstanding English portrait-engraver (*see under* intaglio) of the 17th century, born in London. He was in France during the Commonwealth and is said to have studied with *Nanteuil.

Falcone, Aniello (1607–56) Neapolitan painter, celebrated internationally above all for his battle scenes (e.g. Naples, Capodimonte; Paris, Louvre), although he also executed *frescos (Naples, S. Paolo Maggiore, Sant'Agata Chapel; Gesù Nuovo, sacristy; Barra, Villa Bisignano) and historical subjects other than battles (Madrid, Prado). He was the pupil of *Ribera and the teacher of *Andrea di Lione and Salvator *Rosa.

Falconet, Etienne-Maurice (1716–91) Individualistic, temperamental French sculptor and writer on art, a pupil of Jean-Baptiste *Lemoyne (*see also* Pigalle). Like his teacher, Falconet never went to Italy, arguing for the superiority of modern over ancient sculpture, and modelling himself on *Puget – whose *Milo of Crotona* he was accused of plagiarizing in his first Salon piece, a plaster of the same subject (1745; marble version, 1754, both Paris, Louvre). Slow to make his mark at the *Academy, and never receiving a major French crown commission, Falconet was first patronized by Mme de Pompadour (e.g. *Music*; *Cupid*, 1757, both Louvre), then other rich bourgeois, for whom he evolved a type of highly finished small-scale statuary, usually of the female nude, comparable in its erotic charm to the paintings of *Boucher (e.g. *Baigneuse* 1757, plaster, Leningrad, Hermitage; marble, Louvre). Such work gained him, from 1757, the effective directorship of the Sèvres factory, where his figures were adapted for duplication in porcelain. More to his inclination were the large-scale sculptures he executed for Parisian churches (St Roch, Invalides) of which little survives. Finally, in 1766 he unexpectedly gained the chance of working on a statue

commensurate with his talent and ambition: an equestrian *Monument to Peter the Great* (unveiled 1782, St Petersburg). The rearing bronze horse, with its calm rider in 'timeless' clothes stretching out his hand to protect his city, rises on a great jagged granite outcrop. Peter's head was the work of Falconet's devoted pupil, assistant and daughter-in-law, **Marie-Anne Collot**, a portrait sculptor whose bust of Falconet, *c*.1768, is now in Nancy, Musée. Falconet left Russia in 1778, after which he executed no more sculpture, perhaps through encroaching blindness. In 1783 he suffered a paralytic stroke. While the monument to Peter the Great exercised no direct influence in France, where Falconet continued to be known as the author of *Rococo figurines (e.g. London, Wallace), it remains one of the greatest sculptural works of the century, at once the culmination of *Baroque equestrian monuments and, in its naturalism (*see under* realism) and its characterization of Peter as a beneficent prince-philosopher, an embodiment of the Enlightenment and a precursor of *Romanticism.

Falk, Robert (1888–1958) Russian painter, born and trained in Moscow. On the art board of the Commissariat of Enlightenment 1918–21, he taught until 1928 at the new art workshops. His work was influenced by *Expressionism, but remained close to natural appearances, and from 1925 to 1928 he was a member of the group promoting *naturalistic art dedicated to celebrating Soviet life and achievements (*AKhRR). He was in France 1928–38 and in Soviet Central Asia until 1944 when he returned to Moscow. A retrospective in Moscow in 1966 established him posthumously as a major Soviet painter.

Fancelli, Domenico di Alessandro (1469–1518) Florentine sculptor, probably a pupil of *Mino da Fiesole. His importance consists of introducing Italian *Renaissance forms to funerary monuments in Spain, where he is recorded sporadically from 1510, arriving to install tombs commissioned from him and executed in Italy (Seville, Cathedral; Avila, Santo Tomás; Granada, Royal Chapel).

Fancy Picture A term first given in 18th-century England to a new type of painting inspired by 17th-century *genre and the more recent French *fête galante. They may have been designed originally to make money by the engraving rather than as paintings. 'Fancy Pictures' may have something in common with the *Conversation Piece – that is, they may represent informal groupings of figures as well as a single figure picturesquely dressed and posed – but they are not portraits. Unlike the *fête galante* and the Conversation Piece, 'Fancy Pictures' may be either large or small in scale. Some of the most famous were painted by *Gainsborough (*Girl with Pigs*, Castle Howard; *Girl with Faggots*, Manchester, Gallery) but credit for creating the genre in Britain is usually given to *Mercier.

Fantastic Realism Tendency developed into a national school in Austria after the Second World War and associated with fantastic and *Surrealistic images presented in minute detail.

Fantin-Latour, Henri (1836–1904) French painter and print maker, best known today for his luminous flower paintings which were ardently collected by the English and which sustained him financially. 'In front of those peonies and roses, I think of *Michelangelo!', he said and was, in fact, the creator not only of two famous group portraits, *Homage to *Delacroix* (1864) and *A Studio at Batignolles* (1870; in homage to *Manet; both Paris, Orsay), but also of mythological paintings and *lithographs, many of them taking their subjects and stimulus from music, notably that of Berlioz, Schumann and Wagner. He visited Bayreuth in 1876 to attend Wagner's *Ring* cycle and subsequently based several of his images on this. Partly through his friendship with *Whistler, Fantin made repeated visits to England; in 1864 he guided Rossetti around the artistic sights of Paris. Though he knew some of the *Impressionists well, Fantin's passion for poetic and sometimes fanciful subjects deriving from his own imagination brought him closer to the *Symbolists. In his later years he had

some success as a society portraitist, but his portraits are those of his family and friends, often austere in style but painted with great delicacy.

Fantuzzi, Antonio (recorded 1537 to 1550) Bolognese painter and etcher (*see under* intaglio), whose primary importance is for art in France. He worked in Bologna for *Parmigianino, making chiaroscuro prints (*see under* relief prints) from the latter's designs. From 1537 to 1550 he is recorded at Fontainebleau as an aide to *Primaticcio, designing *grotesque ornaments for the ceiling of the Galerie d'Ulysse. Between 1542 and 1545 he executed numerous etchings, among the first in France, at first reproducing designs by *Giulio Romano and *Rosso, later those of Primaticcio; he also reproduced ancient statuary. His prints are an important source for our knowledge of many of the vanished decorations at Fontainebleau.

Farington, Joseph (1747–1821) English landscape painter and topographical draftsman. He is chiefly remembered, however, for his diaries, compiled from 1793 until the year of his death, which provide a detailed history of the contemporary English art world (most of original manuscript, Windsor, Royal Library; publication of the full text completed in 1999).

Farnese Illustrious Italian family originating from Farneto near the lake of Bolsena; they rose to notable importance as patrons of art and architecture in 1534 with the election of Cardinal Alessandro I Farnese (1468–1549) to the papacy, taking the name Paul III. The Pope is particularly remembered for his patronage of *Michelangelo as painter and architect; it is to him that we owe not only the *Last Judgment* in the Sistine Chapel, and the seldom seen *frescos in the Pauline Chapel in the Vatican, but also Michelangelo's designs for St Peter's, the systematization of the Capitoline Hill, and the Palazzo Farnese, begun by Antonio da *Sangallo the Younger. Paul III was, however, also the patron of *Perino del Vaga and Pellegrino

*Tibaldi in the great *Mannerist decorations of the Pauline apartments of the Castel Sant'Angelo in Rome. The Pope's 'nephew' – actually the son of his son Pier Luigi – Cardinal Alessandro II Farnese (1520–89) was the greatest patron of his day. He was instrumental in bringing *Titian to Rome (and is recorded by him in several portraits, including the famous triple likeness with his grandfather, Paul III, and his brother Ottavio (1521–86), now in Naples, Capodimonte). He encouraged *Vasari to write the *Lives of the Artists*, and commissioned his great decoration in the Palazzo della Cancelleria, Rome: the Sala dei Cento Giorni. His fortress/palace at Caprarola was painted with frescos by Taddeo and Federico *Zuccaro and other outstanding *Mannerist artists. Cardinal-Protector of the Jesuits, he paid for their church of the Gesú by Vignola. He collected many of the ancient works of sculpture now in Naples (*see below*). He, and his brother Cardinal Ranuccio Farnese (1530–65), employed *Salviati and *Daniele da Volterra to decorate rooms in the Palazzo Farnese in Rome, although the greatest paintings in that impressive palace are the mythological ceiling frescoes by Annibale and Agostino *Carracci, brought to Rome by Alessandro II's great-nephew, Cardinal Odoardo Farnese (1573–1626), who had previously employed them in the Farnese palace at Parma.

Elisabetta Farnese (1692–1766) became the wife of the Bourbon King of Spain, Philip V. Through this connection, their son, Charles III, brought the majority of the Farnese collections to Naples, where they remain today.

Farnese Bull Ancient marble sculptural group, representing the myth of the punishment of Dirce, tied to the horns of a wild bull by her stepsons, to be trampled to death for her bad treatment of their mother, whom she had succeeded as wife of the King of Thebes. Like the *Farnese Hercules*, it was excavated in the Baths of Caracalla (1545), and taken to the Palazzo Farnese, where in 1550 it was partially restored on the advice of *Michelangelo. Federico *Zuccaro described it as a 'marvellous

mountain of marble' and as remarkable as the *Laocoön, but doubts about its quality were expressed with increasing frequency from the late 16th-century, although because of its size and complexity it continued to be one of the most famous pieces of sculpture in the world.

Farnese Hercules Gigantic ancient marble statue of Hercules leaning on his club. It is signed by an Athenian sculptor, Glycon. Enormously admired from its discovery in the Baths of Caracalla in Rome in 1546 until the end of the 19th century, it was copied in every medium and on every scale. A print by *Goltzius records that it was drawn and engraved almost as much from the back as the front. It remained displayed in the first courtyard of the Palazzo Farnese until 1787 before being sent to Naples (now in Museo Nazionale). *See also Farnese Bull.*

Fattori, Giovanni (1825–1908) Italian painter, leader of the *Macchiaioli group. From the first a *realistic painter, he developed during the 1860s (when the *Impressionist style was beginning to form) a concentrated mode of representing people and moments within actions by means of bold silhouettes and summary contrasts of tone and colour. There is something filmic about those of his scenes that imply narrative, and his art is thought to have influenced the vision of 'spaghetti' westerns. He also painted some fine portraits, and he stimulated the work of younger artists through his teaching, in Florence, during the 1880s.

Fautrier, Jean (1898–1964) French painter, briefly trained in London and Paris. *Lithographs he made in 1928 as images for Dante's *Inferno* have been seen as heralding *Art informel, a claim strengthened by his *Hostages* paintings in 1943, *abstract and done in thick *impasto as symbols of war and victimization. In 1957 he had a retrospective in Paris and in 1960 he won the main painting prize at the Venice Biennale.

Fauvism Term derived from a pejorative criticism, in which a pleasing sculpture

shown in the same part of the Paris 1905 Salon d'Automne as certain paintings was described as a *Donatello 'parmis les fauves' (among the wild beasts). The paintings were by *Matisse, *Derain, *Marquet, *Vlaminck and others; the same critic saw in them an 'orgy of pure colours'. 'Pure' here meant used for their own sake, not in their traditional descriptive role; 'orgy' implied that the painters were out of control. The Fauves (as they were soon known) did tend to use vivid hues, influenced by *Neo-Impressionism and by Van *Gogh's and *Gauguin's expressive colours; some of them used brushstrokes in an apparently haphazard way, breaking up colour areas and thus also what they were representing. Fauvism can be seen as a French precursor to *Expressionism, but never claimed its fervour. Its subject matter ranged from portraits to landscapes and images of perfect happiness, the Golden Age of ancient myth. Matisse, *Rouault, Marquet and *Manguin had met in the studio of *Moreau; Derain met Matisse in 1898 and introduced him to Vlaminck in 1901. Others – *Friesz, *Braque and *Dufy – came into the circle from Le Havre. The result was a loose association, with Matisse, Derain and perhaps Vlaminck as the dominant figures. After 1907, the prominence of *Cézanne and then of *Cubism denied Fauvism its temporary place as the most radical trend in French art, but meanwhile foreign painters visiting Paris had come under its influence, notably Poles and Russians; art from Paris, collected and exhibited abroad (especially in Berlin and Moscow) made a direct impact on local artists. The general message of Fauvism was taken to be that modern painting would be barbarous, a *primitive mode refuting proprieties. This was a misunderstanding, but had its basis in fact. For example, Matisse, Derain and Vlaminck admired and owned African masks from about 1904. Later, Matisse described his Fauvist work as alien to his true nature.

fecit Often abbreviated to *f.* or *fec.* Latin for 's/he made it'. Formerly often written on a work of art after the artist's signature to indicate authorship. Sculptors or engravers (*see under* intaglio) used

sculpsit, or its abbreviations, meaning 's/he carved – or cut, chiselled – it'; engravers also used *incidit* or its various abbreviations and derivations, from the verb meaning 'to cut'. On prints, the name of the executant was often differentiated from that of the draftsman or 'inventor' of the design, which would be followed by *invenit, inv.* In the case of *reproductive prints, the name of the painter was usually followed by *pinxit, pinx.*, 's/he painted it'.

Federal Art Projects Programmes sponsored by the US government to aid artists during the depression that followed the New York stock market crash of 1929. In 1933 the painter George Biddle (1885–1973) persuaded President Roosevelt to support a scheme; about the same time the Artists' Union approached Harry Hopkins, director of the Federal Emergency Relief Administration. The Public Works of Art Project resulted. It ended in 1934, having employed nearly 3,750 artists, mostly on representations of American life and landscape. Later that year a fund taking 1% of the monies designated for new federal buildings was set up by the Painting and Sculpture Section of the Treasury Department to commission murals and sculpture through competitions. This scheme ended in July 1943 with over 1000 murals and 300 sculptures. A related scheme, the Treasury Relief Art Project, operated from 1935–9, commissioning smaller works; the score here was 10,000 easel paintings, 89 murals and 43 sculptures. 1935 also saw the institution of the Works Progress Administration's Federal Art Project under Holger Cahill. This was the largest project, and covered music, theatre, films and literature as well as fine art and photography. It sponsored more than 100,000 paintings, 2,500 murals and 2,000,000 posters. In 1939 its name was changed to Art Program of the Works Projects Administration. It closed in 1943, by then renamed the Graphic Section of the War Services Division.

Fedotov, Pavel (1815–1852) Russian painter, first an amateur and member of the Petersburg Corps de Garde encouraged to study at the Academy there with a view to becoming a painter of battle pieces. In the event, his interest turned to *genre painting. Like *Hogarth, whom he took as his model, he created images of contemporary life, mostly of middle- or upper-class society, to moralize about honesty and pretence in human relationships. His work owed something to Dutch 17th-century genre painting and to Russian book illustration, in his day attaining a new vividness to accompany a new type of questioning and critical fiction. Fedotov himself did some illustrations, notably for Dostoevsky's early books. In 1844 he left the army to devote himself fully to art and his vein of social criticism became more marked. His work was often in the form of suites of drawings with a marked caricature element; from 1846 on he worked primarily in oils and found his work praised and collected. After 1848, which brought news of revolutions in the West and repressive measures in Russia, he experienced harassment from the censor on account of his friends as much as for his portrayal of Russian *mores*. His work became more fervent in content and at times *classical in manner. His example was important to the *Wanderers. He died young, after psychological crises that finally removed him to an asylum. His work is best seen in the Tretyakov Museum in Moscow.

Feininger, Lyonel (1871–1956) American-German painter, born in New York, who went to Germany in 1887 to study music, but in fact studied art in Hamburg and at the Berlin Academy. Money earned from drawing cartoons took him to Paris for six months in 1892 and for two years during 1906–8. In 1907 he began to paint, under the impact of *Post-Impressionism. On a third visit to Paris, in 1911, he met Robert *Delaunay and saw the *Cubist paintings at the Salon des Indépendants. In 1913 he exhibited with the *Blaue Reiter group in the *Sturm Gallery, Berlin. He had a one-man show there in 1917. In 1918 he joined the *Novembergruppe and got to know the architect Gropius who asked him to join the *Bauhaus faculty. Feininger's woodcut, *The Cathedral of Socialism*, was used for the opening Bauhaus proclamation in

1919. Until 1925 he was one of the Weimar school's Form Masters, concerned principally with prints and printing; in 1923, when Gropius gave priority to industrial work, he ceased to teach regularly. In 1926 he was given a non-teaching post which he held until the Dessau school closed in 1932. In 1937 he moved to New York.

Elements of Cubism combine with mannerisms taken from his caricatures in his early paintings of slightly grotesque town scenes and figures. The fantasy element never quite left his art, but more patent was his development of Cubism's transparent planes into a gently *Expressionist mode, close in spirit to the landscape painting of German *Romanticism. His subjects were frequently medieval towns and villages and their churches. Boats at sea sometimes provided motifs for similar compositions in which planes of light cluster and expand to convey a sense of marvel and piety.

During the 1920s he exhibited in Germany, the USA and Mexico with *Klee, *Kandinsky and *Yavlensky. In 1931 he had a large retrospective at the Nationalgalerie in Berlin and one-man shows in Hanover, Leipzig and Hamburg in 1932. In America he had many exhibitions and gained several distinctions.

Feinmalerei German for Fijnschilder. *See under* Dou, Gerrit.

Feitelson, Lorser (1898–1978) American painter, who grew up in New York where museums and the *Armory Show involved him in art. By the age of eighteen, largely self-taught, he was a figure in the New York art world, but it was in Los Angeles, where he settled in 1927 after visits to Paris, that he became a leading artist. In his early work he fused *Renaissance idioms with elements of *Cubism; then *Surrealism held him for a while. But it was through setting colours and tone in contrast and exploiting tensions between positive and negative forms, that he made his international name as a *hardedge painter.

Feke, Robert (*c*.1705–*c*.50) Portrait painter, recorded in Boston, Newport and Philadelphia. He may have been born on Long Island, which would make him the first native American artist of major significance. His *Royall Family* group (1741; Cambridge, MA; Harvard Law School) paraphrases *Smibert's *Bermuda Group*; his later works, however, although indebted to engravings of English portraits, achieve an elegant and monumental style of his own.

Félibien, André (1619–95) French architect and man of letters. Between 1647 and 1649 he was secretary to the French Ambassador in Rome, where he came to know *Poussin very well. Poussin's biography in Félibien's five-volume Lives of the Painters, *Entretiens sur les vies et sur les ouvrages des plus excellens peintres anciens et modernes*, 1668–88, is our best source for the life, works and views of this artist, although Félibien somewhat exaggerates Poussin's *classical bias. As secretary to the French *Academy, Félibien wrote the Introduction to the 1669 publication of the lectures delivered before the Academy in 1667. In this important text, he set out the clearest exposition of the academic hierarchy of the *genres. His views, however, are generally more liberal than the academic doctrines propounded under the Directorship of *Lebrun, allowing greater importance to the imagination, and recognizing the merits of the Venetian and Flemish schools.

Felixmüller, Conrad (1897–1977) German painter, born and trained in Dresden, and from 1915 a political activist, making drawings and woodcuts for socialist periodicals such as *Die Aktion* and for left-inclined art journals such as *Der *Sturm*. These images were in the strident idiom of Die *Brücke. In 1919 he joined *Dix and others in founding a Dresden *Sezession group while also joining the Communist Party and the Berlin *Novembergruppe. Winning the Rome Prize of Saxony in 1920, he chose to spend it by working in the industrial Ruhr Gebiet. He travelled in Switzerland, France and Belgium and had several exhibitions, in Germany and abroad, until 1933 and the Nazi era. That year his work was shown in Dresden as examples of decadence; in 1937

he was well represented in the touring exhibition *Degenerate Art and more than 150 of his works were confiscated. He tried, and failed, to elude oppression by leaving Berlin, where he had settled in 1934. In the last year of the war he fought and was captured in Russia. From then on his works, paintings and graphics, were exhibited widely, notably in East Germany. In 1949 he became professor at the Luther University in Halle, until 1962 when he retired and returned to Berlin. From the early 1920s on his work was *realistic in a manner close to some of those artists who in 1925 were presented as *Neue Sachlichkeit: it still had an *Expressionist sharpness of form and colour but used distortion moderately to convey the appearance of people and their settings, though sometimes he used a more visionary, *Grosz-like, synthetic idiom. His later paintings are more descriptive than declamatory. In 1974 he was awarded a gold medal at the Florence Graphic Art Biennale.

Female Half-Lengths, Master of the (active second quarter 16th century) Netherlandish painter, probably active in Antwerp, influenced by *Patenier. He is named after a *Concert of Three Female Figures* now in Austria, Rohrau, Harrach Coll.; a large number of paintings of varying quality are associated with him (London, National).

Ferber, Herbert (1906–91) American sculptor, also dentist. He studied dentistry at Columbia University in 1927–30 and attended evening classes in art. A visit to Europe made him aware of *Expressionism and the work of *Barlach, and he carved symbolic and expressive figures in wood and stone which gradually became more spatial through the influence of *Moore. In the 1940s he began to construct metal sculptures, soon wholly *abstract, welding steel rods and sheet into dramatic, spiky forms and building up their surfaces with molten metal; this work was seen as a sculptural development within *Abstract Expressionism. He received commissions for sculptures in and on religious buildings, and, in 1969, for the John F. Kennedy Federal Office Building, Boston. Retro-

spective were shown at Bennington College (1958), New York (1961), San Francisco (1962) and touring from the Walker Art Centre, Minneapolis (1962–3).

Fergusson, John Duncan (1874–1961) British painter, trained first in medicine, self-taught as painter though he visited Paris repeatedly in the 1890s and spent some time at the Académie Colarossi. His work became known through exhibitions on both sides of the Channel. From the idiom of *Whistler and *Impressionism he moved on to *Fauvism, but used emphatic outlines, curves and volumes, often in celebration of the female nude. One such, *Rhythm* (1911; University of Stirling) provided the name for a magazine launched by John Middleton Murry and Katherine Mansfield in 1911; Fergusson was its art editor. After the First World War he lived and worked in France and Britain, and was prominent in the art world of Scotland, becoming President of the New Scottish Group in 1940. A retrospective was shown in Glasgow in 1948; another in London in 1964. A centenary exhibition was shown in London, Glasgow and Edinburgh in 1974. A substantial group of his works is at the University of Stirling.

Fernandes, Vasco (c.1475–1542) Outstanding painter, active at and around Viseu in north-central Portugal during the reign of Manuel I (*see also* Manueline style). He is often referred to as 'Grão Vasco', 'Great Vasco'. His work is much influenced by Netherlandish artists. The style of the five surviving panels from Lamego Cathedral (now Lamego, Museum) painted during 1506–11 recalls that of Rogier van der *Weyden; by 1520–35, Fernandes seems to have become familiar with prints by *Lucas van Leyden (Coimbra, Santa Cruz; Viseu, Grão Vasco Museu). *Renaissance and *Mannerist influences, in particular that of *Metsys, are integrated in the great works of his last period, 1535 to 1541, from the cathedral at Viseu (of which the most striking is the panel of *St Peter*, Viseu, museum).

Fernández, Alejo (c.1475–1545) Lyrical Spanish painter, of German or

Flemish extraction and influenced by Netherlandish art, notably that of *Metsys and the Antwerp *Mannerists. He was the leading painter in Seville after his arrival there from Cordova in 1508 (Seville, Cathedral).

Fernández, Gregorio (1576–1636) Spanish *Baroque sculptor active mainly at Vallodolid, where he may have studied with a follower of *Juni; he was also influenced by Pompeo *Leoni. The *naturalism of his life-size wooden statues, made to be carried in procession by religious fraternities during Holy Week, is enhanced by their exceptional *polychromy, of which the *encarnado was done by the leading artists of the city (Vallodolid, Museum; San Martín; Santa Cruz). Less well-known are Fernández's altar carvings, in which sculptures in the round are combined with relief panels of figures in half-section against a painted background (Vitoria, San Miguel; Plasencia, Cathedral; Vallodolid, Las Huelgas).

Ferrari, Gaudenzio (c.1475/80–1546) Northern Italian painter, born in an Alpine valley on the border between Piedmont and Lombardy. Like all the artists of these regions, he was much affected by late *Gothic German art. His important work at the *Sacro Monte of Varallo (c.1517–30, see also Morazzone, Tanzio da Varallo) is in his most Germanic and vernacular mode: the *realism of his painted backdrops and of the terracotta sculptures which he designed gives way to *expressive near-*caricature. Like *Pordenone, however, he was master also of a more polished style, influenced by *Leonardo da Vinci (e.g. *Madonna degli Aranci*, 1529, Vercelli, S. Cristoforo). In 1534 he was called to Saranno to complete a decorative project left unfinished at the death of *Luini: the *illusionistic dome of S. Maria dei Miracoli, which seems to owe nothing to the domes of either Pordenone or *Correggio. After 1535 he settled in Milan, where his style lapsed into a pedestrian Lombard version of Roman *classicism (e.g. Milan, Brera). He was very influential on younger Piedmontese and Milanese artists.

Ferretti, Gian Domenico (1692–1768) Florentine *Rococo painter, the dominant artist in Tuscany from the second quarter of the 18th century. His often dark colours and unstable, dramatic compositions, influenced by Giuseppe Maria *Crespi in Bologna, where Ferretti finished his training to return to Florence in 1719, set him apart from the Florentine followers of *Pietro da Cortona. There are numerous *frescos by him in churches and palaces; among the most notable are the decoration of the Badia, Florence (1734) and of Sts Prospero e Filippo, Pistoia; among rare easel paintings is the *Liberation of St Peter*, Berlin, Staatliche.

Fête galante Untranslatable French term, roughly equivalent to 'outing of polite company'. A new type of painting created in 18th-century France by *Watteau, inspired by Flemish and Italian precedents (notably *Rubens and the more bucolic *fête champêtre* of *Giorgione) and contemporary theatre, the *fête galante* is specifically associated with the *Rococo style. It represents elegant men and women at play in an idealized landscape or park-like setting. They are always depicted in full length and on a small scale, although the actual painting need not be small. While Watteau's followers (*see* Pater, Lancret) trivialized the genre, his own *fêtes galantes* always carry a sense of melancholy, of the transience of love and happiness. Formally, albeit not in spirit, the English 18th-century *Conversation Piece, when set outdoors, may be related to the *fête galante*, and was indeed influenced by engravings after Watteau and his followers. *See also* Fancy Picture.

Fetti, Domenico (c.1588/9–1623) Roman-born painter mainly active at the court of Mantua (1613–21/2). Despite having studied in Rome with a Florentine painter, he was most of all influenced by Venetian art. As court painter, he was forced to execute some large-scale public commissions (e.g. Mantua, cathedral; Palazzo Ducale) but he was most successful and happiest in small *cabinet pictures, to which he devoted himself after his removal to Venice in 1622. He is best known for his

paintings in this manner of 12 of the 30 New Testament parables and two of the sayings of Christ; 10 of these pictures exist in more than one version (e.g. Rome, Capitoline; Florence, Pitti; Bologna, Pinacoteca; Alnwick Castle; Burghley House: Birmingham, Barber; York, Gallery; Dublin, National; New York, Metropolitan). Fetti's warm humanity, lyrical colour and vibrating light transformed the pictorial traditions of Venice into a recognizably 17th-century idiom. He influenced Johann *Liss, and through him, as well as directly, subsequent Venetian painting.

Feuchtmayer, Joseph Anton (1696–1770) Important South German *Rococo sculptor and stucco artist, pupil of his father **Franz Joseph Feuchtmayer** (d.1718), and an effortless inventor of opulent decorative forms, for which many sketches survive. His most important creation is the high altar of the Augustinian monastery church at Beuron, largely destroyed during the 'restoration' of the church in 1874–5 (sketches, Constance, Gemäldegalerie; Munich, Staatlichen Graphischen Sammlung). The pilgrimage church of Neu-Birnau (1746–53) contains his most celebrated figure of a *putto, the 'Honey Licker'.

Feuerbach, Anselm (1829–80) German painter, son of an archaeologist, who became Central Europe's leading *Romantic *classicist. He studied painting in Düsseldorf, Munich and Antwerp; it was Paris during 1851–4, especially working with *Couture, that implanted the ideal of modelling himself on antique and *Renaissance art in combination with *Rubens's and *Delacroix's warmth of movement and colour. In 1854 he took a studio in Karlsruhe but a commission took him to Venice later that year and his interests took him further, via Padua and Florence, to Rome in 1857. He settled there. In his work he aspired to an ideal of Renaissance spirituality; a coolness in his composing and colour schemes makes his work seem a little remote and artificial as though the experiences it embodied, however powerfully staged, were second-hand. Yet at a time when international painting tended to the

expressive use of paints and colours, his work represented commitment to *disegno. It stands out in mixed displays on account of its firmness and monumentality. It invites comparison with the contemporary French classicism of *Puvis.

His paintings may be seen in many Central European museums, most impressively in the Neue Pinakothek, Munich.

Ficherelli, Felice, called **Il Riposo** (c.1605–69) Florentine painter, nicknamed *Il Riposo*, 'rest', 'at ease', because of his retiring nature. He was a pupil of *Jacopo da Empoli, and inherited the latter's talent as a copyist of earlier masters, such as *Perugino, and narrative directness (Florence, S. Spirito; S. Maria Nuova; Certosa). During the 1630s he came under the influence of *Furini and *Bilivert, executing *cabinet pictures intended to arouse conflicting sentiments of fascination and revulsion (Genoa, Michetti Coll.; Rome, Accademia; Florence, del Bravo Coll.; Dublin, National).

Field, Erastus Salisbury (1805–1900) American *primitive painter of Massachusetts, admired for the strong design qualities of his portraits. In New York, in the 1840s, he began work with a camera, using daguerreotypes as the basis for his work. From about 1850 he added *History painting to his range and for the 1876 centennial of the American Revolution produced his most admired work, the *Historical Monument to the American Republic*, an assemblage of visionary towers painted with attention to every architectural detail (Springfield, MA, MFA).

Field, Robert (c.1769–1819) English-born American, Canadian and Jamaican painter, miniaturist and portrait-engraver (*see under* intaglio). Trained as an engraver at the Royal *Academy Schools, he went to the United States in 1794. Until 1800 he worked in Philadelphia, then the new capital of Washington and in Maryland; he moved to Boston in 1805. In 1808 he settled in Halifax, Canada, where he was the leading portraitist until his departure in 1816 for Jamaica.

Fielding, Anthony Vandyke Copley (1787–1855) One of a prolific Yorkshire family of watercolourists. He studied in London under *Varley, worked first in his master's manner and gradually came under the influence also of *Turner, making a name for himself especially as a painter of seascapes. In 1831 he became president of the (Old) Watercolour Society. *Ruskin first saw his work there and Fielding was one of a number of artists who taught Ruskin drawing and watercolour painting in the 1830s and '40s.

figura serpentinata *See under* Michelangelo.

figurative art Art that represents or illustrates any aspects of the visible world, i.e. not necessarily figures, as opposed to *abstract art; an alternative term to 'representational art'.

Fijnschilder *See* Dou, Gerrit.

Filarete (*c.* 1400–69?) Florentine-born architect and sculptor, active mainly in Rome and Milan. His real name was Antonio Averlino. His most important work of sculpture is the bronze door of the main portal of St Peter's, Rome, 1433–45. Although probably trained in *Ghiberti's studio, Filarete modelled his relief style on Early Christian ivories and late antique sculpture, thus executing the first *Renaissance work in which an 'indigenous' Roman style is evident. The only other surviving works of sculpture certainly by Filarete are the equestrian bronze statuette, based on the *classical monument of Marcus Aurelius and cast in Rome, now in Dresden, Albertinum; a signed Processional Cross in Bassano, Cathedral, and a bronze medal self-portrait (London, V&A). He is the author of an interesting *Treatise on Architecture*, which discusses the role of sculpture in architectural programmes.

Filippo Napoletano; Filippo d'Angeli, called (*c.* 1590–1629) Italian painter and printmaker, trained in Naples and active mainly in Florence, where he developed a new kind of realistic *landscape painting,

sometimes on a large scale (Florence, Pitti), which greatly influenced *Callot – who in turn introduced Filippo to engraving (*see under* intaglio) – and *Poelenburgh. His later years were spent in Rome, where his paintings entered most aristocratic collections.

Filla, Emil (1882–1953) Czech painter and sculptor, who studied at the Prague Academy, became known as an *Expressionist painter and during extended studies in Italy, Germany and France became a committed *Cubist. He spent the war years 1914–18 in the neutral Netherlands but was back in Prague by 1920 to lead a Cubist movement in painting and sculpture there. From paintings in a more or less Analytical Cubist manner, with still life as their characteristic theme, he turned in the 1930s to subjects expressing violence and his expectation of war. He was in Buchenwald concentration camp during the Second World War, but survived and returned to his career as artist and teacher afterwards, when his paintings became more descriptive. He wrote essays and books on art, among them *Art and Reality, A Painter's Reflections* (Prague 1936; in German).

Filonov, Pavel (1883–1941) Russian painter, trained at the St Petersburg Academy and elsewhere, and a member of the Union of Youth Society in 1910–14. In 1912 he showed in the Donkey's Tale exhibition in Moscow and travelled for six months in western Europe. In 1913 he and Iosif Shkolnik designed sets and costumes for *Vladimir Mayakovsky. A Tragedy*. After the Revolution, Filonov was among those enrolled as leaders of Soviet culture. His work was included in the *First Russian Exhibition, Berlin, and in 1924 he briefly taught in the reformed *academy in Petrograd. But his artistic thought did not lie easily with those of his colleagues, and in 1925 he opened his own school, the Collective of Masters of Analytical Art. A major exhibition planned for him around 1930 never opened. He went on teaching and supervising work done by his school, but his work and theories were much criticized

in the 1930s. In 1967 there was a retrospective in Novosibirsk, and ten years later the State Russian Museum in Leningrad accepted from his sister a large collection of his paintings, drawings and manuscripts. Though aware of western art, Filonov was deeply and lastingly attached to Russian traditions and *primitive art. He is best understood as a late *Symbolist, picturing heads and figures with what he called their 'orbit', their intuited context made visible, their 'biodynamic entity'. His paintings offer a 'hallucinatory journey through a nightmare forest of symbols' (John E. Bowlt).

Finch, Alfred William (1854–1930) Belgian painter of British family who from 1897 on worked in Finland. 'Willy' Finch studied at the Brussels *Academy and with his friend *Ensor helped found Les *Vingt group in 1884. In 1887 he saw work by the *Neo-Impressionists in a Les Vingt exhibition and was converted to their method, using it intensely and at times austerely until about 1892, when painting took second place in his work to ceramics in which he became eminent. In 1897 a Swedish painter caused him to visit the pottery works at Borga in Finland; Finch stayed in Finland, from 1902 on teaching ceramics at the Helsinki School of Industrial Arts. He went on painting, although in a softer style, and in 1903 organized an exhibition of *Impressionist and Neo-Impressionist painting for Helsinki which is seen as the starting point for modern painting in Finland. His influence there as artist was felt more in the realm of design than in fine art.

Finiguerra, Maso (1426–64) Florentine goldsmith, draftsman and pioneer of engraving (*see under* intaglio), trained in *Ghiberti's workshop. He was praised as a master of *niello* decoration, and some of the earliest-known engravings, tiny precious works printed either from plates intended to be inlaid with niello or cast replicas of such plates, are attributed to him. He is also the author of drawings in line and wash, including large examples on vellum (Hamburg, Kunsthalle).

Finlay, Ian Hamilton (1925–) Scottish artist and poet, born in the Bahamas of Scottish parents and trained at Glasgow School of Art. After wartime army service he held various jobs, mostly agricultural and became known as a writer and publisher. His writings included concrete poetry and this he related to apophthegmatic works of art, two and three- dimensional, sometimes setting words in satirical contrast to the image they accompany. Some reveal his sensibility to nature; others his horror at man's pretence of idealism. Since 1966 he has lived at Stoneypath in the Southern Uplands of Scotland where he has developed a garden and temple as the location for many of his works; the latter has given rise to a protracted legal tussle with his local authority. A retrospective was shown in Edinburgh (Scottish NG of MA) in 1972; another at the Serpentine Gallery, London, in 1977.

Finsonius, Ludovicus, also called **Finson, Louis** (*c.*1580–1618) Flemish painter born in Bruges, an early follower of *Caravaggio. He visited Italy twice, but spent most of his working life in Provence, and is important in introducing the Caravaggesque style to France, mainly through altarpieces in which the influence of *Elsheimer is also apparent (Aix-en-Provence, St-Jean de Malte), but also through his occasional *genre pictures and portraits (*Self-Portrait*, 1613, Marseilles, Musée).

Fiore, Jacobello del *See* Jacobello del Fiore.

First Russian Exhibition *Erste russische Kunstausstellung*, an official Soviet exhibition organized for the Comissariat for Enlightenment by the painter David *Shterenberg as chairman of its art board. *Lissitzky was sent to Berlin to see to its presentation at the Galerie van Diemen in 1922; it had a second showing in 1923 at the Stedelijk Museum, Amsterdam. War, the Russian Revolution and the disturbed political and cultural situation in Berlin during the post-war years had both broken communications between Russia and

Germany, but Konstantin Umanski's articles in a German journal and his book *New Art in Russia* (Munich 1920) had whetted an appetite for this new art. The exhibition, in effect, complemented Umanski's reports. The display included a wide range of paintings and a small number of sculptures, including work by *Archipenko, *Chagall, *Ekster, *Filonov, *Gabo, *Kandinsky, Lissitzky, *Malevich, *Popova, *Rodchenko, Vladimir *Stenberg and *Tatlin. The American collector Katherine Dreyer bought works by Malevich, *Medunetsky and others from the exhibition; these are now in the Yale University Art Gallery, New Haven. A show commemorating this historic exhibition was presented in 1983 by the Annely Juda Gallery, London.

Fischl, Eric (1948–) American painter, born in New York and trained at Arizona State University and the California Institute of Arts. His painterly but at the same *realistic paintings, seen in New York from 1980 on, deal with crises of adolescent sexuality. Ordinary scenes reveal tensions centred on individual experience, in terms that reflect ordinary middle-class behaviour and its moral ambiguities.

fixative *See under* charcoal.

Flanagan, Barry (1941–) British sculptor, who studied at the Birmingham College of Art, before a period in 1960 in the sculpture department of St Martin's School of Art, London, where *Caro was teaching, and a longer time there during 1964–6. Already an enthusiast for Alfred Jarry's philosophy of Pataphysics, Flanagan made concrete poetry in 1964–5, in 1966 and 1968 had his first solo exhibitions of sculpture at the Rowan Gallery in London, and was picked by the British Council for the 1967 Biennale des Jeunes in Paris. His sculpture from the first rejected the *avant-garde position maintained by Caro and his more immediate followers. Though it was *abstract, it did not insist on that, nor on metal or construction, nor on achieving a fine visual composition: it used an, at that time, shocking range of materials to make sculptural events whose

titles added to their mysteriousness. Thus *four cash 2'67* (1967; London, Tate) consists of four standing forms made of sacking filled with sand, a large ring cut from linoleum and a length of thick rope. Some leeway is permitted in their setting up (some later Flanagan sculptures varied considerably in their arrangement from show to show), but the result remains at once surprising and theatrical. His second show at the Rowan Gallery consisted of more focused works giving form to such verbs such as 'pile', 'stack' and 'bundle': *Pile 3* (1968; London, Tate) is a pile of folded blankets; *Heap 4* (1967; London, Arts Council), is a heap of limp, sand-filled tubes of jute. With such works and *June (2)* (1969; London, Tate), a large canvas propped up by three rough poles, Flanagan aligned himself, in some instances went ahead of, the latest informal sculpture made by Americans such as Robert *Morris and Eva *Hesse. He was included in the Arts Coucil's 1969 show of ultra-avant-garde paintings and sculpture 'Six at the Hayward' and in the exhibition 'When Attitudes become Form' which announced the international birth of *Conceptual art and *Earthworks in Bern, Krefeld and London. But he reacted even against this apparently open-ended grouping as too selfconsciously concerned with clever ideas and their presentation.

Flanagan's work of the 1970s demonstrates this reaction. He made poetic stone carvings, some of them suggesting an urge to find the origin of sculpture rather than add to its latest manifestations; he made ceramics; he modelled for bronze casting. He abandoned the whole notion of abstract sculpture. From the time of *Arno Pebble (the elephant)* (bronze image on found stone base; 1973), he has worked mostly on animal sculptures large and small. These include horses fashioned in homage to those of St Mark's, Venice (1980), and included in his show of bronzes at the 1982 Venice Biennale. He has gone on to make a long series of sculptures of hares – naturalistic hares but also hares as ironic images of mankind: hares boxing, hares playing cricket, a *Nijinski Hare* (1996) and a *Large Monument* (1996) in which hares re-enact *The Thinker* and *The Shadows* over him on

*Rodin's famous *Gate of Hell*. Flanagan's bronzes are, or have been, shown all around the world and are thus the best-known aspect of his work. He shows regularly at the Waddington Galleries, London.

Flandrin, Hippolyte (1809–64) French painter in the *Neoclassical tradition. He had studied under *Ingres and in 1830 won the Prix de Rome. He used his time in Italy to study *Renaissance *fresco painting, and, returning to Paris in 1838, worked principally as a painter of religious cycles in the city's churches, among them St-Germain-des-Prés.

Flavin, Dan (1933–) American artist born in Jamaica into a family of Irish and German descent and Roman Catholic by religion. He was educated in a Catholic school in New York state, was trained as meteorologist by the US Air Force and served as such in South Korea. In 1956 he was a student at the New York School for Social Research and attended art history classes at Columbia University during 1957–9. He had no artistic training, but made watercolours and constructions that were seen at his first solo show in 1961. That year he began to build light into his constructions, and in 1963 he exhibited a single yellow fluorescent tube, hung at 45 degrees to the horizontal, called it *Diagonal of May 25, 1963* and dedicated it to *Brancusi. This very direct work, using a *readymade industrial product, associated it both with *Duchamp and with the *Minimalism that was emerging in the USA and elsewhere, and in 1966 Flavin contributed to its debut exhibition, 'Primary Structures', at the Jewish Museum in New York. From this time he showed frequently in solo and group exhibitions in the USA and abroad: his work's simplicity, its consisting primarily of light and its industrial base made it timely as well as exceptionally appealing as an immaterial phenomenon, and relatively easy to transport and install. Depending on how they are displayed, they can have a markedly sacred character. Moreover, he was ceaselessly inventive in developing his 'proposals' as he liked to call them. He could use and mix a range of colours and sizes, he could arrange them in different positions and quantities, including room-filling installations, and liked to dedicate individual pieces or series to artists, thus humanizing compositions that otherwise might seem wholly impersonal. In 1990 he made a series called *Untitled (for Lucie Rie, master potter) 1990*; each piece consisted of six vertical tubes and six shorter ones projecting at right angles from the tops or bottoms of the verticals, and the colours varied from strong to subtle. In 1992 the Guggenheim Museum in New York reopened after rebuilding with an exhibition of his large neon works.

Flaxman, John (1755–1826) English sculptor and draftsman. He achieved international fame and influence through his outline illustrations to Homer, Aeschylus and Dante, executed between 1790 and 1793 in Rome (where he lived, 1787–94) and engraved originally by Tommaso Piroli; a later version of the *Odyssey* published in England was re-engraved by, among others, Flaxman's friend William *Blake. The judgment of another close friend, *Romney, 'They are simple, grand and pure . . . They look as if they had been made in the age when Homer wrote' echoed the general view of these illustrations, and Jacques-Louis *David's prediction, 'This work will cause pictures to be painted' was amply confirmed by painters as different from each other as *Ingres, *Goya, *Runge and the *Nazarenes. Although ranked as a *Neoclassical artist, Flaxman sought out influences in *Gothic sculpture and early Italian *frescos as well as in Roman sarcophagi and Greek vase paintings in the collection of Sir William Hamilton. His early genius for 'pure line', however, can be said to have been 'discovered' – after his training in the *Academy Schools in London – by the pottery entrepreneur Josiah Wedgwood, for whom he was modelling cameos, classical friezes and portraits in 1775 for mass reproduction. Throughout most of his working life Flaxman received commissions for funerary monuments (e.g. 1795, William Collins, Chichester, Cathedral; 1795–1801, Earl of Mansfield, London, Westminster Abbey; 1808–10, Nelson, London, St Paul's). The most successful are considered to have been his

smaller monumental reliefs, notably the one to Agnes Cromwell in Chichester Cathedral, 1799–1800, the design for which was reused in the monument to Mary Hartford, 1800–1, Bristol Cathedral (also, e.g. 1814–19, Georgiana, Countess Spencer, Northamptonshire, Great Brington). Flaxman's colossal late group *St Michael and Satan* (1819?–26), still in the sculpture gallery at Petworth, Sussex for which it was commissioned along with other works is his best-known free-standing sculpture. In 1810 Flaxman was appointed the first Professor of Sculpture at the Royal Academy. There are drawings by him in London, British Museum; Royal Academy; V&A; and drawings and plaster maquettes for monuments in London, University College.

Flegel, Georg (1563–1638) German painter, specializing in landscape (*see under* genres) and *still life, which he pioneered under the influence of Flemish artists (Kassel, Staatliche).

Flémalle, Master of A name invented by art historians in the late 19th century to identify the painter of an important group of Early Netherlandish pictures, evidently by the same hand but neither signed nor documented. He is now frequently thought to have been Robert *Campin, an older contemporary of Jan van *Eyck and the master of Rogier van der *Weyden. Since there is no absolute proof, however, both names are used.

Flinck, Govert (1615–60) German-born Dutch painter, a pupil of *Rembrandt *c.*1633–6. His early work closely imitates Rembrandt's manner (*Samuel Manasseh ben Israel*, 1637, Stichting, Kunstbezit; *Isaac blessing Jacob*, 1638, Amsterdam, Rijksmuseum), but in the 1640s he abandoned his master's *chiaroscuro for the lighter and brighter style of *Van Dyck. He became not only a fashionable portraitist but also the most successful Dutch painter of allegorical and historical decorations for palaces and public buildings. He was patronized by Amalia van Solms, the widow of Prince Frederick Hendrick of Orange (*Allegory in memory of the Prince of Orange, with the portrait of his widow Amalia van Solms*, 1654, Amsterdam, Rijksmuseum). After successfully completing two *history paintings for Amsterdam town hall, Flinck received the most important public commission given to any 17th-century Dutch artist: 12 paintings for the building's great civic hall. Flinck died shortly afterwards, however, and the commission was redistributed among a group of artists, including Jan *Lievens, Jacob *Jordaens, and *Rembrandt.

Flint, William Russell (1880–1969) British painter, best known as the producer of a great number of watercolours peopled by elegant, often somewhat exotic, female nudes.

Florentin, Dominique; Domenico del Barbiere, called (*c.*1506–65) Florentine-born sculptor and modeller in stucco, painter, engraver (*see under* intaglio), mosaicist and ceramicist. He is recorded in France with *Rosso in 1537; he remained there to become one of the leading members of *Primaticcio's team at Fontainebleau and, from 1541, the most eminent sculptor in Troyes. As a collaborator on the *Monument for the heart of Henri II* (Paris, Louvre) and on other projects, he is thought to have influenced *Pilon. His engravings show his familiarity with the earlier work of *Michelangelo; they were also important in propagating the designs of the painters of Fontainebleau.

Floris or **de Vriendt, Cornelis** (1514?–75) and **Frans** (1516/20–70) Brothers, the elder a sculptor and architect and the younger a painter, who between them dominated art not only in their native Antwerp but throughout the Netherlands and as far abroad as Northern Germany and Scandinavia.

Cornelis's busy workshop raised Antwerp *c.*1550 into the leading sculptural centre of the Netherlands. In addition to church furnishings and tombs, he specialized in the design of ornamental motifs. Although *grotesque ornament had been introduced to Flanders by Pieter *Coeck – perhaps Cornelis Floris's teacher – it was the publication in Antwerp of Cornelis's

series of engraved ornamental designs, 1548–77, which really popularized in the north the taste for this form of Italianate decoration. It also introduced to the Netherlands the *strap-work designs evolved at Fontainebleau (*see* Rosso).

Paradoxically, Cornelis's sculpted monuments do not display an abundance of decoration; their austerity demonstrates his grasp of *classical principles, learned from his close study of the antique, of *Raphael and of the sculpture of Andrea and Jacopo *Sansovino, during his stay in Rome in 1538. His shop concentrated on the working of black and red marble, with alabaster for the figures. Their most important monuments, in which it is difficult to distinguish individual hands, are the memorial to Duchess Dorothea, 1549, Köningsberg (now Kaliningrad) cathedral; tabernacle, 1550–2, Zoutleeuw (Léau) St Leonard; tomb of King Frederick I of Denmark, 1550–after 1553; Schleswig, cathedral; tomb of Jan III van Merode, 1554, Gheel, St Dymphna; tomb of Duke Albrecht I of Prussia, 1568–74, Köningsberg, cathedral; tomb of King Christian III of Denmark, 1568–after 1576, Roskilde, cathedral; rood-screen, c.1570–3, Tournai, cathedral.

Frans Floris has been called the most important Flemish painter of the 16th century. According to Karel van *Mander, he had over 100 pupils; the best-known of them is Maerten de *Vos. His workshop in Antwerp continued to influence Flemish painting until the return of *Rubens from Italy in 1608, and echoes of his manner may be discerned even in the work of later Dutch painters such as *Rembrandt.

An eclectic artist, Frans Floris combined the earthy *realism of his native tradition with Italianate forms and ideals – sometimes within the same picture (e.g. *Holy Family*, c.1556, Brussels, Musées). He painted religious and mythological themes, and may be considered to have anticipated the expressive *Baroque portrait of the 17th century (*Portrait of a woman*, 1558, Caen, Musée). Having studied with the Italianate painter Lambert *Lombard, 1538–40, around 1541 he followed his brother Cornelis to Rome, where he much admired *Michelangelo's *Last Judgement*. He was

directly influenced too by *Giulio Romano, *Tintoretto and ancient Graeco–Roman sculpture. Late in life he was affected also by the *Mannerism of the School of Fontainebleau, where some of his pupils had worked c.1566 (e.g. *Athena visiting the Muses*, Condé-sur-Escaut, Town Hall). Other works Antwerp, Museum; Amsterdam, Rijksmuseum; Florence, Uffizi; Kremsier, Archiepiscopal; Brunswick, Museum; etc.

Flötner, Peter (c.1495–1546) Swiss-born sculptor, printmaker and architect, mainly active in Nuremberg. He visited Italy c.1520 and again soon after 1530, and on his return helped, like *Dürer, to popularize the Italian *Renaissance style throughout northern Europe, above all through his *plaquettes in lead and other metals. His most famous work is the *Apollo Fountain* (1532, Nuremberg, Germanisches), based on *Barbari's engraving of Apollo and Diana.

Fluxus Name of a group or movement, from the Latin for 'a flowing', formed in Germany in 1962 by the Lithuanian-born American theorist and art philosopher George Maciunas (1931–78). He wished to instigate an anti-art, anti-bourgeois programme involving and mingling several art forms and operating mostly outside the world of art commerce. In spirit, therefore, Fluxus came close to a revival of *Dada, though its work was seldom as openly political as some of the Dadaists were. What it presented, during about ten years of notable activity, was often in the form of *Happenings, as in street events; it gave some permanence to its doings through publications. Many American artists played some part in Fluxus, but its main arena was Germany where *Beuys and *Vostell were involved for a time.

Fontana, Lucio (1899–1968) Italian painter and sculptor who was born in Argentina, the son of an Italian sculptor, and came to Italy as a child. He lived in Milan where he qualified as a surveyor; he also served as a soldier in the 1914–18 war and was injured. In 1922 he joined his father in Argentina and started working as

sculptor. In 1924 he returned to Milan where he studied at the Academy during 1928–30. He worked as a *figurative and as an *abstract sculptor during the 1930s. In 1934–5 he made severely abstract metal sculptures, many of which were destroyed (replicas have been made of a few), and he signed a pro-abstraction manifesto in 1935. He also received public comissions for figurative work. During these years he also began making ceramic sculptures. In 1940 he returned to Argentina and in 1946 co-founded an academy in Buenos Aires. This published the *White Manifesto* the same year, incorporating his developing theory and programme of 'Spatialism'. He returned to Milan in 1947 where he issued further statements about 'Spatialism' and in his art experimented with the physical and metaphysical properties of space. In 1949 he made his first perforated paintings and soon after turned to slashing them with a knife. Thus space intruded into planes prepared as fine monochrome paint surfaces; the contrast between these and the action that is still read as destructive creates a remarkable frisson. Later Fontana was to load paintings with sequins or coloured glass. A series of ovals done in this way is entitled *The Death of God*. He also produced large-scale installations, some of them with coloured neon light in black settings, and new ceramic or metal sculptures, rich with colour and enriched further with coloured glass. His inventiveness exceeded any desire to establish a brand image, yet there is something refined and subtle about even his most ebullient productions that makes them recognizably his. He exhibited frequently in groups and by himself, and at the 1966 Venice Biennale received the International Grand Prize for Painting.

Fontana, Prospero (*c*.1512–97) and his daughter **Lavinia** (1552–1614) Prospero was an Italian *Mannerist painter from Bologna. He went as a young man to Genoa, where he was employed as an assistant to *Perino del Vaga in the decoration of the Palazzo Doria; in 1551 he was active in Rome with Taddeo *Zuccaro, and in about 1560 also spent a brief period at Fontainebleau assisting *Primaticcio. He worked longest, however, as a member of

*Vasari's teams in Florence and Rome, and it is Vasari who is the greatest influence on his own paintings (e.g. *Disputation of St Catherine*, Bologna, Madonna del Baraccano). Only in his fifties did Fontana depart from his dependence on Vasari's *maniera*, when, perhaps under the impact of Venetian and Lombard art he turned to a greater naturalism (*see under* realism) and expressivity (*see* expression), particularly noticeable in such late altarpieces as the 1576 *St Alessio distributing Alms*, Bologna, S. Giacomo. Lavinia Fontana, influenced by her father's late style, became a highly reputed portrait painter (e.g. Modena, Pinacoteca; *Self Portrait*, Florence, Uffizi); she also executed religious pictures (Bologna, Madonna del Baraccano; Pieve di Cento, Collegiata; Budrio, Pinacoteca).

Foppa, Vincenzo (*c*.1430–*c*.1516) The leading painter in Lombardy until the arrival of *Leonardo da Vinci, he may have studied under Squarcione (*see under* Mantegna) and was certainly influenced also by Jacopo *Bellini and *Gentile da Fabriano (London, National, Wallace; Bergamo, Accademia, Carmine; Milan, Brera, Poldi-Pezzoli, Castello; Washington, National).

Forain, Jean-Louis (1852–1931) French painter and caricaturist, son of a house painter of Reims. He studied at the Ecole des Beaux-Arts in Paris and became famous as a caricaturist, supplying images and captions of point and artistic brilliance to such journals as *La Vie Parisienne*, *Figaro*, and *Rire*. Impulses came from *Goya and *Daumier, also the visual wit of *Manet and of *Degas whom he admired especially, as well as Toulouse-*Lautrec. His paintings were first shown in 1909; in 1913 there was a comprehensive Forain exhibition in the Musée des Arts Decoratifs in Paris. He painted dancers and domestic, society, theatre and brothel scenes, the elegant and the poor, a day at the races and a day in court.

foreshortening A method of representation in which objects are depicted according to the laws of *perspective as if

receding in space. Extreme foreshortening, best demonstrated through elongated forms of which the width is parallel to the picture plane and the length at right angles to it, is typically used for dramatic effect: e.g. a pointing or blessing hand seeming to jut out of the picture, as in *Caravaggio's *Supper at Emmaus*, London, National. Steep foreshortening of objects and figures painted on a ceiling, as if they were descending or ascending directly overhead, is called *di sotto in su* (Italian, 'from below upwards'), and such effects are often combined with *quadratura* painting of architecture.

Forte, Luca (1600/15–before 1670) Ill-documented Neapolitan painter, one of the earliest *still-life specialists in the city (*see also* Ruoppolo), influenced by *Caravaggio and Spanish *bodegónes* (Rome, Corsini; Florida, Sarasota, Ringling).

Foucquières or **Fou[c]quier, Jacques** (1590–1659) Flemish *landscape painter. His early landscapes were influenced by de *Momper (Cambridge, Fitzwilliam; Nantes, Musée). In about 1620, just before moving to France in 1621, he turned to the more *classicizing manner of Paul *Bril. His major commission from the French King Louis XIII having been to decorate the Long Gallery of the Louvre with landscapes, he was one of the artists who intrigued against *Poussin on his arrival in Paris to design the Gallery's decoration. He was the teacher of Philippe de *Champaigne.

Foujita, Tsuguharu (1886–1968) Japanese-French painter, born and trained in Tokyo but worked in Paris from 1913 on (apart from the Second World War years which he spent in Japan). He associated with a group of foreign painters, including *Chagall and *Modigliani, and painted in a delicate style which has a certain Eastern flavour.

Fouquet, Jean (c.1420–in or before 1481) The foremost French artist of the 15th century, best known today for the panel paintings attributed to him (*Charles VII*, c.1445; *Guillaume Jouvenal des Ursins*,

c.1455, both Paris, Louvre; *Melun Diptych*, c.1450, Berlin Staatliche, and Antwerp, Musée; *Lamentation*, c.1470–5, Nouans, parish church) but active also as an illuminator of luxurious manuscripts (*Book of Hours of Etienne Chevalier, 1452–60, Chantilly, Musée; Boccaccio's *Des Cas des Nobles Hommes et Femmes Malheureuses*, c.1458, Munich, Staatsbibliothek; *Grandes Chroniques de France*, c.1458, and Josephus's *Antiquités Judaïques*, c.1470–5, both Paris, Bibliothèque Nationale), designer of decorations for festivals and triumphal entries, and of sculpted tombs and altars. The *Antiquités Judaïques* is his only documented work; the rest of his *oeuvre* rests on attribution. For over 30 years he ran a large and active workshop which executed many commissions for members of the French court, although Fouquet was officially appointed court painter only in 1474. He may have executed a portrait of the Pope Eugene IV and his two nephews in Rome during 1443–7, perhaps while accompanying a French mission in 1446.

Fouquet's painting style assimilates certain elements of Italian art, notably central vanishing point *perspective (not consistently used by him) and generalized handling of form. It is distinguished by sober restraint, as in the small enamel *Self-Portrait* (c.1450, Paris, Louvre). Despite the absence of naturalistic (*see under* realism) surface detail the portrait of *Charles VII* is strikingly unidealized, so that the king's unprepossessing features and melancholy expression jar painfully with the pompous contemporary inscription, 'the most victorious King of France', on the frame.

Fourdrinier, Paul *See under* Monamy, Peter

Fra Angelico *See* Angelico, Fra or Beato.

Fra Bartolommeo *See* Bartolommeo or Baccio della Porta.

Fra Galgario *See* Ghislandi, Giuseppe.

Fragonard, Jean-Honoré (1732–1806) Ostensibly the last French painter of

*Rococo frivolity, he was – like the sculptor *Clodion – an individualist celebrating nature, impulse and instinct. His style, whether in his many chalk, pen or wash drawings, in pastels, gouache or oils. in his engravings and etchings (see intaglio), was always energetic, spontaneous and painterly. Although, especially late in life, he could produce highly finished surfaces he is particularly renowned for the sketchiness of many of his pictures. In the same way that he often effaced the distinctions between the *genres – notably between landscape and genre or *fête galante, or between portrait and *Fancy Picture – so he seems to have abolished the boundaries between drawing and painting, sketch and finished picture. Equally, he conflated in his work the influence of Italy (notably *Tiepolo, *Giordano, *Solimena, *Castiglione) with that of the north, not only *Rubens (in part directly, in part through *Watteau) but also *Ruisdael and *Rembrandt (e.g. several variants of a copy of Rembrandt's Holy Family now in St Petersburg, Hermitage; San Francisco, de Young Museum; taken up later in the painting now in Amiens, Musée). With a few exceptions where a commission is dated, Fragonard's work is difficult to date; there are many variants of the same or similar compositions and his style varies rather than evolving.

Born in Grasse in south-east France, Fragonard was brought to Paris as a child. After a brief, unhappy apprenticeship under *Chardin he became a pupil of *Boucher in 1751, then worked under Carle van *Loo at the *Academy school. Certain presumed early decorations (pc and Chicago, Fowler McCormick), follow Boucher's subject matter and tonality, although Fragonard seems to have quickly abandoned Boucher's characteristically blue and rose harmonies for a palette organized around shades of yellow (see also under colour).

After winning first prize at the Academy Fragonard was sent to the French Academy in Rome in 1756; his last few months in Italy were spent in the company of a collector and patron at the gardens of the Villa d'Este at Tivoli and in a long return voyage home, 1761. While the impact of Italy was decisive, he experienced it in the first place through landscape – the Academy's Director, *Natoire, encouraged him to go on sketching expeditions into the countryside, (sometimes with Hubert *Robert) – and only secondly through the contemporary or near-contemporary artists listed above. Neither the antique nor the *Renaissance seems to have left any mark on his work. Above all, the sparkling Italian light and the Tivoli gardens continued to haunt him, in the gigantic cypresses and other trees which surge above the minuscule protagonists of such pictures as the Blind Man's Buff and Swing (Washington, National), and the fountains, cascades and statues which animate these and others of his decorative fêtes galantes. A more direct record of Tivoli is found in a small group of paintings executed either in Italy or soon after (Paris, Louvre; Amiens, Musée; London, Wallace) and, above all, in a large number of wonderfully poetic drawings (e.g. Besançon, Musée).

Fragonard's large, melodramatic Corésus and Callirhoé appeared at the Salon in 1765 (Paris, Louvre), a bid for recognition as a history painter (see under genres). But after showing again at the Salon of 1767 he virtually disappeared from official artistic life under the monarchy, working almost entirely for private patrons, many of whom became his friends. A commission for a *fresco for a ceiling at the Louvre, given him in 1766, was at his insistence exchanged for an oil of smaller size in 1776. The most important semi-official commission he ever received was from Louis XV's mistress Mme du Barry, for a set of four decorative paintings on the Progress of Love for her *Neoclassical pavilion at Louveciennes (1771–3, New York, Frick). These works, generally now acknowledged as Fragonard's masterpieces, were rejected by du Barry for Neoclassical paintings by *Vien. They were to be used by the artist to decorate his own reception rooms at Grasse where he retreated in 1790 during the Revolution.

After the disaster of this commission Fragonard, with his wife and at the expense of yet another patron who accompanied them, undertook a second trip to Italy, 1773–4 (e.g. drawing, Amsterdam,

Rijksmuseum; paintings, pc; New York, Metropolitan). A rarely seen, very large painting of a fair in a mysteriously wooded park, generally called *La Fête à Saint-Cloud* (now Paris, Banque de France) may date from either just before the voyage in 1773 or from 1775–80.

In addition to erotic small paintings and larger decorative works Fragonard painted a number of fantasy portraits – that is, portraits of mainly real people in fancy dress. What the purpose or destination of these dashingly painted works were has never been elucidated (Paris, Louvre, Petit Palais; Williamstown, Clark Institute; Liverpool, Walker). From the late 1770s he seems also to have turned to more domestic subjects, 'happy families', mothers and children, saved from *Greuze-like sentimentality by the brio of their pictorial technique (e.g. Amiens, Musée; London, Wallace). The following decade saw him essaying either proto-*Romantic themes (e.g. Buenos Aires, Museo) or even *Neoclassical compositions. Some of the more tightly painted pictures were probably executed in collaboration with **Marguerite Gérard**, his sister-in-law and pupil, with whom Fragonard and his wife lived from 1775 in what was almost certainly a *ménage-à-trois*.

Although he was of republican sympathies and a Freemason, with the collapse of the art market during the Revolution Fragonard left Paris for Grasse, 1790–1. Under the patronage of *David, the teacher of his son **Alexandre-Evariste Fragonard** (1780–1850), he was drawn into Revolutionary art politics and administration, eventually becoming charged with the creation of a new national museum.

Frampton, George (1860–1928) British sculptor, trained in London. He became a full Royal Academician in 1912 and was President of the Royal Society of British Sculptors in 1911–12. He was joint head, with the architect W.R. Lethaby, of the Central School of Arts and Crafts in London. His best known sculpture is *Peter Pan* (1911, London, Kensington Gardens). He was an adroit modeller, and was admired especially for the works in which he combined materials such as ivory and marble with bronze.

Frampton, Meredith (1894–1984) British painter, son of the sculptor George *Frampton. He was trained in the Royal *Academy Schools and was a regular exhibitor at the RA from 1920 on. Portraits dominate his output but he also painted some fine still lifes. In either case he worked in a naturalistic style (*see* *realism) at once insistent and delicate that gives even his portraits an almost *Surrealistic, rather than a photographic, character, and makes his still lifes hypnotically unreal. Such painting took as much time as skill, and he ceased working in 1945 when it was clear his eyesight was failing him.

Franceschini, Baldassare, called **Il Volterrano** (1611–89) Precocious Florentine painter from Volterra; the outstanding *Baroque decorative artist in Florence after the departure of *Pietro da Cortona in 1647 and before the arrival of Luca *Giordano in 1682 (Florence, Pitti; SS. Annunziata; S. Croce, Niccolini Chapel; Villa Poggio Imperial etc.). He was also a fine portraitist, and executed *cabinet pictures, whose *sfumato was influenced by *Furini (Udine, Museo; many private colls.). One of his most popular pictures is the lively *The Parish Priest [Pievano] Arlotto's Practical Joke* (Florence, Pitti); another anecdote on this theme was painted by *Giovanni da San Giovanni, whom Franceschini briefly assisted with frescos in the Palazzo Pitti.

Franceschini, Marcantonio (1648–1729) *Classicizing decorative Bolognese painter, pupil of *Cignani, and dependent also on the latter's teacher *Albani; he was called the 'Bolognese *Maratta'. His greatest work is probably his *fresco cycle in the church of Corpus Christi, Bologna, 1687–94. Franceschini's pupil **Giulio Quaglio** (1668–1751) also became a successful fresco painter.

Francesco di Giorgio Martini (1439–1501/02) Celebrated Sienese-born architect, military engineer, painter and sculptor, trained under *Vecchietta. His early wooden statue of St John the Baptist also shows the influence of *Donatello (1464, now Siena, Pinacoteca; two painted

altarpieces, 1471, 1475, also in the same gallery). In 1475–7 he entered the service of Federigo da Montefeltro in Urbino, maintaining his connection with the Montefeltro court even after Federigo's death in 1481. He is thought to have designed the *perspectivized intarsia decorations of the Duke's studios in the castles of Urbino and Gubbio (the latter now New York, Metropolitan). A bronze medal of Federigo was cast during his years at Urbino, and three major bronze reliefs (now in Venice, Carmine; Perugia, Pinacoteca; stucco casts only after lost bronze original, London, V&A). In 1497 he completed two bronze angels for the high altar of Siena Cathedral, in which the influence of *Leonardo da Vinci, whom he had met in Milan in 1490, has been discerned.

Francia; Francesco Raibolini, called (*c*.1450–1517/18) Bolognese goldsmith, first recorded as a painter in 1486; his soft and graceful style, much imitated in and around Bologna, was formed first on that of *Costa, later increasingly on *Perugino (e.g. Bologna, Pinacoteca). There are works by him also in many other Italian and foreign collections, including London, National; New York, Metropolitan; Paris, Louvre; Washington, National; Milan, Brera; Rome, Capitoline, Borghese; etc.

Franciabigio, Francesco (1482/3–1525) Florentine painter, active until *c*.1506 in *Albertinelli's workshop and recurrently associated with *Andrea del Sarto (entrance cloister of SS Annunziata, 1513; two scenes in the Chiostro dello Scalzo, 1518–19; decoration of the Salone in the Medicean villa at Poggio a Caiano, 1521). His work, less sophisticated than Andrea's, is frequently more dramatically forceful (e.g. Florence, Uffizi; Vaduz, Liechtenstein Coll.). He is now best remembered for his portraits (e.g. Berlin, Staatliche; London, National).

Francis, Sam (1923–94) American painter, first trained in medicine, then in art at the University of California. He adopted *Abstract Expressionism, and visited Japan and France where he was influenced by *Art informel. He had his first one-man

show in Paris in 1952, and soon was admired in the USA as well as in Europe for his lyrical canvases. In the context of an art heavy with emotional display, his stood out for its freshness.

Francisco de Hol[l]anda (1517–1584) Portuguese illuminator and writer on art, the son of Antonio (recorded *c*.1495–*c*.1540), a miniaturist from Holland. He spent the years from 1537 to 1541 in Italy, studying fortifications and antique remains (sketchbook, Escorial, library). His manuscript, *De Pintura Antiga*, *Of Ancient Painting*, which like all his writings was not published until modern times, records his friendship with *Michelangelo, and purports to quote the Florentine master's views on art, in which northern European painting is compared unfavourably with Italian, and its appeal to the pious is deprecated. He painted the small *Our Lady of Mercy protecting the Royal Family* now in Lisbon, Museu.

Francisque *See* Millet, Jean-François, called.

Francke, Master or **possibly Frater** (active first half of 15th century) Influential painter, probably trained in Paris, active in Hamburg in Germany, where his realistically detailed and narratively inventive International *Gothic style in the spirit of the *Limbourg brothers replaced the manner of Master *Bertram and his followers. His major work is the *Englandfahrer* (or *Thomas à Becket*) *Altarpiece* for the guild of merchants trading with England, 1424, Hamburg, Kunsthalle, but he is the author also of the *St Barbara Altarpiece*, *c*.1415, Helsinki, National; and two images of Christ as Man of Sorrows (Hamburg, Kunsthalle; Leipzig, Museum).

Francken Prolific dynasty of Flemish painters. **Hieronymus Francken** (1540–1610) was an Italianate Antwerp painter who studied with Frans *Floris before going to work at Fontainebleau in 1566. In France, he became painter to the king, largely on his reputation as a portraitist, although only two small portraits by

him are known today (Pommersfelden, Museum; *Self-Portrait*, Aix-en-Provence, Musée). He specialized also in pictures of masquerades and ballroom scenes. Finally, he was also a painter of large-scale altarpieces, and in this capacity he returned occasionally to his native city, once, in 1571, to complete an *Adoration of the Magi* left unfinished by Floris. There are altarpieces by him in Paris, Notre-Dame; Antwerp, St Charles Borromeo and Musées. The eclecticism he had learned from Floris, with its admixture of Flemish *realism, Central Italian figure design and Venetian colourism (*see under* disegno), was tempered by a cold *classicism under the influence of his sojourn at Fontainebleau. He died in Paris. His younger brother **Frans I Francken** (1542–1616) was a somewhat less intensely classicizing artist, influenced by Maerten de *Vos (altarpiece, 1587, Antwerp, cathedral). Their brother **Ambrosius I Francken** (1544–1618) was also a pupil of Floris. He occasionally collaborated on altarpieces with de Vos (Antwerp, St Jacobskerk) and he is known to have painted figures in landscapes by other artists.

Frans II Francken (or Frans Francken the Younger) (1581–1642) is now the best-known member of the family. A son of Frans I Francken, he produced some large altarpieces (Antwerp, Museum; Amiens, cathedral). But his main speciality was in countless small *cabinet pictures, on religious and mythological themes as well as *genre and fantastical scenes such as the *Witches' Sabbath* (1607, Vienna, Kunsthistorisches). There are pictures by him also in Paris, Service de Récupération: Sarasota, Museum; etc. His work is comparable to that of Jan and Pieter II *Brueghel, and, like theirs, it gave rise to a school of minor painters of genre **Christian Jansz van der Laemen** (1606?–52?); his pupil, **Hieronymus Janssen**, called 'The Dancer' (1642–93) and Frans's own son, **Frans III Francken**, who made numerous copies of his father's pictures, as well as painting the figures in the works of other artists, notably the church interiors by Peter I and Peter II Neefs (*see under* Steenwijck). Other, less well-documented members of the Francken family were also

painters, including a daughter, **Isabella** **Francken**.

François, Guy (1580–1650) French painter from Le Puy. He spent the early part of his career in Rome, where he was influenced by *Caravaggio and *Saraceni. On his return home by 1613, he painted large altarpieces for local churches, most of them still *in situ*.

Frankenthal style A mode of landscape painting indebted to *Coninxloo, who took refuge in this German locality in 1587.

Frankenthaler, Helen (1928–) American painter, who studied at Bennington College, Vermont, and briefly with Hans *Hofmann, and became a leading second-generation *Abstract Expressionist. She used thin paints and unprimed absorbent canvas, so that colour and cloth fused, while variations in the density of paint and overlaps of form enabled her also to suggest space. Her paintings are both lyrical and dramatic. This controlled use of staining (as opposed to depositing paint) gave an important impetus to Morris *Louis. She exhibited frequently from 1951.

Freake Limner or **Master** (active 1670s) Unknown painter in Colonial New England, named after his portraits of John Freake and of his wife Elizabeth Freake with Baby Mary – notable both for its tenderness and the detailing of the lace collar – now in the museum in Worcester, MA (*c.*1674). The dignified portrait of the Gibbs children (1670, Boston, MFA) and that of Alice Mason (1670, Quincy, Massachusetts, Adams House) are also attributed to him.

Fréminet, Martin (1567–1619) French *Mannerist painter and architect, the last artist active in the so-called Second School of Fontainebleau (*see also* Ambroise Dubois and Toussaint Dubreuil), in the service of Henry IV as their predecessors, *Rosso, *Primaticcio, Nicolò dell'*Abate had been in that of Francis I and Henry II. After spending some 15 years in Italy,

mainly in Rome where he was much influenced by the Cavaliere d'*Arpino, Fréminet was summoned to Paris upon the death of Dubreuil in 1602. His most important surviving work is the ceiling, 1608, of the Chapel of The Trinity at Fontainebleau, for which he also designed the high altar.

French, Daniel Chester (1850–1931) American sculptor, creator of the monumental figure of Abraham Lincoln in the Lincoln Memorial, Washington (1922).

Fresco (Italian, fresh) A method of wall painting with water-soluble pigments over damp plaster, one of the most durable forms of wall decoration as long as the supporting wall is protected from damp. Probably for this reason the method gained currency mainly in central Italy, with its suitably dry climate. There vast numbers of frescos were painted, in churches and public buildings but also in private houses, where fewer have survived, from the 13th through the 18th centuries. In the 16th century the fashion for frescoing exterior façades became widespread, but little of this type of decoration remains. Ceiling frescos are an important feature of the 17th-century Italian *Baroque style.

Buon fresco is applied through several stages. The wall having been rough-plastered, a finer coat of plaster, the *arriccio*, is then applied. On this the entire composition is drawn, whether free-hand as from the 13th to the 15th centuries, or by tracing a full-scale drawing on paper, the cartoon (16th century). The reddish-brown pigment utilized in the underdrawing is called sinopia, and this term is now applied to the drawing on the *arriccio* itself. Many sinopie have been revealed through the process of detaching frescoes from their original support in the course of restoration and conservation. Over the *arriccio*, a still finer coat of plaster, the *intonaco*, is applied only to that area which can be painted whilst damp, that is, in one day. For this reason, that area is called a *giornata*, a day's work, from the Italian word for day. The covered portion of the sinopia is drawn, or incised, in the *intonaco* to join up with the portion still visible on the *arriccio*,

then painted with pigments dissolved in water or lime-water. As the *intonaco* dries the pigments are chemically bonded with the plaster, becoming part of the structure of the wall. The unpainted edges of *intonaco* are chiselled off, to be joined by the following day's *giornata*. These joins being faintly visible, the working speeds of fresco artists can be judged: *giornate*, the work of a single day, vary widely in size, from a single head to large tracts of drapery or landscape. Fresco proceeds from the top of the wall downward, to avoid splashing, and for this reason the normal narrative flow of early fresco cycles, such as that in *Giotto's Arena Chapel, is in tiers from the top of the wall to the socle. In time, the tier system was replaced by a more *illusionistic, less narratively copious, form of decoration: the walls seem to dissolve as large-scale figures pose within fictitious architectural or landscape settings. *Raphael's frescos in the Vatican *Stanze are of this type.

Freud, Lucian (1922–) British painter, born in Berlin, the grandson of Sigmund Freud. His family emigrated to London in 1932. He studied painting at the Central School of Arts and Crafts and at Goldsmiths' College and had his first exhibition in 1944. His work was soon seen outside Britain in mixed British exhibitions and at the 1954 Venice Biennale. A large retrospective was shown in London in 1974, since when he has been known internationally as an outstandingly powerful painter. His first works were *primitivist but soon he evolved for himself a *realism characterized by strong forms and at times rich brushwork. Above all he asserts the particularity of objects and surfaces giving his subjects great presence, suggesting emotional tension and opening up resonances of meaning. Figures (nudes, portraits, heads) dominate his production.

Freundlich, Otto (1878–1943) German painter and sculptor. He was in Paris 1909–14, close to the *avant garde and contributing to *Cubist group shows. From 1919 on he was a member of the *Novembergruppe in Berlin. In 1924 he returned to France and became a leading *abstract painter. His work was denounced

as *degenerate by the Nazis, and in 1943 he was arrested by the Germans in south-west France. He died in a concentration camp.

Friedrich, Caspar David (1774–1840) German painter, born in Greifswald in Pomerania, close to the Baltic Sea, and now famous for, principally, landscapes and seascapes charged with religious symbolism. Friedrich studied at the Copenhagen *Academy under *Abildgaard and others. From 1798 on he lived in Dresden, but returned repeatedly to the North coast and travelled also in the mountains of Germany and Bohemia. His early work was mostly in pen and wash on paper, but already used truthfully observed natural imagery as sermons on life and death. From 1807 on he worked mainly in oils and began to find eminent purchasers for his work as well as commissions. The first of these, for *The Cross in the Mountains* (1807–8), was for an altarpiece showing a tall wooden crucifix on a rocky mountain-top among fir trees, with Christ's figure facing into the picture towards the setting sun. With its elaborate carved frame, to Friedrich's design, the whole work is a complex statement about religious faith and hope, but it was gravely criticized at the time by those who demanded an established religious subject. For Friedrich nature was a church, every part of it rich in transcendental significance. The artist's task was to use this resource, starting from detailed drawings as his stock of models. Human beings and their activities also served his symbolism: sailing ships in harbour, real or imagined Gothic buildings in the mountains, a tiny ship crushed by great shifting slabs of ice (*Arctic Shipwreck*, 1824; Dresden State Collection), or isolated figures gazing at the sea, as in *The Monk by the Sea* (1809; Berlin, Schloss Charlottenburg) of which has friend the poet Heinrich von Kleist wrote that 'Since in its uniformity and limitlessness it has no other foreground than the frame, looking at it makes you feel your eyelids have been cut off.'

Friedrich's work, often on quite large canvases, was highly regarded in his earlier years. Famous writers, including Goethe, were his friends and acquaintances. The King of Prussia and the Crown Prince, and later Nicholas I of Russia bought his work; he was visited by important artists; he was elected to membership of the Dresden Academy, which brought a stipend; he was close to, and influenced, *Runge and younger artists such as *Dahl and Kersting. But in 1825 he suffered a serious illness. This was followed by an incapacitating stroke in 1835, and he returned to working on paper. In any case the advance of *Romanticism had brought a new, more vaguely enthusiastic, note to landscape painting and had made fashionable pictures relying on nostalgia for a medieval world, to Friedrich a denial of true spirituality in art. His coolly passionate paintings were no longer in demand. During the decades that followed his death he and his work were largely forgotten, until it was studied again, and honoured, from the 1890s on, in time to attract the attention of *Munch, *Hodler, *Nolde, *Klee and other key figures in early *Modernism. Friedrich's work is best seen in the Dresden State Collection.

Friesz, Othon (1879–1949) French painter, born and trained in Le Havre where he became a friend of *Dufy. In 1898 he came to Paris and was soon drawn to the circle around *Matisse and thus became one of the *Fauves in 1905, though his painting remained closer than his colleagues' to *Impressionism.

Frink, Elisabeth (1930–93) British sculptor, trained in Guildford and London. During 1967–73 she lived in France. She was made a Dame in 1982. She is known for her modelled sculptures of birds, horses and men, in a style which may be described as dramatic *naturalism. She received a number of public commissions (*Horse and Rider*, 1975, Piccadilly, London) and also produced portrait busts of eminent sitters. She showed many times after her first solo exhibition in 1955.

Frith, William Powell (1819–1909) British painter, first of *History paintings but from 1851 on, and with great success, of contemporary *genre scenes. A York-shireman, his parents wanted him to be a

painter, and so Frith studied in the Royal Academy Schools to emerge a painter of historical and literary subjects, drawing on authors from Shakespeare and Molière to Sterne and Dickens. The attention gained by the *Pre-Raphaelites with their modern subjects led him to picture a generous slice of Victorian life as observed on *Ramsgate Sands*. Exhibited at the RA in 1854 it was much admired by all and bought by Queen Victoria. Frith went on to paint a number of such panoramic scenes, full of little anecdotes and warranting detailed reading like a Dickens novel. Among the most famous are *Derby Day* (1858; coll. H.M. the Queen), *The Railway Station* (1862; Egham, Royal Holloway College) and *Private View Day at the Royal Academy* (1883; pc). He accompanied these unsentitious narrative scenes with series of moralistic paintings, and also went on producing history paintings of limited and deteriorating quality. Although he was reluctant to give it any credit, photography served him for data; *Derby Day*, for example, benefited from specially commissioned photographs. An Associate of the RA in 1845, and a full Academician in 1852, Frith exhibited at the RA and elsewhere until the turn of the century. In 1951 the Whitechapel Gallery in London, and Harrogate Art Gallery put on a Frith retrospective. His *Reminiscences* in three volumes (1888+) give a lively account of his world.

Froment, Nicolas (recorded from 1450 to 1490) French painter from the Languedoc, influenced by the Flemish art of the *Master of Flémalle or the early work of Rogier van der *Weyden. An early *triptych of the *Resurrection of Lazarus*, signed and dated 1461, is now in the Uffizi in Florence and was perhaps painted for a convent near that city. He is recorded in Avignon between 1468 and 1472, and may there have come to the attention of Duke René of Anjou, who commissioned Froment's masterpiece, the *Altarpiece of the Burning Bush* in which the Duke and his second wife appear in *donor portraits (1476; Aix-en-Provence, Cathedral). The work is notable for its complex imagery,

based on texts in honour of the Virgin, and its combination of Flemish and Italian elements – the latter particularly noticeable in the Tuscan landscape, which recalls similar passages in the work of *Piero della Francesca and the *Pollaiuoli.

Fromentin, Eugène (1820–76) French painter and art historian, admired in his day for paintings on Oriental subjects and scenes, drawing on visits to North Africa during 1846–52. He was the author of *Masters of Past Time* (1876), a valuable study of Netherlandish and French painting.

Frost, Terry (1915–) British painter, who turned to art while a prisoner-of-war in Germany in 1943, and was long associated with the *St Ives School. He exhibited frequently in Britain and America. His work is *abstract, though at times it reveals its sources in landscape and other subjects, and is marked by strong forms and colours and an exceptional sense of energy and rhythm.

Frottage (from the French *frotter*, to rub) A technique introduced into *Surrealist art by *Ernst, who, in 1925, took rubbings from floorboards as the basis for graphic work and paintings, then also introduced rubbings from other surfaces and objects. The technique recommended itself especially because the forms and patterns produced did not originate in the artist's mind but served to stimulate his imagination and that of the observer.

Frueauf, Rueland the Elder (1440/1450–1507) and his son, **Rueland the Younger** (d. *c.*1545) Austrian painters. From 1470, Rueland the Elder was the leading master in Salzburg and Passau; after many years of working in a manner derived from Rogier van der *Weyden, he changed in the 1490s to a calmer, more *classicizing mode (Vienna, Österreichische). Rueland the Younger is mainly known through the fragments of a dismembered altarpiece of 1505–1507 (Klosterneuburg, Stiftsmuseum), notable for their spacious landscape backgrounds.

Fry, Roger (1866–1934) British critic, painter and art historian who achieved international fame as writer and impresario. During 1906–10 he was retained by the Metropolitan Museum, New York, as its roving curator, advising on purchases. A founder of *The Burlington Magazine* in 1903, in 1909–19 he was its joint editor, giving it a major role in the presentation of modern art. In 1910 and 1912 he put on exhibitions in London in which the *Post-Impressionists, as he called them, appeared as modern masters, notably *Gauguin, Van *Gogh and *Cézanne. In Cézanne he saw the key painter of modern times. The second exhibition gave more prominence to living artists and included *Matisse, *Picasso, *Braque and other *Cubists, as well as Russian and English sections. The essays published as *Vision and Design* in 1920 recommended a broad range of unconventional art, from the *primitive to *Giotto and Cézanne. His study of Cézanne was published in 1927. From 1920 on he was a central figure of what has become known as the *Bloomsbury Group of writers and painters. In 1933 he became the Slade Professor of Fine Art at Cambridge; the lectures he gave there were published posthumously as *Last Lectures*. For him, meaning in art was given by its formal expression; this emphasis served its purpose in a society too wedded to the descriptive or literary content of art, but is now attacked for its aestheticism.

Fuller, Isaac (d.1672) Idiosyncratic English painter, active in Oxford at the same time as *Dobson and in London. He trained in France under François Perrier (*see under* Lebrun, Charles) sometime before 1635. He is now known chiefly for the *bravura* of his portraits (*Self-Portrait*, three variations: Oxford, Bodleian; Queen's College; London, National Portrait; *Unknown man*, London, Tate; *Edward *Pierce*, Sudeley Castle) and his reputation as a drunkard. His altarpieces for the chapels of Oxford colleges have disappeared (John Evelyn, in his diaries for 1644, described the one for All Souls as 'too full of nakeds for a chapel'), as have the life-size mythological divinities he painted to decorate a room at the Mitre Tavern in Fleet Street (*Vertue praised the 'fiery colours' and muscularity of the Bacchic figures). Five large canvases of the adventures of Charles II after the Battle of Worcester are now in London, NPG.

Fulton, Robert (1765–1815) Celebrated in his native America as the inventor of the steamboat, Fulton is important primarily as a mechanical engineer; he was earlier, however, a painter of miniature portraits and of landscapes (Philadelphia, Pennsylvania Academy). Sponsored in 1786 to study in London, he became a pupil of Benjamin *West and exhibited at the Royal *Academy.

Funk Art Name given to the wild and disruptive work, mostly in the form of *assemblages, done by a number of artists in the San Francisco Bay area in the 1950s and 60s, and associated with the *anti-art tradition of *Dada. The junk materials used, and the subjects and stylistic impact, were intended to refute polite taste and the by then acclaimed, but all too solemn, art of the *Abstract Expressionists. It was given a definitive exhibition at the University of California, Berkeley, in 1967.

Furini, Francesco (1603–46) Influential Florentine painter. Although he also painted *frescos (Rome, Pal. Bentivoglio; Florence, Pitti), the works for which he became famous were *cabinet pictures of morbidly voluptuous nudes, brooding in half-length against a dark background and executed in extreme, albeit delicate, *sfumato. They are indebted to Guido *Reni and to the *tenebrism of *Manfredi, with whom Furini studied briefly during his stay in Rome, 1619–22. A crisis of conscience made him temporarily assume the priesthood in 1633; in this time he only painted religious works. There are paintings by him in Puerto Rico, Ponce, Museum; Florence, Pitti; Duke of Newcastle.

Fuseli, Henry (1741–1825) Born in Switzerland as Johann Heinrich Füssli, he became celebrated and influential under

his part-italianate, part-anglicized alias as a teacher and writer on art, and a visionary draftsman and painter. His declared ideals were *Neoclassical, yet his work exemplifies *Romantic excess – heroic, demonic or erotic. An eloquent proponent of *History Painting in his lectures at the Royal *Academy, he nevertheless executed paintings and drawings illustrating, or sublimating, private obsessions, notably with violence and the figure of the 'femme fatale' more familiar from late 19th-century imagery.

The son of the portrait painter and writer on art **Johann Kaspar Füssli** (1707–82), Johann Heinrich was forced by his father to train as a Zwinglian minister. In 1762, in consequence of a political pamphlet, he had to leave Zurich with his friend and fellow-polemicist, the theologian Lavater, whose influential treatise on physiognomy he was later to illustrate. After travels throughout Germany and an extended stay in Berlin, he came to England in 1765, first working as a translator, most significantly of *Winckelmann. *Reynolds encouraged him to devote himself to painting, and to train in Rome, where he remained from 1770 to 1778. His fiery response to the antique, to *Michelangelo and *Mannerist art, his summary but *expressive drawing style, and his choice of themes influenced other northern artists in Rome (see, e.g. Abildgaard, Hamilton, Sergel, Banks), where he became virtually the leader of a school of painting. On his return to Zurich he painted a heroic incident in medieval Swiss history for the Town Hall, The Three Confederates (in situ); he also fell passionately in love with a niece of Lavater's. His proposal of marriage refused by the girl's father, Fuseli left for London in 1779. The painting which sealed his international fame, The Nightmare (1781, Detroit, Institute of Art), in which an incubus straddles a voluptuous young woman, is thought to refer to this unconsummated love affair. From 1786, he was one of the most active contributors to *Boydell's 'Shakespeare Gallery' (London, Tate; Paris, Louvre etc.) In 1788, he married a 'social inferior', Sophia Rawlins, who features in innumerable near-pornographic drawings. In 1790 he began work on a 'Milton Gallery', to consist of over thirty paintings by him alone; opened in 1799, it proved to be a critical success but a public failure (London, Tate; Zurich, Kunsthaus etc.). Other 'serial' works by Fuseli include illustrations to Dante, to Spenser's Faerie Queen, to Nordic myths and legends, medieval and modern German poems, fairy tales, etc. Perhaps his most haunting image, however, is the drawing of The Artist in Despair over the Magnitude of Antique Fragments, in which a small figure weeps by the gigantic fragments, a hand and a foot, of a colossal Roman statue of Constantine (1778–80, Zurich, Kunsthaus).

Futurism An Italian movement in literature and the fine arts, associated also with music, photography, film, drama and architecture, launched in 1909 in Paris by the writer *Marinetti. He repudiated Italy's weighty cultural past, asserted her maturity as a modern nation, campaigned for the completion of her unification, and proposed the modern urban experience as the only subject for modern art. A group of artists formed around him in Milan, notably *Boccioni, *Carrà, and *Russolo; *Balla in Rome and *Severini in Paris became members. They campaigned for their ideas through public performances which attracted attention in Italian cities. Their first major exhibition was shown in Paris in 1912 and developed into two shows which in 1912–13 toured London, Berlin, Brussels, Munich, Vienna, Breslau, Hamburg, Dresden, Zurich, Amsterdam, Rotterdam, The Hague and Chicago. Manifestos on Futurist painting and sculpture appeared in 1910 and 1912. Marinetti and/or some of the exhibiting artists lectured and published statements in most of these cities during the exhibitions. Their vehemence against the past, together with the fragmented and uncouth character of their works, gave 'futuristic' its sense of headlong foolishness; their art, largely an emendation of *Cubism for the sake of greater dynamism, propagated Cubist methods along with their own ideas, so that their impact was sometimes referred to as Cubo-Futurist. Their hopes for Italy's political identity sharpened in 1914 into a campaign to bring her into the

European war. Some of the Futurists did
not survive it, but younger artists had
joined to provide reinforcements with which
Marinetti was able to renew Futurism in
1916, with Balla as a central figure. The
movement continued into the 1920s and was
associated with Italian Fascism, principally
through the involvement of Marinetti
himself.

Fyt, Jan or **Joannes** (1611–61)
Outstanding and influential Flemish
painter of monumental *still lifes, famous
especially for his depiction of trophies of
the hunt; also the most important appren-
tice and assistant of Frans *Snyders. In
1633–4 he was in Paris; he then travelled in
Italy, returning to Antwerp by 1641. He
may have visited the northern Netherlands
in 1642. Under Dutch influence he turned
from the extrovert *Baroque manner of
Snyders to a more contemplative mode,
combining large-scale decorative arrange-
ment with meticulous depiction of different
surfaces (Stockholm, Museum; London,
National; Frankfurt, Städel; Amiens,
Musée; Madrid, Prado; The Hague,
Mauritshuis; Copenhagen, Museum; New
York, Metropolitan; St Petersburg,
Hermitage; etc.).

G

Gabiou, Marie-Elisabeth *See under*
Lemoine, Marie-Victoire.

Gabo, Naum (1890–1977) Russian-
American sculptor, born in Bryansk, south
of Moscow, brother of Antoine *Pevsner.
Gabo adopted his professional name in
1915 when he made art his career. Before
then he had embarked on medical studies
in Munich, changed to science and then
to engineering, and attended art history
lectures. He visited Italy and also Paris
where he met *Archipenko. In 1914 he left
Germany because of the war and went
to Oslo where Pevsner joined him. In
February 1917 they returned to Russia and
settled in Moscow. After the Revolution
he declined a teaching position under the
new Commissariat of Enlightenment but
collaborated with the new régime. In
Norway he had made figurative construc-
tions of planes whose edges define silhou-
ettes without enclosing space. In Russia, in
1919–21, he made his first wholly *abstract
pieces, e.g. a *kinetic sculpture made to
vibrate by an electric motor (London,
Tate), also model projects for monuments.
In August 1920 Gabo and Pevsner put on
an open-air show of paintings and sculp-
ture in Moscow. Their *Realistic Manifesto*
was published and fly-posted concurrently.
In it Gabo asserted that space and time
were now the basic elements of art. He
rejected the sculpture of masses, associ-
ating his work with that of engineers.

In 1922 Gabo went to Berlin. There the
*First Russian Exhibition included at least
nine Gabos. In 1924 his constructions were
shown in New York and Paris, many of
them now in plastics and resembling three-
dimensional mathematical diagrams of
variable scale. Diaghilev commissioned the
décor for *La Chatte* from him and in 1926
Gabo made a model for the set in Paris,
staying with Pevsner who contributed an
abstracted figure: the ballet and décor were
realized in 1927. Gabo's first one-man exhi-
bition of constructions was shown at the
Kestner Society, Hanover, in 1930.

In 1932 he left Berlin for Paris where he
joined *Abstraction-Création. In 1935 he
moved to London. His work was included
in the exhibition 'Cubism and Abstract Art'
at the Museum of Modern Art, New York,
in 1936. He co-edited and contributed two
essays to *Circle* in 1937. In 1938 he visited
the USA where an exhibition of his work
toured. From 1939 to 1946 he lived near St
Ives in Cornwall. After the war he settled in
the USA. In 1948 an exhibition at MoMA,
New York, shared with Pevsner, was the
occasion for his major statement, 'The
Philosophy of Constructivist Art'. From
this time on he showed frequently on both
side of the Atlantic and received commis-
sions for large-scale public sculptures, e.g.
for the Baltimore Museum of Art (1950–
1) and the Bijenkorf store in Rotterdam
(1954–7). In 1959 he gave the lectures pub-
lished as *Of Divers Arts* at the National
Gallery of Art, Washington. He subse-
quently received many honours, including a
British knighthood in 1971.

Gabo rejected the utilitarian direction
taken by the Russian *Constructivists,
insisting on art as self-sufficient work, the
product of new conceptions of space and
of new materials as well as of personal
conceptions. The original impulse presum-
ably came from Archipenko's experimental
work and was furthered by *Tatlin's con-
structions. But Gabo found his own direc-
tion, attending more to mathematics and to
forms of growth in nature. Among his most
poetic works are the *Linear Constructions in
Space* (1932+) in which perspex forms are
wound about with nylon thread to produce
transparent forms made visible by light.
His example has been crucial in the history
of western *Constructive art. His work is
to be seen in many collections around the
world, including the Tate Gallery, London,
to which he also left a collection of small
works and maquettes.

Gaddi, Taddeo (recorded 1332–66) and
his son **Agnolo** (recorded 1369–96)
Florentine painters; Taddeo was the best-

known pupil of *Giotto, Agnolo is the most important of his three painter sons. The earliest dated works by Taddeo, the 1332–8 *frescos of the *Life of the Virgin* in Florence, S. Croce, Baroncelli chapel, demonstrate, through their descriptive and *expressive complexity, his dependence on the Sienese *Lorenzetti brothers as well as on his teacher. The famous scene of the *Annunciation to the Shepherds* pioneers nocturnal light effects. On the socle of the east wall is painted the earliest known example of post-antique independent *still life: a fictive niche enclosing liturgical vessels.

Even more strikingly *illusionistic, and on a much larger scale, are the c.1340–50 frescos in the former refectory of S. Croce depicting *The Last Supper* as taking place in the viewer's own space in front of a wall painting of *The Tree of Life* – a mystical Crucifixion illustrating the *Meditations* of St Bonaventure – and scenes from the *Lives of Sts Benedict, Louis, Francis* and *Mary Magdalen*. His 1342 frescos in Pisa, S. Francesco, have largely disappeared, but there are panel paintings by him in Florence, Uffizi; Berlin, Staatliche (indebted to Bernardo *Daddi); Pistoia, S. Giovanni Fuorcivitas.

In the best known of his works, the frescos of *The Legend of the True Cross*, c.1380, S. Croce, choir, Agnolo Gaddi abandoned almost totally the sober realism of Giotto, already diluted in his father's Baroncelli frescos, in favour of a fantastical and decorative style based on abrupt transitions of scale and complex colour harmonies. Several panel paintings have been attributed to him, and he was recorded as working in the Vatican, 1369.

Agnolo Gaddi trained Cennino Cennini, author of *The Craftsman's Handbook* (*Il Libro dell'Arte*) c.1390, our best source of information on the painting techniques of Giotto and his followers, and on many procedures followed by artist-craftsmen of the 14th and even 15th centuries.

Gainsborough, Thomas (1727–88) Portraitist, painter of landscapes and of *Fancy Pictures. Unlike his great rival, *Reynolds, he was not a learned artist, being musical, not literary; he did not aspire to the Italian Grand Manner, and his antecedents are rather to be found in Dutch, Flemish and French *Rococo art. Equally unlike Reynolds and other fashionable portraitists, he did not rely on drapery painters to assist him in the production of over 700 portraits. The beauty of his mature and late works depends in large measure on the charm of his flickering, spirited, autograph touch. All the parts of the picture have been worked on together, so that no area of the canvas is lifeless; form dissolves into texture, colour and air. Although the term 'impressionism' has been used to describe Gainsborough's style, his aims should not be confused with those of 19th-century *Impressionism. His goal was not the transcription of optical reality, but the evocation of sensibility, and it should not surprise that his late landscapes were composed from little models he made from pebbles, dried weeds, etc., and that his Fancy Pictures romanticize the lot of the rural poor.

Born in Sudbury, Suffolk, the youngest son of a cloth merchant, he showed a precocious talent for painting. Around 1740 he was sent to London. He had no academic training, but worked with the French engraver *Gravelot, and restored Dutch landscapes, notably *Ruisdael, whom he also copied. On periodic visits back to Sudbury he painted Suffolk landscapes in this style (e.g. *Cornard Wood*, finished 1748, London, National). Late in the 1740s or in the early 1750s, he met, and was influenced by, *Hayman. After his marriage in 1746 he seems to have lived mainly in Sudbury, where he tried to combine the landscape painting he loved with the portraiture he needed to do to earn a living. These fresh *Conversation Pieces, or small full-length single portraits in landscape are among the first paintings in which equal attention is lavished on the landscape and the figures, often gauche and ill-proportioned (e.g. *Mr and Mrs Andrews*, c.1749, London, National). In these years he must have continued to visit London, as his city-scape in the Foundling Hospital testifies (*The Charterhouse*, 1748). Between c.1752 and 1759 he was settled in Ipswich, where he turned to the more lucrative portraiture on the scale of life (e.g. *William Wollaston*,

c.1759, Ipswich, Christchurch Mansion). Artistically, the most successful portraits of these years are the informal, unfinished, pictures of his daughters (. . . *chasing a Butterfly*, 1755/6; . . . *with a Cat*, 1757/8; London, National). In 1759 he moved to Bath, where two important factors caused him radically to remodel his style: for the first time, he attracted a fashionable metropolitan clientele, and he encountered the works of *Van Dyck (e.g. copy after *Lords John and Bernard Stuart*, St Louis, MO). The full impact of Van Dyck is best judged in Gainsborough's female full-length portraits, which now combine elegance with ease of manner, a new, more tender, colour range and a loosening of paint texture (*Mrs Philip Thicknesse*, 1760, Cincinnatti, Museum; *Mrs William Henry Portman*, *c*.1767/8, Viscount Portman). Simultaneously, however, his landscape backgrounds become no more than artificial backdrops. His reputation spread to London; in 1768 he was invited to become a founder-member of the Royal *Academy. In 1774 he moved permanently to London, acquired a great practice, including, in 1780, the Royal Family (*George III, Queen Charlotte*, Windsor Castle). After a quarrel with the Academy in 1784, he ceased to exhibit there, holding private exhibitions in his house.

From the time he had settled in Bath, he had painted landscapes, mainly for his own pleasure (Birmingham, Barber). In London, falling back on earlier landscape studies, and relying increasingly on his artificial models, he began to explore certain idealized rural themes, notably that of *The Cottage Door* (*c*.1780; Cincinnatti, Museum; California, Huntington). After seeing a version of one of *Murillo's pastoral *Child St John* pictures in the late 1770s, he started to paint the pictures by which he himself set most store, the 'Fancy Pictures' of rural beggar children, gypsies and child labourers. Ragged and melancholy, but well-fed and meltingly pretty, these figures found a ready response (Castle Howard; Manchester, Gallery, etc.).

There are paintings – especially portraits – by Gainsborough in almost all major museums in Britain and the USA.

Galgario, Fra *See* Ghislandi, Giuseppe.

Gallego, Fernando (*c*.1440–after 1507) Spanish painter from Salamanca, working in an *expressive Hispano-Flemish style showing some affinities to that of Dieric *Bouts, albeit with a preference for more sober colours. He was the most influential Castilian painter of his time, and the first whose career can be documented (*Retable of St Ildefonso*, *c*.1475–80, Zamora, Cathedral; *Triptych*, Salamanca, New Cathedral; 1473, astrological *frescos – much repainted – University library). An ill-documented relation and follower, Francisco Gallego, was paid in 1500 for the *Retable of St Catherine* in the Old Cathedral, Salamanca.

Gallen-Kallela, Akseli (1865–1931) Finnish painter who altered his Swedish name, Alex Kallen, to make it Finnish and became a leading figure in Finland's nationalist movement of the 1890s, asserting native culture in the face of Russian imperialism. He was trained first in Helsinki and arrived in Paris in 1884 a convinced *naturalistic painter in the *Bastien-Lepage manner. He studied in the Académie Julian and the studio of Cormon. More important, he was part of a Scandinavian circle. Honeymooning in Karelia in 1890, he started work on what was to be a series of narrative easel paintings on themes from the collection of Finnish legends, the *Kalevala* (Helsinki, Athenenum Taidemuseum), in an anti-naturalistic idiom, combining abstract emblems with flattened illustrational forms. In 1899 he painted four large *Kalevala* murals in this manner for the Finnish Pavilion at the Paris Exposition of 1900. In other paintings he combined symbolic forms with naturalistic description, as in *Waterfall at Mäntykoski* (1894) when he painted five gold lines, as harp strings, down the middle of a tall and detailed landscape, and in *Symposium (The Problem)* (1894) where he showed himself, two other painters and the composer Sibelius, who have evidently been drinking and arguing through the night, being visited by a mythical creature, probably a sphinx, seen only in two large wings

intruding on the left (both paintings in private collections). *Avant-garde groups invited him to show abroad, as when he exhibited in *Munch in Berlin in 1895, with *Kandinsky's circle in Munich in 1902, with the Vienna *Sezession artists in 1903 and with Die *Brücke in Dresden in 1910. In 1914 a large selection of his work was shown in San Francisco and toured to New York and Chicago; he also showed in Paris. He travelled avidly. In 1895 he was in London, making contact with William *Morris and the *Arts and Crafts movement; in 1897 he was studying fresco painting in Italy; in 1909–11 he was in Africa; in 1923 he visited Mexico and lived during 1924 in Taos, New Mexico. In 1918 he volunteered to fight against the Russians in Finland's War of Independence.

Galli *See* Bibiena.

Galloche, Louis *See under* Lemoyne, François.

Gambara, Lattanzio *See under* Romanino, Girolamo.

Gargallo, Pablo (1881–1934) Spanish sculptor, trained at the Barcelona Academy and noted for his adaptation of the *Art Nouveau aesthetic and skills there to modern art purposes. In Paris from 1911 on, close to *Picasso, he made masks of hammered and sheet metal, playing concave against convex to bring out ambiguities of perception. Memorial exhibitions were shown in Paris and Madrid in 1935 and the Venice Biennale of 1955 included a retrospective of his work.

Gargiulo, Domenico *See* Spadaro, Micco.

Garofalo, or Garofolo, Il; Benvenuto Tisi, called (*c.*1481–1559) Italian painter active in Ferrara; he may have been born in Garofolo, as his nickname implies. He painted mainly religious pictures, in an eclectic and somewhat stiffly linear style (Ferrara, Pinacoteca; *frescos, Cathedral; S. Francesco) but also some sophisticated mythological subjects, like the *Pagan Sacrifice* in London, National, drawn from

both illustration and text of the *Hypnerotomachia Poliphili*, a mythological fantasy published in Venice in 1499. An obscure *Allegory of Love* (London, National) shows the ill-digested influences of *Michelangelo and *Giorgione. He also painted two *illusionistic ceiling decorations in Ferrara (Palazzo Ludovico il Moro, 'Sala del Tesoro'; ex-Palazzo Trotti, now Seminario) which wittily elaborate the theme of *Mantegna's fictive *oculus* in the Palazzo Ducale, Mantua.

Gaudier-Brzeska, Henri (1891–1915) French sculptor who came to London in 1911 with his Polish companion Sophie Brzeska and added her name to his. His work developed through study of living figures and animals and through influences ranging from *Michelangelo to *Rodin, *Epstein and primitive and archaic artefacts. His work became rhythmic and expressive of energy. His *Red Stone Dancer* (1913–14: London, Tate) sets geometrical forms against tensed curves; *Birds Erect* (1914; New York, MoMA) presents carved forms that hint at their organic source but are dramatized by *Cubist faceting. Gaudier-Brzeska came to know literary figures, including the poet Ezra Pound, and artists. He appears in *BLAST* (1914) as co-signatory of the *Vorticist manifesto and author of an article on the principles of sculpture; *BLAST 2* (1915) printed an article he sent from the trenches in northern France. In 1914 he showed in the first exhibition of the *London Group and his work was included in the Vorticist exhibition of 1915. In 1914 he had enlisted in the French army; in 1915 he was killed on active service. His reputation has grown as modern sculpture has achieved museum status. Ezra Pound's memoir, published in 1916, combined enthusiasm with acute comment. H.S. Ede's biography, *Savage Messiah* (1931) is a work of friendship. Ede's collection, at Kettle's Yard, Cambridge, includes several Gaudier sculptures and many drawings.

Gauguin, Paul (1848–1903) French painter, whose life as well as work has been seen as representing an all-out rejection of western civilization. He was born in Paris,

lived in Peru during 1851–5, and then again in France. From 1865 to 1871 he was in the merchant service and the French navy. He took up painting in 1871 as a hobby while working in a Paris stockbroker's office. In 1873 he married Mette Gad from Copenhagen. Gauguin's passion for painting grew. He attended evening sessions at the Académie Colarossi and, having met Camille *Pissarro, began to buy *Impressionist pictures. In 1876 a Gauguin landscape was accepted by the Salon. By 1879 he was painting under Pissarro's guidance and in 1880–3 he exhibited in the annual Impressionist exhibitions. In 1883 he left his job to be a professional painter. In 1884, the incomeless father of five children, he moved the family to the less expensive city of Rouen. Later that year Mette returned to Copenhagen with two of the children; he followed her there, took a job and in 1885 had an exhibition which failed totally. He and one son, Clovis, returned to Paris. He showed in the 1886 Impressionist exhibition. He spent five months in Brittany, at Pont-Aven, meeting there *Bernard and other French and foreign painters.

Back in Paris he kept alive by selling paintings from his collection and studied making ceramic sculptures. In April 1887 he sailed to Panama, worked as a labourer on the canal and moved on to Martinique, but dysentry and poverty drove him back to Paris. He spent February–October 1888 at Pont-Aven where, influenced by Bernard, his art changed dramatically. *Vision after the Sermon* (1888; Edinburgh, Scottish NG of MA) is a key example. Then he went south to Arles to stay with Van *Gogh: they would form the nucleus of an artists' brotherhood, living cheaply and working together in the warmth of Provence. After Van Gogh's breakdown that December Gauguin returned to Paris. At the 1889 World's Fair he was impressed by Javanese and Indonesian art. He spent June 1889–February 1890 in Brittany, and again June–November 1890. That winter he became part of the *Symbolist circle of writers and painters in Paris. They gave a banquet in his honour in March 1891 and a few days later he left France for Tahiti.

He lived first in and near Papeete. He was ill and in extreme poverty; attempts to sell his work in France failed and he returned to Paris in August 1893. April–November 1894 he spent in Brittany. An attempt to auction his Tahitian work was disastrous, and that May Gauguin sailed for Tahiti again. Ill and moneyless, he had to spend a month in hospital. 1897 found him in better health and out of debt, but by the end of the year all his troubles had worsened. He began his large canvas *Where Do We Come From?*... (Boston MFA) that December and in January 1898 attempted suicide. Calmer days followed: paid work in Papeete, money from France and hospital treatment eased his situation, also news from Paris that the dealer Vollard had bought thirteen of his paintings, though at low prices. But he painted little, partly for lack of materials. In August 1901 he transferred to La Dominique, Marquesas Islands, where he was able to live better on what money came from France. 1903 found him again unwell, unable to paint and involved in a lawsuit. He died that May.

Gauguin's painting started from the *realism of the *Barbizon School, became Impressionist and then *Symbolist, giving priority to the imagination and the affective powers of form and colour. Paintings done in Martinique show heightened colours but it was a range of *primitive influences, including *Bernard's example, that brought the major change: Breton costumes and art, Japanese prints, and what he saw of other exotic arts in Paris. From now on his work sought the quality of folk tales, and the South Seas environment and what he learned of native religion provided him with new material. He wanted his art to address the great questions of life in ways that reflected daydreams and stimulated a meditative response. Yet he never abandoned European ways, and out of this combination of the exotic and the traditional came his powerful appeal to younger artists. The *classical tradition echoes in his work even when his motifs are Tahitian: *Where do we come from?*... is in composition *Neoclassical for all its idols, native figures, unnatural colours and vague themes.

Far from ignoring western art, Gauguin's primitivism was a refreshing

contribution to it. He carved reliefs and free-standing objects, and made ceramic sculptures, and some of these relate more directly to primitive artifacts; yet the finest of them, the painted relief *Be in Love and You Will be Happy* (1889; Boston MFA) owes little to primitive influences but instead almost everything to his ability to sidestep conventional formulae to represent emotional tensions. The bold delineation of figures, the strong, often unnatural colours and his use of decorative patterning, gave his paintings remarkable influence in the *Art Nouveau period and subsequently on *Fauvism and *Expressionism. His writings established him as one who had gone native in a paradise of love and visual riches. His chief impact came with his retrospective at the 1906 Salon d'Automne, where a memorial show had been put on a few months after his death.

Gaulli, Giovan Battista; called **Baciccio** or **Baccicia** (1639–1709) Genoese painter best-known for his *illusionistic ceiling *frescos in the Gesù, Rome, executed during 1672–85 under the influence of *Bernini. This type of church decoration, fusing together painted areas, three-dimensional decorations and the actual architecture, was to reach its final expression in Germany and Austria (*see also* Andrea Pozzo). Before settling in Rome in 1657 Gaulli had based his style on the Genoese works of *Van Dyck and *Strozzi; perhaps on Bernini's advice he visited Parma in 1669 and was much affected by *Correggio, whose *sfumato* handling is evident at the Gesù. His first frescos were the pendentives for S. Agnese in Piazza Navona, 1668–71. After Bernini's death his colour range became paler and he turned to more *classical compositions, such as the one of his last ceiling fresco, SS. Apostoli, 1707. Gaulli was also one of the prime portraitists of his time; he painted likenesses of all seven popes from Alexander VII to Clement XI as well as most of the cardinals (e.g. Rome, Nazionale.)

Gauricus, Pomponius (*c.*1480–1528/30) His name in Italian is Pomponio Gaurico. Poet, humanist and professor of philology at the University of Naples, the author of

a seminal treatise on sculpture, *De Sculptura seu statuaria libellus*, published in Florence in 1504 but conceived at the University of Padua and drafted around 1500 in Venice, where Gaurico was in exile from the Kingdom of Naples. Written in Latin under the influence of *Classical texts (notably *Pliny), Florentine Neo-Platonic philosophy and Venetian and Paduan *all'antica sculpture, (*see* Riccio and the Lombardi, *under* *Pietro Solari), *De Sculptura* relegates to a lower sphere questions of the physical making of sculpture, and emphasizes the importance of drawing (*see also disegno*) in sculptural practice. Gauricus advocates endowing the sculpted figure with dignity and the semblance of inner life and 'animation', in imitation of ancient statuary; he singles out *Ghiberti as the father of 'modern' sculpture, and praises *Donatello.

Geertgen tot Sint Jans (Little Gerard of the Brethren of St John) (1460/5–90/5) The best-known Dutch painter of the 15th century. Born at Leyden, he is presumed to have been the pupil in Haarlem of **Albert Ouwater** (active from 1450 to 1480), from whom he would have learned the new naturalistic (*see under* realism) idiom of Van *Eyck; he may, however, have been an apprentice in Bruges in 1475/6. *The Holy Kindred* (*c.*1485; Amsterdam, Rijksmuseum), attributed to him, shows an indebtedness to Ouwater's only known work. His best-attested pictures are two panels from a triptych painted for the Knights of St John in Haarlem (1490/5; Vienna, Kunsthistorisches). These, and other pictures grouped around his name, demonstrate an interest in landscape and in the nocturnal light effects with which he is now particularly associated (*Nativity, at Night*, London, National; other paintings, Berlin, Staatliche; Rotterdam, Boijmans Van Beuningen).

Gelder, Aert or **Arent de** (1645–1727) *Rembrandt's last and best pupil, *c.*1661–*c.*1663, was also his closest follower, and the only Dutch artist to continue working in Rembrandt's manner during the 18th century, albeit he brightened Rembrandt's limited colour range to include blue, green

and violet. In addition to portraits (e.g. *The Family of Herman Boerhave*, *c*.1722, Paris, Louvre) Gelder painted basically two types of history pictures (*see under* genres), mainly from Scriptural sources: those, derived from Rembrandt paintings, which focused on the interaction of a few life-size half-length figures (e.g. *Abraham Entertaining the Angels*, Rotterdam, Boijmans Van Beuningen; *The Feast of Belshazzar*(?), 1682–5, Los Angeles, Getty) and those, frequently related to Rembrandt's etchings, in which many small-scale figures appear at a distance (e.g. *Scenes from the Passion*, *c*.1715, Aschaffenburg, Museum; Amsterdam, Rijksmuseum).

genres (French for varieties, types, categories) There is no comprehensive system of categorization universally employed in art theory or in the study of the visual arts. It could be argued, however, that classifying art by genres – that is, according to subject matter and function, supplemented by medium – might be more useful than categorizing it by styles, as is normally done in art history (*see* Gothic, Renaissance, Mannerism, Baroque, Rococo, classicizing Neoclassicism, Romanticism). Genres play an important role in determining scale, format, cost and even style in the commissioning and production of works of art. Generic aptness and coherence are key, components of the art-theoretical notion of *decorum.

A ranked ordering of pictorical genres was evolved in the Italian Renaissance by analogy with ancient Graeco–Roman theories of literary genres, to accommodate the growing number of uses to which painting was put, and the growing differentiation between the arts of *disegno* and manual crafts. This system of categorization applies only very partially to sculpture, although it has been influential on Western art as a whole. It was given its definitive expression in the Preface written by *Félibien to the 1669 publication of lectures delivered at the French *Academy in 1667. In the academic hierarchy of the genres the highest category is *history painting** (from the Italian *istoria*), large-scale narrative in the grand manner, comparable to the literary genres of tragedy or epic which

represent the actions of people 'better than ourselves'. Thus history painting may depict episodes from the lives of saints, Christ and the Virgin; from ancient mythology, literature and history, and, by extension, from more recent literary texts and historical events, provided that the actions represented are 'noble' and worthy of serious consideration. On a par with history painting is *allegory. These types of painting are particularly suited to the decoration of princely palaces or of public buildings and public spaces, where they can both express, and help to form, communal ideals. The painter who specializes in this category of art is to be ranked on a par with the ancient tragic poet and public orator, since he not only requires comparable gifts of intellect and imagination, but may be thought to wield comparable influence.

The second-highest pictorial category in the academic hierarchy of the genres is **portraiture**. Although it lends itself also to small-scale private forms, portraiture concerns itself with the depiction of heroic personages for public viewing.

Third in the academic hierarchy of the genres is the representation of everyday life, comparable with the ancient literary category of comedy, depicting the actions of people 'like ourselves or worse than ourselves'. Since the 19th century this category has been confusingly called **genre**: thus genre is one of the genres. Before the 19th century people spoke of 'everyday subjects', 'market scenes', 'banquet scenes', 'brothel scenes', etc. If, in their pure form, history painting and allegory are associated with public venues and a large scale, pure genre is associated with domestic settings and a small scale. Genre painting thrived as never before in the 19th century. Ordinary people and their doings increasingly provided subjects for art, as for literature. Genre painting delivered savage satires of society and political and social revolutions forced interest in the condition of the working classes, making it possible for genre painting to advance towards history painting as a serious art form. In the 20th century the rapid development of film provided more effective ways of delivering images of contemporary life and, as photography and video have become

prominent as means of art, so also has social reportage.

The fourth and fifth categories are not primarily concerned with the depiction of human actions. They are *landscape and *still life respectively.

From the very beginning, genres could be conflated or subdivided. Thus landscape comprises seascape, mountain scenery, townscape, harbour or river scenes, etc. It is only a matter of emphasis which determines whether a painting representing peasants labouring in the fields is classified under landscape or genre. Even today the Spanish recognize two categories of what we might call still life: the *florero* or flowerpiece, and the *bodegón*, or representation of foodstuffs, which has always admitted the human presence. Still life, always a popular genre, has admitted such specialities as still lifes with shells, with fish, with trophies of the hunt, with musical instruments, with books. Moralizing intentions could be expressed almost as easily in the 'lower' genres as in the highest, and Dutch 17th-century painting, which evolved so many forms of genre, landscape and still life, must be read with this in mind. Thus a 'merry company' of young people enjoying a banquet may have been intended to remind the viewer of human society before the Flood, and a still life, of the Preacher's words in Ecclesiastes, 'vanity of vanities, all is vanity' (*see* Still life). The hierarchy of genres continued to exercise some pressure within the academies during the 19th century even while it was being weakened in academic practice and undermined in extra-academic art circles. History painting remained the most highly regarded art form, but in that age of historicism and archeological research it came to lack artistic energy and innovative thought. Generally art progressed by attending to other forms, with landscape predominating.

Although, as has been said, the academic hierarchy of the genres was evolved primarily for pictorial art, it is possible to speak of the genres of sculpture: funerary monuments, for example, or equestrian statuary, portrait busts, etc. Sculpture provided a succinct form of 'history' in statues of the heroes of religion and of ancient and modern history, and by the end

of the 19th century genre themes and portraits of animals had been added to its accepted range. Sculptors then embarked on new ambitious subject matter, employing narrative history and mingling the genres, to give human significance to constructed objects and *vice versa*. When sculpture rejected the pedestal and the architectural frame, around 1960, it became townscape and landscape; installations that transform environments into poetic places naturally followed.

The term may thus be applied loosely to mean any type of art which has a format, function or subject which distinguishes it from any other type. Even within painting, it is thus possible to consider, e.g. the altarpiece, or illusionistic ceiling paintings, as forming discrete genres with their own characteristic problems and traditions.

Gentile da Fabriano (*c*.1385–1427) Italian painter from Fabriano in the Marche. Celebrated in his day for his technical perfection and his novel pictorial language, at once elegant and naturalistic (*see under* realism), he has been categorized in modern scholarship as a leading exponent of the International *Gothic style. This pigeon-holing obscures his innovations – notably in the use of light to create unity of space – which were indeed quickly eclipsed by those of *Masaccio. Yet Gentile's influence, preponderant in Florence *c*.1420–3 even over Masaccio himself, continued to affect artists throughout the 15th century. *Masolino, Fra *Angelico, Benozzo *Gozzoli, *Domenico Veneziano and *Piero della Francesca are among those most indebted to him, as were all those painters required by conservative patrons to paint *polyptychs on a gold background. Gentile, in turn, remained receptive to novelty. Originally influenced by Lombard miniatures, subsequently by developments in Venice, by contact with Franco-Flemish panels and perhaps miniatures in Brescia, by Florentine 14th-century painting and 15th-century sculpture, he adopted those innovations of Masaccio which he could have seen by the time he left Tuscany for Rome in 1427.

First recorded in 1408 in Venice, Gentile

achieved fame and prosperity in that city. Unfortunately, all his Venetian works have been lost, including the illustrious commission of a naval battle painted in *fresco 1411–14 in the Great Council Hall of the Doge's Palace, one of the scenes destroyed by fire in 1577 (*see also*, e.g. Bellini, Titian). From 1414 to 19 he was in Brescia, where he decorated the chapel of the Broletto, or municipal palace, for the city's ruler, Pandolfo Malatesta (destroyed, 16th century). In Brescia, Gentile met Pope Martin V, on his way back to Rome from the Council of Constance, and was invited to work for him. In 1419/20 he followed the pope to Florence. By 1422 Gentile had been enrolled in the Florentine painters' guild. His earliest surviving documented work, the *Adoration of the Magi* (1423, now Florence, Uffizi) was painted for the sacristy of S. Trinita for Palla Strozzi. A key document of Italian 15th-century art, this work represents the acme of medieval panel-painting technique as recorded in Cennino's (*see under* Gaddi) treatise, while firmly embracing the notion of painting as an extension of visual experience. The narratives of the *predella demonstrate most clearly Gentile's interest in complex lighting schemes, as in the nocturnal *Nativity*; in problems of picturing action in panoramic landscape, as in the *Flight to Egypt*, and in continuous townscape, as in the *Presentation in the Temple*. The whole is expressed with Gentile's characteristically humane warmth: splendour contrasts with simplicity, religious solemnity with intimacy.

In the following two years Gentile ran a busy workshop in Florence, employing at least two assistants, of whom one may have been Jacopo *Bellini (e.g. panels now in Pisa, Museo; New York, Frick; Florence, I Tatti; New Haven, CT, Yale). The major work following the *Adoration* was the Quaratesi polyptych for S. Nicolo sopr'Arno of 1425, now dismembered (central panel, *Madonna and Child*, Coll. HM the Queen, on loan London, National; four flanking *Saints* with four roundels of saints, Florence, Uffizi; four predella scenes, Vatican, Pinacoteca; one predella scene, Washington, National). In unified spatial planning and colour harmonies this work extends the experience of the *Adora-

tion. The predella scenes were especially praised by *Vasari.

In 1425 Gentile repaired to Siena to paint a (lost) polyptych for the city notaries; the work was interrupted to paint a fresco of the *Madonna and Child* for the cathedral of Orvieto, Gentile's second documented work to survive, albeit in poor condition and with a figure of St Catherine added in the 16th century. Finally, in 1427, Gentile reached Rome to begin working for Martin V at St John Lateran, on a decoration which influenced the *iconography and disposition of the later wall paintings in the Sistine chapel. The narrative scenes were completed after Gentile's death by *Pisanello (in 1431–2), but the whole decoration was destroyed in the remodelling of the basilica in 1647.

In addition to the works above, Gentile's most important extant work is the signed but undocumented Valle Romita polyptych painted for a Franciscan church near Fabriano, c.1410–12, and reassembled in a modern frame in Milan, Brera.

Gentileschi, Orazio (1563–1639) and his daughter **Artemisia** (1593–1652/3) *Caravaggesque painters. Born in Pisa, Orazio came to Rome in 1576, and in the early 1600s was drawn to *Caravaggio's manner albeit remaining loyal to his Tuscan heritage, apparent especially in his range of colours which included blues, yellows and violets. After a stay in Paris, 1623–5, he became court painter to Charles I in England, where he shed the remnants of his Caravaggesque *tenebrism. In addition to his principal English works (nine ceiling paintings for Greenwich, Queen's House, after 1635, now London, Marlborough House) there are paintings by him in Milan, Brera; Fabriano, cathedral; Los Angeles, Getty; Vienna, Kunsthistorisches; etc.

Unlike her father, Artemisia continued to paint sensational Caravaggesque subjects, notably of Old Testament heroines, catering to private collectors throughout Europe (e.g. *Judith and Holofernes*, versions in Naples, Capodimonte; Florence, Pitti, Uffizi). She was also sought after as a portraitist, although few works in this genre have survived (*Self-Portrait as the Personification of Painting*, '*La Pittura*', Coll. HM

The Queen). She became notorious at 19, through the trial of the art entrepreneur Agostino Tassi, whom her father accused of raping her 'many times'. After Tassi's imprisonment, Artemisia married a Florentine and although the marriage broke down, she lived in Florence 1612–21. Her clients there included the Grand Duke Cosimo II. In 1621 she followed her father to Genoa, then spent some time in Venice. Around 1630 she settled permanently in Naples, leaving the city in 1638–40 to visit the dying Orazio in London. Her public commissions, like three large altarpieces in Pozzuoli (late 1630s) show the influence of the new Bolognese *classicism.

Gérard, François-Pascal (1770–1837) French painter, who studied with J.-L. *David in Rome and in Paris dominated court portraiture under the Consulate and the Empire; he managed to continue in this role under the Restoration. He also painted mythological subjects in a manner which is now seen as shallow and too sweet but which at the time was admired for its stylization and directness; an oustanding instance is *Psyche receiving Cupid's first Kiss* (1798; Paris, Louvre).

Gérard, Marguerite *See* Fragonard, Jean-Honoré.

Gerhaert, Nikolaus (active 1462–73) Sculptor influential throughout southern Germany. His figure style is marked by a new physical expansiveness and highly individualized physiognomies and poses; it is indebted to Claus *Sluter. Signing himself as *von Leyden*, he may have been a native of Holland or trained there. His earliest known work is the tomb of Archbishop von Sieck in Trier (1462, Diocesan Museum), but throughout the 1460s he was based in Strasburg (portal for New Chancellery, fragments in the Musée de l'Oeuvre Notre-Dame; Frankfurt, Liebighaus), travelling also to Constance (cathedral high altar, destroyed). From 1469 until his death he was employed in Vienna, mainly on the tomb of Emperor Friedrich III (St Stephen's Cathedral).

Gerhard, Hubert (1540/50–1620) Dutch-born sculptor, a pupil in Florence

of Giovanni *Bologna. He was the first sculptor active in Germany to employ the monumental style of the Italian *Renaissance, as opposed to the ornamental *Mannerism of, e.g. the *Jamnitzer workshop. From 1581, he worked for members of the Fugger family in the castle at Kirchheim (e.g. fountain, 1584–94, surviving bronze group, 1590, now Munich, National); from 1589, for the city of Augsburg (*Augustus Fountain*, compl. 1594; *see also* Adrian de Vries). After 1584 Gerhard also worked for Duke Wilhelm V in Munich, mainly on the ducal palace (e.g. *Perseus Fountain*; fountain figures, now Residenz-Museum) and the new Jesuit church of St Michael (e.g. façade figures; *see also* Hans Reichle). With the Duke's abdication in 1597, he found employment with the Archduke Maximilian at Innsbruck, probably returning again to Munich in 1613.

Géricault, Theodore (1791–1824) French painter, born into a well-to-do family, Géricault was first seen by his contemporaries as a gifted amateur. He studied under Carle *Vernet and *Guérin and made a strong debut at the 1812 *Salon with his *Officer of the Imperial Guard*, but went to Italy in 1816 to energize his conception of art before *Michelangelo's frescos. He was already attached to the art of *Rubens and *Gros, examples of dynamism and heroics. He now sought to make antique grandeur a vehicle for modern subjects and worked hard on a large canvas dedicated to an aspect of the Roman carnival, the riderless *Race of the Barberi Horses*; two small versions exist, in Paris and Baltimore (Walters). He returned from Rome in 1817, earlier than intended. He was looking for a theme with which to make his mark and found it in a book published that year, a story of ministerial mismanagement and injustice, of human savagery and suffering and of man's weakness before the forces of nature. *The Raft of the Medusa* was shown at the 1819 Salon as 'a Scene of Shipwreck' but everyone knew its subject and its provocative nature. On a vast scale, in heroic and darkly dramatic terms (which owed as much to the masters he admired as to his picturing 'a horrible fact taken from modern reality' (Lorenz Eitner)), Géricault had portrayed

a scene without heroes and caused by incompetence and villainy. It was a personal protest, echoing no official or anti-official ideology. It was also, clearly, a major work calling for purchase by the state. This did not eventuate.

There was awe, but also much criticism. Early in 1820 Géricault arrived in England. He arranged to have his great painting exhibited in London, Edinburgh and Dublin, earning him money as well as an instant reputation, and enabling him to make contact with British painters such as *Constable, whose sensitive use of colour and light influenced him. *Racing at Epsom* is one of the fruits of this: a surprisingly brisk painting though based on a conventional sporting print. Géricault had made *lithographs of *realistic subjects in Rome and Paris; in London he published a suite of twelve prints, some on affecting themes of poverty and disease. Back in Paris, with the encouragement of the psychiatrist Georget, he painted ten portraits of insane men and women of which five are extant (Ghent Museum; Winterthur, Oskar Reinhardt coll.; Paris, Louvre; Lyon, Musée; Springfield, MFA): anonymous portraits of great dignity that represent deeply disturbed individuals as clinical types. Other works of these last years, during which Géricault's health deteriorated drastically, show an Orientalism which *Delacroix would take further, as in the watercolour *Lion Hunt* (Cambridge, MA., Fogg). Altogether this short and restless career produced 191 paintings, six sculptures, 180 drawings and 100 lithographs, many of them unknown until the memorial exhibition shown in Paris in the centenary year of his death. Delacroix, who knew Géricault from 1817 on, could be called his disciple, but Courbet and other *realist painters also looked to him as their master. The Musée d'Orsay in Paris has almost all his major works, including those not otherwise ascribed here.

Gérôme, Jean-Léon (1824–1904) French painter and sculptor. He became known as a painter of Oriental subjects after several visits to Egypt. His paintings have a meticulously smooth and detailed finish and he did his best to uphold this *academic virtue in the face of the

century's growing taste for sketchy painting and for the disjointed technique of the *Impressionists.

Gerstl, Richard (1883–1908) Austrian painter, trained at the Vienna Academy and stimulated by new French art seen in Viennese exhibitions as well as by *Expressionist trends in Viennese painting, e.g. *Kokoschka. He was intensely emotional and the portraits that form almost his entire output are expressive in ways that could not fail to make him seem incompetent, even mad, to his contemporaries: his *Portrait of the Schönberg Family* is in cheerful colours whose effect is countered by the explosiveness of the brushwork; his *Laughing Self-Portrait* (both Vienna, Österreichische Galerie) confronts us like a gargoyle. He had enjoyed a close relationship with the composer Schönberg but this ended with Gerstl's eloping with Frau Schönberg; she returned to her husband after a short interval, and Gerstl committed suicide. He had helped Schönberg to paint; his influence on professional artists appears to have been nil, partly because of his aloofness from the art world and his short career, partly because for long it was felt that his work was too wild to warrant attention.

Gertler, Mark (1891–1939) British painter, born in London into a Polish-Jewish family. Gilbert Cannan's novel *Mendel* (1916) is largely a biography of the artist; the sculptor Loerke, in D.H. Lawrence's *Women in Love* (1920), is a portrait of him. In 1920 he had his first one-man exhibition. It included the painting Lawrence called 'the best *modern* picture': *The Merry-Go-Round* (1918; London, Tate), a dramatically simplified image of people on a roundabout as a grim allegory of life, owing more to sculpture such as *Epstein's than to any contemporary painting. His taste for mighty forms led him to adopt elements of *Picasso's *Neoclassicism. As his awareness of French art grew, his work took on qualities derived from *Derain, *Matisse and others, also from *Renoir and *Cézanne. His life was dogged by disappointments and illness and he committed suicide in 1939. There was a memorial exhibition of his work at

the Whitechapel Art Gallery that year. He was then forgotten, but came into prominence again after 1970, with exhibitions and books on his life and work.

Gesamtkunstwerk (German: 'complete', 'collective' or 'total work of art') Early 19th-century research into the way the ancients used colour on temples and sculpture previously assumed to be left white, stimulated fierce controversy between those who considered this use of colour barbaric and vulgar and those who saw in it perfection of value hitherto unknown. The dispute raised the question whether each of the arts should insist on its different priorities or whether, as the German critic and philosopher argued, this insistence on keeping the arts divided did not lead to the decadence of each of them and to the weakening of their benefit to society. The composer Richard Wagner (1813–83) adopted the term to refer to his concept of a music drama in which music, poetry, plot, stage action and design and all contributing elements, preferably including the location, act together to make one integrated work of art, conceived and/or controlled by one creative mind. This essentially *Romantic concept is an extension of the purposeful collaboration between the arts that found its climax in *Baroque religious art, with architects, painters, sculptors and decorative craftsmen consciously providing a setting for enactments involving well-understood rituals performed through music, movement, speech, etc. Wagner's influence was wide and intense. His own ambitions were realized with the opening of the Bayreuth Opera House in 1876 with the first performance of the complete *Ring des Nibelungen*. The *Gesamtkunstwerk* idea is met with frequently in modern art, notably in *Kandinsky and the *Blaue Reiter and is, as in Wagner, associated with fullness and enveloping persuasiveness of presentation. It is to some degree implicit in the development of *Happenings and *Installation art in their recourse to multi-media compositions with or without action.

gesso The Italian word for gypsum, a white mineral composed of calcium sulphate dihydrate, mixed with animal glue to make a smooth and non-absorbent *ground for subsequent layers of paint and gilding in the preparation of early panel paintings.

Gheeraerts, Marcus the Younger (*c.*1561–1635) Leading painter of the late Elizabethan period and under James I. Brought to England in 1568 by his father, the painter and engraver **Marcus Gheeraerts the Elder** (*c.*1520–*c.*90) who returned to his native Bruges in 1577, he was one of a group of Protestant refugee artists whose influence at court was only displaced *c.*1615–20 with the arrival of, e.g. *Mytens. His father's second wife was a sister of the painter **John de Critz** (1555–1642); he himself married their younger sister, thus becoming his stepmother's brother-in-law. His own sister married Isaac *Oliver. While no works can be attributed with certainty to de Critz (although *see*, e.g. London, NPG) a large number of the formal, heraldic 'costume pieces' of Elizabethan and Jacobean portraiture can be ascribed to Marcus Gheeraerts whether through a signature (e.g. Oxford, Bodleian, Trinity College; Penshurst; Coll. HM the Queen; Duke of Bedford) or on the basis of inscriptions in his style. Among the latter works are the famous 'Ditchling' portrait of *Elizabeth I* (1592?, London, NPG) and of *Thomas Lee as a Hibernian Knight* (1594, London, Tate).

Gheyn, Jacob I de (*c.*1530–82) **Jacob II de** (1565–1629) and **Jacob III de** (*c.*1596–1641) Dynasty of Dutch draftsmen and painters, of whom the best known is Jacob II de Gheyn. Like his father, Jacob I de Gheyn, Jacob II de Gheyn designed stained-glass windows, but he was also a pioneer of drawings of domestic subjects, of the painted *vanitas still life (New York, Metropolitan; New Haven, CT, Yale) and of flower pictures (The Hague, Gemeentenmuseum). He studied in Haarlem with *Goltzius, worked in Amsterdam 1591–5 and Leiden 1595–8, after which he settled in The Hague, where he was employed at the court of Prince Maurits of Orange. He began to paint only

*c.*1600. His son, Jacob III de Gheyn, also worked for the court, and is known for still lifes featuring books, a novelty introduced by his father.

Ghiberti, Lorenzo (1378–1455) Florentine goldsmith, painter and bronze sculptor, famous for his authorship of two of the three bronze doors of Florence baptistry (1403–24; 1425–52). His workshop became the training ground of many exponents of the Florentine *Renaissance: *Donatello, *Michelozzo, Paolo *Uccello among others. Despite a restrictive contract for the first doors, Ghiberti also accepted commissions for the monumental bronze statues for the Florentine Guild Hall Church, Or San Michele: *St John the Baptist*, compl. 1414; *St Matthew*, compl. 1422. A third, *St Stephen*, dates from 1427–8. In addition, he participated in the design of the Siena baptismal font, and executed two of its narrative bronze reliefs: *The Baptism of Chirst* and *St John Preaching before Herod* (compl. 1427). From 1403 to 1443 he furnished cartoons (*see under* fresco) for stained-glass windows in Florence cathedral, and throughout his career he continued to practise as a goldsmith.

He also gained a reputation as an architect, but his design for the dome of Florence cathedral was rejected in favour of that by *Brunelleschi, his unsuccessful rival in the 1401 competition for the baptistry doors. Ghiberti's trial panel for this competition (Florence, Bargello) already demonstrates the abiding character of his art, transitional between *Gothic and Renaissance. His dual allegiance, to antiquity on the one hand and to northern European Gothic on the other, is demonstrated also in his *Commentari* (*c.*1447) a treatise on the fine arts which contains an account of his own life. Ghiberti was on friendly terms with leading Florentine humanists; the rise in status of the Florentine artist in the Renaissance, from craftsman to professional man, is dramatically illustrated in his career and through the *Commentari*. His sons **Tommaso** and **Vittorio** (1416–97) inherited his workshop, and Vittorio supervised the execution of the bronze surrounds of the baptistry doors.

Ghika, Nikolas (1906–) Greek artist who in Paris, in 1922, turned from literature to painting. He had his first one-man show in 1927. He took ideas and methods from modern and historical sources, including *Picasso's decorative *Cubism and magical elements in *Surrealism. From 1942 until 1960 he taught at the Athens Technical University. He had many exhibitions on both sides of the Atlantic, and in 1973 was honoured by being the first living artist to be given a one-man show at the Athens National Gallery.

Ghirlandaio, Domenico Bigordi, called (*c.*1448–94) Florentine painter. With, his painter-mosaicist brother **Davide** (1451–1525; Orvieto, cathedral façade mosaics) he ran one of the leading workshops in Florence, *c.*1480–94, specializing in *frescos but also producing mosaics and works in tempera on panel; the young *Michelangelo was apprenticed to him 1488–9. His son **Ridolfo Ghirlandaio** (1483–1561) was trained after Domenico's death by Davide, later by Fra *Bartolommeo, and was deeply influenced by *Leonardo da Vinci. Ridolfo is best remembered for his portraits (e.g. Florence, Pitti; London, National; Washington, National) but was the author also of numerous religious paintings (e.g. Florence, Uffizi) and festival decorations.

Although to modern eyes Domenico Ghirlandaio's work is apt to look prosaic, it exemplifies the concerns of the most advanced Florentine artists in the last days of the Medicean Republic. Deeply rooted in Florentine traditions, he looked to *Giotto and *Masaccio (via Filippo *Lippi) for patterns of narrative and *perspectival construction, and used almost entirely the tried-and-true techniques advocated by *Cennino. From his visits to Rome (*see below*), he imported to Florence the latest *all'antica* models: details from reliefs on the Arch of Constantine and on sarcophagi; *grotesque decoration. Finally, he was, like his patrons, deeply responsive to the newest Netherlandish art, borrowing its motifs and emulating its effects of surface naturalism (*see under* realism).

A pupil of *Baldovinetti after training by his goldsmith father, Ghirlandaio executed

his first significant Florentine work c.1472: a *Madonna of Misericord* for the Vespucci family, Florence, Ognissanti. In 1475, Ghirlandaio's workshop was in Rome, decorating the Sistine library in the Vatican (destroyed). Around 1475–6 he painted the chapel of S. Fina at the Collegiata in San Gimignano, assisted by his favourite pupil and future brother-in-law, the San Gimignese **Sebastiano Mainardi** (c.1455–1513; active in Pisa 1493–5). In 1480 Ghirlandaio was working once more in Florence, Ognissanti, on the *Last Supper* in the refectory, and, in the church, on a fresco of *St Jerome in his study* which was closely influenced by a panel of the same subject by Van *Eyck and *Christus Petrus, then in the possession of the *Medici. This work, dignified but stolid, may be contrasted with a similarly derived but more *expressive *St Augustine* by *Botticelli in the same church.

In 1480–1 Ghirlandaio was one of the team working on mural frescos in the Sistine Chapel in the Vatican (*see also* Perugino, Botticelli, Cosimo Rosselli). Here for the first time in his work we find the mixture of historical narrative and contemporary portraiture which characterizes his best-known and most accomplished projects: the decorations of the Sassetti chapel in Florence, S. Trinita, 1485, and of the Tornabuoni chapel, now choir, Florence, S. Maria Novella, c.1486–90. The former, the best preserved 15th-century family chapel in Florence, houses also the tempera-on-panel altarpiece by Ghirlandaio. In addition to motifs *all'antica*, this *Adoration of the Shepherds*, 1485, depicts a group of shepherds inspired by an analogous group in the *Portinari altarpiece* by Hugo van der *Goes, which reached Florence only in 1483.

As elaborate as the narratives of the *Life of St Francis* in the Sassetti chapel, but larger and more extensive, are the tiered *Lives of the Virgin and of St John the Baptist* in the much larger Tornabuoni chapel. Although still relying on Florentine recensions of the legends, these frescos include more *all'antica* elements than the Sassetti. Both cycles have been avidly studied by historians, since Ghirlandaio transposes, in the earlier cycle, all events in the life of the saint to contemporary Florence, and both

cycles include life-like 'witnesses' from among the families and connections of the patrons.

In addition to these key works, Ghirlandaio executed the fresco decoration in the Sala dei Gigli in the Palazzo della Signoria, Florence, 1481–4. This room, an outstanding monument to the ethos of the Florentine Republic, has an important marble portal sculpted by *Benedetto da Maiano. (Since 1988, it also contains Donatello's bronze *Judith and Holofernes*, originally an outdoor sculpture.) An important altarpiece by Ghirlandaio still stands in *Brunelleschi's Ospedale degli Innocenti for which it was painted, 1488. A badly-restored mosaic over *Nanni di Banco's north portal of Florence cathedral was designed by Domenico in 1489. There are other works in Paris, Louvre; London, National, and many drawings in various museum print rooms, including Florence, Uffizi; London, British; Vienna, Albertina.

Ghislandi, Giuseppe; called Fra Galgario (1655–1743) The most distinguished Italian Late *Baroque portraitist. His comparative obscurity in our time can only be explained by the fact that most of his works remain in his native city, Bergamo. Although many are in private collections, the Accademia Carrara has excellent examples on view: from the touchingly fresh likeness of his youthful assistant, to the grandiloquent double portrait of *Count Giovanni Secco-Suardo with his servant*. He studied in Venice with Sebastiaro *Bombelli, and spent some years there and in Milan, before returning to Bergamo to live and work in the friary of Galgario. His portraits combine Venetian colourism (*see under disegno*), although always against a dark ground, with Lombard *realism, and his mastery of character rivals that of *Moroni. Single examples also in Venice, Accademia; Milan, Brera; Minneapolis, Institute; Hartford, CT, Atheneum.

Ghisolfi, Giovanni (1623–83) Milan-born painter active in Rome from 1640. He was the first Italian artist to specialize in imaginary topographical views of Roman

ruins, scenically arranged. These *vedute ideate* (*see veduta*) anticipate, and inspired, the more famous works in the same genre by *Panini (e.g. Rome, Spada).

Giacometti, Alberto (1901–1966) Swiss sculptor and painter, son of Giovanni *Giacometti. He studied painting and sculpture in Geneva, and he went with his father to the 1920 Venice Biennale to see the work of *Archipenko. In 1922 he went to Paris where he worked with *Bourdelle and became acquainted with *Cubist sculpture and *primitive artefacts. He exhibited with his father in Zurich in 1927 and had his first one-man show in Paris in 1932. By then he had been recognized as a *Surrealist: he was making imaginary objects, with and without containing frameworks. Some heads and abstract pieces of the mid-1930s show his Cubist interests but soon he was modelling figures and heads that with their miniature size signal psychological as well as physical distance; at times they echo the hieratic figures of Egypt. Out of these grew the elongated figures with narrow heads for which he became famous in the 1950s. His 1948 exhibition in New York presented this new work – tall, thin figures of men and women. The philosopher Sartre associated it with the Existentialists' pessimistic perception of the world; Barnett *Newman's comment was perhaps more to the point: these sculptures look 'as if they were made out of spit – new things with no form, no texture, but somehow filled'. Around 1950 Giacometti modelled groups of such figures, walking across *The Square* (1949) or illogically clustered as *The Glade* (1950). In 1955 he had retrospectives in London and New York; in 1956 he showed at the Venice Biennale. He worked often from life, in two and three dimensions. His modelling was a long and intense process that partly explains his figures' attenuation: he worked on a vertical armature, looking past it at the model but always intent on what his memory held of the glance made a moment earlier or intense recollections of figures glimpsed elsewhere. His paintings and drawings emerge similarly: his marks constantly reconfirm the first tentative gesture by means of others; life, space and light

are suggested by their opposite. What he offered, he said, was approximations where others offer a false completeness. Commissions for public sculpture tended to come to nothing, but in 1961 he made a tree for the otherwise bare stage of Beckett's *Waiting for Godot*. His sculptures, most of them in bronze editions, are shown and collected around the world. David Sylvester's collected writings about Giacometti (1995) are outstanding examples of sympathetic criticism.

Giacometti, Augusto (1877–1947) Swiss painter, second cousin of Giovanni, noted for *abstract paintings in which the spring and dawn landscapes favoured by some *Art Nouveau painters become all-over manifestations of light and colour; other works are abstract variations on Old Master paintings.

Giacometti, Giovanni (1868–1933) Swiss painter, father of Alberto. His work was in part *Impressionist but also derived from Cuno Amiet and *Hodler.

Giambologna *See* Bologna, Giovanni.

Giambono, Michele di Taddeo (active 1420–62) Venetian painter and mosaicist, member of a family of artists from Treviso. He evolved an individual, elegant yet *expressive version of the International *Gothic style of *Gentile da Fabriano and *Pisanello (Venice, Accademia; Correr etc.; mosaics, S. Marco, Capella Mascoli).

Gian Cristoforo Romano *See under* Isaia da Pisa.

Giaquinto, Corrado (1703–65) Painter educated in the Neapolitan *Academy of Francesco *Solimena; he specialized in large-scale *Rococo decoration in *fresco and on canvas. During 1723–53 he worked mainly in Rome, having joined the studio of **Sebastiano Conca** (1679–1764) with whom he collaborated on frescos in Rome and Turin (1732, Rome, S. Nicola dei Lorenesi; 1733, Turin, Villa della Regina; 1740–2, Turin, S. Teresa).

Elected to the Roman Academy of St Luke in 1740, he became its president in 1750. In 1753 he succeeded *Amigoni as court painter in Madrid, where he also became Director of the Academy of S. Fernando (Madrid, Royal Palace; palaces of the Escorial; Aranjuez). Upon the arrival of *Mengs in 1761/2, Giaquinto returned to Italy. Other works London, National; Oporto, Museo; etc.

Gibbons, Grinling (1648–1721) English wood carver and sculptor, born at Rotterdam. He may have been trained in the *Quellin workshop at Amsterdam Town Hall and came to England at about the age of 19. He is best remembered for his naturalistic (*see under* realism) decorative festoons of fruit, flowers, etc. carved in wood (London, V&A, St Paul's, Hampton Court, Blenheim, etc.), but he was also a monumental sculptor, who may, however, have relied heavily on studio assistants, notably Arnold Quellin, for this branch of his production (London, Trafalgar Square, Chelsea Hospital, etc.). In 1684 he was made Master Sculptor to the Crown. His late work shows an increasing interest in the antique.

Gibson, John (1790–1866) English sculptor, who began his career in Liverpool and in 1817 went to London but was intent on going to the source of classical art, Rome. He arrived there in 1817 and received instruction and help from *Canova and *Thorvaldsen. His fame grew and commissions multiplied, and friends urged him to return to London to pursue his career. He preferred to stay in Rome, and remained there almost continually until his death, working blithely in a *Neoclassical manner, but reputed to be helpless in all matters other than art. In the 1840s he began to introduce gilding and then also other colours into sculpture, following the practice of the ancient Greeks as revealed by archeology. This was a major break with convention and attracted condemnation as well as imitators. *The Tinted Venus* (1852; Liverpool, Walker) was the most controversial instance, with delicate flesh tint, blue eyes, and blonde hair gathered into a golden hair net.

Gilbert, Alfred (1854–1934) British sculptor, trained first as surgeon, then as sculptor in London and Paris. He returned to London in 1884 after years in Italy. His *Perseus Arming* (London, V&A) was sent from Rome for the 1882 Royal Academy exhibition and was much noticed, being technically bold and unconventional in the movement of the wiry young figure. His adroitness was social as well as artistic, and his talent for light theatricality served him well with commissions for such large display pieces as the *Clarence Memorial* (1892–1926; Windsor, Albert Memorial Chapel) with its polychrome bronze effigy and hovering aluminium angel. The commission caused financial and other problems, and Gilbert was for a time forced to elude his creditors by fleeing to Belgium. In 1926 he came back to England to finish it and re-establish his career. He received further commissions and honours and in 1932 a knighthood. His best-known work is the fountain he made in 1886–9 for Piccadilly Circus, fusing *Renaissance and *Baroque elements with fluencies of form that hint at the emerging *Art Nouveau style, and topped with a spirited figure of Eros in aluminium.

Gilbert and George Two artists (Gilbert Proesch, born in the Dolomites in 1943 and George Passmore, born in Devon, England, in 1942), who met as sculpture students at St Martin's School of Art in London and in 1969 became known as 'living sculptures', dressing in identical suits and shoes and painting their faces and miming with inept solemnity to a popular song of previous days, 'Underneath the Arches'. Their first 'one-man' shows were mainly in British art schools, but soon they were performing abroad, on the Continent (1970), in America (1971), in Australia (1973) and Japan (1975), enlarging their range of 'living sculpture' presentations. At the same time they added other art forms to activities they continued to consider sculptural, postcard sculptures, magazine sculptures, films and videos, installations of various sorts and pictures that were first clustered photographs; and, from the mid-70s on, photographic images grouped together to make large pictures, and close-

packed exhibitions of such pictures, in which Gilbert and George appear among large and small images of boys and men, black and white, plants, the crucified Christ, as well as photographically enlarged drawings. The presentation tends to be flat and poster-like, often symmetrical in composition, and often discordant in the combining of idioms and in flat, harsh colours. Interpretations of their work have been contradictory: pro or anti-fascist?, pro or anti-religion? self-heroicizing as well as homoerotic and at times obscene? R.H. Fuchs sees it as 'social emblems in that great English tradition that began with *Hogarth'. What is certain is the whole world has responded to their art, including Moscow where they showed at the Artists' Association in 1988.

Gill, Eric (1882–1940) British sculptor, son of a Brighton clergyman. He studied at Chichester Art School and then worked for a London architect while studying under Edward Johnston, the typographer. He worked first as a carver of inscriptions. In 1910 he carved his first figure in low relief, shown with other pieces in London the following year. In 1913 he became a Roman Catholic and was commissioned to carve a set of *Stations of the Cross* for Westminster Cathedral (1914–18). They owe something to *Giotto in their concentration. In other carvings Gill showed his allegiance to *Epstein and to *primitive art as sources of new energy. Generally he preached and practised the artistic and moral value of craft. Commissioned in 1929 to make the *Prospero and Ariel* group above the entrance to Broadcasting House, London, Gill carved a relief of God the Father and God the Son, complete with stigmata ('even if that were not Shakespeare's meaning, it ought to be the BBC's').

He rejected the name of artist, seeing himself as a craftsman. From 1907 he lived and worked in Ditchling, near Brighton, where he formed a craft-and-religion community on the basis of William *Morris's ideas. Lettering and inscriptions were as important to him as figurative work, and he made many drawings and prints, using an energetic but generally unsubtle line.

His book *Art and a Changing Civilization* (1934) offered to 'debunk art'; he wished to reunite 'the artist concerned to express himself' and 'the workman deprived of any self to express'. His autobiography (1940) speaks bluntly of his artistic, religious and sexual life.

Gillies, William (1898–1973) British painter of the Scottish school. Before and after the 1914 war he studied at Edinburgh College of Art. In 1924 he studied in Paris with *Lhote but was drawn more to the colour painting of *Bonnard than to the *Cubist tradition Lhote represented. In 1926 he joined the staff of Edinburgh College of Art, retiring as Principal in 1966. What remained of Cubist influence in his work yielded to greater *naturalism in his Scottish still lifes and landscapes, especially after a *Munch exhibition in Edinburgh, 1931, tempted him into more expressive brushwork. After retiring he left Edinburgh for Midlothian and there painted the landscape around him. He was knighted in 1970. The Scottish National Gallery of Modern Art in Edinburgh has a large collection of his work.

Gillis, Nicolaes *See under* Dijck, Floris van.

Gillot, Claude *See under* Watteau, Jean-Antoine.

Gillray, James (1757–1815) Outstanding English satirical draftsman, influenced by *Hogarth. Trained as an engraver (*see under* intaglio), he issued some 1500 *caricatures between 1779 and 1811 – when his career was cut short by insanity. They are more polemical than *Rowlandson's, and are aimed against the royal family and the leading politicians of England as well as against the French and Napoleon.

Gilman, Harold (1876–1919) British painter, trained in Hastings and London, where he met *Gore. He was influenced by *Sickert and Lucien *Pissarro, and worked in an *Impressionist manner moderated by Sickert's low tones and subjects. He was a founding member of the *Camden Town

Group in 1911; in 1913 he was the London Group's first president. *Ginner's arrival from Paris in 1910, *Fry's exhibitions of French painting in 1910–11 and 1912, and a visit to Dieppe and Paris led Gilman to embrace *Post-Impressionism: bright colours, simplified form and flattened space. He developed a mode of drawing with pen and ink in which modelling and distance were given through dots; it was learned from Van *Gogh whose controlled use of colour also appears in Gilman's later paintings. There was a memorial exhibition in London in 1919.

Gilpin, Sawrey (1733–1807) Apprenticed to a landscape and marine painter, Gilpin later specialized in animal, especially horse, painting. Although lacking *Stubbs's knowledge of anatomy, he shared Stubbs's frustration at the lowly status of the 'sporting painter' and at being excluded from the Royal *Academy at its foundation. In reaction, he executed some literary and history pictures (*see under* genres) with horse protagonists: three episodes of *Gulliver and the Houyhnhnms* (1768–72; Southill; York, Gallery; New Haven, CT, Yale); *The Election of Darius* (1769; York, Gallery). In 1795, he became Associate of the Royal Academy, and an Academician in 1797. He was the younger brother of the Rev. William Gilpin, the exponent of the *Picturesque.

Ginner, Charles (1878–1952) British painter, trained in Paris, whose first allegiance was to *Post-Impressionism. In 1910 he moved to London and became part of the *Sickert circle. He was a founder member of the *Camden Town Group in 1911 and the London Group in 1913. 'All great painters by direct intercourse with Nature have extracted from her facts which others have not observed, and interpreted them by methods which are personal and expressive of themselves – this is the great tradition of Realism', he wrote in 1914 in an article he titled 'Neo-Realism'. His personal *realism was delivered via thick, rich paint and emphatic colours built up and placed with deliberation to suggest space and still leave a feeling of Post-Impressionist flatness. His preferred subjects were unglamorous street scenes, made poetic by his treatment.

Giordano, Luca (1634–1705) The leading Neapolitan painter of the second half of the 17th century, so prolific that he was nicknamed *Luca fà presto*, 'paint-fast Luke'. The son of a painter, **Antonio Giordano**, Luca trained in his native city in the circle of *Ribera; his early work reflects Ribera's *Caravaggesque style, as well as some of his pictorial themes, such as the half-length pictures of philosophers (Hamburg, Kunsthalle; Rome, Nazionale; Vienna, Kunsthistorisches; Buenos Aires, Museo). After Ribera's death in 1652, Luca left Naples to study in Rome, Florence and Venice, where he attended particularly to the painting of *Pietro da Cortona, one of the founders of the Roman High *Baroque, and to the great 16th-century masters of colourism (*see under disegno*), *Titian and *Veronese. Luca evolved a personal synthesis of *realism and Baroque painterliness, which was modified throughout his career as he came into contact with, for example, the *classicizing paintings of *Maratta. In turn, Luca's innumerable altarpieces, collectors' pictures and decorative cycles influenced many Italian and foreign painters. He received important *fresco commissions in Florence (Palazzo Medici-Riccardi, 1682–5; Carmine, 1682) in Naples (Montecassino, 1677–8, destroyed in World War Two; S. Brigida, cupola, 1678, and Sacristy, completed posthumously by pupils after Luca's designs of 1702; S. Gregorio Armeno, 1678–9). During 1692–1702 he worked at the court of Charles II of Spain, where he carried out grandiose decorative schemes in royal palaces (Escorial, Buen Retiro, Madrid) and churches (Toledo, cathedral) as well as altarpieces and other easel paintings. His late works anticipate 18th-century *Rococo, and were greatly esteemed by, among others, *Fragonard. There is now a large, narrative canvas in London, National.

Giorgione; Giorgio da'Castelfranco, called (1476/8–1510) Venetian painter from Castelfranco; the nickname by which he is known means 'Big George'. Despite the brevity of his career, the scarcity of

facts concerning his life and work, and the small number of pictures securely attributed to him, he is one of the most celebrated and influential of artists, credited with laying the foundations of the Venetian High *Renaissance. Basing himself on the style of Giovanni *Bellini, his probable master, he lent it greater monumentality, sensuousness and lyricism. Like Bellini from the 1490s onwards, he adopted colour as the basic constituent of pictorial representation (see under disegno; also colour). His paintings were built up through harmonies of complementary colours, with relatively few hues, generally in their most saturated state. Forms are enveloped in a dense atmosphere, like light passing through haze; this *sfumato, unlike *Leonardo da Vinci's, was based primarily not on gradations from dark to light but from hue to hue. One of the first Venetian artists to work predominantly for private collectors, he extended the narrow range of traditional subject matter – virtually all religious – to include landscape, reclining nudes, pseudo-portraits of beautiful youths and young women. In these paintings, the suggestion of a poetic mood, dreamlike and introspective, takes precedence over narrative. Such 'Giorgionesque' imagery was widely imitated, perhaps even in his lifetime.

Of the many paintings associated with Giorgione only a handful is universally agreed to be by him. A ruined fragment is all that remains (Venice, Ca' d'Oro) of the one documented work, the 1508 frescos on the canalside façade of the Fondaco dei Tedeschi – the warehouse of the German merchants in Venice. The young *Titian worked on the side façade. Of the remaining secure attributions the Castelfranco Madonna (c.1504) in the cathedral of his home town is Giorgione's only known altarpiece. The enigmatic little picture known as the Tempesta, described in a 16th-century source as 'a landscape with a storm, a soldier and a gypsy', is usually assigned to about the same date (Venice, Accademia). The portrait of an unknown woman, called Laura after the emblematic laurel leaves behind the figure and attributed on the basis of a contemporary inscription on the back, dates from 1506 (Vienna, Kunsthis-

torisches). The Three Magi, also called Three Philosophers, is given to Giorgione by the same source as the Tempesta (c.1508, Vienna, Kunsthistorisches). It is said to have been completed by Giorgione's disciple *Sebastiano Veneziano. Finally, the Sleeping Venus (1509–10, Dresden, Gemäldegalerie) was completed by Titian, to whom are owed the rustic landscape and the incongruous bedding. A group of disputed Giorgionesque works of c.1510 are now also usually attributed to the young Titian (e.g. Fête Champêtre, Paris, Louvre). Various museums own works accepted by some scholars to be by Giorgione. Of these, the St Petersburg Judith, the San Diego Terris portrait and the Giustiniani portrait in Berlin have won the greatest consensus.

Giornata (pl. giornate) See under fresco.

Giotto (first recorded 1301–37) Florentine painter, uniquely celebrated in early Italian literature, as in later art-historical writings, for creating a new *realistic and dramatic pictorial style. Influenced by recent developments in sculpture (see Giovanni Pisano) and painting (see Cavallini, Cimabue) Giotto evolved an individual manner, less lyrical and descriptive than that of his older contemporary *Duccio, but more focused on the telling moments of narrative. He stands at the beginning of the tendency in Italian art to dissolve the picture or relief surface and involve the viewer as a witness to the event depicted. His *iconographic inventiveness is accompanied by increasing mastery of the human form, human movement and facial expression, as of *expressive groupings.

Giotto is recorded working in Rome, Avignon and in Naples at the court of Robert of Anjou (1328–32). In 1334 he was made chief architect of the cathedral, Florence. But the mosaic of the Navicella in St Peter's, Rome (c.1300 or after 1313) has not survived in its original form, and the Avignon and Neapolitan works have been destroyed. Not one of his surviving works is documented. On the basis of secondary sources, however, the touchstone of Giotto's oeuvre is the Scrovegni, or Arena,

Chapel in Padua (*c*.1304–13) of which he may have been the architect. Under a starry vault, and within a fictive architectural enframement, window-like pictorial fields arranged in tiers across the walls of the nave recount the *Lives of the Virgin's parents*, the *Life of the Virgin*, the *Infancy*, *Ministry*, *Passion* and *Apparitions of Christ*. The undivided west wall carries a large fresco of the *Last Judgement*. The socles of the side walls are painted with fictive marble reliefs of the *Virtues* and *Vices*. The arrangement is designed to make apparent thematic and symbolic relationships, but the allegorical programme is overshadowed by the emotional and spiritual profundity of individual scenes. Giotto's last surviving *frescos are the cycles in the Bardi and Peruzzi chapels (Florence, S. Croce, *c*.1315–*c*.25). As late as the end of the 15th century they still provided Florentine artists with compositional models and a repertoire of individual gestures.

A famous cycle of paintings in the upper church of S. Francesco, Assisi, is sometimes attributed to Giotto, but its authorship and dating are in doubt. (*See* Master of the St Francis cycle.)

Of the panel paintings (Paris, Louvre; Bologna; London, National; etc.), only the *Ognissanti Madonna* (Florence, Uffizi) reflects the quality of Giotto's fresco paintings. It is in the tradition of the great enthroned madonna panels of the 13th century and can be compared with Cimabue's *S. Trinita* and Duccio's *Rucellai* Madonnas in the same gallery. Less stylized than either of these, it compensates for a certain loss of drama with increased rationality of space and volume.

Giotto's influence continued in Florence through most of the first half of the 14th century (*see* Taddeo Gaddi) but by the Black Death of 1348 and after, his humane and realistic art had been superseded by more stylized and hieratic forms (*see* Orcagna). He becomes a major inspiration once more from the first quarter of the 15th century (*see* Masaccio).

Giovane, Palma *See* Palma Giovane.

Giovanni d'Alemagna *See under* Vivarini, Antonio.

Giovanni da Majano *See under* Benedetto da Majano.

Giovanni da Milano (recorded from 1346 to 1369) Italian painter from Lombardy, active in Florence by 1346 and last heard of working at the Vatican in Rome. His major surviving work is the powerful *fresco decoration of the Guidalotti, later Rinuccini, Chapel in S. Croce, Florence, indebted both to *Giotto and to *Barna da Siena. The dated and signed panel of the *Pietà* (1365, Florence, Accademia) is one of the earliest representations of this theme in Florence.

Giovanni da San Giovanni; Giovanni Mannozzi, called (1592–1636) Spirited Florentine painter from San Giovanni Valdarno, best-known for his lively and colourful *fresco decorations throughout Tuscany. He was influenced by his contacts with Northern artists, such as *Callot in Florence and the Bamboccianti (*see under* Laer, Pieter van) in Rome, where he worked in 1623–4 and in 1627. His famous façade decoration of the Palazzo dell'Antella on the Piazza S. Croce in Florence, 1619, includes a copy of *Caravaggio's *Sleeping Cupid*. His Roman masterpiece is the apse fresco of SS. Quattro Coronati. He also painted canvases with unconventional renderings of unusual themes, such as *Venus combing Cupid's hair for Fleas* and *The Wedding Night* (Florence, Pitti); *see also* Franceschini, Baldassare.

Giovanni da Udine; Giovanni Nanni, called (1485–1561/4) Italian painter and modeller in *stucco, an ancient Roman technique which he reinvented. He was born in Udine (Museo; stucco decoration of the cathedral dome, recently destroyed by earthquake) and also worked in Florence (*c*.1532–3, S. Lorenzo, Medici Chapel, his contribution destroyed) and in Venice (e.g. Palazzo Grimani, 1536–40), but is best known for the inventive *grotesque decorations he designed and executed in the Vatican while a member of *Raphael's workshop in the 1520s and early 1530s.

Giovanni del Biondo (recorded from 1356 to 1392) Florentine painter,

notable for his harsh, metallic treatment of form and violent colour contrasts; his work, like that of *Orcagna, stresses the hieratic and symbolic nature of sacred imagery (Florence, Uffizi; Cathedral etc.).

Giovanni di Paolo (recorded 1426–82) One of the most attractive of the 15th-century Sienese painters. More than his main rival *Sassetta, *Vecchietta or *Matteo di Giovanni, he reworks the schemata of 14th-century masters like the *Lorenzetti and *Simone Martini; he borrows from *Gentile da Fabriano and Fra *Angelico, and is profoundly influenced by *Ghiberti's and *Donatello's bronze reliefs for Siena Baptistery; he re-uses parts of his own compositions. Yet despite borrowings and repetitions his work seems fresh. Like the International *Gothic artists of the generation before him he reconciles decorativeness with the minute observation of nature (as in the roses painted in the border of his *St John retiring to the Desert* *predella panel in London, National), and tradition with modernity. He is a consummate story-teller: the predella panels in London, in Philadelphia (Johnson Coll.), in the Vatican (Pinacoteca), Cleveland, Ohio, (Museum), New York (Lehman Coll.) temper epic with fairy-tale. Except for the 'single-field' altarpiece commissioned by Pope Pius II for Pienza Cathedral, and some devotional panels (e.g. Montepulciano, Sant'Agostino), he painted old-fashioned *polyptychs whose figures, seemingly isolated in separate fields, relate to each other through subtle and poetic rhythms of expression, line and colour (Siena, Pinacoteca; New York, Metropolitan; Washington, National; Avignon, Musée; Baschi, Parrocchiale; churches in localities near Siena).

Giovanni di Pietro *See under* Matteo di Giovanni.

Giovanni[no] dei Grassi (recorded 1389–98) Italian architect, sculptor, designer of stained-glass windows and illuminator active in Lombardy. His work, which blends Italian and trans-Alpine elements, demonstrates especially clearly the unity of the arts, characteristic of the *Gothic style, and heralds the development of International Gothic (*see also* Gentile da Fabriano, Pisanello). He was employed on the building and decoration of Milan cathedral, but is now celebrated particularly for a medical manuscript, the Memorandum Book or Tacuino in the Biblioteca Comunale, Bergamo, in which the drawings of animals, made from direct observation, are particularly remarkable. Giovanni's son Salomone may have assisted him on the illuminations of other manuscripts.

Girardon, François (1628–1715) *Classicizing French sculptor, a close collaborator of *Lebrun, trained in the Royal *Academy and in Rome, 1645–50. His early works show his dependence on *Sarrazin, but his famous groups for Versailles, *Apollo and the Nymphs of Thetis* (1666) and *The Rape of Persephone* (1677–99), both moved from their originally planned emplacement, demonstrate his study of the paintings of *Poussin as much as of ancient sculpture. The same principles of composition emphasizing parallel planes can be observed in his many other commissions (e.g. tomb of Richelieu, 1675–7, Paris, Sorbonne). After *c.*1690 he began to be displaced in royal favour by his more *Baroque rival, *Coysevox.

Girodet-Trioson, Anne-Louis (1767– 1824) French painter, a pupil of J.-L. *David. He won the Prix de Rome and went to Rome in 1790 where he worked in a *Neoclassical manner rendered exceptionally poetic by effects of light. Back in Paris in 1795 he worked principally as a portrait painter until, in 1801, Napoleon commissioned a painting on the theme of *Ossian receiving the Spirits of the French Heroes* (Château of Malmaison), in which he 'deployed the resources of illusionism to construct a dense tissue of physical impossibilities' (Thomas Crow, 1995). This and his much more succinct *Entombment of Attala* (1808; Paris, Louvre), a morbid subject taken from the novel of Chateaubriand and presented with relative calm, prove him a precursor of *Romanticism, though his vehemently dramatic, vast painting recording an insurrection against Napoleon's occupation of Egypt in 1798,

The Revolt at Cairo (1810; Château of Versailles) is constructed on *Neoclassical lines. He and his studio also produced identical copies of *Napoleon I in Imperial Robes* (1812; example in Montargis, Girodet Museum) for distribution to the several imperial courts.

Girolamo da Fiesole *See under* Colombe, Michel.

Girtin, Thomas (1775–1802) English landscape painter, principally in watercolours. He worked as a topographical draftsman, and then in the service of Dr Monro of London made copies of the work of John Robert *Cozens in company with *Turner. From 1796 on Girtin travelled around Britain making landscape studies that became increasingly personal and expressive and made use of broad washes to record space and light. Turner and other *Romantic painters learned from him. Shortly before his death a vast panoramic painting of London, probably in tempera on canvas, was exhibited in the city; it does not survive but there are watercolour studies for it in the British Museum. This and the V&A, also in London, have fine collections of Girtin's work.

gisant *See under pleurant.*

Gislebertus, Master (recorded 1120–35) Sculptor active in Burgundy. The signed relief of *The Last Judgment* in the tympanum of the west doorway of the cathedral at Autun, carved between 1125 and 1135, is one of the great masterpieces of monumental French sculpture, celebrated for its *expressivity, achieved through bold distortion of form and the dynamic rhythms of figures and drapery. The no-less-celebrated reclining *Eve* from the cathedral's north transept portal, now in the museum, testifies to Gislebertus's indebtedness to *Classical sculpture. He is thought to have served his apprenticeship in the abbey at Cluny, and probably worked at Vézelay between 1120 and 1125, although only his influence is apparent in the even freer and more agitated relief on the tympanum of the inner door at Vézelay, 1125–35.

Giulio Romano; Giulio Pippi called (1499–1546) Roman-born painter, architect and designer of brilliantly fertile invention. He was the favoured pupil and one of the heirs of *Raphael, whose workshop he joined as a boy. From 1524 he lived in Mantua as court artist to the Gonzaga, dominating the artistic life of the city and gaining celebrity throughout Italy. Since virtually all his projects in these years were carried out hurriedly and by assistants, he must be judged through their conception and design rather than their execution. Classified as a *Mannerist artist, Giulio shared and extended Raphael's interest in archeology, becoming not only a master of motifs *all'antica* but also applying to painting certain principles of Roman art, notably relief sculpture as known through sarcophagi, triumphal columns and arches. Paradoxically, when compared to Raphael's High *Renaissance mode (as in the Stanza d'Eliodoro), the effect appears unclassical (*see* classicism). This can already be observed in the *frescos of the Sala di Costantino in the Vatican completed after Raphael's death under Giulio's direction (1521; 1524). An equally stylized effect is evident in Giulio's altarpieces, the *Stoning of St Stephen* (*c.*1521, Genoa, S. Stefano), *Madonna della Gatta* (*c.*1523, Naples, Capodimonte) and *Holy Family with Sts Mark and James* (*c.*1524, Rome, S. Maria dell'Anima).

Of his projects in and around Mantua, the main surviving ones are the Palazzo del Tè – a lavish villa contiguous to Federico Gonzaga's famous stables and conceived as a pleasure palace – and the Appartamento di Troia in the old ducal palace, designed as an armoury. Both are lavishly decorated with frescos, the themes of which are predominantly taken from ancient mythology, although the Tè also contains a large room decorated with portraits of Federico's favourite horses. The most elaborate decorations in the Tè depart in contrasting ways from the High Renaissance ideal of harmony. The explicitly erotic Sala di Psiche elaborates *all'antica* motifs and styles – the latter now also related to painted ceiling decorations in the Golden House of the Roman emperor Nero, albeit with naturalistic *foreshortenings. It is thus blatantly

a work of artifice. The famous Sala dei Giganti, on the other hand, based on the mythological tale of the defeat of the Titans by the gods of Olympus, deviates from classical balance through a surfeit of naturalism (*see under* realism). The visitor thrust into the room risks, at first sight, being crushed to death by falling masonry along with the brutish giants, succumbing to the thunderbolt of Jove on the ceiling.

Many drawings by Giulio survive in various collections and print cabinets, a large number recording his designs for silversmiths. The reader should be aware that this entry does not discuss Giulio's works of architecture and civil engineering.

Giunta Pisano (recorded 1229–54) Italian painter, author of three signed Crucifixes executed for churches in Assisi (S. Francesco), Bologna (S. Domenico) and Pisa (now Museo). He was the first to give a pronounced sway to the body of Christ on the Cross, thus emphasizing the Saviour's human agony rather than his divine nature. His work influenced *Cimabue.

Giusti, Antonio (1479–1519) and his brother **Giovanni** (1485–1549) Italian sculptors, who came to France together in 1504/5, and settled in Tours, changing their name to Juste. Antonio revisited Italy between 1508 and 1516; he owned a house in Carrara where *Michelangelo sometimes stayed, and probably brought back to France information about contemporary artistic events in Italy. The brothers' most important work is the tomb of Louis XII and Anne of Brittany at St-Denis, 1515–31, which may echo Michelangelo's first scheme for the tomb of Julius II, and is also indebted to Andrea *Sansovino.

Giustiniani Wealthy Italian family from Genoa, established also in Rome and Venice. The Marchese Vincenzo Giustiniani (1564–1638) was, after Scipione *Borghese, the most distinguished patron of the arts in early 17th-century Rome. In a letter to one of his friends, published by the Abbate Michele Giustiniani in 1675, he defended the eclecticism of his taste

in painting, which included his protégé *Pomarancio (Cristoforo Roncalli) and the Cavaliere d'*Arpino, the *Carracci and Guido *Reni, as well as the artist with whom he is most particularly associated, *Caravaggio, and his northern followers. He commissioned early works by *Poussin, *Claude and *Testa, although by the late 1620s he concentrated mainly on his outstanding collection of ancient sculpture, recorded in two volumes of plates, the *Galleria Giustiniana*, published in 1631, the first illustrated catalogue of an art collection.

Giusto de'Menabuoni (active *c.*1349–87/91) Italian painter, born in Florence, where he may have trained with Bernardo *Daddi or *Maso di Banco; it is thought that he left Florence during the Black Death in 1348. All his known works were executed in Lombardy in the 1360s, and Padua, where he had moved by 1370 and spent the rest of his life. He is best remembered for his vigorously illusionistic (*see* illusionism) *fresco decoration of the Baptistery, mid-1370s, and of the Belludi Chapel, Basilica di S. Antonio, early 1380s, in Padua, but he also executed works on panel. A signed *polyptych dated 1363 is now divided between Rome, Schiff-Giorgini Coll. and Athens, Georgia, University of Georgia, Museum; a small triptych (London, National) is signed and dated 1367.

Glackens, William (1870–1938) American painter, who worked first as artist-reporter for Philadelphia's *Record*. He attended evening classes at the Pennsylvania Academy and got to know *Henri who encouraged him to paint and to visit Paris. Glackens went there in 1895 and looked especially at *Manet and *Whistler. He joined Henri in New York and was one of his circle of *realists, denounced and praised when they showed as The *Eight in 1908. Though he preferred middle-class scenes to his colleagues' politically explicit realism, he was counted a member of the *Ashcan School. His work became more *Impressionist and came under the spell of, especially, *Renoir. Dr Albert C. Barnes employed him from 1912 on to buy

paintings for his collection at Merion, Philadelphia.

Glarner, Fritz (1899–1972) Swiss-American painter, born in Zurich, trained in Naples and drawn into *abstract painting by contact with Robert *Delaunay and Van *Doesburg in Paris from 1923 on. He moved to New York in 1936 and was a member of *American Abstract Artists. When *Mondrian arrived Glarner recognized in him his essential master and developed a version of *Neo-Plasticism which he called Relational Painting. Glarner's paintings offer a light variant of Mondrian's more austere idiom, and served well for large-scale work, e.g. his murals in the Time-Life Building in New York (1960) and the Justice Building, Albany, NY (1968).

Glasgow Boys Preferred name of painters working in Glasgow and sometimes referred to as the Glasgow School, but they were not a 'school' nor strictly a group. They did not share a style or principle and there was no sort of membership other than the fact of their belonging to that city and that they exhibited together in Europe and in America. Their sense of being allies appeared to form around 1880, when some of them worked *naturalistically under the influence of the *Barbizon School and of the *Hague School. In the later 1890s the influence of *Whistler makes itself felt in the work of others. Outstanding among them were John *Lavery and James *Guthrie.

glaze, glazes *See under* colour.

Gleizes, Albert (1881–1953) French painter whose career began after working in his father's fashionable design shop; he exhibited from 1902. His early paintings reveal social concerns and a spiritualist bent. In 1906, with writers such as Jules Romains and René Arcos, Gleizes founded the Abbaye de Créteil community. *Le Fauconnier brought him into the *Cubist circle: he painted portraits and figure subjects in which the motif, dramatized by faceting, seems beset by solid geometry. In 1912 he exhibited with the *Section d'Or and published *On Cubism*, written with

*Metzinger. Broad geometrical forms and heraldic structures developed in Gleizes's paintings from about 1914 on. In 1927 he founded a second community at Moly-Sabata, near Vienne in the south of France. In his last years he returned to Roman Catholicism and used his art for religious themes and feelings. In 1947 Paris saw an exhibition entitled 'Gleizes, Cubism and its Culmination in Tradition', referring to his fusing of elements of Cubism with the *classical tradition. A retrospective of his work was shown in New York in 1964.

Gleyre, Charles (1808–74) Swiss-French painter, born in Switzerland, who came to Paris in 1838 and is remembered more for his teaching at the Ecole des Beaux-Arts, and subsequently in his own school, than for his middle-of-the-road paintings. Some of the future *Impressionists studied under him and benefited from his undogmatic guidance.

glue-size painting The most straightforward of the early easel-painting techniques (*see also* tempera, oil paint), used on canvas or other cloth. Pigments ground in water were combined with the same animal-skin glue used to size canvases or panels and to bind *gesso or chalk grounds. The paint partially soaked into the fabric, becoming to some extent incorporated into its fibres. The relative opacity of pigments in a glue medium results in good coverage with a thin layer of paint, an advantage if the picture was to be rolled for transport or used for a temporary decoration. Because of the absence of a protective coating and the fact that the glue medium remains permanently soluble in water, these early paintings on unsupported cloth are very vulnerable to damage; very few are known, although the National Gallery, London, has a particularly beautiful example on linen, *The Entombment of Christ* by Dieric *Bouts.

Gnadenbild (pl. *Gnadenbilder*, German, image of grace) A miraculous image. The German term is normally used for images produced, or copied, in northern Europe in the Late Middle Ages, when

private devotion to images was particularly important. *See also Andachtsbild.*

Gnadenstuhl (German, throne of mercy/ grace) *Iconographic motif imported some time in the early 15th century into German and Austrian art from France, via manuscript illuminations. The enthroned God the Father, from whom the Dove of the Holy Ghost emanates, holds out the crucified Christ.

Gober, Robert (1954–) American artist who worked as carpenter while beginning a career as painter, then turned to sculpture, becoming known internationally for his sculptures and *installations, involving familiar objects from plumbing fixtures to the artist's own leg cast in wax, apparently protruding from a wall. His work touches on issues in *Surrealism, *Minimalism and the *kitsch *naturalism pioneered by Jeff *Koons; behind it stands *Duchamp's invention of the *readymade.

Goeritz, Mathias (1915–81) German-Mexican sculptor, trained in Berlin. He worked in Paris, 1936–8, and in Spain before going to Mexico in 1949. His earlier work combined *Expressionism with its enemy, *Dada; some of it was *abstract and thus foreign to Mexico's dominant socially orientated art, as in *Siqueiros and *Rivera. From the late 1950s on Goeritz found opportunities for large-scale sculpture, e.g. for the 1968 Olympics. This work has been associated with *Minimalism, but is intended to bear human, even humanitarian, meaning.

Goes, Hugo van der (active 1467–82) Important but ill-documented Netherlandish painter, probably born in Ghent. His *oeuvre* has been reconstructed by comparison with the *Portinari Altarpiece*, attributed to him by *Vasari, and commissioned by Tommaso Portinari, an agent of the Medici bank in the Netherlands, for his family chapel in the Florentine church of S. Egidio, where it was installed in 1483 (now Florence, Uffizi). Conceived to Italian specifications, the Portinari triptych (*see under* polyptych) includes a central panel

larger than any hitherto painted by a northerner. It weds the minutely descriptive naturalism of Jan van *Eyck to a new monumentality. But what most impressed Florentines (and was to be imitated by *Ghirlandaio in the altarpiece of the Sassetti chapel, 1485) was the social and psychological *realism of Hugo's painting. The Portinari Altarpiece, since it was immediately despatched to Florence, had no impact in the Netherlands, but we can trace its effects on Florentine art through the 16th century, counteracting the tendency to *idealization endemic in Italian *Renaissance art.

The Adoration of the Kings, also called the Monforte altarpiece (Berlin, Staatliche) has been attributed to Van der Goes. The two votive panels (or organ shutters?) executed on behalf of Sir Edward Bonkil for the church of the Holy Trinity, Edinburgh (now on loan from HM the Queen, Edinburgh, National) have also been ascribed to the artist, possibly with studio assistance and some contemporary repainting.

Hugo's originality in relation to Netherlandish painting of his time is amply demonstrated also in *The Death of the Virgin* (Bruges, Musée). The composition is exceptional in setting the bed at a near right angle to the picture plane, so that the face of the Virgin is foreshortened, and the surrounding apostles deployed in an ellipse from foreground to background.

We know from a contemporary monastic chronicle that Hugo spent the last five or six years of his life in a monastery near Brussels, although he continued painting and receiving distinguished visitors, among them the future Emperor Maximilian. He seems to have suffered bouts of melancholia and delirium, and may have entered the monastery both from religious scruples and for a measure of care and protection during his periods of mental illness. The account has tempted art historians to read signs of mental instability into the artist's paintings – a tendency that should be resisted. Although deeply affecting, Hugo van der Goes's painting is as fully controlled and rational as that of any artist of his day.

Goethe, Johann Wolfgang von (1749–1832) Celebrated German poet,

dramatist, scientist; court official and privy councillor to the Duke of Weimar; prolific draftsman, connoisseur, critic and theoretician of art. Only his activities in the sphere of the visual arts are touched upon here. An early allegiance to *Romanticism – expressed in his 1772 essay *Concerning German Architecture*, extolling the *Gothic style of Strasbourg cathedral, and through his championship of such contemporary artists as Johann Heinrich Füssli (Henry *Fuseli) – was replaced, after two visits to Italy in 1786–8 and 1790 (*see also* Tischbein, Johann Heinrich Wilhelm), by a deep commitment to *Classical art, the mature works of *Raphael and the values of objectivity and harmony which they exemplify. Goethe now reacted with hostility to the subjectivity and 'dangerous excess' of the Romantic movement, although well aware of its creative aspects, as he made clear in his appreciative comments on *Runge, *Friedrich and individual *Nazarenes. He attempted, without much success, to influence artists by publishing an art journal, *Propyläen*, and establishing an annual painting competition in Weimar, 1799–1805. More significantly for the course of art history, in 1810 Goethe published his *Zur Farbenlehre*, *Theory of Colours*, in which he purported to refute Newton's *Optics*. *Eastlake's 1840 translation into English was read by *Turner and inspired a pair of paintings exhibited in 1843 (*Shade and Darkness – the Evening of the Deluge*, and *Light and Colour (Goethe's Theory)* – *the Morning after the Deluge – Moses writing the Book of Genesis*).

Goethe's ideas about art and nature and about the creative process were widely influential, around 1800 and again a century later when there was renewed interest in *Romanticism. His view that artistic creation originated in the unconscious was welcome to a generation that became *Expressionist and *Surrealist. More important, his conviction that nature is dynamic and governed by laws of organic development through metamorphosis from primary forms was taken to support the modern idea that art itself can or should be governed by organic laws relating to materials and processes as well as to the existence, as part of nature, of the artist. *Klee

has been the most evident beneficiary of this faith.

Gogh, Vincent van (1853–90) Dutch painter active mainly in France and counted a *Post-Impressionist. Almost unknown in his lifetime, he was, during his years as full-time artist, totally dependent on his brother, Theo, who worked for the dealer Goupil in Paris and supplied him with paints and canvases. Vincent wrote many letters to him, also to other relatives and artist friends. His reputation grew quite quickly after his death. Articles with reproductions and the publication of some of these letters began in Paris in 1891 (the first by *Bernard); from 1903 on albums of reproductions of his work and then monographs, the first in 1911, were published in Amsterdam. By that time a number of artists, French and foreign, had been stimulated by the work of Van Gogh, notably the *Fauves and the *Brücke. The drama and pathos of his life and knowledge of his spiritual and psychological crises, had sharpened this awareness. Today Van Gogh is one of the most highly priced and one of the most popular artists in the world, yet emphasis on his madness and the passionate execution of his paintings suggests that he is not well understood.

He was born in Zundert, Holland, the son of an evangelical pastor. One of his uncles was an art dealer and Vincent's first job was in his uncle's firm in The Hague, recently taken over by Goupil of Paris. He saw much and learned much about art, especially the great Dutch masters and the new Hague School. He worked for Goupil in London and in Paris. An unhappy relationship with his landlady's daughter in London appears to have triggered a depression which led to his dismissal in 1876. He turned to religion for comfort and purpose, studying the Bible. A short period working for a bookseller in Dordrecht broadened his interest in literature in Dutch, French and English; he read avidly (novels by Zola, George Eliot and Dickens, historical works by Michelet and Carlyle) and some of his reading was later reflected in his painting. But religion dominated him. He decided to become a pastor like his father, studied for this in Amsterdam and Brussels and in late

1877 went to work amongst the poor of the Belgian mining district, the Borinage. His colleagues found him too zealous and dismissed him. Repeatedly he found himself ostracized because of his headlong involvement with the down and out, even by artists, and this developed in him a sense of self-reliance and self-direction which ultimately led him to channel his reading and his experience of art and the world, together with his passionate feeling for humanity, into art.

He had always drawn. From 1880 on he worked at art full time. He studied briefly in Brussels, then lived in his parents' house in Etten. Between December 1881 and September 1883 he lived in The Hague again, in part studying with the painter Anton Mauve. His drawing style became firmer, both in representing the forms and energies of working peasants and the forms and spaces of nature; his painting became more assured and expressive, with emphatic forms and movements in low colours. His *Potato Eaters* (1885) is the climax of this period, a tougher version of what others had treated as an often sentimental subject. Eager to make progress he went to Antwerp to study at the academy, but after a few weeks he moved on, taking with him memories of *Rubens and of the Japanese woodcuts he had bought there.

He suddenly decided that he had to be in Paris. In February 1886 he descended on Theo, using him as a base from which to explore art and artists and the city of art itself. *Pissarro and *Impressionism soon lightened his touch and his colours; *Seurat and *Signac led him to think of more controlled ways of using pure colours; *Gauguin and *Bernard hinted there were areas of the imagination to be made visible. The Louvre deepened his understanding of past art. All the artists he knew admired Japanese prints and confirmed his passion for them. Twenty-four months later Vincent just as suddenly went south, towards the sun and, he hoped, a world untouched by Paris's anxieties where he and artist-friends might live and work in amity, like the *Barbizon painters.

He arrived in Arles as spring arrived too. The light and the colours made him think of Japan. He was glad to be amid landscape again. He drew and painted energetically, finding new ways to capture the vigour he sensed in nature and wanted to impart to his human subjects. Everything was charged with symbolic value for him as well as being intensely itself: the series of *Sunflowers* (1888) a potent instance in its basic opposition of yellow and blue and in its sublimation of specific blossoms into images of individual life and death as well as of the sun; the series of the postman's wife as *La Berceuse* (1888–9), the motherly woman rocking an invisible cradle; together, he wrote, these images would comfort the seafarer far from home. But he needed the particular flower or person or landscape. Gauguin came to Arles to work with him and challenged that habit, forcing him to work from his head, and in the end broke Vincent's spirit. He attacked his visitor, though Gauguin was by far the tougher and bigger man, and then cut part of his ear off and gave it to a local prostitute. He was insane and had to be put away.

From this time on he was liable to attacks of madness and subsequent weakness and lethargy; a form of epilepsy is today's diagnosis. He worked in periods of lucidity yet his art was disturbed by these experiences. The forms now became more agitated, his colours colder. He painted what he saw around him and memories of Holland, also personal versions of engraved works by *Millet, *Delacroix and *Rembrandt. Some of these are religious subjects (e.g. his transcription of Rembrandt's etching *The Raising of Lazarus* (1890)), but then he tended to see the world in supernatural terms, the scene of *The Sower* (1888) necessarily becoming a resonant statement about life and death. He continued to write to Theo, the letters leaving one in no doubt as to his sanity when he paints and writes. There is the same analytical intelligence at work as before, the same control of brush-strokes and colour in his paintings, the same careful and constructive use of different nibs and of inks of different tone and intensity in his pen drawings. He had to use his media with all possible directness and economy.

In May 1890 he moved to Auvers-sur-

Oise, to live in the house of Dr Gachet, doctor, painter and a friend of artists. It was a good home for him. He worked incessantly, hoping yet to become a successful artist and justify his brother's trust and help. The portrait of Dr Gachet is one of his most powerful works (1890; Paris, Orsay), an unusually intense harmony of strong design and colour: red against green, blue against orange. Nonetheless, on 27 July 1890, out in the fields, Van Gogh shot himself; he did not die until two days later, in Theo's arms. Theo lived only another half year and they are buried side by side in the cemetery at Auvers.

During his short career, Van Gogh developed from a tonal painter into one using colour at its most intense, placing his touches side by side, often in complementary hues that enhance each other's intensity. Having found expressiveness first in the sharpened, emphatic outlines he gave to his subjects in his earlier drawings of, for example, peasants at work, he developed for his painting a range of marks, from short to long, straight to curling, which characterized the object and at the same time enabled him to use colours to maximum effect. What strikes one as vehemence is the product of knowledge and control, a slow constructing of, at the same time, the representation and the picture surface as a tapestry of brushstrokes. This is perhaps most patent in his self-portraits, notably those he did after his first attack of madness (December 1888): e.g. *Self-Portrait with Bandaged Ear* (1889; London, Courtauld). In his drawings, similar marks enabled him to represent objects and also space with great vividness, the several tones of inks and sizes of marks giving them subtle modulations that one senses as close to colour. His work, together with his letters – one of the greatest 19th-century bodies of writing about art – is an outstanding achievement. Many painters responded to Van Gogh's use of vivid forms and colours but seemed unaware of the poetic content of his images. Displays of his work in Paris in 1901 and 1905 and in Cologne in 1912 were especially influential. Amsterdam has the Rijksmuseum Vincent van Gogh (where works mentioned here without location are to be found); a large collection is in the Rijksmuseum Kröller-Müller near Otterlo.

Golden Fleece Russian art journal (*Zolotoe Runo*) owned and edited by the Moscow banker, Nikolai Riabushinsky, 1906–10. Unlike most Russian cultural journals but like *World of Art*, it was apolitical, bringing news of art in Paris and of Russian *Symbolism and reporting on new music and writing. It also presented exhibitions. The first, in 1908, had French and Russian sections and included the first major showing of *Matisse outside France; the second, 1909, mingled French and Russian art; the third and last, 1909–10, all Russian, implied the triumph of Russian *primitivism over Symbolism; this was confirmed in the journal.

golden section The proportion of the two divisions of a straight line or of the two dimensions of a plane figure such that the smaller is to the larger as the larger is to the sum of the two. The ratio, which cannot be expressed as a finite number, is approximately 8:13, but artists in the past would have used their dividers to measure it, without recourse to complicated calculations. It is found in natural forms, and was discussed by ancient writers and in the *Renaissance, most notably by *Leonardo da Vinci's and *Piero della Francesca's friend, the mathematician-friar Luca Pacioli. Although the golden section may not be a 'mystical' proportion, it is a uniquely visually satisfying one, used, for example, in many standard sizes of drawing paper or canvas for painting. As a compositional device, it avoids bilateral symmetry while preserving the semblance of harmonious order. *See also Section d'Or.*

Goltzius, Hendrick (1558–1616) Versatile and prolific Haarlem graphic artist and painter, one of the most influential northern European artists of his day. Despite his crippled right hand, he was an unsurpassed draftsman and engraver (*see under* intaglio), able to reconstruct the style and technique of earlier masters such as *Dürer and *Lucas van Leyden. He is one of the most important means of transmission of Italianate themes and

motifs to northern Europe, first, through his engravings after the *Mannerist *Spranger, 1585–90; and, following his trip to Rome in 1590, through his drawings and prints of mythological subjects and after antique statuary, in the style of *Raphael and *Parmigianino. Paradoxically, he also specialized in *realistic engraved portraits of the leading personalities of the day and in minute studies of animal and plant life. He is the first printmaker to make *chiaroscuro prints of landscape, and the first Dutch artist to produce open-air drawings of the Dutch countryside (Rotterdam, Boijmans Van Beuningen; Amsterdam, Rijksprentenkabinet; Paris, Coll. F. Lugt). These anticipate, and may have directly influenced, the landscape paintings of the 17th-century Dutch school.

Goltzius began also to paint c.1600, frequently allegorical or mythological works as eclectic as his prints (Amsterdam, Rijksmuseum).

He had become friends with Karel van *Mander shortly after the latter's arrival in Haarlem in 1583; it was Van Mander who introduced him to the work of Spranger, and who stimulated his interest in Italian art, occasioning both his *Mannerist and his *classical phases. Goltzius's stepson, Jacob *Matham, was his most gifted pupil.

Golub, Leon (1922–) American painter, trained in Chicago. He explored the image of man: man militant, man triumphant, man the victim, using heroic formulae taken from the *classical tradition but disrupted, e.g. his use of a lacquer medium which he scars and pits. He associated man's urge to greatness with other urges that make man fall into viciousness.

Gonçalves, Nuño (active 1450 to 1470) The leading Portuguese painter of the 15th century, court painter to Alfonso V (1437–81). He is almost certainly the author of the *Retable of St Vincent (c.1460–70, Lisbon, Museu), a four-panelled *polyptych in a Hispano-Flemish style indebted to Dieric *Bouts. Surrounding the saint are highly individualized and severely powerful portraits of members of the royal court.

Goncharova, Natalia (1881–1962) Russian painter, daughter of an architect. She studied sculpture in Moscow but in 1900 turned to painting and thus met *Larionov, her lifelong companion and, ultimately, husband. They travelled in Russia and the West, studying modern art and also Russian icons and folk art. From 1904 on she exhibited in Russia and in Paris. She contributed with Larionov to *Golden Fleece exhibitions and made an impact with her *primitivist paintings in the last of these. She and Larionov organized the first Jack of Diamonds (1910) and the Donkey's Tail (1912) exhibitions and showed work in them; she also sent to other exhibitions in Moscow, St Petersburg and Kiev, and in 1912 showed work in Munich and London. During 1912–14 she made images for *Futurist literary anthologies. In 1913 she made with Larionov, and appeared in, the only Russian Futurist film. Her peasant and religious paintings in a primitivist manner were now succeeded by paintings that showed a Futurist enthusiasm for machines and dynamics and echoed Larionov's *Rayism. In 1913–14 she had a large solo exhibition in Moscow and St Petersburg. In 1914 she went to Paris with Larionov for a joint exhibition there and made designs for Diaghilev's ballet, *The Golden Cockerel*. In 1915 she and Larionov went to Lausanne and then settled in Paris. Among the décors she did for Diaghilev are those for *The Wedding* and for *The Firebird* (1923 and 1926). She had retrospectives in Paris in 1948 and 1956 and a major exhibition of her work and Larionov's was presented in London in 1961.

Gonzaga Illustrious Italian family. Originally named Corradi, landowners from Gonzaga, south of the Po, in 1328 they became professional soldiers and lords of Mantua and its territories, which they ruled until 1708. Famous for their thoroughbred horses and their patronage of letters, they also attracted outstanding artists, and accumulated one of the greatest art collections of Europe. A large part of it was sold to the English King Charles I in 1627–30, to finance, it is said, the 'purchase' of court dwarves (but more likely to offset the effects of plague, a crisis

of succession and the sack of the city). *Alberti worked mainly as an architect, *Pisanello as painter and medallist, *Antico as a medallist and decorative sculptor, for Ludovico Gonzaga, the second marquess (ruled 1453–78); *Mantegna was the court artist of Ludovico and his successors Federico (ruled 1478–84) and Francesco (ruled 1484–1519), to be followed by Lorenzo *Costa. The patronage and collections of Francesco's wife, Isabella d'*Este, have been outlined in the entry on her family. Her son, Federico, fifth Marquess and from 1530 first Duke of Mantua (ruled 1519–40) attracted *Giulio Romano to the city, had his portrait painted by *Titian and acquired some thirty more works from the artist. Preferring 'something pleasant and beautiful to look at' to pictures of saints, he commissioned the *Loves of Jupiter* from *Correggio. *Rubens was recruited by Duke Vincenzo (ruled 1587–1612) in 1600, originally to aid Frans *Pourbus the Younger to compile a collection of pictures of beautiful women; less famous, the excellent painter Domenico *Fetti worked for Duke Ferdinand (ruled 1612–26).

Gonzalez, Eva (1849–83) French painter who studied first under the academician Chaplin but in 1867 became *Manet's pupil. (He painted her portrait, now in the National Gallery, London.) Her work reflected his in a manner modified enough to be found acceptable by the *Salon and showed an increasing interest in social themes. She married in 1878 and died shortly after giving birth.

González, Julio (1876–1942) Spanish sculptor, born into a Barcelona family of metal workers. He learned the craft and attended painting classes in Barcelona. In 1900 the family moved to Paris where Julio became intimate with the *Picasso circle. He painted and made metal masks. His brother's death in 1908 caused his withdrawal from the art world and during the First World War he worked as a welder at the Renault factory. Afterwards he painted and sculpted and about 1927 finally opted for sculpture, working in wrought and welded iron. In 1931 he helped Picasso with his metal sculptures. His own work, already

*Cubist in its juxtaposing of planes, now became *abstract and at times linear though still anthropomorphic; the tension between these poles gave it at times a *Surrealist flavour but González's art-world association was with *Cercle et Carré. In the later 1930s, with the Civil War in Spain, his work became more monumental and representational though the heroic figure *Montserrat* (1937; shown in the Spanish Pavilion in the Paris World Exhibition) is exceptional in its *naturalism. IVAM Centre Julio González in Valencia (Spain) has the largest collection of his work.

Gore, Spencer (1878–1914) British painter, trained at the Slade School of Fine Art where he met *Gilman. *Sickert drew his attention to *Degas; under the influence of both Gore painted theatre and music-hall scenes. He and others formed a group around Sickert, basing art on observation of everyday life; Gore contributed knowledge of the *Neo-Impressionist way of using touches of pure colour. He was a founder member of the *Camden Town Group and of the London Group. The influence of *Gauguin, and perhaps of Gilman, is noticeable in his later landscapes with their broader colour patches and flattened representations.

Gorky, Arshile (1905–48) American painter, born in Armenia, as Vosdanig Manoog Adoian. In childhood he was stimulated by folk traditions and ancient Armenian art. In 1916 his family fled from the Turkish invasion; his mother died in 1919. In 1920 Gorky joined relatives in the USA at Providence, R.I. He attended high school there but was soon teaching drawing in Boston. In 1924 he moved to New York and adopted the name of the Russian peasant author Maxim Gorky (Gorky, also chosen by him, means 'bitter'). From 1926 to 1931 he taught at the Grand Central Art School. Meanwhile he explored modern art in museums and books. *Picasso's influence shows in his work, sometimes fused with elements from Armenian art. He worked for the *Federal Art Projects, in 1935 painting ten murals in oil on the theme of aviation in a manner derived from Stuart *Davis and *Léger. They were thought too

*abstract but in the end were set up in Newark Airport; only two survive. In the late 1930s he came under the influence of *Miró and *Masson; his way of painting loosened, his forms hovering between representation and abstraction. His themes and idiom became more personal, his paint thinner and his forms biomorphic and at times painfully attenuated. *The Liver is the Cock's Comb* (1944; Buffalo, Albright-Knox) demonstrates his poetry and passionate colours; *Agony* (1947; New York, MoMA) speaks of mental and physical pain. In 1946 a studio fire destroyed many of his paintings; in the same year he was found to be suffering from cancer. In 1948, after a car crash in which his neck was broken, he killed himself. He has been called an abstract *Surrealist: although his late paintings appear abstract they speak a personal language of ideograms, often with erotic or at least biological meaning. His influence on other *Abstract Expressionists was marked; *De Kooning claimed him as his master. In 1945 Gorky had a one-man show in New York; there were retrospective exhibitions in New York in 1962 and in London in 1966.

Gormley, Antony (1950–) British sculptor, born and trained in London, at the Central School, Goldsmiths College and the Slade School. Earlier, he had studied at Trinity College, Cambridge (archeology, art-history and anthropology), and had travelled extensively in the Near and Far East during 1971–4. He was included in international group shows from 1980 on and had his first solo show in London in 1981, in New York in 1984, on the Continent in 1985. By this time he had focused on making his own body, cast in lead, the form of his art, and its pose and placing in the gallery, alone or one of several, crouching, standing, lying, on the floor, up a wall, hanging from the ceiling. From these come the content or expression of his art. The figures are generalized, not self-portraits. At times he shrinks or enlarges them. In 1984 he made a small terracotta figure crouching on a large head (London, British Council). He makes other forms and objects – fruits, fish, a lead glider (*Vehicle*, 1987), etc. – but his male figure

remains the centre of his art, at times greatly enlarged. His monumental figure in iron, *Angel of the North* (1995–8) stands outside Gateshead in northern England. Since 1990 he has used thousands of hand-sized terracotta figures, hand-moulded by amateur helpers and characterized primarily by their raised, staring eyes, to suggest timeless humanity and its perplexities; his title for these crowds is *Field*, and they have been seen in several countries. *Antony Gormley* (London 1995) includes interviews and selected Gormley texts, as well as illustrations and other data.

Gossart or **Gossaert, Jan**; also called **Mabuse** (*c.*1478–1532) Flemish painter, the earliest of the so-called 'Romanists', a pioneering and influential artist who was the first Fleming to travel to Rome with a patron in order to record ancient works of art. A native of Maubeuge in Hainault, and trained probably in Bruges, he became a master in Antwerp in 1503. Around 1507 he entered the service of Philip of Burgundy, accompanying him on his mission to the Vatican in 1508. After Philip's death he worked for other members of the ducal family, finally settling in Middleburg, where he died.

Gossart's early work is based entirely on Flemish examples, Hugo van der *Goes in particular (*Adoration of the Magi, c.*1507, London, National). After his trip to Rome he combined Flemish elements with motifs borrowed directly from ancient art or from intermediaries such as Marcantonio Raimondi (*see under* Raphael), Jacopo de'*Barbari and *Dürer (e.g. Palermo, Galleria; Prague, Gallery; Vienna, Kunsthistorisches). In 1515 he began a series of mythological paintings for Philip of Burgundy at the castle of Suytborg, completing them alone after the death in 1516 of his collaborator, Jacopo de'Barbari. The surviving panel of *Neptune and Amphitrite* (now Berlin, Staatliche) is the first example of *classicizing nudes in Flemish painting (*see also Venus and Cupid*, 1521, Brussels, Musées).

In addition to his altarpieces and the decorative mythological works, Gossart remains well known for his portraits, combining Flemish naturalism (*see under*

realism) and psychological penetration with Italianate monumentality (e.g. Munich, Alte Pinakothek; Paris, Louvre; Berlin, Staatliche; London, National).

Gothic A style label applied to the art and architecture of northern Europe from the 12th to the 16th centuries. Although primarily associated with a type of architecture developed on the Ile-de-France, the term is applied also to decorative and figurative art. Typical Gothic *genres are manuscript illumination, stained glass, tapestry and other textiles, goldsmith's work and ivory carvings. Sculpture other than miniature is almost entirely conjoined with architecture, where it can serve both ornamental and symbolic ends. The word Gothic derives from Goth – the Germanic people who, with the Lombards, destroyed the Roman Empire – and was first used by Italian writers (*see* Vasari) to indicate the non-*Classical styles of northern European art. Because of this extremely broad application, it is difficult to summarize the characteristics of Gothic art. In general, however, Gothic (and its derivatives, Late Gothic, International Gothic – a courtly type associated also with such Italian artists as *Giovanni dei Grassi, *Gentile da Fabriano and *Pisanello) is distinguished by the primacy of pattern and rhythm, decorative line and decorative colour. Striking *realism of detail is unrelated to any rationally organized total system of representation, and natural forms tend to be subsumed to ornamental ends. Despite its derivation, Gothic does not necessarily connote the anti-*Classical; some Gothic sculpture – as for example at Reims and Amiens – emulates antique prototypes.

Gottlieb, Adolph (1903–74) American painter, trained in New York and Paris. In the 1930s he exhibited with a group known as The Ten, dedicated to *Expressionist and *abstract painting, and worked for the *Federal Art Projects. In 1941 his paintings became compartmentalized arrangements of signs and invented hieroglyphs, echoing the *primitive art he studied and collected and seeking to symbolize states of mind. In his later paintings

he reduced the number of divisions and enlarged the motifs until, in the *Burst* series of 1957–74, he juxtaposed two forms, one explosive, the other quiescent, cloud-like. He was close to *Rothko and *Newman and prominent in the second wave of *Abstract Expressionism. His work was seen in major retrospectives in New York in 1957 and 1968 and was included in many exhibitions of the new American painting in the USA and abroad.

gouache (French, from Italian *guazzo*, from Latin *aquatio*, fetching of water, watering place) Opaque watercolour paint; pigments are ground in water and mixed with gum. *See also* body-colour.

Goudt, Hendrick *See under* Elsheimer, Adam.

Goujon, Jean (*c*.1510–68) The leading French sculptor of the mid-16th century, admired chiefly for his reliefs, which form the greater part of his known *œuvre*. He also practised as an architect. Both the early and late years of his career are ill-understood. His mature style, as exemplified principally in the decorative panels of the *Nymphs* and *Naiad* from the *Fontaine des Innocents* (1547–9, now Paris, Louvre) shows the influence of *Primaticcio and *Cellini, but is more *classical.

Goujon's first recorded work, the 1540 organ loft columns at St Maclou, Rouen, argues for first-hand experience of Roman architecture. He is generally credited with the sculpture of the tomb of Louis de Brézé, albeit not the design of the whole (*c*.1540, Rouen, cathedral). Possibly in 1544, after carving the reliefs for the chapel at Ecouen (now Chantilly, Musée), Goujon transferred to Paris (St Germain l'Auxerrois; Paris, Louvre; *Fontaine des Innocents*, as above; Hôtel Carnavalet, *c*.1547–9; Louvre palace, relief and free-standing sculpture, 1549–53, heavily restored in the 19th century). His name appears in the royal accounts until 1562, when he is thought to have left France for Bologna. His place in the French capital was taken by Germain *Pilon. *See also* Bontemps, Pierre.

Gower, George (active 1573–96) Leading Elizabethan portrait painter, an Englishman of noble birth whose self-portrait (1579, Milton Park) justifies, through an inscription, his earning a living by painting. There are pictures by him in London, Tate, and some of the surviving portraits of Queen Elizabeth have been attributed to him, notably the Woburn Abbey version of the 'Armada' portrait. He seems to have been associated with *Hilliard, although the patent giving them exclusive rights to represent the Queen seems never to have been executed.

Goya, Francisco de (1746–1828) Spanish painter, son of a master gilder and trained as painter in Saragossa from the age of 14. He failed to enter the Madrid *Academy but studied with the academician Francisco Bayeu and went to Italy in 1770 at his suggestion. There, in 1771, he won an honourable mention in a competition at Parma Academy and soon after returned to Spain, married Bayeu's sister and worked with him on frescos in Saragossa Cathedral. In 1774 he followed an invitation from *Mengs to make cartoons for the royal tapestry factory in Madrid. In 1780 he painted his first royal portraits and became a member of the Academy. In 1784 he received commissions for paintings from the Duke and Duchess of Osuna; in 1785 he was elected deputy director of the Academy and in 1786 he was made Painter to the King and commissioned to make further cartoons for tapestries.

The new king, Charles IV, made him Court Painter in 1789 and soon Goya was painting royal portraits. In 1792 a major illness interrupted his career: he retired to Cadiz for some months, partly paralysed and permanently deaf. In 1795 he was elected the Academy's director of painting but he returned to Madrid only in 1797. Soon he was fully active again, doing *frescos in San Antonio de la Florida, Madrid, in 1798 and etching his first suite, the 80 *Caprichos*, in 1799. That year he became First Court Painter and in 1800 he painted *The Family of Charles IV*, the climax of a series of portraits of the royal family and of courtiers, including the much

more sympathetic painting of the Countess of Chinchon and a pompous one of her husband, the chief minister, Godoy (1800–1; Madrid, Academy). *The Naked Maja* and *The Clothed Maja* were probably painted for Godoy about this time. Around 1803–4 Goya lost royal favour: his satirical *Caprichos* and liberal sympathies may have contributed to this. He went on painting portraits, now mostly of middle-class sitters.

France had already involved Spain in a war against Britain. In 1807 and 8 Napoleon sent his troops into Spain, engendering anti-French protests and occasioning the abdication of Charles in favour of Ferdinand VII. Goya pictured the popular uprising and its suppression in two paintings of 1814, *The 2nd of May 1808* and *The 3rd of May 1808*. His response to what he saw as the martyrdom of Spain and the bestialization of humanity engendered 82 etchings *The Disasters of War* (1810–13; not published until 1863); the awesome fantasy know as *The Colossus* (1812) was his allegory both of terror and of Spain's potential revival. When Napoleon made Joseph Bonaparte king of Spain, Goya was confirmed as First Court Painter and expected to paint the foreign monarch; he certainly painted an *Allegory of the City of Madrid* (Madrid, Town Hall) which originally included a portrait of the king taken from a print, also rather unsympathetic portraits of some of Joseph's courtiers and more engaging ones of some of the ruffians who had organized themselves into anti-French guerilla bands. British forces entered Madrid in 1812 and Goya painted three portraits of the Duke of Wellington (London, National and Apsley House, and Washington, National). Ferdinand VII's return, in 1813, was followed by persecution of all who had not distanced themselves from the foreign government. Goya narrowly escaped punishment and painted two portraits of the king, but was no longer of the court. His etchings suite on the history of bull-fighting (33 plates, published in 1816) now occupied him, also paintings for friends and for private patrons and the best of his self-portraits, aged about 70. Another, of 1820

(Minneapolis, Institute of Arts), shows
him gravely ill and supported by his
doctor. He still received religious com-
missions but his most remarkable works
of those years are the 14 'black' paintings
with which he decorated two rooms in
his house on the outskirts of Madrid
between 1820 and 1823 (now transferred
to canvas). Combining features from the
Caprichos and *The Colossus*, they are the
most private and imaginative of his
images, matched only by the *Disparates* or
Proverbios etchings done at this time
(not published until 1864).

In 1824, when persecution of liberals
became more intense, Goya left Spain.
He spent most of the rest of his life in
Bordeaux, painting portraits and other sub-
jects, including some miniatures in ivory in
which the chance action of water on black
paint suggested the images, and exploring
the new print technique of *lithography for
a series of five images of bullfighting, *The
Bulls of Bordeaux*.

Goya's art mirrored the precarious poise
of his country, balancing heavy ecclesiasti-
cal traditions and folklore against flashes of
enlightenment and totalitarian rule against
the revolution in France. His career opened
on the model of the industrious appren-
tice's and became that of the *Romantic
genius, working for himself and for close
friends in opposition to officialdom. Always
firmly based in his *realistic perceptions,
even when – as in the *Caprichos* – he used
irrational images to press for reason and
reasonableness, he had recourse to *Rococo
devices in his first tapestry cartoons,
then steeped himself in the example of
*Velázquez, on occasion used *Baroque
formulae, and came to work more and more
for himself, deploring the time and atten-
tion demanded by commissions and pro-
ducing more drawings and prints. His focus
was increasingly on the potential of his
media, of paint as paint and of line and tone
in drawings and in etchings with *aquatint.
His 'black' paintings and his late etchings
demonstrate a freedom from the duty of
accurate description unprecedented at
the time and matched only in the art of
*Turner and of *Redon before the 20th
century. He was also the most humane of
artists, coming close to caricature in his

portraits of royalty while affording full
dignity to his more common sitters, and
assaulting superstition and clerical and
political oppression while creating awesome
images of human suffering. But even his
most powerful accounts of what happened
around him are shaped in terms of imagery
rooted in pictorial and graphic traditions;
many of his most potent compositions,
graphic or painted, are constructed accord-
ing to firm *classical principles.

*Delacroix and other early 19th-century
artists knew and admired his graphic work,
and *Baudelaire praised the *Caprichos*
for a quality he considered peculiarly
modern: Goya's 'love of the ungraspable,
a feeling for violent contrasts . . . and for
human countenances weirdly animalized by
circumstances'; these recommended him
also to the *Symbolists of the later 19th
century. By that time Goya's work in
general had become widely known, thanks
in part to the *Realists' and the *Impres-
sionists' study of his use of tone and colour
without precise delineation as a means
to representation. In the 20th century
such extreme productions as his 'black'
paintings came to be seen as crowning
achievements rather than the aberrations of
a sick and bitter old man. His paintings are
best seen in the Prado Museum in Madrid,
including all those here referred to without
location.

Goyen, Jan van (1596–1656) Prolific
painter and draftsman, the leading master
of the 'tonal' phase of Dutch landscape, in
which the topography and humid atmos-
phere of the Dutch coast dominate over the
representation of human activities (*see also*
Salomon van Ruysdael, Pieter de Molijn).
Born in Leiden, he studied with six
different masters, of whom only Esaias
van de *Velde of Haarlem seems to have
influenced him. He settled in The Hague
in 1631, but travelled frequently, not only
as a painter but also as a valuer, auctioneer
and art dealer, and speculator in real estate
and tulip bulbs. In the 1650s he was influ-
enced by the new *classical trend of Dutch
art (*see also* Jacob van Ruisdael) and intro-
duced more forceful accents into his land-
scapes, and stronger contrasts between
light and dark. Most major galleries in

Europe and in the US have examples of his work.

Göz, Gottfried Bernhard (1708–74) German painter, engraver (*see* intaglio) and publisher active in Augsburg, where he had been a pupil of Johann Georg *Bergmüller. In 1744 he was appointed Court Painter and Engraver to the Emperor Charles VII; also obtaining the latter's patent for colourprints and founding a publishing business. He executed many *frescos and altarpieces in Swabia and Bavaria, as well as portraits, miniatures and engravings.

Gozzoli; Benozzo di Lese, called (*c*.1422–97) Florentine painter, the prolific author of narrative *fresco cycles in provincial centres in Umbria, Lazio and Tuscany. These were painted in a manner both 'modern' – in their use of *perspective, for example – and archaicizing, linear yet colourful, ornate and full of incident, recalling the International *Gothic style. His best-known work is the decoration of the chapel in the Medici palace, Florence, depicting the *Adoration of the Magi* (1459–*c*.63). Benozzo was a pupil of, then an assistant to, Fra *Angelico at the friary of S. Marco in the late 1430s and early 1440s. During 1445–7 he worked with the sculptor *Ghiberti on the east doors of Florence baptistry, but during 1447–9 rejoined Fra Angelico as his principal assistant at the Vatican and in Orvieto cathedral. From 1450–3 he painted independently in Montefalco in Umbria (1450, S. Fortunato, frescos; 1451, altarpiece now in Vatican, Pinacoteca; *c*.1451–2, S. Francesco, his first extensive fresco cycle of the *Life of St Francis*; S. Francesco, chapel of S. Jerome, frescos and *illusionistic fresco *'polyptych') and in Viterbo, north of Rome (1453, S. Rosa, frescos destroyed 1632). In 1454–8 he worked once more in Rome (e.g. frescos, S. Maria in Aracoeli). Back in his native city, he executed the chapel decoration already mentioned, before moving out again to the provinces: 1464–5, S. Gimignano, choir frescos of the *Life of S. Augustine* in S. Agostino, more *classicizing than the Montefalco cycle. Simultaneously, he furnished the cartoon (*see under* fresco) for the *Martyrdom of St Sebastian*

for the Collegiata, executed by assistants, and various other works in or near S. Gimignano. From 1467 to 83 he was employed on his most extensive commission, a cycle of 26 frescos complementing the 14th century series at Pisa, Camposanto; all nearly completely destroyed in World War Two. Also lost are the 1484–95 frescos for Pisa, S. Michele in Borgo. In 1495–7 Benozzo was in Florence, but he died in Pistoia, where he had taken refuge from the plague.

There are panels by him in Washington, National; Ottawa, National; London, National; Paris, Louvre; etc. Disdained by modern art historians for his archaicism and relative lack of *expressivity, Benozzo was in demand among contemporaries: religious orders in provincial centres, and the luxury-loving Piero di Cosimo de'*Medici in Florence. His art reflects not only the influence of his master Fra Angelico, but also that of *Domenico Veneziano, *Piero della Francesca, Filippo *Lippi and his contemporary *Andrea del Castagno.

Grabar, Ivor (1871–1960) Russian painter and art historian, born in Budapest. He studied academic subjects and art in St Petersburg before going to Munich in 1896 to study in the Azbé Art School as well as architecture at the Polytechnic. He began as an *Impressionist painter but was subject to influences from many artists, being a persistent traveller in Europe as well as an energetic researcher and critic. With V. Kamenov and V. Lazarev he edited the thirty-volume *History of Russian Art* from 1910 on. This did not prevent him from painting and exhibiting busily, first with the *World of Art and frequently thereafter, while also teaching. He also became director of the Tretyakov Museum in Moscow, director of the Institute of Art History and director of the All-Russian Academy of Arts. His autobiography was published in 1937; his many letters were published during 1974–83.

Graf, Urs (*c*.1485–1527) Swiss goldsmith, designer for stained glass, experimental printmaker, best known for his pen-and-ink drawings of which about 100 – more than half the extant total – are in

the Print Room of the Basel Kunstsamm-lung. Graf was a brawler and on several occasions enlisted as a mercenary soldier in foreign campaigns on the Italian peninsula and in France. From *c*.1511 his prints and drawings chronicle the swaggering, lustful and bloody life of soldiers of fortune and their camp followers, while some mytho-logical figures and a few religious scenes stress the lascivious or sadistic aspects of the subject. *Genre scenes of Basel street life hint at parody and *caricature; perhaps only the Alpine landscapes are recorded in a neutral manner. Although stylistically conservative, Graf was technically as auda-cious as he was in his subject matter; in 1513 he made the first dated etching (*see under* intaglio).

Graff, Anton (1736–1813) Swiss painter settled in Dresden, where he was appointed court painter to the Elector of Saxony in 1766. He is noted primarily for his portraits of the best-known German poets, musicians and philosophers of his time (Winterthur, Oskar Reinhart Foundation).

graffito or **sgraffito**, pl. **graffiti** (from the Italian *graffiare*, to scratch) Term used for the medieval and *Renaissance tech-nique in which paint was applied over gold or silver leaf and then partially scraped away to create a decorative design; it was used especially to represent cloth-of-gold or cloth-of-silver textiles. A similar technique was employed with different-coloured plasters on the façades of houses (a famous example is the Palazzo Niccolini, no.15, Via de' Servi, Florence), and the term can describe any kind of design scratched through a layer of one colour or material onto a different ground, in ceramics for example. In the modern period the plural 'graffiti' is used for unauthorized designs, usually incorporating writing, sprayed, scribbled or scratched on walls and other surfaces by vandals, political activists etc. 'Graffiti art' has lately been recognized as a genuine form of artistic expression, and the young Afro-American Jean-Michel *Basquiat, friend and collaborator of *Warhol, is the outstanding example of a sophisticated graffito artist who translated the genre from walls to canvas and gallery-based commercial success.

Graham, John (1881–1961) Russian-American painter, born Ivan Dabrowsky in Kiev and involved in the avant-garde art world of Moscow. In 1920 he emigrated to the USA, changed his name and became something of a guru to a circle of younger artists such as *Gorky and David *Smith, introducing them to *Surrealist theory and to the new art of Paris. His paintings and drawings, in a variety of styles, include elegantly drawn heads accompanied by arcane symbols. He summarized his ideas in *System and Dialectics of Art* in 1937, but his personal influence seems to have been more compelling. He had one-man shows in Baltimore (1926), Paris (1929) and New York (1931 and 1960). After he died there were retrospectives in Chicago, Minnea-polis and New York.

Gran, Daniel (1694–1757) One of the most outstanding Austrian *Baroque painters, decorator of princely palaces praised by *Winckelmann for his treatment of *classical *allegory in the ceiling *frescos of the Prunksaal in the imperial library, the Hofbibliothek, in Vienna, 1726–30. He was equally adept at painting religious frescos and altarpieces (Vienna, Minoritenkirche; Karlskirche; Schön-brunn, castle chapel etc.).

Granacci, Francesco (1477–1543) Florentine painter, a pupil of Domenico *Ghirlandaio at the same time as *Michelangelo. He was later (1508) to advise the latter on the technical problems of *fresco painting in the Sistine Chapel. Like *Pontormo, who influenced him, he painted scenes for festivals (e.g. 1515, entry of Pope Leo X de'Medici into Florence) and also stage scenery, specializing in paint-ing on stuffs. Around 1515 he executed two scenes for the decoration on panel of the famous Borgherini bedroom (now Florence, Uffizi, Palazzo Davanzati), on which Pontormo, *Andrea del Sarto and Bachiacca (1495–1557) also collaborated.

Grand Manner The term used in 18th-century England to designate *istoria*

or History Painting (*see under* genres), and
by extension lofty *idealization applied to
other genres, such as portraiture. It usually
implies the scale of life or over-life size, and
a dependence on the formulae of ancient
Graeco-Roman or *Renaissance art. It is
much used by Sir Joshua *Reynolds in his
Discourses.

Grand Tour The extensive travels
undertaken on the Continent by young
British aristocrats in the 18th century to
complete their education. It normally
entailed a lengthy visit to Italy to view at
first hand the remains of Roman antiquity
and *Renaissance art, and to acquire works
of art, ancient and modern, for the deco-
ration of English country houses and
town residences. *Batoni executed many
portraits of Grand Tourists, while *Patch
*caricatured them; *Panini created archi-
tectural fantasies of Rome for them, and
*Piranesi grandiose records of Roman
monuments and designs for furniture and
interiors; *Canaletto and *Guardi provided
souvenirs of Venice. Their taste for the
paintings of *Claude mainly accounts for
the important collections of his works in
English country houses, and the *classiciz-
ing 'improvement' of their parks.

Granet, François-Marius (1775–1849)
French painter who was born and died in
Aix-en-Provence but worked principally in
Paris and in Rome. In Paris he worked for
a time in the studio of J.- L. *David. From
1802–19 he was in Italy where *Ingres
painted his portrait. In 1821 he visited
Assisi and did a painting of the church of
S. Francesco which was acquired by the
French king. From 1830 until his death he
worked in Paris though his paintings still
spoke of his attachment to Italy. Their
subjects range widely, from *History and
*landscapes to affectionate scenes of Italian
religious and secular life. The Musée
Granet in Aix has the best collection of his
paintings and drawings.

Grant, Duncan (1885–1978) British
painter, born in Invernessshire, who spent
his childhood in India and Burma and
studied art in London but benefited more
from working in Paris in 1906 and 7 and

from visiting Italy in 1908. He became
friends with Vanessa *Bell and Roger
*Fry. His paintings – mostly portraits,
landscapes and interiors – mixed *Impres-
sionist and *Post-Impressionist elements
with *Fauvism, but also moved between
geometrical *abstraction (around 1915) and
decorative mythological subjects (e.g. *Venus
and Adonis*, 1919; London, Tate). He was
seen as one of the two leading painters of
the *Bloomsbury Group, the other being
Vanessa Bell with whom he lived for many
years in Sussex at Charleston Farmhouse,
which they decorated in a lighthearted
manner. There were retrospectives in
London (1959) and Colchester (1963); in
1966 there was an exhibition of his work
and of Vanessa Bell's in Bristol. His 90th
birthday was celebrated with four concur-
rent shows. He showed abroad at the Venice
Biennali of 1926 and 1932. The Tate
Gallery, London, has several of his more
important works.

Grasser, Erasmus (*c.*1450–1518)
Sculptor active in Munich, author of
emphatically posed figures, most notably
the 10 (originally 16) *Morris-dancers* for
the Tanzsaal of the Alte Rathaus, 1480
(Munich, Stadtmuseum).

Grassi, Giovanni[no] dei *See*
Giovanni[no] dei Grassi.

Gravelot, Hubert F. B. (1699–1773)
French engraver (*see under* intaglio) and
book illustrator, trained in the studio of
*Boucher, He is the main purveyor of
the French *Rococo style to the British
School (*but see also* *Mercier). During two
extended visits to England from 1733 to
1755 he illustrated most of the important
books published in London, influencing
*Hogarth, *Hayman (with whom he
collaborated on Hanmer's *Shakespeare*)
and *Gainsborough, who probably worked
with him.

Graves, Morris (1910–)
American painter, trained in Beaumont,
Texas, after a visit to the Far East per-
suaded him to a meditative kind of art, in
which visual experience is transformed via
the 'inner eye'. A little bird became one of

his favoured motifs, a symbol of the human spirit. In his paintings he combined Oriental with *Surrealist idioms. He lived, as isolated as he could, in and near Seattle in the Pacific Northwest, but studied for some time in 1937 with Father Divine in Harlem, New York. In the later 1930s he worked for the Federal Art Projects. He met *Tobey in 1935 and explored his friend's calligraphic technique, combining it with his bird image in the *Blind Bird* series. He refused to do war service in 1942 and was sent to prison, an experience that marked him deeply. When Hiroshima was destroyed in 1945 he made every effort to go and help but was refused the necessary permits. He went to Hawaii in hopes of a Japanese visa; this too failed but while there he studied Chinese vessels in the Honolulu Academy, adding their fantastic animals to his vocabulary of motifs. He visited western Europe in 1949 and Japan in 1954. In his last years he developed a form of three-dimensional painting. His is a deeply religious art, mystical and physically fragile except for the late constructions which were intended as a bridge between his visual poetry and the technology of space travel.

Grebber, Frans de (1573–1649) and his son **Pieter** (*c.*1600–52/3) Dutch painters from Haarlem, specialists in History Painting (*see under* genres). Frans de Grebber was particularly important as a teacher, his most illustrious pupil being the architect-painter Jacob van *Campen, who ensured his participation in the decoration of the Oranjezaal in the Huis ten Bosch for Prince Frederik Hendrik, the Stadtholder. He was also the teacher of, among many others, *Saenredam, and of his own son, the gifted painter and draftsman Pieter, who also studied under *Goltzius and was influenced by *Rembrandt's *chiaroscuro. In addition to narrative paintings Pieter de Grebber also executed many portraits (e.g. Lisbon, Nacional; other works, Caen, Musée; Turin, Sabauda).

Greco, El; Domenico Theotocopulos, called (1541–1614) Greek painter and architectural theorist, born on the Venetian-ruled island of Crete, best known for his work in Toledo, Spain, where he

settled in 1576/7. Out of his training as a painter of *icons in Crete, his experiences in Venice (1558–70, 1572–6) and Rome (1570–2), El Greco wrought an idiosyncratic *Mannerist style combining Western and Byzantine elements. In his mature works we can distinguish the flame-like *figura serpentinata* of *Michelangelo and his central Italian followers; the free handling of the brush, the *alla prima* application of paint and the colourism (*see under disegno*) of *Titian, motifs from whose works of the 1560s appear in El Greco's pictures until 1600; the dramatic movement and *chiaroscuro of *Tintoretto; compositions, motifs and the elongated figure canon of prints by *Parmigianino and *Schiavone. From the *Byzantine East he inherited a preference for breaking up large curvilinear patterns into smaller jagged-edged areas of sharply differentiated colour, whose spatial relationship is often left unclear, as in mosaic; reducing landscape backgrounds to symbolic shapes and at times violating, for symbolic reasons, the rules of Western *Renaissance *perspective. Above all, both in the religious paintings which form the greater part of his production and in his portraits, El Greco employed painting as a vehicle for intensely *expressive spirituality.

After initial success with Philip II (*Adoration of the Holy Name of Jesus*; small-scale version London, National; full-scale canvas, 1578, Madrid, Escorial), El Greco's visionary style displeased the king (*Martyrdom of St Maurice* and the *Theban Legion*, 1582, Madrid, Escorial) and the Greek artist, deprived of a post at court or any further royal commissions, continued to work for the churches, convents and hospitals of Toledo among whom he had found enthusiastic patronage immediately after his arrival in the city (*c.*1577, *retable of S. Domingo el Antiguo, for which he designed the architectural/sculptural frame as well as painting eight large pictures). Among his other works for Toledo the most important are: the *Disrobing of Christ* (*El Espolio*) (1577–8, cathedral); *Agony in the Garden* (1580–6, now Toledo, Ohio, Museum); his masterpiece and the largest single work he ever painted, the *Burial of the Count of Orgaz*, which includes among its many

portraits one of his young son **Jorge Manuel Thetocopulos** (*b.*1578, later painter and architect) (1586, S. Tomé); three great altarpieces for S. José (1598–9, one *in situ*, two in Washington, National); a mystical scene from the Apocalypse for the Hospital of St John (*Clothing of Martyrs*, 1610–14, now New York, pc). Other works were commissioned for e.g. a royally endowed convent in Madrid (1596, now Madrid, Prado; Rumanian State Coll.; Villanueva y Geltrú, near Barcelona, Museo Balaguer); and the Hospital of Charity at Illescas (1603–4). From *c.*1603 his paintings are characterized by ever-greater luminosity and restlessness. He began also to base religious compositions on northern European, mainly Flemish, prints (e.g. *Resurrection*, 1608–10, Madrid, Prado, from an engraving after *Blocklandt).

El Greco's earliest extant portraits date from his stay in Rome, 1570–2 (Naples, Capodimonte) and he continued to execute vigorous likenesses virtually throughout his career. One of the most attractive is the untypical female portrait, *A Lady in a Fur Wrap*, perhaps representing El Greco's mistress and the mother of his son, Jerónima de las Cuevas (*c.*1577–9, Glasgow, Burrell; in the same collection, *Portrait of a Man*, 1590s; also New York, Frick).

Several variants are known of an *Allegorical Night Scene* showing a boy lighting a candle, sometimes including a monkey and a grinning youth (e.g. Earl of Harewood Coll.; Edinburgh, National). Stylistically, this group of pictures resembles the nocturnal scenes of Jacopo *Bassano.

Finally, two landscape paintings by El Greco are known, one being the famous turbulent and ghostly *View of Toledo* (*c.*1604–10, New York, Metropolitan). Of the artist's complex personality the best-known trait is his arrogance. When he was in Rome, the 'problem' of nudity in Michelangelo's *Last Judgement* was being debated at the Papal court (*see* Daniele da Volterra). El Greco antagonized other artists by volunteering that if the fresco were demolished he would paint a better as well as a more decorous one (*see* decorum). As late as 1611 he was to say to *Pacheco

that 'Michelangelo was a good man – alas, he did not know how to paint!'

Greco, Emilio (1913–) Italian sculptor who worked first as a carver of funerary monuments, then studied briefly in the Palermo Academy and had his first show in 1946 in Rome. He had a great success with his mannered nudes, elegant and witty transcriptions of *classical prototypes.

Green, Valentine (1739–1813) English *mezzotint engraver and publisher. He made his reputation with reproductions of Benjamin *West's *history paintings; in 1773 he was appointed Mezzotint Engraver to the King, and, in 1775, Engraver Associate at the Royal *Academy and Engraver to the Elector Palatine. Between 1778 and 1783, when he quarrelled with *Reynolds over the right to engrave the portrait of the actress Mrs Siddons, he made 19 mezzotints after Reynolds, including a series of female portraits which Green published as the *Beauties of the Present Age*.

Greenaway, Kate (1846–1901) British illustrator of children's books, portraying childhood lightly and charmingly as an age of perfect innocence and happiness. *Ruskin praised her excessively, *Gauguin more aptly, and her influence can be found in a wide range of North European art.

Greenberg, Clement (1909–94) American art critic, a champion of Jackson *Pollock and of American *Abstract Expressionism from 1943 on and subsequently of a movement he led and named *Post-Painterly Abstraction, as well as of the American sculptor David *Smith and the British sculptor, close to the Post-Painterly Abstractionists around 1960, Anthony *Caro. Trained in art and firmly based in Marxism and modern art history, Greenberg wrote eloquently and with conviction, dominating English-language art criticism and debate until the 1960s. He also exerted influence directly on a number of artists, most noticeably in the USA and Britain, not least because his magisterial judgements were for some time linked to

effective promotion of artists and types of art in the galleries. John *Latham's action of 1966 signals both the status at that time of Greenberg's selected and partly re-written essays, published as *Culture and Society* in 1961, and an intelligent artist's refutation of it. Since the 1970s critical opinion has dismissed Greenberg's writings as essentially formalist (like Roger *Fry's half a century earlier): though his early criticism reflected a Marxist insistence on art's role in society, his mature writing, from about 1940 on, presented art as an activity driven by its own inherent logic. It was this logic he was at pains to delineate.

Its core was the conviction that each medium has its own opportunities and demands. Progress and quality reside in purification, excluding all functions distracting from these. This idea is close in spirit to the *Post-Impressionist definition of painting as colours ordered on a flat surface (*Denis, 1890) and to the broader *Modernist slogan 'Truth to Materials' which for a while governed the work of sculptors such as *Brancusi, *Epstein and *Moore and enouraged *primitivist tendencies in *Expressionist art, especially printmaking. Greenberg's secondary aim was to detach American art from European Modernist as well as traditional models, and this involved celebrating America's gradual welcoming of what he recommended as the art of liberal-thinking museums, media and managerial society even when these depended for their existence on capitalism. In 1955 he noted with satisfaction that what he then called 'American-type painting', the work of the Abstract Expressionists, was being imitated in Paris and thus ending the open and latent domination of what had been the last great movement in art, *Cubism. In titling an article of 1965, in *Art in America*, he plainly asserted what he had earlier implied, that in art 'America takes the Lead'.

He witnessed the rise to fame and fashion of *Johns and *Rauschenberg at the end of the 1950s and then the noisy eruption of *Pop art about 1962, and denounced these as of little or no value, as did other critics of his generation. For Greenberg, they sinned against the principle of purity and the elimination of all extraneous visual and conceptual concerns. They also, of course, challenged the pre-eminence of Abstract Expressionism and drew attention away from Post-Painterly Abstraction. For a time Greenberg's voice had been dominant and his judgements had been respected and echoed; now there was lively opposition from artists and critics representing less high-minded and exclusive values, and associated both with more immediate social content and with youthful, often ironic attitudes. Greenberg's 'collected essays and criticism' of 1939–69, edited by John O'Brian, were published in four volumes in 1986 and 1993. They retain their interest as showing the developing ideas and polemics of a perceptive and passionate mind.

Greene, Balcomb (1904–) American painter, one of the founders of the *American Abstract Artists group and its first chairman. His work was close to the geometrical art prominent in the *Abstraction-Création society of Paris. Under the influence of *Surrealism and emerging *Abstract Expressionism, it became less geometrical and constructive, using colour in loose, expressive configurations.

Greenwood, John (1727–92) Colonial American painter from Boston; after the death of *Smibert and *Feke's abrupt departure in 1750 he had the virtual monopoly of the city's portrait market. His style, less solemn than that of most colonial painters, influenced the young *Copley, who knew Greenwood as an associate of Peter *Pelham. In 1752 Greenwood suddenly shipped out for Surinam in Dutch Guiana, a stopping place for New England merchant ships. Here he produced the first-known *genre scene produced by an American artist: the hectic *Sea Captains carousing in Surinam* (St. Louis, City Art). He later turned up in London, where he became an art dealer.

Greuze, Jean-Baptiste (1725–1805) From 1755 or, most especially, 1761 to *c*.1780 one of the most popular French painters, celebrated for his 'elevated'

*genre pictures, analogous to popular contemporary bourgeois novels and sentimental drama and ostensibly preaching the virtues of family harmony and the simple life. The best-known is *L'Accordée du Village* or the *Village Betrothal*, which caused a sensation at the Salon of 1761 (Paris, Louvre; others also Louvre; St Petersburg, Hermitage; Moscow, Pushkin; Portland, Oregon, Museum; London, Wallace; etc.). To modern eyes these tableaux, engraved, and described at length by the artist in exhibition catalogues, seem sentimental and melodramatic, with erotic undertones that look unwholesome when allied to their sometimes slick and glossy handling of paint. More unwholesome still are Greuze's morally ambiguous Fancy Pictures of voluptuously pretty girls, often mourning their lost virginity with the aid of allegorical props (e.g. *Girl Pining over a Dead Bird*, c.1765, Edinburgh, National; *The Broken Jug*, Louvre; *Girl with Broken Mirror*, London, Wallace). Apparently affiliated to 17th-century Dutch genre, Greuze's works have as their true forerunners respectively *Poussin (both compositionally and in their insistence on a variety of emotional reactions being read sequentially by the viewer) and the swooning or suiciding late female figure compositions of *Reni.

That Greuze had looked closely at Poussin may be demonstrated by his *Academy reception piece: *Septimus Severus and Caracalla* (1769, Paris, Louvre). The painting, modelled after Poussin's *Death of Germanicus*, was turned down by the Academy for reasons that are not now clear, and Greuze was refused a classification as a history (*see under* genres) painter. At this unexpected slight, the artist broke with the Academy and never exhibited again at its annual Salon until after the fall of the monarchy.

Born at Tournus, Greuze trained at Lyons and first made his mark at the Salon of 1755 with *The Father of the Family expounding the Bible*; he then left for Italy, returning to Paris in 1757. Italy proved to be of little significance in his art. Perhaps surprisingly, in view of his best-known production, he was not only an excellent draftsman but a strongly *realistic portra-

itist (e.g. Paris, Jacquemart-André). For a while after his return to France he took up the more painterly, impasto technique of *Chardin, and in this mode executed some affecting likenesses of children (e.g. *Schoolboy memorizing his lesson*, 1757, Edinburgh, National). With the advent of *Neoclassicism and the rise of *David, he lost his popularity, although, welcoming the Revolution, he continued to execute portraits of its leaders. Favoured by the Bonaparte family he was commissioned in 1804 for a portrait of *Napoleon as First Consul* (1804–5, Versailles). For this his last work, he shared the single posing session with the young *Ingres.

Grien, Hans Baldung *See* Baldung, Hans.

Grimaldi, Giovanni Francesco, called Il **Bolognese** (1606–80) Italian painter, architect and engraver (*see under* intaglio) from Bologna, chiefly active in Rome. He is best remembered for his *cabinet pictures of *classical landscapes in the style of Annibale *Carracci, but he also executed *frescos (Rome, Pal. Santacroce; Villa Doria Pamphili, where he also worked as an architect; Quirinal Palace, Gallery, under the direction of *Pietro da Cortona; S. Martino ai Monti). In 1649–51 he worked in Paris, carrying out decorations in the Mazarin Palace (now Bibliothèque Nationale) and the Louvre.

Grimmer, Jacob *See under* Bruegel.

Grimshaw, John Atkinson (1836–93) British painter who worked mainly in the North of England and lived in Yorkshire until his last years, spent in London. The son of a Leeds policeman, he worked as a railway clerk until the end of the 1850s when marriage and contact with artists led him to commit himself to painting. His success was remarkable. He exhibited only occasionally, working mainly for private patrons and painting mostly townscapes and dock scenes they could recognize, nocturnal views often at once accurate – he used photographs and a camera obscura – and atmospheric. The Leeds City Art Gallery has the best collection.

Gris, Juan (1887–1927) Spanish painter, born José Vittoriano González. Trained in Madrid, he moved in 1906 to Paris where he did drawings for journals. He started painting about 1910, encouraged by *Picasso, and began to exhibit in 1912 and to experiment with *collage. He proved one of the most consistent *Cubists, developing a form of Synthetic Cubism in which design dominates representation: all-over divisions and rhythms determine the lay-out, generating the shifts or dislocations that make his images Cubist; his colours tend to be as sober as his painting technique. His usual subject was the still life; figures appear occasionally. During the First World War he worked in the south of France and impressed *Matisse with his formal austerity. In 1919 Gris had a large exhibition in Paris. In his last years his work became even more controlled and included a few sculptures. His clarity gave him his present status as one of the two or three leading Cubists after Picasso and *Braque. *Kahnweiler had become his contractual dealer as early as 1912; after 1920 Gris avoided commitment to anyone but exhibited in Paris and elsewhere. He also worked for the Ballets Russes from 1922 on, and illustrated books by major writers. During 1923–5 he published articles on Cubism and lectured at the Sorbonne. In 1946 Kahnweiler published a book on Gris which includes letters the painter wrote to him; an English translation appeared in 1947.

grisaille A painting executed entirely in tones of grey, often used decoratively to imitate stone relief. Monochrome paintings in other colours – imitating, for example, bronze reliefs – are called camaïeu, from the French word for cameo.

Gromaire, Marcel (1892–1971) French painter, largely self-taught. He was a soldier in the 1914–18 war. He used his art, combining *Expressionism and *realism with formal methods derived from *Léger, to portray the life and aspirations of ordinary people. There was a large retrospective exhibition of his work in Paris in 1957. The Petit Palais in Paris has a substantial Gromaire collection.

Grooms, Red (1937–) American sculptor, a creator of *Happenings and known internationally for his rumbustious *assemblages of urban scenes, indoors and out, ranging from the interior of his studio (1965–6; Washington, Hirshhorn) to Manhattan Island (1976).

Gropper, William (1897–1977) American painter and graphic artist who studied with *Henri and *Bellows, drew cartoons for various periodicals and painted vigorous, even aggressive pictures in protest against poverty and injustice.

Gros, Baron Antoine-Jean (1771–1835) French painter, a *classicist by training, *Romantic by instinct and, thanks to the tension created by these polarities, the creator of epic images of the splendours and miseries of the Napoleonic wars. His father was a painter of miniatures. In 1785 young Gros entered the studio of J.-L. *David and in 1787 the *Academy school. From 1793 to 1800 he was in Italy, studying, teaching and producing his own drawings and paintings in several cities. In Milan he was introduced to Napoleon who gave him his first major commission, the entirely successful *Bonaparte on the Bridge of Arcole* (shown at the 1801 Salon). This led Napoleon to appoint him to various supervisory roles in Italy but these ended when the French armies had to leave Italy.

Back in Paris he strove to make his name. He had a great success in the 1804 Salon with *The Plague at Jaffa*. In the Salons of 1806 and 1808, respectively, he drew applause with paintings representing the battles of Abouqir (Versailles, Duroc) and Preussisch-Eylau. He was awarded the Légion d'Honneur by the Emperor and found himself fully occupied painting portraits of the Emperor, his family and his court, as well as further battle pieces. There was some lessening of his energies as painter after 1809, perhaps because of an unhappy marriage and a tendency to depression. After Napoleon's fall, Gros was able to establish himself with the restored Bourbons as court portraitist and was made a Baron in 1824. David, on the point of emigrating, charged him with defending

the great classical tradition against Romanticism. Gros, by now professor at the Ecole des Beaux-Arts, responded by producing laborious but lame *History paintings in a *Neoclassical style. These brought mockery from the critics and Gros committed suicide. The Musée d'Orsay has the strongest collection of his paintings (including those named here and not otherwise placed); some of his other major works are in the Musée Duroc, Versailles.

Grosz, George (1893–1959) German painter and graphic artist, trained at the academies of Dresden and Berlin. From 1910 on he was publishing satirical cartoons in Berlin papers. In 1914–15 he served in the German army but suffered a breakdown and began to make drawings for left-wing journals. In 1916 he Anglicized his first name in protest against anti-British propaganda. He became a close friend of the publisher Wieland Herzfelde and published poems and drawings in his journal *Neue Jugend* (New Youth). He was called up in 1917 and again invalided out. Back in Berlin he published his first major series of lithographs, at once *realistic and satirical, portraying cosmopolitan life as a rat-race moderated only by stupidity. In 1918 he, Herzfelde and Herzfelde's brother *Heartfield were among the first to join the German Communist Party. They collaborated on satirical publications; Grosz also worked with Heartfield on puppets for the theatre and on *collages. They were prominent in the Berlin *Dada movement, giving it a political direction. But painting was Grosz's chief ambition. *Dedication to Oskar Panizza* (1918; Stuttgart, Staatsgalerie) is a nightmare vision of the modern city, *Pillars of Society* (1926; Berlin, Staatliche) a denunciation of militarism, the venal press and a corrupt clergy in pictorial terms that echo *Dürer's. He wanted to create 'modern *History paintings' in the tradition of *Hogarth. His portraits combine sharp realism with dramatic presentation and allowed him to be seen as a champion of *Neue Sachlichkeit. Yet it was as a graphic artist that he was admired and feared. 1921 saw the publication of *The*

Face of the Ruling Class (55 drawings), 1923 *Ecce Homo* (100 drawings), 1930 *Love above All* (60 drawings) among other suites. He also made theatre designs for Piscator and other left-wing directors, some of them in collaboration with Heartfield. Six months in Russia, in 1922, convinced him that all forms of *abstract art were useless: art must have an immediate social message and effect. His pursuit of this caused him to be put on trial in Berlin on three occasions, charged with disseminating obscene images, and fined.

In 1932 he was visiting tutor at the Arts Students' League in New York. The following year he emigrated to the USA, where he taught, painted and exhibited while his art was being defamed in Germany. In 1938 he acquired American citizenship. His autobiography *A Little Yes and a Big No* came out in 1946. In 1954 he revisited Germany and in 1958 he was again in Berlin where he was made Honorary Member of the Academy of Fine Art. In 1959 he moved back there but died soon after. His work had softened in America; one wonders what effect his return home might have had. But it had remained satirical, a protest against art that merely pleases as well as against mankind's grossness.

grotesque (from the Italian *grottesche*, of a grotto or crypt) In the history of art, the term has a significance quite distinct from that of its everyday usage. It denotes a type of decoration used in antiquity and revived by *Renaissance artists excavating 'grottos' – i.e. buried ruins, such as those of the Golden House of Nero in Rome. Grotesque decoration is essentially representational, and made up largely of natural forms. But it subverts the natural order by depicting these forms as metamorphosing one into the other: thus plant forms change into human shapes, or half-animal, half-human beings such as harpies or sphinxes. The organizing principle of antique grotesque decoration and its Renaissance imitations, which differentiates them from either *Gothic or *Rococo imagery on the same theme, is bilateral symmetry. Forms do not interlace, as in arabesque, but 'grow' one out of the other on either side of, or along, a central axis, or 'stem'. *Perugino

and *Ghirlandaio were among the first artists to revive true grotesque decoration; *Raphael supervised the painting of the *logge* of the Vatican palace with grotesques, *see* *Giovanni da Udine.

ground The prepared surface of a support to be painted, or the substance with which it is prepared. The ground provides a barrier between the support and the painted layers, reducing absorbency and chemical interaction; it serves to smooth out imperfections such as knots and joins in wooden panels, or the weave of canvas. Where it is smooth and white, like *gesso, it provides a reflective underlayer. A coloured ground, on the other hand, may lend a warm overall tonality to a picture, or provide a middle tone, or a dark tone; 17th-century painters often used a warm reddish-brown ground which was left bare in places to suggest shadow (*Rubens and *Rembrandt often relied on this device; *Poussin's reddish grounds have become obtrusive as the surface layers of oil paint became translucent with age). In etching (*see under* intaglio) the ground is the acid-resistant wax preparation rolled on to the plate. *See also* fresco for mural grounds; bole.

Groupe de Recherche d'Art Visuel Association of artists exploring the potential of light and motion, founded in Paris in 1960 and including *Yvaral, *Morellet and *Le Parc. The group, known by its acronym GRAV, exhibited many times in Paris and outside France, especially during 1961–5. Its concerns allied it to *Op Art and *kinetic art.

Grund, Norbert (1717–67) Bohemian painter of small *cabinet pictures, mainly on metal or panel, depicting scenes from everyday life or pastoral idylls (Prague, National).

Grundig, Hans (1901–58) German painter, born in Dresden and trained at the Dresden *Academy where *Dix was a senior student. In 1925 he exhibited with Dix and other leftwing artists and in 1926 he joined the Communist Party. He worked as a house painter until, in 1928, he found himself unemployed. During 1930–2 he made his most powerful pictorial protests, in paintings and often in linocuts, images of city life as lived by the underclass and images of class war, as in *Strike* (1930, linocut) and *Hunger March (Café Republik)* (1932, painting; Dresden, Staatliche Kunstsammlungen). His art was denounced and confiscated by the Nazis and his continuing struggle against fascism led to periods in prison and then a concentration camp. He returned to Dresden in poor health but continued to work as artist and teacher (he was professor and rector of the Dresden College of Art) until his death. His wife **Lea Grundig** (1906–77), née Langer, became a Communist at the same time as he. She had studied at the Academy too, against parental opposition. She worked mainly as a graphic artist, making linocuts and etchings, influenced by *Kollwitz, but becoming harsher in line and tone – as in the streetscene *Children playing at Firing Squad* (etching from the suite 'Under the Swastika', 1934). In prison for two years, she managed in 1939 to emigrate to Palestine where she continued her work. In 1949 she returned to Dresden and was professor at the College of Art, like her husband, in 1964 becoming president of the Artists Association of the German Democratic Republic.

Grünewald, Matthias (*c.* 1470–1528) German painter whose real name was Mathis Gothart Neithart; he was called Grünewald by his 17th-century biographer Joachim *Sandrart, in the *Teutsche Akademie*, where Sandrart confuses him with Hans *Baldung Grien. His identity and the facts of his biography were not established until the 20th century.

'Master Mathis the Painter' was court artist to the archbishops of Mainz, for whom he also designed waterworks and fountains, *c.* 1508–25. He is best known today for the complex folding *polyptych called the Isenheim Altarpiece, completed in 1515 for the Hospital Order of St Anthony at Isenheim (now Colmar, Musée). The sculpted portions are attributed to Nikolaus *Hagnower. The altarpiece would have been seen daily by the sick treated by the Order and the original destination accounts in some measure for the

work's gruesome *iconography, with its stress on the physical wounds of Christ in the *Crucifixion* (central panel, exterior) and *Lamentation* (*predella, exterior and first opening), the prominent syphilitic demon in the *Temptation of St Anthony* (right wing, second opening), and the inclusion of St Sebastian, one of the 'plague saints' (right wing, exterior) in addition to St Anthony, who reappears in every arrangement of the polyptych. But the *expressive intensity of this work results less from its imagery than from its pictorial treatment. In this as in his other paintings Grünewald distorts proportions and exaggerates the play of light and shade for symbolic and emotional ends.

Grünewald ranks second only to his contemporary, *Dürer, in the history of German *Renaissance art. But their aims and gifts were very different. Like Dürer, Grünewald was a great draftsman, but he relied on drawing only as a preliminary to painting; his true medium is not graphic but pictorial (there are over 30 drawings, however, executed in mixed technique with chalk, in Berlin, Kupferstichkabinett). His use of colour is at once rich and sombre, relying on dramatic contrasts. More importantly still, where Dürer sought to reconcile Italianate *idealization with northern European naturalism (*see under* realism), Grünewald stresses the conflict inherent between those two types of representation.

In 1525 Grünewald left the service of Albrecht von Brandenburg, former Archbishop of Mainz and, since 1518, cardinal, because of his sympathies with the Peasants' Revolt. Although forgiven by Albrecht, he did not return to Mainz but settled in Frankfurt, departing in 1528 for Halle, where he died. A list of books left behind him in Frankfurt suggests that, like Dürer, he had become a Lutheran.

In addition to the Isenheim Altarpiece, Grünewald painted panels for other *retables, including additional *grisaille wings for the Heller Altarpiece (*see* Dürer), now in Frankfurt, Städel, and Donaueschingen, Sammlungen. Three altarpieces in Mainz are known to have been lost through Swedish looting. Other works are to be found in Washington, National; Freiburg

im Breisgau, Augustinermuseum; Stuppach, parish church; Karlsruhe, Kunsthalle, and Munich, Alte Pinakothek.

Gruppello, Gabriel (1644–1730) Versatile and prolific Flemish sculptor, celebrated as the chief sculptor of the Elector Palatine Johann Wilhelm in Düsseldorf (from 1695; *see also* Adriaen van der Werff, Godfried Schalcken, Rachel Ruysch).

A pupil of Artus II *Quellin from 1658, Gruppello participated in the decoration of Amsterdam Town Hall (now Royal Palace) in 1663. After working in Versailles, Brussels, Apeldoorn and Potsdam, on sculptures ranging from fountain figures through portraits in full- and bust-length and medals, he settled in Düsseldorf, producing Italianate mythological sculpture on the scale of life and in collectable small format, an equestrian statue of the Elector (*c.*1703–13, Market Place) and many religious sculptures both for churches and personal use (e.g. St Maximilian; Theresienhospital; St Cecilia). His most famous work, however, and surely one of the most extraordinary pieces of public sculpture of all time, is the 7 m-high Bronze Pyramid (compl. 1716) set on a 5 m-high stone base (1743) on the Paradeplatz, Mannheim, and made up of innumerable figures sculpted in the round in complex interlacing poses, personifying virtues and vices in allegorical actions glorifying the Elector, whose seated portrait is included near the base of the pyramid.

Guardi, Francesco (1712–93) and his brother **Giovanni Antonio** (1698–1760) Members of a family of painters from the Trentino active in Venice. The work of their father **Domenico** (1678–1716) and brother **Nicolo** (1715–86) has either not survived or not been identified. Francesco is now celebrated for his *vedute* and *capricci* (*see below*) but began his career collaborating with Giovanni Antonio in a family 'firm' of which the latter was the dominant partner, and which turned out uneven and derivative paintings in many *genres: altarpieces (Berlin, Staatliche); scenes from mythology (e.g. Liverpool, Walker); battle pieces; flower pieces; genre scenes in the manner of Pietro *Longhi; *frescos (1750s, Venice, Cà Rezzonico).

An unresolved problem of attribution between the two brothers is presented by the sparkling figurative decorations of the organ parapet at Angelo Raffaele, Venice (after 1753? after 1773?). A newly discovered altarpiece by Francesco, dating from after his brother's death, that is, *c.*1777, in the parish church of Roncegno, proves that the artist continued to paint some large-scale figure pieces after the dissolution of the Guardi 'firm'. But from *c.*1760 his main work consisted of the famous views of Venice, at first influenced by *Canaletto whose designs he often copied (e.g. Waddesdon Manor). Soon, however, Guardi freed himself both from Canaletto's more prosaic manner and from literal topography, to concentrate on poetic *capricci*. While his *Rococo colours and airy touch have affinities with the work of his sister's husband, *Tiepolo, their careers could hardly have differed more. Guardi's pictures became smaller, some barely larger than matchboxes, and ever more allusive, painted in rapid shorthand in oils diluted nearly to watercolour thinness. His clientele is almost totally unknown to us, the main exception being the Englishmen who patronized him. He seems to have had no studio, although his son **Giacomo** (1764–1835) possibly assisted him and often copied his work, later specializing in *gouache views of Venice which, however, lack the freshness of those by Francesco. The industry in fake and pastiche Guardis began early; the artist himself painted many versions of his own works. His drawings (e.g. Venice, Correr; Vienna, Albertina; London, V&A) show even greater spontaneity than the paintings.

Most large public collections – including London, National; Milan, Poldi-Pezzoli; Paris, Louvre – have works by Guardi.

Guariento di Arpo (recorded 1338–68/ 70) Paduan painter; his earliest and most significant surviving works in Padua are the 29 panels from the ceiling of the Capella del Capitano, anticipating, in their geometric variety, 16th-century Venetian painted ceilings. Most of his apse decoration for the church of the Eremitani, Padua, was destroyed in 1944 (*see also* Mantegna), although marbling and *grisaille

figures remain. These, and his one signed work, the *Crucifix* now in Bassano, Pinacoteca, show him to have been the closest of *Giotto's immediate Paduan followers. In 1365–7 he painted a vast *Coronation of the Virgin* fresco in the Sala del Maggior Consiglio of the Doge's Palace, Venice. Ruined in the fire of 1577, it was replaced by *Tintoretto's *Paradise*; when this was taken down in 1903 large fragments of Guariento's fresco were uncovered and are shown, along with the *sinopia, in a neighbouring room. It remains outstanding for its elaborate many-tiered *Gothic architecture, copied in 1438 by *Jacobello del Fiore.

Guercino; Giovanni Francesco Barbieri, called (1591–1666) Precocious and largely self-taught painter from Cento, a small town in the Duchy of Ferrara, near Bologna. He became one of the most famous Italian artists of the 17th century, author of notable *frescos, altarpieces and collectors' pictures. He also executed some small-scale pictures on copper. Having forged a highly personal, emotionally charged pioneering *Baroque style notable for its *chiaroscuro, he retreated, under pressure from the prevailing climate of critical opinion in Rome during his stay there, 1621–3, into a lighter hued, more *classical manner, marrying Venetian *colorito* with *disegno* but maintaining his earlier romantic outlook.

Trained in the technical rudiments of his art by local artists, Guercino was influenced by *Caravaggio, but even more by Lodovico *Carracci, one of whose finest altarpieces was in Cento; he also studied the Carracci workshop frescos in Bologna. He emerges as an independent artist by 1613, executing portraits, decorative friezes and altarpieces for patrons in Cento and Bologna (Cento, Pinacoteca; Villa Giovanina; Casa Provenzali, now Benazzi; Brussels, Musées). By 1618 he had gained considerable success and undertook a study trip to Venice. His early style may best be assessed in his masterpiece of 1620, *St William of Aquitaine receiving the Cowl* (Bologna, Pinacoteca).

Summoned to Rome in 1621 by his chief Bolognese patron, Cardinal Ludovisi,

recently elevated to the papacy as Gregory XV, Guercino seemed set to vanquish the current classicizing style, exemplified in *Domenichino's *St Cecilia* frescos of 1613–14. His main work in Rome, the frescos of the Casino Ludovisi, challenged, through the *illusionism of the *Aurora* on the ceiling of the entrance hall, Guido *Reni's *Aurora*, 1613–14, Casino Rospigliosi. Where Reni had planned his ceiling decoration like an easel painting hung over the viewer's head, Guercino's personification of Dawn seems to charge in her horse-drawn chariot across the open sky. The *quadratura* framework (*see* illusionism) was executed by **Agostino Tassi** (*c.*1580–1644).

By 1623 the artist seemed to have lost confidence in his earlier manner. With Gregory XV's death of the same year, he must have lost faith in his ability to compete for commissions in Rome. He returned to Cento, where he conducted an extremely successful international mailorder business in large altarpieces and collectors' paintings. He refused invitations to the royal courts of England and France. After Guido Reni's death in 1642, he moved to Bologna and assumed his rival's position as the city's leading artist. In addition to the works cited above, there are paintings by Guercino in many churches throughout Italy, including naturally Cento and Bologna. In Cento he may have designed the façade of a new church for the Confraternity of the Rosary, of which he became Prior, and for which he endowed and decorated a chapel, 1641.

In addition to paintings in many collections, there are splendid drawings by Guercino, including landscape drawings, in, e.g., Oxford, Christ Church and Windsor, Library.

Guérin, Giles *See under* Sarrazin, Jacques.

Guérin, Pierre-Narcisse (1774–1833) French painter, a second generation *Neoclassicist. He was in Rome in 1803–5 and again, as director of the French *Academy there from 1822 until his death, revisiting France during those years. He painted grand *Histories on *classical themes, including some taken from French classical drama, as well as dramatic portraits, somewhat warmer and occasionally sweeter than Neoclassicism required, and on this account, as well as his being the master of *Géricault, *Delacroix, *Delaroche etc., he assumes a transitional place between Neoclassicism and French *Romanticism.

Guglielmo della Porta *See* Porta, Guglielmo della.

Guido da Siena (active *c.*1260–80) Italian painter, with *Coppo di Marcovaldo the founder of the Sienese school (*Madonna and Child*, Siena, Palazzo Pubblico; *polyptych, Pinacoteca).

Guillaumin, Armand (1841–1927) French painter who became an *Impressionist through contact with *Pissarro and *Cézanne after years of amateur painting. He took a night-time post in order to be able to paint in daylight and married a university lecturer who was able to give him some support, but it was not until he won a lottery in 1892 that he was able to paint full-time. Having painted scenes in and around Paris, he now roamed all over France in search of landscapes. His best paintings combine a fine sensitivity to light and skies with compositional solidity, reflecting the effectiveness of Pissarro's example. In his later work the colour is heightened, possibly under the influence of Van *Gogh.

Gulbransson, Olaf (1873–1958) Norwegian-German painter and caricaturist, trained in Oslo but active from 1902 in Munich where he supplied the satirical journal *Simplicissimus* with images of bourgeois pretentiousness. He was also a fine painter, noted for portraits of eminent contemporaries such as Thomas Mann and Wilhelm Furtwängler, but was capable also of lyrical paintings of landscape.

Günther, Ignaz (1725–75) Outstanding Bavarian *Rococo sculptor, son of a cabinet-maker and painter specializing in sculpture *polychromy. After peripatetic years of apprenticeship and training,

which included sculpture classes at the Vienna *Academy, he settled in 1754 in Munich, where he was a pupil of Johann Baptist *Straub. Günther worked for the court and for many churches in Munich and throughout Bavaria (e.g. Weyarn, 1755–65; Rott am Inn, 1759–62; Starnberg, 1766–8). His woodcarvings are usually polychromed in delicate colours, or white and gold; with his pen and watercolour drawings, they are among the most important achievements of later 18th-century German art.

Günther, Matthäus (1705–88) One of the most important *fresco painters of the Bavarian *Rococo; he worked in the studio of Cosmas Damian *Asam between 1723 and 1728, and was based in Augsburg from 1731, becoming one of the most popular decorative painters of churches in Bavaria, Swabia, Franconia and the Tyrol (e.g. Rott am Inn, 1760–3). He also decorated the castles of Stuttgart and Sünching, painted altarpieces and made etchings (*see* intaglio prints). In 1740 Günther acquired the artistic estate of Johann Evangelist *Holzer; from 1762 to 1784 he was Director of the Augsburg *Academy of Art.

Guston, Philip (1913–80) American painter, born in Canada the son of Russian immigrants. He grew up in Los Angeles where he had some formal art training but was largely self-taught. After studying the work of *Orozco and *Rivera at Claremont, California and in Mexico, he moved to New York in 1934 and worked as muralist for the *Federal Art Project. During this time he came to know several of the painters who would become the leading *Abstract Expressionists; *Pollock he knew already from high school in Los Angeles. He taught at Iowa State University during 1941–5, now working on easel paintings, and spent 1945–7 at Washington University, St Louis, as artist-in-residence. His paintings presented social issues by means of allegory, mingling early *Renaissance and *Surrealist elements. From 1947, in New York and at Woodstock, NY, he worked to simplify his idiom. Out of this came *Tormentors* (1948; San Francisco, MoMA),

an *abstract painting containing linear and other forms similar to those he used in his semi-abstract studies for it and that would reappear in his work at the end of the 1960s. Meanwhile he had a marked success with fully abstract paintings, subtle in colour and articulated at first by vertical and horizontal brushstrokes that referred both to *Mondrian's abstracted seascapes of 1913–15 and to *Monet's late *Waterlilies* series. Changes in Guston's work in the later 1950s and early 60s, with larger forms surfacing to hint at pictorial dramas, implied deep restlessness. He spent a few years drawing and painting with great intensity on a small scale. His 1970 solo show of new paintings at the Marlborough Gallery, New York, horrified his earlier admirers who found his new work raucous and stupid. In 1972 he withdrew from his contract with the gallery. He was appointed University Professor at Boston University the same year, and in 1975 the College Art Association gave him its Distinguished Teaching Award. In 1973 a retrospective exhibition of his drawings was shown at the Metropolitan Museum, New York, and from 1974 on a series of solo exhibitions, mostly at the David McKee Gallery, New York, presented his new work, seen in major exhibitions from 1978 on in San Francisco and other major American centres.

This new work both returned to his earlier themes and gave monumental status and Surrealistic resonances to commonplace objects, coarsely pictured: a comic-strip self-image, shoes with and without legs, hands with cigarettes, light bulbs, ladders, a gigantic head rising or setting over the sea. The voice was new, the paintings were at once meditative and energetic, their themes seemed eternal in so far as they could be elucidated. He said, 'Around 1970 I became a movie director.' We are still torn between seeing what followed as travesties or tragedies; in this it is akin to the plays of Samuel Beckett. Guston's early painting had been theatrical in its management of figures and props on the pictorial stage; the work of his last decade is more deeply theatrical in that it can be powerfully dramatic and awesome. In 1978 he ended a lecture with the words: 'You see, I look at my paintings, speculate about them.

They baffle me, too. That's all I'm painting for.' Since then, the work his earlier champions found hateful has found admirers around the world as a model of art stripped of all aesthetic aspirations, particularly its modern claim to be sublime.

Gutfreund, Otto (1889–1927) Czech sculptor, trained in Prague and under *Bourdelle in Paris during 1909–10. He was one of the first artists to attempt to make *Cubist sculpture, responding to what he saw of the movement in Paris and subsequently in Prague exhibitions. There he was a member of a group seeking to combine Cubist formal methods with *Expressionist rhetoric and themes: his bronze figure of *Anxiety* (1911) is faceted but also marked by a *Munch-like directness of pose and dramatised expression. He also made portrait busts and reliefs that imply the influence of *Boccioni, and free-standing figures in which slender forms embrace space as a constituent of the sculpture. During the war he worked predominantly with scraps of wood, constructing them into still lifes and a *Seated Woman* (1916). Such works mark him out as the leading *Modernist sculptor in Eastern Europe. In the 1920s he turned to a more *naturalistic and popular idiom, incorporating elements of folk art. He died by suicide. Some of his best sculptures, including those named above, are in the National Gallery in Prague. He is also well represented in the National Collection of Czech Modern Sculpture in Zbraslav.

Guthrie, James (1859–1930) British painter, one of the early *Glasgow Boys, and painter of urban and rural scenes that comment on ordinary life in *naturalistic manner of the *Barbizon School and,

after a visit to Paris in 1882, of *Bastien-Lepage. His later work was primarily society portraiture. He was knighted in 1903.

Guttuso, Renato (1911–87) Italian painter from Sicily, first trained in law. He started painting in 1931 and in 1933 moved to Rome. He used his art to protest against Fascism and all oppression, and to make Communist statements on Italian issues. This meant working in a dramatic but more or less *realistic manner, but his base in a wide understanding of art history prevented him from opting for an idealizing *Social Realist style. Instead his work is marked by references to art, and is generally energetic and incisive. In 1940 he secretly joined the Italian Communist party. In 1941 he painted a *Crucifixion* which drew fierce criticism from the government and the Church because of its anti-Fascist message, and in 1943 he left Rome for a while. He returned in 1944 and joined the resistance. He was elected a councillor for his native town of Bagheria in 1973, and a senator in 1976. In 1977 there was a large retrospective in Cologne.

Guys, Constantin (1805–92) French graphic artist. He fought in the Greek War of Independence and reported on the Crimean War but is known principally for his portrayal of Paris society. His drawings and watercolours combine a light and elegant touch with a degree of *realism that impressed contemporary artists and won the approval of Thackeray and of *Baudelaire who found in his work the focus on contemporary urban life he promoted as essentially modern. Guys did not flourish, however, and died in poverty.

Haacke, Hans (1936–) German artist, born in Cologne, who became known in the 1960s as the creator of kinetic sculptural works exploring the actions of fluids and air, and subsequently the life of animals. From 1965 on he has lived mainly in New York but has also worked and taught in Germany. Since 1970 his work has focused on socio-political issues as revealed in art institutions. Like an investigative journalist he has researched various aspects of art collecting and presenting to create installations which exhibit his findings without verbal polemics. Oustanding examples have been his listing, on seven panels, of the Trustees of the Guggenheim Museum, New York, and their corporate affiliations and, also in 1974, his presentation, in 10 panels, of the previous owners of *Manet's Bunch of Asparagus* in the Wallraf-Richartz Museum, Cologne. Because of the political and economic implications of this data, the work, commissioned by the museum for its 'Project 74' exhibition, advertised as 'Art remains Art', was refused by it and was shown at the appointed time in the Maenz Gallery in Cologne. His 1992 solo show in New York (John Weber Gallery) was titled 'The Vision Thing', words used by President Bush to refer to his plans for the future, and consisted of works criticizing Bush's policies and their social effect.

Habsburg or **Hapsburg** The complex fortunes of this imperial dynasty, which takes its name from Habsburg or Habichtsburg ('Hawk Castle') in the Swiss canton of Aargau, the seat of its founder, Count Albert, in the 12th century, are indistinguishable from the history of Europe. Through conquest in German, Austrian and Bohemian lands, and by dynastic marriages in the Netherlands, the Iberian peninsula, Italy and Eastern Europe, they ruled vast swathes of the continent until 1918. This entry can only touch on some of the highlights of their art patronage, focusing on its most distinguished phases from the accession of Maximilian I as 'Holy Roman Emperor of the German Nation' in 1493 to the death in 1633 of the Archduchess and Infanta of Spain, Isabella Clara Eugenia, ruler of Belgium with her husband and cousin, Maximilian's great-great-grandson Archduke Albert (*d.*1621). A postscript is provided by the collecting activities of Archduke Leopold William (*d.*1656).

Almost all of Maximilian I's artistic patronage was through the printing press, and he employed the most famous German draftsmen and printmakers, his court painter *Dürer, *Burgkmair, *Altdorfer, *Huber, *Cranach, *Baldung Grien, and *Breu to make marginal drawings in his Prayer-Book, and to design the woodcuts (*see under* relief prints) of the *Triumphal Arch* and *Triumphal Procession*. Dürer's woodcut portrait of the Emperor has remained famous, and was copied by *Lucas van Leyden among others.

Through Maximilian's marriage with Mary of Burgundy, his grandson, Charles V (*d.*1558), inherited the vast artistic riches of Flanders and Burgundy. Through his mother, Joanna the Mad, he inherited the kingdom of Spain. He became Holy Roman Emperor at 19 and master of Italy at 30. Ensuring the election of his younger brother Ferdinand (*d.*1564) as king of Hungary, of Bohemia – effectively heir to the empire in Germany and Austria – he himself took up residence in Spain. Although his youthful portraits had been painted by various Flemish and German artists, notably *Orley and *Cranach, he discovered *Titian at the court of the *Gonzaga in Mantua, and enlisted him as his court painter; some years later Leone *Leoni became his court sculptor. Both continued to be employed by his son, Philip II, King of Spain (*d.*1598), although Titian never left his beloved Venice for Spain. Philip also imported younger artists: El *Greco, whose work did not, however, please; and, for the decorations of his new palace, the Escorial, Federico *Zuccaro and

*Tibaldi. The Netherlander, Anthonis *Mor, left Spain rapidly, fearing the Inquisition; his portraits remained in Philip's collection, which was enriched also by 15th- and 16th-century Netherlandish paintings, notably the works of *Bosch and *Patenier. Philip II's grandson, Philip IV (d.1665), heir to these rich and cosmopolitan royal collections, was to welcome *Rubens, but employed as his court artist the greatest native Spanish painter, *Velázquez.

At Charles V's death in 1558 his brother Ferdinand had refused to relinquish the Empire in favour of his Spanish nephew Philip II, thus ensuring the permanent rupture between the Spanish and the Central European branches of the dynasty. It was Ferdinand, ruling from Vienna, who discovered the curious Milanese painter *Arcimboldo, one of the favourite artists of Ferdinand's son and successor, the Emperor Maximilian II (d.1576). An eclectic lover of the arts, Maximilian fruitlessly attempted to lure to Vienna the great sculptor Giovanni *Bologna employed in Florence by the Emperor's son-in-law, the Grand-Duke Francesco de' *Medici. Forbidden to leave, Giambologna nonetheless enriched Austria and Bohemia with duplicates of his sculptures and designs; he also recommended the painter Bartolomeus *Spranger to the Emperor. Scarcely did Spranger reach Vienna, however, when Maximilian died; fortunately for the artist, his son, Rudolf II, was to prove the greatest aesthete and collector of the whole family. He moved his capital from Vienna to Prague, surrounding himself not only with works of art and artists but also with scientists, such as the great Danish astronomer Tycho Brahe and his successor at court Johannes Kepler. Spranger, now court artist, summoned other Italianate northerners to assist him: the sculptor Adriaen de *Vries; the painter Hans von *Aachen. Combining his interests in art and science, the Emperor attracted Netherlandish painters of nature: Georg *Hoefnagel, Roelandt *Savery, Jan 'Velvet' *Brueghel.

In 1612, Rudolf II, increasingly eccentric, was deposed, dying ten months later; in 1648 Prague was sacked by Swedish troops and his great collections were pillaged and scattered. A new and less fantastical art, however, throve in the newly-formed archducal court of Brussels, under the patronage of Rudolf's youngest brother, Albert, and his wife Isabella, daughter of Philip II of Spain. Having at last achieved peace in the Netherlands with the truce of 1609, the Archdukes were intent on restoring the lost prosperity and artistic splendour of the old Burgundian court. Their chief agent in this task, appointed court artist with the special dispensation to live not at Brussels but in Antwerp, was the great *Rubens, heir to virtually the whole pageant of Habsburg artistic patronage traced here, and much more besides.

One of Isabella's successors, governor-general of the Spanish Netherlands from 1647 until 1656, Rudolf II's second cousin Archduke Leopold William became one of the great princely collectors of the 17th century. His collections, now dispersed, were immortalized in paintings by his court artist and curator, David *Teniers the Younger.

Hackaert, Jan (c.1629–85 or later) Italianate Dutch landscape painter, influenced by Jan *Both. He travelled in Switzerland and Italy in the 1650s. His best work, formerly identified as Lake Trasimeno, but now known to be *The Lake of Zurich* (Amsterdam, Rijksmuseum) evokes space and atmosphere through a subtle treatment of light and shade – evident also in his paintings of light-dappled woodland scenes.

Hackert, Jacob Philipp (1737–1807) German landscape and portrait painter, the best-known of a large family of artists, which included his brother **Johann Gottlieb Hackert** (1744–73). Initially taught by his father, Jacob Philipp entered the Berlin Royal *Academy in 1754, where he first studied the *classicizing landscapes of *Claude and other 17th-century artists. He visited Sweden and Paris in 1764, Rome and Naples in 1768 and 1770. From 1782 to 1799 he lived in Naples, where he became court painter to King Ferdinand IV and, in 1787, met *Goethe who wrote his

biography in 1811. After the fall of the Bourbon Kingdom of Naples he settled in Careggio near Florence. He specialized in *idealized views of famous sites, eagerly sought after by foreign visitors (Hamburg, Kunsthalle; Shropshire, Attingham Park).

Haen, David de *See under* Baburen.

Hagenau, Nicholas von *See* Hagnower, Nikolaus or Niclas.

Hagnower, Nikolaus or **Niclas** (*c*.1445– after 1526) Leading sculptor in Strasbourg. He is known principally for the (undocumented) wood sculpture of the Isenheim altar (Colmar, Musée, *c*.1500–15; *see also* Grünewald), executed in his characteristically coarse, assertive style. He was probably the father of **Friedrich Hagenauer**, a Strasbourg-trained sculptor who became the greatest of the portrait medallists of the 1520s.

Hague School Informal group and succession of Dutch landscape painters centred on The Hague, discernible from the 1850s, prominent as a major development in European painting in the 1870s, and soon after challenged by the Dutch response to *Impressionism and *Symbolism which centred on Amsterdam, but active and reputable on into the 1910s. The work of this school is typically traditional in subject-matter, looking back to Dutch 17th-century painting, and abreast of the new French painting of landscape and rural life as seen in the *Barbizon School. Particularly characteristic of the Hague School work is its regard for 'truth' not in terms of detailed reportage but as a sensitive response to atmosphere through tonality and subdued colours as well as an element of personal, poetic involvement revealed as much in the handling of the medium as in the choice of subject. Jozef *Israëls was seen as the father of the school, though much of his work was portraiture; among other leading figures were Anton Mauve (1838–88) and the *Maris brothers, Jacob (1837–99), Matthijs (1839–1917) and Willem (1844–1910). Dutch and Belgian painting were closely linked, and the influence of the Hague School can be seen also in English and American painting in the last decades of the nineteenth century. Both Van *Gogh and *Mondrian admired and were indebted to aspects of the school's work.

Halley, Peter (1953–) American painter, born and working in New York, trained at Yale University and the University of New Orleans. His paintings are *abstract and wholly or predominantly geometrical and, in his recent work, appear to be layered with large, squarish forms painted over stripes and rectangles. These stripes turn out not to be continuous above and below those larger units. His colours, patiently applied, are chosen for their disharmony, and the fact that these forms can be of differing textures, and in fact are achieved by means of contrasting commercial paint media, makes alogical and paradoxical compositions that at first glance seem quite straightforward. Thus Halley brings an almost subliminal confusion into a kind of painting traditionally associated with clarity. When possible, he articulates the walls on which they are shown with other, more reticent lines or patterns. Thus his exhibitions become *installations and his canvases can be seen as temporary intrusions into an already aestheticized interior.

Hals, Frans (1581/5–1666) Dutch portrait specialist, famous since the mid-19th century for his bravura handling of paint and his vigorous evocation of character.

Although probably born in Antwerp of Flemish parents, he was raised in Haarlem, studied there with Karl van *Mander, and remained in practice in the city throughout his life. With the exception of his first dated portrait (*Jacobus Zaffius*, 1611, Haarlem, Hals) his earliest known work consists of earthy *genre scenes (*Merry Company* or *Shrove Tuesday Revellers*, *c*.1615–17; *Yonker Ramp and his Sweetheart*, 1623, New York, Metropolitan). Some of the vivid spontaneity achieved in his genre pictures was transferred by him to commissioned portraits (e.g. *The Laughing Cavalier*, 1634, London, Wallace). Between 1616 and 64, Hals painted nine life-size group portraits,

more than any other leading painter of the day (*Officers of the Haarlem Militia of St George*, 1616, *c*.1627, *c*.1639; *Officers of the Haarlem Militia of St Hadrian*, *c*.1627, *c*.1633; *Regents of St Elizabeth's Hospital*, *c*.1641; *Regents of the Old Men's Home*, *c*.1664; *Regentesses of the Old Men's Home*, *c*.1664; all in Haarlem, Hals; the so-called *Meagre Company*, 1633, finished by Pieter *Codde, 1637, Amsterdam, Rijksmuseum). He began the transformation of the group portrait from stilted assemblage of individual faces, like a class photograph, to the sweeping, unified *Baroque composition, brought to its apogee in *Rembrandt's *Night Watch*.

In the 1640s and 1650s he executed a number of companion pictures of husbands and wives (e.g. *Stephanus Geraerdts*, Antwerp, Museum; *Isabella Coymans*, Paris, p.c.; both *c*.1650–2) and some life-size family group portraits (e.g. London, National). His clientele now included civic leaders and professional men, theologians, university professors, his most illustrious sitter being Descartes (*c*.1649, Copenhagen, Museum). Despite his continuing success, Hals is documented as being in financial difficulties throughout his career. The legend that he was a drunkard and a wife-beater, however, rests on a case of mistaken identity in the documents of the period.

From the bright colours of the 1620s, Hals shifted to more monochromatic effects in the 1630s, the earlier blond tonality giving place to subtle distinctions between predominantly black hues, of which the painter Vincent van *Gogh was to write: 'Frans Hals had no fewer than 27 blacks'. In the same way, the boisterous mood of the early pictures was replaced after 1650 by austere and even tragic dignity.

Several of Hals's sons became painters: **Harmen Hals** (1611–69); **Frans Hals II** (1618–69); **Reynier Hals** (1627–71); **Claes Hals** (1628–50) whose work is sometimes confused with his father's. Frans's brother and pupil **Dirck Hals** (1591–1656), influenced primarily by *Buytewech, became a specialist of small-scale, elegant Merry Companies (e.g. Vienna, Akademie) and small pictures of one or two figures in an interior (e.g.

Philadelphia, Museum) anticipating the genre paintings of the next generation. In addition, Frans Hals was the teacher of Adriaen van *Ostade and Philips *Wouwerman, and the probable teacher of Judith *Leyster.

Hamen y León, Juan van der (1596–1631) Renowned painter of *still life active at the court of Madrid; he was also an able portraitist, and had an active career as a painter of religious subjects. Of noble descent, son of a half Spanish, half Flemish mother and a Flemish father who had emigrated from Brussels to Spain before 1586, Van der Hamen was himself a member of the Flemish royal Guard of Archers. His luxurious still lifes responded to the taste for Flemish art in Madrid (*see* e.g. Frans *Snyders). He arranged these motifs, however, on rectilinear stone ledges against a dark background developing from the manner evolved by *Sánchez Cotán. His subtle geometry is matched by his virtuoso depiction of the most varied surface textures and effects of light, and by an exquisite feel for colour patterns. There are works in Madrid, Prado; Washington National.

Hamilton, Gavin (1723–98) Scottish gentleman-painter, antiquary and art-dealer, resident mainly in Rome (1740s; 1756–98). A leading member of the *classicizing coterie around J. J. *Winckelmann, author of *Reflections on the Imitation of Greek Art in Painting and Sculpture*, he was, along with *Mengs, a precursor of *David and indeed a direct influence on the French artist. Unable to fulfil his ambition as a history (*see under* genres) painter in London, where, at the end of his training in Rome he painted a few portraits (*c*.1752), he returned to Italy and in the 1760s began his cycle of illustrations to the *Iliad*. Commissioned individually by different patrons, sometimes at the artist's insistence as part payment on works of art in which he traded, the *Poussinesque paintings were never hung together, but the effect of a cycle could be imagined through the engravings which Hamilton had executed and which made his reputation throughout Europe and as far as Russia. There are

paintings by Hamilton in Edinburgh, National; Glasgow, University; Rome, Borghese, and in a few private collections.

Hamilton, Richard (1922–) British painter, trained in art in evening classes and through advertising work, then at St Martin's School and the Royal College of Art, all in London. To this he added in 1940 a course in engineering drawing and further art study at the Slade School. In 1952–3 he taught design at the Central School of Arts and Crafts, and from 1953 until 1966 he was a lecturer in Fine Art at Durham University (later Newcastle University) where he and *Pasmore instituted a basic design course. He also taught through exhibitions: he presented Growth & Form in London 1951, and Man, Machine and Motion, Newcastle 1955. In 1955, with the artist John McHale and the architect John Voelcker, he created an environment for the This is Tomorrow exhibition in London; his collage *Just what is it that makes today's homes so different, so appealing?* (Tübingen, Kunsthalle), done for the poster, is a synthetic image of popular Anglo-American taste and aspirations. In 1952–5 he was a member of the Independent Group which met at London's Institute of Contemporary Arts to discuss questions of style and meaning in an age of popular mass-media taste.

In 1950 he had exhibited engravings. In 1955 he had his first one-man show of paintings done since 1950; in 1964 his second, of work done 1956–64. From this time on he exhibited frequently, attracting serious critical attention, patronage and demands for further exhibitions, but mostly from outside the UK. E.g. during 1967–70 he exhibited at Kassel, New York, Hamburg, Milan and Berlin. In 1970 the Tate Gallery, London, put on a large retrospective, shown also in Eindhoven and Bern. It presented a body of work dedicated to exploring style as a symbolic and synthetic language in art and in high-commercial and common advertising, to offering a discourse requiring intelligent attention, and to questioning the traditional distinction between high art and low-brow, popular imagery. His means include fragmentary citations juxtaposed to imply

conflict yet revealing consonances. 'I marvel that marks and shapes, simple or complex, have the capacity to enlarge consciousness, can allude back to an ever-widening history of mankind, can force emotional responses as well as aesthetic ones and permit both internal and external associations to germinate the imagination of the spectator' (1969). His attention focused as much on how marks could be made and their burden of tradition as to the visual idioms of his day; his art, with its datable references to the present, was understood by him as part of a long history. James Joyce's *Ulysses* was a major stimulus; *Duchamp became his particular master and in 1965–6 he organized for the Arts Council in London a great Duchamp exhibition which included his reconstruction of Duchamp's *Large Glass* (London, Tate). Hamilton's work is grouped with the *Pop artists', yet his range and sheer learnedness is foreign to them and his purpose has been neither to celebrate nor satirize contemporary iconography, but to use it as a starting point for an exploration of the functioning and values of art. In 1978 he was asked by the London National Gallery to present some of its paintings in the company of one of his own. In a short text, he associated himself especially with Jan van *Eyck and the 'crystallization of thought that gives us an instant awareness of life's meaning'.

He was a lucid exponent of his own work and guide to others', especially Duchamp and more recently Dieter *Roth with whom he collaborated on a number of occasions. His *Collected Words* were published in 1982. His major exhibitions since 1970 have included those in New York (1973), Berlin (1974), London (1975 and 1993) and Amsterdam (1976). In 1989 he had a one-man show within the São Paulo Bienal; in 1994 he represented Britain at the Venice Biennale.

Hanson, Duane (1925–) American sculptor whose highly *naturalistic figures, life-size in fibreglass and made as real as possible by means of glass eyes, hair, actual clothes and props, though relentlessly objective, took on an air of polemical *realism in their pursuit of the common American man and woman. This work,

begun about 1967, became known through solo shows from 1970 on and was received as part of the *Pop art movement.

Happening Term coined by *Kaprow in 1958 for his art event in the Reuben Gallery, New York, involving spectators in moving objects in the gallery. He wanted people to interact with things and situations so that all distinction between art and life would disappear. Action would spring from unplanned reaction to be art. The composer John Cage provided impetus and model, and some support came from knowledge of *Dada and *Surrealist events. Other artists soon presented Happenings, sometimes in collaboration with *Kaprow; before long they were put on in London, Paris, Amsterdam, Düsseldorf, Cologne, Berlin etc. Among artists prominent in the movement were *Dine, *Oldenburg, *Rauschenberg, *Beuys, *Kantor and *Vautier. The *Fluxus movement started as a German variation, and *Performance art emerged in the 1970s as a more consciously dramatic form.

Hard-Edge Painting A term introduced in America in 1958 to refer to *abstract painting that combined flat brushwork and firm contours, often with strong colours, and thus distanced itself from the expressive methods of *Abstract Expressionism. (An alternative term, preferred by some practitioners, was Abstract Classicism, but this did not achieve wide currency.) It thus referred to a wider range of art than *Post-Painterly Abstraction yet included some of the work promoted under that label, such as that of *Noland, alongside that of Ellsworth *Kelly and younger artists, some of them also becoming known as *Minimalists, such as *Mangold. Though such painters might have been thought to continue the tradition of the *American Abstract Artists, they considered their principles as well as methods distinct from this older group's; the work of some European painters of the post-Second World War period have also attracted the term, such as *Mortensen.

Hare, David (1917–) American sculptor and photographer. He studied

chemistry and taught himself art and photography, becoming known as a documentary photographer with a penchant for experiments linking him with the *Surrealists. In the 1940s he made his first sculpture, of wire and feathers. Soon he was using a variety of other materials, and a visit to Paris in 1958 gave added impulse to his technical and formal inventiveness. From 1946 on he exhibited frequently and his work has been included in exhibitions of modern American art in the USA and abroad. In 1969 he had a retrospective exhibition at the Philadelphia Museum of Art.

Haring, Keith (1958–90) American artist, born in Kutztown, Penn., trained at the School of Visual Arts, New York during 1978–9, but indebted primarily to the art of Walt Disney and of Andy *Warhol. Stimulated by the Disney characters his father drew for him in childhood, he himself started drawing cartoons at the age of ten. He rapidly developed his own characteristic idiom of unvaried lines and flat colour, testing them first in graffiti and semipublic work, full of humour and human sympathy but occasionally polemical in a good cause, and then entering the art world proper with solo and group exhibitions all around the world. His work comes in many forms and sizes, from lapel buttons and skate boards to murals and large steel sculptures, as well as the running Spectacolor Billboard in Times Square, New York (1982) and the body of the singer Grace Jones (1986). In 1997 a memorial retrospective exhibition was shown at the Whitney Museum, New York, while some of his sculptures were set up along Park Avenue. In developing his own set and code of characters, starting from Disney's Mickey Mouse and his own Andy Mouse, always combined with his personal, entertaining but also punchy idiom, Haring achieved an unprecedentedly broad base of public appreciation. He used this in support of humanistic campaigns (against drugs, AIDS, financial greed; for human wellbeing in many ordinary forms) as well as entertainment, and he considerd that art's purpose in the modern world should be that. He died of AIDS. His personal logo was a crawling

baby in a halo of light, the *Radiant Child*. His first public work included thousands of drawings he made during the early 1980s in New York's subway 'for the love of doing it and for the love of drawing and for the love of the people that were seeing it'. He added: 'I don't think that since then I've ever done anything as pure as that', but the effect of his work is to join people in affection for themselves and each other.

Harnett, William Michael (1848–92) American painter of still life, born in Ireland, much admired for his detailed *trompe l'œil pictures.

Harpignies, Henri (1819–1916) French landscape painter. His style was influenced both by his friend *Corot and by the work of the *Barbizon School. He exhibited regularly at the *Salon from 1853 on and was awarded gold medals at intervals. Whereas the *Impressionists worked with a broken surface, his landscapes present clear forms in solid paint that has a flattening effect. He was also made a Chevalier, then an Officier, and in 1901 a Commandeur de la Légion d'Honneur.

Harrison, Newton (1932–) American artist, teaching since the late 1960s at the University of California in San Diego and known for his projects and programmes for ecological survival systems and monumental entertainments. He intended to make art a vehicle for speaking of world problems and demonstrating the aesthetic value of solutions to practical issues. A recent scheme, with Helen Mayer Harrison, is *Devil's Gate Transformation* shown as a project in 1987, proposing 'through mural, model and discourse, the improvement of wildlife habitat, water percolation, recreational use, and flood control in the 175 acres behind Devil's Gate Dam, Pasadena.'

Hartigan, Grace (1922–) American painter who about 1950 became known as an *Abstract Expressionist, producing rich, warm paintings. Gradually she abandoned figuration and her work became wholly *abstract, varying from a heavily

dramatic to a lighter, more lyrical mode. She has had many solo exhibitions since her first in 1951 and has often been included in major exhibitions of modern American art.

Hartley, Marsden (1877–1943) American painter, born in Lewiston, Maine. At 13 he was making drawings of insects and flowers for a naturalist. In 1892 he began studying art, in Cleveland and New York. His first exhibition, at *Stieglitz's gallery in 1909, was of intensely *naturalistic paintings done in *Segantini's deliberate manner. In 1912 he went to Paris to study *Cubism and other new tendencies, but found the new art of Germany more congenial and in 1913 he showed in the First German Autumn Salon at the *Sturm Gallery in Berlin. He was painting semi-abstract compositions incorporating signs and symbols. In 1916 he returned to the USA, weary, he said, of Expressionist emotionalism, and made paintings composed of angular planes in clear colours. He spent the decade 1921–31 working in different places and idioms. He lived in Gloucester, MA, in 1931 but was soon in Mexico, then Germany, Bermuda and, in 1934, in Maine. There he made his home for the rest of his life and achieved his mature work, owing something in its gravity to *Ryder, to *primitivism, and to *Matisse's sophisticated simplifications. His colour became finer and more personal, especially in the landscapes, at once representational and charged with a visionary intensity but stated in economical, quiet terms. He was commemorated in 1944 in a retrospective in New York, since when his work has also become known in Europe.

Hartung, Hans (1904–) German-French painter, who studied art history, philosophy and art in Leipzig, Dresden and Munich and during 1927–35 travelled and lived in various parts of western Europe. In 1935 he left Germany for Paris where he again met *Kandinsky and became part of the *avant-garde. In 1939, when the war began, he was interned. For a time he was in the French Foreign Legion. When the Germans occupied France he escaped to Spain where he was again interned before rejoining the Legion

in North Africa. Fighting in France in 1944 he was seriously wounded and lost his right leg. In 1945 he returned to Paris and to painting. In 1946 he was naturalized French and was awarded the Croix de Guerre and the Légion d'Honneur. From this time on he painted passionately, developing the calligraphic marks in his pre-war drawings and watercolours into a monumental style, apparently impulsive but in fact carefully worked. He was a major figure in the *Art informel movement and in 1960 won the first prize for painting at the Venice Biennale.

Hassam, Childe (1859–1935) American painter, first a wood engraver, who, after periods in Europe, including three years in Paris, became the leading American *Impressionist.

hatching A technique used to build up the paint surface in quick-drying media such as egg tempera, and for shading in drawing, print-making and metal-engraving. It consists of fine lines laid close together in parallel, either following the outline or at an angle to it; when the lines intersect, the term 'cross-hatching' is used.

Hausmann, Raoul (1886–1971) German artist, born in Vienna. In 1900 moved to Berlin to study art. He began to write criticism for *Der *Sturm, Die Aktion* and other periodicals. During this time he met Arthur *Segal and Hans *Richter and, in 1918, Richard *Huelsenbeck. He became one of the most active of Berlin *Dadaists, was known as 'Dadasoph', the Dada thinker, organized Dada exhibitions and contributed to Dada events in Berlin, around Germany and in Prague. He founded the journal *Der Dada* in 1919 and was one of the creators of Berlin Great Dada Fair in 1920. He performed phonetic poems and displayed them in poster form; pictorially he worked mainly, and admirably, on satirical photomontages. He was a friend of *Schwitters and in 1923 presented with him a 'Merz-Matinée' in Hanover. In the 1920s and 30s he worked principally as photographer, but then, living in France during the Second World War, turned to painting *gouaches.

Hay, Jean *See* Moulins, Master of.

Haydon, Benjamin Robert (1786–1846) British painter, born in Plymouth, trained in the Royal *Academy Schools in London. He was seized with the conviction that it was his destiny to lead his nation's painters in the elevated business of *History painting. At first he seemed marked out for success. He saw a first commission, for *The Murder of Dentatus* (Mulgrave Castle, Yorkshire, pc), as his opportunity to change the direction of art, and his whole career, as painter, as teacher in his private school and, from 1832, as a lecturer, was led and ruined by this ambition. He was enchanted by the beauty of the 'Elgin marbles' – the Parthenon sculptures Lord Elgin had brought to London and which, partly thanks to Haydon's persuasion, the state bought in 1816 (London, British Museum) – but also had a *Hogarthian feeling for the fun and foibles of contemporary life. His History paintings, much laboured over, tend to be pompous; his *genre paintings of contemporary life are more vivid but lack the focus of a dominant idea: see, for example, *Punch, or May Day* (1929; London Tate Gallery). Charming and irate in turn, burdened by the duties of genius, Haydon made life difficult for himself professionally and failed financially. He tried to feed himself and his large family through accepting commissions for portraits, whereas his *Mock Election* (1827; London, Kensington Palace) was bought by the king. He spent some time in prison for debt; of this and of his life as artist his diaries and autobiography give a lively account. In 1843 he failed in the competition for murals for Parliament and in 1846 he committed suicide in despair.

Hayez, Francesco (1791–1882) Italian painter, born in Venice to a Franco-Italian couple. From the first his work combined a strong sense of colour with firm, *classical, drawing. He went to Rome on a scholarship and associated with *Canova. In 1812 he won a competition in Milan with his *Laokoön* (Milan, Brera). In 1820 a *History painting of his was acclaimed at the annual show in Milan and he moved to the city to benefit from the

business it brought his way. He was referred to as the 'Italian *Delacroix' but his work was marked by care and fullness rather than the Frenchman's fiery convictions and performance. His portraits show qualities of psychological insight as well as economy not found in his larger works.

Hayman, Francis (*c*.1708–76) English painter and engraver, one of the most versatile British artists in *genre if not in style (he was criticized for 'the large noses and shambling legs of his figures'). Having started out as a stage painter, he went on to paint monumental scenes on ceilings. As an engraver (*see under* intaglio) he illustrated Shakespeare, Congreve, Milton, Pope and Cervantes. *c*.1744–55 he painted religious narratives (*The Finding of Moses*, 1746, London, Foundling Hospital; *see also* Hogarth); illustrations to Shakespeare (*Wrestling Scene from As You Like It*, *c*.1744, London, Tate) and theatre pieces; *Fancy Pictures; scenes from popular life (*Sliding on the Ice, The Dance of the Milkmaids on Mayday*, London, V&A); sporting pictures; *Conversation Pieces (*Conversation in the Painter's Studio*, London, NPG) and portraits.

A pivotal figure in British art, he was associated with the influential French engraver *Gravelot, with *Hogarth (at the Vauxhall Gardens; in the Foundling Hospital; on a trip to Paris, when they were both imprisoned; in promoting the St Martin's Lane Academy), and with *Gainsborough, who was probably working with him and with Gravelot in the 1740s. Having been President of the Society of Artists, 1766–8, he seceded to become a founder member of the Royal *Academy, and, in 1771, its first Librarian.

Hayter, Stanley William (1901–88) British engraver, who turned to art in 1926 after studying chemistry. He settled in Paris and there in 1927 he opened a studio, Atelier 17, where he developed his own techniques and images while also providing a centre for the study of engraving processes. Many of Paris's leading artists worked there at some time (*Picasso, *Dalí, *Chagall etc.). During 1940–50 he worked in New York, but then returned to Paris

and reopened Atelier 17. His own work was mostly *abstract and explored line and its spatial connotations, and in his later years it included colour through a controlled use of inks. His scientific interests served his work as artist and helped him to achieve new effects.

Heade, Martin Johnson (1819–1904) American landscape painter, trained principally in England, France and, for two years, in Rome, absorbing a range of styles. He moved frequently in the USA before settling in New York in 1859, becoming a close friend of *Church. He made repeated visits to Central and South America, but his characteristic work was done while living in New York and making studies nearby. He painted the salt marshes of Rhode Island and Connecticut (e.g. *Salt Marsh Hay*, Youngstown, Ohio, Butler Institute), and spectacular seascapes. In 1883 he moved to Florida where he embarked on flower still lifes and a series of ambitious landscapes, but with that move he was lost sight of in the centres of art.

Heartfield, John (1891–1968) German artist, brother of the journalist and publisher Wieland Herzfelde. Born Helmut Herzfelde, he studied art in Munich and Berlin. He anglicized his name during the First World War. In 1918 he joined the German Communist Party. From 1915 on he had worked in Berlin with and close to *Grosz, making polemical images from photographic and drawn elements and also by means of *photomontages, often using specially made photographs. Much of this work was done for journals published by his brother, shortlived because of prosecution. He contributed to the Dada Fair of 1920 and during the following years worked for the Berlin theatres, notably for the productions of Piscator. During 1929–33 he made many photomontage caricatures for the *Arbeiter Illustrierte Zeitung* (Workers' Illustrated Paper), work he continued to do from Prague. In 1930 he visited Moscow and had an exhibition there; in 1937 he exhibited in Prague. During 1938–50 he lived in London, doing illustrations and book covers; for some months in 1940 he was

interned. In 1950 he returned to Germany, settling in Leipzig. He worked for theatrical companies, had a retrospective in the Deutsche Akademie der Künste in 1957 and was given a professorship there in 1960. Other exhibitions followed, in Germany and abroad. Herzfelde's book about him appeared in Dresden in 1962.

Heckel, Erich (1883–1970) German painter. Studying architecture in Dresden he met the three other young men who together in 1905 founded Die *Brücke group of artists. His work was usually more gentle than that of his friends and he early developed an interest in making woodcuts, sometimes after their paintings. Like theirs, his work developed under the influence of Van *Gogh and *Gauguin, and after the group moved to Berlin in 1911 assimilated some of the surface qualities of *Cubism. During the First World War he served as a medical orderly and was able to find time for painting. Landscape came to dominate his output, and this continued after the war when it lost much of its *Expressionist strength. The Nazis confiscated his work and exhibited some of it as *degenerate. After the war he was honoured as one of the leading *Modernists in German art. From 1949 to 1955 he taught at the academy of Karlsruhe.

Heda, Willem Claesz. (1599–1680) Dutch *still-life specialist active in Haarlem. Along with Pieter *Claesz., he is an originator of the tonal 'Breakfast Piece': a simple meal, painted more or less at eye level, usually in silvery tones. After 1640 Heda's compositions became larger and more decorative, introducing touches of colour and a more dramatic *chiaroscuro, and assuming a new vertical format (e.g. St Petersburg, Hermitage). The paintings of his son and pupil Gerrit (*c.*1620–before 1702) are so similar that they are often hard to distinguish, especially since both father and son usually signed simply 'Heda' (Amsterdam, Rijksmuseum).

Heem, Jan Davidsz. de (1606–83/4) Son of the Utrecht painter **David de Heem** (1570–1632), he was trained by Balthasar van der *Ast and became one of the greatest European *still-life specialists. During *c.*1625–9 he worked in Leiden, where his favourite theme was a *vanitas still life of scholarly books executed in subtle tones of grey and ochre. In 1636 he moved permanently to Antwerp. Here he developed the speciality which won him international fame: lavish displays of expensive foodstuffs and flowers and precious metal vessels and glassware. De Heem's 'Banquet Pieces' combine Flemish *Baroque exuberance and colouristic splendour with the compositional and tonal control of the modest Dutch 'Breakfast Pieces' (*see* Claesz. and Heda). His son, **Cornelis de Heem** (1631–95), followed in his footsteps, and his works were frequently copied in succeeding centuries (Amsterdam, Rijksmuseum; Edinburgh, National; London, National, Wallace; Paris, Louvre; etc.).

Heemskerck, Maerten van (1498–1574) Dutch painter and draftsman. A pupil or assistant of Van *Scorel 1527–9, he had already absorbed the latter's Italianate manner before his own trip to Rome, 1532–6. His sketch-books recording Roman views and antiquities became – and remain – a most valuable record (Berlin, Kupferstichkabinett), the drawings of ancient sculpture serving at various times as a source for engravings (*see under* intaglio) and the views providing our best information on, e.g. the appearance of the Capitoline Hill, or the history of the rebuilding of St Peter's, before the interventions of *Michelangelo.

Heemskerck's early paintings include vigorous portraits (e.g. Amsterdam, Rijksmuseum; Kassel, Kunstsammlungen; New York, Metropolitan) and the famous *St Luke Painting the Virgin*, dedicated to the Haarlem painters' guild before his departure for Rome in 1532 (now Haarlem, Hals). Upon his return from Italy he began also to paint mythological scenes (Prague, Nostiz Coll.; Vienna, Kunsthistorisches; Amsterdam, Rijksmuseum), altarpieces (now Linköping, cathedral; The Hague, Mauritshuis; Brussels, Musées) and more portraits (Rotterdam, Boijmans Van Beuningen; Amsterdam, Rijksmuseum). His *Self-Portrait with a view of the Colos-*

seum (1553, Cambridge, Fitzwilliam) is unparalleled in its dramatic impact.

Although deeply affected by Michelangelo, Heemskerck seems to have been more directly influenced by younger artists such as *Pontormo, *Salviati and *Giulio Romano. Having settled in Haarlem, he left the city only once, during the Spanish siege of 1572, when he went to Amsterdam. In 1540 he became dean of the Haarlem painters' guild. Engravings after his paintings as well as his many drawings influenced many northern European artists.

Heintz, Joseph the Elder (1564–1609) Swiss-born architect and painter. After a period in Italy, he entered the service of the Emperor Rudolf II as artist, architect and art-buyer; he was active throughout the *Habsburg lands in Central Europe, and died in Prague. His brother **Daniel** and sons **Ferdinand** and **Joseph Heintz the Younger** (recorded 1600–after 1678) were also artists; the latter arrived in Venice by 1625 and remained there probably until his death, painting lively scenes of Venetian festivals (Correr) as well as religious pictures for churches (S. Antonino; S. Sofia; S. Fantino).

Heizer, Michael (1944–) American sculptor, son of a geologist and a leading figure in Land Art on account of his monumental *earthworks in the Nevada Desert (*Nevada Depression*, 1968) and elsewhere in the American south-west. Using also concrete and other materials he has worked on a vast scale, as well as making smaller works, capable of being exhibited and sold.

Held, Al (1928–) American painter, trained in New York and Paris. He adopted the *Abstract Expressionist idiom of *Pollock but sought to clarify it until, in the 1960s, he turned to an entirely controlled and soon geometrical form of painting, often large-scale and markedly outgoing. Some of this work is in black and white, some in bright colours, in either case suggesting lively typographical methods pursued on the scale of architecture. The Empire State Plaza in Albany, N.Y. has a 30-metre long mural by him, done in 1971.

Hélion, Jean (1904–87) French painter, trained as engineer but drawn into painting by contact with Paris artists working in the late 1920s. He co-signed Van *Doesburg's *Concrete Art manifesto in 1930 and joined the *Abstraction-Création group in 1932. He visited Britain and America but returned to France in 1940 to join the army. He spent some time in a German labour camp, and when peace and freedom returned developed a figurative idiom out of the curved planes he had been composing earlier. Populist in character, and owing something to the example of *Léger, his work has an un-Légerlike quality of irony, apparently mocking its own rather heroic tones.

Helst, Bartholomeus van der (1613–70) Dutch portraitist, born in Haarlem, established in Amsterdam from *c*.1627. He replaced *Rembrandt as the city's leading portrait painter in the mid-1640s, catering to the governing classes with brightly coloured portraits influenced by *Van Dyck. He continued to be admired throughout the 18th century, and his group portrait of *Captain Bicker's Company* (Amsterdam, Rijksmuseum) was praised by *Reynolds above Rembrandt's *Nightwatch*. Other works are in The Hague, Maurits-huis; London, National, Wallace; Rotterdam, Boÿmans-Van Beuningen; etc.

Hemessen, Jan Sanders van (recorded from 1519 to 1564) Netherlandish painter active in Antwerp and Haarlem; he specialized in genre-like religious scenes, such as the *Prodigal Son* (Brussels, Musées Royaux) or *The Calling of Matthew* (Munich, Alte Pinakothek; Vienna, Kunsthistorisches), acted out by large, often half-length figures close to the picture plane. While some of these figures show Italian influence, others are *caricatures. His work is thus related both to *Metsys and to *Marinus van Reymerswaele; like the latter he painted many pictures of *St Jerome*. His daughter **Katharina** or **Catharina van Hemessen** (1527/8–after 1566?) is known mainly through a number of small signed portraits of both men and women (Brussels, Musées; London, National); she is supposed to have

accompanied Mary of Hungary, Regent of the Netherlands, to Spain in 1566. Both Jan Sanders van Hemessen and Katharina have at times been identified as the *Brunswick Monogrammist.

Henri, Robert (1865–1929) American painter, born Robert Henry Cozad. He studied art in Philadelphia and in Paris where he lived 1888–91 and was impressed by the work of *Manet. He encouraged a group of artists in Philadelphia to adopt *Impressionism but subsequently turned rather to the darker manner of Manet and of Frans *Hals, and drew attention also to the work of his local predecessor, *Eakins. He spent 1895–1900 mostly in Europe, and then settled in New York, teaching at the School of Art and encouraging his Philadelphia friends who joined him in New York to dedicate their art to representing the urban life around them in truthful, unpolished terms. These brought them all into conflict with the art establishment, and in 1908 he put on the exhibition The *Eight to show his and his friends' work in the company of work by other unconventional painters. The following year he opened his own school. In 1910 he organized a second exhibition, including The Eight and many others, and scored with it a major popular success. After 1910 much of his work was in the form of vivid portraits, and gradually it became more colourful. He was no theorist, and taught a sympathetic regard for humanity; art must penetrate the seen to reveal the nature of mankind. His book, *The Art Spirit* (1923) is a collection of his letters, lectures and sayings.

Hepworth, Barbara (1903–75) British sculptor, born at Wakefield in Yorkshire and trained in Leeds and London. A scholarship took her to Italy for 1921–4, where she married the sculptor John Skeaping. They returned to London in 1926 and in 1927 had a joint studio exhibition; in 1928 they showed together with a third artist. These events brought a valuable circle of admirers and patrons. Hepworth's work had qualities of elision and rhythmical development of form. In 1931 she met Ben *Nicholson whom she later married, joined the

Seven and Five Society and made an *abstract sculpture pierced horizontally by a hole or tunnel: its positive and negative form seem to have impressed *Moore who began making holes through his sculptures the next year. In 1932 she and Nicholson exhibited together in London; their art, though quite diverse in many respects, developed in harmony and, though later they were to divorce, Nicholson always retained a high regard for her work. In 1932, 33 and 35 they visited Paris, meeting leading artists such as *Picasso, *Brancusi, *Mondrian and *Gabo. They joined *Abstraction-Création and in 1934 *Unit One in London. In 1936 Hepworth contributed to *Circle. Her sculpture in the 30s took on international traits such as geometrical abstraction, while continuing the organic mode of her earlier work. Many of her pieces place two or more forms in relation to each other, sometimes larger forms nestling smaller ones, so that it is not fanciful to see in them a reference to maternity: in 1929 she had had a son by Skeaping; in 1934 she had triplets.

In 1939 she and Nicholson moved to St Ives in Cornwall and were joined there by Gabo. She had begun to use wood a few years earlier; in St Ives she used it more frequently, at times with string to create visual tensions against curved masses, and she introduced colour in response to the light of her seaside home. Landscape sensations were now embodied in her work, also an elegiac note reflecting the ancient stones of Cornwall and perhaps the context of world conflict. In 1943 a retrospective of her work was shown in Leeds; in 1950 her work was shown at the Venice Biennale; in 1953 she won second prize in the international competition for a sculpture to commemorate the Unknown Political Prisoner (*see under* Butler). Commissions for public sculpture came to her in 1950 (for the 1951 Festival of Britain) and thereafter, and 1956 saw a particularly successful exhibition in London. In 1959 she was awarded the first international prize at the São Paulo Bienal. She was now also modelling sculpture for casting in bronze and sometimes bending sheet metal. By the early 60s she was an international star, receiving academic and national honours and exhibiting

around the world. Some of her pieces were now of a superhuman size yet they rarely lacked human connotations and, when carved, sympathy for the material. In the 60s some of her pieces were again geometrical and some were constructed but generally her work continued and developed the organic and rhythmical character of her most personal creations.

In 1965 she was made Dame of the British Empire. After her accidental death her studio and garden in St Ives were made into a Hepworth museum. Examples of her work can also be seen in many civic and national museums, including the Tate Gallery where she had a major retrospective in 1968.

Herbin, Auguste (1862–1960) French painter, trained in Lille and Paris, who under *Cubist influence developed an *abstract and symbolical idiom for paintings and polychrome wood relief constructions. He was a founder member of *Abstraction-Création and maintained his geometrical abstract work with a persistence rare in his generation, backed by a theoretical system which he set out in a book of 1949.

Hering, Loy (c.1484–c.1555) German sculptor, apprenticed in Augsburg; in 1513, after a visit to northern Italy, he returned to near-by Eichstätt. He created monumental ecclesiastical stone sculptures (Augsburg, St Georg, *Redeemer*), and, around 1520, two richly ornamental bishops' tombs (Eichstätt, cathedral; Bamberg, cathedral). He turned also to small-scale works for collectors, a genre in which he excelled (stone reliefs, London, V&A; Berlin, Staatliche; a bronze statuette of *Venus*, Moscow, Museum of Fine Art). Many of his designs, both religious and secular, were based on prints by *Dürer; a relief-statuette of *Adam and Eve* (London, V&A) adapts a woodcut (*see under* relief prints) by *Baldung. His prolific workshop exported works as far as Vienna and Carinthia.

Herkomer, Hubert (1849–1914) German-born British painter, a succssful illustrator who became known as a painter of scenes of social distress (e.g. *Hard Times*,

1885, Manchester CAG; *On Strike*, 1891, London, Royal Academy). He was hyperactive, running his own art school, composing Wagnerian music; he drove a car and worked as designer for early films, promoted socialism and Welsh nationalism and wrote an autobiography.

Herman, Josef (1911–2000) Polish-British painter, born and trained in Warsaw, who came to England in 1940. From 1944 to 55 he lived in a Welsh mining village and painted its life and people. His paintings are mostly in low colours and weighty in form and subject. 'Form must be decisive', he wrote in 1979, 'its solidity and its stability is to establish the emotional energies at work in each picture.' In a country without a school of *Social Realism, his work stands out for its images of workers but its mode is poetic rather than *realistic.

Hermaphrodite An antique marble statue of the reclining Hermaphrodite – the mythical offspring, half male, half female, of Hermes and Aphrodite (Mercury and Venus). Seen from the back, it has the graceful appearance of a nymph; the male genitalia are visible from the front. Several antique versions of the *Hermaphrodite* are now known, but the most celebrated was found early in the 17th century and entered the Borghese collection; like the *Borghese Warrior* it was purchased by Napoleon, brother-in-law of Prince Camillo Borghese, in 1807 and is now in the Louvre in Paris. It was replaced in the Villa Borghese by another version. The prime version was one of the most admired statues in the Borghese collection in the 17th and 18th centuries, although its more scandalous feature was often suppressed in copies and adaptations – it inspired, for example, *Canova's *Nymph*. Other copies were not so reticent – in the mid-18th century Lady Townshend is reported to have said of one that it was 'the only happy couple she ever saw'. The pneumatic *illusionistic mattress of the Louvre *Hermaphrodite* was added in 1620 by *Bernini, and has been much admired in its own right.

Heron, Patrick (1920–) British painter. During 1947–50 he wrote art

criticism for the London *New Statesman*, and during 1955–8 for New York *Arts*. His painting derived from *Cubism and became *abstract though charged with nature's light and space in the mid 1950s. In 1956 he settled in a house overlooking the sea near *St Ives. Colour, in soft bands – which may have influenced American *Abstract Expressionism – and then in firmer fields and islands, became his theme. Nature, especially his immediate environment, was his chief stimulus though the work was abstract. Size and internal scale, the tensed placing and quality of colour areas, their sharp or smudged edges, such elements provided him with all the variables he needed. Solo exhibitions and contributions to mixed shows have established him internationally. 'Painting has still a continent to explore, in the direction of colour (and in no other direction)', he wrote in 1962. An early admirer and champion of the Abstract Expressionists, he has insisted that developments in British abstract colour painting, notably his own, were parallel to, and in some respects anticipated, their work.

Herrera, Francisco the Elder (*c*.1590–1657) and his son **Francisco the Younger** (1622–85) Spanish painters, active in Seville and Madrid; Francisco the Younger also practised as an architect. Unusually for a Spaniard, Francisco the Elder also worked as an engraver (*see under* intaglio), a miniaturist and a draftsman with the pen. A pupil of *Pacheco, he worked in Seville *c*.1610–*c*.40, at first in a derivative *Mannerist style (e.g. *Pentecost*, 1617, Toledo, Museo). Under the influence mainly of *Roelas, he began to apply pigment more freely, finally arriving at a boldly dramatic colouristic manner in the mid-1630s (e.g. Rouen, Musée; Bilbao, Museum; Paris, Louvre). Around 1640 he settled in Madrid (e.g. Lazaro Galdiano). His liquid brushwork foreshadows the 'vaporous style' of *Murillo.

Francisco Herrera the Younger studied architecture and painting in Rome, and *still-life painting in Naples. Returning to Seville at about the time of his father's death, he was named co-president with Murillo of the new *Academy of Painting,

leaving almost immediately, however, for Madrid. He was appointed court painter in 1672, but worked almost exclusively as an architect from 1679. His sketchy technique and luminous colours anticipate the *Rococo (e.g. Madrid, Prado; Seville, cathedral).

Hesse, Eva (1936–70) American sculptor, born in Hamburg (Germany) and brought to New York in 1939. She studied art in New York and at Yale University, and had her first solo exhibition in 1963. She made sculpture out of many materials, rubber, latex, fibreglass, string, etc., creating sequences and groups of forms of remarkable delicacy yet disturbingly evocative. After the bold, impersonal forms of *Minimalism, she represented a return to intensely personal poetry. Shortly before her death she said: 'Absurdity is the key word. It has to do with contradictions and oppositions.' She exhibited frequently. In 1972 a retrospective exhibition was shown in New York and four other US centres; in 1979 another was in London, Otterlo and Hanover.

Hesselius, Gustavus (1682–1755) and his son **John** (1728–78) Colonial American portrait painters. Gustavus Hesselius, born in Sweden, studied in England and went to America in 1712; he was active chiefly in Philadelphia, where in 1735 he executed his best-known works, the earliest representations of American Indians as named individuals: the Delaware chiefs *Lapowinsa* and *Tishcohan* (Philadelphia, Historical Soc. of Penn.) John Hesselius settled in Annapolis, Maryland in 1763, where he was the first teacher of Charles Willson *Peale (*Charles Calvert and his slave*, 1761, Baltimore, Museum).

Heyden, Jan van der (1637–1712) The first Dutch artist to devote himself almost exclusively to townscape. Mainly active in Amsterdam, he painted over 100 identifiable views of towns in Holland, and of Brussels and Cologne, as well as architectural fantasies, some *still lifes and landscapes. His illustrated work on the fire-hose, which he is said to have invented, was published in Amsterdam in 1690. There

are paintings by him in most important European galleries including London, National, and in Washington, National.

Hicks, Edward (1780–1849) American naïve painter, author of the famous composition of *The Peaceable Kingdom*, which he produced in some 100 versions, all loosely derived from an English engraving illustrating the Old Testament prophecy of Isaiah, ch. 11. He was a coach and sign painter by trade, and a Quaker minister; in some of his versions of *The Peaceable Kingdom* he introduced a vignette of his Quaker ancestor, William Penn, making his famous treaty with the Indians (New York, MoMA).

Highmore, Joseph (1692–1780) English painter, older contemporary of *Hogarth. He was among the earliest artists in Britain to illustrate literary themes (Richardson's *Pamela*, London, Tate, V&A; Cambridge, Fitzwilliam; Melbourne Hall), to paint religious history paintings (*see under* genres) (London, Foundling Hospital) and portraits of personality more than of status, including a splendid *Conversation Piece on the scale of life, Mr Oldham and his friends* (London, Tate).

Hildebrand, Adolf von (1847–1921) German sculptor, son of an eminent liberal economist who had to leave Germany for Switzerland with his family after the 1848 revolutions. Hildebrand grew up in Bern where plaster casts of ancient sculptures, in the University, determined his career. He studied in Nuremberg and Munich and went to Rome in 1867. There he became a close associate of Conrad Fiedler, the critic and philosopher, and of *Marées with whom he was to collaborate on several commissions. Their influence on him was profound, as was that of Italy and its art. He showed works in the Vienna World Fair of 1873 and in Berlin in 1884, on both occasions meeting with high praise, but he lived mainly in the south. In 1873 he worked with Marées in Naples. The following year he purchased some monastic buildings outside Florence, converting them into his home and work place; Marées lived with him there for a time. In 1889 Hildebrand

won the first prize in a competition for a monument to Wilhelm I to be erected in Berlin but the Emperor vetoed its execution. His first major commission was therefore that for the Wittelsbach Fountain in Munich, 1891–4, a careful but effective composition of basins, sculptures and water that led to further commissions and wide recognition. He worked busily on tombs and other monuments, fountains and also single figures. What characterized his work was his passion for clarified form, involving an appearance of *classicism without any loss of *naturalism. Thus he presented a modern classicism, not based on the imitation of ancient prototypes but adopting what he considered to be the classical method, and also *Michelangelo's, of conceiving and creating three-dimensional works as though they were reliefs in several planes. He avoided sentimental rhetoric and dramatic gestures, and shunned *Rodin's expressive surfaces, fragmentary forms and transient poses. His work, apart from civic sculptures, is best seen in the public galleries of Berlin and Munich, but his very considerable influence, on art history and aesthetics as well as sculpture, stems from his book, begun as a tribute to Marées, *The Problem of Form* (1893; many subsequent editions). In this he argued for sculpture's need of perceptual clarification, and also stressed the truth of carving as against modelling's artificiality.

Hill, Anthony (1930–) British *Constructive artist, born and trained in London, who worked with *Pasmore and Kenneth and Mary *Martin to develop a Constructive movement in England. He spent time in Paris where he met artists such as *Vantongerloo and *Picabia; he corresponded with *Duchamp, *Bill and *Biederman. From painting and collage, always *abstract, he moved into constructed reliefs (1954+) and free-standing screens (1965+). He had his first solo exhibition in London in 1958. His art related to mathematics rather than nature; his intimacy with mathematicians was significant. He studied proportional systems and symmetries and did research in topology, much of it published (1963+). Highly regarded in the world of international Constructive art,

he contributed to survey exhibitions and to conferences. In 1968 he edited *DATA*, a collection of essays by contemporary artists, architects and scientists. In 1973 he started a parallel line of production for which he adopted the name *REDO*, collages and reliefs in a *Dada spirit made up of printed ephemera. A major retrospective exhibition was shown in London in 1983.

Hill, Carl Frederick (1849–1911) Swedish landscape painter, who studied in the Stockholm Academy before going to France where *Corot, the *Barbizon painters and then also the *Impressionists influenced him. He was not willing to exhibit with these, however, hoping to win the approval of the *Salon juries with luminous pictures that at times come close to those of *Harpignies. Repeated rejections from the Salons brought out a tendency to depression in him which led on to madness at an early age, but he went on painting and drawing and allowed into his imagery elements of fantasy that give his later work additional interest.

Hiller, Susan (1942–) American-born British artist. Hiller turned to art from archeological field work, and after travels in Europe, India and the Far East. She settled in London and had the first of many solo exhibitions in 1973. She uses many media and often installations to explore the social and psychological undertow of imagery and other processes of communication. Her work has been described as 'a process of mapping: the mapping of the self, of cultural formations, of the boundaries between forms, of language itself' (John Roberts, 1984).

Hilliard, Nicholas (*c.*1547–1618/19) English goldsmith and miniature painter, the greatest visual artist at the court of Elizabeth I, whose portrait he painted several times from 1572 (London, NPG; other miniatures of the Queen, e.g. *The Drake Jewel*, 1575, pc; locket, after 1600, London, V&A). He combined ornamental virtuosity – it must be remembered that most of his miniatures were meant to be worn as jewels and were set accordingly – with psychological penetration. In his treatise on miniature painting, the *Arte of Limning*, *c.*1600, he wrote of striving to catch 'these lovely graces, witty smilings, and these stolen glances which suddenly, like lightning, pass and another countenance taketh place', extending his private portraits' emotional range through emblems such as flames, hearts, roses, etc. The refined, poetic yet trenchant imagery of his miniatures has been compared with the world of Shakespeare's earlier plays and sonnets. While his theory of art was Italianate, his practice related to the art of the French court, which he visited in 1576–8. Unlike his pupil and rival, Isaac *Oliver, he modelled his sitters' likenesses through delicate line and sunlit colours alone, without the use of shadows. Although some portraits of Elizabeth on the scale of life have at times been attributed to him, they are inferior to his miniatures. His son, **Lawrence Hilliard** (1582–after 1640) was also a miniature painter. Other works, Coll. H.M. the Queen; Greenwich, Maritime; New York, Metropolitan; Cambridge, Fitzwilliam; Oxford, Bodleian Library. *See also* Gower, George.

Hillier, Tristram (1905–83) British painter, born in Peking but educated in England and converted to painting while studying accountancy. He studied art in London and Paris and had a solo exhibition in Paris in 1929. In 1933 he was part of *Unit One, contributing to its exhibition and book. By this time he was under the influence of *Surrealism, and developing a semi-*abstract Surrealism redolent of sea and travel. After 1938 his work became more representational without losing its poetry.

Hilton, Roger (1911–75) British painter, trained in London and Paris. After the Second World War (during which he became a prisoner of war) he was one of the pioneers of *abstract art in the UK. Though he lived principally in London, he was associated with, and particularly influential within, the St Ives School. His was a lyrical, lively, sometimes strikingly rough kind of abstraction, incorporating suggestions of figures and landscape but primarily a deploying of colour in the form

of paint. He exhibited frequently, won a prize at the 1964 Venice Biennale and had a retrospective in London in 1973. By this time his health was poor but he still produced vivid work, now openly figurative and humorously brusque. He is seen as one of the most potent artists of his time, working in what often appeared a rough and impetuous manner, but with exceptional intelligence and clarity. His last years saw him producing many works on paper, vivid, inventive and often humorous.

Hirschfeld-Mack, Ludwig (1893–1965) German-Australian artist who studied in Munich, then in Stuttgart under *Hölzel, and at the *Bauhaus, where he developed a series of 'light performances' akin to *abstract films but using lights and screens within boxes. In 1926–7 he ran the Basic Course at the Dessau Bauhaus, then left to teach in other German schools. In 1938–40 he was in Britain where he was interned and sent to Australia. Released in 1942 he became art master at a Victoria school, introducing Bauhaus methods to the continent. He retired in 1957 to give more time to painting and developing his colour studies. He had solo exhibitions in Melbourne and a retrospective at the Art Gallery of New South Wales in 1974.

Hirst, Damien (1965–) British artist, trained as painter in Leeds before studying at Goldsmiths College, London, 1986–9. In 1988 he organized a show of his own and his friends' work under the title 'Freeze' and managed to get media attention for it; several of the young artists included in it have remained associated with him, but labels sometimes put on them, whether 'BritPack' or 'Young British Artists', implying a distinct group, are unhelpful shorthand for a loose association that changes with each occasion. He became a media star with the widely reported news that the collector Charles Saatchi had bought his *The Physical Impossibility of Death in the Mind of Someone Living* (1991): a tiger shark suspended in preserving fluid in a glass-and-steel case. This looked both shocking and fascinating in newsprint photographs, and it implied an elaborate process of planning, acquiring

and installing as well as the artist's bold pursuit of a big idea. Other creatures in tanks followed, notably the famous *Mother and Child Divided* (1993), consisting of a cow and a calf bisected lengthways, in four tanks placed so that we can walk between the two halves of each. *Some Comfort Gained from the Acceptance of the Inherent Lies in Everything* (1995) may be the last of the sequence. Here twelve chunks of two cows, cut transversely, are displayed in twelve tanks arranged in one line but shuffled so that the pieces do not add up as we look at them. Hirst also makes wall-mounted cabinet works which resemble the walls of pharmacies; one of them is called *Pharmacy* (1992), subsequently the name of a London restaurant Hirst ran for a while. He has been producing paintings of two sorts, circular ones made by dropping colours on to a spinning canvas and letting centrifugal force distribute them, and others, rectangular or partly rectangular, bearing neat colour spots and titled with pharmaceutical names of substances. They range in date from 1992 to 1996. An earlier piece, *A Thousand Years* (1991), is a two-room tank in which maggots feed on a cow's head before turning into flies and being slaughtered by an electric fly killer. Death and decay fascinate him, as these and many other works indicate, as well as his own statements. In 1997 his book, *I Want to Spend the Rest of My Life Everywhere, with Everyone, One to One, Always, Forever, Now* appeared to mixed reviews: at once serious and mocking, revealing and selective, it presents an artist intent on stardom but also a hard-working organizer of his life. His work calls for a variety of skills and knowledge, as well as technical facilities and support. The art world witnesses the development of a young art tycoon and cannot help wondering what he will do next. In 1995 he won the Turner Prize. His name and work are well known outside Britain now, he and his associates being seen as the spearhead of progressive British art. His work was prominent in the Royal Academy's 1997 exhibition 'Sensation', which critically was both promoted and pummelled by the media though mostly on account of others' contributions. In 1998 it was shown in Berlin, where it was well

received, but its 1999 showing in New York, at the Brooklyn Museum, was forcefully opposed by the Roman Catholic mayor of the city.

Hispano-Flemish style *See under* Dalmau, Luis.

History painting In Italian Renaissance art theory and later in the *academies of art, the highest and most demanding of the *genres or categories of painting. The English and French words 'history', 'histoire', are misleading: history painting is not necessarily the painting of historic scenes. The term derives from the Italian *istoria*, 'story', 'narrative', in contrast to *immagine*, *icon, a single timeless figure. The distinction must have originated in the decoration of churches, which has from earliest times included both iconic figures and narrative scenes. The latter, normally involving several figures in action and emotionally engaged, posed the greater artistic challenge. By 1435, when *Alberti, in his treatise *On Painting*, wrote that '*istoria* is the greatest task of the painter', he was influenced not only by current Florentine artistic practice, but also by ancient Graeco-Roman literary theory, which differentiates between various kinds of narrative. He identifies *istoria* with tragedy and epic poetry: the representation of the noble, the exemplary deeds and vicissitudes of personages 'better than ourselves' – figures from the bible and saints, but also pagan divinities and the heroes of ancient myth, and of more recent literary texts and historical events. *Allegory, when presented in narrative form, becomes *istoria*. According to ancient authors, the highest art aims to elevate the mores of the whole community, making *istoria* particularly suited to the decoration of public spaces: churches, town halls, princely palaces. History painting is thus an art of persuasion and education of the many; to this end it is preferably practised on the scale of life or larger (but *see* Poussin).

The history painter must employ intellect and imagination, thereby raising the artist above the craftsman. Like the poet and the orator, he should affect viewers'

hearts and minds. He must, like the modern film director, cast actors suited to their allotted roles within the story (*see* decorum), design for them telling poses, gestures and *expressions, select the most appropriate point of view. Perhaps every major development in Italian Renaissance art can be understood as a response to the challenge of history painting. *Giotto, in the Arena Chapel, Padua, *c.*1304–13, condensed the narrative to moments of greatest drama, focusing on the key actors, and inventing new scenes of pathos and suspense. Around 1427 *Masaccio used *perspective and *foreshortening to remove, optically, the barrier between the painted scenes and the viewer's own space (Florence, S. Maria del Carmine, Brancacci Chapel), ransacking the then-known repertory of ancient sculptures for expressive poses and gestures. In the next century, *Leonardo de Vinci deployed his even greater mastery of perspective, expression, light and shade in the *Last Supper* (Milan, S. Maria delle Grazie, ex-refectory). It remains the Christian history painting *par excellence*: a seemingly 'authentic record' of a unique event and, simultaneously, a cogent representation of that event's profound, universal, significance. The eloquence of the *nude in *Michelangelo's history paintings surpasses anything in ancient art: who, having once seen it, can forget his scene of God transmitting the spark of life to the recumbent Adam on the ceiling of the Sistine chapel? *Raphael, consistently transformed static motifs and dry allegory into compelling and poetic history painting (e.g. *Entombment of Christ*; Vatican, Stanza della Segnatura; *Sistine Madonna*), mastering an ever-broader range of visual effects. The same can be said of *Rubens in the 17th century (e.g. *Allegory of War and Peace*, '*Minerva protecting Peace from Mars'*).

The history of history painting, so deeply identified with western art itself, continued, but by the late 18th century the genre was devalued both through the increasingly vapid prescriptions of the academies and the semantic confusion between *istoria* and history. If Benjamin *West's *Death of General Wolfe*, 1771, just about succeeds in elevating, albeit tenden-

tiously, a historical event into a history painting, can the same be said of *Copley's *Watson and the Shark*, 1778, which records a horrific but ethically insignificant accident? While *David's *Oath of the Horatii*, 1784, revives the moral grandeur of 17th-century history painting, Delaroche's finicky costume-piece, *The Execution of Lady Jane Grey*, 1833, seems to belong to an altogether different, more sentimental and less elevated category: tragedy reduced to popular melodrama.

The 19th century saw the lower art forms usurping the status and the special attention reserved for the highest, while melodrama increasingly infected history painting when ambitious 19th-century painters attempted this elevated art form. As some degree of education became more accessible and the art public grew, the canon of subjects fit for history treatment increased too and the great models to which history painters had looked gradually lost their authority. Time-honoured historical events lost their agreed value, as anecdotes such as the one chosen by *Yeames for his costume drama *And When Did You Last See Your Father?* (1878; Liverpool, Walker), large in size, but small in content, came to be preferred. There are many examples of history painting being demeaned by routine production and by the loss of idealism that came with finding subjects in contemporary literature.

Conversely genre subjects could be given the weight of history painting to assert their moral value. When *Millet or *Daumier presented labourers as heroic figures in the manner of *Michelangelo, or *Courbet painted a large group portrait of his fellow citizens gathered for *A Burial at Ornans* (1850; Paris, Orsay), they were subverting established social values. The *academies became more liberal in countenancing genre, landscape and *still-life painting even while they insisted on giving pride of place to history painting. The first president of the Royal Academy, Joshua Reynolds, who was eager to make history painting the Academy's chief business, should have been pleased to see his successor, *Leighton, made a peer. Yet Leighton's work was widely criticized both as an anachronism and for its low intellectual

ceiling and poor drawing. Contemporaries, such as the *Pre-Raphaelites, had set new standards, charging their work, whether history or genre, with emotion and immediate relevance. Manet had been thought to mock great prototypes when he echoed *Raphael and *Giorgione in his *Déjeuner sur l'Herbe* (1853; Paris, Orsay), a modern-dress genre scene; later in the century Jean Béraud painted his *Mary Magdalen in the House of the Pharisee* (1891; Paris, pc) as a modern-dress drama with the heroine played by a famous prostitute and only Christ not in evening dress. This seemed as odd then as Stanley *Spencer's later picturing of biblical scenes as part of the life of his native Cookham. Both painters were intent on giving their religious subjects an immediacy that academic routines had diminished.

The 20th century seemed to take little interest in the entire matter of the genres and certainly ceased to give special status to history painting. Nonetheless, the forms of history painting endured as a resource to be drawn on when artists wanted to demonstrate the seriousness of their work, as when *Boccioni used a triptych format for his *States of Mind* genre scenes, and *Dix used it to denounce the horrors of war and of post-war urban society. *Picasso composed *Guernica* (1937; Madrid, Reina Sofia) like a triptych, making it an allegory using modern and traditional images and an unrealistic, partly *Cubist, partly *Expressionist idiom; we remember the bombing of Guernica because of the painting. An alternative was to turn to *abstract art to speak of grave matters while avoiding tired academic formulae. This is what *Malevich, *Kandinsky and *Mondrian did, and later *Rothko and *Newman. Meanwhile the Mexican muralists of the 1920s and after, notably *Rivera, used forms and methods derived from pre-Renaissance religious fresco painting to propagate socialist ideas; and the fascist regimes of Germany and Italy, in the 1930s and early 40s, adopted classical formulae in art and architecture to give themselves imperialist airs. Since then the forms and sometimes classical manner and subjects of history painting have been used by *Post-Modernist painters to

demonstrate the impossibility of progress and significance in art and their own ironic detachment from such issues.

Antique relief sculpture provided many basic lessons for history painting. Free standing sculpture often represented mythical and historical figures but could not readily present stories of any complexity, though *Bernini worked marvels in carving succinct religious and secular narratives. *Rodin took up the challenge, making multi-figure free-standing sculptures on historical subjects and loading his *Gates of Hell* with biblical and literary figures and events. Today few subjects remain that can evoke an interested understanding in western society and elevate its mores. An exception might be made for the *Nativity* of Christ: for good commercial reasons we are kept alert to its meaning. Meanwhile we look to film for our narratives, epic or comic, and have been taught to look at art for style and personality, not subject matter and deeper truths.

Hitchens, Ivon (1893–1979) British painter, born and trained in London. Influenced by *Braque, he developed his lyrical idiom in the 1930s. It emerged fully with his move into the Sussex countryside in 1940 when he was bombed out of his London home. His mature paintings are mostly landscapes, loose and liquid in technique to record nature's intervals and rhythms, not particular details, musical in effect rather than directly descriptive. A wide format, associated with seascapes but also used by *Turner for some of his landscapes, enabled him to set forms in quasi-sequential order, inviting us to read across the picture. He also painted eloquent nudes and flower pieces, but it is his poetic attachment to the countryside that identifies him as heir to the English *Romantic landscape tradition.

Hoare, William (*c.*1707–92) English portrait painter. He spent the years 1728–37 in Italy, although, unlike *Ramsay or *Reynolds, he was never able to reconcile British portraiture with the Italianate *Grand Manner. From 1739 he worked in Bath, where he was the leading portraitist in oils and pastels until the arrival of

*Gainsborough. His daughter **Mary Hoare** (*c.*1753–1820) worked in pastels.

Hobbema, Meyndert (1638–1709) Dutch landscape painter, the best-known pupil and follower of Jacob van *Ruisdael. His work is lighter in tonality and mood than that of his master, but also more repetitive in subject matter and treatment. A favourite motif is a water-mill in a woodland clearing. In 1668 Hobbema married the kitchen maid of an Amsterdam burgomaster and acquired the lucrative position of wine gauger to the Amsterdam octroi. After this he painted little. His best, and most famous picture, however, dates from as late as 1689: *The Avenue, Middelharnis* (London, National), has been called the swan-song of Dutch landscape painting.

Höch, Hannah (1889–1978) German artist, member of the Berlin *Dada group and especially close to *Hausmann. She began to make puppet figures and *collages in 1917, the latter now greatly admired for their formal chaos and sharp political content. The Nazis forced her to cease working.

Hockney, David (1937–) British painter, born in Bradford, Yorkshire, and trained there and at the Royal College of Art, London. He won its Gold Medal and other awards in 1961, quickly became famous as a leading figure in the *Pop art movement and had his first solo show, the first of many, in London in 1963. A retrospective was shown in London in 1970 and went on to Hanover and Rotterdam. In 1974 he had a prestigious solo exhibition in Paris. In 1961 he had visited New York and from early on his fame in America matched that in Europe. His lifestyle helped, as did his combination of humanity and worldly wisdom voiced in a permanent Bradford accent, his handling of hedonistic pleasures, especially in California (which became his preferred home), and also his passion for painting, drawing, print making and, more recently, photography. His talent as draftsman was patent from the beginning of the 1960s, when he produced book illustrations and fine individual etchings; his talent as painter showed first in epigram-

matic images made in a predominantly graphic style. By the mid 1960s he was handling large and delicately nuanced paint surfaces and in the 1980s his painting took on a semi-*Expressionist character incorporating qualities and devices from *Picasso. Portraits, interiors, exteriors, landscapes with and without figures: he produced in remarkable quantity and quality and he must be accounted one of the most successful artists of the century, exceptional also in that this success was gained with art that is usually cheerful and often cheeky and parodistic. His drawings and etchings are among the deftest of this century; posterity may well acclaim him the greatest of modern portraitists.

Hodges, William (1744–97) British landscape painter and draftsman, a pupil of Richard *Wilson and his most accomplished imitator. Not meeting with success in London, he joined Captain Cook's second voyage to the South Pacific as official landscape painter, 1772–5 (e.g. *Tahiti; The Monuments of Easter Island*, Greenwich, Maritime). From 1780 to 1784 he visited India, and in 1790 Russia. Hodges skilfully adapted Wilson's technique and rules of composition to exotic material, while maintaining an air of documentary fidelity.

Hodgkin, Howard (1932–) British painter born and trained in London, at the Camberwell School of Art and then at the Bath Academy of Art at Corsham. He taught at Corsham 1956–66, and then at Chelsea School of Art in London 1966–72. He exhibited paintings and prints frequently in London where his first solo show was in 1962, and from 1973 on also in New York. His work formed part of modern British painting exhibitions in Europe and America from 1964 on, and in Japan in 1982. He represented Britain in the 1984 Venice *Biennale, and this group of works went on to other centres in Europe and the USA. He has served as Trustee both of the Tate Gallery and the National Gallery in London, won the Tate Gallery's Turner Prize in 1985, and in 1992 was awarded a knighthood.

The particular qualities of his art elude

definition. His early paintings, until about 1975, feel close to *Pop art without drawing on Pop art's normal sources: they are more or less flat and bright in colour and pattern, they incorporate oblique representations of specific people and many of them feel humorous or epigrammatic. Their sources are in *Matisse and the *Intimism of *Bonnard and *Vuillard more than in contemporary art, also in Persian and especially in Indian miniature painting. He made the first of numerous visits to India in 1964, has formed a collection of Indian art and is regarded an expert in that field. Their joint influence can be seen in the frequent use of areas of bright pattern, and his inclusion of a painted border or frame, occasionally from 1962, frequently from about 1970 and, from the 1980s on quite regularly. These assert the presence of his paintings as coloured objects more than as descriptions of their named subjects. Most of them are quite small and, from 1970 on, usually on panel. They invite absorption from close to, when they can seem like toy stages; from any distance they glow like jewels.

Hodgkin paints very slowly, returning to a picture again and again to adjust its forms and colours, sometimes drastically. Since the mid-1970s his paintings have become more saturated in colour and more abstract, while his titles have indicated a greater range of subjects, including emotional states and private occasions, as well as particular cities and landscapes. They appear to be powered by recollections, which are partly censored in being represented and partly abstracted to emerge as pictorial equivalents of an experience. The gap between their specific titles and what we see has become wider, so that his paintings can hold one as puzzles though he asks viewers not to attempt to read their content. Some titles are more evocative than indicative, such as *When did We Go to Morocco?* (1988–93) and *Haven't We Met? Of Course We Have* (1994). Hodgkin's prints, often larger than his paintings, are occasions for exploring new technical means such as the addition of carborundum to pigments, and often refer to landscapes. In every work, sheer beauty appears to be the primary aim, and less humour

than in the earlier work. Each picture, however, has to have its individual character or quirk and calls for patient attention, with the result that large exhibitions, though valuable and newsworthy, tend to weaken their individual impact. An exhibition of his paintings since 1975 was organized by the Fort Worth Art Museum in Texas and was seen also in New York and Düsseldorf before coming to London in 1997. The Tate Gallery in London holds a representative selection of his paintings.

Hodler, Ferdinand (1853–1918) Swiss painter, born in Bern, son of a carpenter and stepson of a house-painter. From 1871 he lived in Geneva where he won first prize in painting competitions in 1874, 76 and 82. In 1890 he produced his first major work, *Night*. This large painting, excluded from an exhibition by the Geneva authorities in 1891, was shown nearby and attracted so much attention that he decided to show it in Paris where it was awarded a silver medal. His style had been *naturalistic; the new work depended on naturalism in its parts yet was imaginative in theme and composition, stressing the flatness or mural-like quality of the whole and offering itself as an epic visual poem. In 1897 it gained a gold medal at a Munich exhibition. He showed regularly in Paris, where in 1900 he won a gold medal with a companion work, *Day*. Until about 1910 his country found him too unconventional while France, Germany and Austria admired him as a major *Symbolist. From 1910 on commissions and honours were given him at home as well as abroad. During his last twenty years he partnered his public art with more evidently personal landscape painting, imbued with a sense of nature's light that associates it with *Impressionism. These are fine, exhilarating works, as are his powerful portraits, but his importance lies in his presenting historical and allegorical themes in firmly choreographed murals and clear, affecting terms that seem untouched by contemporary art yet show affinities to *Gauguin and *Matisse. The Kunstmuseum in Bern owns some of the finest of these works, including the two named. Through his friendship

with Emile Jacques-Dalcroze, Hodler influenced the development of modern dance.

Hoefnagel, Georg or **Joris** (1542–1600) Much-travelled and highly original artist, born in Antwerp, the pupil of the *gouache and watercolour specialist **Hans Bol** (1534–93). He was a book illuminator (Vienna, Kunsthistorisches) and a miniaturist, specializing in decorative but scientifically accurate flower and insect pictures (Lille, Musée). He also composed an *emblem book (1569). During 1561–7 he travelled throughout France and Spain; in 1569 he visited England; in all these countries he executed topographical views of cities. It is to him that we owe the best visual record of Henry VIII's vanished Nonsuch Palace. Hoefnagel also left behind him in England the first oil painting showing an English *genre scene (*Wedding at Horsleydown in Bermondsey*, Hatfield). In 1591 he entered the service of the Emperor Rudolph II in Prague, and died at the Imperial court in Vienna. Many of his works, including the views of cities, were engraved by his son, **Jacob Hoefnagel** (*b.*1575).

Hofer, Carl (1878–1956) German painter who studied in Rome and Paris and brought into his work Oriental qualities through visits to India in 1909 and 11. In 1918 he was appointed instructor at the Berlin College of Art. His post-war painting was pessimistic in character and dominated by a few figurative themes. In 1933 he was dismissed and his work was subsequently classified *degenerate; in 1945 he was made director of the college. He asserted his distance from the *Expressionists yet is classed as one because of the poetic character of his work, but he avoided their strong colours, distortions and *abstraction.

Hofmann, Hans (1880–1966) German-American painter, renowned as teacher. He was taught *Post-Impressionist painting in Munich; in Paris from 1903 to 14 he had contact with modernist artists, then opened a school in Munich in 1915. In

1930 and 31 he taught in California, then moved to New York where he opened a school in 1933; he continued teaching there, and also in the summer in Provincetown, MA, until he gave up teaching in 1958 to devote himself full-time to painting.

In the USA he represented cosmopolitan modernism, confronting American Scene painting and then arming *Abstract Expressionists with lessons on the dynamics of colour. For him the interaction of colour areas in relation to the picture plane is the essence of painting, and though this identifies him with the core tradition stemming from *Cézanne, the vigour of his art links it to *Expressionism. It is without the anxieties of *Abstract Expressionism, and affirmative where that is said to speak of alienation and Cold War fears. He exhibited in New York from 1944 on and had a retrospective at the Museum of Modern Art in 1963. Many New York painters were directly and indirectly his disciples.

Hofmann, Ludwig von (1861–1945) German painter, trained under his uncle Heinrich at the Dresden Academy, in Munich and in Paris. He was impressed by the *classical *Symbolism of both *Puvis and *Marées, and a period in Rome (1894–1900) confirmed both his feeling for southern light and warmth and the Northerner's distanced appreciation of them. In 1906 he visited Greece with the writer Gerhart Hauptmann. These influences meet in the murals he painted 1905–6 in the Museum and 1907 in the New Theatre of Weimar where he taught at the art school. His easel paintings deal with imaginary, usually lyrical subjects, often with nude or semi-nude female figures amid timeless nature. Critics noted his affinity with the new dance styles of the turn of the century; among his best works are his studies of Ruth St Denis dancing. Hugo von Hofmannsthal wrote the introduction to his *lithographic suite *Dances* (1905). Hofmann also did illustrations to writings by Hauptmann and others and the set for Max Reinhardt's production of Maeterlinck's *Aglavaine et Selysette*. His art was essentially poetic, and made its mark because of its combination of a classical, in effect often pagan, vision with exceptionally vivid colour, making him a kind of German *Post-Impressionist.

Hogarth, William (1697–1764) English painter and engraver (*see under* intaglio), a controversial and quarrelsome figure in his own day, now recognized as probably the most innovative and interesting of British artists. Despite having been appointed Serjeant Painter to the King in 1757, Hogarth died an embittered and disappointed man, frustrated in his ambition to succeed *Thornhill (his father-in-law from 1729) as a famous English painter of monumental histories (*see under* genres). Hogarth's essays in the genre, notably the huge *Pool of Bethesda* and *Good Samaritan* painted *gratis* for the staircase of St Bartholomew's Hospital, London, in 1736 and 1737, earned him neither renown nor commissions, and he remains best known for his small-scale 'modern moral subjects' and satires, and his theatre pieces. Almost as notable as the narrative subjects are Hogarth's portraits, which are forthright and painterly. A vociferous patriot, who fulminated against the fashion for Old Masters and contemporary Continental artists, Hogarth was himself heavily indebted to French art and the Old Masters, transmitted mainly through engravings. He was one of the first English artists to adopt the new *Rococo aesthetic, and despite his professed contempt for things French (e.g. *The Roast Beef of Old England, &c.*, 1748, London, Tate) he relied at times on Parisian engravers for his own editions of engravings after his paintings (*Marriage à la Mode, c.*1743; paintings, London, National).

Hogarth's paradoxical career began with an apprenticeship, never completed, under an engraver of silver plate. His technical training in painting he owned to *Vanderbank's 1720 *Academy, although his sparkling fresh paint surface seems to have been self-taught. It is best seen in his late oil sketches (e.g. *The Shrimp Girl*, London, National; *Hogarth's Servants*, London, Tate). Having set up shop as a copper-plate engraver, Hogarth soon turned from shop

cards, book illustrations and single satirical prints to the painting of small portrait *Conversation Pieces in the manner of *Mercier, and a new genre which Hogarth himself may have initiated, the theatre picture. Six versions of a scene from John Gay's *Beggar's Opera* (pc; London, Tate; drawing, Windsor, Royal Library) are the first securely attributable pictures by him. His first financial success came with yet another new venture: *The Harlot's Progress* (1732), a series of paintings, now lost, of which Hogarth executed and published, on subscription, the engravings. *Harlot* brought in its wake many piracies, causing Hogarth to take up the cause of an Engraver's Copyright Act, finally passed in 1735. *The Rake's Progress* series followed immediately (paintings, London, Soane). These new 'modern moral subjects' or 'comic history paintings' not only provided Hogarth with a means of livelihood independent of commissions: they enabled him to find, as he wrote, 'an intermediate species of subjects between the sublime and the grotesque'. *Marriage à la Mode* (*c*.1743) was the first of the series to deal with high life and to attack a specifically modern vice. Hogarth's difficulty in selling the paintings of this series caused him to concentrate solely on engravings in the following years: *The Effects of Industry and Idleness* (1747); *Beer Street and Gin Lane* (1750/1); *The Four Stages of Cruelty* (1750/1), drawn and cut in a purposely coarse vernacular style. His last ambitious series, *The Election* (*c*.1754, London, Soane) finally conflated his popular manner and his pictorial ideal, as enunciated in his treatise, *The Analysis of Beauty*, 1753.

Hogarth's first excursion into portraiture on the scale of life, like that into large-scale history painting at St Bartholomew's, was occasioned by rivalry from a foreign artist. Again combining his philanthropic and his artistic interest, he donated a full-length seated portrait (1740) of his friend Captain Thomas Coram, founder of the Foundling Hospital, to the institution, of which he was himself a founding governor. By organizing also the donation of four biblical histories (including his own *Moses Brought to Pharaoh's Daughter*, 1746), Hogarth created in the hospital the first permanent public gallery of English art. The hospital was later to win the lottery for his *March to Finchley* (1750).

Hogarth's last years were increasingly darkened by polemic. Having himself founded St Martin's Academy (1735) along the lines of Vanderbank's, he now opposed the growing agitation by younger artists for a real state Academy of art on the Continental model. The failure of his *Sigismunda* (1758/9) marks the failure of his last attempt to assert the supremacy of the English artist over the foreign import. Becoming involved in political polemic, he executed several prints attacking Wilkes (*The Times*, Plates I and II, 1762/3; *John Wilkes*, 1763; *The Bruiser*, 1763) and Wilkes's retaliation hastened the onset of an illness, followed by a paralytic stroke, from which he never really recovered.

Hohenfurth Master *See* Vyšší Brod Master.

Hol[l]anda, Francisco de *See* Francisco de Holanda.

Holbein, Hans the Elder (*c*.1460/ 5–1524), his brother **Sigmund** (after 1477–1540) and his sons **Ambrosius** (*c*.1494–1519) and **Hans the Younger** (1497/8–1543) Family of painters from Augsberg, the most cosmopolitan German city of the *Renaissance and a dissemination point for Italianate artistic ideas. The best known is Hans Holbein the Younger, the last great German painter of the century (see below).

Hans Holbein the Elder was an important artist, influenced by the art of the Netherlands, which he may have visited during his long *Wanderjahre. He is at his best in the 200 or more independent drawings, mainly portrait heads, executed in the Netherlandish technique of silverpoint (Berlin, Staatliche; Copenhagen, Museum). From *c*.1515 he tried, less successfully, to assimilate Italian influences in his work (*St Sebastian Altarpiece*, 1515–17, Munich, Alte Pinakothek). His most important commissions were executed from 1499 to *c*.1510; the Roman Basilicas of Sta Maria Maggiore (1499) and of St Paul (*c*.1504) for the convent of St Catherine,

Augsburg (now Augsburg, Museum); high altar for the Dominican church, Frankfurt (1500–1, now Frankfurt, Städel); the design for the high altar for Kaisheim (1502, now Munich, Alte Pinakothek); a votive table for Ulrich Schwarz (c.1508, now Augsburg, Museum). In addition to the works already listed, there are *realistic painted portraits in Basel, Kunstmuseum; a series of *Madonnas* (e.g. Munich, Böhler Coll.) and the last known work, *The Fountain of Life* (1519?) an altarpiece now in Lisbon, Museu.

Hans Holbein was the head of a busy workshop in Augsburg and the teacher of both his sons. Hans Holbein the Younger, after leaving his father's shop, made his brilliant solo debut in Basel in 1515–16, with the obverse of a signboard painted by his brother Ambrosius, the marginal drawings of Erasmus's *Praise of Folly*, woodcuts for book illustrations (*see* relief prints), and the paired portraits of the Burgomaster of Basel, *Jakob Meyer* and his wife *Dorothea Kannengiesser* (Basel, Kunstmuseum). In their clarity and precision of line these works already surpass those of his father, and anticipate Holbein's later success as portraitist to the Tudor court. Around 1517 Holbein set out via Lucerne on travels in northern Italy, returning to Basel in 1519. Many works of the 1520s owe a debt to Italian models, notably to the murals by *Bramantino and *Leonardo in Milan: *frescos for interiors and façades of houses in Basel and Lucerne, now largely destroyed (e.g. Great Council Chamber, Basel Town Hall, 1521–2; façade, 'House of the Dance', Basel, design in Berlin, Staatliche); religious works (*The Man of Sorrows* and the *Mater Dolorosa*, c.1519/ 20; *Last Supper, Scenes from the Passion*, c.1520–3; *Dead Christ*, 1521, Basel, Kunstmuseum; *Virgin*, 1522, Solothun, Museum; *Oberreid Altarpiece*, 1521–2, Freiburg, cathedral) and even portraits (Magdalena Offenburg as *Laïs of Corinth*, 1526, Basel, Kunstmuseum). Simultaneously, however, Holbein looked to German and Netherlandish art: to *Baldung and *Metsys (e.g. portraits of Erasmus, London, Basel, Kunstmuseum; c.1523, Paris, Louvre).

He continued also to create designs for woodcuts and metal-cuts; the most famous is the text-less *Dance of Death*, designed 1523–6, published 1538. In 1524 Holbein went to France, where he acquired the three-colour (red, white, black) pastel technique of portrait drawing (*see also* Jean Clouet) which he was often to use later. Recommended by Erasmus to Sir Thomas More, Holbein travelled to England in 1526. A number of portraits resulted from this first visit, notably the *Group portrait of More and his family*, the first non-devotional group portrait in northern Europe, now known only through an old copy (London, NPG) and a drawing (Basel, Kupferstichkabinett), and *William Warham, Archbishop of Canterbury* (London, Lambeth Palace; another version, Paris, Louvre). He was back at Basel in 1528. Despite the efforts of the town council to keep him in the city, however, the increasing violence of reformatory iconoclasm (*see under* icon) and narrowing opportunities for painters drove him once again to abandon his wife and children and return, in 1532, to England, where he was compelled virtually to abandon religious painting. More being now in disgrace, Holbein found his patrons among the German merchants of the Steelyard. His portrait of *Georg Giesze* (1532, Berlin, Staatliche) reintroduces the format and *iconography of a work by Jan van *Eyck. A still life with *vanitas* connotations is depicted with equal precision in the full-length life-size double portrait of the *French Ambassadors* (1533, London, National), in which, however, a large skull in *anamorphic perspective intrudes into the foreground space. Later portraits employed a simpler and less time-consuming formula, setting the figure against a neutral background, often a cool blue, enlivened, as on a medal, by an identifying inscription. In 1537 Holbein entered the service of Henry VIII, having already portrayed many members of the court and Parliament (e.g. *Robert Cheseman*, 1533, The Hague, Mauritshuis; *Sir Richard Southwell*, 1533, Florence, Uffizi). In addition to easel portraits of the king (e.g. Rome, Nazionale), of his wives (e.g. Vienna, Kunsthistorisches) and prospective brides (e.g. London, National; Paris, Louvre), Holbein was called upon to

execute mural decorations of Tudor dynastic pretensions (e.g. 1537, London, Whitehall Privy Chamber, now lost; cartoon (*see* fresco), London, NPG) and to design state robes, jewellery, silver plate, book-bindings, pageant accessories, etc. More than 250 designs for craftsmen are known. The easel court portraits – most of them under-life-size half-lengths – became more and more formalized and frontal, only the hands and face fully modelled, spatial depth reduced to surface pattern. Holbein's late, *iconic style was the source for *Hilliard's Elizabethan miniatures.

Hans Holbein the Younger's older brother, Ambrosius, left their father's workshop in 1514. After painting decorative murals at Stein am Rhein, 1515–16, he joined his brother in Basel, where he specialized in book illustrations in woodcut. In addition, he left excellent portraits (Basel, Kunstmuseum; St Petersburg, Hermitage). The brothers' paternal uncle, Sigmund Holbein, spent many years in the Augsburg workshop, but died in Bern. Works attributed to him are in Schweinfurt, Schäfer Coll.; The Hague, Mauritshuis; Nuremberg, Museum.

Holguín, Melchor Pérez (*c.*1660–*c.*1725) The outstanding colonial South American painter, born at Cochabamba, Bolivia, and active at Potosí, then a city of 30 churches and monasteries. Basing his compositions on Flemish *Mannerist engravings (*see under* intaglio), he invested them with *expressive details, sometimes drawing on Indian costumes and customs (La Paz, Banco Central; Potosí, Santa Teresa; Madrid, Museo de América). His best pupil was **Gaspar Miguel Berrío** (active 1730–58), whose pictures reflect Holguín's figure types (Potosí, Santa Monica).

Hollar, Wenceslaus or **Wenzel** (1607–77) Prolific draftsman and etcher (*see under* intaglio), born in Prague and trained by Matthäus *Merian in Frankfurt. In 1636, while working in Cologne, he was engaged by the Earl of *Arundel to tour Europe with him, and was brought by him to England. Hollar is best-known for his topographical views and his fashion-plates, both of which are important sources for the appearance of 17th-century Europe and its inhabitants; particularly fascinating are his views of London before the Great Fire of 1666. The most celebrated of these is a panoramic print published in 1647, drawn from the roof of Arundel House on the Strand (demolished 1678), where Hollar had an apartment. There are drawings by Hollar in London, British Museum; Windsor, Royal Library; Cambridge, Pepysian Library; etc.

Hölzel, Adolf (1853–1934) German painter, who studied in Vienna and Munich and visited Paris in 1882 and 1887. He settled in Dachau where he established an influential school of painting where *Nolde was one of his students. Emphasizing, in the spirit of both *Neo-Impressionism and of *Jugendstil and the affective properties of forms, colours and structures, then being explored and debated in near-by Munich, Hölzel experimented with increasingly *abstracted imagery, at first from a landscape base but then frequently using traditional religious and folk subjects, generalizing them sometimes beyond recognition to bring out the musical quality of each design as a means of poetic expression. This he taught as the basis of all art, developing throughout his career a theory of pictorial harmonics which often brings him close to the thought and action of *Kandinsky; there are sentences in Kandinsky's theoretical writings that echo the older man's words. By 1900 Hölzel was venturing into designs which he called '*abstract ornaments' and which he considered the beginnings of a new art. In 1905 he became professor at the Stuttgart Academy where his ideas appalled his colleagues but attracted numerous students, among them *Itten and *Schlemmer who developed his methods further and based their teaching at the *Bauhaus on them. In 1915–17 Hölzel made his first and only large work that appears to be abstract and, as he would have said, musical as opposed to literary, when he designed stained glass windows for the Bahlsen Company in Hanover. In his last years he made a series of studies in pastels that, in exploring colour, teeter on the edge of abstracted figuration and wholly abstract but accentu-

ated, rhythmical composition. Some of his writings were published in 1933. His memorial exhibition in 1953 was accompanied by a catalogue which includes a selection of his notes and sayings.

Holzer, Jenny (1950–) American artist, born at Gallipolis, Ohio, and trained at the Rhode Island School of Design. She worked as an *abstract painter but also produced typed texts some of which were published on the walls of So-Ho, New York, as *Truisms* in 1977. Soon she found other means of making her often self-contradictory aphorism public, from T-shirts and stone inscriptions to running LED signs. A few were electronically displayed in 1982 on the Spectacolor Board in Times Square, New York, stating, *inter alia*, that 'private property created crime'. Holzer's solo shows started in 1978; in 1990 she represented the USA at the Venice Biennale. Her art is public in mode, sometimes private in utterance but always accessible and, in its methods of reiteration amid silence, ritualistic.

Holzer, Johann Evangelist (1709–40) Outstandingly gifted and versatile German painter, pupil of *Bergmüller. He was able to work successfully on the miniature scale of ornamental book illustrations, or of fan painting, influenced by prints after *Watteau (Karlsruhe), as well as altarpieces (Meran, Museum) and monumental *fresco. His illusionistic (*see* illusionism) dome painting for St Anton, Partenkirchen, is one of the most beautiful in German art. Sadly, much of his work is lost. Little remains of many façade frescos for Augsburg houses; the famous *Country Dance* façade is now known only through engravings by Johann Esaias Nilson; only his vivid oil sketches remain for the frescos of Münster-Schwarzach (Augsburg, gallery); his *Allegory of Flora* in the Summer Residence in Eichstatt is very damaged. Holzer's artistic estate was acquired by Matthäus *Günther.

Homer, Winslow (1836–1910) American painter, trained as an illustrator. His first paintings were deliberately *naturalistic and illustrational, but after a visit to Paris in 1867, where he saw *Manet's broad manner of painting, his style became fresher and more vivid. His pictures, in oils or watercolour, are of contemporary life, notably that of seafarers, encouraged by some months (1881–2) on the north-east coast of England, and re-enforced by his subsequent years on the coast of Maine.

Hondecoeter Dynasty of Dutch painters specializing in birds and animals. **Gillis d'Hondecoeter** (*c.*1580–1638) may have been a Flemish refugee who settled in Utrecht; he studied with *Savery and, like him, painted animal-filled landscapes (Stockholm, National). He trained his son, **Gijsbert** (1604–53), who brought a new *naturalistic element to the rendering of poultry and birds; his pictures in this genre closely resemble the work of Aelbert *Cuyp (Rotterdam, Boijmans Van Beuningen). The best-known of the family is **Melchior d'Hondecoeter** (1636–95), a pupil successively of his father Gijsbert and his uncle, Jan Baptist *Weenix. His pictures of poultry yards, and dramatic compositions of exotic birds and poultry in action (e.g. Kassel, Staatliche) made him internationally famous; in addition to these he also painted decorative, mural-sized canvases for a country estate near Weesp (Munich, Alte Pinakothek). In 1670, two years after obtaining citizenship in Amsterdam, he executed his most famous work, *Birds on a Balustrade, with the Amsterdam Town Hall in the Background* (Amsterdam, Historisch), in which the proud birds on the balustrade may be intended to satirize the haughtiness of the Amsterdam city fathers.

Hone, Nathaniel (1717–84) Irish-born British painter; originally a specialist in miniature portraits. After marrying well and settling in London, he spent a period of study in Italy, 1750–2; he then gave up miniatures for the more lucrative practice of portraits in oils (*Kitty Fisher*, London, NPG; numerous *Self-Portraits*, London, NPG; Royal Academy; Dublin, National; Manchester, Museum). He showed several *Fancy Pictures, with his children as models, at the Royal *Academy, but is best remembered for a painting he was forced to

withdraw from exhibition there: *The Conjurer* (1775, Dublin, National). This is a satire on the practice of the then-President of the Academy, *Reynolds, of using the poses of the Old Masters in his own painting, and foreshadows the new ideology of the *Romantic period and the cult of 'originality'. Hone's sons, Horace (1754–1825) and Camillus (1759–1836) were also painters, as was a brother, Samuel (*b*.1726).

Honoré, Master (active 1288–d. shortly before 1318) *Illuminator working in Paris, the immediate predecessor of *Pucelle. In 1296 he was paid for the *Breviary of Philip the Fair* (Paris, Bibliothèque Nationale) more *naturalistic in its figure modelling than earlier French manuscripts, and perhaps influenced by sculptural reliefs. Other works by him in Paris, Arsenal; Nuremberg, Stadtbibliothek.

Honthorst, Gerrit van (1590–1656) Called Gherardo della Notte or delle Notti (Gerard of the Night, or Nights) in Italy, where he established his reputation as a painter of nocturnal scenes, he was one of the so-called Utrecht *Caravaggisti (*see also* Terbrugghen; Baburen), the only one to establish an international reputation. A pupil of *Bloemaert, he is said to have been in Rome by 1610–12; he returned to Utrecht in 1628. He enjoyed the patronage in Italy of the most aristocratic collectors, and continued to find favour in court circles all his life: at the invitation of Charles I he came to London for six months in 1628 (*Mercury presenting the Liberal Arts to Apollo and Diana*, Hampton Court); in 1635 he produced a long series of history pictures (*see under* genres) for the Danish King Christian IV; from *c*.1635 until 1652 he was painter to the Stadholder at The Hague, executing allegorical decorations and a large number of court portraits. In Rome he had painted many religious works (*Christ before the High Priest*, London, National), some of them for churches (S. Maria della Scala, etc.) but such themes found little favour outside Italy. Of greater importance for the evolution of Dutch painting were his genre pictures (*Supper Party*, 1620, Florence, Uffizi). His modification of Caravaggio's illumination by depicting artificial light, its source sometimes hidden by a silhouetted motif, influenced the young *Rembrandt and perhaps Georges de *La Tour.

Hooch, Pieter de (1629–after 1684) Dutch painter, best-known for his pictures of the domestic life of women and children executed at Delft *c*.1655–*c*.62. These seem to have influenced the greater Delft artist, *Vermeer; they may owe something to the *perspectival studies of Carel *Fabritius. From *c*.1647–*c*.1655 de Hooch specialized in guardroom and barrack scenes. After his move to Amsterdam in the early 1660s his homely interiors gave way to highly decorated salons, fashionable musical parties, etc., and the gentle daylight of the Delft pictures to a harsh *chiaroscuro derived from *Rembrandt's pupil Nicolas *Maes. There are paintings by de Hooch in major collections in the US and on the Continent, and in London (National, Wallace, Apsley). His work influenced many lesser Dutch artists.

Hoogstraeten, Samuel van (1627–78) A pupil of *Rembrandt at the same time as Carel *Fabritius, probably in the 1640s. He visited Vienna, 1651, Rome, 1652, and London, 1662–6, but worked also in The Hague, where he is mentioned in documents in 1658 and again in 1671. He finally settled in his native town of Dordrecht. A poet and essayist as well as a painter, he was appointed provost of the Holland mint. As an artist he is best remembered for his *perspective peep boxes (London, National; Detroit, Institute) and perspectivized architectural paintings (The Hague, Mauritshuis). He also executed *trompe l'œil* (*see under* illusionism) *still lifes (Vienna, Akademie) which anticipate 19th-century American rack pictures. His portraits are less innovative (Amsterdam, Rijksmuseum; Dordrecht, Museum). But perhaps his greatest contribution to the history of art is his treatise, *Introduction to the Advanced School of Painting: or, The Visible World* (1678), a much-expanded version of Van *Mander's preface to the *Schilder-Boeck*. Although written long after the death of Rembrandt in 1669, the treatise purports to record a disputation among the master and three of his pupils (Carel Fabritius,

Abraham Furnerius, and Hoogstraeten himself) and certainly reflects Rembrandt's views on painting.

Hopf[f]er, Bartholomeus (1628–99) Dutch-born and trained painter and draftsman, son of a German merchant from Augsburg. He worked sporadically in Augsburg from 1648 and through the early 1650s, executing portrait drawings of 14 of the city's Lutheran ministers; they were engraved by Bartholomeus Kilian in 1656. In 1657 he settled in Strasbourg, where he painted the large meeting room in the Town Hall.

Hopper, Edward (1882–1967) American painter born at Nyack, NY, and trained first as graphic illustrator at a commercial art school and then as painter under *Henri in New York. He made three visits to Europe during 1906–10 but was untouched by new tendencies there, holding on to the *realism of Henri and his associates, though later he stressed his distance from their social polemics. He was always more a conscious constructor of compositions than they, perhaps because of his years of graphic work, including the etchings of 1915–23 when he did almost no painting in oils. He painted urban and village life but avoided the anecdotal subjects of The *Eight and the scenes of work and leisure that dominated American realism. A note of alienation is evident in his work from early on, though he said commentators made too much of it. His scenes are generally without action or conviviality; many are uncannily still, with light and space their main offering and human beings subservient and inexpressive. Windows reveal little looking inwards and not much more looking out, though they hold the attention of inhabitants as though offering means of escape. Buildings protect but also separate. Hopper said: 'What I wanted to paint sunlight on the side of a house', but generally he could not do so without implying disappointment or dread. In his last years his colours and his mood lightened while he retained his feeling for unbroken surfaces and a rhythmical placing of forms. He exhibited frequently, especially in the 1920s, 40s and

60s, and had retrospectives in New York in 1933, 1960 and 1964. Outside the USA his work has made its mark only in recent decades, aided perhaps by recalling scenes in the films of Hitchcock and others, shot after Hopper laid down his brushes in 1965.

Hoppner, John (1758–1810) Eclectic and facile English portrait painter; he imitated *Reynolds and *Romney, *Lawrence and *Raeburn. He was appointed Portrait Painter to the Prince of Wales, the future George IV, in 1789, four years before his stodgier rival, *Beechey, was appointed Portrait Painter to Queen Charlotte (Windsor Castle, Coll. H.M. The Queen; London, NPG).

Horace *See* under Philostratus.

Horn, Rebecca (1944–) German multi-media artist, trained in Hamburg and in London at St Martin's School of Art. She became known internationally in the 1980s for her films of *Performance art and her installations, still and kinetic, some of them reflecting on German history, many of them using her own body or the particular location as theme or vehicle. A major retrospective made its debut at the Guggenheim Museum, New York, in 1993 and toured Europe in 1994–5.

Hoskins, John *See under* Cooper, Samuel.

Houbra[c]ken, Arnold (1660–1719) Dutch painter, a pupil of *Hoogstraten, now remembered only for his three-volume work on the lives of Netherlandish painters: *De Groote Schouburgh der Nederlantsche Konstschilders en Schilderessen, The Great Theatre of Netherlandish Painters*, 1718–21. A successor of Van *Mander's *Schilderboek*, it is the most important source of information on 17th-century Dutch painters. The book was illustrated with engravings (*see under* intaglio) by Arnold's son **Jacobus** (1698–1780), a leading Dutch portrait engraver.

Houdon, Jean-Antoine (1741–1828) While not particularly celebrated in his day, he has become the most famous 18th-

century French sculptor, especially for his portrait busts and the statue of the *Ecorché (1767, Gotha, Institut) – the 'flayed' figure of a man originally executed as a model for St John the Baptist (1767, Rome, S. Maria degli Angeli) – casts and replicas of which have been used at the French *Academy and elsewhere for teaching anatomy to artists. Although Houdon experimented with various styles, from the *Mannerism of *Primaticcio (Diana, 1780, Lisbon, Gulbenkian) through *Rococo (Shivering Girl, 1785, Montepellier, Musée) and *Neoclassicism (1781, d'Ennery Tomb, Paris, Louvre), his most characteristic mode is a sober, even scientific, *realism. It is this quality which disturbed contemporaries, who accused him of a lack of imagination and *decorum.

Born the son of a concierge '. . . at the feet of the Academy', Houdon began to sculpt at an early age and was later the pupil of Michel-Ange *Slodtz, and influenced by both Jean-Baptiste *Lemoyne and *Pigalle. Having won first prize at the Academy school in 1761 he spent 1764–8 in Rome, where he executed the Ecorché at the French hospital, the St John the Baptist and its more famous companion in S. Maria degli Angeli, St Bruno (1767). He first revealed his ability as a sculptor of portrait busts with Diderot (1771, New Haven, Seymour Coll.; Paris, Louvre); among his many other famous sitters were the American ambassador to Paris, Benjamin Franklin (e.g. 1778, New York, Metropolitan), Voltaire (full-length seated statue, 1781, Paris, Comédie française; busts, marble, London, V&A; terracotta, Cambridge, Fitzwilliam; Baltimore, MD, Walters), Gluck (terracotta, 1775, London, Royal College of Music), Thomas Jefferson (1789, Boston, MA, Museum), Napoleon as Emperor (1806, Dijon, Musée). Houdon's busts of children are especially notable for their freshness and intimacy (mainly private collections).

In 1785 Houdon went to America to press for a commission, which never materialized, for an equestrian statue of Washington. To this end, he executed an écorché model of a horse (compare with the anatomy studies of *Stubbs). His standing statue of Washington, dated 1788 but completed only 1792, is in the State Capitol, Richmond, VA; a bronze copy stands outside the National Gallery, London.

Housebook Master (also known as the **Master of the Amsterdam Cabinet**) (c.1447/52–after 1505?) Important print-maker and painter working in the Middle Rhine area. German or Dutch origins have both been claimed for him. He is called after a book of secular subjects, now in Schloss Wolfeg, Germany. His other name derives from the fact that 80 of his prints, 63 in unique copies, are in the collection of the Amsterdam Rijksmuseum Printroom or cabinet. Only 89 prints by him are known in all, 69 of them in a single copy.

A few paintings by him and his workshop are known, notably the dismembered Passion altarpiece (Freiburg im Breisgau, Augustiner-museum; Berlin Staatliche). But he is far more interesting as a maker of prints, many of them drypoints on lead plates (see under intaglio), a technique only rarely used again until *Rembrandt, since it does not permit many copies to be run off the press. It has the advantage, however, of allowing far more spontaneous working of the plate than copper engraving, and of producing a rich velvety tonality.

The Housebook Master's secular prints introduced such motifs as the naked *putto into German art. Even many of his religous subjects are characterized by humour and an individualistic approach to nature. Where playfulness is not appropriate, he evokes pathos and dramatic tension. The prints must have been made for a small circle of sophisticated collectors and friends, who appreciated their pictorial qualities and the Master's original interpretation of traditional subjects. Albrecht *Dürer, although he made only three drypoints in his entire career, was much influenced by him.

Hoyland, John (1934–) British painter, born in Sheffield, trained there and in London. A bursary took him to New York in 1964 and gave him contact with painters such as *Louis and *Noland. He had produced *abstract paintings, mostly of linear structures on a colour field, in the

early 60s; after the American experience his colour areas became broad and quasi-architectural though he soon abandoned the hard edges of Noland's colour forms for a more spatially dynamic presentation learned from *Hofmann. He had a solo exhibition in London in 1964 but made his mark with a two-part show in 1967. From that time on he exhibited frequently in Europe and the Americas, and his work, predominantly abstract, has taken on a variety of formal themes and of orchestration through colour harmonies or discords, densities of paint, and hard or soft forms. Whereas the work of 1967 suggested architectural and at times landscape spaces, that of the 70s and since has tended to advance from the canvas on the strength and physical assertiveness of his acrylic paints. His admiration for the art of Hofmann was declared in a Hofmann exhibition he organized for the Tate Gallery, London, in 1988.

Hrdlicka, Alfred (1928–) Austrian sculptor, born in Vienna. After studying dentistry he turned to painting under Gütersloh and then sculpture under *Wotruba. His sculpture, and also his drawings and prints, took human suffering for their theme; his idiom in all media has been a traditional *naturalism heightened with heroic action and figuration, and given a modern flavour by means of complexities and obscurities that at times suggest the graphic work of *Picasso.

Hubbuch, Karl (1891–1979) German painter, born in Karlsruhe where he began his art training at the *Academy and where he was professor in 1930–3, when he was dismissed and forbidden to make art, and again during 1948–57. He also studied in Berlin, alongside *Grosz, under Orlik. Like Grosz, he early on determined to use his art for social criticism. He took a clear view of society as divided between those hungry for wealth and power and the workers who are hungry only for peace and the right to work. His paintings serve as a pictorial stage on which both sorts perform in suitable settings. He also painted portraits in which he appears to be testing his sitter's place in society, and slightly mocking

pictures of ordinary people in some heroic role, as in his female portrait as *The Swimmer of Cologne* (1923; Mannheim, Kunsthalle).

Huber, Wolf or Wolfgang (c.1485/90–1553) The youngest of the major exponents of the *'Danube school' style (*see also* Albrecht Altdorfer, Jörg Breu the Elder, Lucas Cranach the Elder). Born at Feldkirch in Austria, he set out on his *Wanderjahre c.1505, drawing the picturesque scenery on his way to Innsbruck and Salzburg (e.g. *Mondsee*, drawing 1510, Nuremberg, Museum) and along the Danube. By 1515 he had become court painter and architect to the Bishop at Passau, where he remained, with occasional visits to Austria, for the rest of his life. More dependent on nature than Altdorfer, whom he may have met c.1510, but more romantic than *Dürer, whose work he knew well, Huber remained a master of the landscape pen-and-ink drawing as an independent work of art (e.g. London, British; Berlin Staatliche). He is, however, also the author of altarpieces (Feldkirch, parish church; Munich, Museum; Vienna, Kunsthistorisches; St Florian; Berlin Staatliche) and of portraits, in several of which landscape plays an important part (Merion, PA, Barnes; Dublin, National; Philadelphia, Museum).

Hudson River School Informal association of American landscape painters working in the middle of the 19th century. Founded by *Cole and influenced by *Turner and others in Europe, they gave *Romantic significance by building moral themes and *History subjects into an art form previously considered of lower status. Other leading members were Jasper Cropsey (1823–1900) and Asher B. Durand (1796–1886).

Hudson, Thomas (1701–79) English painter, son-in-law of *Richardson. c.1746–55 he was the most fashionable portraitist in London, but he relied on standard patterns and much of the execution of his paintings was left to specialized studio assistants. His fame today rests almost totally on the fact that he was the teacher of

*Reynolds (London, Foundling Hospital, Royal College of Physicians; Greenwich, Maritime; Edinburgh, National; etc.).

Huet, Christophe (*d*.1759) French *Rococo decorative designer, painter and engraver (*see under* intaglio), stylistic heir of Audran (*see under* Watteau, Jean-Antoine). His interior decorations include playful Oriental motifs, and animals – especially monkeys – dressed up and behaving like humans (Chantilly, Condé; Paris, Hôtel de Rohan).

Hughes, Arthur (1830–1915) British painter, member of the *Pre-Raphaelite movement, in his earlier years capable of bright, slightly sentimental paintings, combining clear *naturalism with romantic feelings, as in *April Love* (1856; London, Tate) and *The Long Engagement* (1859; Birmingham City). Much of his later work was as illustrator.

Huguet, Jaime (before 1414–92) Influential Spanish painter, mainly active in Barcelona, where he succeeded *Martorelli as the leading master of the Catalan school; his early works, however, were executed in Zaragoza and Tarragona. His International *Gothic style went further than Martorelli's in its brilliant draftsmanship and preference for surface richness (Barcelona, Museo; Tarrasa, Sta María).

Hume, Gary (1962–) British painter, trained at Goldsmiths College, University of London. In 1988 he was included in Damien *Hirst's 'Freeze' exhibition, since when his work has been in many group and solo exhibitions in Britain and abroad. Using gloss paint on canvas and on panels of various materials, Hume first presented monochrome rectangles that he called *Doors* and which thus were neither *figurative nor *abstract. Additional forms on them could enhance or contradict their likeness to doors, and by the early 1990s he was incorporating much-simplified human and other images, sometimes portraits of pop stars, in his shiny, anti-aesthetic range of pictures. These could refer to works of art of other ages, or equally to current magazine illustrations. In 1999 Hume repre-

sented Britain at the Venice Biennale with a retrospective selection that opened with a roomful of new work in which gloss paint on aluminium panels delivered multiple outlines of naked girls or floating swarms of angels. All his work has inhabited a puzzling location between banality and mysteriousness; his colours, in particular, echo the sophisticated but commonplace use of colour in packaging but validate this as art without the artist's personal touch as a justification.

Humphrey, Ozias (1742–1810) English portrait painter, active in Bath before settling in London in 1763. From 1773 to 1777 he was with *Romney in Italy, and he visited India from 1785 to 1788. He was a miniaturist until an accident in 1772 affected his eyesight, when he switched to oils, and later, in 1791, to pastels, becoming soon afterwards 'Portrait Painter in Crayons to His Majesty' George III. He went blind in 1797. There are works by him in London, NPG.

Hundertwasser (1928–2000) Pseudonym of Friedrich Stowasser, Austrian painter, at times calling himself Friedensreich ('empire of peace' or 'rich in peace') Hundertwasser ('hundred waters'). He was born in Vienna, attended a Montessori school and had three months at the Vienna Academy. He was influenced by *Schiele and others before attaining his popular semi-abstract style, jewel-like in execution and fairy-tale in mode. He exhibited widely and with great success.

Hunt, William Henry (1790–1864) British painter, trained by *Varley and in the Royal *Academy Schools, London. He became famous for intensely objective studies of fruit, flowers, birds' nests etc., done in a new technique of watercolour painting, with opaque body-colour hatched and stippled to produce a kind of *pointillism of a fairly systematic though intuitive sort. These works were praised by *Ruskin and exercised a wide influence.

Hunt, William Holman (1827–1910) British painter, co-founder of the *Pre-Raphaelite movement and one of the most

admired painters of his age. He studied first under a London portraitist, then in 1844 entered the Royal *Academy Schools where he became a close friend of the gifted *Millais. Hunt's first paintings employed themes from recent literature. *The Eve of St Agnes* (London, Guildhall), shown at the Royal Academy in 1848, drew the enthusiasm of *Rossetti who sought Hunt out. The Brotherhood they founded that September offered the diffident Hunt a supportive framework in the face of general criticism; it was he who most fervently represented the group's principles throughout his career: thorough *naturalism and subjects that would offer the world not entertainment but moral instruction – both called for by *Ruskin.

Also painted in 1848, *Rienzi vowing Justice* (London, pc), its theme taken from Bulwer-Lytton's best-selling novel, raised political issues in a year of revolutions and was painted out of doors with a patience that in itself implied rebellion against academic methods. Ruskin's 1851 letters in defence of the Brotherhood appear to have confirmed Hunt in his pursuit: *The Hireling Shepherd* (1852; Manchester City) is a remarkable piece of moralizing *genre painting, its intense outdoor naturalism almost blinding us to its solid 'rebuke to the sectarian vanities and vital negligences of the day' (Hunt), i.e. the irresponsibility and worldliness of clerical practice. His *Strayed Sheep* (1852; London, Tate) is not only a brilliant piece of landscape painting: the sheep, dangerously close to a cliff-top and in some instances entangled in brambles, are ourselves. *Delacroix praised its use of colour and light when the painting was shown in Paris in 1855. In 1854 he exhibited two paintings heavy with moral symbolism, one directly religious, *The Light of the World* (Oxford, Keble College), and one secular, *The Awakening Conscience* (London, Tate). Biblical subjects, he decided, had to be painted in biblical lands. In 1854 he went to Palestine and painted on the shores of the Dead Sea *The Scapegoat* (Port Sunlight, Lady Lever), a painfully literal account of a goat put out to die in a harsh, vividly colourful landscape. He subsequently spent many years in Florence and in Palestine and laboured long over elaborate religious paintings based on detailed studies that tend to outweigh the pictures' message. One of his last paintings, *The Lady of Shalott* (1886–1905; Hartford, CT, Wadsworth Atheneum), is a complex and quite fantastical evocation of Tennyson's poem.

Having met with abuse, Hunt's work from the 1850s on drew the admiring attention of a wide world, including the new collectors created by industrial developments in the north of England. London's Tate Gallery has some of his best works; others are in the municipal galleries of Liverpool, Manchester and Birmingham. He was awarded the Order of Merit in 1905. Five years later he was accorded a state funeral and buried in St Paul's Cathedral, London. His two-volume *Pre-Raphaelism and the PRB* (1905) is a passionate account of his work and principles.

Hunter, George Leslie (1879–1931) British painter, spoken of as one of the 'Scottish Colourists'. His parents emigrated to California and left Hunter in San Francisco when they returned home in 1899. He got himself to Paris in 1904 and steeped himself in the art of the *Post-Impressionists and the *Fauves, learning to give priority to colour in his paintings. Back in San Francisco, he prepared his first solo exhibition only to lose everything in the great earthquake of 1906. He returned to Scotland, and settled in Glasgow, developing his art with an eye, especially, on the work of *Matisse. In 1923 he exhibited in London together with his 'Colourist' colleagues, *Peploe and Cadell. His first London solo show was in 1928 and in 1929 he exhibited in New York. He expected to move to London in 1932 but death intervened.

Huszár, Vilmos (1884–1960) Hungarian-Dutch painter, born Vilmos Herz in Budapest. He adopted his Hungarian name around 1900, left Hungary in 1904 and settled in the Netherlands in 1909. In Budapest he was trained in decorative painting and in styles from *realism to *Art Nouveau stylization. Contact with Van der *Leck led him to flatten and simplify his compositions and also to work in stained glass, making apparently *abstract

designs derived from nature. Van *Does-
burg bought one of his paintings from a
mixed exhibition in 1916 and he was one of
the first members of *De Stijl, designed the
magazine's logo and letterheading and con-
tributed a series of articles to successive
issues. Much of his work continued to be
abstracted from figures, flowers etc. but he
also studied the representation of move-
ment, made a *Mechanical Dancing Figure*
(1917-20; lost) and puppets for a mechan-
ical ballet. Especially in the 1920s he was
also employed on interior design, typo-
graphy and advertising. His later work
included emphatically realistic as well as
abstracted paintings and drawings. He
exhibited many times from 1902 on in
Hungary, Holland, France and Germany,
including retrospectives in 1955 (Amster-
dam), 1959 (The Hague) and 1985 (The
Hague and Budapest).

Huygens, Constantijn the Elder
(1596-1687) Dutch nobleman, patron
of the arts and letters, diplomat, secretary
and adviser to princes of the House of
Orange. In 1629 he singled out for praise
the young and as-yet unknown *Lievens
and *Rembrandt, and was instrumental in
obtaining commissions for the latter from
the Stadholder, Prince Frederik Hendrik.
At least a dozen portraits of him existed
by contemporary artists, including Lievens

(Amsterdam, Rijksmuseum), *Miereveld,
*Van Dyck and Thomas de *Keyser
(London, National).

Huysum or **Huijsum, Jan van** (1682–
1749) Vastly acclaimed Amsterdam
flower painter of international reputation
(London, National, Wallace; Dulwich,
Gallery; Hamburg, Kunsthalle; etc.). A
pupil of his father, the flower painter
Justus van Huysum (1659–1716), he
worked in the tradition established by
Willem van *Aelst: asymmetrically com-
posed ornamental bouquets, painted with
an enamel-smooth finish, in cool light
tones, with vivid blues and greens. They
were intended to instruct as well as delight;
inscriptions occasionally point the moral
(e.g. Amsterdam, Rijksmuseum). He is
the author also of some fruit *still lifes
and a few decorative Italianate landscapes
(e.g. Amsterdam, Historisch). Van Huysum
is exceptional in painting from nature,
rather than relying on a collection of drawn
or painted studies. Since his bouquets
contain flowers from different seasons,
double dates appear on some of his
pictures.
 He attracted many imitators – amongst
them his younger brother, **Jacobus van
Huysum** (*c*.1687/9–*c*.1740) – well into
the 19th century, and was an influence on
porcelain decoration.

I

Ibbetson, Julius Caesar (1759–1817) English landscape painter. He came to London in the later 1770s and was employed in copying or forging Dutch landscapes, and also the works of *Gainsborough and *Wilson. In addition, he painted small Shakespearean scenes for *Boydell's Gallery in the manner of de *Loutherbourg. Most of his life after 1800 was spent in his native Yorkshire, painting topographic views (Leeds, Gallery).

icon (from the Greek *eikon*, image) In *Byzantine art, an icon is a Christian cult image. It is conceived as a proxy: veneration passes through the image to the Imaged. The struggle between Iconoclasts (image-destroyers) who opposed the veneration of images, and Iconodules, who supported it, divided Byzantine Christianity from 730 to 843. By extension to other art, an icon is an image stressing the timeless and hieratic aspect of the subject and allowing maximum eye contact of the viewer with the image. 'Iconic' thus tends to denote static, frontal figures, sometimes with exaggeratedly prominent eyes. In the semiology of art, however, an icon means merely a sign which shares some of the characteristics of that which it signifies – i.e. a representation, such as a portrait.

iconography (from the Greek, *eikono-graphia*, a sketch or description) In art history, the term broadly signifies 'imagery' and to study iconography means to study works of art in terms of their imagery rather than their style or technique. This obviously involves analysing the symbolic connotations of images. 'Iconology' is a word coined to describe the total system of symbols, or social myths, enshrined in the visual imagery of a given culture. It is sometimes used to mean uncovering hidden, perhaps unconscious, significances, and presupposes a link, or underlying unifying principle, between or behind all manifestations of a culture. In this way, iconology is akin to stylistics, in the sense that style labels such as *Gothic are meant to link diverse works of art, and may be thought to reveal some underlying aesthetic predisposition. Whereas the study of iconography is an essential part of the study of all art, required to recover the intended original significance of a work of art, the study of iconology is a philosophically loaded activity; the two words should not be used, as they sometimes are, as synonymous.

The term 'iconography' has the other function of denoting a range of representations of a particular thing. We might speak, for example, of studying the iconography of Justice: such a study would catalogue all the different ways in which Justice has been represented, and trace the evolution of the dominant representation. The iconography of Charles I would list all the known portraits and portrait types of that ill-fated king. In the 16th and 17th centuries, the term simply meant a collection of portraits, and it occasionally is still so used.

idealization In theory, idealization in art is a means of elevating representation from the particular to the general, from relative to absolute significance. Its justification derives from the Platonic theory of Ideas. Plato asserts that only Ideas (perfect forms existing in the Divine Intellect and apprehended through the human intellect) are real; phenomena which are evident to the senses are shadows or distortions of the Ideas. Idealization is an integral part of academic theory and practice in Western art. Sir Joshua *Reynolds's Third Discourse to the Royal *Academy (1770) sets out the clearest academic prescription for idealization: 'His [the painter's] eye being enabled to distinguish the accidental deficiencies, excrescences and deformities of things, from their general figures, he makes out an abstract idea of their forms more perfect than any one original; and what may seem a paradox, he learns to design naturally by drawing his figures unlike to any one object.

This idea of the perfect state of nature, which the Artist calls the Ideal Beauty, is the great leading principle, by which works of genius are conducted.' In practice, as Reynolds goes on to say, the laborious task of abstracting ideal form from a comparison of actual forms may be shortened 'by a careful study of the works of the ancient sculptors'. Because it is founded upon intellectual principle, and is thought most nearly to approximate timeless perfection, the *Classical ideal thus gains its canonical value in academic art.

The ability of the artist to idealize has been closely related to his claims for high social status. Mere craftsmanlike dexterity is not enough. Reynolds concludes: '. . . it is not the eye, it is the mind, which the painter of genius wishes to address . . . [it] is that one great idea, which gives to painting its true dignity, which entitles it to the name of a Liberal Art, and ranks it as a sister of poetry.'

illumination Hand-painted decoration, usually in *body-colour, of manuscripts or of early printed books with ornamental initial letters, pictorial borders or miniature scenes. It became widespread in Europe during the Middle Ages, and is a major art form of the *Gothic and International *Gothic styles (see also Books of Hours; Giovanni dei Grassi; Jacquemart de Hesdin; Limbourg brothers; Pucelle, Jean). Major Early *Renaissance artists also practised, or influenced, book illumination: Jan van *Eyck is associated with the manuscript of the Turin Book of Hours, and a number of lavish northern Italian manuscripts were produced in a style derived from *Mantegna. The painters of illuminations are called illuminators. Illuminated illustrations were largely replaced in the 16th century by woodcuts and engravings (see under relief and intaglio prints).

illusionism A special kind of *realism, which is intended to deceive the viewer either into believing that a pictorial or sculptural representation is the actual thing represented, or into misjudging his real environment. The former type of illusionism is often termed trompe l'œil (French, deceive the eye). The latter type

may consist of painted 'extensions' of actual architecture, which rely on a highly technical use of *perspective and *foreshortening. Although trompe l'œil is most often used for objects represented at close range, the distinction is not rigid, and both types of illusionism may coexist. A striking example is the 'cupola' designed by *Pozzo for the Church of S. Ignazio in Rome (c.1685). A flat painting on canvas, it gives, viewed at an angle from the nave, the illusion of a hemispherical cupola complete with articulated and windowed drum, coffering and lantern. The illusion only breaks down when the viewer stands directly under the painting. The pictorial 'extension' of the wall architecture on ceilings and vaults is termed quadratura; a specialist in this field of decoration is a quadraturista. The original centre for this type of painting was Bologna, northern Italy; see also Colonna and Mitelli.

impasto See under oil paint.

Impresa (pl. imprese) See under emblem books.

impressionism A movement in painting, an extreme form of *naturalism, developed in France around 1870 and made public in exhibitions from 1874 on. Abused for a time for disregarding everything conventionally thought necessary for art, Impressionism from the 1880s influenced painters in other countries and found a growing public. By about 1910 it was in wide demand as a benign and unproblematic form of painting, thus contrasting with new *avant-garde tendencies and theories. In the 1890s the French government refused the *Caillebotte bequest, consisting of some of the Impressionists' finest works (after various delays it became the basis of the collection shown in the Jeu de Paume and now in the Musée d'Orsay). Today Impressionist painting draws the largest crowds, the highest prices and the loudest publicity, and is mistaken for a norm in artistic practice. Other art forms adapted Impressionist aims in so far as they could, e.g. sculpture (see Medardo *Rosso), and Impressionism has been emulated in films and photography, but it is fully

represented only in painting. Even there distinction must be made between the true Impressionists and others who influenced them, were influenced by them or for other reasons were part of the wider Impressionist circle.

Thirty painters showed in the 1874 Impressionist Exhibition, when a critic mocked part of the title of *Monet's *Impression: Sunrise* (1872; Paris, Marmottan) and thus named the movement. Four of the group were true Impressionists: Monet, *Renoir, *Pissarro and *Sisley. Their mature work was mostly landscapes, painted in the open air on small white canvases to capture the visual experience. Forms were left undefined, even the human form; a scene was chosen but normally left without the compositional rearranging or completing of traditional landscape painting; these scenes were often sunny and redolent of leisure, and lacked specific content or moral meaning. The fused brushstrokes and modulated colours of traditionally skilled painting gave way to unmixed colours juxtaposed in strokes that spoke of the immediacy of the oil sketch and tended to give an all-over texture and vividness. In addition there was a stylistic unity about these Impressionists' work that made it seem impersonal and incompetent.

The Impressionists were not a defined group with a membership list. Those who exhibited under the label varied from year to year (no exhibitions in 1875, 1878 and 1883–5), affected by disagreements over new associates and over whether or not it was permissible to attempt to show also in the *Salon. *Cézanne, then an informal pupil of Pissarro, showed in the first exhibition, *Gauguin and *Seurat showed in the last (1886), and they are better labelled *Post-Impressionists. *Degas showed from 1874 to 1886 but not in 1882. *Manet, in some ways a father figure to the group, kept aloof from their exhibitions. They learned from the *Barbizon School, from *Turner, *Constable and other English painters, from aspects of *Delacroix and from French landscapists such as *Boudin and *Daubigny, above all from *Courbet as the champion of *Realism and the painter of vivid naturalistic landscapes, but they saw

Manet as an inspiring challenger of academic practice. It is likely that they were influenced by contemporary writers' interest in describing the commonplace (notably Zola who defined a work of art as 'a corner of nature seen through a temperament'), by science's materialism and by philosophical determinism. Most of the Impressionist circle came from simple backgrounds, long struggled against financial difficulties, and inclined to left-wing views but they did not use their paintings to make political points unless of the broadest sort, as in the suggestion that sunshine and fresh air are a blessing to all, that railways were part of their world and that all people, observed at some distance on the boulevards of Paris or in the countryside, are equal to the eye. Brought together by their attention to optical experience, they diverged markedly by the 1880s, so that it would be generally truer to see real Impressionism as a phase in their individual careers and as an extreme which had in time to be abandoned or amended if the painter was not to stand still.

Other countries, especially Germany, the USA and Great Britain, showed Impressionist tendencies from the late 1880s on, and reacted with similar initial hostility, sometimes enhanced by hostility to a French art movement, though the idiom tended to be modified in terms of local preferences. The insistence on optical facts remained exclusive to the French Impressionists in their purest phase, roughly from 1870 to the early 1880s.

imprimitura, imprimatura Italian for 'priming'. A pigmented layer sometimes applied to modify the colour or absorbency of a white *ground, at times over the whole canvas or panel or selectively to certain colour areas. It may consist of paint, glue size or other media.

Indiana, Robert (1928–) American painter, born Robert Clark, associated with *Pop art, who called himself the 'American painter of signs'. He had made *abstract paintings based on natural forms and also wooden constructions. Discarded stencils led him to put letters and words on these and into paintings derived from the

décor of pinball machines. He used key words like 'LOVE', 'EAT', 'DIE', and saw 'himself as an heir of Melville and Whitman; there is nothing "cool" about Indiana's art' (Michael Compton). He enjoyed international success in the 1960s, culminating in a retrospective in Philadelphia in 1968.

Informal Art, translation of *Art informel*: see also Tachism.

Inglés, Jorge (George the Englishman) (active 1450s) Painter active in Castile, where he executed the region's earliest-known *retable in the Hispano-Flemish style, notable for its *donor portraits of the Marquis de Santillana and his wife (Madrid, on loan to Prado).

Ingres, Jean-Dominique (1780–1867) French painter, associated with maintaining the authority of *classical art in the age of *Delacroix and *Romanticism, but in fact the creator of a complex art, of at times dazzling perfection, derived from contradictory sources and governed by a unique sense of pictorial harmony. Born at Montauban in southern France, the son of an artist, Ingres studied at the Toulon Academy and, from 1797, in J.-L. *David's academy in Paris. Like some of his fellow students there, Ingres sought a purified, archaic classicism. He demonstrated it at the Ecole des Beaux-Arts when he won the Rome prize with his *Ambassadors of Agamemnon* (1801; Paris, Ecole des Beaux-Arts), and then trumped that with the amazing *Venus wounded by Diomedes* (1804–5; Basel), flat, hard, and made additionally unrealistic by the use of gold leaf. Only thinly educated in the classics, Ingres here and elsewhere showed his great devotion to Homer as the archaic myth-maker of classical civilization.

His three portraits of the Rivières, father, mother and teen-age daughter (1805), shown in the 1806 *Salon, demonstrated his versatile artistry. The father's rectangular image is both sober and elegant, the mother's a seductive polyphony of curves in an oval format, the daughter's, with its rounded top, a slender, columnar form set against a cool landscape and an innocent blue sky. The same Salon saw his *Napoleon on the Imperial Throne* (1806; Paris Musée de l'Armée) in which, combining elements from *Flaxman and Van *Eyck's enthroned Christ in the Ghent altarpiece, Ingres created a barbaric *icon of power. A similar image dominates his *Jupiter and Thetis* (1811; Aix-en-Provence, Musée Granet), her curves and sensuous gestures profiled against his rock-like façade.

Ingres sent this painting from Rome where he had gone in 1806. There he drew and painted portraits, partly to finance his extended visit, but he also produced studies of the nude, with and without benefit of *History settings, e.g. *Oedipus and the Sphinx* and the *Valpinçon Bather* (both 1806), combining classicism with *naturalism and, in the latter, masterly subtle modelling that contrasts with his earlier hardness. This suavity, almost blinding us to extraordinary distortions, characterizes also his *Grand Odalisque*, an exotic nude of cool sensuality which, shown at the 1819 Salon, threw critics into disarray (1814). More typically at this time, Ingres was painting small, jewel-like History subjects, sometimes in several versions, to catch a new market: e.g. *Paolo and Francesca* (c.1814; Chantilly, Musée Condée, and other versions), from Dante and, from Ariosto, *Roger saving Angelica* (1819), a combination of semi-*Gothic fantasy, echoed in the fantasy art of 1980s comics, and erotic nudity; though the critics hated this too, it was bought by the government.

In 1820 he was commissioned to paint an altarpiece for Montauban Cathedral of the *Vow of Louis XIV*, intended to advertise the Bourbon monarchy's piety. In it he combined forms from de *Champaigne and from *Raphael. Although he was unable to reconcile these sources, the result was greatly admired at the 1824 Salon. Ingres had come to Paris with the painting and found himself enrolled as the head of the traditionalist party in French art. In 1825 he was awarded the Légion d'Honneur and membership of the Academy, and became one of its most ardent and effective teachers, in spite of (or because of) his singularity and eccentricities. He was

commissioned to paint a ceiling canvas for the Louvre and produced the *Apotheosis of Homer* (1827) showing his hero reigning over major artists, poets and musicians, including *Raphael, Dante, *Poussin, Shakespeare, Racine and himself, all arranged in a symmetrical composition.

In 1834 he showed another large altarpiece at the Salon to find it severely criticized by a press doubtful of the value of such pictures. He swore never to show at the Salon again and left for Rome to direct the French Academy there for six years. A painting he did there in emulation of David, *Antiochus and Stratonice*, was exhibited in Paris in 1840 and received with enthusiasm in spite of its cold, sharp colours and dangerous subject (incestuous longings, from Plutarch). Ingres returned to Paris in 1841 the undisputed master of French art (though Delacroix threw doubts on his intelligence, meaning perhaps his education).

In 1849 Ingres's wife died and he felt his career was ended. In 1852, aged 72, he married again and burst into action with a series of fine portraits, including *Madame de Moitessier Seated* (1844–56; London, National), a powerful combination of naturalism and a figure design taken from the Greek frescos at Herculaneum. The *Turkish Bath* (1862), based on accounts of life in Constantinople, serves as an anthology of his representations of female nudes, heaped up here in irrational eccentricity. In its original square form it was considered indecent by Prince Napoleon who had commissioned it; reworked and made circular, it entered the collection of the same Turkish tycoon who soon after acquired *Courbet's painting of lesbian lovers, *Sleep*. This linking of major works by the uncouth new *Realist and the visually highly sophisticated traditionalist, joined by their passion for the representation of female flesh and, in these works, by their lack of tact, is a comment on the limitations of stylistic categories.

Long respected and disdained for his role as chief academician and the opponent of Delacroix, Ingres is now seen as one of the truly great and inventive painters of his century and at times an influence on ours. *Degas was his heir in some ways, as was *Seurat; *Picasso greatly admired his draftsmanship. Recent studies have emphasized the diversity of Ingres's interests and shown *Romantic impulses at work within the classicist. There are major collections of his work in the Ingres Museum in Montauban and in the Musée d'Orsay, Paris (home of the works mentioned here without a location). He was the subject of a major exhibition in New York (Metropolitan) and London (National) in 1999.

ink Coloured fluid used with a pen or brush for writing, drawing or painting. Artists' inks, which stain but have no body, have been prepared from various substances – such as lampblack, red ochre, or ferrous sulphate boiled with plant galls – bound in gum and water. Inks were used in China and Egypt by the 3rd millennium BC, moulded into dry sticks or blocks, diluted with water for use. Ink in dry form, whether imported from the East or not, is still called 'Chinese' or 'Indian/India ink'. Printers' inks are pigments mixed with oil and varnish, and are opaque.

INKhUK Acronym of the Russian for Institute of Contemporary Culture, founded in Moscow in 1920 under the Commissariat of Enlightenment, at Kandinsky's suggestion, to investigate the constituent elements of art and test their psychological action. Debate led to dispute and at the start of 1921 Kandinsky resigned, yielding to a group led by *Rodchenko, Aleksei Gan and Aleksei Babichev, dedicated to a more objective and anti-psychological programme. A similar institute was created in Petrograd in 1922, with *Malevich and *Tatlin as heads of sections for a time. This closed in 1927, INKhUK in 1929. Both had been fora for the discussion of principles and methods, in particular those of *Constructivism.

Innes, George (1825–94) American landscape painter whose mature style was formed in France, where he associated with the *Barbizon painters, and in Italy. His work became very popular thanks to the luminosity and poetic imprecision with

which he communicated a mystical view of the world.

Innes, James Dickson (1887–1914)

British painter, principally of landscapes. He was an associate of Augustus *John, like whom he brought qualities of modern French painting into his work, notably aspects of *Matisse, without committing himself to *Modernism or sacrificing his personal, visionary qualities.

Installation art

The 1960s saw young artists' career paths blocked by older generations or waves of commercially viable individuals and movements. This added necessity to the widespread urge, conspicuous in the art schools, to fuse and enlarge the range of pursuits and means that could be brought under the umbrella of 'art'. *Happenings, *Performance art, Earthworks and *Installation art were some of the ways in which this was explored, and these could also be offered as going beyond the traditional art forms and evading the commercial system of art objects brought to market through galleries, and thus claim especial virtue. Installations were often ephemeral, made for one place or occasion, though collectables ones, not made for one specific site, have also been created that can be set up and taken down and stored: for example, Walter *De Maria's *Earth Room* (1968) has been exhibited more than once and is now a permanent installation in New York, and the British sculptor Richard Wilson's work *20:50*, a room part-filled with sump oil to be viewed from a footbridge, was shown in Matt's Gallery, London, in 1978 and again in Edinburgh at the Royal Scottish Academy and is in the London collection of Charles Saatchi. Michael *Craig-Martin's still-life line drawings of clustered objects are made of adhesive tape and can be made, unmade and made again by those who own them as mural form of Installation art. In the 1960s the Groupe Recherche d'Art Visuel made kinetic light environments that could travel. Yves *Klein's exhibition *Le Vide* (The Void), shown in Paris in 1958, was an empty gallery room and is sometimes pointed to as the first installation, but before that there were Lucio *Fontana's

Spatial Environments and a number of dramatically installed *Surrealist exhibitions, made by *Duchamp and others, in which individual works of art became elements in a complex and compelling environment, while some of the *Dadaists' exhibitions, notably in Berlin and Cologne, were arranged to make a shocking general impact. In 1923 *Lissitzky created his *Proun Room* as part of an exhibition in a Berlin railway station: *Proun* forms, like those in his paintings and prints, now disposed in two and three dimensions on the six internal sides of a cubic space large enough to be entered and viewed.

intaglio prints

These are made by tearing, cutting or eroding the surface of a highly polished plate of metal, usually copper. The marks thus made can hold printer's ink and can be printed on paper in a press (compare with relief prints). The three basic processes of intaglio printing are drypoint, engraving, etching. *See also* mezzotint, aquatint.

In *drypoint* a sharp round point is used to tear the surface of the plate by being thrust into the metal and dragged along through it. It creates a rut or trench and a ridge, or burr, of displaced metal standing up on either side of the rut. The burr gives a velvety quality to the printed line but wears away quickly during printing.

In *engraving* a trench is cut in the surface of the plate by a graver or burin which gouges or scoops out a shaving of the metal as it travels along the surface. Even the sharpest burin will still leave a minute burr along either side of the rut. In early 15th-century engravings this burr was left to wear away in the course of printing; later engravers scraped the burr away before printing, ensuring greater uniformity between impressions. *See also niello*, Finiguerra, Maso.

In *etching* the lines to be printed are eroded in the surface of the plate by chemical means. The plate is covered with a ground, composed principally of wax; this ground may be coloured, or blackened with smoke after it is laid. The etcher uses a point to draw his design on the ground, just hard enough to pass through the ground but not to dig into the metal. Acid

is then applied to the surface; it bites into the exposed metal of the drawn lines, but does not attack the metal covered by the ground. The length of exposure to the acid determines the depth of the lines, and thus the amount of ink they will carry. Parts of the design can be covered with ground, or 'stopped out', and the rest of the plate bitten again thus providing variations of tone in the finished print.

Intaglio plates are printed by having tacky printer's ink spread over the warm plate and worked down into the lines. The surface of the plate is then wiped, more or less clean at will, and the inked plate is laid face up upon the bed of the press. Damp paper is then laid on the plate; protected by blankets or felts; and the bed is rolled through the press, so that the soft paper is pushed into the inked trenches of the plate and takes up the ink. The lines in an intaglio print will stand up above the surface of the paper.

Thomas *Bewick (1753–1828) developed an intaglio printing process using 'end wood', or blocks of wood cut across the grain. Wood engraving became a standard 19th-century method of book illustration.

intarsia or tarsia Italian word for marquetry. An inlay technique used for creating designs in different coloured woods, or on wood with other materials such as ivory. Wood intarsia was much used in *Renaissance Italy for decorating choir stalls (*Lotto, Bergamo, Sta Maria Maggiore) panelling and cupboards (celebrated schemes were executed for Federico da'Montefeltro in the ducal castles of Urbino and Gubbio; the latter ensemble now New York, Metropolitan). Wood intarsia, more easily made with straight-cut than curved pieces, often explored the effects of linear *perspective. *Donatello is said to have chided *Uccello for his excessive interest in this subject by telling him that his drawings of perspectival 'oddities' were 'only fit for intarsia.'

Intimism From the French term *Intimisme* used for the small and undramatic domestic scenes painted by *Bonnard and *Vuillard in the 1890s and 1900s, remarkable for the similar but distinct ways

in which the two painters explored harmonies of form and colour, silhouettes and patterns.

intonaco *See under* fresco.

invenit, inv *See under fecit.*

Ipoustéguy, Jean (1920–) French sculptor who, in the 1960s, became known for elaborate figurative sculptures and 'sculptural landscapes' usually in bronze, more recently also in marble. In 1964 he won a major prize at the Venice Biennale.

Irwin, Robert (1928–) American artist who turned from painting canvases, via study of perceptual psychology, to creating effects of light and space which would put 'the viewer in the *Mondrian', as he said. In 1968–9 he produced a series of 'disk paintings' by spray-painting near-white colours on to gently convex circular surfaces; properly hung and lit they hover mysteriously, inflecting space and light. There followed polished prismatic plastic columns and environments reformed by screens of light, string and scrim, and public works such as his *Three-Ring Maze* in Seattle, where blue fencing material and plum trees cheer visitors to the jail. He has exhibited frequently in the USA and occasionally in Europe.

Isaia da Pisa (active 1447–64) Ill-documented sculptor from Pisa, active mainly in Rome, where he adopted *Filarete's *classical style (St John Lateran; S. Salvatore in Lauro; S. Agostino; St Peter's; Grotte Vaticane). He worked also in Orvieto (1450–1) and on the Aragonese Triumphal Arch in Naples (1456–9; *see also* Francesco Laurana). His son **Gian Cristoforo** (*c.*1470–1512) trained originally as a metalworker but later practised also as an architect and marble carver. Taught by Andrea *Bregno, he brought his classicizing sculptural style and decorative repertory back to Bregno's native Lombardy where, as **Gian Cristoforo Romano**, he worked from 1491 to 1501 on the Visconti monument in the Charterhouse in Pavia, influencing Benedetto

*Briosco and *Amadeo amongst others. Charged with the reliefs of the Holy House at Loreto, he died before he could execute any of them, and was succeeded by Andrea *Sansovino.

Isenbrandt or Ysenbrandt, Adrian *See under* David, Gerard

Isidro de Villoldo *See under* Berruguete, Alonso.

Israéls, Jozef (1824–1911) Dutch painter, a leading figure of the *Hague school, once highly regarded for his pathetic *genre paintings, now perhaps too readily disregarded in the context of Modernism and its successors. He studied painting in Amsterdam and then travelled to Paris and in Germany before settling in The Hague. Many of his paintings speak of the lives of fisherfolk; others deal with Jewish history and customs. His initial debt to *Rembrandt was gradually modified by elements of The Hague *naturalism and even touches of *Impressionism: his literary emphasis gave way to more purely pictorial communication through tone and at times very beautiful colour. His portraits are warm and grave.

Istoria *See under* genres.

Itten, Johannes (1888–1967) Swiss painter and teacher, son of a teacher and first trained as one. After some attempt to study art in Geneva he tried Stuttgart where from 1913 to 1916 he worked under *Hölzel and met *Schlemmer and *Baumeister. In 1915 he painted his first *abstract pictures and in 1916 contributed to an exhibition, 'Hölzel and his Circle', shown at the *Sturm Gallery. During 1916–19 he worked in Vienna. He opened his own school, admitting a variety of mature students and devising a common course to provide analytical and expressive experience and reveal the talents of each. He met Alma Mahler and through her the architect Walter Gropius who invited him to teach at the *Bauhaus. There, during 1919–22, he developed his Basic Course and also for a time directed the work of the craft workshops. Stimulated by Oriental

philosophy and practices he also promoted an ascetic way of life which appealed to young people in that time of post-war confusion and stringencies. He resigned in 1923 when Gropius introduced a more industry-orientated programme. His painting had moved on from expressive abstract compositions to symbolic semi-*naturalistic ones. From 1926 to 31 he worked and taught in Berlin in his own school, developing his colour theory. In 1930 he published his *Tagebuch* (diary) as 'a contribution to a counterpoint of art'. In 1932 he moved to Krefeld where he developed his ideas at a textile design school. In 1938 he moved to Amsterdam. On his 60th birthday he was offered the directorship of the Zurich Museum of Applied Art and its School. He also took on direction of the Zurich Textile School and formed the Rietberg Museum of non-European art. He published books on colour (1961) and on his Bauhaus teaching (1963). In 1966 he exhibited within the Venice Biennale; other major exhibitions included those in Amsterdam (1957), Zurich (1964) and Bern (1971). His later work ranged from delicate nature studies to abstract colour compositions.

Ivanov, Alexander (1806–58) Russian painter, son of a professor at the St Petersburg Academy and trained there. In 1830 a scholarship took him through Germany to Rome, where he stayed until 1857, giving most of his time to preparing one major painting, *Christ Appearing to the People*. This, almost a Baptism of Christ but placing its emphasis on the event as Christ's beginning his mission to all the world, involved endless studies and research. Ivanov was in touch with the *Nazarenes and influenced by their attention to detail; like them he worked with missionary zeal, encouraged in this by the writer Gogol.

The vast painting finished, he moved it with difficulty to Russia where it was exhibited and much discussed. Ivanov began planning and finding sponsorship for a worldwide network of temples to all the religions as a step towards universal brotherhood. His work continued to hold attention in Russia as a potent democratic

statement, and Ivanov was one of the few artists to be included in Lenin's plan for monuments to the precursors of the 1917 Revolution. The critic Punin called *Christ Appearing to the People* 'the first modern painting'. It is now in the Tretyakov Museum in Moscow together with a few other works; others are in the Russian Museum, St Petersburg.

ivory The hard, smooth yellowish-white substance forming the tusks of certain animals, notably elephants and walrus. It has been prized as a carving material since antiquity, when it was sometimes combined with gold. Carved ivory plaques were laid over wood by Early Christian, *Byzantine and early medieval artists to make book covers for manuscripts of the New Testament, and liturgical objects of every kind, even a celebrated 6th-century bishop's throne (Ravenna, Archiepiscopal; London, British), while the natural curvature of whole elephant tusks was exploited in *Gothic statuettes, particularly those of the Virgin Mary.

Jackson, Gilbert (recorded 1622–40) Minor English portrait painter influenced by Cornelius *Johnson. Although based in London, he probably travelled the provinces; some twenty signed and dated portraits by him are known, and others can be recognized by his liking for dresses of strong grass green, often with garish vermilion bows. Perhaps his most impressive work is he portrait of *Lord Keeper Williams* (1625, Oxford, St John's College).

Jacobello da Messina *See under* Antonello da Messina.

Jacobello del Fiore (recorded 1394–1439) First important native Venetian painter of the 15th century, working in a decorative International *Gothic idiom influenced by *Gentile da Fabriano's and *Pisanello's *frescos in the Doge's Palace – although one of his last works is a version of *Guariento's 1365/7 *Coronation of the Virgin* (Venice, Accademia).

Jacopo da Empoli (1551–1640) His real name was Jacopo Chimenti. Florentine painter, born in Empoli. After *Santi di Tito, he is a leader of the Florentine reaction against the cold *Mannerism of *Vasari (*see also* Poccetti, Bernardino), deliberately returning to the values of the Florentine High *Renaissance as represented by *Andrea del Sarto and Fra *Bartolommeo, and the early, *expressive *maniera* of *Pontormo. He became an excellent copyist of these masters, passing on this talent to his pupil Felice *Ficherelli. His independent works are notable for clarity, strong colours, forms of monumental simplicity allied to an interest in *naturalistic gesture and detail of costume or setting. In addition to his forceful altarpieces (Florence, S. Remigio; SS. Annunziata; Plymouth, Museum) he executed *still lifes and portraits of distinction, and worked on festival decorations.

Jacquemart de Hesdin (recorded 1384–*c.*1413) Franco-Flemish painter and illuminator, documented at Poitiers and at Bourges, in the service of the Duke of Berry, for whom he illuminated several sumptuous *Books of Hours. His refined style is influenced by Jean *Pucelle and directly by Italian models. He was followed in the Duke's service by the *Limbourg brothers.

Jacquet, Alain (1939–) French artist associated with *Pop art. His speciality was redoing well-known paintings by posing them with modern people, photographing them and then printing them on canvas in a way that, like half-tone printing, shows the images as dots. This demotion of famous works was accompanied by multiplication: some of Jacquet's pictures were *multiples, produced by the hundreds like colour reproductions – which they almost are.

Jamesone, George (*c.*1590–1644) Scottish portrait painter, working in a style akin to that of Cornelius *Johnson (Kincardine, Kinnaird Castle; Edinburgh, National). He was the teacher of John Michael *Wright.

Jamnitzer, Wenzel (1508–85) Viennese-born goldsmith and sculptor working in Nuremberg from before 1534, the eldest member of a large dynasty and founder of a long-lived workshop. He specialized in small figures, reliefs on caskets and ornamental table-ware in an Italianate *Mannerist style. The small scale of his work belies its lasting and widespread influence (Munich, Residenz; Amsterdam, Rijksmuseum; Vienna, Kunsthistorisches; Berlin, Staatliche; New York, Morgan Library; etc.). **Christoph Jamnitzer** (1563–1618) is, after Wenzel, the best-known member of the family.

Janssen, Hieronymous (called 'The Dancer') *See under* Francken.

Janssens, Abraham (1573/4–1632) Italianate Flemish painter, one of the leading artists in Antwerp before the arrival of *Rubens in 1608. He made at least one trip to Rome, in 1598 (a second trip *c*.1604, in which he would have seen the work of *Caravaggio, has been postulated but is not documented). His early work is in a complex *Mannerist idiom indebted to *Spranger (*Diana and Callisto*, 1601, Budapest, Museum), but he later came to paint in a powerful, monumental, *classicizing style (Antwerp, Musum; Malines, St Janskerk; Valenciennes, Musée). Towards the end of his life, however, he fell under the spell of Rubens, loosening his brushwork and the clear architectonic structure of his previous figure design (1626, Ghent, St Michael).

Jardin, Karel du *See* Dujardin, Karel.

Jarman, Derek (1942–96) British painter, stage designer, filmmaker and writer. Trained in stage design at the Slade School of Art in London, Jarman became known in the late 1960s as painter and, partly through working for the filmmaker Ken Russell, as set designer. His own filmmaking, relying on the super-8mm camera and subsequently on video, involved much technical experimentation and tended to sophisticated, often specifically art-centred subjects observed with the eye of a painter. They ranged from *Caravaggio* and *The Tempest*, based on the life and work of the painter and on Shakespeare's play, to *Blue*, a screen filled with light while the spectator's imagination is fed with sound and words; made in the last year of his life it dealt openly with the certainties and daily uncertainty of AIDS and the drugs with which he was expected to combat it and their side-effects. His eyesight deteriorated drastically in his last years but he had continued to paint throughout his life and never quite gave up. He wrote poetry and books reflecting on his work, and then also on his illness and approaching death with fear and resolution, anger and love. His creativity seemed infinite, filling even his last years with exhilaration and giving him a saintly image in the eyes of his growing public.

Jawlensky *See* Yavlensky.

Jean de Liège (*d*.1382) Sculptor from the Southern Netherlands, recorded in Paris as a 'maker of tombs'; he was employed by Charles V of France, but most of his work has been destroyed. An exception is the tomb of Philippa of Hainault, Queen of England, in Westminster Abbey, London (*c*.1365–7).

Jegher, Christoffel or **Christophe** (1596–1652/3) Flemish printmaker, the leading specialist of his time in the old-fashioned technique of woodcut (*see under* relief prints). Active in Antwerp, he specialized in book illustration and decoration, but is best-known for his superbly vigorous *reproductive prints, many of them in *chiaroscuro with the use of colour, after *Rubens, dating mainly from the early 1630s and made in direct collaboration with the painter.

Jenkins, Paul (1923–) American painter who worked in both New York and Paris on *abstract canvases of veils and rills of paint. His intention was to confront us with visual splendour: 'I paint what God is to me', he said. The influence of Morris *Louis and Helen *Frankenthaler is patent but white priming keeps the thinned paint on his surfaces, so that the visual quality is different. A film made about him in 1966 – *The Ivory Knife* – won the Golden Eagle award.

Jensen, Alfred (1903–81) American painter trained at San Diego, in Munich and in Paris where he was influenced by *Masson and *Herbin. In 1951 he settled in New York and began to exhibit regularly. From the mid-50s on he developed his characteristic way of using paintings to present discoveries about colour, numbers and number structures, magnetic phenomena, etc., which he said manifested the interconnectedness of the world and humanity's place in it.

Jervas or **Jarvis, Charles** (*c*.1675–1739) Irish-born portrait painter, active mainly in London. After studying with *Kneller he spent some years travelling throughout the

Continent, settling in Rome in 1703 and returning to London in 1709. He painted portraits mainly of his literary friends (e.g. *Jonathan Swift*, London, NPG) and of aristocrats, and in 1723 was appointed Principal Painter to George I. Immensely conceited, he painted copies after *Van Dyck and *Titian, which he felt, mistakenly, rivalled the originals.

Joanine style A Portuguese form of *Rococo associated with King John V and flourishing *c.*1715–35, which was evolved by Italian and French artists attracted to Portugal by the new wealth created through the discovery of gold and diamonds in Brazil. One of its main exponents was the French sculptor **Claude Laprade** (active 1699–1730; e.g. clay figures, altar, 1727, Oporto, cathedral).

Joest of Kalkar, or of Haarlem, Jan (1455/60–1519) German-born painter, often surnamed after the town of Kalkar, where he painted the wings for the sculptured high altar of the church of St Nicholas. In 1509 he settled in Haarlem. He may have trained in the Netherlands, for his style is influenced by that of the Haarlem master Albert Ouwater, the teacher of *Geertgen tot Sint Jans, as well as by Gerard *David of Bruges. His work is characterized by an expressive mix (*see under* expression) of Late *Gothic agitation and Italianate *Renaissance clarity. A number of independent, psychologically penetrating portraits by him survive. He was a relative, and perhaps the teacher, of Bartel *Bruyn.

John, Augustus (1878–1961) British painter, born in Tenby in Pembrokeshire (Wales), brother of Gwen (*see* next entry). He studied at the Slade School of Art in London, was admired there as draftsman and won a painting prize with a *History painting rich in Old Master echoes but served up with modern slightness. He was to go on attempting monumental subject paintings and making drawings and sometimes etchings in great number and of varying quality, but his main activity was portrait painting, of the rich and famous, of his women and children and of the gypsies

he sentimentalized and when convenient emulated. He displayed his admiration for the Old Masters; less obvious is his response to the new art of Paris, especially *Picasso's and *Modigliani's stylishness. During the 1914–18 war he served as Canadian War Artist but produced only studies of individual soldiers, not the monumental paintings asked for. Among his finest portraits are those of eminent writers; his love of women and eye for a pleasing silhouette gave some of his female portraits verve. But it was John's personal vividness – Bohemian behaviour combined with intimacy with top people – that brought him the notoriety plus indulgence with which British society rewards its favourites. In 1942 he was awarded the Order of Merit.

John had his first one-man show in 1899. He exhibited regularly with the *New English Art Club from that year on. He became an Associate of the Royal Academy in 1921 and a full Academician in 1928. The American collector John Quinn, his patron for some years, caused his work to be prominent in the 1913 *Armory Show, thus creating an American public for his work. In due time John's great reputation brought a reaction, so that a London exhibition in 1954 served more to question his fame than to justify it. His autobiography, *Chiaroscuro*, was published in 1952.

John, Gwen (1876–1939) British painter, sister of Augustus whose contemporary she was at the Slade School. She then studied in Paris, settling there in 1904. She worked as a model and thus met *Rodin who was her lover as well as employer for some years. He urged her to work at her drawing yet considered her an amateur. She had in fact exhibited occasionally with the *New English Art Club, had shared a London exhibition with Augustus in 1903 and was included in the *Armory Show in 1913. In Paris she sometimes sent work to the annual artists' exhibitions, and there was a little solo exhibition of her work in London in 1926. She painted lively copies of a 17th-century portrait of its founder for the Convent at Meudon; her direct portraits are more taciturn than these, but combine simplicity

with unusual delicacy of tone and texture. She also produced a few fine interiors and flower studies, as well as drawings and watercolours of outstanding quality. Her range was small but her artistic ambition is revealed within it, as well as an uncertainty which led her to rework formal devices. She lacked entirely her brother's personal vividness and lived a secluded life, eluding recognition of her exceptional qualities as artist. Her reputation has risen since her death, beginning with a memorial exhibition shown in London in 1946. In 1968 and 1985 there were major exhibitions, also in London.

Johns, Jasper (1930–) American artist, who came to New York from South Carolina in 1949 and became known in the mid-1950s for his representations of the American flag and other standard images such as targets and numbers, and was thus associated with *Pop art. He was soon attaching real objects to his paintings and going on to making sculptures; he also turned from typical images or signs to covering canvases with *abstract marks. He was asserting an art of thought and irony against the heart-on-sleeve rhetoric of *Abstract Expressionism. *Duchamp was his particular hero: Johns too sought an art of paradox: 'I think that the picture isn't pre-formed, I think it is formed as it is made; and might be anything . . . And I think that the statements one makes about finished work are different from the statements one can make about the experience of making it' (conversation with David Sylvester, 1965). His intelligent and inventive work attracted thoughtful criticism and, after the shock of seeing America's renowned school of painting questioned, patronage. His first solo exhibition in 1958 was followed by many others; already in 1959 some of these were in Europe. In 1964 his first retrospective was shown in New York. In 1967 he won first prize at the São Paulo Bienal and at the International Exhibition of Prints in Ljubljana (Yugoslavia). A retrospective was shown in New York in 1977 and Johns has continued to hold the attention of the art world, winning the chief painting prize at the Venice Biennale in 1988.

Johnson, or **Jonson, Cornelius** (1593–1661/2) British-born portrait painter and miniaturist of Flemish and German extraction; he fled from the Civil War in 1643 and settled in Holland, where he may have trained as a youth, and where he is also known as Janssens van Ceulen. He died at Utrecht (pendant portraits of *Baron van Lieve and his Wife*, Centraal Museum). His English works, dating from 1619, consist mainly of portrait busts in fictive stone or marble oval surrounds (e.g. *Lady of the Kingsmill Family*, Sussex, Parham Park) although under the influence of *Mytens he also ventured into the three-quarter length showing the hands of the sitters (*The Family of Arthur, Lord Capel*, 1639, London, NPG). In his latest English works the influence of *Van Dyck is discernible (London, Blackheath, Ranger's House), with a loss of Johnson's own shy and retiring charm.

Jones, Allen (1937–) British painter, prominent in the British *Pop art wave of the early 1960s. His first solo exhibition was in London in 1963; the following year he had one in New York, since when he became one of the most exhibited of British artists around the world. Images of women and couples dominated his work and he found elements of style as well as subject in fetishistic sex magazines. His richly endowed, erotically costumed sculptures of women as furniture (1969) mark an extreme in his pursuit of the theme of woman as a fantasy object and tended to overshadow his continuing exploration, through carefully wrought paintings and, increasingly, sculpture, of the languages of erotic fantasy and of advertising. He contributed ideas and designs to a number of stage, film and television presentations but showbiz involvement remained a seeding element in his work, a form of applied research which stimulates his studio work. A retrospective exhibition toured British and German centres in 1979–80.

Jones, David (1895–1974) British painter and writer of Welsh extraction. He studied in London in 1909–15 and also, after war service, from 1919 to 1922. He became a Roman Catholic in 1921 and

joined *Gill's community for some years. An urge to *primitivism struggled with his visionary temperament. He was a member of the Seven and Five Society from 1928 until 1933 when a breakdown led him to give priority to writing. *In Parenthesis* (1937), in prose and verse, was hailed by T.S. Eliot as a work of genius; a second major text, equally difficult to classify, is *The Anathemata* (1952). In the 1940s painting, drawing and making watercolours again dominated his work and took on a markedly personal character, modern in some respects, in others traditional, as he found ways of narrating elaborate legends or describing simpler subjects such as still lifes in long, fine lines and gentle colours. A retrospective was shown in London in 1954. His death was followed by memorial exhibitions in Cambridge and London.

Jones, Inigo (1573–1652) British draftsman and architect; adviser on art and antiquities to the Earl of *Arundel and King Charles I. Before he became Surveyor of the Office of Works in 1615 he was employed at the Stuart court mainly as a designer of masques – theatrical entertainments for which leading poets, such as Ben Jonson, wrote the texts and which were acted out by royalty and courtiers in mythological and allegorical guise (*see* allegory). Although Jones is celebrated for introducing a pure *Classical style – based on the work of the Italian *Renaissance architect Andrea Palladio – to England (Greenwich, Queen's House; London, Whitehall, Banqueting House), his innovative and eclectic scenery and costume designs are indebted to *Mannerist artists such as *Buontalenti, *Rosso, *Primaticcio, *Parmigianino and *Schiavone, whose work he would have known from books and prints before studying it at first hand on his voyages to the Continent around 1600, in 1603, 1609 and with Arundel in 1613–15. The finest collection of Jones's drawings is at Chatsworth House, Derbyshire.

Jones, Thomas (1742–1803) British landscape painter, a pupil of *Wilson and, like him, a Welshman. His ambitious *idealized landscapes with 'histories' in the style of Wilson have been largely forgotten (St Petersburg, Hermitage), and he is mainly known for the watercolour sketches made directly from nature during his years in Rome and Naples, 1776–82/3, which in their luminous spontaneity anticipate those of *Corot (Cardiff, National; London, National).

Jongkind, Johan Barthold (1819–91) Dutch painter who worked mostly in France and is seen as a precursor of *Impressionism on account of his response to light and atmosphere, particularly in the many seaside paintings he did on the Normandy coast. He was associated with the *Barbizon painters but worked in a lighter, more spontaneous manner than they, also making etchings in which delicate lines create a fine atmospheric effect.

Joos van Cleve (also known as Joos Van Cleef) (active by 1511–1540/1) Formerly known as the Master of the Death of Mary (after two paintings on this theme, 1515, Cologne, Museum; Munich, Alte Pinakothek) his real name was Joos van der Beke, but he was called after his native town of Cleves. Active in Antwerp from 1511, he was dean of the guild in 1515 and 1525, and one of the most prolific and eclectic of the city's painters. He was influenced by earlier Flemish art (e.g. *Gossart, *Patinir, *Metsys), by *Dürer, by *Raphael – whose tapestry cartoons had arrived in Brussels in 1517 – and by *Leonardo. The latter's influence was probably transmitted to Joos during his stay at the court of France, where he was invited by Francis I to paint portraits of the king and his entourage (Philadelphia, Johnson Coll.; Hampton Court). There are also works by Joos and his workshop in New York, Metropolitan; Brussels, Musées; Vienna, Kunsthistorisches; etc. His son **Cornelis van Cleve** (1520–67) was also a painter.

Joos van Ghent (also **Justus of Ghent**; and in Italian, **Giusto da Guanto**) (active 1460–*c*.80) Netherlandish painter, **Joos van Wassenhove**, best known for his work at the court of Urbino in Italy. His documented altarpiece of the *Communion of the Apostles* (*Institution of the Eucharist*),

1472/4, which has a *predella by *Uccello, is still in Urbino (ducal palace, now Galleria). Much of the decoration he designed, and executed in collaboration with his assistant, 'Pietro Spagnuolo' (identified as Pedro *Berruguete) for the Duke of Urbino's private study or *studiolo*, however, has been dispersed. Fourteen mainly imaginary portraits of illustrious men (1476) are still in the *studiolo* (Urbino, ducal palace) but another 14 are in Paris, Louvre. A portrait of *Duke Federico da Montefeltro with his son* is in Urbino; another of the *Duke with courtiers listening to a lecture* is in the British Royal Collection. Two allegorical figures of *Liberal Arts*, perhaps from the *studiolo* of the Montefeltro palace at Gubbio, are now in London, National; a further two from the original set of seven were in the Berlin Museum, but were destroyed in World War Two.

Joos's birthplace and training are unknown. He matriculated in the painters' guild in Antwerp in 1460; was in Ghent from 1464 to 1468/9, and in contact with Hugo van der *Goes, for whom he stood guarantor with the painters' guild, in 1465 and 1467. Some time after 1468 he left for Rome, to spend the rest of his life in Italy. In addition to the works listed above he has been generally credited with the authorship of a painting in tempera on linen (New York, Metropolitan) and a triptych (*see under* polyptych) in the Cathedral of St Bavo, Ghent.

Jordaens, Jacob (1593–1678) The leading painter in Antwerp after the death of *Rubens. He was apprenticed to Adam van *Noort, who later became his father-in-law, becoming a Master of the Antwerp painters' guild, specializing in fictitious tapestries in watercolour, in 1615, and Dean of the guild in 1620–1. His early works show the influence of *Van Dyck, of the *classicizing style of Rubens *c*.1610, and of *Caravaggio, although he himself never went to Italy. From *c*.1620 many of his paintings were completed with the help of his pupils. Although he continued to borrow motifs from Rubens, his work from 1620–35 is marked by greater *realism, a tendency to crowd the surface

of his pictures, a preference for burlesque even in lofty themes and on a large scale (e.g. *St Peter finding the Stater*, also called *The Ferry at Antwerp*, Copenhagen, Museum). In these years he also painted illustrations of Flemish proverbs and boisterous depictions of Flemish festivals and feasts. During 1635–40, when Rubens was ill with gout, and after his death in 1640, Jordaens was called upon to work from Rubens's sketches (e.g. Madrid, Prado) and to complete large-scale decorations originally commissioned from Rubens (e.g. for the Queen's House, Greenwich; now lost). These works show a falling-off of his exuberance, which was fully recovered, however, *c*.1645, most notably in his huge decorative canvas of 1652, the *Baroque *Triumph of Prince Frederick Hendrik of Orange* (Huis ten Bosch). In his later years Jordaens joined a Calvinist community tolerated in Catholic Antwerp. The restrained classicism and cooler colour of his late paintings, many of them on moralizing subjects, fit well both with a new general artistic trend imported from France and with his religious convictions (e.g. Kassel, Gemäldegalerie). He never ceased, however, to carry out commissions for Catholics. In addition to the works mentioned above, there are paintings by Jordaens in churches and museums in Antwerp, and in many galleries throughout Europe and the USA.

Jorn, Asger (1914–73) Danish artist, born Asger Jørgensen. He worked with *Léger in Paris in the 1930s and in Denmark during the Second World War. In 1948 he was one of the founding members of the *Cobra group and became known as a leading member of the *Expressionist, semi-*abstract tendency associated with that group and seen as part of *Art informel. His paintings, some of them large murals, are sometimes abstract but more often peopled with mythical creatures, called up by energy and paint and left precariously balanced on the line between monstrosity and black humour.

Josephson, Ernst (1851–1906) Swedish painter, trained in Stockholm and

in Paris where he became a central figure in a Swedish artistic circle. His paintings combined a *realism rooted in *Courbet with mythical subjects, beautiful but disturbing and expressing his fear of spiritual forces; after a breakdown in 1888 they are more graphic in technique and utterly personal in their treatment of religious themes. This brought his art close to that of *Ensor and of *Nolde. When a group of his pictures was shown in Berlin in 1909, Nolde bought several of them.

journeyman (from French *journée*, a day's duration) Under the guild system governing the professional activities of artists in most northern European cities (and, less thoroughly, in Italy) in the Middle Ages and the *Renaissance, a journeyman was someone who had completed his apprenticeship but had not, or not yet, become a master allowed to set up his own establishment. The term implies that a journeyman is hired by the day, but this was in fact rarely the case; various city statutes specify that he might be hired by the week, the month or the year, and others lay down a minimum period of notice. A young artist on his *Wanderjahre might work as a journeyman (*see* e.g. Dürer), although little is known of the mobility of journeymen as a group.

Jouvenet, Jean (1644–1717) French painter, born at Rouen. After his move to Paris, he was strongly influenced by the art of *Poussin; *Lebrun became his patron, and gave him many royal commissions, although Jouvenet gradually grew away from his influence. Despite being one of the few members of the French Royal *Academy not to make the voyage to Italy, he became increasingly attached to *classical ideals, specializing in grandiose altar paintings of austere colouring, often in several versions of the same composition (e.g. *Deposition*, Pontoise, St-Maclou; St Petersburg, Hermitage; Dijon, Palais des Etats; Toulouse, Musée). Engravings after his paintings assured the wide diffusion of his work. He was the maternal uncle and teacher of Jean *Restout the Younger.

Juan de Flandes (recorded 1496–1519) Spanish painter of Flemish extraction, employed at the court of Queen Isabella of Castile from 1496. After her death in 1504 he worked for Salamanca University and Palencia Cathedral. He is remembered for an extensive series of delicately-painted miniature panels, mainly with scenes from the life of Christ and the Virgin Mary, once assembled as an altarpiece for Queen Isabella (now dispersed e.g. Madrid, Royal Palace; Washington, National; Paris, Louvre; Detroit, Institute; London, National). Three of the original series were painted by **Michel Sittow** (1469–1525), a painter of German extraction trained in the Netherlands and employed at the court of Castile between 1492 and 1502; he was in Spain again in 1515–16 (Washington, National; Paris, Louvre).

Juan de Juanes *See under* Masip, Juan Vicente.

Juan de Juni *See* Juni, Juan de.

Judd, Donald (1928–94) American painter, sculptor and critic, trained in New York, best known for *Minimalist sculptures he preferred to call Specific Objects. During his time as a painter, mostly in the 1950s, he was better known as an exceptionally thoughtful and fiercely plain-spoken critic. His first sculptures, in 1963, were simple pieces in wood and metal, eluding personal expression and all but the simplest compositional means, such as juxtaposition and repetition. A typical Judd piece is a series of repeated stereometric shapes in sheet metal, neatly set out on the floor or up or along a wall. In 1965 he was able to stop work as a critic ('Obviously art critics should be paid much more') and concentrate on inventing and designing the very precise objects, mostly rectangular and hollow, and made for him by professional sheet metal workers, that made him one of the heroes of the Minimalist movement. Their simplicity derives from careful consideration of size, interval and apparent weight, moderated by sheen or colour, applied or belonging to the material. He made firm negative claims for them: 'I

couldn't begin to think about the universe or the nature of American society. I didn't want work that was general or universal in the usual sense. I didn't want it to claim too much . . . One or four boxes in a row, any single thing or such a series, is local order, just an arrangement, barely order at all.' Yet man-made order appears to be the essence of his art, together with the rich experiences simple forms yield when observed closely. He trusted in his direction totally: this is how art must go in an industrial society. Otherwise it is 'only show and monkey business'. In his last years the Dia Foundation enabled him to create a Judd Museum in Marfa, Texas, where he converted an old army base into elegant display spaces for his work, as well as placing other pieces, in concrete, on adjacent land.

Juel, Jens (1745–1802) Danish painter, trained in Hamburg, the most successful portraitist and a pioneer of landscape painting in Denmark. In 1772, subsidized by some of his titled female clients, he travelled to Rome, where he worked during 1774–6, returning to Denmark in 1780 via Paris and a three-year stay in Geneva. Juel adapted his style to his clients, painting sober and intimate likenesses of townspeople and professional men in a manner derived from Dutch 17th-century *realism and influenced by *Chardin, and borrowing *Rococo formulae for his many likenesses of royalty and aristocrats. He taught at the *Academy in Copenhagen from 1784, his two most important students being the German painters Caspar David *Friedrich and Philip Otto *Runge. Towards the end of his life he modified his style once again in accord with the prevailing *classicism of French and English portraiture of the time, probably transmitted through prints and drawings. There are works by Juel in Copenhagen, Museum.

Jugendstil *See* Art Nouveau.

Juni, Juan de (*c.*1506–77) The most important of the French sculptors who settled in Spain in the 16th century; his great rival Alonso *Berruguete called him 'the best foreign carver in Castile'. He worked in terracotta and in stone. Probably born in Champagne, he may have studied at Fontainebleau (*see* Primaticcio, Rosso). He was influenced by Italian art and ancient sculpture, notably the *Laocoön* group excavated in Rome in 1506, but we do not know whether he actually visited Italy. After a period in Oporto, 1531–2, he is recorded in Leon in 1533. He settled in Vallodolid in 1541. His earliest work in Spain is in the High *Renaissance style. By 1538 he had adopted the canons of *Mannerism. Emotion and movement increase in his later works, anticipating the *Baroque of *Bernini. His three masterworks are the altars dedicated to the Immaculate Conception in Burgo de Osma, cathedral; Vallodolid, Cathedral; Medina de Ríoseco, Benavente chapel (*see also* Jerónimo Corral); there are powerfully expressive statues in Vallodolid, Angustias; Museum; Avila, San Segundo).

Junk art Term used in the 1950s and 60s for art assembled from urban rubbish. Though such art belongs to the broad category of *assemblage and stems from the *Cubist invention of *collage, Junk art implies a rhetorical purpose, condemnatory or at least satirical.

Juste brothers *See* Giusti, Antoni and Giovanni.

Justus of Ghent *See* Joos van Ghent.

Kabakov, Ilya (1933–) Russian artist, born in the Ukraine, living since 1945 in Moscow where he attended the Surikov Art Institute (formerly Moscow School of Art). A Jew who had grown up amid appalling hardship and is steeped in memories of Stalinist authoritarian oppression, Kabakov has dedicated his multifarious art to questioning all orthodoxies and systems. From the 1960s on he benefited both from visits abroad and to seeing western art exhibitions in Russia, and also to the sense of a new freedom for the arts in Russia, yet the 60s also saw some return to official denunciations of art considered 'nihilistic' and unsupportive of the state. Kabakov learned to disguise his intentions in illustrations, paintings and multimedia works, at times adopting *Surrealist methods together with compositional means taken from *Constructive art. In 1965 Kabakov's work was included in an exhibition in Castello Spagnolo, Italy. In 1968 he shared with his friend Bulatov an exhibition at the Bluebird Cafe in Moscow where unorthodox artists could present their work just for one night. Much of his work at this time – drawings, albums of sequences of narrative drawings, and paintings – was illustrational and innocent in manner yet absurd in content and in the tension created between an image and its accompanying words. Language as much as imagery needed cleansing, and in the 1970s he adopted *Conceptualism as his central method. In Russia, he claimed, it would not be cushioned by historical *Modernism and art commerce and would be experienced as the only means of expression possible in the cultural void created by decades of dictatorship and the repression again exercised in Brezhnev's Russia. A 1978 Moscow exhibition of contemporary German art, including work by *Beuys and *Polke gave him an opportunity both to parody *Expressionism and to adopt what he insisted on calling rubbish, i.e. any found material, preferably 'the pathetic remnants of life', combined with an explanatory commentary for each item. From this, formal galleries not being available, came Kabakov's main work, a long sequence of carefully planned installations, including, among the first, one entitled *Victory over the Sun*, recalling in mockery the Russian *Futurist opera for which *Malevich had made his designs, but dedicated to those who died when Soviet planes shot down a Korean airliner in 1983.

By this time Kabakov was seen as the leader of a small but prominent Moscow avant-garde. In 1985 there were exhibitions of his work in Paris and Bern; in 1986 a show of his drawings, albums and painting toured Germany. But installations were his main concern now. In 1987–8 he went to Graz in Austria on a fellowship to work on an installation exhibited there, and shortly after he made another in New York, at Feldman Fine Arts in SoHo. In July 1988 he moved to Berlin on a year-long fellowship and showed the installation *The Man Who Flew into Space* with great success at the Pompidou Centre in Paris. Many more installations have followed during the 1990s, in European cities, in New York, Santa Monica, Pittsburgh and Tokyo. He adopted the name 'Total Installation' for his always additive and inclusive work, as in *Mental Institution, or Institute of Creative Research*, shown in 1991 in Malmø, Sweden: 'it seems to me that every artist is a patient in an insane asylum', or *Life of Flies*, shown in 1992 in four large galleries of the Cologne Kunstverein, recycling and adding to many years of images and texts on flies in art, society and philosophical discourse. His hope is to exhibit a 'Total Installation of Total Installations' as a theme park of Soviet consciousness.

In 1993 Kabakov received both the Max Backmann Prize and the Beuys Prize in Germany, and was invited to represent Russia at the Venice Biennale. He turned the official national pavilion, dating back to Tsarist times, into a building site and behind it set up a tiny timber pavilion, permanently closed and almost too small to

enter, but rich in red stars and flags and issuing loud May Day march sounds, words, songs, clatter, from loudspeakers. The traditional conviction, that Russia will one day save the world, is both embodied in and mocked by such a work. Kabakov, a member of the Moscow Artists' Union (which normally controls art work in the city) since 1959, has recently been excluded from it as unfit to be a Russian artist, while the western world sees him more and more clearly as a key and forward-looking figure in modern art.

Kahlo, Frida (1907–54) Mexican painter, born in Coyoacan near Mexico City, daughter of a German Jewish immigrant and a Mexican. In childhood she suffered polio, which affected her right leg. At 18 she was gravely injured in a bus accident; from then on, throughout her life, she had frequent operations, was almost permanently in pain, often bedridden or in a wheelchair, and took drugs as well as drink. Recuperating in 1925 she began to paint. She had met *Rivera when he was painting a mural at her school; in 1929 she married him and though their married life swung between passion and conflict and both had relationships outside it (in 1939 they divorced; in 1940 they remarried), they were emotionally dependent on each other. Kahlo accompanied Rivera to San Francisco (1930), New York and Detroit (1931–2). Both had studios in her native home, the Casa Azul, which Rivera enlarged; that also is where Trotsky lived after his arrival in Mexico in 1937. By the late 1930s Kahlo was part of the international art world, largely through the *Surrealists' interest in her work. *Breton visited her in 1938, the year in which the film star Edward G. Robinson bought four of her paintings and her first solo exhibition was held, in New York. In 1939 she went to Paris where Breton organized an exhibition called 'Mexico' which included her work. In 1940 two Kahlo paintings were included in the Twenty Centuries of Mexican Art exhibition at the Museum of Modern Art in New York. In 1943 she exhibited in Philadelphia and in New York and undertook teaching in Mexico's School of Painting and Sculpture. In 1953 a Kahlo

retrospective exhibition was shown at the Galeria de Arte Contemporaneo, Mexico City.

Her paintings, vivid and declamatory, fuse modern methods and influences, including those of Henri *Rousseau and *O'Keeffe, with those of Mexican folk art, especially that of the *ex voto picture, words and image recording her life and explaining events or afflictions as gestures of gratitude to a supernatural helper. Most of her paintings are portraits, many of them self-portraits accompanied by symbolic objects that speak of her loves and pains. Still lifes too, often representing flowers and fruits, symbolize her joys and sufferings. The Casa Azul was opened in 1958 as the Frida Kahlo Museum; other works are in New York (MoMA) and Paris (Pompidou) and in many private collections.

Kahnweiler, Daniel-Henri (1884–1976) German-French art dealer. In 1907 he opened the Galerie Kahnweiler in Paris, presenting the *Fauves and then, from 1908, the *Cubists: *Braque and *Picasso, soon also *Léger and *Gris. He spent the war years, until 1920, in Switzerland where he wrote *The Way to Cubism* (part published 1916; whole 1920). In 1920 he returned to Paris and opened the Simon Gallery. His sequestered stock was sold by auction in 1921–23, the prices showing Cubism's firm standing. He took on new artists, including *Laurens and *Masson. In 1937 he became a French citizen. He left Paris when the Germans invaded in 1940. In 1944 he resumed dealing, now through the Leiris Gallery, and wrote more books and essays, on Gris (1956) and other artists and issues, also publishing texts by others. An interview entitled *My Galleries and Painters* was broadcast and published in 1961 (in English 1971). *For Kahnweiler*, published in 1965, an act of homage by artists and writers, includes a bibliography of writings by and about him.

Kalf, Willem (1619–93) Probably the greatest Dutch painter of *still life. He is famous as an exponent of *pronkstilleven, or 'still lifes of ostentation', although his mature works are monumental in effect, and suggestive of philosophical meditation

rather than luxury and ostentation. Many of the expensive objects in these still lifes reappear in several paintings: a blue and white Ming porcelain bowl in no fewer than 16 pictures, an Augsberg goldsmith's chalice in 13, etc. Such borrowed objects may have been re-utilized by Kalf from drawings, yet the final effect is never that of mechanical or monotonous repetition.

Kalf was the son of a wealthy and civic-minded Rotterdam cloth merchant. Little is known of his education. In 1642–6 he is known to have lived in Paris; from this period date peasant or 'stable' interiors (and a few exteriors) with prominent kitchen still lifes of copper and brass vessels and utensils to one side in the foreground (e.g. Dresden, Kunstsammlungen). These were to prove influential on French painters of the 18th century (*see* Chardin) and later. At the same time Kalf developed a type of true still life, with costly vessels grouped together in profusion, some lying on their sides (e.g. Cologne, Wallraf-Richartz).

Some time after 1651 Kalf moved to Amsterdam, where, *c*.1653–63, he created the still lifes for which he is best known. The objects are now fewer in number, and no longer in seeming disarray. They are often arranged in a vertical format, on a richly patterned Oriental carpet against a dark background. Colour harmonies are equally restrained, but, in conjunction with the broad brushstroke, sumptuous (Berlin, Staatliche; London, National; etc.). These works are classed in the heroic or *classic phase of Dutch 17th-century art, like the monumental landscapes of *Ruisdael.

Kandinsky, Vasilii (1866–1944) Russian painter, born in Moscow. He studied economics and law, but in 1896 turned down a law lectureship at Dorpat University, going instead to Munich to study art. He had drawn and painted as an amateur, just as he played the piano and the cello. About 1896 he saw a *Monet painting and was deeply moved by its colour and light though unable to make out its subject: the catalogue said *Haystack*. This experience, also the music drama of Wagner, a visit to Vologda province which confronted him with the living reality of folk art and piety, these fed the artist in him, but no more than Moscow itself, with its thousand cupolas and bells.

In 1896 he enrolled in a Munich art school, meeting there *Yavlensky, and other Russians. By 1900, a student now in the Munich Academy, he began to send work to Russian exhibitions. In 1901 he published his first piece of art writing and helped form the artists' association Phalanx, which put on exhibitions and offered teaching. One of his students was Gabriele *Münter, his companion until 1914. The Phalanx school closed in 1903. He travelled and exhibited widely, notably in Munich, St Petersburg, Dresden and above all Paris, where he was elected to the jury of the 1905 Salon d'Automne. He sent regularly to the Paris Salon des Indépendants during 1907–12 as well as to exhibitions in Germany and Russia, and continued to write for Russian journals. Summer 1908 saw his first stay in Murnau in the Bavarian foothills. In 1909 Münter bought a house there and until the war they divided their time between Munich and Murnau. 1909 saw also the founding of the New Artists' Association, Munich; he was its first president.

He painted, made woodcuts and designs for craft work, wrote poems and 'abstract' stage compositions, e.g. *The Yellow Sound*. His early paintings were *naturalistic portraits and landscapes, accompanied by smaller works, sometimes in tempera, of scenes from old Russian life and legends in an *Art Nouveau idiom. The example of *Gauguin and the *Fauves made his work more openly expressive and colourful. During his Murnau summers he saw and collected Bavarian devotional glass paintings, and in 1909 he made his own first attempts in that medium. In 1910 he saw a Mohammedan art exhibition in Munich and painted his first 'compositions'. He also spent some weeks in Russia, contributing to exhibitions in Moscow and Odessa. In 1911 he made the acquaintance of *Marc and *Macke and entered into correspondence with Schönberg after hearing his music. He and Marc began work on an art annual. This involved new contacts and also correspondence, e.g. with *Delaunay in Paris. In December he, Münter and Marc left the New Artists' Association, and soon opened

the 'First Exhibition of the Editorial Board of the Blue Rider': *Der *Blaue Reiter* was the name he and Marc had chosen for their almanac, published May 1912. Kandinsky's main theoretical text, *On the Spiritual in Art*, dated 1912, had appeared in December 1911; two further editions appeared in 1912; his Russian version was read to a meeting in St Petersburg in 1911 and published there in 1914, sections in English were published by *Stieglitz in New York in 1912 and an English translation of the whole was published in London in 1914. Other writings of his spread similarly.

His painting was meanwhile undergoing its Odyssey into *abstraction. Colour and generalized form now dominated over depiction of figures and scenes. The apparently abstract works of 1912–14 incorporate riders, mountains and churches, boats with rowers, angels with trumpets, etc., in compositions whose general theme was the Apocalypse. He hesitated before wholly abstract painting, wishing not to be merely decorative; signs would hold the viewers' attention and permit the picture's music, its colour, rhythm and space, to make their impact.

When war came, in August 1914, he returned to Moscow and began work on his second treatise. He produced no paintings in 1915. In subsequent paintings his forms hardened, approaching *Suprematism. From January 1918 he and *Malevich were colleagues on the art board of the new Commissariat of Enlightenment. He and Malevich were charged with leading its film and theatre sections, and in 1919 he and *Rodchenko planned a national museums system; he, *Tatlin and others also ran the art board's international office. In 1920 he drew up a programme for research to be pursued by *INKhUK. In 1921 he co-founded the Russian Academy of Artistic Sciences and was appointed its vice-director, but that December he left for Berlin.

In 1922 he accepted a post at the Weimar *Bauhaus. He taught parts of the Basic Course and led the mural painting workshop. His work was included in the *First Russian Art Exhibition. In 1923 he had his first solo exhibition in New York. He contributed to the Bauhaus exhibition and events in Weimar that August-September. In Dessau he completed his second treatise, *Point and Line to Plane*, published as a Bauhaus book in 1926. His 6oth birthday was celebrated with a travelling exhibition. Invitations to teach in various parts of the world (Tokyo 1922, New York 1931), personal contact with key artists and associations (*Duchamp 1929, *Cercle et Carré 1930) and his first solo exhibition in Paris, suggest his status as painter and theoretician. In 1933 he left for Paris, where he lived and worked until his death, in touch with *Miró and others and exhibiting frequently, even secretly during the German occupation.

His painting became almost wholly abstract in the 1920s, and much cooler in style, developing the visual language he outlined in his 1926 text. His apparently more spontaneous work of 1912–14, thought of as more poetic and expressive, stimulated the development of *Abstract Expressionism in the USA. Kandinsky hoped to make similar, more measured contact through his later work which he saw as a 'new *Romanticism . . . a block of ice with a burning flame inside'. His work is widely disseminated, with the Guggenheim Museum, New York, holding a particularly fine group of pre-1914 paintings. *Kandinsky: Complete Writings on Art* was published in 1982.

Kändler, Johann Joachim (1706–75) German *Rococo sculptor, celebrated for his designs for the Meissen porcelain factory, to which he was appointed in 1731. Among his best-known works are the decoration on porcelain of the Japanese palace in Dresden, and the 2,200 pieces of the dinner service called the Swan Set (1737–41; Dresden, Porzellansammlung).

Kane, John (1860–1934) American painter of Scots origin. He worked as a miner, carpenter etc., before taking up painting at the age of fifty. In 1927 some of his paintings were shown and admired at the Carnegie International in Pittsburgh, since when he has been seen as an outstanding figure in *naïve painting.

Kanoldt, Alexander (1881–1939) German painter, one of the foundation

members of the Munich New Artists' Association in 1909 and its organizing secretary. In 1913 he was a founding member of the New Secession of Munich. Visits to Italy confirmed him in his simplified *realism, and in 1925 he showed in the *Neue Sachlichkeit exhibition. That year he was given a professorship at the Breslau Academy. He taught there until 1931 when he moved to Garmisch where he formed a private school. From 1933 until 1936 he directed the State School of Art in Berlin.

Kantor, Tadeusz (1915–90) Polish artist who worked in several media, beginning with a clandestine experimental theatre he produced in Cracow during the German occupation in the 1940s. Influenced by many modern developments in art, notably *Expressionism, *Art informel and *Conceptual art, and committed to radicalizing the theatre, his work crossed many boundaries and he himself worked peripatetically, expanding his work outwards from inherited principles and methods, and moving around the world, with Poland always as his centre.

Kapoor, Anish (1954–) Indian-British sculptor. He was born and grew up in Bombay and studied art in London at Hornsey and Chelsea Colleges of Art during 1973–8 and he was included in group exhibitions from 1974 on, in solo exhibitions from 1980. From 1981 on his work was seen frequently, in Britain and abroad, and received continual critical attention. He was then making abstract objects in wood and other materials – archetypal in character and quite impersonal in manner, but suggesting symbols for mountains, sea and sex – and covering them individually with powdered colours he brought from India where they are traditionally used on celebratory occasions. Thus the material of the forms was obscured. Set directly on the floor, soon also affixed to walls, they appear both new and timeless, exotic but also directly relevant, and profoundly appealing on account of their colour. His work was included in the Junior ('Aperto') section of the 1982 Venice Blennale; in 1990 it was the major

show presented in the British Pavilion there and won the Premio Duemila with work of a different sort. He was now cutting openings into the tops or sides of massive blocks of stone, and giving these interior spaces deep colours that invite our looking but leave it unsatisfied: the outline of each recess is clear but its depth is impenetrable, so that we find ourselves drawn into an awesome, dreamlike experience. If the earlier sculptures signalled his Indian origins, principally through the use of sprinkled colours, the new belonged to a global world of compelling experiences, seemingly man-made but close to exceptional natural phenomena and not essentially modern except by being presented as art. In 1991 he won the prestigious Turner Prize. Since 1995 he has used other means to similar effect, carefully forming coloured wood, fibreglass or metal, and also highly polished steel, in large units placed on or at times into the floor or fixed to walls, to transform sensations of mass and void and also, by distorted reflections, the appearance of our environment, in dramatic and mysterious ways. His role, he has said, is not to deliver messages but to give 'poetic existence' through his sculpture to 'phenomological and other phenomena'. A selection of these was shown in his solo exhibition at the Hayward Gallery, London, in 1998.

Kaprow, Allan (1927–) American artist who turned from making *assemblages to organizing performances he called *Happenings. These, presented in galleries or other such spaces, involved collaborative actions scripted by him to suggest emotional crises or perplexities. This work, beginning in the late 1950s, was of immediate influence in and beyond America. His book, *Assemblage, Environments & Happenings*, published in 1966, became a sort of bible for a wide range of art performances and their commentators.

Kassak, Lajos (1887–1967) Hungarian artist, poet and editor. In 1916 in Budapest he created the journal *MA* (Today) which also presented *avant-garde exhibitions. He was prominent in Hungary's Republic in 1919; his journal

was banned by the new regime that summer, two weeks before the republic collapsed. He went to Vienna where *MA* continued as journal and art centre, giving especial prominence to post-Revolution Russian developments and to *Dada. He himself produced art, most persuasively in the form of concrete poetry. In 1922 *MA* published the *Book of New Artists* by Kassak and *Moholy-Nagy. In 1926 Kassak returned to Hungary and edited *Dokumentum* until 1927. He continued to write and produce art, exerting much influence on new generations of Hungarians.

Katz, Alex (1927–) American painter, born and trained in New York, known for powerful figure paintings. In his earlier years he made cut-out figures – painted figures glued to plywood – and his canvases have shown a similar brusque firmness. Often large and rather bleakly presented, with little or no context, his figures seem without emotion or sensitivity, and reject any sentimental engagement. His first solo exhibition was in 1954 in New York. In 1986 he had a retrospective at the Whitney Museum, New York. His work has been seen abroad from 1970 but remains primarily an American interest.

Kauffer, Edward McKnight (1890–1954) American painter, long active in Britain as poster designer. The *Armory Show caused him to go to Europe: to Munich where he found artists exploring the frontier between art and design, and then to Paris. In 1914 he settled in London and soon worked as a graphic artist for the London Underground. He also painted and exhibited but it is his adaptation of themes and devices from a wide range of art to the purposes of poster design that is his memorable achievement. In his earlier years he showed inclinations to *Cubism, *Futurism and *Vorticism; subsequently elements of *Surrealism and of *Constructive art appear; he was also drawn to the imagery of photography. Book illustrations, photomurals, décor for the ballet *Checkmate* (1937), demonstrate his versatility. When the Second World War began he returned to the USA where he worked for a number of companies, including the New York Subway.

Kaufmann, Angelica Catherina Maria Anna (1741–1807) Tyrolese painter of portraits and *Classical narrative, probably most successful in her decorative pictures for the interiors of Robert Adam's London houses. She was trained in painting by her father, with whom she worked throughout Italy, making her reputation originally as a copyist of Old Master pictures. Her international fame dates from her 1764 portrait of J.J. *Winckelmann painted in Rome (Zurich, Kunsthaus; five replicas exist, and the artist also produced an etching after the painting). In 1765 or 1766 she travelled to England with the wife of the English Resident in Venice; a royal portrait commission caused her to be sought after as a society portraitist. She became a founder member of the Royal *Academy, exhibiting there 1769–97. In 1781 she married (after the failure of a first marriage) the Italian decorative painter **Antonio Zucchi** (1726–1795) with whom she returned to Italy, continuing to paint for monied travellers and the leading European nobility. There are works by her in London, Kenwood, NPG, Royal Academy; New York, Metropolitan; etc.

Kaulbach, Wilhelm von (1805–74) German painter. An exceptional talent and the ambition to be the great German *History painter of his day brought early success. *Cornelius gave him a place in the Düsseldorf Academy and employed him on frescos in Bonn and Munich. Independent commissions followed. In 1837 Kaulbach made his first visit to Italy and found himself drawn into *naturalism by his love of scenery, but Cornelius persuaded him back to the more elevated path of *classical idealism. Kaulbach's *Battle of the Huns* (1834–7; Poznan, Muzeum Narodowe), a work more than 6.5 metres across, made him famous because of its drama; Liszt composed a piece for two pianos under its inspiration. But, as so often with 19th-century monumental painting, the urge to display information of a heroic sort outweighed painterly aims. Made court painter by Ludwig I of Bavaria in 1837,

Kaulbach went to Rome where he illustrated *Goethe's popular *Reineke Fuchs*, a great success. His monumental painting meanwhile deteriorated and met with criticism. In 1849 he became director of the Munich Academy. He used a commission, to paint *frescos on the exterior of Munich's Neue Pinakothek, to make swingeing attacks on fellow artists and intellectuals in a time of uncertain taste and principles. His designs, on canvas, are brilliant; the execution of the frescos, by assistants, brought vehement complaints. He painted strong, sometimes genial portraits but it is as illustrator – of texts by a wide range of authors from Homer to Heine – that he is still admired today. The Bayerische Staatsgemäldesammlungen in Munich have a major collection of his work.

Kawara, On (1933–) Japanese *Conceptual artist who worked first in his own country, painting images expressing Japan's collapse at the end of the war, then travelling in the West before settling, in 1965, in New York. Much of his work has been words on postcards and telegrams, the simplest statements in plain type usually, sometimes rubber-stamped, a plain, obsessive record of existing, disseminated to friends through the post.

Kelly, Ellsworth (1923–) American painter and sculptor, who studied in New York and Boston. In Paris (1948–54) he moved from *naturalism and *abstracted natural forms to presenting colour in geometrical designs. In the later 1950s he began to make sculpture, close kin to his paintings. Apparently cool and impersonal, his art reveals a poetic sensitivity to colour surfaces, scale and space. His first one-man show was in Paris in 1951; though most of his exhibitions since then have been in the USA his art is known internationally.

Kempeneer, Pieter *See* Campaña, Pedro de.

Kennington, Eric (1888–1960) British painter and sculptor, remembered principally for his drawings and paintings of soldiers and also for his memorial sculpture. He was an official War Artist in both World Wars. In 1930 he executed sculptures for the Shakespeare Memorial Theatre at Stratford-upon-Avon.

Kensett, John Frederick (1816–72) American landscape painter of the Hudson River School. In the 1840s he travelled and studied in Italy, Germany and England before returning to America and making his reputation with luminous, optimistic readings of nature.

Kent, Rockwell (1882–1971) American painter, student first of architecture, then of art, at Columbia University under *Henri. He developed a restrained though dramatic style in which tonal contrasts dominate monumentalized compositions. He was an active radical and was awarded membership of the USSR Academy of Art in 1962 and the Lenin Peace Prize in 1967; he was also a member of the US National Institute of Arts and Letters. He gave much time to writing, including three volumes of autobiography (1945–55).

Kent, William (1685–1748) A protégé of Lord Burlington, known primarily as an architect and landscape gardener. He had, however, studied painting in Rome in 1714/15, and his work for Burlington began in London in 1719 when Kent completed the paintings at Burlington House which Sebastiano *Ricci had left unfinished.

Kessel, Jan van (1626–79) Flemish *still-life painter, grandson of Jan 'Velvet' *Brueghel whose tradition of flower and fruit painting he continued. His speciality, however, was the zoologically correct depiction of insects, butterflies, caterpillars, shells and fish, which he combined with flowers in decorative garlands influenced by those of Daniel *Seghers, sometimes playfully depicting the creepy-crawlies wriggling to form the letters of his name (e.g. Nostell Priory). Spanish connoisseurs were particularly attracted by these small precious pictures, and the Prado in Madrid has no fewer than forty of them.

Kessel, Jan van (1641–80) Little-known Dutch landscape painter, a pupil of Jacob van *Ruisdael and much influenced by him (Brussels, Musées Royaux).

Ketel, Cornelis (1548–1616) Dutch painter from Gouda, pupil of Anthonie *Blocklandt in Delft. In 1566 he completed his training in Paris and Fontainebleau. Unable, because of the Dutch Wars of Religion, to find work when he returned home, he left in 1573 for London, where he remained until 1581, employed as a portraitist able to capture a realistic likeness (Oxford, Bodleian). As his biographer, Van *Mander, records, his painted *allegories were less in demand; only the reverse of the portrait of a German merchant in London (Amsterdam, Rijksmuseum), and a recently discovered fragment of a larger work (San Francisco, Delman coll.) remain. He settled finally in Amsterdam, becoming famous for his life-size civic-guard group portraits, the first to show guardsmen standing at full length – a lively formula which proved an immediate success (and a precedent for *Rembrandt's 'Nightwatch'). None of the complex allegorical works executed at this period has survived.

Kettle, Tilly (1735–86) English portrait painter, influenced by *Reynolds, *Cotes and *Romney. Rejected by the Royal *Academy, he visited India, 1769–76, the first painter of any consequence to make the journey. The success he achieved with portraits of princes and nabobs again eluded him on his return to London. After a short visit to Dublin he died in Syria on his way back to India (Greenwich, Maritime Museum).

Key, Willem (c. 1515–68) and his nephew, **Adriaen Thomasz. Key** (c. 1544–after 1589) Flemish painters active mainly in Antwerp, known for their sober portraits of famous people (Antwerp; Koninklijk); they also painted altarpieces, many of which were destroyed by iconoclasts. A pupil of Lambert *Lombard – although his religious works seem directly indebted to Quinten *Metsys – Willem Key in turn probably taught his nephew, whose later portraits, however, are more influenced by those of Anthonis *Mor.

Keyser, Hendrick de (1565–1621) and his son **Thomas** (1596/7–1667) Hendrick was an architect and the most important Dutch sculptor of the first half of the 17th century, specializing in portraiture (Amsterdam, Rijksmuseum) and in decorative sculpture. Both are combined in his masterpiece, the tomb of Prince William I in the Nieuwe Kerk, Delft; there are also works by him in Rotterdam and in London, V&A. His son, Thomas, was the leading portrait painter in Amsterdam until the arrival of the young *Rembrandt in 1631/2, but see also Eliasz. Nicolaes. He executed important group portraits and militia pieces on the scale of life (Amsterdam, Rijksmuseum), which emphasize individual likeness at the expense of compositional unity. More artistically successful were his small full-length portraits of one or two figures (London, National) and the small equestrian portraits he popularized. After 1640, he virtually stopped painting, becoming active as a stone merchant and mason. Hendrick's other sons, **Pieter** (1595–1676) and **Willem** (1603–after 1678) were also sculptors.

Khnopff, Fernand (1858–1921) Belgian painter, prominent in the *Symbolist movement. Steeped in literature, he turned from law studies to art at the Brussels Academy and making visits to Paris. There, in 1878, he was thrilled by the art of *Moreau, *Millais and *Burne-Jones. He helped found the Groupe des *Vingt in 1883 and in the 1890s he showed regularly in the Rose+Croix (Rosicrucian) exhibitions in Paris. His work became well known in England where he had contacts. The journal *The Studio* printed many reports on art in Belgium written by him. His art centred on meditation, in many of its images and in spirit, from the early *naturalistic paintings of people at home (*Listening to Schumann*, 1883; Brussels, Musées Royaux; *Stéphane Mallarmé's Poetry – Listening to Flowers*, 1892; p c: Mallarmé was his favourite poet) to intensely atmospheric, dreamy images of unreal situations and strange compositions, though still

rooted in observation. Several of his later paintings and drawings feature a young woman and an ancient Greek winged bust, in fact his own bronze version of a *Head of Hypnos* (Sleep) probably by Scopas, in the British Museum, London.

Kiefer, Anselm (1945–) German painter-sculptor who turned to art studies in Freiburg and Karlsruhe from French and Law, and studied further with *Beuys in Düsseldorf. From 1971 on he lived in Hornbach (South Germany), using as studio an attic that features in his early work. He was painting and making graphic images and *Photobearbeitungen* (treated photographs). In 1969 he published a set of such photos, taken at different European sites outside Germany, showing himself giving the Hitler salute. This was the first display of what for years was his central concern, setting images, names and locations illustrative of German cultural history and its resource of myth against the barbarism of and despoliation earned by Fascism. He was pushing at a national and international taboo in a manner that left his position ambiguous. His imagery is often assembled; his most familiar means have been oil or acrylic paint, sometimes applied over a photograph, augmented by additions and treatments of many sorts, from straw and sand to hacking at the painting and attaching shaped sheet metal to it. Colour is rejected, perhaps because of its association with sensuality (see *disegno*) in favour of textures and darkness. His over-life size construction of steel shelving and books of lead, *High Priestess (Zweistromland)* (1985–92), refers to the Tarot and to the land between the Tigris and the Euphrates, and presents a challenging image of the civilization reputedly born there.

His theme had widened, from Germany's role in civilization to the fate of all art and knowledge. He had been exhibiting since 1969, from 1977 on also outside Germany. In 1980 he shared the German Pavilion at the Venice Biennale with *Baselitz, and their displays were hotly debated. Since then he has been known internationally as an artist commenting on Germany's situation in the world with gravity and with a searching self-consciousness. His debt to Beuys's shamanistic endeavours to divine the meaning of life through all manner of processes and materials is clear; he has added a more direct use of historical and occult symbolism. Thus, and also on account of the surprises his development away from and back to pictorial means has offered, he has been honoured as a kind of latter-day *history painter, working after decades when *avant-garde art eschewed discussible content, confronting issues at once modern and ancient. He ceased work during 1991–3, moved to southern France and travelled widely. His work since then has taken an even wider perspective and employs more direct references to theology and mysticism, e.g. to Robert Fludde's 17th-century account of the cosmos, presenting himself as a magus and thus echoing the *Symbolist ambitions of a hundred years ago.

Kienholz, Edward (1927–94) American artist, who settled in Los Angeles and in 1961 began to make life-sized, *Surrealistic tableaux using real furniture and *naturalistic figures, nightmarish in effect. They became more *realistic and polemical. *The Portable War Memorial* (1968) combined a sculptural rendering of a war photograph of a group of US soldiers with furniture, a road-side hot-dog stand and Coke machine and a dustbin figure singing 'God bless America'. His work calls attention to social abuses and illusions through its shocking, sometimes inappropriately amusing impact.

Kiesler, Frederick (1896–1965) Rumanian-Austrian-American architect and sculptor. He studied art and design in Vienna 1980–12, and was then active in Vienna and in Berlin where he associated with *Richter, *Moholy-Nagy and with Van *Doesburg who brought him into the *De Stijl movement in 1923. His activities ranged widely but were noticed mainly in the field of stage design, e.g. for *R.U.R.* and *Emperor Jones*, Berlin 1923 and 1924, and his concept of an *Endless Theatre* (1925–6). He was concerned to mobilize all available media and a range of fixed and movable or developable structures as

human environments, and his work stands out for its rejection of any primary idea of style and its focus on the triad space/body/vision as programme. Inevitably much of his work remained on the level of models, some of them large-scale. In 1926 he moved to America where he developed his ideas of spatial formation, especially in architecture. In 1942 he designed the interior of Peggy Guggenheim's Art of this Century in New York as a curved blue tent within which sculptures hovered in mid-air, sustained by cords in tension, and paintings were pivoted at variable angles. The gallery survived for five years.

Kiff, Ken (1935–) British painter, trained at Hornsey School of Art, London, during 1955–61, since when he taught part-time, including periods at Chelsea School of Art and the Royal College of Art. His work, paintings, prints and drawings, has been seen in group shows since 1970 and in a stream of solo shows, mostly in London and New York, since 1980. He works in London but has spent periods in the USA at print workshops in Santa Barbara, CA, and more recently in New York, mostly working on monotypes. In 1991–3 Kiff worked at the National Gallery in London as Associate Artist, and exhibited the product of this residency there in 1993–4. Kiff is often seen as a later *Expressionist because of the vivid colours and brushwork he often employs and the fantastical imagery that he sometimes incorporates in his essentially visionary art. At the National Gallery he engaged in an intense dialogue with a number of the paintings displayed there, but his position *vis-à-vis* the whole tradition of pictorial art, not only in the West, but more particularly that shaped by modern masters such as *Matisse, *Picasso and *Klee, is one of deep respect. He wrote in 1993: 'I have to keep looking at the tradition, at the work which embodies the understanding of the artists who understood most.' This keen attention to what especially the recent past offers is combined, in his work, with exceptional technical skills and attention to many media, so that paintings that seem spontaneous and even feverish come out of a long process of making and revising, with proportions and scale as carefully weighed as colour chords and the interaction of clear and of loosely suggested forms. A keen interest in music and in poetry underwrites his endless enquiry into the possibilities of visual art. He is in this sense essentially *classical, and though his art can seem exclusively personal in content, it reveals characters and situations which are both autobiographical and typical, akin to the symbolical narratives of fairy tales and mythology, including the lives of the saints.

kinetic art Art that moves or gives the illusion of movement. *Duchamp's *Bicycle Wheel* mounted on a kitchen stool was the first work of art made to incorporate movement (1913); *Gabo's *Realistic Manifesto* (1920) used the scientific term 'kinetic', associating 'kinetic rhythms' with the perception of time. In 1919–20 he made a mechanized kinetic sculpture, a metal rod vibrated by an electric motor and thus appearing to take on a wave form: his intention was to demonstrate the kinetic principle, not to create a self-sufficient work of art. Some later Gabos, hang in space and allow for the possibility of rotation. These examples show three types of kineticism in art: dependent on manipulation of movable parts, on a mechanical force and on its positioning. The Italian *Futurists wanted art to reflect the dynamics of modern life but had sought ways of allegorizing this rather than incorporating it. *Archipenko in 1913–14 made figurative sculptures with movable limbs. *Tatlin's tower project (1919–20) proposed rotating units within its visually dynamic skeleton. Duchamp and Man *Ray in 1920 worked on a motorized optical device involving rotating disks painted with lines, and embarked on a stereoscopic film of such designs. These essays remained exceptional though some outstanding examples in the 1920s kept the idea alive, notably *Moholy-Nagy's *Light-Prop* (1922–30). *Surrealism exploited movement and manipulability in some of its objects (*Giacometti, *Miró) and *Calder emerged as the first specialist kinetic artist, making his first moving sculptures in Paris in 1931. By the 1950s there were many, e.g. *Bury and *Tingueley.

The 1971 exhibition 'Movement in Art', shown in Amsterdam, Stockholm and Copenhagen, included work by 75 artists. Other forms of moving art were being invented meanwhile, e.g. slowly *auto-destructive art as when acid acts on nylon, and the melting of a column of ice or the growth of grass (*Haacke).

King, Phillip (1934–) British sculptor. He spent a year in Paris (1953–4), then studied languages at Cambridge. He also made sculpture and in 1975–8 studied under *Caro. In 1958–9 he worked as assistant to Henry *Moore and visited Greece on a scholarship. He exhibited from 1961 and had his first London solo exhibition in 1964. From 1966 he had solo exhibitions abroad, in New York, Paris and Venice (1968 Biennale) followed by European tour, etc. Greece persuaded him that sculpture could be *abstract and that it should concern objects in light. His first pieces were bare, assertive forms. *Rosebud* (plastic, 1962; New York, MoMA) speaks of life and growth and is given a dramatic answer in *Genghis Khan* (1963; London, Tate). Both enclose space without mass and weight; there followed a series in which spatial articulation is a prime concern and very large sculptures set out like fragments of architecture (e.g. *Span*, 1967; Otterlo, Kröller-Müller Museum, and Melbourne, National). In 1969, stimulated by *Matisse, King began to use sheet metal in curved and curving planes leaping through space and light, as in *Ascona* (1972; Belfast, Ulster Museum). More massive pieces followed, some with concrete lumps or pieces of slate and timber; lightness plays against dramatic weight. In 1980 he won a commission for a very large sculpture outside the European Patent Office in Munich, and there have been other commissions for publicly visible works, as well as free exploration of a wide range of ideas, not excluding hints of figuration and, in the 1990s, ceramic sculptures first shown at the Yorkshire Sculpture Park in 1996. In 2000 he was elected President of the Royal Academy.

Kip, Johannes *See under* Knyff, Leonard.

Kirchner, Ernst-Ludwig (1880–1938) German painter, a key figure in *Expressionism and member of Die *Brücke. A student of architecture in Dresden and briefly of painting in Munich, he came to art wanting to bring new energies into people's lives. He was one of the first since *Gauguin to incorporate design ideas from *primitive art forms in his art. His Dresden studio was dramatized by quasi-barbaric hangings, sculpture and furniture, some of which can be seen in his paintings. With his Brücke friends he developed a brusque and colourful style of painting, full of animal vigour, best seen in his pictures of male and female bathers. In 1911 he moved to Berlin and found a new theme and note in his paintings of metropolitan streets and their promise of dangerous pleasures. Vigour was replaced by stridency, yet the first Berlin years saw some of his most powerful images, mostly portraits of himself and others. Army service led to a breakdown from which he never fully recovered. In 1917 he was sent for his health to Switzerland and he lived there until his suicide. His later paintings combine echoes of his pre-war work with borrowings from international figurative modernism.

He dominated the Brücke group. This led to its disbanding in 1913 when his *Chronicle* of its history and aims was felt by others to be too exclusively devoted to his particular priorities. He also wrote art criticism, including reviews of his own work, under the pseudonym Louis de Marsalle. 1933 saw a major retrospective in Berlin coinciding with the first moves to have him classed *degenerate.

Kisling, Moïse (1891–1953) Polish-French painter, born and trained in Cracow. From 1910 on he worked in Paris, close to the *Cubists and to *Chagall and *Modigliani. He developed an elegant, semi-*naturalistic style which brought success, especially in portrait painting. During the Second World War he lived in the USA, returning to France in 1946.

Kitaj, R.B. (1932–) American painter. Born Ronald Brooks, he took the name of his stepfather. He grew up in New York and studied at Cooper Union. During

1950–5 he divided his time between working as a seaman and studying art, mostly in Vienna and Paris. In 1956–7 he was in the US army. He used his ex-army grant for study at the Ruskin School in Oxford (1958–9) and at the Royal College of Art in London (1960–1). He began to show in student exhibitions in 1958 and in 1960 won an Arts Council prize. He became known as a senior, exceptionally serious member of the *Pop movement. His first solo exhibition (London 1963) showed him reflecting on modern literature and history. Stylistically too his art is allusive, a confection directed by current concerns and admirations. He has continued to live in an environment of intellectual enquiry, principally in London; at times he has worked and taught in the USA. In 1976 he directed an exhibition for the Arts Council, entitled 'The Human Clay' and intended as a polemic against *abstract and *Conceptual art and as a defence of art rooted in observation, especially of human beings. He had himself recently begun to use pastels, following *Degas, and his paintings had taken on a dramatic, sometimes moodily romantic quality without abandoning their learned character. His passionate and also scholarly interest in recent history has at times mingled with his self-image as a pilgrim in an ugly world made beautiful by intellects and creativity. His influence on others, in Europe and beyond, has been marked, but his 1994 retrospective at the Tate Gallery in London was attacked for what some claimed to be a patronizing presentation of very uneven work. He was given a special award at the Venice Biennale of 1995.

kit-cat The English name for a canvas size, 36 × 28 inches (92 × 71 cm), used in portraiture, a vertical format which has the advantage of allowing the sitter's head, upper torso and one hand to be shown on the scale of life. The name derives from the Kit Cat club, a dining club meeting in a tavern run by Christopher Cat, whose members – predominantly Whig politicians – were portrayed between 1702 and 1717 in a famous series by *Kneller, now in London, NPG. Although Kneller popularized this format in England, it was derived by him from 17th-century Dutch portraits, notably from the studio of *Rembrandt.

kitsch A German noun used in English for lack of an equivalent, meaning (an object of) vulgar and sentimental taste, thus referring to countless old and new objects of the industrial age, most of them mass-produced and apparently the enemy of everything that makes art art. This attracted the attention of *Pop artists and of others such as *Koons who have offered existing or specially confected kitsch objects as works of art. *Duchamp originated this challenge to art's priorities.

Klapheck, Konrad (1935–) German painter, born in Düsseldorf and trained at the city's *Academy where later he served as professor. In 1955, when expressive *abstraction (*Art informel) dominated western art, he began to paint monumentalized images of mass-production objects: typewriters first, then sewing machines, telephones, bicycle bells, agricultural machinery etc. They are painted assertively and impersonally, on a plain ground, without indication of their size in reality and in simplified forms and colours that give them a distinct, visionary character. Titles indicate a meaning not inherent in the objects themselves; thus one of his sewing-machine pictures is entitled *Inquisition*. This elevation of the images beyond the merely factual allies them both with the art of *Léger and of *Surrealism. *Breton in 1965 hailed him as part of a new wave of Surrealism. The Munich Kunsthalle mounted a Klapheck retrospective exhibition in 1985.

Klee, Paul (1879–1940) German painter, born at Münchenbuchsee, near Bern, in Switzerland. A gifted writer and musician, he opted for art and studied at the Munich Academy. In 1901–2 he visited Italy where he was impressed especially by *Renaissance architecture and the Naples aquarium. In 1905 he made his first visit to Paris. In 1906 he married and moved to Munich.

His early work was almost exclusively drawings and prints, many of them satirical. He showed graphic work in mixed

exhibitions and joined a Swiss graphic artists' society. Meanwhile he had been making watercolours and paintings on glass and had come to admire the paintings of Von *Marées, Van *Gogh and *Cézanne. In 1910–11 he had his first major exhibition (Bern, Zurich, Winterthur, Basel). In 1912 he contributed 17 graphics to the second *Blaue Reiter exhibition. That April he visited *Delaunay in Paris and saw also work by *Matisse and the *Cubists. His translation of Delaunay's essay 'On Light' appeared in *Sturm in January 1913 and his work was shown in Sturm exhibitions later that year. In April 1914 he went with *Macke and another painter to Tunisia. He returned home abruptly, suddenly convinced that he had grasped the action of colour and was now a painter. His work at this time shows the influence of Cézanne and Delaunay. He was in the German army during 1916–19 but continued to work and exhibit. 1920 saw his first retrospective, of 362 works, shown in Munich. In January 1921 Klee began teaching at the *Bauhaus in Weimar. He joined the staff of the Dessau Bauhaus in 1925; his *Pedagogical Sketchbook* was published as a Bauhaus Book. His work was included in a *Surrealist exhibition in Paris the same year, highlighting the element of fantasy in his work. Much of it was *abstract and *constructive, e.g. colour patterns on a geometric basis, some of it hovered between abstraction and *figuration, acquiring identity from added details, e.g. shapes annotated to become a landscape, a face, buildings. He sought a wide range of themes and expression, uniting 'devilish' and 'heavenly', microcosmic and universal as also line and colour. He usually worked on several pieces concurrently, relying on interaction between the marks made and his responsive eye and spirit. He said it was akin to nature's mode of creation, thus overcoming the opposition of abstract to figurative: 'the artist is a human being, nature himself, a part of nature in nature's space'. His teaching included supervising bookbinding, the metal workshop and weaving, and a series of lecture-demonstrations on form and colour in relation to nature. His notebooks for these have been published (1956 and 1970), a compendious exegesis showing

Klee's roots in the thought of German *Romanticism, and the origin of formal motifs that recur in his art.

In 1930 a large Klee exhibition went from Berlin to the Museum of Modern Art in New York. He took up a professorship at the Düsseldorf Academy in 1931 and showed 252 works in the city's Kunstverein. In 1933 he was dismissed and emigrated to Bern. During the last seven years of his life, in declining health, he produced some of his most eloquent works, rich in colour and strong in line. In February 1940 there was an exhibition of 213 works in Zurich to celebrate his sixtieth birthday.

Widely acknowledged, though as one standing outside the mainstream of modern art, his importance has become clearer as his influence has become more marked. His conception of the generative process has been adopted by many artists. His work is seen frequently – e.g. the 1987 exhibition shown in New York, Cleveland and Bern – and countless books and articles have been devoted to him. He produced more than 10,000 works. The Bern Kunstmuseum houses a substantial proportion of them.

Klein, Yves (1928–62) French *Conceptual artist. Proficient in jazz, judo and languages, he was self-taught as painter. After travels he settled in Paris in 1955. In 1956 he exhibited a group of monochrome canvases. The public's reaction led him to paint only in a blue he patented as International Klein Blue. In 1957 he exhibited monochrome paintings and objects in Paris, Düsseldorf and London. In 1958–9 he made large blue panels for the new Opera House at Gelsenkirchen (Germany), and in Paris exhibited 'Le Vide' (emptiness), painting the windows of a gallery blue and its interior white; he also showed in Düsseldorf and again in Paris and in mixed exhibitions in the USA and Europe. In 1960 he demonstrated a way of making monochrome paintings by getting models to press their blue-dipped bodies against canvases as a performance accompanied by his music, one note played by a small band. That October the group *Nouveaux Réalistes (New Realists) was founded in Klein's

apartment. In 1961 there was a Klein retrospective at Krefeld, including a *Fire Wall* and a *Fire Fountain* and he had solo exhibitions in New York, Los Angeles, Rome and Milan. His stated aim was to detach the immaterial spirit of creation from objects and commercial processes. His work was seen as a revival of *Dada but he rejected this association.

Klimt, Gustav (1862–1918) Austrian painter, born and trained in Vienna. With his brother Ernst and another painter he formed an artist-decorators' firm which produced paintings for public buildings. In 1897 he was a founder of the Vienna *Secession and its first president. One of three paintings he was preparing for the ceiling of the University's hall was displayed in its 1900 show and caused a scandal with its stress on female nudity and his unliterary account of its subject, *Philosophy*. When *Klinger's sculpture of Beethoven was shown at the Secession, in 1902, Klimt painted a *Beethoven Frieze*. This too occasioned controversy. Klimt had major shows in the Secession exhibitions of 1903 and 4. In 1905 he and a group of like-minded artists left the association. In 1908–9 they put on exhibitions under the name Kunstschau (art spectacle). The first was of Austrian art and crafts and included a roomful of Klimt portraits and allegories; the second was international. Klimt's art, highly stylized and developed as ornamental surfaces but dependent on close observation of anatomy, was still dominant and divided Viennese opinion. His painting with a gold ground, *The Kiss* (1908) was both derided and bought by the nation. In 1905–9 he made decorations for the Palais Stoclet in Brussels, designed by the Viennese architect Josef Hoffmann and furnished by his craft and design workshops (Wiener Werkstätte): Klimt provided mosaic panels for the dining room. Influenced by the Art Nouveau of Glasgow, by exotic and *primitive art (which he collected) and by *Hodler's compositions, he attained new heights of sensuous design. In his portraits this provides an expressive as well as gorgeous setting for the faces of his sitters. In his last years he also painted landscapes

balanced between patterning and convincing portrayal. The Österreichische Galerie in Vienna has a number of Klimt's paintings, including *The Kiss*.

Kline, Franz (1910–62) American painter, prominent among the *Abstract Expressionists. He was trained at Boston University and in London (Heatherley School of Art) during 1931–8, then settled in New York. After working in a *realistic manner and stimulated by the example of his friend *De Kooning, Kline developed an *abstract idiom dependent first on great brushstrokes, for a time in black on white canvas, subsequently also on glowing colours. He had solo exhibitions from 1950 on and was a prize-winner of the 1960 Venice Biennale. Major retrospectives were shown in Washington (1962), London (1964) and New York (1968); another toured Europe in 1994–5.

Klinger, Max (1857–1920) German painter and sculptor, best-known today for a suite of nightmarish etchings. The variety of his work and the richness of his imagination make a summary account difficult. Conscious of but a little detached from the new ideas and styles of contemporary art in Europe, he was not associated with any of the movements of his day, though much of his work could be called *Symbolist.

Born in Leipzig, he returned there after periods at the academies of Karlsruhe and Berlin and visits to Rome and Paris, sending work to *avant-garde exhibitions in Vienna and Munich. *The Judgment of Paris* (1886–7; more than 7 metres long; Vienna, Kunsthistorisches Museum) was received with awe in Vienna and proved him as innovative a painter as *Klimt but in a mode at once *naturalistic and Symbolist. An earlier painting, *The Attack* (1878; Berlin, Staatliche) had surprised his public with its sharp, almost filmic *realism: a man in a suit and a bowler hat is about to be mugged by four villains in a bleak suburb. Some of this bareness can be found also in his more comfortable *History paintings; a visit to Rome added a visionary apprehension of the nude in landscape, not unlike that of *Puvis but more

assertive, as in *Blue Hour* (1890; Leipzig Museum). Back in Leipzig he worked long on a synthesis of Christian and pagan concepts in his *Christ on Olympus* (finished 1897; Leipzig). During the years that followed he gave priority to etchings and to sculpture. His *Beethoven Monument* (1899–1902; Leipzig), a large sculpture in diverse marbles, alabaster, bronze and ivory, an almost monstrous homage to superabundant genius, was shown to great acclaim in Vienna, Düsseldorf and Berlin and today tests our confidence in the face of such richness. Among his many suites of etchings, *Paraphrase on the Finding of a Glove* (1881) remains the most admired as a foretaste of *Surrealist and film narrative. His theoretical work *Painting and Drawing* was first printed privately and then published in 1895.

Klyun, Ivan (1873–1942) Russian painter, who studied art in Warsaw, Kiev and Moscow. He was close to *Malevich from 1913 into the 1920s, contributing to the 1915 Zero-Ten exhibition in Petrograd and the 1916 exhibition The Store in Moscow. In 1917 he was charged with directing the new Commissariat of Enlightenment's exhibition programme, and from 1918 on he taught in Moscow new art workshops (*VKhUTEMAS). In the 1920s, like *Rodchenko, he adapted his pictorial idiom to the design of practical structures such as loudspeaker and projection kiosks and architectural projects but in 1925 he contributed to the exhibition of Easel Painters. Representational painting had been refreshed for him by the example of the *Purists and *Léger, as well as the work of *Picasso and *Gris.

Knapton, George (1698–1778) English portrait painter, a pupil of *Richardson and the teacher of *Cotes; his lively and direct works are sometimes mistaken for *Hogarth's. From 1725 to 1732 he was in Italy, and is best-known as a founder-member of, and first Painter to, the Society of Dilettanti – established in 1732 as a dining club for gentlemen who had travelled to Italy and now wished to encourage the arts. He executed 23 portraits of the members (1741–9), most of them in fancy

dress and all in animated poses; London, Society of Dilettanti. Knapton also had a large practice in portraits in crayon. There are portraits by him in London, Marlborough House; Dulwich, Gallery; Chatsworth; Althorp; etc.

Kneller, Sir Godfrey (1646/9–1723) Born in Lübeck, trained in Amsterdam under *Bol, and perhaps in contact with the aged *Rembrandt, Kneller became the dominant artistic personality of his time in England, where he settled in 1676 (*but see* Lely). After the Revolution of 1688 he shared the office of Principal Painter with *Riley, assuming the whole office on Riley's death in 1691. He was knighted in 1691/2, and created a baronet in 1715. He was the first painter to rise to such eminence in Britain; his social status reflects both the stature of his sitters, drawn from the leading figures of the period, and the quality of his work. Despite an immense output, made possible only by extensive use of specialized assistants and a studio run as an assembly line, Kneller at his autograph best demonstrates psychological acuity and technical brilliance (*see* e.g. *Philip, Earl of Leicester*, 1685, Kent, Penshurst Place; *The Chinese Convert*, 1687, London, Kensington Palace; *Kit Cat* series, 1702–17, London, NPG). His notorious personal vanity, and a certain cynicism attendant upon his enormous practice and studio methods, did not prevent him from showing concern with the training of young artists. He became the first Governor of the first *Academy of Painting to be set up in London, and continued active in the post until he was replaced in 1716 by *Thornhill.

Knight, Laura (1877–1970) British painter, born Johnson, married to the painter Harold Knight. She became an Associate of the Royal Academy in 1927 and a full Academician in 1936. Those were the years of her greatest reputation, which spread to the USA where she exhibited repeatedly. Her favourite subjects were gypsies and circus artistes. She painted them with affection and little style. She was a War Artist during the Second World War and after it was commissioned to paint

portraits at the Nuremberg trials. She was made a Dame in 1929.

Knyff, Leonard (1650–1722) Dutch painter of landscape, animals and occasionally portraits, active in England (*Arthur, Third Viscount Irwin*, 1700, Leeds, Temple Newsam). He drew the topographical views of royal palaces and country estates which were engraved by his compatriot, Johannes Kip (1653–1722), to illustrate the lavish *Nouveau Théâtre de la Grande Bretagne*, or *Britannia Illustrata*, published originally in 1707 or 1708.

Kobell, Ferdinand (1740–99) and his son and pupil, **Wilhelm von Kobell** (1766–1853) The best-known members of a family of German artists from the Palatinate, specializing in landscape. Ferdinand Kobell was court painter at Mannheim, moving to Munich when the court transferred there in 1792. After a period of painting imaginary views based on Dutch prototypes, he evolved a type of brightly coloured topographical view, laying the foundations of *realistic Munich *Biedermeier-era landscape (Munich, Bayerische). Wilhelm von Kobell, court painter in his turn for the Elector Karl Theodor of Bavaria and ennobled in 1833, added to this tradition an interest in Dutch 17th-century animal painting (*see* Berchem; Potter; Wouvermans) and English sporting prints, especially those featuring jockeys or hunters (*see* Wootton, Stubbs). Between 1805 and 1807, after the War of the Coalition which had seen an alliance between Bavaria and Napoleonic France, he painted a cycle of monumental battle scenes for King Maximilian I celebrating the victories of the two armies and the ruling Wittelsbach dynasty; these were followed by large battle paintings for Crown Prince Ludwig, 1807–15 (Munich, Neue Pinakothek; Bayerische). He took immense pains to record the events with the greatest possible accuracy, avoiding, however, the heroic or pathetic rhetoric of French battle painting as practised for example by Horace *Vernet, which he studied in Paris in 1809–10. Kobell also painted small-scale pictures of horses and riders, skilfully integrated in a landscape setting featuring

identifiable motifs. The schematic and apparently naïve quality of these pictures is a deliberate return to the 'simplicity' of old German and Italian paintings admired also by the *Nazarenes (Winterthur, Oskar Reinhart Foundation).

Købke, Christen (1810–48) Danish painter who studied at the Royal Academy of Copenhagen from the early age of eleven until 1832, and became an outstanding painter of portraits, landscapes and townscapes and occasional *genre scenes. His mostly calm, luminous, factual presentation of unexceptional subjects tends to hide behind it nationalistic pride and, through the inclusion of significant symbolic objects, his *Romantic need to incorporate moral meaning. Many of his best paintings are in the Statens Museum for Kunst in Copenhagen.

Kobro, Katarzyna (1898–1950) Russian-Polish sculptor, born and trained in Moscow and then in Vitebsk where she worked under *Malevich and married *Strzeminski. In 1922 she went to Poland, took Polish nationality in 1924 and was an active member of the avant-garde groups Blok and Praesens. She developed a form of *Suprematist sculpture, using simple geometrical forms, usually metal planes in primary colours, for spatial structures which are akin to architectural projects. In 1936 she and Strzeminski had a joint exhibition in Cracow. Much of her work was destroyed by German troops during their occupation of Poland; most of what remains is in the Muzeum Sztuki, Lodz. A major exhibition was shown in Warsaw and Lodz in 1956–7.

Koch, Josef Anton (1768–1839) Austrian landscape painter, born in the Tyrol, who studied in Stuttgart before travelling in the Alps and going to Rome, settling there in 1795. There he came under the influence of the *Neoclassicism of *Carstens and *Thorvaldsen and subsequently also of the art of the *Nazarenes. His knowledge of and enthusiasm for the high Alps, and his poetic rendering of mountainous landscapes, make him a precursor of *Romantic German landscapists

while his insistence on clear lighting and the precise rendition of forms, including figures, come from Neoclassicism; their combination make him a bridge figure between two movements often seen as wholly distinct. When he painted *Histories he often chose new, proto-Romantic subjects outside the *classical range, such as the poems of Ossian and the plays of Shakespeare. His *landscapes, with or without important figures in them, are epic statements about nature, retaining some echo of the simplicity of Koch's peasant origins and thus also recalling the directness of early landscape painting around 1500 when painters' eyes first recognized natural scenery as a significant motif for art.

Kokoschka, Oskar (1886–1980) Austrian-British painter, born in Bohemia at Pochlarn, trained in Vienna. His first productions – e.g. the picture book *The Dreaming Youths* with his own poems – were admired and in 1908 he exhibited in the Kunstschau exhibition organized by the *Klimt circle. This, and his activity as playwright, brought contact with the intellectual avant garde: the architect Loos, the writer Kraus, the composer Schönberg etc. Two of his plays were performed in 1909 and one of them, *Murderer Hope of Women*, was published in *Sturm* magazine in 1910, stimulating *Expressionist drama, with drawings for the play and portrait drawings. In 1909–12 he painted portraits seen as the first to reveal modern existential anxieties. In 1910 he had his first solo exhibition, at the Folkwang Museum in Hagen. His contribution to a Vienna exhibition, in 1911, met with abuse for its morbidity but also praise. In 1912 his work was included in the first and third Sturm gallery shows and in the Cologne Sonderbund exhibition. 1912–14 saw his passionate affair with Alma Mahler, celebrated in *The Tempest* (Basel, Kunstmuseum) and other works. In November 1914 he volunteered for the Austro-Hungarian army. He was gravely wounded in August 1915, receiving a bullet in the head and a bayonet in his side, and was hospitalized in Brno and Vienna. In August 1916, back in uniform, he suffered shell-shock and returned to hospital. He

was unwell for some time, and went to Dresden to convalesce and also to form new art contacts. He commissioned a life-size, hyper-realistic female doll to use as model and companion in 1919. That year he was appointed to a professorship at the Dresden Academy.

His post-war paintings give priority to colour and are the most solid of his career; the landscapes particularly found a ready public. In 1922 his work was shown in the German pavilion at the Venice Biennale, and in 1923 he abandoned his professorship to travel, painting landscapes and townscapes. He lived in Paris for part of 1931 and of 1932–3 but disliked the city and returned to Vienna. In 1934 he moved to Prague, opposed to the Nazis and tired of Vienna's 'oppressive little world'. He painted Thomas Masaryk, president of Czechoslovakia (1935–6, Pittsburgh, Museum of Art), also an ironic self-portrait as 'degenerate artist' (on loan to Edinburgh, Scottish NG of Modern Art) when he learned that his work featured in the German *Degenerate Art exhibition. In 1938 he fled to Britain and spent the war years in London, Cornwall and Scotland. He painted portraits, landscapes and allegories but failed to gain the interest of the British public. In 1947, granted British nationality, he embarked on travels in Europe and the USA. Exhibitions, beginning with the 1947 retrospective at the Basle Kunstmuseum, demonstrated his status as the great surviving Central European painter: he was asked to lecture and to write, his plays were performed and honours came to him. In 1953 he settled at Villeneuve in Switzerland, his home for the rest of his life. That summer he gave his first Summer School of Seeing in Salzburg (until 1963). Major exhibitions were now frequent on both sides of the Atlantic. He supervised and added two essays to Edith Hoffmann's book on his life and work (1947). His autobiography appeared in 1971, his collected essays in 1973–6 and his collected letters in 1984–8.

Egocentric but rooted in European humanism, certain of his greatness yet anxious to see it acknowledged, he was a major *Expressionist, rejecting the term while claiming exclusive rights to it. His

art demonstrates his regard for traditional themes and values, from those of the Greek tragedians to the educational theories of Comenius of Prague. Re-presented through his art, these would save the world from itself if only he could catch its attention.

Kolbe, Georg (1877–1947) German sculptor, trained in Dresden, Munich and Paris, and admired for his graceful figures, mostly female nudes, in bronze.

Kollwitz, Käthe (1867–1945) German graphic artist and sculptor, born Schmidt in Königsberg (East Prussia), trained there and in Berlin and Munich. In 1891 she married a doctor and settled with him in a poor area of north Berlin. Her first series of lithographs, *The Weavers' Revolt*, was shown at the annual Berlin art show in 1898; William II vetoed the award to her of a prize. In 1899 she gained a gold medal at a Dresden show; in 1902 and 1905 the national collections in Berlin bought some of her work. In 1907 *Klinger gave her an award enabling her to spend time in Florence and Rome. 1913 saw the publication of a catalogue of her graphic work and an album of her prints. Thus, although her theme was poverty, injustice and suffering and her idiom was a monumental *realism stimulated by *Daumier and *Steinlen, her work found admiration outside the conservative establishment. About 1910 she began to work also as sculptor. Her son's death at the front in 1914 led her to work for many years on a memorial, exhibiting parts of the monument as they became ready. Her 50th birthday in 1917 was marked by exhibitions in Berlin, Königsberg and Bremen and in 1919 she became a member of the Prussian Academy. Her woodcut commemorating the murdered communist Karl Liebknecht was published in a large edition in 1920. She made many prints as propaganda for the poor and hungry and against war. Her work was well represented in a German exhibition touring the USSR in 1924–5; in 1927, when her 60th birthday was honoured with exhibitions in Berlin and Karlsruhe, she visited Russia at the invitation of *AKhRR. In 1928 she was given

charge of the master class in graphics at the Berlin Academy. In 1933 she resigned and in 1936 her work was removed from an Academy exhibition; it was not denounced as *degenerate, presumably because of its popularity. By finding a strong and memorable form for each theme, Kollwitz produced powerful, unglamorous images that at their best attain universality.

Koninck, Philips (1619–88) Dutch painter, trained in Rotterdam by his elder brother **Jacob Koninck** (1614/15–after 1690) and associated with *Rembrandt after his return to his native Amsterdam c.1640. Although chiefly known in his own day as a painter of *genre and portraiture, he is now mainly remembered for his panoramic landscapes of the Dutch countryside, originally influenced by Rembrandt and Hercules *Seghers but evolving into original creations based on realistic scenery and characterized by an unbroken horizon line and subtle alternation of luminous areas of sunlight and transparent shadow under a carefully studied cloudy sky (Amsterdam, Rijksmuseum etc.). Philips's and Jacob's cousin **Salomon Koninck** (1609–56) was also a painter, imitating Rembrandt's early pictures of scholars at their studies and his dramatically lit biblical scenes.

Koons, Jeff (1955–) American artist, self-taught, who turned from work in a museum and on Wall Street to exhibiting inflatable toys, and then domestic appliances, as art – on sculpture bases and in plexiglass cases. In 1987 he showed an exhibition in three places concurrently (Chicago, New York and Cologne), consisting of collected *kitsch objects. His own blithe-young-man image was increasingly associated with his objects and he became a notable presence in his sculpture when he married the Italian porn queen 'Cicciolina' properly Ilona Staller) and made many representations of himself and his wife in moments of sweet togetherness, including love-making, and in a variety of media from photographs to cast glass. The cheap gorgeousness of some of his work reflects on mass-produced religious imagery of the last two centuries and on

some of the *Baroque's most seductive creations.

Kossoff, Leon (1926–) British painter, born and trained in London, most significantly at the Borough Polytechnic's art classes given by *Bomberg, from whom he learned the identification of insight and emotion with the physical manipulation of paint. His paintings deal with the real world in the form of nudes, portraits, close-ups of individual buildings, townscapes and public interiors such as busy subway stations or swimming pools, sometimes in dark tones but increasingly in light, even silvery tones given off by his dense, furrowed surfaces. The same motifs are pictured repeatedly. Neither celebrating nor condemning, Kossoff's paintings suggest engagement and sympathy in lifting reality on to a visionary plane.

Kosuth, Joseph (1945–) American artist, trained in New York, who in the mid-1960s emerged as a *Conceptualist. He claimed that works of art were tautological forms of communication. He exhibited dictionary definitions of words, in the case of *One and Three Chairs* (1965, New York, MoMA) bringing together a definition of the word 'chair', a photograph of one and an actual chair. *The Seventh Investigation, Art as Idea as Idea, Proposition One, 1970* was an ephemeral display of a definition in four diverse contexts and thus inflected by its use. He showed a wide range of verbal pieces in the 1993 Venice Biennale.

Kounellis, Jannis (1936–) Greco-Italian artist ('I am a Greek person but an Italian artist'), who left Greece for Rome to study art. His first show, in Rome in 1960, was of stencilled letters, numbers and signs, in reaction to the fashionable *Art informel of the time; subsequently he turned away from painting and associated with the *arte povera tendency, working in a great variety of materials and making installations in which finite and organic matter are contrasted and the transience of civilization is suggested. He has shown all over Europe since 1977, and in the USA since 1986.

Kraft, Adam (active 1490–1508) Leading Late *Gothic German stone sculptor in Nuremberg. A high proportion of his work consists of narrative relief sculpture, influenced by painting (Nuremberg, St. Sebalduskirche 1490–92; Municipal Weigh-House, 1497; *Stations of the Cross*; 1508, Germanisches), but his most celebrated achievement is the towering tabernacle of St Lorenz in Nuremberg, 1493–6, incorporating reliefs and groups of the Passion and statuettes of prophets and angels, and supported by sturdy portrait-like figures possibly representing the sculptor and his assistants.

Kramskoi, Ivan (1837–87) Russian painter, trained first by an *icon painter and subsequently at the Petersburg *Academy. He became one of the leaders of the *Wanderers but his chief ambition was not so much to portray Russia and her peoples as to succeed *Ivanov as the nation's creator of significant, reformatory *History painting. His *Christ in the Wilderness* (1872) complementing Ivanov's great painting, shows a perplexed and brooding Christ sharing humanity's perpetual hesitation between good and evil, between (as the painter states it) left and right. This Christ was received as a model for the 'new man' proposed by Russian critical novelists such as Belinsky and Chernishevsky, devoting a self-disciplined life to improving the lot and the awareness of the Russian people. A persuasive image, it recalls something of the mode, and some of the limitations, of *Pre-Raphaelite painting. Kramskoi's most enjoyable paintings are his portraits of such eminent engaged contemporaries as the writers Tolstoy and Nekrassov and the painters Shchedrin and Litovchenko as well as a particularly fine self-portrait, and anonymous peasant portraits. His *Inconsolable Grief* (1884) shows his wife beside the coffin of their son. The Tretyakov Gallery in Moscow has a large collection, including some of his best portraits, and the two paintings named above. Others are in the Russian Museum, St Petersburg.

Kremser–Schmidt *See* Schmidt, Martin Johann.

Krieghoff, Cornelius (1815–72) Canadian painter, born in Amsterdam. He learnt his art in Germany but moved to Quebec via the United States, settling there in 1853. He is famous for his carefully worked paintings of Canadian scenery and daily life, full of informative detail but also firmly constructed on academic lines.

Krohg, Christian (1852–1925) Norwegian painter, trained principally in Germany where he was influenced by the fresh *naturalism of *Menzel and *Liebermann, before spending months in Paris during 1881 and 2, absorbing the example, particularly, of *Bastien-Lepage and *Manet. These experiences located him close to *Impressionism, but he never adopted Impressionism's broken surface and colour analysis. He made many visits to Skagen, where he painted scenes of the life of fisherfolk and artist-visitors. Mostly he lived in Christiana (Oslo), a prominent member of its progressive artist-and-writer circle, the Christiana Bohemians. His novel *Albertine* (1886), the story of a working-class girl forced into prostitution by middle-class *mores* and police oppression, brought prosecution and notoriety, and Krohg pictured scenes from it in paintings that were equally controversial; they are lively but not in themselves morally subversive images. *Albertine in the Police Doctor's Waiting Room* (1887) is the most famous example. Similarly, his scenes of daily life touch on hardships and suffering without insisting on them, though in *The Sick Girl* (1881) he concentrates our attention on the dying child by his frank rendering of illness and his compositional austerity. Both these paintings are in the National Gallery, Oslo, which has a substantial collection of his work. When a new Christiana *Academy was founded in 1909, he was its first director, remaining in post until his death.

Krøyer, Peder Severin (1851–1909) Danish painter, born in the fishing town of Stavanger, Norway, but brought up in Copenhagen where he studied at the Royal *Academy. He travelled widely and spent time in Paris before becoming one of the leading painters in the artists' colony and

fishing village of Skagen. He continued to travel and work abroad, and was known and honoured internationally, but Skagen was his home and Skagen scenes, including portraits, dominate his work (and are best seen in the Skagen Museum). These tend to be in a lively *naturalistic manner rooted in open-air painting, but Krøyer also worked from photographs, as for his famous series of 'blue hour' pictures of the beach at Skagen, when, in mid-summer, everything is enveloped in a blue haze. His paintings of two women, dressed in white, deep in converation as they stroll along the water's edge, indebted to *Whistler in compositional economy and in giving priority to atmosphere, are at once naturalistic and expressive of *Symbolism's desire to deliver universal meaning through poetic imprecision.

Kubin, Alfred (1877–1959) Austrian graphic artist, trained in Munich, who became known for his macabre, often nightmarish drawings. These reflect his neurotic character as well as his interest in *Goya and in the darker side of *Symbolist art. In 1907 he wrote a fantastic novel, published in 1909 as *Die andere Seite* (The Other Side) and republished in 1917 with an autobiographical chapter which he rewrote at intervals throughout his life. His first exhibition was in Berlin in 1902; his first album of drawings was published in 1903. His fame grew and continued through the Nazi period during which he became a professor at the Berlin Academy.

Kubišta, Bohumil (1884–1918) Czech painter, trained in Prague and in Florence. Influenced by *Munch and *Kirchner, he worked in a fervent *Expressionist idiom which included elements of *Fauvist colour. A visit to Paris in 1909 was followed by a turn to *Cubism which he adapted for himself as a means of seeking spiritual truths at once personal and relevant to modern urban life. To this end he turned sometimes to religious themes, such as *The Raising of Lazarus* (1911–12; Pilsen, West Bohemian Gallery) and *St Sebastian* (1912; Prague, Narodni), a kind of self-portrait. Poverty led him to become a soldier in 1913. He served in the

Great War and died of influenza shortly after it ended.

Kuhn, Justis Englehardt (recorded 1708–17) Naturalized American painter of German extraction. He settled in Annapolis, Maryland, where he painted portraits of local notables (Baltimore, Historical Society).

Kuhn, Walt (1877–1949) American painter, active first as an illustrator but trained as painter in Paris and Munich during 1901–3. He was one of the leading organizers of the *Armory Show and advised John Quinn and other US collectors on their purchases of modern art. As a painter he worked in the area of *Fauvism and *Expressionism. He developed a particular liking for painting circus figures. One of his best known pictures is *The White Clown* (1931; New York, Whitney).

Kuindzhi, Arkhip Ivanovich (1842–1910) Russian landscape painter, son of a Greek cobbler. He studied at the St Petersburg *Academy, but joined the *Wanderers in 1875, becoming famous for firm landscape paintings, close to natural appearances but reconstructed to bring out dominant forms and tonal contrasts, achieving 'a monumental quality which assured that his work was received as a celebration of Russian national identity' (John Milner, 1993). In the 1890s he taught landscape painting at the Academy, where *Roerich was among his students. The Tretyakov Gallery in Moscow and the Russian Museum in St Petersburg have several examples of his work.

Kulmbach, Hans Süss, von (c.1480–1522) German painter, designer of woodcuts (*see under* relief prints) and stained glass, he was the most important pupil of *Dürer after Hans *Baldung, joining the master's Nuremberg workshop in about 1500. He is thought to have worked also with Jacopo de'*Barbari. Presumably born in Kulmbach, he was active mainly in Nuremberg, where he became a citizen in 1511, but in that year and 1514–16 he executed some altarpieces

for churches in Cracow, Poland, which he probably visited. Dürer's influence is equally strong in the *Tucher Altarpiece* of 1513, Nuremberg, St. Sebalduskirche, and in the male portrait busts in Berlin, Staatliche and Munich, Alte Pinakothek, although Hans von Kulmbach's colour is less harsh than that of Dürer, and his line less agitated and hard.

Kuniyoshi, Yasuo (1893–1953) Japanese-American painter, born in Japan but brought to the USA in 1906 and trained in Los Angeles and New York. He introduced a flavour of the Orient into his otherwise *primitivist but wholly western art. His style and subjects changed in the late 1920s when he was influenced by *Pascin and by *Derain and painted less romantic, more everyday subjects such as still lifes and landscapes. In the 1940s, affected by international events, his art again became more personal and poetic. He had major exhibitions in the USA in 1942 and 1961, and in Japan in 1954 and 1975.

Kunstkammer (German, art-room) A word applied to the often highly decorated small chambers in which 16th-century collectors kept examples of natural wonders and exotica as well as small-scale works of art such as medals, coins and statuettes.

Kupecký, Jan, also known as Johannes Kupetzky (1667–1740) Prolific Czech *Baroque portrait painter, active in Vienna and in Italy, where he lived from 1686 to 1709. After 1723 he finally settled in Nuremberg. There are works by him in Prague, National; Castle.

Kupka, František (1871–1957) Czech painter, trained at Jaromer, Prague and Vienna, mostly in the tradition of *Nazarene painting. During the same years (1888–93) he studied *Baroque art and folk art and committed himself to spiritualist study and practices. His work brought him commissions in Vienna but in 1896 he moved to Paris. For a time he repressed his mysticism, working as an illustrator for fashion and anarchist journals whilst deepening his knowledge of science.

He associated with *Villon, *Duchamp, *Gleizes, *Léger and other painters. In 1912 he exhibited *Amorpha, Fugue in Two Colours* (Prague, Narodni), a large *abstract composition, and probably participated in the *Section d'Or exhibition. The 1914–18 war interrupted his work; he was prominent among Czech volunteers fighting alongside the French. 1921–2 saw his first solo exhibition in Paris and the first book about him, and the Prague Academy made him its Professor in Paris. In 1924 he presented a retrospective which was widely noticed. Ill health and depression inhibited him but in 1931 the founding of *Abstraction-Création encouraged him to pursue his work, as did his inclusion in the New York (MoMA) exhibition Cubism and Abstract Art in 1936. In 1946 he showed in the Salon des *Réalites Nouvelles and his 75th birthday was celebrated with a major retrospective in Prague and purchases by the Czech nation. In 1951 he had his first solo exhibition in New York. Shortly before his death the Museum of Modern Art in New York bought a group of paintings and Kupka gave it a large number of drawings. A memorial exhibition of his work was shown in 1958 at the Musée National d'Art Moderne, Paris, to which his widow made a large donation in 1963. Kupka's interest in symbolism, in the representation of movement and in abstract colour compositions to present conceptions of life and the cosmos make him, like *Kandinsky, one of the major creative forces in modern painting, dedicated to exploring an area beyond the visible world.

L

Labille-Guiard, Adélaïde (1749–1803) French portraitist in pastels and oils. She was praised by contemporaries for painting with 'masculine vigour', and her work is both sober in its naturalistic (*see under* realism) portrayal of character and rich in its depiction of costume and setting – in contrast with that of her rival, Mme *Vigée-Lebrun, which is more 'feminine' in its exploitation of sentiment. Both were received in the French *Academy on the same day in 1783. Labille-Guiard became *Premier Peintre* to the daughters of Louis XV (Versailles) and shortly before his execution Louis XVI commissioned a portrait of himself from her, which was never painted. Because of her revolutionary sympathies, she was able to remain in Paris throughout the 1790s.

Labrador, Juan Fernandez, El (documented 1630s) One of the few Spanish *still-life painters to achieve international fame in his lifetime. Although some flower paintings by him are known (Madrid, Prado) and some landscapes and religious pictures documented, he specialized above all in the painting of grapes – sometimes nothing more than a bunch hanging by a cord against a dark background (compare *Sánchez Cotán). These pictures were widely copied and imitated. The *trompe l'oeil* treatment of this motif, which came to be a test of still-life painters throughout Europe, was doubtless suggested by an anecdote related in Pliny the Elder's *Natural History*, a Latin text of the 1st century which contains the only surviving history of ancient art: grapes painted by the Greek artist Zeuxis are said to have been so lifelike that birds came to peck at them. 'El Labrador' means 'the Rustic', and the painter lived outside Madrid, we do not know where, coming to court only occasionally to accept commissions and deliver pictures to the royal household and wealthy collectors in the capital. From 1629 Labrador was closely associated with Sir Francis Cottington and his secretary Arthur Hopton, English diplomats at the Spanish court; between 1632 and 1633 Hopton sent five Labrador still lifes to England for Cottington's wife and for Charles I (Hampton Court, coll. H.M. the Queen). Other works are in Madrid, Naseiro coll.; Cerralbo; Prado.

Lachaise, Gaston (1882–1935) French-American sculptor, born and trained in Paris. In 1906 he moved to the USA, to Boston first, in 1912 to New York. He produced lively portrait busts of writers and artists but also, in a more hieratic idiom, sculptures of Woman, compendium of universal forces and object of desire. His large *Standing Woman* (1912–27, bronze) is a major example; in the 1930s he also made *abstractions of feminine anatomy that border on the bizarre. In these and in commissioned decorative work for elevator doors, radiator caps, friezes etc., he fused *Art Nouveau design with *primitive fetishism. He had many solo exhibitions in the USA, including retrospectives in 1935, 1963 and 1967.

Lacroix, Charles de *See under* Vernet, Claude-Joseph.

Laemen, Christian Jansz. van der *See under* Francken.

Laer, Pieter van (*c.*1592–1642) Haarlem painter, possibly trained by Esaias van de *Velde, resident in Rome *c.*1625–38. He was the first artist to specialize in small-scale pictures of Roman street life, adapting *Caravaggio's *chiaroscuro and naturalism (*see under* realism) to outdoor scenes with numerous full-length figures (Rome, Nazionale; Spada; Hartford, CT., Atheneum; etc.). Despite being held in low esteem by art critics, his paintings were much prized and lastingly influential. Van Laer's physical deformity and small stature earned him the nickname Bamboccio (poppet); his pictures gave the name *bambocciate* (trifles) to the whole genre, and his

numerous followers are termed *Bamboc-cianti*. He was a prominent member of the Netherlandish artists' fraternal organization in Rome, the *Schilderbent, and an associate of *Poussin and *Claude Lorrain; his influence extended even to the great Spanish painter *Velázquez. His Italian followers included Michelangelo Cerquozzi (1602–60) and Micco *Spadaro; among the northerners the most prominent were the Flemings Jan Miel (1599–1663) and Michiel *Sweerts.

Laermans, Eugene (1864–1940) Belgian painter, deaf-mute from the age of 11. His art tells of the wretchedness of the poor and heralded *social realism and Flemish socially-orientated *Expressionism. He had a major exhibition in 1899. He became blind in 1924 and in 1927 was made a baron.

Laethem-Saint-Martin Name of a village near Ghent (Belgium) and of the artists' association established there. Stimulated by those of *Barbizon, *Pont Aven and elsewhere, and taking some of their moral stance from the *Pre-Raphaelites, the artists distanced themselves from urban tensions and aimed at significance and a quasi-religious artistic character. George *Minne was the dominant figure in the first generation there; Van den *Berghe, *Permeke and the de Smet brothers settled there before the 1914–18 war. Subsequently the association represented a strong Belgian *Expressionist tendency.

La Fargue, Paulus Constantijn (1729–82) Dutch painter and etcher (*see under* intaglio) born and active in The Hague. The most prolific member of a family of topographical artists, he specialized in views of the cities and villages of South Holland (London, National).

La Fosse, Charles de (1636–1716) French painter, one of the most original of the group of decorative *history painters which included Noel and Antoine *Coypel and the *Boullongne; a forerunner of *Rococo. He began his training under *Lebrun, but was much more affected by his study years in Italy, 1655–60 in Rome

and 1660–3 in Venice, where he was particularly attracted to *Veronese; he also visited Modena and Parma, discovering *Correggio, on whom he was to base the designs of his dome paintings in Paris (e.g. Saint-Louis-des-Invalides, 1692). During the later 1670s La Fosse was mainly occupied as assistant to Lebrun (Tuileries, Versailles palaces); in the 1680s, however, he abandoned *classicism for colourism (*see under disegno*), championed by his friend Roger de *Piles (Paris, Louvre; Toulouse, Augustins; decorations for Trianon). From 1689 to 1692 La Fosse was in London working on the decoration of Montagu House; on its completion he was summoned back to Paris, forced to refuse William III's inducements to stay in England and work at Hampton Court.

La Fresnaye, Roger de (1885–1925) French painter, trained in Paris. Guided first by *Nabi principles, then influenced by *Cézanne and by *Cubism, especially by Robert *Delaunay, he did paintings that attend to humanist themes belonging to the tradition of *Romanticism. During the 1914–18 war he served in the army, caught tuberculosis and never fully recovered. There was a large exhibition of his work in Paris in 1923.

Lagoor, Jan de (active 1645–59) Dutch landscape painter active in Haarlem, a follower of Jacob van *Ruisdael (London, National).

Laguerre, Louis (1663–1721) Learned French painter of allegorical mural decorations, he worked for a while with *Lebrun before arriving in England in 1683/4, as an assistant to the architectural painter Ricard. Both men worked for *Verrio at Christ's Hospital in 1684, and with him at Chatsworth during 1689–94. While most of the royal commissions before 1688 and after 1699 went to Verrio, Laguerre painted many of the most important wall and ceiling decorations in great houses (Burghley; Devonshire House; Marlborough House; Blenheim). He is generally considered far superior to Verrio in both invention and execution. From *c.*1711 his rival *Thornhill, who had learned much

from him, tended to supplant him in public esteem, and in his later years Laguerre devoted himself increasingly to portraiture and history painting (see under genres). Little of his easel painting is known to have survived.

La Hyre, Laurent de (1606–56) French painter of large altarpieces, decorative ensembles, portraits and landscapes, born and active in Paris, where in 1648 he was one of the founder members of the Royal *Academy. Unlike *Vouet or *Lebrun he neither went to Italy nor ran a large studio, but trained several apprentices including his youngest brother, **Louis de La Hyre** (1629–53) and perhaps a number of other siblings. Early in his career, around 1623, he spent some time in Fontainebleau; influenced by *Primaticcio, he painted erotic scenes in a *Mannerist style (Heidelberg, Kurpfälzisches). In the late 1620s he began to execute commissions for altarpieces in a *tenebrist style derived at second hand from *Caravaggio (e.g. *Martyrdom of St Bartholomew*, Mâcon, Cathedral). From the late 1630s, however, he largely abandoned this *naturalist mode to become one of the chief exponents of French *classicism in the manner of *Poussin, adopting a lighter palette and more static compositions, and modelling his figures after antique statuary – as can be seen in his *allegorical figures of the Liberal Arts of 1649–50, the only surviving, albeit dispersed, remains of his decorative schemes for Parisian town-houses (London, National; Orléans, Musée; Holland, Heino, Foundation Hannema-De Stuers; New York, Metropolitan; Switzerland, Bürgenstock Castle; France, private coll.). Other works by La Hyre in Paris, Louvre; Rouen, Musée; St Petersburg, Hermitage; Orléans, Musée.

Lairesse, Gerard de (1640–1711) Influential Flemish-born Dutch painter, etcher (see intaglio) and theoretician of art. Both through his practice and his treatises and lectures, he single-handedly revitalized decorative and large-scale painting in Holland.

The precocious son of a painter father, de Lairesse studied also with a *classicizing painter who had worked for many years in Paris. Fleeing from a broken engagement, he settled in Amsterdam, where he acquired citizenship in 1667. Despite his training, he initially admired *Rembrandt, but was soon won over to the artistic tenets of the French *Academy through a circle of intellectuals promoting French fashions. Most of his energies as a painter were devoted to easel paintings of mythological scenes (e.g. Brunswick, Museum; Antwerp, van den Bergh; Amsterdam, Rijksmuseum) and to vast classicizing decorative schemes in public buildings, palaces (e.g. The Hague) and the houses of rich merchants. He was the first Dutch artist to paint *illusionistic ceiling pictures on canvas (Amsterdam, Rijksmuseum).

De Lairesse went blind c.1690. He supported himself by lecturing on art theory; the lectures were collected and published in two volumes: *Fundamentals of Drawing*, 1701, and the famous *Groot Schilderboek* (*Great Book on Painting*) 1707, which became one of the most widely read and used handbooks on art in the Dutch Republic (reprinted 1712, 1714, 1716, 1740, 1836) and translated into German, English and French.

Lam, Wilfredo (1902–82) Cuban painter who studied in Havana and in Madrid. He had his first exhibitions in Madrid and Barcelona in 1928 and 1929. In 1938 he moved to Paris where he worked in *Picasso's studio. He had a Paris exhibition in 1939 and joined the *Surrealist movement, leaving France for the USA with *Masson and *Breton. He showed in New York in 1942. He returned to Cuba and, stimulated by a visit to Haiti, fused totemic and Voodoo imagery with his Picasso-based Surrealism. The energy of his paintings was rewarded with many exhibitions and prizes, notably in the 1960s when he lived in Albisola Mare, near Genoa (Italy) and was part of an international art world pivoting on New York and Paris.

Lamb, Henry (1883–1960) British painter, born in Australia but brought up in Manchester. He studied medicine but in 1907 moved to London to study art. He is best known for his portraits, notably that of

the writer Lytton Strachey (1914, London, Tate), and these dominated his output, reflecting a lively social life, but he was an official War Artist in the two world wars and on other occasions too painted memorable images of human experience, e.g. *Death of a Peasant* (1911, ditto). A major exhibition of his work toured the UK in 1984.

Lambert, George (1700–65) English landscape painter, influenced by *Wootton and Gaspard *Dughet. He produced the first *picturesque 'portraits' of country houses, showing an acute awareness of the principles of landscape gardening as evolved by William *Kent (Chatsworth, Derbyshire). He became chief scenery painter at Covent Garden Theatre, London applying the same kind of artifice to both his paintings in oils and his scene paintings. There are also pictures by him, in a similar vein, of the simpler English rural scene (London, Tate).

Lamberti, Niccolò di Pietro (*c*.1370–1451) Florentine sculptor, employed on the Porta della Mandorla, Florence cathedral, in 1393 and on a *Virgin and Child* for a niche on the Guild Hall Church, Or San Michele. In 1415 he executed, for the cathedral façade, a *St Mark* (Florence, Opera del Duomo) which makes a poor showing beside its companion figures, *Nanni di Banco's *St Luke* and *Donatello's *St John*. In 1416, he moved to Venice with his son, **Pietro di Niccolò Lamberti** (*c*.1393–1435); there he played a leading part in the sculpture for the façade of S. Marco. He is recorded in Bologna 1428–39.

Lancret, Nicholas *See under* Watteau, Jean-Antoine.

Land Art *See* Earthworks.

Landers, Sean (1962–) American artist, working in New York, who specializes in not specializing and changes his media continually – painting, sculpture, videos, installations, etc. – in order to submit artistic practices and ideals to humorous scrutiny. The images that result

often involve a degree of caricature or false naïvety. Among his several exhibitions, an early one, shown in 1990 at the Andrea Rosen Gallery in New York, was entitled 'Work in Progress? Work?' He has shown repeatedly at that gallery but also contributed to group and thematic exhibitions abroad, including the young artists' section of the 1993 Venice Biennale.

landscape As an autonomous *genre of painting, landscape was first evolved in ancient Roman mural and stage decoration. Perhaps its earliest revival on a similar scale was in Ambrogio *Lorenzetti's *frescos of *Good and Bad Government* in Siena Town Hall in the late 1330s. Two small panels, views of a walled city and of a coastline, have also been attributed to Ambrogio (now Siena, Pinacoteca). The Black Death of 1348 seems to have put an end to these precocious experiments in poetic *naturalism. Analogous later developments date from the late 15th and early 16th centuries, when the *Renaissance recovery of *Classical texts seems to have created a demand for view painting from both Italian and northern European artists. Only rarely were Renaissance landscape paintings devoid of narrative elements, even in the work of recognized 'specialists', such as *Patenir and his follower Herri met de *Bles, or the Venetian *Giorgione; *Altdorfer's *Landscape with a Footbridge* (*c*.1520; London, National) is a rare exception in the oil medium, although perhaps not originally intended for sale, like *Dürer's watercolour records of his journey to Italy in the 1490s. The basic pictorial concerns of landscape painting are the depiction of distance and natural light – which is perhaps why one of the most accomplished landscape (more properly, townscape) murals of the 16th century was the work of a specialist in *perspective, and is consequently seldom included in histories of landscape: *Peruzzi's *illusionistic Sala delle Prospettive or delle Colonne, *c*.1516, Villa Farnesina, Rome, in which fictive columns frame the same views that actually once surrounded the villa. Despite the number and high quality of 16th-century landscape paintings (*Polidoro da Caravaggio's chapel laterals in San Silvestro al Quirinale,

Rome, *c.*1525, and Pieter *Bruegel's *Season* paintings of the 1560s), view painting did not really come into its own until the 17th century. Although ranked low in the *academic hierarchy of the genres, it attracted wide theoretical interest, an enormous clientele, and some of the finest artists of the time, from Annibale *Carracci, *Elsheimer, *Claude and *Poussin in Rome, *Rosa in Naples, Rome and Florence, to *Rubens, *Ruisdael and *Rembrandt in the Netherlands. Under 'landscape' we must now consider also its sub-categories, such as marine painting (Jan van de *Cappelle), townscape (Van der *Heyden, *Vermeer) or that hybrid of the two, the view of Venice (*Canaletto, *Guardi). The genre's importance in 19th-century art can hardly be overstressed, from *Turner and *Constable to the *Impressionists. It only remains, perhaps, to remind readers of the function of human figures in landscape painting, for the real distinction between landscape as ornament and landscape as an autonomous genre is not the presence or absence of human figures, nor even whether they are included as actors in a narrative or merely as *staffage. When foreground figures take up most of the picture surface, the landscape is mere adjunct – which is why *Leonardo da Vinci, despite his interest in landscape and his famous landscape drawings, did not produce landscape paintings. In 'true' landscape painting, on the other hand, the figures – whether dispersed throughout the landscape or merely deployed in the foreground – exist to indicate scale and to evoke the viewer's empathy. Sensitive as we are to our own size, we know that a small full-length figure in the foreground of a landscape is *already* at some distance from us; that a house, a tree or a mountain smaller than that person must be further still in the distance. A human figure walking on a road invites us to follow, or to meet, him or her, like the hunter whose face coincides with the vanishing point (*see under* perspective) in *Hobbema's *The Avenue, Middelharnis.* Finally, the colourful clothes allowed to human beings justify a spot of bright colour wherever the painter needs it in the composition, regardless of the prevailing colour of foliage, ground, sea or sky.

18th-century landscape painting saw the emergence of new attitudes to the natural environment, including a refreshed concept of the sublime as experienced before nature at its roughest and most intimidating. The English concept of the *'picturesque' invited connoisseurs to see nature in terms of paintings and to variegate their gardens to echo its unruly character. Before nature man thought himself in the presence of divine powers, and with the onset of *Romanticism landscape painting became openly religious in spirit, as in the art of *Friedrich who composed landscape paintings in the manner of sermons and of *Palmer whose rhapsodic early landscapes can be read as religious poems. *Turner elevated landscape to the status of *history painting both by seeding pictures of landscape with historical actions, as in *Snow-storm: Hannibal and his Army crossing the Alps* (1812), and by endowing with history-painting grandiloquence scenery and even urban events or combinations of nature's and man's forces in such scenes as *The Burning of the Houses of Lords and Commons* (1835) and *Rain, Steem and Speed* (1844). Menwhile John *Martin was picturing dramatic moments from the Bible in sweeping panoramic landscape settings, while their American contemporary Thomas *Cole led what became known as the Hudson River School in presenting unspoilt reaches of the new continent as parables of God's power and goodness. Some of his successors, including Albert *Blerstadt and Fitz Hugh *Lane, have become known as the Luminists thanks to their calm and clear landscape paintings, charged with the beauty of natural light. In England the Norwich School of the early 19th century, notably John *Crome and John Sell *Cotman, extended the Dutch tradition by picturing local scenery accurately but with a new breadth of treatment, especially in watercolours. In his native Suffolk, and then more widely in the south of England, John *Constable was to find many subjects through which to express man's piety before God's work as well as nostalgia for a departing world of innocent rustic life of social harmony and utility.

*Corot and other French painters had taken to making fresh, small studies of

town and landscapes in the 1820s. With paint now being packaged in tubes, it became not only possible but morally preferable to paint oil sketches out of doors, subsequently also larger paintings such as those of the *Pre-Raphaelites and the *Barbizon painters. The Danish painters of the early 19th century developed a particular quality of intimacy in their landscapes, while the Barbizon School radiated its influence throughout Europe and across the Atlantic. *Courbet's emphatic *realism, which included finding equivalents for nature in the material of paint, impressed itself on younger Frenchmen who would emerge as *Impressionists as well as on painters in southern Germany. Whereas Courbet pictured remote places in his native region of France, the Impressionists at first stayed close to Paris and included street scenes in their *naturalistic accounts of light, colour and space; they also observed closely special natural effects, such as snow and mists. By the 1880s some of them became more concerned with the demands of pictorial organization and/or pursued effects of light with scientific zeal in series of representations. *Symbolism invited a more poetic and inventive use of landscape, as in *Gauguin and *Puvis, and encouraged Van *Gogh to inject human significance into ordinary scenes by means of a heightened use of colour and form and emphatic delineation. *Seurat's landscapes, analysed and systematized to render colours and tones exactly, were also organized along classical principles to convey quiet grandeur. *Cézanne, working mostly in the south of France, adapted Impressionism into a means of slow, acutely observant painting of familiar scenery. The *Wanderers' movement in Russia adapted Barbizon naturalism in picturing rural subjects as well as scenery with nationalistic affection.

With the growing public interest in paintings of landscape and of rural life, artists congregated in colonies to live and work in a convivial and inexpensive manner: such artists' colonies developed, after Barbizon, at such places as Grez-sur-Loing, Pont-Aven and Concarneau in France, at Skagen in Denmark, at Abramt-sevo in Russia, at Newlyn and St Ives in England and in the USA at Provincetown, MA. The colonies' emphasis on particular locations and their special character encouraged a regionalism which eventuated in the insistently north-German art of *Nolde and the Catalan art of *Miró, as well as the emphatic, anti-cosmopolitan regionalism of such American painters as *Dove, *Benton and *Wyeth, and, in her later years, *O'Keeffe. The Mediterranean coastline of France could count as an extended artists' colony, attracting many notable painters in the wake of Cézanne and Van Gogh, most notably *Bonnard. Southern Spain has exercised a similar appeal: *Bomberg, for example, spent his last years mainly in Ronda, making that inland town a centre for landscape painters.

Landscape and still-life painting had provided opportunities for experiment and innovation in the 19th century while the hold of academic methods still dominated in the matter of figure painting, though the *Post-Impressionists from the 1880s on also addressed that area in anti-conventional ways. Cézanne, particularly, charged all of them with new, and to some extent interchangeable, energies. The *Fauve painters picked up this theme from Puvis and from Cézanne, but combined it with freely painted landscapes in vivid colours. *Braque got from Cézanne the organizing and representing of landscape in terms of geometrical forms, which led him into the transparent and insubstantial geometry of *Cubism. *Mondrian studied Cubism in connection with specific town and landscapes to develop, about 1914, his minimal notation of nature in black marks on white, and proceed, in 1920–21, to his *abstract compositions. With roots in *Art Nouveau and in *Symbolism, *Kandinsky developed a mode of landscape painting which readily accommodated apocalyptic signals and from about 1912 moved towards complete abstraction. Meanwhile Impressionist painting of natural subjects had invaded even countries averse to foreign influence, often in the moderated idiom of such as *Bastien-Lepage that made them easier to accept.

The *Expressionist vehemence achieved

by the *Brücke painters in their peopled landscapes of 1908 and after, they applied also to townscapes after they moved to Berlin around 1911. In England Paul *Nash personalized his naturalistic idiom to give his landscapes a transcendent, sometimes apocalyptic quality. *Sutherland found a dramatic note in his Welsh landscapes of the late 1930s whilst *Hitchens, in and after the 1940s, painted rural Sussex in quasi-abstract freehand terms. Ben *Nicholson, in the 1940s and early 50s the dominant painter in *St Ives, from then on lived in Switzerland and based his abstracted landscapes on what he saw daily from his windows and also what he saw in his travels around Europe. *Abstract Expressionism is often said to reflect the scale of America as well as the pioneering that opened up its western regions. *Pollock certainly got from *Benton some of his dynamism (Benton hated the results). *Pop artists at times used formulae and signs associated with landscape and the open road, and *Hockney's paintings of the 1980s and after have included Californian landscapes synthesized from scenes viewed successively from his car. *Hodgkin's much distilled paintings of occasions and places include resonant images of specific landscapes. Generally, though, having achieved parity with the other genres, and having provided a means for recreating painting as an unacademic and properly ambitious activity, landscape painting has lost its primacy in modern art to abstract and to discursive art involving figures and actions. Meanwhile *Earthworks and other forms of land art have enabled artists to express profound feelings for nature's minutiae and immensities.

Landseer, Edwin (1802–73) British painter and occasionally sculptor, famous for his representations of animals in England and abroad. A fine *naturalistic artist, he gave *Romantic significance to his work by making his animals portray human emotions (taken by his contemporaries to prove his insight into animal psychology). This heroicization – as in *The Monarch of the Glen* (1850; Edinburgh, Guinness plc) – and often sentimentalization of animals – as in *The Old Shepherd's Chief Mourner* (1837;

London, Tate) – and at times pre-Disney disguise of human types as animals – as in *Dignity and Impudence* (1839; ditto) – made his art widely popular. In effect, he made animals characters in *History and *genre painting. His collectors ranged from Queen Victoria to the many who bought his pictures in the form of engravings. He was knighted in 1850 and in 1865 was offered the presidency of the Royal *Academy, which he refused. In 1867 he made the vast lions at the foot of Nelson's Column in London's Trafalgar Square. 1874 saw a posthumous retrospective at the Academy; 1961 another.

Lanfranco, Giovanni (1582–1647) Painter from Parma, he introduced to Rome the *illusionism of *Correggio's domes, initiating a new phase of *Baroque decoration (1625–7, S. Andrea della Valle). During 1634–46 he was the most successful *fresco painter in Naples, influencing later Neapolitan decorative painters, notably Luca *Giordano (Gesù Nuovo, cupola, 1634–6; S. Martino, 1637–9; SS. Apostoli, 1638–44; Cathedral, Capella del Tesoro, 1643 – originally commissioned from his rival, *Domenichino).

A pupil of Agostino *Carracci, after his master's death in 1602 he joined his brother Annibale Carracci in the service of the *Farnese in Rome. Despite rivalry with Annibale's pupils and followers, notably *Guercino, *Reni and Domenichino – which caused him to retire back to Emilia, 1609–11 – Lanfranco was able to establish himself as one of the leading painters of successive papal courts and powerful aristocratic patrons, modifying the *classicizing style of the Carracci school through an admixture of *Caravaggesque *chiaroscuro and the freer, more painterly mode of Correggio. The prelude to his great dome painting at S. Andrea was the loggia vault of the Villa Borghese, 1624–5, a more dynamic and freer critique of Annibale's Farnese Gallery ceiling. His move to Naples was motivated, however, by his eclipse in the 1630s by the artists of the Barberini court, *Bernini and *Pietro da Cortona.

Lanyon, Peter (1918–64) British painter, born in St Ives and trained there

and in Penzance, as well as at the *Euston Road School in London. During the Second World War he was influenced by Ben *Nicholson, *Hepworth and *Gabo, who came to St Ives. He made free constructions and turned his paintings, formerly representation of local landscapes, into more or less *abstract compilations of form and colour recalling landscapes and figures. He responded to the example of American *Abstract Expressionists, was included in a 1951 mixed show in New York and had a solo exhibition there in 1957. During 1940–5 he had served in the British air force; in 1959 he took up gliding. A gliding accident ended his life. His work was seen in many mixed exhibitions around the world from the 1950s on. A retrospective was shown in London in 1968 and toured the country.

Laocoön One of the most celebrated and influential surviving ancient marble sculptures, discovered in 1506 in Rome (*see also Apollo Belvedere; Belvedere Torso; Barberini Faun; Borghese Warrior; Pasquino; Farnese Bull; Farnese Hercules*). It illustrates a famous passage from Virgil's *Aeneid*: serpents emerge from the sea to crush to death the Trojan priest Laocoön and his sons. Although quickly recognized by Giuliano da *Sangallo as the work by Hagesandrus, Polidorus and Athenodorus of Rhodes which was praised by *Pliny in his history of ancient art, it is now thought to be a Late Hellenistic copy of this 1st century AD group. Soon after its discovery the group was bought by Pope Julius II; its effect on Italian art was instantaneous in all media, including gold jewellery, although full-scale versions are comparatively rare (e.g. marble copy by *Bandinelli, now Florence, Uffizi). Particularly admired and influential was the expression of Laocoön, immediately adopted in painting (e.g. *Pontormo's *Visdomini* altar); the ecstatic face with eyes raised to heaven became virtually a hallmark of Guido *Reni's Christian and secular saints and martyrs. Laocoön's dignified restraint became a cornerstone of *Winckelmann's notion of the *expressive ideals of Greek art: 'noble simplicity and calm grandeur'. Winckelmann's description inspired the famous treatise in aesthetics, *Laokoön, An essay upon the Limits of Painting and Poetry*, 1766, by the great German dramatist and critic Gotthold Ephraim Lessing.

Like a number of the antique works listed above, the Laocoön was removed to France after Napoleon's conquest of Italy, 1798, and was returned to the Vatican in 1816; it is now displayed in the Belvedere court.

Laprade, Claude *See under* Joanine style.

Largillierre or **Largillière, Nicolas de** (1656–1746) French painter known primarily for his portraits and votive works (only surviving example of the latter, 1696, Paris, St-Etienne-du-Mont) but the author also of *still lifes (e.g. Grenoble, Musée). Born in Paris, he was trained in Antwerp under a painter of still lifes and peasant scenes; during c.1674–80 he worked in London as a drapery and accessory assistant to *Lely. In 1682 he settled in Paris and was received as a member in the *Academy in 1686, rising to Director in 1738–42. By the end of the 1680s he had become the favoured portraitist of the rich Parisian bourgeoisie – as his friendly rival *Rigaud was of the court aristocracy – adapting for them English variants of naturalistic (*see under* realism) Flemish and Dutch portrait formulae (e.g. Paris, Louvre; Strasbourg, Musée; Washington, National). He was the teacher of *Oudry and welcomed *Chardin into the Academy.

Larionov, Mikhail (1881–1964) Russian painter, trained intermittently in Moscow where he met *Goncharova, his life-long companion and ultimately wife. He exhibited frequently from 1906 on and organized exhibitions, notably the three *Golden Fleece exhibitions of Russian and French modern painting (1908–9). In 1910 he and Goncharova organized the Jack of Diamonds and in 1912 the Donkey's Tale exhibitions (all in Moscow). His painting during this period turned from *naturalism and *Impressionism to a folk-art based *primitivism rich in traditional Russian themes. He contributed illustrations to Russian *Futurist miscellanies in 1912–13.

In 1913 he published his manifesto *Rayists and Futurists* (signed also by Goncharova and others), announcing *Rayism as a synthesis of international modern styles, and showed Rayist paintings in the exhibition Target. In 1912–13 his paintings were included in shows in London and Berlin; in 1914 he had a joint exhibition with Goncharova in Paris. He served briefly in the Russian army in 1914–15 but was invalided out and left Russia with Goncharova to work for Diaghilev in Switzerland and, from 1917, in Paris. He designed a number of ballets, including Stravinsky's *Le Renard* (1922) and acted as Diaghilev's artistic advisor. Much of his later work was book illustrations, though he also repainted and redated some of his earlier works. His and Goncharova's Rayist works were shown in Rome in 1917 and in New York in 1922. Large joint retrospectives of their work were shown in Paris in 1952 and in London in 1961.

Larkin, William (1580s–1619) English portrait painter enjoying noble patronage by 1606. He was active both as a miniaturist (*Edward Herbert, 1st Baron Herbert of Cherbury*, c.1609–10, Charlecote Park) and on the scale of life (nine full-length portraits, seven of women, formerly in the family collection of the Earls of Suffolk at Charlton Park, Wiltshire, now Blackheath, Ranger's House). The artist's exaggeratedly stiff and two-dimensional style in the life-size works allowed for the painstaking recreation of expensive fabrics and elaborate patterns of lace, embroidery and Turkey carpets, with brushstrokes imitating individual stitches.

Larsson, Carl (1853–1919) Swedish painter and illustrator. Larsson, born in the slums of Stockholm and trained in the Stockholm Academy and in Paris, was ambitious to be a famous painter of History *frescos (see genres)*. He obtained commissions but fame eluded him at first. During 1882–5 he worked in the artists' colony at Grez-sur-Loing, south of Paris, painting in the open air in a fresh *naturalistic style developed by *Bastien-Lepage. Back in Sweden, he worked again on murals. Winning the competition for the decoration of the staircase of Stockholm's National Museum, in 1891 he went to Florence to study painting at the source. But his fame and popularity derive from the watercolours he did, from about 1895 on, of life in and around his house at Sundborn, in a province (Dalarna) rich in folk lore. He designed its décor in a manner echoing Scandinavian 18th-century interiors but also the pioneering work of *Morris and Van de *Velde, in a light, flat style that conveyed a sense of innocence and honesty. Sets of such watercolours served as illustrations for his own books: *My Family* was the first, published in 1895. He and his wife were the subject of an exhibition in London (V&A) in 1997.

Lassaw, Ibram (1913–) American sculptor, born in Egypt and brought to New York in 1921. He studied art there, soon turned to *abstraction under the influence of *Arp and made organic forms in plaster. He was one of the founders of *American Abstract Artists in 1936 and its president 1946–9. He exhibited frequently internationally and had many solo exhibitions in New York from 1951 on, by which time he had turned to working in metal and to finding a sculptural equivalent to the expressive spatial forms of *Abstract Expressionist painting, especially *Pollock's. Much of his commissioned work has been for synagogues though his perception of the Jewish faith is marked by his studies in Zen Buddhism.

Lastman, Pieter (1583–1633) Amsterdam painter. c.1603–c.1606 he was in Rome, where he was deeply influenced by *Elsheimer and, through him, *Caravaggio. On his return to Amsterdam he specialized in vigorous, albeit small, history paintings (*see under* genres), narratively clearer, more *realistic and more *expressive, than those of the earlier generation of Dutch Italianate painters (*see* especially Cornelis van Haarlem; Bloemaert). Like Elsheimer he used landscape to set the dominant mood of a scene, and a mixture of *Classical and Orientalizing accessories (such as turbans) to locate the story in pagan or Biblical antiquity. Around 1610 he began to introduce crowds of figures, which act as a chorus to

intensify and comment upon the dramatic action. In 1623-4 the young *Rembrandt spent six months in Lastman's studio, and was deeply marked by his teaching, as was his colleague Jan *Lievens. There are pictures by Lastman in Rotterdam, Boijmans Van Beuningen; Munich, Alte Pinakothek; London, National; etc. He, and a group of Amsterdam artists closely related through common interests and also by marriage, etc. are frequently known as the 'Pre-Rembrandtists'; see also Pynas, Jan and Jacob.

Latham, John (1921–) British artist and pioneer of Neo-*Dada and *Conceptual art. He was born in Rhodesia, Africa and trained at Chelsea Art School in London. The first of many solo exhibitions was held in 1948 and he became known in the 1950s as a radical artist intent on testing the institutions as well as the means of art. From sprayed painting (1954 on) he moved to pictorial reliefs and constructed sculptures using damaged, sometimes charred and painted, books. In 1966 he founded the Artists' Placement Group which sought to bring artists into non-art working environments, not so much for the artists' benefit but to educate industry etc. in creative thought and expression. In 1967 his post as part-time teacher at St Martin's School of Art ended when he returned to its library a copy of Clement Greenberg's *Art and Culture* as a phial of fermented liquid derived from chewing its pages. Himself a busy verbalizer of often rather obscure ideas, he has had many exhibitions in which words and images compete for attention, sometimes obscuring his seriousness and his commitment to rationality and humanism in society.

La Tour, Georges de (1593–1652) Important Lorraine *Caravaggesque painter, active in Lunéville from c.1620. Although he received two commissions from the Duke of Lorraine in 1623-4, he worked mainly for the local bourgeoisie and the French administration; Louis XIII of France owned a painting by him, and in 1639 he is mentioned as having the title of King's Painter. By the 1630s he seems to have given up entirely his earlier low-life

*genre subjects, to concentrate on religious themes executed in a highly individual, simplified manner which, together with the apparently humble settings and social origins of the painted protagonists, reflects the ideals of the religious revival led in the Lorraine by the Franciscans.

La Tour's earliest known paintings (e.g. *Fortune Teller*, New York, Metropolitan) continue the manner practised in Nancy by *Callot. Some time c.1621, and again c.1639-42, perhaps during trips to the Netherlands, he seems to have come into contact with *Caravaggio's Dutch followers in Utrecht, *Terbrugghen and *Honthorst. Paintings from c.1620-5 employ *chiaroscuro and a minute surface naturalism (see under realism), stressing the texture of hair and the wrinkles of aged skin (e.g. two versions of *St Jerome*, Stockholm, Museum; Grenoble, Musée; *Hurdy Gurdy Player*, Nantes, Musée). In the next phase of his work, beginning with *Job and his Wife* (Epinal, Musée) La Tour introduces an unshaded candle: the chiaroscuro is now based on warm coppery red tones suggesting candlelit night scenes (e.g. *Penitence of St Peter*, 1645, Cleveland, Ohio, Museum; *Jesus and St Joseph in the Carpenter's Shop*, c.1645, Paris, Louvre). In the last, and greatest group of paintings, the motif of an unshaded, or sometimes shaded, flame is kept but surface description is reduced to a minimum. Although forms are pressed close to the viewer, sometimes cut off by the frame, they are represented in paradoxically distant, generalized terms. The compositions are correspondingly simplified; movement is eliminated. A mysterious stillness is produced, and these paintings are at once both monumental and intimate (*Denial of St Peter*, 1650, Nantes, Musée; *St Sebastian*, c.1650, Berlin, Staatliche; *Nativity*, c.1650, Rennes, Musée). La Tour, more than any of Caravaggio's followers, converts the Italian master's *tenebrism and low-life naturalism into a noble *classicism.

Latour, Maurice-Quentin de (1704–88) The best-known French portraitist of the mid-18th century. His pastel portraits are vivid and vivacious almost to the point of *caricature. Born in Saint-Quentin, he

arrived, after an early stay in London, in Paris probably during Rosalba *Carriera's visit in 1620–1; her success prompted him to adopt the pastel medium (*see also* Liotard). His sitters ranged widely through society; he charged high fees and presented himself as a 'character', capricious, vain, opinionated and often rude. There are works by him in Geneva, Musée; Paris, Louvre; Saint-Quentin, Musée; etc.

Laurana, Francesco (*c.*1430–1501/2) Dalmatian-born sculptor probably trained in a Venetian studio operating in Dalmatia, perhaps that of a disciple of Bartolommeo *Buon. He worked in Naples on the Aragonese Triumphal Arch, 1454–8, and again in the early 1470s (*Virgin and Child*, Chapel of St Barbara, Castelnuovo, 1474; *Virgin and Child*, S. Maria Materdomini); in France at the court of René of Anjou in 1461–6, when he was employed as a medallist and again in 1477–83 and *c.*1498–1501/2; and in Sicily, 1467–after 1471. He is best known, however, for a series of nine female portrait busts usually ascribed to his second Neapolitan period, *c.*1472–4, but probably executed in two separate periods, 1472–5 and 1487–8. These busts, (now in Florence, Bargello; New York, Rockefeller Coll., Frick; Vienna, Kunsthistorisches; Washington, National; Paris, Louvre, Jacquemart-André; Palermo, Museo; and formerly in Berlin, Kaiser Friedrich), are to a great degree abstract images, a subtle type of court art in which the representational demands of portraiture are restricted in favour of geometrical approximation. Laurana's inexpressive manner is nearly as successful in his statues of the Virgin and Child, but his narrative scenes demonstrate his rudimentary grasp of spatial construction and *expressive movement. In France, his work turned to Late *Gothic pathos and grotesque, especially marked in the relief at Avignon which depicts *Christ carrying the Cross*.

Laurencin, Marie (1885–1956) French painter, born and trained in Paris. She joined the artists' circle living in the *Bateau-Lavoir in Montmartre, becoming a friend of *Picasso and the lover of *Apollinaire. There are hints of *Cubism in her pre-1914 work but her talent was for decorative compositions, often of doe-eyed girls in gentle colours. She illustrated books and did stage designs: in 1923–4 for the Diaghilev ballet *Les Biches*, in 1928 for the Comédie Française's *À quoi Rêvent les Jeunes Filles*.

Laurens, Henri (1885–1954) French sculptor, born and trained in Paris. He was influenced by *Rodin and then by archaic and medieval forms of sculpture. He became a close friend of *Braque in 1911 and was drawn to *Cubism but did not show his more experimental works when he exhibited in 1913–14. These were coloured constructions in wood or wood and metal, among them the assembly of cones and planes *The Clown* (1914?; Stockholm, Moderna), spatial and nearly *abstract, and *Head* (1915; New York, MoMA). In 1916 and 1918 he had one-man shows in Paris that attested his association with Cubism. In 1918–20 he gave priority to relief sculptures in a neat Synthetic Cubist idiom, executed in terracotta or stone; in 1920 he began to make bronzes of female figures, his primary medium and theme thereafter. These soon lost the planar emphasis of Cubism and became curvilinear and volumetric, at times dramatically so. In this way he attached himself to the *classical tradition but used it with expressive freedom. In 1925 he designed the décor for the Diaghilev ballet *Le Train bleu*. In 1951 he had a retrospective in Paris; in 1953 he won the major prize at the São Paulo Bienal.

Lavery, John (1856–1941) British painter, trained in Glasgow and Paris and a member of the Glasgow School before moving to London. His early work shows the influence of *Whistler and of *Bastien-Lepage and is of real quality and charm, as in *The Tennis Party* (1885; Aberdeen AG&M). He became a successful painter of society portraits, deft but shallow. He received a knighthood in 1918.

Lawrence, Jacob (1917–) African-American painter, especially significant as among the first black American painters of note. In the 1930s he attended art classes organized by the Works

Progress Administration (see Federal Art Project) and, like others around him, saw art as a means of commenting on social conditions. Much of his art deals with the culture and situation of the black in America. Oustanding is a series of sixty paintings of *The Migration of the Negro* (1940–1; divided between New York, MoMA and Washington, Phillips Coll.). His manner is generally illustrational and graphic, and many of his pictures are in tempera.

Lawrence, Sir Thomas (1769–1830) British painter, the pre-eminent portraitist of his day. Son of a Bristol inn keeper, the young Lawrence learned early how to charm guests and please them with his portrait drawings. When the family moved to Oxford, the ten year-old boy did the same for the city's eminent residents. In Bath, from 1780 on, he sought instruction in painting and studied pictures in local collections. In 1787 he moved to London where success came rapidly. In 1790 he painted *Queen Charlotte* (London, National) and *Elizabeth Farren* (New York, Metropolitan), both vivid and entertaining, the second gaining additional charm from showing the elegant lady enjoying a spacious, refreshing landscape. In 1812 he was appointed court painter. In 1815 he was commissioned to paint Europe's rulers and dignitaries as they came together for the Vienna Congress after Napoleon's defeat. The commission also called for a visit to Rome in 1818–19 to paint *Pope Pius VII* (the most brilliant papal portrait since *Velázquez's), and one to Paris, in 1825, to paint *Charles X*. The set hangs together in the specially built Waterloo Chamber of Windsor Castle. In 1820 Lawrence was elected president of the Royal *Academy, succeeding directly *West and, at one remove, *Reynolds whose example and success had certainly sustained him.

lay figure articulated manikin, model of the human figure which can be given any pose and, appropriately costumed, be used by artists in the absence of a live model or sitter.

Lazzarini, Gregorio *See under* Tiepolo, Giovanni Battista.

Lear, Edward (1812–88) British poet and artist, best known for the 'Nonsense Verses' he published from 1846 on with his own illustrations, but also a reputable draftsman and watercolourist, first for the Zoological Society and then for the Earl of Derby, recording creatures in his menagerie. In 1837 Lear went to Italy which later became his base, but this was the first of many journeys in the Mediterranean countries and the Near East, during which he made many coloured drawings which he then worked up into watercolours and oil paintings to be exhibited and sold in London. Topographically accurate, the best of them also give convincing accounts of large landscape spaces and of particular qualities of light.

Lebrun, Charles (1619–90) French painter and designer; from 1663 until the death in 1683 of his patron, Colbert, the powerful minister of Louis XIV, he was the virtual dictator of the visual arts in France. Director of the Gobelins, the royal factory which produced all the furnishings, including tapestries, for Versailles, and the reorganized Royal *Academy of Painting and Sculpture, he channelled all the great commissions of the crown and controlled the training of artists and artisans, outside all guild restrictions. He himself was responsible, in 1663, for the decoration of the Galerie d'Apollon, Paris, Louvre, and, from 1671 to 81, for designing every aspect of the interior decoration of the great royal apartments at Versailles. He executed, with assistants, the series of ceiling paintings of the *Life of Louis XIV* in the Galerie des Glaces and the Salons de la Guerre and de la Paix begun in 1678, and completed in 1684 and 1686 respectively.

Although, in theory and in his academic teaching, Lebrun championed the rational *classicism of *Poussin, in practice, when designing vast decorative ensembles, he relied on a classically tempered *Baroque which owed much to the example of *Pietro da Cortona. Despite condemning the Flemish school, he was indebted to *Van Dyck for the naturalism (*see under* realism) and warm colouring of his own very accomplished portraits (e.g. *The Chancellor Séguier*, 1661, Paris, Louvre).

And when, after 1683, he was gradually displaced from royal commissions by *Mignard, he continued to paint, on a smaller scale, intimate and luminous works reminiscent of Dutch *Caravaggesque painters (e.g. *The Nativity*, c.1689, Louvre).

First trained by **François Perrier** (1590–1650), a collaborator of *Vouet who had studied in Rome under *Lanfranco, and by Vouet himself, Lebrun was sent to Rome, 1642–6, by his first protector, Ségur, studying part of the time with Poussin. Although he obtained commissions for decorative and religious works immediately upon his return to France, his reputation was made c.1650 with his *illusionistic Baroque ceiling for the Hotel Lambert, Paris. In 1661 he received his first commission from the king, the *Family of Darius before Alexander* (Paris, Louvre) – the first instance of the mature style, reminiscent of Poussin but freer, more picturesque and less severely heroic, which Lebrun was to impose on all of France (*see*, e.g. Sarrazin).

In addition to the decorative schemes and administrative duties undertaken by Lebrun for the crown, he executed a few easel paintings for corporate clients (e.g. Lyon, Musée). Earlier smaller scale works are in Nottingham, Gallery; Dulwich, Gallery; London, V&A; etc. Tapestries woven to his designs are in Paris, Gobelins; and an enormous collection of his drawings can be found in the Louvre. As a theoretician and teacher he is mainly remembered for his influential treatise on the representation of the emotions, *Méthode pour apprendre à dessiner les passions*.

Under Lebrun's leadership and with the active financial and institutional protection of Colbert, Paris became the artistic capital of Europe, reversing the historical supremacy of Italy. The change, and Lebrun's influence, may be gauged from his election in 1675 to the post of President of the Academy of St Luke in Rome.

Le Brun, Christopher (1951–) British painter, born in Portsmouth and trained at the Slade School and the Chelsea Schools of Art in London, and soon seen in many group exhibitions and, from 1980 on, solo exhibitions, in Britain and abroad, in Europe and America. He was a prize winner at the John Moores Liverpool exhibitions in 1978 and 1980 and worked in Berlin during 1987–8 as Guest of the DAAD Artists' Programme. At a time when artists frequently use traditional modes or quotations in a spirit of irony, Le Brun makes patent his attachment to the imagery and emotional address of *Romanticism and *Symbolism, notably the work of *Delacroix and *Puvis and more recent expressive painters such as *Monet (his *Waterlilies*) and *Guston (in his abstract and semi-abstract phase). Specific commissions, for a series of paintings on Wagner's operas and of biblical scenes (in Liverpool Cathedral), draw on and augment his interest in poetic images and narrative and in staging actions pictorially, but he also invents his own motifs and has recently painted abstract pictures in which his lyrical brushwork conveys both structure and the pleasures of colour, light and space. In 1997 he began to make bronze sculpture, mostly of horses set against large disks, sometimes with contrasting patinas. One of these is entitled *The Motif is not the Subject*, a theme that could be applied to most of his work: he asks the viewer to attend not only to the often compelling imagery he employs but also to the poetic and structural processes through which it is made visible. This could be said of all good representational art (Le Brun's intimacy with western art is exceptional; he has served as Trustee both of the Tate and the National Galleries), but he claims the area between the visible, often titular, subject and the content, or inner subject, his particular concern. Some of his thoughts are set out in an essay on *Morandi in the Tate Gallery's *Giorgio Morandi – Etchings* catalogue, 1991.

Leck, Bart van der (1876–1958) Dutch painter, briefly associated with the De *Stijl movement. He worked for some time in stained-glass workshops, then was trained as an artist in Amsterdam and became a painter deploying simplified form and colour in increasingly flat compositions. By 1910 he had developed a severe formal idiom for paintings of workers and soldiers. In 1916 he painted his *Mine Triptych*, apparently an *abstract composition

of bars of primary colour on white and black backgrounds, in fact a reductive representation of miners in the side panels and of the interior of a mine in the centre. In other works he similarly reduced a scene or motif to geometrical forms in primary colours and thus influenced De Stijl, but he never subscribed to the group's insistence on full *abstraction and left it in 1920. He continued to use his elementary idiom, for decorative designs as well as paintings, though some of these, done in the last five years of his life, appear to be wholly abstract. His work was seen in mixed exhibitions and a few solo shows; more important, he enjoyed the patronage of Mrs Kröller-Müller and his work could be seen in her museum from 1916 on. The Museum at Otterlo owns 42 paintings and over 400 drawings by him, including the *Mine Triptych*. He published theoretical essays in *De Stijl* magazine and elsewhere but, owing to his reclusive personality, was lost sight of as a pioneer. There was a memorial exhibition in Amsterdam in 1959 and a full exhibition in Otterlo and Amsterdam in 1976.

Le Clerc, Jean *See under* Saraceni, Carlo.

Lecomte, Felix (1737–1817) French sculptor, best-known for his portrait busts, especially the much-duplicated *Marie Antoinette* (1783, Versailles). He shared some commissions with *Caffiéri and *Clodion.

Le Corbusier (1887–1965) Swiss-French architect, one of the great men of modern architecture but also a committed painter and sculptor. He was born Charles-Edouard Jeanneret at La-Chaux-de-Fonds (Switzerland) and studied engraving at the local art school before turning to architecture. In 1917 he moved to Paris and the following year began to paint. With *Ozenfant he created *Purism and wrote *After Cubism*, critical of recent *Cubism's merely decorative character. In 1920 he and Ozenfant exhibited paintings together and founded the journal *L'Esprit Nouveau* (28 issues 1920–5) which reported on film, theatre, music and design and promoted a

new Cubism, classical in its harmonies but using mass-produced objects for its motifs. From 1928 on he signed his work with the name of one of his grandfathers, Le Corbusier. His painting became more three-dimensional and vigorous and at times included figures or partial anatomies as well as still life objects. From the end of the 1930s he investigated the relationship of sculptural form to architecture, and in 1946 he began to make wood sculpture with the help of a cabinet-maker. There were major exhibitions of his art in Zurich (1938 and 1957), Paris (1953 and 1962) and Bern (1954). Outside the High Court in the Capitol of the city of Chandigarh in India, his greatest achievement in architecture and planning, stands his monumental sculpture, the *Open Hand*, designed in 1964 as 'symbol of peace and reconciliation'.

Le Fauconnier, Henri (1881–1946) French painter who came to Paris in 1901. He painted landscapes in the manner of *Cézanne, about 1910 became part of the *Cubist circle and exhibited with the Cubists in 1911 (*Abundance*, 1911; Hague, Gemeentemuseum). His work was seen in Germany and Moscow during 1912–14. During the 1914–18 war he lived in the Netherlands, developing a form of *Expressionism. He returned to Paris in 1920 and to a more austere idiom in the years that followed. Through his teaching, he influenced many younger artists all over Europe.

Lega, Silvestro (1826–95) Italian painter who in 1859 became one of the *Macchiaioli. *The Trellis* (1869; Milan, Brera), of women drinking coffee in a pergola spattered with light falling through leaves, suggests *Impressionism in its spirit and *naturalism but without Impressionism's fragmenting brushstrokes.

Léger, Fernand (1881–1955) French painter, son of a Norman cattle-breeder. He worked first as architectural draftsman, then moved to Paris and studied painting. Deeply influenced by *Cézanne in 1907, he became part of the circle of *Apollinaire, the *Delaunays and the poet Cendrars. In 1911 he showed his first major painting,

Nudes in a Forest (1911, Otterlo, Kröller-Müller). In the years that followed he developed his form of Cubism, dominated by contrasts of form and colour, positive and negative, at times in *abstract compositions. In 1913 and 1914 he lectured at the Académie Wassiliev. He fought in the French army during 1914–16, was gassed at Verdun and demobilized at the end of 1917. He began to paint again, incorporating his war experiences – of comradeship and of the dramatic forms of guns and aeroplanes rather than of violence and death: *The Game of Cards* (1917, ditto). During the next years his paintings were dominated by forms celebrating machines and the urban scene, as in *The City* (1919, Philadelphia MoA). In his paintings of the early 1920s he created a modern *classicism, more legible and less fragmentary, for figure compositions and still lifes. He associated with *Purism and with the *De Stijl artists, did stage design (*Skating Rink* and *The Creation of the World* for the Swiss Ballet in 1922–3) and made the film *Mechanical Ballet* with Man *Ray in 1924. Some of his paintings of the mid-1920s, done for architectural settings, were abstract while others used simplified motifs; examples of this sort were included in *Le Corbusier's Pavillon de l'Esprit Nouveau at the Paris Decorative Arts Exhibition of 1925.

By the late 1920s he had an international reputation. His work combined qualities of *Surrealism with his characteristic strong, plain forms and was shown on both sides of the Atlantic. In 1940 he moved to New York. While in the USA he contributed to Hans *Richter's film *Dreams that Money Can Buy* (1944), painted, exhibited and taught. On his return to France in 1945 he joined the Communist Party. He made a large mosaic for the church of Assy in 1946–9, did the decor for the ballet *Le pas d'acier* (Champs-Elysées Ballet, 1948) and made book illustrations. In 1949 he made designs for ceramics executed at Biot in the South of France where in 1950 he established a ceramic workshop. Subsequently he lived at Biot and in 1960 a Léger Museum was created there. In the 1950s Léger made designs for stained glass windows and painted murals for the assembly hall of the United Nations, New

York (1952). His work took on monumental splendour in honouring the life of ordinary people.

His career spans from early investigations of painting as a means of capturing modern sensations in abstract and near-abstract dynamic compositions to heroic images of common life in terms that admit their debt to the great tradition of French *classicism and to folk art, thus affirming contemporary life as well as art's energies.

Legros Family of French artists, of whom the best known is the sculptor **Pierre Legros the Younger** (1666–1719). He won first prize for sculpture at the *Academy in 1686. During 1690–5 he was a pensioner at the French Academy in Rome, finally dismissed for accepting private commissions (statues for altar, S. Ignazio). He remained in the city as an independent artist, the principal sculptor for the Jesuits. There are works by him in S. Ignazio; Gesù; St Peter's. Perhaps the best known is the gruesomely *realistic *polychrome marble statue of *St Stanislaus Kostka on his death-bed*, in the Novitiate annexe of S. Andrea al Quirinale. Other works are in Paris, Louvre; Turin, cathedral. Late in life he also worked for the Olivetans at the monastery of Montecassino.

His father, **Pierre Legros the Elder** (1629–1714), was the King's Sculptor in Paris, and from 1702 professor of sculpture at the French Academy. There are works by him on various façades of the palace at Versailles; Paris, Invalides, Louvre; Chartres, cathedral. **Jean Legros** (1671–1745), Pierre the Younger's brother, specialized in portrait painting, having studied at the Academy under *Rigaud.

Lehmbruck, Wilhelm (1881–1919) German sculptor, trained in Düsseldorf where in 1904 he saw a large exhibition of the work of *Rodin, *Meunier and other modern sculptors. He visited Paris in 1907 and 8 and settled there in 1910. He had contact with *Brancusi, *Archipenko and the *Cubists and was able to free himself from the influence of Rodin. His *Kneeling Woman* (1911, in stone and in bronze), one of five sculptures he showed at the Cologne

*Sonderbund exhibition in 1912, represents his mature idiom in the expressiveness of its attenuated forms, and attracted notice. In 1913 his work was included in the *Armory Show. In 1914 he returned to Germany. He lived in Berlin 1915–16 and in Zurich 1916–19. In 1919 he was elected a member of the Prussian Academy; the notification may not have reached him. He committed suicide that March in despair at human destructiveness. He is associated with *Expressionism yet his art is without its energy and uncouthness: it is gentle and exploits the *classical tradition of presenting nude figures yet sought harmony in disproportion, as El *Greco had done. Duisburg, near where he was born, has a fine Lehmbruck Museum.

Leibl, Wilhelm (1844–1900) German painter. Son of the Kapellmeister of Cologne Cathedral. At the Munich Academy Leibl was influenced by *Holbein and *Van Dyck in Munich's Alte Pinakothek. A portrait gained him a gold medal in Düsseldorf in 1869. He went to Paris on *Courbet's advice and found there a warm reception for his work. But he returned to Munich when the Franco-Prussian war started in 1870. Meeting more opposition (*Böcklin called him 'boring' and 'lazy-minded'), he moved in 1873 to Unterschöndorf on the Ammersee. He found his subjects now among the local peasants and produced some of his most solid images, including *The Village Politicians* (1877; Winterthur, Stiftung Oskar Reinhardt). In subsequent paintings detail tended to dominate over control of the whole. In the 1890s his work showed some of the fluencies of *Impressionism. Still mocked by many for his stylelessness, Leibl was nonetheless awarded the title of Professor in 1892. *Trübner drew a Berlin collector's attention to Leibl's work; this man bought all available Leibls, arranged an option to buy those to come and took Leibl in 1898 on a visit to Belgium and Holland. The following year a Leibl exhibition was shown at the Berlin *Sezession, and in 1900 he was awarded Bavaria's Order of St Michael. During his lifetime and since, Leibl has been seen by Germans inclined to naturalism as the greatest painter of the

nineteenth century. Berlin (National), Cologne (Wallraf-Richartz and Munich (Neue Staatsgalerie) have many of his paintings.

Leighton, Frederic (1830–96) British painter and sculptor of great fame and large output, trained in Frankfurt, Rome and Paris and a convinced *History painter. He had an early success with *Cimabue's Madonna carried in Procession through the Streets of Florence* (1885; bought by Queen Victoria, on loan to National London), a fine piece of pre-Hollywood epic art, studied and seductive in every part and full of detail, historically correct or invented. Lack of talent was countered by a sensuous imagination and hard work. He brought new life in to British sculpture with his bronze *Athlete struggling with a Python* (1874–7; London, Leighton House). His preference for *classical subjects and smooth, elaborate craftsmanship make him historically a reactionary in the age when contemporary subjects and especially *Impressionism became fruitful, but he had many admirers and became a leading figure in the British art world. He was elected president of the Royal *Academy and knighted in 1878; just before his death he became Lord Leighton, the only artist peer ever created.

Leinberger, Hans (*c.*1480/5–*c.*1531/5) Powerfully *expressive German sculptor, active in Landshut, then the capital of Lower Bavaria, 1513–30; from 1529 he seems to have drawn a salary from the Ducal Court. Working mainly in wood, he excelled both in free-standing monumental figures, whose deeply and rhythmically-carved draperies are so dynamic that they have been called 'proto-*Baroque', and in pictorial reliefs, influenced by the painters of the *Danube school and perhaps by *Mantegna (collegiate church, Moosburg, *c.*1511–14). An over-life-size *polychrome *Virgin and Child* once hung free in Landshut, St Martin's; the Rorer memorial tablet of 1524 in the same church shows Leinberger's first use of *Renaissance ornament. Not all of his sculpture was, however, purely devotional, and one of his greatest free-standing figures is the bronze statue of Count Albrecht

von Habsburg, made about 1514–18 for the funerary monument of the Emperor Maximilian (Innsbruck, Hofkirche); the medium allows for even greater freedom, so that the figure's stance almost approaches dance – as it does in the *Tödlein*, the 'Little Death' in Ambras Castle.

Lely, Sir Peter (1618–80) The most important painter working in England in the second half of the 17th century. Although extremely successful as a painter of landscapes, *genre and narrative as well as portraits during the Commonwealth and Protectorate, Lely is mainly identified with court portraiture after the Restoration in 1660. His most famous series, the *Windsor Beauties* (Hampton Court), demonstrates best the animated, voluptuous, but flatteringly generalized portrait style which he evolved at this time, although (as in the series of the *Admirals* 1666/7, Greenwich, Maritime, or *Van Helmont c.*1671, London, Tate) he could, at will, return to a more sharply individuated and penetrating mode.

Lely was born in Westphalia of a Dutch family named Van der Faes, trained in Haarlem under Pieter de Grebber and arrived in London between 1641 and 1645. His early portraits echoed the style of *Dobson (Althorp; Syon House). Under the influence of a work by *Van Dyck, Lely evolved the 'portrait in a landscape', which became a dominant British type until the end of the 18th century (e.g. *The Young Children of Charles I*, 1646/7, Petworth). In the 1650s, he painted mythological pictures (*Europa*, Chatsworth; *Sleeping Nymphs*, Dulwich, Gallery) and anecdotal scenes in the Dutch manner (*The Duet*, 1654, Batsford Park). With the Restoration, Lely was appointed Principal Painter in Ordinary to the King. He was knighted in the year before his death. Investing his considerable fortune in works of art, Lely accumulated one of the finest private collections in Europe, making his studio virtually an *academy for the training of younger artists. Its sale after his death has been called 'the first of the spectacular picture auctions of the modern world'.

Lemoine, Marie-Victoire (1754–1820) French painter, a specialist in *genre and portraiture, especially of female sitters. She numbered at least two members of the French royal family among her clientele, and continued to exhibit after the Revolution. Her best-known picture is the *Studio of a Woman Painter*, New York, Metropolitan. Her sisters, **Marie-Denise Villers** (1774–1821) and **Marie-Elisabeth Gabiou**, closely imitated her style.

Lemoyne, François (1688–1737) Leading French painter from *c.*1725 until his suicide; the more successful rival of Jean-François de *Troy. Unlike the latter, he specialized almost entirely in decorative mythological pictures in outdoor settings (e.g. London, Wallace; St Petersburg, Hermitage; Nancy, Musée; Paris, Louvre). Trained by a leading 'Rubéniste' (*see under disegno*), Louis Galloche (1670–1761), Lemoyne modelled his work especially after *Rubens, *Correggio and *Veronese, responding directly also to observed landscape. In 1724 he travelled in Italy with a patron, but his acquaintance with Italian *Renaissance art had already been made through Parisian collections. Ambitious to carry out large decorative schemes, he lost the 1719 commission for the ceiling of the Banque Royale to *Pellegrini, but received major commissions for vaults in Paris, St Thomas d'Aquin and St Sulpice (sketch, Paris, Louvre); the culmination of these *illusionistic ceiling decorations was the *Apotheosis of Hercules* (comp. 1736, Versailles, Salon d'Hercule), the last *Baroque large-scale decoration in France, which won him the post of *Premier Peintre* to the King. The death of his wife, and of his great protector at court, the Duc d'Antin, may have precipitated the fit of madness in which he hacked himself to death. He was the teacher of *Natoire and *Boucher.

Lemoyne, Jean-Baptiste (1704–78) Best-known member of a dynasty of French sculptors, not to be confused with his uncle, **Jean-Baptiste Lemoyne the Elder** (1679–1731), a minor and short-lived artist influenced by his study of *Rubens (*Death of Hippolytus*, Paris, Louvre).

Jean-Baptiste Lemoyne was the son of the sculptor **Jean-Louis Lemoyne**

(1665–1755), trained under *Coysevox and himself an accomplished portraitist (e.g. busts of *Mansart*, 1703, Paris, Louvre; *Coysevox*, Paris, Ecole des Beaux-Arts) as well as the author of decorative *Rococo groups such as the *Crainte de l'amour* (1742, Paris, Rothschild Coll.). Stricken by blindness, Jean-Louis increasingly relied on his gifted son from the 1720s; like his father, Jean-Baptiste never went to Italy, although he was offered a place at the French *Academy in Rome in 1728. He was trained by his father and the latter's friend Robert Le Lorrain, and sought the help and advice of 'Rubéniste' (*see under disegno*) painters such as François de *Troy and François *Lemoyne. He was most at ease as a modeller in terracotta, and his work stresses fleeting movement and surface texture in a way more pictorial than sculptural, for which some of his contemporaries criticized him (e.g. *Baptism of Christ*, 1731, Paris, St Roch). His vivacious and *expressive portrait mode, however (busts, e.g. Paris, Louvre, Arts Décoratifs, Jacquemart-André, Comédie française; Rouen, Musée; Vienna, Kunsthistorisches), earned him the favour of Louis XV, of whom he executed a series of portraits over 40 years (e.g. 1757, New York, Metropolitan), beginning with the bronze equestrian monument for Bordeaux commissioned from his father and himself (1734, Place Royale; destroyed in the French Revolution). His pupil *Falconet was in the studio when the statue was being executed and recalls it in his own bravura *Peter the Great*.

Most of Jean-Baptiste Lemoyne's church decorations – some of them in *polychrome – and funerary monuments have been destroyed or mutilated (fragments, Paris, St Roch; Ecole des Beaux-Arts; Dijon, Musée). His attachment to a pictorial mode of sculpture, his relative indifference to the antique and his neglect of the nude made him the virtual contrary of his arch-rival, *Bouchardon. In addition to Falconet, he was the much-loved teacher of *Pigalle and *Pajou.

Le Nain, Antoine (*c*.1600/10–48), **Louis** (*c*.1600/10–48) and **Mathieu** (*c*.1600/10–77) French painters, brothers born at Laon and working in Paris by 1629.

Their beginnings are ill-documented, and their birthdates of *c*.1588, *c*.1593 and *c*.1607 respectively, long recorded in the literature, have been shown to be erroneous at least in the case of Antoine and Louis: all three, the youngest of five children, belong to the same artistic generation, which may explain their professional closeness until the deaths of Antoine and Louis, their habit of signing works only with a surname, and the subsequent difficulties of attributing individual works to one or the other. Best remembered for their striking small *genre paintings of peasants and to a lesser extent those of artisans, gaming soldiers and children – all low-life subjects known in France as *bambochades*, after the Italian *bambocciate* (*see under* Pieter van Laer) – they are known also to have painted portraits in miniature, in small scale (e.g. Paris, Louvre; London, National) and on the scale of life, and larger-scale mythological, allegorical and religious works for collectors and churches in Laon and Paris. Most of the latter disappeared during the French Revolution (but rediscovered mythologies now Orleans, Musée; Reims, Musée; allegories, Paris, Louvre; chapel decoration, Paris, St-Jacques du Haut-Pas, Louvre; Nevers, St-Pierre, Saint-Sacrement; other religious subjects London, National; New York, Farkas Foundation; Paris, Louvre, Notre-Dame; Darmstadt).

It is with history painting (*see under* genres) that the Le Nains, trained under an unknown artist in Laon, first made their reputation, both in their native city and in Paris, and Mathieu is known to have continued to produce such works after his brothers' deaths in 1648. Recent scholarship also reverses the long-held notion that genre painting, and specifically rustic genre, was a prerogative of the provinces: on the contrary, it would appear that only in the capital was a wide clientele of collectors creating a demand for this type of painting. It is likely, therefore, that the Le Nains began to produce their most characteristic works only after *c*.1629. Their genre pictures are typified by intense *realism, an absence of overtly comical, satirical or moralizing intent, and vigorous brushwork; particular attention is paid to the effects of natural or

artificial light. Probably the most original and the best painted are the 'peasant meals' with figures grouped in an interior around a white tablecloth (e.g. Paris, Louvre; London, National) and the exterior scenes with peasants, of which only eight are now known (Paris, Louvre; St Petersburg, Hermitage; Karlsruhe, Kunsthalle; Hartford, Atheneum; San Francisco, Legion of Honor; Washington, National; London, V&A). Equally noteworthy and often engraved, one of the works which assured the survival of the artists' name into the 19th century, is the remarkable *Forge* (Paris, Louvre). An unfinished *Portrait of Three Men* (London, National), recently restored, gives a precious insight into the artists' technique and may represent the three brothers, *c*.1645–8.

Lenbach, Franz von (1836–1904) German painter, trained first as builder by his father but then as painter, principally at the Munich Academy under Piloty whom he accompanied to Italy during 1858–9. In 1863–6 he was again in Rome. The success a self-portait and a portrait of his sister had at the Paris Salon of 1867 showed him that portrait-painting was his forte. From this time on he developed his strengths as a dramatic, basically *naturalistic portraitist, learning from tradition but relying also on his gift for catching a likeness. Bismarck and Kaiser Wilhelm I were among his sitters and were honoured with exceptionally fine paintings. The magnificent house Lenbach commissioned in Munich in 1883 now contains the Stadtische Galerie. His paintings can be seen there and in several other German galleries as well as in the Metropolitan Museum, New York.

Lens, Andreas Cornelis (1739–1822) Flemish painter and writer on art, one of the first *Neoclassical artists in Belgium. He executed altarpieces as well as smoothly graceful mythological narratives (Ghent, St Michael; Antwerp, Musées). A pupil of Balthasar Beschey (1708–1776), a continuator of the Jan *Brueghel-*Teniers tradition in Antwerp, Lens abandoned this tradition, and the equally tired imitation of *Van Dyck and *Rubens current in contemporary Flemish painting, after

studying with *Mengs in Rome. An admirer of *Winckelmann, he published a book on ancient costume, 1776, and an influential treatise *On Good Taste and Beauty in Painting*, 1811.

Leonardo da Vinci (1452–1519) Italian painter, sculptor, architect, civil and military engineer, student of the natural sciences seeking to discover the mathematical laws governing all observable phenomena, musician, designer of courtly entertainments: Leonardo is still revered as the very model of the 'universal genius'. The breadth of his mind is manifest in the numerous manuscripts – preparations for treatises never completed, working sketch- and notebooks – now in libraries in London, Madrid, Milan, Paris, Rome, Turin and Windsor. While Leonardo's brilliance remains unique, it should be pointed out that his range of activities was not, in itself, unprecedented – see, for example, Francesco di Giorgio, whom Leonardo knew and whose treatise on architecture he owned.

Leonardo's importance within the history of art stems from his mastery in representing natural effects, allied to a supreme ability to *idealize. He was the originator of the style we call the High *Renaissance (*see also* Michelangelo, Raphael). As a painter, he created some of the world's most potent and influential images. The *Last Supper* (*c*.1495–7, Milan, S. Maria delle Grazie, refectory) remains the best-known Christian *istoria* (*see under* genres); the so-called *Mona Lisa*, more properly *Portrait of a Lady on a Balcony* (*c*.1505–14, Paris, Louvre) established a long-lived portrait formula. Even Leonardo's lost or never completed works influenced the evolution of the genres they exemplify; the never-cast equestrian *Monument of Francesco *Sforza* in Milan (*c*.1485–93, full-scale clay model destroyed) and its projected reprise, the *Trivulzio monument* (designs, *c*.1508–9); the never-finished mural of the *Battle of Anghiari* (1503–6, Florence, Palazzo della Signoria, Great Council Chamber, now Salone del Cinquecento; painted copies, Munich, Hoffman Coll.; Florence, Uffizi; drawing by *Rubens after an engraving, Paris, Louvre);

the lost *Madonna and Child with the Yarn-winder* (*c*.1501, best copy, Scotland, Drumlanrig) and *Leda and the Swan* (*c*.1504–16, best copy, Wiltshire, Wilton House); the cartoon (*see under* fresco) of the *Madonna, Child, St Anne and St John* (*c*.1508, London, National) and the related unfinished painting of the *Madonna, Child, St Anne and a Lamb* (*c*.1508, Paris, Louvre) – all these furnished contemporaries and later generations with an unendingly fascinating stock of pictorial compositions, poses, facial types and expressions. More general painterly problems were defined and resolved by Leonardo, notably the problem of tonal unity (*see under* colour) which ensures that all the forms represented within a single picture seem to be consistently lit from one or more predetermined light source, regardless of the local colour of any given area. To this end Leonardo evolved his famous *chiaroscuro, in which the tonal structure of the entire painting is established in monochrome, from deepest black shadows to light highlights, then coloured through the application of translucent glazes in varying hues. The early monochrome stages of this procedure can be seen in the unfinished *Adoration of the Magi* (1481, Florence, Uffizi). Leonardo's first use of chiaroscuro as a means of imposing tonal harmony is, however, already observable in the immature but completed painting of the *Annunciation* (*c*.1473, Florence, Uffizi) in which the black underpaint can be seen to 'tone down' the bright hues of the Virgin's garments. More obvious perhaps is the use of chiaroscuro to suggest three-dimensionality, 'relief': the dark 'shadowed' areas seem to recede, the highlights to come forward. The *Annunciation* also demonstrates Leonardo's early interest in the pictorial problem of *perspective. Two kinds of perspective are employed here: *linear*, in which the orthogonal edges of architecture and pavement are carefully inscribed to direct the eye to the vanishing point on the horizon, and *aerial*, in which colours fade gradually to a pale blue haze in the distance. Yet another pictorial device associated with Leonardo appears in a slightly later picture, the portrait of *Ginevra de'Benci* (1474?, Washington, National). This is *sfumato, the blurring of transitions

from dark to light or from one hue to another. *Sfumato* is used strikingly throughout the *Madonna of the Rocks* (1483–*c*.6, Paris, Louvre) which is also the earliest completed painting by Leonardo fully to achieve tonal unity. The second version of this subject, an altarpiece of the *Immaculate Conception* (*c*.1495–1508, London, National), which is not fully complete and may not be autograph in every detail, is darker in tone, anticipating the *expressive mystical *tenebrism of the *St John the Baptist* (*c*.1509, Paris, Louvre).

While no work of sculpture by Leonardo's own hand survives, *Rustici's bronze group over the north door of Florence Baptistry was executed to his design and under his close supervision.

The large number of unfinished works in Leonardo's *œuvre*, and the comparatively small number known to have been completed, point to a complex of factors differentiating the artist from most of his contemporaries. Some works, it is true, were abandoned as a result of circumstances beyond Leonardo's control. Thus the Sforza monument was left uncast when, with the French invasion of 1494, the required bronze was despatched to be made into cannon. But Leonardo's ever-proliferating studies in other fields absorbed time which might have been devoted to painting or sculpture. Equally important, the evolution of each work, from preliminary ideas relating to the original commission, through to techniques, was at every stage experimental, thus time-consuming and not suitable to be left to assistants. Finally, Leonardo's ideal of finish was very high; the *Mona Lisa*, for example, is built up in innumerable, slow-drying layers of translucent glazes. These temperamental, intellectual and artistic factors were decisive in shaping Leonardo's career.

Born the illegitimate albeit welcomed son of a notary from Vinci near Florence, Leonardo was raised in his father's house and apprenticed, some time after 1464 (1469?), to Andrea del *Verrocchio. He stayed in his master's workshop after the termination of his apprenticeship, until at least 1476. Verrocchio's influence can be seen to have been immense; most of the motifs of Leonardo's art, and his technical

interests, can be traced to his studio. Yet, while Leonardo's artistic aims were deeply rooted in Florentine tradition – which he himself traced proudly back through *Masaccio to *Giotto – his disposition ill-suited him to the commercial and competitive practice of art in Florence in the 1480s. Abandoning unfinished the commissioned *Adoration of the Magi*, he left the city *c.*1482 to enter the service of Duke Ludovico Sforza in Milan. A salaried appointment, varied employment and the intellectual stimulus of a court which drew into its orbit distinguished mathematicians, philosophers, musicians and writers, proved congenial. Leonardo spent 18 highly creative years in Milan, leaving only with the final collapse of Ludovico's reign in 1499. After visits to Mantua (portrait drawing of Isabella d'Este, Paris, Louvre) and Venice, he returned to Florence in 1500. He was to remain there, with lengthy interruptions, until 1508. Despite these interruptions, the Florentine years also proved remarkably fertile. The overthrow of the Medici in 1494 had resulted in the establishment of a vigorous Republic, unchecked by the execution of Savonarola in 1498, and the broadening of the base of government led to the construction of the huge Great Council Hall and the awarding of the *Battle* commissions to Leonardo and Michelangelo. Although finished paintings were few, Leonardo's compositions attracted interest and excitement from the general public as well as other artists, and his work of these years played a formative role in the evolution of Raphael's style, as well as that of *Fra Bartolommeo and *Andrea del Sarto. Nevertheless, recalled to Milan by a lawsuit over the non-completion of the *Madonna of the Rocks*, Leonardo was persuaded to remain there in the service of the French, hoping to redeem the failure of the Sforza monument with an equestrian statue commissioned by Ludovico Sforza's enemy, the mercenary general of the French forces, Trivulzio. In 1513, the French having lost control of Milan to Ludovico's son Massimiliano Sforza, Leonardo had to forsake this project also. Accompanied by his pupils – one of whom, the well-born and educated Francesco Melzi, was to become his literary

executor, preserving the precious notebooks – Leonardo now found refuge in Rome under the protection of Giuliano de'*Medici, the brother of the newly elected Medici pope, Leo X. After Giuliano's death in 1516 Leonardo accepted the invitation of the French king, Francis I, to join his court at the Château of Cloux near Amboise, where he remained from 1517 until his death two years later. Tradition has it, wrongly, that he died in the King's arms – but it is true that he was fully appreciated, not only for his artistic and technical gifts but as 'a very great philosopher'.

Leoni, Leone (*c.*1509–90) Tuscan sculptor, active mainly in northern Italy. Like his rival *Cellini he trained as a goldsmith and gained a reputation as a medallist while aspiring to execute large-scale works. He was engraver at the papal mint in Rome (1537–40) but was condemned to the galleys for assaulting and disfiguring the Pope's jeweller. Freed in 1541/2 through the intervention of Andrea Doria, admiral of the imperial fleet, Leoni became master of the imperial mint in Milan (1542–5; 1550–89). In 1548 he entered the service of Charles V as a sculptor, executing, mainly in bronze, many portrait sculptures of members of the *Habsburg family (Madrid, Prado; Vienna, Kunsthistorisches). His *œuvre* includes two allegorical portrait groups: *Charles V restraining Fury* (1549–64, Madrid, Prado) and *Ferrante Gonzaga Triumphant over Envy* (1557–94; Guastalla, Piazza Roma). Leoni is the most prolific court portraitist of the Renaissance; his most innovative work, however, is the sculptural decoration of his own house in Milan (via Omenoni).

His son **Pompeo Leoni** (*c.*1533–1608), with whom Leone collaborated on the high altar of the Escorial, executed the bronze portrait statues of Charles V and Philip II and their families for their monuments in the Escorial (1591–8).

Leopardi, Alessandro (active after 1482–1522/3) Bronze sculptor, active mainly in Venice, where during 1488–96 he completed the Colleoni monument left unfinished by *Verrocchio, for which he

designed the base. His principal independent works are the bases of three flagstaffs in the Piazza San Marco.

Le Parc, Julio (1928–) Argentinian artist who was trained in Buenos Aires and moved to Paris in 1958. One of the founders of the *Groupe de Recherche d'Art Visuel, he investigated the affective properties of *kinetic art and of electric light, often together as in the *Labyrinth* he made for the 1963 Paris Biennale. In 1966 he was controversially awarded the main painting prize at the Venice Biennale. Some of his work was designed to attract viewer participation, and at times in the 1970s the basis of such work was political, e.g. anti-imperialist.

Lépicié, Michel-Nicolas-Bernard (1735–84) French painter, associated today with *genre pictures but equally esteemed in his lifetime for his history paintings (*see under* genres), some of which are early examples of inspiring national subject matter (e.g. *William the Conqueror invading England*, 1765, Caen, Lycée Malherbes; *cf.* Benjamin *West's 1773 *Death of Bayard*). Trained first under his father, the distinguished engraver (*see under* intaglio) and biographer **Bernard Lépicié** (1698–1755), then under Carle van *Loo, he was influenced by both *Chardin and *Greuze – imitating the paint texture of the former and the sentimentality of the latter (*L'enfant en pénitence*, Lyon, Musée). He is best remembered for his *Le Lever de Fanchon* (1773; Saint-Omer, Musée), a painting still redolent of *Rococo eroticism and charm, but already imbued with the 'innocent purity' and 'simple virtues' of working-class life, as preached in contemporary bourgeois novels and drama.

Lépine, Stanislas (1835–1892) French landscape painter who studied with *Corot. His best paintings show a remarkable skill in modulating tones by means of soft brushstrokes, and thus suggesting effects of light without emphatic colours. He exhibited in the first *Impressionist exhibition of 1874 but never adopted Impressionist methods.

Leprince, Jean-Baptiste (1734–81) French painter, a pupil of *Boucher. About 1758 he travelled to Russia, where he was extensively employed on decorative paintings for the palaces of the Empress Elizabeth. On his return to Paris in 1763, he made a speciality of paintings and etchings (*see under* intaglio) of Russian customs, costumes, and landscapes (Paris, Louvre).

Le Sueur, Eustache (1616–55) French painter, much admired in his day and in the 18th century for combining tender sentiment with the severe *classicism of *Poussin, notably in his series on the *Life of St Bruno* painted 1648–c.50 for the Charterhouse of Paris (now Paris, Louvre). Trained from c.1632 by *Vouet, he imitated his manner until the early 1640s (e.g. St Petersburg, Hermitage), turning, however, to Poussin and to *Raphael – whose works he knew only through engravings (*see under* intaglio) – in his decorative panels for the Cabinet de l'Amour (c.1646–7) and the Cabinet des Muses (c.1647–9) in the Hôtel Lambert (now Louvre). From c.1650 he modelled his work increasingly on prints after Raphael's tapestry cartoons, imitating their fullness of form to the point of caricature (e.g. Paris, Louvre; La Rochelle, Musée; Marseilles, Musée; Tours, Musée).

Le Sueur, Hubert (c.1595–c.1650) French sculptor and caster in bronze, who settled in England in 1625. He was patronized by Charles I, whose equestrian statue he executed in 1633; it was erected in Charing Cross in 1765. He also made the funerary monument to the Duke of Buckingham, his wife and children, in Westminster Abbey, and helped to popularize the bronze portrait bust in England (e.g. London, St Margaret, Lothbury).

Lessing, Gotthold Ephraim *See under* Laocoön.

Leutze, Emanuel Gottlieb (1816–69) American painter of German origin, painter of *Washington crossing the Delaware* (1851; New York, Metropolitan Museum), a large *history painting representing

an event from the American War of Independence and treated in the tradition of Raphael and Poussin but in a semi-*academic, more or less *naturalistic technique characteristic of his age.

Levasseur A dynasty of Canadian sculptors active in Quebec: **Noël Levasseur** (1680–1740), the son of a family of joiners and carvers; he was responsible for the altar-piece in the chapel of the Hôpital Général (1721) and the altar screen of the Ursuline Chapel (from 1732). His workshop included his cousin **Pierre-Noël Levasseur** (1690–1770), best known of the family for figure carving, and his sons **Jean-Baptiste Antoine** (1717–after 1777) and **François-Noël** (1702–94).

Levine, Jack (1915–) American painter, trained in Boston. His origins and the Depression led him to devote much of his art to upbraiding criminality and official dishonesty in paintings whose Old Masterly brilliance contrasted with their sordid, satirical meaning. He also painted biblical subjects in a thoughtful and grave manner. He had his first solo exhibition in New York in 1938 and many retrospectives from 1953 (Boston) on. His work has been seen very little outside the USA.

Levitan, Isaak Ilych (1860–1900) Russian landscape painter. Born in Lithuania, he settled in Moscow and studied painting at the Moscow School of Art from 1873 on. He exhibited with the *Wanderers and became a member of the society in 1891. He travelled in western Europe before taking charge of the landscape studio of the Moscow College. He exhibited with the *World of Art association in the late 1890s. His earlier landscapes are *naturalistic and painted with deliberation, but the later ones, from about 1890 on, are lighter in touch and are outstanding examples of the international near-*Impressionistic manner that spread from Paris in those years. Vivid, often using particular scenes and conditions of weather and light to convey a mood, Levitan's landscapes are valued as the first valid and significant account of the land and seasons of Russia.

Lewis, Percy Wyndham (1882–1957) British painter and writer, born in Nova Scotia, who studied at the Slade School in London and worked for a time in Munich, Madrid and Brittany as well as Paris. He wrote poems, novels and stories as well as polemics, and from 1909 was published as much as exhibited. He showed in exhibitions organized by *Fry in 1912 and joined the *Omega Workshops in 1913. A dispute with Fry caused him to leave. Lewis's work at this time partook of *Futurism, *Cubism and *primitivism. When he and his associates exhibited in Brighton in 1914 their section was labelled 'the *Cubist Room'; subsequently, at Ezra Pound's suggestion, they named themselves *Vorticists. He exhibited in London Group shows and others during 1914–15 and with his friends produced two miscellanies, *Blast No. 1* and *Blast No. 2*. In 1919 he had his first solo exhibition; his second, 1921, was followed by years devoted to writing. He travelled in Europe and North Africa and made several visits to America. In 1932 he held an exhibition of his portraits and this was followed by another period without exhibitions, mainly because of ill health. In 1937 his first autobiographical book was published and he had a major exhibition; two further volumes of autobiography were published in 1939 and 1950. In 1938 his portrait of T. S. Eliot (South Africa, Durban AG) was rejected from the Royal Academy summer exhibition. During 1939–45 he was in the USA and Canada. Back in London, in 1946, he was art critic of *The Listener* until he lost his sight in 1951. 1949 saw a retrospective exhibition in London; another, at the Tate Gallery, was in 1956.

A harsh *avant-gardist until 1915, Lewis later painted sharply elegant portraits that combined some of the style of Vorticism with a traditional conception of painting as solid forms represented in apparent space. His later writings rejected experimentation and asserted traditional values.

LeWitt, Sol (1928–) American artist who emerged in 1965 (first solo show, New York) as one of the leading figures in *Minimal art with regular open cubic lattices in white-coated aluminium. He

excluded personal expression in ways that challenge conceptions of the nature and the visibility of art. This allied him with the *Conceptualist tendency, to which he contributed a system of giving instructions for murals to be executed by any willing person. His prints demonstrate combinations of linear patterns serially in black and white and in colour. His work was seen internationally in the late 1960s and continues to draw attention as a logical and compelling demonstration of the rewards of economy and clarity.

Leyden, Lucas van *See* Lucas van Leyden.

Leyster, Judith (1609–60) Precocious Dutch painter; she may have been a pupil of Frans *Hals in Haarlem, and is one of his closest followers. She painted mostly *genre scenes, but she also did some portraits and *still lifes. In 1636 she married the genre painter **Jan Miensz. Molenaer** (c.1609–68) and from the 1630s she began to paint small pictures in his manner. There are no works by her dated later than 1652. (Amsterdam, Rijksmuseum; Stockholm, Museum; London, National; etc.)

Lhote, André (1885–1962) French painter who first worked as wood carver and then, self-taught as painter, moved to Paris where he had his first solo show in 1910. This brought him into contact with the *Cubists whose geometrical planes he adapted to landscapes and figure subjects, e.g. sport scenes, in a regulated, flat and decorative idiom. From 1917 on he wrote articles and books on art and he became an influential teacher, opening his own academy in 1922. He was a champion of modern art as extending the traditions of Egypt, Greece and France. His work was seen in many mixed and solo exhibitions, in Paris and then also internationally. A retrospective was shown in Paris in 1958, and his death was followed by memorial exhibitions in Albi, Limoges and Paris.

Liberale da Verona (c.1445–c.1529) Italian painter and outstanding illuminator (*see* illumination) from Verona, where he returned in 1487 after working in Siena and

Venice (*frescos in Verona, Museo; St Anastasia; Cathedral; bishop's palace; other churches; two panels, London, National). His illuminations, of much higher quality than his frescos, can be admired in, e.g. the large choir-music manuscripts of the Libreria Piccolomini, Siena Cathedral. Liberale's paintings, whether on a miniature or a large scale, are indebted to *Mantegna.

Lichtenstein, Roy (1923–97) American painter. Born in New York, he was trained at Ohio State University. He exhibited geometrical and near-*abstract paintings in the early 1950s. Teaching at Rutgers University, New Jersey (1960–3), he met *Kaprow and others interested in consumer culture. In 1961 he began to paint free-hand versions of comic-strip frames, complete with text bubbles, and showed them in 1962. He contributed to the first shows of what was to be called *Pop art in 1962–3, had solo shows in New York, Paris and Turin, and moved to New York. Many more exhibitions followed in the 1960s, including retrospectives touring on both sides of the Atlantic in 1967–9. His subjects and sources changed with time: advertisements provided motifs and a dead-pan idiom for representing common objects; comic strips offered narratives which he normally concentrated in one frame, from Disney scenarios to romance and war; he also paraphrased diagrams and reproductions of famous painters' work and commented on Abstract Expressionism with paintings of mighty brushstrokes. His free-hand technique had given way to carefully prepared renderings: the banal source was imitated but refined and monumentalized. He used stencils which broke up his colour areas into dots, like enlarged newsprint illustrations. From the mid-1960s on he also made sculptures of a decorative and period sort. Some of his paintings and sculptures come close to *Minimalism in their concentration, yet his work always has a strong sense of historicism and of parody.

Licini, Osvaldo (1894–1958) Italian painter. From about 1930 on he produced *abstract and *Constructive paintings, shown at the 1950 Venice Biennale. At the

1958 Biennale he won Italy's painting prize with expressive semi-*Surrealist work.

Licinio, Bernardino (c.1490–c.1550) Venetian painter, trained in the workshop of Giovanni *Bellini when it was under the pervasive influence of *Giorgione – several of his pictures have been attributed to the latter. He executed Giorgionesque Concerts and Seduction Scenes, half-length Madonnas and Saints in the style of the young *Titian, altarpieces (Venice, Frari), *sacre conversazioni* in the manner of *Palma Vecchio (London, National); in the 1530s, in common with other Venetian artists, he emulated the *classicism of *Raphael, transmitted through prints. But he is generally at his best in portraits, whose sober *realism resembles that of *Moroni (York, Gallery; London, National). The best-known is the group portrait of his elder brother Arrigo Licinio, also a painter and part-author of this work and his family (c.1535; Rome, Borghese). It includes the likenesses of Arrigo's elder sons, **Fabio**, who became a goldsmith and etcher (see under intaglio) and **Giulio** (1527–91), who trained as a painter with Bernardino and became his assistant. In his Lives of the Artists *Vasari erroneously identified Bernardino Licinio with *Pordenone, and the confusion was only cleared up in this century.

Liebermann, Max (1847–1935) German painter who studied in Berlin and Weimar but found his style and many of his subjects through contact with the *Barbizon painters in France and the *Hague painters in the Netherlands. In Berlin he was prominent among those who opposed the *academic traditions passionately upheld by the court and who followed foreign ideas and methods instead of promoting a national and heroic idiom. His subjects tended to be peasant and simple urban life as well as landscapes, and his style took on some of the fluency and lightness of *Impressionism. He was one of the founders and first president of the Berlin *Sezession in 1898 and from 1922 until 1933 was President of the Berlin Academy. His art was admired and collected from the first, but the fact that he was a Jew made him a target of all who wanted the German empire to develop an art free of foreign influences and dedicated to exalting the nation state. Thus he was seen as a cultural enemy not only by the Kaiser but also by younger nationalistic artists such as *Nolde.

Liège, Jean de See Jean de Liège.

Liesborn, Master of (active second half of the 15th century) German painter active in Westphalia, influenced by the style current in Cologne (see Lochner, Stephan). He is named after the dismembered high altarpiece of the Benedictine Abbey at Liesborn, Westphalia, dedicated 1465 (fragments Münster, Westfälisches; London, National).

Lievens, Jan (1607–74) Dutch painter, etcher (see under intaglio) and designer of woodcuts (see under relief prints). His reputation has been eclipsed by that of his friend *Rembrandt, but Lievens was a more precocious artist. After two years working in Amsterdam with Pieter *Lastman (c.1617–19, or perhaps c.1619–21) he returned to his native Leiden as an independent artist; the influence of Lastman is evident in his work of the early 1620s (e.g. The Feast of Esther, c.1625, Raleigh, NC, Museum). During c.1625–31 he may have shared a studio with Rembrandt; the two young men worked on each other's pictures, and their hands occasionally were, and still are, confused. Lievens's work from this period relies more than before on *chiaroscuro (Raising of Lazarus, 1631, Brighton, Gallery; Prince Charles Ludwig of the Palatinate and his governor as Alexander and Aristotle (?), 1631, Los Angeles, Getty). In 1630 Lievens was adjudged superior to Rembrandt in grandeur of invention and boldness, while Rembrandt surpassed Lievens in the expression of inner life. About the time that Rembrandt went to Amsterdam, 1631/2, Lievens departed for England, where he worked as a portrait painter before settling in Antwerp, 1635–44. Having absorbed the influence of *Van Dyck and *Rubens, he continued to paint in the light, elegant Flemish manner after his return to the Netherlands in 1644. In addition to

fashionable portraits, he executed large-scale narrative decorations for the residence of the Princes of Orange, the Huis ten Bosch; for the new town hall of Amsterdam, and for the Rijnlandhuis in Leiden.

Life of the Virgin, Master of the (active second half of the 15th century) Painter active in Cologne but possibly trained in the Netherlands. He is named after a series of eight panels on the Life of the Virgin (Munich, Alte Pinakothek; London, National).

Limbourg, Pol, Herman and **Jean** or **Jehanequin** (recorded from 1399 – all three dead by or in 1416) The Limbourg brothers were apprenticed to a goldsmith, but became illuminators, first for the Duke of Burgundy, 1402–4 (moralized Bible, Paris, Bibliothèque Nationale), and after his death for the Duke of *Berry. They illustrated at least part of three *Books of Hours for this patron, including all of the sumptuous *Très Riches Heures* now at Chantilly, Musée (1413–16). It is the first Book of Hours of which the calendar received elaborate full-page illustrations, one for each month, showing typical peasant activities and the seasonal recreations of the nobles. In their mixture of decorative elegance, Italian *idealization (notably in many of the figure poses derived from Italian art), and sharp observation of natural phenomena and social reality, the illuminations of the Limbourg brothers are among the most accomplished examples of the International *Gothic style. *See also* Jean Malouel; Boucicault Master.

limn, limner Archaic words for miniature painting and miniature painter – *Hilliard's treatise of *c.*1600 was called *The Arte of Limning*. 'Limner' is applied to the early portrait painters of Colonial America, whose unsophisticated, flat and patterned likenesses are – wrongly – thought to resemble those in medieval manuscript illuminations and Elizabethan miniature portraits. *See also* Freake Limner; Schuyler Limner.

Lindner, Richard (1901–78) German-American painter who left

Germany for Paris in 1933, emigrated to the USA in 1941 and became an American citizen in 1948. He had worked in advertising in Germany and in the USA he did illustrations for *Vogue* and other leading magazines. From 1950 on he gave priority to painting and in 1952 gave up his illustration work. The paintings normally show hieratic figures whose fleshy abundance contrasts with their attributes, painted firmly and without grace to create *icons rich in cultural references yet destabilized by stylistic conflicts and fragmentations within the image. He exhibited frequently from 1954 on; in the 1960s his work was seen internationally.

Linnell, John (1792–1882) British landscape painter in oils and watercolour, who studied with John *Varley and at the Royal Academy Schools. His early work shows him intent on *naturalistic representations, achieved often with the aid of a *camera obscura* or other graphic devices, made all the more intense by religious convictions that identified all the visible world with divine goodness. In 1818 he became a friend and patron of William *Blake and part of Blake's Shoreham circle; Samuel *Palmer became his son-in-law. Linnell's later pictures are less focused, more generalized, in the manner of Palmer.

Liotard, Jean-Etienne (1702–89) Much-travelled painter and pastellist. Born in Geneva, where he settled again in 1758, he studied and worked in Paris, 1723–36. Probably influenced by the success of Rosalba *Carriera on her Parisian visit 1720–1, he specialized in pastel portraits. In 1736 he set out on extensive travels; in Rome he met Englishmen who took him with them to Constantinople, where his stay resulted in *genre studies of Turkish life and costume. He also worked in Vienna, London and Holland. Within the pastel medium, Liotard achieved remarkably *realistic effects of texture, lustre and reflection – as in the *Maid Carrying Chocolate* (Dresden, Gemäldegalerie). His portraits, too, were sharply realistic, earning from Walpole the exclamation that they were 'too like to please'. There are works by him in Geneva, Musée; London,

V&A; Amsterdam, Rijksmuseum; Vienna, Akademie.

Lipchitz, Jacques (1891–1973) Russian-Lithuanian sculptor. He came to Paris to study art in 1909 and stayed, becoming a French citizen in 1924. In 1940 he fled from the invading Germans, arriving in the USA in 1941. He became a US citizen in 1958. In his last years he travelled in connection with commissions, especially to Israel, and lived his last years in Italy. His first exhibited pieces were sensitively modelled figures that drew praise from *Rodin, but from 1913 he worked as a Cubist, modelling or carving sculptures in which Cubist formal clusters suggest standing figures. In 1915 he began to construct 'detachable' figurative sculptures by slotting pieces of card or wood into each other, whilst also continuing with his more massive Cubist works. From 1920 on the American collector Dr Albert Barnes bought and commissioned pieces from him, enabling him to work more freely and to cast in bronze works that would otherwise have been left in vulnerable materials. At this stage Lipchitz turned to exploring what he termed 'transparents', sculptures of a more open and linear sort, and used them to present traditional, significant subjects, from the Bible, mythology and other honoured sources. Being Jewish himself, he identified with the persecution of Jews in Russia and Central Europe. Abandoning the geometric faceting of Cubist sculpture along with Cubism's light-hearted contemporary subjects, he developed an intensely personal, expressive idiom that in large-scale works retained the rough forms of modelled clay to marked dramatic effect. He exhibited frequently, and was successful in attracting commissions for public works, from *Prometheus* (1937, for the Paris World Fair's Science Pavilion) to the 15-metre high *Peace on Earth* (1969, Los Angeles County Music Center) and the even taller *Our Tree of Life* commissioned by Hadassah University in Jerusalem in 1967 and set up posthumously on Mount Scopus in 1978.

In 1942 Lipchitz had begun to exhibit regularly in the USA. In 1954 a major retrospective was shown in New York (MoMA), Minneapolis and Cleveland.

From 1946 onwards he exhibited also in France and then ever more widely as an international star, notably in Germany and Israel. A studio fire in 1952 destroyed many early pieces, especially maquettes but also current work. This disaster appears to have stimulated him to further invention, as in his 'semi-automatic' pieces made by squeezing warm wax and developing images suggested by the result, and also combining wax with found materials. His free process of modelling forms in themselves not directly descriptive and bringing them together in sometimes wildly *Baroque compositions, at once heavy and open to the passage of air and light, gives his post-Cubist work a personal, often disconcerting quality that has led to the possibly too high valuation of the more easily categorized *Modernist work he did in Paris. Yet this free use of matter combined with his focus on serious and sententious subjects gives Lipchitz's later work a particular status in modern sculpture thanks to its thematic as well as formal vehemence.

Lipchitz and his family donated groups of works to the Israel Museum, Jerusalem, the Centre Georges Pompidou, Paris, the Kröller-Müller Museum, Otterlo, the University of Arizona Museum, Tucson, the Tate Gallery, London, and the Tel Aviv Museum of Art. The Tate Gallery also holds an important Lipchitz documentary archive.

Lippi, Fra Filippo (1406/7–69) and his son **Filippino** (1457–1504) Leading Florentine painters. Filippo, author of many panel paintings and two important *fresco cycles (Prato, cathedral, 1452–64; Spoleto, cathedral, 1467–9) was esteemed by contemporaries for the charm and lively grace of his work, qualities which earned him the patronage and support of the Medici family. Earlier 20th-century critics dismissed him as an ingratiating 'illustrator'. Current opinion sees him as a complex artist, experimental in attempting to reconcile conflicting trends in contemporary art. In his growing interest in aerial *perspective and tonal painting he is viewed as direct precursor of *Leonardo da Vinci. He was probably the teacher of *Botticelli.

An orphan placed in the friary as a child,

Filippo took his vows as a Carmelite in 1421 in S. Maria del Carmine in Florence, where c.1427 *Masaccio and *Masolino were to paint the Brancacci chapel. His earliest work was clearly based on Masaccio (*Reform of the Carmelite Rule*, 1432, fresco fragments from Carmine cloister). He left the Carmine in 1432. Paintings on panel from the 1430s through the early 1450s demonstrate his departure from Masaccio's severe unadorned manner without, however, abandoning its spatial and volumetric implications (*Tarquini Madonna*, 1437, Rome, Nazionale; *Barbadori altarpiece*, 1438, Paris, Louvre; other works Florence, S. Lorenzo, Pitti, Uffizi; Munich, Alte Pinakothek; London, National). Influenced by Fra *Angelico and Netherlandish art, he strove to counteract the pictorially disruptive tendency of single-vanishing-point perspective through colour, used to create a vibrant pattern across the picture surface, and a decorative use of line. In the later 1450s the balance thus achieved was fragmented towards greater decorative fantasy (e.g. *Adoration*, Florence, Uffizi). Finally, late scenes in the Prato frescos announce the new more monumental style of the 1460s in which deep space is once again emphasized and dualities between *realism and decoration exploited to dramatic ends.

Filippo is notorious for having induced a nun, Lucrezia Buti, to elope with him in 1456; he was then chaplain to her order in Prato. From this union, which was regularized – after years of conflict with the ecclesiastical authorities – through the intercession of the *Medici, issued their son, Filippino ('little Filippo'). In Spoleto with his father 1467–9, the boy returned to Florence after Filippo's death; by 1472 he was working with Botticelli. A number of pictures once attributed to the anonymous 'Amico di Sandro' (friend of Sandro Botticelli) are now assigned to him in the years 1475–80 (e.g. London, National). Between 1481 and 3 he completed the lower tier of frescos left unfinished by Masaccio and Masolino in the Brancacci chapel. It was to be the only time he painted in a Masaccio-esque manner; his works, for most of the religious and civic institutions of Florence, are closer to the manner of Botticelli and

the young Leonardo da Vinci in their restless play of ornamental lines and planes, and use of Netherlandish colour (e.g. *Vision of St Bernard*, Florence, Badia; *Adoration of the Magi*, Uffizi; other panel paintings in Florence, Pitti; Paris, Louvre; Copenhagen, Museum; Bologna, S. Domenico; Genoa, Palazzo Bianco; etc.). In 1487 he was commissioned to fresco the Strozzi chapel in S. Maria Novella; the work was interrupted in 1488 by a call to Rome to decorate Cardinal Carafa's chapel in S. Maria sopra Minerva (1488–93). The Roman experience was of great importance to the evolution of Filippino's style. The full impact of Rome on the artist can best be appreciated in the Strozzi chapel in Florence, completed in 1502, where Filippino's interest in archeology and his detailed study of *classical sarcophagi and other ancient relief sculptures is fully apparent, especially in the famous details of musical instruments. The Strozzi chapel decoration, ordered in lunettes and large square pictorial fields instead of the hereto more usual tiers, is poised visibly at a point of transition in Florentine art between the Early and the High *Renaissance.

Lippold, Richard (1915–) American sculptor who studied industrial design and was self-taught as artist. In 1941 he began to make sculpture out of wire, first in curves to suggest organic forms but soon in straight lines and when possible on a large scale, the lines in space presenting interpenetrating stereometric forms as lines of light. A major commissioned work is *Flight* in the Pan American Building, New York (1962–3).

Lipton, Seymour (1903–86) American sculptor, a dentist who turned to making sculpture in 1932. His early work was descriptive and anecdotal, reflecting social malaise. In the mid-1940s he began to work sheet steel, sometimes enriched with brass rods, in an expressive manner that was influenced by *Surrealism and intended to express war and anxiety. Sharp forms and savage textures were presented sometimes as bird forms, sometimes as embodiments of malevolent myths, but in the early 1950s his images became more

positive, suggesting generation and natural growth. Much of his work hovers on the edge of *abstraction and symbolical *figuration. Through this and his method of instinctive creation it can be seen as allied to the painting of *Abstract Expressionism.

Liss, or Lys, Johann or Jan or Giovanni (*c.*1597–1629/30) Eclectic German-born painter who had a great influence on subsequent Venetian artists, particularly in the 18th century (*see* especially Piazzetta, Pittoni, Sebastiano Ricci). He settled in Venice in 1629, after a brief preliminary visit in 1621 and shortly before the advent of the plague which killed him. His late style, anticipating the *Rococo, is best seen in his much-copied altarpiece of the *Vision of St Jerome* (*c.*1628, Venice, S. Nicolò da Tolentino); it was preceded by a variety of other styles reflecting his earlier travels. *c.*1615–19 he had worked in Haarlem, Amsterdam and Antwerp, coming into contact especially with *Hals and *Jordaens. On his first stay in Venice he was most affected by Domenico *Fetti, who showed him how to translate into Italian terms his small-scale Dutch-inspired *genre pictures. A stay in Rome *c.*1622–mid-to-late 1620s introduced him to the work of *Caravaggio, Annibale *Carracci, and northern artists such as *Elsheimer and the brothers *Bril. By the time of his second stay in Venice his idiom was more truly *Baroque than that of any other artist who had worked there, and, as we have seen, he quickly moved towards that even greater freedom of handling and disintegration of form characteristic of the Rococo. There are only a few paintings by Liss, some in Venetian private collections; Berlin Staatliche; London, National.

Lissitzky, El (1890–1947) Russian painter and designer, born Lazar Markovich Lissitzky, trained as architect in Darmstadt and Moscow in 1909–14, also travelling in Italy and visiting Paris in 1912–13. His first art work was illustrating Jewish Passover stories in an idiom close to *Chagall's. In 1918 he was appointed to the art panel of the new Commissariat of Enlightenment. In 1919 Chagall invited him to teach graphics and architecture at the Vitebsk art school but soon Lissitzky came under *Malevich's influence there and developed his own form of *Suprematism. He called his paintings and prints Proun, probably an acronym for 'project in affirmation of the new', describing this work as 'the interchange station between art and architecture'. He worked on festival decorations and produced the best-known *abstract revolutionary poster, *Beat the Whites with the Red Wedge* (1919). In 1921 he taught architecture at the *VKhUTEMAS but later that year went to Berlin to make contact with new artists and designers in the West and to help organize the *First Russian Exhibition there. In 1922–3, with the Russian writer Ilya Ehrenburg, he published a multilingual journal *Veshch/Gegenstand/Objet* promoting Suprematist and *Constructivist attitudes and work; he also made alliances with *Dadaists and Van *Doesburg, published his Suprematist picture book *The Story of Two Squares* (1922; designed 1920), in Hanover issued two sets of lithographs, *Prouns* and *Victory over the Sun* (1923) and designed the form, lay-out and typography for Mayakovsky's book of poems, *For the Voice* (1923). In 1923 he had a solo exhibition at the Kestner Society in Hanover. His *Proun Room* (1923) is a chamber articulated with Proun motifs in two and three dimensions, abstract but possibly symbolical; the original was made for a major exhibition in Berlin, a reconstruction is in the Stedelijk-Van-Abbemuseum, in Eindhoven (Netherlands). He wrote extensively, and a selection of his texts is included in the book written and edited by his widow, S. Lissitzky-Kueppers, in 1967–8. All this work, together with his friendly personality and presence at conferences such as the International Congress of Progressive Artists (Düsseldorf 1922), propagated his design and theories and, joining forces with *De Stijl in the person of Van Doesburg, led to a Central European art and design idiom, best referred to as *Elementarism, which was of cardinal influence on the *Bauhaus and on international architecture and design. His unhesitating embrace of modern technology contrasts with the more traditional and spiritual thinking of Malevich.

Tuberculosis took him to Switzerland in 1924 but he remained busy, editing the modern art survey *Kunstismen* (art-isms) with *Arp, designing advertisements, contributing to the new design journal *ABC*, etc. In 1925 he had to leave Switzerland. He returned to Moscow where he taught, collaborated on an architectural journal and designed communal housing. He was outstanding among exhibition designers, working in the West on a room for abstract art for a Dresden exhibition in 1926, another for a museum in Hanover in 1927–8, and the admired Soviet sections of the Pressa exhibition in Cologne (1928), of the Film und Foto exhibition in Stuttgart (1929), of the International Hygiene Exhibition in Dresden (1930), and others. In Russia too he worked on exhibitions as well as architectural and stage design, notably his reconstruction of a theatre and stage for Meyerhold's intended production of *I Want a Child* (1929). He wrote *Russia: The Reconstruction of Architecture in the Soviet Union* (Vienna, 1930). In the 1930s he worked principally as photographer and on typography and layout, but occasionally also on exhibition design.

A fine and inventive artist, Lissitzky's greatest achievement was his propagation of new Russian ideas and methods in western Europe where his influence on Elementarism and on specific individuals, in particular László *Moholy-Nagy, was marked. Through lectures and publications he developed and disseminated his thought.

lithograph, lithography (from a Greek compound meaning 'writing with stone') A method of printing and printmaking, invented in 1798 by a German, Alois Senefelder (1771–1834), as a means of printing first text (his own plays) and then also 'music and pictures'. He had experimented with printing from etched stones (*see* Intaglio). The novelty of what he at times called 'Chemical Printing' was that the printing could be done from a flat surface treated with gum arabic and written or drawn on with a greasy medium. This would give any number of clear pulls, without loss of definition as with etching or engraving. A resident of Munich, where he first patented the

process, he published the first printed drawings (by the Swiss artist Conrad Gessner) in London in 1799. Lithography was rapidly promoted among artists and the first collection of lithographs, published in London in 1803, included drawings by *West, *Barry and *Fuseli. A first series of lithographs was published in Berlin during 1804–8 and included a drawing by the architect Schinkel. In France the new method took hold after the Napoleonic wars; among the first practitioners in France were such eminent artists as *Géricault, *Delacroix, *Chassériau and the aged *Goya. By this time it was possible to give both tone and colour by lithography, and soon it was found that all colours could be printed by overprinting red, yellow, blue and black, at first for reproductive purposes. Senefelder had experimented with putting text on the stone from 'transfer paper' – easier to handle but also reversing the text so that it would print legibly. *Manet, *Daumier, *Menzel and other mid 19th-century artists made use of this, whereas colour lithography as a creative medium was not developed until the later part of the century when it flowered at the hands of such artists as *Toulouse-Lautrec and *Bonnard. Countless artists produced lithographs in the 20th century, among them *Kandinsky, *Matisse, *Picasso, *Chagall, *Braque and, more recently, Henry *Moore, *Rauschenberg, *Jorn and *Hockney. Lithography can match the fluidity and variability of line; colour it prints in fine, usually translucent layers.

Lochner, Stephan (active from *c*.1430–51) The outstanding painter in Cologne, where he is first recorded in 1442. In the course of his career he succumbed increasingly to Netherlandish influences, modifying his own decorative International *Gothic style towards greater naturalism (*see under* realism) but without ever compromising the soft and luminous prettiness of his work, even in scenes of martyrdom and the torments of the damned (*Last Judgement altarpiece*, *c*.1435–40, central panel Cologne, Wallraf Richartz, wings Frankfurt, Städel; Munich, Alte Pinakothek). His major painting, which Albrecht *Dürer paid to be shown in 1520, is the *Adoration*

of the Magi, combining the *iconography of an Adoration with that of a *maestà (*c*.1440, Cologne, cathedral). But he is perhaps best known for the sweetness of his Madonna pictures, notably the *Madonna in the Rose Bower* (*c*.1438–40, Cologne, Wallraf-Richartz). (Other works in Cologne, Archiepiscopal; Lisbon, Gulbenkian Coll.; and London, National). His one dated picture, a *Presentation in the Temple*, 1447, is in Darmstadt, Museum.

Lohse, Richard Paul (1902–88) Swiss *Elementarist painter. Apprenticed to a commercial artist, then a noted progressive independent graphic designer while painting in his spare time, Lohse soon specialized in geometrical *abstract paintings in which colours are organized in sometimes simple, sometimes complex systems. This narrow-seeming programme results in dramatic, often joyous visual objects in which all elements are equally valued yet dynamic and spatial effects are experienced optically. Given titles that summarize each painting's constituents and structure, and dates that refer to when the idea for each was first noted for development and to when it was executed, the paintings do not carry any additional meaning. Lohse's sociopolitical views were leftwing, and he associated the impersonal openness, radiance and equality exhibited by his paintings with democratic principles.

He was the leading member, with Max *Bill, of a broadening *Constructive art tendency developing in neutral Switzerland during the Second World War, and he looked to De *Stijl, born in neutral Holland in 1917, and particularly to *Mondrian, as his chief model, though he also knew and was influenced by the example of such artists as *Klee, *Arp and *Taeuber-Arp, *Vantongerloo and *Vordemberge-Gildewart. He exhibited frequently from 1930; from 1947 also outside Switzerland. Eager to promote Constructive art, he formed and was involved in several artists' associations, organized exhibitions, wrote books and articles and edited collective publications. His sixtieth birthday was celebrated by a book of tributes written by more than thirty artists working in several countries. His work is in many museums, including the Zurich Kunsthaus, the Basel Kunstmuseum and Amsterdam's Stedelijk Museum. A Richard P. Lohse Foundation in Zurich administers his estate.

Lomazzo, Giovanni Paolo (1538–1600) Italian *Mannerist painter, poet and art theorist, active in Milan (S. Marco, Capella Foppa, *c*.1570). Cataracts caused him to go blind by 1572, but – contrary to what is often written – he had already drafted most of his influential treatise on painting before this. It was published, in defiance of the author's original intentions, as two separate texts: the *Trattato della arte della pittura* in 1584, and the *Idea del tempio della pittura* in 1590 – the former mainly concerned with rules or techniques, the latter with theory. Essentially, both books form a single whole, in which the author argues for the intellectual dignity of the art of painting according to a Neo-Platonic hierarchy of value, in which manual execution is the lowest and intellectual idea the highest; the artist, according to Lomazzo, forms his ideas not through imitation of the contingent visible world, but through contemplation, in direct contact with the immutable realm of forms in the Divine Intellect. This notion is elaborated with Neo-Platonic astrological lore and with elements of Christian meditative practice as set out in the *Spiritual Exercises* of St Ignatius Loyola, first published in 1548. In practical terms, Lomazzo advocates that the artist must first imagine his composition in his mind, and only when all the details of it are clear should he make an Idea-sketch, which is the basis of further studies and the final execution. In effect, stripped of its metaphysical apparatus, Lomazzo's treatise formulated *academic routine for centuries to come. The first of the *Trattato*'s seven books was translated into French in 1649, and the first five books were translated into English: *A Tracte containing the Artes of curious Paintings, Carvings, & Buildinge . . . Englished by R*[ichard] H[aydocke], 1598. This edition contains new information on English painters, among them Nicholas *Hilliard.

Lombard, Lambert (1506–66) Italianate Netherlandish painter and architect,

the leading 'Romanist' in Liège; after studying with *Gossart in Middleburg he made the journey to Rome in 1537–8. His major work, the altarpiece for the high altar of St-Denis, Liège, shows his indebtedness to *Raphael's Vatican *Stanze*. The *polyptych has been dismembered, with only one panel remaining in the church, others are in Liège and Brussels, Musées. Far finer is his self portrait (or perhaps a portrait of him by his pupil, Frans *Floris? also in Liège, Musée). Works by Lombard were engraved (*see under* intaglio) by Hieronymus *Cock, but his chief importance is as the teacher of Frans Floris and Willem *Key.

Lombardo or **Lombardi, Pietro, Antonio** and **Tullio** *See* Pietro Solari.

Long, Richard (1945–) British sculptor and *Conceptual artist, born and trained in Bristol and then also at St Martin's School of Art in London, during 1966–8, during which time he began to work with natural objects in landscape (*see under* Earthworks). Soon he was travelling all over the world to make his art, adopting and modestly processing nature, often in inaccessible places, and photographing the result for display in galleries. In imposing his arrangements and other marks of his presence, he acts as a *classicist, adding human concepts of order to nature's. Introducing nature's materials into galleries, as when he brings stones, boughs or river mud indoors to form them into rings, reactangles and lines, he seems to be nature's champion as *Constable and other outstandingly *naturalistic landscape painters were before him, yet much of his work is ephemeral and known only through his careful documentation, thus commenting on the notion of the permanent work as the essential vehicle of art and on nature as a resource to be worked with respectfully.

Longhi, Pietro (1702–85) Venetian painter of aristocratic and bourgeois *genre, somewhat flattering recorder of the life and entertainments of polite society, always in a small format. (Venice, Querini-Stampalia, etc.). His son, **Alessandro** (1733–1813), was a well-known portrait

specialist, and the author of a book on contemporary Venetian painters (*Compendio delle Vite . . .* , 1762).

Longo, Robert (1953–) American artist, trained at North Texas State University at Denton and at New York State University College in Buffalo. In 1973 he travelled in Europe. From 1977 he lived in New York where he became known for his *performance pieces and for complex art works, '*combines' and *installations using sculptural, photographic and painterly techniques. His first solo exhibition was in 1981; since 1986 he has shown abroad, in Tokyo, Paris and Rotterdam. His work allegorizes life in the city and the tensions between individual existence and the commands of totalitarian social systems.

Loo, van A dynasty of successful painters, of whom the most important is Carle van Loo or Vanloo, as he was known in France (*see below*). The eldest, **Jacob van Loo** (*c.*1615–70) was a Flemish-born Amsterdam painter of aristocratic *genre and small-scale biblical and mythological pictures (St Petersburg, Hermitage; Glasgow, Gallery). He settled successfully in Paris in 1661. His son, **Louis Abraham** (*d.*1712) in turn had two sons trained as painters: **Jean-Baptiste** (1684–1745) and **Charles-André**, called **Carle** (1705–65).

After training as a history painter (*see under* genres) in Rome and Genoa, Jean-Baptiste van Loo worked as a court painter in Turin, 1712–19. From 1719–37 he was employed in Paris, painting pictures for churches and achieving fashionable success with an equestrian portrait of the youthful Louis XV, 1723. In 1737, however, he moved to London, quickly establishing himself as a leading portrait painter, patronized by the Prince of Wales and the Prime Minister, Sir Robert Walpole (Rousham, Oxon; St Petersburg, Hermitage; London, NPG; Paris, Louvre and various churches; Versailles; etc.). In 1742 he retired through ill-health, returning to his birthplace, Aix-en-Provence, where he died. Jean-Baptiste taught his much younger brother Carle, as well as his own sons, **Louis-Michel** (1707–71; *see below*), François, who was killed in an

accident in Italy while still a student, and **Charles-Amédée-Philippe** (1715–95), who became rector at the French Royal *Academy and later served at Berlin as court painter to Frederick the Great.

Carle van Loo, only fourteen on his brother's return to France in 1719, was enrolled at the Academy, winning a medal for drawing and first prize for painting in 1724. These successes were repeated at the French Academy in Rome (first prize, 1727). Carle, precocious, industrious and amiable, if by all accounts stupid and uncultivated, quickly rose to be one of the most admired painters of his day. He modelled himself on *Raphael, the *Carracci, *Domenichino, and *Maratta, forging a rather bland and dry version of the Grand Manner. In view of his untiring production of decorative paintings for public spaces (Turin, 1732–4; Paris, Hôtel de Soubise, 1737), solemn, enormous altarpieces and cycles of paintings for Paris and other French churches (Paris, Saint-Sulpice, 1739; Saint-Eustache, 1742; Notre-Dame-des-Victoires, 1746, 1753–5; Besançon, Cathedral, Chapelle du Saint-Suaire, 1740–50), large-scale history paintings on *Classical themes (such as his self-chosen reception piece at the Academy, *Apollo flaying Marsyas*, 1735, Paris, Ecole des Beaux Arts; *Augustus closing the Doors of the Temple of Janus*, c.1750; *Sacrifice of Iphigenia*, painted for Frederick the Great, 1757, Potsdam, Neues Palais), and his etchings of academy nudes, c.1743, it is ironic that by the end of the century Carle van Loo should have been reviled as the arch-exponent of effeminate *Rococo. In addition to his works in serious modes, however, Carle also produced more typically Rococo pictures: exotic hunts for the King's private apartments at Versailles (1738/9, now Amiens, Musée; *Boucher was also employed on this decoration); modern dress *fêtes galantes* (e.g. *Rest during the Hunt*, 1737, for the King's private dining room at Fontainebleau, now Paris, Louvre); elegant genre with exotic costumes, Spanish (St Petersburg, Hermitage) and Turkish (London, Wallace) and even decorative landscapes.

In 1762 Carle was made *Premier Peintre* to the King, and became Director of the Academy in 1763. Although he had showed full-length portraits of the Queen (1747) and King (1750; Versailles) and a self-portrait (1753) at the official Academy exhibitions, Carle was later to eschew portraiture, perhaps because it had become the exclusive speciality of his talented nephew Louis-Michel. An equally successful student at the Academy, Louis-Michel had accompanied his uncle to Rome, and spent the years 1727–33 in Italy. During 1737–52, he was portrait painter to the Spanish court of Philip V at Madrid, where he was instrumental in the founding of the Spanish Academy of San Fernando (1752). There are royal portraits by him in the Prado, Madrid, and a likeness of Philip of Bourbon, Duke of Parma (c.1739) in Mexico (F. Gonzáles de la Fuente). After his return to Paris, he executed formal state portraits of Louis XV (c.1761; one of many versions is in London, Wallace) but was also capable of spirited studies of character, such as his half-length likeness of the philosopher, essayist and critic Diderot (1767, Louvre). He painted a large-scale group portrait of the family of his uncle Carle (Paris, Arts Décoratifs), and succeeded Carle as governor of the Academy School.

Lopes, Gregório (c.1490–c.1550) Portuguese painter; he served as court artist under Kings Manuel and John III; at least 65 works by him survive, most of them in Lisbon, Museu. Apparently trained as a painter of backgrounds, he followed this speciality for years, and even in his altarpieces the most original aspect is the landscape or architectural background. He often included his insignia, a tiny ladybird, as a signature.

López de Gámiz, Pedro (recorded 1551–69) Late *Mannerist Spanish sculptor, known for his huge carved walnut wood altar of 1551–69 in Santa Clara at Briviesca. His style was influenced by the art of *Michelangelo in Florence, where he is thought to have studied.

Lorenzetti, Ambrogio (active 1319–48?) and his brother **Pietro** (recorded from 1320–48?) Sienese painters, contemporaries

of Simone *Martini and like him influenced by *Duccio. They were even more affected by Duccio's experiments in descriptive *realism than by his decorative effects, although Ambrogio's Madonna and Child pictures in particular demonstrate his supreme sensitivity to two-dimensional patterning as well as his acute powers of observation (see e.g. the Madonna del Latte, mid-1320s? Siena, Seminary). Both brothers formed connections with Florence, and, responding to the art of *Giotto, they in turn influenced his Florentine followers, notably Taddeo *Gaddi and Bernardo *Daddi. Like Duccio and Giotto before them they looked closely also at the work of Giovanni *Pisano. Their own daring experiments in representation were cut short by the Black Death of 1348.

Ambrogio was probably the younger and the more innovative of the two. His evocations of antique prototypes remained famous even during the *Renaissance, the best-known being the personification of Peace in the fresco of Good Government, (Sala de'Nove, Siena Town Hall). Here the political ideals and effects of Tyranny and of a Sienese type of Good Government are contrasted (1338-9). Scholastic *allegory is combined with panoramic views of city and countryside, renowned both for their poeticized naturalism of detail and their system of synthetic *perspective, in which diminution proceeds in all directions from a focal point in the centre. Ambrogio's interest in landscape is manifested also in the two small panels (mid-1320s? Siena, Pinacoteca) which are the earliest surviving pure landscape paintings in Italian art.

Less well known than the Town Hall murals but equally astonishing are two frescos in S. Francesco, Siena, removed from the now-destroyed chapter house. The Franciscan Martyrdom demonstrates complex *foreshortenings, and the Reception of St Louis of Toulouse accommodates a superbly individuated crowd into an ample architectural interior whose spatial clarity is unprecedented. The same can be said for Ambrogio's last surviving dated picture, the panel of the Annunciation (1344, Siena, Pinacoteca) in which a true vanishing-point perspective is approximated.

Pietro's most important surviving works are the frescos in the lower church of S. Francesco, Assisi (mid-1320s-early 1340s), combining Ducciesque *iconography with Giotto's dramatic economy. The triptych of the Birth of the Virgin (1342, Siena, Cathedral Museum) exploits the frame of its separate pictorial fields to represent a unified, complex architectural space, elaborating notions already embodied in Pietro's Arezzo polyptych (1320, Arezzo, Pieve). The brothers collaborated in 1335 on frescos for the façade of the hospital of S. Maria della Scala, Siena, now lost, and it is apparent that despite stylistic differences they shared ideas and exchanged designs throughout their working lives, anticipating many developments of 15th- and 16th-century art, and unsurpassed in any period for originality and profundity.

Lorenzo di Credi See Credi, Lorenzo di.

Lorenzo Monaco (c.1370–1424) Possibly Sienese-born Florentine painter, a Camaldolese monk in the monastery of S. Maria degli Angeli, Florence, by 1391. He was to transmute the sober, monumental style of Agnolo *Gaddi, *Spinello Aretino and other late 14th-century Florentine artists into a graceful, sophisticated calligraphic idiom which was related both to earlier Sienese painting (e.g. *Duccio, Simone *Martini) and contemporary International *Gothic, and was influential on later Florentine art, e.g. *Masolino. There are panels by him in Florence, Accademia, Uffizi; Monte San Savino, S. Maria delle Vertighe. His only sizeable extant work in *fresco is the Bartolini Salimbeni Chapel, Florence, S. Trinita (c.1423), for which he also executed the panel altarpiece.

Lorenzo Veneziano (recorded from 1356 to 1372) Venetian painter, a follower of *Paolo Veneziano. Lorenzo, however, replaces Paolo's Byzantinism (see under Byzantine) by *Gothic elements acquired through visits to Bologna, where he is documented in 1368, and Verona (see also Vitale da Bologna, Altichiero). His style is more three-dimensional and less *idealizing than Paolo's, and has been called 'an expression in painting of the new, intimate

type of devotion first popularized by the Franciscans . . . in Central Italy'. His most important surviving works are the Lion *polyptych, 1357–9, Venice, Accademia, and the De'Proti polyptych, Vicenza, cathedral; other paintings are in Paris, Louvre; Berlin, Staatliche.

Lorraine or **Le Lorrain** *See* Claude Gellée.

Loscher, Sebastian (1480/85–1548) German sculptor, mainly active at Augsburg, although his *Wanderjahre* seems to have taken him not only to the Upper Rhine but also to Northern Italy, perhaps as far south as Tuscany. Returning to Augsburg shortly after 1510, he entered the circle of the painter *Burgkmair, bringing his own store of directly observed Italian *Renaissance forms. These are evident in his principal work, the decoration and monuments of the Fugger Chapel (Augsburg, St Anne; pieces in Berlin, Staatliche; Vienna, Kunsthistorisches), designed and largely executed by him with the assistance of others, and in the small-scale statuettes and reliefs he made from the 1520s until his death – such as the relief of the *Virgin and Child with a Donor* (*c*.1520, Munich, Bayerisches) in which motifs from the Lombardi (*see* *Pietro Solari) are effectively exploited.

Loth, Johann Carl (1632–98) Like Johann *Liss, Loth was a German-born painter who settled in Venice to become one of the city's leading artists (at a fallow time for native talent). The son and pupil of his painter-father in Munich (his mother was herself a miniaturist and the daughter of a Munich sculptor), Loth reached Rome soon after 1653. There he became friendly with **Willem Drost** (recorded 1652– after 1663), an ill-documented pupil of *Rembrandt and long-time resident in Italy (New York, Metropolitan; The Hague, Bredius, etc.); whether Drost was influenced by Loth or vice-versa remains a moot point. In Venice, Loth adopted the *tenebrist style of the Venetian followers of *Caravaggio. His prosaic interpretation of mythological (London, National) and religious themes did not prevent him from

running a large workshop producing numerous paintings for the European aristocracy, and altarpieces for churches in Venice, on the mainland, and his native Bavaria (e.g. Munich, St Peter's). He was the teacher of **Daniel Seiter** (1649–1705) who became one of the leading painters of Turin.

Lotti, Lorenzo *See* Lorenzetto.

Lotto, Lorenzo (*c*.1480–1556/7) Peripatetic and eclectic Venetian-born painter. Widely cultured but intensely pious and disquiet, he was unable to compete successfully with his more urbane Venetian contemporaries (*see* Giorgione, Titian) and worked mainly in provincial centres. The originality and high quality of his *œuvre*, dispersed and various in style, have been appreciated only since the late 19th century.

Lotto is first documented at Treviso, 1503–6, then in the Marche (*polyptych for Recanati, S. Domenico, 1506–8, now in Pinacoteca Comunale). In 1509 he was paid for work in the *stanze* in the Vatican, alongside *Raphael; his role in Rome has not been identified, but mutual influences are acknowledged. By 1512 he was once again in the Marche, but during 1513–25 he settled in Bergamo, where he executed major altarpieces, portraits and devotional pictures for private houses (Bergamo, S. Bartolomeo, S. Spirito, S. Bernardino, Accademia; Madrid, Prado; St Petersburg, Hermitage; Rome, Nazionale; London, National; etc.). Towards the end of his stay in Bergamo he also began supplying the designs for the marquetry of the choir stalls in S. Maria Maggiore, 1524–33. In 1524 he frescoed the oratory of the Suardi family at Trescore, in the Alpine foothills near Bergamo. For purposes of popular religious instruction, this astonishing decoration employs an archaicizing 'vernacular' idiom, executed, however, with sophisticated pictorial means.

In 1526 Lotto moved to Venice (Venice, Carmine, Accademia) continuing to supply works also to provincial patrons. Prolonged visits to the Marche (1534–9; e.g. Jesi, Biblioteca) and Treviso (1542–5) testify to his lack of success in his native town. In

1550 he tried but failed to raise money with a public auction of his paintings in Ancona. Finally, in 1552, the impoverished and tragic old man sought refuge in the Holy House at Loreto, where he became a lay brother, continuing, however, to paint (Loreto, Pinacoteca, Palazzo Apostolico). His last work, the probably unfinished *Presentation in the Temple*, is one of the most personal and moving pictures of the century.

During his long career, Lotto absorbed many diverse influences, forging them into a variable but intensely individual idiom. His basic vocabulary, derived from Giovanni *Bellini, was enriched through the experience of northern European art, to which his long stay in the sub-alpine Lombardo-Venetian provinces made him receptive. The direct influences of *Grüne-wald, *Altdorfer, *Dürer and *Holbein have all been detected in his work, as well as those of northern Italian mediators between German and Italian modes, such as *Pordenone. Perhaps his deep and highly emotional religious convictions also predisposed him to the Christian *expressivity of German art, as they made him attend to the vernacular art of provincial craftsmen-artists. At the same time, he was well aware of central Italian *Renaissance developments. His final stay in Venice exposed him to the mature works of Titian. But his own pictorial intelligence and originality radiate through all his works – from the great altar-pieces to the psychologically searching portraits of which he is one of the finest masters. In addition to the works already cited, there are paintings by him in Paris, Louvre; Vienna, Kunsthistorisches; Naples, Capodimonte; Hampton Court; Rome, Borghese; Milan, Brera; Philadelphia, Museum; Cambridge, MA, Fogg; etc.

Louis, Morris (1912–62) American painter, born Morris Louis Bernstein and trained in Washington. Here he was close to *Noland with whom he exhibited in 1954. He had turned from *Abstract Expressionism to a more serene idiom influenced by *Frankenthaler's way of staining canvases and by Noland's search for flat colour compositions. Louis devel-

oped ways of running paint on to unstretched canvas so as to control the direction and width of the flow. This made for an impersonal quality of surface but he showed a strong sense of pictorial drama as he varied his formal devices and increased the size of his paintings, from the 'Veils' and 'Florals' series of the 1950s to the 'Unfurleds' of the early '60s and the glowing stripes or pillars (of fire?) he was doing when he died. There were many one-man shows from 1957 on and retrospectives after his death in New York, at the 1964 Venice Biennale and in Amsterdam, Baden-Baden and London in 1965. His paintings, wholly *abstract, represent an apogee of the *Romantic search for the sublime through controlled spontaneity and partial *automatism; size, scale and interval; resonant colours in acrylic paints, juxtaposed and at times mingling. His work was presented, by the critic Clement Greenberg and others, as prime examples of *Post-Painterly Abstraction.

Loutherbourg, Philip James de (1740–1812) Alsatian-born painter of battle scenes, shipwrecks and landscapes, a member of the French *Academy from 1767. In 1771 he came to London, and from 1773 to 81 was stage and scene designer at the Drury Lane Theatre. He made many technical innovations increasing the range and credibility of natural effects on stage; in 1778/9 he staged a pantomime, *The Wonders of Derbyshire*, which concentrated exclusively on landscape as a form of theatrical representation, and for which he studied well-known Derbyshire views. The idea was further developed in his own panoramic moving peepshow, the *Eido-phusikon* (1781) in which landscape painting, combined with artful lighting and sound effects, simulated a wide range of natural phenomena, from the cheerful to the *Picturesque and the *Sublime. He also depicted the dramatic new landscape of the Industrial Revolution. In 1805 he published *The Romantic and Picturesque Scenery of England and Wales*. De Loutherbourg's work, while not perhaps itself 'high' art, was an important influence on *Romantic painting (*see* especially Turner); his *Eido-*

phusikon inspired the Showbox, with its paintings on glass, of *Gainsborough.

Lowry, Laurence Stephen (1887–1976) British painter born near Manchester and trained in Manchester and Salford during 1905–25. His chosen task was to represent the working-class people and environment of that area in a quasi-*primitivist style which could express fellow-feeling as well as at times a satirical view of the common man. He had an exhibition in London in 1919 and some reputation in the years that followed, becoming a Royal Academician in 1962. But his popularity sprang from a touring exhibition in 1966 and was confirmed by crowds pressing into his 1976 retrospective at the Royal Academy in London. A Lowry museum opened in Salford in 2000.

Luc, Frère or **Luc, Claude-François** *see under* Vouet, Simon.

Lucas van Leyden (*c*.1489–1533) Dutch painter, draftsman and engraver, one of the most important artists of the 16th century. A pioneer of *genre painting, he was innovative also in landscape and generally in spatial and narrative construction. Originally influenced by *Dürer, *Gossart, Jacopo de' *Barbari and by direct contact with Italian prints and paintings, he in turn exercised great influence, notably on Italian artists, through his 172 engravings (*see under* intaglio). The engraver Marcantonio Raimondi (*see under* Raphael), the Florentine painters *Andrea del Sarto and *Pontormo, and others, borrowed motifs from his prints; *Vasari proclaimed him to have been an even better artist than Dürer. *Rembrandt was to be inspired by his engraving of the *Ecce Homo*, 1510.

A youthful prodigy, Lucas studied first with his father, the Leiden painter **Hugo Jacobsz.**; after the latter's early death he entered the workshop of *Cornelis Engelbrechtsz. Soon, however, he was working independently; the first dated work is the accomplished engraving of *Mohammed and the Monk Sergius*, 1508. His early paintings, such as the *Adoration of the Magi* (*c*.1500–10, Merion, PA., Barnes) already

show an interest in deep space contrary to the emphasis on surface ornamentation of his teacher, and this interest is combined with one in Italianate *Renaissance architecture and *perspective in the *Ecce Homo* already mentioned. The earliest known genre scenes date from *c*.1510 (*Chess Players*, Berlin, Staatliche; also *The Card Players*, *c*.1514, Wiltshire, Wilton House; *Gambling Scene*, *c*.1520, Washington, National). These paintings of half-length figures grouped around a gaming board or table were probably meant to convey moral overtones. The suggestion is given additional weight by their later full-length transformation in the small but monumental *triptych *Worship of the Golden Calf* (*c*.1525, Amsterdam, Rijksmuseum), where the moral message is unambiguous.

There are other paintings by Lucas in Leiden, Museum; St Petersburg, Hermitage; London, National; Munich, Alte Pinakothek; Boston, Museum; Amsterdam, Rijksmuseum; Paris, Louvre. A small self-portrait, *c*.1525(?) is in Brunswick, Museum. Most important print collections have copies of his engravings, which combine northern and Italianate modes of *hatching.

Luce, Maximilien (1858–1941) French painter, active first as wood engraver, who became part of the *Neo-Impressionist circle in 1887. From then on he exhibited regularly in the Paris Salon des Indépendants, becoming president of its society in 1935. He was also a member of the Brussels Groupe des *Vingt, exhibiting there in 1889–92. He adopted the Neo-Impressionist method and gave it currency in the Low Countries. He was an anarchist-communist and was imprisoned for his activism in 1894. Having contributed illustrations to anarchist journals he subsequently also did many paintings of a socially polemical sort, portraying the life of French and Belgian workers. Around 1900 his style became more *Impressionistic. His first solo exhibition was in 1888; others followed, the first outside France being in 1914 in Düsseldorf. His society honoured him with a memorial exhibition in 1942.

Ludovisi Italian family from Bologna. Their patronage of art in Rome dates from the short reign, 1621–3, of Pope Gregory XV Ludovisi, during which preference was given to the work of the Bolognese pupils of the *Carracci, notably *Domenichino and *Guercino. Equally if not more influential, however, was the outstanding collection of ancient sculpture owned by the papal nephew, Cardinal Ludovico Ludovisi, most of it excavated during the construction of his villa near the Porta Pincia, on the site of a Roman imperial garden. It included, among other works which became celebrated throughout Europe, the seated *Ludovisi Mars* (now Rome, Terme), whose pose was adapted by *Velázquez for a painted version of the god, and the *Dying Gladiator*, also known as the *Dying Gaul* (now Rome, Capitoline), ceded to the French in 1797 and returned to Rome in 1815, many times copied and reproduced in various media, and praised by connoisseurs, artists and poets for its pathos (Byron described it in the fourth canto of *Childe Harold*, 1818). In 1776, a hanged smuggler, having been dissected for the benefit of the Royal *Academy in London, was cast in the *Gladiator*'s pose and was nicknamed 'Smugglerus'.

Cardinal Ludovisi entrusted Alessandro *Algardi with the restoration of his antique statues, thus paving the way for the Bolognese sculptor's Roman career.

Luini, Bernardino (*c*.1480–1532) The Milanese painter most obviously influenced by *Leonardo da Vinci, albeit only in superficial traits such as facial types and expressions, and, in easel works, an exaggerated *chiaroscuro. Where he did not copy Leonardo's designs he remained an old-fashioned Lombard artist, and was consequently very popular with his conservative provincial patrons, especially as an executant of decorative narrative *fresco cycles (e.g. Chapel of S. Giuseppe, formerly Milan, S. Maria della Pace, now Brera; decorations for Robia family houses, now Washington, National; Berlin, Staatliche; etc.; Saronno, S. Maria dei Miracoli – *see also* Gaudenzio Ferrari). Other paintings are in London, National; Cambridge, MA, Fogg; Paris, Louvre; etc.

Luks, George Benjamin (1866–1933) American painter who studied at the Pennsylvania Academy and in Düsseldorf. Back in Philadelphia he worked as illustrator but was drawn into Robert *Henri's circle and to painting in a purposeful *realistic manner. He moved to New York in 1897 where he pictured the slum life of the Lower East Side in an exceptionally vigorous manner. He exhibited with The *Eight in 1908 and in the 1913 *Armory Show, and taught at the Arts Students League during 1920–4.

Luminism Movement in American landscape painting, flourishing particularly in the 1850s (the decade also of Thoreau's *Walden* and of Whitman's *Leaves of Grass*), identified by modern art historians (initially by John I.H. Baur in 1954) and seen as the final phase of the *Husdon River School. In some essentials it suggests a reaction against that school's ambitions, in that Luminism was concerned with giving poetic resonance to represented scenes, not by introducing human subjects, but by dwelling on the conditions of light and sky, serene or dramatic and, often, by treating particular areas of unspoilt America repeatedly. The note struck is usually one of pride and optimism, the theme is that of contemplation of nature as a spiritual activity. The Civil War years of the 1860s brought in an apocalyptic note and a sense of loss. The major figures include *Church and *Heade; others, notably *Bierstadt, are associated with it. Luminism was the subject of a definitive exhibition and catalogue at the National Gallery of Art in Washington in 1989.

Lundqvist, Evert (1904–94) Swedish painter, trained in Stockholm, who worked in France and Germany during 1925–31 and returned to Stockholm to paint in an *Expressionist manner strengthened by *classical form and composition. In his fifties he was a leader of *Neo-Expressionism, opposing the decade's *abstract tendency with his powerfully colourful paintings.

Lurçat, Jean (1892–1966) French painter who turned from studying medi-

cine to train as artist. For a time he was part of the *Cubist movement. Travels in the 1920s and the rise of *Surrealism caused his art to become more dramatic. From 1936 on he worked often and closely with the Gobelin and Aubusson tapestry weaving workshops, and it was his tapestries that became famous in the 1940s and 50s, bringing him major commissions.

Lys, Jan *See* Liss, Johann.

M

Mabuse *See* Gossart, Jan.

MacBryde, Robert (1913–66) British painter of Scottish origin, trained at the Glasgow School of Art. He met there Robert *Colquhoun. They lived and worked together, settling in London in 1941, until Colquhoun's death, part of the broadly based *Neo-Romantic movement but influenced more particularly by the art of *Picasso and of their friend, Yankel *Adler.

Macchiaioli Nickname of a group of Italian painters, 'makers of patches'. Purposefully active in the 1860s but neither particularly successful nor valued historically until this century, they worked outdoors to capture effects of light and colour by means of contrasting patches of colour and tone. These are lively in their oil sketches; much less so in their finished paintings, which have the earthy tones of the *Barbizon School from which they derived their basic impulse.

Macdonald-Wright, Stanton (1890–1973) American painter who at 17 went to Paris where he began his art studies, becoming especially interested in colour theory. In 1911 he met Morgan *Russell and they founded *Synchromism, a mode of *abstract or near-abstract colour painting, challenging the pioneer status of Robert *Delaunay. In 1913 they exhibited Synchromist work in Munich, Paris and New York. He returned to the USA in 1916 and showed at *Stieglitz's gallery. In 1919 he settled in California and worked on bringing colour into films. From 1935 to 42 he worked for the *Federal Arts Project, producing murals and inventing a synthetic medium for them. He travelled in the East, steeped himself in Oriental art and became a Zen Buddhist. He had retrospectives at Los Angeles in 1956 and Washington in 1967. Having done *figurative work intermittently and at times ceased painting, he returned to abstract colour painting in his last years.

Mach, David (1956–) British sculptor, who studied at the Duncan Jordanstone College in Scotland and the Royal College of Art in London, where he finished in 1982. Within a few years he was working and exhibiting all over the world, admired as something between a conjurer and a miracle worker because of his inventive, sometimes monumental use of found materials. He made a large submarine, *Polaris*, in 1983 out of car tyres; it became notorious because someone, trying to set fire to it, caused his own death. He has used many other materials, and will yet turn to new ones, from sliced bread and filled, empty or part-filled milk bottles, to unwanted newspapers and magazines and, recently, wire coathangers, to make a great variety of images, some of them including animals or heraldic beasts fashioned by himself.

Machuca, Pedro (active 1517–50) Spanish painter and architect from Toledo, best-known for the palace he designed in an Italian *Renaissance idiom for Charles V in the grounds of the Alhambra at Granada (begun 1527, construction continued until 1568). His early career is ill-documented; he trained in Italy for some ten to fifteen years before returning to Spain in 1520, and, with Alonso *Berruguete, participated in the rise of Italian *Mannerism. Most of Machuca's paintings have disappeared; his key surviving picture is the *Madonna del Suffragio* (*The Virgin with the Souls in Purgatory*), painted in Italy in 1517, and influenced by *Raphael and *Michelangelo (Madrid, Prado).

Macip, Vicente Juan *See* Masip, Vicente Juan.

McIver, Loren (1909–) American painter whose fantasy-laden work brought her to notice in the 1930s

when *Surrealism crossed the Atlantic. Her work was included in the definitive exhibition Fantastic Art, Dada and Surrealism at the New York Museum of Modern Art in 1936. Subsequently she travelled in Europe. She had many solo exhibitions in New York and elsewhere from 1938, and a retrospective circulated from the Whitney Museum, New York, in 1953.

Mack, Heinz (1931–) German artist who with *Piene founded the *Zero group in 1957. His contribution was reliefs and cubes in which patterned glass and polished metal combined, sometimes with the help of movement, to reflect light in ever-varying ways. He and the group exhibited frequently from 1958 on and from the 1960s he developed large-scale works such as the tall *Light Column* he created for a television programme, also water and wind sculptures.

Macke, August (1887–1914) German painter, trained in Düsseldorf where he worked as stage designer, and in Berlin with *Corinth. He visited Paris in 1907 and 1909, becoming acquainted with *Impressionism and then with *Fauvism. In Bavaria, in 1911, he made friends with *Marc, got to know *Kandinsky, and helped them on the *Blaue Reiter Almanac* before returning to his home in Bonn. In 1912 he and Marc visited *Delaunay in Paris; in 1914 he, *Klee and Moilliet went to Tunisia. Soon after he was called up for war service and that September he died in action. His work is gentle in style and spirit, a Fauvism without wildness, moderated by Delaunay's use of pattern and colour; its characteristic subjects are landscapes and benign scenes of town life.

McLean, Bruce (1944–) British artist, trained in Glasgow and at St Martin's School in London under *Caro. Reacting against his teachers, he sought ways of evading object-centred art production and found them in impermanent forms of sculpture and then in using himself as sculpture, performing poses that satirize typical great works. Asked to show at the Tate Gallery in London in 1972, he decided on a one-day retrospective entitled *King for*

A Day. He formed Nice Style with some of his Maidstone College students, presenting pose performances with music. The group dissolved in 1975 but he went on to make other *Performance works, some in collaboration with Sylvia Ziranek, satirizing institutional politics. Sketches done for these productions led him in 1981–2 to make paintings with hints of figures and movement. In 1985 he won the John Moores Liverpool prize for painting. A deft and inventive artist in several media, above all a man of verve and sharp humour, McLean steers by scepticism towards the art world and its publics.

Maclise, Daniel (1806–70) British painter of *History and *genre pictures, also a busy caricaturist. His ambition to be recognized as a painter led him to study French and German painting and to be commissioned to paint murals for the Palace of Westminster (the House of Lords), notably the monumental *Death of Nelson* and *Meeting of Wellington and Blücher* (1857–64). He also based paintings on popular English plays and novels.

McTaggart, William (1835–1910) British painter, born in Scotland on the Mull of Kintyre and trained and resident in Edinburgh. His work, in watercolours and in oils, developed from portraits and *genre subjects to Scottish land- and seascapes characterized by his free and vigorous use of brushstrokes, dramatizing the life of nature as well as picture-making as a human act, expressive of will and feelings. He is thought of as a Scots *Impressionist but his art owes little to his younger French contemporaries and is closer in spirit to that of *Constable, not least in his lasting attachment to the scenes of his boyhood.

McTaggart, William (1903–81) British painter, grandson of the preceding, trained in Edinburgh and through studies in France. Indebted to the example of *Peploe and Hunter, McTaggart was also influenced by the post-*Fauvist paintings of *Derain and later, thanks to a 1931 exhibition in Edinburgh, to the art of *Munch. This encouraged an *Expressionist tendency in him, reinforced by an interest in *Nolde,

*Soutine and *Rouault. Glowing colours and dense paint characterize his still lifes and seascapes. McTaggart was president of the Royal Scottish *Academy in 1959–69 and was knighted in 1963.

Maderno, Stefano (*c.*1576–1636) Lombard-born *classicizing sculptor working in Rome, initially as a restorer of antiques, then making terracotta reductions of classical statues (e.g. Venice, Ca' d'Oro; St Petersburg, Hermitage), many of which were also cast in bronze. He is celebrated for his recumbent life-size statue of *St Cecilia* (1599–1600, Rome, St Cecilia in Trastevere), which commemorates the discovery of the martyred saint's body in 1599 and is supposedly based on direct study, although it actually reflects a Hellenistic sculpture.

Madrazo y Agudo, José (1781–1859) Spain's leading *Neoclassical painter, trained in Madrid and under J.-L. *David in Paris. During 1806–18 he worked in Rome where he absorbed the example of *Canova. Back in Madrid, he dominated as a portrait and *history painter and became director of the Prado Museum. His son **Federico** (1815–94) succeeded him in all these roles and generally inherited his father's style but did not himself exercise comparable influence.

Maelwael, Jan *See* Malouel, Jean.

Maes, Nicolaes (1634–93) Dutch painter, best known for his *genre pictures of the domestic life of women and children, painted *c.*1654–60. He was a pupil of *Rembrandt, whose *chiaroscuro he adopted in these paintings, and whose Holy Family motifs he secularized. After 1660, however, Maes abandoned genre painting and became a portrait specialist, lightening and brightening his colours in accordance with Flemish and French fashion. There are paintings by him in Amsterdam, Rijksmuseum; in his native Dordrecht, Museum; and in many major collections outside Holland.

Maestà In Italian art, a large-scale representation of the Madonna as Queen of Heaven, enthroned in majesty among saints and angels with the Christ child on her lap. The term is usually reserved for 13th- and 14th-century examples, such as *Duccio's *Maestà*, formerly the high altarpiece of Siena cathedral (completed 1311). Later and more intimate versions of the theme are called *sacre conversazioni* (sing. *sacra conversazione*).

Maffei, Francesco (*c.*1600–60) Italian painter born and trained in Vicenza, living for much of his career in Venice and influenced by the great Venetians of the previous century, *Veronese, *Tintoretto, *Bassano, and by his 'foreign-resident' contemporaries *Liss and *Strozzi. His work is often attractively bizarre, painted with a nervous and rapid brush, and exhibiting sophisticated dissonances (Vicenza, Galleria). In 1657 he settled in Padua (S. Giustina).

Magical Realism Term used by the German critic Franz Roh in his 1925 book *Post-Impressionism*, subtitled 'Magical Realism. Problems of the New European Painting', and developed in discussions of the *Neue Sachlichkeit exhibition. He implied a loaded *realism, distinct from that associated with the *Barbizon painters, *Leibl and others whose work comes close to *naturalism; thus a realism akin to the poetic proto-*Surrealist images of *Pittura Metafisica in which objects are made important by being made strange. Without any clear definition, it has been used more recently to make distinctions within *New Realism and *Pop art, pointing to latent significances. A. H. Barr's 1943 exhibition at the Museum of Modern Art, New York, entitled American Realists and Magic Realists, drew attention to paintings in which meticulous detail made imaginative subjects acceptable as representing reality.

Magnasco, Alessandro (often called Lissandrino) (1667–1749) Genoese specialist in macabre and fantastical *cabinet pictures. His rapidly darting, flickering brushstroke can be traced to the late studies of *Castiglione; the disquieting content of his pictures, however, owes more to *Callot or *Rosa's scenes of witchcraft.

Magnasco went as a youth to Milan, where, excepting for a stay in Florence *c.*1709–11, he remained until 1735. There are paintings by him in Milan, Castello, Poldi Pezzoli; Genoa, Palazzo Bianco; Cleveland, Ohio, Museum; etc. *See also* Bazzani, Giuseppe.

Magnelli, Alberto (1888–1971) Italian painter, first stimulated by *Futurism. In Paris in 1913–14 he studied *Cubism, and after turning to *abstraction back in Italy he was influenced by *Pittura Metafisica. From 1933 he lived in Paris, a member of *Abstraction-Création and painting abstracts. After the Second World War he was prominent as a champion of structured abstract painting, with firmly outlined geometrical forms, when *Art informel was dominant. He had major exhibitions at the 1950 Venice Biennale, in Zurich in 1963 and in Paris in 1968.

Magritte, René (1898–1967) Belgian painter, trained at the Brussels Academy. His mother committed suicide by drowning in 1912. He lived in Brussels from 1918, except for a period in Paris in 1927–30. He had worked in a style fusing *classicism and *Cubist methods when a reproduction of a de *Chirico revealed to him the force of pictorial illogicality. He painted full-time from 1925 and in Paris made contact with the *Surrealists. He had already found an individual, apparently impersonal, idiom in which everything is represented prosaically as though imagination delivered only the plainest of facts. It is the situation of figures and other objects, or their partial transformation, or some small inversion of normality (as in a night scene under a brilliant sky), or a conflict between what is represented and what the words accompanying it signify, that creates his particular sort of conceptual shock and the widening ripples of resonance that reveal him as a great pictorial poet. His objective style, he said, would subvert everyday experience, and the titles he used add another turn to his unscrewing of cognitive habits. His art looks like riddles but is there to challenge our ready acceptance of art and of reality. In his last year Magritte began to make sculptures of some of his painted images.

That year also, a major retrospective was shown in Rotterdam and Stockholm. He died a few days after it opened. His work is spread around the world; the Menil Collection, Houston, Texas, has a large number of important examples.

mahlstick *See* maulstick.

Maiano, Benedetto and **Giuliano da** *See* Benedetto da Maiano.

Maillol, Aristide (1861–1944) French sculptor, trained at the Paris Ecole des Beaux-Arts. Influenced by *Gauguin, he painted and designed in a *primitivist manner, exhibiting with the *Nabis in the 1890s. Around 1900 he turned to making sculpture, specializing in modelled nude female figures in a variety of simple poses and varying somewhat in the expression given by these poses, but all following a *Neo-Classical formula adapted to his taste for firm young peasant bodies, not unlike those painted and modelled by *Renoir. A visit to *Greece in 1908 gave added conviction to his *classicism. He showed his sculpture in 1905 and was commissioned to make a monument to the French revolutionary Blanqui – an especially powerful female nude. His figures speak of fullness and vigour, of smooth masses as well as attractive bodies, but otherwise are silent. This can be felt as a welcome contrast to the nervous, sometimes sentimental rhetoric of *Rodin but is a limited programme. It takes an extensive display, such as those in Paris in 1937 and in New York in 1976, to show Maillol's inventiveness with his chosen theme. To many he represented tradition within modern art and this guaranteed him success.

Mainardi, Sebastiano *See under* Ghirlandaio.

Maino, Juan Bautista *See* Mayno, Juan Bautista.

Maitani, Lorenzo (*c.*1270–1330) Sienese architect and sculptor. He was master of works for Orvieto Cathedral from 1310 until his death, and designed the façade with its unique marble reliefs, the

finest of which are attributed to him. French *Gothic ivory carvings may have influenced his sculptural style, and he in turn may be an influence on Andrea *Pisano.

Makart, Hans (1840–84) Austrian painter whose elaborate and luxurious pictorial productions dominated Viennese taste in the last decades of the 19th century, and the representative of everything the *avant-garde of the 1890s and after despised. Son of the caretaker of Schloss Mirabell in Salzburg, an amateur painter of real talent, Makart studied at the Vienna Academy, where he was found talent-less, and then at the Munich Academy under Piloty who encouraged him also to travel in western Europe. In 1869 he settled in Vienna. He took the art of *Veronese as his base but heaped on to this all the riches he could find in European 17th- and 18th-century art, as well as a wealth of visual data from non-European cultures. Thus a visit to Egypt in 1875–6 resulted in, among other works, the vast and sensual painting *Cleopatra on the Nile* (1875; Stuttgart, Staatsgalerie). He was also an attractive portraitist, intent on a supportive image rather than psychological subtleties. The Österreichische Galerie in Vienna has a rich collection of his work.

Malatesta, Sigismondo (1417–68) Italian mercenary captain and lord of Rimini from 1422. As an art patron he is remembered chiefly for his creation of the Tempio Malatestiano – the conversion, begun in 1457 and never completed, of a medieval church in Rimini, San Francesco, into a *Renaissance *all'antica celebratory/funerary chapel for himself and his mistress, Isotta degli Atti. The architect was *Alberti; *Agostino di Duccio, *Matteo de'Pasti and *Piero della Francesca contributed to the decoration.

Malbone, Edward Greene (1777–1807) American miniature painter, born at Newport, Rhode Island, and trained under Benjamin *West at the Royal *Academy, London. He worked in Boston, New York, Philadelphia, Charleston and Savannah, Georgia, where he died (Providence, Athenaeum).

Malevich, Kasimir (1878–1935) Russian painter, born near Kiev and trained there and in Moscow. He associated with *Larionov and *Goncharova, participating in their 1910–12 exhibitions and sharing their interest in *primitivism. He had worked in *Symbolist and *Impressionist ways; now he developed a folk-art-based style of dynamic, simplified forms and strong colours for representations of peasants that look iconic and may be symbolic, e.g. *The Woodcutter* (1912). In 1912–14 he was a member of the Union of Youth, and at this time explored aspects of *Cubism, bringing painted forms and scraps of paper and other extraneous material together to form synthetic compositions of a certainly symbolical sort. He used *collage and painted rectangles of colour to hide the figures announced in some of his titles, as in *Woman at the Poster Column* (1914). He called such work 'alogism', associating it with the anti-rational use of language explored by the Russian *Futurist poets. In 1913 he worked with the poet Kruchenykh and the painter-musician Matyushin on an opera performed that December, *Victory over the Sun*, for which he designed costumes and backdrops. From these sprang *Suprematism, developed during 1915 and launched in December/January 1915–16 in Petrograd when he showed 39 Suprematist paintings in the Zero-Ten exhibition. His room was dominated by the *Black Square* (strictly: four-cornered figure; Moscow, Tretyakov Gallery), hung like an *icon high up across a corner, among other paintings of squares, rectangles forming broad crosses, circles, and then also more complex and numerous forms, all apparently floating within a white space, flat geometrical forms mostly without indications of mass and painted in black or simple colours. These *abstract paintings refer us to a new reality, cosmic and spiritual, and to the 'higher consciousness' to which Peter Uspensky in Petrograd and others in the West drew attention as the next stage in human evolution. Malevich joined faith in this with a form of deism; his paintings, partly derived from icons, reflect traditional Russian piety. He published a statement and lectured during the exhibition, and showed the paintings again in Moscow

in 1916, in Moscow and Vitebsk in 1919 and in his Moscow retrospective of 1919–20.

By that time the situation had changed dramatically with the Bolshevik Revolution, his appointment to the art board of the new Commissariat of Enlightenment and the use of Suprematism (very temporarily) as the new state's visual idiom. In 1919 he went to teach at the new art school set up in Vitebsk by *Chagall, and soon turned that into a Suprematist centre, applying the style to all manner of things: trams, ceramics, street decorations for festivals, propaganda etc. He named the centre Unovis (acronym of 'for the new art'); *Lissitzky was his ablest colleague in it. Local difficulties led Malevich to move with his best students to Petrograd in 1922; he taught there in the new *INKhUK set up by *Tatlin. His painting had reached some sort of limit in 1920–2 with a series of white-on-white paintings; now he worked on three-dimensional studies in wood and plaster, exploring the bases of a new architecture for earthly and space structures. Some of these were shown in Leningrad in 1926 and Moscow in 1932–3. In 1922 his paintings had been included in the *First Russian Art Exhibition in Berlin. In 1927 he visited Warsaw and Berlin where he exhibited. He left his exhibits in Germany and most of them are now in the Stedelijk Museum, Amsterdam (including the works mentioned here and not otherwise located). His text The Non-Objective World was selected and published as a *Bauhaus Book. In Russia he returned to painting peasant figures in a manner close to those of 1912–13 and doing portraits in a plain *naturalistic manner close to *Holbein's.

Though Suprematism is the most radically abstract idiom before *Neo-Plasticism, in so far as his pictures represent something, as opposed to being something, they are traditional. It is this that distinguishes them from contemporary *Constructive and *Constructivist developments. The Tretyakov Museum in Moscow holds a number of his early, mature and later works.

Malouel, Jean, also called **Jan Maelwael** (recorded 1396–1415) Netherlandish painter from Nijmegen, uncle of the *Limbourg brothers. From 1397 until his death he worked for Philip the Bold, Duke of Burgundy, and the Burgundian court. In 1398 he was commissioned to paint five large pictures for the Charterhouse of Champmol, where in 1401 he also began the gilding and *polychromy of *Sluter's Well of Moses. While none of his documented work survives, a large round panel of the Pietà, now in the Louvre, Paris, but probably from Champmol, is attributed to him. Although it has much of the elegant lyricism associated with the International *Gothic style and manuscript illumination, it is more intensely emotional. Related to it is a Martyrdom of St Denis also in the Louvre, which is thought to have been commissioned from Malouel and completed in 1416 by his successor at the court of Burgundy, **Henri Bellechose** (d. 1440/4).

Malton, Thomas (1748–1804) English topographical watercolour painter of city views, influenced by *Sandby (A *Picturesque Tour through the Cities of London and Westminster, published 1792).

Malvasia, Count Carlo Cesare (1616–93) Italian nobleman, amateur painter and important writer on art. He was a canon in Bologna cathedral and a lecturer in law at the university, and a fierce Bolognese patriot. His encyclopedic Felsina Pittrice, Vite de Pittori Bolognesi, 1678, is our chief source for the lives of 17th-century Bolognese painters, many of whom he knew personally (see especially the Carracci, Guercino); he disapproved of Annibale Carracci's departure for Rome (see also Bellori). In disputing the primacy of Tuscan art, Malvasia was the great antagonist of *Baldinucci.

Mancini, Giulio (1558–1630) Sienese-born Roman doctor and writer on dance and painting. Trained in Padua, he was first attached to the hospital of S. Spirito and the papal prisons in Rome, rising to become Pope Urban VIII's personal physician. His Considerazioni sulla pittura, 'Considering painting', written for 'gentlemen' and 'dilettantes' in 1619–21,

with additions dating from 1624–8, includes the first biographies of the *Carracci and *Caravaggio. It is also a major source for *Poussin and *Pietro da Cortona among others. In 1623–4 he also wrote *Viaggio per Roma per vedere le pitture che si ritrovano in essa*, 'Voyage to Rome to see the pictures found there', the first modern secular art guide to the city; he also wrote a guide to the art works of Siena. Mancini praises invention and imagination in art above technique, elevating the literary/poetic content of painting; the *Considerazioni* . . . , circulated only in manuscript until the 20th century, are the inspiration for the theories later propounded in the French Royal *Academy (*see also* Félibien).

Mander, Karel van (1548–1606) Flemish-born painter, poet and theoretician of art. His stay in Italy in 1573–7 inspired his important treatise on painting, *Het Schilderboek* (1604). This contains the first extensive account of the lives of the major northern European artists of the 15th and 16th centuries, for which it remains a principal source; a condensed Dutch translation of *Vasari's *Lives of the* [*Italian*] *Artists* (1568), with original additions of later material; and a long poem, 'The Fundamentals of the Noble and Liberal Art of Painting', which adapts current Italian art theory and the social aspirations of Italian artists to the northern context. In 1583 Van Mander fled his native land for Haarlem in the northern Netherlands to escape the effects of the war with Spain. With *Cornelis van Haarlem and *Goltzius he is one of the originators of the Italianate style known as Haarlem *Mannerism. His own paintings, however, by no means all conform to his own precepts, but include also rustic *genre (St Petersburg, Hermitage).

Mandyn, Jan, also called **Jan Mandyn van Haarlem** (1502–*c.*1560) Netherlandish painter, born in Haarlem but active in Antwerp by 1530; a follower of *Bosch, albeit less fantastic and more decorative. The initialled *Temptation of St Anthony*, 1547, now in Haarlem, Halsmuseum, forms the basis for other attributions to him.

He was the teacher of *Mostaert and *Spranger.

Mánes, Josef (1820–71) Czech painter, widely travelled in East European regions under Hapsburg rule in his time, but a key figure in the development of a Czech national pictorial culture rooted in folk traditions and patriotic hopes. His work is best seen in the National Gallery of Prague. The Mánes Union is a focal society for Czech artists and has counteracted isolationist tendencies by bringing work by foreign artists to Prague.

Manet, Edouard (1832–83) French painter, often represented as the originator of modern painting and leader of the *Impressionists. The truth is more complex. His father was a senior civil servant and magistrate; his mother the daughter of a diplomat. The son was expected to study law; art studies were forbidden. Rebelliously, he decided to go to sea and it was not until 1849 that his father yielded. At the beginning of 1850 Manet started six years of study in *Couture's studio, to which he added evening sessions in the Académie Suisse, many hours of copying in the Louvre, notably works by *Giorgione, *Titian, *Velázquez and *Delacroix, and further studies and copying on visits to Holland, Italy and Austria. This avid search for a footing in the traditions of painting appears to have gone from the first with a distaste for literary subjects of the sort demanded by *History painting. His first known works were portraits. His *Guitarplayer* (1860; New York, pc), a character study with marked Spanish qualities, gained him a medal at the 1861 *Salon. The same qualities are found in several other works of the early sixties, such as the costume portrait of *Lola de Valence* (1861–2) and his first significant outdoor scene, painted in the studio, *Music in the Tuileries Gardens* (1862; London, National), showing a crowd of people, some of them his friends, standing and seated under the trees of the park – much of it painted broadly, as though out of focus, with sharper details here and there, the whole suggesting daylight though without certain sunshine. It can be seen as

a reponse to Baudelaire's call for an art reflecting modern life, using the form of the *fête galante* without the choreographic charms and emotional tensions of the 18th-century prototype. His father's death in 1862 left Manet independent and financially secure. In 1863 he married the woman who had been his mistress for thirteen years and exhibited in the Salon des Refusés a painting that was to be seen as a sort of manifesto: *Le Déjeuner sur l'Herbe*. Its design was based on a well-known print after *Raphael showing a group of mythological figures; the combining of naked or near-naked women and clothed men was familiar from the Louvre's Giorgione, *Fête Champêtre*. Manet's painting was considered an affront to morality and to art in its adoption of old-master imagery for a scene evidently modern and also in its broad, flat, graceless presentation of it. The sacred, if pagan, here looked merely bohemian. He showed a religious subject in the 1864 Salon, *The Dead Christ with Angels* (New York, Metropolitan), as well as a *Dead Torero* (Washington, National), Spanish in style as in subject. His chief exhibit in 1865 was *Olympia* (1863). Again, the outcry was both inept and accurate. Manet had based his picture on Titian's *Venus of Urbino* yet seemed to caricature it stylistically, flattening the composition and turning the Venetian's rich colour into a harsh contrast of dark against light (with a black servant and a black cat to underline his choice), and morally by showing a very real model, probably a prostitute, in a challenging pose and mood. It was easy to see that he was attacking the poetry and charm the Venetians had brought into painting in the guise of honouring ancient deities; what was less easily appreciated was that he was also essaying a new form of pictorial construction inspired by Velázquez though indebted also to the *Neoclassicists' feeling for silhouettes.

Manet deepened his understanding of Spanish painting when he visited Spain later that year. *The Fife*, a frontal portrayal of a boy soldier that owes much to *Goya, was rejected from the 1866 Salon, infuriating the writer Emile Zola who became Manet's champion. Unwilling to risk

exclusion from the Paris 1967 World Exposition's art section, he exhibited independently. Among his new paintings was the large *Execution of Emperor Maximilian of Mexico* (Mannheim, Kunsthalle), like its model, Goya's *The Third of May*, picturing a piece of painful recent history.

Perhaps influenced by some of his young admirers, among them *Monet and *Renoir, he gave more attention to landscape and townscape subjects, and, especially after the 1870–1 war in which he served, did some outdoor painting following their example. But he would not join them in promoting their work outside the Salon. Nor did he ever adopt the full Impressionist method, content to aerate his scenes with a fresh and sketchy manner. By now his work found many admirers among collectors as well as painters, and it took on an element of social vivacity that was new to him and pre-echoed some of the interests of turn-of-the-century artists. Pains in his legs kept him in the studio though he left Paris in the summer. A series of restaurant and music-hall scenes culminated in the poetic and mysterious *Bar at the Folies-Bergères* (1882; London, Courtauld). He also painted a number of outstanding portraits as well as the group portrait known as *Le Déjeuner dans l'Atelier* (1868; Munich, Neue Staatsgalerie). Some of his finest productions of the last years were simple still lifes in oils or pastel.

After he died a memorial exhibition proved the popularity his work had achieved; his fame has grown apace since then. His example encouraged a flattening of pictorial space and thus a turning away from *Renaissance exploitation of perspective, but it also showed how *classical themes could carry new meaning; above all, he provided a light and vivid mode of outdoor painting in oils which people associated with Impressionism and which attracted painters reluctant to commit themselves to the full Impressionist method of colour notation (e.g. *Liebermann and *Corinth in Germany and *Henri in the USA). The major collection of Manet's paintings is in the Musée d'Orsay, Paris (it includes paintings here cited without location) and in New York's Metropolitan Museum.

Manfredi, Bartolomeo (1582–after 1622) Mantuan-born Roman painter, imitator of *Caravaggio, the low-life aspects of whose art he exaggerated to the detriment of spiritual qualities. He executed Caravaggesque *genre subjects, which had been characteristic of Caravaggio's early, light-hued phase, in the *tenebrist manner of Caravaggio's later style. His work, known only from *c.*1610, has sometimes been confused with that of *Valentin. It is Manfredi, more than Caravaggio himself, who influenced the northern *Caravaggisti* in Rome (*see* e.g. Honthorst; Terbrugghen). (Rome, Nazionale; Vienna, Kunsthistorisches; Brussels, Musées; etc.)

Mangold, Robert (1937–) American painter, trained at the Cleveland Art Institute and then at Yale University, receiving his MFA in 1963. In 1962, living in New York and working as attendant and then assistant librarian at the Museum of Modern Art, he exhibited in a show of *Hard Edge Painting; his first solo show was in 1964. At this stage his work was monochromatic, painted on boards and associated with *Minimalism. By the end of the 1960s he was using more expressive forms, including shaped canvases, and stronger colours, and then also textured surfaces. The blatant use of brushstrokes has become more marked recently, also his exploring of variously shaped canvases, including those he calls 'Frame Paintings' which have a central opening, usually combined with a dominant but disrupted geometrical form. He has thus worked in an area between impersonal Minimalism and the use of singular, paradoxical compositions and personal qualities. The Guggenheim Museum gave Mangold a retrospective in 1971; other major exhibitions have been seen in the USA and Europe.

Manguin, Henri (1874–49) French painter, a student in *Moreau's studio and later associated with *Fauvism. After the Fauve scandal of 1905–6 his art, never extreme, became milder and more tonal. He worked mostly in the south of France, painting landscapes.

Mannerism A style label applied to certain types of art produced *c.*1520–*c.*1580, mainly in central Italy, and diffused thence to France, the Netherlands, Spain and the imperial courts in Prague and Vienna. Mannerism is interposed in the history of styles between High *Renaissance and *Baroque art. There is little consensus, however, among historians as to the canon, the distinguishing formal characteristics, and the significance of Mannerist art. The word derives from the Italian *maniera*, which has a long history of usage in the literature of manners and the arts before being incorporated into a visual style label (by Luigi Lanzi in 1792). *Maniera* has neutral, favourable and pejorative meanings. It can signify 'style' in the sense of 'stylish' or as a style associated with a place, a period or an individual. It can denote knowledge of the 'rules', as for example the *Classical orders of architecture. It can mean technical facility and, by extension, excessive facility deployed at the expense of study either of nature or of the problems of representation: reliance on stereotype.

This critical polyvalance persists in modern definitions of Mannerism, which in turn colour our perceptions of the works of art to which they are attached. Mannerist art has been variously defined as decadent; as a conscious rebellion against the *classicizing ideals of the High Renaissance, symptomatic of 'anguish', either of 'the age' or of 'neurotic' individuals, or of 'higher spirituality'. More recently, Mannerism has been viewed as an art of courtly artifice, refinement and elegance, *expressive works being excluded from the canon. Each of these definitions may apply with greater or lesser truth to some work of art of the 16th century. They err, as do all essentialist definitions of style, in postulating a single descriptive and explanatory principle. Mannerism is not a coherent movement on the 20th-century model of an association of artists pursuing a joint programme. Insofar as the term has general applicability, however, this depends on the following. Mannerist artists and their courtly or metropolitan audiences shared a certain sophistication, the knowledge of various artistic modes transcending local schools. In particular, they shared a

reverence for High Renaissance art, notably the work of *Michelangelo: his almost exclusive concentration on the human figure, his ideals of youthful grace or mature musculature, his formulae of *contrapposto*, etc. His use of the antique relief style for painting (*Battle of Cascina*), as well as sculpture, was widely emulated (by *Pontormo, *Rosso Fiorentino, *Bronzino among others). With this precondition, Mannerism embraces different kinds of art, and Mannerist artists sought out influences to suit their needs and the task in hand. *Polidoro's monochrome façades for Roman town houses (1520s) are painted with antique motifs in the antique relief style, but his 1534 altarpiece of *Christ Carrying the Cross* for a Spanish congregation in Sicily (now Naples, Capodimonte) mingles Flemish references with a schema derived from a *Raphael prototype itself based on a *Dürer print. The visionary and expressive religious paintings of Pontormo, and to a lesser extent those of the young Rosso, also depend on Dürer prints. *Parmigianino emulates the suavity of Raphael, joined to the colourism of his great compatriot from Parma, *Correggio, and occasionally conflated with Michelangelesque echoes. The decorative schemes for state apartments invented (1540s–70s) by *Vasari, *Perino del Vaga, *Salviati, Pellegrino *Tibaldi and others, draw their inspiration from princely festival entries and masques as much as from Raphael's *Stanze* and Michelangelo's Sistine Chapel ceiling, while *Giulio Romano's Mantuan decorations assimilate antique motifs and style (and sometimes – as in the Sala dei Giganti in the Palazzo de Tè, 1537 – a nearly style-less *illusionism). The Grand Ducal sponsorship of Giovanni *Bologna's Florentine bronze workshop, and the use of his small bronzes as diplomatic gifts, account in great measure for their complex, unfeeling, preciosity; his religious works and large equestrian statues are far simpler and more direct of address. If High Renaissance art at its most characteristic is a harmonious balance of illusionism, *idealization, and expression, Mannerism is less a single style than a willingness by artists to tip that balance in one direction

or another, their ability to differentiate between representation and stylization.

Mannozzi, Giovanni *See* Giovanni da San Giovanni.

Mansi Magdalen, Master of the (active early 16th century) Netherlandish painter, a follower of Quinten *Metsys. He is named after the 'Mansi' *Magdalen*, now in Berlin, Staatliche; an esoteric *allegory on Fortitude, London, National, demonstrates this artist's access to humanist erudition and patronage.

Mantegna, Andrea (1430/1–1506) Outstanding northern Italian painter, engraver (*see under* intaglio) and occasional sculptor; influenced by his friend *Alberti, he also practised as an architect. From 1460 until his death – except for 1488–90 when he was allowed to work in Rome on a papal chapel (destroyed in the 18th century) – he served as court painter to the *Gonzaga at Mantua. Conservative in certain technical respects – he continued to work meticulously in tempera at a time when most artists were experimenting with oils – he was innovative in *perspective and in recovering the detailed appearance of Graeco-Roman antiquity, the remains of which he studied and collected. He was the first artist of the *Renaissance to clothe *classical and mythological scenes in (nearly) accurate antique costume and appurtenances. Although 16th-century artists and critics had reservations about his dry, precise pictorial style, they continued to praise his skill in devising *illusionistic schemes, notably the *frescos of the so-called Camera degli Sposi completed in 1474 in the ducal palace at Mantua (*see below*). Cosmè *Tura, *Crivelli and Gentile and Giovanni *Bellini – whose sister he married in 1453 – are among the artists most directly influenced by Mantegna's style as a whole; *Correggio's dome paintings in Parma, on the other hand, owe only their illusionistic perspective to him. Although Mantegna's works in reproduction look, and are often said to be, linear, many of his easel paintings (as well as the *Triumphs of Caesar* discussed below) are

executed on coarse canvas which blurs and softens the hard edges. Thus the linearity of his imitators, including the youthful Giovanni Bellini, in fact often exceeds his own.

Between 1441 and 5 Mantegna trained under his 'adoptive father', the mediocre Paduan tailor-turned-painter Francesco Squarcione (1397–1468). Squarcione's importance as a teacher may have been exaggerated, but he trained able students (see e.g. Vivarini), and had accumulated a large collection of casts after ancient sculpture, recent 'advanced' works of painting, and drawings. His own style, influenced by Filippo *Lippi, is known now only through two works (Padua, Museo; Berlin, Staatliche). It demonstrates a romantic, excitable attitude vis-à-vis the antique and an *expressive use of line – traits which left their mark on Mantegna. Probably more influential, however, on the precocious young artist (who was to be locked in lawsuits with his former teacher from 1448–57) were the Paduan works of *Donatello and the Venetian works of *Uccello and *Andrea del Castagno; he must have also known the now-lost paintings of *Piero della Francesca in Ferrara.

In 1448 Mantegna, not yet of age, was contracted for part of the decoration of the Ovetari Chapel in the church of the Eremitani in Padua, along with Antonio *Vivarini and Giovanni d'Alemagna. In the event, Mantegna executed most of the frescos, including scenes from the Lives of Sts James and Christopher (completed by 1457). Most of the cycle was destroyed in an air raid in 1944. Surviving remnants and earlier photographs demonstrate, however, the striking novelty of Mantegna's rigorous application of perspective to the various tiers of the cycle and his almost obsessive recreation of the material culture of ancient Rome.

The next most important work initiated by the artist before his removal to Mantua in 1460 was the San Zeno altarpiece for S. Zeno in Verona (main panels in situ, original *predella panels now Paris, Louvre and Tours, Musée). Technically a *triptych, the altar daringly creates spatial unity between its painted portions and the

wooden architecture of the frame, designed by Mantegna. It reflects the bronze structure erected by Donatello on the high altar of the Santo in Padua.

Of the many works executed during Mantegna's long tenure at the Gonzaga court, which included portraits (e.g. Naples, Capodimonte), small devotional pictures, both with full-length figures and in half-length (e.g. Florence, Uffizi; Milan, Brera; Vienna, Kunsthistorisches) altarpieces and allegories (see below), the most important are the frescos of the camera picta, the painted room now known, inaccurately, as the Camera degli Sposi or 'bridal chamber', and the nine large canvases of the Triumphs of Caesar (now Hampton Court). The decoration of the camera picta, a square room in the oldest part of the ducal palace complex in Mantua, was executed in 1465–74, partly a secco on dry plaster and with an oil varnish (which accounts for its poor state of preservation but probably also for the glowing, festive colours). It consists of a vaulted ceiling painted illusionistically to resemble white stucco reliefs of Roman emperors and mythological scenes set against a gold mosaic background. In the centre an equally fictive oculus, or round opening (like the real one in the Roman-built Pantheon in Rome) 'opens' to the sky. Ladies of the court, servants, a peacock, playful winged *putti look down, leaning against the simulated marble balustrade, on which a potted orange shrub balances precariously – all in masterful *foreshortening. The actual architecture of the room, once an audience chamber, has been transformed in paint into an open loggia. On two walls, painted brocade curtains are drawn between fictive pillars; on the other two, the curtains are 'pulled back' and looped to reveal a Court Scene above the fireplace and The Meeting on the wall left of it. Both include portraits of members of the Gonzaga family and court (including Ludovico Gonzaga's much-loved old dog, Rubino, lying under his master's chair). Two illustrious visitors, never actually present in Italy at the same time, the Emperor Frederick III and King Christian of Denmark, are inserted into the Meeting scene. The unaffected naturalism

(*see under* realism) of the portraits and their vivid immediacy have tempted scholars to identify the particular occasions represented, but no allusion to specific events may be intended. What is stressed is the continuity of the dynasty and its secular and ecclesiastical standing and the affectionate, self-assured ambience at court. The ideological value of naturalism has never been more apparent: Mantegna's 'unflattering' art makes us believe in the innate dignity of his sitters, the harmony of their relations with servants and dependants, their natural right to rule.

In contrast, the *Triumphs of Caesar* (in fact only the Gallic Triumph as described in ancient and contemporary texts), painted for no known permanent location probably between *c.*1484–*c.*1506, makes no overt reference to the Gonzaga. The theme was an accepted one for the decoration of princely palaces and no other work shows better Mantegna's empathy with the culture of ancient Rome, and his ability to deploy archeological material in an intensely poetic way.

The *Madonna della Vittoria* was commissioned in 1495 to commemorate Francesco Gonzaga's inconclusive victory over the French at Fornovo (now Paris, Louvre). Mantegna's interest in Flemish painting (*see especially* Van Eyck) can be deduced from the meticulous depiction of surface textures. In 1497 he completed the first of his two allegorical paintings for the *studiolo* of Francesco's wife, Isabella d'*Este: the *Parnassus*; the second, *Minerva expelling the Vices*, was finished in 1504; a third, *Myth of the God Comus*, was completed after Mantegna's death by Lorenzo *Costa (all now Paris, Louvre). Finally, the National Gallery in London now owns a remarkable *Introduction of the Cult of Cybele to Rome* (1505–6) painted for Francesco Cornaro, a Venetian tracing his lineage to one of the ancient Roman protagonists in this event. Mantegna has painted the scene in *camaïeu* to resemble a large agate cameo. The work not only brings to life an episode of Roman history, in a medium recalling the ancient art forms of stone relief and cameo gems – it also defies the angry criticism of his first teacher and exploiter, Squarcione: 'Andrea [should]

have painted his figures . . . as if they were of marble seeing that [they] resembled ancient statues . . . rather than living creatures.' The magic of the painting, and of Mantegna's art, is that its figures resemble *both* ancient statues *and* living creatures, the most perfect 15th-century evocation of antiquity.

Manueline style Portuguese style of sculptural decoration flourishing 1450–1540. It is named after King Manuel, and includes motifs from Portugal's overseas enterprises of navigation and exploration: crocodiles, exotic plants, African angels, seashells, etc., as well as figures from the medieval bestiary and Italianate *Renaissance ornaments. Its chief exponent was **Diogo Pires the Younger** (active 1511–35).

Manzoni, Piero (1933–63) Italian artist who began his career as a landscape painter but in the 1950s, stirred by the example of *Klein and of Lucio *Fontana, experimented with a variety of methods, visual effects and ideas, so that his later work varied widely in style and character. His 'Achromes' are pictorial reliefs in which found materials are coated with monochrome paint. He also signed naked bodies, inflated balloons of 'Artist's Breath' and produced sealed cans of (if he is to be believed) 'Artist's Shit'. These and other works, often humorous, represent his engagement with the thought of *Duchamp and made him a forerunner of *Conceptual art.

Manzù, Giacomo (1908–91) Italian sculptor of simple origins, drawn to sculpture by illustrations of modern art and deeply affected by seeing the Romanesque bronze doors of San Zeno in Verona. He began to work as sculptor full-time in 1930, influenced by Medardo *Rosso's *Impressionistic approach. His first solo exhibition, in Rome in 1936, was well received. In the 1940s he made a series of reliefs on the theme of the Crucifixion with Fascism as a sub-theme. In 1952 he was commissioned to make doors for St Peter's in Rome; they were installed in 1964. He also made doors for Salzburg Cathedral in

1957–8. In 1933 he had modelled a life-size *Girl on a Chair* of which he made several versions subsequently. Similarly he made a long series of Cardinals, beginning in 1934, succinct reliefs whose meaning is ambiguous but whose modelling is very fine. His art stands aside from modern movements, acknowledging its primary debt to the relief sculpture of *Renaissance Florence.

Maquette A sculptor's small preliminary model, usually in clay or wax, equivalent to a painter's rough sketch.

Maratta or Maratti, Carlo (1625–1713) Roman painter born in the Marche; the chief pupil of Andrea *Sacchi, whose studio he joined at the age of 12 and remained connected with until Sacchi's death in 1661. An artist of great distinction if not striking originality, he forged an individual style reconciling his master's *classicism (with its strong debt to *Raphael) with certain *Baroque tendencies. The resultant Grand Manner, sometimes dramatic, always clear and dignified, had by 1700 replaced the *Baroque style of *Pietro da Cortona and *Bernini (*see also* Gaulli). By 1680 Maratta had acquired international fame as the greatest painter of his age. His reputation has been devalued since, however, largely because later generations judge him through studio works and the innumerable copies and replicas of his many small Madonna and Child pictures. There are altarpieces by him in Roman and Sienese churches. He also worked in *fresco (1676 onwards, Rome, Palazzo Altieri) and was an admirable official portraitist (e.g. Vatican, Pinacoteca). His many pupils contributed to the success of Maratta's manner in Rome and throughout European courts (but see the countervailing influence of *Pozzo in Austria and Germany).

marble a metamorphosed limestone recrystallized by heat or pressure; by extension, any hard limestone which can be sawn, carved and polished; a sculpture made in such a stone. Quarried in Mediterranean countries, marble has been prized by sculptors and architects since the invention of metal tools over six thousand years ago.

Greek white marbles from Mount Pentelicon and the islands of Paros and Naxos were favoured in Graeco-Roman antiquity, as well as the white marble from Carrara in Tuscany, *Michelangelo's preferred material. Ancient Greek marble sculpture was tinted (*see* polychromy), while the Romans sometimes used marbles of different colours within a single figure or sculptural group. Since the *Renaissance, natural white marbles have been the preferred stone medium for monumental work. Marble sculpture differs from *bronze or *terracotta statuary in being subtractive rather than additive: that is, stone must be removed from the block, while clay, or the wax used in casting metal, is added during modelling, in the same way that paint is adding during painting. This has led some sculptors to find greater integrity in direct stone carving. For Michelangelo, Form was confined within the marble block as Platonic Ideas are imprisoned in matter (*see* Idealization, Realism), and the notion was revived by 20th-century sculptors (*see*, e.g. Gill, Hepworth, and the younger Henry Moore). Other sculptors in marble have not scrupled to design figures with protruding limbs etc. carved from several blocks of marble (*see* Bernini), or have employed craftsmen to copy in stone, by means of a *pointing machine, works modelled in clay, wax or plaster. Marble statuary, because of its weight, can never achieve the bold cantilevered effects of bronze.

Marc, Franz (1880–1916) German painter, born and trained in Munich. Influenced by what he saw in Paris in 1903 and 7, he moved from *naturalism into a more poetic idiom of gently simplified forms in enriched colours. His *Red Horses* (1911; Rome, pc) is possibly the most popular painting by a 20th-century painter of repute. In 1912, after a visit with *Macke to *Delaunay, his style took on some of Delaunay's geometrical *abstraction. His subject matter focused increasingly on animals in landscape: their innocence, he claimed, gave him access to truths denied to the human race. In their fate he saw a symbol of the Apocalyptic events confronting mankind. In one almost abstract work, *Fighting Forms*

(1914; Munich, Bayerische Staatsgemalde-sammlungen) he seemed to prophesy the war in which he lost his life. A member of the New Artists' Association of Munich, he left it with *Kandinsky; together they edited the *Blaue Reiter Almanac to which he also contributed text, and organized two Munich exhibitions.

Marcks, Gerhard (1889–1981) German sculptor, self-taught, one of the first teachers to be appointed to the *Bauhaus. He was charged with the ceramic workshop (which continued to function in Weimar after the closing of the Bauhaus there). His sculpture adds elements of medieval art to more recent traditions. After the Second World War he taught in the Hamburg School of Art.

Marcoussis, Louis (1883–1941) Polish-French painter, born Ludwig Markus in Warsaw and trained in Cracow. In 1903 he went to Paris where, around 1910, he became one of the *Cubists. His own Cubism is varied and multiple but is marked by a delicacy and confidence not always found in his friends' work. Among his finest works are *engravings done for the poems of *Apollinaire and others.

Marcus Aurelius The equestrian bronze statue of the Roman Emperor Marcus Aurelius Antoninus (121–180 AD), the most important ancient statue to have survived virtually intact above ground after the fall of the Roman Empire – probably because it was mistaken for a likeness of Constantine, the first Christian Roman Emperor. It is first recorded in the 12th century in front of the Lateran Palace in Rome, then the papal residence. By 1538 it had been moved to the Capitol, and *Michelangelo used it as the focal point of his design of the entire piazza, where it remained until recently (it has been moved indoors to preserve it from pollution). *Marcus Aurelius*, first reproduced as a bronze statuette by *Filarete, inspired the great equestrian monuments of the Early *Renaissance (see Donatello, Verrocchio) and has been studied by all artists commissioned to produce an equestrian portrait, whether in sculpture or in painting. It has

been engraved (see intaglio) more often than any other work of antiquity.

Marées, Hans von (1837–87) German painter born into the Prussian aristocracy. He was trained in Berlin and then in Munich where he met *Lenbach with whom he went to Rome in 1864. He had gone to paint copies of old masters for a patron; he found he could scarcely bear to do so, overcome by the glory of the *classical tradition. The painter of *Barbizon-type landscapes, of acute portraits owing something to *Rembrandt, and of military scenes was transformed, through many struggles, into Germany's most fervent seeker of classicism's richness in imagery of calm warmth, clear design and physical fullness. Like his approximate contemporaries in France, *Puvis and *Cézanne, Marées was seized with the desire to picture, in an idiom apt for his time, the ancient vision of a Golden Age of contentment. That the urge was in him before he went south is proved by *The Bath of Diana* (1863) in whose clotted paint Venetian beauty is held within a firm design reminiscent of *Poussin.

In Italy Marées became friends with the writer Conrad Fiedler and with the sculptor *Hildebrandt. Their relationship was intense, difficult and fruitful. Fiedler helped Marées financially, gave important theoretical stimulus to both artists and was to write about Marées after the artist's death; he also paid for the frescos Marées was commissioned to paint in the new Zoological Station in Naples and executed with untypical despatch in 1873 with Hildebrandt's assistance. In them contemporary life-size figures are shown in ageless scenes: fishermen bringing in nets and rowing a boat out into the Bay of Naples, women beneath orange trees, an old man, a boy and a young man busy in an orange grove (the Ages of Man), a group of men (Marées and his friends) outside a trattoria. They offer panoramic views of the station's surroundings. Stylistically they owe much to *Raphael's grand manner but their purpose is not narrative so much as to present a luminous vision at once ancient and modern.

The arcadian life remained his main

theme in paintings long worked on in design and execution, many of them heavy with a combination of oil paint and tempera. *The Golden Age* is the title of two large paintings on panel (1879–85 and 1880–3); *The Hesperides* (1884–7), a composition of nude men, women and children in an orange grove, and *The Courtship* (1885–7), showing two lovers on the left, a solitary man (Narcissus) on the right and a scene of wooing in the centre, are elaborate triptychs. In other paintings he used Christian references, as in the three-part *Three Horsemen* (1885–7), bringing together images of St Martin, St Eustace and St George. The last painting, on his easel when he died, is his *Ganymede* (1887), a broadly painted image of the young man lifted up by an eagle, hinting at the departure of an elevated spirit.

All the paintings referred to are in the Neue Pinakothek in Munich; its collection includes also some of his best portraits, including the double portrait of himself with Lenbach (1863) and several fine self-portraits. Other major works are in the National Gallery in Berlin, the Kunsthalle in Hamburg and in Wuppertal's Von-der-Heydt Museum. A small exhibition shown in Berlin in 1885 made little impression, but there have been many admirers among subsequent generations of artists and critics. Partly because of the delicate condition of many of the best paintings, Marées's reputation is not high outside Germany; a centenary exhibition of his paintings and drawings was shown in Munich in 1988. As one of the boldest and most sensitive renewers of the classical tradition of modern times, he deserves more general recognition.

Marescalco, Il; Buonconsiglio, Giovanni, called (active from before 1495 to after 1530) Italian painter from Vicenza, influenced by Bartolommeo *Montagna and Giovanni *Bellini. He worked in Venice from *c.*1495.

Mariette, Pierre-Jean (1694–1774) The best-remembered member of a family of French art-dealers, painters, print publishers and printmakers active in Paris. Mariette, himself an amateur etcher (*see*

under intaglio) and collector, honorary member of the *Academies of France and of Florence, King's Councillor and Controller of the French Royal Chancery, is now known above all for his writings on art, especially the *Abécédario de P.J. Mariette*. Begun as a correction of and additions to the *Abecedario Pittorico* of Padre Orlandi, a dictionary mainly of Venetian artists' lives, Mariette's work, still in manuscript at his death and published in six volumes in 1851–60, is a major source for the biographies of 18th-century French artists and architects. His *Traité des pierres gravées*, 1750, is also often consulted. He visited Vienna in 1717 and in 1718 went on to Venice, where he met and became friends with Rosalba *Carriera and *Zanetti – the direct cause of both artists' departure for Paris in 1719.

Marin, John (1870–1953) American painter, trained in Philadelphia and New York, who spent 1905–10 in Europe, mainly in Paris, yet returned to New York little touched by *avant-garde methods. His early watercolours and oils, mostly of urban scenes, owe more to *Whistler and the *Nabis than to more recent tendencies. In 1912 his style quickened, under the influence both of *Cézanne and of *Futurism, and his subject matter became more specifically his lyrical response to New York. 'The whole city is alive; buildings, people, all are alive': he made his art deliver that excitement through delicate linear structures and striking light effects. His first solo exhibition was in *Stieglitz's gallery in 1909; many others followed, especially from 1920 when he had his first retrospective. He spent many summers in Maine, painting the sea. At times his colour was vivid but it is the interaction of lines with washes of colour that typifies him, as is his welcoming of nature's forces and of man's handiwork seen as a form of nature.

Marinetti, Filippo Tommaso (1876–1944) Italian poet, creator and chief of the Italian *Futurists. Born in Egypt and educated at the Sorbonne in Paris, he lived mainly in Milan. He gave much energy to the propagation of Futurism through

lectures and publications. His often-recited poem of war 'Zang-tumb-tumb' (1914) was printed in unconventional typographical disarray, a visual and aural demonstration of what he called 'parole in libertà' (words in freedom). Fiercely nationalistic, he gave his support in the 1920s to Mussolini and the Italian Fascist movement.

Marini, Marino (1901–80) Italian sculptor, trained at the Florence Academy and active first in graphics. He became known as sculptor in the 1930s, winning sculpture prizes in Rome (1935 and 1954), Paris (1937), Venice (1952 Biennale). He had developed an idiom for modelled figurative sculpture dramatic in form and rich in archaic references. His favourite themes included a man on horseback in a variety of situations of marked monumentality. He brought great vigour also to his portraits, combining sculpture's power with a characteristic, dashing image.

Marinus van Reymerswaele (active c.1509–after 1567) A Netherlandish painter whose identity and biography have not been decisively established from documentary evidence. Reymerswaele or Roymerswaele was a place in Zeeland. The name appears as a signature on a group of pictures portraying half-length figures of *St Jerome*; *Two Tax Gatherers*; and a *Banker (or Money-changer) and his Wife*; these images are repeated in many variants. All are painted in brightly lit and extravagant detail, and all (with the partial exception of St Jerome) are grotesque, probably satirizing different types of human folly, such as pedantry, greed, avarice, etc. The formula of the grotesque half-length secular representation may be related to *Metsys, but the format and the subjects themselves are not rare in Netherlandish art, and half-length grotesque figures are depicted in a religious context, the *Mocking of Christ*, by Hieronymus *Bosch. It is now usually said that the purpose of Marinus's works is unclear, but that may be because we no longer relish the combination of elaborate execution with humour and satire, which we can accept best on a reduced scale in drawings or prints. Yet in the Late Middle Ages, the *Renaissance and even the 17th century,

humour and satire were as much appreciated in all forms of the visual arts as they were in literature, especially in northern Europe. At any rate, not only were Marinus's pictures popular enough for him to replicate, but they were much imitated by other, anonymous, artists. Probably the best example of Marinus's *Tax Gatherers* is in London, National; other works by him are in Antwerp, Musées; Madrid, Prado; Vienna, Kunsthistorisches; etc.

Maris, Jacob (1837–99) Oldest of three Dutch brothers, all of them painters, trained partly at the Hague Academy. Jacob moved to Antwerp in 1854 for further studies and travelled in western Germany. He returned to The Hague in 1857 but settled in Paris in 1865. In 1871 he moved back to The Hague where he remained, becoming a leading member of the informal *Hague School. In Paris he produced mostly Dutch scenes, including composite views of parts of Dutch towns, meeting a demand for Dutch subjects in a gentle *naturalistic style, but he also painted fine French landscapes that owed something to *Corot in their harmonious use of nuanced grey tones. Back in Holland, he allowed colours more prominence but also broadened his brushstrokes, so that his paintings, often presenting key features such as bridges and towers, took their vividness not only from the play of light and dark and his subtle establishing of the major silhouettes but also from the paint itself. *Mondrian was indebted to him in his early paintings, e.g. to Maris's *Dordrecht – the Grote Kerk* (Montreal, Fine Arts). **Matthijs** (1839–1917) followed Jacob to Antwerp, back to The Hague and then, in 1869 to Paris, living with his brother and working partly alongside him and partly following his personal inclination to sentimental but firmly constructed figure subjects, such as the little *Woman with Child and Kid (The Introduction)* (The Hague, Gemeentemuseum) and the larger scene of a mother carrying her baby away from the church in *The Christening* (1873; Utrecht, Centraal). In 1877 Matthijs moved to London where his figure subjects allied him to the *Pre-Raphaelites, but he had little success there. **William** (1845–1910) had his first instruc-

tion from his brothers. Like them he visited Germany and Paris, but also, unlike them, Norway. Otherwise he lived and worked in The Hague, a close friend of *Mauve. Like Jacob's, his paintings gradually moved from harmonious greys into slightly bolder colours and more prominent brushwork; his subjects were Dutch landscapes and townscapes. The Gemeentemuseum has a good selection of work by all three.

Marmion, Simon (*c.*1425–89) Franco-Flemish painter and 'prince of *illuminators', probably born at Amiens, settled in Valenciennes by 1458. He is recorded in Tournai in 1468. Marmion's feeling for light and delicate colours, subtle shading and poetic landscape settings influenced successive generations of Netherlandish miniature painters, although no securely documented works by him are now known. The shutters of an altarpiece once in St Bertin, St Omer, now in Berlin, Staatliche and London, National, are the key panel paintings attributed to him; among manuscript illuminations are a *Crucifixion* page added to the *Pontifical of Sens* (before 1467, Brussels, Bibliothèque) and a *Book of Hours (1475–81, London, V&A).

Marquet, Albert (1875–1947) French painter who became part of the *Matisse circle in the late 1890s and was one of the *Fauves in 1905–6. His subsequent work, landscapes and port scenes, was relatively *naturalistic and subdued.

Marseus van Schrieck, Otto (1619/ 20–78) Influential Dutch painter of reptiles and insects in 'forest floor' scenes – a sub-type of flower painting which he may have invented, and which found enormous popularity among connoisseurs and other artists from the 1660s through 1680s (*see also* Mignon, Abraham; Ruysch, Rachel; Withoos, Matthias). He was in Italy from the late 1640s to 1657, and was known among the *Bentvueghels in Rome as the 'Snuffler' because of his habit of prowling around the countryside in search of models; once settled in Amsterdam he kept a menagerie of snakes, lizards and toads on a small country estate. Some, if

not all, of his works were meant to convey moralizing sentiments (Cambridge, Fitzwilliam; Berlin, Staatliche Schlösser und Gärten). He was for a while the teacher of Willem van *Aelst.

Marsh, Reginald (1898–1954) American painter, born in Paris into a family of well-to-do painters. He grew up in New Jersey and studied at Yale and in New York at the Art Students League under *Sloan, *Luks and others during the 1920s. At that time he worked as an illustrator for the press, making many sketches of crowd scenes, both gloomy, as when he pictured life in the Bowery district of New York, and cheerful, showing much the same people at Coney Island, at the movies and in other places of entertainment. His work was in the spirit of the *Ashcan School. He painted murals under the Public Works of Art Project in the 1930s. His smaller works are often in tempera, and he sought to bring an Old Master quality to his *genre scenes. As he got older, the influence of *Rubens and the *Renaissance becomes increasingly apparent in his work.

Marshall, Ben (1767–1835) English sporting painter, a follower of *Stubbs. Trained as a portraitist, after his move to Newmarket in 1812 he came to specialize almost exclusively in horse racing and hunting scenes (New Haven, Yale Center).

Martin, Agnes (1912–) American painter, born in Canada. She became known in the 1960s as a *Minimalist painter of fine grids drawn on square canvases, delicate and at times barely visible but intense in the concentration of their simplicity. Meditative, even visionary in what they offered, they also represented an extreme in the Minimalist range of two-dimensional art. She worked in New York until, in 1967, she moved to New Mexico where, after an interval without painting, she began to paint equally delicate paintings in stripes of colour. She has made a point of letting the hand-made aspect of her images show, so that there is an inspired nervousness about her compositions that speaks of spiritual journeyings rather than impersonal mechanical perfection.

Martin, John (1789–1854) British painter. He began to exhibit landscapes in 1811 but turned to picturing visionary scenes developed from texts in the bible, Milton's *Paradise Lost*, etc. Influenced by the work of *Turner and many other *History painters, they are characterized by vastness of scale in their landscape and architectural settings, the vehement action of crowds and highly dramatic lighting. Reproduced as *engravings, sometimes as book illustrations, these works were very popular and Martin enjoyed a profitable career. His fame diminished quickly after his death, though three of his last and most ambitious paintings toured Britain and the USA until the 1870s and were widely admired. Their subject is the Apocalypse: *The Great Day of his Wrath, The Last Judgment* and *The Plains of Heaven* (1851–3; London, Tate). Their manner is that of the most lavish of Hollywood epics, but his intentions were entirely serious: like others of his time (e.g. *Ivanov, *Blake), he believed that materialism and war signalled the imminent end of the human race.

Martin, Kenneth (1905–83) British *Constructive artist trained in Sheffield and at the Royal College of Art in London where he met his future wife Mary (*see* next entry). His early work was close to the *realism of the *Euston Road School. In 1948–9 he made his first *abstract paintings and soon he became a leading contributor to a British Constructive movement initiated by *Pasmore. Early in the 1950s he began to make *kinetic constructions in the form of 'screw mobiles' hung so as to rotate. In the 1960s he also made standing constructions, large and small. At the end of the 60s he embarked on what he called his 'Chance and Order' works, two-dimensional explorations, using number series as a chance element and a set of rules, to discover rectilinear arrangements of infinite variety and strong visual force. These are seen at their best in the paintings of 1970+: bars of colour set against a square white field. The results are of astonishing vitality for all their economy of means. He had many exhibitions, some of them with his wife, from 1954 on. His quality and standing were established most tellingly in

the 1975 retrospective at the Tate Gallery in London.

Martin, Mary (1907–69) British *Constructive artist, born Mary Balmford, trained at Goldsmith's School of Art and at the Royal College of Art, London, where she met Kenneth, her husband from 1930 (*see* above). She was then a *naturalistic painter. In the 1940s her work showed her growing interest in geometrical forms and in 1948–9 it became wholly *abstract. Subsequently it was primarily reliefs with projecting and receding cube and wedge forms, at times with light-reflecting surfaces, occasionally on a large scale as in the mural commissioned for Stirling University.

Martini, Arturo (1889–1954) Italian sculptor and painter who studied under *Hildebrandt in Munich. In the 1920s he was prominent among those Italian artists who argued for, and practised, a return to *classical values in art. Yet his work, far from merely *academic, always had qualities of expressive strangeness in it, reflecting the uneasy cultural times he was living through. When he was around fifty he took up painting, and in 1945 he set sculpture aside with an essay 'Sculpture: a dead language'.

Martini, Simone (recorded from 1315 to 44) Italian painter, praised by Petrarch (Sonnets 57, 58), for whom he executed a portrait of Laura, now lost, and decorated a manuscript of Servius's *Commentary on Virgil* (1340–4, Milan, Ambrosiana). A subtle, sophisticated artist and one of the great Sienese followers of *Duccio (*see also* Ambrogio and Pietro Lorenzetti), Simone moved freely between descriptive *realism and abstract decoration, and was a master of public propaganda as of intimate small-scale panels, like his *Christ Returning To His Parents* (1342, Liverpool, Walker). The former mode is evident in his earliest known work, the *Maestà* of 1315 and 1321, painted on the end wall of the Council Chamber, Siena Town Hall. Executed largely *a *secco, and with the addition of gold-leaf and three-dimensional embossing, it is a commentary on *Duccio's *Maestà* for the High Altar of Siena Cathe-

dral; but its function is not purely religious. The Virgin as Governor of Siena addresses her counsellors, urging political and social unity while proclaiming the city's magnificence.

Even more striking is the pictorial formula arrived at in the altarpiece of *St Louis of Toulouse* (1317, Naples, Capodimonte). Here the dynastic claims of Robert of Anjou are conjoined with the transcendental ones made on behalf of his brother Louis, ascetic Franciscan friar and reluctant bishop of Toulouse, who renounced the crown of Naples in favour of Robert. The grandeur of a large-scale cult image is combined with the preciousness of a courtly *objet d'art* and, in the likeness of Robert, with the naturalism of a portrait from life. The *predella scenes are the earliest surviving examples of separate scenes grouped around a clearly defined central axis. A coherently organized *perspective scheme similarly characterizes the undated decoration of the Chapel of St Martin in the lower church of S. Francesco, Assisi (*c*.1317? or *c*.1339?). Simone's contribution is agreed to include not only the frescos but also the design of the stained-glass windows.

It is generally agreed, despite recent controversy, that in 1328 Simone returned to Siena to paint, on the other end wall of the Town Hall Council Chamber, facing his own *Maestà*, the fresco of *Guidoriccio da Fogliano*. The fresco's authorship and dating are, however, under debate.

Simone and his brother-in-law, Lippo *Memmi, together signed the *Annunciation* (1333; Florence, Uffizi). The frame is not original. A less well-known altarpiece, to the Blessed Agostino Novello (Siena, Cathedral Museum) reverts to an older format: a large *iconic figure flanked by evocative smaller narratives of his miracles. From *c*.1340 to his death in 1344 Simone was at the Papal court in Avignon. His most important *iconographic invention, the *Madonna of Humility*, a Virgin seated on the ground with her Child, dates from this period. The original is lost, but it is reflected in countless Italian and French examples of which the earliest known (1346) is in Palermo. Simone's influence on French illumination is incalculable.

Martorelli, Bernardo (recorded 1427–52) Spanish painter and miniaturist, active in Barcelona, where he may have trained with *Borassá. The elegance of his International *Gothic style became increasingly intermixed with dramatic *naturalism (Chicago, Art Institute; Paris, Louvre). He was succeeded as the leading painter of Catalonia by Jaime *Huguet.

Marville, Jean de *See under* Sluter, Claus.

Mary of Burgundy, Master of (active 1476–*c*.1490) Outstanding Netherlandish *illuminator, often identified with Alexander *Bening. He is named after two beautiful *Books of Hours probably made for Mary of Burgundy, daughter of Charles the Bold, Duke of Burgundy, and wife of Archduke, later Emperor, Maximilian of Austria (now Vienna, Österreichische Nationalbibliothek; Berlin, Kupferstichkabinett). His miniatures are characterized by a *trompe l'oeil* treatment of the frame, often strewn with *still-life elements seen in close-up, which becomes a window into deep space where the religious scene is enacted.

Marzal de Sax, Andrés (recorded from 1393 to 1410) Painter from Germany – probably Saxony, as his name indicates – active in Valencia in Spain. The outstanding work attributed to him is the *retable of Saint George now in London, V&A, in which decorative pattern co-exists with dramatically brutal *naturalism. Marzal de Sax's son, Henry, is documented in 1407 when he was apprenticed to a silversmith.

Masaccio, Tommaso di Ser Giovanni di Mone, called (1401–28?) The greatest Italian painter of the Early *Renaissance. His grave, monumental style, dramatically intense but stripped of all flourish and ornament, combining naturalism (*see under* realism) with geometric abstraction, became influential only long after his death when his famous *frescos in the Brancacci chapel, Florence, S. Maria del Carmine, served as a school to leading Florentine artists. Perhaps the most important of those who studied his

work was *Michelangelo (drawing, Munich, Graphische Sammlung). Traces of his influence may be discerned also in the work of *Leonardo da Vinci and *Raphael; *Vasari considered Masaccio the founder, with his predecessor *Giotto, of the Florentine school.

Born in Castel San Giovanni, the modern San Giovanni Valdarno not far from Florence, Masaccio (the nickname means Large, or Clumsy, Tom) matriculated in the Florentine guild in 1422, although we do not know where, or under whom, he trained. His earliest known work, discovered in the 1960s, is also dated 1422 and comes from Cascia, a tiny town in the Valdarno (S. Giovenale triptych (see polyptych) now Florence, Uffizi). Albeit traditional in most respects, the painting already demonstrates certain features of Masaccio's mature style, notably the spatial unity conveyed by the converging floor boards of the triptych's ground plane; the space-defining role of the Madonna's throne in the centre panel; the triangular shape formed by the Madonna and her attendant angels on the picture plane; the angels' heads in lost profile (i.e. turned away from the viewer so that little of the profile is seen); the strongly modelled, athletic nudity of the Child; and the general breadth of the body and drapery painting, represented as if in real daylight sharing the viewer's space. Like the handling of space and volume, the use of colour is sober and economical. Although the work recalls both earlier Giottesque painting and the contemporary sculpture of *Donatello, it is boldly individualistic and innovative.

Masaccio's next known work, the Madonna and Child with St Anne and Angels for the Florentine church of S. Ambrogio (c.1423, now Florence, Uffizi) probably marks his entry into the Florentine art market. Under now unknown circumstances the picture was painted in collaboration with, or finished by, *Masolino da Panicale, who was responsible for the angels and the cloth of honour. There is no evidence to support the supposition that Masolino was Masaccio's teacher, or even that he was noticeably older, and his own style, indebted to *Lorenzo Monaco, seems to have made no impact on Masaccio.

The style of the S. Ambrogio altarpiece is even more vigorous than that of the S. Giovenale triptych, and further breaks down the barriers between the world of the spectator and the painted image.

In 1426 Masaccio executed his only documented work, the great polyptych for the Carmine in Pisa, now dismembered (central panel, London, National; *predella panels and flanking saints, Berlin, Staatliche; pinnacle Crucifixion, Naples, Capodimonte; half-length saints from pinnacles? Pisa, Museo). The tendencies already noted in the S. Giovenale triptych are more boldly advanced in the central panel of the Madonna and Child in London. Especially noteworthy are the *all'antica architecture of the Virgin's throne and the geometrically correct *foreshortening of the lutes played by the musical angels. The lighting throughout, but especially on these objects, has been studied from life, and falls naturalistically from a single source on the upper left of the viewer's space, casting graduated shadows unprecedented in Florentine painting.

Masaccio's greatest surviving works, however, are not on panel but in fresco: the cycle from the Life of St Peter executed with Masolino in Florence, S. Maria del Carmine, Brancacci chapel, c.1427 and finished later in the century by Filippino *Lippi (lower register only), and the 'funerary chapel' fresco known as The Trinity in S. Maria Novella, before 1428, to which *Brunelleschi probably contributed the design of the scientifically foreshortened architecture.

A short entry precludes even a summary discussion of the striking novelties of Masaccio's contribution to the Brancacci chapel, from the *perspectival scheme of the whole to the dramatically *expressive and anatomically convincing nudes of the Adam and Eve in the Expulsion from the Garden of Eden and of the youths in the Baptism of the Neophytes, to the breakdown of spatial and psychological barriers between viewer and painted event of the large Tribute Money and of the Miracle of the Shadow Healing. The chapel was damaged by fire in the 18th century and the vault repainted; the window above the altar was enlarged earlier and the altar itself

remodelled, cutting into and covering part of the painted wall. A recent restoration has used as a guide the colours uncovered under the altar moulding, and reveals a fresher, brighter palette than hitherto suspected, as well as additional details. The Brancacci frescos demonstrate Masaccio's supreme gifts as a narrative artist; like Giotto he employs bodily posture to reveal emotional states. His mastery of perspective and lighting is put to the service both of religious symbolism and of what has been called the 'eye-witness principle', by which the viewer seems to witness, and even participate in, the events depicted.

An equal control of pictorial means is demonstrated in the *Trinity* fresco – an unprecedented image, both complex and accessible. Covered over and partly destroyed in Vasari's remodelling of S. Maria Novella, it has only recently become visible again, in its original location.

Masaccio's ill-documented and brief working life left a legacy of paintings which, like the sculpture of Donatello and the cathedral dome of Brunelleschi – his contemporaries and friends – remain powerfully eloquent: rooted in Giottesque tradition, they were a leavening agent for the subsequent evolution of the Florentine school, yet are timeless in their profound humanity.

Masereel, Frans (1889–1972) Belgian painter best known as a graphic artist, making images of human life amid the oppression and constriction offered by capitalism and the modern city. These were produced as woodcuts, usually in narrative sequences, that owe much to *Expressionism and thus also to *primitive idioms. His work was widely admired in the 1920s and 30s and has remarkable power as a non-*naturalistic form of *realism, at once polemical and intimate.

Masip or **Macip, Juan Vicente** (*c.*1475–*c.*1545) and his son, known as **Juan de Juanes** (*c.*1523–79) Spanish painters, active in Valencia. Masip almost certainly went to Italy and studied in Venice and the Veneto; his work, in which massive figures fill the picture space, was influenced by

*Pordenone and perhaps *Sebastiano del Piombo (Segorbe, Cathedral; Valencia, Cathedral). Juan de Juanes, one of the most popular and often reproduced painters in Spain, softened his father's style, producing highly *idealized and colourful devotional images of the Virgin and Child, the Holy Family, the Immaculate Conception and the Saviour, based on prints after *Raphael; probably his best work, however, are the scenes from the life of St Stephen (Madrid, Prado) where he is also influenced by Quentin *Metsys.

Maso da San Friano; **Tommaso Manzuoli**, called (1532–71) Italian painter, active in Florence in *Vasari's entourage. The latter's prevailing *Mannerist style is softened, however, through Maso's study of the Florentine High *Renaissance, notably *Andrea del Sarto (Cambridge, Fitzwilliam) and of *Pontormo's *expressive early *Mannerism (Oxford, Ashmolean).

Maso di Banco (recorded 1341–50) No factual information about his *œuvre* has reached us, and there are a number of contested attributions (e.g. *Pietà di S. Remigio*, Florence, Uffizi) but the tradition that he painted the frescos and window in the Bardi di Vernio Chapel, Florence, S. Croce (late 1330s?) has never been challenged. The decoration of this chapel demonstrates originality both of narrative mode and formal characteristics, assimilating the lessons of *Giotto and the *Lorenzetti in a totally personal way.

Masolino da Panicale (1383/?*c.*1400?– 1447?) Famous but poorly documented Florentine painter from Panicale. He matriculated in the Florentine guild in 1423, the year of his only dated work (*Madonna of Humility*, Bremen, Kunsthalle) which shows the influence of the refined style of *Lorenzo Monaco. At about the same date he probably collaborated with *Masaccio on the S. Ambrogio altarpiece, *Madonna and Child with St Anne and Angels* (now Florence, Uffizi). The two definitely collaborated on the famous *frescos of the Brancacci chapel, Florence, S. Maria del Carmine, *c.*1427, although

under circumstances which are still imperfectly understood. In 1424 Masolino was paid for a cycle of frescos on the *Story of the True Cross* in Empoli (fragments from entrance only, Empoli, S. Agostino). Some time in the second half of the 1420s he worked in Hungary. By the end of the decade, leaving the Brancacci chapel unfinished, he left Florence for Rome (*c*.1430, frescos of the *Life of St Catherine of Alexandria*, S. Clemente; S. Maria Maggiore, altar fragments now Naples, Capodimonte.) Perhaps in the mid-1430s he painted a cycle of the *Life of St John the Baptist* in the baptistry of the Collegiata, Castiglione Olona, not far from Milan.

Although Masolino briefly fell under Masaccio's influence, his style always remained distinct from the latter's. Extravagant use of single-vanishing-point *perspective in his work serves to frame, punctuate or interrupt the narrative rather than to focus the viewer's attention on significant figures or episodes. Greater use is made of decorative detail. Finally, although his control of anatomy and modelling almost conforms to Masaccio's new naturalistic (*see under* realism) canon, his figure style retains the delicate charm of Lorenzo Monaco's, albeit in less mannered, attenuated form.

Masson, André (1896–1987) French painter who grew up in Brussels where he received art training from the age of 11. In 1912 he went to Paris for further study. He was a soldier in the 1914–18 war, and badly wounded. He returned to painting in 1919, working at various jobs to earn money. In 1922 *Kahnweiler gave him a contract and in 1923 began to show his work. In 1924 he had his first solo exhibition and *Breton invited him to join the *Surrealists. His earlier work had combined traditions of *figuration with elements of *Cubism. Now he employed *automatism in graphic work and then also in paintings made with glue and sand, producing images of desire and violence. From 1929 to 37 he was outside the Surrealist group but exhibited with it again in 1938. In 1941 he went to New York and then to New Preston, CT. In 1945 he returned to France and exhibited in Paris. In 1950 he showed in Basle with *Giacometti; 1964 saw the first major retrospective, in Berlin and Amsterdam, and in 1965 he painted a ceiling for the Théâtre de France, Paris. From 1977 physical disability reduced his working to graphics. His work is characterized by symbolical expression and by passion. In protest (as against the fascist revolt in Spain) as also in self-revelation, it speaks of aggression.

Massys, Quentin *See* Metsys, Quentin.

Master of . . . The respectful form of address, Master (Maestro, Meister, Maistre or Maître, etc.) indicating a high level of skill and the licence from guild, corporation or civic authorities to run a workshop, employ assistants and teach apprentices, was placed before the first name of artists and architects in the Middle Ages: Master *Bertram. By extension, the form 'Master of . . .' was coined by art historians to identify now-anonymous artists associated with a particular location, work or group of works, or patron. Thus the Master of *Moulins was the painter of an altarpiece in Moulins Cathedral; the Master of the *Life of the Virgin is the author of panels on this subject from St Ursula, Cologne; the Master of *Mary of Burgundy illuminated two *Books of Hours for Mary of Burgundy, daughter of Charles the Bold, Duke of Burgundy.

Rather than producing an unwieldy list of 'Masters of . . .', we have entered these artists under their individual titles: Moulins, Master of; Life of the Virgin, Master of the; Mary of Burgundy, Master of.

Master of the Amsterdam Cabinet *See* Housebook Master.

Matham, Jacob (1571–1631) Accomplished and influential Dutch engraver (*see under* intaglio) from Haarlem. He was the stepson and most gifted pupil of *Goltzius, continuing to produce prints from his designs after the latter's death. He also executed some *reproductive engravings after *Rubens.

Matejko, Jan (1838–93) Polish painter, trained in Munich and Vienna, who worked in Cracow, primarily on large *history paintings, full of narrative detail and stage-craft, presenting major events in the history of his country. In 1873 he was appointed director of the Cracow School of Fine Arts.

Mathieu, Georges (1921–) French painter, largely self-taught, who became one of the leaders of *Art informel in Paris in the later 1940s, admired for his large *abstract paintings done with great speed, using tubes of paint to draw lines directly on prepared canvas. In the 1950s he executed such paintings in public around the world, repeating the same configurations like one signing his name. He published four books on his kind of painting, and in 1963 had a major Paris retrospective.

Matisse, Henri (1869–1954) French painter who studied law and turned to painting when recuperating from an operation in 1890. He studied in Paris under *Bouguereau and *Moreau, meeting in the latter's studio *Marquet, *Rouault and others, and then also under *Carrière, meeting *Derain. He began to send paintings to open exhibitions in 1896. In 1897 he met *Pissarro who encouraged his interest in *Impressionism and *Neo-Impressionism and caused him to visit London to study *Turner. He was married and poor yet in 1899 he bought a small *Bathers* paintings by *Cézanne, a small *Gauguin painting and a Van *Gogh drawing. In 1900 he attended classes in sculpture; he was to model sculpture, mostly figures, intermittently until 1950. He had his first solo exhibition in 1904. That summer he spent at Collioure, in touch with *Signac who bought his first major painting *Luxe, Calme et Volupté* (1904–5; Paris, Orsay) when it was shown in Paris the following spring: a *classical composition painted in a semi-Neo-Impressionist style. He and Derain worked in Collioure in the summer of 1905. When they and a number of friends showed their energetic and colourful paintings that autumn in Paris

they were denounced as *Fauves. In 1906 he showed *The Joy of Life* (1905–6; Philadelphia, Barnes) and had a solo exhibition before visiting Algeria. In 1907 he visited Italy and also became acquainted with *Picasso with whom he exchanged paintings. A Matisse school was organized by painters wanting to work under him and in 1908 the Moscow collector Shchukin began to buy from him.

His paintings had by this time assimilated their sources, becoming strikingly economical in the spirit both of *classicism and of Persian painting. In his *Notes of a Painter* (published 1908) Matisse stressed his need to present experience through careful distillation to attain a serene image incorporating the warmth of the original impulse. In 1910 he visited Munich to see a major exhibition of Islamic art, and the following year he went to Moscow to see to the installing of his two large paintings *Dance* and *Music* (1909–10; St Petersburg, Hermitage) on Shchukin's staircase. He was shown collections of Russian *icons and his high praise of them was widely reported. That winter and the following he painted in Morocco, and in 1913 he had two solo exhibitions in Paris and was included in the *Armory Show. He, with Picasso, was now seen as the leading new painter in Paris, and his work was being bought by Americans, Russians and Scandinavians. Unfit for military service, he spent the years of the First World War mostly in Nice, and subsequently tended to divide his time between Nice and Paris. His painting took on a formal severity that owed something to his contact with *Gris but without abandoning his preferred subjects: female figures, interiors with figures, still lifes, portraits, landscapes.

The post-war years brought an easier style into his work and thus also acceptance in France: the Luxembourg Museum made the first French public purchase in 1921 (when the Shchukin and Morosov collections were united in Moscow as a Museum of Modern Western Art they included nearly 50 Matisses), and in 1925 he was awarded the Légion d'Honneur. In 1927 he won the first prize for painting at the Carnegie International in Pittsburgh and had a retrospective in New York. In 1930 he

completed his series of four large reliefs, *The Back*, begun in 1909. In 1931, after a visit to the USA, he was commissioned by Barnes to paint a mural for his Foundation. The result, *The Dance* frieze, was installed in 1933; a previous version is in the Musée d'Art Moderne de la Ville de Paris. Both combine extreme simplification with great formal energy. In this they characterize his 1930s style: e.g. *Pink Nude* (1935; Baltimore Museum of Art), the last of 21 versions on the same canvas photographed as they proceeded, each strong, the last one as sensuous as it is succinct.

The later 1940s brought a further 'flowering', as he said, powerful yet decorative. 1945 saw an honorific retrospective in Paris, 1946 an exhibition in Nice and a documentary film. In 1944–7 he worked on *Jazz*, 20 plates prepared as *collages of shapes cut by him from paper he had coloured, reproduced by means of stencils. This brilliant work prefaced a series of large and small works done by collaging paper shapes, at once drawn and carved freehand with scissors, for a variety of purposes: a series of *Blue Nudes*, a frieze of bathing and diving figures for a swimming pool, vestments and stained glass windows for the Chapel of the Rosary in Vence, other decorations, and two large square pictures, *The Snail* and *Memories of Oceania* (London, Tate and New York, MoMA), all done in 1951–3. The achievement of a semi-invalid, this late phase not only crowns his career; it shows him contributing to the great *abstract art movements of the day.

It is right to think of him as a painter. He was also one of the greatest graphic artists of the century, working in a variety of styles to create 'a likeness, not a copy' as he said (echoing Cézanne). He was one of the century's boldest modellers of sculpture, finding in that process a stimulating complement to his painting and drawing. He was also an outstanding book illustrator (e.g. for poems by Mallarmé, 1932; Joyce's *Ulysses*, 1935), stage designer for the Russian Ballet (e.g. *Le Chant du Rossignol*) and, though agnostic, the creator of fine religious images for the church at Assy, 1948, and the Chapel of the Rosary at Vence, 1948–51. His statements, like his art, reveal an ardent intelligence rooted in appreciation of the past and of other cultures and confident in the validity of personal expression.

A Matisse Museum was opened in his home town of Le Cateau-Cambrésis in 1952; that in Nice was formed after his death. Countless exhibitions, shown since 1954 around the world, have established him as a great modern master.

Matsys, Quentin *See* Metsys, Quentin.

Matta (Roberto Matta Echaurren, 1911–) Chilean painter who worked mainly in Paris and, from 1939, in the USA. He was trained as architect, arrived in Paris in 1933, and worked with Le *Corbusier before being drawn to *Surrealism and becoming a painter of nightmarish visions involving cosmic spaces and mutant creatures that seem to metamorphose between being figures and *abstract elements before our eyes. In this way he pictured an inner reality of 'perpetual transformation' and thus of psychic states. His method was largely *automatist and this, backed by his close knowledge of art in Paris and his open, enthusiastic character, made him a figure of especial importance in the emergence of *Abstract Expressionism; *Gorky was especially indebted to him.

Mattei Wealthy and noble Roman family, with estates and titles in Lazio and southern Umbria. At the turn of the 16th century and in the early years of the 17th, the three Mattei brothers, **Ciriaco** (1542–1614), **Girolamo** (1545–1603) and **Asdrubal** (1554–1638), were among the greatest collectors of modern painting and ancient sculpture in Rome. Most of their vast collections have been dispersed. Notable among the painters working for them were *Caravaggio, who in 1601 resided in the family palace and painted the famous *Supper at Emmaus* (London, National) and the newly discovered *Capture of Christ* (on loan to Dublin, National) for Ciriaco; Paul *Bril, who decorated various of their palaces with landscapes and topographical views of their estates; *Pietro da Cortona, who decorated

a gallery for Asdrubal; and *Passarotti. It has been said that their taste for landscape and Caravaggesque *naturalism was conditioned by their close links with the church reformers Filippo Neri, founder of the Oratorians, and Carlo Borromeo.

Matteo di Giovanni (active 1452–95) Also called **Matteo da Siena**. Italian painter from Borgo San Sepolcro, the author of the *polyptych wings which once framed *Piero della Francesca's *Baptism*. He was one of the artists (*see also* Giovanni di Paolo, Sano di Pietro, Vecchietta) commissioned by the Sienese Pope Pius II to execute 'modern' square-panel altarpieces for the cathedral in the Pope's newly-built *Renaissance city of Pienza, where they can still be seen. Mainly, however, Matteo was active in Siena, where his debt to the great Sienese masters of the 14th century, notably Simone *Martini, is clearly visible; like *Sassetta and Vecchietta, however, he shows himself aware of the latest developments in Florentine art – individual figures often recall those of the *Pollaiuolo (*see*, e.g. the large *Assumption of the Virgin*, London, National) – and decorative elements *all'antica* are introduced. Matteo is best known for his huge and beautiful altarpiece of 1472 in Sta Maria della Neve, Siena, designed as a single arched panel supported by a *predella to harmonize with the Renaissance architecture of the church. Other works in Siena, various churches; Museo dell'Opera del Duomo. As a young man, Matteo di Giovanni worked in collaboration with Giovanni di Pietro, who was commissioned around 1450 to paint a copy of Simone Martini's *Annunciation* altarpiece of 1333.

Maulbertsch or **Maulpertsch, Franz Anton** (1724–96) The last and most important Austrian decorative painter in the *Rococo style; he was appointed Imperial Court Painter in 1770 and worked throughout the *Habsburg realms in Austria, Bohemia and especially in Hungary (e.g. Gyor, cathedral), where he executed the majority of his wall and ceiling *frescos and altarpieces. He also painted some portraits and made etchings (*see under*

intaglio) inspired by those of *Rembrandt. Maulbertsch was primarily influenced by his predecessor, Paul *Troger, and by Venetian painters, notably *Bencovich; he probably also studied the work of the eccentric Mantuan, *Bazzani.

maulstick also called **mahlstick**; from the Dutch maalstock, paint stick. A long stick with a padded knob at one end, used to steady the hand holding the paintbrush. It is first recorded in 16th-century Netherlandish pictures of St Luke painting the Virgin, and often appears in artists' self portraits.

Maurer, Alfred (1868–1932) American painter, trained in New York and Paris, who attached himself, like *Manet and *Whistler, to the tradition of subtle tonal painting associated with *Velázquez, then switched to the brisque colourism of *Fauvism and in 1907 to the formal condensations of *Cézanne. His work was shown by *Stieglitz in 1909 and 10. In 1914 Maurer returned to New York. Paris had meant freedom among friends; New York was to him disapproving authority. His art approached *abstraction, became more *naturalistic in the 1920s, then combined elements of *Cubist analysis and transparency for paintings of heads and figures that suggest distress about relationships, perhaps reflecting that with his father. His work was generally disregarded, and when his father died he ended his own life.

Mayno or **Maino, Juan Bautista** (1578–1649) Outstanding pupil of El *Greco in Toledo (*see also* Pedro Orrente, Luis Tristán). The son of a Milanese father and a Spanish mother, he visited Italy in his youth, returning to Toledo by 1611. In 1613 he professed as a Dominican in the friary of S. Pedro Martír where he had been painting the main altarpiece since 1612. Around 1620 he was transferred to Madrid, becoming drawing master to the future Philip IV. An outstanding portraitist, perhaps influenced by *Velázquez (e.g. Madrid, Prado; Oxford, Ashmolean) he also executed landscapes in the manner of Annibale *Carracci and *Domenichino

(Madrid, Prado) and shows evidence of having known at first hand the work of *Caravaggio and his Roman followers. In 1627 he helped Velázquez win favour at court by adjudging him the victor in a painting competition. His excellent, large narrative painting, the *Recapture of Bahía* (1635, Prado) once formed part of the decoration of the Hall of Realms in the royal palace of Buen Retiro, alongside, among others, Velázquez's *Surrender of Breda* and canvases by *Zurbarán and Vincencio *Carducho.

Mazo, Juan Bautista Martínez del *See under* Velázquez.

Mazzoni, Guido (recorded from 1473 to 1508) Northern Italian sculptor born in Modena. He specialized in life-size *polychrome groups modelled in terracotta, of pious subjects such as the Nativity, the Lamentation and the Entombment of Christ, sometimes for funerary monuments. Less frenetic than the famous group by *Nicolò dell'Arca, they are marked by extreme naturalism (*see under* realism) *genre details derived from northern *Gothic sources. In 1489 he moved to Naples, and in 1495 accompanied Charles VIII to France, where he remained – with the exception of a brief return home in 1507 – until 1516. He died in Modena. His marble tomb of Charles VIII at Saint-Denis was destroyed in 1793. Terracotta groups, or single-figure fragments, can be found in Modena, cathedral and Museo; Crema, S. Lorenzo; Padua, Museo; Ferrara, S. Maria della Rosa; Naples, S. Anna dei Lombardi.

Mazzoni, Sebastiano (*c.*1611–78) Complex and original Italian painter and poet from Florence. Forced out of the city for satirizing some important person, he settled in Venice about 1648; influenced by Bernardo *Strozzi, he developed his free brushwork to an even greater degree of spontaneity and bravura, excelling above all in visionary scenes with single figures of extreme psychological intensity (it has even been speculated that he may have seen prints by *Rembrandt) (Venice, S. Benedetto; Carmine).

Meadows, Bernard (1915–) British sculptor, trained at Norwich Art School and the Royal College of Art where he later was professor of sculpture from 1960 to 1980. In 1936–9 he was studio assistant to Henry *Moore, always remaining a close friend. His work, mostly modelled and cast in bronze, was usually close to *abstraction but incorporated natural forms, of plants, animals and occasionally humans.

Medici Italian banking and merchant family. From 1434, when Cosimo de'Medici the Elder, leader of the so-called 'popular' party, returned from ten years' exile, until 1737 with the death of Gian Gastone, the last Medici Grand Duke of Tuscany, they were almost uninterruptedly rulers of Florence. The changing character of their rule – which until 1531 observed the constitutional forms of the oligarchic republic of Florence, from 1537 became openly aristocratic and dynastic, and from 1569, with the elevation of the Duchy of Tuscany to a Grand Duchy, monarchic – is reflected in the changing patterns of their art patronage. The activities as patron of **Cosimo de'Medici the Elder** (1389–1464) still largely fit into the traditions of communal religious life: the refurbishment and enlargement of his parish church, San Lorenzo, begun by his father and entrusted to *Brunelleschi; financing the statue of the bankers' guild at Or San Michele by *Ghiberti; the rebuilding of the priory of San Marco by *Michelozzo, and its decoration by Fra *Angelico. Even the construction of the palazzo Medici by Michelozzo can be thought to contribute to the magnificence of the city of Florence, as can Cosimo's commissions from *Donatello. Cosimo's son **Piero the Gouty** (1416–69), continued to patronize Michelozzo, who designed for him sumptuous tabernacles to house miraculous images in SS. Annunziata and San Miniato; the latter is adorned with a majolica decoration by Luca della *Robbia. Piero's taste for gaudy splendour is reflected in the *frescos by Benozzo *Gozzoli for the chapel of the Medici palace; he employed *Verrocchio, *Mino da Fiesole, the *Pollaiuolo brothers, and Filippo *Lippi. His son and successor,

Lorenzo the Magnificent (1449–92), the most famous member of the family, was a poet, patron of letters and collector of antique gems; his artistic commissions were few, although he advised in architectural matters, and as an instrument of diplomacy recommended Florentine artists to non-Florentine patrons. Perhaps his most important contribution to the history of art is his employment of *Bertoldo as curator of his sculpture garden, the first 'school' in sculpture of the young *Michelangelo. His second cousin, **Lorenzo di Pierfrancesco** (1463–1503) was the patron of *Botticelli's famous mythological and *allegorical works. The Medici were ousted from Florence in 1494, but returned in 1512. Lorenzo the Magnificent's son **Giovanni** (1475–1521), elected pope in 1513, and taking the name of Leo X, with his cousin **Giulio de'Medici** (1479–1534) commissioned Michelangelo to design a façade – never built – for San Lorenzo, and the famous Medici chapel in the same church, never completed. Leo X is remembered as a patron above all in Rome, where he employed *Raphael, who portrayed him both in the *frescos of the Vatican Stanze and in easel painting. While still a cardinal, his cousin Giulio set up a famous competition between Raphael and *Sebastiano del Piombo. He in turn became pope in 1523, as Clement VII. Painted by Sebastiano, he also employed Raphael's heir *Giulio Romano, and the Florentine sculptor *Cellini, whose memoirs describe both the medals he executed for the pope and his own exploits during the Sack of Rome in 1527, when Clement was besieged in the Castel Sant'Angelo. In 1537, when the direct line of Cosimo the Elder was extinguished through the murder by his own cousin of Clement's much-hated illegitimate son Alessandro, the post of head of the city's government was offered to a youthful distant cousin, **Cosimo di Giovanni delle Bande Nere de'Medici** (1519–74). Unexpectedly forceful, he was confirmed as Duke by both Emperor and Pope, and from 1569 ruled as Grand Duke Cosimo I, establishing the first truly autocratic court of Florence, in which art was used primarily as a tool of dynastic propaganda. The foremost

Florentine *Mannerist artists contributed to his artistic programme, although *Pontormo fared less well under this regime than his pupil *Bronzino, Cosimo's chosen portraitist; *Vasari contributed both as an architect – notably in the creation of the Uffizi – and painter-decorator, in which capacity he covered up the remains of Michelangelo's and *Leonardo da Vinci's incompleted *Battle* murals in the Palazzo Vecchio; *Ammanati worked as both sculptor and architect on the Palazzo Pitti, now the ducal residence. Cosimo's son and successor, Grand Duke **Francesco I** (1541–87), was the great patron of Giovanni *Bologna and his pupils; through his marriage to Joan of Austria, daughter of the *Habsburg Emperor Maximilian II, duplicates of Giambologna's sculptures were sent to enrich the artistic repertoire of Austria and Bohemia. Francesco's daughter, **Maria de'Medici** (1573–1642) became Queen of France by marriage to Henry IV Bourbon in 1600, and is celebrated in *Rubens's famous cycle of her life, now in the Louvre. Of Cosimo I's later descendants, Cardinal **Leopoldo de'Medici** (1617–75) is remembered for his support of the chronicler of art *Baldinucci, and his initiation of the celebrated Uffizi collection of artists' self-portraits; the Grand Duke **Cosimo III** (1642–1723) for his patronage of Carlo *Dolci and of that patient artist's virtual antithesis, Luca *Giordano.

Medina, Sir John Baptist (c.1679–1710) The most successful Edinburgh portrait painter of his time, he has been called '*Kneller's equivalent in Scotland'. His style, albeit not his colour harmonies, is based on Kneller's, and was carried on by his son well into the 18th century. Of Spanish family, Medina was born in Brussels and trained there. He came to London in 1686; in 1688/9 he settled in Edinburgh, and was knighted in 1706. A series of oval portraits, including his finest work, a self-portrait (1708), hangs in the Surgeons' Hall, Edinburgh. There are also works by him in the Scottish National Portrait and in many Scottish collections. He taught the most distinguished Scottish portraitist of the next generation, William *Aikman.

medium In the broad sense, the category of a work of art determined by its materials and method of production; in painting, the substance with which *pigments are mixed to make paint: drying oils for oil paint; water for *watercolours; egg for *tempera, etc. *See also* colour, fresco, gouache, ink, size.

Medunetsky, Konstantin (1899–*c*.1935) Russian artist trained in Moscow before and after the Revolution, and involved in making avant-garde street decorations for its anniversary in 1918. He was one of the founders of Obmokhu and exhibited with it in 1919–23. Under the influence of *Tatlin and *Rodchenko, he joined the *Stenberg brothers in 1922 in exhibiting constructions and calling themselves *Constructivists, and with them spoke on the principles of their art at *INKhUK. His work was included in the *First Russian Exhibition in Berlin, where the American collector Katherine Dreier bought *Construction No. 557* (1920; New Haven, Yale University AG). His models for propaganda stands were shown at the Paris Exhibition of Decorative Arts in 1925. He also designed film posters and stage sets.

Meidner, Ludwig (1884–1966) German painter and poet who just before the 1914–18 war painted dramatic visions of the destruction of cities, hinting at war and Apocalypse. *Revolution* (1913; Berlin NG) shows a political action against the background of an exploding city; *The Town and I* (1913; lost) has the artist's head, wild-eyed, before a similar background. He served in the army during the war and turned against his ardent *Expressionism. He gave priority to poetry and taught art in a Jewish school in Cologne before fleeing to England in 1939 and finding himself interned.

Meissonnier, Ernest (1815–91) French painter whose early *Barricade, rue de la Martellerie* (1848; Paris, Orsay) is a powerful piece of polemical *realism in its account of the results of street fighting in that year's revolution. His career, remarkably successful, depended on detailed

depictions of historical *genre subjects from Napoleonic times or earlier, often of the politer end of military and ecclesiastical social life. These now seem like foretastes of commonplace historical filmmaking, but were greatly admired in their time. He too admired himself greatly, as did *Dalí, in some respects his modern disciple. Paris (Orsay) and London (Wallace) have large collections of his work.

Meit, Conrat (active 1496–1550/51) German sculptor from Worms, important for his small-scale collectors' statuettes, made in metal, boxwood and alabaster and depicting mythological and biblical subjects – some of them, such as the naked Judith and Adam and Eve, more sensuous than devout. He also made miniature portrait busts (Cologne, Kunstgewerbe; Munich, Bayerisches; Vienna, Kunsthistorisches; Nuremberg, Germanisches; London, British; Berlin, Staatliche). Between 1506 and 1510 he was at the court of Frederick the Wise at Wittenberg, collaborating with *Cranach; soon afterwards he settled in the Netherlands and became court sculptor to the Regent, Margaret of Austria, at Malines. In 1534, after Margaret's death, he settled in Antwerp. His later works include the Virgin and Child in Brussels, Sainte-Gudule, the first life-size Madonna in northern European art, and the unfinished alabaster *Pietà* in Besançon Cathedral. Meit's Italianate-Netherlandish *Renaissance style can be related to Cranach, *Dürer, and *Gossart, as well as to engravings by or after Italian artists (*see also* Mone, or Monet, Jean).

Meldolla, Andrea *See* Schiavone, Andrea Meldolla.

Meléndez or **Menéndez, Luis** (1716–80) Spanish painter, mainly known for his still lifes but the author also of two striking self-portraits (1746, Paris, Louvre; *c*.1770, Madrid, PC). 45 of his monumental yet sober paintings of foodstuffs were placed in the dining room of the royal palace at Aranjuez; 44 of these are still known. There are works by him in Madrid, Prado; New York, Metropolitan; London, National; etc.

Mellan, Claude (1598–1688) French painter and virtuoso engraver (*see* intaglio). He was in Rome 1624–37; on his return to Paris he perfected a system of shading by swelling and tapering parallel lines with little, and sometimes no, cross-hatching. Although he made *reproductive prints after *Poussin, *Vouet, and his own rare paintings, he is remembered primarily for his portrait engravings (*see also* Nanteuil, Robert), and was celebrated for his *Sudarium of Saint Veronica*, a 'portrait' of Christ as miraculously imprinted on Saint Veronica's kerchief, published in 1642, made up of one continuous line which goes round from the centre at the tip of Christ's nose to the edges (forming not only features but also hair, beard, drops of blood, crown of thorns and halo) like the groove on a gramophone record.

Mellery, Xavier (1845–1921) Belgian painter who studied at the Brussels Academy and in 1871 visited Italy to absorb the art of the *Renaissance. He was an instinctive *Symbolist, striving to reveal the invisible forces at work within the real, 'the soul of things' as he said, and drawing was his primary means for that, often in chalk. The silent, meditative character of these images found an echo in the art of *Khnopff. Mellery hoped also to paint decorative cycles for public locations, but these were not realized other than in smaller easel paintings which he was able to show in Brussels and in Paris. He exhibited by invitation with Les *Vingt and other avant-garde associations in Brussels and in the *Salon de la Rose+Croix in Paris.

Melone, Altobello *See* Altobello Melone.

Melozzo da Forlì (1438–94) Painter and perhaps architect from Forlì in Romagna, active also in Urbino, 1465–75; Rome, *c*.1469–70, 1475–*c*.1484, *c*.1489; and Loreto, *c*.1484. He was celebrated by contemporaries for his skill in *illusionistic *perspective. Traditionally a disciple of *Piero della Francesca, he would have known the latter's works in Urbino, as well as those of that other researcher in

perspective, *Uccello. His own painting, however, is more vigorously *realistic than that of either of these masters. Although he may have helped design the famous *studiolo* in the ducal palace at Urbino, his major commissions were executed for Pope Sixtus IV and his relations: the *fresco of *Sixtus IV ordering Platina to reorganiaze the Vatican library* (1475–77, detached *c*.1820, now Vatican, Pinacoteca) with its illusionistic architecture and life-like portraits; the apse fresco of SS. Apostoli, Rome (1478–80; apse demolished 1711; fresco fragments Vatican, Pinacoteca; Quirinale; drawing for the head of an apostle, London, British.) Melozzo's vault fresco at Loreto, S. Casa, was largely executed by his best-known pupil and assistant, **Marco Palmezzano** (1459/63–1539). Its scheme of painted architecture and foreshortened seated prophets may have influenced *Michelangelo's early designs for the Sistine Chapel ceiling.

Melzi, Francesco *See under* Leonardo da Vinci.

Memlinc or Memling, Hans (*c*.1440–94) Prolific and eclectic German-born Netherlandish painter, the main artist in Bruges – where he settled in 1465 – in the last quarter of the century. Although he was the chief follower of Rogier van der *Weyden, in whose workshop he may have spent some time, and re-used Rogier's figure poses and compositions, he lacked this master's intensity and pathos. The gentle charm of Memlinc's work made him the favoured Early Netherlandish painter of 19th-century art lovers. He is, however, a stronger painter than appears at first sight: experimental in his naturalistic (*see under* realism) handling of space, in his revival of pictorial modes pioneered by Jan van *Eyck and Hugo van der *Goes, and in his search for rational order, clarity and monumentality. His eclecticism is evident not only in the freedom with which he adapts earlier pictorial inventions to his own uses, but also in the flexibility he demonstrates in resolving the varying problems of different artistic tasks. Thus his famous reliquary casket, the metre-long *Châsse of St Ursula*

(1489, Bruges, Hospital of St John) employs delicate colour and decorative undulating pattern to stress both the narrative and the jewel-like effect of painted panels inserted into a miniature *Gothic shrine, while the St Christopher Altarpiece (1484, Bruges, Museum) unifies monumental figures and landscape, continuous across three panels, through *chiaroscuro and the rhythmic repetition of strong colours on simplified surfaces.

Many portraits by Memlinc survive, some derived from diptychs or triptychs (see under polyptych) whose companion panels have not survived, others painted as independent works. Albeit dignified and elegant, they are more individuated than portraits by Rogier; like his other works, they demonstrate Memlinc's willingness to experiment with different formats and by changing the relationship of figure to background. There are works by Memlinc in many European and American collections, but the largest and most significant portion of his work remains in Bruges, Hospital of St John.

Memmi, Lippo (recorded 1317–57) Sienese painter, brother-in-law of the much greater artist Simone *Martini, with whom he signed the Annunciation now in the Uffizi, Florence (1333). In 1317 he frescoed, with his father Memmo di Filipuccio, a *Maestà in the new town hall in S. Gimignano, which reworks Simone's Siena Town Hall Maestà of 1315. There are Madonnas on panel in Orvieto, Siena, Altenburg and Berlin.

Mena, Pedro de (1628–88) Late *Baroque Spanish sculptor from Granada, much admired for his severe, life-like *polychrome statues. He studied first with his father, the sculptor Alonso de Mena (1587–1646); more importantly, he became the assistant of Alonso *Cano on the latter's return to Granada in 1652 (see also Mora, José de), executing one of the four statues commissioned from Cano for the Convento del Angel. Other early works also show Cano's influence (Granada, San Antón). After Cano's departure in 1658, Mena also left his native city, to install himself in Malaga, where he remained

except for visits to Madrid and Toledo in 1663. One of his most stirring and most-copied works, Saint Francis, is in Toledo Cathedral. Mena's Malaga workshop produced numberless altars and sculptures, not only for Malaga itself (cathedral, choir stalls; San Domingo, Virgin of Bethlehem, destroyed 1931; other local churches) but also for Madrid, Granada, and Cordova. Among his favourite themes were half-length figures and busts of the Ecce Homo and the Virgin Dolorosa (e.g. 1673, Madrid, Descalzas Reales).

Mengozzi Colonna, Gerolamo (c.1688–c.1772) Italian quadratura painter (see under illusionism; also *Colonna, Angelo Michele) born in Ferrara but active mainly in Venice. He is best known for the architectural settings he painted for Giovanni Battista *Tiepolo's *frescos (Venice, Palazzo Labia). His son **Agostino** (c.1725–92) followed the same speciality (Venice, Ospedaletto, music room).

Mengs, Anton Raffael (1728–79) Portraitist and one of the most important painters of *Classical, allegorical and religious subjects of the second half of the 18th century. He espoused the theories of J. J. *Winckelmann, whom he met in Rome in 1755 (portrait, New York, Metropolitan), and sought out models in the excavations at Herculaneum and Pompeii. He is a precursor of the *Neoclassicism of *David.

His father and first teacher, Ismael Mengs, was court painter at Dresden, and had him christened after Antonio *Correggio and *Raphael. In 1740 he left for Rome, where he studied under Benefial and from the masters of the High *Renaissance. Appointed court painter upon his return to Dresden in 1746, he soon departed once more for Rome, where in 1748 he converted to Catholicism and married. His first major works were the ceiling *frescos of the Villa Albani (1761) which first fully reveal his allegiance to Winckelmann and the Antique, and eschew all *Baroque *illusionism or *Rococo frivolity. After completing the Parnassus, Mengs left for Madrid, where he had been appointed court painter, and began decorating the ceilings of the Royal Palace.

These are markedly less austere than those of the Villa Albani, possibly under the pressure of competition from *Tiepolo. Back in Rome in 1769, Mengs was elected *Principe* of the Academy of St Luke, and painted the decoration of the Camera dei Papiri in the Vatican (1772–3). In 1775 he returned to Madrid, completing the two ceilings begun a decade earlier and painting a third. Illness overtook him in 1776, and he left Madrid for Rome, where he died. In addition to the works *in situ*, there are paintings by Mengs in Dresden; Madrid, Prado; London, V&A, NPG, Apsley; etc.

Menzel, Adolf von (1815–1905) German painter, son of a printmaker who brought the family to Berlin in 1830 to set up a print workshop and died soon after. His son took over the business and found that lithographs for a poem by *Goethe and a book of Prussian history were well received as convincing but also lively images. Other commissions followed, notably one for illustrations to a life of Frederick II printed in 1839 from wood blocks most delicately cut under Menzel's supervision to match his drawings. In 1836 he had begun to paint in oils. In the 1840s he made a series of exceptional *naturalistic paintings, domestic interiors, a corner of Berlin, the railway line from Berlin to Potsdam (1847), whose simple subjects and fresh, airy treatment were entirely novel to German painting and anticipated the fluent *Impressionism of *Manet's later paintings. In 1849 he embarked on a series of eight paintings developing ideas he had drawn for the life of Frederick II, these occupied him until about 1860 and, in their human directness combined with historical tact, enchanted a public eager to find education combined with entertainment in these engaging *History paintings. In 1865 he made a visit to Paris. In 1875 he painted his *Ironworks*, a new subject for German art, showing men toiling amid furnaces and wheels and pullies, not as a piece of social commentary so much as a celebratory account of a new sort of place and activity.

In 1853 Menzel became a member of the Berlin Academy. Many honours followed, the highest that academies, universities and the German emperor could bestow on a

painter including, in 1898, his elevation to the hereditary nobility. The National Gallery in Berlin presented a memorial exhibition; the same gallery has the collection of Menzel's work.

Mercier, Philip (1689?–1760) A peripatetic artist, son of a French Huguenot exile in Berlin, Mercier is mainly remembered as one of the significant French influences on the formation of British painting (*see* especially Hogarth, Hayman, Morland, Gainsborough). He was trained by a Frenchman, Pesne, at the Berlin *Academy; in Italy, and in Paris; in the early 1720s he was making etchings (*see under* intaglio) after *Watteau. In 1725/6 he introduced a new genre, the *Conversation Piece, to England (*Viscount Tyrconnel and his family*, Belton House). After working from 1728/9–36/7 as Painter to the Prince of Wales (*Portrait of Frederick, Prince of Wales; Frederick, Prince of Wales, and his Sisters at Concert*, 1733; London, NPG) he created yet another new genre, the *Fancy Picture on a large scale. Many of these works were widely diffused in popular engravings (e.g. *Girl with Kitten*, engraved 1756; Edinburgh, National). By 1740 Mercier was working in Yorkshire (York, Gallery; Temple Newsam; Burton Agnes), travelling to Scotland, Ireland and London. In 1752 he all but settled in Portugal, but throughout his travels he never lost the French cast of his art, its most consistent characteristic.

Merian, Matthäus the Elder (1593–1650), his daughter **Maria Sibylla** (1647–1717) and his son **Matthäus the Younger** (1621–87) Family of German-Swiss artists. Matthäus the Elder, born in Basel and trained as an engraver (*see under* intaglio) in Zurich, married into a family of publishers. From 1619 to 1624, he travelled around the environs of Basel and in southern Germany, making drawings which he later transformed into prints. In 1625 he took over the publishing house of his in-laws, the De Bry, in Frankfurt, which he ran until his death in Schwalbach. Under his direction the firm published topographical views of cities and landscapes in Central Europe, many of which he etched himself;

in Frankfurt his most important pupil and assistant was Wenzel *Hollar. Maria Sibylla is remembered for her poetic yet exact watercolour and *gouache paintings of insects and butterflies, flowers and fruit. She also painted in oils (Vienna, Kunsthistorisches). She settled in Holland, and from 1699 to 1702 she visited the then-Dutch colony of Surinam to study the insects, on which in 1705 she published a book, the *Metamorphosis Insectorum Surinamensis*. The best collection of her work is in St Petersburg, Academy of Sciences. Her brother, **Matthäus Merian the Younger** studied painting with *Sandrart, and practised as both painter and engraver in Amsterdam, London, Paris, Italy and Germany; he became especially known for his oil and pastel portraits (Basel, Öff. Kunstsam.).

Merry Company *See under* Buytewech, Willem.

Meryon, Charles (1821–68) Prolific French etcher, who began as a painter but made his reputation with series of etchings, mostly of the medieval buildings of Paris. Periods of mental illness were reflected in his later work as *Bosch-like visions of evil.

Mesdag, Hendrik Willem (1831–1915) Dutch painter and art collector, famous for the encircling *Panorama* he painted in 1881, a *naturalistic representation of the beach and sea at Scheveningen, and set up in what is now the Mesdag Museum in The Hague.

Messerschmidt, Franz Xaver (1736–83) Sculptor, born at Württemberg and educated mainly at the Vienna *Academy, where he became Professor in 1769. Forced to resign in 1774 because of mental illness, he is now chiefly known for a series of 69 grimacing heads in alabaster and lead, of which 49 survive (1770–83; mainly Vienna, Österreichische). Called *Charakterköpfe*, they are less studies in physiognomy or pathognomy than attempts to exorcise the private demons of his illness. Despite their pathological causality, they demonstrate Messerschmidt's characteristic ability to combine *realism with *classicizing stylization.

Mestrovic, Ivan (1883–62) Croatian-Yugoslav sculptor of peasant origin. He was sent to study at the Vienna Academy and soon exhibited with the Vienna *Secession, admired for the expression of human feeling in his work, e.g. his fountain with life-size figures *At the Well of Life* (bronze, 1904; Zagreb, Theatre Square). In 1907 he moved to Paris where he showed frequently and worked on a vast architectural and sculptural project *The Temple of Vidovdan*, to be a monument to Serbo-Croat history and its heroes (model and figures in Belgrade, National Museum). In 1909 he exhibited over 50 works in Vienna. By this time he was seen as a major artist and the great representative of his country. His work was marked by an urge to monumentality, echoing that of *Michelangelo, and by a personal, sometimes mannered *Neoclassicism using formal ideas also from archaic Greek and medieval art. Between the wars he was director of the Zagreb Academy; an exhibition toured Central Europe in 1933. During the Second World War he went to Switzerland, and after it to the USA where he was professor of sculpture at Syracuse and Notre Dame universities. An orator more than an inventor, he charged his human images with physical and emotional power. His work is seen best in the Belgrade National Museum and in the Mestrovic Gallery, Split.

metalpoint A metal wire, usually of silver but sometimes also of lead or even gold, employed in a holder as a drawing tool on coated paper. The point deposits a thin coating of metal on the slightly rough surface, which (in the case of lead or silver) rapidly tarnishes, producing a fine grey line like that of a hard graphite pencil.

Metaphysical Painting *See* Pittura metafisica.

Metsu, Gabriel (1629–67) Eclectic Dutch painter, son of a painter of Flemish origin, **Jacques Metsu** (*d*.1629). He was born in Leiden, and was instrumental in forming the painters' guild there (1648); he may also have spent some time in Utrecht (*c*.1650). In these early years he executed a number of history paintings (*see under*

genres), including biblical scenes and allegorical subjects (Leiden, Museum; The Hague, Mauritshuis). After settling in Amsterdam in 1657, he turned exclusively to smaller scale genre and *Conversation Pieces (Berlin, Staatliche; St Petersburg, Hermitage; London, National, Wallace). His best-known work is the poignant *Sick Child* (Amsterdam, Rijksmuseum).

Metsys, Quinten or Quentin Massys or Matsys (*c*.1465/6–1530) The leading painter in Antwerp from *c*.1510 until his death, and an important influence for change in northern European art. An eclectic and perhaps self-taught artist born in Louvain, he borrowed freely from the Italians, notably *Leonardo, but also from *Dürer, and from past Netherlandish masters such as Jan van *Eyck, Rogier van der *Weyden and Hugo van der *Goes. All these influences he fused and assimilated, without, however, finding a consistent style of his own. Metsys's variousness is especially evident in his portraits. The famous profile *Portrait of a Man* (1513, Paris, Jacquemart-André) may be based on a Leonardo *caricature, while the likenesses of *Erasmus* and *Petrus Aegidius* painted for Sir Thomas More in 1517 (Rome, Nazionale and Longford Castle, Wilts. respectively) utilize 15th-century northern scholar-portrait formulae. For this reason undated portraits – as indeed all his undated paintings – are difficult to place in his *œuvre* (e.g. portraits in Chicago, Institute; New York, Metropolitan; Vaduz, Liechtenstein Coll.).

Metsys's early work has been grouped with reference to the earliest dateable painting, the 1507–9 *St Anne Altarpiece* (now Brussels, Musées). This astonishing triptych (*see under* polyptych) combines northern *iconography and composition with Italianate architecture, set against a mountainous landscape painted in Leonardesque aerial *perspective; *Gothic figure types and faces are *idealized and softened with *sfumato *chiaroscuro, clearly also indebted to Leonardo. Similar effects are observable in works now in Lyon, Musée; Brussels, Musées, and a trip to northern Italy has been suggested.

The next great commission, the *Deposi-tion Altarpiece* for Antwerp cathedral, 1508–11 (now Musée) demonstrates another feature which characterizes some of Metsys's work: his ability to juxtapose elegance and the grotesque (*see also* Madrid, Prado; New York, Metropolitan). Metsys's friendship with Erasmus may have influenced him to put his talent for the grotesque at the service of satirical or moralizing *genre, which was to influence later artists, notably *Marinus van Reymerswaele. The best-known satirical work is the *Unequal Pair* (Washington, National). Typically, Metsys's pictures in this vein fuse the influence of *Bosch with that of Leonardo's caricatures. His grandson, **Quentin Metsys the Younger** (*c*.1543– 89) lived in London from *c*.1581 to 88. He has recently been revealed as the painter of the famous '*Sieve Portrait*' of Queen Elizabeth I, in Siena, Pinacoteca.

Metzger, Gustav (1926–) Stateless artist, born in Nuremberg of Polish-Jewish parents, a refugee to Britain in 1939. He studied sculpture and drawing, and then also painting in Britain and abroad, including three years with *Bomberg, but sought a more spontaneous and socially significant mode of expression, issuing his first *Manifesto of Auto-Destructive Art* in 1959 and a second in 1960, when he gave his first lectures and demonstrations of this art form, painting with acid on nylon which melts as the acid sinks into it. Metzger went on to find other methods of making self-destructive art, and promoted his challenge to permanent art objects in further lectures, demonstrations and conferences, for example the Destruction in Art Symposium, held in London in 1966, which involved a month-long series of events. He proclaimed his enmity to both the commercial art system and to the comforts he feels the bourgeoisie derive from it. Better that all artists should stop producing such commodities for a while and let the system collapse. An effective and busy polemicist, Metzger continued to explore the field of Auto-Destructive and also, from 1962 on, Auto-Creative art whereby an art object or event is elicited by variety of processes. Bridging science and philosophy, he presents his theories and productions as

extensions both of the history of art, with its increasing engagement with technology, and of the natural environment, global and cosmic. His book, *Damaged Nature, Auto-Destructive Art* was published in 1996. A touring exhibition of his work opened at the Oxford Museum of Modern Art in 1999.

Metzinger, Jean (1883–1957) French painter who turned from *Fauvism to *Cubism, exhibiting with the Cubists in 1910 and 11, and a founder of *Section d'Or. With *Gleizes he wrote the first extensive explanation of Cubism in *Du Cubisme* (1912). Later his work became firmly representational.

Meulen, Adam Frans van der (1632–90) Flemish painter of views, travel and hunting scenes, and battles, active in Brussels until 1664 (Madrid, Prado; London, National). *c.*1665 he was brought to Paris by Colbert, to become the chief recorder of the campaigns of Louis XIV's armies. His fluent and elegant paintings and designs for the Gobelins tapestry works are marked by great accuracy of topographic and military details, concealing the brutal aspects of battle behind clouds of gunsmoke and focusing on handsomely dressed cavalry officers in the foreground (Versailles, palace). He was one of *Lebrun's principal assistants.

Meunier, Constantin (1831–1905) Belgian artist who studied sculpture at the Brussels Academy but, impatient at tradition's hold, turned to painting and associated with the *avant-garde. In 1878 he began to paint steelworks, coal-mines and factories. A visit to Spain confirmed his *realism; the example of *Millet led him to give heroic character to the anonymous workers he painted and, from 1884 on, also modelled for bronze. Working now both as painter and sculptor and in a manner tending now to realism, now to idealization of form and grouping that smacks of *classicism, Meunier established himself as the champion of the working class. His work was admired among progressives in Belgium and abroad, in Paris (a retrospective 1896), in Dresden and Berlin where he

and his work went in 1897, and in Vienna: he presented a number of his works to the Vienna *Secession in 1898. The vividness of his sculptures relates him to *Rodin, but his distortions, exaggerated musculature and simplified, mask-like faces remain close to Millet's. His work is best seen in the Musée Meunier and Musées Royaux; his most important sculpture is a public work, the *Monument to Labour* (1894–1901) in the Place de Trooz – all in Brussels.

Mezzotint A special type of *intaglio print, invented in the 17th century but widely practised in the 18th, notably for the reproduction of paintings. The technique is especially suitable to this end, because it facilitates the controlled engraving of tone rather than of line, as in traditional copper engraving with the use of a burin. A toothed chisel, the 'rocker', is held upright and pushed while being rocked back and forth with its edge pressing on the metal plate. This makes it possible to lay an even, close mesh of burred pits all over the surface of the plates. Tints are then scraped or burnished into this to produce an even tone. Sharp edges can be pointed up by engraving or etching lines.

Michalowski, Piotr (1800–55) Polish painter, active principally in Cracow. He spent 1831–5 in Paris where he made copies of *Géricault's paintings. This experience, combined with his innate talent and energy, made him Poland's leading *Romantic artist.

Michaux, Henri (1899–1980) Belgian-French poet and painter, working in Paris from 1924 and beginning to paint in 1926. In the 1940s and after he became known for *automatist images made first with gouache, then, more directly, with Indian ink, and later ink and crayons. His work was seen as an important extension of *Art informel because of its source in the unconscious, which at times he sought to reach by taking mescalin.

Michel, Georges (1763–1843) French landscape painter, little known in his lifetime though he exhibited in the *Salon, but

of significant influence on the *Barbizon painters as an example of a landscape painter working out of doors. His close knowledge of Dutch 17th-century landscape art gave his work historical roots; out of his personality and under some influence from *Romanticism, he added to this qualities of poetry and mood that gave his work additional resonance.

Michelangelo Buonarroti (1475–1564) The towering genius of Italian 16th-century art and the first artist whom contemporaries viewed in this light. A sculptor, painter and architect, and important in the history of Italian literature for his poems, he is probably the single most influential European artist, with the possible exception of his rival, *Raphael, a paradigm of the *expressive and self-willed artist despite the fact that he worked virtually throughout his life on commission and his career was beset with frustration and compromise. Some of his best-known works were left incompleted (e.g. the Medici Chapel, Florence, S. Lorenzo, 1520–34) or went through successive abortive stages before being completed largely by others (notably the tomb of Pope Julius II, 1505–45, Rome, S. Pietro in Vincoli).

A member of a minor noble Florentine family, he successfully resisted social definition as an artisan-artist, never running a workshop in the normal sense and suppressing the facts of his training. It is known that he spent 1488–9 of a projected three-year apprenticeship with *Ghirlandaio, and his sculptural training is ascribed to *Bertoldo, curator of Lorenzo de' *Medici's collection of antique sculpture. He lived in the Medici palace from 1490 until Lorenzo's death in 1492. Since Bertoldo seems to have worked exclusively in bronze, some scholars have suggested a period in the studio of *Benedetto da Maiano. Whatever the facts of his training, Michelangelo acquired a good grounding in the techniques of panel painting – as revealed in the 1986 cleaning of the *Doni* tondo or roundel (c.1504, Florence, Uffizi) – of *fresco – demonstrated in the recent restoration of his most extensive fresco work, the Sistine chapel ceiling (1508–12,

Rome, Vatican) – and of marble carving. At the same time, however, his relative independence of workshop routines enabled him to innovate technically, for example in the use of claw chisels and by his way of blocking out a projected statue in the round from one dominant face, as in relief sculpture, thus keeping as long as possible the chance of revision and change (e.g. *St Matthew*, 1506, Florence, Accademia). In painting, too, he seems to have been the first artist fully to exploit the effect of chromatic, as opposed to tonal, modelling (*see* colour), as is now apparent in the cleaned Sistine chapel vault.

Despite the radical break with Florentine workshop practice Michelangelo was deeply imbued with the traditions of Florentine art. As a youth, c.1490, he drew after figures in frescos by *Giotto and *Masaccio (Paris, Louvre; Munich, Alte Pinakothek; Vienna, Albertina). He looked long at *Donatello (*Madonna of the Stairs*, c.1491, Florence, Casa Buonarroti). Despite its *classicizing style and classical subject, the relief of the *Battle of the Centaurs* (1492, Casa Buonarroti) follows 15th-century Florentine practice (e.g. *Ghiberti's east door, Florence, baptistry) in jutting forward from top ('background') to bottom ('foreground'). Equally contrary to ancient practice (*see*, however, *Belvedere Torso*), but in accord with Florentine ideals of the statue in the round, the *Bacchus* (Florence, Bargello) made during Michelangelo's first stay in Rome, 1496–1501, is carved as a serpentine figure with no single predominant view. (The *figura serpentinata*, so important in Michelangelo's two-figure groups – e.g. the *Victory* originally for the tomb of Julius II, c.1521–3, now Florence, Palazzo Vecchio – like so much of his formal language, became one of the hallmarks of *Mannerist style.) He drew variations after *Leonardo da Vinci's cartoon of *St Anne with the Virgin and Child* (e.g. Oxford, Ashmolean). Most significantly, however, he identified the highest goals of art with Florentine *disegno*. In so doing he redefined the notion. He did not, for example, engage in the Florentine tradition of perspectival experiment – despite demonstrating his understanding of *perspective in the painted architectural

framework of the Sistine Chapel ceiling. He embraced only that aspect of the tradition which defined high art as the representation of the human figure in action. Through his example, *disegno*, as later taught in the *academies of art throughout Europe, became virtually synonymous with the representation of the nude, especially the male nude, and *composition* with the complex manner in which active figures relate to each other and to their pictorial or architectonic space. Thus a typically sculptural ideal came to dominate even pictorial notions of the Grand Manner.

In October 1494, as Florence was threatened by the advance of the French army of Charles VIII, Michelangelo fled to Venice and from there to Bologna, where he completed the tomb of S. Dominic (*see* Niccolò dell'Arca) and studied Jacopo della *Quercia's reliefs on the portal of S. Petronio. In Florence again in 1495/6 he carved a sleeping *Cupid* (lost) which was purchased from a dealer in Rome as a genuine ancient work. During 1496–1501 he was in Rome, where he made the *Bacchus* already discussed, and the *Pietà* in St Peter's for a French cardinal. The *iconography was probably suggested by French examples, but the execution, both highly naturalistic (*see under* realism) in its handling of anatomy and highly *idealized in physiognomy, was totally Italianate.

The years 1501–5 in Florence, now declared a republic, were perhaps the most prolific in Michelangelo's life. He carved the gigantic *David* (now Florence, Accademia) from a block quarried in 1466 but spoiled in the blocking out; the *Bruges Madonna* (Bruges, Notre Dame); figures for the Piccolomini altar by Andrea *Bregno (Siena, cathedral); the (unfinished) *Pitti* and *Taddei Madonnas* (Florence, Bargello and London, Royal Academy respectively) and painted the *Doni* tondo. He received at this time a commission for 12 Apostles for Florence cathedral, of which only the *St Matthew* was begun, and for a mural of the *Battle of Cascina* to decorate the Grand Council chamber of the Palazzo della Signoria along with Leonardo's *Battle of Anghiari*. Only the cartoon was prepared when Michelan-

gelo was summoned to Rome by Pope Julius II to begin work on what should have been the most magnificent sculptural work of the age, a gigantic free-standing tomb for St Peter's, but which turned into the virtually life-long torment of his career – the 'tragedy of the tomb' in the words of his protégé and biographer Condivi. As noted above, the existing monument is a sad compromise between original hopes, overweening patronal and artistic ambition, the demands of a career dominated by the will of successive popes, changing artistic ideals and political and religious circumstances. The monument underwent six distinct phases. The first project of 1505 was abandoned by the Pope for the construction of Bramante's new St Peter's, and replaced by a bronze statue of Julius for Bologna (destroyed) and the fresco decoration of the Sistine Chapel ceiling, 1508–12. A second project dates from after Pope Julius's death in 1513, and is recorded in a contract with his executors. The pieces of the tomb carved at this time include the so-called *Dying and Rebellious Slaves* (Paris, Louvre) and the *Moses*, now on the wall tomb in S. Pietro in Vincoli. Work on this project was interrupted by the wish of the newly elected pope, Leo X (Giovanni de'Medici) to erect a façade for the Medici parish church of S. Lorenzo; the contract for this was given to Michelangelo in 1516/17 (cancelled 1520) and preceded by a new, reduced contract for the tomb in which the latter was redesigned as a true wall monument. Four unfinished figures of *Slaves* in Florence, Accademia, probably date from this time. From 1520 Michelangelo was busied on work for the new chapel in S. Lorenzo, which replaced the commission for the façade and was to include tombs of Leo's father, uncle, nephew and younger brother. After Leo's death in 1521 pressure from the new pope, Adrian VI, and Julius's heirs, forced Michelangelo to return to work also on the tomb. The elderly Adrian, however, having died in 1523, was succeeded by Leo's cousin, Giulio de'Medici, as Pope Clement VII and Julius's tomb was once again set aside in favour of the Medici chapel and a new library for S. Lorenzo (after 1524). Embittered discussions on a new, further reduced project for the tomb

were underway in 1525–6 but were interrupted by the Sack of Rome in 1527 and the re-installation of a republican government in Florence. Despite his long association with the Medici, Michelangelo was an ardent republican and was charged with fortifying the city against the pope's return (drawings, Casa Buonarroti). The city, however, capitulated. In 1530 Michelangelo was pardoned by Clement and returned to work on the Medici commissions. A new project for the Julius tomb dates from 1532, at the instance of the pope to include figures sculpted by others. The monument was now to be erected, not at St Peter's, but in Julius's titular church while cardinal, S. Pietro in Vincoli. By this time unfinished statues for the tomb were both in Florence and Rome; it has been suggested that the *Virgin and Child* in the Medici chapel had been carved originally for the Julius tomb. The final instalment in the tangled and increasingly unhappy saga of the tomb – in which Julius's heirs accused Michelangelo of fraud – dates from after Clement's death in 1542. His successor, Paul III, appointed Michelangelo supreme architect, sculptor and painter to the papal court. For Paul III 'the tomb was no more than an obstacle to the execution of papal commissions', the first of which, already planned by Clement, was the *Last Judgement* in the Sistine chapel (1535–41). By putting pressure on Julius's heirs Pope Paul was able to arrange in 1542 for a new final contract, the results of which are to be seen today. The only statues by Michelangelo dating from this period and thus to scale with the much-reduced monument are the *Contemplative Life, Rachel*, and the *Active Life, Leah*. They contrast both in scale and in style with the much earlier *Moses*, who in turn has been placed inappropriately in a niche on the lower storey rather than a corner of the first storey as originally planned. Other figures were executed by **Raffaello da Montelupo**. For a work which overshadowed so much of the artist's life the final result is disjointed and visually disappointing, yet, when studied with a knowledge of the tomb's history and of the dispersed statues which were carved at various stages of the project, it provides a matchless resumé of Michelangelo's creative impulses. In the

same way, the exuberance and formal beauty of the Sistine Chapel ceiling of the first decade of the century can be contrasted with the sombre penitential grandeur of the *Last Judgement* of the mid-century, the first great artistic project in Rome after the Sack. The Medici chapel in Florence, having been abandoned unfinished when Michelangelo moved definitively to Rome in 1534, was systematized in its present state under the direction of *Vasari. The result is more stark than originally intended, and the wall monument for Lorenzo and Giuliano de'Medici remains incomplete.

After finishing the *Last Judgement* Michelangelo was set to work on the frescos for the Pope's private chapel in the Vatican, the *Conversion of St Paul* and the *Crucifixion of St Peter* (1542–50), which developed further the apocalyptic style of the *Judgement*. His conversion from the humanist and Neo-Platonic aestheticism of his youth to the deeply religious and meditative spirituality of these years in which the Church, under threat from the Lutheran Reformation, was itself reforming, is attested not only by these great papal frescos but also in drawings (many in London, British) and in his last sculptural groups of the *Pietà* (1552 onwards, Florence, Opera del Duomo; Milan, Castello). Michelangelo's friendship with the intellectual and pious Vittoria Colonna, celebrated in many of his poems, was deeply instrumental in this conversion.

In 1547 Michelangelo became chief architect of St Peter's; his old age was largely occupied with architectural projects beyond the scope of this entry, albeit it has often been said, rightly, that his building design relies on the same principles of motion, light and shade and organic form as his sculptural practice.

Michelozzo di Bartolommeo (1396–1472) Florentine architect and sculptor in metal, marble, terracotta and stucco. He worked with *Ghiberti, 1417–24, on the latter's first doors for Florence Baptistry and the *St Matthew* for Or San Michele, and in 1437–42 on the cleaning and chasing of the Doors of Paradise. He ran a studio in partnership with *Donatello, 1425–33; the

main commissions undertaken by the firm were the monument to the anti-pope John XXIII Coscia in Florence baptistry, for which Michelozzo executed the greater part of the marble figure sculpture; the monument of Cardinal Brancaccio for S. Angelo a Nilo, Naples, executed in Pisa; the Aragazzi monument for the parish church of S. Maria, now cathedral, for Montepulciano – this monument, now disassembled (two reliefs, London, V&A), seems to have been largely Michelozzo's work – and the exterior pulpit at Prato cathedral, for which Donatello executed the marble reliefs. From 1445–7 and again 1463–4 Michelozzo was associated with Luca della *Robbia on the bronze doors of the north sacristy of Florence cathedral. The silver figure of *St John The Baptist* surmounting the altar of Florence baptistry (1452; now Cathedral Museum) is Michelozzo's, as are the *Madonna* reliefs in marble in Florence, SS. Annunziata and Bargello, in terracotta in Budapest, Museum, and in stucco at Ortignano, S. Michele a Raggiolo. These non-collaborative works confirm the individuality of his strongly *classical style. The reader should recall, however, that Michelozzo is known primarily as an architect, his most famous building being the *Medici palace, Florence.

Miel, Jan *See under* Laer, Pieter van.

Miereveld or **Mierevelt, Michiel van** (1567–1641) Dutch painter from Delft, who studied history painting with Anthonie van *Blocklandt, the founder of Utrecht *Mannerism, (e.g. Stockholm, Nationalmuseum) but turned to fashionable portraiture on his return to his native city. He is known, if not now much admired, for his thousands of meticulous portraits, many of members of the ruling house of Nassau and the court at The Hague (Amsterdam, Rijksmuseum etc.). These were often repeated by his pupils, among them his sons **Pieter** (1596–1623) and **Jan** (1604–33) van Miereveld (a collaborative 'anatomy lesson' group portrait by them is in Delft, Gasthuis). Many of his portraits were also reproduced by contemporary engravers, mostly by his son-

in-law **Willem Jacobsz. Delff**. Miereveld was the teacher of Paulus *Moreelse.

Mieris, Frans van, the Elder (1635–81) Gerrit *Dou's best student and, after his death, the chief representative of the Leiden school of Fijnschilders, popular with princely collectors. His small *genre paintings were imitated by his sons **Jan** (1660–90) and **Willem** (1662–1747) and by Willem's son, **Frans Mieris the Younger** (1689–1763). There are paintings by him in St Petersburg, Hermitage; London, National; Schwerin, Museum; Vienna, Kunsthistorisches; etc.

Mignard, Pierre (1612–95) French painter, the chief rival of *Lebrun whom he succeeded in 1690 as First Painter to the King and Director of the *Academy. Having studied for some time in Paris under *Vouet, Mignard lived in Rome, 1636–57, visiting Venice and other north Italian towns in 1654–5 (altarpieces, Rome, S. Carlo alle Quattro Fontane). His style was formed on Annibale *Carracci, *Domenichino and *Poussin, although he pretended allegiance with the Venetian colourists in the quarrel between the *Poussinistes* and the *Rubénistes* (*see under disegno*), mainly to oppose Lebrun. In 1657 he was summoned back to France by Louis XIV, achieving success in the decoration of private houses and churches (e.g. Paris, Val-de-Grâce, dome, 1663), but mainly as a portraitist, the only field in which he showed any originality, giving life to the tired tradition of the *Portrait historié* (e.g. *Comte de Toulouse as Cupid asleep*, Versailles; *Marquise de Seignelay as Thetis*, 1691, London, National; *Louis XIV at the Siege of Maastricht as a Roman Emperor*, 1673, Turin, Galleria).

Mignon, Abraham (1640–79) Dutch flower painter, born in Frankfurt where his parents were religious refugees. He moved to Utrecht in 1659 with his first teacher, the flower painter Jacob Marrel (1614–81), to study with Jan Davidsz. de *Heem, one of whose ablest followers he became (Oxford, Ashmolean). Mignon was a deacon of the Walloon Church, and the gloomy mood of his experiments in 'forest floor' scenes and

cave interiors may have been intended to evoke *vanitas* ideas of transience (*see also* Marseus van Schrieck, Otto).

Mijtens, Daniel *See* Mytens.

Millais, John Everett (1829–96) British painter, founder with *Hunt and *Rossetti of the *Pre-Raphaelite Brotherhood (PRB) in 1848. By this time he had already been noticed as a precocious student. Some of the strongest early PRB paintings are his, e.g. *Lorenzo and Isabella* (1849; Liverpool, Walker). Ruskin's championing of the PRB led to personal contact in London and on journeys, and an elaborately *naturalistic portrait of Ruskin standing by a stream in Scotland (1853–4; London, pc) – also to Effie Ruskin's having her marriage annulled and marrying Millais in 1855. Having painted mostly religious and historical subjects, Millais now produced two outstanding examples of *genre painting, *The Blind Girl* (1854–6; Birmingham, City) and *Autumn Leaves* (1855; Manchester, City), a tender scene Ruskin particularly admired. Subsequently Millais's manner of painting became richer and more painterly, his subjects, when he was not painting society portraits, much more popular. Famous instances are *The Boyhood of Raleigh* (1870; London, Tate) and *Bubbles* (1886; A. & F. Pears Ltd.); the latter, already disseminated in the form of reproductions, was adapted to serve as advertisement for soap. Many international honours came to Millais in the 1870s and 80s, including a knighthood and a brief spell as president of the Royal *Academy in 1896. Many of his best paintings are in the galleries already mentioned and in the Lady Lever Art Gallery, Port Sunlight.

Milles, Carl (1875–1955) Swedish sculptor who studied in Paris and under *Hildebrand in Munich. He worked in a range of styles and under various influences, including that of *Rodin, and, like Rodin, looked back to medieval sculpture and even to pre-Columbian Mexican art. He received many official commmissions in Sweden and in the USA where he taught during 1931–45. The Millesgarden at

Lidingo, Stockholm, shows many of his sculptures.

Millet, Jean-François (1814–75) French painter of landscapes and *genre subjects and a prominent member of the *Barbizon School. He was born into a peasant family and himself worked on the land though a relative, a priest, encouraged him to read and develop his general education as well as an understanding of the bible. His father helped him find art training in Cherbourg, and the town of Cherbourg sent him to Paris in 1836 with a three-year study grant. His early paintings included erotic scenes in an 18th-century spirit as well as biblical subjects. He also painted portraits; in 1840 two of them were his first exhibits in the *Salon. Idyllic and romantic subjects, painted with great fluency, met with some success but did not satisfy the painter. In the later 1840s he gave priority to simple domestic and rustic themes and in 1848 for the first time exhibited a painting of rural life, *The Winnower*, following it with variants

In 1849 he left Paris with his wife and children for Barbizon, where he met Théodore *Rousseau and other painters. From this time rustic subjects occupied him almost exclusively and generally they brought him praise and purchasers though some commentators feared, and others recommended, the socialist preaching in them. Millet himself was more concerned to express the biblical grandeur of rural life and labour, untouched by capitalism and industrialization, in terms at once monumental and gentle. One critic aptly praised him as 'a great painter who walks in clogs the road of *Michelangelo' when, in the Salon of 1857, he showed *The Gleaners* in which three powerful female figures, peasants but at the same time also suggestive symbols (Fates?) dominate the foreground while an unearthly light beyond picks out other figures and horsemen, and buildings presented as simple geometry. Contemporaries valued the *classical overtones in many of Millet's paintings, which associated them with Homeric times. They also found some of Millet's characters vulgar and clumsy, especially those in whom the hardship of rural life was most strongly expressed.

By the time of the Paris World Exposition of 1867 his fame was very wide, notably because of *The Angelus* (1858–9), shown there and subsequently available in countless reproductions. American painters in Paris made his work known in the USA: the Boston Museum of Fine Arts has a major collection of Millets. The Musée d'Orsay in Paris has most of the key paintings. Altogether Millet met with much praise, occasional honours, and reasonable commercial success. Yet he and his large family were never far from poverty, and when he died *Corot had to help them financially. Younger artists of several generations learned from him, among them *Daumier, *Seurat and Van *Gogh, the last of whom painted several free versions of Millet subjects.

Millet, Jean-François, called Francisque (1642–79) Flemish-born French landscape painter active mainly in Paris, where he moved in 1659; he is also said to have visited Holland and England. No signed pictures by him survive, but several are authenticated by early *reproductive prints. He worked mainly in the style of *Poussin and *Dughet, sometimes with touches of Salvator *Rosa's *picturesque manner (*Mountain Landscape with Lightning*, London, National). His son **Jean** (1666–1723) was also a painter, as in turn was his son **Joseph** (1697–1777).

miniature A very small painting; now applied mainly to portraits that can be worn as jewellery or held in the hand (*see* e.g. Hilliard, Oliver) and to manuscript *illuminations. The word is not related to the Latin *minutus*, tiny, but derives from *miniare*, to paint in red, from *minium*, an artificial opaque orange-red pigment also called red lead, used by the *miniator* to emphasize initial letters. The miniature portrait, which flourished principally from the 16th through the 19th centuries, fused the techniques of manuscript illumination with the *Renaissance tradition of the portrait medal (*see* Pisanello).

Minimal art, Minimalism Movement principally in sculpture but also seen in two-dimensional art, important from the mid-1960s on as a reaction against *Pop art and *Abstract Expressionism's display of personal dramas. Minimalism is characterized by impersonal, clear and almost undifferentiated forms, often of the simplest stereometric sort and sometimes on a large scale. An alternative name was Primary Structures. John *Graham had proposed 'minimalist painting', self-sufficient and made with the simplest of means. The Minimalist sculptors presented basic forms and implied a minimum of aesthetic input. In 1965 the British philosopher Richard Wollheim wrote of art with 'a minimal art content', including *Duchamp's use of existing objects. The exhibition Primary Structures, shown at the Jewish Museum, New York, in 1966 was of work by US and British sculptors. From this event spread a movement that could be related to the Egyptian pyramids and to *Malevich's *Black Square*, and accommodated a host of explanations and variations. As so often, the label obscures differences of method and purpose sometimes more significant than common qualities, as when *Bladen's space-dominating solids are lumped together with *LeWitt's tacitly insistent grids of white bars. Among the most important artists associated with Minimalist sculpture are Robert *Morris, Donald *Judd and Carl *Andre, and those already named. Agnes *Martin stood out as the subtlest among the Minimalist painters. There were many other Minimalist shows in the 1960s and 70s. What they revealed was the complex qualities to be found in pure forms – in effect, their maximalism. Minimalism can be seen as part of a broad trend in the 1960s exploring the values of colour and form, of surface and space, density and lightness, as in *Op art, *Post-Painterly Abstraction and other movements of the time.

Mino da Fiesole (1429–84) Florentine sculptor, now chiefly remembered as the author of the earliest surviving portrait bust of the *Renaissance (*Piero de'Medici*, 1453, Florence, Bargello) and other busts of Florentine personalities (Florence, as above; also Washington, National; Berlin, Staatliche; Paris, Louvre). But he was active also on church sculpture: funerary

monuments, tabernacles and pulpits for Roman and Tuscan churches. Many of these works were undertaken in collaboration with other sculptors.

Minton, John (1917–57) British painter, trained in London and Paris. He served in the British army during 1941–3, and then became a prominent painter thanks both to his attractive personality and his energetic working as artist. He painted portraits, landscapes and figures in interiors and made book illustrations and occasional stage designs, and he also taught at leading London art schools during 1943–56. His melancholy combined with his primarily graphic way of painting to make him a leading figure in the English *Neo-Romantic movement. His reputation declined together with this movement in the 1950s.

Miró, Joan (1893–1983) Spanish painter, born and trained in Barcelona. After an illness in 1911 he convalesced at Montroig, south of Tarragona; from then on he tried to spend part of each year there and thought of it as his real home. In 1919 he made his first visit to Paris where he became friendly with *Picasso; from this time on he spent many winters in Paris. In 1921 he had his first Paris solo exhibition. His paintings at this time were stylized *naturalism, giving detailed accounts of objects within rhythmic compositions. Their effect is unreal, and soon fantasy and the search for an emblematic image replaced that naturalism. He joined the *Surrealists in 1924 and in 1925 contributed to their first exhibition. Some of his paintings were now openly fantastical, with objects rendered as signs and their context as broad washes of colour, at times with words and symbols. In 1928 he visited the Netherlands; on his return he painted four works, titled *Dutch Interior* (New York MoMA and elsewhere), after postcards of 17th-century Dutch *genre subjects but parodying their proud naturalism to create disturbing visions. He had a major solo exhibition in Paris that year; he showed in New York in 1930 and in London in 1933 and many other exhibitions followed. In 1926 and 1932 he designed ballets for

Diaghilev and Massine. His art stood on the borderlands between *Cubism, Surrealism and *primitive fetishism; technically it switched between painting, graphic and painting techniques combined, *collage and *assemblage; and procedurally it varied from prepared compositions to spontaneous images, sometimes stimulated by hallucinations caused by hunger and by the media themselves. He said he could not distinguish between art and poetry, yet his art also represents the freedom claimed by many moderns to assert the autonomy of their particular means without indebtedness to literature.

From 1940 to 1948 he was in Spain. The Civil War had caused him to make images of unusual ferocity; the Second World War evoked images of uncertainty and fear, but also the more impersonal set of gouaches, *Constellations* (1940–1), of little signs and forms on a tinted ground. These were shown in New York in 1945. Miró was in New York during 1947–8. 1951 and 59 saw retrospectives at the Museum of Modern Art there, and it can be claimed that Miró's work contributed to *Abstract Expressionism and also to the tendencies emerging to dethrone it. He was now an international star, prize winner at the Venice Biennale in 1954, creator with the potter Artigas of ceramic murals for the Paris UNESCO building (1957–8) and for Harvard University (1959–60), and the hero of many exhibitions, astonishing the world with his fecundity.

This was revealed additionally by his turning to sculpture in several materials and proving his mastery of large, flat colour paintings, wholly *abstract, deriving their character from the density or slightness of the colour areas. The paintings' power resides in the control of scale and minimal marks; scale is all important in the sculptures too, but these are cheerful creations, friendly monsters released from some of his earlier paintings and prints. Having influenced many contemporaries and younger artists, Miró was now at times drawing on them. Barcelona has a Miró Foundation with a major collection; a Miró Museum is in Palma; and the Maeght Foundation, near Vence in the south of France, has a number of his works,

including sculptures set up in the grounds. His work also features in the world's major modern art museums, notably the Museum of Modern Art in New York.

Mitelli, Agostino *See under* Colonna, Angelo Michele.

mobile Term first used in 1932 by *Duchamp for *Calder's hand- or mechanically-operated sculptures, and subsequently used by Calder for his standing or hanging constructions with elements moved by the passage of air. It has since been used for similar work by other sculptors, *kinetic but requiring currents of air and other such extraneous impulses for its motion.

Mochi, Francesco (1580–1654) Talented Tuscan sculptor, the son of the Florentine sculptor Orazio Mochi, who worked on the bronze doors of Pisa cathedral. Francesco was exceptional in being able to undertake his own casting, and is best known for his bronze equestrian statues of *Ranuccio and Alessandro Farnese* (1612–25, Piacenza, Piazza Cavalli) and the colossal marble *Veronica* in one of the piers of St Peter's, Rome (1629–40; *see also* Bernini, François Duquesnoy). Like his first independent work, an *Annunciation* for Orvieto cathedral (1603, now Orvieto, Museo), these sculptures are remarkable for their concern with movement; the *Veronica* was criticized by contemporaries for 'running'.

modello Italian for model; in English it usually denotes a small painted, drawn or three-dimensional proposal for a larger work of art, finished enough to be shown to a patron before final approval of the commission.

Modernism The adjective 'modern' distinguishes ideas and usages of the present and of the recent past from earlier ones, even when these are still generally adhered to. To *Vasari modern art meant the unsophisticated art of the Middle Ages, lacking the methods brought in by the revival of ancient learning and art we call the *Renaissance. For *Baudelaire, to be

modern art had to reflect contemporary society. Subsequently Modernism and Modernist were words attached to developments in the arts that were opposed to, or to some degree divergent from, the ideals and canons represented by the *classical tradition, prioritized in the *academies. When Modernism in the visual arts began is a matter of dispute. Some make 1863 the key date, with *Manet's challenging translation of time-honoured mythological subjects into scenes whose meaning is modern and secular; or 1874, with the first *Impressionist exhibition; or around 1888, with *Gauguin and *Bernard's anti-*naturalistic style, rejecting the idealism of academic art and its technical refinement in favour of a *primitivistic idiom partly derived from folk art: primitivism undermined the principle of imitation of appearances to which sophisticated art had generally aspired. These starting points are all in the history of French art, and there is no denying the role of Paris both as the arena in which French and other artists worked to test and establish new traditions and where a context of critical debate developed around them. Yet one is tempted to associate the origins of Modernism with *Romanticism and its challenge, throughout Europe, to the unique authority of classicism and its emphasis on the individual artist as the source of meaning and authenticity. From it came a self-consciousness, in matters of style and other priorities, and also the urge to form diverging groups or movements, new to the history of art yet characteristic of late-19th-century and of 20th-century art. This urge was, however, always countered by a contrary urge to individualism in thought and practice: all groupings were temporary; the more short-lived the firmer the orthodoxy they appeared to represent, even if their names continued to serve as rallying calls.

With the approach of 1900 the awareness of a new beginning in art was heightened by a wider sense of a new age opening to which changes in daily life and expectation of further changes (e.g. electricity for light and power, radio, aeroplanes, an agreed global time system, etc.) gave experiential reality. At the same time political upheavals – socialism and anarchism – engaged with

systems already weakened by the 19th century's succession of revolutions and wars. Modernism was widely, but not exclusively, associated with life in an industrialized society, and battle was joined with those who preferred art to reflect past ages and their relative stability. By the beginning of the First World War, in 1914, all the cultural centres of Europe and New York were kept aware of dramatic new developments in the arts, and particularly in the visual arts, by exhibitions, specialist journals and the press in general, although the response was largely negative and patronage was remarkably slow to engage. By 1914 it was also clear that Modernism was not one direction in the broad stream of modern art – though it was sometimes associated with an overcoming of *Impressionism as the last style rooted in imitating natural phenomena – but many, exhibiting marked differences in theory and practice. *Fauvism and *Cubism were contradictory from the start; *Futurism owed some of its methods to *Cubism but had significantly different goals; Russian Futurism differed notably from Italian Futurism; Duchamp's denial of visual communication as art's inalienable priority was beginning to be noticed; etc. Thus Modernism was never one movement, and became more divided as *abstraction became prominent, *Dada assaulted art's claim to be a civilizing force, and *Surrealism saw some painters return to detailed *naturalism to present their visions of an inner world while others ventured into a free, instinctive sort of abstraction. Totalitarianism's assault on all forms of Modernism, notably in Germany and Russia in the 1930s, abetted by a still quite general dislike of Modernist art forms, suggests both the challenge to authority in the name of personal freedom represented by Modernism and the need to repress it, not least its habit of international cross-fertilization, in the name of national consolidation.

Around 1970 *Post-Modernism emerged as a term implying the end of Modernism and a new pluralism in the arts, first in architecture where the so-called International Style had become dominant and was being devalued by replication. Springing from the ideas and methods of major architects such as *Le Corbusier,

Mies van der Rohe and Gropius, themselves active internationally and of wide influence, the International Style, crudely associated with the notion of functionalism in response to the industrialized world which it served, was felt to be stifling regional traditions, alternative building methods and individual hopes of fame through personal innovation. No such central orthodoxy existed in Modernist art, so that the champions of Post-Modernism have needed to demonize Modernism as a stultifying force, solemn and homogeneous. Modernism has been accused quite specifically of formalism, of elevating consideration of means and methods over communication. In 1920s Russia formalism had been developed as a theory of literature that emphasized its artificiality and distance from ideals of truth or *realism as generally understood, and concerned more with undermining these ideals than with serving them. Thus formalism was seen as the enemy of political cohesion in Communist Russia and all departures from naturalism or realism were accused of it. It is not, however, possible to show formalism as a controlling principle in Modernism at large.

Modersohn-Becker, Paula (1876–1907) German painter, born Paula Becker, who in 1898 joined the artists' colony at Worpswede, near Bremen, and in 1901 married the painter Otto Modersohn there. She made four visits to Paris (1900, 3, 5 and 6) during which she studied a wide range of art, at times guided by the poet Rilke who introduced her to *Rodin and sharpened her perception of *Cézanne. She exhibited with her associates in 1899 and 1906 at the Bremen Kunsthalle which now has a Modersohn-Becker Foundation; in the same city the Ludwig-Roselius collection has major examples of her work. Finding the sweet-tempered *naturalism of the Worpswede school too slight, she developed a more assertive and *primitive idiom from a variety of sources, using dense paint and emphatic forms. In 1906–7, responding to *Gauguin as well as to Cézanne, she achieved a quiet monumentality seen at its best in *Reclining Mother and Child* (1906; Bremen, Ludwig-Roselius Sammlung). She died a few days after giving birth.

Modigliani, Amedeo (1884–1920) Italian painter and sculptor, trained in Italy but formed as an artist in Paris where he worked from 1906 on. Much of his life he was poor and ill, suffering from pleurisy and then tuberculosis, but he was also a studious and hard working man, *pace* the myth that portrays him as a genius producing art by accident between affairs and drinking. *Cézanne was a major influence, but Modigliani stayed clear of *Cubism, opting rather for a reading of Cézanne's simplified forms and colours which links them with archaic sculpture and with the sophisticated line of *Botticelli. He rejected *Futurism because of its campaign against the past. Instead, he was inspired by the example of *Brancusi, whom he got to know in 1909, to make a series of heads and figures treated as caryatids and capitals, carved in soft limestone obtained nocturnally on Paris building sites. Here too he developed extremes of simplification, carried over into painting when he returned to this medium in 1914. There followed a remarkable series of figure paintings, portraits of fellow artists and of unnamed individuals and also long, languorous female nudes: at once primitive and elegant, alive and iconic, traditional and, particularly in their combination of fine linear design with understated but effective spatial dispositions, firmly modern. His one solo exhibition, in 1917, was closed because the nudes were considered obscene. He lived often in poverty and certainly imprudently, and though his wildness may have been exaggerated it seems he was willing to let disease carry him off. The day after he died his partner since 1917, Jeanne Hebuterne, killed herself.

Moholy-Nagy, László (1895–1946) Hungarian-American artist, photographer and designer, born László Nagy near the village of Moholy in Hungary, a student of law before the 1914–18 war, self-taught in everything else. As a soldier he began to write poetry and to make drawings of war scenes. 1919 saw the rise and fall of a Hungarian Soviet state, backed in cultural matters by *Kassak. After the counter-revolution, Moholy followed Kassak to Vienna and worked with him there in early 1920, continuing to do so when he moved to Berlin in February and associated with *Haussmann and other ex-*Dadaists and with the Russian *Lissitzky: all of them sought to develop an international *constructive art to replace *Expressionism and Dada. Moholy had gone from naturalistic and Expressionist drawing to painting emblematic compositions of shapes and signs suggesting modernity. By 1922, when he showed at the *Sturm Gallery, he was painting *abstracts similar to Lissitzky's 'Prouns'. That year he visited Van *Doesburg in Weimar and, with Kassak, produced the *Book of New Artists*, a review of progressive developments in art and design. In 1923 he joined the *Bauhaus staff to direct the Basic Course and the metal workshop. He reformed both to direct activities towards industrial design, with particular success in the field of lights and lighting fixtures. In the Dessau Bauhaus he promoted photography and typography and produced 14 Bauhaus Books which included his own *Painting, Photography, Film* (1925) and *From Material to Architecture* (1929; later republished as *The new vision*). He made his first documentary film in 1926: *Berlin Still-Life*.

In 1928 he left the Bauhaus and set up a design office in Berlin. He did stage designs and in 1930 organized the Bauhaus section in a decorative arts exhibition in Paris, showing there his *Light Prop*, the motif of his film *Light Play*. In 1932 he joined the Paris group Abstraction-Création, participated in the congress of CIAM (International Congress of Modern Architecture) and settled in Amsterdam where he had a major exhibition in 1934. In 1935 he moved to London where he worked as photographer, film-maker and design consultant. In 1937 he settled in America to head the New Bauhaus in Chicago. It closed in 1938 for financial reasons but in 1939 he opened his own School of Design there, later called Institute of Design. During 1943–6 he prepared his 'visual testament', *Vision in motion* (1947).

Like Lissitzky, Moholy saw all these activities as linked on the levels of production and of human expression. His objective and impersonal art is charged with a passionate faith in the constructive poten-

tial of mankind. His paintings, especially, achieved real grace and originality within their stylistic limits. His most interesting sculptural work is the kinetic *Light Prop*, developed during 1922–30 for a spectacle produced by the action of coloured lights on its turning forms in metal and plastic, known to us through reconstructions and his black-and-white film. He began to make *photograms in 1922 and by the mid-1920s was a busy photographer, stimulated by the example of *Rodchenko. Love of light and lightness marks all his activities. His faith in constructive work made him an inspiring teacher. Through his books, especially, he exercised a worldwide influence on art and design teaching, following the lead given by Lissitzky. In 1947 the Guggenheim Museum in New York presented a large memorial exhibition.

Moillon, Louise (1610–96) Leading French *still-life painter, the best-remembered member of an artistic dynasty of Protestant faith which comprised her father, the portraitist and art dealer **Nicolas Moillon** (1555–1619) and several painter-siblings, of whom the most notable was **Isaac Moillon** (1614–73), received in the French *Academy in 1663. She specialized in pictures of fruit or vegetables, piled in Delftware bowls or wicker baskets, poised on a table or stone ledge against a dark background; some of her works are animated, in stiff imitation of Frans *Snyders, by the addition of figures (*Fruit and Vegetable Seller*, 1630, Paris, Louvre). Other paintings Dessau, Museum; Chicago, Art Institute; Toulouse, Augustins; Strasbourg, Musée.

Mola, Pier Francesco (1612–66) Italian painter, born near Como into a family of artists; his father, an architect, moved to Rome by 1616. Mola's work, like that of Salvator *Rosa, eschewed both the sumptuous and the austere versions of *Baroque *classicism identified with *Pietro da Cortona and Andrea *Sacchi respectively for a more intimate and romantic vein, best seen in small paintings in which landscape is a major *expressive component (e.g. *Rest on the Flight into Egypt*, *St John Preaching in the Wilderness*,

London, National). Trained in Rome by the Cavalier d'*Arpino, he left c.1633 to study under *Albani in Bologna, remaining in northern Italy until 1647. During these years he was markedly influenced by the early work of *Guercino, with its extreme yet softly modelled *chiaroscuro, and by *Veronese, whose rich warm colouring he emulated (both influences are evident in the famous and splendid *Barbary Pirate*, 1650, Paris, Louvre). In 1657 he worked for the Chigi family in Rome and received his major official commission, the *fresco of *Joseph and his Brethren* in the Quirinal Palace; he was official painter in Prince Pamphilj's household for a number of years, until a quarrel in 1661 led to the destruction of what might have been his masterpiece in the Palazzo Doria at Valmontone.

Molenaer, Jan Miensz. (c.1609–68) *See under* Leyster, Judith.

Molijn or Molyn, Pieter de (1595–1661) One of the originators of the 'tonal' phase of Dutch landscape art, in which the topography and humid atmosphere of the Dutch coast dominate the representation of human activities (*see also* Salomon van Ruysdael, Jan van Goyen). He was born in London; in 1616 he joined the painters' guild at Haarlem, where he remained for most of his life. There are paintings by him in Brunswick, Museum; New York, Metropolitan; Prague, Gallery.

Molinari, Guido (1933–) Canadian painter, born and trained in Montreal, who moved on from *automatist work to becoming a champion of geometrical *abstract painting, first in black and white and then as colour compositions. He represented Canada at the 1968 Venice Biennale and a retrospective toured Canada in 1976.

Momper, Joos or Jodocus de (1564–1635) Prolific Flemish landscape painter, perhaps a pupil of Lodewijk Toeput. He specialized in decorative and fantastical mountain scenes, painted in a technique of translucent glazes and bold brushstrokes indebted to Pieter *Bruegel the Elder. A journey across the Alps has been postulated but is

not documented. Received in the Antwerp painters' guild in 1581 and made its Dean in 1611, he ran a busy workshop in the city, in which he was probably succeeded by sons who continued producing pictures in his style. A younger member of the family, however, **Frans de Momper** (1603–60), who became master in Antwerp in 1629, worked in Holland during 1645–50, largely adopting there the technique and compositions of Jan van *Goyen, although his earlier style relies on the elder de Momper. His work from 1650–60 is influenced by *Teniers (Leipzig, Museum; Brussels, Musées). The elder de Momper is known to have been in contact with Jan Brueghel the Elder and his son Jan the Younger, who furnished the figures in some of his landscapes, and whose village views and open vistas he occasionally emulated (e.g. Oxford, Ashmolean). He or his workshop furnished decorative landscapes for the Castles of Rosenborg at Copenhagen and Frederiksborg at Hillerød; there are also paintings by him in Vienna, Kunsthistorisches; Dresden, Gemäldegalerie; Kassel, Gemäldegalerie; Chicago, Institute.

Monaco, Lorenzo *See* Lorenzo Monaco.

Monamy, Peter (1681–1749) Marine painter, the first important English imitator of Willem van de *Velde the Younger (*see also* Woodcock, Robert; Scott, Samuel, and Brooking, Charles). Monamy's knowledge of ships outstrips his ability to paint water, and his sea battles are reconstructions of earlier depictions (Greenwich, National Maritime). Engravings (*see under* intaglio) by Paul Fourdrinier (active 1720–60) record his most popular paintings, now destroyed: illustrating a ballad by John Gay, 'Sweet William's Farewell to Black Eyed Susan', these patriotic sea pieces decorated four of the supper boxes at Vauxhall Pleasure Gardens, London – a commission perhaps obtained for Monamy by his friend *Hogarth.

Mondrian, Piet (1872–1944) Dutch painter, born at Amersfoort and trained at the Amsterdam Academy. He first followed the *naturalism of the *Hague school but awareness of new tendencies and also an interest in Theosophy led him to become more selective from among the forms before him and the colours on his palette. By 1908 he was using the bright colours of *Fauvism, though in a flat and controlled manner, for paintings of isolated motifs: church tower, windmill, tree. His *Evolution* triptych (1910–11) is a triple image of a woman's spiritual development, close in pose and style to his *Red Windmill* (1910). Simplification led him to *Cubism. The two versions of *Still Life with a Ginger Pot* (1911) are *Cézannist and *Cubist, but his Cubism is to do with structure, not with ambiguities of representation.

Early in 1912 he moved to Paris, where he dropped one of the 'a's from his original name, Mondriaan. In his new paintings Cubism becomes a means of structuring and of recording degrees of visibility in observing buildings and trees. By 1914 they appear abstract though still derived from seen motifs. That summer he visited Holland and was kept there by the outbreak of war. While it ran its course, he sought further clarification. The 'Pier and Ocean' series of 1914, short vertical and horizontal black lines on white grounds, conveys the scene by minimal means that still suggest observation. In the years that followed he tried dispositions of soft and firm colour rectangles with and without grids of grey or black lines, also diamond-shaped (square but hung so that their sides are diagonal) paintings of such grids alone, all now without a specific visual motif: he was searching for a universal language, capable of expressing experience through dynamic relationships of its elements. In 1915 he had met Van *Doesburg; in 1916 he met Van der *Leck and began to write the essays that were published in *De Stijl* in 1917+, and brought together in Paris as *Neoplasticism* in 1920. A 50th birthday exhibition in Amsterdam had little success; a 1922–3 De Stijl exhibition shown in Paris brought art-world notice but little money.

He had returned to Paris in 1919. In 1921 he attained his pictorial language: asymmetrical arrangements of rectangles of primary colour held by a structure of black bands on a white ground, using rectangular or square canvases mounted so as to

project rather than be contained in a frame. Some of these are diamond-shaped again, and he wanted them hung higher than normal, according them a quasi-religious status. That cannot describe the visual force of all these *icon-like paintings, the patiently worked density of his paint surface, the attention given to the location and varying breadth of the bands, also to hues and intensities of his primaries and whites, the amazing range of expression they carry. Reduction led to discoveries, and it was also in accord with philosophical ideas, partly derived from those of the Theosophical thinker M.H.J. Schoenmaekers along with the Dutch term *Nieuwe Beelding* (Neoplasticism). Art's task is to teach mankind its potential for true harmony, not to promote greed and patriotism or stir longings. It offers models for a better world; when this exists art will no longer be needed. From 1921 on he explored the vein he had opened up, in Paris until 1938, in London 1938–40, then in New York. In 1925 he withdrew from De Stijl because of Van *Doesburg's call for the use of diagonal structures. Mondrian held to the vertical/horizontal but again demonstrated the use of the diamond format. In the mid-1920s his art began to find purchasers, mostly American and German. He showed with *Cercle et Carré and joined *Abstraction-Création. Acquainted with Ben *Nicholson, he contributed to *Circle. He lived an austere, disciplined life in rooms arranged in the manner of his paintings. He had a passion for the latest dances and their music, and was perhaps the first painter to work to music from a gramophone.

New York evoked a late style of great virtuosity. He began to use bands of colour which, weaving over and under each other, imply space. He interrupted the bands with little squares of colour and placed larger colour areas outside the bands' control. Popular music and city sensations contributed to this new dynamism, sensed as exaltation in *Broadway Boogie-Woogie* (1942–3; New York, MoMA) and in the unfinished *diamond-format *Victory Boogie- Woogie* (1942–4; pc). Mondrian's influence on European painters was marked in the 1920s, and on American painters in

the 1940s. He is a major figure in *Constructive art. Moreover, he has been a model to artists intent on researching a particular area on the edges of art and design or art and ideas. The best collections of his work are in the Rijksmuseum Kröller-Müller, Otterlo, and in the Gemeentemuseum, The Hague (which holds the works mentioned above without location).

Mone, or **Monet, Jean** (*c.*1480–*c.*1550) Lorraine-born sculptor, trained probably in France and Italy, and practising mainly in the Netherlands (1524/5–50), although he is also recorded at Aix-en-Provence (1512–13) and in Spain (1516–17). In 1522 Charles V conferred on him the title of 'artist of the emperor' (alabaster relief portrait of Charles V and his consort, 1526, Gaesbeck, castle). Mone's chief works were alabaster altarpieces, the first *classicizing *Renaissance altars in the Netherlands (1533, Halle, St Martin; 1538–41, Brussels, Sainte-Gudule).

Monet, Claude (1840–1926) French painter, one of the creators of *Impressionism, in some ways its most steadfast practitioner but also the one who took Impressionism into new, contradictory ways to become, in the 1940s, a major influence on *Abstract Expressionism. He was born in Paris, son of a merchant who took his family to Le Havre in 1845. Young Monet had a talent for *caricature. *Boudin took an interest in him, showed him how to paint *landscapes in the open and advised him to seek further training in Paris. Monet went there in 1859, but ignored the guidance he had gone to seek. He got unreliable financial support from his family, maintained himself by selling caricatures, associated with *Courbet's circle and, working at the Académie Suisse, became friends with *Pissarro. He spent a year on military service in North Africa. He returned to Normandy in 1862 and met *Jongkind who helped him transmit into painting what his eyes, already opened by Boudin's example and the clear light of Africa, showed him. Late that year Monet returned to Paris and, partly to reassure his relatives, entered the studio of *Gleyre. There he met *Bazille, *Renoir and *Sisley who responded to his

pursuit of *naturalistic landscape painting. In 1864 he worked on the Normandy coast near Honfleur, painting seascapes two of which were accepted by the 1865 *Salon and well received by the critics. He was in the *Barbizon area in 1865 and painted his *Déjeuner sur l'Herbe*, echoing *Manet's controversial work but in much more visually truthful terms. He hoped to show it in the Salon but it was not finished in time; it was damaged by damp later and only portions of it remain. Unlike Manet, he was never tempted to adapt time-honoured formulations, but he was open to a wide range of stimuli from 19th-century art, not only that of France. In 1870 he was in London, fascinated by *Turner, *Constable and the fog; in 1871 and 2 he travelled in the Netherlands. About this time he began collecting Japanese woodblock prints. His father's death in 1871 meant the end of family support; friends helped financially and the dealer Durand-Ruel had begun to buy paintings from him but it was to be some years before Monet escaped the handicap of poverty. In 1871 he settled with Camille, whom he had married the previous year, on the banks of the Seine at Argenteuil. Renoir joined him there and they worked together, developing the technique which became known as Impressionism thanks to Monet's painting of 1874, *Impression, Sunrise* (Paris, Marmottan), shown that year in the first Impressionist exhibition. The river at Argenteuil, and from 1878 at Vétheuil, winter weather (especially the hard snow and ice of 1878–9), and in 1876–7 the Paris station of Saint-Lazare, provided his chief subjects. In 1886 he rented a house at Giverny, which he later bought and which remained his home. He travelled occasionally in France and to Holland in search of alternative motifs; later he went further afield, to Norway and repeatedly to London and Venice, but Giverny, where the Ept flows into the Seine, and especially the garden he developed there, was to become his chief resource.

His art came directly from nature and he had no need of a studio, he told a critic in 1880; innocence and spontaneity were the basis of his art. Yet increasingly he painted in the studio, using studies made out of doors, or finished indoors pictures begun outside; increasingly too he saw painting as a campaign of visual enquiry, returning to his motif in order to study it under different conditions of light. This enquiry can be seen both as scientific and as musical, a composing of variations on the same theme, and it may have been his reponse to the methodical, and thus to some critics the more intelligent and solid, methods of *Seurat and his disciples. Some of Monet's motifs dominate over the visual effects nature's light and atmosphere work on them: dramatic rock formations on the Etretat and Belle Ile coasts (1883–6), the winding colonnade of poplars along the Ept (1891), the front of Rouen Cathedral (1892–4). In other instances – the haystacks near his house (1889–91), a quiet section of the Seine observed from his boat studio in the mornings under diverse conditions (1896–8) – nature is the prime theme; even London's Houses of Parliament (1904) provide merely a stage set for nature's performance.

Meeting with more certain public response, he paid great attention to his image in French art and to his status. In 1889, during the great Exposition, he shared a large and lavishly catalogued show in Paris with *Rodin. The 145 works he exhibited included his *Creuse Valley* series of that year, hung together to bring out his responsiveness to the variability of visual experience. It was a success, critically and financially, but also established that purchasers would always break up his series. As he grew older his eyesight was afflicted with cataracts so that some of the effects he wanted eluded him and he had to rework canvases again and again. When possible, he kept series by him so as to finish all the canvases together, in relationship to each other, before exhibiting the ensemble. One critic declared him 'a symphonist and a decorator' and another echoed it: Impressionism, once seen as the art of capturing transient effects of light, had matured into an expansive art, capable of development. The experience of a moment had always been the latent motif of his art; Andrew Forge suggests that in the later paintings Monet meditates on time, on the moment as something anticipated, remembered and enshrined in colour.

From around 1910, the Japanese bridge he had built at Giverny, his flower beds and paths arched over with trees, above all his waterlily pond flanked by weeping willows, became his prime and obsessional motifs. His paintings grew in area, soon demanding two, three even four canvases per image and a specially constructed studio, and they gave rise to the idea of a gallery in which they would envelop the spectator. 1918 brought the thought of donating paintings to the state to celebrate the victorious ending of the war. In his last years the plan was realized, with the energetic help of the great political leader, Clemenceau, in terms of two elliptical galleries developed in the pavilion of the Orangerie in Paris's Tuileries Gardens, lined with his *Nymphéas* or *Waterlilies* on twenty-two canvases. These are only a small part of his amazing production of the time, though he destroyed many works and of the pictures that remain many were substantially repainted before he considered them finished. The largest is eighty-five times larger than *Impression, Sunrise*. In fluent brushstrokes he reinvented his experience of water and flowers, reflections and shadows, depths and upper spaces, weaving them together as a tapestry of paint.

Monet's long adventure with paint and light has earned increasing admiration and stimulated endless debate. By the time he died *abstract painting was well established and some had wondered whether his paintings too would not soon lose all references to nature. But nature remained the only master he admitted to, and it was a symphonic metamorphosis of nature, time transformed into a surface hinting at polyphonic spaces, that these last works present us with.

The Orangerie, the Musée Marmottan and the Musée d'Orsay in Paris are prime sites for seeing Monet's work. Americans were among his busiest early purchasers so that several USA galleries display his work, notably the Museum of Modern Art in New York.

Monnoyer, Jean Baptiste (1634–99) Leading French decorative painter, a collaborator of *Lebrun under whose direction he executed elaborate flower

pieces for overdoors (e.g. Paris, Louvre, Galerie d'Apollon; Versailles). Lord Montagu, who had been Ambassador to Paris from the 1660s, brought him to London to work at Montagu House until its completion *c.*1692 (a number of these flower pieces survive at Boughton House, Northamptonshire).

monotype *See under* Castiglione, Giovanni Benedetto.

Monro, Dr Thomas *See under* Cozens, Alexander.

Monstrance A liturgical vessel in which the consecrated Host of the Eucharist is exposed for adoration, motivated by the belief that Christ is physically present in the Eucharist. The monstrance, like the *ciborium, is richly decorated. *See also* altarpiece, baldacchino.

Monsù Desiderio *See* Barra, Didier and Nomé, François de.

Montagna, Bartolommeo Cincani, called (*c.*1450–1523) North Italian painter, born near Brescia and trained in Venice; he became the leading artist of Vicenza (S. Corona; S. Lorenzo; sanctuary of Monte Berico; Museum) and influenced later generations of Vicentine artists (*see* Marescalco), but there are altarpieces and *frescos by him throughout Lombardy and the Venetian mainland (e.g. Bergamo, Carrara; Milan, Brera; Padua, Scuola di S. Antonio; Pavia, Certosa; also Venice, Accademia) as well as in museums outside Italy (e.g. London, National). His austerely geometric and powerful style was influenced by *Antonello da Messina. His son and pupil **Benedetto Montagna** (recorded *c.*1522 and *c.*1552) was both a painter and an engraver (*see under* intaglio).

Montañés, Juan Martínez (1568–1649) Pehaps Spain's greatest sculptor, called 'the God of Wood' by contemporaries. Trained in Granada, by 1588 he was established in Seville, where he studied the ancient statues in the collection of the Duke of Alcalá and the works of *Torrigiano

and Juan Bautista Vázquez (1510–88). He accomplished the transition from *Mannerism to *Baroque and influenced not only other sculptors but the leading painters in Seville 1600–25: *Pacheco – who carried out the *polychromy on his figures after 1604 – *Zurbarán, *Velázquez, and above all his follower Alonso *Cano, who was both sculptor and painter.

Montañés supplied churches and other religious establishments throughout Andalusia and the overseas colonies, notably Chile (e.g. altar, 1607/22, Lima, Concepción). He conformed to the demands of the austere Spanish form of the Counter Reformation in the didactic content and popular *realism of his figures – although the latter was always tempered with a strong residue of *Renaissance *idealization. Carving figures relating to the cult of the Virgin, Christ and various saints, he was instrumental in establishing *iconographic novelties: the *Christ of Clemency* (1603–6) is one of the first images in Spain showing the crucified Saviour alive, '. . . looking at any person who might be praying at his feet' as the contract specified, and the *Immaculate Conception* (1629–31, both Seville, cathedral), albeit not the first, is one of the most influential embodiments of the doctrine. His range within such figures was wide, from the ingenuous *Christ Child lifting his Arms* (1606, Seville, cathedral) to the tautly nervous *St Francis Borgia* (1610, Seville, University Chapel) and the pathetic processional figure of the *Christ of the Passion* (c.1618, Seville, S. Salvador).

Monte, Cardinal Francesco Maria del *See under* Caravaggio, Michelangelo Merisi da.

Montefeltro Noble Italian family, lords of Urbino almost uninterruptedly from 1234 until 1508, when Duke **Guidobaldo da Montefeltro** (1472–1508) having died childless, was succeeded by his nephew and heir Francesco Maria della *Rovere. The member of the family best-known for his activities as a patron of the arts was the learned Duke **Federico da Montefeltro** (1422–82), captain of the papal armies, who ruled from 1444,

and built a new palace on the rugged bluff of Urbino in the most modern *Renaissance idiom. Its architect, the Dalmatian Luciano Laurana (1420/5–79) was succeeded by *Francesco di Giorgio Martini; the Duke's friend, *Alberti, may have advised on the later stages of the building. *Piero della Francesca, Paolo *Uccello, *Signorelli, *Joos van Ghent and Pedro *Berruguete were all employed at Urbino, either by Federico or by his son Guidobaldo.

Monticelli, Adolphe (1824–86) French painter, born in Marseille and principally resident there. He studied in Paris in 1846–9 and returned there often in the 1860s, but is seen as essentially a southern painter, affected by Italian *Baroque traditions as well as by the *Barbizon School, especially by *Diaz. He painted landscapes, portraits and still lifes, but also fantasies and *History paintings such as his *Don Quixote and Sancho Pansa* (Paris, Musée d'Orsay). He tended to use rich colours thickly and energetically, in spirit a *Romantic painter but pre-echoing *Fauvism and *Expressionism. *Cézanne was interested in his work; Van *Gogh praised his flower pieces and learned from them. Monticelli was successful enough to employ pupils on some of his paintings and to invite forgery, and his reputation faded after his death.

Montorsoli, Giovanni Angelo (c.1507–63) Peripatetic Florentine sculptor associated with *Michelangelo in the Medici Chapel and recommended by him to Pope Clement VII as restorer of the antique group of the *Laocoön*, 1532. His most important independent works were executed in Genoa, 1543–7 (S. Matteo; *Pietà* and statues; crypt tomb of Andrea Doria) and in Messina, where he became master of works of the cathedral in 1547 (*Fountain of Orion*, 1550; *Altar of the Apostles*, cathedral, c.1552; *Fountain of Neptune*, 1557, also Museo). When it was erected, the *Orion* fountain was the largest, tallest and sculpturally most elaborate fountain in Italy; it inspired the construction of *Ammanati's fountain in Florence. Montorsoli became a member of the Servite

religious order while still in Florence, 1530–1, and executed a number of works for the Servite church of SS. Annunziata.

Moore, Henry (1898–1986) British sculptor, born in the mining town of Castleford, Yorkshire, and trained at Leeds School of Art and the Royal College of Art, London. While learning traditional methods, he studied alternative traditions in the British Museum. He responded to the art of *Gaudier-Brzeska and *Epstein and began to work directly in wood and stone, suiting his action to the nature of the material. From 1923 he made almost annual visits to Paris; in 1925 a scholarship took him to Italy. In 1928 he had his first one-man show, in London; in 1931 his second. This and his first commissioned work, a relief figure for St James's Park Underground station, drew much abuse, also from his colleagues at the RCA where he was teaching. He left that post and was invited to start a sculpture department at Chelsea School of Art.

By the mid-20s he had found his two main themes, Mother and Child and the single female figure, as vertical half-figures and torsos and then also as the Reclining Woman. Picasso's *Neoclassicism can be seen in them, soon fused with a hieratic formality suggested by a Mexican Chacmool figure. The 1929 *Reclining Figure* (Leeds City AG), indebted to both, also pays homage to hard stone and soft flesh. The maturity shown here permitted new adventures, particularly into a suggestive form of *abstraction that implied awareness of Paris *Surrealism: e.g. the *Four-Piece Composition* (1934; London, Tate). He had in 1930 joined the Seven and Five Society which included *Nicholson, *Hepworth and other *avant-gardists; in 1933 he was a member of *Unit 1; in 1936 he was a founder of the English Surrealist group, without giving Surrealist principles exclusive rights over his art. The same years saw him carving concentrated forms, abstract yet probably rooted in some visual motif, also wooden forms threaded with string, as well as opened-up and pierced-through reclining figures in stone or in wood, which are influenced by Hepworth. The caricaturists' mad modernist sculptor had been

born, burrowing through chests in search of novelty.

In 1940 bombs damaged his London studio and he moved to a house near Much Hadham, Hertfordshire, which remained his home. Materials for sculpture were scarce and he drew more, that year beginning the *Shelter Drawings* of Londoners huddled in Underground stations to escape the bombing. There followed the *Madonna and Child* (1943–4) commissioned for St Matthew's, Northampton, and a series of Family Groups. These works attained something like popularity though the figures were simplified and monumentalized. The war produced a sense of community which made it easier for Moore to address his work to a wide public; paternity (his daughter was born in 1946) added its warmth. In 1945 he received the first of many academic awards, an honorary degree from Leeds University. In 1946 he went to America for the first time, for his first major retrospective shown at the Museum of Modern Art, New York. In 1948 he won the first prize for sculpture at the Venice Biennale. In 1951 he had his first British retrospective, at the Tate Gallery in London. Countless other honours followed, from all over the world, and an accelerating demand for exhibitions and for large sculptures in urban settings. He preferred to see them dominating a landscape, backed by a broad sky. He met commissions mostly by proposing or developing an existing work (exceptions include the Bouwcentrum Wall, Rotterdam, 1955, in brick, and the Time-Life screen in London, 1951–2).

To the London Festival of Britain show of 1951 he sent a gaunt *Reclining Figure* in bronze. He used this material often from the late 1940s on, at first in thin, stretched forms lacking the organic life he found in carving. Working in bronze meant that pieces existed in limited editions plus their parent form in plaster. This had practical advantages, but also enabled Moore to make remarkable donations. Some of his gravest works were done in bronze, including rare male figures such as *Warrior with Shield* (1953–4) and the *Three Upright Motives* (1955–6), almost a Crucifixion. Severity had succeeded the genial mood of the 1940s. There was also a widening of his

thematic range, though when he was asked to make a sculpture for the UNESCO building in Paris, he decided on a reclining figure carved from huge pieces of Travertine marble (1957–8). Yet not all the bronzes are severe. Some are evident additions to the *classical tradition, notably draped figures such as that made for the Time–Life building, London, in 1952–3. In 1951 Moore had visited Greece, deepening his already close knowledge of ancient sculpture. He was taking possession of his European inheritance.

1959 saw the start of a new series of Reclining Women, large two- and three-part figures of bone forms amplified and textured to suggest rocks and cliff faces. Other new ideas were brought to fruition in the 1960s and 70s, and he produced graphic works on new themes (e.g. the elephant's skull etchings, 1969, and the sheep drawings, 1972). The British Order of Merit, 1953, was followed by the European Erasmus Prize in 1968. 1972 saw the most gratifying of all his exhibitions when Florence, the city of Michelangelo, offered itself as his open-air gallery. Major exhibitions were shown also in Hong Kong and Japan (1968), Madrid (1981), New York (1983) and Delhi (1987). No artist has been known more widely; no sculpture has ever been more sought-after. Moore gave a large number of sculptures and graphic works to the Art Gallery of Ontario in 1974 and to the Tate Gallery in 1978, and he endowed Leeds City Art Gallery with a Sculpture Study Centre. There were many other gifts and much kindness, especially to young artists. He gave British sculpture international status and was a model of professional commitment. A foundation administers his estate.

Mor van Dashorst, Anthonis (also known as **Antonio**, or **Antonius, Moro**) (1517/21–76/7). Utrecht-born portrait painter, a pupil of the Italianate Jan van *Scorel. As portraitist to the *Habsburg courts in the Netherlands and in Spain, Mor forged a highly polished style of state portraiture, fusing meticulous technique and sober Dutch *realism with the grandeur of pose and mood, and the tonal refinement, of *Titian's portraits. His

influence on Spanish art was lasting, transmitted through his pupil Sanchez *Coello, to the latter's pupil *Pantoja, and perceptible still in the early court portraits of *Velázquez. He is said to have revived portrait painting in the Netherlands. The label *Mannerist which is sometimes attached to Mor's work is misleading, and refers to its international status rather than to any over-refinement of proportions or exaggerated complexity of pose.

By 1549 Mor was working in Brussels for the Emperor Charles V's minister Granvelle and for Mary of Hungary, the Regent of the Netherlands. The latter dispatched him to Lisbon to paint the Portuguese royal family, 1552. Around this time he also visited Rome. In 1554 he painted Mary Tudor on behalf of her bridegroom, Philip II of Spain, presumably in London although the visit is not documented and must have been brief (three versions by Mor: Castle Ashby; Boston, Gardner; Escorial). Brought to Spain by Philip, whose portrait he painted after the battle of St Quentin, 1557 (Escorial), Mor took fright at accusations of Protestantism and fled back to the Netherlands in 1558. There he continued, however, to work for Philip. Other portraits by Mor can be found in Madrid, Prado; London, National, NPG; Kassel, Gemäldegalerie; New York, Metropolitan; a self-portrait, Florence, Uffizi.

Mora, José de (1642–1724) Spanish sculptor active mainly in Granada; from *c*.1667 to 1680, he was also employed as Royal Sculptor in Madrid. Like Pedro de *Mena, he was a pupil of Alonso *Cano. A solitary and withdrawn artist, who succumbed to mental illness in his last decade, he produced *polychrome statues remarkable for their contemplative quietism (Granada, Santa Ana; San José; Charterhouse).

Morales, Luis de, nicknamed 'El Divino' (*c*.1520/5–86) The greatest native *Mannerist painter in Spain; he may have studied with Hernando *Sturmio in Seville. He is documented at Badajoz from 1546 until his death, leaving only for brief journeys to fulfil commissions, including some in Portugal (Elvas, São Salvador;

Lisbon, Museum). Between 1558 and 1578 he painted, with assistants, many large composite altarpieces usually depicting the Passion of Christ (Sanlúcar, Santa María de la O). His fame was mainly spread, however, through small exquisite panels for private devotion (London, National).

Morandi, Giorgio (1890–1964) Italian painter, born and trained in Bologna. He was involved in *Futurism around 1914. In 1919 he became acquainted with *Carrà and de *Chirico and in 1921–2 showed with them in Berlin and Florence, exploring in his art what de Chirico called 'the *metaphysics of the common object'. He was to paint many landscapes but it is *still life he is remembered for: clusters of bottles, jugs, bowls, vases and canisters, painted or etched in diverse groupings and with variations in light and colouring, so that they take on the character of actors on a stage, simple images charged with tacit drama. His etchings became known first but in 1948 he won a prize for painting at the Venice Biennale and from this time on his work has been shown and honoured on both sides of the Atlantic.

Morazzone; Pier Francesco Mazzuc-chelli, called (1573–1626) With *Cerano and Giulio Cesare *Procaccini, one of the three foremost painters of Milan in the early 1600s. Their pre-eminence is commemorated in the unusual joint commission of an altarpiece, the *Martyrdom of SS. Rufina and Seconda*, called the '*Tre Mani*' ('three-hander'), early 1620s, now Milan, Brera. Unlike Cerano and G. C. Procaccini, however, Morazzone avoided competing for work within the city of Milan itself. Having established his family in his native village of Morazzone, he travelled throughout Lombardy, and to a lesser extent Piedmont and Liguria, painting *frescos and large altarpieces *in situ*. His style was formed by contact with contemporary Roman *Mannerism during a youthful stay in Rome, *c.*1592–8, perhaps in the studio of the Cavaliere d'*Arpino (partly destroyed frescos, Rome, S. Silvestro in Capite), through study of Venetian painting, notably that of *Tintoretto, and by local traditions. Fundamental to these was the

work in the 1520s of his great predecessor at the *Sacro Monte of Varallo, Gaudenzio *Ferrari, whose 'hand' Morazzone was contracted to imitate in his own contributions to the pilgrimage site, 1605–14.

morbidezza Italian word meaning 'softness'; it must not be confused with the English word 'morbidity', disease. In the visual arts it implies soft transitions from one colour or tone to another, graceful and delicate contours and features – all that is the contrary of harshness or hardness in drawing, painting or sculpture. The word became fashionable in English 18th-century art criticism, when it was often admiringly applied to *Correggio.

Moreau, Gustave (1826–98) French painter, an early and major *Symbolist. Moreau started from the *Romantic emotionalism of *Chassériau, to develop a feverish visionary style for religious, historical and mythological figures, painted in *impasto to luxurious, encrusted effect. His sources range widely, from Italian *Renaissance painting to *Byzantine art and *Rembrandt. All his images, whatever their source or status, appear to belong to the same super-charged exotic and erotic world, with females made seductively evil, men seductively epicene. Salome was a recurring subject, and Huysmans and Oscar Wilde are indebted to his picturing of her. One version is in Paris's Musée Moreau, another, among other Moreaus, in the Musée d'Orsay. His watercolours, more or less *abstract experiments in search of pictorial dramatics, are sometimes thought to have influenced the *Abstract Expressionists; they may well have had some impact on their European equivalents, *art informel and *Tachism. Moreau was a well-liked teacher; among his students were *Matisse and *Rouault, the latter becoming the first curator of the Moreau Museum.

Moreau, Louis-Gabriel (1740–1806) and his younger brother, **Jean-Michel** (1741–1814) French artists; Louis-Gabriel, called Moreau l'aîné, the elder, painter to Louis XVI's brother, the Comte d'Artois, and etcher, specialized in fresh, simple

landscapes of the country around Paris which anticipate the work of *Corot and the directly observed cloud studies of *Constable (e.g. *View of Vincennes from Montreuil*, Paris, Louvre). Jean-Michel, Moreau le jeune, the younger, was a printmaker, designer and book illustrator, whose work gives a vividly detailed picture of upper-class Parisian life (e.g., *Monument du Costume*, 1783; Paris, Bibliothèque Nationale).

Moreelse, Paulus (1571–1638) Dutch painter, architect and poet. A pupil of *Miereveld in Delft, he visited Italy at the turn of the century and returned to make his career in Utrecht (*see also* Baburen, Terbrugghen, Honthorst). His history paintings (*see under* genres), reveal, in their tempered *Mannerism, the influence both of the older Utrecht painter *Bloemaert and of *Caravaggio (e.g. *Beheading of John the Baptist*, Lisbon, Museo Nacional de Arte Antiga). He is more important, however, for being perhaps the first Dutch artist to execute full-length, court portraits life-size (e.g. *Sofia Hedwig, Duchess of Braunschweig Wolfenbüttel*, Coll. H.M. The Queen) influenced by *Van Dyck, as well as *allegorical portraits (e.g. the same sitter with her children, as *Charity*), and portraits in pastoral dress (Amsterdam, Rijksmuseum).

Morellet, François (1926–) French artist, one of the founders of the *Groupe de Recherche d'Art Visuel. He specialized in structures of interlaced lines, most tellingly presented as three-dimensional wire grids shaped as spheres and hung in space.

Moretto; Alessandro Buonvicino, called (*c.* 1498–1554) Veneto–Lombard painter from Brescia, associated mainly with Catholic Reform patrons in his native city, for whom he executed religious paintings with explicit doctrinal content or in everyday settings (Brescia, Pinacoteca and churches). He was a prominent member of the Confraternity of the Sacrament, for whose chapel in S. Giovanni Evangelista he painted, with *Romanino, important decorations on canvas, later to affect *Caravaggio (*see also* Savoldo). He executed, too,

a few portraits, which are fundamental to the development of Lombard portraiture and influential on his probable apprentice *Moroni (e.g. New York, Metropolitan; London, National; Brescia, Salvadego Coll.).

Morisot, Berthe (1841–95) French painter from a well-to-do family. She studied informally with *Corot and *Barbizon painters, became *Manet's friend and sometimes model and married his brother in 1874 when she was already a mature painter. She encouraged Manet to paint out of doors and herself was one of the most committed *Impressionists, exhibiting with them regularly. Her lively technique suggests *Renoir's benign manner, moderated towards the greyish tones of Corot. Her work is best seen in Paris (Orsay), but Washington (National) has particularly fine examples and Santa Barbara, California (MoA) owns her amazing *View of Paris from the Heights of the Trocadero* (1872), an early Impressionist masterpiece giving an effect of freshness in spite of the extensive care that must have gone into it, and combining her two main subjects, landscape and women with children.

Morlaiter, Giovanni Maria (1700–81) Leading Venetian *Rococo sculptor, notable for precise modelling, exquisite decorative detail and narrative brio. Although his family came from the south Tyrol, he himself was born in Venice, where his father is recorded as a resident in 1697. He received virtually all the major sculptural commissions for new churches in Venice and its dependencies (Venice, SS. Giovanni e Paolo; San Rocco; Padua, Cathedral; Dalmatia, Prcanj, Marienkirche); his greatest works are in the Gesuati, where they complement paintings by *Piazzetta and Giovanni Battista *Tiepolo, and where he worked for at least fifteen years. Many of his clay and terracotta models are in Venice, Ca'Rezzonico. One of the founder-members of the unofficial Venetian *Academy in 1724, and appointed Director in 1755, Morlaiter was on the jury which awarded *Canova the Academy's prize in 1775.

Morland, George (1763–1804)
English painter of landscape and rustic
*genre. Although he began, *c.*1785, with
portraits and sentimental vignettes of rural
life, in the 1790s he produced unvarnished
representations of rural poverty (London,
Tate; Edinburgh, National). These works
were bowdlerized in the many engravings,
executed by his brother-in-law William
Ward, which popularized his *œuvre*, so that
the paintings' contemporary significance
has, until very recently, been overlooked.
The son of a minor artist and restorer,
Henry Robert Morland (*c.*1730–97),
Morland was trained by his father and
employed by him to restore and fake the
Dutch Old Masters, who influenced him.
Upon reaching independence, he dissoci-
ated himself from polite society, living
amongst the urban and rural proletariat; he
became an alcoholic; was arrested as a
French spy whilst fleeing his creditors in
1799 and afterwards imprisoned for debt.
He lived out most of his last years within
the rules of the King's Bench; his later
production is largely hack work to pay off
his debts. Even at the time of his greatest
success, however, Morland refused to work
for individual patrons or dealers, preferring
to sell through an agent and maintain his
independence, in defiance of the norms
of 18th-century art production. There is
a remarkably unflinching self-portrait of
*c.*1802–3, *The Artist in his Studio with Mr
Gibbs frying up* (Nottingham, Castle),
which shows the bleak consequences
of Morland's personal and professional
rebellion.

Morley, Malcolm (1931–)
British-American painter, from 1964 resi-
dent in New York. Combining elements of
*Pop art and *Photorealism, he made his
reputation in the 1970s and 80s with large
paintings based on carefully transcribed
postcards or posters, giving them political
point by selection or added marks.

Mornauer Portrait, Master of the
(active *c.*1460–80) German painter,
named after his vigorous portrait of
Alexander Mornauer, town clerk of Land-
shut in Bavaria, now in London, National.
A portrait of Archduke Sigismund of the

Tyrol (Munich, Alte Pinakothek) is also
attributed to him.

Moro Antonio *See* Mor van
Dashorst, Anthonis.

Moroni, Giovanni Battista (1520/24–
78) One of the greatest portrait
painters of his century. Born near Bergamo
(where *Lotto had worked *c.*1513–25) he
was apprenticed to *Moretto in Brescia
(*see also* Romanino, Savoldo) and has
been called a stylistic link between these
two Veneto-Lombard centres: rooted in
Lombard *realism but affected by Venetian
colourism (*see under disegno; also* Giorgione,
Titian). He remained close to Moretto,
sharing his Catholic Reformation outlook
and basing his relatively few religious
paintings on those by his master (e.g.
Trento, S. Chiara, S. Maria Maggiore;
Milan, Brera). His dependence on
Moretto's portraits was, however, soon
outgrown.
 Moroni's portraits encompass a wide
social range of sitters – ecclesiastics at the
Council of Trent, Bergamesque nobles and
professional men, and the famous *Tailor*
(*c.*1570, London, National) and *Sculptor*
(Vienna, Kunsthistorisches). As is usual for
the period, men far outnumber women, the
exceptions being noblewomen, depicted
perhaps on the occasion of their marriage
and/or as pendants to the portraits of
their husbands (e.g. Bergamo, Accademia;
London, National). Moroni painted on
canvas, coarsely woven at first, finer later,
when the paint itself came to be more
thinly and fluidly applied. All but one of
the known likenesses engage the spectator's
gaze (*Canon Ludovico di Terzi*, London,
National is the exception) although in other
respects there are unusually many varia-
tions of pose, format (from full-length to
bust) and viewpoint (level with the sitter's
eyes to high above or low beneath). Schol-
ars have divided his portrait *oeuvre* into
mainly two groups: a 'rose' or 'red' period,
lasting until *c.*1560, so-called from the
prevalent warm tone of the paintings and
the colour of the sitters' costumes, and a
'grey' period late in his life, in which cool
black, white and grey tones predominate,
echoing the Spanish influence on dress as

in art. The apparent directness and intimacy of these works are far removed from the courtly portraiture of, e.g. *Van Dyck.

Moroni's example was to influence Bergamesque painters through the 18th century (*see* Giuseppe Ghislandi). For a long time he was a favourite of English collectors and remains particularly well represented in the National Gallery, London, although many paintings in private hands were sold to American museums (e.g. Washington, National; Boston, Gardner; Chicago, Institute).

Morris, Robert (1931–) American sculptor, trained in Kansas City, MO, and in San Francisco. In New York he pursued graduate studies in art history. Among his first sculptures is *Box with the Sound of its Own Making* (1961; pc): a wooden box from which a tape recorder gives out the noise of making it. It is a *Conceptual piece, the biography of a rough timber cube perhaps mocking the *Abstract Expressionists' talk of heroic daring. His *Four Mirrored Cubes* (1965) present and deny simplicity by exhibiting everything but themselves. He was one of the leading *Minimalist artists in the mid-1960s, producing some of the most striking and intelligent works. He also collaborated with *De Maria and others on dance and theatre pieces. In the later 1960s he worked with soil and sods, and with lengths of felt which he cut into mighty strips whose gravity counters his almost random action upon the material. Subsequently he continued his intense exploration of the relationship of perceptual and emotional responses to stable forms. A selection of his writings was published in 1993 as *Continuous Project Altered Daily*.

Morris, William (1834–96) British artist, poet, political writer and designer-craftsman. Of solid middle-class family, Morris went to Oxford intending to become a clergyman. There he met *Burne-Jones and started reading *Ruskin. He decided he would be an architect and entered the office of a leading London architect, G.E. Street. But he also got to know the *Rossetti circle and was persuaded to be a painter. He joined Rossetti in working on murals for the Oxford Union in 1857. The following year he painted his fiancée Jane Burden in the *Pre-Raephaelite manner as *La Belle Iseult* (London, Tate), his only known easel painting. He believed that painting should be on walls and furniture, and his subsequent work was of this sort, e.g. scenes from the life of the warrior saint on the *St George Cabinet*, c.1862 (London, V&A). The cabinet itself was designed by Philip Webb (1831–1915) who in 1859 designed the Red House, in Bexley Heath in Kent for Morris, a milestone in the history of modern architecture. Morris involved his artist friends in furnishing and decorating it, and this led him in 1861 to set up a business, producing first stained glass and furniture, and then also wallpapers and printed textiles. Later he took more personal control of the firm, which in 1875 became Morris and Company. Its production widened to include woven fabrics, tapestries and carpets. The firm was employed in the decoration of several churches, with Burne-Jones doing paintings and sharing in the work of designing stained glass. Morris wanted to be both designer and craftsman, though in practice he had to employ assistants in order to supply his growing market. Already in 1865 he sold the Red House in order to live 'above the shop' in London; in 1871 he leased Kelmscott Manor in Oxfordshire to release the space in London for workshop use, and the Manor became partly another workshop where Morris wrote and worked on calligraphy and illuminated manuscripts. The Kelmscott Press he founded in 1891 was located in Hammersmith; its best known publication is the 'Kelmscott Chaucer' (1896).

Led into political criticism by Ruskin, Morris in 1883 became a committed socialist and communist, giving an increasing share of his time and exceptional energy to politics, lecturing, writing and editing to promote socialism in England. The reform of art and design was intimately linked to his view of society, which he saw as enslaved by capitalism, under which

honest, honourable work of individuals had been turned into the repetitive, meaningless labour of the many, living in intolerable conditions, by the demands of competition and for the profit of a few, depriving the worker of even a low level of decent living, let alone any satisfaction in his work. The crafts would show the way by bringing designing and making back into the same hands. Morris believed, he wrote in reviewing the 1884 Royal Academy exhibition, 'that the new art will come to birth amidst the handicrafts . . . and that the academical art which was developed from that misreading of history which we call the Renaissance, will prove a barren stem.' Medieval art and its continuation in rustic traditions of making and decorating provided the main guidelines, to be developed by hands-on experience in modern times. Morris was aware that his own firm could only point the way and that its goods would reach only a small section of society. Yet his firm's impact was marked by 1883, when a reviewer wrote that the name 'Morris' was a household word standing for 'neat not gaudy' things, 'English in taste, not French'. Shortly after his death, his friend Walter *Crane described Morris's 'revival of the mediaeval spirit' as marked by 'a return to simplicity, to sincerity; to good materials and sound workmanship; to rich and suggestive surface decoration, and simple constructive forms'.

Morris's kind of design, intimately related to the processes and materials involved and with an eye to the function of the product, associates him with the priorities of *Post-Impressionism and contributed directly to the development of the *Art Nouveau taste for flat, not directly *naturalistic images and patterning. His influence, often linked to that of Ruskin, was great wherever reform of the arts was in question. But the *Bauhaus, starting from Morris's emphasis on the crafts' centrality, was already behind the times and soon had to adjust its principles. In Holland and in Russia, with De *Stijl and *Constructivism, Morris's thinking was associated with rejection of industrial production and thus with regressive medievalism by the generation that rejected the aestheticism of Art Nouveau as well as the bourgeois values of academic art.

Mortimer, John Hamilton (1740–79) With *Wright of Derby he was a pupil of *Hudson (1756/7), and in the 1760s practised as a portraitist and painter of *Conversation Pieces in the style of *Zoffany. His reputation, however, rests on scenes of bandits and 'horrible imaginings' in the manner of Salvator *Rosa, and on romantic literary subjects which anticipate the work of *Fuseli. In 1775 he exhibited four companion pictures, *The Progress of Virtue* (London, Tate), slightly disingenuous 'moral subjects' which have been compared with similar works by *Greuze.

Moser, George Michael (1704–83) Swiss gold and silver chaser and enameller who settled in England in the 1720s. He had a drawing school in the 1730s, and later became a leading figure in the St Martin's Lane Academy founded by *Hogarth; in 1768 he was elected the first Keeper of the Royal *Academy. He was important in popularizing *Rococo, later *Neoclassical, designs, inspired by or copied from prints by French artists, of which he owned a notable collection. His daughter **Mary Moser** (1744–1819) was a popular flower painter and, like her father, a foundermember of the Academy. Her portrait appears (as a painted portrait along with that of Angelica *Kauffmann) in *Zoffany's group picture of *The Academicians of the Royal Academy*, 1772, in the Royal Collection.

Moser, Koloman (1868–1918) Austrian painter and designer, one of the founders of both the Vienna *Secession and of the Wiener Werkstätte (Viennese Workshops). His work ranged from typography (including typewriter type with little squares for full stops) to painting and exhibition design. He left the Werkstätte in 1906 but continued busily to teach, design and occasionally paint.

Moser, Lukas (active 1432) Outstanding German painter, now known solely from one work, the *Magdalen Altarpiece* in

the church at Tiefenbronn near Pforzheim in the region of Baden. The painting, notable for its forceful *naturalism and sculptural form, bears a remarkable inscription in German which, translated, reads, 'Cry art, cry, and mourn bitterly, no one wants you anymore, so oh woe; 1432, Lukas Moser, painter from Weil, master of this work, pray to God for him.'

Moses, Anna Mary Robertson 'Grandma Moses' (1860–1961) American *naïve painter of New York State, who turned to painting in the 1930s after a busy farmstead life that had left time only for occasional decorative painting for her home. Once she set to, in her 70s and after, she produced generously: paintings on canvas and, more habitually, on board as well as pictures made from yarn in the 30s and 40s and a series on tiles in 1951–2. Her earlier pictures were based on magazine illustrations; later daily sights and memories served her even better for serene scenes of country life, present and past in her lifetime, but also projected back into the 18th century and including historical scenes such as the *Battle of Bennington* (1953; three versions). Her work gained in confidence and range, always combining observed detail with generalized representations of figures and environment. Known from the 1940s on, she became a national heroine through the media. In 1955 she was commissioned to paint President Eisenhower's farm; after her death her *July Fourth* (1951) was chosen for a stamp to mark Senior Citizens' Month. She told her story in *My Life's History* (1952). The Bennington Museum, Bennington, VT, has the best collection of her work.

Mostaert, Gillis the Elder (*d.*1598) Netherlandish *landscape and genre (*see under* genres) painter, an imitator of Pieter *Bruegel the Elder, as were his brother **Frans** (*d.*1560?) and his son **Gillis the Younger** (*b.*1588).

Mostaert, Jan (*c.*1472–after 1554) Ill-documented Haarlem painter; much of the information about his life and work comes from Karel van *Mander. Active in the painters' guild of his native city, he also served intermittently at the court – in Brussels and Malines – of the Regent of the Netherlands, Margaret of Austria (probably from before 1519–after 1521). Despite his early dependence on the older Haarlem painter *Geertgen tot Sint Jans, he introduced elements of the more modern and sophisticated southern Netherlandish art, of *Gossart and *Patinir in particular, into the background of his later portraits and altarpieces. There are works attributed to him in Brussels, Musées; Amsterdam, Rijksmuseum; Liverpool, Gallery; Würzburg, Museum; London, National; etc. An imaginary 'West Indian landscape with many nude people, a fantastic cliff and exotic houses and huts' has been identified from Van Mander's description as a picture now in Haarlem, Hals, or perhaps an unknown replica.

Motherwell, Robert (1915–91) American painter trained in art in Los Angeles and San Francisco and in philosophy at Stanford University and Harvard. In 1935 and 1938–40 he studied at Grenoble and Oxford and then, back in the USA, art history at Columbia University. Interested in psychoanalysis and *Symbolist theory, he was drawn to the *Surrealists residing in the USA and became a full-time painter partly under their influence. In 1943 he contributed *collages to an international collage exhibition at the New York gallery Art of This Century, and had there his first solo exhibition in 1944. From 1945 on he edited the 'Documents of Modern Art' and 'Documents of 20th-Century Art' series (including the milestone volume, *The *Dada Poets and Painters*, 1951) and was prominent among New York's artists and teachers of and writers about art. In 1948 he joined with *Rothko and others in founding the New York advanced painting school 'Subjects of the Artists'. A central figure of American *Abstract Expressionism by this time, he was isolated within the loose group by his relative youth and by his admiration for and debt to French theory and practice. He produced many paintings, large and small, as well as collages and prints, balancing *Expressionist subjectivity with pictorial drama. His painting can be both lyrical and intense, as in the

long 'Elegy for the Spanish Republic' series, begun in 1949. Though this and other series can be seen as variations on a particular formal and colouristic theme, Motherwell was never associated with one particular method or image, though the dramatic use of black and white on a large scale was seen as characteristic. Admired as a writer and lecturer, a selection of his texts was published as *Collected Writings of Robert Motherwell* in 1992. His first retrospective show, at MoMA, NY, in 1965, toured Europe and established him internationally as a major figure in 'the new American painting'.

Moulins, Master of (active by 1483–c.1500) Outstanding French painter, named after his chief surviving work, the *triptych of c.1498 in Moulins Cathedral. He is sometimes identified with Jean Hay, who signed an *Ecce Homo* now in Brussels, Musées. The influence on him of Hugo van der *Goes is particularly evident in his superbly individuated *donor portraits (Autun, Rolin; Paris, Louvre etc.). The half-length of a young girl in the Lehman Collection, New York, Metropolitan, is presented as an autonomous work but may come from a larger, devotional whole. Other works, Chicago, Art Institute; London, National (perhaps fragments of the same altarpiece) show the master's replacement of Hugo van der Goes's emotional intensity by grave elegance and assured clarity of space, form and colour.

Moulthrop, Reuben (1763–1814) Colonial American portraitist, working throughout the rural centres of Pennsylvania, New York and Massachusetts, where he toured a sort of side show of wax effigies of well-known people. His skill as a sculptor carried over to his painted likenesses, which are unusually successful in evoking space and volume (New Haven, Yale University)

Mucha, Alphonse (1860–1939) Czech painter and graphic artist who trained and worked in Paris. He is famous for his *lithographic posters, representing mostly female figures in flat flowing lines and pale colours, accompanied by crisply

distorted lettering. This work was an important contribution to the development of *Art Nouveau, and became very popular in the 1960s when reproductions of his posters were sold in large quantities.

Muche, Georg (1895–1987) German painter. Trained in Berlin and Munich, he taught at the *Sturm School in Berlin and was appointed to the *Bauhaus in 1920. He was closely associated with *Itten there, but involved himself in post-Itten activities, especially in working on exhibitions and designing an experimental house. In 1927 he went to Berlin to work with Itten again. From 1931 on he taught at Breslau and at the Krefeld Textile School. His earlier paintings are in an expressive *abstract style, colourful and busy, but during the 1920s he returned to a simplified *figuration.

Mudéjar Spanish term used to describe an Iberian style of architectural or sculptural ornament evolved by Moorish artists working under Christian rule, distinguished by a proliferation of geometric star-patterns or interweaving organic forms. In the *Renaissance, a similar flattened ornamental style, with Italianate elements such as *grotesques, was called Plateresque, because of its resemblance to the work of silversmiths (from *plata*, silver).

Mudo, El *See under* Navarrete, Juan Fernández.

Müller, Otto (1874–1930) German painter, trained in Breslau and Dresden. First influenced by *Böcklin's pantheism, he became one of the Brücke circle in Berlin in 1910 and known as one of the *Expressionists though his paintings of gypsies, often of naked girls, among trees have an easy charm which their angular forms cannot disguise. He developed a technique of tempera painting on canvas. In 1919 he returned to Breslau and taught there until he died.

Mulready, William (1786–1863) Irish-born painter, active in England, first as painter of landscapes too *naturalistic to

please the public, then, under the influence of *Wilkie and of Dutch 17th-century painting, of touching *genre pictures. His tones became fresher, on a white ground so that his outdoor scenes especially were more flooded with light. Some of his mature work, e.g. *The Sonnet* (1839; London, V&A), with its subject of innocent peasant love, anticipated *Pre-Raphaelite methods. *Ruskin responded to his meticulous way of working but found *The Younger Brother* (London, Tate) 'the least interesting piece of good painting I have ever seen.'

Multscher, Hans (first recorded 1427–59/67) German stone and limewood sculptor, whose workshop in Ulm produced much of the best sculpture of its period in southern Germany and influenced later artists (*see* Michael Erhart). He had direct experience of the Burgundian sculpture of Claus *Sluter's followers. In 1433 he signed a *retable altarpiece for Ulm Minster; in 1456–9 he worked at Sterzing (now Vipiteno) on a retable for the Pfarrkirche. Many fragments of this dismantled altarpiece have been identified (Sterzing, Museum, Pfarrkirche; Innsbruck, Ferdinandeum; Munich, Museum). Multscher's workshop also produced paintings, but it is not clear whether he himself was a practising painter.

Munch, Edvard (1863–1944) Norwegian painter who developed from *naturalism to an intensely personal sort of *Symbolism, stimulated by the work of Van *Gogh, *Gauguin and the *Neo-Impressionists. His mother died when he was 5, an elder sister when he was 14: his art expresses the fear and pain these losses and his sexual anxieties brought him. A visit to Paris in 1885 was followed by a longer stay in 1889–90. In 1892 a Berlin artists' group arranged a Munch exhibition which caused a great scandal and had to be closed. He spent much of 1892–1908 in Berlin among writers such as Richard Dehmel and August Strindberg. During these years he also produced his first graphics, lithographs and woodcuts taking on an equal importance to painting in his work.

At times they served as intimate forms for particularly private subjects, at others gave wide currency to images of dread and thus contributed to the flowering of *Expressionism. Formal discoveries in them could serve for paintings and vice-versa. His subjects up to 1908 were drawn directly from personal experience: sickness and death, lust and jealousy, fear of sexual disease, fear of life. This last is unforgettably pictured in *The Scream* (1893) in which nature echoes man's soundless cry through oppressive colours and a sky and landscape seen as snaking forms. His understanding of female sexuality as vampirism echoes his time's obsession with the *femme fatale* – but the stridency of his horror singles him out.

1908 brought a breakdown and treatment; in 1909 he returned to Norway. From now on his art was more outgoing and could find a public role, as in his Oslo University murals (1909–16), but the old urgency is not lacking, especially in his self-portraits. He lived at Ekely outside Oslo and when he died left to the city over 20,000 works. These form the Munch Museum in Oslo; the Oslo Nasjonalgalleriet owns *The Scream* and other major works. During his lifetime there were many exhibitions in Oslo and several German cities as well as Prague and Stockholm.

Munkácsy, Mihály (1844–1900) Hungarian painter whose family name, of Bavarian origin, was Lieb and who adopted the name of his birthplace to signal his national allegiance. He was trained in Budapest, Vienna and Munich, and came under the influence of *Courbet when he visited Paris in 1867. His first major works adopted his *realism of theme and style, as in *The Condemned Man's Last Day*, done in Düsseldorf in 1868 (Budapest, MFA). In subsequent years he moderated this realism, using glowing colours and a softer, more personal brushstroke on landscapes, *Genre scenes, sometimes also *history paintings, biblical and historical, e.g. *Milton dictating 'Paradise Lost'* (New York, Lenox Library) which won him a gold medal at the Paris Salon of 1878. The most representative collection of his paintings is Budapest's Museum of Fine Art.

Munnings, Alfred (1878–1959) British painter, principally of horses and their owners and president of the Royal Academy during 1944–9. The quality of his paintings is under dispute, marked as they are by a liveliness that to many appears spurious. His insistence on art as a cheerful rendering of pleasant subjects made him the committed enemy of any deviations from this supposed norm. He became famous through his speech at the RA annual dinner of 1949 when he made a wild attack on modern art and artists. This, broadcast live, occasioned a media scandal, but also drew attention to the increasingly routine nature of Munnings's much sought-after high-society art. His autobiography appeared in three volumes in 1950, 51 and 52.

Münter, Gabriele (1877–1962) German painter who, after early travels and art study, in 1902 entered the Phalanx school in Munich and met there *Kandinsky who admired her abilities. Her work too sought symbolical simplification through study of *primitive art. They lived and travelled together to Paris and elsewhere, and she exhibited with him on several occasions. She developed a strong idiom for landscapes, figure subjects, still lifes and interiors, including partly humorous compositions showing Kandinsky, *Yavlensky or *Klee observed in conversation. In 1913 she had a retrospective in Berlin. In 1914, after a joint exhibition in Stockholm, Kandinsky and she went their separate ways. Her subsequent work was more pensive and expressive. In 1917 she had a major exhibition in Copenhagen, then did not paint for some years until she lived with the art historian Johannes Eichner, repeated some of her earlier pictures and painted new still lifes and landscapes. In her last years she experimented with *abstract compositions in strong colours. The Lenbachhaus in Munich has a large collection of her work.

Murillo, Bartolomé Esteban (1618–82) With *Zurbarán, whom he displaced in public esteem, the foremost painter active in Seville; one of the greatest and most pro-lific Spanish *Baroque artists. Throughout the 18th and 19th centuries his international fame out-ranked that of *Velázquez and rivalled that of *Raphael. Works by him, in English collections by 1729, directly inspired *Hogarth, *Reynolds and *Gainsborough. But the mild and suave temper and 'vaporous style' of his mature and late religious paintings, and their wholesale reproduction as pious images and for the 'chocolate-box' market, produced a reaction which led to his dismissal, c.1900, as a mere purveyor of sickly sentimentality. Only since the comprehensive exhibition of his works on the occasion of the tercentenary of his death in 1982 have Murillo's qualities as an artist, at once highly sophisticated and genuinely popular, come, once again, to be recognized outside his native country.

The youngest of 14 children of a prosperous barber-surgeon, he was brought up after his parents' deaths in 1627 and 1628 by his older sister and her surgeon husband, and trained as a painter with a relative of his mother's. Shortly after his marriage in 1645 he began the series of major works that were to occupy him in Seville until the end of his life, which was precipitated by a fall from scaffolding whilst engaged on a painting for the high altar of the Capuchin church in Cádiz (completed by his disciple Meneses Osorio, d.1721). He never remarried after his wife's death in 1663; of their nine children only four survived their mother, and only three their father. The family's piety is indicated by the religious vocations of the painter's only daughter, who became a Dominican nun, his oldest son, a subdeacon, and his youngest son, a canon of Seville cathedral. Murillo himself belonged to several religious confraternities. The artist's increasing loneliness has often been cited as a factor compensated for in his paintings, increasingly populated with smiling children, frolicsome cherubs and warmly affectionate Madonnas.

Murillo's earliest known work, *The Virgin Presenting the Rosary to St Dominic* (c.1638–40, now Seville, Archbishop's palace) shows the influence on him of earlier Sevillan painters: his master, Juan

del Castillo, but above all the luminous colourism of *Roelas in the celestial apparition and the tight modelling of Zurbarán in St Dominic's habit. These contrasting modes continue to coexist in his first major commission, the series of scenes from the lives of Franciscan saints – stressing the virtues of the love of God and one's neighbour and including no scenes of martyrdoms – which Murillo painted 1645–8 for the small cloister of the Friary of S. Francisco. In 'low-life' scenes such as *S. Diego Giving Food to the Poor* (now Madrid, Academia) the earth tones, hard modelling and naturalistic (*see under* realism) details of Zurbarán predominate, whilst Roelas's golden glow envelops the heavenly cortège in scenes such as the *Death of St Clare* (Dresden, Gemälde-galerie; other paintings from the series now Paris, Louvre; Madrid, Academia; Raleigh, NC, Museum; Williamstown, MA, Clark Institute; Ottawa, National; Toulouse, Musée des Augustins).

In the group of large-scale Madonnas painted *c.*1650–5, Murillo abandoned Zurbarán's *tenebrism and sculptural monumentality for more translucent and elegant effects, influenced by the work of *Van Dyck, known in Seville (e.g. *Virgin of the Rosary*, Madrid, Prado; *Virgin and Child*, Florence, Pitti). The compositions of these and later Madonna and Child pictures, of which he was to become the greatest Spanish exponent, were indebted to prints after *Raphael. Zurbarán's manner was to persist longer, however, in the secular *genre paintings of vagrant and mendicant children which, perhaps on the suggestion of Dutch and Flemish merchants resident in Seville, and almost certainly for a foreign market, Murillo began to paint *c.*1645–50 (e.g. *Boy Killing a Flea*, Paris, Louvre). Some 25 such pictures, which in turn became lighter in colour and more ingratiating in mode, made his reputation abroad and are the source of Reynolds's and Gainsborough's *Fancy Pictures. The best are now to be found in Munich, Alte Pinakothek; Dulwich, Gallery; Paris, Louvre. While certain groups – such as the several depicting an older woman searching for fleas in a child's hair – are clearly indebted to Dutch prints, others are among

the most pictorially inventive and spontaneous 17th-century compositions, precursors of, and influential on, the *Rococo. As in Dutch *genre paintings, moralizing symbolism cannot be excluded in reading these pictures.

The great Sevillan church, monastic and charitable institution series begun at S. Francisco continue with the four large paintings for S. Maria la Blanca, a medieval synagogue newly converted into a church (1662–5; Madrid, Prado; Paris, Louvre; Faringdon, Buscot Park). The technique, increasingly fluid, translucent and animated, now heralds Murillo's later, renowned 'vaporous style', but is held in check with firm draftsmanship and architectonic compositions; these works are certainly among his highest achievements. There follow important cycles and series for the Capuchins (*c.*1665–6; 1668) and the Agostinians (after 1666), now mainly hung in Seville, Museo. During 1668–74 he executed six very large and two smaller paintings illustrating, with the altar, the *Seven Works of Mercy*, for the church of the Hospital de la Caridad, to which charitable confraternity he had been admitted in 1665 (four *in situ*; others London, National; St Petersburg, Hermitage; Washington, National; Ottawa, National; *see also* Valdés Leal). Celebrated in Murillo's lifetime, these remained the most famous works of art in Seville until their partial dispersal in 1810. In 1675, for the church of the Hospital de los Venerables Sacerdotes, he executed, together with other paintings, a famous *Immaculate Conception* (now Madrid, Prado), painted in his most mature style. The theme is one with which, as with that of the Virgin and Child, Murillo is especially identified (but *see also* Pacheco).

For a private patron, the Marqués de Villanmanrique, Murillo executed, *c.*1665, a series of landscapes illustrating Old Testament scenes from the *Life of Jacob*; the masterly landscape backgrounds, influenced by *Momper, are among the finest of the century (now Dallas, Meadows; Cleveland, OH, Museum; Detroit, Institute; El Paso, Museum).

Although only a few portraits by him are known, they rank among the best in

Spanish art. Perhaps the most exceptional is the portrait of *Don Antonio Hurtado de Salcedo in Hunting Dress* (*c.*1664, Spain, pc). Probably inspired by Velázquez's royal portraits for the hunting lodge of the Torre de la Parada – Hurtado was Philip IV's Secretary of State – it introduces a landscape background, a dog-keeper and three dogs in naturalistic contrast to the commanding Hurtado. Less grandiose but no less impressive are the portraits of ecclesiastics, the *Canon Justino de Neve* (*c.*1660–5, London, National) and *Canon Juan Antonio de Miranda* (1680, Madrid, Duke of Alba). The likenesses of the Dutch merchant *Josua van Belle* (1670, Dublin, National) and the Flemish poet and merchant, Murillo's friend *Nicolás de Omazur* (1672, Madrid, Prado), both resident in Seville, are closely modelled on Dutch portraits. A pendant portrait of Omazur's wife is known today only through a copy. Of the two known autograph self-portraits, the one now in London, National (*c.*1670) inspired Hogarth's *Self-Portrait* in the Tate.

In 1660 Murillo co-founded the Art *Academy of Seville, of which he served as first President together with Francisco *Herrera the Younger. His belief in Italianate academic precepts is borne out by his extant graphic œuvre, which includes many excellent drawings from the life and compositional studies.

Musscher, Michiel van (1645–1705) *See under* Hooch, Pieter de.

Muziano, Girolamo (1532–92) From *c.*1575 the leading painter at the Papal court, the author of many Counter-Reformation altarpieces in Roman churches. Born in Brescia and trained in Padua and Venice, he never forsook Venetian colourism (*see under disegno*), especially

in the conspicuous landscape backgrounds of his religious compositions; his sober figure style, however, was modelled on *Sebastiano del Piombo. Outside Rome he is now probably best remembered as the author of pioneering landscape drawings made before his arrival in the city, *c.*1549 (Florence, Uffizi), some of them executed during a bout of fever which caused him longingly to recall 'limpid rivulets and vivacious fountains . . . flowering meadows and verdant landscapes' seen on his travels. During 1573–6 similar drawings by him were used for a series of six engravings (*see under* intaglio) by the northerner Cornelis Cort, depicting hermit saints in landscape. Muziano supervised the decoration with *fresco landscapes of the Villa d'Este at Tivoli, 1563–6.

Mytens or Mijtens, Daniel (*c.*1590– before 1647) Chief of the precursors of *Van Dyck in England. Born at Delft and trained at The Hague, he was introduced into England before 1618 by the great patron of the arts, Thomas Howard, Earl of *Arundel. In 1621/2 he succeeded Van *Somer as court painter, being particularly favoured by Charles, Prince of Wales. On Charles's accession to the throne, Mytens was appointed Painter of the King's Chamber, and sent back to the Low Countries to study the latest fashions in Flemish portraiture. He returned to execute a continuous series of royal portraits until after the arrival of Van Dyck in 1632. By 1637 Mytens was once again living in The Hague, where he acted as agent for Lord Arundel's collection. Mytens's portraits lack the elegance and nobility of Van Dyck's, but at their best (e.g. *First Duke of Hamilton*, 1629, Edinburgh, National) they combine sympathetic interpretation of character with a wonderful sense of colour and atmosphere.

N

Nabis A group of young Paris painters stimulated by the example of *Gauguin to develop *primitivist styles, with simplified and flattened forms and heightened, poetic colours. 'Nabi' is the Hebrew word for prophet, and in choosing it they pointed to exotic and at times religious interests. Some of the painters had religious purposes: notably *Sérusier and *Denis. Others were more concerned with creating decorative works in which ordinary life is shown as visual harmony: notably *Bonnard and *Vuillard. *Maillol was a member for a time, and *Toulouse-Lautrec was associated with them. The group formed when Sérusier came from Brittany in 1888 with news of Gauguin's ideas and methods. Its members had frequent contact and exhibited together until 1899. In its religious and un-*naturalistic work it forms part of the broad *Symbolist movement.

Nadelman, Elie (1882–1946) Polish-French-American sculptor, born in Warsaw, and trained there and in Munich before going to Paris about 1904. He arrived in New York in 1914 with a substantial reputation for sculpture that combined modern simplification with *classical idealization in heads and figures. He had an exhibition in *Stieglitz's gallery, was soon seen as a major figure in new American art. He carved and modelled, and in the 1920s developed what he called *galvano-plastique* (electro-plated metal skin on a plaster form). He collected American folk sculptures and for a time made sculptures illustrating contemporary people and their lives, as in *Woman at the Piano* (about 1917; New York, MoMA), with marked folk-art elements in them.

naïve art Modern term for a modern phenomenon: unschooled art produced by individuals untouched by the sophisticated art methods and theories available to them. This distinguishes naïve art from folk art which has its own traditions and canons and, though the term *primitive is also often used, from the art of tribal societies and races remote from western civilization. Grandma *Moses, Henri *Rousseau and Alfred *Wallis are outstanding instances of naïve painters in New York State, Paris and Cornwall respectively, and it is striking that each of them painted energetically and seriously for many years, not as a hobby or as 'Sunday painters'. Unaware of, or unresponsive to, the *naturalistic and either idealizing or *realistic conventions of western fine art since the *Renaissance, their bright and childlike paintings strike us as direct and spirited, and thus as a relief from the more self-conscious and often troubled art of the professionals, so much so that their first admirers were, in each case, professional artists ready to admire their simple strength. The interest that *Delaunay, *Kandinsky and *Picasso, among others, took in the art of Rousseau, and similarly the discovery and support Wallis received from Ben *Nicholson and Christopher Wood and their friends, are well-known instances of such recognition. There have been and are many other naïve artists at work, especially in Europe. Their example suggests that innate talent operates in this area too. Attempts to develop schools of naïve painting, e.g. in Yugoslavia, have tended to harm a vein of creativity which is best left untouched.

Nakian, Reuben (1897–1986) American sculptor, born and trained in New York and apprenticed to Paul Manship. Through him he met *Lachaise whose smooth, inflated forms appear in his work of the 1920s. He made series of portrait busts in the 1930s and an over life-size statue of the baseball player Babe Ruth (1934). He worked for the *Federal Art Projects from 1936, and in the 1940s transformed his methods and style to develop an apparently improvisatory idiom marked by rough, expressive surfaces and carrying mythological or poetic themes, under the influence of *Abstract Expressionism.

Nanni di Banco (*c.*1374–1421) One of the most gifted Florentine sculptors of his generation. He was three times associated with *Donatello on the sculpture of Florence cathedral: in 1407–8 they executed companion figures of *Prophets* for the Porta della Mandorla; in 1408 Nanni carved an *Isaiah* for the northern tribune, and Donatello a companion marble *David*; and in 1410–13 Nanni completed his *St Luke* for the façade (Cathedral Museum) which antedates by two years Donatello's companion *St John*. The *St Luke* anticipates many of Donatello's stylistic innovations, particularly the sense of a bulky body beneath the drapery, and the figure's autonomy of movement, but lacks the energy which infuses the *St John*. Nanni's study of antique sculpture is even more evident in his group of the *Quattro Santi Coronati* for Or San Michele (*c.*1413). The four life-size figures are grouped together like the half-length figures on Roman grave altars. Nanni executed also a *St Philip* and a *St Eligius* for Or San Michele. His last major work, the relief of the *Assumption of the Virgin* above the Porta della Mandorla, abandons this *classicizing mode, however, to return to *Gothic forms, especially in the figure of the Virgin.

Nanni di Bartolo (called **Rosso**) (active 1419–51) Florentine sculptor, employed on the façade of Florence cathedral in 1419, and on statues for the bell tower from 1421 (*Abdias*, Florence, Cathedral Museum). By 1424 he had left Florence for Venice, and the rest of his career was pursued there and throughout northern Italy (doorway, Tolentino, S. Nicola, 1432–5; Brenzoni monument, Verona, S. Fermo Maggiore).

Nanteuil, Robert (*c.*1623–78) Highly accomplished French draftsman and engraver (*see under* intaglio). He specialized in portraits, many reproducing paintings by Philippe de *Champaigne, others original, of the great figures of mid-17th-century France. He was the father-in-law of Gerard *Edelinck.

Nash, David (1945–) English sculptor who studied in London and settled in North Wales. Since 1970 he has been working with wood, carving the fresh wood of fallen trees or trees that had to be felled, also planting trees in order to prune, fletch and graft them to grow to a particular form or pattern. His tools and methods have developed over the years, from the first rough carving of balls or seed-like forms to the tall Columns, Ladders, Gates, Sheaves etc. of the 1990s, made often on the spot for exhibitions around the world or as permanent, sometimes growing, public sculptures. Nash welcomes the cracking and warping unseasoned wood undergoes indoors, just as he welcomes the action of wind and weather on his outdoor sculptures. Sometimes he chars the wood, both to give it a protective surface and for the sake of the colour, thus adding to the range already available from timbers around the world. For this, and also where heat is needed for working, Nash builds ephemeral stoves out of local materials ranging from slate or ice to bamboo. The same living off the land is found in Nash's ability to work alone or, when the project demands, with assistants found locally, language apparently being no barrier when working together on a shared project.

The ecological message of Nash's work is clear – and is reinforced by his use of every part of a large tree, down to the last twigs which he makes into charcoal to draw with. The sculpture is also charged with symbolism, trees being themselves rich in ancient meanings and the objects or images Nash finds in them often echoing traditional signs and emblems. His first solo show was in Wales, in 1973. By the end of the 1970s his work was being bought and selected for exhibition abroad, and he has since become one of most exhibited and sought-after artists in the world. 1996 saw the completion of a public sculpture in Eastbourne, *Eighteen Thousand Tides*, consisting of ten oak treetrunks that had served to buttress Eastbourne's sea groynes for twenty-five years and were now set up, one, two, three and four, within a circle of low oak stumps.

Nash, John (1893–1977) British painter, younger brother of Paul *Nash whose example led him into art. He became

a member of the London Group and was an official War Artist in the First and Second World Wars. His work was mainly in landscape in which he showed a touch of his brother's visionary powers combined with an elegant *naturalism.

Nash, Paul (1889–1946) British painter, elder brother of John *Nash. He was trained at the Slade School of Art, London, and had his first exhibition in 1912, of landscape drawings and paintings of a partly visionary, *Symbolist sort. He served in the British army in France, in 1917 he exhibited in London watercolours of the landscape of war, and returned to the front as War Artist, now also producing substantial oil paintings. For a while he turned to theatre design, but his main concern continued to be landscape, in oil and watercolour paintings and occasional prints. In the late 1920s *Cubist forms appear in his work and he also began to use photographs as source material for paintings. His wife gave him a camera in 1929 and soon photography became an additional medium. A 1928 de *Chirico exhibition in London led him into effects of space and perspective that brought him close to *Surrealism; for a while, alongside new visionary landscapes, he now painted also interiors and urban subjects.

He wrote occasional art criticism and in 1932 he formed and publicized a small group of *avant-garde British artists and designers as *'Unit One'; they exhibited in 1934. In 1936 he served on the committee of London's International Surrealist Exhibition and showed in its exhibition that year.

He is now seen as a key figure in the English *Neo-Romantic movement of the late-30s and '40s, fusing in his work and interests elements of English traditional pastoral and poetic art (as in *Blake and *Palmer) with international elements though his contact with Continental *Modernism was slight. The Tate Gallery in London showed a memorial exhibition of his work in 1948 and holds a major collection of it.

National Academy of Design Formed by New York artists in 1826 in reaction against the American *Academy of Fine Arts and its promotion of traditional European values. Samuel Morse, painter and inventor of the Morse code, was its first president. Its exhibitions were of the work of New York artists only. The principle it represented was *naturalism, and it resisted the onset of new forms of naturalistic painting such as *Impressionism, and thus declined in significance.

Natoire, Charles-Joseph (1700–77) French painter, and student, like his far more talented contemporary *Boucher, of François *Lemoyne. Although chiefly remembered for his *Rococo decorations in Paris, Hôtel de Soubise, 1737–8, he is more historically significant as the author of the earliest French decorative scheme based on a national-patriotic theme (*History of Clovis*, 1736–7, Troyes, Musée). Appointed Director of the French *Academy in Rome in 1751, he was forced to resign in 1774 through administrative incompetence and as his style fell out of favour. He never returned to France, but retired to Castel Gandolfo, where he turned to landscape – a genre in which his work anticipates that of Hubert *Robert and *Fragonard. He was the teacher of *Vien.

Nattier, Jean-Marc (1685–1766) French painter, best known for his work as a portraitist, in which speciality he followed his father, **Marc Nattier** (1642–1705). Although a master of the decorative *Rococo style fostered at court by Louis XV and Mme de Pompadour, he was also capable of simplicity and directness, as in his portrait of the queen, *Marie Leczinska* (Versailles) or of one of her daughters, *Madame Adélaïde*, (Paris, Louvre). He occasionally allegorized his sitters, as in the *Duchesse d'Orléans as Hebe* (Stockholm, Museum) or included allegorical figures with their likenesses, as in the *Maréchal de Saxe crowned by Time* (Dresden, Gemäldegalerie). Having been very popular at court, his work fell out of favour in the last years of his life and he died in neglect and poverty. (Other works London, National, Wallace; New York, Metropolitan, Frick; and in French provincial museums.)

naturalism term used for a way of representing the appearance of things in the visible world with as little departure from this truth as possible, excluding elements of personal expression or emphasis and, as far as possible, any tendency to *abstraction or patterning. The term *realism is often used for this, but is best reserved for a style or selective purpose that asserts the reality of certain aspects of the world, usually those associated with hardship, against others that may be considered more pleasing and thus more art-worthy. Naturalism implies a high degree of objectivity, even when it is powered by a sense of the natural environment as God's creation. The naturalistic representation of things has been known in western art since the Egyptians and the Greeks; naturalistic and coherent representations of scenes, with or without figures and actions, is an achievement of western art of the *Renaissance, and may be said to have climaxed at various times, in the art of Jan van *Eyck, *Vermeer and *Constable and other open-air painters of the early nineteenth century, among others. The skills of eye and hand that all-out naturalism demands have sometimes been abetted by visual aids such as the *camera obscura which projected an image of a lit scene on to a screen or a piece of paper. Photographs came to be used as artists' aids in the second half of the 19th century, though images based on, or painted over, photographs tend to reveal this mediation in a certain deadness. *Photorealism, emerging in the late 1960s, was at first seen as a potent form of naturalism but the technical process involved in projecting, sometimes adjusting and combining, photographs for painting in the best hands resulted in an intensity that was remote from that of patient observation.

Naumann, Bruce (1941–) American artist in many media and forms, associated with *Body art, *Conceptual art, *Performance art, art photographs, films, videos with and without sound, as well as sculpture of several kinds, etc. In many of these activities he was an initiator or early participant. Having studied mathematics, physics and then art at Wisconsin University and then pursuing postgraduate painting studies at the University of California at Davis (1964–6), he gave up painting and focused on procedures and processes in art as symbolical forms of behaviour, conveying messages out of his own experience and bearing poignantly on our reading of the world. In 1966 he had his first solo show, in Los Angeles, but it was with his show at the Leo Castelli Gallery in New York, 1968, that his work became known: he showed body moulds, neon sculptures and photographs. In 1969 he showed at the Konrad Fischer Gallery in Düsseldorf and in Paris at Galerie Sonnabend. He enlarged his already extensive field of work during the 1970s by making sculptures calling for interaction from the viewer, but since then his main work has been in the form of made or appropriated objects, commenting satirically on the world, including neon pieces mocking our fascination with power and sex. In 1979 he moved to Pecos in New Mexico where he appears to live a rancher's life while continuing to produce his challenging work. He has received many honours, including in 1991 the Max Beckmann Prize awarded by Frankfurt.

Navarrete, Juan Fernández (1526–79) Spanish painter, a deaf mute also called El Mudo (the mute), from 1568 the leading native-born painter at the court of Philip II after *Becerra. He was educated in Italy, studying in Venice, perhaps under *Titian, and possibly in Rome. His many works at the Escorial are still *in situ*; in their debt to the *naturalism and *tenebrism of *Bassano, combined with the heroic Roman manner, they prefigure *Caravaggio.

Nay, Ernst Wilhelm (1902–68) German painter who studied under *Hofer and became known as a painter of landscape and still life in a manner close to *Expressionism but marked by a more meditative, at times mystical, approach. The Nazis labelled him *degenerate but he was able to continue working while serving in the army in France. After the war, honoured as a German *modernist who had survived the barbarian period, he moved into total or near *abstraction, com-

bining a growing interest in colour with gestural and expressive marks, and was thus seen as a German champion of *Abstract Expressionism. In 1964 he represented West Germany at the Venice Biennale. His book on the structural value of colour was published in Munich in 1955.

Nazarenes An association of German and Austrian painters, six of whom first came together in 1809 in Vienna as the Brotherhood of St Luke. As this name implied, their intention was to connect back to the pre-*Renaissance guild system and thus also to evade the *academic system which took its place, their aim being to bring renewed vitality and purpose to Christian art. Their models for this were late-medieval German and early *Renaissance Italian art. They were stimulated ideologically by early *Romantic writings about art and its relation to religion. Before the end of 1809 the Brotherhood moved to Rome where they 'became monks in a monastery of art' (Fritz Novotny, 1960) and became known as the Nazarenes; most of them were Roman Catholics. The most prominent and enduring members were *Cornelius, *Schnorr von Carolsfeld, and Von *Schadow.

The urge to simplify art by returning to what seem like first principles is a recurring phenomenon in western art, though never quite unambiguous: *Giotto's successful redirection of painting is a major instance of it, others are J.-L.*David and the *Neo-classicists, notably a group of David's students who called themselves 'The Primitives', and the *Pre-Raphaelite Brotherhood who modelled themselves initially on the Nazarenes. They too were pre-Raphaelites in that they steered by the example of Italian art up to and including the early work of *Raphael, but not the increasingly complex art Raphael delivered in his Stanze frescos. *Fresco painting itself attracted them both for the clarity of design and colour it called for and for its functional association with architecture and especially churches, so much so that they led a revival of fresco painting that bore substantial fruit in the century that followed. For this they had many fine models,

from Fra *Angelico to *Pinturicchio, and the two major fresco schemes they worked in Rome suffer from too many and too dominating borrowings from such forerunners. In 1816–17 *Overbeck, Schadow and others collaborated on frescoes in the house of the Prussian consul-general (now in Berlin Staatliche); soon after they formed sub-groups (Cornelius and two others, Schnorr by himself, and Overbeck and another) to paint murals in three rooms of the Casino Massimo. Like the reformers already mentioned, they were seeking to give back to painting, after a century devoted to frivolous and decorative art, the serious moral purpose for which *history painting had been developed.

In this and other respects they were more in tune with *classicism and classical principles than they knew, and especially to the contemporary movement, *Neoclassicism, which was centred on Rome – even in their use of new literary material, such as Goethe's *Faust*, and rediscovered Northern myths such as the *Nibelungenlied*. This enlargement of their range of subject matter, at first almost exclusively religious, coincided with a dispersal of the group, from about 1820 on, several of the artists returning to their native countries in response to major commissions. These prove the success of their venture. In fact they exercised a marked influence on artists from various countries, including Britain and Russia.

Neefs, Pieter the Elder and Pieter the Younger *See under* Steenwyck, Hendrick van.

Neer, Aernout or **Aert van der** (1603/04–77) Dutch specialist of the 'tonal' phase of landscape painting (*see also* Jan van Goyen, Salomon van Ruysdael, Pieter de Molijn). Leaving behind the grey-brown-green tonality of other practitioners of this mode, and of his own earlier paintings, he turned to the representation of snowy winter landscapes, nocturnal, and especially moonlight, scenes, for which he has become famous. The treatment of coloured light characteristic of these pictures may have been inspired by certain

late landscapes of *Rubens. Van der Neer settled in Amsterdam in the early 1630s; opened an inn there in 1659, and was bankrupt in 1662. There is some falling-off in the quality of his work from that date, although the nocturnes with burning towns produced in his late period anticipate, and may have influenced, effects exploited by *Turner.

Aert's son, **Eglon Hendrick van der Neer** (1634–1703), practised mainly as a painter of aristocratic *genre, but there are some landscapes by him demonstrating a deliberate return to *Elsheimer. There are works by both artists in London, National, Wallace; New York, Metropolitan; and in many galleries on the Continent.

Neithart, Mathis Gothard *See* Grünewald, Matthias.

Neizvestny, Ernst (1926–) Russian artist, principally sculptor. He attended a school for artistically gifted children and – after war service during which he was wounded and declared dead – studied art in Riga and Moscow as well as philosophy. In 1959 he won a national competition for a monument to Russia's victory in the war. Three years later he was involved in a public verbal clash with the Soviet premier, Khrushchev. This does not seem to have inhibited his career in Russia; from 1965 on he exhibited outside the Soviet bloc and in 1974 he was commissioned to carve Khrushchev's tombstone. The character of his work has varied widely, from idealized *naturalism of a traditional sort to *Cubist near-*abstraction; its common element is headlong energy. In 1976 he emigrated to Switzerland and in 1977 to New York, since when he has taught and produced a wide range of two and three-dimensional work as well as writings. In 1987 a *Tree of Life* museum of his work opened in Uttersberg, Sweden; a Neizvestny Museum has more recently opened in Sverlovsk in the USSR. A selection of his writings has been published in English in 1990 as *Space, Time, and Synthesis in Art*.

Nelli, Ottaviano (*c*.1375–1444) Italian painter from Gubbio, working extensively throughout Umbria and the Marches both in *fresco (e.g. Gubbio, S. Maria Nuova) and panel. His graceful mature style was influenced by International *Gothic Lombard miniatures (*see*, e.g. Giovanni dei' Grassi).

Neoclassicism Term used first in the 16th century for literature that pointedly adopted *classical forms and themes, and later given to decorative and architectural styles that opposed the rich complexities and suave appeals of the *Baroque and *Rococo in the 18th. It was associated with better archeological knowledge of antiquity through the rediscovery of sites including Herculaneum and Pompeii, but also with discipline and coldness, entering art and design as a mode of 'noble simplicity', the phrase used by the art historian *Winckelmann for the essential virtues of Greek sculpture. But self-limitation implies passion, and it is clear that the best Neoclassical art – J.-L. *David's earlier paintings, *Canova's sculpture and *Flaxman's drawings – is inventive as well as being based on ancient models. It embodies emotional elements excluded from the work of more imitative and routine Neoclassicists. Thus Neoclassicism became associated with *academies, just as *Romanticism implied a revolt against controls, yet it is useful to see Neoclassicism as part of the broad wave of Romanticism, both representing an urge to poeticize and sublimate the world and find heroic formulations for experience and history.

Winckelmann's writings (*Thoughts on the Imitation of Greek Works*, 1755, and *History of the Art of Antiquity*, 1764) were quickly translated into other languages, suggesting a public ready for their ideas. *Mengs promoted similar thoughts in relation to modern art. Though Greek as opposed to Roman culture was recognized as model and yardstick, Rome served as the international testing ground for the new classicism, Greece being in the hands of the Turks. Major exportations of Greek art – as in Lord Elgin's appropriation of the sculpture of the Parthenon, the chief temple on the Acropolis of Athens, brought to London, bought by the nation and placed in the British Museum – provided a powerful stimulus. Books of engravings,

of Greek originals and of Roman copies (the two categories often being confused), provided essential information. But many ambitious artists spent time in Rome to study classical masterpieces and debate their beauties with colleagues.

Neoclassicism became the style of the French Revolution through the example of David and a more abundant version of it was adopted by Napoleon as emperor. Thus Neoclassicism is associated with republicanism and liberty, and then also with empire and authority. In architecture the Neoclassical style was used for garden temples first, then for private houses, churches and government or municipal buildings, and then for banks. Thus its political message was jettisoned while its general tenor survived, signifying control, honour and solid dignity. All Europe, from Dublin and Glasgow to Moscow and St Petersburg, responded to the movement, as did the USA. By the mid-19th century it had faltered, without quite dying out. The early 20th century saw a Neoclassical tendency in architecture, again using the classical idiom, soon coarsened by the totalitarian rhetoric of Russia, Germany and Italy, and in a transfigured but still apparently noble and simple *modernist idiom in, especially, the architecture of Mies van der Rohe and his many followers. The 1980s partly welcome a Neoclassical revival in architecture and in painting, in both cases modified by a playfulness that was praised as irony but served mainly to undermine the principles that give Neoclassicism its value.

Neo-Impressionism Name given in 1886 to *Seurat's more scientific and methodical *Impressionism when he, *Signac and *Pissarro exhibited examples of it in the last Impressionist exhibition.

Neo-Plasticism Term used by *Mondrian in its Dutch form, *Nieuwe Beelding*, in his articles in *De Stijl* magazine during 1917–19, and in the French version, *Néo-Plasticisme*, he used from 1921 on, to identify his mature art and the principles behind it. He derived the Dutch title from the writings of the Dutch philosopher and Christian theosophist Schoenmaekers. The

German version *Neue Gestaltung* captures Mondrian's meaning best: just as *Gestalt* means many things, including shape, figure, configuration, pattern, and, in psychology, integrated whole, so Mondrian used it to mean 'new forming' in the widest sense as well as specifically his own theories and *abstract images.

Neo-Romanticism A movement in British art, also in poetry, film, stage design etc., associated with a revival of interest in British medieval art and architecture and in the visionary art of William *Blake, Samuel *Palmer and other artists working in the early nineteenth century. One of the initiators of the movement was David *Piper, who in the mid-1930s turned from painting *abstracts to making topographical drawings and collages and in 1942 published an illustrated book *English *Romantic Art*, offering models to the movement by then well under way. The Second World War, beginning in 1939, separated Britain from Continental influences; before that awareness of a neoromantic tendency in French painting and design, notably in the art of Christian Bérard and Tchelitchev, had contributed to the aversion Piper and his friends felt for the international abstract art with which British artists such as Ben *Nicholson and *Hepworth had been forming an alliance. During the long war years it was natural to emphasize and heroicize native British characteristics, and often these were contrary to French examples, with their elegance and effeteness. Thus Celtic and Romanesque antiquities surfaced alongside themes and stylistic elements derived from Blake and Palmer, and an apocalyptic note comes from gloomy and sometimes threatening visions of landscape. As war brought cataclysm to British cities, minds turned more and more to a dream of a new land sprung out of half-forgotten old myths, while some artists escaped reality by fantasizing about a timeless Mediterranean land.

London was the focal point of the movement, but there were important contributions from Scots and Welsh artists working in their countries, driven in part by distinct cultural energies. But London was also in the front lines of the war. Street lights were

extinguished even before war was declared; nocturnal bombing raids on London began in September 1940 and the population began to hide in cellars and in subway stations while the war raged noisily over their heads. Darkness became a theme in art, as well as electricity as a potent force against annihilation, giving power to searchlights and to armaments factories. A wide range of British artists turned to such themes, united in their desire to use aspects of the visible world again for their poetic purposes, among the senior ones Henry *Moore, Ceri *Richards and Graham *Sutherland and among the younger ones, apart from those already mentioned, Robert *Colquhoun, Robert *MacBryde, John Craxton and Michael *Ayrton.

Neri di Bicci (1419–after 1491) Mediocre but much-employed Florentine painter, head of a productive workshop whose surviving records from 1435 to 1475 are an important source for our knowledge of the activities and clientele of a popular *Renaissance artist. There are works by him in most Florentine museums and many churches.

Neroccio di Bartolommeo Landi (1447–1500) Sienese painter and sculptor, a pupil of *Vecchietta and an occasional collaborator of *Francesco di Giorgio Martini. Like all the Sienese artists of his time, he looks both towards Florentine *Renaissance developments and the Sienese tradition rooted in *Duccio. There are works by him in Siena, Palazzo Comunale; Palazzo Chigi-Saracini; Cathedral; Washington, National.

Netscher, Caspar (1635/6?–84) Dutch painter, born in either Prague or Heidelberg, the son of Johannes Netscher, a sculptor from Stuttgart. He studied with *Ter Borch at Deventer, c.1655–c.8, and specialized at first mainly in *genre, with the occasional religious or classical subject. In 1662 he settled at The Hague, giving up genre scenes for small-scale half-length portraits of the aristocracy, widely respected for their fastidious attention to the texture and details of costly costume. He was much imitated, most closely by his sons

Theodorus (1661–1732) and **Constantijn** (1668–1723). There are paintings by Netscher in London, National, Wallace; The Hague, Mauritshuis; etc.

Neue Sachlichkeit (New Objectivity or Sobriety) German movement in painting, formed and publicized in 1925 by G.F. Hartlaub in an exhibition of that name at the gallery he directed in Mannheim. He had noticed a variety of tendencies turning away from *Expressionism to a calmer and optimistic concern with visible reality and also to something quite different, a satirical use of *naturalism as in the work of *Grosz and *Dix. It is doubtful that this movement had any existence outside the galleries; the more directly naturalistic artists associated with it were able to flourish under National Socialism while the others could not.

Nevelson, Louise (1899–1988) Russian-born American sculptor who studied art principally in New York and turned in the 1940s from carving to *assemblage. In the 1950s she became known for assembled sculptures, often in the form of reliefs on a large scale, in which a variety of found objects gathered into boxes joined to form murals with one unifying and denaturing colour. In the late 1960s she turned to using plexiglass, aluminium and then also steel to make lighter, partly transparent constructions. She exhibited frequently from 1933, in solo exhibitions from 1941 (New York), and internationally from 1962 when her work was included in the Venice Biennale.

Nevinson, Christopher Richard Wynne (1889–1946) British painter associated in England with *Vorticism and in Paris, through *Severini, with *Futurism. He exhibited as a Vorticist in Brighton and London during 1913–14 but his friends repudiated his eager support of *Marinetti. Unfit for army service, he worked for the Red Cross and painted war subjects, shown in his first solo exhibition, London 1916. These were in a geometricized, semi-Futurist idiom, but after the war he turned away from Futurism to work in a softer, more naturalistic style.

New English Art Club An art associ-ation founded in London in 1886 by painters in touch with new French art and eager to dissociate themselves from the conventional values of the Royal *Academy. *Clausen and *Sargent were prominent among the founders; *Sickert was to press for a more direct connection to *Impressionism and, in due course, to lead a secession from the Club. New associations formed in the early years of the new century, including the *Camden Town Group, and the NEAC found itself losing what avant-garde role it had had as the Academy became more liberal and modern tendencies became more radical in Britain.

New York School Term coined to indicate the first generation of innovative painters working in New York and achieving an individual style and reputation within *abstraction and, mostly, *Abstract Expressionism during the 1940s, often in close interaction, notably *De Kooning, *Gorky, *Guston, *Hofmann, *Mother-well, *Newman, *Pollock, *Reinhardt and *Rothko, but applied also, by extension, to their many New York followers.

Newman, Barnett (1905–70) Ameri-can painter, born in New York of Polish immigrants. He studied painting in the early '20s and in 1929–30, gave up painting during 1940–4 and destroyed almost all his early work. He now used biomorphic forms but it was with *Onement I* (1948; pc) that he found a way of eluding European traditions and an art that would carry primordial experience through basic, quasi-ritualistic means. *Onement I* is a field of red bisected by a vertical piece of tape painted orange: it conveys a strong sense of unity, of a single act and a single experience, and he recognized in it a recipe capable of endless exploration. This followed. Much of his subsequent work is large (Newman was much concerned with how such paintings would be exhibited), and the vertical stripes could be soft- or hard-edged. Such varia-tions, and also his exploitation of a range of colours and internal contrasts of scale, gave his paintings great dramatic force and made him, especially in the later '50 and '60s, one of the most internationally admired of

*Abstract Expressionist painters. In 1948 he had joined *Rothko, *Baziotes and *Motherwell in founding the New York art school 'Subject of the Artist' and he was generally associated with the meditative, quasi-religious art of, especially, Rothko. In 1950 he had his first solo exhibition (Betty Parsons Gallery, New York). Some of his paintings were included in the 'New American Painting' show organized by the Museum of Modern Art, New York, to tour Europe in 1958–9 and from this time his work was shown around the world. His series of fourteen black-and-white paint-ings *Stations of the Cross* (1958–66; shown New York 1966) established him as a creator of metaphysical images of trans-cendental import, but the economy of his means and his command of scale and space made him also a major influence on the *Minimalists, most of whom did not intend their work to carry ideas about life and death.

Niccolò dell'Arca (*c*.1435–94) Eclec-tic sculptor of south Italian origin, active in Bologna from 1462 as a carver in marble and a modeller in terracotta. His 'surname' is derived from the tomb – *arca* – of St Dominic by Nicola *Pisano, Bologna, San Domenica Maggiore, for which Niccolò carved a lid decorated with marble statuettes, 1469–73 (later completed by *Michelangelo). His style here, as in his large *Madonna di Piazza* (1478, Bologna) demonstrates knowledge of both Burgun-dian and Tuscan sculpture. Niccolò's masterpiece is universally acknowledged to be his dramatically *expressive terracotta group of the *Lamentation*, originally *poly-chrome (1463, Bologna, S. Maria della Vita), anticipating the more placid terra-cotta groups of Guido *Mazzoni.

Nicholson, Ben (1894–1982) British painter, son of the painters William *Nicholson and Mabel Pryde. He studied briefly at the Slade but did not decide on a career in art until he married Winifred *Nicholson in 1920. In the early twenties, after some months in Italy, the young Nicholsons worked part of the year in the Ticino, Switzerland, travelling there via Paris and adding knowledge of *avant-

garde art to their attachment to early *Renaissance painting. Winifred helped Ben to use colour poetically; Ben sharpened Winifred's sense of form. From the mid-twenties they lived mostly in the Cumbrian hills, painting still lifes and landscapes in a range of simple, semi-*primitive idioms; they also visited and painted in Cornwall. In 1931–2 Nicholson met the sculptor Barbara *Hepworth who became his second wife in 1938. They worked in London, part of a local circle of adventurous art people who included *Moore and *Read, but they also made visits to Paris where they joined *Abstraction-Création and had personal contact with leading artists such as *Arp, *Braque and *Mondrian. In London they contributed to *Unit One. Both Nicholson and Hepworth moved from *figurative to *abstract art around 1933, though their work is never devoid of echoes of the visible world. In Nicholson's case abstraction took the form of carved relief compositions reminiscent of minimal still lifes carved from what frequently were tabletops, painted matt white during 1934–8, and then also two-dimensional compositions with strong colours of the same free but geometrical sort. Though this work is called *Constructivist and was criticized in the 1930s for its association with Russian extremism, for Nicholson it was an intuitive art that combined direct-ness and simplicity with light and thus with health. He was interested in Christian Sci-entism and in the book *Circle, where others asserted their alliance to technology and modern science, he wrote that for him art was akin to religion.

In 1939 the Nicholsons moved to Corn-wall and lived in and near St Ives during and after the Second World War, becoming the leading figures in a strong local modern art community. During the war Nicholson returned to painting and to landscapes and still lifes which showed the imprint of his economical reliefs as well as echoing his earlier primitivism. Figurative art found purchasers whereas abstract art did not, and for some years Nicholson located his work somewhere between the two and found ways of combining lyrical colour compositions using still-life forms with polyphonic linear structures. From about

1950 on he became known internationally, receiving prizes and commissions for murals. He represented Britain at the 1954 Venice Biennale and had a major retrospec-tive at the Tate Gallery in London in 1955.

In 1958 he left St Ives, moving with his new wife, Felicitas Vogler, to the Ticino in the heart of Europe. From there he trav-elled frequently, especially to Brittany, Italy and Greece. He was again making reliefs, often on a large scale and constructed by cutting and combining boards rather than carving into wood. These now referred to landscape experiences, to mountains, water and sky, to the colours and textures associ-ated with the seasons, and to the height-ened sense of space and scale gained by driving through and flying over the land. On his travels he made many drawings, often of buildings, in which his feeling for succinct and athletic line found its finest expression. He tended to explain his art in terms of the natural grace and efficiency of the flight of birds or the movements of cats, or in terms of the best tennis players' partly instinctive command of trajectory (he was himself a talented and cunning player of tennis and table tennis). During 1965–8 he produced a series of etchings using his characteristic line and with engraved tone; many of these are irregular in shape, assert-ing the objectness of the image. He used the backs of unwanted prints as a three-dimensional surface for drawings, often with coloured washes, to achieve the same objectivity. At a time when much art gave profound or merely fashionable expression to Cold War and Existentialist anxieties, Nicholson continued to use art as a vehicle for joy and admiration.

In 1971 he came back to England, living first near Cambridge and then in London. He had eye troubles but worked as before, mostly on reliefs and then also on a new series of small drawings, referring to land-scape and to still-life motifs and giving them a slightly *Surrealist and ominous presence, and again using irregular formats. He had been awarded Britain's highest distinction in 1968, the Order of Merit. Since 1949 he had been exhibiting outside Britain as much as in Britain, and in his last decades honours were heaped upon him. His reputation stands high, yet

absolute stardom eludes him still because of his repeatedly asserted freedom to change his methods and idiom though not his basic position. Many see the white reliefs of the 1930s as the climax of his career, and perhaps his fame would be firmer had he continued producing them, but he was not willing to curtail his mobility in art or in life. His work is found in many collections. The Tate Gallery, London, has many of the best paintings and reliefs. Kettle's Yard, Cambridge, shows fine examples of his early work in a context of the work of others he knew and admired and in a domestic setting he would have enjoyed.

Nicholson, William (1872–1949) British painter and printmaker. He trained at *Herkomer's school, where he met and married the painter Mabel Pryde, and briefly in Paris. Ben *Nicholson was their first child. During 1894–7 he worked with his brother-in-law, the painter James *Pryde, as the *Beggarstaffs. Nicholson continued to build a reputation as printmaker in Britain and abroad, but he was determined to be a painter and established himself as a successful portrait painter, working mostly in London but at various times having homes also near Oxford, at Rottingdean in Sussex, and in Wiltshire. Between portraits he painted landscapes and still lifes for his own satisfaction. In their concentration and finely controlled tone, these are brilliant contributions to the tradition of sophisticated *naturalism initiated by *Manet and developed by *Whistler. He was knighted in 1936.

Nicholson, Winifred (1893–1981) British painter whose family name was Roberts but who used the professional names of Nicholson, being married to Ben *Nicholson 1920–38, and Dacre. She was a painter of still life, landscape and portraits, with a special gift for poetic, revelatory colour and light, suggesting intimations of the eternal in her experience of nature. She contributed an essay on colour to *Circle and in the 30s produced a number of *abstract paintings, but, though she admired such artists as *Mondrian, her work was never far from specific visual subjects. A major exhibition of her work

was shown at the Tate Gallery in London in 1987; during her lifetime she had exhibited many times, in solo and in group shows. Some of her correspondence and essays are published in the book assembled by her son, Andrew Nicholson, *Unknown Colour* (1987).

Nicolaes Eliasz. *See* Pickenoy.

Nicolò dell'Abate *See* Abate, Nicolò dell'.

niello, pl. nielli (From late Latin, *nigellum*, a noun drawn from the adjective *nigellus*, 'blackish') Originally a type of metal decoration popularized in 15th-century Florence. It consisted of filling-in lines incised in gold or silver plaques with *nigellum* or *niello*, a black enamel-like substance, which was then baked. Some of the earliest engraved images printed on paper (*see under* intaglio) were made in Florence in the 1450s by goldsmiths using either incised plaques before they were filled in with *niello*, or sulphur-cast replicas of such plaques. The word has also come to be used for these small and precious little engravings. *See also* Finiguerra, Maso.

Nigreti, Antonio *See under* Palma Giovane.

Nigreti, Jacopo *See* Palma Vecchio.

Nilson, Johann Esaias *See under* Holzer, Johann Evangelist

Noguchi, Isamu (1904–88) American sculptor, born in Los Angeles but raised from the age of two in Japan, his father's country, until he returned at fourteen to the USA to attend high school. He began to study medicine in New York but also attended evening classes in art which confirmed his desire to be a sculptor. He saw a *Brancusi exhibition in 1926, in 1927 he used a fellowship as a means of studying in Paris and worked for six months as Brancusi's assistant. He made *abstract sculptures in stone, wood and sheet metal, and showed these in his first exhibition, back in New York, in 1929. In 1931–2 he was in China and Japan, studying and

practising various forms of Oriental arts. He returned to New York where he got to know *avant garde artists such as John *Graham and Arshile *Gorky. Like Gorky and others he worked for what became the *Federal Art Project, but his proposals for public sculpture were rejected. From 1935 on Martha Graham employed him repeatedly to design stage sets and costume for her dance company. In several of these he used *Surrealistic biomorphic forms, often as flat, interlocking units. In the 1940s he made relief sculptures that were lit internally, and progressed from these to furniture and lamp designs for commercial producers. In 1947 he conceived a vast *Sculpture to be Seen from Mars*, to be made from sand and legible only from outer space, and he made sets for the ballet *The Seasons*, composed by John *Cage and choreographed by Merce Cunningham.

From 1952 he travelled extensively in Europe and the Far East and generally divided his time between Japan and the USA. Gradually his interest in making sculptural gardens and urban spaces began to hold the attention of architects and patrons, but many of his projects remained unrealized until the early 1960s when he created a marble garden for the Beinecke Rare Book Library at Yale University, a garden for the Chase Manhattan Bank in New York and a sculpture garden for the Israel Museum in Jerusalem. In 1968 he had a retrospective exhibition at the Whitney Museum in New York. Commissions for public works came to him frequently by this time, in Japan (fountains for the 1970 Osaka Exposition and for Tokyo) and in America where in 1964 he achieved a *Monument to Ben Franklin* in stainless steel he had proposed in 1933 (Philadelphia). The Walker Art Center in Minneapolis exhibited some of his large projects in 1978 as 'Noguchi's Imaginary Landscapes'. His studio in Long Island City, NY, became the Noguchi Garden Museum in 1985. In 1986 he represented the USA at the Venice *Biennale. Much of his finest work is abstract carvings in stone, conveying 'a traditional Japanese reverence for living stone as the home of nature spirits' (Dore Ashton). In his sculptural

environment he hoped to create places of contemplation akin to the Zen gardens he had first studied in 1932.

Nolan, Sidney (1917–92) Australian painter, born and trained in Melbourne where he was among those threatening art conventions with relatively wild, irrational productions. During his war service (1941–5) he began to paint landscapes in a personal, visionary style as well as narrative scenes from memory. After the war he worked as an illustrator and assisted with the magazine *Angry Penguins*. Drawn to the life and legend of the outlaw Ned Kelly, he explored North-Eastern Victoria and painted 27 pictures in celebration of this folk hero; then also a series related to the life of Eliza Fraser of Fraser Island, Queensland. The series were exhibited in 1948 in Melbourne and Brisbane. In 1949 there was a Nolan exhibition at UNESCO in Paris, in 1950 he showed in London, and he spent part of 1950–1 in Europe. In 1954 the film *Back of Beyond*, on which he had worked with John Heyer, won the Grand Prix at the Venice Film Festival; at that time Nolan's paintings were on show at the Venice Biennale. He now settled in London and embarked on a new Kelly series; more recently he has also tackled Dante's *Divine Comedy* in a suite of drawings. He was widely honoured, and knighted in 1981.

Noland, Kenneth (1924–) American painter, trained at *Black Mountain College (with *Bolotowsky and *Albers) and in Paris, and cardinally influenced by *Frankenthaler's staining technique (1952+) and by *Greenberg's conception of painting as a pure art, devoid of personal expression and concerned with integrated two-dimensional form and colour. His new work began to be exhibited in 1959 and by the mid-60s Noland was one of the best known American painters on the international scene, with major exhibitions on both sides of the Atlantic and representing his country at the 1964 Venice Biennale. He has explored a variety of pictorial formats to elicit new kinds of structure within the limits of the flat, unmodulated image.

Nolde, Emil (1867–1956) German-Danish painter who, in 1920, changed his name from Hansen to Nolde, his birthplace in Schleswig. He was trained as cabinet-maker and in 1892–8 taught craft and design in St Gall (Switzerland). He studied painting in Munich for a few months, under *Hölzel, and then in Paris (1899–1900). A fantasy element shows in his early paintings though mostly they are *naturalistic landscapes. In 1901–2 he worked in Berlin, and thereafter divided his time between Berlin and Schleswig. In 1906 he became a member of the Berlin *Sezession; for part of 1906–7 he was a member of the *Brücke group and lived in Dresden. His drawings and etchings still at times revealed his instinct for fantasy and the macabre; his painting was now an emotionally heightened form of *Impressionism. His powerful colour and brush-work influenced his Brücke friends, and they interested him in their woodcut technique. In Berlin he saw work by *Munch and had his first one-man show (1906). In the years that followed, Nolde developed a vehement form of painting, often of natural scenes, sometimes of frenzied human beings, as in *Wildly Dancing Children* (1909; Kiel, Kunsthalle).

In 1909 he produced the first of a series of religious paintings, coarse and passionate: *The Last Supper* (Copenhagen, Statens Museum). Another, *Pentecost* (1909; Bern, pc) was refused exhibition by *Liebermann, president of the Berlin Sezession, in 1910; Nolde published an attack on Liebermann and was made to resign from the association, but was praised by some for this protest, coloured by anti-Semitism and nationalism as well as by enmity between generations. The event clarified his aims: he would create a North German art, void of debilitating influences, but close to the people and deriving guidance from that great forerunner of North German people-orientated painting, *Rembrandt. In 1913–14 he joined an expedition to New Guinea where he drew the natives and studied their culture: 'Everything which is primeval and elemental captures my imagination.' On his return he found Germany at war; after the war the part of Schleswig where he lived became Danish by plebiscite. He continued to live and work there and in Berlin, becoming more widely known through mixed exhibitions and publications. His 60th birthday was the occasion for major one-man exhibitions and an honorary degree from the University of Kiel. That year Nolde bought a farm and wharf in the German part of Schleswig; he built a house there to his own design and named it Seebüll. In 1931 he had shows in Switzerland and New York.

His main subjects were now landscapes, flower pieces and portraits, but included also heads, figures and masks that seem grotesque but to him were humorous. He had joined the National Socialist party in Schleswig to support a regeneration of the German spirit. When it came to power he was soon designated *degenerate. He protested against the confiscation of his work and its display in the Degenerate Art exhibition: 'my art is German, strong, austere and sincere.' He wrote three volumes of autobiography (published 1934, 49 and 58). In 1941 he was ordered to cease all work, so he painted in secret. After the war he received many honours in Germany; his 80th birthday was the occasion for major exhibitions. When he died, Seebüll became the Nolde Foundation, holding archives and a large collection of his work.

Nollekens, Joseph (1737–1823) Vastly successful English sculptor, best-remembered for his vivid portrait busts (e.g. London, Wellington Museum; National Portrait; Norfolk, Holkham Hall; Lincolnshire, Brocklesby) and funerary monuments (e.g. London, Westminster Abbey; Cumberland, Wetheral Church). His father, **Joseph Francis Nollekens** (1702–48), known as 'Old Nollekens', was a painter born in Antwerp who came to London in 1733; he specialized in small *Fancy Pictures in imitation of *Watteau and *Pater. Joseph Nollekens was apprenticed in 1750 to *Scheemakers and from 1760 to 1770 worked in Rome, dealing in antiques and repairing ancient statues. He was a fluent modeller in terracotta; the V&A, London, has a group of attractive 'sketches' never intended to be carried out

in marble, although he also carved a number of decorative statues of ancient deities, more *Rococo than *Neoclassical in style (Lincoln, Usher Gallery). Despite this, he was admired by *Flaxman, who said that he was the first English sculptor 'who had formed his taste on the antique, and introduced a pure style of art.'

Nomé, François de (1593–*c*.1640) Born in Metz but working from *c*.1610 mainly in Naples, de Nomé specialized in small pictures of fantastical architecture, in which the figures were inserted by other artists. His identity has, until recently, been combined with that of his compatriot Didier *Barra under the name of **Monsù** (corruption of Monsieur) **Desiderio**.

Non-Objective *See* *abstract.

Noort, Adam van (1562–1641) Flemish painter, teacher of *Rubens, 1592–6, and of Jacob *Jordaens, whose father-in-law he also became. Many paintings formerly attributed to him have been discovered to be youthful works by Jordaens. He is recorded as being a portraitist as well as a *history painter, but none of his portraits is known. Like his near-contemporary Otto van *Veen, Rubens's teacher after 1596, Noort seems to have evolved from a belated dependence on the manner of Frans *Floris, through a *Mannerist phase, to a form of *classicism. His late work, however, is influenced by the spirited brushwork of Jordaens. There are drawings by Van Noort in Antwerp, Moretus; Rotterdam, Boijmans Van Beuningen; and paintings by him in Antwerp, Rubenshuis; Brussels, Musées; Mainz, Museum.

Northcote, James (1746–1831) Portraitist, painter of *Fancy Pictures, and one of the first artists to contribute to *Boydell's Shakespeare Gallery. He also attempted to emulate *Hogarth with some series of 'modern moral subjects'. In 1771–5 he lived as a pupil and assistant in *Reynolds's house; from 1777 to 1781 he studied in Rome. His works are studded with quotations from ancient and Italian art. There are paintings by him in Dulwich,

Gallery; London, V&A; Glasgow, University; but he is probably best remembered today for his biography of Reynolds.

Norwich School A group of English *landscape painters centering on the Norwich Society of Artists, founded in 1803 and presenting annual exhibitions 1805–25 and again, as the Norfolk and Suffolk Institution, 1828–33. *Crome and *Cotman were the leading artists at the start; their pupils and Cotman's sons were prominent later. No one style was promoted beyond that of a general *naturalism on the model of Dutch 17th-century painting and early *Turner; Norwich itself was frequently their subject. The first of Britain's regional art institutions, its life depended on support from local middle-class interests.

Nost (originally van Ost) **John** (recorded from 1678 to 1711/13) Flemish-born sculptor who settled in England in about 1678, and by 1686 was foreman to Artus III *Quellin, whose widow he was to marry. He is remembered above all for his lead garden statues (Derbyshire, Melbourne Hall; Hampton Court; etc.) His son **John Nost** (d.1780) continued his practice.

Notke, Bernt (*d*. after 1509) Important sculptor from north-west Germany, active in Lübeck (Stockholm, St Nicholas, *St George and the Dragon*, 1489; Lübeck, St Mary's, tomb of Hermen Hutterock, *c*.1508–9).

Novecento Italiano The name of an artists' group formed in Italy in 1922, meaning 'the Italian Twentieth Century'. Formed in reaction against the aggressive *Modernism of *Futurism, and also against the international character of *Impressionist and *Symbolist tendencies inherited from the late 19th century, the Novecento group stood for nationalism and a return to *Renaissance and *classical values. Among the most significant artists involved in this were *Carrà, Campigli and Marino *Marini. The group exhibited for the first time in 1926; being concerned with politics it was soon linked to Fascism, and thus it dissolved in 1943.

Novembergruppe An association of German artists, architects and composers, formed in November 1918 shortly after the end of the First World War and the departure of the Kaiser. Their aims were radical and their stylistic range was wide, but they shared a desire to make art truly popular and functional in society again. César Klein and Max *Pechstein were its initiators; *Müller and the architect Walter Gropius were prominent among its members. They formed the Arbeitsrat für Kunst (Workers' Council (Soviet) for Art) and worked on proposals for art education and the use of art by the new republic. The association ended in 1924 when left-wing hopes of creating a fraternal society faded.

nude A form of representation which is of special importance in the history of western art, having become in Graeco–Roman antiquity a prime vehicle of *idealization. A nude differs from the representation of a naked human being (*see* e.g. *under* Pigalle) in that it suppresses individual resemblance and particular circumstances in favour of harmonious, or abstract, design and timeless generalization.

O

O'Conor, Roderic (1860–1940) Irish painter who studied in Dublin and Antwerp before going to Paris where he adopted the striations he saw in the work of Van *Gogh as the dominant characteristic of his expressive art. In 1892 he went to Pont-Aven where he became closely involved with *Gauguin, *Bernard and their circle. He befriended Gauguin, helping him financially but decided against accompanying 'that maniac' to Tahiti. His work took on some of the *Synthetist qualities of their art, including strong flat shapes repeated across a flat composition, requiring distortion of nature's forms for the sake of rhythmic patterning and to suggest nature's energies. These are, however, more marked in the series of landscape prints O'Conor made at Le Pouldu in 1893 than in his paintings in which he continued to explore Van Gogh's lines in contrasting colours.

O'Gorman, Juan (1905–82) Mexican painter and architect, a follower of *Le Corbusier as architect, as painter admired for his contribution to the new tradition of Mexican narrative and symbolical mural painting that began with *Orozco and *Rivera. In 1937 he painted *Man's Conquest of the Air* in Mexico International Airport and in 1942 the *History of Michoacan* in San Augustin, Patzcuaro.

O'Keeffe, Georgia (1887–1986) American painter, trained in Chicago and then New York where she came into touch with modern developments in art and with Oriental traditions, both directing her towards semi-*abstract images. *Stieglitz showed her work in 1916 and 1917 and frequently thereafter, and she served as a model for many of his photographs. They married in 1924. Her characteristic pictures of this time, often watercolours, were tersely simplified versions of natural phenomena, e.g. a series of flower paintings of single blossoms in luminous colours. She also painted landscapes and townscapes, and from 1929 worked for part of each year in New Mexico, settling there after Stieglitz's death. The landscape, buildings and also animal bones of New Mexico became her dominant motifs, dramatically and austerely shown in broad forms suggesting great spaces and the passing of time. Her work has been seen in many solo and group shows, and in major retrospectives, but rarely outside the USA. Her firm manner associated her with the *Precisionists, yet her work is both more expressive and more epic in celebrating her experience of life and nature.

Ochtervelt, Jacob (1634–82) Dutch painter, a specialist of elegant *genre, said to have been a pupil of *Berchem at the same time as de *Hooch. He was mainly active in Rotterdam. Like those of *Ter Borch, many of his female figures are dressed in sumptuous satin (Birmingham, City Art; St Petersburg, Hermitage; Kassel, Kunstsammlungen).

Oeser, Adam Friedrich *See under* Donner, Georg Raphael.

oil paint Paint made by mixing ground pigments with drying oils. These do not dry by evaporation but set by a slow and gradual process to a glossy surface; the oils used vary, walnut and linseed being the most frequent. While some pigments are opaque in oil, others, like the red and yellow dyestuffs called 'lakes', or the green compounds known as 'copper resinates', are translucent. It is this property of 'glazes' (*see also under* colour) that is the basis of the painting technique of the Early Netherlandish artists of the 15th century, although the legend that the Van *Eyck brothers invented painting in oils is just that – a legend. Treatises and other documentary sources show that drying oils were familiar painting materials north and south of the Alps at least as far back as the 8th century, used for oil-resin varnishes and for painting on stone and glass. Despite their

slow drying time, oil paints had also been used in northern Europe for painting on panel as early as the 13th century, as we know from a group of painted altar frontals from various churches in Norway and the *retable of *c*.1270 in Westminster Abbey, London. They seem to have been used more widely on panels in England and France in the early 14th century. Technical improvements in the refining and preparation of drying oils around the beginning of the 15th century, however, may have hastened their general adoption in the Netherlands, and the full exploitation of their optical possibilities. By extending translucent glazes over most of the painted surface, exchanging the pre-mixed tonal modelling of *tempera painting for an equally disciplined system in which forms are modelled and colour effects obtained by applying glazes of varying thickness over opaque and semi-opaque underlayers, Jan van Eyck and his compatriots were able to achieve a far greater degree of *naturalism.

In nature, the purest and most saturated hues occur not in the shadows, as in tempera painting, but somewhere between the highlights and the mid-tones, and this is made possible in oil painting through layering coloured glazes over opaque under-layers in a related but somewhat lighter colour. More layers of glaze are applied in the shadows, fewer in the highlights. Both shadows and highlights retain the colour of the drapery or object depicted, because no white or black is mixed with the original pigment. Secondly, the transparency of oil paints makes it possible to paint convincing cast shadows, and imitate the fine gradations of ambient light. Finally, the slow setting time of oil paints enables them to be manipulated on the surface of the picture, whether with a brush or the fingers: transitions can be softened, or the texture of paint used to imitate the different textures of materials in reality.

Later developments, north of the Alps and in Italy (*see especially* Tura; Giovanni Bellini; Leonardo da Vinci; Titian) have further increased the mimetic potential of oils, while the varied brushstrokes and thicknesses of consistency possible with oil paint have made it a far more eloquent

medium than tempera, with its anonymous network of hatchings, could ever be. The single long tapering black brushstroke that runs the whole length of *Velázquez's *Rokeby Venus*, the encrusted jewels of *Rembrandt's *Belshazzar's Feast* built up with impasto (paint as thick as toothpaste, created with certain opaque pigments, such as lead white, which aid the drying of oils) – these are only some of the innumerable effects of oil painting. In the 19th century the mass production of paints, thicker and more even than hand-ground mixtures, made possible the impassioned surface textures of Van *Gogh, while without the invention of the metal tube, in which slow drying oil paints could be stored almost indefinitely, the outdoor pictures of the *Impressionists could never have been painted.

Oldenburg, Claes (1929–) American sculptor, born in Stockholm (Sweden) and brought to the USA in 1936. He studied English and art at Yale University and art (1952–4) in Chicago. In 1956 he moved to New York and became part of a movement, involving also *Kaprow and *Dine, that answered the high rhetoric of *Abstract Expressionism with spontaneous, often ephemeral art events in the form of *Happenings etc. In 1962 he organized 'The Store', a solo exhibition in rented shop premises where he assembled plaster and papier-mâché imitations of everyday things; in 1963 he made *The Bedroom*, a full-scale mock-up of a motel bedroom seen in perspective. These works associated him with *Pop and this was clinched by his gigantic versions of hamburgers, ice cream cones, furniture and utensils, in painted plaster or stuffed canvas, popular and witty but also disturbing. As sculpture, the soft objects were of particular interest because of their patient account of their motifs and their thorough denaturing of them; at times he made hard and soft versions of the same object, stressing his transforming role. From 1965 he produced a series of projects for vast sculpture in public spaces. These have become his prime activity, especially since he began working with the art histo-

rian, Coosje van Bruggen, in the late 1970s. A few were realized before this time, such as the lipstick mounted on a mobile tractor for Yale University (1969); many more since, in Europe as well as in America. He has shown in countless solo and group exhibitions and retrospectives in the USA and abroad. In 1969 a major exhibition shown first in New York (MoMA) was seen also in Amsterdam, Düsseldorf and London; in 1995–6 an exhibition had its debut in Washington (National) and went on to Los Angeles, New York, Bonn and London.

Olis, Jan (*c*.1610–76) Dutch painter, a specialist of 'guardroom' *genre scenes, active mainly in Dordrecht (London, National).

Olitsky, Jules (1922-) American painter, born in Russia, brought to the USA in 1924, and trained in New York during 1939–47 and in Paris 1949–51. Having produced textured paintings with hints of *figuration, then *hard-edge *abstracts, he began in 1964–5 to use a spray gun to place clouds of colour on his canvases. This work was seen as a major contribution to *Post-Painterly Abstraction in its eschewing of forms and divisions of the surface; subsequently he painted heavily impastoed monochromatic canvases emphasizing paint as matter rather than vaporous hue. From 1968 on he also made sculptures in which aluminium or steel sheet was formed into broad curving forms and sprayed with colour.

Oliver, Isaac (before 1568–1617) Born in Rouen, Oliver came to England as a child in 1568. He is best known as a miniaturist, although he also painted portraits on the scale of life (*Frances, Countess of Essex*, Welbeck Abbey). Where his master *Hilliard's style relates to that of the French court, Oliver's is influenced by Dutch and Italian painting; he may have visited Holland in 1588, and was in Venice in 1596. Unlike Hilliard, he modelled his sitters' likenesses in light and shade. Not as jewel-like as Hilliard's, some of Oliver's full-length miniatures resemble large-scale state portraits in format, pose and attrib-

utes, as well as style (*Third Earl of Dorset*, 1616, London, V&A). Oliver was made 'limner' or miniature painter to Queen Anne of Denmark in 1604, and had the monopoly of her and of Prince Henry's portraits in miniature. He also made some religious and narrative drawings, and copies after Italian compostions.

Omega Workshop Founded in 1913 by Roger *Fry, this London workshop specialized in commissioning furniture and furnishings from craftsmen and decorating them. Duncan *Grant, Vanessa *Bell, Wyndham *Lewis and other painters contributed to this work, the products being marked with the Greek letter *omega*. The workshop did not thrive commercially and closed in 1920. It is remembered for the bright patterns and fluent figurative imagery it added to simple, well made objects.

Oosterwyck, Maria van (1630–93) Dutch flower and *still-life painter, financially the most successful pupil of Jan Davidsz. de *Heem. She was the daughter of a preacher, and, according to *Houbraken, 'unusually religious'; many of her pictures have *vanitas* elements (e.g. Vienna, Kunsthistorisches; The Hague, Mauritshuis).

Oostsanen, Jacob Cornelisz. van (1470–1533) Dutch portraitist and designer of woodcuts (*see under* relief prints), he is the first important artist working in Amsterdam. His early work is indebted to the Haarlem painter *Geertgen tot Sint Jans, but he later came under the influence of *Dürer, especially in his woodcuts. His paintings, crowded with elaborately costumed figures and surface movement, have been characterized as Late-*Gothic *Mannerist (Amsterdam, Rijksmuseum; Enschede, Rijksmuseum; Berlin, Staatliche; Kassel, Museum). He may have been the second teacher of Jan van *Scorel. *See also* Alkmaar, Master of.

Op Art Abbreviation of 'optical art', used since 1964 to refer to art the prime characteristic of which is its stimulation

of the retina by means of patterns and contrasts of form, tone and hue. An Op art movement was discerned by critics in the 60s and promoted in exhibitions and texts. Prominent among the artists associated with it were *Soto, *Vasarely and *Riley, but many others contributed to it with more or less inventiveness and point. Notable forerunners, in some of their works, include *Balla and *Albers. By 1970 (the date of a major study of Op art by Cyril Barrett) the movement as such had vanished though some artists continue to explore the dynamics of optical stimuli.

Opie, John (1761–1807) British painter, whose work marked a return to Dutch and Flemish 17th-century art as a source of inspiration. The precocious son of a Cornish carpenter, he was taken up at the age of 14 by John Wolcot, a former pupil of Richard *Wilson, who was practising medicine in Cornwall. Having noted Opie's natural talent for *realistic representation and *chiaroscuro effects, Wolcot trained him, secretly, on prints by, and after, *Rembrandt and other *tenebrists. In 1781 Wolcot launched Opie in London as an untaught prodigy, 'the Cornish Wonder'; he became a successful society portraitist, albeit always at his best in the portrayal of unaffected old people (*Mrs Delaney*, 1782, London, NPG) and children (*Children of the Duke of Argyll*, c.1784, Inveraray). His first multi-figured subject picture, *The School*, exhibited at the *Academy in 1784 (Lockinge, Loyd Coll.) was much praised. From 1786 he began to paint seven pictures for *Boydell's Shakespeare Gallery, and other costume pieces, some for Bowyer's Historic Gallery (1790s), which influenced the development of the historic costume piece of the 19th century. But his talent declined as the literary content of his pictures increased, and his early, naturalistic, work is his best. There are paintings by Opie in many British museums, including London, Tate.

Oppenheim, Meret (1913–85) German-Swiss artist, associated with *Surrealism and a close friend of Man *Ray in the 30s. Her *Fur-Covered Cup, Saucer and Spoon* (1936; New York, MoMA) is the best known of her Surrealist objects; it was much admired in a Paris exhibition in 1936 and, later that year, in the Museum of Modern Art's show 'Fantastic Art, Dada, Surrealism'.

Orcagna, Andrea; Andrea di Cione, called (active 1343–68) Florentine painter, sculptor and architect. His one surviving authenticated painting is the altarpiece in the Strozzi chapel, S. Maria Novella, Florence (1357), which was of an unprecedented subject in Tuscan altarpieces, an adult *Christ in Majesty with Saints*. Stressing the transcendental and hieratic aspects of its theme, this work rejects *Giotto's innovations for a deliberately archaicizing stylization. The chapel itself was decorated (1350s) with huge crowded frescos of *The Last Judgement, Paradise* and *Hell* by Andrea's brother **Nardo di Cione** (active 1343–65/6), whose major works they are. In 1355 Andrea became master of works of the guild church, Or San Michele, for which he designed and carved the ciborium-like tabernacle enshrining *Daddi's painting of the *Virgin and Child*. A younger brother, **Jacopo di Cione** (active 1362–98) completed the altarpiece of *St Matthew* (Florence, Uffizi) left unfinished at Andrea's death. Other works by Nardo and Jacopo di Cione in London, National.

Orchardson, William Quiller (1835–1910) British painter who came to London from Scotland and is best remembered not for his early Regency period *genre scenes but for domestic dramas in contemporary high life, finely painted and composed, such as *Mariage de Convenance* (1883; Glasgow City AG&M) and *The First Cloud* (1887; Melbourne, National). Their horizontal format and effective staging give a strong suggestion of stills from theatrical productions, and the public's interest in them relates to the continuing interest in the social dramas of the time, from Ibsen to Pinero, with their reliance on psychological empathy. *Whistler, *Degas and other major painters of the time admired them, but the writer George Moore questioned his 'vicious desire to narrate an anecdote'.

Ordóñez, Bartolomé (*c*.1490–1520) One of the founders of Spanish *Renaissance sculpture (*see also* Diego de Siloe). A wealthy gentleman from Burgos, he probably studied in Florence under Andrea *Sansovino, and knew the youthful reliefs of *Michelangelo. His 1514–15 marble relief of the *Adoration of the Magi* (Naples, S. Giovanni a Carbonara) demonstrates his mastery of *rilievo schiacciato* and Florentine compositional principles. He died at Carrara whilst working on the (incomplete) monument to the parents of Charles V, Joan the Mad and Philip the Handsome, set up in Granada in 1603 (Royal Chapel).

Orientalism Stimulated by *Romanticism's taste for the exceptional and the exotic in human beings and in scenery, as well as the major European nations' growing economic interest in exploiting colonies, a number of mainly French painters took to travelling to North Africa and the Middle East in the 19th century – and rarely to the Far East – and to producing scenes of 'Oriental' history and contemporary life. *Delacroix was one of the first and the most convincing; many others followed, notably *Gérôme with his highly worked, sometimes salacious, accounts of Arab life. Orientalist art was welcomed at the *Salon but began to lose its hold on the public's taste by the 1880s. The Society of Orientalist Painters, founded in Paris in 1893, was its tombstone. Recent criticism has tended to emphasize the extent to which Orientalism meant the selective exploitation of foreign *mores* to sustain the Europeans' sense of cultural as well as military superiority.

Orley, Bernard or **Barend van** (1491/2–1541) Leading Brussels painter, he became court artist, first to the Regent Margaret of Austria, 1518, then to her successor, Mary of Hungary, 1532. Trained by his father, **Valentin van Orley**, he was influenced by Italian art mediated through engravings and the cartoons by *Raphael which he studied from 1517, as supervisor of the tapestries woven from them in Brussels. His mature style is also indebted to *Gossart. Although he never achieved a convincing fusion between Netherlandish *naturalism and Italianate *idealization, he is one of the major exponents of Flemish *Mannerism, both in portraiture and altarpieces (Brussels, Musées; Antwerp, Museum) and in designs for tapestries and stained glass (the latter for Brussels, Ste-Gudule). A portrait drawing of him by *Dürer is still preserved; he invited the German master to an elaborate dinner during Dürer's trip to the Netherlands, 1520–1. He was the teacher of Pieter *Coecke van Aelst.

Orlik, Emil (1870–1932) Czech painter, graphic artist and designer, born in Prague, trained in Munich and active primarily in Munich, Vienna and Berlin. He absorbed aspects of *Post-Impressionism in Paris (where he bought a Cézanne still life in 1904) and of *Art Nouveau and Jugendstil, as, for example, in the prints of *Valotton and William *Nicholson. He made hundreds of *lithographs and *woodcuts, and from 1905 until his death taught at the Berlin Applied Art Museum, working also for the Berlin theatre as stage and poster designer. He was an inveterate traveller (Far East, Africa, USA, as well as around Europe) and took an optimistic view of the many lifestyles he encountered and recorded in countless drawings.

Orozco, José Clemente (1883–1949) Mexican painter, trained as architectural draftsman and largely self-taught as painter. He lost his left hand and the sight of one eye in an accident. Drawn to art by the example of *Michelangelo, he worked first as a cartoonist and then became known as a painter of heroic murals in a style derived from the Italian *Renaissance but tending to gigantism and melodrama. The first of these was done in 1923 in the National Preparatory School in Mexico City. From 1927 to 34 he worked on mural cycles in the USA, profoundly influencing younger artists in California and New York. He also had one-man exhibitions in Paris (1925) and New York (1930). He painted further cycles in Guadalajara and Mexico City after his return to Mexico in 1934. He had one-man exhibitions in Mexico City in the 1940s and also a major retrospective.

His studio in Guadalajara has become an Orozco museum.

Orpen, William (1878–1931) Irish-British painter, trained in Dublin and at the Slade School in London, who became the most fashionable and wealthy portrait painter of his day, succeeding *Sargent in this role. He also painted nudes and figures in interiors, such as *The Mirror* (1900; London, Tate), and also open-air landscapes. He divided his time between Dublin, where he was involved with the poet W.B. Yeats in promoting an Irish cultural renaissance, and London where he became a prominent Royal Academician. During 1917–18 he served as an Official War Artist, was knighted, and was also commissioned to record the Peace Conference at Versailles. From this time on he worked both in Paris and in London. Orpen had great technical facility and may be called a *realist painter in the tradition of *Velázquez and *Manet, especially when he chose a 'democratic subject' (as it was labelled at the time) in his imposing portrait of *Le Chef de l'Hôtel Chatham, Paris* (1921; London, Royal Academy). Orpen's work as a war artist is best seen in London's Imperial War Museum.

Orphism Tendency in painting invented by *Apollinaire in 1912 as a direction within *Cubism and characterized by a lyrical spirit expressed through the optical and emotional energies of colour. His particular champion in this regard was Robert *Delaunay, but he mentioned also *Léger and *Picabia, and failed to mention *Kupka whose work of around 1912 entirely warranted his being seen as a leading Orphist. There was never an Orphist movement; Apollinaire wanted to draw attention to a musical quality in current painting, certainly not limited to these artists nor indeed to Paris.

Orrente, Pedro (*c.*1570–1645) Called 'the Spanish *Bassano', he was the oldest of *El Greco's pupils (*see also* Luis Tristán, Juan Bautista Mayno). During his travels across Spain he executed many nocturnal bucolic scenes on Old Testament themes, some until recently falsely attributed to Jacopo Bassano (e.g. Lisbon, Museu), as well as large narratives from the New Testament and the lives of saints. Some time during 1600–10 he adopted the *tenebrist style of *Caravaggio (1616, Valencia, cathedral; 1617, Toledo, cathedral) which, during Orrente's first stay in Valencia in 1616, influenced Francisco *Ribalta.

Orsi, Lelio (*c.*1511–87) Italian *Mannerist painter and architect from Novellara, where he executed many decorative *frescos on façades and interiors, although virtually all his work in this field has perished. His style was influenced by *Correggio, *Giulio Romano and, after 1555 and a visit to Rome, by *Michelangelo. His surviving paintings are small, vigorously expressive (*see under* expression) collectors' pictures of religious scenes, such as *The Walk to Emmaus* (London, National) or *The Martyrdom of Saint Catherine* (Modena, Estense).

Os, van Dynasty of Dutch painters active from the late 18th century, mainly in The Hague. The founder, **Jan van Os** (1744–1808) painted decorative fruit and flower pieces in the manner of Jan van *Huysum and some seascapes in the manner of Willem van de *Velde the Younger (e.g. London, National). His son **Georgius Jacobus Johannes** (1782–1861) and his daughter **Maria Magrita** (1780–1862) followed his example in *still life. Georgius van Os also painted landscapes and made lithographs; in 1826 he settled in Paris and worked for the Sèvres porcelain factory. Another son, **Pieter Gerardus** (1776–1839) drew inspiration from Paulus *Potter for the paintings of cattle in which he specialized (The Hague, Gemeentemuseum). His son and pupil **Pieter Frederik** (1808–92) was the teacher of Anton *Mauve.

Ostade, Adriaen van (1610–85) and his brother **Isaack** (1621–49) Adriaen was a painter and etcher resident in Haarlem, a prolific specialist in peasant scenes. He is supposed to have been a student of Frans *Hals and may have known *Brouwer; the influence of *Rembrandt is also detectable in his work. By the middle of the century

his boisterous, disorderly subjects gave way to more 'respectable' figures, in keeping with the greater prosperity of Holland in general, and of Ostade, who married well, in particular. More than 800 of his paintings, and some 50 etchings (*see* intaglio) are known. He was much in demand by princely collectors in the 18th century, and his work is to be found in most well-established galleries. He probably taught Jan *Steen, but his principal pupil was his younger brother, Isaack, who, after an initial period of emulating his brother's peasant interiors, went on to specialize in exterior scenes, often combining winter or summer landscape and *genre, especially the activity in front of a country cottage or a roadside inn (Haarlem, Hals; Basel, Kunstsammlung; Berlin, Staatliche; London, National; etc.). Adriaen van Ostade's 'first and best pupil' was said to be **Cornelis Bega** (1631/2–1664), who produced paintings and etchings of peasant scenes in imitation of his master (e.g. London, National). During the last years of Adriaen's life, however, **Cornelis Dusart** (1660–1704) entered his studio, assisting Adriaen in completing his pictures. After Adriaen's death Dusart inherited unfinished paintings by both Adriaen and Isaack, completing them for the market in his coarser, more caricatural style.

Oudry, Jean-Baptiste (1686–1755) French painter, the leading *Rococo specialist of aristocratic *still-life and hunting pieces, close to the decorative manner of the two *Weenix brothers. Trained by *Largillière, he was capable of great tonal finesse (*see under* colour): the *White Duck* (1753, Coll. Dowager Marchioness of Cholmondeley) is a virtuoso piece composed almost entirely in shades of white and silver. While most of Oudry's paintings combine still-life, living animals, plants and architecture against a background of decorative landscape (e.g. London, Wallace), he also executed a major cycle of panoramic hunting scenes in topographical landscapes (e.g. Fontainebleau, Château). These *Royal Hunts* document the expeditions of Louis XV, and were intended as cartoons (*see under* fresco) for tapestries to be made at the Beauvais tapestry works,

where Oudry had been appointed official painter in 1726; in 1734 he was made Director, becoming Inspector of the Gobelins tapestry works in 1738, and in 1748 Chief Inspector. He also worked for private patrons and foreign collectors, the most devoted of whom was the Duke of Mecklenburg-Schwerin (Schwerin, Museen).

Ouwater, Albert van (documented 1467) Netherlandish painter of the generation of Petrus *Christus, said by Van *Mander to have been the founder of the Haarlem school of painting and the teacher of *Geertgen tot Sint Jans. Although Van Mander praises Ouwater as a landscapist, the only authenticated painting by him is the *Raising of Lazarus* (Berlin, Staatliche), a scene set in a church interior, identified from a detailed description of a copy seen by Van Mander.

Ovens, Jürgen (1623–78) German painter, born in Schleswig-Holstein. He is said to have been a pupil of *Rembrandt's, but more probably studied with Gerard *Dou and was influenced by Jan *Lievens. He became a fashionable portraitist in Germany and Holland, but also executed History Paintings (*see under* genres) and *allegories. He is now chiefly remembered for having painted the large *Oath of Claudius Civilis* which in 1662 replaced Rembrandt's famous picture of the same subject in the Town Hall (now Royal Palace) in Amsterdam.

Overbeck, Friedrich Johann (1789–1869) German painter, a founder and one of the leading artists of the *Nazarenes. Deeply religious and seriously high-minded, he, unlike some of his friends, remained in Rome for the rest of his life, apart from visits to Germany, and painted religious subjects almost exclusively, basing his style increasingly on that of *Perugino and the young *Raphael. He also painted portraits, often of his artist friends, in a similarly clear and innocent style.

Ozenfant, Amedée (1886–1966) French painter, trained in his native Saint-Quentin and in Paris. He became interested

in *Cubism but thought it confused and unstructured. In 1917 he allied himself to *Le Corbusier. They published the book *After Cubism* in 1918, launching *Purism which they further discussed and contextualised in the journal *L'Esprit Nouveau* (1920–5), and summarized in *La Peinture moderne* (1924). During the later 20s Ozenfant produced mural paintings and also the book *L'Art* (in English as *Foundations of Modern Art*, 1931). During 1935–8 he lived in London and from 1938 in New York, founding art schools in both. His painting, previously exceptionally economical while also decorative, became much more prolix.

Paalen, Wolfgang (1905 or 7–1959) Mexican painter, born in Vienna, who went to Mexico in 1939 after more than a decade in Paris. He had worked in various modes, including *abstraction, but went to Mexico a convinced *Surrealist and helped organize the 1940 International Surrealist Exhibition in Mexico City. His Surrealist paintings often represent semi-human, semi-animal 'Saturnine Princes', close-packed in a jungle setting. In 1941 he turned to a style he called 'Dynaton' and published related theories in the journal *Dyn* (1942–44). Subsequently he painted abstract paintings of a peculiarly violent sort.

Pacchiarotti, Girolamo *See* Pacherot, Jérôme.

Pacheco, Francisco (1564–1654) Sevillan painter and scholar, the director of an artistic and literary *academy; from 1618 chief censor of the Inquisition in Seville. He was the author of the important treatise *El arte de la pintura, su antiguedad y grandeza* (*The art of painting, its antiquity and greatness*), published in 1649. An excellent teacher, he was the master of *Herrera the Elder, Alonso *Cano and *Velázquez, who married his daughter in 1618. He executed the *polychromy on the sculptures of Juan Martinez *Montañés.

Despite generous praise in his treatise for the naturalistic *bodegones* of Velázquez, Pacheco remained a *classicizing *Mannerist working largely from prints after Italian and Netherlandish masters and in a dry, hard technique dependent on Flemish painting (e.g. Seville, Count Ibarra). As censor for the Inquisition, he showed particular interest in religious *iconography, most notably in the new doctrine of the Immaculate Conception, which was propagated with particular fervour in Seville (cathedral; S. Lorenzo). Only as a portraitist did Pacheco show pictorial – as opposed to verbal – understanding of the new style (e.g. Williams-

town, MA, Museum). His unfinished *Book Describing the True Portraits of Illustrious and Noteworthy Gentlemen* contains excellent portrait drawings (mostly preserved, Madrid, Lázaro Galdiano).

Pacher, Michael (active *c.*1462–98) German painter and sculptor (or perhaps only designer of sculpture produced in his workshop) based in the south Tyrol. The sculpture is northern in style, a synthesis of *Multscher's later manner and the new grand figure type of *Gerhaert; Pacher's painting, however, demonstrates first-hand knowledge of Paduan art and especially the work of *Mantegna. The most complete extant work is the high altarpiece, St Wolfgang, Pfarrkirche (1471–81, restored in 1861).

Pacherot, Jérôme (1463–*c.*1540) Italian ornamental sculptor active in France, where he was important in the spread of *Renaissance decoration. Perhaps identical with Girolamo Pacchiarotti of Genoa, he was recruited with other Italian artists by Charles VIII of France during his incursion into Italy in 1495. His best-known work is the frame for Michel *Colombe's relief of *Saint George and the Dragon* in the chapel at Gaillon, 1508–9.

Padovanino, Il; Alessandro Varotari, called (1588–1648) Italian painter born in Padua, to which he owes his nickname. In 1614 he settled in Venice, where he remained except for a period in Rome in 1637, when he was summoned to copy *Titian's *Worship of Venus*, then in the *Ludovisi collection (*but see also* Aldobrandini), before it was sent to Spain. Cassiano dal *Pozzo acquired a number of pictures from him, helping to launch the vogue in Rome for Venetian painting. With his pastiches of Titian's early works, Il Padovanino also influenced 17th-century painting in Venice itself. He often depicted unusual subjects from mythology and ancient history, such as *Cornelia and her*

Sons (London, National; probably an old copy) and *Penelope bringing the Bow of Ulysses to her Suitors* (Dublin, National).

Pajou, Augustin (1730–1809) French sculptor, whose career, like that of his older contemporary, the painter *Vien, successfully survived the most extreme political upheavals: he worked for Mme du Barry, and received crown commissions under Louis XV and Louis XVI, but later also served on official committees during the Revolution and under the Directoire, and was still exhibiting officially commissioned works in 1802 and 1803 under the Consulat of Napoleon (Paris, Palais du Sénat, Chambre des Députés). His style is characterized by a slightly sentimentalized *classicism, and although he produced many portrait busts, including one of his teacher Jean-Baptiste *Lemoyne (terracotta, 1758, Nantes, Musée; bronze, Paris, Louvre) the best examples of his work are his reliefs (e.g. St Petersburg, Hermitage). From 1772–92 he served as designer for the medals of the Académie des Inscriptions, and added relief figures to *Goujon's famous *Fontaine des Innocents*, Paris. His best-known works are the gilded wooden reliefs in the opera house at Versailles, 1768–70. (Other works Paris, Institut; Ecole des Beaux-Arts; many fine drawings, some at Princeton.) He became the father-in-law of *Clodion.

Pala Sforzesca, Master of the (active *c.*1490–5) Italian painter active in Milan, named after an altarpiece (*pala*) which includes *donor portraits of Duke Lodovico *Sforza and his family (Milan, Brera). It shows the combined influence of *Foppa and *Leonardo da Vinci. Other works attributed to him are in London, National.

Paladino, Mimmo (1948–) Italian artist, born in Paduli, near Benevento. He has exhibited frequently since 1975, from 1978 also outside Italy, becoming known for paintings, drawings and sculpture in which ancient and modern, primitive and sophisticated forms meet to present poetic imagery. Totemic symbols, medieval art and also *Cubism are

invoked in works that have a marked theatrical and mythical character.

Palamedesz., Anthonie (1601–73) Dutch portrait and *genre painter from Delft, specializing in guardroom scenes (*see also* Codde; Duck; Duyster) and 'merry company' pictures (*see also* Dirck Hals) (e.g. The Hague, Mauritshuis). His younger brother and pupil, **Palamedes I Palamedesz.** (1607–38), born in London, was a specialist in pictures of cavalry battles (e.g. Vienna, Kunsthistorisches); his nephew **Palamedes II Palamedesz.** (1633–1705) was also a painter.

Palermo (1943–77) Adopted name of Peter Schwarze, German painter who studied under *Beuys in 1963–4. His painting went rapidly through many changes, but was principally *abstract and colourful and included ephemeral 'wall paintings' and 'wall drawings' made for particular occasions.

palette *See under* colour.

Palizzi brothers Italian painters, trained in Naples and associated with *naturalistic paintings mostly of landscape and animals. **Giuseppe** (1812–88) moved to Paris and was affected by the example of the *Barbizon school. **Filippo** (1819–99) stayed in Naples where he became director and then president of the Naples *Academy.

Palma Giovane or **the Younger, Jacopo Nigreti**, called (*c.*1548–1628) Eclectic and prolific Venetian painter, whose long stay in central Italy, first in Pesaro, then, 1567–*c.*75 in Rome, converted him to a *Mannerist idiom. On his return to Venice he also adopted successful formulae from *Veronese and *Tintoretto, and occasionally the naturalistic vein of Jacopo *Bassano. He soon found favour with the Venetian government (Doge's Palace, Great Council Hall, *c.*1578) and with the Counter-Reformation clergy (e.g. S. Giacomo dell'Orio, *c.*1584; Oratorio dei Crociferi, 1583–96), as well as with princely patrons throughout Italy and abroad. After the death of Tintoretto in 1594 he became

the leading artist in Venice. He was the great-nephew of *Palma Vecchio, and the son of the painter **Antonio Nigreti** (1510/15–after 1575). There are works by him in many Venetian churches, and in museums in Italy and abroad.

Palma Vecchio or the Elder; Jacopo Nigreti, called (c.1480–1528) Venetian painter born near Bergamo, possibly trained by *Carpaccio, but soon influenced by *Giorgione and *Titian. Although he executed portraits (e.g. London, National) and some altarpieces (Venice, S. Maria Formosa, c.1522–3; Vicenza, S. Stefano, c.1523) he is best known for two domestic genres which he developed: *sacre conversazioni* of horizontal format, in which the figures are disposed in front of an extensive landscape (e.g. London, National; Vienna, Kunsthistorisches; Florence, Uffizi; Munich, Alte Pinakothek) and half-length quasiportraits of beautiful women, perhaps Venetian courtesans (e.g. Madrid, Thyssen; Vienna, Kunsthistorisches; cf. Titian, *Flora*; *Woman in Blue Dress*). He was the great-uncle of *Palma Giovane.

Palmer, Samuel (1805–81) British landscape painter. Already embarked on his career, Palmer met *Linnell, *Stothard and others at the age of 17, became part of William *Blake's Shoreham circle and proved a devout follower of his mystical theories and art. Blake's illustrations to Virgil's *Eclogues* inspired an intense series of painted or drawn landscapes, not *naturalistic but conceived as visions of Paradise and represented in a partly fantastic and archaic manner in which the influence of *Dürer and other German printmakers of around 1500 mingled with impulses from Blake. Political unrest caused Palmer to lose this sense of actual landscape as a presage of Heaven. In 1835 he went to Wales, and in 1837 to Italy for a two-year honeymoon with Linnell's daughter, Hannah. From this time on, he worked in a more *classical vein, abandoning his earlier intensity. That early work achieved its present fame in the 1930s when *Surrealism became a conscious movement in Britain and Palmer, together with Blake, was seen as a native precursor of what became a *Neo-

Romantic movement. The poet and art critic Geoffrey Grigson in 1942 published the first book on Palmer, but had written about his work earlier in discussing the work of the Neo-Romantic artists.

Palmezzano, Marco *See under* Melozzo da Forlì.

Palomino, Antonio (1655–1726) Spanish painter, scholar and writer on art. A native of Cordova, he had studied briefly with *Valdés Leal before moving to Madrid in 1680; he became court painter to Charles II in 1688. After 1699 he specialized in large allegorical *fresco decorations for churches in various cities throughout Spain. His main importance, however, resides in his writings: the third volume of his treatise on painting, the *Parnaso español pintoresco laureado* (1724), modelled on *Vasari's *Lives . . .* , is our most valuable source for the history of Spanish painting in the 16th and 17th centuries. Summaries in English and French were published in 1739 and 1749/62 respectively.

Pamphili or Pamphilj Noble Roman family, important art patrons after the election of **Giovanni Battista Pamphili** (1572–1655) to the papal throne in 1644 as Innocent X, following the death of Urban VIII *Barberini. Although lacking his predecessor's flair, Innocent X is nevertheless responsible for some of the most impressive works of 17th-century art. He remodelled the Piazza Navona in Rome, the site of his family palace. Rejecting, however, the plans of his otherwise-favoured sculptor, *Algardi, for the central fountain of the piazza, he succumbed to the exhilarating model by *Bernini, whose Fountain of the Four Rivers is one of the greatest achievements of *Baroque sculpture – just as Innocent's portrait by *Velázquez, now in the family collection in the Palazzo Doria Pamphili on the Corso, is one of the greatest Baroque paintings. Algardi, however, was extensively employed by him in St Peter's, and designed the lavish villa, studded with antique reliefs and sarcophagus fronts, built for the Pope's nephew, Prince **Camillo Pamphili** (1622–66), the only one of the

family with a genuine interest in the arts. Giving up the cardinalate granted him by his uncle to marry the wealthy Olimpia *Aldobrandini in 1647, Camillo commissioned *fresco decorations from *Pietro da Cortona, *Mola, *Preti, and paintings by *Claude, and supported the construction of Bernini's church S. Andrea al Quirinale for the Jesuit order with which the family were closely connected.

panel A rigid painting *support, made from butt-joined planks of wood, widely used for portable paintings until generally supplanted by *canvas. In Italy, where wood for shipping and construction was scarce, painters were forced to rely on the porous but quick-growing white and black poplar. In northern Europe, the preferred wood was the denser oak, exported from Poland and the Baltic Republics through the port of Gdansk. It continued to be used by artists through much of the 17th century, and was *Rubens's favoured painting support. Other rigid materials on which paintings have been executed, such as copper, slate, tin or zinc, may by extension be referred to as panels. *See also* gesso.

Panini or **Pannini, Gian Paolo** (1691/2–1765) Painter specializing, from *c*.1735, in celebrated views of Roman architecture and ruins. He depicted real topography as well as imaginary views, but was not, as is sometimes said, the originator of *vedute ideate*, having been anticipated by Giovanni *Ghisolfi. Born at Piacenza and probably trained in architectural drawing, he moved to Rome in 1711. His reputation was established with his *fresco decorations of the Villa Patrizi (1718–25, destroyed) and in the Quirinal Palace (*c*.1722). Commissioned by Cardinal de Polignac for a series of paintings recording celebrations on the birth of the heir to the French crown in 1729, and married to a Frenchwoman, Panini forged close relations with the French *Academy in Rome, influencing many French artists, including the more poetical Hubert *Robert. His architectural fantasies also affected *Piranesi. There are many variants of compositions by Panini which are found

in numerous collections in Rome and abroad.

Pantoja de la Cruz, Juan (1553–1608) Spanish court portraitist, a pupil and follower of *Sánchez Coello. He was particularly in demand after the death of Philip II in 1597; during 1600–7 he executed 66 royal portraits, of which at least nine are of Philip III (best versions Vienna, Kunsthistorisches; Hampton Court; Escorial; Madrid, Prado; Cambridge, MA, Fogg) and eight of Queen Margarita (best versions, Buckingham Palace; Houston, Museum). After the disastrous fire of 1604 at the Pardo Palace, Pantoja restored mutilated portraits by Sánchez Coello, confusing later attributions. Pantoja also executed religious works, some of them incorporating portraits of the royal family (e.g. Madrid, Prado; Toledo, Cathedral). The poses of Pantoja's sitters were influential on later court portraitists, including *Velázquez.

Paolo Veneziano (active 1321–before 1362) The first named Venetian painter whose work has survived in any quantity; founder of the Venetian school. He popularized the *polyptych, or composite altarpiece carved, gilded and painted on wood, which replaced wall *mosaics as the most important element in Venetian church decoration for nearly two centuries. Paolo's style is still mainly *Byzantine, although it has been called a 'personal synthesis of the Byzantine and the *Gothic'. Views differ on the influence of *Giotto's *frescos in neighbouring Padua on him (Dignano, cathedral; Venice, Frari, Accademia; Bologna, S. Giacomo Maggiore; etc.) Paolo's sons Luca and Giovanni collaborated with him in 1345 on the panels of the covering of the Pala d'Oro, a jewelled Byzantine gold and enamel altarpiece behind the high altar of Saint Mark's, Venice; and in 1358 he painted the *Coronation of the Virgin* (New York, Frick) with his son Giovanni.

Paolozzi, Eduardo (1924–) British sculptor and print-maker, born in Edinburgh of Italian parents. He attended evening classes in Edinburgh in order to

become a commercial artist; in 1945–7 he studied sculpture at the Slade School of Art (then in Oxford), and in 1947 had his first one-man show. He was in Paris 1947–9, absorbing *Surrealist ideas and methods and beginning to make his long series of *collages of found imagery from magazines and technical and scientific publications which later caused him to be classed with *Pop artists. From 1949 he worked in London, rapidly becoming known as a resourceful young artist working in two and three dimensions. In 1950 he received the first of many public commissions, for a fountain for the Festival of Britain South Bank exhibition. In the 1950s he was a member of the Independent Group at the Institute of Contemporary Arts, joining in the Group's debates about popular imagery in art and the media and contributing to exhibitions exploring this area. He taught in London art schools, and went on to teach outside Britain, on both sides of the Atlantic, becoming especially well known in West Germany where in 1981 he was appointed professor of sculpture at the Munich Academy, a post he was able to combine with teaching sculpture at London's Royal College of Art. He was made a Royal Academician in 1978 and knighted in 1989.

His sculpture has varied greatly in process, form, material and imagery, sometimes responding to the new tendencies of the time, sometimes detached from them, but always revealing personal factors. Among these are the urge to question honoured images while exploring disregarded mass-media images of yesterday and today. They also include an interest in humanity's confrontation with the machine: robot figures, convoluted machine-like compositions as freestanding sculptures and as reliefs (the latter at times made from discarded offcuts: rubbish organized to take on machine characteristics). In the 1960s he made human images with relief surfaces formed by a multitude of accretions and impressions which gave them a distressed and decayed look. In the 1980s he again turned to heads and figures, more *classical now but disrupted and broken open as were the heads he cut and collaged from magazines in the 1950s.

Behind them all lies continuous study of images of man from the ancient Greeks' to *Rembrandt's and William *Blake's: Paolozzi's, some of them portraits and self-portraits, are by these means charged with energy and also a modern quality of transience. Some of his work, notably in 1960s, was smooth and new-born in appearance; much of it since has looked found, archeological, a modern art that has been rediscovered in some future age to remind the world of 20th-century concerns.

Paolozzi has had many one-man exhibitions since 1947; from 1960 these were often abroad.

paper A substance made from cellulose fibres derived from plants, rags, or wood, fermented in water and formed into thin sheets suitable for writing, drawing and printing on. The ancient Egyptians, Greeks and Romans used papyrus reed, the Chinese and Japanese bamboo, rice straw, and mulberry bark. Although paper was made in Fabriano in Italy as early as the 12th century, and in France, Southern Germany and Switzerland in the 14th century, the principal drawing and writing surface in medieval Europe was vellum, a fine parchment made from the skins of calves or kids. Paper-making expanded only after woollen clothes had been largely replaced by linen, providing suitable rags for the paper mills, and in response to the evolution of the printing press. The ready availability of paper in turn stimulated a significant expansion in the role of drawing in the artist's workshop. *See also* watercolour, papier collé.

Pareja, Juan de (*c.*1610–*c.*70) Spanish painter of part-African origin. He was an assistant – a slave, says *Palomino – of *Velázquez, and accompanied the latter in 1649–51 on his second visit to Italy, where Velázquez painted his likeness (now New York, Metropolitan) as an exercise before portraying the Pope, Innocent X. Although Palomino claims that Pareja painted portraits close in style to those by Velázquez, none has been identified, and his religious works, like the signed and dated *Calling of Saint Matthew* of 1661 now in Madrid, Prado, are at best barely competent.

Paret y Alcázar, Luis (1746–99) Painter, the most important of *Goya's Spanish contemporaries, born in Madrid in the same year as his great Aragonese rival. A lifelong adherent to the *Rococo style in which he had been trained at the Royal *Academy directed by Corrado *Giaquinto, Paret earned the epithet 'the Spanish *Watteau' for his elegant *genre scenes of court life, such as the *Masked Ball* (1766, Madrid, Prado) executed under the patronage of the king's brother, Don Luis de Borbon, who between 1763 and 1765/6 had sponsored the artist's study trip to Rome. The relationship, seemingly so fruitful, was, however, ill-fated. In 1775, through the agency of the king's confessor, Don Luis was publicly disgraced for his promiscuity; Paret was accused of procuring young women for the prince's pleasure, and exiled to Puerto Rico. There he became the leading artist and established a local school of painting. (The same stern confessor believed Paret's Rococo altarpieces for Aranjuez to be too frivolous, and had them replaced with more sober *classicizing works by *Mengs and Francisco *Bayeu.) In 1779 the artist was permitted to return to Spain provided he remained more than forty leagues from the court of Madrid; he chose the northern city of Bilbao. Here he executed two famous flower pieces (Madrid, Prado), and the works for which he is now chiefly remembered, a series of views of Cantabrian ports, perhaps begun at the instigation of the Prince of Asturias, the future Charles IV, before the official commission from Charles III in 1786. These pictures, inspired by a similar group of French ports commissioned by Louis XV from Claude-Joseph *Vernet, earned Paret the additional sobriquet of 'the Spanish Vernet'. Dispersed during the Peninsular War, the eight known paintings from the series are now in Madrid, Palacio de la Zarzuela; Bilbao, Bellas Artes; Caen, Beaux-Arts; National Trust, Upton House; London, National, and private collections in London and Spain.

Parler Influential and extensive dynasty of masons and sculptors from Cologne. The best known is **Peter Parler** (1330–99), who played a major part in the development of *Gothic art in Central Europe. He was summoned to Prague by the Emperor Charles IV in 1353 to continue work on St Vitus's Cathedral, begun in 1344 by the French master mason Matthias of Arras (d.1352). The Parler workshop is responsible not only for the building itself but for sculptural tombs (Lady Chapel; Reliquary Chapel) and the famous busts in the triforium, 1374–85, which formed the first gallery of sculpted portraits of historical figures in post-antique European art. They include a gravely realistic *Self-Portrait* and vigorous depictions of Matthias of Arras, Charles IV and his family, and ecclesiastical dignitaries. Peter Parler's sons **Wenzel** and **Johann** carried on the construction of the Cathedral; his nephew **Heinrich** worked in Prague as a sculptor. The sculpture on the Portal of St Peter in Cologne Cathedral is the work of a Parler workshop, and the limestone bust of a woman found in a cloister near the cathedral is thought to be the work of **Heinrich IV Parler**.

Parmigianino; Girolamo Francesco Maria Mazzoli, called (1503–40) Precocious painter and etcher from Parma – hence his nickname. Assimilating the influences of *Correggio, *Raphael and *Michelangelo, he forged an original and extremely elegant form of *Mannerism which was widely influential throughout Europe, especially as it spread by means of his etchings (*see under* intaglio; *also* Primaticcio; Nicolò dell'Abate and, especially, Bartolomeus Spranger).

Trained by his uncles, the painters Michele and Pier Ilario Mazzola (*see also* Bedoli; Girolamo Mazzola), after the death of his father in 1506, he was painting independently from the age of 18 (*Mystical Marriage of St Catherine*, 1521, Bardi, S. Maria). In 1522–3 he executed the *fresco decoration of side chapels in Parma, S. Giovanni Evangelista, where Correggio had been painting the dome (1520–3). Around 1523 he decorated the ceiling of a small room in the Sanvitale castle at Fontanellata; the episodes from the tale of *Diana and Acteon*, drawn from Ovid's *Metamorphoses*, unfold in an *illusionistic arbour inspired by Correggio's ceiling in

the Convent of S. Paolo, Parma. In 1524 Parmigianino also painted his patron at Fontanellata, Galeazzo Sanvitale (Naples, Capodimonte) – one of the earliest of many highly refined yet *expressive portraits (e.g. London, National; York, Gallery; Copenhagen, Museum; Rome, Borghese; Parma, Galleria; Madrid, Prado). Later that year the young artist travelled to Rome to gain an entry to the papal court, bringing with him, as a demonstration of his talents, one of the great virtuoso pieces in the history of art: the *Self-Portrait in a Mirror* (now Vienna, Kunsthistorisches), a prime instance of optical *realism.

Parmigianino's main Roman work was the large altarpiece, *The Madonna and Child with Sts John the Baptist and Jerome* (1526–7, London, National), which demonstrates his study of Raphael and Michelangelo along with his continuing allegiance to Correggio.

After leaving Rome following the Sack of 1527, Parmigianino settled in Bologna (1527–31), where a series of major religious works testifies to his continuing search for refinement and complexity (Bologna, Pinacoteca, S. Petronio; Dresden, Gemäldegalerie; Florence, Uffizi). In 1531 he returned to Parma, signing a contract for the decoration of the apse and vaults of the church of the Steccata. Although this commission gave him great difficulty – to the point where the overseers had him imprisoned in 1589 for breach of contract – the east vault, the only part completed, is one of the most beautiful decorative works of the century. In combining painted with carved areas, it anticipates the *Baroque vault effects of *Gaulli.

The best-known easel painting of these years is the unfinished *Madonna of the Long Neck* (*c*.1535, Florence, Uffizi), the culmination of Parmigianino's synthesis of religious meaning with artificial grace.

Taking refuge from the overseers of the Steccata at Casalmaggiore, where he was to die, Parmigianino completed his last work, *Madonna and Child with Sts Stephen and John the Baptist* (now Dresden, Gemäldegalerie) in a newly grave manner. Great beauty of colour is combined with near-abstraction of form, more brittle and austere than in the Uffizi Madonna.

*Vasari records that Parmigianino's last years were devoted to alchemy, although this may be a rumour caused by his interest in the chemical procedures of etching. The artist seems certainly to have undergone a period of severe depression. The change in style of the Dresden picture has given rise to conjectures of a religious conversion in the year following his imprisonment.

Parodi, Filippo (1630–1702) Influential *Baroque sculptor from Genoa; he was the teacher of his son, the sculptor, painter and architect **Domenico Parodi** (1668–1740). Filippo studied in Rome with *Bernini, 1655–61, and on his return home met Pierre *Puget, an artist of similar tendencies. There are works by him in Genoese churches (S. Marta, S. Maria di Carignano; S. Carlo). He also worked in Venice (S. Nicolo dei Tolentini), where he taught Andrea *Brustolon.

Parri Spinelli *See under* Spinello Aretino.

Parrocel Family of painters from Provence. The best known are the third generation **Joseph Parrocel** (1646–1704) and his elder son **Charles Parrocel** (1688–1752). Joseph was trained mainly in Venice, where he studied *Tintoretto and *Veronese, but also later painters like *Fetti, *Strozzi and Jan *Liss; he settled in Paris in 1675. A large composition of *St John the Baptist Preaching*, 1694 (Arras, Musée) shows a brilliance of colour and handling completely contrary to contemporary French taste and almost foreshadowing *Delacroix. In Italy he had also worked with Jacques *Courtois, however, and his reputation rests primarily on his battle paintings. His son Charles spent a year in the cavalry, becoming less interested in battles than in horses. He studied them for his influential illustrations of the *School of Cavalry* published in 1733, and painted them in *genre scenes of military life (*Halte des Grenadiers*, *c*.1737, Paris, Louvre). Between 1744 and 1745 he recorded Louis XV's victories on the battlefield (Paris, Louvre; Versailles).

Pascin, Jules (1885–1930) Bulgarian-French-American painter, born in Bulgaria of Spanish and Italian parents. He was trained in Munich and Vienna where he worked as an illustrator. In 1905 he moved to Paris; in 1914 he went to Great Britain and then the USA. Back in Paris in 1920, he was part of a Montmartre circle that included *Chagall and *Soutine, painting portraits and also biblical subjects. The day his exhibition at the Galérie Petit, Paris, opened, he committed suicide. He is best remembered as a fine draftsman, and also as painter of delicate, sensuous nudes and semi-nudes.

Pasmore, Victor (1908–98) British painter who attended art evening classes in London while working as a clerk and only gradually was able to give painting priority. In the 1930s he experimented with *abstraction but joined the *Euston Road School as a *naturalistic painter with a special gift for nuances and simplifications in the tradition of *Whistler. These brought him a substantial reputation, and he shocked the British art world in 1947 by announcing his conversion to total *abstraction, proving it in paintings and relief compositions and arguing the necessity of abstract art in statements and articles influenced by the example and writings of *Biederman. He turned from painting to making relief *constructions. These used transparent and reflective surfaces in perspex which took the place of the fine luminosities and sharp details of his paintings; it is clear now that the same sensibilities were at work, and this also applied later when he gave priority again to painting, making abstract compositions of bulging forms in which it is not difficult to see echoes of his earlier figure paintings. Working energetically, from 1966 mostly in Malta, he has exhibited frequently in Britain, on both sides of the Atlantic and in Japan. In the 1990s he has returned to figurative drawing, sometimes combined with painting, for some of his work, referring to his Mediterranean environment but also to war and slaughter, embodying variations on a *Picasso painting. His abstract paintings, too, have taken on Mediterranean and marine qualities in their luminous colours and mobile forms.

Pasquino The name given to three fragmentary ancient marble sculptures, all versions of the same group of a standing figure with a youth in his arms. The most battered and the most famous is in Rome, Piazza del Pasquino. It is first recorded from *c.*1500, and has given its name, supposedly derived from that of a schoolmaster near whose house it was found, to the other two. A more complete version was discovered not long before 1570, also in Rome, and was acquired by Cosimo I, Grand Duke of Tuscany; it is now in Florence, Loggia dei Lanzi. It is probably this group which has been most influential on artists from the 16th to the late 19th century; a drawing by *Menzel of 1848 (Berlin, Staatliche) poignantly records its appearance, as a cast, in the store-room of the cast gallery in Berlin. The third version was also bought by Cosimo and is now in Florence, Palazzo Pitti. The composition is thought to illustrate an episode in Homer's *Iliad*: Menelaos holding up the body of Patroclus after he had been fatally wounded by Hector. The word 'pasquinade' refers to the habit, which grew up in the mid-16th century, of affixing satirical and libellous epigrams to the Roman *Pasquino*.

Passarotti or **Passerotti, Bartolommeo** (1529–92) Bolognese *Mannerist painter, a pupil of Taddeo *Zuccaro in Rome *c.*1551–65 and himself a teacher of the *Carracci in Bologna. Although he executed many altarpieces for Bolognese churches, in which he experimented with a variety of styles derived from *Correggio (1565, S. Giocomo Maggiore) to *Tibaldi (*c.*1575, S. Maria del Borgo), he is now best remembered for his stridently naturalistic low-life *genre pieces (from *c.*1575, e.g. *Butcher's Shop*, Rome, Nazionale). Inspired by the Flemish paintings of Pieter *Aertsen and Joachim Beuckelar, and Vincenzo *Campi's Italian derivations, these works combine near-*caricature with illusionistic *still life and, despite their very different character, were to influence Annibale Carracci's more solemn genre pieces.

pastel A stick of colour made from powdered pigment bound with resin or gum, developed in the 16th century from the coloured chalks used for drawing. Pastels are applied dry to paper, allowing the artist to work from the first stages of a composition directly in colour without laborious line and tonal preparation, and their colour as applied represents the final result. In the heyday of pastels in the 18th century (*see,* e.g. Rosalba *Carriera, Maurice Quentin de *Latour, *Liotard, *Perronneau, *Roslin) they were smudged and blended on the paper, producing soft and atmospheric effects, often in the pale range of chalky tones which has given the word 'pastel' its popular meaning. Their fragility was to some extent counteracted by spraying a transparent resin fixative on the finished image, which had the disadvantage, however, of somewhat reducing the vividness of the colours and imparting a sheen to their original velvety texture. When the use of pastels was revived in the 19th century, their greatest exponent, *Degas, employed fixative as an integral element of the creative process, applying it to successive layers of black charcoal or coloured pastel outlines and hatchings, overlaying colours rather than blending them. As well as reconciling the two historic antagonists, line and colour (*see under* disegno), this technique permitted him to achieve more brilliant juxtapositions of pure colour, and extremely varied textures.

Pasternak, Leonid (1861–1945) Russian painter, principally of portraits. Born in Odessa, he studied there, in Moscow and in Munich and during 1894–1918 taught at the Moscow Art School. He exhibited with the *World of Art group and, in 1919 in Moscow's Sixth State Exhibition. In 1921 he left Russia for, first, Berlin and, after emigrating to Britain in 1938, Oxford. His art belongs to the wide sphere of more or less *naturalistic painting to which *Impressionism gave a new vividness. He was the father of the great writer Boris.

Pasti, Matteo de' (*c.*1420–67/8) Illuminator and medallist, he became court artist to Sigismondo *Malatesta in Rimini,

and worked as an architect on the reconstruction of the interior of the Tempio Malatestiano (1447–*c.*60). He is thought to have been responsible for the finest of the carvings in the building, the most richly sculptured *Renaissance edifice in Italy. (*See also* Agostino di Duccio; Alberti; Piero della Francesca.)

pastiglia An Italian word for the raised patterns made in *gesso used as a form of ornament in early panel paintings.

Patch, Thomas (1725–82) English painter who lived in Italy from 1747, specializing in *caricature groups of *Grand Tourists. He also painted conventional landscapes and made prints of *frescos by *Giotto and *Masaccio.

Patel, Pierre (*c.*1605–76) and his son **Pierre-Antoine Patel** (1648–1707) French decorative *landscape painters from Picardy, active mainly in Paris. Although he seems never to have travelled to Italy, Pierre Patel executed landscapes with *Classical ruins, in a rather colder and more pedantic imitation of *Claude; they were usually incorporated in the panelling of rooms, as for example in the Cabinet de l'Amour at the Hôtel Lambert in Paris (*see also under* Lebrun; paintings now in the Louvre; other works London, National; Cambridge, Fitzwilliam; St Petersburg, Hermitage). Pierre-Antoine Patel anticipated the *Rococo with his more picturesque ruins.

Pater, Jean-Baptiste *See under* Watteau, Jean-Antoine.

patina A film of oxide formed on the surface of a metal, especially the blue-green oxidation of *bronze or copper; it occurs naturally with age through exposure to the atmosphere. Because the effect on bronze sculpture is pleasing, it has often been induced artificially. Patina is damaged by atmospheric pollution due to the use of coal and hydro-carbon fuels. Those who oppose the cleaning of works of art by restorers sometimes confuse this damage, which if unchecked leads to corrosion, with genuine patina. By extension, the word is applied to

the darkening or discoloration of paintings caused by dirty or oxidised *varnish.

Patinir, Patinier or Patenier, Joachim
(c.1475/80–1524) A native of the Meuse river valley, master in the Antwerp painters' guild in 1515, he is the first known landscape specialist in European art. Although not himself the inventor of the panoramic landscape, he established the type in Flemish painting; signed or documented works are very few, but a host of contemporary imitations are still attributed to him.

Two basic forms of landscape construction are associated with Patinir. In one, the landscape, depicted as if from a high viewpoint, recedes without a break 'as far as the eye can see' to a distant horizon (*Passage to the Infernal Regions*, c.1520–4, Madrid, Prado). In the other, the painting is divided in two along a diagonal; in one half the view is unimpeded to the high horizon, but in the other it is blocked by a tall rock formation, itself usually enlivened by paths winding into the distance (*Flight into Egypt*, c.1515–20, Antwerp, Museum). In both, a system of reddish-brown foreground, green middle ground and blue background simulates the effects of aerial *perspective. Narrative incidents with human figures and/or architectural forms are inserted into both landscape types with no account taken of the height of the viewpoint, thus creating a dual perspective. The foreground figures may be represented as if at a considerable distance from the viewer – this is the case in the two paintings cited – or they may loom large in the foreground, as in the *Baptism of Christ* (c.1515–20, Vienna, Kunsthistorisches) or in the *Temptation of St Anthony* (c.1520–4, Madrid, Prado). In the latter picture the figures were executed by Quinten *Metsys, who became the guardian of two of Patinir's three daughters after the artist's death. Earlier examples of collaboration with Joos van *Cleve and other, unnamed artists are recorded by Van *Mander.

Although Patinir's landscapes always contain narrative, their real theme is the grandeur of nature. This is apparent despite the fact that the works themselves are small and made up of miniature elements: the very rock masses are painted from stones brought into the workshop, as advocated in Cennino Cennini's *Book of the (Painter's) Craft* (*see under* Gaddi) and practised both south and north of the Alps. Later followers – the chief of them Patinir's nephew Herri met de *Bles – were to stress more the elements of *genre and of the landscape as a setting for human action.

Peale, Charles Willson (1741–1827),
father of Raphaelle and Rembrandt (*see* following entries) The elder Peale was an American portrait painter, miniaturist, sculptor, natural scientist and inventor, the founder of America's first museum of natural history in Philadelphia, 1786. He worked briefly with John Singleton *Copley in Boston. In 1767, a group of Maryland gentlemen financed a trip to London, where he studied with Benjamin *West, returning home in 1769. As a painter, he is best remembered for the *trompe l'œil* portrait of his sons Titian and Raphaelle, *The Staircase Group*, at the bottom of which is added an actual wooden step (c.1795; Philadelphia, Museum). Peale also executed portraits of George Washington (e.g. Philadelphia, Pennsylvania Academy) and likenesses of the founding fathers Benjamin Franklin, Thomas Jefferson and James Madison which are reproduced on U.S. paper currency, coinage and postage (*see also* Gilbert Stuart).

Peale, Raphaelle (1774–1825) American painter, son of the painter and naturalist Charles Willson *Peale and brother of Rembrandt *Peale. His reputation now is that of a still-life painter but he began his career as an itinerant painter of miniature portraits. He first exhibited still lifes in 1812 and soon developed exceptional skills in the genre, choosing sparse subjects and representing them with an exactitude that made him the outstanding *trompe l'oeil* painter of the century.

Peale, Rembrandt (1774–1860)
American painter, brother of the preceding and cherished pupil of his father, Charles Willson Peale. He visited London and Paris

between 1802 and 1810, and was impressed by the work and status of Benjamin *West and J.-L. *David. He returned to the USA in 1814, hoping to prove himself a great *History painter. His *Court of Death* (1824; Detroit, Institute of Arts), an over-wrought allegory, became widely known through his *lithographic version of it. Later he combined periods abroad, mostly in Italy, with painting in several American cities. His best works are portraits, including those of Jefferson (1805; New York, Historical Society) and Washington (c.1823; New York, Metropolitan).

Pearlstein, Philip (1924-) American painter, a 'post-*abstract *realist' as he said, asserting the primary value of the human image in painting after the success of American *Abstract Expressionism. He studied first at the Carnegie Institute in Pittsburgh and in 1949 moved to New York where he studied art history. He turned from landscape painting to frequently large-scale paintings of nudes, often multiple, male and female bodies observed under strong light and described in vigorous but ungestural paint, with heads given less prominence or even omitted. His insistence on the body seemed like an intrusion in the 1960s but contributed to a wider return to figure painting without *Pop stylizations. His work had a polemical purpose and focus which justifies the label 'realist'; it has sometimes been associated with the heightened *naturalism which flourished around 1970 as Superrealism and *Photorealism, but this now seems unjustified.

Pechstein, Max (1881-1955) German painter. He studied first interior decoration in his native Zwickau, and then art in Dresden where he became a member of the *Brücke group. In 1907-8 he was in Italy and Paris learning the methods of *Fauvism, especially the use of bright colours in large areas. Among his best paintings are the vigorous interiors and lakeside scenes with nude figures of 1909-10, suave and rhythmical but suggesting primitive energies. In 1910 he was one of the founders of the New Secession group in Berlin; this led to his exclusion from the Brücke group in 1912. In 1913-14 he visited the Palau islands in the Pacific to have first-hand experience of primitive life, returning, after adventures occasioned by the 1914-18 war, with cheerful paintings which greatly added to his popularity. In 1918 he helped found the *Novembergruppe in Berlin. From 1923 until dismissed by the Nazis in 1933 he taught at the Berlin Academy; he was reappointed in 1945.

Peeters, Bonaventura the Elder (1614-52) The best-known of a dynasty of Flemish artists, and the leading painter of seascapes in Flanders, working in a style close to that of the Dutch marine specialist de *Vlieger (Greenwich, National Maritime). His sister **Catharina** (1615-76) painted *still lifes as well as seascapes. His brother **Gillis** (1612-53) painted mainly small intimate landscapes in the Dutch manner, while his younger brother **Jan** (1624-80) was also mainly a marine painter, as was Gillis's son **Bonaventura Peeters the Younger** (1648-1702). They were not related to the still-life painter Clara *Peeters.

Peeters, Clara (1594-after 1657?) Flemish *still-life painter active in Antwerp, where she was one of the pioneers of the 'spread-table' composition (*see also* Beert, Osias). She was in Holland in 1612 and 1617. Some of her 'breakfast pieces' with massive arrangements of cheeses are virtually indistinguishable from those of Van Schooten in Haarlem (*see under* Dijck, Floris van).

Pelham, Peter (c.1695-1751) London-born engraver (*see under* intaglio) and painter who emigrated to Boston, where in 1748 he married John Singleton *Copley's widowed mother. Although he died when Copley was only 13, it was he who introduced the boy to models of European art, in books of engravings which he had brought from England, and taught him the rudiments of engraving and painting. He was an associate of *Smibert. There are many engraved portraits of Boston luminaries by Pelham.

Pelizza da Volpedo, Giuseppe (1868–1907) Italian painter, trained in Milan, Florence and Rome and introduced to *divisionism in the 1890s by his friend, the painter Plinio Nomellini. Nomellini also raised his social consciousness, and Pelizza became a painter who took *naturalistic subjects, such as sheep walking in file along a raised path across watery marshland *The Mirror of Life (That which the First One Does, the Others Follow)* (1895–8; Turin, Civica Galleria d'Arte Moderna), in order to communicate comments on contemporary society. *The Fourth Estate* (1898–1901; Milan, ditto), 5.5 metres across, is his masterpiece. It shows a crowd of workers, male and female, calmly marching towards the viewer, and comes close to being photographic in character though it is filled with light and Pelizza's delicate use of divisionism fills the picture with colour and flattens it spatially. Although the image was used for socialist propaganda the painting was not well received, and Pelizza turned to less overtly political subjects for his later work.

Pellegrini, Giovanni Antonio (1675–1741) One of the earliest Venetian painters of light-hearted *Rococo decoration to have an international career; a charming and influential precursor of *Tiepolo. Trained first in Milan, he was formed mainly through study of the work of Sebastiano *Ricci and Luca *Giordano. He married one of the sisters of Rosalba *Carriera. Brought to England in 1708 by the British Ambassador to Venice, Pellegrini painted decorations at Kimbolton Castle, at Castle Howard, and at Narford, where most of his surviving work in Britain is now to be found. He was also involved, with *Kneller, in the foundation of the *Academy in London in 1711. In 1713 he left for Düsseldorf (Bensburg Castle, decorated 1713–14), returning to England only briefly in 1718/19. He painted the ceiling of the Bank of France in Paris in 1720 (destroyed) and worked in the Castle at Mannheim (1736–7) and elsewhere. There are easel paintings by him in London, National; Paris, Louvre; Vienna, Kunsthistorisches; etc.

Penck, A.R. (1939–) German painter, born Ralf Winkler in Dresden. He painted from the age of ten but when he decided he wanted to study art professionally he found it impossible to get a place in the art academies. He associated with painters of his age, such as *Baselitz, and worked at various jobs. In 1961 he exhibited some paintings in Dresden. A committed socialist, he found the 1960s a period of stasis and muteness in East German art and political life. He developed his characteristic stick-figure painting style as a vehicle for parables about contemporary issues. His art became known in the West when he exhibited in Kassel (*Documenta 5) in 1972. He served in the People's Army in 1973. In 1980 he was permitted to emigrate with his family to London where he has remained. He has published books and made films, writes poetry and composes music.

Pencz, Georg (*c*.1500–50) As a young man he called himself Jörg Bencz. Nuremberg painter and printmaker, a master both of large-scale mural painting and tiny engravings (*see under* intaglio). He was in *Dürer's workshop in the early 1520s, and painted murals in Nuremberg town hall after Dürer's designs. In 1525, he, along with Sebald and Bartel *Beham, was temporarily expelled from the city for anarchism and atheism. He went to Northern Italy *c*.1530, and to Florence and Rome in 1539. The Venetian influence transmitted to him in Dürer's shop was strengthened by his first trip (e.g. Cracow, Jagiellon Chapel; Berlin, Staatliche) and after the second the imprint of Tuscan and Roman *Mannerism (e.g. *Bronzino) becomes apparent in his portraits (e.g. Nuremberg, Museum; Karlsruhe, Kunsthalle; Darmstadt, Museum), in his mural paintings (Nuremberg, Hirschvogel House; Landshut, palace) and in his prints (series of the *Planets*). After Bartel Beham's death in 1540 Pencz was summoned to Landshut to work for the Duke of Bavaria; he died shortly after taking up an appointment as court painter to the Duke of Prussia.

Penni, Giovanni Francesco *See under* Raphael.

Pentimento (pl. *pentimenti*, Italian, repentance, qualm) *See under alla prima.*

Peploe, Samuel John (1871–1935) British painter, born in Edinburgh. He attended evening classes at the Edinburgh College of Art (and later taught there). He spent much of 1894 in Paris, at the Académies Julian and Colarossi, and returned to Scotland to paint landscapes on the island of Barra and figure subjects in Edinburgh. He continued to make visits and to work abroad. In 1910–12 he was in Paris, exchanging a style rooted in the deft tonal art of *Hals and *Manet to one using bright colours and lively brushwork in the manner of the *Fauves. Landscapes and still lifes now dominated his output, bringing him success in Paris, London and Edinburgh. Back in Edinburgh, and reflecting the interest raised by *Fry's *Post-Impressionist exhibitions in London, he developed his idiom further, combining bright colours with firmly outlined shapes that sometimes took on some of the angularities of *Cubism without adopting the fragmentation and instability central to Cubist aesthetics. S.J. Peploe became known as one of the Scottish Colourists, together with Francis Cadell and Leslie *Hunter; they were friends, sometimes worked together away from home and remained in close touch with Paris. Peploe showed in Paris and New York as well as in England and Scotland. His older brother **William Watson Peploe** (1869–1933) was a bank manager, poet and part-time artist. His drawings parodying the art of *Beardsley and the taste for Japanese art are evidently humorous; two tiny abstract studies in watercolour and ink, done in 1918, though quite compelling, may also have been made in play.

Pereda, Antonio de (1611–78) Precociously gifted Spanish painter. After executing one of the large battle scenes for the Hall of Realms in the royal Buen Retiro Palace (*Relief of Genoa*, 1634, Madrid, Prado) he may have fallen victim to the jealousy of Philip IV's court artist, *Velázquez: following the death in 1635 of his protector, Giovanni Battista Crescenzi, Marqués de la Torre, Pereda never again

worked for the king. He is now best known for his splendidly elaborate large-scale *vanitas* *still lifes, among the masterpieces of Spanish *Baroque (Vienna, Kunsthistorisches; Madrid, Royal Academy of San Fernando; Florence, Uffizi).

Peréz de la Dehesa, Bartolomé (1634–98) Spanish flower painter, pupil of *Arellano. He executed the gilded panels painted with vases and garlands of flowers which formed part of the sumptuous *Camon Dorado*, a sort of alcove enclosing the king's bed. Only one of the panels is known today (Madrid, pc).

Performance art Said to have grown out of *Happenings, Performance art has always been more theatrical, at times ritualistic and normally more scripted, often taking acting and movement to extremes of expression and endurance not permitted in the theatre. Words are rarely prominent; music and noises of various kinds often are. Dramatic or humorous and irreverent events were staged by Italian and Russian *Futurists, as well as by *Dadaists and by the *Surrealists, to promote their ideas and draw media attention. Performance art is done for its own sake and while it is at times amusing and close to circus acts, it can be intense, disturbing and, in some hands, disgusting in ways that challenge conventional ethics. A group of artists working in Vienna, including Günter Brus (1938–) and Hermann Nitsch (1938–), involved their own and others' bodies, including animals, in actions coloured by blood and excrement, testing the public's attraction/repulsion responses to the area where lust and disgust meet. In Britain, among a variety of actions including Performances occupying several days, both lighthearted and serious, the work of Stuart Brisley (1933–), by himself or with a group of collaborators, stood out in the 1970s for its gravity and point as well as for the demands it made on himself. Performance art has been enrolled in support of political demonstrations and of live music. *Gilbert and George began their joint career with Performance pieces, while *Beuys alternated his with lectures which are in themselves a form of Performance.

Several American *Conceptual artists, such as Robert *Morris and Bruce *Naumann have included Performance in their repertoire, and the growing use of video has enabled these and other Performances to be repeated and multiplied in reproduction.

Peri, Laszlo, known as **Peter** (1889–1967) Hungarian-British sculptor, born in Budapest. Out of Hungary when the Communist government fell, he decided not to return. From 1919 he was in Berlin, a fervent socialist and a friend of *Moholy-Nagy. From a *Cubist style he developed, by 1921, a way of composing geometrical forms in coloured concrete reliefs; these were then associated with *Constructivist art. In 1924 he exhibited a major work in this idiom, but then turned to architectural design, working for the Berlin architectural department. In 1929 he returned to figurative sculpture. In 1933 he moved to London and became known as a left-wing sculptor of daily life in relief (concrete or reinforced plastics) and as free-standing objects.

Perino del Vaga; Piero Buonaccorsi, called (c.1500–47) One of the most influential decorative artists of the 16th century; his stylish version of *Mannerism found many followers, especially in Genoa and Rome. Born in Florence, Perino arrived in Rome c.1516 in the company of a painter called Vaga, whose name he adopted. In 1518 he joined *Raphael's workshop, becoming one of the chief executants on the Vatican Logge. He left Rome after the Sack of 1527, settling in Genoa (1528–36/7), where he was in charge of the remodelling and redecoration of the Palazzo del Principe for Andrea Doria, and founded a long-enduring local school (Basa-donne altarpiece, 1534, now Washington, National). From 1537 he worked again in Rome (1539, SS. Trinità dei Monti; detached *fresco now London, V&A), becoming the chief decorator of Pope Paul III Farnese, for whom he executed his greatest surviving project: the Pauline apartments in the Castel S. Angelo, consisting of the Sala Paolina (completed after his death, mainly by Pellegrino *Tibaldi) and the adjoining smaller rooms, the Sale of Psyche and of Perseus.

Permeke, Constant (1886–1952) Son of a Belgian marine painter, Permeke studied art in Bruges and Ghent and then joined an artists' colony at *Laethem-Saint-Martin. He was wounded in the war and sent to England where he painted warm bucolic subjects. Back in Belgium in 1918, he settled at Ostend and then at Jabbeke, near Bruges, painting fisherfolk and peasants in a weighty, earthy style that lent his figures monumentality without raising difficult social issues.

Permoser, Balthasar (1651–1732) Outstanding Austrian-born Late *Baroque sculptor, the dominant artistic personality in Dresden in the early 18th century. After an unfruitful apprenticeship in Salzburg, Permoser went to Italy, where he remained c.1675–89, working in Venice, in Rome – in the studio of *Bernini – and in Florence (S. Gaetano). Italian records speak of him variously as 'Baldassare Fiammingo' – 'Baldassare the Fleming' – or as 'Belmosel' and 'Delmosel'. In 1689 he was summoned to Dresden by Johann Georg III of Saxony; he remained there for the rest of his life, executing and designing sculpture in marble, alabaster and sandstone, and training numerous pupils, among them *Roubiliac. His style in sculpture, influenced by Bernini, is highly painterly, and, like Pierre *Legros the Younger in Rome, he experimented with the *polychrome effects of different coloured marbles within a single work (e.g. *Scourging of Christ*, Dresden, Moritzburg, Hofkirche; Leipzig, Museum). His most extensive work, however, is for the Zwinger, a court surrounded by arcades and pavilions, for a projected but never completed palace in Dresden, 1709–17. Other works in various Dresden churches; Bautsen, Stadtmuseum, etc.

Perov, Vasili Gregorevich (1833–82) Russian painter who studied at the Moscow Art College and spent some time in Paris in 1863. By this time he had demonstrated his interest and talent for contemporary *genre paintings, elaborately staged scenes portraying events in themselves often unexceptional, as in *Easter Procession in the Country* (1861) which pictures an annual

event so as to invite criticism of the priest, who appears to be drunk, and the partial blindness of the pious to poverty and exclusion. Like the Russian writers of his time, he described life in order to invite a questioning of its conventions. He was a founder member of the *Wanderers and prominent among the group's exhibitors and organizers. Encouraged by public interest, he let his genre paintings become larger and more openly critical of society. He also painted lively portraits of important contemporaries such as the writers Ostrovsky, Turgenev and Dostoevsky. These, as also *Easter Procession* are in the Tretyakov Museum in Moscow; others are best found in the Russian Museum, St Petersburg.

Perréal, Jean, also called **Jean de Paris** (*c.*1455–1530) French painter and *illuminator, designer of funerary monuments (Nantes Cathedral, tomb of Francis II of Brittany; Brou, tombs for Margaret of Savoy) festival entries, medals, much admired by his contemporaries. By 1483 he was in the service of the city of Lyon; soon afterwards he entered that of the Duke of Bourbon. By 1494 he was at the royal court, becoming chief court artist (and the predecessor of Jean *Clouet). He visited Italy three times: with Charles VIII in 1494, and with Louis XII in 1502 and 1509. On one of these occasions he met *Leonardo da Vinci, who mentions him in his notebooks. Perréal's 1516 *allegorical miniature illustrating Jean de Meung's poem, the *Dialogue de l'Alchimiste* (Paris, Bibliothèque Nationale) shows the influence of Italian *idealization, while even his miniature portraits demonstrate his mastery of *naturalism (Paris, Bibliothèque Nationale). The panel portrait of Louis XII now at Windsor Castle has been said by some scholars to be his one certain work, while others consider it to be a copy of a painting by him.

Perrier, François *See under* Lebrun, Charles.

Perronneau, Jean-Baptiste (1715?–83) French engraver (*see under* intaglio) who became a sharply observant portrait specialist in *oils and *pastels. The popu-

larity in Paris of Maurice Quentin de *Latour led him to seek work in Italy in 1759 and Russia in 1781; he died in Amsterdam, where he had often worked. There are works by him in London, National; Dublin, National; etc.

perspective A method of representing three dimensions on a two-dimensional surface, as in drawing, painting and shallow relief. The term originates in optics rather than art, and the *Renaissance invention of precisely calculated recession and diminution is indebted to a study of medieval optics. All types of **linear perspective** depend on the illusion of parallel lines at right angles to the picture plane (orthogonals) meeting at a 'vanishing' point in the distance. In ancient scenography, and the mural painting it inspired, the effect is imperfectly approximated, no systematic vanishing-point or points governing the convergence of all receding orthogonals. The great Florentine innovator *Giotto (*d.*1337) used two distinct methods of perspective construction. In his earlier work he set buildings at an angle to the spectator, the receding orthogonals converging rather imprecisely beyond the sides of the picture field. Later, he tended to set buildings parallel to the picture plane, with the orthogonals above the horizon line sloping downwards, and those below sloping upwards. The Sienese Ambrogio *Lorenzetti (*d.* 1348), and some northern European artists of the 15th century, evolved empirical methods of representing recession and diminution based on the notional curvature of the visual field: objects diminish in scale from the centre to the periphery, as well as from front to rear. *Brunelleschi's pioneering demonstration of mathematically constructed perspective employed a peephole and a mirror, and probably involved two vanishing-points at the sides of the demonstration panel (*see also under* Bibiena). *Alberti evolved a simpler method, which could be used to represent not only actual buildings (as was the case with Brunelleschi's construction) but also imagined ones. Described in his treatise *On Painting* (1435 and 1436), later elaborated by other artists, this so-called *costruzione legittima* employs a single vanishing point

on the horizon, usually but not necessarily in the centre of the composition, corresponding to the spectator's viewpoint in front of the picture. An intersection of the 'visual pyramid' enables the artist to calculate the precise scale of objects diminishing in the distance. The Albertian *costruzione legittima* has several advantages. It allows the depiction of a measurable environment. It serves to clarify narrative, to help focus the viewer's attention, and to mobilize his or her empathy by making the viewer an eye-witness to the event or scene depicted. It can also be used to make symbolic points, either through application or by disruption of the laws of optics (as, respectively, in Masaccio's *Tribute Money*, Brancacci Chapel, and *Holy Trinity*, S. Maria Novella, both in Florence).

Linear perspective is utilized in such specialized illusionistic forms as *quadratura* painting (*see under* illusionism). **Aerial** and **colour perspective** deal with the diminution through distance of colour intensity and definition. They were first studied systematically by *Leonardo da Vinci. The perspectival representation of irregular objects, while obviously related to the representation of space and regular volumes, requires much more complex calculations. This branch of perspective study was of particular interest to *Uccello, but treated also by Leonardo, *Mantegna, *Piero della Francesca and *Dürer.

Perugino; Pietro Vanucci called (*c.*1450–1523) Influential Umbrian painter, born near Perugia, the principal centre of his activity – hence his nickname. Although it now appears that *Raphael was his assistant, rather than a pupil, the latter's early works bear the unmistakable imprint of Perugino's mature style: gently pious, gracefully posed and clearly positioned figures set against sunlit landscapes, perhaps inspired by Netherlandish art (*see* especially Rogier van der Weyden). Perugino's workshop procedure of drawings from the life was taken over by Raphael, along with many actual compositions. Indeed, the years 1482–91 saw the general diffusion of Perugino's style and imagery throughout central Italy. After about the first decade of the 16th century,

however, Perugino's nearly unchanging manner came to be seen as old-fashioned and provincial.

The artist's early formation is not documented; he is thought to have been a pupil of *Piero della Francesca *c.*1465, and from *c.*1470 to have worked in Florence in the circle of *Verrocchio; there are signs also of the influence of *Botticelli. He probably worked in Perugia, Palazzo dei Priori, 1475, and fragments still exist of his first securely dated commission, the 1478 *frescos in Cerqueto, S. Maria Maddalena. In 1479 he was in Rome, painting the chapel of the Conception in St Peter's (destroyed 1609), and in 1480/1–2 he was in charge of the mural decoration of the Sistine Chapel, working with *Ghirlandaio, Botticelli and Cosimo *Rosselli. His fresco altarpiece and two flanking scenes were later to be destroyed by *Michelangelo to accommodate the *Last Judgment*.

During 1482–95 Perugino worked mainly in Florence; outstanding works in that city are his *Last Supper* in the ex-convent of S. Onofrio, *c.*1495 and the *Crucifixion* in the chapter house of S. Maria Madalena dei Pazzi, 1493–6. Easel paintings from this period are mainly to be found in Florence, Uffizi, Pitti, Accademia; also Vatican, Pinacoteca.

Perhaps in 1496–7, but probably closer to 1500–7, Perugino and his shop painted the vault and walls of the Collegio del Cambio in Perugia. This important decoration, consisting of *grotesques and pagan divinities in the vault, and *allegorical figures of the cardinal virtues enthroned above their historical exemplars on the walls, influenced Raphael's frescos in the Stanza della Segnatura.

*c.*1499, Perugino was also at work on a *polyptych for the Charterhouse in Pavia (London, National, fragments). The *Marriage of the Virgin* (Caen, Musée), commissioned for Perugia cathedral in 1499, was also begun, but only after some delay, and completed *c.*1505. It was later copied, and 'corrected', by Raphael. From about the same date is the *Battle of Love and Chastity*, a laboured allegorical composition for Isabella d'*Este's *studiolo* in Mantua (*see also* Mantegna; Costa). Around 1507, Perugino was at work once more in the

Vatican, painting the vault in the Stanza dell'Incendio; the recent restoration reveals that his workshop methods were as inventive as ever in the efficient use of cartoons (*see under* fresco) for the grotesque ornament.

Peruzzi, Baldassare (1481–1536) Sienese-born painter and architect, mainly active in Rome from *c.*1503 until the Sack in 1527, and again in 1530–1 and from 1535 until his death. Some of his most important and influential pictorial work has been lost to us: for example, his **all'antica* façade decorations, which influenced those of *Polidoro da Caravaggio, and his scenery for the theatre, the main arena for his researches in *perspective and perspectival *illusionism. His interest both in archeology and in perspective is well illustrated, however, in his decoration for the Villa Farnesina in Rome (ceiling fresco, Sala di Galatea, *c.*1510; frieze, Sala del Fregio, *c.*1511; Sala delle Prospettive, or delle Colonne, *c.*1516). Despite his debt to *Raphael, Peruzzi retains a Tuscan and 15th-century ideal of grace, witty, precise, slightly precious and less monumental. This may be observed also in his *frescos for S. Maria della Pace (1516 and *c.*1518) and in his decorations in the loggia of the Villa Madama (1521). The reader should be aware, however, that Peruzzi's present stature in the history of *Renaissance art derives mainly from his architectural practice in Rome and in his native Siena.

Pesellino, Francesco di Stefano, called (*c.*1422–57) Florentine painter. His only documented work is a large altarpiece commissioned in 1455 for a church in Pistoia, and finished after Pesellino's death by Filippo *Lippi, who may have been his teacher. Cut up into several pieces probably in the 18th century, the altarpiece has been gradually reassembled and is now in London, National (one fragment is on loan from the Collection of H.M. the Queen; a fragment of legs and feet on the lower right is a modern reconstruction) with the exception of a *predella panel rediscovered in 1995 in St Petersburg, Hermitage. Several *cassone* panels produced in Pesellino's successful workshop are also known

(Boston, Isabella Steward Gardner; London, National).

Pesne, Antoine (1683–1757) French-born portrait painter, trained by his father, the portraitist Thomas Pesne. He lived in Italy from 1705 until 1710, when he was summoned to Berlin to become the first court painter under the Prussian Kings Frederick I, Frederick William I and Frederick the Great. In 1723–4 he worked in London. Besides court portraits, he also painted *genre pictures in the manner of *Lancret, and *allegorical ceiling and wall decorations in the Prussian royal palaces of Rheinsberg, Charlottenburg, and Sanssouci. There are portraits by him in Berlin, Staatliche.

Pettoruti, Emilio (1892–1971) Argentine painter who worked in Europe during 1913–23 and got involved with *Cubism and *Futurism and, returning to Buenos Aires in 1924, startled the art public there by exhibiting his own, not exceptionally tough *Modernist paintings and then, in 1930, as director of La Plata's Museum of Fine Arts, exhibiting new work from Europe. This stimulated a positive response among many of the younger artists of that time, which some of them pursued in Paris and other European centres. Pettoruti's own paintings tended to be firmly designed and painted; in his later years he turned to *abstraction in response to developments in the USA and in Europe.

Pevsner, Natan, known as **Antoine** (1886–1962) Russian-French sculptor, brother of *Gabo. He studied at the Kiev Academy and became interested in *icons and folk art and combined elements of these with *Cubist influences in his early paintings. During 1912–14 he was repeatedly in Paris, in touch with *Archipenko. In 1915 he joined Gabo in Oslo and began to make sculpture; in 1917 they settled in Moscow and in 1920 he signed Gabo's *'Realistic Manifesto' and exhibited semi-*abstract paintings alongside Gabo's sculptures on Tverskoi boulevard in Moscow. He was professor in the new art studios, later *VKhUTEMAS, from 1918 until 1922

when he left Russia for Berlin, going on to Paris in 1923. Here he gave priority to three-dimensional work, constructing geometricized figures. He made one such as part of Gabo's décor of the ballet *La Chatte* in 1926. In 1931 he joined *Abstraction-Création and became known as an abstract sculptor of curving planes formed by straight rods, twisting through and enveloping space.

Philipson, Robin (1916–92) British painter, born in Lancashire but living from the age of 14 in Scotland and trained at the Dumfries Academy and the Edinburgh College of Art where later he taught and became head of Painting and Drawing (1947–82). From 1973 to 1983 he was president of the Royal Scottish Academy. His earlier paintings took characteristics from older Scottish painters such as *Gillies and tended to be rich in colour and expression, but from c.1950 on, partly under the influence of *Kokoschka, they became more vehemently expressive, with energetic brushwork and strong colours pushing his motifs, as in his series of cocks fighting, an explosive theme, or Crucifixions, or cathedral interiors, to near-*abstraction.

Phillips, Tom (1937–) British painter, composer and writer. He studied English at Oxford and then painting at Camberwell School of Art in London. Passions for literature, languages and music have from the first mingled with Phillips's passion for art; also, he has an appetite for exploiting existing visual materials. His art thus has a conceptual bias and a stylelessness that marks it out as post-*Duchampian though his values are consistently humanist. Among his ongoing projects has been his close study and reworking of details of postcards in which he finds visual interest and human significance worth pursuing and putting to public use, and his finding in 1966 a novel of 1892, *A Human Document*, as a territory to be mined over many years and redelivered through many editions and adjusted pages as his *A Humument*, which generated also many other works and occasions, including his opera *Irma* (1969; first perfomed 1970). Early contact with Dante's

Inferno in English led to his making his own translation and images and publishing the work in his own Talfourd Press as well as a trade edition (1985). Phillips's long interest and increasing expertise in African art, reflected in his own work and in a fine collection of African sculpture, led also to his curating the exhibition 'Africa: The Art of a Continent' at the Royal Academy, London, in 1995. His own art was summarized in a retrospective in the same place in 1992. He has had many commissions for portraits, as well as for decorative work in restaurants and for theatrical décor. He has published a substantial body of poetry, essays and reviews.

Philostratus The name of a family of Greek rhetoricians and writers from Lemnos during the 2nd and 3rd centuries; they are almost invariably conflated in art-historical accounts. The three of importance for the history of art are **Flavius Philostratus** (c.175–244/9), the author of a *Life of Apollonius of Tyana* in which that philosopher is made to emphasize the 'beholder's share' in the reading of artists' images. Of greater significance for the evolution of European art are Flavius's son-in-law, **Philostratus of Lemnos**, born c.190, and the latter's grandson, **Philostratus IV**, the authors of the *Eikones* or, in the more usual Latin translation, *Imagines*, 'pictures'. Written as exercises in rhetoric, i.e. literary form, these are vivid descriptions of real or imaginary paintings in a collection in Naples. Such descriptions or *ekphrases* were an ornamental feature of Greek literature from Homer onwards, and are at the basis of the Latin tag by the Roman poet Horace, *Ut pictura poesis*, 'Poetry is like painting', much misquoted to justify the elevation of painting to the higher status of its 'sister art' poetry. It was the desire to have a collection of '*classical' paintings such as those described in a manuscript of the *Imagines* that inspired Alfonso d'*Este of Ferrara in the early 16th century to commission *Titian's *Bacchanales*, and Philostratus is an important source for all painters – *Poussin among them – intent on rivalling the lost pictorial masterpieces of antiquity. *See also* Pliny.

photomontage A form of *collage employing photographic images, whole or as fragments. The technique was promoted by the Berlin *Dadaists, notably *Hausmann, *Höch and *Grosz, and developed into a major form of political *caricature by *Heartfield. In Russia *Rodchenko used it as a means of illustrating Mayakovsky's poem 'About That' in 1923. There was a 19th-century tradition of cutting up printed images and mounting them for decorative, sometimes humorous purposes which may have stimulated modern artists to develop it as an art form, extending the *Cubists' interest in building up images through collage.

Photorealism Partly in response to the dominance of *abstract art and then the emergence of *Pop art and *Minimalism, an extreme form of *naturalism was promoted in America in 1967–8 which made no secret of being achieved by working from photographs, normally by projecting these on to large canvases. It seems that a number of American painters were engaged in working like this – there always had been, continuing the 19th-century tradition of detailed naturalistic painting and *trompe l'oeil* – and that dealers and critics looking for an alternative artform in the late 1960s, selected practitioners and presented them as a new movement. Subjects could vary greatly, urban or rural, everyday or exceptional, agreeable or disagreeable, and the messages found in this art could be positive, emphasizing the visual richness of the urban scene, as in Richard *Estes's shop fronts, or negative, as when Malcolm *Morley crossed out in red paint a carefully rendered scene of a South-African horse race in *Race Track* (1970; Aachen, Neue Galerie). Other leading painters included in this movement were Ralph Goings, Howard Kanowitz and Robert Cottingham. Sculptors were also enrolled whose work aimed at a similarly extreme visual exactness, such as John de *Andrea, Duane *Hanson and Nancy *Graves, using a variety of materials including hair, glass eyes, real clothing and accessories, etc. as well as a basic structural material, often fibreglass. The sculpture can amaze the spectator by its lifelikeness,

but lacks the quasi-scientific detached observation the one-eyed vision of the camera imparts to the paintings. It is therefore better presented under the term *Superrealism. In either case, Photorealism was and remains very popular and of course strikes many echoes with the art of the Old Masters, especially those celebrating their visual environment with or without including sentiments or meanings, such as painters of still lifes and interiors of Spain and Holland in the 17th century. It may also be argued that it gave painters untouched by modern art's urge to find new idioms and deliver new insights an opportunity to work with traditional skills and purposes. Photorealism quickly found imitations and extensions among painters in other countries, especially in Europe, but lost its appeal during the 1970s as photographs and video became accepted as forms of art.

Piazzetta, Giovanni Battista (1683–1754) Outstanding Venetian painter. Trained partly in Bologna under Giuseppe Maria *Crespi, he remained faithful to the latter's *chiaroscuro, stressing the sculptural monumentality of figures – in almost total contrast to the prevalent *Rococo style (e.g. Venice, Gesuati; Milan, Brera). Notoriously slow and deliberate in execution – in especial contrast to *Tiepolo, who as a young man was nonetheless influenced by him – he was atypical also in remaining in Venice after his return from Bologna, 1711, while most Venetian artists worked extensively abroad (*see* e.g. Sebastiano and Marco Ricci). Despite his relative unproductivity, he was appointed the first Director of the newly created Venetian *Academy, 1750; he spent the last few years of his life teaching rather than painting and left his widow virtually destitute. His altarpieces were in great demand not only in his native city but also abroad, especially in Germany, as were his rather enigmatic, poetic *genre works (e.g. Dresden, Gemäldegalerie; Cologne, Wallraf-Richartz). Even his history paintings (*see under* genres) had certain plebeian overtones, a lack of social pretensions reminiscent of *Caravaggio. Other works London, National; Lille, Musée; Venice, Accademia, and in various Venetian churches.

Picabia, Francis (1879–1953) French painter, born in Paris (his father was Cuban), and trained at the Ecole des Beaux-Arts and under *Pissarro. He worked successfully as an *Impressionist but was then involved in *Cubism, associating particularly with *Duchamp and becoming a founding member of *Section d'Or in 1911. By 1909 he was painting *abstract colour compositions and in 1912 he was seen as one of the *Orphists, proposing a new form of lyrical painting with musical associations. In 1913 he spent time in the USA (where his work was included in the *Armory Show), and with Duchamp stimulated the development of a New York *Dada group. At this time he began to make satirical mechanistic images; he continued with these during the war, which he spent principally in Barcelona, publishing a Dada review *391* and making contact with the Dadaists of Zurich. With some of these he promoted Dada activities in Paris from 1918 on, and subsequently he joined the *Surrealists. In 1925 he designed the ballet *Relâche* (music by Satie) and in 1926 worked with René Clair on the film *Entr'acte*. His painting had meanwhile returned to figuration but made use of many materials and styles, developing tastes for parody and paraphrase which have caused him to be seen as a pioneer of the self-conscious stylistic manoeuvres associated with *Post-Modernism. Financial independence perhaps made it possible for him to work with a degree of freedom and self-mockery unusual among artists. His reputation declined in the 40s and 50s, but a retrospective at the Grand Palais in Paris, in 1975, drew renewed attention to the radicalism of his ideas and made them available in a substantial catalogue.

Picasso, Pablo (1881–1973) The most famous artist of modern times, most versatile and most fruitful, was born in Malaga, only son of a painter who symbolically handed over his brushes when the boy was 13. From 1892 he studied at Coruña and Barcelona art schools and, for a few months in 1897, at the Royal *Academy in Madrid. By now his strong but quite unoriginal work, paintings and drawings, had been favourably noticed. In 1899 he returned to

Barcelona and became part of a circle of artists and writers who met at the café Els Quatre Gats, associating as a local *Art Nouveau movement stimulated by French art such as *Steinlen's, but also by Spanish expressive art such as El *Greco's, and often representing the life of the poor in a *realistic manner. In 1900 a painting of his was included in the Paris Universal Exhibition. That October Picasso and his friend Casagemas visited Paris and Picasso painted his first Paris pictures, a café scene and a Pierrot with dancer, influenced by *Toulouse-Lautrec. Until 1904 he spent part of each year in Paris. In 1901 he began to exhibit and to sell his work there, being seen as a 'brilliant newcomer'. Casagemas's suicide affected him deeply. Death and deprivation became dominant themes in his work and by the end of 1902 he was working in Barcelona and in Paris in the manner known as his Blue Period. *La Vie* (1903, Cleveland Museum of Art) is the outstanding work of these years, suggestive in content and sombre in mood.

His spring 1904 visit to Paris became his emigration. He took a studio in the *Bateau-Lavoir, close to the circus which he and his friends frequented. He formed a liaison with Fernande Olivier who lived with him for seven years: like his other sexual relationships this one impressed itself on his work. Its tone and colour lightened – Rose Period – and its themes were often related to circus performers, harlequins, clowns etc. He was also making occasional modelled sculptures, e.g. *The Jester* (1905). A visit to Holland in the summer of 1905 brought a more solid, sculptural quality into his painting, reinforced in 1906 by his visit to Gosol in the Spanish Pyrenees: his painted figures became more massive and primitive under the influence of ancient Iberian sculpture. That autumn he completed his portrait of Gertrude Stein (New York, Metropolitan), making her face a hard mask with sharp details. The sculptural character of his painting at this time shows powerfully in *Two Nudes* (late 1906; New York, MoMA).

By this time Picasso was recognized as part of the Paris *avant garde and friendly with *Matisse, *Derain and other leading figures. Impelled by the example of

*Cézanne, but reacting also to Matisse's *Bonheur de Vivre*, he began planning a large figure painting: theirs were outdoor scenes of happiness, his would be a dramatic brothel scene. The result, left unfinished in 1907, was *Les Demoiselles d'Avignon* (New York, MoMA), in which elements of Cézanne and Matisse, as well as El Greco and, at the last moment, African masks, jostle to make a discord of harsh forms and colours and contradictory styles. Some of its angular forms have caused it to be seen as the first *Cubist painting, but its size and subject matter as well as other aspects suggest rather a summation of ideas, ambitions and impulses affecting him up to that point. There followed an exploratory period in which ideas from African sculpture conflict with painterly methods. In 1907 Picasso carved massive figures in wood in a quasi-African manner. The same massiveness shows in several of his 1907-8 paintings, notably the *Dryad* or *Large Nude* and *Three Women* (1908, both St Petersburg, Hermitage Museum) in which tone is used to establish solid forms and relief at the expense of colour and atmosphere.

*Braque, working in the same building, was disconcerted by the *Demoiselles*. Their friendship ripened in 1908 as Braque developed his first Cubist paintings. *Three Women* owes something to Braque's careful interrelating of tilting, close-toned planes. Picasso was moving towards Braque's new art, and soon they were working closely together to develop Cubism. It is as the great Cubist that Picasso has been inscribed in the annals of Modernism. Yet Cubism misrepresents him; the painter of life's passions diverts himself, playing intricate formal games, mostly with still-life motifs, in an essentially French vein. The humour he shows in his Cubist work is characteristic, but not the impersonal, exploratory method. For a while the sculptural emphasis continued, but by spring 1910 Picasso's paintings showed all the ambiguities of form and space that Braque had been developing, and 1911 saw the climax of early ('Analytical') Cubism in the work of both.

In 1912 they went their separate ways, stylistically (although the work of both is labelled Synthetic Cubism) and physically.

Picasso moved into a smart apartment with his new lover, Eva. He introduced *collage into his paintings, and used larger forms, stronger colours sometimes, and a lot of visual jokes. He also made constructed as well as modelled sculptures, including the metal *Guitar* (New York, MoMA) which launched *constructed art. By 1913 there was a new flavour in his work, a stridency (e.g. *Woman in an Armchair*; New York, pc) that points to the 1920s and *Surrealism, and also at times a willingness to form apparently *abstract images. Picasso's international fame was extensive by now, and he was selling for substantial prices through *Kahnweiler's gallery. He knew he had replaced Matisse as leader of the avant-garde. The 1914-18 war interrupted his public progress: Kahnweiler had to close his gallery and its stock was sequestered though Leonce Rosenberg came forward to be Picasso's dealer. Many of Picasso's friends left Paris for the front. In 1915 Eva died. Picasso painted his harshest Synthetic Cubist picture in *Harlequin* (late 1915; New York, MoMA) and thought it the best thing he had ever done.

What came next was not harshness but charm and wit. In 1916 the poet Cocteau proposed that Picasso should make the designs for a ballet for which Satie was preparing the music. In 1917 Picasso went to Rome to work with Diaghilev and the Ballets Russes company. The ballet, *Parade*, was premièred in Paris that May. Picasso had meanwhile fallen for one of the dancers, Olga Koklova; they married in July 1918. They lived in high society and Picasso's work now switched between a decorative late Cubism and a fine academic *classicism influenced by *Ingres. He made further designs for Diaghilev, and also drawings of ballet dancers, some of which announce a new massiveness in his figure style. This emerges fully in 1921 with the monumental *Three Women at the Spring* (New York, MoMA); for other subjects, especially still lifes, Picasso still used a decorative form of Cubism. *The Dance* (1925; London, Tate) is the opposite: strident, violent in action and distortion, harsh in colour, flat and thin in its forms, an image of pain. The Surrealists now pointed to Picasso as their natural leader. Unhappy

with Olga, he worked on disturbing themes, violent lovers, the Minotaur, aggressive females confronting a classical view of himself, monstrously abstracted bathers, the Crucifixion, etc. He spent time in his friend *González's studio, learning how to construct metal sculptures by welding. Meanwhile he fell in love with Marie-Thérèse Walter and embarked on a long liaison with her. His pleasure in her resulted in rounded and colourful images of women and in large, cheerful modelled female heads in plaster, as well as other markedly harmonious productions, such as his etchings for Ovid's *Metamorphoses* (1931). He now worked at the château of Boisgeloup as well as in his Paris studio and in González's. In 1932, after many smaller exhibitions, he showed 236 works in Paris and in Zurich, from the Blue Period to the present. The critics' response was mixed, some seeing a decline, others marvelling at his vast talent.

The first issue of *Minotaure*, a Surrealist journal (1933), had a Picasso cover and illustrated some of his Crucifixion drawings in which bones suggest figures and also *An Anatomy*, drawings of figures paraphrased in terms of furniture and utensils. Domestic tension mounted with the news of Marie-Thérèse's pregnancy; Picasso and Olga separated. For a time he ceased to paint, and gave time to writing Surrealist poems, some of which were published. In 1936 he met the photographer Dora Maar and painted her. The Spanish Civil War broke out; Picasso's sympathies were wholly with the republican government which had made him director of the Prado Museum in Madrid. In January 1937 he produced the two etchings with words, *Dream and Lie of Franco*, a sharp satire on the general, sold to make money for the Republicans. In three weeks in May–June he painted his great mural for the Spanish Pavilion at the Paris International Exposition: *Guernica*, dealing in almost monochrome symbolism with the bombing of a Spanish town as an instance of all violence (now Madrid, Reina Sofia). He went on developing motifs related to it, notably the *Weeping Woman* (London, Tate) and other emotional portraits of Dora. *Guernica* and associated studies were shown in London,

Leeds and Liverpool in 1938, and in 1939 in New York, Los Angeles, Chicago and San Francisco, to raise money for Spanish Relief. It attracted crowds. 1939 saw also a great retrospective, at the Museum of Modern Art in New York and then on tour in the USA.

1939 brought the victory of Franco in Spain, the onset of the Second World War and difficulties for Picasso as a foreigner in France. There was further domestic strife: Marie-Thérèse and Dora becoming aware of their lover's duplicity. Picasso divided his time between Royan and Paris where the occupying Germans failed to gain his respect. In 1943 he met Françoise Gilot. Much of his work now exhibits extreme distortion and harshness; some of it is classical and calm, notably the large bronze *Man with Sheep* (1944). His *Head of a Bull*, a bicycle saddle and handlebars (1943; Paris, Musée Picasso), is both witty and grave; a modelled *Death's Head* in bronze and copper (1943; ditto) he kept by him for the rest of his life. In 1944 it was announced that he had joined the Communist party; a special display of Picasso's work at the Salon d'Automne in Paris that year drew loud protests, against his politics and against his art, but also statements in his support from leading intellectuals.

From 1946 Picasso and Françoise lived together. In Antibes, offered studio space in the Palais Grimaldi, he opted for decorating it with murals; in 1947 it became Antibes's Musée Picasso. That August Picasso began working at a pottery in Vallauris, making a long series of painted ceramics and giving new life to a dying industry. In 1948 he attended the Congress of Intellectuals for Peace, in Poland, and visited Auschwitz. His lithograph of a pigeon was for the poster of Paris's Peace Congress in 1949 and became known as the 'Dove of Peace'. In 1950 he attended the Second World Peace Conference in Sheffield; that November he was awarded the Lenin Peace Prize. 1950–3 saw him making major assembled sculptures, subsequently cast in bronze, e.g. *She-Goat* (1950) and *Baboon and Young* (1952). In 1954 he began a long, intermittent, series of sculptures of a new sort, cut shapes of sheet metal folded to become three-dimensional

and self-supporting. The first of these were heads but later he made whole figures and animals, and some were produced as monumental public sculptures (e.g. that in the Chicago Civic Centre, 1964–7). Like the ceramics, these were light-hearted works.

In 1954 Picasso began to live with Jacqueline Rocque. A major retrospective of his art was shown at the Grand Palais in Paris in 1955 and in amended form in Munich, Cologne and Hamburg. That summer he acquired a large villa outside Cannes, La Californie, and painted a series of interiors of his studio there, and the following year his long series of variations on Velázquez's *Las Meninas* (Barcelona, Museo Picasso). A very large 75th Anniversary Exhibition of his work was shown in New York in 1957 and subsequently in Chicago and Philadelphia. In 1957–8 he painted a mural for the **UNESCO** building in Paris on the theme of *The Fall of Icarus*. In 1958 he added the château of Vauvenargues, below Cézanne's Mont Saint-Victoire, to his properties, filling it with his work, and in 1961, having married Jacqueline, a villa outside Mougins, near Cannes. His 80th birthday brought major exhibitions and tributes, and in 1963 the Museo Picasso opened in Barcelona. In 1964 a retrospective in Tokyo, Kyoto and Nagoya took him to Japan. A vast retrospective was shown in the Grand and Petit Palais in Paris in 1966. Picasso, having lately undergone an ulcer operation and saddened by the death of friends including Cocteau and *Breton, did not attend and, in 1967, refused the Légion d'Honneur award. A retrospective, directed by his friend, the artist and writer Roland Penrose, was shown in London and New York in 1967–8; another, of his prints only, was in New York in 1969. 1972 saw the exhibition 'Picasso in the Collection of the Museum of Modern Art' in New York, with a catalogue by William Rubin. Picasso was now living at Mougins, making mostly prints and drawings. After his death on 8 April 1973 he was buried at Vauvenargues.

Reported on from his earliest professional days, Picasso was the most public of artists, the subject of intimate biographies and photographic chronicles as well as

many monographs and an infinity of essays and reviews. Christian Zervos began in 1932 to publish his catalogue of Picasso's work. His life seemed public too: his involvement in the world of ballet as well as of art, his taste for bullfights and for days on the Côte d'Azur. Clouzot's film, *Le Mystère Picasso* (1955), showed him working his magic effortlessly. It seemed he could make spirited art out of anything while also living well, in beautiful places, in the company of beautiful women and befriended by the great. His late paintings included lively variations on paintings by *Delacroix, Velázquez, *Manet and others, as well as sometimes jocular treatments of time-honoured *History painting themes, e.g. *The Rape of the Sabines*. These attracted the charge that he had lost his appetite for innovation and was content to amuse himself by making versions of the art of others and at times his own. Since his death this work has been reconsidered as being of great significance as well as masterly. An exhibition of his late work in several media was shown in Paris and London in 1988.

Far from being the playboy of art, as some had called him, Picasso was a complex man, driven to create by a fear of impotence and death. He early abandoned the Catholicism of his youth but felt the presence of dark forces which only art, love and the company of friends could keep at bay. One of these (Crespelle) quotes him: 'I think about Death (La Mort) all the time; she is the only woman who never leaves me.' Also, far from being the great destroyer of traditions, Picasso, like all the greatest artists, saw himself as a fresh link on the great chain of art. He knew the masters intimately and in his boldest moments felt he measured up to them.

Pickenoy *See* Eliasz., Nicolaes.

picture plane The surface of a picture; the term is used in Western art when speaking of the degree of relief or recession of painted motifs. In gold-*ground medieval paintings, the picture plane may appear to be an opaque surface situated behind the figures, which seem to

protrude into the viewer's space. With the development of linear *perspective in the *Renaissance, it came to be defined as a transparent, sometimes permeable, membrane covering an imaginary opening in wall or ceiling, and separating the viewer's actual three-dimensional space from a fictive space optically continuous with it. In this convention, painted objects may seem to straddle the picture plane, and figures to move from our space into that of the painting, or vice-versa – a device first exploited by *Masaccio in the Brancacci chapel, and a staple of *illusionistic *Baroque ceiling painting.

Picturesque 'worthy of a picture' An aesthetic category, between the *Sublime and the Beautiful, formulated in the 18th century with special reference to landscape and landscape art. Its foremost exponents were English, notably the **Rev. William Gilpin** (1724–1804) and **Sir Uvedale Price** (1747–1829). 'The two opposite qualities of roughness and of sudden variation, joined to that of irregularity, are the most efficient causes of the picturesque' (Price). It has been said, justly, that Picturesque theory was a socio-political response as much as an aesthetic one: it enabled the squirearchy to view distressing or threatening aspects of country life as pictorial themes rather than practical or ethical problems. Price again: 'In our own species, objects merely picturesque are to be found among the wandering tribes of gypsies and beggars; who in all the qualities which give them that character, bear a close analogy to the wild forester and the worn-out cart-horse, again to old mills, hovels, and other inanimate objects of the same kind.'

Piene, Otto (1938–) German artist, one of the founders of the *Zero Group and known for his work with light, on 'screen pictures' and subsequently also in *kinetic sculptures, light ballets and light theatre, combining projected light with smoke. Since 1972 he has been professor of Environmental Art at the Massachusetts Institute of Technology and director of the Center for Advanced Visual Studies there. He has worked also with fire and with

air, finding ways of engaging man-made objects with nature's elements.

Pier Francesco Fiorentino (1444/5–after 1497) Derivative Italian painter from Florence. There are pictures on panel and in *fresco by him throughout the area of San Gimignano, where he ran a busy workshop (e.g. San Gimignano, Palazzo Comunale; Collegiata; Pinacoteca; Empoli, Museo della Collegiata; Certaldo, Palazzo Comunale; Volterra, Galleria).

Pierce, or **Pearce, Edward the Younger** (c.1635–95) English architect, mason and sculptor in both stone and wood, son of a painter, Edward Pierce the Elder (d.1658), some of whose decorative work remains in Wilton House. He was much employed by Sir Christopher Wren on the rebuilding of churches in the City of London. His best work, however, was as a sculptor of portrait busts, the most notable being a brilliant likeness of Wren now in Oxford, Ashmolean, perhaps carved to celebrate Wren's knighthood in 1673. Isaac *Fuller's portrait of Pierce is in Sudeley Castle.

Pierino da Vinci (1520/1 or 1531–54) Precocious and sensitive Florentine sculptor in marble. After a stay in Rome in 1548, he returned to Tuscany imbued with the sculptural ideals of *Michelangelo and learned in his techniques; his two-figure group of *Samson Slaying a Philistine* (1549, Florence, Palazzo Vecchio) is based on sketches by the older master, and the relief of *Cosimo I as Patron of Pisa* (1549, Rome, Museo Vaticano) attempts to transcribe the painting style of the Sistine Chapel into marble.

Piero della Francesca or **dei Franceschi** (c.1415/20–92) Painter and mathematical theorist from Borgo San Sepolcro (the modern Sansepolcro) near Arezzo. Albeit not as neglected in his day as sometimes supposed, and indeed influential on central and northern Italian artists (*see*, e.g. Bramantino and Melozzo da Forlì), he has gained particular fame in the modern period for his generally light palette (*see under* colour), his interest in geometry

(including *perspective) and his monu-
mental, architectonic sense of form and
pictorial composition.

Piero's life is badly documented. We do
not know by whom or where he was
trained. Scholars disagree on the chro-
nology of his extant works, on the causes
for the delays between commissioning and
completion of major projects (e.g. *Miseri-
cordia* *polyptch; *True Cross* *frescos, *see
below*), on the order of execution of
the various portions of such works and
on the degree of collaboration by assistants.
Much of his *œuvre* is lost, notably impor-
tant frescos in Ferrara and the Vatican.
Other works have been dismembered and
partly destroyed (*St Augustine* polyptych;
central panel lost; flanking and *predella
figures now Lisbon, Museu; London,
National; New York, Frick; J. D. Rocke-
feller Coll.; Milan, Poldi Pezzoli; Wash-
ington, National); others have been cut
down (*Madonna and Saints with Federico II
da Montefeltro*, Milan, Brera; *St Antony*
polyptych, Perugia, Galleria), reassembled
in modern frames (*Misericordia* polyptych,
Urbino diptych, *see below*), or damaged
through overcleaning (e.g. *The Nativity*, *see
below*). Finally, a small, now celebrated
picture, *The Flagellation* (Urbino, Galleria)
presents an *iconographic puzzle: the
identity of three figures in the foreground.
All these factors impede our reading of
Piero. Yet, except for *The Flagellation*
which must have had special significance
for a private patron, his work is unexcep-
tional in content. Other than portraits (*see
below*) only one secular painting by him is
known: a fresco fragment depicting *Her-
cules* (Boston, Gardner). Even the famous
impassivity of his figures is not markedly
greater than that of Fra *Angelico's, who
may have influenced him. Piero's fascina-
tion resides neither in a rejection of narra-
tive and symbolism nor in complex
*iconography, but in his pictorial methods:
the way in which he reconciles abstract
geometry with *naturalism – an interest
fuelled through contact with Netherlandish
art, mainly in Urbino (*see* Joos van Ghent)
– and the old-fashioned requirements of
provincial patrons with the newest optical
advances of Florentine art-science. What
little is documented of his biography

suggests that he was civic-minded and
conventionally devout. There is some
disagreement in the sources about whether
or not he went blind some time before
his death; in either case he seems to
have stopped painting by the 1480s and
concentrated on writing mathematical
treatises.

Piero is first recorded in 1439, assisting
*Domenico Veneziano on frescos in S.
Egidio, Florence (destroyed). By 1442 he
was back in Borgo San Sepolcro where in
1445 the Confraternity of the Misericordia
commissioned from him the gold-
grounded polyptych now reassembled in a
modern frame (Sansepolcro, Pinacoteca).
In defiance of the contract, the work was
completed only in 1462 and not all 23
panels are by Piero. The influence of
*Masaccio is evident throughout. Although
the altarpiece of the *Baptism of Christ*
(London, National) may date from 1448–
50, and the lost Ferrara frescos *c.*1450,
the next secure landmark in Piero's career
is the fresco of *Sigismondo *Malatesta
Kneeling before St Sigismondo*, dated 1451
(Rimini, Tempio Malatestiano). Here, the
demands of state portraiture, religious
*icon, heraldry, architectural decoration
and the realistic depiction of a fortress are
all reconciled. In 1452, after the death of
the Florentine Bicci di Lorenzo, Piero took
over the decoration of the choir of S.
Francesco in Arezzo. The frescos of *The
Legend of the True Cross* (completed 1459?
1466?) are generally considered his master-
piece. They combine miracle stories,
history, Old and New Testament and the
celebration of two feasts of the Church, the
Exaltation of the Cross and the Rediscov-
ery of the True Cross. The cycle, however,
which has undergone several restorations,
is badly damaged.

Of Piero's other works in fresco, the
best known are the *Madonna del Parto*
(1450?–5? 1460? Monterchi, votive chapel,
now cemetery) and the *Resurrection of
Christ* (1463–5, Sansepolcro, Pinacoteca).
The pregnant Madonna is a rare but not
unknown subject in Italian art. The reader
is cautioned not to believe the fiction, per-
petuated even by scholars, that the painting
marks the burial place of Piero's mother:
the chapel and its fresco altarpiece long

pre-date the cemetery. The hieratic symmetry of the *Resurrection* recalls that the image, originally in the town hall, realistically represents the heraldic emblem of Borgo San Sepolcro: the Town of the Holy Sepulchre, founded by pilgrims returning from the Holy Land.

Piero's debt to Netherlandish art is especially noticeable in his panel paintings, in which he makes use of *oil glazes laid over tempera (*see also* colour). It is perhaps most marked in the diptych portraying the Count, later Duke, of Urbino, Federico da *Montefeltro and his wife Battista Sforza (1460? 1465? 1473? Florence, Uffizi). On the reverse of each portrait Federico and Battista are shown riding 'in triumph' on a pageantry chariot peopled with appropriate allegorical figures. Although the couple are depicted in profile, as on *classical medals and their contemporary emulations (*see* Pisanello), they are placed high above a luminous panoramic landscape, continuous across both panels and comparable with the landscapes in the background of many Netherlandish paintings (e.g. Van *Eyck's *Rolin Virgin*). The showy frame which now interrupts the landscape dates from the 19th century. Although the iconography of *The Nativity* (*c.*1470–5? London, National) may have been borrowed from Filippo *Lippi, the motif of the naked Christ Child lying on the ground, adored by the kneeling Virgin, ultimately also derives from Netherlandish art. The unfinished appearance of this work probably results from its radical overcleaning in the 19th century.

The last major work thought to have been executed by Piero is the so-called Brera altarpiece, showing Federico da Montefeltro kneeling before the Virgin and Child surrounded by saints (before 1474, Milan, Brera). The famous ostrich egg suspended over the Virgin was, in fact, an object suspended in the apses of some Byzantine and Abyssinian churches, where it symbolized Creation and the four elements. Before the painting was cut down on all sides it must have shown much more of the painted architecture, the composition, situating the Virgin and her holy companions in the apse of a church, had a profound influence on Venetian altarpieces (e.g. Giovanni *Bellini).

According to tradition, Piero was the teacher of Luca *Signorelli.

Piero di Cosimo (1462–1521) Idiosyncratic Florentine painter, a longtime pupil of Cosimo *Rosselli, whose name he adopted and whom he assisted in the Sistine Chapel in Rome, 1481–2. Renowned for his fantastical imagination, Piero was in demand as a designer of processional floats and costumes, and made a particularly deep impression with his macabre Triumphal Chariot of Death for the Carnival of 1511. The same imagination is evident in the mythological panels, now dispersed in various museums, which formed part of one or more room decorations on the theme of prehistory or the early history of humankind (Hartford, CT, Atheneum; London, National; New York, Metropolitan; Ottawa, National; Oxford, Ashmolean). Another such panel, the *Liberation of Andromeda* (*c.*1510, Florence, Uffizi) maintains the same fairy-tale charm while demonstrating, notably in its use of *sfumato*, Piero's growing debt to *Leonardo da Vinci. Even his large altarpieces incorporate, especially in the background landscapes, fantastical details (e.g. *Immaculate Conception*, *c.*1505, Florence, Uffizi) which are perhaps indebted as much to northern European prints as to the Florentine *cassone* tradition. Although Piero had pupils and disciples – the most notable being *Andrea del Sarto – he became increasingly reclusive and eccentric.

Pietà (Italian, pity) A pictorial type abstracted from the narrative of the Passion of Christ, not so much intended to represent a specific moment in that narrative but to serve as a timeless focus of pious meditation and prayer. It is a representation of the dead Christ, carried down from the cross prior to burial, supported on his mother's lap. A pictorial parallel is often drawn between the grieving older Madonna holding the dead adult Christ, and the youthful Madonna with a sleeping infant Jesus. Strictly speaking, a *Pietà* comprises only the two figures of Christ and Mary; where other mourners are depicted, and the

scene is thus close to narrative, the imagery is known as a *Lamentation*. This difference, however, is not observed in Italian and, by extension, by many writers in other languages. Like most other meditative devotional imagery (*see also andachtsbild*), the *Pietà* was a late Medieval northern European development.

Pietersz., Pieter *See under* Pieter Aertsen.

Pietro da Cortona; Pietro Berrettini, called (1596–1669) Architect, painter, decorator and designer of sculptural monuments. Born at Cortona in Tuscany to a family of stonemasons, he became, with *Bernini and the architect Borromini, the third great creator and exponent of Roman High *Baroque. His later work, however, heralds the end of the Baroque in its avoidance of extreme *illusionism and insistence on clear divisions between painting and three-dimensional enframement. It gave rise to a sumptuous kind of decorative *classicism which became the international ornamental style throughout Europe and particularly in France (*see* Lebrun). Nonetheless, Pietro da Cortona is identified with the anti-classicist faction of the *Academy of St Luke in Rome (*see* Andrea Sacchi) of which he was elected 'prince' from 1634–8. Although an easel painter he lacked the moral seriousness of Sacchi and *Poussin (e.g. Rome, Capitoline; S. Maria della Concezione; S. Lorenzo in Miranda; Cortona, S. Agostino; Paris, Louvre) he was unmatched as a master of large-scale mural painting in Rome from the 1630s. While this entry is limited to his achievements as a painter and decorative artist, the reader should be aware that as a brilliant architect Pietro da Cortona influenced even Bernini (e.g. Rome, S. Maria della Pace).

Apprenticed to a mediocre Florentine painter, he followed him to Rome in 1612/13. His early studies were mainly of *Raphael and a copy of the latter's *Galatea* won him the influential patronage of the Sacchetti family from 1623. At the Palazzo Sacchetti, he met Cardinal Francesco *Barberini, the nephew of Pope Urban VIII, who became his lifelong patron, and the cardinal's learned secretary, Cassiano dal *Pozzo. The latter employed him, as he did other young artists, including Poussin, to compile a corpus of ancient works of art remaining in Rome – the source of Pietro da Cortona's antiquarian interests. Fittingly, his most famous pictorial work was executed in the Palazzo Barberini, 1633–9: the ceiling decoration of the Gran Salone, a landmark of Baroque ceiling painting. This famous *fresco combines, in a wonderfully exuberant yet disciplined whole, several traditions of *illusionistic vault and ceiling painting. (*See* Annibale Carracci; Correggio; Veronese.)

While passing through Florence in 1637, Pietro da Cortona was persuaded by Ferdinand II de'*Medici to fresco a small room in the Pitti Palace (Camera della Stufa). From 1640–7 he was to decorate ceilings of a suite of rooms. This time a real stucco enframement, some of it in very high relief, in pure white and pure gold, separated the painted areas. This is the decoration, at once stately and festive, which was adopted internationally and gave rise to the 'style Louis XIV'. Upon his return to Rome in 1647 he began his most extensive church decoration: the frescos in S. Maria in Vallicella, 1647–51, 1655–60, where the separation of painted areas and decorative enframement was once again observed, although the frescos themselves look back to *Lanfranco and Correggio. Between 1651–4, however, he painted for Pope Innocent X the ceiling of the long gallery of the Palazzo Pamphili, Rome; its luminous colour range anticipates the work of Luca *Giordano and the 18th century, and, unlike the public frescos of S. Maria in Vallicella, the decoration appealed to the refined taste of connoisseurs by recalling High *Renaissance and antique design. In 1652 he published, together with the Jesuit Ottonelli, a *Treatise on Painting* in which he upheld the traditional Renaissance ideals of *decorum and the moral function of art. *See also* Courtois, Guillaume, Jacques.

Pietro Solari, called **Pietro Lombardo** (*c.*1435–1515) and his sons **Tullio** (*c.*1455/60–1532) and **Antonio** (*c.*1458–1516) With Antonio *Rizzo, the first fully

*classicizing sculptor in Venice, where Pietro worked from c.1467, after a probable visit to Florence prior to 1462 and periods of activity in Bologna (1462–3, S. Petronio) and Padua (1464–7, S. Antonio). In addition to running a sculpture workshop, Pietro practised as an architect; after the flight of Rizzo in 1498, he became master of works in the Doge's palace. Member of a branch of the *Solari family, he was called Lombardo after his native region, Lombardy. To a greater extent than Rizzo, whose work remained eclectic, the Lombardi workshop evolved an autonomous Venetian *Renaissance sculptural style, first discernible in the *Mocenigo monument* (1476–80/1) and even more clearly in the *Marcello monument* (after 1480; both in Venice, SS. Giovanni e Paolo). This technical and stylistic advance is even more marked in the *Zanetti* (after 1485) and *Onigo* (after 1490) *monuments*, in which Tullio and Antonio played a more important part (Treviso, cathedral, S. Nicolò, respectively). Other major funerary monuments by the workshop are to be found in Venice, S. Suriano; S. Maria dei Frari, and include the *Tomb of Dante* in Ravenna (1482). Pietro also designed the lower part of the new façade of the Scuola di S. Marco, Venice (1488–90) with *perspectivized reliefs executed by Tullio and Antonio; he is also known to have worked on the choir screen of S. Maria dei Frari.

Tullio Lombardo had a more consuming interest in the antique than his father. He is known to have collected classical statuary, and many of his own works copy or adapt Graeco-Roman prototypes. The *Vendramin monument* which he probably designed and largely executed (compl. 1494, originally Venice, S. Maria dei Servi, now SS. Giovanni e Paolo; figure of *Adam*, New York, Metropolitan) has been called 'a manifesto of Venetian classicism'. Tullio's reputation as a 'humanist sculptor' is particularly sustained in his lyrical portrait-like reliefs, inspired by Roman grave portraits (Vienna, Kunsthistorisches; Venice, Correr). Among his other important works are the marble relief altarpiece for Venice, S. Giovanni Crisostomo (1499–1502) and two reliefs for

the Chapel of St Anthony of Padua (1501–20, Padua, S. Antonio), a complex to which Antonio Lombardo also contributed a relief (1505). From c.1515–28 Tullio worked on commissions outside Venice: in Ravenna cathedral; at Belluno; for Isabella d'Este in the ducal palace at Mantua, and at Feltre.

Antonio Lombardo's career is the least well documented. In addition to his presumed participation in the Lombardi workshop monuments from c.1475, and his authorship of the relief in Padua mentioned above, his main activity while in Venice relates to the Zen chapel in St Mark's (bronze *Virgin and Child*, model 1506, date of casting unknown). After 1506 he moved to Ferrara, where he was employed by Alfonso d'*Este on the mythological reliefs for the Camerini d'Alabastro in the Castello (*see also* Titian; Dossi Dossi). The greater part of these dispersed reliefs is now in St Petersburg, Hermitage; Florence, Bargello. Antonio's style has been characterized as more pictorial than either his father's or brother's.

Pigalle, Jean-Baptiste (1714–85) Leading French sculptor. Like *Falconet Pigalle was of humble origins, a student of Jean-Baptiste *Lemoyne and an individualist, but unlike him he rose to high honours, receiving many major commissions from the crown and becoming, exceptionally for a sculptor, Chancellor of the *Academy. His work is distinguished by its vigour and *naturalism – most startlingly evident in his full-length statue *Voltaire nu* (1770–6, Paris, Institut) in which the philosopher's body is depicted with the sagging muscles, stiff joints and wrinkles of old age – in other words, 'naked' rather than *classically '*nude', and was posed for by an old soldier.

Despite not having won first prize at the Academy School in Paris, Pigalle was allowed to work at the French Academy in Rome, 1736–9. Although demonstrably familiar with both antique and *Baroque sculpture in Rome, he seems to have been influenced relatively little by either. Before returning to Paris in 1741, he spent two years in Lyons, where he may have executed the terracotta model for his successful

reception piece for the Academy, the *Mercury* (exhibited 1742, now New York, Metropolitan; marble version, 1744, Paris, Louvre; *see also under* Chardin). In the years following he was to be employed by Mme de Pompadour and the French crown (e.g. bust of *Mme de Pompadour*, 1748–51, New York, Metropolitan; the allegorical *Love and Friendship Embracing*, 1758, Paris, Louvre). His greatest work, the funerary monument to the Maréchal de Saxe (Strasbourg, St Thomas) was commissioned and designed in 1753 but completed only in 1776. The commission itself led to his being selected by the city of Reims to execute a large monument to Louis XV, of which only the allegorical figures at the base remain (compl. 1765, Reims, place Royale), and the success of this prompted *Bouchardon to name him as his successor on the monument to Louis XV in Paris (destroyed).

In addition to large-scale works Pigalle executed some portrait busts, chiefly of professional men who were his friends (e.g. Orléans, Musée). His self-portrait of 1780 is at the Louvre. One of his best-known early works is the nude *Enfant à la Cage* (1750, Paris, Louvre), ostensibly a *putto* *all'antica* but actually the portrait of the one-year-old son of a patron.

pigment Any colouring agent; the ground particles that, when held in suspension in a *medium, make up paint. Pigments have been derived or manufactured from a wide range of animal, vegetable and mineral sources. Among the more unusual are dyestuffs extracted from scale insects; the red resin called dragon's blood; natural ultramarine ('from across the sea') blue, made from lapis-lazuli found only in Afghanistan, and costlier than gold. Chemical advances in the 19th century provided artists with cheap synthetic ultramarine, and with the stable and brilliant green, yellow and orange pigments that are the glory of the *Impressionist palette. *See also* colour.

Pijnacker or **Pynacker, Adam** (1621–73) Italianate Dutch painter of landscapes in the manner of Jan *Both (e.g. Munich, Gemäldesammlungen) and harbour scenes

indebted to Jan *Asselijn (Amsterdam, Rijksmuseum; St Petersburg, Hermitage; Hartford CT, Atheneum; Vienna, Akademie). He is said to have spent three years in Italy, although there is no documented record of the presumed voyage. After working at Delft (1649) and Schiedam (1658) he settled in Amsterdam, producing huge decorative wall hangings for patrician houses.

Piles, Roger de (1635–1709) French picture expert, diplomat and occasional spy on behalf of Louis XIV; influential writer on art. His *Conversations on the Knowledge of Painting*, 1677, and *Dissertation on the Works of the most famous Painters*, 1681, argued that the prime interest of painting was visual and irrational, rather than literary, moral or didactic and dependent on subject matter, as advocated at this time by the French Royal *Academy and its official historiographer, *Félibien. De Piles elevated the amateur – in the sense of 'connoisseur' – over the practitioner as the best judge of painting. In the earlier *Dialogue on colourism*, 1673, he puffed the reputation of *Rubens over *Poussin when the Duke of Richelieu sold his collection of paintings by the latter to acquire works by the former. De Piles became the chief 17th-century champion of *coloris*, colourism (identified with Rubens and Venetian art, *see* e.g. Titian) against *dessein*, that is, *disegno and the *classical ideal, and thus prepared the way for the ascendency of the *Rococo style in French art. In the last decade of his life he became the leading and official theorist of the Academy; the lectures which he gave regularly over the next years were combined and published in his *Course on Painting through Principles*, 1708. The full force of his arguments, however, resurfaced only in the 19th century, in *Delacroix's ideas about art.

Pilgram, Anton (*c*.1450/60–after 1515) Architect and sculptor, born in Brünn. From 1511–15 he was in Vienna as master mason of St Stephen's cathedral; at this period he executed also his first sculpture (organ-bracket with self-portrait, pulpit with busts of the Fathers of the Church).

Pillement, Jean-Baptiste (1728–1808) Influential French *Rococo designer, printmaker and painter of decorative *landscapes and marine views. He was born in Lyon, the centre of the French silk industry, worked as a textile designer at the Gobelins factory, and as a decorative painter in Spain and Portugal in the 1740s. He was in London by 1755, when the first of his many series of design prints were published: *A New Book of Chinese Ornaments Invented & Engraved by J. Pillement* and *A New Book of Chinese Designs*; even more influential than his Chinoiserie designs and Italianate landscapes were his prints of flowers. Pillement left England in about 1760, but continued to exhibit landscapes in London until 1780; he married the engraver Anne Allen. His last success was as a decorative painter for Queen Marie-Antoinette; with the falling-out of fashion of Rococo design, he retired to Lyon where he seems to have died in poverty.

Pilo, Carl Gustaf (1712/13–92) Swedish painter, best-known member of an artistic dynasty which included his father, the Polish painter **Olof Pijhlow** (1668–1753) and his brother **Jöns** (1707– after 1750). Fleeing an affiliation case at home, he became First Portrait Painter to the Royal Court of Denmark (Copenhagen, Museum).

Pilon, Germain (c.1525–90) Leading French sculptor in marble and bronze; the successor of *Goujon in Paris, although a more *expressive and naturalistic artist. Probably trained in the workshop of his father, the sculptor **André Pilon**, he is first recorded in 1558 as sculptor on the tomb of Francis I designed by the distinguished architect Philibert de l'Orme (*see also* Bontemps, Pierre); in 1560 he was working for *Primaticcio on the *Monument for the heart of Henry II* (Paris, Louvre, *see also* Florentin, Dominique). His early manner, influenced by Primaticcio, gives way to greater *naturalism in the bronze kneeling figures of the King and Queen, and their marble recumbent nude effigies, on the tomb of Henry II and Catherine de'Medici executed to Primaticcio's design (1563–70, Paris, St-Denis). During the 1570s he was active making portrait busts in both marble and bronze (Paris, Louvre; London, Wallace) and medals; both types of work suggest familiarity with contemporary Italian sculpture, notably that of Leone *Leoni, briefly in Paris in 1549 and in touch with Primaticcio in 1550. Pilon's main projects in the 1580s were groups for the Valois Chapel at St-Denis, commissioned by Catherine de'Medici (c.1580–5, fragments now Paris, Louvre, St-Paul-St-Louis, St-Jean-St-François) and tombs for the Birague family in Paris, Ste-Catherine du Val-des-Ecoliers (fragments, Paris, Louvre). These last works are increasingly dramatic. The same expressivity is evident in the related bronze relief of the *Deposition*, showing traces of the influence of *Michelangelo and his school. Most of Pilon's successors, however, eschewed his last, emotional manner, in favour of the more elegant style of his early works. The chief of these followers is **Barthélemy Prieur** (active 1573–1611) but statues deriving from Pilon's were executed in France well into the 17th century.

Pineau, Nicolas (1684–1754) Brilliant French designer and carver of *Rococo decoration, son of the carver Jean-Baptiste Pineau (recorded from 1680–94). From 1716 until 1727 he was employed at the imperial court of Russia, where his chief surviving work is the Cabinet of Peter the Great in the Grand Palais at Peterhof, and where he also practised as an architect. On his return to Paris, he executed the decorations for several town houses, evolving an elegantly delicate, freely asymmetrical style, the 'genre *pittoresque*' or 'picturesque style', which, diffused through engravings, became extremely influential. Although the houses in which Pineau worked in Paris have been destroyed, some wall decorations from the Hôtel de Villars, 1732–33, have been transported to Waddesdon Manor, Buckinghamshire.

Pino, Paolo *See under* Dolce, Lodovico.

Pintoricchio; Bernardino di Betto, called (c.1454–1513) Painter and miniaturist from Perugia. His nickname,

'rich painter', derives from the lavish use of gold leaf and expensive pigments with which he delighted his wealthy clients, and for which he was to be criticized by *Vasari. An abundance of small-scale detail and ornament detracts from monumentality in most of his large-scale *frescos. From c.1473 until 1481 when he was inscribed in the painters' guild in Perugia, he was an assistant to *Perugino, whom he may have followed to Rome to work in the Sistine Chapel. Perugino's poetic style still prevails in Pintoricchio's first major work, the frescos of the Bufalini chapel, Rome, S. Maria Aracoeli, c.1486. Other works in Rome from the 1480s are mainly lost (e.g. Palazzo Colonna), with the exception of frescos in S. Maria del Popolo, where between 1485–9 Pintoricchio and his assistants decorated at least four chapels (della Rovere chapel still extant). He was to return to this church in 1508–9 to execute the spectacular ceiling decoration of the extended apse. His best-known works in Rome, however, are the luxurious decorations of the Borgia apartments in the Vatican, executed 1492–4 for Pope Alexander VI Borgia. Progress on these was interrupted in 1492 while Pintoricchio painted in the cathedral at Orvieto, and they were completed by assistants. By 1495 the artist was back in Perugia (Galleria). There followed a series of private devotional Virgin and Child pictures (now, e.g. Washington, National; Warsaw, Museum; S. Mariano, CA, Huntington; Cambridge, MA, Fogg). In 1500–1 Pintoricchio was working in Spello, S. Maria Maggiore, Baglioni chapel where he left a self-portrait in the guise of a fictive panel painting, modelled on that of Perugino painted in 1500 in the Cambio in Perugia. The first contract for his second-most famous work, the decoration of the Piccolomini Library, Siena cathedral, dates from 1502, but the frescos were not executed until 1505–7. *Raphael may have contributed designs for several of the episodes from the life of Pius II Piccolomini. Meanwhile, 1504–6, Pintoricchio painted frescos in the chapel of St John the Baptist in the cathedral. On his return from S. Maria del Popolo in Rome in 1509 (see above) he contributed to the scenes from the Odyssey of a room in the Petrucci palace

(or Palazzo del Magnifico), Siena (now London, National; see also Signorelli).

pinxit, pinx See under fecit.

Piombo, Sebastiano del See Sebastiano Veneziano.

Piper, John (1903–92) British painter who contributed to the 1930s British *abstract painting movement with compositions of tilting planes, arranged like flats in a stage set. In 1942 he published British Romantic Artists, showing the survival of William *Blake's and *Palmer's *Romanticism in a sequence of British artists, including himself. Always interested in old buildings, during the war he became the chronicler of their destruction by bombing, attracting the nation's interest and affection. His work has continued to be romantic in every sense, sometimes more topographical, at times extravagantly theatrical. He has worked in many media for different occasions, including stained glass, stage design, tapestries and book illustrations, as well as painting in oils and watercolours.

Pippi, Giulio See Giulio Romano.

Piranesi, Giovanni Battista (1720–78) Venetian architect, etcher (see under intaglio), designer, archeologist, restorer and dealer in antiquities, champion of Roman versus Greek art and architecture, Piranesi had an electrifying effect on contemporary taste, architecture and the decorative arts, nowhere more than in Britain. He is the greatest single influence on the architect Robert Adam. His visionary, melodramatic etchings of Prisons, growing out of his early training in scenography, captured the imagination of a younger generation; their impact belongs to the history of *Romantic art (see also Sublime). Born on the Venetian terra firma to a family of master builders and hydraulic engineers, Piranesi was trained in architecture and stage design. He first went to Rome as a draftsman in the retinue of the Venetian ambassador. Unable to find work as an architect, and influenced by the Venetian tradition of *vedute and *capricci as much

as by the lucrative Roman practice of *Panini, he entered the studio of a Sicilian engraver of Roman scenes, Giuseppe Vasi, from whom he learned the rudiments of etching. From 1741 he was producing small etched *vedute* of Rome which were incorporated in guidebooks and published in a collection, *Varie Vedute di Roma Antica e Moderna* in 1743. The larger-scale *Vedute di Roma* in 135 plates were produced from the late 1740s until his death, and posthumously by the family firm headed by his son Francesco. In 1743 he published 12 plates of architectural fantasies, ideal structures and imaginary scenes of ruins, intended to reprove the mediocrity of contemporary architecture. This *Prima Parte di Architetture e Prospettive* (the projected 'second part' was never published, but the 1750 *Opere Varie di Architettura, prospettiva, groteschi, Antichità* . . . may be said to have taken its place) revealed the creative potential of antique ruins for contemporary design; Piranesi was to explore this theme throughout his career. Forced to return to Venice through lack of funds in 1744, Piranesi now encountered the works of his greatest contemporary compatriot in the visual arts: G. B. *Tiepolo. The contact transformed Piranesi's etching style from a dry and tight manner to the fluent, boldly dramatic *chiaroscuro style we now associate with his name. The four plates of *Grotteschi*, and the 14 plates of the first version of his celebrated *Imaginary Prisons* (*Invenzioni capric di Carceri*; published after his return to Rome *c.*1745, refashioned then reissued early in the 1760s) express both the change of style and the final fusion of Venetian and Roman preoccupations. In 1756, his growing concern with archaeology culminated in the four volumes of *Antichità Romana*; while his publications of the 1760s, beginning with *della Magnificenza ed Architettura de'Romani*, reflect his involvement in the Graeco-Roman controversy. Despite his passionate championship of the Romans, however, his last work, completed after his death by his son Francesco, was a series of 20 plates of the Doric temples at Paestum.

Piranesi's contacts with practising architects, French and, above all, British, proliferated from the mid-1750s. Not until the

1760s, however, did he receive his first substantial architectural commissions, as well as commissions for decorative schemes and furniture, from the Venetian-born Pope Clement XIII Rezzonico and members of his family. The decorative schemes are recorded in the *Diverse Maniere d'Adornare i Cammini*, a compilation of chimney pieces, furniture and interior designs published in 1769. With the pope's death in the same year, the influence of the Rezzonico family inevitably waned, but their place was taken up by Piranesi's now numerous British patrons. His activity as a dealer and restorer, much of it with British *cognoscenti* and antiquaries such as Gavin *Hamilton, is recorded in the *Vasi, Candelabri, Cippi, Sarcofagi*, issued as single plates from *c.*1768, collected in two volumes in 1778. Despite considerable studio assistance, these plates achieved widespread popularity and influenced architectural and interior ornament throughout Europe, most especially in England.

Pires, Diogo the Younger *See under* Manueline style.

Pisanello; Antonio Pisano, called (*c.*1395–1455) Celebrated Italian painter, draftsman and medallist in bronze and silver; with *Gentile da Fabriano, whom he succeeded in *fresco cycles in Venice and Rome (*see below*) the foremost International *Gothic artist. Born in Verona of a Pisan father, he spent most of his career as a peripatetic artist working at princely courts, notably for the Visconti in Pavia and Milan, the Gonzaga in Mantua, the Este in Ferrara, the Malatesta in Rimini, Alfonso of Aragon in Naples – as well as in the Doge's Palace in Venice and in the papal church of St John Lateran in Rome. Most of his frescos are lost and he is now best represented through his medals (various museums) and some panel paintings (e.g. London, National; Washington, National) and by numerous drawings, including studies of animals (e.g. Paris, Louvre), of costume (e.g. Chantilly, Musée; Oxford, Ashmolean), and a famous depiction of hanging men (London, British), used in the background of a

fresco in Verona (S. Anastasia, *see below*). Pisanello excels both in the lifelike description of detail and in creating overall patterns of great ornamental beauty; contemporaries praised his poetic gifts as much as his *naturalism. He struck portrait medals of all the major personages of his day; the *verso* often depicts an *impresa* (*see under* emblem books) combining image and motto. His painted portraits (e.g. Paris, Louvre; Bergamo, Accademia) mainly follow the profile format of the medals.

Trained probably under a local artist, Stefano da Verona, Pisanello was summoned to Venice *c.*1415 to complete the fresco decoration of the Great Council Chamber begun by Gentile da Fabriano (*c.*1415–22, destroyed by fire 1574). Around 1424 he was in Pavia decorating the Visconti Castle; his frescos of animals, hunting scenes and jousts – themes current in his extant drawings – were destroyed by French artillery in 1527. Also from 1424–6 is his fresco of the *Annunciation*, part of the Brenzoni monument in Verona, S. Fermo Maggiore (sculptural portion by *Nanni di Bartolo). In the same years he is also recorded at the *Gonzaga court in Mantua, although his major pictorial project in the ducal palace is thought to date from 1439–40 and 1443–4, or, according to others, 1446–7. This was a never completed fresco decoration rediscovered only in 1969. Sinopie (*see under* fresco) and unfinished fresco depict a battle and other episodes from Arthurian romance. Daring *foreshortenings and vivid action scenes punctuate the overall pattern of the long wall – one of the most remarkable fresco remnants of the century.

During 1428–32 Pisanello was in Rome completing Gentile da Fabriano's fresco cycle at St John Lateran (destroyed); he inherited all Gentile's professional effects. Between 1429–30, however, Pisanello was in Verona, painting the fresco of *St George and the Princess* in the Pellegrini chapel of S. Anastasia – a much-reproduced image which combines courtly elegance, in the figures of the protagonists, with gruesome realism in the hanging men in the background and fairy-tale-like invention in the architecture.

In addition to the works mentioned above there are two well-known small panels by the artist: the *Vision of St Eustace*, and the (over-restored in the 19th century) *Apparition of the Madonna to Sts Anthony Abbot and George* (both London, National).

Pisano, Andrea; Andrea di Ugolino Nini da Pontedera, called (recorded 1330–48?) The most important sculptor active in Tuscany in the second quarter of the 14th century, associated almost exclusively with the first bronze doors of Florence baptistry (1330–6) and some of the reliefs and statues for the cathedral belltower (Florence, Opera del Duomo). A notary's son, he was probably trained as a goldsmith in Pisa. The principal sources for the bronze doors are the 12th-century doors by Bonanno in Pisa Cathedral, French *Gothic metalwork, and *Giotto's frescos in the Peruzzi Chapel, S. Croce, Florence. The two artists must have worked closely together on the bell-tower, and the exact attribution of the relief designs is in some doubt.

His son **Nino Pisano** (documented 1349–68) was the first sculptor to utilize the pictorial motif of the Virgin suckling her Child (Pisa, Museo). He worked in Tuscany, Umbria and Venice (SS. Giovanni e Paolo, Cornaro Monument).

Pisano, Nicola (mentioned from 1258–*c.*84) and his son **Giovanni** (mentioned 1265–after 1314) Along with his one-time assistant, *Arnolfo di Cambio, Nicola and his son Giovanni were the dominant sculptors of late 13th-century Italy. Drawing both on *Classical and *Gothic models, they began the slow process of freeing sculpture from its subservience to architecture, a process accomplished only in the *Renaissance (*see* e.g. Donatello; Verrocchio; Michelangelo). Investing sculpture with greater *naturalism and *expressivity, and expanding its *iconography, the Pisani were instrumental also in the pictorial revolution of the early 14th century (*see* Giotto; Duccio).

Nicola had migrated to Pisa from Apulia in Southern Italy by 1250. His documented works include the pulpit of Pisa baptistry (1260), the pulpit in Siena Cathedral

(1265–8) on which the young Giovanni was also employed, and the great fountain (*Fontana Maggiore*) in Perugia (1278). He and his workshop were also responsible for the tomb of St Dominic (1264–7, Bologna, S. Domenico). His adaptation of a nude Hercules-type for the figure of Fortitude on the Pisa pulpit is probably the most celebrated example of pre-Renaissance classicism.

Giovanni, born in Pisa, is first recorded in 1265 in Nicola's contract for the Siena pulpit. By 1285 he had been granted Sienese citizenship and was working on the design for the façade of Siena Cathedral; this design subordinates architecture to sculpture. Giovanni's figures, distorted for optical and expressive ends, foreshadow Donatello's *Prophets* for the bell tower of Florence Cathedral. In 1301 Giovanni completed the pulpit in S. Andrea, Pistoia, a masterpiece of dramatic narrative realism, and in 1302–10 he was engaged on the pulpit for Pisa Cathedral, the largest and most sumptuous of the four Pisano pulpits. His last work, undocumented but securely attributed on stylistic grounds, is the *Virgin of the Holy Girdle* in the reliquary-shrine of the Cathedral at Prato.

Pissarro, Camille (1830–1903) French painter, one of the creators of *Impressionism. Born in the Virgin Islands and son of a Jewish business man from Bordeaux, he was sent to school in the suburbs of Paris but returned to his family in 1847 to join the business while also developing his interest in art. In 1855 he finally decided for art and returned to Paris where he was impressed by the work of *Corot in the World Exposition and of *Courbet. He sought instruction from several established painters but, in moving from one to another, gives the impression of having taught himself while remaining open to formative influences. From 1859 on he worked intermittently in the Académie Suisse where he met *Monet and, in 1861, *Cézanne. A painting of his entered the 1859 *Salon, and others were shown in some of the Salons of the 1870s, but commercial success and financial sufficiency long eluded him. He had a small allowance from his mother but also an increasing

family thanks to a liaison – not legalized until 1871 – that produced seven children. His evident left-wing political views contributed to this lack of success and were confirmed by it. The Pissarros lived briefly at several addresses in Paris and the Ile de France; in 1892, when he did buy a house, at Eragny, it was with a loan from Monet which he repaid in 1896. Even during his relatively successful years, from the late 1880s on, his work had to be offered at very low prices.

From the start he was interested in a range of landscape painting, with and without figures, as well as the graphic media. His compositions tended to be thought out: even as an Impressionist he planned pictures in drawings and combined open-air painting with work in the studio. What characterizes most of his pictures is a balance of truth to nature's effects and to the solidity both of the land and of the houses, roads, railways etc. man builds on it, lending solidity also to the framed image. From luminous but firm landscapes indebted to Corot and *Daubigny, he turned to the technique of separate touches of paint he saw in Monet. Like him, he was in London during 1870–1, studying works by *Constable and *Turner and other British painters. Unlike Monet, he frequently angled his views to give prominence to industrial buildings, and his paintings of rural life emphasize agricultural labour, much in the spirit of *Millet, rather than offering idylls of peace and leisure. Eager to bring his painter friends and other like-minded artists together as a force outside the academic world, he was the prime mover in organizing the series of Impressionist exhibitions of 1874–86 and contributed to all of them.

The 1880s brought changes of vision and of method. Figures become more prominent, at times dominant, under the influence of *Degas. His brushstrokes become smaller, denser and more ordered; clarity of form and of colour appears to become a conscious aim. In the mid-1880s he associated with the *Neo-Impressionists whose method he saw as a logical growth out of Impressionism and only one step removed from where his own development had brought him. He wanted increased

objectivity, a scientific spirit in place of a *romantic one. He hoped this would also place the artist in harmony with society, especially with the world of working men and women. His paintings of the 1890s seem more detached from this world, though illustrative of it, as though they, for all their naturalism, gave us visions of peasants and townfolk rather than their accounts of present-day reality. 'Work is a wonderful regulator of mind and body', he said at this time, meaning its effect on himself but also implying a view of work as the harmoniser of mankind. It is a busily harmonious world of agriculture and urban activity he now represents, while arguing for anarchism with his friends and supporting radical journals.

In 1904 there was a memorial exhibition at the Galéries Durand-Ruel in Paris. The first museum exhibition was in Paris in 1930. Though he remains the least glamorous of starring Impressionists, painters have long admired the warm, constructive character of his work and of his nature. He gave advice and companionship to younger painters when they needed it, notably to Cézanne whose description of him – 'humble and colossal' – is often quoted, and to *Gauguin. His son Lucien *Pissarro worked with him on prints during the later years and was the recipient of wise and lively letters from his father.

Pissarro, Lucien (1863–1944) Franco-British painter, oldest son of Camille *Pissarro who taught him. He exhibited in the last *Impressionist exhibition in 1886, and settled in England in 1890, bringing with him the method of outdoor painting and the *Neo-Impressionist style. He associated with *Sickert's circle, in 1906 joined the *New English Art Club and in 1911 the *Camden Town Group. He painted throughout his life but perhaps his main achievement was his work as a wood-*engraver and the founding of the Eragny Press in 1894.

Pissarro, Orovida (1893–1968) British painter, daughter of Lucien *Pissarro. There was a memorial exhibition of her work in Oxford, at the Ashmolean Museum, in 1969.

Pistoletto, Michelangelo (1933–) Italian artist who first worked with his father as restorer, then underwent several influences, notably that of *Bacon, and in 1962 began the mirror paintings with which he became known: figures painted or silk-screened on to paper and mounted on a polished steel sheet which reflects the environment in which it is placed, thus playing with different sorts of reality and with stillness against movement. He subsequently became an artist of the *Arte Povera tendency, making installations of many kinds, and since 1980 has been making large figure sculptures out of polyurethane or marble.

Pitocchetto *See* Ceruti, Giacomo.

Pittoni, Giovanni Battista (1687–1767) Eclectic Venetian *Rococo painter; in 1758 he succeeded *Tiepolo as head of the Venetian *Academy. His light and vibrant colour has been variously described as 'sophisticated' and 'sugary'; although he was much in demand by contemporaries, notably from Germany, where he dispatched many altarpieces, his work on a large scale is inclined to sentimentality. There are paintings by him in Venice, Accademia, various churches; Edinburgh, National; London, National; Cambridge, Sidney Sussex College, Fitzwilliam; various museums in Germany; etc.

Pittura Metafisica Metaphysical Painting, a short-lived but significant Italian movement, sprang from the chance meeting in 1917 of *Carrà, de *Chirico and the latter's brother, the poet (and occasional painter) Alberto Savinio, in a military hospital in Ferrara. The two painters already knew of each other and formed an immediate alliance, being able to paint in the hospital, and were encouraged by Savinio's poetry. Carrà had been among the leading painters of *Futurism. De Chirico had been working in Paris, admired by *Apollinaire and *avant-garde artists as a painter of mysterious urban scenes and still lifes. Metaphysical Painting sprang from their urge to explore the imagined inner life of familiar objects when represented out of their explanatory contexts: their solidity,

their separateness in the space allotted to them, the secret dialogue that may take place between them. This alertness to the simplicity of ordinary things 'which points to a higher, more hidden state of being' (Carrà) was linked to an awareness of such values in the great figures of early Italian painting, notably *Giotto and *Uccello about whom Carrà had written in 1915. Their art, normally seen as purposeful *naturalistic representation of figures, objects and actions in a controlled scenic space, could also seem mysteriously still and removed from the ordinary world; in the midst of war it offered a poetic language both in-turned and strong and a corrective to the disruptive, fragmenting tendencies within *Modernism. This desire to reattach his art to the great Italian past was stronger in Carrà, whose paintings of the time are also more economical and focused than de Chirico's; the latter continued to explore the enigmatic nature of the daily world in a more wide-ranging manner. The two artists were together for only a few months in the spring and summer of 1917. Other painters were affected by their example and ideas, most notably *Morandi. The movement, as such, may be said to have dissolved by 1920 but its reverberations were felt for a long time, contributing both to the more poetic aspects of *Surrealism and to the revival of classicism in the painting of *Sironi and others in the 1920s.

Pizzolo, Niccolò (1421–53) Italian sculptor and painter from Padua, a pupil and assistant of *Squarcione and of *Donatello during the latter's stay in the city. He was commissioned with *Mantegna to work on the Ovetari Chapel of the Eremitani church in Padua, but completed only the bronze-coloured terracotta altarpiece before being killed in a fight; the paintings of the apse and part of the left wall for which he was contracted were executed by Mantegna.

Place, Francis (1647–1728) English amateur draftsman and printmaker, best known for his architectural and topographical drawings, of which the best,

consisting of views in and around York, are in that city's Art Gallery.

plaquette Small metal reliefs, usally cast in *bronze or lead by the *cire perdue process, and applied as decoration to a variety of objects. Like prints, they could be made in multiple copies, and like prints they were portable and influential on other artists (*see also* Flötner).

Plateresque *See under Mudéjar.*

Playing Cards, Master of the (active late 1430s) The earliest-known German engraver (*see under* intaglio), named after a set of prints made for gaming cards, depicting human figure, animals, flowers, etc. (now mainly divided between Dresden, Kupferstichkabinett, and Paris, Bibliothèque Nationale). These appear to have been executed with a dry-point stylus rather than a burin, and were almost certainly printed by hand-rubbing and not with a press. Influenced by contemporary drawing practice, he introduced parallel-line hatching. Many copies were made of his prints; in the 1450s a number of the plates were cut apart and the figures reprinted individually, suggesting that they came to be used as models by *illuminators and other artisans, as an adjunct to workshop model-books.

pleurant French, 'he/she who weeps'. A term used to describe the anonymous mourners often found on early funerary monuments in Burgundy and France, such as the famous hooded monk of Claus *Sluter's tomb of Philip the Bold. Standing, walking or seated, *pleurants* are distinguished on such monuments from *gisants*, supine statues of the dead.

Pleydenwurff, Hans (documented 1457–d.1472) German painter; he came from the Bamberg region and in 1457 received permission to live in the inner city of Nuremberg, whose chief artist he became. His *realism and dramatic *expressivity, influenced by Rogier van der *Weyden and Dirck *Bouts, whose work he might have seen during a trip to the Netherlands in the early 1450s, are clearly

seen in the divided diptych of *The Man of Sorrows adored by Count Georg von Löwenstein* (*c*.1455–60; Basel, Kunstmuseum; Nuremberg, Germanisches National), the *Breslau Altarpiece* (1462; Nuremberg, Germanisches National) and the *Crucifixion* (*c*.1472, Munich, Alte Pinakothek). His son **Wilhelm** (d.1494) was a painter and engraver (*see under* intaglio). *Wolgemut joined Pleydenwurff's workshop by 1465; he married Pleydenwurff's widow and succeeded him as the leading artist in Nuremberg.

plein air French for 'open air', term used to say that certain paintings were done, or styles are associated with, execution out of doors in front of the motif. Sketches of various sorts had long been, perhaps always have been, made out-of-doors, but around 1800 a number of painters made small *plein air* oil paintings, thinking of them, and sometimes exhibiting them, as 'sketches'. In *Romanticism the call for authenticity accorded special value to sketches of every sort, and some painters chose to do much of their work out of doors, British painters such as *Bonington and *Constable (whose major works were done in the studio on the basis of sketches), French painters of the *Barbizon School, and then the *Impressionists and their international followers, though *Degas thought the method reprehensible. 19th-century design of light paint boxes and, from about the middle of the century, paint being available ready-mixed in tubes, made open-air painting much more manageable than before.

Pliny the Elder (AD 23–79) Roman soldier, administrator and author. He was killed observing, from a ship moored offshore, the eruption of Vesuvius that destroyed Pompeii and Herculaneum. His main importance to artists and art historians stems from the volumes dedicated to the visual arts in his massive encyclopedia, *Natural History*. These pages are the only surviving account of the history of ancient art to have come down to us from antiquity. Pliny's method is to chart the 'progress' of art from primitive beginnings to mimetic mastery (the ability to represent all

phenomena observable in reality) through the contributions of individual artists. Not only were his notion and criteria of perfectability adopted in the *Early Renaissance (explicitly by *Ghiberti in his *Commentari*, to be followed by *Alberti) but his terms and categories influenced the very evolution of the *genres in European painting, creating a demand among patrons for categories of art known in antiquity, and encouraging artists to specialize in such categories. The process of identifying living artists with figures from the pages of Pliny began in the 15th century; the translation of Pliny into most modern European languages is thought to have spurred the rise of *still life and *genre painting. When the *Laocoön* was discovered in Rome in 1506, Giuliano da *Sangallo instantly identified it as a sculptural group praised by Pliny (it is, however, a copy of the lost original). *See also* Philostratus.

Poccetti, Bernardino (1548–1612) Florentine painter. After a probable period of study in Rome, he graduated *c*.1580 from being a decorative painter of *grotesques and façades to become one of the leading narrative *fresco artists in Florence, adapting his *Mannerist draftsmanship to the demands of *naturalist Counter-Reformatory church decoration. By the 1590s he had evolved a 'reformist', largely retrospective style echoing the idiom of both High and Early *Renaissance masters such as *Raphael, *Andrea del Sarto, *Ghirlandaio (1580s, Rome, main cloister of S. Maria Novella; cloister of S. Pier Maggiore; 1590s, Val d'Ema, Charterhouse; 1599, Florence, S. Maria Maddalena dei Pazzi; 1602, S. Marco, Cloister of S. Antonio; 1610, Hospital of the Holy Innocents). His secular decoration, however, remained more wedded to the elegant complexities of *Mannerism (*c*.1585, Florence, Palazzo Capponi; 1603, Palazzo Usimbardi).

Pock, or **Pockh** or **Bock, Tobias** (1608–83) German painter from Constance, mainly active in Vienna where he executed numerable altarpieces for the city's churches (e.g. Schottenkirche). He and his brother, the sculptor **Johann Jacob**

Pock, worked together on the high altar of Vienna cathedral (finished by 1647).

Poelenburgh, Cornelis van (*c.*1586–1667) A leading member of the first generation of Italianate Dutch painters. Born in Utrecht, he studied there with *Bloemaert before leaving for Italy where he remained *c.*1617–*c.*25. There, his painting style was formed after the works of *Elsheimer, and to a lesser extent Paul *Bril. After his return to Utrecht, his Arcadian landscapes, often with ruins and nude figures, sometimes with mythological scenes, proved very popular, especially in aristocratic circles. He also sometimes painted figures in landscapes by other artists. During 1637–*c.*9 he was in London at the invitation of Charles I. There are works by him in Utrecht, Centraal; Copenhagen, Museum; Florence, Uffizi; London, National; Toledo, Ohio, Museum; etc.

pointillism English version of *pointillisme*, the technique of applying paint in points or little spots, used by the Neo-Impressionists, often over a ground of the colour of the thing being represented, to give controlled brightness and exactitude to the inclusive visual colour experience, calculated by so many spots of this primary colour and so many spots of that. Calculation was so much part of the process that such paintings could be made in the studio and under artificial light once the colour analysis had been prepared. The effect of control now strikes one as more noticeable than that of visual exactness: *Seurat's larger canvases tend to an all-over greyness that differentiates them from the *Impressionists' more spontaneous and much brighter works. *Sisley and other Seurat followers tended to exaggerate their colour effects in consequence and enlarged their points to short strokes. Applying paint in dots occurs occasionally in *Titian and other early painters in oils, and is quite marked in *Constable – touches of white to render wet foliage etc. – and also in later *British painting in oils and watercolours, e.g. the work of William Henry *Hunt. It was the Neo-Impressionists' insistence on it that gave it prominence towards the end of the 19th century. They referred, however, to *Divisionism, meaning the analytical process rather than the application of paint. Pointillism itself suggested ways of rendering painted objects insubstantial, and in this way it was used by *Cubists and *Futurists.

pointing machine A mechanical device for transferring precisely the design of a three-dimensional model, whether clay, wax or plaster cast, to a stone block. The method consists of establishing parallel points on the model and the block, which is then drilled to the desired depth. It was first developed by the Greeks, much used by the Romans, and assumed great importance again in the 18th and 19th centuries. By raising *modelling* above *carving*, which it reduces to a merely mechanical skill, pointing interposes studio assistance between the creative process and the finished product. A revulsion against the practice led to a revival of direct carving from the end of the 19th century. (*See also* John Bacon.)

Poliakoff, Serge (1906–69) Russian-born French painter. He arrived in Paris when he was 17. He studied painting under *Friesz, and also in London (Chelsea and Slade Schools of Art). He began making *abstract paintings in the late 1930s, and became known in the 1950s and 60s for dense paintings in which colourful shapes are tightly jig-sawed together.

Polidoro da Caravaggio; Polidoro Caldara, called (*c.*1500–43) Important painter, whose most influential works, Roman monochrome façade decorations *all'antica*, are now known to us mainly through drawings and prints. They provided a readily visible source of antique motifs and compositions on which such major artists as Taddeo *Zuccaro, *Rubens and *Poussin were to draw. Although not conspicuously mannered, these works are an important example of, and influence on, *Mannerism.

Polidoro, born in Caravaggio in Lombardy (like the better-known Michelangelo Merisi, called *Caravaggio) came to Rome untrained in art. He worked from *c.*1518 as a plasterer at the Vatican

549 POLLAIUOLO, ANTONIO DEL

Logge. Encouraged by the artists in *Raphael's workshop, he began to paint (dados, sala di Costantino; ceiling *fresco, Villa Lante, now Palazzo Zuccaro), soon forming a partnership with Maturino, a Florentine adept at drawing after the antique and a family friend of *Peruzzi. Inspired by Peruzzi's façade paintings, Polidoro and Maturino decorated the exteriors of a dozen palaces, between 1524 and the Sack of Rome in 1527, with friezes of Roman histories and architectural and decorative motifs in *grisaille.

Polidoro's side paintings in the Fetti chapel, S. Silvestro al Quirinale, c.1525, are an equally remarkable, if less immediately influential, adaptation of Roman models. Scenes from the Lives of Mary Magdalen and St Catherine of Siena are depicted in two nearly pure landscapes, in which the narrative figures are reduced to the scale of *staffage. Imitating the 'impressionism' of one type of ancient Roman wall painting, these works are also a highly personal response to nature. They anticipate, and may have influenced, the landscapes of Annibale *Carracci and his pupils (see especially Domenichino).

Polidoro left Rome after the Sack; after a brief stay in Naples, he settled in Messina in Sicily, where he seems to have undergone an intense religious conversion. His great altarpiece painted there, the Road to Calvary (before 1534, now Naples, Capodimonte), borrows simultaneously from the Flemish and German modes prevailing in Sicily, and from a composition by Raphael – itself inspired by *Dürer, and destined for a Sicilian church, but which Polidoro would have known in Rome. Despite these dual origins, it is a deeply personal and evocative work, as are the dark, thinly painted devotional panels executed for private collectors in Messina and only recently rediscovered (mainly Naples, Capodimonte).

A prolific draftsman, Polidoro left many drawings, some of them autonomous works and not in preparation for paintings. A number recall *Michelangelo's lunettes in the Sistine Chapel; others are fantasies of landscapes or ruins.

Polidoro died, murdered by a thief, in Messina.

Pollaiuolo, Antonio del (c.1431/2–98) and his brother Piero (c.1441–96) Florentine artists, Antonio primarily a goldsmith, sculptor in bronze and designer, Piero primarily a painter. Their surname derives from their father's occupation: pollaiuolo, Italian for 'poulterer'. Although they also ran separate workshops, the brothers operated as a team on most major commissions, in which Antonio was the senior partner and the more able artist. His innovativeness, technical expertise and love of experiment are exemplified in his most influential work, the large engraving (see under intaglio) called The Battle of the Ten Nudes (early 1470s), a pattern or model-sheet of anatomical studies of male bodies in vigorous action, which remained a prime artistic source, not only in Italy but throughout Europe, for centuries. Piero's more conventional talent is demonstrated in his independent altarpiece of The Coronation of the Virgin (1483, San Gimignano, Collegiata). His Six Virtues of 1469–70 for the Mercanzia – the Florentine merchants' court – now in Florence, Uffizi, have been heavily damaged and restored. The brothers' first joint commission, which is still extant, was their contribution of a wall painting and an altarpiece on panel to the Chapel of the Cardinal of Portugal in Florence, S. Miniato al Monte (1466–7; altarpiece now Uffizi; see also Rossellino; Baldovinetti; Luca della Robbia). But the partnership's espousal of *iconographic and formal novelty, coupled with traditional craftsmanship, can best be observed in their most famous collaborative works: the altarpiece of The Martyrdom of St Sebastian (1475, London, National) and the free-standing bronze tomb of Pope Sixtus IV (c.1484–93, Rome, St Peter's).

Other important works by the Pollaiuolo firm are the small bronze statuettes on mythological themes (Florence, Bargello; Berlin, Staatliche; New York, Frick), although they are unclassical in their anatomical emphasis; and the bronze wall Tomb of Pope Innocent VIII (1492–8, Rome, St Peter's). Antonio Pollaiuolo also contributed to the silver altar for Florence baptistry and designed 27 embroideries with scenes from the life of St John the Baptist for the baptistry vestments (now

Florence, Opera del Duomo). His drawings became quickly popular and are now difficult to distinguish from workshop copies, imitations by contemporaries and later copies (but *see* the designs for an equestrian monument to Francesco Sforza, Munich, Graphische Sammlung, and New York, Metropolitan).

Pollock, Jackson (1912–56) American painter, the most famous of the *Abstract Expressionists and associated with the term *Action painting because of the physical performance demanded by his mature work. Born at Cody, Wyoming, and having grown up in California, Pollock studied under *Benton at the Arts Students League in New York, adopting some of Benton's macho lifestyle, but also worked with *Siqueiros and was affected by his and other Mexican muralists' powerful rhetoric. Growing awareness of *Surrealism in America, together with the Jungian therapy he embarked on in 1937 because of his alcoholism, encouraged Pollock to find symbolic themes in ancient myths. He was also attracted to the ephemeral ritualistic sand paintings made by American Indians in Arizona. He worked for the *Federal Art Project during 1935–42, and in 1943 had his first solo show, at Peggy Guggenheim's Art of this Century gallery in New York, at the recommendation of various critics and artists, including *Duchamp and *Mondrian. At this point his paintings combined vigorous, sometimes apparently frantic application of brushstrokes with abstracted figures and other creatures as well as geometrical forms and symbols; *Picasso was evidently a pervasive influence. Robert *Motherwell was interesting him in *automatism, but Pollock proved reluctant to be part of any Surrealist group. Guggenheim commissioned him to paint a long mural for her apartment, and he did this, in one long night it is said, in January 1944. It consists of a sequence of rhythmic, gestural marks, abstract though with some hint of figuration, making verticular clusters on the horizontal expanse. The Museum of Modern Art in New York in 1944 bought one of the paintings seen in his 1943 show, and from this time on Pollock exhibited frequently and was seen as a rising

but controversial American artist. His second solo show at Art of this Century, in March 1945, caused *Greenberg to hail him as 'the strongest painter of his generation'. Pollock was now living with the painter Lee Krasner, whom he married in October 1945. Their financial situation was still very constrained, partly owing to Pollock's drinking and his habit of working in bouts interrupted by periods of self-doubt and inactivity. In November 1945 they moved out of New York to East Hampton, hoping to make their situation easier. Pollock worked there in a small, unlit barn, and began to paint on the floor, working on the canvas from all sides and extending his means by dribbling and splashing liquid paints from a brush or stick, or direct from a can. In the winter of 1947–8 he was quoted describing this way of working and adding 'When I am *in* my painting I'm not aware of what I am doing.' Such quotations, and then also photographs of him at work (notably those taken by Hans Namuth published in 1951), promote his image as a new kind of artist, working instinctively and wearing jeans.

Some of Pollock's most admired paintings stem from the period 1948–50, during which he was able to give up drinking. From 1948 on he showed at Betty Parson's Gallery in New York, Art of this Century having closed. His first show there included his first dribbled paintings; with these, *De Kooning said, 'Jackson's broken the ice', and several painters and critics now recognized his force and pre-eminence among the New York painters. Also in 1948 a group of his new paintings was shown at the Venice Biennale and in Florence and Rome. In 1949 he took to giving his paintings titles in the form of numbers and dates, sometimes also naming colours, in place of the poetic titles he had used earlier. He said in 1950: 'Abstract painting is abstract'. (Today it is often said that some suggestion of a figurative idea can often be traced in his apparently abstract paintings.) That year another group of Pollocks was shown in Venice and Milan. As Pollock's painting became known internationally it was subjected to a great variety of critical responses, negative as well as positive. Attention was drawn to his avoidance of

traditional methods, and opinion was divided as to whether the results were merely crude and meaningless or whether they showed a marked advance in modern painting, a major step beyond anything achieved in Europe, able to express particular spiritual states as well as a unique American feeling for open spaces and a pioneering urge to investigate them. The Museum of Modern Art continued to purchase selected examples of his work, but Pollocks were not yet selling widely, and in 1952 he switched to the Sidney Janis Gallery. That November Greenberg organized a small retrospective Pollock show at Bennington College in Vermont. In 1953 four Pollocks were included in a show of contemporary American art which the Museum of Modern Art organized for Paris and other European cities. By this time, Pollock had again turned to alcohol and was producing very little, so that his 1955 show at Sidney Janis's had to be a mini-retrospective, with just one work from 1954 and one from 1955, his last painting. He had found it difficult to move on from his large, densely structured paintings of around 1950, being tempted to bring figurative imagery back and attempting to redramatize the results further by means of collage and other structural interventions. The fact that Lee Krasner was beginning to exhibit regularly and make a name for herself also appears to have caused him difficulties, marital as well as artistic. While Krasner was away in Europe, in the summer of 1956, Pollock embarked on a relationship with a young painter. On 11 August 1956, driving drunk with her and a friend of hers, Pollock crashed into a tree, killing himself and the other woman.

In spite of renewed claims, recently, of painting's demise as a viable art form, Pollock continues to be seen as a key figure in modern art and his way of painting either as a leap forward, opening up new possibilities, or as the climax and end of western pictorial art. Many a young painter has attempted to work like him, though none has thrived by merely imitating him. The concept of the painting as a record of a series of actions has remained vital, also the less original concept, exploited more radically by Pollock than anyone

before him, of art arising spontaneously out of instinctive working with materials, including the physique of the artist. He also demonstrated, more tellingly than other painters, the rewarding ambiguity of painting as a static and flat material object and the suggestions of both time and space that arise from successive marks. Using a variety of materials, enamel paints and metallic paints, and sometimes adding sand, bits of glass and other matter, Pollock also explored different qualities of mark and texture. As critics and other viewers overcame the disorientation occasioned by his jettisoning of traditional methods and forms, they recognized the elegance and richness, and occasionally the relative austerity, of Pollock's often very large, oceanic canvases. His ambiguous personality, veering between sensibility and articulacy and aggressiveness when drunk, gave him distinctive status among his fellow artists. His dramatic death, widely discussed and seen by many as suicide, added to his visibility. In 1949 *Life* magazine had asked 'Is He the Greatest Living Painter in the United States?', suggesting he was that in the eyes of a growing number of critics and collectors. Ten years later, thanks in part to further circulating shows sent by the Museum of Modern Art into Europe, of modern American art and then, in 1959, of 'The New American Painting', in which he was shown alongside a handful of contemporaries, almost all of them of the New York School, Pollock was being seen as challenging Picasso as the greatest artist in the world. If painting's viability was sustained by the example of both these men, Pollock's had proposed the death of easel painting. If painting's claim to a leading role among art forms related to the exceptional degree of authenticity it could offer, his example remains the most convincing. Commanding ever higher prices, his work is sought by collectors around the world while he himself is seen as a cardinal figure in the art of the 20th century. Already in 1955 the art historian and critic Leo Steinberg had written that 'Questions as to the validity of Pollock's work . . . are simply blasted out of relevance by these manifestations of Herculean effort, this evidence of mortal struggle between the man and his

art.' To this should be added the fact that with success, art became not only the Angel with which this Jacob had to wrestle but also the engagement that gave him purpose. It was presumably his sense of success slipping from him that led to his early death.

polychrome, polychromy From the Greek *polychromos*, many-coloured. Usually employed in art history with reference to sculpture painted in many colours to imitate natural appearances. Ancient polychromy on marble was translucent, whilst that on terracotta was opaque. The process was particularly common on the wood sculpture of pre-Reformation Germany and of Spain (*see also encarnado*). Colours were applied over a gesso ground and, in places, over a ground of gold leaf for greater luminosity. The pigments could then be scratched out to create designs, as, for example, of gold brocade.

polyptych A painting or relief made up of separate pictorial fields, usually an altarpiece. The polyptych altarpiece evolved from the single-panelled *antependium* and *dossal* in the late 13th century. The fully developed polyptych (mid-14th to 15th century) consists of many separate panels of different sizes and shapes, some containing single figures, others narrative scenes, unified by an architectural and decorative system of framing. Some polyptych frames are hinged, allowing for different pictorial effects at different times. A diptych consists of two panels, a triptych of three; many such simple polyptychs were produced on a small scale for private devotions. (*See also* Bernardo Daddi; retable.)

Pomarancio The nickname of two Italian Late *Mannerist painters working in Rome. The first was **Nicolò Circignani** (1516–96), favoured painter of the Jesuits, remembered in particular for the horrific scenes of martyrdom he painted in Santo Stefano Rotondo, the church of the German novices of the Order (other works in the Gesú; S. Gregorio Magno). The second was Nicolò's pupil **Cristoforo Roncalli** (1552–1626), a protégé of Vincenzo *Giustiniani and his counsellor

in artistic matters. He was a favourite of the Oratorians, for whom he painted the portrait of St Philip Neri and an altarpiece of St Domitilla; he is also the author of one of the great altarpieces of St Peter's commissioned by Clement VIII *Aldobrandini.

Pont Aven, School of Group of artists who worked at this small town on the south coast of Brittany during the years 1886 and *c*.1891, and were led by the example of *Bernard and *Gauguin to go beyond *Impressionism in search of a more significant and resonant art. In paintings and prints, and studying objects at first hand but then working from memory and instinct, they pictured local folk events and subjects in a style eschewing *naturalism in favour of an *abstracted idiom favouring pattern, outlined forms, un-naturalistic or exaggerated colours and unsophisticated compositions of a traditional, folkloristic sort. Into this they fed ideas from medieval stained glass, Japanese prints and early Italian painting, as well as ideas from the art of *Puvis de Chavannes. Hence they called themselves '*Synthetists', and they showed together during the Paris World Exhibition of 1889, but not within it, at the café of Monsieur Volpini. There were more than a hundred exhibits, including albums of prints by Gauguin and Bernard that nobody wanted to buy in spite of their modest price. Also prominent among the Pont Aven artists were *Sérusier, *Séguin and *O'Conor.

Pontius, Paul *See under* Bolwert, Schelte à.

Pontormo; Jacopo Carucci, called (1494–1557) Perhaps the last great Florentine painter, chief exponent of Early Florentine *Mannerism (but *see also* Rosso). His nickname refers to the Tuscan village where he was born. Although solitary and eccentric, Pontormo is not adequately characterized as a 'neurotic' artist, and even less as an artistic rebel. On the contrary, his mature style, albeit profoundly original, is a logical summation of Florentine tradition, and assimilates into that tradition the latest researches of

*Michelangelo's Roman *frescos and the newly imported northern European prints, notably by *Lucas van Leyden and *Dürer. His only extant large-scale work of secular decoration, the *Vertumnus and Pomona* fresco in the salone of the *Medici villa at Poggio a Caiano, 1520–1, anticipates certain 18th-century developments in its daring but perfectly harmonized synthesis of *naturalism, *classicism and the pastoral.

We do not know precisely the facts of Pontormo's training. His earliest surviving work, the *Sacra Conversazione* of 1514 (Florence, SS. Annunziata, chapel of the Company of St Luke) demonstrates his dependence both on Fra *Bartolommeo and on *Andrea del Sarto, whose assistant he became briefly sometime *c.*1512. The *Visitation* (1515–16, SS. Annunziata forecourt) is more monumentally Sartesque. Only with the altarpiece in S. Michele Visdomini, 1518, is High *Renaissance equilibrium disrupted. Although this disruption of Renaissance canons seems to point forward to mid-16th century *Mannerism, its aims are different. The latter, as exemplified for example in the paintings of *Vasari, exploits superficially similar effects in order to enhance, not *expressivity but *idealization. Pontormo's communicative and expressive aims in the Visdomini altar link him, rather, with earlier Florentine artists, notably *Donatello. Different again, however, are the unnaturalistic devices of Pontormo's contributions to the Borgherini decoration of the *Story of Joseph* (*c.*1515, London, National; *see under* Andrea del Sarto). The non-classicism of these paintings is dictated primarily by ornamental and narrative requirements; they should be judged as a culmination of the *cassone, or furniture-painting, tradition rather than as independent easel paintings. The decorative lessons learned here on a small scale were applied, however, to later large-scale works: not only the fresco at Poggio a Caiano (see above) but also the *Passion* cycle for the Charterhouse of Galluzzo outside Florence (1523–4; five frescos in cloister, now detached). Albeit closely based in composition on prints of the *Passion* by Dürer, these now sadly damaged frescos ally extreme

pathos with the most refined elegance of form and colour. On the other hand, the oil painting of the *Supper at Emmaus*, once *illusionistically framed in an 'additional doorway' to the refectory in the guest wing at the Charterhouse (1525, now Florence, Uffizi) eschews formal beauty for naturalism and a darker tonality. The pilgrim-guests of the Charterhouse were thus invited to identify with the pilgrims of Emmaus, and found the living Christ breaking bread among them (the 'divine eye' above Christ's head is a later addition). This pictorial manner anticipates the naturalism of *Caravaggio and his followers.

In the decoration of the Capponi chapel in Florence, S. Felicità, 1525–8, which is partly lost and where he was assisted by his pupil *Bronzino, Pontormo turned once again to a brighter chromatic scale (*see* colour). Motivated perhaps by the natural darkness of the chapel, the colour testifies also to the influence of Michelangelo's lunettes in the Sistine Chapel as revealed in their recent cleaning. The particular accent of beauty in pathos, however, is specifically Pontormo's; his range of feeling is different from, and perhaps more complex than, Michelangelo's. It may be found again in such easel paintings as the *Visitation* (*c.*1528, Carmignano, Pieve).

In addition to altarpieces and devotional easel paintings (e.g. Paris, Louvre; St Petersburg, Hermitage; Florence, Uffizi, Pitti) Pontormo also executed portraits, unprecedented in their suggestion of inner feelings allied to outward elegance (Lucca, Pinacoteca; Philadelphia, Museum; Washington, National; Florence, Uffizi). These had their greatest influence on the more numerous, but shallower, portraits of Bronzino.

It has become axiomatic in art-historical literature that, with the fall of the Florentine Republic in 1530, Pontormo's emotionally communicative art ceased to please. He was certainly not personally suited to the climate of the princely Medici court, and Vasari has some harsh things to say of his late works. Nevertheless, historical judgement is probably skewed by the loss of his major commissions of these years. For the Medici continued steadily to employ him: in 1532 he made designs for

the completion of the salone decoration at Poggio a Caiano, left unexecuted with the death of Clement VII de'Medici in 1534; in 1535–6 he decorated the Medicean villa at Careggi, and between 1537–43 a loggia in their villa at Castello. Both of these works were destroyed later, although drawings for all the late projects exist, mainly in Florence, Uffizi. Around 1545–9 he furnished cartoons (*see under* fresco), alongside Bronzino and *Salviati, for Cosimo I de'Medici's new tapestry works (tapestries now Rome, Quirinale). In 1546 he began the decoration of the choir of the Medici parish church of S. Lorenzo, left uncompleted at his death. These enormous frescos, retelling stories from Genesis and a combined *Resurrection* and *Last Judgement*, influenced by but transforming Michelangelo's *Last Judgement*, were unhappily destroyed when the choir was rebuilt in 1742. Once again, only the poignant and eloquent drawings remain.

Poons, Larry (1937–) American painter who studied music in Boston before attenting the Museum of Fine Arts School there, and became known in the mid-1960s for his subtle paintings that were both *Minimalist and *Op art, combining a delicate grid with precisely painted little circles, later ovals, of another colour, rhythmically rather than regularly disposed. He explored this quasi-musical device for some years before venturing into much thicker paint surfaces, again in subtle colours, but now articulated by means of cracks and disturbed textures.

Pop Art Movement that emerged quite suddenly in British and American painting and graphics at the beginning of the 1960s and took for its source material the imagery of mass culture, exploring it in opposition to the high intellectual culture presumed to be the resource and habitat of fine art. The phrase 'pop art' had been used by the English critic Lawrence Alloway in 1958 to refer to advertising and other commercial graphics; the word 'pop' had been prominent in a poster image made by Richard *Hamilton in 1956. In the early 1960s 'pop music' became the term for the songs purveyed by the Beatles and other

groups to a vast international public of young people, and at that time it looked possible that modern art had at last found an idiom appealing to that public, perhaps to a wide range of publics. There was indeed some interaction between the worlds of Pop Art and pop music. Some of the Beatles and other pop music stars were former art students; eminent artists associated with Pop Art made sleeves for pop albums; design ideas were derived from Pop Art inventions, thus feeding back into the commercial realm on which it had drawn; television programmes, increasingly dedicated to the promotion of pop music and pop stars, became also the prime means by which Pop Art became known outside the art world.

Fine art had previously dipped into the well of popular culture: respect for folk legends, song and artefacts was part of *Romanticism's openness to *primitivism. The late 19th century saw artists studying and deriving their own styles from folk art, and many early 20th-century artists borrowed directly from low art, as when Russian painters such as *Larionov, *Goncharova and *Tatlin echo the formats of shop signs, *Cubists, *Futurists, *Dadaists and others incorporate words and pictures from newspapers and magazines in their pictures, and *Duchamp enrolls a variety of non-art objects, including advertisements, in his work. The Pop Art movement was not unaware of these pre-echoes but gave its priority to mass imagery and became so well known so quickly that it was felt at the time that something radical had happened, not least the most remarkable widening of the definition of art. There were those who regretted it, especially in the USA where *Abstract Expressionism had established a new national art at a high level of poetic endeavour. 'New Vulgarism' was one of the labels put on the movement by commentators reluctant to see art lowering its sights. Others saw Pop Art more positively and distinguished between contributions to it.

The term covers a wide range of approaches and concerns. In Britain Pop Art included narrative and *iconic or even heraldic images. Peter *Blake, combining an interest in fair-ground and pop imagery

with a fine *naturalistic technique, cele-
brated the stars of old music hall and new
pop groups. *Kitaj and *Hockney brought
back narrative, drawing on a variety of old
models and not necessarily on contem-
porary commercial art; Kitaj's subjects were
sometimes openly, sometimes indirectly,
political so that his work could be classified
as *History painting, while Hockney's, early
on indebted as much to *Hogarth as to
graffiti, tended to *genre. Other British
artists imbued portraiture and townscape
(e.g. Allen *Jones) and still life (e.g. Patrick
*Caulfield) with Pop Art qualities.
Hamilton, older than they, displayed his
interest in modern product design and
advertising in his paintings, while Richard
*Smith adopted the visual strategies of
high profile advertising and transformed
his images by means of suave colours and
brushwork that leave them balanced
between the commercial images that were
his sources and masterly fine art painting.
America usually provided this source mate-
rial: the US consumer world looked entirely
glamorous to a Britain where war-time
rationing had continued into the peace.

American artists could take a cooler
reading of that world, though their work
remained ambiguous in its attitude to
consumerism. *Warhol and *Lichtenstein
can be said to celebrate the triumph of
capitalism, especially if one overlooks (as
people tend to do) the extent to which they
transmogrified their models, by refine-
ment or by further vulgarization through
repetition. The shallow grand manner
of the hoarding is well caught in *Rosen-
quist's vast paintings, their fragmentary
representations and symbols querying
the advertisers' hard-sell rhetoric, while
*Oldenburg's sculpture heroicizes com-
monplace objects until they teeter on the
brink of absurdity while confronting us in
the guise of monumental art. Is it the
objects or our appetite for grandeur that is
in question?

In both countries Pop Art achieved
notoriety and positive fame almost at
once. Doubters were silenced because of its
inherent youthful energy and headlong
inventiveness; the *abstract art dominant in
both countries suddenly seemed highbrow
and elitist. Gallery goers found themselves

enjoying an art that dealt with familiar
motifs in a discursive and entertaining
manner; the media found it full of interest
and could bask in its reflected glory or at
least charm. None of the artists really
considered himself a Pop artist but none
excluded himself from Pop Art's success.
In Continental Europe too Pop artists
emerged, exploring, exploiting and to some
degree commenting on the media world
and its interaction with the supposedly
separate world of culture (see *Fahlstrom,
*Raysse). Art was left seeming a good deal
less remote. At the same time, accidentally
it seems, art again proved its power to make
memorable the transient and monumen-
talize the commonplace.

Popova, Lyubov (1889–1924)
Russian painter and designer who studied
in Moscow before coming under *Vrubel's
influence, visited Italy to study early
*Renaissance art and toured Russian towns
to look at old buildings and medieval paint-
ings. In 1912 she was working in Moscow,
in close touch with *Tatlin and *Vesnin.
In 1912–13 she was in Paris, practising
*Cubism and interested in *Futurism.
In 1915 she began to make reliefs, and
exhibited as one of the Tatlin circle in
the Zero-Ten exhibition of 1915–16 in
Petrograd. In 1916–17 she allied herself to
*Malevich and worked as a *Suprematist:
her paintings, with titles such as *Painterly
Architectonics*, now set large flat or appar-
ently curving planes of colour, modulated
by tone and texture, into a shallow picto-
rial space where previously she had used
metal and wood to set forms into real space.
After the Revolution she worked for the
new Ministry of Enlightenment and for
*Proletkult, and with Vesnin taught 'colour
construction' in the new art workshops
whilst contributing to the debates of
*INKhUK. She showed with *Rodchenko
and others in the 1921 $5 \times 5 = 25$ exhibition
in Moscow, asserting the end of easel paint-
ing as a self-justifying art form. In 1920 she
and Vesnin had made designs for a mass
open-air festival, at Meyerhold's invitation;
in 1922 Popova supplied him with an inno-
vatory piece of *kinetic stage apparatus (as
opposed to scenery) for *The Magnanimous
Cuckold*, and designed standard outfits (as

opposed to costumes) for the actors in it. Her apparatus and other arrangements for Meyerhold's *The Earth in Turmoil*, 1923, consisted of a movable gantry-like construction and real things such as lorries; they could be used in the open air even more readily than on a stage, enabling the production to be toured. In 1923–4 she worked alongside *Stepanova on making textile designs for mass-production at a Moscow factory. Her death, from scarlet fever, removed from the Russian scene a much-admired progressive artist, and the same year saw a large memorial exhibition of her work. Her work is in many collections, including the Tretyakov Gallery and the Bakhrushin Theatre Museum, Moscow, and the Russian Museum, St Petersburg.

Porcellis, Jan (*c*.1584–1632) Recognized by contemporaries as the greatest marine painter of his time, Porcellis was born in Ghent, and worked in Rotterdam, Middleburg, London, Antwerp, Haarlem and Amsterdam before settling at Zoeterwoude in southern Holland. He accomplished the transition from the Early *Realist seascape with its emphasis on detailed, multicoloured ship portraiture (*see* Hendrick Vroom) to a tonal, monochromatic representation of skies, seas and atmosphere. His son, **Julius Porcellis** (*c*.1609–45), adopted his style and subject matter. There are works by Jan Porcellis in Berlin, Staatliche; Leiden, Museum; Munich, Gemäldesammlungen; etc.

Pordenone; Giovanni Antonio de Sacchis, called (*c*.1484–1539) Inventive painter from Pordenone in Friuli, north-east of Venice. From his experience of Venetian art (*Carpaccio, Giovanni *Bellini, *Giorgione and *Titian), of nearby Mantua (*Mantegna), central Italy (*Michelangelo, *Perino del Vaga) and northern Europe (e.g. *Dürer) he forged a violently *expressive idiom, at times stylish, at others intentionally populist, using *illusionism to enforce the spectator's – especially the provincial spectator's – involvement in the painted drama. A precursor of the *Baroque, he is usually

classified as a Mannerist artist, and certainly influenced the *Mannerism of, e.g. *Tintoretto. In important respects, however, he shares the theatrically expressive *realism of the Lombard *Sacro Monte decoration.

Some time between 1516 (*Madonna della Misericordia*, 1515–16, Pordenone, cathedral) and 1520 (Treviso, cathedral, 1520; Cremona cathedral, 1520–2) Pordenone encountered Roman *Renaissance art. The Treviso dome (destroyed in World War Two), projected a dramatically foreshortened God the Father into the viewer's space (*cf*. the nearly contemporary work of *Correggio). Complementing an altarpiece by Titian below, Pordenone used the opportunity for a critique of the latter's figure of God in the Frari *Assumption and Coronation of the Virgin*, 1518, with references to Michelangelo's Sistine chapel and *Raphael's Chigi chapel. (*See also* Boccaccino, Altobello Melone).

In the Cremona *frescos Pordenone replaced *Romanino, continuing and exaggerating the latter's 'German' manner and aiming for the coarse dramatic effects of popular miracle plays. The Spilimbergo cathedral organ shutters (1523–4) are equally dramatic and illusionistic; this mode is further explored, but with greater elegance, in the decoration of the Pallavicini Chapel in the Franciscan church at Cortemaggiore (1529–30; altarpiece now Naples, Capodimonte). From *c*.1530 Pordenone worked mainly in Venice (S. Stefano, S. Maria dell'Orto, S. Giovanni Elemosinario; Murano, S. Maria degli Angeli; Doge's Palace) where he became the chief rival of Titian. His many palace façade decorations, emulating those of *Peruzzi and *Polidoro da Caravaggio in Rome, are mainly known through drawings (e.g. London, V&A). He died at Ferrara, where he had been summoned to design tapestry cartoons (*see under* fresco). Other works Budapest, Museum; London, National; Venice, Accademia; Piacenza, Madonna di Campagna; Alviano, parish church.

Porta, Bartolommeo or **Fra Bartolommeo della** *See* Bartolommeo or Baccio della Porta.

Porta, Guglielmo della (*c.*1490–1577) Outstanding Lombard sculptor active above all in Rome, where he worked in both marble and bronze; in 1547 he succeeded *Sebastiano del Piombo as keeper of the apostolic seal. He is first securely recorded from 1534 to 1537 in Genoa, in partnership with his uncle, the sculptor **Gian Giacomo della Porta** (*c.*1470–1555) (Cathedral, Cibo Chapel, also known as the Chapel of the Apostles). He moved from Genoa to Rome in 1537; in both cities he was associated with *Perino del Vaga, but after his arrival in Rome he came in contact with *Michelangelo, who became the major influence on him. His greatest work is the Tomb of Pope Paul III Farnese, originally planned, as had been Michelangelo's Tomb of Pope Julius II, as a free-standing monument incorporating a chapel-like interior. After the sculptor's death it was finally installed as a niche monument (Vatican, St Peter's), with some of the original *allegorical statues transferred to the Palazzo Farnese, but still crowned with the enthroned bronze statue of the pope. Other major works in Rome are the Cesi tombs, S. Maria Maggiore; the monument to Bernardino Elvino, S. Maria del Popolo; there is also a marble bust of Paul III in Naples, Capodimonte. Guglielmo's son and heir, **Teodoro della Porta** (1567–1638) was also a sculptor, as was his illegitimate son, named **Fidia** after the ancient Greek sculptor Phidias (relief, a version of a design by Guglielmo, New York, Metropolitan). A number of major lost works are recorded in a sketchbook by Guglielmo now at Düsseldorf.

portrait historié (French, narrative portrait, always used in the original language.) A portrait in which the sitter is depicted in the guise of a figure from literature, history, mythology or the Bible.

portraiture *See under* genres.

Posada, José Guadalupe (1851–1913) Mexican graphic artists whose vast output of satirical prints and cartoons had the character of folk broadsheets and made dramatic use of folk images such as animated skeletons in order to parody the doings of the rich and powerful and to denounce injustice. His narrative and allegorical images influenced the socio-political art of Mexico of the 1920s and after.

Post, Frans (1612–80) Dutch *landscape painter from Haarlem. Between 1637 and 1644 he was in northeast Brazil, then a Dutch colony, in the retinue of the newly appointed governor-general, Johan Maurits of Nassau-Siegen. He recorded the landscape around him in somewhat naïve but vivid paintings (e.g. Paris, Louvre) and in many topographical or otherwise accurate drawings. On his return to Haarlem he used these latter to produce versions and repetitions of Brazilian scenes (Amsterdam, Rijksmuseum etc.) and even biblical scenes set in Brazil among Brazilian fauna and flora (Rotterdam, Boijmans Van Beuningen), his early naïveté giving way to more conventional and less fresh compositions. He also drew designs for prints published in Caspar van Baerle's description of Brazil in 1647. Frans Post's elder brother, **Pieter** (1608–69) was an outstanding architect, working primarily for the Orange-Nassau court; presumably as a hobby, he painted cavalry skirmishes and a few landscapes, subtle in execution and palette (Paris, Institut Néerlandais).

Post-Impressionism Term used by Roger *Fry to distinguish the work he presented in two London exhibitions, in 1910 and 1912, from the art of the *Impressionists and its emphasis on *naturalism, and including a wide range of work by French, Russian and British artists of the time. It is today associated especially with the work of four great painters who had been influenced by Impressionism but had gone on to develop a more formal or symbolical mode: *Cézanne, *Gauguin, *Seurat and Van *Gogh, but is also used quite broadly to encompass a wide range of artists moving on from Impressionism and/or *academic and *Courbet-style *realism into more poetic idioms, usually those in which pictorial order is given visible priority.

Post-Painterly Abstraction *Greenberg's term, first used to title an exhibition in 1964, to distinguish the paintings

displayed in it from the gestural, often impassioned art of the *Abstract Expressionists. It referred to a calmer, more constructive use of designed colour areas, often in more or less symmetrical, even heraldic compositions, though it also accommodated looser, lyrical rather than epic, applications and dispositions of colour. Prominent among Greenberg's Post-Painterly Abstractionists were Morris *Louis, Kenneth *Noland, Helen *Frankenthaler.

Potter, Paulus (1625–54) Precocious Dutch animal painter, the son of **Pieter Potter** (1597/1600–52), painter and owner of a factory for embossing and gilding leather, best known for his *vanitas* still-lifes (Amsterdam, Rijksmuseum). Paulus's work is notable for his sense of atmosphere and meticulously rendered lighting. He often set his scenes of cattle and farmyard animals in clearly identifiable times of day and weather conditions (London, National; St Petersburg, Hermitage). Although most of his work is in a small format, he is famous for the huge canvas depicting a life-size *Young Bull* (1647; The Hague, Mauritshuis). This monumental heroization of a single motif silhouetted against the sky has acquired symbolic connotations related to the Dutch national character (*see also* Asselijn). It is typical of the *'classical' phase of Dutch painting, perhaps best exemplified in the landscape painting of Potter's contemporary Jacob van *Ruisdael. Paulus Potter's work influenced later animal painters well into the 19th century.

pouncing In art, a method of transferring a full-scale design to the surface about to be painted by dusting a coloured powder, usually chalk or charcoal, through holes pricked along the outlines of a drawing on paper or parchment. The word is also used for the traces of this process in the finished work.

Pourbus, Pieter (*c*.1510–84), his son **Frans the Elder** (1545–81) and the latter's son **Frans the Younger** (1569–1622) Dynasty of painters originating in Bruges and best known as portraitists, although

Pieter did not begin to work in this genre until 1551. After an apprenticeship with Lancelot Blondeel he remained in Bruges, where his paintings for the municipality and in churches are characterized by traditional compositions, bright colouring and precise brushwork. Frans the Elder worked with Frans *Floris from 1562 and became master at Antwerp in 1569, specializing mainly in portraiture, somewhat more flexible in style than his father's and at times incorporating *genre motifs (e.g. Brussels, Musées). The most accomplished member of the family was Frans the Younger. In the Antwerp guild from 1591, he was called to the court in Brussels to execute official portraits of the Archdukes Ernest and Albert and Infanta Isabella, of which many replicas and engraved copies exist. These works, and some bourgeois portraits of the same years (Leeds, Gallery; *Self-Portrait*, 1591, Florence, Uffizi) are, however, eclipsed by the portraits which he painted during his term as court artist at Mantua, 1600–*c*.9. These refined yet precise images of figures immobilized amongst the precious details of costume are some of the most striking examples of the *Mannerist portrait of status (*see also* Anthonis Mor), emulated – but quickly surpassed – by Pourbus's compatriot and colleague at the Mantuan court, *Rubens. Outstanding works from this period are in Rome, S. Carlo al Corso; Mantua, Palazzo d'Arco and private collections; Vienna, Kunsthistorisches; Madrid, Prado. From 1609 until his death Frans Pourbus the Younger served as court painter in France. Here he married a sober *naturalism, evident especially in his likenesses of non-royal personages (e.g. *The Duke of Chevreuse*, 1612, Northamptonshire, Althorp) to the formalism of his official portraiture. This style not only came to dominate French portraiture in the reign of Henry IV and the regency of Marie de'*Medici but influenced later practitioners, notably Philippe de *Champaigne. Pourbus's *The Last Supper*, 1618, now Louvre, introduced an equally sober Venetian Grand Manner, learned in Mantua, to Parisian artists, and made a lasting impression on *Poussin, evident even in the latter's Roman works.

Poussin, Gaspar *See* Dughet, Gaspar.

Poussin, Nicolas (1594–1665) French-born painter active in Rome from 1624, with the exception of 1640–2 when he worked for Louis XIII in Paris. He is, however, of decisive importance for the later evolution of French art, notably through the teaching in the Royal *Academy, and is the virtual founder of French *classicism. His name was adopted in France for the pro-*disegno faction in the long-lasting contest between *Poussinistes* and *Rubénistes* (*see also* Rubens). In the wider history of art, his importance consists in having elevated gallery-sized easel paintings of narrative subjects to the high seriousness and status of *istoria*, or history painting (*see under* genres), hitherto reserved for works on the scale of life.

Born of a peasant family near Les Andelys in Normandy, Poussin was first attracted to painting in 1611 through the activity at Les Andelys church of the minor Late *Mannerist **Quentin Varin** (*c*.1570–1634). In the following year he left to study painting, first in Rouen, then in Paris, where he trained for a while with a Flemish portraitist, **Ferdinand Elle** (*c*.1580–1649). The most important influence on him at this time, however, seems to have been his access to the Royal Library, where he studied engravings after *Raphael, *Giulio Romano and *Polidoro da Caravaggio, and the royal collection of sculpture, where he first saw Roman reliefs and statues. Some time *c*.1616–17 and again *c*.1619–20 he tried to go to Rome, but had to turn back in Florence and Lyon respectively, on the first occasion because of some unspecified accident, on the second because his money was claimed by a creditor. In 1622 he was commissioned by the Jesuits in Paris for six large tempera paintings, now lost, for the celebrations of the canonization of Sts Ignatius Loyola and Francis Xavier. When these attracted attention, he gained employment at the Luxembourg Palace, and met the patron of his first extant works, the Italian poet Marino, protégé of the Queen Mother Marie de'*Medici. The drawings illustrating The *Metamorphoses* of Ovid which he executed for Marino

(Windsor, Royal Library) resemble in style the work of artists of the so-called Second School of Fontainebleau, notably *Dubreuil.

With Marino's help Poussin finally succeeded in reaching Rome. His early years there, from 1624–*c*.30, were ones of experiment, in which he adapted his style to suit his commissions. The two battle pieces now in St Petersburg, Hermitage (*Victory of Joshua over the Amorites, Victory of Joshua over the Amalekites*, 1625–6) show his debt to Giulio Romano and Polidoro. Soon after his arrival, he worked in the studio of *Domenichino, and the latter's influence is visible in, e.g. *Apollo and the Muses on Mount Parnassus* (Madrid, Prado) whose general composition is based on Marcantonio Raimondi's (*see under* Raphael) engraving after Raphael's *fresco in the Stanza della Segnatura. Other paintings, such as the *Holy Family with St John* (*c*.1627, Karlsruhe, Kunsthalle) show the influence of *Titian in the handling of colour. The most accomplished painting of this period is *The Death of Germanicus* (1627, Minneapolis, Institute), which employs Titianesque colour for a composition inspired by ancient reliefs, of a type to which Poussin would often return in the middle period of his life – a full-length-figure *istoria* under two metres in length and one and a half metres high.

In 1628–9 Poussin received two large-scale public commissions, which should have sealed his reputation: the altarpieces of *The Martyrdom of St Erasmus* for St Peter's (1628–9, now Vatican, Pinacoteca) and of *The Virgin appearing to St James* for a church in Valenciennes (1629–30, now Paris, Louvre). The former, which makes use of a design for the same altar by *Pietro de Cortona, remained the artist's only large-scale picture on public view in Rome, but it was slated by most critics as lacking in *naturalism, strength, richness and harmony of colour. The latter, the most *Baroque of Poussin's pictures, is close in feeling to the work of *Bernini, and is the only surviving painting by the artist to employ a detail identified with *Caravaggio: the dusty feet of the man kneeling in the foreground. It was later to enter the collection of Richelieu in France.

Whether because of the failure of the *Erasmus*, or the effects of a grave illness in 1629/30, or because of his own sense of his limitations when working on a large scale, Poussin was not afterwards to seek this type of commission. (When, during his stay in France 1640–2 commissions for altarpieces and the large decorative scheme of the Long Gallery in the Louvre were thrust upon him, he reacted with unease, and returned to his beloved Rome on a pretext as soon as possible.) Instead, in the 1630s, he retired from the public arena, to paint relatively small-scale pictures for a circle of connoisseurs clustered around the scholarly Cassiano dal *Pozzo. Poussin participated in Cassiano's project of recording in drawings all the relics of ancient Rome (now Windsor, Royal Library). A series of paintings mainly on mythological themes, *Bacchanals*, *Triumphs* and scenes based on Ovid's *Metamorphoses*, testify both to the tastes of these scholarly patrons and to Poussin's growing familiarity with ancient literature and artefacts; formally, the paintings of *c.*1629–33 rely heavily on Titian's early mythologies for Alfonso d'*Ester at that time visible in Rome; after that date Venetian colourism is gradually replaced by the clearer daylight, full modelling and classicizing compositions of Raphael and his 17th-century followers, Annibale *Carracci and *Domenichino (Paris, Louvre; London, National; Munich, Alte Pinakothek; Dresden, Gemäldegalerie; Detroit, Institute; Philadelphia, Museum; etc.). Even in the tales of love from Ovid, Poussin stresses *allegorical significance over erotic appeal: Stoical notions of the cycles of nature – fertility and death – inform these works, as well as the small group devoted to scenes from Tasso's *Gerusalemme Liberata*, the only modern poem interpreted by Poussin (e.g. London, Dulwich; Moscow, Pushkin; Berlin, Staatliche). The most elaborate of the *Bacchanals*, and the most elaborately archeological, were painted for Cardinal Richelieu, and helped to establish Poussin's French reputation.

Towards the end of the 1630s Poussin no longer concentrated on poetical and mythological themes, beginning to interpret texts which allowed for more dramatic

pageantry: from the Old Testament (e.g. London, National; Edinburgh, National; Vienna, Kunsthistorisches; Melbourne, National) or from ancient history (e.g. Paris, Louvre; New York, Metropolitan). The increasing seriousness of his work becomes especially apparent in the great first series of the *Seven Sacraments* commissioned by Cassiano dal *Pozzo, of which the last, *The Baptism*, was taken by Poussin to Paris and not completed until 1642 (now Washington, National; others executed *c.*1638–40, five surviving now Belvoir Castle).

Poussin went to Paris reluctantly at the insistence of Richelieu and the King; as has been said, his sojourn at the court in Paris was not a success, and further complicated by the envious intrigues of rivals like *Vouet. But the visit had important and beneficial consequences. While in Paris he established contacts with a circle of intellectual bourgeois: minor civil servants, small bankers, merchants, who were to be his best patrons for the latter part of his life and to influence his whole outlook. The most important of them was Chantelou, for whom he had already painted the important *Fall of Manna* in Rome in 1639 (Paris, Louvre). It is through Poussin's letters to Chantelou especially, but also to his other French mail-order clients, that we gain the fullest insights into the painter's artistic ideals. It is also on this correspondence that some of the teachings of the Academy are based: Poussin's insistence, for example, that his paintings be *read*, figure by figure, or his theory of the Modes based on musical theories, which can best be related to notions of *decorum.

During 1642–*c.*52 Poussin produced his most monumental, most solemn and classicizing works for these patrons, who in general allowed him to choose his own subjects, now drawn from the New Testament more often than the Old, and from Stoic ancient historians (mainly Paris, Louvre; also Washington, National; Dublin, National; St Petersburg, Hermitage; New York, Metropolitan; Copenhagen, Museum). For Chantelou, he painted a second series of *Seven Sacraments*, 1644–8 (Edinburgh, National). In the second half of the 1640s, perhaps

inspired by his friend *Claude, he began to paint classicizing landscapes (e.g. Knowsley; Oxford, Ashmolean).

From c.1653, however, his style changed once more, becoming even more intense and personal. The figure compositions are increasingly understated (e.g. St Petersburg, Hermitage). The landscapes, however, in which he returns to mythological subjects for allegorical ends, are less orderly and less subject to the laws of geometry. Nature assumes a grander and wilder aspect and is free from the intrusion of architecture, as it might have appeared at the dawn of time (e.g. New York, Metropolitan; Cambridge, MA, Fogg; Moscow, Pushkin). In his last great commission, the four landscapes of the *Seasons* painted for the Duc de Richelieu 1660–4 (now Paris, Louvre) cosmic symbolism is related to the earliest history of humankind as outlined in the Old Testament.

However alien Poussin's classicizing principles and, even more, his philosophical outlook may now seem, he is in certain important respects one of the first truly modern artists. Virtually self-taught, he was able to impose his ambitions, and his limitations, on his patrons. Choosing the scale and format which best suited his gifts, he nonetheless escaped the stigma of being a painter of second-rank *genres; he chose his own themes; bullied his patrons into showing, viewing – and even framing – his pictures as he wished. He worked, at least after 1642, to his own tempo. Above all, he became accepted as his patrons' intellectual equal or even superior, a painter-philosopher. It is the image which he left to posterity in his second *Self-Portrait*, painted for Chantelou in 1649–50 (Paris, Louvre).

Poussinistes *See under disegno.*

Pozzo, Andrea, also called **Fratel** ('Brother') or **Padre** ('Father') **Pozzo** (1642–1709) Northern Italian painter and architect, from 1665 a Jesuit lay brother; a painter of altarpieces and a specialist in *perspective (e.g. 1676–7, Mondovi, Jesuit church). His best-known work is the *illusionistic ceiling decoration of the huge Jesuit church of S. Ignazio in

Rome (c.1691–4); this combines a *quadratura* framework with figures arranged in loosely connected light and dark areas reminiscent of *Gaulli's *frescos at the Gesù. The programme, combining a *Triumph of St Ignatius Loyola* with details of the missionary activities of the Jesuits throughout the world, was admired by the Austrian ambassador, Prince Liechtenstein, to whom Pozzo explained it in a letter published in the 19th century. In 1703 the artist settled in Vienna, where his major work, the secular *Triumph of Hercules* in the great salon of the Liechtenstein palace, did much to spread Gaulli's innovations to Austria and Germany. Pozzo was also the author of a much-translated treatise on *perspective.

Pozzo, Cassiano dal (1588–1657) Italian scholar, collector and patron of the arts and sciences. Born in Piedmont, educated in Tuscany, he moved to Rome, where he became the secretary of Cardinal Francesco *Barberini, with whom he travelled to France and Spain. He is best remembered for his sustained patronage of *Poussin, and for compiling a 'Paper Museum' – drawings after antique and Early Christian monuments commissioned from many artists, Poussin among them, but also *Pietro da Cortona and Pietro *Testa. A member of the remarkable Accademia dei Lincei (*Academy of the Lynxes) whose primary aim was to study nature from direct observation and to which Galileo was an early recruit, he also obtained drawings of animals, plants and minerals. Cassiano's planned encyclopedia was never published, but the most important section of the Paper Museum survives at Windsor, Royal Library, and London, British Library and British Museum.

Prampolini, Enrico (1894–1956) Italian painter, member of the *Futurists from 1912, but associated also with the Zurich *Dadaists in 1916, the Berlin *Novembergruppe in the early 1920s, active in Paris 1925–37. He was a member of *Cercle et Carré and of *Abstraction-Création, and was known internationally as an artist interested in exploring a wide variety of materials and methods, mostly to

produce *abstract images. Much of his work was for the theatre, and it also included exhibition installations, as for the 1932 Exhibition of the Fascist Revolution.

Pratt, Matthew (1734–1805) American painter, a pupil of Benjamin *West in London; in 1765 he escorted West's Pennsylvania sweetheart, Elizabeth Shewell, across the Atlantic to marry him. Pratt is remembered for his painting of *The American School*: West in his studio instructing fellow artists (New York, Metropolitan). *See also* John Trumbull, Ralph Earl and Gilbert Stuart.

Precisionism Tendency in American painting after about 1915, reflecting the influence of *Cubism, of photography and of Joseph *Stella's urban scenes, and associated with urban and industrial subjects presented with clear edges and colours. Not directly descriptive, the best Precisionist work, such as *Sheeler's and *Demuth's, transformed motifs into generalized, poetic accounts of lines and planes, often giving them a timeless and monumental character and avoiding any signs of personal artistic expression.

Preda *See* Predis.

predella A box-like structure at the base of an altarpiece or *retable, acting as a support to the main panel as it rests on the altar table. The word is usually applied to the decorated front, which normally consists of a row of small paintings or reliefs. The earliest known predellas seem to have formed part of *Cimabue's altarpiece for S. Chiara in Pisa, 1301, and *Duccio's *Maestà* for the Chapel of the Nine in Siena Town Hall, 1302, both no longer extant). Although, especially in northern Italy, the predella may consist of a strip of single bust-length figures of saints, it is most characteristically narrative, illustrating stories from the lives of saints, Christ or the Virgin Mary, under the *iconic representation of these personages on the main panel and wings, if any, of the altarpiece. Predella paintings were a favoured location for pictorial experimentation in 14th- and 15th-century Italy.

Predis or **Preda** Italian painters active at the court of Lodovico *Sforza in Milan. The best-documented is **Giovanni Ambrogio** (*c.*1455–after 1508) who is named in the contract for *Leonardo da Vinci's *Virgin of the Rocks* now in London, National; he worked together with his brother **Evangelista** (d.1490 or soon after). After the French invasion, Ambrogio de Predis went to the court of the *Habsburg Emperor Maximilian I, who had married Bianca Maria Sforza, Lodovico's niece, in 1493. Another brother was **Cristoforo**, an *illuminator.

Prendergast, Maurice (1859–1924) American painter, born in Canada, and trained partly in Paris (1891–4 or 5), who lived and worked mainly in Boston but visited France again in 1907, 9 and 14 and Italy in 1898–99 and 1911. He exhibited with the *Ash Can School in 1904 and 8, but was not a critical *realist working in the manner of *Manet so much as a spirited illustrator of contemporary life, usually outdoor scenes, in the manner of *Bonnard and *Vuillard's *Intimism. He is thus best seen as an American *Post-Impressionist. He worked on his paintings over several years, so that it is difficult to date them. He also made a large number of *monotypes of similar subjects, of which more than fifty are in the Terra Museum of American Art, together with some of his paintings.

Pre-Raphaelite Brotherhood An association of British painters, formed in 1848 and consisting of Holman *Hunt, Dante Gabriel *Rossetti and *Millais, aged 21 and still students at the Royal *Academy Schools in London, and four others, including Rossetti's brother William who acted as secretary to the group. Exhibiting in 1849, the three leaders of the group used the initials 'PRB' instead of signatures; their work was well received and the absence of individual names gave an air of mystery to the group. The meaning of the initials became known through the PRB journal, *The Germ*. Their work was less well received in 1850 when, in particular, Millais's painting *Christ in the Carpenter's Shop* was denounced by Dickens and by art critics as not only

blasphemous but also ugly. The PRB were intent on ending the Academy-backed prevalence of, it seemed to them, false and purposeless art, and to establish an art combining truthful *naturalism with moral edification. The learning as much as they could in London of the practices of the Italian early *Renaissance painting up to the time of the young *Raphael and of the Flemish painters of the same period, notably the Van *Eycks, they developed a painstaking technique of small colour touches on a white ground and making elaborate nature and figure studies, and sometimes small paintings, out of doors. They were *history painters, taking their subjects from the bible, from Shakespeare, Boccaccio and other famous writers, as well as from modern writers such as Keats, Tennyson and Browning, and from history. In 1851 *Ruskin wrote in support of the paintings they were showing at the Royal Academy and he continued to speak out on their behalf. Ford Madox Brown, never a member of the group, was closely associated with them and contributed first-hand knowledge of the early Italian art they admired and of the *Nazarenes on whose practices and ideas they in part modelled theirs. He also encouraged them to include landscape and modern subjects in their range. In the early 1850s, with Hunt working in Palestine and Rossetti withdrawn from the group, Millais remained as the key figure of the disintegrating PRB and attracted new followers, some of them, such as John *Brett, introduced by Ruskin. Rossetti meanwhile involved two Oxford undergraduates, *Burne-Jones and William *Morris in working with him on decoration in the Oxford Union building. From this sprang a second PRB with Rossetti as its leader, while Hunt and Brown worked through several years on elaborate compositions. The second PRB may be said to have ended with the death of Rossetti in 1882. By this time Burne-Jones had become the dominant painter in the group and Pre-Raphaelitism merged with international *Symbolism.

Preti, Mattia (called the **Cavaliere Calabrese**) (1613–99) In 1630 he left his native Calabria for Rome, where he painted numerous *Caravaggesque easel pictures of musicians and cardsharps (Rome, Doria; Oxford, Ashmolean; St Petersburg, Hermitage; etc.). His *fresco style, however (Rome, S. Andrea della Valle, 1650/1; Modena, S. Biagio, 1653–6), derives from Emilian and Venetian examples, studied during his travels as well as through the Roman works of *Lanfranco, *Domenichino, and, above all, *Guercino. During 1656–60 he worked in Naples, and quickly became leader of the local school. There are many frescos and altarpieces (e.g. in S. Domenico Soriano, Sant'Agostino degli Scalzi) and easel paintings for collectors (e.g. Capodimonte) from this period. He evolved a dramatic new style in which details emerge from shadows, and figures appear *à contre-jour (see, e.g. Almsgiving, Naples, De Vito Coll.). From 1661 until his death he spent most of his time in Malta, having gone there to paint the vault and apse of the Co-Cathedral of St John in Valetta; he was made a Knight of the Order of St John. His output in these years was immense, aided by a thriving workshop, and he received commissions from Italy, Sciliy and Spain (e.g. Preaching of St Bernardino, Siena, Cathedral).

Previtali, Andrea (c.1470/80–1528) Italian painter, born in or near Bergamo into the Cordeliaghi family; he adopted the name Previtali some time around 1510. He was active in Venice – in the inscription on a painting of 1504 (London, National), he claims to be a disciple of Giovanni *Bellini – but returned to Bergamo c.1511; he died in Venice. The small devotional paintings and altarpieces in which he specialized also show the influence of *Cima, *Palma Vecchio and, from around 1511, *Lotto; the Salvator Mundi ('Saviour of the World') motif of which he painted several versions derives from Netherlandish prototypes. There are works by him in Bergamo, Accademia and various churches; Padua, Pinacoteca; Venice, Accademia; S. Giobbe.

Price, Sir Uvedale *See under* Picturesque.

Prieur, Barthélemy *See under* Pilon, Germain.

primary colours *See under* colour.

Primaticcio, Francesco (1504–70) Painter, sculptor, designer, architect and art impresario from Bologna; the originator, with *Rosso, of the influential French School of Fontainebleau and chiefly responsible for the coldly elegant, yet erotic, form of *Mannerism associated with it. Primaticcio left Bologna in 1526 to work under *Giulio Romano at Mantua (*classical stucco frieze, Sala dei Stucchi, Palazzo del Tè, *c*.1530). In 1532 he joined Rosso at the château of Fontainebleau. Of the decorations he executed there both Rosso's death in 1540 all have perished except for a chimney piece for the Chambre de la Reine, but we know from drawings that his first work, for the Chambre du Roi, was based on a drawing by Giulio.

In 1540–1 Primaticcio went to Rome on behalf of Francis I of France, to obtain moulds of the most famous ancient statues then known. The bronze casts made subsequently of the *Laocoön*, the *Apollo Belvedere*, the *Marcus Aurelius* and reliefs from Trajan's Column thus became available to French artists, with profound effects on the development of French art. Upon his return from Rome, Primaticcio began a new, even more important series of decorations for Fontainebleau. Although many of these are lost, what remains, and drawings and engravings of what has been destroyed, demonstrate that in the period 1540–50 Primaticcio gradually freed himself from the influence of Giulio. He now created, in stucco sculpture and in painting, that elongated and slender canon of figure drawing – influenced by *Parmigianino and reinforced by *Cellini – which was to become characteristic of French painting for the rest of the century, and of northern European Mannerism even longer (*see*, e.g. Wtewael). The most important example of the new style was the Galerie d'Ulysse, destroyed in the 18th century, but recorded in prints by Theodoor van *Thulden.

In 1546 Primaticcio undertook a second trip to Rome, returning with a cast of *Michelangelo's Vatican *Pietà*, executed

for a French cardinal and thus of special significance in France. His architectural activities began with works of decorative sculpture: the the grottoes at Fontainebleau and at Meudon, influenced by Giulio's rusticated work and perhaps by the unfinished *Slaves* projected by Michelangelo for Julius II's tomb. There are drawings by Primaticcio in many collections, notably Paris, Louvre, Ecole des Beaux-Arts; Chantilly, Musée; London, British; and easel paintings, some of scenes from the Galerie d'Ulysse, in e.g., Toledo, Ohio, Museum; Barnard Castle.

priming *See under* imprimitura; ground.

primitive, primitivism The Latin word *primitivus* means the earliest of its kind. From this stems 'primitive', used ambiguously in cultural matters to indicate an early, unsophisticated stage in the developing arts, as well as cultures in which little or no development is apparent to western eyes. In so-called fine art this can refer to a wide range, from archaic Greek art and Italian and Flemish painting before the full *Renaissance of the 15th and 16th centuries, to untutored art production as found in folk art, children's art and the art of the insane, and also, especially misleadingly, to the artefacts of 'primitive' cultures, produced by those whom until recently westerners called 'savages' though we now recognize the sophistication inherent in their cultures. It required a change of attitude, above all a willingness to see the qualities of tribal art, especially that of Africa and Oceania, for 'primitive art' to be acknowledged as a valuable aspect of human creativity; this depended on a positive aesthetic response, and, following upon this, a growing understanding of the methods and purposes of art objects previously regarded as mere curiosities. Artists played key roles in this, often stimulated by dissatisfaction with what western art had to offer. A group of J.-L.*David's students called themselves *Les Primitifs* and sought for a more austere, minimalist *Neoclassicism than he professed. The *Nazarenes and the *Pre-Raphaelites emulated the less sophisticated styles of early Renaissance

painting before Raphael's work reached its maturity and commanded such a wide influence. Gauguin, a particularly persuasive model, claimed to be turning his back on his own civilization when he went to Tahiti in 1891 to 'live like a savage', having previously left Paris for the peasant environment of Brittany. A number of artists considered leaving Europe with him, but to some extent they could learn from primitive art forms by visiting ethnographic collections in European cities, notably Paris, Berlin and Dresden, by studying exotic art productions from the cheap Japanese woodblock prints increasingly valued by artists in the West from the 1860s on and by studying the movements of Javanese and Japanese dancers as Rodin did. Folk art was studied increasingly in the 19th century alongside prehistoric and early regional cultures, especially at the edges of western civilization: Celtic, Norse and Slav art in Europe, and native arts in America from that of the American Indians to the pre-Columbian Aztecs and Mayans in the south. It was artists who brought samples of African and Oceanic art into their studios and borrowed expressive forms from them for their own paintings and sculptures from about 1905 on, as did *Matisse, *Picasso, *Derain and others in Paris and the *Brücke artists in Dresden, just as it was artists in Russia who exhibited their own anti-*academic work alongside primitive paintings such as shop-signs, popular woodblock prints (*lubki*) and children's art. Soon there were exhibitions of primitive art in sophisticated avant-garde galleries and well illustrated books on such art by major critics, as well as influential texts by critics such as Roger *Fry recommending the particular qualities of, say, African and old Mexican art. Australian aboriginal bark paintings were first recognized for their value as art by the painter Margaret Preston who had studied and worked in Europe and published an article on 'The Indigenous Art of Australia' in *Art in Australia* magazine in 1925. The range of interest and understanding has continued to grow, with closer study of the art of the insane and of children, as well as with further discoveries, including more and more rock paintings and carvings in

various countries and the art of the Inuit in the north of North America. If at first the visual qualities of primitive art dominated the response of westerners, better understanding of the social and religious functions of such art has added new dimensions to it, so that what was a quick enrolment of strange art forms changed gradually in a fuller appreciation and respect for them. The *Blaue Reiter Almanach* of 1912 was a moment of particular significance in that it referred to and, even more, illustrated a wide range of exotic and primitive art objects, including children's drawings, together with western medieval and modern art, to the exclusion of the Renaissance and *classical art so long held to be the highest achievements of western culture. 'Primitive' is also used for the work of untutored artists working outside the art world, such as Grandma *Moses, Henri *Rousseau and Alfred *Wallis, but the instinctive sophistication found by artists in their work has led to 'primitive' being gradually replaced by the term *'naïve'.

prints, printmaking *See* aquatint; intaglio prints; lithograph; mezzotint; relief prints.

Prix de Rome A state bursary to Rome originally awarded for up to four years to prize-winning students at the French Royal *Academy in Paris, now for three years to students of the Ecole des Beaux-Arts. It was initiated by Louis XIV's minister Colbert in 1666 when he founded the French Academy in Rome, whose seat since 1803 has been the Villa Medici near Santa Trinità dei Monti. Prizes for architecture began to be awarded in 1723, and prizes for engravers and musicians in the 19th century. The Prix de Rome, intended to enable French students to study ancient Roman and *Renaissance art and architecture at first hand, rests on the academic assumption of the *classic – that is, canonical – status of such art. The system has been adopted by other countries, and extended also to archeologists and historians of art and architecture.

Procaccini, Camillo (*c*.1561–1629) and his more gifted brother **Giulio Cesare**

(1574–1625) Painters from a Bolognese artists' family; their careers evolved mainly in Milan, where they settled *c*.1587–8. From that date until *c*.1600 Camillo was the leading painter in the city, displaced after the return from Rome of Cardinal Federico Borromeo by the cardinal's protégé, *Cerano. After 1610, Giulio Cesare, trained initially as a sculptor and active as a painter only from *c*.1600, was, with Cerano and *Morazzone, one of the three foremost artists in Milan (the unusual joint commission of an altarpiece, the *Martyrdom of SS. Rufina and Seconda* known as the '*Tre Mani*' or '*Three-hander*', early 1620s, now Milan, Brera, commemorates their predominance).

Productivism A movement in Russian *Modernism which called for artists to use their skills and experience on the design and production of necessary objects, not art objects. Thus they would directly serve the new Soviet state of the early 1920s and find a valid role for artists, similar to the engineer's and the factory manager's, free of the taint of serving bourgeois tastes and close to the proletariat. *Tatlin's concern with the nature and use of materials stimulated this movement; its chief proponents were the critic Osip Brik, the theoretician and designer Aleksei Gan and the painter-designer-photographer *Rodchenko. To some extent it paralleled, but it also predated, the *Bauhaus's emphasis (1923+) on creating prototypes for mass production, but in Russia economic conditions and the reluctance of industry to use the Productivists left the movement with little practical outcome, so that it is seen historically as a misguided, though well-intentioned, extreme tendency within *Constructivism.

profil perdu French, 'lost profile'. The term is used to describe the image presented when the head is turned so far from the spectator as to present only one ear, the outline of a cheek and the chin, and perhaps the tip of the nose – that is, somewhere between a true profile and a view of the back of the head. This informal and attractive pose, obviously unsuitable for portraiture or the depiction of expression,

stresses the three-dimensionality of the figure and its capacity for movement. It appears first in decorative ancient art – as in the famous *Maiden Gathering Flowers* from a 1st-century wall painting in Stabiae, now in Naples, Archeologico – and was revived in the *Renaissance.

Proletkult Short form of *Proletarskaya kultura* (proletarian culture), name given to a programme of urban working-class education for cultural output developed in theory by Bogdanov (doctor, philosopher, anthropologist and writer), Maxim Gorky (writer of peasant origin), and Lunacharsky (poet, playwright and the Soviet state's first Commissar for Englightenment and Education) years before the October 1917 Revolution. Bogdanov was the prime mover in realizing the programme immediately, first in Petrograd and, early in 1918, in Moscow. He argued that the people's political and economic progress must be carried by cultural development, and this could not be left to a government of mixed origins and ideals. It required people committed to working-class ideology by birth or a proven socio-political position. Bogdanov saw the bourgeois cultural inheritance as the enemy. Excluding anyone who could be contaminated by the bourgeois past, and thus depending mainly on amateurs, he and his colleagues encouraged workers individually and in groups to write, perform plays, make art, compose music etc., all relevant to the workers' concerns and often by methods and in materials not known to tradition. Writing was the main product, and some of it has remained; performances were often directly political and continued for some time as part of Soviet peripatetic propaganda. Some leading figures in Proletkult argued for the direct involvement of all culture with industrial production; some of the debates that led to *Productivism were held at the Moscow Proletkult centre. Lenin believed that Soviet culture would have to spring out of close, critical understanding of bourgeois culture. While Lunacharsky was inclined to smile on Proletkult among several other tendencies, Lenin, who disagreed with Bogdanov on basic points of political

theory, resented the existence of Proletkult, had Bogdanov removed from its main committee in 1920, and in 1921 took control of what remained of the movement by placing it under the Commissariat.

pronkstilleven Dutch, 'still-life of ostentation' The painting of luxury wares (such as imported Chinese bowls and vases, silver vessels, Venetian glass, mounted nautilus shells) which is characteristic of the third, and final, phase of Dutch *still-life painting in the 17th century. *See also* Willem Kalf.

Prout, Samuel (1783–1852) British watercolourist of landscapes and townscapes, largely self-taught. He did many watercolours and drawings of English scenery and from 1819 on travelled frequently on the Continent, making pictures and supplying images for publication as engravings in books for tourists, and collecting material for his several drawing manuals. Old buildings came to dominate his Continental scenes, in watercolours and also in deft pen-and-ink drawings which *Ruskin particularly admired.

provenance (French, 'origin') The record of ownership and location of a work of art, ideally from the moment it leaves the artist's studio to the present day.

Provost, Jan (recorded 1491–1529) Netherlandish painter, born at Mons and working first at Valenciennes, perhaps with *Marmion. After a short stay at Antwerp he settled at Bruges in 1494 (*see also* David, Gerard). Only his late work has been indentified; it is characterized by inventive departures from tradition, sometimes in the direction of *caricature (*Disputation of St Catherine*, Rotterdam, Boijmans Van Beuningen) at other times accentuating the tragic theme through compositional devices (*Christ carrying the Cross*, 1522, Bruges, Hospices). Provost was often commissioned to do temporary decorations, such as those for the state entry of the Emperor Charles V into Bruges in 1520 (*see also* Blondeel, Lancelot, who has been said to carry on Provost's lively artistic spirit).

Prud'hon, Pierre-Paul (1758–1823) French painter of the *Neoclassical period. Born into the large family of a poor stonemason, Prud'hon showed his talent early and was given a place in the Ecole des Beaux-Arts of Dijon and awarded Dijon's Rome Prize. In Rome he was close to *Canova, admired the work of *Raphael and fell in love with that of *Leonardo da Vinci ('father, prince and best of all painters', he called him) and *Correggio. In 1789 he returned to France. He warmly supported the Revolution, had the interest and support of J.-L. *David, and became known for portraits and allegorical and mythological subjects, painted with great care and unusual delicacy. David, who did not wholly approve, called him 'the *Boucher, the *Watteau of our age'; Prud'hon seems to have compensated for a life of domestic misery through this otherworldly refinement which also resulted in many commissions being left unfinished.

He had a great success with his *Justice and Divine Vengeance pursuing Crime* (1808), large and for him unusually fierce. He received commissions for decorative paintings and for portraits, and these continued through the days of Empire and Restoration. In the *Salons of 1819 and 1824 he exhibited major religious paintings, *Assumption of the Virgin* and *Crucifixion*, the latter, unfinished, reflecting his melancholic state. His contemporaries especially admired the cool, silvery tone of his paintings; in the context of Neoclassicism's relative firmness this lends an effeminate air to his work though his delicacy can also be a relief from paraded masculinity in the work of his contemporaries. The Musée d'Orsay in Paris has the fullest representation of his paintings, including those named here; his qualities are sometimes seen at their best in his drawings.

Pryde, James (1866–1941) British painter, Scots by birth and training, and brother-in-law of William *Nicholson with whom he collaborated on posters and illustrations under the joint name 'The *Beggarstaffs'. His paintings show much dramatic contrast and emphasis, not always justified by their subjects. A memorial exhibition toured Great Britain in 1949.

Pucelle, Jean or **Jehan** (d.1334) Innovative French illuminator active in Paris, where he ran a large workshop. The first 14th-century northern artist to fall under Italian influence mediated through the papal court at Avignon, he introduced imagery and ideas of space derived from *Duccio into French painting. His best-known work is the *Book of Hours of Jeanne d'Evreux* (1325–8; New York, Cloisters) illuminated in a delicate and luminous *grisaille, with occasional colour washes.

Puget, Pierre (1620–94) The greatest French *Baroque sculptor. Born in Marseille, he spent most of his life there and in Toulon, except for 1640–3, when he worked in Florence and Rome under *Pietro da Cortona, and 1660–7, when he was in Carrara and Genoa (S. Maria di Carignano, Sauli family sculptures). His *expressive manner, best seen in the anguished *Atlantes* (1656, Toulon, Hotel de Ville portal) and the *Milo of Crotona devoured by a lion* (1671–82, Paris, Louvre) – taken to Versailles by his son François – is founded on the work of Pietro da Cortona, *Bernini and *Michelangelo. An intractable, even arrogant, individualist, he was unable to find favour at the French court until the death of Colbert in 1683 (*see also under* Lebrun; Mignard), and even then only briefly (*Perseus and Andromeda*, compl. 1684, now Louvre). His most important marble relief, *Alexander and Diogenes* (1671–93, Louvre) reached Versailles after the death of Louvois, Colbert's successor and Puget's patron, and was prevented by intrigue from ever reaching the King's eyes; his last work, the relief of *S. Carlo Borromeo in the Plague at Milan* (1694, Marseille, Musée) was refused by the King. There are paintings by Puget in local churches in Toulon, where he was also employed designing the decoration of warships and executed architectural designs for the reconstruction of the arsenal; other works of sculpture are in the Louvre and in churches in Genoa.

Pulzone, Scipione (*c.*1550–98) Italian painter from Gaeta; he specialized in portraits of princes of the church and state, and altarpieces, in both of which his lack of emotional expressivity and scrupulous accuracy of description, coupled with a return to the compositions of *Raphael, have been defined as Anti- or Counter-*Mannerist. He worked in Gaeta, Rome, Naples and Florence (Cambridge, MA, Fogg; Naples, Capodimonte; Rome, various churches; Borghese; Nazionale).

Purism A programme or set of ideas promulgated in 1918 by the painter *Ozenfant and the painter-architect Jeanneret (*Le Corbusier) as a corrective extension of *Cubism. Adopting Synthetic Cubism's use of flat ornamental planes, Purism proposed a highly ordered pictorial art compounded of images derived from common objects in clear forms and colours, proving the *classical beauty of mass-produced things and hoping to reconcile a broad public to the world of the machine. Their book *After Cubism* (1918) set out their basic thoughts, and these were developed in the journal *L'*Esprit Nouveau* (The New Spirit) they published from 1920 to 1925, dealing with many aspects of art, design, music, film and literature. *Léger was associated with them but was not a Purist; there was, strictly, no Purist group or movement.

putto (pl. *putti* Italian for boy or child.) In art the word indicates a chubby, usually but not invariably naked, figure of a child, first used as a decorative motif in *Classical art and revived in the *Renaissance. *Putti* have the proportions of babies, but play games and perform tasks of which real babies would not be capable. They are related to *amorini*, 'little loves' (sing. *amorino*) or Cupids, who are equipped with wings and accompany Venus or signal scenes of love. From the Renaissance onwards, *putti* or *amorini* in a Christian context usually represent cherubs, although the Christ Child, the child John the Baptist, and the Holy Innocents all came to be depicted as *putti*.

Puvis de Chavannes, Pierre (1824–98) French painter, associated with *Symbolism but important also for leading a return to *classicism. He was honoured with many commissions for murals, was widely respected and influenced *avant-

garde painters such as *Seurat, *Cézanne, *Hodler and, later, *Picasso and de *Chirico, yet he was largely forgotten in the 20th century until recent studies and exhibitions confirmed his achievement.

Son of a well-to-do engineer of Lyon, Puvis decided late on his art career when illness and a visit to Italy led him to abandon engineering studies for painting. He studied in Paris from 1846 on, under Henri Scheffer, *Couture and *Delacroix. Recognition came slowly but then warmly. He began painting murals (usually on canvas for fixing to walls) in 1861–5 with a cycle of *allegories in the Musée de Picardie in Amiens. As his style matured what characterized them was their calm and harmony, arrived at through careful construction by means of geometrical division and the use of large areas of gentle, more or less flat colour. He insisted on finding his own themes for these works while respecting their location, working his compositions up from small drawn and painted studies to full-size cartoons (see *fresco). The Amiens cycle was followed by others with increasing frequency, including those in the Palais Longchamps in Marseille (1868–9), two series of images of the life of St Geneviève in the Panthéon, Paris (1876–7 and 1897–8), in Paris's Hôtel de Ville (1891–3), and in the Public Library of Boston, MA (1894–8). Among the single murals he produced, the outstanding example is *Summer* (1873; Chartres, M). Easel paintings occupied him between the cycles, at times providing initial formulations for them; some of his small paintings achieved continuous fame on account of their resonant subjects as well as beauty, among them *The Poor Fisherman* (1881; Paris, Orsay) and *Ariadne* (New York, Metropolitan).

Pynacker, Adam *See* Pijnacker, Adam.

Pynas, Jan (1583/4–1631) and his brother **Jacob** (*c.*1585–after 1648) Dutch painters; since they both signed their work 'JP' or 'J. Pynas', it is difficult to differentiate their pictures. Probably born in Haarlem, they went to Italy about 1605; on their return Jan worked for a short time in Leiden then settled in Amsterdam after a second journey to Rome in 1615; Jacob worked in Amsterdam, then settled in Delft. Like the better-known *Lastman, they were influenced by *Elsheimer in painting landscapes with biblical or mythological scenes, and are classified among the 'Pre-*Rembrandtists' (New York, Metropolitan; St Petersburg, Hermitage; London, National; etc.)

Q

quadratura *See under* illusionism.

quadro riportato; pl. quadri riportati
Italian, literally 'carried picture'. It is used
to describe pictures painted on a ceiling to
look as if they were framed easel paintings
hung overhead instead of at eye level on a
wall. The device was evolved as a *classi-
cizing reaction to the extreme *illusionism
of *Baroque ceiling painting (*see* e.g. *Reni's
Aurora in the Casino of the Palazzo
Rospigliosi, Rome) but is sometimes used in
conjunction with it. Annibale *Carracci's
*fresco ceiling of the Farnese Gallery in
Rome wittily depicts a whole gallery of
quadri riportati to complement the sculpture
gallery originally situated below.

Quaglio, Giulio *See under* Marcanto-
nio *Franceschini

Quarton, Enguerrand, called
Charonton in Provence (documented
between 1444 and 1466) French painter
from Laon, recorded in Aix, Arles and
Avignon in the South of France. The
famous 'Avignon' *Pietà* (now Paris, Louvre)
has been attributed to him, but the only
documented works which survive are the
Virgin of Mercy, 1452, painted with Pierre
Villate (Chantilly, Musée) and the even
more impressive *Coronation of the Virgin*,
1454 (Villeneuve-lès-Avignon, Hospice),
iconographically based on St Augustine's
City of God. The Provençal landscape here
is so precisely depicted that the mountain
to the left of the Crucifix has been identi-
fied as *Cézanne's favourite motif, the
Mont-Ste-Victoire.

Quast, Pieter (1605/6–47) Dutch
painter of *genre and satirical subjects,
active mainly in The Hague and
Amsterdam (Hamburg, Kunsthalle;
London, National).

Queirolo, Francesco (1704–62)
Virtuoso Italian sculptor, born in Genoa
and active mainly in Rome and Naples. His
most famous work is the *allegory of *Disin-
ganno*, 'Deception unmasked': human
reason, in the shape of a winged boy,
freeing a man from the meshes of decep-
tion's net – realistically carved in marble –
in the Sansevero Chapel in Naples.
Queirolo's virtuoso *Disinganno* is matched
by the veiled female figure of *Modesty* by
*Corradini and the shrouded *Dead Christ*
by *Sammartino in the same chapel.

Quellin, Quellinus Important
dynasty of Flemish artists; their tangled
family relationships are all the harder to
unravel because different members of the
clan used different forms of the family
name. The patriarch of the family was the
sculptor **Erasmus Quellin the Elder**
(1548–1639) active in Antwerp (cathedral).
Of his two sons, **Erasmus Quellinus
the Younger** (1607–78) was a painter and
draftsman, an assistant to *Rubens in the
1630s. His painting style was much influ-
enced by *Van Dyck (Antwerp, St Jacobs-
kerk, Museum; Vaduz, Liechtenstein
Coll.). His younger brother, the sculptor
Artus I Quellin (1609–68) was an impor-
tant figure in both Flemish and Dutch art.
After a period of study in Rome under
the Italo-Flemish sculptor François du
*Quesnoy, he settled in Antwerp in 1639,
executing works which are among the
earliest *Baroque sculptures in the Nether-
lands (Antwerp, Plantin, St Pauluskerk;
Brussels, Cathedral). In 1650 he was called
to Amsterdam to provide the sculptural
decoration for the new town hall, now the
Royal Palace. He gathered around him a
large workshop including his cousin(?)
Artus II Quellin. While working on the
town hall he also carried out other
commissions, mainly funerary monuments
(Amsterdam, Rijksmuseum; Bokhoven
on the Meuse, parish church; Antwerp,
Musée, St Andreaskerk). He returned to
Antwerp in 1664.
 Artus II Quellin (1625–1700) has
been called a sculptor in search of new
forms. His independent works range from

dramatic Baroque *illusionism (e.g. Antwerp, cathedral; St Jacobskerk; Bruges, cathedral) through *classicizing draped figures in the manner of François du *Quesnoy (Tournai, cathedral) to a tender proto-*Rococo (Antwerp, St Pauluskerk). He was the master of Gabriel *Gruppello. His sons also became notable sculptors. The elder, **Artus III Quellin** (1653–86), also called Arnold by English writers and sometimes mistakenly identified as a son of Artus I, emigrated to England in the early 1680s. He executed some independent commissions for City patrons and at Court, and collaborated with Grinling *Gibbons on monumental statues (London, Trafalgar Square, Chelsea Hospital). The younger, **Thomas Quellin** (1661–1709) also worked for a while in England, but his main activity was in Denmark, where he executed many funerary monuments (e.g. Copenhagen, Frauenkirche).

The painter **Jan Erasmus Quellinus** (1634–1715) was a son of Erasmus Quellinus the Younger. He was in Rome by 1660; on his return to the Netherlands he became court painter to the Archdukes Leopold I, then Joseph I, at Malines. His large decorative landscapes, inspired by *Veronese, are typical of the classicizing Late Baroque in the Netherlands. His older brother, the engraver (*see under* intaglio) **Hubertus Quellinus** (1619–87) was in Rome in 1650. He specialized in prints after the works of members of his family including a series on the decoration of the Amsterdam town hall.

Quercia, Jacopo della (*c*.1374–1438) Sienese sculptor, in 1401 one of the contestants in the competition for the second bronze doors of the baptistry, Florence. His trial relief has not survived (*see* Ghiberti, Brunelleschi). His earliest extant recorded work is a *Virgin and Child* for Ferrara Cathedral (1406; Ferrara, Opera del Duomo), but far better known is the slightly later *Tomb of Ilaria del Carretto* in Lucca Cathedral (*c*.1406; mutilated and incompletely reassembled, 1429). The effigy, Burgundian in type, is celebrated for its haunting beauty, but almost equally remarkable are the winged *putti* with garlands decorating the sarcophagus,

dependent on ancient Roman prototypes. The mixture of *Gothic and *Classical idioms is typical of Quercia. At Lucca he executed also tomb slabs and an altar for the Trenta family (1416–22; S. Frediano). His first major work in Siena is the Fonte Gaia, an architectural/sculptural fountain complex facing the Town Hall (commissioned 1409; executed 1414–19; marble sculptural fragments now in the Town Hall, replaced by casts in the original location). Between 1417 and 1431 he participated also on the Siena baptistry font (bronze relief of *Zacharias in the Temple*, marble upper section of font, 1428–30; *see also* Ghiberti, Donatello). Quercia's most accomplished work is the central doorway of S. Petronio, Bologna (1425–38), left incomplete at the artist's death. *Michelangelo admired the reliefs of the Genesis scenes. The development of Quercia's style is thought to demonstrate his familiarity with the work of *Sluter at Dijon as well as with *Classical remains.

Quesnoy, du Family of Flemish sculptors, of whom the best known is François du Quesnoy (*see below*), although his father **Hieronymus I**, or **Jerome, du Quesnoy** executed the tabernacle of the church of St Martin in Aalst in 1604, and was the author of the much-loved *Manneken-Pis* in Brussels (original destroyed in 1817; the present statue is a copy), a fountain in the form of a urinating *putto*. Putti became the speciality of Hieronymus's brilliant oldest son, **François**, or **Francesco, du Quesnoy** or **Duquesnoy**, called *Il Fiammingo*, 'the Fleming' (1594–1643). Born in Brussels, in 1618 François received a government bursary to study in Rome, and spent the rest of his life there. He died in Livorno, on his way, reluctantly, to take up a post offered him many years before at the French court.

Much of François du Quesnoy's work is lost, for during his first years in Rome he was employed on small-scale sculpture for collectors, on wooden reliquaries, and in restoring ancient marbles. His study of Roman antiquity was further deepened by his participation in the collection of drawings after all known Roman and Early

Christian remains being compiled by young artists on behalf of Cassiano del *Pozzo. Upon *Poussin's arrival in 1624, *Il Fiammingo* became friendly with him, and they shared a house. He also came to know *Sacchi, and was generally drawn into a circle of serious-minded artists with antiquarian interests. In 1627–8 he was employed by the sculptor *Bernini on the sculptural decoration of the Baldacchino, the giant bronze canopy over the high altar of St Peter's in the Vatican.

His reputation established, he was chosen to execute one of the four gigantic statues planned by Bernini for the piers supporting the dome of St Peter's (the other three are by Bernini himself, and by Francesco *Mochi and Andrea Bolgi). Du Quesnoy's *Saint Andrew* (1629–40) is one of only two monumental statues by him, the other being *Saint Susanna* (1629–33) in S. Maria di Loreto, Rome. Although *St Andrew* successfully negotiates its enormous scale, it is the *Susanna* which became celebrated and widely influential. More or less disregarded today by all but specialists, *Susanna* seemed to contemporaries to have achieved the perfect synthesis of the study of nature and of antique ideals.

Like the *Susanna*, du Quesnoy's many reliefs and statues of *putti* (e.g. tombs of Andren Vryburch, 1629, and Ferdinand van den Eynde, 1633–40, both in Rome, S. Maria dell'Anima; *putto* frieze, Naples, SS. Apostoli; London, V&A; etc.) continued to exert their influence through the 18th century. Countless sculpted and painted *Baroque and *Rococo representations of children, cherubs and *putti* testify to the lasting importance of this facet of du Quesnoy's art. He was himself indebted, in addition to the direct study of the antique, to *Titian's painting of the *Worship of Venus*, or *Children's Bacchanal*, then in a Roman collection (1518–19, now Madrid, Prado). Towards the end of his life, however, he became increasingly attracted to the chubbier, even more vigorous *putti* of *Rubens, whose strain of Flemish *realism may have recalled to him his native roots. Du Quesnoy's brief career illustrates, among other things, the sometimes forgotten interdependence of painting and sculpture in the art of the past.

François's brother, **Hieronymus II du Quesnoy** (1602–54), was trained by him, and completed the commission given to François for the monument of Bishop Anton Triest in the cathedral of Ghent (*c.*1640–54). Hieronymus worked for several years in Spain, in Florence and in Rome, returning to the Netherlands after his brother's death in 1643. He was an eclectic sculptor, admired for a statue of *St Ursula* in Brussels, Notre Dame du Sablon, and three figures of apostles for the cathedral. He was condemned to death by strangling for having committed sodomy in a chapel where he was working.

Artus I *Quellin was also trained in François du Quesnoy's Rome workshop.

R

Rackham, Arthur (1867–1934) British artist and journalist, and an outstanding and well-remembered illustrator of, especially, fairy tales, with drawn and coloured pictures full of his intense, sometimes macabre imaginings and dexterously handled details of everything from clothes and furnishings to goblins and tree-trunks.

Radziwill, Franz (1895–1983) German painter associated with the *Neue Sachlichkeit movement. He studied architecture before turning to art studies. He became a professional painter after his military service ended in 1918, joined the Berlin *Secession and became friendly with *Dix and *Grosz. He worked in Dix's Dresden studio in the later 1920s, and in 1933 was asked to run a master-class in the Düsseldorf Academy until the Nazis dismissed him in 1935. Forbidden to work in Germany, he travelled in Africa and South America, but served again in the German forces during 1939–45. Subsequently his work became well known in his own country, and admired for its combination of *naturalism with unexpected pictorial events such as areas of decay in substantial-looking architecture and the threatening appearance of aeroplanes and of comets over peaceful landscapes.

Raeburn, Sir Henry (1756–1823) Outstanding Scottish portrait painter, active mainly in Edinburgh – the first native painter of international stature to find adequate employment in Scottish society (cf. Ramsay, who was based in London). First apprenticed to a goldsmith, and later employed as a *miniaturist, he seems to have been largely self-taught as a painter in oils, in which his earliest certain portrait is *George Chalmers*, of 1776 (Dunfermline Town Council). He made no preliminary drawings, but worked directly on the canvas in bold brushstrokes – his famous 'square touch' – which could degenerate into mere facility, but at its best

was admirably suited to the rugged Highland chiefs, bluff soldiers and advocates, who sat to him, and could encompass the tenderness more appropriate to his female sitters. Between 1784 and 1787 he visited London and Italy. He was elected to the Royal *Academy in 1815. In 1822, on the occasion of George IV's visit to Edinburgh, he was knighted, and in 1823 was appointed His Majesty's Limner for Scotland. There are many portraits by him in Edinburgh, National – including the famous and exceptional *Reverend Robert Walker skating on Duddingston Loch* (traditionally 1784, but more probably c.1794) – and in London, NPG.

Raffaellino del Garbo See under Andrea del Sarto; Bronzino.

Raffaello da Montelupo See under Michelangelo.

Raggi, Antonio See under Bernini.

Raimondi, Marcantonio See under Raphael.

Rainer, Arnulf (1929–) Austrian artist, largely self-taught and known mostly for self-portrait photographs, of his head or whole body, painted and scribbled over in demonstration of disgust. He teaches at the academies of Vienna, where he lives, and Stuttgart. He has exhibited frequently and widely, especially since the late 1960s, and has received many prizes.

Ramírez, Felipe See under Sánchez Cotán.

Ramos, Mel (1935–) American painter, prominent in the *Pop movement, specializing in representing figures, mostly taken from comics and pin-ups, in bold relief against a flat ground in a heraldic advertising manner. Recently he has also used typical landscape imagery drawn from postcards and posters, insisting always on

the contrast between his plastic formulations and the real world.

Ramsay, Allan (1713–84) Scottish-born portrait painter. Having worked in Rome with Imperali and in Naples with *Solimena (1736–8) he anticipated *Reynolds in wedding the Italian Grand Manner to British portraiture. His *Norman, Twenty-second Chief of Macleod* (1748, Skye, Dunvegan Castle) adapts the pose of the *Apollo Belvedere* to a contemporary subject some five years before Reynolds's *Commodore Keppel*. Ramsay further differed from other British portraitists in his extensive use of drawings to establish the pose, and in his special emphasis on *expressive gestures of the hands, for which many drawings exist (Edinburgh, National). From *c*.1739 Ramsay was settled in London, which was to remain his base, although many of his sitters were Scottish. In 1755–7, perhaps in reaction to the rising reputation of Reynolds, freshly come from Italy, Ramsay returned to Rome. This time, however, he drew at the French *Academy and studied the *classicizing frescos of the Bolognese school; on his return, he accentuated the delicacy and gracefulness of his style, perhaps to distinguish his work further from that of Reynolds. His portrait of his second wife (1557?, Edinburgh, National) is a fine example of his silvery later manner, as are *Lady Mary Coke* (1762, Mount Stuart) and his portraits of Queen Charlotte. He was recognized to excel in portraits of women, unlike Reynolds, who began to imitate Ramsay in this respect. After 1760, although not officially appointed King's Painter, he was almost exclusively engaged on royal portraits, many of them studio repetitions, mainly the work of assistants. He refused a knighthood, was not connected with the Royal Academy, and virtually ceased to paint after 1769, possibly as a result of an accident to his arm. Son of the author of *The Gentle Shepherd*, he himself turned to literary production in later life. The best collection of his pictures is at Edinburgh, National and Portrait; but there are excellent examples also in London, Foundling Hospital; NPG; Tate; V&A; Courtauld; and in other galleries and private collections throughout Britain.

Raphael (Raffaello Santi) (1483–1520) Celebrated Italian artist. Younger than either *Leonardo or *Michelangelo, he was associated with them in the formation of what we now call the High *Renaissance style. Personable, ambitious, prolific and an excellent organizer, until his premature death he suffered none of the professional setbacks which marked the careers of these two men. One of the greatest draftsmen in Western art, painter in *fresco, on canvas and panel, architect, designer of sculpture (*see* Lorenzetti) and of decorative ensembles, the favourite of successive papal courts, Raphael came to be enshrined in art *academies as the author of images which fused truthful imitation with *idealization: a paragon of *classicism. His designs of late collaborative works verging on *Mannerism were attributed to members of his workshop (e.g. frescos, Vatican, Stanza dell'Incendio, 1514–17) and even autograph paintings by him were modified in restoration, the better to conform to this notion of his *œuvre* (e.g. *Canigiani Holy Family*, *c*.1505–7, Munich, Alte Pinakothek). A sentimental view of the artist was also propagated through 'chocolate-box' reproductions of some of his compositions (e.g. *Madonna della Sedia*, *c*.1514, Florence, Pitti) and paintings and prints purporting to represent episodes of his life (*see* e.g. Ingres). His outstanding success with contemporaries and the idolatry of posterity brought about a reaction among some 20th-century viewers. However, he is now being seen again as the vigorous and eclectic artist who dramatically changed direction several times during his short working life. Far from being mainly the saccharine master of 'dear Madonnas' (the theme of the series of collectors' pictures painted *c*.1500–*c*.1510, in which he assimilated the lessons of Florentine art – e.g. Berlin, Staatliche; Edinburgh, National; Florence, Uffizi, Pitti; St Petersburg, Hermitage; Munich, Alte Pinakothek; Paris, Louvre; Vienna, Kunsthistorisches; Washington, National), Raphael was also a portraitist unsurpassed in lifelike representation (e.g. *Pope Julius II*, 1511–12, London, National; *Donna Velata*, 'Woman with a Veil', *c*.1512–15, Florence, Pitti; *Baldassare Castiglione*, *c*.1514–15, Paris, Louvre; *Pope*

Leo X with Cardinals Giulio de'Medici and Luigi Rossi, 1517–19, Florence, Uffizi). His mature altarpieces transformed static traditional schemata into new dynamic modes; the *Sistine Madonna* (*c*.1512–14, Dresden, Gemäldegalerie) anticipates *Baroque visionary effects. As a painter of mural-scale *istorie* (*see under* genres) he was unrivalled in invention, clarity of narration, richness of spatial, colouristic and light effects, and yielded little, in his mature works, to Michelangelo in dramatic power (e.g. Vatican, Stanza d'Eliodoro, *c*.1511–14; tapestries for Sistine Chapel, cartoons (*see under* fresco) 1515–16, London, V&A). As a designer of secular decoration he demonstrated freshness and verve (*Loggia of Pysche*, Rome, Villa Farnesina, *c*.1517–18). Raphael's studies of the antique also resulted in workshop recreations of Roman *grotesque decorations (Vatican, Logge, 1518–19, Loggetta, 1519; Cardinal Bibbiena's bathroom, 1516).

The facts of Raphael's training are uncertain. His father Giovanni Santi, a minor but cultivated painter of Urbino, died in 1494. Some time after that date Raphael left Urbino to join the studio of *Perugino. By 1500, the date of the first extant documentary record, he was already an independent master. Although the earliest securely known Raphael paintings closely resemble Perugino's (e.g. *'Mond' Crucifixion*, 1503, London, National) they also demonstrate a superior ability to construct a *perspective scheme – as can be seen through comparing Perugino's *Marriage of the Virgin* (1499–*c*.1505, Caen, Musée) with Raphael's painting of the same subject (1504, Milan, Brera). Raphael must thus have learned his methods of pictorial construction elsewhere than in Perugino's studio, presumably in Urbino. Giovanni Santi had been a friend of *Melozzo da Forlì, admired *Mantegna and must have known the works painted in Urbino in the late 1460s and 1470s by *Uccello and *Piero della Francesca respectively. All of these artists were famous students of perspective. What Raphael had not already learned from his father by the time of the latter's death, he may have done later from some other member of the Santi workshop. It has

been suggested that he remained in Urbino until as late as 1499, perhaps completing an apprenticeship with Timoteo Viti (1469–1523), an Urbinate artist who returned to the city in 1495 after studying with Francesco *Francia in Bologna. Raphael would then have joined Perugino as an independent artist to assist with specific commissions. In this capacity he would have been free to assist *Pintoricchio with designs for the latter's frescos in the Piccolomini Library, Siena Cathedral, 1504 (drawings, Florence, Uffizi, Contini-Bonacossi Coll.; Oxford, Ashmolean). Whatever the facts of the years 1494–1500, documents and paintings reveal that the years 1500–8 were spent working throughout Umbria and Tuscany. The paintings of *c*.1504–8 – altarpieces, Madonna and Child pictures (*see above*) and portraits – increasingly demonstrate Florentine, and especially Leonardo's, influence. Notable examples are the *Colonna Altarpiece* (*c*.1504–5, New York, Metropolitan), the *'Madonna of the Meadow'* (1505, Vienna, Kunsthistorisches); pendant portraits of *Angelo and Maddalena Doni* (*c*.1505, *c*.1506 respectively, Florence, Pitti). By 1507, when Raphael completed *The Entombment* for a funerary chapel in Perugia (now Rome, Borghese) the influence of Michelangelo and the antique is clearly discernible. The stages through which this painting was created can fortunately be traced in extant drawings (Oxford, Ashmolean; London, British; Florence, Uffizi).

In 1508 the artist ws summoned to the court of Pope Julius II to help with the redecoration of the papal apartments, the suite of three inter-connecting rooms in the Vatican palace known as the Stanze and the larger Sala di Costantino. The first artist to have been involved was Perugino (ceiling of the Stanza dell'Incendio); the second *Sodoma; other painters from Tuscany, Lombardy and the Veneto were also employed. By October 1509 Raphael had been appointed Writer of Papal Briefs and was in charge of the decoration of the Stanze. The first room to be decorated by him (the second in location) is now called the Stanza della Segnatura (1508–11); it contains the famous lunette-shaped wall

frescos known as the *Disputà* ('Disputation on the Holy Eucharist'); *The School of Athens*; *Parnassus*; *The Three Cardinal Virtues*, with, below, *Pope Gregory IX Handing out the Decretals* and *Emperor Justinian Handing out the Pandects*. The ceiling paintings make clear that these subjects illustrate the practitioners and exemplars of *Theology*; *Philosophy*; *Poetry*; and *Justice* or canon and civil law. The *iconography of this room, animated through Raphael's impulse to increasingly dramatic narrative, in fact resembles the more static emblematic imagery of Perugino's decoration of the Collegio del Cambio, Perugia, in which Raphael participated. The second room in which Raphael worked (and the third in location within the apartments) was the Stanza d'Eliodoro or of Heliodorus (1511–14). Here the wall decorations are more properly narrative, illustrating miraculous interventions in human history, symbolically parallel to events in Julius's career. The scenes comprise *The Expulsion of Heliodorus from the Temple*, an Old Testament subject; *The Freeing of St Peter*, from the Acts of the Apostles; the *Mass at Bolsena*, which illustrates a medieval miracle; the *Repulse of Attila the Hun from the walls of Rome*, a chronicle of the Early Christian Church. A portrait of Julius as either witness or participant is incorporated in each fresco; at his death in 1513, the newly elected pope, Leo X, was aptly featured as Attila's adversary, Leo I.

On the death of the architect Bramante in 1514, Raphael was appointed architect in charge of the rebuilding of St Peter's and papal demands on his time increased continually (*see above* for some of the projects executed 1514–20). Thus his role as executant in the final room, the Stanza dell'Incendio (1514–17) is lesser than in the other two, although all the designs seem to have been his. The fresco of *The Fire in the Borgo*, chronicling a 9th-century miracle of Pope Leo IV, demonstrates Raphael's mounting interest in archeology, his study of architecture, and a growing predilection for isolating expressive 'sculptural' figures and groups. Other scenes include *The Sea Victory at Ostia*; *The Coronation of Charlemagne* and *The Oath of Pope Leo III*. All refer to Leo X's Carolingian predecessors,

whose example also motivated Leo's commission of the narrative tapestries for the Sistine Chapel (*see above*), where Raphael – and Leo – were to compete directly with Michelangelo and his patron Julius II.

By now Raphael was obliged to employ many assistants. His studio practice, based on that of Perugino, involved a methodical approach to building up a composition step by step, from rough 'idea' sketches, studies for separate groups, studies from life of individual figures, with details of heads, hands, etc., to more finished compositional studies, squared enlargements and finally full-scale cartoons. Teams of assistants could intervene at various stages of the process under Raphael's guidance. Increasingly, they became executants of the finished painting, so that Raphael's drawings are a truer record of his intentions (as in the *Loggia of Pysche, see above*). The main exception is his mature portraiture, entirely, or nearly so, autograph (*see above*). His best-known assistants and his heirs were **Giovanni Francesco Penni** (1488–1528) and *Giulio Romano, who completed the Sala di Costantino after Raphael's death. Two younger artists, *Perino del Vaga and *Polidoro da Caravaggio, began their careers working on the Logge (*see above*).

Raphael's early fame was partly the result of his having been the first artist whose work was widely reproduced. The Bolognese engraver (*see under* intaglio) **Marcantonio Raimondi** (*c.*1480–1534), who worked in Rome, 1510–*c.*27, is the most famous of his interpreters through the medium of prints. Although for the great part of the 16th century the Stanze were inaccessible to artists as well as to the general public, their decorations became known through Marcantonio's engravings after preliminary drawings, sometimes differing in detail from the finished frescos.

Above all, however, Raphael's enduring popularity, at least until our own day, rests on his ability to formulate images of seemingly universal relevance. Sometimes intimate, at other times grand, his art at all times addresses itself to communication. Raphael, 'always imitating, and always orig-

inal', in *Reynolds's phrase, makes manifest to us our own aspirations.

Ratgeb, Jörg (*c*.1480–1526) German painter born in Swabia; he may have spent his *Wanderjahre* in the Netherlands, where he would have become acquainted with the work of *Bosch and *Patinir. He is recorded at Heilbronn, Frankfurt (*illusionistic murals in the Carmelite convent, 1514–18) and Herrenberg, where he painted his best-known work, the gruesomely *expressive *Herrenberg Altarpiece* (1519, Stuttgart, Staatsgalerie) which also shows his debt to *Grünewald. He was executed at Pforzheim for having taken part in the Peasants' Revolt.

Rauschenberg, Robert (1925–) American artist who turned from studying pharmacy to art studies in the USA and Paris that culminated at *Black Mountain College in 1948–9. He presented *happenings with *Cage and worked for Merce Cunningham's dance company, and made *Minimal paintings in white and in black before producing '*combine' paintings in which real objects obtrude in the illusionistic context of marks on a flat surface; also sculptural objects in which *assemblage and *collage come together with painting to offer disturbing, even macabre images, disrupting conventions of harmony and coherence that had survived modern developments. This work was seen as a new form of *Dadaism and especially as an assault on the sublimities of *Abstract Expressionism, yet the serial compositions and single compositions he made by means of transferring newspaper illustrations to paper or canvas show an open seriousness about real events and their context of values. His Dante illustrations (1959–60; New York, MoMA) offer a modern visual parallel to the medieval text. He has gone on, through several pictorial and sculptural media, sometimes using mechanical means to render them *kinetic, to explore the area lying, as he said, between art and life and to restate his aversion from all false parading of artistic superiority.

His first solo exhibition was in 1951 (New York), and he was soon exhibiting also in Europe; retrospective shows in major galleries began in 1963 (New York, Jewish M). In his attack on the rhetoric of Abstract Expressionism he has often been associated with Jasper *Johns.

Ravilious, Eric (1903–42) British artist and designer who studied painting at the Eastbourne School of Art and book illustration at the Royal College of Art in London, where Paul *Nash influenced his style and vision. He worked in Sussex and in Essex, developing a particular passion for the Sussex landscape. From 1940, as an Official War Artist, he produced a large number of exceptionally fine watercolours, with simplified forms but very exact drawing and tonal qualities, finding magical, even *Surrealist qualities in such scenes as coastal defences and the Sussex Downs in winter. The aeroplane in which he flew in July 1942 failed to return. The Towner Art Gallery in Eastbourne and the Imperial War Museum in London have good collections of his pictures.

Ray, Man (1890–1977) American multifarious artist, born in Philadelphia, originally a painter but subsequently a maker of significant sculptures and assembled objects, who became best known in Paris as a photographer and film-maker and was associated with *Cubism, *Dadaism and *Surrealism. His early work, in New York and influenced by what he saw in the Armory Show, was close to Cubism in its use of blockish figures. Humour was already a factor in his art when, in 1915, he met *Duchamp and became part of the collector Walter Arensberg's circle. His large painting, *The Rope Dancer accompanies Herself with Her Shadows* (New York, MoMA) consists of large, flat and sharp-edged colour areas that suggest paper collage and a few details that say little about, certainly do not represent, the dancer. The idea may have been stimulated by Duchamp's notorious *Nude descending a Staircase*; the execution is quite personal and makes Ray a forerunner of the semi-*abstract art of Stuart *Davis and of dramatic abstract colour areas in such artists as Clyfford *Still. He made Dadaist and proto-Surrealist works in 1916 and after, using and adapting objects from the real

world, like Duchamp but without imitating him. Among the best known is the metronome with a photograph of an eye attached to its clicking arm (*Indestructible Object*, 1923, now known only in replica), and his *Enigma of Isadore Ducasse* (1920), now known only in his own photograph of a sewing machine wrapped in a blanket and tied with string, in homage to the poet Lautréamont, a.k.a. Isadore Ducasse who in the early 1870s had written: 'beautiful as the chance meeting of a sewing-machine and an umbrella on a dissecting table', a quotation to be admired and repeated by the Surrealists.

In 1921 Ray moved to Paris. There he discovered by accident what he called the Rayograph and others call the photogram: an image formed by exposing a sheet of photographic paper to light and developer on which objects have been placed so as to protect the sensitized surface. The results are mysterious; the process is constructive. Ray left Paris in 1940 when the Germans occupied the city and moved to Hollywood until, in 1951, he returned to Paris. During that first Paris period, he was fully engaged in Dada activities in various media, including films, painting and drawing. He gave priority to photography, making Dada images and inventing new effects of a semi-abstract sort, but also being increasingly sought after for very fine, often seductive portraits (male and female friends) and nudes (female). He continued to paint and draw in many styles as well as make strange or satirical objects, often in a Dada spirit, and while some of the paintings of his last decades are relatively *academic, he continued to explore the world of humour and sedition in his drawings.

Rayism, Rayonism A form of near-*abstract and abstract painting developed by *Larionov in 1912–13, fusing *Futurist ideas of mobility and multiplicity of experience with an *Orphic stress on colour and light. He published his Rayist manifesto and a theoretical statement in 1913; the former was signed by a number of artists, but *Goncharova alone appears to have adopted his new method purposefully; both abandoned it after 1914.

Read, Herbert (1893–1968) British poet, critic and writer on art who championed the English *avant-garde of the 1930s and aided *abstract and *Surrealist art's establishment in Britain. A fine literary critic as well as writer on art and philosophy, he gave wide-ranging support to new art while fearing the nihilism he sensed in any return to *Dadaism. An idealistic anarchist, he gave much time to institutions and events that promoted modern art all over the world and to persuading the world of modern art's importance. He received many international honours. His acceptance of a knighthood in 1953 was seen by some as a denial of his anarchism but is better understood as a means of reinforcing his championship of modern art in a philistine society. He wrote many books about aspects of art and about art's function in society; *Education through Art* (1943) was probably the most influential. A major centenary exhibition, of art and documents, 'Herbert Read: A British Vision of World Art' was shown in Leeds in the centenary year of his birth; its catalogue is rich in information about Read's many activities and the rebuffs and acclaim he experienced.

readymade Term used by *Duchamp for the mass-produced objects he enrolled as his own works of art by selecting and sometimes signing them, without attending (he claimed) to any possible aesthetic quality in them. When he combined or otherwise altered such objects he named them 'adjusted readymades'.

realism An important but slippery term (*see also* next entry). Most uses of the word in discussing earlier art hinge upon the notion of resemblance: a work of art is said to be realistic if it resembles the world of appearances as perceived by a viewer from a particular vantage-point and in specific light conditions. Difficulties arise from the fact that the term may be applied with a bias founded in its use in medieval philosophy. That is, realism in art may consist of representing 'universals' rather than 'particulars': the geometric forms and mathematic principles thought to underlie the ever-changing, 'accidental' world of appearances.

In this usage, realism comes close to its seeming contrary, *idealization. The supreme example of an artist striving to reconcile both notions of realism is *Leonardo da Vinci. His work, however, hardly seems to the modern viewer to be realistic. The more commonsense usage, implying observation of, and resemblance to visible phenomena, has, from the 17th century, implied also a form of *social realism. *Genre painting, depicting the behaviour of 'people like ourselves or worse than ourselves' in contemporary dress and settings, is said to be realistic. This usage may have a polemical edge. For example, portraying Jesus and the Apostles in their actual social milieu, as carpenter and fishermen etc, is a form of realism which may run counter to notions of *decorum (see, e.g. Caravaggio). Artists specializing in contemporary imagery, especially of the 'lower' classes, are thought of as realists. Naturalism, which denotes the optically convincing depiction of different surfaces under various conditions of illumination, is a particular kind of realism (see, e.g. Van Eyck). In Italianate art theory, it may denote 'slavish adherence' to observation of the model, lack of imagination or invention (see under disegno). The term can be used to mean the refusal to idealize, the wish to present 'unvarnished truth', as in 'warts and all' portraiture.

*Courbet exhibited his work under the keyword 'Realism', indicating not only visual verisimilitude but also his insistence on subjects that existed in the world of normal experience – thus excluding divinities and fictional subjects – and referred to the ordinary lives of ordinary people rather than to the great and privileged few. His Realism created a late 19th-century movement deserving the same name, notably in Germany, and there have been echoes of it since, always implying an assertion of social relevance.

But 'realism' has also been used many times to contradict this tradition, often to draw attention to the use of real (as opposed to exclusively artistic) methods and materials, each present in its own right and not to provide an illusion of something else. Thus *Gabo titled his manifesto in support of *constructed sculptures the Realist Manifesto, and in 1939 the Galerie

Charpentier in Paris began a series of exhibitions of Constructive art and geometrical abstract painting under the title 'Salon des Réalitiés Nouvelles'.

Redon, Odilon (1840–1916) French painter, a *Symbolist admired especially for his series of black and white *lithographs, but in his later years known also as a painter of easel paintings as rich in colour as in fantasy. He was born in Bordeaux. He studied in Paris with *Gérôme but found better instruction in the words and example of the graphic artist Rodolphe Bresdin. In 1878 *Fantin-Latour introduced him to lithography, enabling him to use his favourite medium, black charcoal, to produce multiple prints. His first suites followed soon after, notably *Dans le Rêve* in 1879, *A Edgar Poe* 1882, *Hommage à Goya* 1885, *A Gustave Flaubert* 1889 and *Les Fleurs du Mal* 1890. In these his intense imagination, at times macabre, often profoundly poetic, revealed itself in dramatic drawings in which humanity was taken close to *caricature. His later suites, including *Rêves* 1891 and *The Apocalypse of St John* 1898, are more harmonious and richly modelled. After 1900 he gave priority to paintings. In some of these, flower pieces or portraits with flowers and at times religious themes, he pushed colour to almost hypnotic levels of intensity. He showed in the last *Impressionist exhibition of 1886 and in the 1890s was recognised as a master by the young *avant-garde. The 1904 *Salon d'Automne included a Redon exhibition and his paintings made a strong impression in the *Armory Show.

Redouté, Pierre Joseph (1759–1840) Belgian painter who worked in Paris as professor at the Jardin des Plantes (Botanical Gardens), wrote and illustrated botanical books and painted flowers for the Bourbon court and for Napoleon's Empress Josephine.

Regionalism A more focused tendency within the wide range of American painters intent, in the 1930s and 40s, on portraying their country and its life in their work, representing scenes characteristic of

the American Midwest and South by means of *naturalism and sometimes *realism. The Regionalist painters protested in their art against the European influences exhibited in the *Armory Show and promoted by *Stieglitz, and spoke through their art for the old, rural ways of America, as against its urban, industrialized and increasingly glitzy present. *Benton was the most assertive among them; *Wyeth a quieter supporter. *Hopper was counted among them but his account of the psychological pressures of provincial existence is not truly Regionalist.

Regnier, Nicolas (1591–1667) Flemish-born painter from Maubeuge, mainly active in Italy, where he was called Niccolò Renieri or Ranieri. He was a pupil of Abraham *Janssens in Antwerp; around 1615 he went to Rome and perhaps studied there with *Manfredi. He settled in Venice – where he became friends with Johann *Liss – some ten years later. All four of his daughters became painters. His early style was based on that of *Caravaggio, but became progressively more elegant under the influence of Guido *Reni; he painted mainly religious works and portraits, sometimes combining the two, as in his *Madonna in Glory with Three Advocates of the Republic of Venice* in the Avogaria of the Doge's Palace, Venice; other works, Venice, Scuola di San Marco; various churches; Hull, Ferens.

Reinhardt, Ad (1913–67) American painter, an unwitting precursor of *Minimalism and an apostle of extreme reduction in image-making, prohibiting all personal expression other than that shown in making such a choice. Trained in art history and in painting, his painting was *abstract from the first and he was a member of *American Abstract Artists during 1937–47. His idiom changed markedly, from a *Mondrian-based geometrical structuring to free-hand marking of the canvas with bright forms, before, in the 1950s, he turned to using darker colours and broad geometrical divisions, ending with a broad Greek-cross form set in a square of an almost imperceptibly different tone of the same rich darkness. Fired by some of the

principles and qualities of Oriental art and crafts, he sought absolute quietness and emptiness; at the same time his paintings (which it is impossible to reproduce well) confirm the *iconic plenitude and force of his work. Like *Malevich's *Black Square* of 1915, Reinhardt's paintings, half a century later, give us the option of seeing them as nihilistic statements of nothingness or as summations of all pictorial imagery. His own extensive verbal statements, presented with unusual wit and acerbity, insist on distinguishing art from life, as in the characteristically titled essay 'Art in Art is Art as Art' published in 1966. He had exhibited frequently from 1943 on, and that year, in which Minimalism appeared as a movement, he had his first retrospective (New York, Jewish M).

Relief prints These are made by cutting away from between lines drawn on a smooth surface; each side of the line has to be cut separately. Ink is then pounded or rolled on to the upstanding lines and printed on a sheet of smooth, or damp, paper laid face down on the inked surface. Originally, the back of the paper was rubbed to produce an impression; from c.1450 printing presses have been used. The height of the lines to be printed can be deliberately varied, so as to increase or decrease the pressure of the press, and thus the darkness of the lines printed, in particular places. The lines in a relief print, in contrast to those of an *intaglio print, are sunk into the paper.

Relief prints can be made from a wood block, usually one cut with the grain ('side wood'). Woodcuts are the oldest of the relief processes. Originally used for printing textiles, they have been applied to printing pictures since c.1400. Metal cuts have been used from the late 1400s. In these, engraver's tools (*see under* intaglio), or decorative punches may be used to remove the parts that are not to print. Many early metal cuts are thus highly patterned, after the manner of goldsmiths' work.

Chiaroscuro prints are relief prints, usually woodcuts, printed from several blocks: a line block is usually printed last; the effect resembles that of a wash drawing.

Rembrandt Harmensz. van Rijn (1606–69) The greatest Dutch painter and graphic artist and one of the leading European masters of the 17th century. Remaining all his life in his native Holland, he rivalled his older contemporary, the much-travelled Fleming *Rubens, in his grasp of the Italianate Grand Manner, and surpassed him in psychological profundity and originality. While social and political circumstances deprived Rembrandt of monumental religious commissions, and he received only one commission for a large-scale public history painting (*see under* genres); (*Conspiracy of Claudius Civilis*, 1661/2; fragment, Stockholm, Museum) he became one of the grandest interpreters of biblical narrative in the history of art; his paintings of mythology and ancient history are equally dramatic, although fewer in number and sometimes obscure in significance (*Rape of Ganymede*, 1635, Dresden, Gemäldegalerie; *Danaë*, 1636, St Petersburg, Hermitage) and his group portraits are composed in the focused and psychologically compelling mode of heroic narrative (*The Anatomy Lesson of Dr Tulp*, 1632, The Hague, Mauritshuis; *The Night Watch*, 1642, and *The Sampling Officers of the Cloth Drapers' Guild*, 1661/2, Amsterdam, Rijksmuseum).

The eighth of nine children of a miller, Rembrandt was intended by his parents for a learned profession, but after grammar school and some short time at the University of Leiden he was apprenticed, first to an unknown painter, secondly to Jacob van Swanenburgh, whose effect on his *oeuvre* is undetectable. The most lasting influence on Rembrandt (with the exception of *Elsheimer and Rubens, who were never his masters) was his third teacher, the Italianate Amsterdam painter Peter *Lastman. After six months with Lastman *c*.1624, Rembrandt returned as an independent master to Leiden, where he worked closely with another former pupil of Lastman, Jan *Lievens. At this time he specialized in small but dramatic narrative paintings, many of them based on the Scriptures, which were admired for their emotional truthfulness and intensity (e.g. *Repentance of Judas*, 1629, pc). He took on the first of his many students, Gerrit *Dou, in 1628.

At about this time Rembrandt also began to form his extensive collection of prints by 16th- and 17th-century northern and Italian masters, and began his own experiments with the comparatively new medium of etching (*see under* intaglio) in emulation of Hercules *Seghers and Elsheimer. Only from *c*.1631 did he begin to execute commissioned portraits, although he had painted portrait compositions of himself and of members of his family.

In 1631/2 Rembrandt moved from Leiden to Amsterdam, where he rapidly gained popularity as a portraitist and began to execute narrative paintings on a large scale, influenced by engravings after Rubens. Like his contemporaries, he experimented with sensational and violent scenes (e.g. *Blinding of Samson*, 1636, Frankfurt, Städel). The most important commission of this first Amsterdam period, however, was a *Passion* series for Frederick Henry of Nassau, Prince of Orange. While only under a metre high, these vertical lunettes intended for the decoration of Frederick Henry's new palace at The Hague were in a format, and of subjects, associated with monumental altarpieces, and in them Rembrandt was able both to acknowledge his debt to Rubens and to compete directly with the Flemish master (five *Passion* scenes, *c*.1633–45, Munich, Alte Pinakothek). In 1634 Rembrandt married Saskia van Uylenburgh (*Saskia in Arcadian Costume*, St Petersburg, Hermitage; London, National). In 1639, to mark his prosperity and rising social status, he bought a large house – the factor mainly responsible for his insolvency in the mid-1650s.

Rembrandt's popularity as a portraitist began to wane in the early 1640s – albeit not, as used to be thought, as a direct result of the supposed unfavourable reception of *The Night Watch*, more properly called *The Company of Captain Frans Banning Cocq and Lieutenant Willem van Ruytenburch*, which transforms the traditional full-length Amsterdam group portrait into a dynamic composition unified through a dramatic use of *chiaroscuro. Taste in Amsterdam now veered towards the lighter and brighter colour key of *Van Dyck, and most of Rembrandt's pupils adapted to the

elegant new manner, whilst Rembrandt himself continued to exploit, although in a less exuberant, more *classical mode, extremes of light and dark tonality. In this decade, especially after Saskia's death in 1642, Rembrandt turned to landscape – observed landscapes of the Dutch countryside in drawings and etchings, romantic fantasy landscapes in paintings. But commissioned works never actually ceased altogether, and some of his most moving and evocative portraits, etched or painted, date from the late 1640s and 1650s (*Jan Six*, 1647, etching, London, British, etc.; *Jan Six*, 1654, Amsterdam, Six Coll.). There was also demand for his work abroad: his etchings were collected internationally, and Don Antonio Ruffo, a Sicilian nobleman, ordered a painting of a philosopher in 1653 (*Aristotle with the bust of Homer*, New York, Metropolitan), of *Alexander the Great* in 1661 (unidentified) and a *Homer* in 1663 (The Hague, Mauritshuis). Double and group portraits were commissioned from him privately (*Jewish Bride*, c.1661, Amsterdam, Rijksmuseum; *Family Portrait*, c.1668, Brunswick, Museum) and for public institutions (*Anatomy Lesson of Dr Deyman*, 1656, fragment, Amsterdam, Rijksmuseum).

Neither commissions nor the sale of etchings, nor the fees of pupils, sufficed in the 1650s to rescue Rembrandt from insolvency, aggravated by the general economic depression. His extensive collection of curios and works of art was sold in 1657. His and Saskia's only surviving child, Titus, b.1641, and Rembrandt's housekeeper and companion, Hendrickje Stoffels, formed a limited company employing him as painter, to evade the regulations of the artists' guild regarding insolvent members. His last years were embittered not only by poverty and litigation, but finally also by the death of Hendrickje in 1663 and of Titus in 1668. Rembrandt was left alone with his 15-year-old daughter by Hendrickje, Cornelia. But the tragedies of his life had no adverse effect on his art. From the 1620s he had used his own face as a model, at first to study expression and the effects of light, later probably to experiment with various modes of portraiture. In his last years these self-portraits became genuine portraits of self, confessional and introspective; they stand, together with one of his last narrative paintings, the *Prodigal Son* (c.1669, St Petersburg, Hermitage), among the greatest monuments of European culture, as much spiritual statements as marvels of technical skill. Rembrandt's mastery of human expression encompassed in particular transitional emotional states (e.g. *Denial of St Peter*, 1660, Amsterdam, Rijksmuseum) and his evocation of the inner life of men and women has never been surpassed. There are paintings by this prolific artist in most major collections, and etchings and drypoints in most print cabinets.

Remington, Frederic (1861–1909) American painter who pictured life in the American West in so lively and heroic a manner that his image of the 'Wild West' imposed itself on the world and provided the base for Hollywood's subsequent development of it. In his later years he also made sculpture. It is said that his *Bronco Buster* exists in over three hundred casts. Ogdensburg, New York State, has a Remington Museum.

Renaissance (French, rebirth) The use of the term to denote a period in European history was introduced in 1855 by the French historian Jules Michelet. Art-historical usage reflects Michelet's chronological definition. Despite disagreement about precise dating, scholars agree that the term applies to art in Western Europe c.1300/c.1400–c.1520/50/c.1600. The earlier dates encompass a time of rapid urbanization, of change from a feudal and ecclesiastical society of status to a capitalist contract society in which secular institutions played an increasing role. The 16th century, in addition, witnessed the rise of the centralized state and national consciousness. Renaissance art thus comes to include a wider range of *genres than medieval art, evolving such secular forms as state and domestic portraiture and the forerunners of modern types like landscape and *still life.

More contentiously, however, the word also functions as a style label, following its use in 1860 by the German-speaking Swiss

scholar Jakob Burckhardt to describe Italian civilization in the early modern period. His usage popularized the notion of cultural rebirth, first formulated as long ago as the 9th century at the Carolingian court (*renovatio*) and applied by Italian writers of the 14th to the 16th centuries to the arts and letters of their own day (e.g. *Vasari, *rinascità*). The two main components of this idea are the 'return to Nature' and the 'revival of *classical antiquity'. Research has clearly demonstrated that in neither of these did Renaissance art break with its immediate past; that the northern European style known as *Gothic had had both naturalistic and classicizing modes, and that the classical tradition had survived in Italy without a radical break. Nonetheless, common parlance still defines Renaissance style as a new preoccupation with the representation of natural appearances and with the formulae of Graeco-Roman art and architecture. This definition, however, not only postulates a disjuncture between medieval and early modern art, but also presupposes that Italy took the lead in the 'rebirth' of art while northern Europe followed – an interpretation which has been, and continues to be, challenged.

In practice, most professional art historians now avoid the use of the term as a label denoting a single style or set of stylistic determinants. According to this more shaded interpretation, artists north and south of the Alps were responding to the new social functions required of art in the period characterized in the opening paragraph of this entry, whilst building on their respective medieval traditions. An interchange of influences between northern Europe and Italy is recognized. Scholars concede to 15th-century Netherlands the primacy in pictorial *naturalism – notably the representation of light through space and reflected from different surfaces (Jan van *Eyck). To 14th- and 15th-century Tuscany they assign the main role in forging monumental narrative, in reconciling optical accuracy with formal order, *expression with *idealization (*Giotto, *Masaccio, *Ghiberti, *Donatello). New techniques (oil painting, monumental *bronze casting, etc.) and new inventions (such as that of linear *perspective), as well

as the adaptation of classical figures and poses, are viewed as instrumental to these ends. The term Renaissance itself tends to be modified to lend it some greater descriptive precision in this dual period and style-label sense. Thus Early Renaissance is usually understood to apply to Tuscan art *c.*1400–*c.*80; High Renaissance to art in Florence and Rome *c.*1500–*c.*20, and in Venice *c.*1510–*c.*80; Northern Renaissance to art *c.*1400–*c.*1550 north of the Alps. *See also* Mannerism.

René of Anjou, Master of (active *c.*1460–65) Outstanding *illuminator working for René, Duke of Anjou, ruler of Provence, King of Sicily and Jerusalem, at his court at Angers, once thought to be René himself – but although the Duke was an amateur painter it is unlikely he would have had the technical competence and leisure to complete the works for which this distinctive artist is known: the illustrations to the *Book of Tourneys* of *c.*1460–5 (Paris, Bibliothèque Nationale) and to the Duke's own *allegorical romance, completed in 1457, the *Livre du Cuer d'Amour Espris (Book of the Heart Seized with Love)* (Vienna, Österreichische Nationalbibliothek), source of the unknown artist's alternative name, Master of the Cuer d'Amour Espris. Neither manuscript gives a definitive clue to the Master's nationality or training. The *Book of Tourneys*, a rule book for staging tournaments, the pageants of late-medieval chivalry, is delicate and sketchy, heightened with translucent watercolour; its stockily-proportioned figures have affinities with those of *Fouquet. The concern with artificial and natural light demonstrated in the *Cuer d'Amour Espris* (notably in the famous night scene of Love giving the Duke's heart to Desire, fol.2, and in the dawn scene of Heart at the magic well, fol.15), might point to a Netherlandish source but has also been compared with *Piero della Francesca.

Reni, Guido (1575–1642) One of the greatest Italian painters of the 17th century, a subtle colourist, a master of graceful line and composition. His unique synthesis of *naturalism and *idealizing *classicism was an important influence. Although few, his

portraits are notable for psychological penetration (*Papal Portrait*, Wiltshire, Corsham Court). From the 19th century until recently, his reputation was tarnished by the stereotypic, sentimental production of his studio, mostly the work of assistants, from the last 10 years of his life.

A Bolognese, trained mainly by Lodovico *Carracci, Reni followed Annibale Carracci to Rome shortly after 1600; he remained there 1600–4; 1607–11; 1613–14; quickly gaining the status of an independent master. His early works fuse classical principles of composition with the dramatic power and use of light of *Caravaggio. Becoming the protégé of Cardinal Scipione *Borghese, nephew of Pope Paul V and a rapacious art lover, Reni received important *fresco commissions (among them *St Andrew adoring the Cross*, S. Gregorio al Celio, 1608; Quirinal Palace, Chapel of the Annunciation – with Bolognese assistants – 1609–12; Palazzo Rospigliosi, Casino dell'Aurora, *Aurora* ceiling, 1613–14) which made him a leading exponent of the style sometimes known as Early *Baroque Classicism. In 1612 he was called to Naples; but in 1614 he renounced his southern Italian successes to return to his native Bologna, remaining there except for an abortive trip to Naples in 1621/2, to decorate the Cappella del Tesoro in the cathedral. He abandoned the project when one of his assistants was assaulted; it was later completed by another Bolognese, *Domenichino.

Back in Bologna Reni executed masterful altarpieces (Bologna, Pinacoteca) and secular collectors' pictures (most leading galleries and many pc) and a series of influential pietistic images conforming to Counter-Reformation *iconography, and echoed in countless devotional prints. A new, lighter and cooler colour scheme pervades his work from *c*.1625. The last pictures have a curious chalky quality and may be unfinished.

Renieri or **Ranieri, Niccolò** *See* Regnier, Nicolas.

Renoir, Pierre-August (1841–1919) French painter, a leader of the *Impressionist movement who soon repudiated its aims. Born in Limoges, son of a tailor who moved the family to Paris in 1844, Renoir worked first as a painter of porcelain, fans and blinds before entering the studio of *Gleyre in 1861. There he met *Bazille, *Monet and *Sisley who became his friends and at times supporters since Renoir lacked all income. In 1862 he also entered the Ecole des Beaux-Arts. Already attracted by the voluptuous painting of 18th-century France, he was influenced by *Courbet and the *Barbizon painters. He showed occasionally in the *Salon but his submissions were rejected repeatedly until 1868 when an outdoor portrait of his mistress, *Lise with a Parasol* (1867, Essen, Folkwang) met with interest. In 1869 he and Monet painted views of a bathing place, La Grenouillière, developing the technique of distinct brushstrokes associated with Impressionism, but in 1870 he exhibited a nude, *Bather with Griffon* (São Paulo, MoA), clearly indebted to Courbet, and a woman dressed in North African costume, *Woman of Algiers* (Washington, National), an obvious homage to *Delacroix. In 1873 he showed a large and elegant double portrait of a lady and a boy riding in the Bois de Boulogne. But he continued to associate with Monet and in some of his paintings the Impressionist technique predominates. In 1874 they painted the same views of the Seine at Argenteuil, and they both painted Monet's wife and son seen in their garden in Argenteuil (Washington, National). His *Nude in Sunlight* (1875), one of several such studies done about this time, marks the emergence of a typical Renoir, the sensuous depiction of a young woman, all flesh and touchable skin under broken sunlight, *naturalistic in its rendering of surface and volume and idealistic in his reduction of the model to the full-bodied, small-headed and characterless type he tended to find even in portraits. Another typical work is his *Ball at the Moulin de la Galette* (1876), a scene of ordinary people in an open-air dance hall, in which colour and movement under broken sun and artificial light are emphasized while the figures are generalized towards uniform charm. Studied on site, the picture was painted in a nearby studio. His *Portrait of Mme Charpentier and her Children* (1878); (New York, Metro-

politan) is luxurious in colour and delicate brushstrokes but also a firm composition doing honour to a well-known society lady; it received some praise when shown at the Salon but was also criticized for its drawing and sketchy execution.

In 1881 Renoir, now selling some of his work to the dealer Durand-Ruel, was able to go on two significant journeys, to Algeria in emulation of Delacroix's search for colour and the exotic, and to Italy in the spirit of *Ingres. He took with him to Italy a young woman who later became his wife; she is the model in two paintings of a blonde bather seen nude in sunlight, full of figure and silhouetted against the contrasting sea (Williamstown, Clark Art Institute, and pc). Their fullness reflects both his personal preference and his search, now, for a monumental image; his models for this were *Raphael and the same Graeco-Roman murals that had stimulated Ingres. He continued his treatment of *genre scenes in three life-size canvases, *Dance at Bougival* (Boston, MFA), *Dance in the City* and *Dance in the Country* (all 1882–3); but such subjects now faded from his output, though when the French state commissioned a painting he worked long and successfully on variations on a genre composition, *Young Girls at the Piano* (1892), echoing elegant 18th-century domestic scenes. That period is also behind the subject that now came to interest him most, nude young women single or in groups as 'bathers', at once modern and ancient. *The Children's Afternoon at Wargemont* (1884; Berlin, National) is a large group portrait of the daughters of a diplomat; it is pale and sparse, and very firmly drawn and composed. It may be significant that *Neo-Impressionist formality was attracting *avant-garde attention at this time. The same cool and controlled design and handling of the paint mark his large painters of nudes, *Bathers* (1887; Philadelphia). This is without the spontaneity, light and atmosphere promised by Impressionism; he was open about his impatience with the movement and had ceased sending to the group exhibitions.

*Fragonard, *Watteau and *Rubens, and also *Corot, now exercised marked influence as Renoir struggled to find ways of ennobling the type of young woman that obsessed him by enshrining her in rich and traditionally valued types of composition. He adopted the Venetian type of the reclining nude for decorative panels and in 1908 produced an openly mythological subject in *The Judgment of Paris* (Japan, pc; a 1913–14 version of the subject is in Hiroshima MoA). He now spent most of his time in the south of France. Arthritis came close to crippling him; he walked with difficulty and his brushes had to be tied to his wrists. This alone may have led to a softer and broader treatment of forms, but he was also searching for a simpler style in which rich surfaces could go with clear but not over-emphatic forms. He worked directly on one sculpture, a life-size bronze figure titled *Venus Victorious* and thus a variation on the same theme; he made other sculptures working through an assistant. His last major painting was *The Bathers* (*c.*1918–19): full, opaque bodies with tiny heads in a delicate setting of trees, grass and water.

In the 1880s, largely through the action of Durand-Ruel, Renoir's reputation had spread abroad, notably to Brussels and New York. Financial ease came slowly. He bought a house in his wife's home town of Essoyes in 1895 (they married in 1890, five years after the birth of their first son); in 1907 he bought some land in Cagnes and built a house there. Often dissatisfied with his work, but especially in the 1880s, he destroyed many paintings. Conservative in his general views, he could seem ungenerous in his response to the art of contemporaries and younger artists. Notwithstanding the evident sensuality of his art, he appears to have been a nervous, uncertain man, troubled by conflicts between his domestic arrangements and the well-to-do society he sought in Paris. Some have said that his art reveals a dislike of women or even a general misanthropy; it is safer to see him as a painter working passionately within a self-imposed limit, that of representing and giving pleasure by means at once personal to himself and linked to the great hedonist art of the past. His work is best seen in the Musée d'Orsay, Paris (location of paintings mentioned above without other indication), but it has spread around the globe, major

and minor examples having achieved enormous popularity in recent years.

Repin, Ilya (1844–1930) Russian painter, preeminent among the *Wanderers. Of simple origins, he was trained in *icon painting before going to the St Petersburg *Academy in 1864. His talent was noted there but he came under the influence of *Kramskoi and gave as much attention to painting scenes of contemporary life as to *History painting, always committing himself to elaborate preparatory studies. He was awarded a travel scholarship by the academy but did not go abroad until he had finished his first great polemical painting, *The Bargehaulers* (1870–3; Leningrad, Russian), which shows eleven men towing a barge up the Volga, in a *realistic but also monumental composition that stresses their humanity as well as their enslavement. In 1873 he went to Vienna and Rome, then settled in Paris where he was drawn to *Impressionism though critical of its slight themes. He brought back to Russia a style emulating the open-air *naturalism of *Manet. He painted a number of vivid portraits, including those of Mussorgsky (1881) and Tolstoy (1887), but his chief efforts continued to go to narrative scenes highlighting moral issues. *Easter Procession in Kursk* (1880–3) is a large composition symbolizing Russia's social problems in a crowd scene; *They did not expect Him* (1884–8) is a finely observed domestic scene given moral weight by its subject, the return of a revolutionary to his family after years of exile; *Ivan the Terrible and his Son Ivan* (1885) is a macabre historical moment portrayed with poignancy.

In 1893 Repin was made a professor at the academy; in 1898 its director. He developed a style close to Impressionism for snapshot-like portraits and, after 1917 when he moved to Finland, experimented with *Neo-Impressionism. The Tretyakov Gallery in Moscow has a substantial Repin collection, including the paintings mentioned here without location.

repoussoir (from French *repousser*, to push back) Any pictorial motif which enhances the sense of spatial recession. In landscape painting, for example, a tree or architectural form stretching from the bottom of the picture field to nearly the top, and painted dark against light in its upper portion, has the effect of 'pushing back' the sky and the other landscape incidents into the far distance. In portraiture, a similar though less extreme effect is achieved by a balustrade interposed between viewer and figure portrayed.

reproductive prints Said of prints (*see under* intaglio or relief prints) which reproduce paintings. *Rubens is the foremost painter whose pictures were reproduced by engravers working under his supervision. *See also under* Bolswert, Schelte à; Jegher, Christoffel; *fecit*.

Restout, Jean the Younger (1692–1768) French painter, mainly known for his austere and deeply felt religious works, which form a link between the *Baroque altarpiece and the revival of moralizing history painting (*see under* genres); (*see also*, e.g. David). He was the most important member of an artistic dynasty from Normandy, trained as a child by his father, **Jean Restout the Elder** (1663–1702); after *c.*1707 he studied in Paris under his maternal uncle, Jean *Jouvenet. His son, **Jean-Bernard Restout** (1732–1797) was a painter and has left an uncompromisingly severe portrait of his father (Versailles, Musée).

Through Jouvenet, Restout looks back to the 17th-century French religious painting of *Le Sueur. Works such as the *Ecstasy of St Benedict* and its famous pendant, the *Death of St Scholastica* (1730, Tours, Musée), *St Vincent with St François de Sales* (1732, Paris, Ste-Marguerite) or the *Martyrdom of St Andrew* (1749, Grenoble, Musée) combine rigour of composition, intensity and truthfulness of expression, with hallucinatory vividness and historical accuracy of detail. His few portraits and secular history paintings are equally sober but emotionally compelling (e.g. Stockholm, Museum; France, Véziers Coll. respectively). He became Director of the French *Academy in 1760 and was the teacher of, among others, the neo-Baroque painter **Jean-Baptiste-Henri Deshays**

(1729–65) hailed by Diderot in 1761 for his moral grandeur.

retable or **reredos** A *dossal or vertically proportioned altarpiece set above and behind the altar table. Retable and reredos are terms usually reserved for the elaborately carved *polyptychs produced, e.g. in Spain and in pre-Reformation Germany, while dossal and altarpiece normally denote an altar decoration in which the painted elements predominate.

Rethel, Alfred (1816–59) German painter and print-maker, trained in Düsseldorf under *Schadow. An ambitious *history painter, Rethel is best remembered for his woodcuts done, he said, 'in the old style', that is the style of *Dürer and his age but to his own contemporaries expressive of the terrors of their own time, notably in *Another Dance of Death, in the year 1848* (1849) which commented allegorically on the 'year of revolutions'. Generally, his work has a rare tragic intensity. He ended his days in an asylum for the insane.

Reynolds, Sir Joshua (1723–92) Through his example as a painter, his position as first President of the Royal *Academy (1768–92), the 15 *Discourses on Art* he delivered there (1769–90), his intimacy with men of letters, and his knighthood in 1769, Joshua Reynolds is without doubt the artist who did most to raise the status of the visual arts in Britain and to draw the British school out of its lingering provincial isolation.

The son of a grammar-school headmaster and former fellow of Balliol, Reynolds was apprenticed at 17 to *Hudson, although roundly declaring that 'he would rather be an apothecary than an *ordinary* painter'. In search of the *extraordinary* dimension, after some years of independent practice as a portraitist in his native Devon and in London (1743–9) he set out for Italy with his friend Commodore, later Admiral and Viscount, Keppel, whose portrait was later to secure Reynolds's reputation (1753/4, Greenwich, Maritime). He was to define his goal most succinctly perhaps in his *Third Discourse* (1770): '. . . it is not the eye, it is the mind, which the

painter of genius desires to address . . . his great design [is] of speaking to the heart . . . [This] is that one great idea, which gives to painting its true dignity, which entitles it to the name of a Liberal Art, and ranks it as a sister of poetry.'

In Italy he strove to master the principles and not merely the devices of the great artists of the *Renaissance and antiquity. While believing that *Ideal Beauty and history painting (*see under* genres) were the highest manifestations of art, he was practical enough to recognize that the British painter could earn a living only through portraiture. Upon his return to London in 1752, therefore, he worked to elevate the British tradition of portraiture by marrying it to elements of the Grand Style – a task in which he had been anticipated in some measure by *Ramsay. Reynolds's portraits of the 1750s were, however, more vigorous and intellectually penetrating than Ramsay's and he enjoyed greater success, albeit not at Court. His citations of *Classical and Renaissance formulae, always at this period tactfully adapted to the individual sitter, extended the symbolic references of the paintings without compromising either likeness or intimacy (*see* e.g. *Georgiana, Countess Spencer and her daughter*, 1760/1, Althorp, which employs a Madonna and Child design to haunting effect). From the 1760s, however, Reynolds began to seek a more overt rhetoric and to combine portraiture yet more closely with history painting, particularly in those pictures intended for public exhibition. One of the earliest of such works is the portrait of his friend Garrick, the famous actor/manager: *Garrick between Tragedy and Comedy* (1762, pc.) in which Comedy is painted in the style of *Correggio and Tragedy in that of Guido *Reni. From the 1760s he also experimented with a form of generalized classical dress, such as that advocated in his *Fourth Discourse* (1771). The series of portraits of ladies engaged in antique pursuits, dressed in 'timeless' gowns, albeit always intelligently conceived (none more so than *Three Ladies adorning a term of Hymen*, 1774, London, Tate) occasionally strike a note of the absurd (*see*, e.g. *Lady Sarah Bunbury sacrificing to the Graces*, 1765, Chicago, Institute). He

exhibited also subject paintings; from the 1770s these began to include *Fancy Pictures, less unremittingly Italianate, more exercises in the style of Old Masters of other schools: *Murillo (*Shepherd Boy*, *c.*1772, Earl of Halifax), *Rembrandt (*Children with Cabbage Net*, 1775, Buscot). The earliest of these anticipate *Gainsborough's Fancy Pieces. In the 1770s he also combined the Fancy Picture with actual children's portraits, for which, perhaps surprisingly, he had a particular flair (*Master Crewe as Henry VIII*, 1776, pc; *Lady Caroline Scott as Winter*, 1777, Bowhill). Late in this decade he abandoned the classical draperies of his historiated portraits, now able to combine grandeur of concept and composition with specifically contemporary dress. The most monumental of British group portraits, *The Family of the Duke of Marlborough* (1778, Blenheim) is perhaps the greatest achievement of this phase.

A journey to Flanders and Holland in 1781 awakened a study of *Rubens, reflected in the more dramatic and livelier style of his last manner (*The Duchess of Devonshire and her daughter*, 1786, Chatsworth; *Lord Heathfield*, 1788, London, National). Although frequently compromised by technical shortcomings – the carmines of his flesh tones have faded, and his reliance on the unstable pigment, bitumen, has caused darkening and lizard-like cracking of paint surfaces – Reynolds's portraits eminently deserve the high praise of contemporaries, not least that bestowed by his rival, Gainsborough: 'Damn him, how various he is!' His *Discourses* remain the clearest, the noblest, and at times most touching, statement of academic ideals in art ever written.

Ribalta, Francisco (1565–1628) and his son **Juan** (*c.*1597–1628) Spanish painters active in Valencia, where Francisco settled in 1598 after working at the Escorial and in Madrid. A single work from his early period survives (1582, now St Petersburg, Hermitage). Francisco's Valencian works until *c.*1611 are wildly eclectic and variable, borrowing from all available sources including prints by *Dürer. After 1612, however, he found a sober monumental style, *Caravaggesque in origin (Madrid, Prado and Valencia, Museum; various churches). Juan Ribalta was an able Caravaggesque painter technically dependent on his father (Valencia, Museum; Torrente).

Ribera, Juseppe or **José de** (called 'Lo Spagnoletto', 'the Little Spaniard') (1591–1652) Influential *Baroque painter and etcher born near Valencia. Shortly after 1610 he travelled throughout northern Italy; *c.*1612 he settled in Rome, where he was influenced by *Raphael, the *Carracci, Guido *Reni and, above all, *Caravaggio, whose bohemian existence he is said to have emulated. In 1616 he transferred to Naples where he gained the protection of the Spanish Viceroys. He left a lasting imprint on the Neapolitan school and had a considerable influence also on Spanish art. A master of the exacting technique of painting *alla prima*, which he combined with precise drawing and masterful modelling, he achieved dramatic compositions by relating large, monumental forms to simple, airy backgrounds, lending dignity to even his most *naturalistic low-life subjects – all traits which affected the art of *Velázquez, *Zurbarán, *Murillo and *Cano. His earliest securely known works, 1621–4, a series of etchings (*see under* intaglio) of saints, grotesque male heads and limbs in various poses, served as a source for artists until the 19th century, *Rembrandt and *Goya among others.

Three periods are distinguished in his work: 1620–35, when he preferred dark backgrounds and violent contrasts of light and dark (e.g. *Drunken Silenus*, 1626, Naples, Capodimonte; *Martyrdom of St Andrew*, 1628, Budapest, Museum; *Christ Disputing with the Doctors*, *c.*1630, Vienna, Kunsthistorisches; the series of *Twelve Apostles and Christ*, *c.*1631–2, all but four now Madrid, Prado); 1635–9, when under the influence of *Van Dyck his backgrounds became lighter, shadows more transparent and *chiaroscuro less pronounced (e.g. *St Joseph and the Budding Rod*, *c.*1635, Brooklyn, New York, Museum; *Laughing Girl with a Tambourine*, 1637, London, Mr and Mrs R. E. A. Drey,

one of several *genre subjects forming a series on the Five Senses, indebted to Flemish art; the *Trinity*, 1636–7; Prado); finally, 1640–52, characterized by an even looser, more liquid modelling and the predominance of airy, silvery tones (e.g. the famous *Club-Footed Boy*, 1642, Paris, Louvre; *St Jerome*, 1644, Prado; *Communion of the Apostles*, 1651, Naples, S. Martino).

Ribera, based as he was in Italy, painted more mythological subjects than any other Spanish artist, albeit often with ironic, genre-like realism. He was also an accomplished portraitist, although few autograph likenesses by him are now known. He was the master of, among others, Luca *Giordano.

Ricci, Antonio and **Fray Juan Andrés** *See under* Rizi, Francisco.

Ricci, Sebastiano (1659–1734) and his nephew and pupil **Marco** (1676–1729) Venetian decorative painters; Sebastiano was the originator of the Venetian *Rococo, whose most brilliant exponent was Giovanni Battista *Tiepolo. Trained in Bologna, Parma and Rome as well as Venice, Sebastiano Ricci synthesized the styles of the great 16th-century decorators, *Correggio and *Veronese, with those of the 17th-century masters of the genre, Annibale *Carracci, *Pietro da Cortona and Luca *Giordano. His own peripatetic career was one of the causes of the international success of the Venetian school from the 1710s. Even before 1710, he had worked in Milan, 1695–8; Vienna, 1701–3; Bergamo, 1704 and Florence, 1706–7, as well as in Venice. Around 1712–16 he was in England, brought there by his nephew Marco, with whom he sometimes collaborated (e.g. *Allegorical Tomb of the Duke of Devonshire*, Birmingham, Barber). His surviving independent masterpiece in England is the *fresco of *The Resurrection* (London, Chelsea Hospital, chapel). Disappointed at not receiving the commissions for Hampton Court and St Paul's, which went to the English *Thornhill, both Ricci returned to Venice via Paris, where Sebastiano copied some of *Watteau's drawings. In addition to altarpieces and decorations *in situ*, there are easel paintings and drawings by Sebastiano in the Royal Collection and in many continental galleries.

Marco Ricci was also a pioneer of the *capriccio*. Influenced by *Magnasco, through his ruin-pieces and romantic scenes, he in turn influenced *Canaletto and *Guardi. He was first brought to England by *Pellegrini in 1708. His later life is ill-documented. Perhaps under the impact of Netherlandish landscape, he began to paint sober yet poetical landscapes of fact, small *gouache pictures on kidskin anticipating 19th-century developments (e.g. Royal Coll.). His etched landscapes (*see under* intaglio) were published in Venice the year after his death.

Riccio or **Crispus; Andrea Briosco,** called (*c.*1470/5–1532) Paduan sculptor, the greatest Italian master of the small bronze statuette or implement *all'antica*, but *see also* 'Antico'. His improvisations on the theme of the satyr are especially renowned (Florence, Bargello; Paris, Louvre; Oxford, Ashmolean). In contact with leading Paduan humanists, he also interpreted contemporary subjects and Christian symbols in antique terms (Della Torre monument, Verona, S. Fermo Maggiore, before 1511; Paschal candlestick, Padua, S. Antonio, 1507–15). Although there is some evidence that he was trained initially as a terracotta artist in Tuscany (*see especially* Della Robbia, Luca and Andrea), Paduan contemporaries refer to him as a pupil of *Bellano.

Richards, Ceri (1903–71) British painter, born near Swansea into the Welsh-speaking family of a tin-plate worker from whom he inherited his love of music and poetry. He studied art in Cardiff and at the Royal College of Art in London, proving himself a gifted draftsman and a young artist alert to the opportunities modern art theory and practice offered; later he taught in the art schools of Swansea and London. His work – paintings, drawings and prints, as well as book illustrations, stage designs, mural panels for liners, and stained glass for Derby Cathedral (1964–5) and the Roman Catholic Cathedral in Liverpool (1965) – varied greatly in manner as well as method,

developing from an initial naturalism to an exceptionally wide-ranging imaginative production to which the example of *Picasso and later *Matisse contributed, together with his own sense of colour and energetic forms in paintings, and in his graphic work especially expressive line and contrasts of light and dark. In the mid-1930s he made a series of semi-*abstract constructed reliefs that owed something to *Surrealism, and in 1937 he exhibited in London with the Surrealists. He went completely *abstract in painting a series of canvases, during 1960–3, echoing the piano music of Debussy (which he delighted in playing), a few of which developed into reliefs. This series owes some of its technical processes to the work of *Ernst. In 1963 he also painted a series of variations on *The Lion Hunt* by *Delacroix who had asserted the primacy of 'the musical in painting'. There was humour and human warmth in all his art, which included many scenes of music-making by his own family. A Richards retrospective was shown at the Whitechapel Art Gallery, London, in 1960. Two years later he represented Britain at the Venice Biennale.

Richardson, Jonathan (1665–1745) A pupil of John *Riley, he became a leading portrait painter in England in the generation after *Kneller. His writings, in which he expounds his theories of High Art and the Grand Manner, are more successful than his solemn but prosy pictures (e.g. London, NPG). These writings had a decisive influence on the young *Reynolds, whose first teacher, *Hudson, was Richardson's pupil. Richardson also owned an important collection of Old Master drawings. He retired from painting in 1740, continuing his literary work with his son, **Jonathan Richardson the Younger** (1694–1771), also a painter but better known as one of the new professional 'art experts'. In 1722 they published together *An Account of some of the Statues, Bas-reliefs, Drawings and Pictures in Italy*, widely used by collectors on the Grand Tour, and by British artists in Italy. There are portraits by the elder Richardson in London, NPG; Edinburgh, Portrait; at Oxford, Christ Church, Bodleian; Cambridge, St John's; at Firle Place, Sussex; etc.

Richier, Germaine (1904–59) French sculptor who studied under *Bourdelle and had some success before the Second World War but became famous after it. The imagery and technique she developed during it, delicately monstrous creatures in bronze that were human presences, insect-like in their slender forms and suggesting suffering, death and decomposition in their fragmentation, could readily be seen as protests against man's violence to man, especially the impersonal, global violence announced by atomic warfare. Those thin and penetrable forms could also be seen as exercises in using external and internal space as positive ingredients in sculpture, but such considerations were secondary to the macabre or pitiable impact made by her images. She won the sculpture prize at the São Paulo Bienal of 1951 and was widely exhibited thereafter.

Richier, Ligier (*c*.1500–67) Sculptor born at Saint-Mihiel in Lorraine (now France) and chiefly employed by the Dukes of Lorraine. He was in Rome from *c*.1515 to *c*.1520, and his style veers between Italian *idealization and *Gothic *realism, sometimes grim or macabre, as in the famous skeleton, partly clothed with shreds of flesh and skin, of the tomb of René de Châlons now in St Pierre at Bar-le-Duc. Other works by him are the *Easter Sepulchre* in St Etienne at Saint-Mihiel, and the effigy of Philippe de Gueldres, Duchess of Lorraine, d.1547, now in the church of the Cordeliers at Nancy. Evidently affected by the religious disturbances of the time in Lorraine, he converted to Protestantism and fled to Geneva, where he died.

Richter, Hans (1888–1976) German artist and filmmaker who studied art and architecture in Berlin and Weimar and after brief war service joined the *Dada group in Zurich in 1916. In 1918 he was back in Berlin where he worked with *Eggeling on *abstract scroll paintings and films. He was one of the editors of the design magazine *G* (for *Gestaltung*, form, form-making) 1923–6, began work on a film with *Male-

vich in 1927, spent some years in Russia and Switzerland working on films, and emigrated to the USA in 1941 where he joined *American Abstract Artists and was naturalized. German and other prizes rained on him as filmmaker and artist after 1945 and his accounts of the Dada movement were instrumental in giving Dadaism renewed prominence.

Riciarelli, Daniele *See* Daniele da Volterra.

Riemenschneider, Tilman (active 1485–1531) Distinguished wood and stone carver, head of a large workshop in Würzburg. With *Stoss, he is the most fully documented German pre-Reformation sculptor. He became Burgomaster 1520–1, but in 1525 he was imprisoned, expelled from the Council and fined for refusing to support the Prince-Bishop against the peasants' revolt. There are no dated works from the last decade of his life, although we know that in 1527 he was employed to repair an altarpiece damaged in the Peasants' War.

Riemenschneider's early work is very eclectic. He was probably trained in alabaster sculpture in Thuringia, and in limewood carving in Ulm, perhaps with Michel *Erhart; he drew also on Netherlandish and Upper Rhenish patterns. He is the first of the limewood carvers to produce altarpieces finished not in *polychrome but with a brown glaze. Documented works *in situ* are to be found in Würzburg, cathedral; Rothenburg, St James; Bamberg, cathedral; Creglingen. There are fragments of sandstone sculpture in Würzburg, Museum; of lime-wood sculpture in Berlin, Staatliche; Munich, Museum; a drawing in Heidelberg, Museum.

Rigaud, Hyacinthe (1659–1743) French portrait painter, *Baroque interpreter of the grandeur of absolutist monarchy (*Louis XIV*, 1701, Paris, Louvre) but simultaneously the first artist in France to emulate the *naturalistic and intimate portratis of *Rembrandt, seven of whose paintings he owned (*The Artist's Mother*, 1695, Louvre). Born in Perpignan and trained in the south of France, he settled in

Paris in 1681. After some years portraying Parisian bourgeois and fellow artists, he broke new ground in 1688 with a commission to paint the King's brother. From this time he became almost exclusively a court painter, whilst his friendly rival, *Largillière, continued to specialize in bourgeois portraits. Rigaud's sitters included most members of the royal family, the great French generals and prelates, visiting foreign princes and diplomats (e.g. Paris, Louvre, Versailles; Madrid, Prado; London, Kenwood; Nottinghamshire, Welbeck Abbey; Perpignan, Musée). To depict them he evolved formulae dependent both on *Van Dyck and the more severe Philippe de *Champaigne. Ennobled in 1727, Rigaud became Director of the French *Academy in 1733.

Rijckaert, Martin or **Marten** *See under* Ryckaert.

Riley, Bridget (1931–) British painter, born in London and trained at Goldsmiths College and the Royal College of Art. She came to analysing visual appearances through study of *Neo-Impressionism but became known in 1962–5 as an *Op artist, working in black and white. Soon she was using subtler tones and since 1966 she has been exploring and exploiting the interaction of colours when inventively organized in twisting or straight bands, often running top to bottom of her canvases or, recently, in shorter units cut by vertical and diagonal lines. She became an international name when she showed in the Responsive Eye exhibition in New York (MoMA) in 1965 and one of her paintings was used on the catalogue's cover. This exhibition presented Op art as a lively international movement but in effect ended it: Riley is one of the very few artists involved in it to have gone on to develop in a fruitful, in her case astoundingly vital, manner. Her choice of colours has varied with her structures, always to deliver a particular visual experience, defined by her as a specific event in the 'dynamism of visual forces'. In 1968 she showed in the British Pavilion at the Venice Biennale and won the International Painting Prize. Since then she

has exhibited frequently around the world. A retrospective toured Continental Europe in 1970–1; another was shown in London in 1971 and toured Britain in 1973. 1998 saw a retrospective at the Abbot Hall Gallery in Kendal (England); 1999 a survey of her 1960s and 70s paintings at the Serpentine Gallery, London. In connection with this, *The Eye's Mind. Bridget Riley: Collected Writings 1965–1999* was published, the words of a remarkably astute thinker, not only about her own art.

Riley, John (1646–91) British portraitist, chief painter to the King jointly with *Kneller after the Revolution of 1688. He had an established reputation, perhaps among the middle classes, even before *Lely's death in 1680. Of this early style, however, we know nothing. From 1680 until his death he painted the great figures of the day (e.g. Oxford, Ashmolean) but his diffidence made him less successful with aristocratic sitters than with persons from humbler walks of life. Two portraits of the latter type are amongst the most sympathetic of the period: *The Scullion* (Oxford, Christ Church) and *Bridget Holmes, housemaid to James II, in her ninety-sixth year* (1686, Windsor Castle). Riley was the teacher of some of the most important portrait painters of the next generation (*see* Jonathan Richardson).

rilievo schiacciato or (Tuscan) **stiacciato** Italian for 'flattened relief'. A form of shallow relief sculpture evolved by *Donatello and associated especially with Tuscan Early *Renaissance artists, notably, in addition to Donatello, *Ghiberti and *Desiderio da Settignano. More pictorial than high relief, *schiacciato* relief relies for its effects on gentle modulations of the surface combined with incised contours and accents. Where the perceived or notional depth of high or medium relief is always directly proportional to the actual depth of the carving, the notional depth of *schiacciato* relief, like that of a painting, is infinite. The technique thus lends itself particularly well to the representation of *perspective, and was utilized by Donatello in the first demonstration of a single-vanishing point perspective in a work of art, the relief at the base of his statue of St George in Florence, Or San Michele (original now Florence, Bargello).

Ring, Ludger tom the Elder (1496–1547) German painter, active in Münster (Cathedral, memorial tablet and cycle of Sibyls and Prophets), and influenced by Netherlandish art. His best works are his portraits (e.g. *Anna Romp*, Cologne, Wallraf-Richartz). His sons, **Hermann tom Ring** (1521–96) and **Ludger tom Ring the Younger** (1522–84), dominated painting at Münster after his death. In addition to portraits and religious works with colourfully costumed figures, the latter painted pioneering flower pieces, such as the 1562 apothecary's cupboard doors now in Münster museum.

Riopelle, Jean-Paul (1923–) Canadian painter who, after a visit to Paris in 1946–7, worked primarily there while remaining in touch with Canadian artists and art events. He contributed to *Abstract Expressionism and *Art informel, his characteristic work being in thick paint applied with the palette knife. He represented his country at the 1962 Venice Biennale and in 1963 a retrospective exhibiton of his work was shown at the main Canadian centres.

Riposo, Il *See* Ficherelli, Felice.

Rippl-Ronai, Josef (1861–1927) Hungarian painter, trained in Vienna, Munich and Paris where he worked with *Munkácsy and associated with the *Nabis. In 1891 he visited Belgium and Russia. In 1902 he settled in his home country where he slowly found a public for his often very colourful portraits and domestic scenes, seen best in Budapest's National Gallery.

Rivalz A family of French painters active in Toulouse and largely educated in Rome. **Jean-Pierre Rivalz the Elder** (1625–1706), a pupil of *Vouet, spent nine years in Rome, settling in Toulouse where he decorated the Hôtel de Ville and practised as an architect. His son **Antoine** (1667–1735) returned from Rome in 1700.

Influenced by *Maratta, albeit a highly individual artist, he showed no wish to live in Paris and from 1726 ran an *academy in Toulouse which taught a chastened Roman *Baroque style; even before this date, however, *Subleyras worked in his studio. Another of his pupils was his son, **Jean-Pierre Rivalz the Younger** (1718–1785). There are many works by the Rivalz in Toulouse, Augustins.

Rivera, Diego (1886–1957) Mexican painter, trained in Mexico City, Spain and Munich. During 1911–21 he worked in Paris, close to the *Cubists. He travelled in Europe and spent some months in Italy in 1918. After returning to Mexico in 1921 he played administrative roles under the Ministry of Culture and himself produced major mural painting schemes in National Preparatory School, the Ministry of Education and many other public buildings in Mexico City. He had joined the Communist Party and in his work sought to develop monumental imagery through which to promote social progress. He visited the Soviet Union in 1927. In 1930 he went to the United States where he painted murals in San Francisco Stock Exchange and the Detroit Institute of Arts; his wish to include a portrait of Lenin in a mural begun in the Rockefeller Center, New York, caused that commission to be cancelled; he painted a version of it in the Palace of Fine Arts back in Mexico City in 1934, and went on to do other murals in his country. *Portrait of Mexico* (1937), written with Bertram Wolfe, is an account of his Mexican murals to that date. In 1928 he had married the painter Frida *Kahlo. In 1955 he made a second visit to Russia.

His populist idiom was based more on Italian early *Renaissance models than on Parisian *Modernism, and served very well his didactic and celebratory purposes, presenting the people, its heroes and key events in strong and legible compositions. It also had limitations of style and invention and can be found repetitive by those who go from one work to the next as opposed to living in their presence. His influence was very great, in the USA as well as in Mexico. The Anahuacalli Museum in Mexico City is his studio transformed into a permanent display of his work.

Rivers, Larry (1923–) American painter, first a professional jazz saxophonist, he then studied painting with *Hofmann and *Baziotes. He had his first one-man show in 1949 (NY) but became known in the 1960s with figurative paintings that fused elements of *De Kooning and *Pop art, using inscribed words, quotations from others' pictures, and passages of deft painting amid sketchiness. Banality and high art upstage each other in the context of an awareness that refused to pretend single-mindedness. In 1965 he had his first retrospective (New York, Jewish Museum). Since then his work has been seen around the world. In 1992 he published his 'unauthorized autobiography', written with Arnold Weinstein: *What Did I Do?* – a lively, blithely scandalous account of his life, saying little about his art.

Rizi, Francisco (1608–85) Prolific Spanish painter, brother of **Fray Juan Andrés Ricci** (1600–1681; *see below*) and son of Antonio Ricci of Ancona, Italy (*d.* after 1631) who had come to the Escorial to work with Federico *Zuccaro in 1585. Francisco was a pupil of Vincencio *Carducho and entered royal service in 1639. As painter to the cathedral of Toledo from 1653 and court painter from 1656, Rizi executed many works in *fresco and *oils at the cathedral and the palace in Madrid, where he set the style of light-hearted architectural decoration, and also painted scenery for the plays presented weekly before the king. The 'decay of Spanish taste' was ascribed to his influence, and he undoubtedly helped to pave the way for the ascendancy in Spain of the *Rococo style. His learned and devout brother Juan, on the other hand, became a Benedictine monk in 1627. For a short time after 1640 he was the drawing master of Prince Balthasar Carlos in Madrid, as his teacher *Mayno had been the drawing master of the Prince's father, Philip IV. His many religious paintings, mainly for Benedictine monasteries (at Silos; Burgos; Medina del Campo; Sopetrán; etc.) and for Burgos Cathedral and several churches in Madrid,

share some of the austere *tenebrism of *Zurbarán, and have something of the grandeur of *Velázquez (e.g. perhaps his greatest picture, the *Mass of St Benedict* of *c.*1650, now Madrid, Academy). He was also an accomplished portraitist (Burgos, Museo), and wrote illustrated treatises on various subjects including architecture and anatomy. In 1662 he went to Rome and later to the monastery at Montecassino, where he died shortly after being offered a bishopric.

Rizzo, Antonio (recorded from 1465–99/1500) With Pietro Lombardo (*see* Solari) the first fully *classicizing *Renaissance sculptor working in Venice, author of the celebrated statues of *Adam* and *Eve* (after 1483, now Doge's Palace). Their softness of modelling is thought to have been influenced by Rizzo's contacts with the painters Gentile and Giovanni *Bellini and *Antonello da Messina. A native of Verona, he is confused in older accounts with both Antonio *Bregno (with whom he collaborated on the Arco Foscari) and *Riccio. Of his several funerary monuments in Venice the foremost surviving is that of Niccolò Tron (1476–80s, S. Maria dei Frari). He also designed the Staircase of the Giants of the Doge's Palace (1491). Appointed master of works in the palace in 1483, Rizzo was accused of embezzlement and fled Venice in 1498, travelling to Ancona, Cesena and Foligno, where he died.

Robbia, Luca della (1399/1400–82) Florentine sculptor. Although he executed outstanding works in bronze and marble, he is remembered most vividly for the glazed terracotta sculpture, predominantly in blue and white, which became the speciality of the della Robbia workshop inherited after Luca's death by his nephew **Andrea** (1435–1525) and the latter's sons, notably **Giovanni** (1469–1529) and **Girolamo** (1488–1566). Luca first springs to prominence in art-historical records with the commission for the *classicizing marble Singing Gallery, or Cantoria, for Florence Cathedral (1431–8; now reconstructed, Opera del Duomo). He must have been a well-established artist by this time, yet nothing is known of his earlier work or

training, which was possibly under *Nanni di Banco. In 1436 he is mentioned by *Alberti in the prologue to the treatise *On Painting* as one of the outstanding innovators of Florentine art, along with *Brunelleschi, *Donatello, *Ghiberti and *Masaccio. His later reliefs were influenced by Donatello's competing organ gallery, begun 1433.

Luca first employed glazed terracotta as a decorative element in 1441–3 (Peretola); a similar combination of marble and *polychrome decoration was employed in the Federighi monument for S. Pancrazio (1454–7; reassembled Florence, S. Trinita). Luca's earliest bronze works are two angels from the Cantoria (Paris, Jacquemart-André); in 1445–7, and again 1464–9, he worked on the bronze doors for the sacristies of Florence cathedral (*see also* Michelozzo). Glazed terracotta as an independent sculptural medium was used by Luca in architectural settings; it is probable that he worked out the technique at *Brunelleschi's instance. The earliest documented work entirely in this medium was the predominantly white-and-blue *Resurrection* lunette over the entrance to the north sacristy of Florence cathedral (1442–5); this was matched by the lunette of the *Ascension* over the entrance to the south sacristy (1446–51). In the years 1440–50 he produced circular reliefs of the Apostles for Brunelleschi's Pazzi chapel. The glazed decoration of Michelozzo's Chapel of the Crucifix in S. Miniato was probably executed in 1447–8, and the ceiling decoration for the Chapel of the Cardinal of Portugal in the same church in 1461–2. The three guild emblems above niches at Or San Michele are usually also assigned to about this date. Two freestanding figures of angels bearing candlesticks were made for the cathedral, 1448–51. Luca's last major work in terracotta was an altarpiece now in the chapel of the episcopal palace at Pescia (after 1472), but throughout this period he and the shop collaborated on many smaller works for private devotion and decoration.

After Andrea assumed control of the shop, the quality of the glazed terracotta products declined. Andrea himself is primarily associated with the glazed terra-

cotta roundels of the Florence foundling
hospital, the Ospedale degli Innocenti
(1487), and with a series of polychrome
altars in the principal church of the Fran-
ciscan shrine at La Verna, made in colla-
boration with his sons, of which replicas
and variants were exported all over Tuscany.

Robert, Hubert (1733–1808) Painter,
French exponent of the Italianate
capriccio inspired by *Panini and
*Piranesi. He was also a forerunner of
*Romantic responses to nature, perhaps
under the influence of *Fragonard, with
whom he became friends during his stay in
Rome, 1754–65. In addition to imaginary
views with ruins, he was also capable of
topographical accuracy. During the last
years of the *ancien régime*, when he was
keeper of Louis XVI's pictures, Robert
executed vivid views of the construction
and demolition of parts of Paris (Paris,
Carnavalet; other works, Paris, Louvre; St
Petersburg, Hermitage; New York, Metro-
politan; Cambridge, Fitzwilliam; etc.).

Roberti, Ercole *See under* Costa,
Lorenzo.

Roberts, William (1895–1980)
British painter who studied commercial
design and then painting in London and
from 1914 on was associated with the *Vor-
ticists, exhibiting with them in 1914–17. He
worked briefly for the *Omega Workshops
and served in the army during 1917–19,
thereafter continuing to develop his parti-
cular form of *Modernism. From the jagged
and often linear forms prevalent in Vorti-
cism and related to *Futurism's search for
ways of representing psychological and
physical actions, he gradually turned to a
calmer idiom of tubular forms representing
figures and other objects, disposed accord-
ing to firm, geometrically determined
controlling lines. In this manner he painted
all sorts of subjects, from those narrated in
Homer to contemporary life: figures on a
beach or struggling to get onto a bus,
domestic scenes, the Queen on horseback
among her guards. This basic *classicism
separated him from his former Vorticist
colleagues and led Wyndham *Lewis to
deny his importance in the group, eliciting

a shower of pamphlets in which Roberts
detailed the validity of his contribution. Of
that there need be no doubt; what is more
to the point is that his subsequent, fully
mature, work represents a major contribu-
tion to classicism within Modernism. A
retrospective exhibition in London, in
1980, closed his career.

rocaille *See under* Rococo.

Rockburne, Dorothea (1921–)
Canadian painter, trained in Montreal and
at *Black Mountain College and prominent
among the artists, on both sides of the
Atlantic, who in the 1970s used art
materials (in her case often paper, drawn
upon and folded) to explore neither image
nor style but the meaning and effects of
making and exhibiting. She had solo exhi-
bitions in New York and then in Europe as
well as the USA from 1970 on.

Rococo, rococo Style label coined,
originally as a term of ridicule, at the end
of the 18th century by Maurice Quai, a
student of the *Neoclassical French painter
Jacques Louis *David. It is applied to
aspects of 18th-century art in France and
elsewhere under French influence, and is
thought to derive from the French word
rocaille, meaning rock- and shell-work for
the incrustation of grottos and fountains,
and, by extension, a whimsical style of
decoration associated with the reign of
Louis XV (1715–74) and the taste of his
mistress, Mme de Pompadour. In the
rococo style all objects, including works of
painting and sculpture, but also wall
panelling, furniture, fabrics, silver and table-
ware, are subsumed to an ideal of elegant,
sometimes frivolous, overall decorative
harmony. The characteristic colour range
of rococo includes white, gold, silver, rose-
pink and sky-blue. Its line is the asymmet-
rical S-curve; *Hogarth's S-Line of Beauty
is a rococo phenomenon. As this style
became identified with the private apart-
ments of aristocratic women, it assumed a
political and even moral significance in the
latter part of the century, being contrasted
with 'masculine', 'severe and upright' clas-
sicism. Yet in its origins the *style rocaille*
was also a reforming style, invoking the

great past masters of colourism (*see under disegno*) – *Correggio, *Veronese, *Rubens – and seeking to add to the emulation of antiquity taught in the *Academy the study of nature in all its variety and spontaneity. Far from having begun as an expression of aristocratic licentiousness, rococo was initially patronized by the bourgeoisie and used to decorate small and unpretentious town houses. Rococo painters were also influenced by the 'little masters' – *genre painters of 17th-century Holland and Flanders – for example *Teniers. And while the ebullient works of *Boucher, for instance, with their sprightly eroticism, can be said to devalue the traditional content of mythological and history painting (*see under* genres), rococo art is not necessarily shallow or licentious. *Watteau and frequently *Fragonard (who had studied *Rembrandt as closely as the Dutch painters of genre) are far from being mere decorators, and their work is often tinged with introspective melancholy and sincere feelings, such as those cultivated in contemporary bourgeois theatre and literature.

Under French influence abroad the style was modified to embrace public art. In southern Germany and Austria rococo ensembles adorned churches and palaces. The grand decorative *frescos of *Tiepolo (virtually the only major Italian practitioner of the style) – lighter, airier and more tender variations of *Baroque mural and ceiling painting – are typical of rococo public design.

Rodchenko, Aleksandr (1891–1956) Russian artist, photographer and designer, one of the leaders of the new Soviet art after 1917 but from 1930 on relatively ignored though not wholly unemployed. He studied art in Kazan (where he met his wife, Varvara *Stepanova) and St Petersburg, and in 1915 moved to Moscow to join the *avant-garde circles around *Malevich and *Tatlin. His *abstract paintings show a personal response to the cosmic images of the former; his drawings of 1917–18, ink lines drawn with a ruler and compasses, suggest Tatlin's influence. Rodchenko was to be the most significant of the *Constructivists who looked to Tatlin as their leader. He lectured on 'The Line' in

*INKhUK in 1921. By this time he, Stepanova and Alexei Gan had formed the First Working Group of Constructivists within the institute, opposing functional and ideological principles to *Kandinsky's programme of investigating the sensory factors operating in the arts; the Group's analysis led them to assert the need for artists to abandon all special, artistic, activities and to work in the factories to develop a new inventive spirit in design and production. He made standing and hanging constructions, some of which he showed in a Moscow exhibition of 1921 alongside constructions by the *Stenberg brothers, *Medunetsky and Karl Ioganson. The two-part exhibition 5 × 5 = 25, shown in Moscow later that year included Stepanova, *Popova, *Vesnin and *Ekster and was intended as an anti-painting manifestation. Another exhibition of constructions, including Rodchenko's, was shown in Moscow in January 1922 as the Exhibition of Constructivists. He was among the youngest contributors to the *First Russian Art Exhibition in Berlin.

From 1922 on he devoted much of his energies to design of various sorts and to teaching design. He designed titles for Dziga Vertov's films and *photomontage covers for the film magazine edited by Gan, as well as posters and advertisements, in 1923 beginning to collaborate with Mayakovsky who provided snappy, popular texts. His photomontages offer a brilliant visual accompaniment to Mayakovsky's love poem, *About That*. For some years he contributed to, and designed the journal *Lef* and its successor *Novy Lef* (1923–5 and 1927–8). In 1925 he headed the team sent to Paris to see to the Soviet display at the International Exhibition of Decorative Arts. This included samples of his own work and for the Soviet pavilion (designed by Melnikov) he created a Workers' Club interior which attracted wide notice in a show otherwise devoted almost exclusively to expensive productions for bourgeois tastes. Back in Russia Rodchenko developed his practice as a photographer and had his work published in several magazines (though later his colleagues unjustly charged him with imitating too closely new work by photographers in the West). He

worked as consultant and designer on films and in the theatre, and in 1929 did designs for Mayakovsky's play *The Bedbug*. Meanwhile he had been teaching in the new Moscow art workshops, with some difficulty asserting the need for a department devoted to production design in the face of the growing emphasis on *Socialist Realistic painting. By 1931 he was under more general attack from reactionary cultural forces. He continued to work, often with Stepanova, on magazines and albums illustrating Russia's progress through photographs, and in the mid-1930s he began to paint again, figurative subjects at first and then, in and after 1940, *abstract pictures too, including some using a drip technique which may have anticipated *Pollock's.

Rodchenko's faith and energy make him in several respects a Soviet equivalent to the West's *Moholy-Nagy, though circumstances sorely limited his opportunities from the late 1920s on. Compared with *Tatlin, he was a practical and hurried operator rather than a thoughtful and poetically creative artist. Books and exhibitions have made his work known outside Russia from the 1970s on. Apart from his important role as animator of new, socially useful activities in the young Soviet state, he is now honoured for his pioneering work as photographer.

Rodin, Auguste (1840–1917) French sculptor, credited with bringing sculpture back to public attention after centuries of its subservience to painting. He started from humble beginnings, worked for many years as a jobbing carver of others' sculpture and was repeatedly rejected from the Paris Ecole des Beaux-Arts. It was only in 1882 that he was able to begin working exclusively for himself. In 1876 he went to Italy to steep himself in the art of *Michelangelo, by then widely regarded as the greatest of all artists. By 1900, when the Paris World Fair included a large exhibition of his work, he was himself spoken of as the greatest living sculptor. By the time of his death he was internationally regarded as the great art genius of his epoch. How he achieved this eminence and his continuing fame remains difficult to determine with any finality.

He made a great deal of sculpture, in Paris and at Meudon in the Paris suburbs. Some of this was commissioned and some of these commissions failed. He received many commissions for portrait busts, and these are exceptionally vivid representations, but when he exhibited a subtle, extremely life-like figure of a male youth, *The Age of Bronze* in 1877, it was denounced as an inartistic life-cast. Yet it drew attention to him, and in 1880 he was commissioned to make a pair of bronze doors for a new museum in the Louvre Palace. He worked on this for the remainder of his life, allowing it to grow in complexity and significance into a compendium of all his creative expression: many of his best-known independent sculptures exist also in this crowded, profoundly expressive relief work with its almost and fully three-dimensional figures, including *The Thinker* and *The Three Shades*, near and at the top of what he called *The Gates of Hell*. It was his reponse to Dante's *Inferno* and Michelangelo's *Last Judgment*. Figures of Adam and Eve were intended to flank the doors; *The Three Shades* is his Adam repeated to make three figures standing close together, and in 1900 he exhibited this trio as a distinct work with the title *The Defeated*. A small striding male figure, first modelled as a torso close to antique prototypes and later given legs modelled from life, to this day lacks head and arms; this echoes the state of many ancient statues but has to be seen as a extraordinarily bold option for a 19th-century sculptor to take, implying that what meaning and dynamics the figure has would be diminished by completing it. We know it as *The Walking Man* (1877–8); an over-life-size enlargement was made in 1907 and casts of this were set up in public places outside France (including Rome, where it is thought to have stimulated *Boccioni to think of making sculpture). A half-walking, half rooted figure of *St John the Baptist* (1878–90) was always a tall and powerful man, an oddly contorted figure that seems to be speaking to us yet was originally carrying a cross. A dramatic piece of *naturalism, it also shows passages of expressive, anti-naturalistic modelling that, together with its patently unidealized pose,

pained contemporary critics. *The Gates* also includes versions of several female nudes Rodin sketched and modelled, often incomplete and in strangely contorted poses, as well as of a group he titled with words from *Baudelaire, I am Beautiful, oh Mortals* (1882), in which he combined a separate *Crouching Woman* and a figure developed from *Torso of a Man (Marsyas)* to form a dramatic free-standing work of the man carrying the woman, originally entitled *The Abduction*. As in the case of the famous *Kiss* and several other works, Rodin renamed many of his sculptures, usually generalizing from a specific literary source to end up with a very general title, comprehensible to all. Ovid, as well as Dante and Baudelaire, suggested titles as well as themes. Rodin's *The Metamorphoses of Ovid* (c.1886), representing one female nude attempting to embrace and kiss another, was exhibited under many titles, including 'Desire' and 'Young Girl and Death'. A young male nude, kneeling but straining upwards in prayer or despair, appears (like the preceding piece) in *The Gates of Hell* and also as a separate work entitled *The Child of the Age* and *The Prodigal Son*; freed from its rocky base and attached, back to back, to a female nude, the work becomes *Fugit Amor* ('love flees') and is also to be found in another part of the *Gates*. An oddly posed, anguished female nude is vertical in the *Gates*, and appears as Orpheus in the marble group *Orpheus and Eurydice*; horizontal it is *The Martyr* (1885) and is adjusted to become *The Fall of Icarus* (c.1895). This recycling of his own creations speaks of their multivalence: Rodin's work is usually intensely expressive but its meaning is broad and variable. He was reluctant to force his sculptures into specific reference by adding identifying objects or properties. At the same time, he sought to overwhelm us with the pathos of his inventions.

This, abundantly clear from the *Gates*, is confirmed in his response to other commissions. In 1884 the city of Calais asked Rodin to make a monument to Eustache de St. Pierre, who in 1347 had offered his life to the English king on condition he lifted his siege of the city, likely to end in the starvation of all in it. Rodin's proposal was for

a monument to Eustache and the five other men who offered to sacrifice themselves. This was contracted for. Rodin made nude studies for the individual figures (though they would appear draped), as well as for heads and hands, seeking to express in different ways their anguish as well as their courage. The maquette showed them on a very high articulated pedestal. This he exchanged for an almost baseless, street-level placing, so that viewers would be directly involved with over-life-size figures. He also struggled to reach the final arrangement of the figures in relation to each other. As set up, in 1895, *The Burghers of Calais* was put on a higher base than he intended; in 1924 it was relocated, in front of the Town Hall and on the minimal base he asked for. (London's cast of the group, the story also being one of England's compassion, was similarly given a much lower base, four decades after it was set up in 1913, just to the south of the Houses of Parliament.) A French literary society in 1891 commissioned Rodin, at Zola's suggestion, to make a monument to the novelist Balzac who had died in 1850, and finish it within 18 months. Rodin researched the subject with all possible care. He was long in doubt whether the sculpture should be clothed or nude, what position it should be in, and at what age Balzac should be represented. Finally, inspired by a work of Medardo *Rosso's, he posed Balzac in full maturity, his body, including his arms, swathed in his dressing gown, with only his head, emphatic features and massive hair, emerging from the erect form, double life-size, which seems to lean back slightly as though in a moment of inspiration. He showed the final plaster model at the *Salon of 1898; it was generally derided and the commission, long overdue, was cancelled. The bronze *Balzac* was not set up, on the Boulevard Raspail, until 1939. In its *abstractness, except for the dramatic head, it can be seen both as the culmination of his century's appetite for statues and as the first non-representational monument, its form making a summary gesture, suggesting excitement and energy, rather than describing a particular man. He made, or inconclusively wrestled with, other monumental commissions, including those for Victor

Hugo, the painters *Bastien-Lepage, *Whistler and *Claude, and for a 100-foot-high *Tower to Labour*. In these, for all their virtues, one sees a sculptor risking excesses of complexity and expression to demonstrate the psychological as well as the physical potency of his work.

Meanwhile he worked also on portraits of living and deceased men and women, including Mozart, George Bernard Shaw and Mahler, as well as combining existing figures and fragments in suggestive, sometimes erotic, groupings: for example, *The Mighty Hand and the Despairing Girl*, a small sculpture in which a three-quarters figure, nude, seems to ward off a clenched hand, much bigger than herself, which Rodin had made as a study for the *Burghers of Calais*. He had photographs made in the studio of his small sculptures set up and lit in this or that arrangement, and sometimes drew on the photographs to note his further thoughts. He modelled more and more figures, incomplete figures, heads, limbs etc., as part of his personal research, filling drawers with plaster casts of them. In his last years a series of dancers, not traditional ballet dancers, but exotic dancers from Java and Cambodia, the 'free expression' dancers Isadora Duncan and Loïe Fuller, and Nijinsky dancing the Faun. He distorted and exaggerated their forms, as though they were quick sketches, and left them in plaster. He cast his own hand as *The Hand of God*, fashioning embracing female nudes, and had it executed in marble.

His appetite for work was equalled by, and was not wholly separate from, his appetite for women. He surrounded himself with models, and drew them in movement and short, intimate poses. He had many student-apprentices, among them a high proportion of women. One of these, Camille Claudel, became his lover; another lover was the painter Gwen *John. Rose Beuret, a country girl, was his companion from early on; he married her in 1917, legitimizing a son born in 1866. He had no fatherly feelings, except for his art.

In 1900 there was a large Rodin retrospective in Paris during the World Exhibition: 150 sculptures and many drawings as well as some of the studio photographs. It included the first public showing of *The Gates of Hell*. Responses were mixed, many visitors being appalled by the vehemence of much of Rodin's work, and its lack of dignity. But this was an international event, with many visitors coming from abroad, and there was praise enough to leave Rodin in no doubt that, though there would always be doubters, the world at large admired him. When Rodin wished to leave his Paris house, now the Rodin Museum, to the nation, the matter was debated and right-wing resistance had to be overcome; as so often, the discomfiting aspects of his work were ascribed to foreign influence and, in the midst of war, had to be denounced. Rodin also left a group of sculptures to the Museum of South Kensington, in London, now the Victoria and Albert Museum.

Rodin had enemies and doubters among his fellow artists, too. He was never part of a movement. It would be possible to show selected pieces as reflecting contemporary tendencies such as *Realism, *Impressionism, aspects of *Post-Impressionism, and his vision could often be called *Symbolist. Sculptors worked for him who became significant in their own right: *Bourdelle is the main instance, whereas *Brancusi was pleased to be enrolled as an assistant but escaped after a short stint lest he be smothered by the great man. Younger sculptors were influenced by him. He had friends among the painters of his generation, *Monet notably. Rodin was first and foremost a modeller, shaping clay with his hands as well as working it with tools before making the plasters that would become bronzes on their own or often a larger scale, or be designated for execution in marble by hired carvers. Often these marbles are his most ingratiating pieces. Brancusi's preferred process of direct carving, his priority for a while, was a way of eluding Rodin. *Matisse's sculpture, always modelled, was certainly indebted to Rodin's though he rejected the idea that sculpture should portray movement. *Picasso too learnt from Rodin, but soon worked against him, as did Boccioni. *Maillol sometimes seems Rodin's full-blooded descendant, using the female figure as his prime material in order to express a variety of themes,

yet Maillol's classicism, especially the integrity of his firm bodies, contains a fundamental criticism of Rodin's spontaneity and emotional handling of material. Of Rodin's significance there can be no doubt, and his impact on the world of sculpture has been unequalled since the time of his chief hero, Michelangelo, whose Medici Chapel, the sculptures and their setting, seemed not only the greatest work of art he ever saw but also contradicted everything tradition had told him sculpture should be. On the way to Italy, he also saw Reims Cathedral. 'It was Michelangelo who liberated me from academicism', he said to Bourdelle, but to grasp him we have to think also of that other pole, his passionate love of the cathedrals of France.

Roelas, Juan de (*c*.1558/60–1625) Pioneering Sevillan painter, a priest, perhaps born at Valladolid where he is recorded as working alongside Bartolomé *Carducho, 1598–1602. In his huge altarpieces, to be found only in Andalusia (e.g. Seville, University church, cathedral, S. Pedro, Museum; etc.), Roelas achieved an eloquent style combining *realism and vigour with delicacy of handling – the 'vaporous style' for which the far-better-known *Murillo was to be praised in the 1660s. Roelas's figure types, compositions, colour-range and open brushwork were also to influence Francisco *Herrera the Elder.

Roerich, Nicolas or **Rerikh** (1874–1947) Russian painter and designer, and archeologist. Trained at the St Petersburg Academy and in Paris. His interest in ancient Russia involved him in archeological expeditions and in painting decorations for Princess Tenisheva at Talashkino. He joined the *World of Art group, exhibited with it and thus also came to making ballet designs for Diaghilev, notably those for *The Rite of Spring* for which, some say, he produced the basic idea and worked with Stravinsky on its development. In 1916 he started to live in Scandinavia and in 1918 was known to have emigrated; nonetheless, he was listed as an artist to be included in the proposed Museum of Painterly Culture and he showed at the First State Free

Exhibition in Petrograd in 1919. He was in London that year, meeting Rabindranath Tagore. During 1920–3 he was in the USA where he founded the Roerich Museum in New York. That year he began to make extended visits to India and Central Asia, for anthropological, archeological and mystical studies. In 1932 he was in Philadelphia where he showed in an exhibition of Contemporary Russian Art. In 1935 he again went to India and beyond, and remained there. His early paintings combined close knowledge of Russian folklore and archeology with a modern, essentially *Post-Impressionist decorative use of paint: 'This is enjoyable make-believe informed by scholarship and learning' (John Milner, 1993). In this way he was an apt choice for stage designs evoking a distant past. Moscow has a Roerich Museum; the Tretyakov Gallery in Moscow and the Russian Museum in St Petersburg have some of his paintings, and his stage designs are best seen in the Bakrushin Theatre Museum, Moscow, the V&A, London, and the Ashmolean, Oxford.

Rogier van der Weyden *See* Weyden, Rogier van der.

Rohan Hours, Master of the, also called Rohan Master (active *c.*1410–30) *Illuminator active in Paris, named for an outstanding *Book of Hours, *Les Grandes Heures de Rohan* (*c.*1414–18, Paris, Bibliothèque Nationale) whose dramatically *expressive miniatures have no parallel in the art of his contemporaries. It has been suggested that he was a Catalan. He collaborated with the *Boucicaut and *Bedford Masters as late as 1415–20, when he apparently passed into the service of the Dukes of Anjou; a panel painting in Laon, Musée, has been attributed to him.

Rohlfs, Christian (1849–1938) German painter, student and then teacher at the Weimar Art School, subsequently resident at Soest. He had contact with *Nolde and his work shows some affinity with that of the *Brücke painters, but he was substantially older and his work was consistently more lyrical than theirs.

Roldán, Pedro (1624–99) Spanish *Baroque sculptor, trained at Granada but active in his native Seville, where he also practised as painter and architect, promoting the unity of all three arts in altars. His chief work is the *retable for the high altar of the church of the Hospital of the Caridad, of which the framework was designed by the church's architect, Pineda. Roldán executed the painted relief background and the foreground sculpture of the *Entombment of Christ*, *polychromed and gilded by *Valdés Leal. From 1664 to 1672 he was director of sculpture at the *Academy. His daughter and pupil **Luisa** (*c.*1656–*c.*1704) is the only woman to have held the position of royal sculptor (to Charles II of Spain). Another of his pupils, his grandson **Pedro Duque Cornejo** (1678–1757) became the leading sculptor of the first half of the 18th century at Seville, Granada, Madrid and Cordova (Granada, Angustias, gigantic statues of the Apostles, 1716–19; Charterhouse, *Magdalen*).

Rolfsen, Alf (1895–1979) Norwegian painter, trained in Copenhagen and in Paris where he knew *Rivera and discussed mural painting with him. He made several visits to Paris subsequently, keeping touch with developments in modern painting. In Norway he became known as a muralist in fresco. His first commission, for the Oslo Telegraph Building (1922), was followed by many others, notably for Oslo Town Hall. His easel paintings included portraits, figure subjects and landscapes, and he made prints and book illustrations, as well as writing about mural painting.

Romako, Anton (1832–89) Austrian painter, trained in the academies of Vienna and Munich (1847–9). He spent much of 1854–6 in Italy and Spain and lived in Rome from 1857 until 1876, adding *genre to his pursuit of *History and portrait painting. In 1876 he returned to Vienna to live out a life marked by solitude and suffering. Thanks to their psychological perception and markedly personal and expressive use of colour and brushmarks, his paintings, disregarded in his day, are now seen as precursors of the decorative and *Expressionist tendencies in Viennese

art after 1900. They are best seen in the Österreichische Gallerie, Vienna.

Romanelli, Giovanni Francesco (*c.*1610–62) Italian *Baroque painter and tapestry designer. Trained by *Domenichino and *Pietro da Cortona's assistant at the *Barberini palace, he came to be much patronized by the Barberini family (e.g. mosaics after his designs, Vatican, St Peter's; *frescos, Vatican, Sala della Contessa Matilda). He was twice in France: his mythological, *allegorical and historical frescos in the gallery of the Hôtel Mazarin, 1646–7, and in several rooms of the Louvre, 1655–7, albeit facile, introduced a restrained and sweetened version of Pietro da Cortona's manner to the French court.

Romanino, Girolamo (1484/7–1562) Veneto-Lombard painter from Brescia, active in and near his native city and throughout northern Italy. His work, until *c.*1540 original and exuberantly free, combines in various admixtures Venetian colourism (*see under disegno*, also Giorgione, Titian), Lombard *realism and the influence of *Dürer's prints. He is best known for his religious *fresco cycles (Cremona, cathedral, 1519–20, *see also* Boccaccino; Altobello Melone; Pordenone; Pisogne, S. Maria della Neve, *c.*1534; Breno, S. Antonio, *c.*1535; Bienno, S. Maria Annunziata, *c.*1540). The last three, in country churches near Brescia, show the influence of Pordenone's popular, 'rustic' manner. He also painted altarpieces (e.g. Padua, Museo; Brescia, S. Francesco; Salò, cathedral) and other religious easel pictures. From 1521–4 he participated with *Moretto in the decoration, on canvas, of the Chapel of the Sacrament, Brescia, S. Giovanni Evangelista, an important ensemble often cited to demonstrate these artists' influence on *Caravaggio (*see also* Savoldo). In 1531–2 Romanino joined *Dosso in the secular fresco decoration of the Castel Buonconsiglio in Trento. From *c.*1540 he collaborated with his son-in-law Lattanzio Gambara (1530–74).

There are works by Romanino in Brescia, Pinacoteca Tosio Martinengo, Congrega della Carità Apostolica; Duomo

Nuovo; Venice, Accademia; London, National; Modena, S. Pietro; Memphis, Tennessee, Brooks Memorial; etc.

Romano, Antoniazzo *See* Antoniazzo Romano.

Romano, Gian Cristoforo *See under* Isaia da Pisa.

Romano, Giulio *See* Giulio Romano.

Romanticism, Romantic It was recognized at the time and has been agreed since that there was a shift of priorities, a loss of shared certainties and a corresponding emphasis on individual experience of the world which showed its first signs in, and at the time of, the French Revolution (1789) and climaxed in the 1830s, after the French monarchy had been restored and the first revolution (1830) against it had reminded society that all systems were under scrutiny. These were international portents. Romanticism was a European movement, significant contributions coming from all sides. The word 'romantic' referred in the first place to verbal and visual attempts to echo the pre-*Renaissance simplicities of medieval chivalric romances; it came to imply a valuing of the imagination over reason and a preference for irregularities over conventional order. German writers, among them *Goethe, claimed that the best creative impulses originated in dark regions of the mind untouched by reason and questioned the need for consequentiality and harmony. Everywhere the concepts of an organic universe and of creativity as an organic process gained ground, becoming the tacit premise for innovation in art. English poets and painters explored a personal, partly spiritual apprehension of nature as environment and life-force. French writers and artists engaged in a war of the styles between those insisting on *classical rules and refining them – with an intensity which itself has Romantic qualities – as *Neoclassicism and those working in open opposition to such rules and to the institutions claiming to uphold them. To a degree difficult to appreciate, for all our knowledge of the period, the western world changed in the half-century that opened with the storming of the Bastille; Romanticism embraces many of the factors in that change just as the Industrial Revolution embraces others.

The cardinal event for art was the dethroning of the classical tradition as the exclusive model. Now it was made to compete with other traditions and models including those of medieval and archaic art, of Nordic as against Mediterranean lore, of primitivism including a new valuation of children's and folk art, and varieties of exoticism. With this went a loss of clarity for the sake of a greater range and impact when the *genres were fused or confused and misappropriated. Social and economic factors made for the loss of known patronage – the demand and supply system that had directed artistic production. Artists increasingly worked independently and exhibited their products in hopes of finding public or private purchasers; exhibitions became necessary markets for the trading of art and galleries came into being as shops where such goods could be examined and acquired; critics became vocal as the public, confronting an unstable and varying supply, needed guidance. Originality and authenticity were offered as yardsticks, on occasion also moral virtue though that was at once countered with the claim that the satisfactions art offered were self-justifying and need not reflect ethical systems. A more general, and essentially Romantic, moral principle was invoked: 'The artist should paint not only what he sees before him but also what he sees within himself. But if he sees nothing within himself he should also forego painting what he sees before him' (*Friedrich).

Rombouts, Theodore (1597–1637) Flemish Caravaggesque (*see under* Caravaggio) painter, like Gerard *Seghers a pupil of Abraham *Janssens in Antwerp. From 1616 until about 1626 he worked in Italy, where he made his reputation with such *genre paintings as the *Two Musicians* (Kansas, Lawrence, University), a hard-edged and harshly lit work which shows only superficial understanding of Caravaggio, as do all the works of his early period after his return home (Madrid,

Prado; Ghent, Musée). Even at this time he borrowed *Rubens's composition for his major religious work, the *Deposition* in Ghent, St Bavo. After about 1630 he also adopted the warmer colouring and freer brushwork of Rubens and *Van Dyck (*The Marriage of St Catherine*, 1634, Antwerp, St Jacobskerk).

Romney, George (1734–1802) Fashionable English portrait painter, usually ranked just below *Reynolds and *Gainsborough amongst the late 18th-century portraitists before *Lawrence. Unlike these two masters, Romney neither penetrates into the character of his sitters nor poeticizes their sensibilities; his strength is in the telling disposition of the figures, the linear pattern of his designs, his fresh, clear colour. At its best, his work has a glossy poise, an authority, achieved in large measure through his study of *Classical statuary and *Raphael.

Romney was the son of a Lancashire cabinet maker, and apprenticed (1755–7) to a travelling portraitist, Christopher Steele. After some years of independent practice in Kendal, he established himself in London (1763) where, except for a visit to Paris in 1764 and a trip to Italy in 1773–5, he remained until retiring back to Kendal in 1798. His best period is generally reckoned to be the half-decade following his return from Rome (1775–80), but there are a few striking later works, including the imposing double portrait of *Sir Christopher and Lady Sykes* (1786, Sledmere) and the uncharacteristically thoughtful *Warren Hastings* (1795, London, India Office). In 1781 he came into contact with Emma Hart (who became Lady Hamilton in 1791) and began obsessively to depict her in over 50 pictures, some from direct sittings or drawings, some from memory. There are works by him in Kendal, Gallery; Cambridge, Fitzwilliam; Eton College; etc.

Ronald, William (1926–) Canadian-American painter who studied at the Ontario College in Toronto and became a leading figure in the development of *abstract art in Canada through his own painting and through his work for the media. During 1955–65 he was in New York, becoming an American citizen and being accepted as one of the second generation *Abstract Expressionists, but then he returned to Canada where he became a well-known TV and radio presenter. He also, following the example of *Mathieu, travelled as a performing artist, painting to rock music before an audience.

Roncalli, Cristoforo *See under* Pomarancio.

Rondani, Giovanni Maria Francesco (1490–1550) Italian painter, active in Parma. He executed *frescos from *Correggio's designs in the nave and Boni Chapel of S. Giovanni Evangelista, and collaborated with *Anselmi on the decoration of the Oratorio della Concezione. Other works, Parma, cathedral; Galleria; Naples, Capodimonte.

Roos, Johann Heinrich (1631–58) and his son **Philipp Peter Roos**, called 'Rosa di Tivoli' (1655–1706) German painters of animals and landscapes (or landscapes with animals). Johann Heinrich was also an etcher (*see* intaglio) and a successful portraitist. He trained in Amsterdam, 1640–51, where he was strongly influenced by the Italo-Dutch artists Nicholas *Berchem and his pupil Karel *Dujardin, and may have visited Italy, 1651–4. From 1654 until his death he worked in Rheinfelden, for the Landgrave of Hessen; in Heidelberg as Court Painter to the Elector Palatinate, and in Frankfurt am Main. He was an accomplished and prolific draftsman; *Sandrart alone boasted of owning 115 of his drawings (e.g. Stuttgart Staatsgalerie; Munich, Staatsgalerie; Brunswick, Herzog Anton Ulrich). The best-known of Johann Heinrich's four painter sons was Philipp Peter Roos. Thanks to a scholarship from the Landgrave of Hesse-Kassel, he settled in Italy in 1677, living for a while in Tivoli – hence his Italian sobriquet, Rosa di Tivoli. Under the pseudonym of 'Mercurius', he was a member of the *Schildersbent in Rome. He mainly painted Italianate landscapes with animals; his topographical drawings have been related to those of van *Wittel.

Rops, Félicien (1833–98) Belgian graphic artist, producing *lithographs at first, etchings from 1857 on. He became famous for his elegant but also emphatically modern erotic images, done mostly as book illustrations. He worked in Brussels and in Paris, associating with *Symbolist writers and artists and eager to give new prominence to etching, especially in Belgium.

'Rosa di Tivoli' *See* Roos, Philipp Peter.

Rosa, Salvator (1615–73) The 17th-century Italian artist most collected by 18th-century English connoisseurs. Poet, actor, musician, satirist, letter-writer, self-professed Stoic philosopher and etcher as well as painter, Rosa was a highly individual and intransigent personality. He is the first Italian artist of stature to rebel against the prevailing system of patronage, by making exhibitions, not commissions, his principal means of attracting sales.

Born and trained in Naples, he was dubbed 'savage Rosa' by 18th-century admirers, who believed him, wrongly, to have spent his youth with bandits and joined Masaniello's revolt against the Spanish (1647–8), 'fighting by day and painting by night'. This view of the artist was supported by the subjects, and to a lesser extent the manner, of his most characteristic works: battle scenes, *landscapes of rugged mountain scenery peopled with hermits or bandits, macabre scenes of witchcraft. The famous series of etchings (*see under* intaglio) the *Figurine*, seemed to hint at enigmatic narratives. But the bold brushstrokes and vivid lights of his landscapes, the portentousness of his self-portraits (London, National; New York, Metropolitan; Siena, Chigi-Saraceni), cannot disguise stereotypic compositions. Even the allegorical and philosophical pictures (*Humana Fragilitas*, Cambridge, Fitzwilliam) are more derivative and conventional than appears at first sight. In truth, Rosa, despite his intelligence and ambition, never completely outgrew his training as a painter of decorative *genres: battle scenes (he studied with the specialist Aniello *Falcone; *see also*

Jacques Courtois), landscapes and coastal views.

Rosa left Naples for Rome in 1635; receiving one commission for an altarpiece from a Neapolitan cardinal (*Incredulity of St Thomas*, Viterbo, Museo, 1638/9), he subsisted mainly by decorative pieces sold through dealers. But in nine years in Florence (1640–9) he broadened his work to include biblical, mythological and philosophical subjects, albeit usually within a landscape framework (*The Philosopher's Grove*, Florence, Pitti) and won a reputation with aristocratic Florentine collectors. Upon his return to Rome in 1649 he vied with *Poussin in the production of heroic narrative landscape (*Landscape with the Baptism of Christ*, *Landscape with St John the Baptist pointing out Christ*, Glasgow, Gallery; *Pythagoras emerging from the Underworld*, Fort Worth, Kimball). Whilst never rivalling Poussin's, these finally won him an international reputation and clientele, as did his technically accomplished etchings, many of them devoted to proclaiming the independence and intellectual eminence of the artist (*The Genius of Salvator Rosa, Alexander in the Studio of Appelles*).

Rosenquist, James (1933–) American painter prominent in the *Pop movement. He studied painting in Minnesota and later at the Art Students' League, New York, where he had contact with *Rauschenberg and with some future Pop colleagues. Before and after these studies (1955–8) he worked as a billboard painter. His Pop work was rooted in this. He juxtaposed what appeared to be sections of advertising and romantic-magazine imagery, and through their discontinuity and irrationality commented sharply on modern urban experience and its dominant values. Like *Oldenburg, he gave common banalities monumental size and weight. He had his first one-man show in 1962; many others followed, on both sides of the Atlantic.

Roslin, Alexandre (1718–93) Swedish-born portrait specialist in *oils and *pastels, who settled in Paris (where he

was often called 'Roslin Suédois') in 1752, after a stay in Italy. His competent likenesses were popular both at the French court and at the other northern European courts to which he was summoned, including those of Sweden, Poland and Russia (Stockholm, National; etc.). His wife, **Marie Suzanne**, née Giroust (1734–72) was also a pastellist.

Rosselli, Cosimo (1439–1506/7) Florentine painter, a pupil of Benozzo *Gozzoli or *Baldovinetti. Although he worked in the entrance cloister of Florence, SS. Annunziata (1476), S. Ambrogio (1485–6) and S. Maria Maddalena dei Pazzi (1505), his main claim to fame is having been commissioned to execute some of the mural *frescos in the Sistine Chapel in Rome, with *Perugino, *Ghirlandaio and *Botticelli. He was the teacher of Fra *Bartolommeo and *Piero di Cosimo, who assumed his name. Other works are in Florence, Uffizi, Accademia; Paris, Louvre; Oxford, Ashmolean; etc.

Rossellino, Bernardo (1409–64) and his brother and pupil **Antonio** (1427–79) Florentine sculptors from Settignano; Bernardo also practised as an architect, notably in Pope Pius II's model town of Pienza. He trained Antonio and his less well-known brothers **Giovanni** (*b.*1417), **Domenico** (*b.*1407) and **Tommaso** (*b.*1422), all of whom were members of the Rossellino workshop, and the sculptor *Desiderio da Settignano. Bernardo Rossellino, under *Brunelleschi's influence, is associated primarily with sculpture in which the figurative portions are subordinated to architecture: tabernacles (1450, Florence, S. Egidio) and wall tombs. His outstanding example of the latter is the monument for the humanist, historian and Chancellor of Florence, Leonardo Bruni (1444–7, Florence, S. Croce). It inaugurated a new type of funerary monument in which the sarcophagus and the effigy of the deceased are contained in a *classical triumphal arch, within whose lunette is carved a roundel with a half-figure of the Madonna holding the Child. This scheme derives from elements in *Donatello and

*Michelozzo's Coscia monument in Florence baptistry, but gives greater emphasis to the architectural enframement. The form was adopted by other Tuscan sculptors, including Desiderio, Antonio Rossellino and *Mino da Fiesole.

Antonio Rossellino assisted his brother on several minor works, emulating – and surpassing – Bernardo's Bruni monument in his tomb for the Chapel of the Cardinal of Portugal in Florence, S. Miniato (1461–6, *see also* Baldovinetti, Antonio and Piero Pollaiuolo, Luca della Robbia). The face of the Cardinal of Portugal's effigy was carved after a death mask, and Antonio Rossellino's influential portrait bust of *Giovanni Chellini*, Donatello's doctor (1456, London, V&A) was unique in its day for being based on a life cast. Almost equally arresting in its evocation of character is the – now badly weathered – bust of *Matteo Palmieri* (1468, Florence, Bargello).

A number of Virgin and Child reliefs have been attributed to Antonio and a heterogenous assortment of youthful busts and reliefs representing the young St John the Baptist and Christ Child (e.g. New York, Metropolitan). Less formally severe than Bernardo's, Antonio's sculpture is notable for its sensitive vivacity (*Virgin with Laughing Child*, terracotta, London, V&A).

Rossetti, Dante Gabriel (1828–82) British painter and poet, son of an Italian Dante scholar who was professor of English in London University and of his Italian, highly literate wife, and brother of the poet Christina Rossetti. At the age of 13 he began to study art, first at Sass's art school in London, then in the Royal *Academy Schools, resisting all attempts to teach him the academic bases of drawing. In 1848 he persuaded Ford Madox *Brown and Holman *Hunt to accept him as pupil, embarked on his first painting, *The Girlhood of Mary Virgin* (1849), and was, with Hunt and *Millais, one of the founders of the *Pre-Raphaelite Brotherhood. His sister Christina stars in *Ecce Ancilla Domini!*, painted in 1850. That year he met Elizabeth Siddal whom he considered the

'image of his soul', brought her home to live with him, and drew and painted her untiringly until her death in 1862, though he also found other 'stunners' to immortalize in his art. *Ruskin became an admirer of his work in 1854 and engaged Rossetti as a teacher of drawing at the Working Men's College. Rossetti was a wayward teacher but supplied very well what Ruskin hoped to present, an emphasis on innocent vision combined with romantic poetry.

When the original Brotherhood disintegrated, Rossetti allied himself to a younger group of painters and designers, notably *Burne-Jones and William *Morris who idolized him. In 1857 he led them and others in painting murals, scenes from the *Morte d'Arthur*, in the new Oxford Union; these were never finished and were technically quite inept. In 1862 he moved into Tudor House in Chelsea with his new model Fanny Cornforth. He was a partner in Morris's firm and was beginning to earn well from his oil paintings. Morris's wife Jane was his mistress for a while as well as his frequent model. He was torn between his women and between his creative activities, his poetry interfering with his painting, his need to sell oil paintings conflicting with his desire to develop more private imagery, mostly in watercolours. He became dependent on drink and drugs in spite of his growing success and being recognized, when *Poems by D.G. Rossetti* was published in 1871, as the country's finest poet-painter. In 1872 he attempted suicide. He recovered and continued to write and paint, often in poor mental and physical health.

Rossetti's art was characterized by unusually rich colour and by flattened compositions heralding the two-dimensionality of much progressive painting in France at the end of the century. Unlike his associates, he felt no urge to moralise through art: he preferred dreaming of a *romantic world of medieval scenes and themes. His only modern subject painting with a moral theme was *Found*, begun in 1854 and developed through many studies but finished after his death by his friends (Delaware, Wilmington Society of FA). Rossetti's work is best seen in the Tate Gallery, London (where the works mentioned above without location are) and in Birmingham's City Museum and Art Gallery.

Rosso; Giovanni Battista di Jacopo, called (1495–1540) Florentine painter and draftsman, with *Pontormo the creator of Early Florentine *Mannerism. A less consistent and less profound artist than Pontormo, he never achieved a similar synthesis of feeling and form, oscillating throughout his career between extremes of *expressivity verging on *caricature and of over-refined elegance. His importance in the history of art stems mainly from his decorative work at Fontainebleau, which became known throughout Europe by means of engravings (*see under* intaglio). He also executed many drawings for reproduction in prints.

Like Pontormo, he first worked under the dominant influences of *Andrea del Sarto and Fra *Bartolommeo (*Assumption of the Virgin*, 1516–17, Florence, SS. Annunziata), later experimenting with effects reflecting 15th-century Florentine art, notably that of *Donatello (*Sacra Conversazione*, 1518, Florence, Uffizi). The famous *Deposition* (1521, now Volterra, Pinacoteca) also demonstrates his interest in northern European prints, especially those of *Dürer. His last major work of this period, the *Moses and the Daughters of Jethro* (1523–4, Florence, Uffizi) exploits the idiom of *Michelangelo's *Battle of Cascina* cartoon.

In 1524 Rosso followed the new *Medici pope, Clement VII, to Rome (*frescos, S. Maria della Pace). His attempt to synthesize the canon of Michelangelo with the grace of *Raphael is evident in the *Dead Christ Supported by Angels* (c.1525–6, Boston, MA, Museum). Maltreated in the Sack of Rome, 1527, Rosso fled to Arezzo and its environs (*Pietà*, 1527–8, Borgo S. Sepolcro, Orfanello; *Resurrection*, 1528–30, Citta di Castello, cathedral). In 1530 he was summoned to France by Francis I, to work at Fontainebleau alongside *Primaticcio. His main achievement for the King was the complex decoration of the Grande Galerie, consisting of *allegorical frescos in sculptural stucco enframements. He is generally credited with the famous *strap-work elements of this enframement. His *Pietà*

(1530–40, Paris, Louvre) returns to the religious expressivity of his early work in Florence.

Rosso, Medardo (1858–1928) Italian sculptor, born in Turin and trained at Milan Academy. In 1884 he went to Paris where he worked in *Dalou's studio and had some contact with *Rodin. His portraits and groups of figures were received with interest and are sometimes described as sculptural equivalents to *Impressionism's concern with light at the expense of form. This makes best sense in relation to some of his groups, in which figures lose their individuality and weight as they merge with each other and their setting, glimpsed rather than mapped, e.g. *Impressions of an Omnibus* (1884, destroyed) and *Man reading a Newspaper* (1894; New York, MoMA). This interest in the flux of experience impressed the *Futurists who hailed him as their forerunner in the 1912 sculpture manifesto. His method of modelling with wax over plaster enabled him also to achieve effects of remarkable delicacy in modelled heads; these, in their implications of symbolism and mood, echo more directly the concerns of *Symbolism and *Art Nouveau. There is a Rosso museum at Barzio in northern Italy.

Roszak, Theodore (1907–81) American sculptor, born in Poland and brought to the USA in 1909. He turned from painting to sculpture in the 1930s and for a time adopted the geometrical mode of *Constructive art, but in the 1940s he became one of those whose three-dimensional work in bronze and steel could be seen as a sculptural form of *Abstract Expressionism. He had many exhibitions in the USA and represented his country at the 1960 Venice Biennale.

Roth, Dieter (1930–) German artist, experienced in a wide range of design, who became known internationally as a ceaselessly inventive neo-*Dadaist, producing a wide range of conceptually disruptive but also stimulating series of works, often by means of collage. Among them are works incorporating bits of foodstuff, decaying over time and thus trans-

forming themselves. Born in Hanover, Roth has lived in Switzerland and Denmark and in 1957 settled near Reykjavik, in Iceland. He has exhibited frequently all over Europe and has repeatedly chosen to work collaboratively with other artists, notably with *Hamilton. Much of his work appears in the form of books, printed in limited editions.

Rothenberg, Susan (1945–) American painter, trained at Cornell and George Washington Universities and at the Corcoran Museum School in Washington, who began exhibiting in 1974 and has been recognized as one of the USA's leading figurative and narrative painters of the 1980s. Her paintings are often large and painted with soft touches that create light and atmosphere, leaving the subject of her pictures indistinct and mysterious.

Rothenstein, William (1872–1945) British painter and teacher, trained in London at the Slade School and in Paris at the Académie Julian, who became a well-known portraitist but from 1898 was prominent as an art teacher, serving as principal of the Royal College of Art from 1920 to 35. He published his memoirs in three volumes (1931–9). His brother **Albert Rothenstein** (1881–1953) was a painter and illustrator and a member of the *Camden Town Group. In 1914 he changed his name to Rutherston to evade anti-German feeling. **John Rothenstein** (1901–92), William's son, was an art historian and critic who became director of London's Tate Gallery (1938–64) and wrote several books on art, including the three-volume *Modern English Painters* (1952–73). John's younger brother, **Michael Rothenstein** (1908–93) was a painter admired especially for his lively and inventive prints.

Rothko, Mark (1903–70) American painter, born in Russia and known until 1940 by his proper name, Marcus Rothkowitz. He came to the USA with his family in 1913, read liberal arts at Yale University and pursued a variety of art studies in New York during 1924–31. (He lived in and near New York from 1925). In 1936–7

he produced paintings for the *Federal Art Project. Friendly with *Avery, *Gottlieb and others, he helped in 1940 to found the Federation of Modern Painters and Sculptors in New York. With *Motherwell, *Baziotes, *Still and others he founded the Subjects of the Artists school in 1948–9, stressing the content of *abstract painting and thus the need for mental and spiritual development in the painter.

By that time he was seen as a major figure in New York's *Abstract Expressionist movement. From *Expressionist figuration and landscapes, via abstract configurations influenced by *Surrealism, he moved in the late 1940s into a mode of abstract imagery that partook of *icon painting in that, through simple forms, it presented itself as a channel between the viewer and transcendental experience. The characteristic Rothko of 1949 and after presented one, two or three soft-edged rectangles of colour floating in a soft environment of other colours, as unstable, mutable (according to lighting conditions and the attention of the viewer) as it was direct. His command of colour was outstanding; so also was his handling of paints, with colours laid over colour to create shifting spatial effects, and these colours were orchestrated to speak in solemn, even threatening, also sometimes cheerfully uplifting terms. He was guided by a fine sense of scale, enabling him to suggest a sublime and awesome presence without having recourse to exceptionally large formats.

In 1958 he produced a set of canvases of a sombre sort for a restaurant in the Seagram Building, New York, but decided the setting was not right for them and later gave them to the Tate Gallery in London. The quasi-religious nature of his work made it difficult for him to see it displayed without special conditions, and it was painful for him to find himself grouped with other *Abstract Expressionists, for some of whom painting was close to physical enjoyment. An ideal commission came to him in 1964 when the De Menil family asked him to make canvases for a non-denominational chapel in Houston, Texas: Rothko placed a triptych over the altar and other canvases where the side altars could be thought to stand, conceiving the whole scheme as one art work and working with the architect, Philip Johnson, on the design of the chapel. (The installation was not completed until 1971.)

His first exhibitions took place in 1933 but it was in the 1940s, with a series of shows at the Betty Parsons Gallery, New York, that he became famous. A major retrospective was shown in New York (MoMA) in 1961 and toured Europe; many other shows followed all over the world. In the 1960s his work took on an increasingly in-turned and pessimistic tone, and culminated in a series of off-white and black-and-white canvases that seemed to speak of emptiness and pain. He killed himself in February 1970, one of the most admired and honoured painters of his generation.

Rottenhammer, Hans (1564–1625) Bavarian painter. After 1588, he went to Italy, making the acquaintance in Rome of Jan *Brueghel and Paul *Bril, who were to paint the landscapes in some of his pictures, and spending 1596–1606 in Venice, where he was influenced by *Tintoretto and *Palma Giovane. From 1606 he worked in Augsburg in a Venetian High *Renaissance style, executing both large-scale altarpieces and decorative ceiling paintings (Munich, Residenz-Museum, various churches; Augsburg, town hall; Bückeburg castle) and small-scale *cabinet pictures, including paintings on copper, in which he anticipated *Elsheimer.

Rottmayr, Johann Michael (1654–1730) Austrian painter, the first major native exponent of the dome and ceiling *fresco decorations which were to become such an important feature of secular, but more especially ecclesiastic, Late *Baroque and *Rococo architecture in Austria and southern Germany (but *see also* Pozzo). From 1696 until his death he worked for the imperial court at Vienna as well as in churches, princely and civic buildings throughout Austria and Germany (Breslau, St Matthias, 1704–6; Salzburg, Residenz, 1710–11; Vienna, Peterskirche, 1715; Karlskirche, 1725; Pommersfelden, Marble Hall, 1717–18; Melk, abbey church, 1719). In addition to Italian influences, Rottmayr

was increasingly indebted to *Rubens, many of whose paintings were housed in Viennese collections. His main follower was Paul *Troger.

Rouault, Georges (1871–1958) French painter born in Paris, who lived in and near Paris all his life. He studied painting with his maternal grandfather and in evening classes, then worked for stained glass makers and, from 1891–95, studied at the Ecole des Beaux-Arts, mostly under *Moreau. When Moreau died, Rouault was charged with curating the Moreau Museum. His early paintings are on biblical themes. In Moreau's studio he met *Matisse, *Marquet and others who were to be known as the *Fauves; through them, and also in response to a current of social criticism noticeable in French art at the turn of the century, he turned to representing prostitutes, weird clowns and monstrous judges, boldly, in thin paint, in a spirit of denunciation. This brought criticism from those who had welcomed his solemn religious works, but the same interest continued to show in his works for some time, notably in the engravings he produced for publication by Vollard in the period 1912–20, including illustrations for Baudelaire's *Flowers of Evil* and a sequence of morbid scenes which he titled *Misères et Guerre* (Miseries and War).

At the same time he changed his idiom and thematic material, turning to hieratic images with qualities reminding us of stained glass in their strong colours and bars of black, of old playing cards and of *icons in their concentration on (often) a single head or figure. Having portrayed human degradation, he now showed the possibility of holiness, giving his paintings the same sense of prayer whether they represented a clown or a saint or the suffering Christ. Patently works of the 20th century, his paintings also seem to speak with the voice of the Middle Ages, with resolute piety amid manmade disasters. This made Rouault one of the most convincing religious artists of our time, and he has sometimes been thought of as a modern *Rembrandt on account of the painterly fullness of his work and its sympathetic tone. Some see his mature work as a form of *Expressionism though it lacks the insistent emphasis on the artist's ego the term suggests.

He exhibited quite frequently and had major shows abroad from the late 1930s on. He was given various honours (e.g. Commander of the Légion d'Honneur 1952) and his 80th birthday was celebrated by the Centre of Catholic Intellectuals in Chaillot.

Roubiliac, Louis François (1702/5–62) French Huguenot sculptor, trained by Balthasar *Permoser at Dresden and Nicolas *Coustou in Paris. From 1735 he is recorded in England, becoming perhaps the most accomplished sculptor to have worked there. His first commission was for a marble statue of Handel for Vauxhall Gardens (1738), but he made his reputation as a maker of portrait busts, evolving a new pattern for each (Birmingham, Museum; London, National Portrait; etc.). During the 1740s he began to obtain commissions for tombs outside London (Worcester, cathedral; Shropshire, Condover) and between 1745–9 he executed his first major London commission, the monument to John, Duke of Argyll (Westminster Abbey). In 1752 he journeyed to Italy with the painter Thomas *Hudson; the work executed after his return is more vigorous, even more dramatic, than before (London, Westminster Abbey, tombs of *General Hargrave*, 1757, *Lady Elizabeth Nightingale*; *Handel*, both 1761). His series of busts of distinguished members of Trinity College, Cambridge, 1751–7, all based on painted portraits, as well as his busts of famous men long dead (*Milton*; *Shakespeare*; *Cromwell*; *Charles I*, terracotta, London, British) demonstrate his ability to recreate imaginatively the semblance of life. Stylistically, his work plays an important part in the development of *Rococo in England. *See also* Cheere, Sir Henry.

Rousseau, Henri (1844–1910) French painter, known as the Douanier (customs officer) in reference to his employment in the French Customs and Excise department after periods in the army, primarily as saxophonist, and his claimed service in the Mexican campaign,

probably a fiction. To supplement his pension he gave violin lessons and began to do paintings, mostly commissioned portraits of ordinary people. Professional artists became aware of his work in the 1880s and he was encouraged to exhibit at some of the annual Salons. His circle of artist acquaintances widened but he seemed immune to influence from the progressive painters who admired his work, attaching himself rather to academic traditions which he sought to uphold in his careful, unschooled productions, free from the trammels of basic academic know-how such as perspective and anatomy. To what extent avant-garde painters took his work seriously or were amused by the existence of this convinced *primitive, it is difficult to say. In 1908 they organized a banquet in his honour at which many historically important artists and critics were present: *Picasso, *Apollinaire, Robert *Delaunay and Wilhelm Uhde, the critic who was to write the first book on the artist (1911). Perhaps we shall never know whether there was an element of conscious cunning in Rousseau, a clever method of sharpening detail and simplifying compositions learned from others' paintings, prints and photographs. What is clear is that those who knew him, tempted at times to test his simplicity, found no chink in his armour. Delaunay and Picasso certainly admired his work, Delaunay looked after Rousseau's estate after the Douanier's death, and *Kandinsky (in Munich) followed Delaunay's example by acquiring some of Rousseau's paintings and showing them in the *Blaue Reiter almanach and exhibition. There was a memorial exhibition within the Salon des Indépendants in 1911, organized by Uhde. Since the 1930s Rousseau's work has acquired status not only among art pundits but also with the wider public; both have come to see him as a fine as well as entertaining painter.

Rousseau, Théodore (1812–67) French landscape painter, from his early years specializing in *plein air* painting and soon notorious on account of the expressive intensity and brusque manner of his brush-work. His rejection of traditional degrees of 'finish', i.e. careful representation of details, excluded him from *Salon exhibitions for many years and even *Baudelaire, who could admire spirited effects of sketchiness found Rousseau's handling too coarse. Rousseau, however, instructed a student that 'What finishes a picture is not the quantity of detail but the accuracy of the general effect'. In 1948 he settled in *Barbizon and became a leading member of the school. The character of his paintings expresses his temperament, open and luminous at times but often melancholic and dark.

Roussel, Ker-Xavier (1867–1944) French painter, one of the *Nabis, known for his pastoral scenes from ancient literature.

Rovere, della Noble and widely connected Italian family originally from Savona, best-known in the history of art for the patronage of two *Renaissance popes: Sixtus IV, the former **Francesco della Rovere** (1414–d.1484), elected in 1471, and his nephew **Giuliano della Rovere** (1443–1513) elected to the papacy in 1503 as Julius II. Sixtus's extensive programme of building and urban renewal is beyond the scope of this entry, but we must note here his creation of the Sistine Chapel in the Vatican, and its mural decoration by a team led by *Perugino and including *Botticelli, *Ghirlandaio and Cosimo *Rosselli, and his foundation of the Vatican Library, marked by a splendid *fresco (now detached) by *Melozzo da Forlì. His tomb, of a new and influential format, was by Antonio del *Pollaiuolo. Julius II to a great extent followed in his uncle's footsteps as a patron, commissioning *Michelangelo's famous ceiling to complement the Sistine Chapel's painted walls. His own tomb, finally cobbled together by Michelangelo as a wall monument in San Pietro in Vincoli, was originally planned to emulate that of Sixtus. It was Julius who, in an act of vandalism/enlightened patronage tore down Old St Peter's to construct a great Renaissance church on the designs of Bramante. Julius is also remembered as the original

patron of the Vatican apartments known as
the Stanze, where *Raphael first made his
Roman reputation.

Rowlandson, Thomas (1756–1827)
English watercolourist and caricaturist. He
was trained in figure drawing in Paris from
1771–3, and in London at the *Academy
schools. In addition to his rollicking *cari-
catures of the life of the times, he came
close to *Sandby in his landscape water-
colours, which are notable for their sensi-
tivity to atmospheric tone.

Roy, Pierre (1880–1950) French
painter who came under the influence of
De *Chirico and from 1925 exhibited with
the *Surrealists. His characteristic paint-
ings combine *naturalistic accounts of inte-
riors and still lifes with bizarre intrusions.
He worked also as book illlustrator and
stage designer.

Rozanova, Olga (1886–1918)
Russian painter, wife of the *Futurist poet
Kruchenykh for whose and others' booklets
she made illustrations and independent
drawings during 1912–16. Her text, 'The
Bases of the New Creation and the Reasons
Why It Is Misunderstood', published in St
Petersburg in 1913, asserted art as a means
of realizing intuitive apprehensions of the
world in *abstract images, the product of
'*constructive processing'. She showed in
the *avant-garde exhibitions of Moscow
and Petrograd and worked with *Malevich
to develop a *Suprematist group and
journal in 1916–17. She worked for the
Commissariat for Enlightenment in 1917–
18, heading the applied arts section, but
died prematurely and was celebrated in a
great memorial exhibition held in Moscow
in 1919. Her work varied greatly (she
stressed the need to avoid all forms of
repetition) but includes some of the sub-
tlest abstract work of the period.

Rubénistes *See under* disegno.

Rubens, Peter Paul (1577–1640) Ital-
ianate Flemish painter, perhaps the great-
est exponent of the *Baroque style which
he pioneered; and the only northern Euro-

pean artist successfully to rival the Italians
in history painting (*see under* genres). He
was also an unmatched designer of altar-
pieces and large-scale mural and ceiling
decoration, working, however, in oils and
not *fresco. His portraits on the scale of life
influenced, among others, his one-time
assistant *Van Dyck, and his landscapes
revolutionized the genre. His work, based
on first-hand study of the antique, the
Italian *Renaissance and his own native
tradition, affected not only countless con-
temporaries but also successive generations
of artists even into the 20th century. The
tag of 'learned painter', while more accu-
rate than for almost any other artist, does
not do justice to the intensely visual quality
of his art, uniquely affirmative of the joys
of life, albeit tempered with a philosophic
moderation and reticence not immediately
perceptible to a modern viewer. He is the
brilliant colourist *par excellence*, so that
'Rubéniste' became the French *Academy's
label for those painters favouring *coloris*
(*colorito*) over *dessein* (**disegno*). Under the
influence above all of *Titian, he evolved
a type of chromatic modelling which
virtually excludes shadows in flesh tones,
suggesting translucence and vibrancy. His
resplendent female nudes, his vigorous
male figures, were criticized in the acade-
mies for lacking *idealization, yet they are
generally based on *classical or Renaissance
prototypes, according to his own precept
for drawing after statuary: transforming
marble into 'living flesh'.

Rubens was born in Siegen, Westphalia,
where his patrician family, originally from
Antwerp, were in temporary exile; most
of his childhood was spent in Cologne.
His father Jan, a learned lawyer, and his
scholarly elder brother Philip fostered
his considerable intellectual gifts. After the
family's return to Antwerp following Jan
Rubens's death in 1587, he attended a
well-known grammar school, leaving in
1590 to become a page to the Countess de
Ligne-Arenberg at Oudenarde. Rubens's
abiding dislike of princely courts, as well as
the roots of his later diplomatic career, may
perhaps be traced to this brief episode.
He soon persuaded his mother to let
him study painting: first with a kinsman,

the landscape artist **Tobias Verhaecht** (1561–1631); from 1592 with Adam van *Noort, and from c.1596 with the erudite Otto van *Veen, who of his three teachers most influenced him. The few securely identified works from this period show Rubens already drawing from prints after *Raphael (Antwerp, Rubenshuis; London, National). In 1600 he left for Italy, where he spent eight formative years. Nominally in the service of the Duke of Mantua, he was able to travel widely, study and work in other Italian centres. In 1603 he was sent by the Duke to Spain with presents for Philip II (equestrian portrait of the *Duke of Lerma*, 1603, Madrid, Prado).

Eschewing the tasks of small-scale portraiture, landscape or *genre normally relegated to Netherlandish artists in Italy, Rubens successfully imposed himself as a painter on the scale of life. At Mantua, he decorated a room with scenes after Virgil's *Aeneid* (1602, fragments only, Prague, castle museum; Fontainebleau, Château) and executed a group of three large paintings for the chancel of the new Jesuit church (1604–5; *Baptism of Christ*, Antwerp, Musée; *Transfiguration*, Nancy, Musée; *Gonzaga family adoring the Trinity*, fragments only, Mantua, Palazzo Ducale; Vienna, Kunsthistorisches). In Rome, he was commissioned twice for altarpieces, first for S. Croce in Gerusalemme (1601–2, now Grasse, cathedral) and then for S. Maria in Valicella (1607, first version Grenoble, Musée; 1608, second version *in situ*). In Genoa, he painted a series of portraits of the local aristocracy, which were to inspire Van Dyck on his visit to the city in 1621 (e.g. Washington, National). Paintings on classical themes dating from his Italian sojourn are now to be found in, e.g. Dresden, Gemäldegalerie; New Haven, Yale.

Rubens's real career as a painter of international stature begins, however, with his return to Flanders in 1609. Although he continued to execute autograph pictures – portraits of the Regents, of his family, friends and special patrons (e.g. Munich, Alte Pinakothek; Vaduz, Liechtenstein Coll., London, Courtauld) collectors' pictures on biblical or mythological themes (e.g. Dresden, Gemäldegalerie; Cologne, Wallraf-Richarz; Kassel, Kunstsamm-

lungen; London, National) or of exotic animal hunts (e.g. Munich, Alte Pinakothek) – his studio, working from coloured oil sketches by the master, furnished pictures for numerous patrons, especially altarpieces for the many Antwerp churches despoiled by Calvinist iconoclasts in the 1560s and 1570s, and for newly-built churches (e.g. Antwerp, cathedral, St Michaelskerk, St Pauluskerk, St Augustinuskerk). For the new Jesuit church, which he may have helped design, Rubens created not only altarpieces (now Vienna, Kunsthistorishes) but an entire, and quite novel, lavish interior decoration, including ceiling paintings in the Venetian mode (1620–1; destroyed by fire, 1718). In 1622–5 he executed, again with studio aid, a large cycle of panegyric biography of the Queen Mother of France, Marie de' *Medici, for her palace of the Luxembourg (now Paris, Louvre). This was to be paired with a series of paintings extolling Marie's late husband, Henry IV, never completed (e.g. Florence, Uffizi).

His classically based pictorial language of life-like *allegory is demonstrated also in his designs for tapestries representing the *Triumph of the Eucharist* for the Regent Infanta's favoured convent in Madrid (1625–7; tapestries, Madrid, Descalzas Reales; sketches, Chicago, Institute; Washington, National; etc.). Rubens's diplomatic work on behalf of the Regents, secret missions to promote the reunification of the Netherlands and peace in Europe, intensified after the death of his much-loved first wife, Isabella Brant, in 1626. His political ideals are evoked in two famous allegorical paintings, *Minerva protecting Peace from Mars* (1629–30, London, National) and *The Effects of War* (c.1637, Florence, Pitti). His missions to Spain, 1628, and to England, 1629–30, resulted not only in his being knighted by the art-loving monarchs of these countries, Philip IV and Charles I, but also in two more major decorative commissions: for the Whitehall Banqueting House ceiling (completed 1634, London, *in situ*), and, for Philip's hunting lodge near Madrid, the Torre de la Parada, a series of mythological paintings based on Ovid's *Metamorphoses* (completed, almost entirely by assistants, c.1636–8;

ensemble destroyed; remaining paintings Madrid, Prado; autograph sketches, Brussels, Musées; Rotterdam, Boijmans Van Beuningen; etc.).

The last major cycle on which he worked was undoubtedly more deeply felt than either of these projects. Not flattering a prince so much as pleading on behalf of his city's stricken economy, he designed the festival entry decorations for the arrival in Antwerp on 17 April 1635 of the Cardinal-Infante Ferdinand, the new Regent of the Netherlands (recorded in engravings published 1642).

In 1630 Rubens remarried, to the young Helene Fourment. When, in the last four years of his life, ill with gout, he went into quasi-retirement, it was as a noble to a newly purchased country manor, Het Steen. Here he painted for his own enjoyment a brilliant series of pictures. Especially remarkable are the landscapes, with their pioneering notation of fleeting weather and light conditions; rustic *genre scenes on themes first popularized by Pieter *Bruegel; and fantasies on pastoral or courtly love, which were the source of the 18th-century *fête galante (e.g. London, National, Wallace, Courtauld; Vienna, Kunsthistorisches; etc.).

Celebrated in his day as the 'Belgian Apelles', Rubens did not content himself with emulating Alexander the Great's famous painter. His diplomatic work has already been mentioned. But he was also genuinely scholarly, an insatiable reader and collector of books, antiques and other art; he was also occasionally a dealer. He corresponded on all manner of subjects with the most erudite people in Europe. The extant letters testify, as do the writings of his contemporaries, to his independence of spirit, his moral courage and his warm affections. In an age of violent sectarianism he was a champion of tolerance and internationalism. His support of monarchs and of the church should be understood as an expression of hope for a united Europe and an affirmation of the enduring values of civilization. *See also* Bolswert, Schelte à.

Rublev, Andrei (1360?–1430) The most celebrated Russian *icon painter, and the only one whose name is familiar in the West. He is documented working in the Cathedral of the Annunciation in the Kremlin at Moscow, and is said to have painted murals in the Cathedral of the Dormition, Vladimir, but the only work universally attributed to him is the panel of the *Old Testament Trinity* (that is, the three angels welcomed by Abraham in Genesis 18), c.1411, now in Moscow, Tretyakov. The graceful and lyrical style of this icon has been compared to that of *Duccio, and marks a break with the harsher, more linear forms of the debased *Byzantine style practised by other Russian icon painters.

Rude, François (1784–1855) French sculptor, son of a coppersmith. He studied sculpture in Dijon and, from 1807, in Paris. An ardent republican and Bonapartist, he went to Brussels in 1814 where he executed various *Neoclassical works, became court sculptor to the Netherlands and did a bronze bust of J.-L. *David in 1826. (A marble version is in the Louvre, Paris, as is a larger, more official bronze bust of David by Rude.) In 1828 Rude returned to France and settled in Paris. There elements of *Romantic fervour entered his work, well seen in his stone relief for the Arc de Triomphe in Paris, *Departure of the Volunteers of 1792* (1836) and in other sculptures celebrating French historical figures. His politics made the *Academy shun him but he had a successful career and, in his bridging of Neoclassicism and Romanticism, he contributed to French art in a manner not unlike *Chassériau's role in painting, though with greater strength of form and expression.

Ruisdael, Jacob van (1628/9–82) The foremost exponent of the 'classical' phase of Dutch landscape painting, notable for its monumentality and the heroization, for symbolic as much as formal ends, of single motifs: a windmill (*Windmill at Wijk*, c.1665, Amsterdam, Rijksmuseum), a clump of trees (*Dunes*, c.1647, Paris, Louvre) or an animal (*see* Paulus Potter).

Ruisdael was born in Haarlem, the son of the painter **Isaak van Ruisdael**, of whose work little is known. An early influence was

his uncle Salomon van *Ruysdael, a leading painter of the 'tonal' phase of Dutch landscape, in which the topography and humid atmosphere of the Dutch coast dominate over the representation of human activities. From the beginning, however, Ruisdael's work differed from that of his uncle by a denser, more opaque, use of paint, more vigorous accents of local colour and more energetic composition.

In the early 1650s Rusidael left Haarlem for the border region between Holland and Germany (*Bentheim Castle*, 1653, Ireland, Blessington, Beit Coll.). Around 1656, he settled in Amsterdam, where he continued to paint the flat countryside near Haarlem as well as the rolling woodlands and streams of the Dutch–German borderland. Under the influence of *Everdingen he added, c.1660, the Scandinavian themes of rocky mountains, fir forests and waterfalls to his repertoire. Although the former subjects are sometimes classified as 'realistic' and the latter 'romantic', there is as much *expressive power in the moisture-laden clouds and fitfully illuminated fields of his *View of Haarlem* (c.1670, Amsterdam, Rijksmuseum) as in the powerful animated trees of the *Marsh in the Woods* (c.1665, St Petersburg, Hermitage). Ruisdael's ability to create a poetic, even tragic, mood through landscape is best seen in the *Jewish Cemetery* (c.1660, Dresden, Gemäldegalerie; an earlier version, Detroit Institute), which seems to symbolize the transience of all earthly things.

Runciman, Alexander (1736–85) and his brother **John** (1744–68) Scottish painters, forerunners of *Fuseli in their intensely-felt paintings of subjects from Shakespeare; Alexander in fact befriended Fuseli on the latter's arrival in Rome. Trained in a firm of decorative painters who embellished the houses of Edinburgh with landscapes derived from Gaspar *Dughet and *Pannini, Alexander went to Rome in 1766; in 1767 he was joined by John (whose teacher he presumably was). Much of John Runciman's work was destroyed by him before he died – probably a suicide – in Naples, but what remains shows him to have been a painter of great promise: three small religious scenes on panel and copper, and a larger panel, *King Lear in the Storm* (signed and dated 1767; all four Edinburgh, National). The *Lear* has been called 'an altogether surprising masterpiece' and is remarkable at this date both in subject and proto-*Romantic sentiment; the free and painterly technique recalls that of *Rubens. The Runcimans' passion for Shakespeare is further documented by a *Self Portrait* of Alexander discussing a passage in *The Tempest* with a friend (1784, Edinburgh, NPG). Alexander Runciman left Rome in 1771, and after a brief stay in London was appointed Director of the Edinburgh *Academy in 1772. His most ambitious work, a series of scenes from Ossian painted in the great hall of Penicuik House, was destroyed by fire in 1899; a number of studies survive in Edinburgh, National, Print Room, which also holds some watercolours by the artist of Scottish landscapes, which betray his knowledge of landscape drawings by *Claude.

Runge, Philipp Otto (1777–1810) German painter of the *Romantic period. It was his ambition to reform art by renewing landscape painting as the art form of the future, in structure echoing plant forms but encompassing all spiritual and material knowledge. To this end he wrote as well as painted but his brief career and few completed works could make little impact in spite of his connection to great literary figures such as Tieck and *Goethe and their warm interest in his work. Alfred Lichtwark, director of the Hamburg Kunsthalle, studied and collected his work towards the end of the 19th century; that is where almost all of it can be seen. Artists and art historians soon came to see him as a major figure in German art who touched on certain modern issues and serves as a model of high-minded creative effort.

Ninth of eleven children in a devout Protestant family of Pomerania, and always of poor health, Runge came to art rather late, studying in the academies of Copenhagen and Dresden during 1799–1803 but learning more from old master paintings than from academic routines, as well as from the radical religious and literary issues of the day. In 1801

he met Tieck whose novel *The Wanderings of Franz Sternbald* (1798) he already admired; their discussions confirmed his aspirations. In 1803 he visited Goethe. During 1802–3 he drew the four *Times of Day*, published as etchings in 1805 and 7, in which a drawing style of pure line, inspired by *Flaxman, severe geometrical design and wide-ranging symbolism came together in 'remarkable works of an entirely new kind' (Friedrich Schlegel), at once 'beautiful and extraordinary' (Goethe). He embarked on making paintings of the *Times of Day*, working on a small and a large *Morning*, influenced in part by German painting of the late-medieval and *Renaissance period. His ambition was to instal the series in the form of vast paintings in a specially designed building whose form would combine with the paintings and also with music and poetry to produce in the visitor an experience of one-ness and ecstasy when 'everything harmonizes in one great chord'. From 1806 on he was in correspondence with Goethe about colour theory and in 1810 published his conclusions as *Colour Sphere*. In his practice as in his writing, he sought the essence and origin of all meaning and methods, choosing clarity and economy as his guide, refusing historicism and requiring every element to carry its message. He painted several remarkable portraits, including that of his parents, his son and his nephew. His portraits of children reveal his search for a meaning beyond that of the immediate context, linking the natural world, minutely observed, to religious perceptions which embraced paganism and Christianity.

Ruoppolo, Giovanni Battista (1629–93) The foremost Neapolitan *still-life painter. His early work is both *naturalistic and dramatic, setting illuminated flowers and vegetables against a dark background. The most important painting from this phase is in Oxford, Ashmolean. After the 1660s he veered towards a more decorative style, with lavish arrangements of flowers and fruit.

Rupert of the Rhine, Prince (1619–82) The nephew of Charles I and a famous cavalry commander in the Civil War, the Bohemian-born Rupert was also an amateur artist and scientist. Although wrongly credited with the invention of *mezzotint – which he probably learned in Brussels in 1654 from its most-likely originator, the soldier and amateur artist Ludwig von Siegen (1609–*c.*1680) – he introduced the technique to England at the Restoration (1660). His best-known mezzotint print is *The Executioner with the Head of Saint John the Baptist*, after a painting by *Ribeira.

Rusconi, Camillo (1658–1728) The most outstanding Italian sculptor working in Rome in the early 18th century, a friend of the painter *Maratta whose work influenced him (*Apostles*, S. Giovanni in Laterano, 1708–18; tomb of Pope Gregory XIII, Vatican, St Peter's, 1719–25).

Ruskin, John (1819–1900) British critic of art, architecture and society. His parents were a prosperous wine merchant and a devout Evangelical Christian. He, of uncertain health, was educated at home in South London until he went to Oxford where he won a major prize for poetry in 1839 and graduated in 1842. Travel, in Britain and abroad, almost annually and sometimes for many months, was part of his education though justified also by health considerations. The most frequent route taken was through France and Switzerland into Italy, and back; more rarely into Germany. In 1845 he made the first of his many foreign journeys without his parents, to satisfy his appetite for nature, especially at its most dramatic as experienced in the Alps, and for art and architecture as found at their most rewarding in Italy, particularly in Florence and Venice. His religious upbringing demanded close study of the bible; his life-long study of nature rested on its being a manifestation of God. Later he came to doubt all religion but the imagination and the poetry of the English bible stayed with him, as well as his sense of the arts as transcending facts and reason. He was encouraged to practise drawing, with and without colour, and sought tuition from the best watercolourists of his day. He became a gifted recorder of many sights, from

animals and mountains to architectural details and whole buildings as well as sculpture and paintings; these often served to illustrate his books and lectures. Above all, having first thought himself a poet, he soon found that his eyes brought him matters of the greatest interest and satisfaction and, though books were always of great importance to him and he wrote some fine literary criticism, art quickly became his primary concern. To know nature called for scientific knowledge, including an understanding of the new science of geology; to know art called for recognition not only of a good artist's intense study of the visible world but also of the powers of the imagination. You do not see with the eye, he wrote; 'you see *through* that, and by means of that, but you see with the soul of the eye'. He developed a painter's eye, finding that 'the arrangement of colours and lines is an art analogous to the composition of music, and entirely independent of the representation of facts'; good colouring has nothing to do with imitating nature but everything with 'abstract qualities and relations'. This remarkable insight must have come from art. From 1833 he visited the Royal *Academy's annual exhibitions fairly regularly, and during 1855–9 and again in 1875 he reviewed them. On occasion his father would buy him paintings he especially admired, and these tended to be Turners.

Already in 1836 he had written a letter in protest against a critic's attack on *Turner's vision and methods. He had met Turner's art first in 1832 in the form of engravings after his landscape drawings, and it seems they had fused in him with his experience of Wordsworth's poetry. He first met the painter in 1840 and a respectful relationship between Turner and the Ruskins developed from this. *Modern Painters*, in five volumes (1843–60), begun as an account of Turner's art, had to become an exercise in educating his readers in the principles and priorities of painting, in what is truth in art and how landscape painting has its own purposes and imaginative levels. This work took art criticism, not only in England, to unprecedented heights of seriousness combined with close knowl-

edge. During the same years Ruskin wrote his most perfect cultural treatise, *The Stones of Venice* (three volumes, 1851–3), in which his passionate account of the city demanded explanations in terms of its history and social relations, and the much shorter *Elements of Drawing* (1857) in which, according to *Monet, 'ninety percent of the theory of impressionist painting' may be found long before the birth of *Impressionism. Before this he had taken time out to set down thoughts stimulated principally by the Romanesque and Gothic buildings of Normandy and Italy as *The Seven Lamps of Architecture* (1849). In 1851 he wrote for the first time about *Pre-Raphaelite paintings in a letter to *The Times* and in opposition to its critic's report, and he was for some time to champion this young movement though always thinking of it as immature. *Unto This Last* (1860), his shortest and most eloquent book, subtitled 'Four Essays on the First Principles of Political Economy', is an incisive assault on capitalism and the first of Ruskin's denunciations of the Victorian market economy which he associated with the dehumanization of manufacture and thus the deepening flood of bad design and inept decoration. Later he would not only write and lecture on this, but also employ his capital in setting up funds, organizations and utopian projects designed to aid and instruct workers, just as, during his first period as Slade Professor of Art at Oxford (1869–79 and 1883–5), he founded a School of Drawing there. He wrote, taught and organized without cease and with a missionary's zeal, until his mind gave way. There were crises in 1876, in 1878 (the year in which *Whistler sued him for libel), in 1881 and 1883, from which time on his mind moved into and out of periods of blackness and despair while his eyesight declined. His father had died in 1864; when his mother died, in 1871, he bought a house near Coniston in the Lake District; this became his primary home and here he wrote his autobiography, *Praeterita* (1885–9). His writings were enormously popular and often republished without his consent, with cheap foreign editions undercutting English ones. Honours were

heaped upon him in Britain and abroad Some he declined but accepted honorary membership of the Academies of Venice, Florence, Antwerp, Brussels and America. From 1879 on Ruskin Societies were founded all over Britain; he was elected to a wide range of learned societies. His corpse was offered a place in Westminster Abbey, but he was buried at Coniston as he had wished.

Cosseted from childhood into adulthood and kept remote from the ordinary life of maturing boys, Ruskin's life as man was marked by many failures. Early feelings of love were not reciprocated; his marriage to Effie Gray, 1848, ended in 1854 by annulment on grounds of non-consummation while he escaped to the Continent and she into the arms of *Millais. His proposal of marriage to the young Rose La Touche, in 1866, born out of feelings formed over six admiring years, had to be rejected. He had always loved the young, and shared Wordsworth's intuition that growing up means losing intimacy with the glories of this world. Similarly he had valued the early stages of art and architectural styles over their full fruition. Meanwhile untold energies went into teaching by various means, including such matters as creating the Oxford Museum and St George's Museum, just outside Sheffield, and setting up farming schemes for the unemployed workmen of the same town.

If much of his teaching was against the progress on which the Victorian age thrived and from which it suffered, highlighting the simpler virtues of the Middle Ages – he spoke of a plan for 'making people old-fashioned – the influence of his brilliant, often contradictory words, exploded over the world and is active still though few have the patience to read his illuminating as well as sometimes contradictory volumes. William *Morris was his most direct disciple and, less direct, through Morris, Roger *Fry. Proust translated him and was influenced by his prose. Ghandi was influenced by his social and political thought. Ruskin was a man of the stature of Marx and Darwin. His criticism was always passionate, and perhaps the least beneficial consequence of his work has been the assumption

that passionate views, often negative and expressed vehemently, make good criticism and good reading. One of the best accounts and assessments of Ruskin's work and value is that written by Quentin Bell, artist and writer and son of Vanessa and Clive *Bell: a slim volume.

Russell, Morgan (1886–1953) Amerian painter who with *MacDonald-Wright launched *Synchromism in Paris in 1913. He had studied architecture before coming to Paris in 1906 and immersing himself in *Impressionism and the work of *Cézanne. After repeated visits, he settled in Paris in 1909, essayed sculpture but returned to painting, exploring Cézanne's 'rhythm in colour' in increasingly *abstract still lifes. He met MacDonald-Wright in 1911 and joined him in developing theories about colour as light. In the spring of 1913 he exhibited the first painting (now lost) to use 'Synchromy' in its title, drawing attention to the concept, not to its subject-matter: *Synchromy in Green*. Later that year he exhibited with MacDonald-Wright as 'Les Synchromistes' at the Bernheim-jeune Gallery in Paris, including, as a culmination of colour studies based on *Michelangelo's *Dying Slave* in the Louvre, a very large canvas *Synchromy in Deep Blue-Violet* (now known only in a smaller version painted the same year), using complementary colours for what is, in effect, an abstract colour composition. Russell abandoned Synchromism in 1916 but continued to paint abstract canvases dominated by colour interaction, now looser and less constructed.

Russolo, Luigi (1885–1947) Italian painter and composer, son and brother of musicians. He turned to art through friendship with *Carrà and other young painters and in 1910 was one of the signatories of the *Futurist painting manifesto. His Futurist paintings tended to be visual interpretations of non-visual experiences, such as the flux of memory, the sensation of hearing music, the mass emotion of a crowd of workers in revolt, also the motion of people and vehicles. From 1912 on he developed a Futurist music, produced by and scored for noise machines he invented

himself. In 1913 he published his manifesto *The Art of Noise* and in 1914 gave a performance of his music in London. He continued to paint, but in a traditionally representational manner.

Rustici, Giovanni Francesco (1474–1554) Florentine sculptor, a pupil of *Verrocchio and later associated with *Leonardo da Vinci, who was closely involved in the *expressive bronze group of *St John the Baptist preaching to a Levite and a Pharisee* over the north door of Florence baptistry, 1506–11, competing with Andrea *Sansovino's *classicizing *Baptism of Christ* over the east door. Four terracotta groups of fighting horsemen also reflect Leonardo's ideas (Paris, Louvre; Florence, Bargello). In 1514 Rustici was employed on Verrocchio's Forteguerri monument in Pistoia cathedral. Having participated in the decorations for the 1515 festival entry of Pope Leo X (Giovanni de' *Medici) into Florence, Rustici was commissioned by the Medici for a bronze fountain figure of Mercury (now pc.). On the expulsion of the Medici in 1528, he left for France, where he worked mainly on an equestrian statue for Francis I, a project abandoned upon the King's death in 1547.

Ruysch, Rachel (1663–1750) Amsterdam flower painter of international fame. The daughter of a distinguished botanist and anatomist, she studied with William van *Aelst, whose asymmetrical compositions she adopted. She also painted insects and reptiles. She was one of the artists patronized by the Elector Palatine, Johann Wilhelm (*see also* Adriaen van der Werff; Godfried Schalcken): her entire production in the years 1710–13 was contracted to him. Rachel Ruysch bore ten children, and perhaps for this reason only about 100 paintings by her are known (Munich, Alte Pinakothek; etc.).

Ruysdael, Salomon van (1600/3?–70) One of the originators of the 'tonal' phase of Dutch landscape, in which the topography and humid atmosphere of the Dutch coast dominate over the representation of human activities (*see also* Jan van Goyen; Pieter de Molijn). Born at Gooiland, hence

his early appellation Salomon de Gooyer, he was settled in Haarlem by 1623. He is best known for the river scenes he began to paint in the 1630s. Around 1650, under the influence of his nephew, Jacob van *Ruisdael, he began to employ the forceful motif of a 'heroic' tree, often against a colourful sunset sky (e.g. *Halt at an Inn*, 1649, Budapest, Museum). At the beginning of the 1660s he painted some *still lifes of objects arranged on a marble surface – perhaps the artificial marble which he is recorded as having invented (e.g. The Hague, Bredius).

His son, **Jacob Salomonsz. Ruysdael** (1629/30–81), was also a landscape painter (e.g. London, National). There are paintings by Salomon in most art galleries in Europe and the United States.

Ryckaert or **Rijckaert** Dynasty of Flemish painters. The best-known is **David Ryckaert III** (1612–61), an imitator of *Brouwer's scenes of peasants in bare interiors (Valenciennes, Musée). About 1639–40 he also began to draw on *Jordaens's and *Teniers's pictures of 'Merry Companies' (for this term, *see under* Buytewech). His grandfather, father and son, **David I, II, and IV**, were all painters, but more important is his uncle, **Martin Rijckaert** (1587–1631/2) who painted landscapes in the manner of *Momper.

Ryder, Albert Pynkham (1847–1917) American painter, an early visitor to Europe but largely self-taught and from 1870 a solitary figure in New York, slowly painting and repainting small visionary scenes, often of the sea, in thick, not very stable paints, and in dramatic, simplified forms. He was, in effect, an American *Symbolist without having any conscious association with the European movement but sharing its admiration for the writings of Edgar Allen Poe. Ten of his paintings were included in the *Armory Show, evidence of the regard fellow artists had for his work.

Ryman, Robert (1930–) American painter who came to New York from Nashville, Tennessee, in 1952 to pursue a career as a jazz saxophonist and

got his art education by serving for some years as a gallery attendant at the Museum of Modern Art. During 1961–6 he was married to the eminent critic Lucy Lippard. His work in art began with paintings and collages exploring the processes and materials of picture-making. He felt an urge to find a focus within the wide visual world this opened up to him, and in the late 1950s decided to work only on square formats and then, in the mid-60s, to abandon sonorous hues for white alone. Used in many ways, in varying densities, with different brushes and actions as well as different surfaces, not always covered completely, testing even different ways of fixing paintings to walls including painting on the wall itself, white painting has proved an infinite range of possibilities, each with its potential of visual stimulus and conceptual meaning. His work has been seen frequently in the USA and in Europe since the late 1960s.

Rysbrack, Michael (1694–1770) The leading sculptor in England between 1720 and 40. Born in Antwerp, he was the son of the painter **Peter Rysbrack** and was almost certainly apprenticed to the distinguished Antwerp sculptor, **Michael Vervoort**, who had spent some ten years in Rome. From his arrival in England c.1720 he received important commissions: a large relief over a fireplace at Kensington Palace (*A Roman Marriage*, 1723), a tomb in Westminster Abbey (Monument to Matthew Prior, 1723), the monument of the painter Sir Godfrey *Kneller (intended for Whitton Church, set up 1730 in Westminster Abbey) and a bust of the Earl of Nottingham (1723, Rutland, Ayston Hall). The latter is a landmark in English sculp-

ture: a deliberate attempt at portraiture *all'antica*. By 1732 Rysbrack had executed over 60 portrait busts, many of which exist in two versions: a terracotta model, from the life if possible, and a marble cut from the model. Several of these are royal portraits (Windsor Castle; London, Wallace; Oxford, Christ Church), and there are many aristocratic portraits, as well as many of the leading professional men of the day (London, V&A, British; etc.). He also executed many imaginary portraits of Great Men, much in demand for the adornment of gardens and libraries. At the same time, he continued to practise as a tomb sculptor. In association with William *Kent he erected the monument to Newton in Westminster Abbey (1731), and its companion, tomb of the Earl of Stanhope (1733); whilst at Blenheim Palace the grander monument to the Duke of Marlborough was erected in 1732. Stylistically, Rysbrack's art has been characterized as conflating *Baroque vigour and *classicizing pose; both tendencies are well illustrated in his bronze equestrian statue of William III (1735, Bristol). In his later years, he was influenced by the dramatic manner of *Roubiliac (e.g. monument of Admiral Vernon, 1763, Westminster Abbey), probably in an attempt to regain the popularity of his earlier work.

Rysselberghe, Théo van (1862–1926) Belgian painter who adopted the *pointillist technique of *Seurat in 1886–87 and in 1888 was one of the founder members of Les *Vingt. In 1897 he moved to Paris and was part of the *Symbolist movement as well as making designs for *Art Nouveau interiors, furniture and stained glass.

Sacchi, Andrea (1599–1661) Roman painter, a pupil of *Albani both in Rome and in Bologna (*see also* Carracci). From c.1621 he had settled in his native city, where, after having painted major altarpieces in a *Baroque style (1622, Rome, S. Isidoro; 1625–7, Vatican, Pinacoteca) he evolved the sober, introspective *classicism for which he is best remembered (*Vision of S. Romuald*, c.1638, Vatican, Pinacoteca; cycle of the *Life of St John the Baptist*, 1639–45, Rome, S. Giovanni in Fonte). In contrast to *Poussin, whose development in these years presents striking parallels, he never lost, however, the rich and warm range of colours of his earliest work (e.g. *Death of St Anne*, 1649, Rome, S. Carlo ai Catinari).

Sacchi had worked under *Pietro da Cortona at Castel Fusano in 1627–9. Their views diverged markedly, however, from 1629–33, when Sacchi was employed painting the ceiling of a small room in the Palazzo Barberini. His fresco of *Divine Wisdom* avoids the *illusionism of Pietro da Cortona's ceiling decoration of *Divine Providence*, begun in 1633 in the Gran Salone of the same palace, and represents only a few figures, in tranquil poses, as on a *quadro riportato* – an easel painting hung up on the ceiling – albeit without a prominent painted frame. The differences between the two artists were voiced in disputes held at the *Academy of St Luke in the 1630s, centred on the number of figures desirable in a composition.

A slow, self-critical artist, Sacchi never achieved the worldly success later attained by his chief pupil, Carlo *Maratta.

sacra conversazione (Italian pl. *sacre conversazioni*, holy conversation; more accurately, holy communing) A representation, normally an altarpiece, of the Virgin and Child attended by saints and sometimes angels. The figures need not be shown conversing, but appear in an architecturally unified space, as opposed to the separately framed pictorial fields of the *polyptych. Unlike its predecessor, the *maestà*, the *sacra conversazione* evokes an intimate mood of meditation and contemplation. The form evolved in mid-15th-century Florence (*Domenico Veneziano, *St Lucy Altar*, c.1445, Florence, Uffizi), was transmitted to northern Italy via *Donatello's sculptural altar for Sant' Antonio, Padua (1443–53, dismantled, partially reassembled), and is particularly associated with the later Venetian altarpieces of Giovanni *Bellini, which in turn influenced, via Fra *Bartolommeo, the 16th-century altarpieces of the Florentine School.

Sacro Monte (pl. Sacri Monti; Italian for Holy Mountain(s)) Sites of popular pilgrimage in Lombardy and Piedmont, all but one of which are situated in the foothills of the Alps. The first and most influential was founded at Varallo in 1486. The intention was to reconstruct exactly the Holy Places in Palestine and recreate, as an aid to piety, scenes from the life of Christ. Each Sacro Monte thus consists of a series of separate chapels enclosing 'tableaux vivants' of *realistic, life-size *polychrome sculptures, usually of terracotta (compare with Guido *Mazzoni), many with real hair and glass eyes, arranged against a background of *illusionistic frescos, rather like the modern exhibits of animals or prehistoric people in a natural science museum.

The construction of the Sacro Monte at Varallo continued until 1765, when 43 chapels had been completed; the end of the 16th century and the 1600s saw an acceleration in the founding of other Sacri Monti, as important tools of Counter-Reformation propaganda among the northern Italian populations most vulnerable to Waldensian and Lutheran heresy. The original conception was expanded to include, e.g. the *Life of St Francis* (Orta, 1592–1795) and the *Mysteries of the Rosary* (Crea, 1589–1615 or after; Varese, 1604–80). Some of the most notable northern Italian artists participated

in their construction and decoration, including the painters Gaudenzio *Ferrari, at Varallo from c.1517–30; *Morazzone, at Varese in 1605–9, at Varallo in 1609–12 and 1615–16, at Orta 1611–20; *Tanzio da Varallo, at Varallo in 1616 and 1628. More importantly for the history of European art, the *expressive *naturalism of the Sacri Monti, edging over into *caricature in the representation of cruel or low-life characters – in much the same way as medieval miracle plays or Late *Gothic Netherlandish and German art – affected all northern Italian artists, including *Caravaggio, whose influence in turn spread across all Europe.

Saenredam, Pieter Jansz. (1597–1665) Dutch painter, resident for most of his life in Haarlem. He specialized in the faithful representation of public buildings and churches, travelling to towns throughout Holland to make careful sketches, which he then worked up into construction drawings used as the basis for meticulously detailed, yet poetic, oil paintings (Amsterdam, Rijksmuseum; London, National; Rotterdam, Boijmans Van Beuningen; etc.). Virtually his only paintings not drawn from firsthand observation were his views of Rome, based on sketches from Maerten van *Heemskerck's Roman sketchbook, which he owned (e.g. Kettwig-Ruhr, H. Girardet Coll.). His understanding of *perspective is thought to have been gained through Jacob van *Campen, like him a student of Frans de *Grebber.

Saftleven, Cornelis (1607–81) and his brother **Herman** (1609–85) Dutch painters, the best-known of a dynasty of artists. Cornelis, active mainly in Rotterdam, painted stable interiors, peasant scenes in the manner of *Brouwer and *Teniers, *landscapes with cattle (Cambridge, Fitzwilliam) and biblical, historical and *allegorical pictures. His most remarkable work is the *Satire on the Trial of Johan Oldenbarnevelt* (1663; Amsterdam, Rijksmuseum) in which the judges who, at an illegal trial in 1619, pronounced the death of the Dutch statesman and champion of religious toleration are depicted as animals. Herman Saftleven painted land-

scapes and farm *still lifes. In 1632 he moved from Rotterdam to Utrecht; he travelled to Germany and after 1650 limited himself to panoramic mountainous landscapes (*View on the Rhine*, 1656, Dulwich, Gallery).

Sage, Kay (1898–1963) American painter who spent many years (1910–14 and 1919–37) in Italy. *De Chirico's example drew her towards *Surrealism, and in 1937 she moved to Paris, becoming part of the Surrealist and *Tanguy circle. Together they escaped to the USA in 1940. Her paintings combined some of the organic forms in mysterious spaces of Tanguy, adding strange architectural elements and draperies. Tanguy's sudden death affected her deeply and she committed suicide eight years later.

Sage, Letitia *See under* Benbridge, Henry.

Saint-Aubin, Gabriel-Jacques de (1724–80) The most talented of four French brothers, *Rococo draftsmen, designers and painters. Although he failed several times to gain first prize at the *Academy (he was once defeated by *Fragonard) and had to earn his living mainly with lively prints of Parisian life, he was an original and engaging painter (*A Street Show in Paris*, 1760, London, National). His sketches of Salon exhibitions are valuable for their art-historical information. His elder brother **Charles-Germain** (1721–86) began as a designer of embroidery and later produced volumes of engravings (*see under* intaglio) after his watercolour studies of flowers. The younger **Louis-Michel** (1731–1779) was a porcelain painter at the Sèvres factory, while **Augustin** (1736–1807) is best-known for his *reproductive prints after the works of contemporary painters.

Saint Bartholomew Altarpiece, Master of the (active c.1470 to c.1510) One of the greatest painters of his day, working in Cologne; he may have come from the Netherlands, and his art derives in large measure from that of Netherlandish

masters (in particular Rogier van der *Weyden, Dieric *Bouts, *Geertgen tot Sint Jans). He is named after the Saint Bartholomew Altarpiece painted for St Columba, Cologne and now in Munich, Alte Pinakothek. Since this work includes the *donor portrait of a Carthusian monk, and the Master's two other surviving monumental *triptychs, the *Incredulity of Saint Thomas* and the *Crucifixion* (Cologne, Wallraf-Richartz) both came from the Charterhouse on the outskirts of Cologne, it has been suggested that the painter may himself have been a Carthusian. His earliest-known work, the *Book of Hours of Sophia von Bylant* (Cologne, Wallraf-Richartz) can be dated from one of its *illuminations to 1475; other works are in Cologne; Paris, Louvre; London, National; Mainz, Landesmuseum. Many of his paintings, large and small, enclose the *expressive and fully volumetric figures within a *Gothic tracery framework, standing them as if on a narrow platform against a landscape, gold-leaf or decorative-textile background, so that they resemble both living people and *polychrome sculptures standing within carved tabernacles; the mixture of contemporary and archaic dress also plays with levels of reality in the manner of the miracle plays of the period.

Saint Cecilia Master (active before 1304 or 1341) Italian painter named after an altarpiece to Saint Cecilia, from a Florentine church destroyed by fire in 1304, now in the Uffizi, Florence. The three final scenes in the cycle of St Francis in the Upper Church of San Francesco, Assisi, are sometimes attributed to him (*see* Saint Francis, Master of). He is also sometimes identified with the elusive *Buffalmacco.

Saint Francis cycle, Master of the So called after the *fresco cycle of the legend of St Francis in the nave of the upper church of S. Francesco, Assisi (probably *c.*1290). A now-unknown painter, sometimes identified with *Giotto, responsible for the overall plan and the execution of some of the frescos of the cycle, which followed upon *Cimabue's frescos in the choir and transepts.

Saint-Gaudens, Augustus (1848–1907) American sculptor, son of a Dublin shoemaker brought to New York when very young. He worked first for a cameo-maker, then for the artist Jules le Breton while also taking drawing lessons at the National Academy of Design. In 1867–70 he worked in Paris, at the Ecole des Beaux-Arts, then went to Italy where he was especially impressed by the work of *Donatello. He found in it a *naturalism still rare in Europe and unknown in American sculpture. Back in New York for two years from 1872, he was again in Europe until 1875, working on his first major commission, for a monument to Admiral Farragut (1881, New York, Central Park), praised in Paris and acclaimed in New York. There is heroism as well as naturalism in it, as also in the large bronze relief monument to Colonel Robert Gould Shaw (1884–96; Boston Common). He was now the leading US sculptor for such work and busy on successive commissions, some of them in association with the architect Stanford White. His equestrian monument to General Sherman (1903; New York, Central Park) is a dramatic group, grandiose but also believable; a more moving and poetic work is the Adams Memorial (1886–91; Washington, Rock Creek Cemetery), dedicated to Mrs Henry Adams but representing her only in the most generalized way: a shrouded, pensive female figure of startling simplicity. For Stanford White's Madison Square Garden, New York, he made a rare nude figure, *Diana*, in hammered bronze sheet and 13 feet high, set up in 1892. Saint-Gaudens's ability to find effective technical as well as artistic solutions to tasks calling for vivid visualization, without adherence to any particular set of stylistic principles, makes him the greatest of American 19th-century sculptors.

Saint Giles, Master of (active *c.*1500) Painter, probably Netherlandish by training, named for two panels representing episodes from the life of Saint Giles, now in London, National; they may once have formed part of the same altarpiece, possibly for a church in Paris, as two panels now in Washington, National. One of the London pictures is a faithful depiction of

the area around the high altar of the abbey church of Saint-Denis near Paris, as it is described in inventories of around 1500.

Saint-Phalle, Niki de (1930–) French sculptor who became known in the 1960s for *assemblages presenting bags filled with paint which spattered widely when shot at and for bulging, cheerfully patterned female figures entitled *Nana*, including one large enough for people to walk into (1963; Stockholm, Moderna Museet). In a similar vein she did theatre décor for Paris. A retrospective of her work was shown at the Centre Pompidou in Paris in 1980.

Saint Veronica, Master of (active c.1420) A painter active in Cologne, named after a picture of *Saint Veronica with the Sudarium* from the church of St Severin, Cologne, now in Munich, Alte Pinakothek; another panel of the same subject is in London, National.

Salle, David (1952–) American artist, born in Norman, Oklahoma, trained at the California Institute of the Arts, Valencia and working in New York. His first solo shows were in 1975. He makes composite two-dimensional images, juxtaposing figures and environmental images, mostly derived from photographs, at times together making shapes that hint at significant objects though without implying a simple comment.

Sallinen, Tyko (1879–1955) Finnish painter, born into a repressive fundamentalist religious family, who came to art in search of free expression, visited Copenhagen and Paris and became an *Expressionist painter under the influence both of *Munch and *Fauvism, using thick paint and bold colours for landscapes and pictures of rustic life. His later work was more controlled and sombre and also more imaginative.

Salon French term, referring both to 'room' and to a social gathering, used since the 18th century for the occasional, then biennial, from 1831 on annual, exhibitions of new paintings and sculpture organized

by the French *Academy of Fine Arts in the Salon d'Apollon within the Louvre Palace. Intended in the first place, and always primarily, for artists trained in the Academy, it was open from 1791 on also to submissions from outsiders, these being subject to approval by a jury of Academicians. With the revolution of 1830 and the reign of the July Monarchy the crown exercised as much influence over these exhibitions and the prizes awarded during them as the Academy, and that meant a less doctrinaire selection (e.g. a warmer welcome to landscapes) and also increased attention to public opinion. In 1848, another year of revolution, the Salon was declared open to all without selection. This resulted in a show of such diversity that it was said a 'French School' was no longer to be found there. In the years that followed the jury system operated again, with such severity in 1863 that the king ordered the opening of a special Salon des Refusés ('of the excluded'), which got as much attention, partly for reasons of scandal, as the official Salon. Unofficial salons were set up during the last decades of the 19th century but did not endure and were not generally of lasting interest. Most significant among them was the Salon des Indépendants, juryless and awarding no prizes, created mainly by *Seurat and *Signac in 1884 and opening each spring, and the Salon d'Automne (the Autumn Salon), founded mainly by painters such as *Renoir, *Vuillard and *Rouault in 1903. During its first years this included memorial exhibitions that were of great influence, notably a *Gauguin section in 1906 and a *Cézanne section in 1907. In Berlin, Herwarth Walden named his largest *Sturm exhibition of new art, in 1913, the First German Salon d'Automne (Der erste deutsche Herbstsalon); because of the war it had no successors. A Paris Salon des *Réalités Nouvelles functioned for some years from 1945 on, specializing in *abstract art.

Salviati; Francesco de'Rossi, called (1510–63) Florentine-born *Mannerist painter, mainly of outstanding secular *fresco cycles but also of altarpieces, tapestry designs and portraits. His style was formed less during his Florentine training

(*Bandinelli, *Andrea del Sarto) than through his enthusiastic studies, part of the time with his friend and chronicler *Vasari, of High *Renaissance and earlier Mannerist art in Rome (*Raphael, *Michelangelo, *Perino del Vaga). He was to work in Rome 1532–8/9; 1541–3; 1548–63, taking on the name, Salviati, of a cardinal who was an early patron and protector (Rome, S. Francesco a Ripa; S. Giovanni Decollato, Palazzo della Cancelleria, S. Maria dell' Anima, Palazzo Sacchetti, Palazzo Farnese, S. Maria del Popolo, S. Marcello al Corso). During 1543–8 he was active at the Florentine court of Duke Cosimo I de'*Medici (Florence, Palazzo Vecchio, Sala dell'Udienza; designs for tapestries, Florence Uffizi, S. Croce). A visit to Venice via Bologna (1539–41) further affected his style, especially through exposure to the work of *Parmigianino. A stay in France (1554–6; Château de Dampierre, destroyed) enhanced, through the influence of *Primaticcio, his own elegance of form and line.

Salviati's brand of Mannerism is far more than a formula for ordering pictorial composition and aestheticizing the human form. It is apparent also in his attitude to partitioning the wall surface of his mural decorations: no painter is more inventive or revels more in playful alternations of levels of reality, perceptual puzzles and witty allusions to earlier art. Clarity of narrative and *expressivity are subsumed to such artful ends, albeit less in his Florentine works than in Rome, where mural decoration of secular spaces was more highly evolved.

Samaras, Lucas (1936–) American artist, born in Greece, brought to the USA in 1948, who studied with *Kaprow at Rutgers University, New Brunswick, New Jersey. He exhibited there in 1955, and from 1959 often internationally, admired for his *Surrealist *assemblages and mirrored environments, also self-images in the form of multiple photographs.

Sammartino, Giuseppe (1720–93) Virtuoso Neapolitan sculptor; of his many works in Neapolitan churches the best known is the *Dead Christ* in the funerary chapel of the Sangro family (also called the Sansevero Chapel, the Pietatella or Santa Maria della Pietà) whose body is discerned under the thin drapery of the shroud covering it (*see also* Corradini, Queirolo).

Sánchez Coello, Alonso (1531/2–88) Spanish painter, brought up in Portugal and trained in Flanders under Anthonis *Mor. Soon after 1552 he became, with Mor and *Titian, the court portraitist of Philip II of Spain, working in a precise, austere but sensitive manner well attuned to Spanish court etiquette. His state portraits were sent as dynastic and diplomatic presents as far afield as the court of the Emperor of China, although due to the disastrous fires which swept the Spanish royal palaces in 1604 and 1734, authentic works by him are now rare. There are, however, four notable portraits by him, 1552–7, in Buckingham Palace; others, Dublin, National; Madrid, Prado. Sánchez Coello was the teacher of Juan *Pantoja de la Cruz.

Sánchez Cotán, Juan (1560–1627) Spanish painter, known principally for his *naturalistic yet geometrically rigorous *still lifes, rediscovered only recently, which pioneered the genre in Spain and spawned many copyists and imitators. One of the few whose name is known was Felipe Ramírez, documented 1628–31 (Madrid, Prado). Sánchez Cotán's bland figurative works, mainly devotional but also including portraits and a few mythological narratives, are of lesser interest. In 1603 he abandoned a thriving practice of nearly twenty years as a painter in Toledo, in order to profess as a lay brother of the Carthusian order in Granada, for which he continued to execute religious pictures (Granada, Charterhouse; El Paular, near Segovia, Charterhouse). Despite modern interpretations of his austere still lifes as quasi-mystical works, most were painted before his religious profession, and are unlikely to have any religious or moralizing significance.

In all of Sánchez Cotán's autonomous still lifes, fruits, vegetables, fowl and game are arranged against a dark background, originally a rich black, within and in front of a framing space that appears to be a

niche or window. The use of linear *perspective in the architectural setting and the protruding fruits or vegetables, and the strong contrasts of light and shadow which exaggerate the modelling of forms, allowed him to achieve a powerful sensation of reality. The objects were not studied from the model afresh for each picture, but from very precise painted studies: favoured motifs, such as the cardoon and the cabbage, are reused in the very same form in several pictures. Only a few of these striking works are known: Madrid, Prado; Granada, Museo; San Diego, California, Museum; Chicago, Art Institute; Princeton, Piasecka Johnson coll.

Sandby, Paul (1730–1809) Watercolourist painter of landscapes. With his brother **Thomas** (1721–98), the architect and draftsman, he was trained in topographical drawing and cartography, but learned to ally meticulous accuracy with a lively feeling for nature. It was through him that the medium of watercolour acquired status, and he was the only watercolourist founder-member of the Royal *Academy. He was one of the first to draw directly in watercolour, as opposed to tinting drawings made first in pencil. Many of his large exhibition paintings were executed in *gouache; he was also the first major artist in England to reproduce his drawings in *aquatint.

The brothers came to London from Nottingham to take up appointments in the Drawing Office to the Tower. In 1746–c.51 Paul served as a draftsman with the Ordnance Survey party sent to the Highlands of Scotland after the rebellion of 1745. This period was formative for his art, resulting not only in paintings of *picturesque scenery but also figure studies. After 1751 he returned to London, often staying with his brother, who had become deputy Ranger of Windsor Forest, carrying out major landscaping schemes, including Virginia Water, which Paul depicted in a series of prints and drawings (Windsor Castle, Coll. HM the Queen). His loving portraiture of individual trees anticipates *Constable. In the 1770s he published series of views of Wales. Influential through these and other works on a younger generation of painters, Sandby also influenced military draftsmen through his employment as chief drawing master at the Royal Military Academy, Woolwich (1768–96), see Cockburn, James Pattison.

Sandle, Michael (1936–) British sculptor, trained at the Douglas School of Art, Isle of Man, and, after serving in the Royal Artillery during 1954–56, at the art colleges of Chester and Colchester and at the Slade School, London. During 1970–73 he worked in Canada. In 1973 he settled in Germany where from 1980 he was professor at the Karlsruhe Academy. In 1973 he returned permanently to England, living and working mainly in Devon. His work has always tended to have the character of memorials and has sometimes been titled as such, for example his *A Twentieth-Century Memorial* (1971–8; London, Tate), a response to the Vietnam War of 1964–75 but mocking all war heroism in its image of Mickey Mouse presiding over a machine-gun and flanked by other Mickey-Mouse heads, all in bronze on a large circular bronze base. Most of his work protests against human violence, including the cultural violence of the media (see his bronze *A Mighty Blow for Freedom: Fuck the Media* (1988), in which a timeless warrior smashes a television set) and the power and the demands of women (*The Queen of the Night* (1999), bronze). His Malta Siege Bell Memorial overlooking the harbour of Valetta, Malta (1990–2) combines a modernized classical temple with a bronze effigy and is both awesome and peaceful. He has made several sculptures for public places in response to commissions as well as many drawings and prints, associated with his sculpture, of remarkable quality.

Sandrart, Joachim von (1606–88) Much-travelled German painter and writer on art. He journeyed to Prague c.1621–2. Apprenticed in Utrecht under Gerrit van *Honthorst, he accompanied his master to the court of Charles I in London. During 1629–35 he worked in Rome, and he has left us precious recollections of northern European artists resident in the city –

notably *Claude, *Poussin, Pieter van
*Laer and du *Quesnoy. In 1637 he settled
in Amsterdam, where he made a name as a
portraitist, and in 1640 received a commis-
sion for one of the six large paintings of
militia companies for the banqueting hall of
the Arquebusiers' Civic Guard, the Klove-
niersdoelen, the most ambitious decorative
project in the Netherlands until the deco-
ration of the Oranjezaal in the late 1640s
(*Civic Guard Company of Captain Cornelis
Bicker, c.1642*, Amsterdam, Rijksmuseum).
In 1674/5 Sandrart founded the earliest art
*academy in Germany, at Nuremberg, and
it is for this body that he wrote his major
work, which includes his Roman reminis-
cences and accounts of the lives of artists,
the *Deutsche Akademie der edlen Bau-, Bild-
und Mahlerey-Kunste*, 1st ed. Nuremberg,
1675.

Sangallo, da Florentine dynasty – so
called after their native district – mainly
important in the history of architecture
but of some significance also for sculpture.
Giuliano Giamberti, called **da Sangallo**
(1445/52–1516) although above all an
architect, influenced decorative sculpture
in Florence in the late 1480s and 1490s
upon his return from a stay in Rome (Flor-
ence, Palazzo Gondi; S. Trinita, Sassetti
chapel; Medici palace, chapel, stalls). His
*classicizing style has been compared to
that of *Bertoldo. His son, **Francesco da
Sangallo** (1494–1576) practised mainly as
a sculptor. His earliest dated work is a *St
Anne with the Virgin and Child* (1522–6,
Florence, Or San Michele) whose compo-
sition depends on *Leonardo da Vinci's
cartoon for an altarpiece on the same
subject, exhibited publicly in Florence in
1501. In 1531–3 Francesco worked at
Loreto for the Holy House (*see also* Andrea
Sansovino). In the 1540s he was active in
Rome as well as in Tuscany, where in 1543
he was appointed architect and master
of works of Florence cathedral, and was
commissioned also for monuments in
Naples (Monteoliveto, S. Severino e Sosio).
In addition to his *St Anne* his main works
in Florence are the *Marzi monument* (1546,
Ss. Annunziata) and the *Giovio monument*
(1560, S. Lorenzo, cloister). He also
executed portrait medals and at least one

portrait bust (Florence, Bargello). Albeit
a dominant figure in the artistic life of
Tuscany in the first half of the 16th
century, he has been described as a heavy
and insensitive sculptor.

sanguine *See* chalk.

Sano di Pietro (1406–81) Sienese
painter, pupil of *Sassetta and a coarse
propagator of his pictorial idiom. He was
one of the artists commissioned by Pope
Pius II to paint an altarpiece for the cathe-
dral of Pienza, the Pope's model *Renais-
sance city (*see also* Giovanni di Paolo;
Matteo di Giovanni; Vecchietta), although
the experience did little to change Sano's
own style. He was a conservative and
commercially successful artist, who ran a
large workshop furnishing the Sienese reli-
gious orders with countless devotional
images and altarpieces (Siena, Pinacoteca;
Paris, Louvre).

Sansovino; Andrea Contucci, called
(*c.*1467–1529) Born at Monte San
Savino, he was the principal *classicizing
Tuscan sculptor of the turn of the century;
his style is transitional between Early and
High *Renaissance. More than any other
major sculptor of the time he specialized
in relief. *Vasari relates that he spent nine
years in Portugal between *c.*1490–9, but this
is now doubted by many scholars. Having
made his reputation in Florence with the
Corbinelli Altar in S. Spirito (*c.*1485–90)
and two statues he was carving for Genoa
cathedral (1501–3) he was entrusted in
1502 with the major commission for a
marble group of the *Baptism of Christ* over
the eastern door of Florence baptistry (*see
also* Rustici). This was left unfinished in
1505 with his departure for Rome, and may
have been completed by Vincenzo *Danti.
To Sansovino's Roman period belong the
Sforza and *Basso monuments* in S. Maria del
Popolo (1505; 1507 respectively); the pedi-
mental group on Giuliano da *Sangallo's
façade of S. Maria dell'Anima (1507?) and
a group of *St Anne with the Virgin and Child*
(1512, S. Agostino) inspired by *Leonardo
da Vinci's cartoon of the same subject
exhibited in Florence in 1501 (*see also*
Sangallo, Francesco da), and associated

with a fresco by *Raphael. In 1513 he was appointed by Pope Julius II to take charge of the greatest relief commission of the High Renaissance, the casing of the Holy House in Loreto Basilica, designed by Bramante, for which he carved a number of reliefs and designed others (installed 1530s), although he was demoted in 1517 from master of works and left in charge of the sculpture alone. His narrative scenes, especially that of the *Annunciation*, were of the greatest importance for Florentine art in the third quarter of the century. Andrea Sansovino was the teacher of Jacopo Tatti *Sansovino, who assumed his name, and probably of the Spaniard Bartolomé *Ordóñez.

Sansovino; Jacopo Tatti, called (1486–1570) Important *classicizing Florentine sculptor, pupil of Andrea *Sansovino, whose name he assumed. He is of great significance also for the history of architecture, which he practised in Venice after the Sack of Rome in 1527. As a sculptor, he was much affected stylistically and technically by his first stay in Rome, 1505–11, when he may have assisted Andrea at S. Maria del Popolo, but principally worked on the restoration of antiques. He came to the notice of the architect Bramante and of *Raphael, joining, as it were, the anti-*Michelangelo party. He competed directly with Michelangelo in his celebrated *Bacchus*, executed after his return to Florence in 1511 and more authentically *all'antica* than Michelangelo's statue of the same subject, and in his *St James* (1511) for Florence cathedral, originally part of the commission for which Michelangelo executed his unfinished *St Matthew*. During this period in Florence he shared a studio with the painter *Andrea del Sarto, for whom he executed small-scale models. Having participated in the decorations for the entry of Pope Leo X (Giovanni de'*Medici) in 1515, he was promised a share in the sculptural decoration of the façade of the Medici parish church, S. Lorenzo, but was rejected by Michelangelo. He returned to Rome in 1518 (*Virgin and Child*, 1518–19, S. Agostino; other statues and monuments, S. Maria di Monserrato; S. Marcello). Before engaging on his

Venetian career (see above) he executed the Nichesola monument for Verona cathedral, and the *Virgin and Child* from this tomb was reproduced as a bronze statuette in his workshop (Oxford, Ashmolean; St Petersburg, Hermitage; etc.). In Venice he was responsible also for sculptural commissions, the most important of which were the tribune reliefs and bronze sacristy door for S. Marco; the Loggetta – which combines relief with architecture – and marble reliefs for Padua, S. Antonio; the Venier monument in S. Salvatore (1556–61); the Rangone monument in S. Giuliano; and the *Neptune* and *Mars* for the Giants' staircase of the Doge's Palace. Throughout his residence in Venice, as in Rome and Florence, Sansovino was in friendly contact with painters – he became the intimate of *Titian, *Tintoretto and *Lotto. Despite his classicism, his tribune reliefs for S. Marco narrate the saint's life with a passion ultimately dependent on *Donatello's reliefs for the altar of S. Antonio, Padua; their vehement diagonal accents particularly influenced Tintoretto.

Santi di Tito (1536–1603) Outstanding though understated Florentine painter from Borgo San Sepolcro. After a stay in Rome 1558–64, where he succumbed to the influence of Taddeo *Zuccaro, he returned to Florence, becoming the first artist to challenge the dominant *Mannerism of Florentine painting in the 1560s (*see*, e.g. Bronzino, Vasari). Santi's *naturalism was tempered with *classicizing recollections of Roman and Florentine High *Renaissance art (e.g. *Raphael, *Andrea del Sarto). The gentleness and lack of rhetoric of his many Counter-Reformatory altarpieces should not obscure the radical nature of his accomplishment (Florence, Ognissanti, S. Croce, S. Maria Novella, S. Marco, Uffizi; Borgo S. Sepolcro, cathedral; Colazzo, Villa Chierichetti; etc.).

Santi, Giovanni *See under* Raphael.

Saraceni, Carlo (1579–1620) Venetian painter resident in Rome from 1598 until 1613, when he moved to Mantua, working at the ducal court until his return

to Venice in 1619. At first closely linked with *Elsheimer, whose precious small-scale pictures on copper he emulated (e.g. London, National; Naples, Capodimonte), he became interested in the work of *Caravaggio (e.g. altarpieces, etc. Rome, Chiesa Argentina, S. Lorenzo in Lucina, S. Maria dell'Anima). Saraceni had contacts with France and Lorraine and a group of pictures brought together under the pseudonym 'Pensionante del Saraceni' ('Saraceni's boarder') may have been executed by an anonymous French artist. During the last year of his life he was assisted by Jean Le Clerc from Nancy (c.1590–c.1633), who completed the large *Oath of Doge Enrico Dandolo* for the Doge's Palace before returning in 1622 to Lorraine, where he may have influenced the early works of Georges de *La Tour.

Sargent, John Singer (1856–1924) American painter, born in Florence, trained in Rome, Florence and Paris, who worked mostly in London. He specialized in portrait painting and was soon a successful portrayer of the aristocratic, the rich and the beautiful, thanks to his exceptional sense of glamour and stylishness, backed by exhilarating brushwork. Visits to Spain and Haarlem gave him close knowledge of the work of *Velázquez and *Hals; the vividness of some his work reveals the influence of *Impressionism. He moved from Paris to London in 1886, after his portrait of a society lady of uncertain virtue and a provocative air caused a minor scandal at the 1884 Salon, and was soon the leading portrait painter in England. In 1887–9 he was in the USA, besieged with commissions. Associate and full membership of the Royal *Academy came in 1894 and 7. His style softened in response to the art of *Reynolds and *Gainsborough, and of their forerunner *Van Dyck. Many of his portraits were now full-length and set into landscapes; others showed groups informally observed in their homes or gardens in the manner of the 18th-century *conversation piece.

Portraiture did not satisfy him. He had early success with *genre paintings based on studies done on his travels. A poetic scene of pretty young ladies and Chinese lanterns in a garden, *Carnation, Lily, Lily, Rose* (London, Tate), was acclaimed at the Royal Academy in 1887; it is still irresistible. But Sargent's ambition aimed higher. In 1890 he was commissioned to paint murals for the public library of Boston, MA. He worked on this for the next twenty-five years on and off, in London and Boston and travelling Mediterranean Europe to study *Renaissance *frescos in order to compose a synoptic presentation of global religious thought. Boston's Museum of Fine Art commissioned other murals from him in 1916 and in 1922 a further commission followed, for the Widener Memorial Library at Harvard. The result satisfied his patrons but have not pleased posterity. In 1918 Sargent accepted the role of Official War Artist. The products of this are in the Imperial War Museum, London, among them the large and impressive painting *Gassed*, based on studies made at the front. During these decades he tried to diminish the time he gave to painting portraits but could not elude the demands of his public.

Art occupied his time almost exclusively and his output was large, including lively landscape paintings in oils and in watercolours. It is to be found in many British and American collections. *Modernism's public success, in the middle years of the 20th century, brought some reaction against Sargent's seductive ways, but his status has been rising since major exhibitions were shown in the USA and Britain from 1964 (Washington, Corcoran) on, including one in the Whitney Museum, New York, in 1987.

Sarrazin, Jacques (1588–1660) Influential French sculptor; late in life he evolved the style which was to dominate sculpture at Versailles for over 20 years, anticipating, in stone or bronze, the pictorial style of *Lebrun and of the court of Louix XIV: a particularly French blend of the *classicizing and the *Baroque (*Tomb of Henri de Bourbon, Prince de Condé*, 1648–63, finished by Sarrazin's assistants; originally Paris, St Paul-St Louis, rearranged in Chantilly, Château).

After training in France, Sarrazin worked in Rome, 1610–*c.*27. On his return, he hesitated for some time between a Baroque manner influenced by the youthful work of *Bernini (e.g. *Enfants à la Chevre*, *c.*1640, Paris, Louvre) and a fully classical style, indebted to his study of *Domenichino and of ancient Roman sculpture (*Caryatids* for the Pavillon de l'Horloge, 1641, Paris, Louvre; executed after Sarrazin's models by his pupil Gilles Guérin). Between 1642 and 50 Sarrazin directed the sculptural decoration of the château at Maisons, executed by **Guérin** (1606–78), **Philippe de Buyster** (1595–1688) and **Gerard van Obstal** (*c.*1594–1668), the most outstanding of his many pupils.

Sarto, Andrea del *See* Andrea del Sarto.

Sassetta; Stefano di Giovanni, called (*c.*1400–1450) With Giovanni di Paolo, the leading Sienese painter of the 15th century, notable for his poetic, calligraphic style. His work, albeit always dependent on his great 14th-century predecessors the *Lorenzetti and Simone *Martini, can be divided into three distinct phases. Around 1426–32, he came into contact with Florentine art, absorbing the *perspectival advances of *Masaccio and their more decorative interpretation by Filippo *Lippi (e.g. *Madonna of the Snow*, 1430–32, Siena, Contini-Bonacossi Coll.). From *c.*1432–6 scholars distinguish a 're-*Gothicizing' or International Gothic tendency; due largely to political events in Siena, Sassetta became acquainted with northern Italian and French miniatures and panels (e.g. *polyptych for his parents' birthplace of Cortona, 1433–4, now Cortona, Museo). In the last period of his life, exemplified through the polyptych for S. Francesco, Borgo San Sepolcro, of 1437–44 (dismembered 1752, fragments in various collections, including London, National; Chantilly, Musée), Sassetta adopted the light colours of *Domenico Veneziano.

Sassetta's first recorded work was a polyptych of 1423 for the Sienese guild of wool merchants (fragments now Siena, Pinacoteca; Barnard Castle, Bowes;

Vatican, Pinacoteca; Budapest, Museum). Fragments from other dismembered altarpieces, such as the one of the *Life of St Anthony Abbot* for Asciano, are in various other museums, e.g. New York, Metropolitan; New Haven, Yale. He died as a result of contracting pneumonia while working on a *fresco for the Porta Romana, Siena, begun in 1447.

Sassetti, Francesco (1421–90) Florentine banker, general manager of the *Medici bank from 1469 until his death. He was a promoter of humanistic studies, a collector of ancient coins and texts, but is best remembered for his patronage of *Ghirlandaio in his family funerary chapel in Santa Trinita in Florence.

Sassoferrato; Giovanni Battista Salvi, called (1609–85) Painter from Sassoferrato in the Marche, working in Rome, where he may have studied with *Domenichino. His highly finished stereotyped images of the Virgin and Child, popular in devotional circles, are so anachronistic that they have been taken for a follower of *Raphael or even *Perugino. He occasionally derived his compositions from designs by *Reni. There are works by him in Rome, S. Sabina, Doria; London, National; Munich, Alte Pinakothek; Genoa, Palazzo Bianco; Naples, Capodimonte; etc. He also executed portraits of ecclesiastics (e.g. Rome, Nazionale).

Saul, Peter (1926–) American painter, exhibiting from 1961 on, known for his harsh, often scurrilous paintings commenting on political and art-world themes in a heavy style based on comic strips.

Saura, Antonio (1930–) Spanish painter living and working in Madrid and Cuenca and exhibiting since 1950, a leading figure in the Spanish school of *Art informel. His work has a typically harsh and deeply disturbing tone, and often includes grossly distorted figures as images of destruction.

Savery, Roelant (1576–1639) Flemish émigré, a pioneer of Dutch landscape painting, but famous also for his repre-

sentations of flowers and animals. In Amsterdam c.1591, he was called c.1604 to Prague by the Emperor Rudolph II, who commissioned him to make sketches in the Tyrolean Alps as a basis for decorative paintings. After Rudolph's death Savery worked for his successor, Matthias, in Vienna (1614). In 1619 he settled in Utrecht, specializing in Alpine scenery and in fantastical landscapes with exotic animals (Vienna, Kunsthistorisches; etc.)

Savinio, Alberto (1891–1952) Italian musician and painter, brother of De *Chirico. He wrote about *Pittura Metafisica and took up painting in 1927, becoming known as an Italian *Surrealist.

Savoldo, Giovanni Girolamo (1480/5– after 1548) Veneto–Lombard painter. Born in Brescia, he is recorded in Florence in 1508 and in Venice from c.1520; he may have worked in Milan c.1532–5. Not a prolific artist, he specialized in paintings of a single figure, normally in half- or knee-length against a distant landscape background. The most striking and accomplished feature of his work is the drapery painting, usually in large blocks of a single local colour minutely modified to depict the effects of different kinds of illumination on reflective materials. Savoldo's selective *illusionism is indebted to a study of Flemish art, although his subjects and their poetic tone bespeak the influence of *Giorgione. Some of his pictures are known in several versions (e.g. *St Mary Magdalen approaching the Sepulchre*, London, National; Florence, Contini-Bonacossi Coll., Berlin, Staatliche). Other works can be found in Rome, Capitolina, Borghese; New York, Metropolitan; etc. Savoldo's historical importance resides in his probable influence on *Caravaggio (but *see* more especially Romanino, Moretto).

Scapigliatura Name of an Italian movement, best translated as 'Bohemians', of the 1860s and 70s in art and literature, firmly anti-*academic and interested more in effects of light than accurate *naturalism or *classical idealization. This interest prepared the way for *Divisionism to take root in Italian painting in the 1880s and 90s.

Schad, Christian (1894–1982) German painter who studied at the Munich Academy and immersed himself in the art life of the city before spending the war years in Switzerland, in touch with the *Dada circle. He made *abstract photograms by placing objects on photographic paper and exposing the arrangement to light, calling them 'Schadographs', earlier, it seems, than Man *Ray and *Moholy-Nagy. From 1927 he was in Berlin where he painted strikingly cold and sophisticated portraits, becoming a prominent painter of the *Neue Sachlichkeit category. During the Nazi period he abandoned painting and did not regain his eminence later when he returned to it.

Schadow, Johann Gottfried (1764–1850) German sculptor who was born and trained in Berlin and died there. He spent 1785–7 in Italy, mostly in Rome and in touch with *Canova. Soon after returning to Berlin he became an associate of the Berlin Academy and its director in 1815. From 1788 on he was head of the royal sculpture workshop and charged with making monuments and statues including the Quadriga on the Brandenburg Gate. Before undertaking a bronze equestrian monument to Frederick the Great he toured Sweden, Russia and Denmark during 1791–2 to study French examples of such statues and the science of bronze casting, but the project was never realized. He was less in the royal favour after 1800 and worked mostly on private commissions before ailing eyesight ended his career in the 1820s.

Schadow, Wilhelm von (1788–1862) German sculptor, one of the three sons of the preceding, all of them artists. Wilhelm was in Italy from 1811–19 and worked with the *Nazarenes as painter. Back in Germany, he taught at the Berlin Academy and in 1826 became director of the Düsseldorf Academy which became a great force in art, attracting students from the USA and other foreign countries.

Schalcken, Godfried (1643–1706) Dordrecht painter, a pupil first of *Hoogstraeten, then of Gerrit *Dou of Leiden, whose technique of 'fine' painting

(*fijnschilder*) he emulated (e.g. *Candlelight Scene*, London, National). Around 1675 Schalcken began to paint more *classicizing and elegant subjects, allegorical and mythological themes and scenes based on antique literary texts (e.g. *Lesbia weighing her Sparrow against her Jewels*, from a poem by Catullus, London, National), both on the near-miniature scale of Dou, like the picture cited above, and of somewhat larger size (e.g. *Venus at her Toilet*, Kassel, Kunstsammlungen). Towards the end of his life, Schalcken worked at The Hague, London and Düsseldorf, where he was court painter to the Elector Palatine, Johann Wilhelm, the patron also of Adriaen van der *Werff and Rachel *Ruysch. His work was eagerly collected during the 18th century, and he influenced a number of lesser painters.

Schäufelein, Hans Leonhard (*c.*1480–1537/40) German designer of woodcuts (*see under* relief prints) and painter; since 'schäufelein' means 'little shovel' in German he often signed his works with an H accompanied by a little shovel. He worked in *Dürer's workshop from *c.*1503, and later designed woodcuts for the Emperor Maximilian's various projects (*see under* Habsburg). Between 1510 and 1515 he was in Augsburg, where he came under the influence of Hans *Holbein the Elder; in 1515 he settled in Nördlingen and became the official city painter. The *Ziegler Altarpiece* of 1521 (Augsburg, Staatsgalerie) is his best-known painting.

Scheemakers, Peter (1691–1781) Flemish sculptor working in England from *c.*1721. In 1728–*c.*30 he undertook a study trip to Rome, returning with many clay models after the antique. Some of these he later repeated in stone (Rousham, Oxfordshire), while others were cast by him in plaster to be sold as sets. He is an important influence in forming the English taste for *Classical sculpture, and in the education of younger sculptors. Scheemaker's classicism, however, predates his Italian voyage, as is demonstrated by the *Monument to the Earl of Rockingham* (1726, Rockingham, Northants) executed with Laurent *Delvaux. During the 1730s, Scheemakers

competed with *Rysbrack; at the end of the decade, probably under the latter's influence, he began to move away from his dependence on the antique towards a more *naturalistic and animated mode (Monument to William Shakespeare, 1740, London, Westminster Abbey). By the end of the 1740s, both he and Rysbrack were overtaken in popularity by *Roubiliac, although Scheemakers continued to take on apprentices, and to receive commissions for monuments in Westminister Abbey and in other parts of the country (*Mr and Mrs Tothill*, after 1753, Urchfont, Wiltshire; *Lord Shelburne*, 1754, High Wycombe, Buckinghamshire; etc.). The practice was carried on by his son, **Thomas Scheemakers** (1740–1808). *See also* Cheere, Sir Henry.

Scheffer, Ary (1795–1858) Dutch painter, born in Dordrecht, who lived and worked in France where he became a leading portraitist and producer of devotional pictures of a chillingly pious sort influenced by the example, not the spirit, of *Ingres. Dordrecht Museum has a collection of his work.

schiacciato or **stiacciato** *See rilievo schiacciato.*

Schiavone; Andrea Meldolla, called (*c.*1510/15–63) Pioneering Venetian painter and etcher (*see* intaglio) largely responsible for the formation of Venetian *Mannerism (*see* e.g. Tintoretto) and influential on the late style of *Titian. His nickname refers to his origins in Zara, an Adriatic outpost of the Venetian empire, although he was not of Slavonic stock; it is responsible for the long-standing confusion between him and another 'Andrea Schiavone', one Andrea di Nicolo da Curzola (1522–82), a lowly furniture painter from Sebenico.

The facts of Andrea's early training are unknown. The greatest influence on him was *Parmigianino, whose elongated figure canon and rhythmic grace he adopted. His mature style, from *c.*1540, amalgamates these elements with Venetian colourism (*see under* disegno, also Giorgione) and monumental Central Italian Mannerism (e.g.

*Salviati, *Vasari). His major contribution, however, consisted of exaggerating the painterly qualities of the Venetian idiom, virtually submerging representation under an *expressive web of pigment. Originally applied to small-scale, possibly furniture paintings, in which such freedom was more acceptable, the technique came to dominate even large scale works (*Adoration of the Magi*, c.1547, Milan, Ambrosiana). In the mid-1550s Schiavone experimented with dark over-all tonalities (e.g. *Sacra Conversazione*, c.1553, Rome, British Embassy; *Annunciation*, c.1555, organ shutters, Belluno, S. Pietro) which also found an echo in Titian's work. The relationship between the two artists seems to have been close and reciprocal: Titian nominated Schiavone to paint three roundels in the Marciana library, 1556, and in 1559 he permitted Schiavone to execute variants after his own *Diana and Actaeon* (Vienna, Kunsthistorisches; Hampton Court).

There are paintings both in oils and *fresco by Schiavone in Venetian churches and the Accademia, but many of his works were executed for private collectors. Of these, perhaps the most astonishing is the *Christ Before Herod* (c.1558–62, Naples, Capodimonte), which simultaneously looks back to Giorgione and forward to *Rembrandt, who may indeed have seen Schiavone's paintings in the sale rooms of Amsterdam. Other works are in Dresden, Gemäldegalerie; Wellesley, MA, Wellesley College; Prague, Hradcany Castle; New York, Metropolitan; London, National; Florence, Pitti, Strozzi; etc.

Schick, Gottlieb (1776–1812) German painter who was born and died in Stuttgart but worked principally in Rome. A precocious draftsman, he began adult art studies at the age of eleven, spending four years in J.-L. *David's studio in Paris and then nine in Rome before returning home. He wished to be admired as a *History painter, and was. Stuttgart's Staatsgalerie has his large *Sacrifice of Noah* (1805) and *Apollo among the Shepherds* (1806–8), as well as some of his calmly *Neoclassical portraits, now generally preferred.

Schiele, Egon (1890–1918) Austrian painter, trained at the Vienna Academy and deeply influenced by the example of *Klimt. His own work can be seen as an *Expressionist version of Klimt's, more angular and discordant, and even more outspokenly erotic. His drawings are probably his most consistently masterful productions; they are mostly of nude or partly clothed men (mostly himself) or young women, bony and strained, their bodies marked with colour as though to suggest abrasions and wounds. Some of the figures are truncated arbitrarily. In several cases he signed the work so as to indicate top and bottom orientations other than the natural ones, so that the figures' location is made strange. The openly erotic character of much of his work earned him a spell in prison. His very last paintings and drawings show rounder and calmer forms, perhaps a maturing, but he died of influenza shortly after a display of his work, at the 1918 Vienna *Secession show, had brought him wide recognition.

Schildersbent Flemish, Dutch, for band of painters. A fraternal association of Netherlandish artists, founded in Rome in 1623 for purposes of mutual assistance and general hilarity, and dissolved by papal decree in 1720 for mocking the sacrament of baptism. Members were given *Bentnamen* (pseudonyms) at a baptism in wine and in ceremonies which mocked the initiation of members of the Order of the Golden Fleece. They called themselves *Bentvueghels*, 'birds of a flock'. Paulus *Bor was a founding member; *Poelenburgh and *Breenbergh also belonged, and Pieter van *Laer, *il Bamboccio*, was a leader of the Bent during his sojourn in Rome c.1625–38.

Schlemmer, Oskar (1888–1943) German artist, trained as a painter under *Hölzel in Stuttgart. He painted murals for the 1914 Cologne Werkbund exhibition. There followed war service, during which he was wounded. In 1919, at the *Sturm gallery, he showed a thoroughly abstracted figure of geometrical elements in relief; from this developed a sequence of other relief and free-standing abstracted figures. At the same time he was working on the

Triadic Ballet, to Hindemith's music, calling for figures turned by their costumes into geometrical solids which moved in strict, quasi-mechanical ways, sometimes solemn, sometimes humorous. It was given its first full performance in Stuttgart in 1922. His drawings and paintings similarly explored figures and space by means of geometrical masses precisely located and, though the figures were extreme simplifications, they remain figures or figure types and can be seen as a modern answer to the *Neoclassical figures of *Flaxman and his German followers.

He taught at the *Bauhaus from 1920 to 1929, charged with the sculpture and stage workshops and at times teaching a course devoted to understanding and representing man moving in space. In 1921–2 he and his students decorated part of the Weimar Bauhaus interior with relief and flat paintings, destroyed by the Nazis. He was professor at the Breslau academy in 1929–32, then filled a teaching post in Berlin but had to leave that in 1933. He then devoted himself to simple design work and naturalistic pictures while working in a paint laboratory. The retrospective show prepared for him in Stuttgart in 1933 was vetoed by the government and his work was displayed as *degenerate in 1937. The cool manner of Schlemmer's art almost hides a passionate attachment to ideals of perfection held as man's response to nature's inconstancy. It shows him deeply averse to any *Expressionist display of energy or emotions and places him in the tradition of artists who give priority to *disegno* over *colorito*. Yet he was an ardent man, with mystical leanings that show most directly in the letters he wrote to his wife and to his painter friend, Otto Meyer-Amden.

Schlüter, Andreas (*c.* 1660–1714) German *Baroque sculptor and architect. Born in Danzig (Gdansk), he was originally active in Poland, but then gravitated to Prussia; in 1694 he arrived in Berlin. His masterpiece in sculpture is the bronze equestrian monument to the Great Elector Friedrich-Willem (1696–1708, Berlin, Charlottenburg Castle). He fell into disfavour when some of his architectural works collapsed, and he sought work in St

Petersburg, where he died shortly after his arrival.

Schmidt, Martin Johann (1718–1801) Popular Austrian *Rococo painter and etcher (*see under* intaglio) known as Kremser-Schmidt from his native region of Krems, the centre of his activity. The son of a sculptor father, with whom he worked at Dürnstein Abbey, he is remembered for his *expressive church *frescos and altarpieces and the many small devotional paintings in whose execution his busy workshop had a major part from *c.* 1786. Influenced by the prints of *Rembrandt in local collections, he took up etching in 1764 to reproduce his own painted compositions. There are works by him throughout local churches and, e.g. Vienna, Melkerhof.

Schmidt-Rottluff, Karl (1884–1976) German painter who added the name of the village where he was born to his family name of Schmidt. He studied architecture in Dresden and met *Kirchner and *Heckel, with whom he founded the *Brücke group in 1905. He visited *Nolde in 1906, bringing the group's invitation to join. His manner of painting at this time came close to Nolde's but he always tended to add a degree of assertiveness to whatever idiom he worked in, heightening colour and toughening design. This is especially noticeable in his woodcuts, which, after he moved to Berlin in 1911, took on characteristics derived from African carvings. In the 1920s his manner became more equable. A member of the Prussian Academy from 1931, he was excluded from it in 1933 and from 1941 on he was forbidden to work as an artist. After the fall of the Nazis he taught at the Berlin High School for Art.

Schnabel, Julian (1951–) American painter who studied art at Houston University in Texas and in New York, had his first solo exhibition in Houston and thereafter worked mainly in New York. The Barcelona architect Gaudi's use of broken ceramics as a mosaic surface led him into glueing broken plates etc. on to canvases and painting over them. The results, exhibited in 1979, bought him quick fame at a time when new forms of *Expressionism

were making news and *figurative art was receiving renewed attention from galleries and critics. He added other extraneous materials to his paintings and began to make sculpture as well as three-dimensional paintings. Apart from its dramatic, sometimes shocking surface qualities, his work developed a striking largeness and, with words and symbolic references, hinted at great human themes and drew attention in a period of stylistic games and irony. Soon he had earned an international reputation, not untouched by doubts. He readily uses styles and methods and images that link him to *Abstract Expressionism and *Beuys as well as to history and religion, so that his work has taken on an all-embracing warmth that makes it compelling to some, sentimental to others. In 1997 he made a feature film celebrating the world and career of Jean-Michel *Basquiat.

Schnorr von Carolsfeld, Julius (1794–1872) German painter, trained in Vienna, who became one of the Roman *Nazarenes in 1817 and painted *frescos in the Casino Massimo. From 1827 on he worked in Munich, primarily on historical narratives, clear in form and colour, executed in fresco in the Munich Residenz. His vivid portraits adopt some of the characteristics of portraits from *Dürer's time. His illustrations for the bible and for novels are admired for the fine quality and narrative drive of his line.

Schöffer, Nicolas (1912–92) Hungarian-French sculptor, born in Hungary and trained in Budapest and Paris, where he settled in 1937. In 1948 he started to construct 'spatiodynamic' towers of plastic and metal designed to reflect light and, from 1954 on, to move. His masterpiece was the tower built in 1961 in Liège, more than 50 metres high and incorporating sound as well as light and motion. With inventions of this kind he sought to create a positive, forward-looking art which (like *Mondrian's) countered the often fashionably sentimental or mournful artistic expression of his age. He exhibited from 1950 on and in 1957 presented 'spatiodynamic spectacles' in the theatre at Evreux, France, and in Grand Central Station,

New York. He created robotic 'cybernetic' sculptures responding to sound and light, and planned whole cities on similar principles of cybernetic technology, hoping his work would be mass-produced and available to all. He won the main prize at the 1968 Venice Biennale and was made Chevalier of the Légion d'Honneur in 1982. A Schöffer Museum was opened in his native town of Kalocsa in 1980.

Schönfeld, Johann Heinrich (1609–82/3) Important German painter, etcher (see intaglio) and jewellery and silverware designer, mainly resident in Augsburg. From about 1633 he spent 18 years in Italy, in Rome and in Naples, where he worked for, among others, the Duke of Gravina. On his return to Augsburg he was patronized by both Catholic courts and monasteries, and Protestant nobles and rich burghers. He is most effective in mythological, historical and poetic subjects, although one of his most prized works today is *The Life Class in the Augsburg *Academy* (c.1670, Graz, Johanneum) a *genre picture of 17th-century artistic practice.

Schongauer, Martin (c.1435–91) Engraver and painter, the most widely influential German artist of the 15th century and the greatest engraver before *Dürer (see intaglio). As a young man, the latter was sent to work under him in Colmar, but – having travelled first throughout Germany – arrived only after Schongauer's death.

Born probably in Augsburg, Martin was taken to Colmar as a child by his father, the goldsmith Caspar Schongauer. One of his brothers, Paul, practised as a goldsmith in Leipzig, and a document of 1465 attests to Martin's matriculation from the University of Leipzig – in which precise capacity it is not known, since he is also recorded working as a painter in a convent near Ulm in 1462. A trip to the Netherlands is usually postulated on *iconographic and stylistic grounds.

The only certified painting by his hand is the *Virgin of the Rose Bower* (1473, Colmar, St Martin) on the basis of which other pictures have been attributed to

his busy workshop (e.g. Colmar, Musée; Munich, Alte Pinakothek; Berlin, Staatliche; Vienna, Kunsthistorisches). Of greater importance in the history of art are the 115 engravings signed with his initials, MS, on either side of a cross and crescent – although some of these are no doubt imitations by other engravers. None is dated. The pictorial effects of his line engravings, and his re-interpretations of Netherlandish compositions, affected painters and printmakers throughout Europe.

Schoonhoven, Jan (1914–) Dutch artist, trained at the Hague Academy, who began to exhibit in 1938 but became known in the 1960s as one of the country's major *Constructive artists and a member of the *Nul* group. He worked in white papier-mâché relief, opposing his modest and calm compositions to the fulsome *Abstract Expressionism fashionable at the time.

Schooten, Floris van *See under* Dijck, Floris van.

Schrieck, Otto Marseus van *See* Marseus van Schrieck, Otto.

Schrimpf, Georg (1889–1938) German painter of simple origins, self-taught, whose solemn, slightly *primitive pictures added a quiet and semi-*classical strand to the various kinds of *naturalistic and *realistic painting assembled in 1925 under the rubric *Neue Sachlichkeit.

Schulenburg, Johann Matthias, Marshal (1661–1747) German professional soldier; he retired to Venice, on whose behalf he had brilliantly defended Corfu against the Turks in 1715 and 1716. Thereafter, at much the same time as Joseph *Smith, he became an outstanding collector and patron of the arts. Unlike Smith, he showed a notable interest in contemporary Venetian sculpture, commissioning a large group of bronzes from *Bertos and marbles from *Corradini. He employed Giovanni Antoni *Guardi, mainly as a copyist of 16th-century Venetian masters, but the nucleus of his collection was made up of history paintings by

*Pittoni and genre and pastoral pictures by *Piazzetta (*see under* genres).

Schut, Cornelis the Elder (1597–1655) Flemish painter, designer and etcher (*see under* intaglio); he is believed to have had his early training under *Rubens, and was one of his most highly regarded successors. He is documented as a prolific painter of altarpieces in Flanders and Cologne, although his work is only now being disengaged from other attributions (e.g. *Massacre of the Innocents*, Caen, Trinité). In 1635 he was employed in the decorations for the triumphal entries of Ferdinand of Austria into both Antwerp and Ghent; to commemorate the latter, he published a volume of engravings by members of the Rubens workshop. He never went to Italy, but visited Spain, where his brother was working for Philip IV.

Schuyler Limner (active 1715 to 1725) Unknown Colonial American portrait painter active in the Albany area, named after one of the prominent local families whose members he portrayed (Albany, Institute of History and Art).

Schwind, Moritz von (1804–71) Austrian painter, associated with the Viennese circle of Schubert and the playwright and novelist Grillparzer. He received major commissions for *frescos, as, for example, in the Vienna Opera House, but is best remembered for his lively, often amusing illustrations to fairy tales and other popular stories, printed as wood-engravings. From 1827 he worked mainly in Munich.

Schwitters, Kurt (1887–1948) German artist, associated with *Dadaism though never a recognized member of any Dada group. He was born in Hanover and trained in art and design in Hanover, Dresden and Berlin. From 1915 on he worked in Hanover, painting portraits and gloomy landscapes but also developing an anti-rational kind of art, assembled bits of urban detritus in two or three dimensions, which he titled 'Merz', a word with a variety of associations but discovered in collaging over part of a bank's letterhead including the word 'kommerzial'. From

1923 to 1932 he published the journal *Merz* devoted primarily to his own Dadaist work but on occasion offering its space to other artists, including *Lissitzky. The Berlin Dadaists had refused to accept him as one of them, so Schwitters waged his Dada campaign alone in Hanover, exhibiting his work in local galleries (including an early exhibition at the Kestner-Gesellschaft) and also, in 1925, at the *Sturm gallery (this exhibition subsequently toured Germany and went on to Moscow). He wrote fine nonsense poetry and, starting from a theme he found in the writings of Huelsenbeck, developed a composition in oral sounds, his *Ur-sonate.* elaborately scored and performed in all seriousness. In his home he gradually developed a *Merz-bau*, using wood and plaster for the basic structure and ceaselessly adding bits of found matter which gave it thematic foci. He referred to it also as his Cathedral of Erotic Misery. It was bombed during the second world war, before which, in 1937, he had emigrated with his son to Norway where he began work on another Merz environment. Imminent German invasion there brought him to the United Kingdom in 1940, where he was promptly interned as an enemy alien. After some months he was released and from 1941 to 1945 he lived in London, painting acceptable pictures but also producing further Merz works. He exhibited in London in 1944 and in New York (MoMA) and Basel in 1948. There was no interest for his work, and in 1945 he moved into the rural setting of Ambleside in Westmorland where he commenced transforming the interior of a barn into a Merz environment (completed section now in the possession of Newcastle University).

Schwitters Dadaism lacked the political drive of the Berlin movement, which may be why it rejected him. Some of it, especially the work of the 1930s and after, tended to a refinement and delicacy which makes one forget its origin in rubbish. There is a great deal of wit in it as well as selectivity, but it was only in the 1960s, after major shows such as that put on by the Kestner-Gesellschaft in Hanover in 1956 and then shown also in Bern and Amsterdam, that his exceptional qualities began to

be noticed by the wider art public. His work is now very highly valued. Schwitters also worked as a commercial designer, especially for the Pelikan ink and stationery company in Hanover, and in 1927 joined with *Moholy-Nagy, *Vordemberge-Gildewart and *Domela in a collaborative design association. The talent he showed for clear-cut and effective compositions and images also informed the best of his Merz assemblages. His writings have gained him a place in the history of modern German literature.

Scorel, Jan van (1495–1562) Eclectic and much-travelled Dutch painter. His first-hand experience of art in Venice and Rome caused him to formulate a unique pictorial blend of northern European and Italian modes; he has been called a 'northern *Raphael'.

The son of a priest, later legitimized by the Emperor Charles V, van Scorel took his name from his native village of Schoorl, near Alkmaar. His first teacher was said to have been Cornelius Buys, tentatively identified with the 'Master of Alkmaar', author of a panel of the *Seven Acts of Mercy*, 1504, now in Amsterdam, Rijksmuseum. He may also have studied under Jacob Cornelisz. van *Oostsanen in Amsterdam, and gone to Utrecht to meet *Gossart. In 1518/19 he travelled to Venice via Basel and Nuremberg, where he may have assisted in *Dürer's workshop. These, at any rate, are the various influences which have been discerned in the *Holy Kinship Altarpiece* (1520, Obervellach, parish church). Later in the same year Van Scorel joined a pilgrimage to the Holy Land – an experience reflected in a drawing of Bethlehem (London, British), the topographic cityscape in the background of the *Entry of Christ into Jerusalem* (1527, Utrecht, Museum) and in the group portrait of the *Pilgrims to Jerusalem* (1527–30, Haarlem, Hals) as well as in the *Portrait of a Jerusalem Pilgrim* (Bloomfield Hills, MI, Cranbrook). His return to Venice in 1521 resulted in his adoption of *Giorgionesque elements (e.g. *Death of Cleopatra*, c.1522, Amsterdam, Rijksmuseum).

In 1522 Van Scorel was appointed by the Dutch pope, Adrian VI, to supervise the

antique collections of the Belvedere (*Adrian VI*, Louvain, University). A predecessor in this post had been Raphael, and Van Scorel employed his time at the Vatican to study his works and those of *Michelangelo, the architecture of Bramante (*see*, e.g. the architectural background of the *Presentation of Christ in the Temple* c.1530–5, Vienna, Kunsthistorisches) and the antique. When the pope died in 1523 Van Scorel returned to Holland. After working in Alkmaar and Haarlem he finally settled in Utrecht, where he was made a canon – a clerical appointment which did not prevent him from taking the sister of another canon as his mistress (*Agatha van Schoonhoven*, 1529, Rome, Doria) and fathering six children. In 1550, famous throughout the Netherlands, he was called to Ghent to restore Jan van *Eyck's *Ghent Altarpiece* (*see also* Blondel, Lancelot). Other works are in Washington, National; Rotterdam, Boijmans Van Beuningen; Berlin, Staatliche; Brussels, Musées. His most important pupils were *Heemskerck and *Mor.

Scott, Samuel (1702?–72) Called 'the English Vandevelde', Scott in his earliest phase as a painter (c.1726–46) was the most important imitator of the marine scenes of Willem van de *Velde the Younger (London, Tate; *see also* Monamy, Peter; Woodcock, Robert; Brooking, Charles). After *Canaletto's arrival in London in 1746 he began almost exclusively to execute views of London. Like Canaletto, he kept drawings made on the spot, from which he produced painted versions and repetitions of many of his compositions, sometimes on a large scale to fit particular locations (e.g. Longford Castle; Hambleden, Bucks). He is at his best combining London river scenes with the marine style of Van de Velde, capturing the cloudy English skies and watery atmosphere rather better than Canaletto and sometimes achieving an unexpected monumentality (e.g. *An Arch of Westminster Bridge*, London, Tate).

Scott, Tim (1937–) British sculptor, trained first in architecture, then at St Martin's School of Art, who emerged

through exhibitions in the 1960s as one of Britain's inventive and original *abstract sculptors, working with coloured elements set into space by means of metal and plastic. His work was included in the 'Primary Structures' show in New York in 1966 (*Minimalism) and was additionally seen in New York, Boston and Washington from 1969 on.

Scott, William (1913–89) British painter, born in Scotland, trained in Northern Ireland at the Belfast College of Art and in London in the Royal *Academy Schools. In 1938, after some months in Italy, he and his painter-wife Mary settled in Brittany, at Pont Aven and opened a school there, but the war forced them to leave and in 1940 they returned to London. After voluntary war service he lived in Somerset, teaching at the Bath Academy at Corsham Court. His paintings now focused on still-life motifs of a spare and linear sort, and occasionally on linear nudes, which led him into *abstract painting with much the same sensibility to line and disposition but more emphasis on colour and space. In 1952 he began to divide his time between London and the west of England.

He had exhibited from 1942 on. In 1954 he had the first of a series of shows in New York, becoming well known among New York artists and bringing back news of developments in American art. In 1958 he showed in the Venice Biennale and in the São Paolo Bienal in 1961. In 1972 there was a major retrospective at the Tate Gallery and in 1990 a commemorative show at the Bernard Jacobson Gallery, both in London.

By the late fifties his still lifes had become ever more concentrated and were often done in thick paint and dark tones. From these he moved into full *abstraction, with colour playing a fuller role on canvases which, larger in size, have something of the character of wall surfaces. The forms appearing in his abstracts at times recall the still-life objects in his earlier work, but they appear as emblems rather than as representations and hover luminously in the shallow spaces suggested by his generally soft, broken backgrounds.

Scrots, Guillim (recorded from 1537–53) Netherlandish portrait painter. In 1545/6 he succeeded *Holbein as King's Painter at the court of Henry VIII (*Edward VI as Prince of Wales; Princess Elizabeth*, 1546/7, Windsor Castle).

Scully, Sean (1945–) British-born painter, trained at Croydon College of Art and Newcastle University, since when he has lived in New York and become an American citizen. His paintings are large and weighty in effect as well as fact; some of them are constructed of two or more canvases to emphasize their physical presence. He emphasizes their spiritual nature. Though they are recognizably his, they do not make overtly personal statements or appeals, but can be seen as extending the *Minimalist work of the 1960s as well developing out of aspects of *Mondrian's and Robert *Delaunay's art. They are softly painted in short, almost brick-like, stripes of contrasting colours, with the stripes bunched in horizontal or vertical groups of two, three or four, these groups contrasting quietly with each other as colour chords and sometimes in scale. A retrospective of his work was at the Whitechapel Art Gallery, London, in 1989.

sculpsit or **sculp.** *See under fecit.*

scumbling The application of a thin layer of semi-opaque paint over another colour to modify it. For the analogous but optically different process of glazing, *see under* colour.

Sebastiano Veneziano or **del Piombo** (*c*.1485–1547) Venetian-born painter, possibly a pupil of Giovanni *Bellini and certainly associated with *Giorgione. From 1511 he resided in Rome, where he became a protégé of *Michelangelo and an instrument of the latter's rivalry with *Raphael. He achieved a fusion of Venetian colourism with central Italian *disegno and Roman monumentality. After Raphael's death in 1520 he was recognized as the leading portrait painter in central Italy (e.g. Dublin, National; Washington, National; St Petersburg, Hermitage; Naples, Capodimonte; Parma, Pinacoteca; Rome, Doria; Los

Angeles, Norton Simon Coll.; etc.). In 1531 he was appointed keeper of the papal seal or *piombo* (whence his second nickname). After this date he painted much less. Some of his later works are executed on stone supports (e.g. Rome, S. Maria del Popolo).

Two major Venetian commissions date from before Sebastiano's departure for Rome: the organ shutters for S. Bartolomeo a Rialto, and the high altar of S. Giovanni Crisostomo. A famous unfinished painting, one of the most important early 16th-century works of the Venetian school, *The Judgement of Solomon* (Kingston Lacy, Dorset) was acquired in 1820 as a work by Giorgione but is now widely attributed to Sebastiano.

His first Roman activity was in the Villa Farnesina (*see also* Peruzzi, Raphael). Early easel paintings of his Roman stay show his gradual synthesis of Venetian and Roman styles (now Cambridge, Fitzwilliam; Florence, Uffizi). After *c*.1515 he was supplied with design ideas, and some working sketches, by Michelangelo, and his work became graver and more monumental (*Pietà*, *c*.1515, Viterbo, Museo). The Sebastiano/Michelangelo rivalry with Raphael was made explicit when in 1516 Cardinal Giulio de' *Medici commissioned Sebastiano and Raphael to paint companion altarpieces for his titular church, the cathedral at Narbonne. Sebastiano's *Raising of Lazarus*, 1518–19, for portions of which Michelangelo supplied drawings, is now in London, National (Raphael's *Transfiguration*, posthumously completed by pupils, is in the Vatican Pinacoteca). Sebastiano took refuge from the Sack of Rome, 1527, in his native Venice, whence he returned in 1529. His sombre final style, evolving during the heyday of Roman *Mannerism, anticipates the austere, legible *Classicism of the Counter-Reformation.

secco, a secco (Italian, dry) A method of wall painting, rather like distemper, in which the pigments are not chemically united with the plaster, as in *fresco. The results resemble true fresco initially but are far less durable. Many so-called frescos are combinations of true, or *buon*, fresco and *a secco*, which is the

method used for certain colours, for retouching or accentuating details, or, since it is easier than *buon* fresco, for large subsidiary areas. As a *secco* portions of a mural flake off in time, our perception of these mixed frescos is affected, sometimes more than we realize if the *buon* fresco extends over most of the picture area.

Secession German term, *Sezession*, used by artists' groups seceding from the *academies and eager to promote their work in opposition to them. This happened in leading German and Austrian centres: in Munich in 1892, in Vienna, where a dramatic new building was created as the group's headquarters and galleries, in 1897, in Berlin in 1899. These groups could themselves harden into a new establishment so that further dissenting organizations were spawned, not necessarily under the label 'Secession', such as the New Artists' Association (Neue Künstlervereinigung) of Munich, formed by *Kandinsky and others in 1909. In Berlin rejections from the Sezession exhibition of 1910 resulted in vehement charges and counter-charges, and the formation, by *Nolde, the artists of Die Brücke and others, of a group called the Neue Sezession.

Section d'Or French for *Golden Section, the term used for a proportional division of a line into two parts so that the shorter is to the longer as the longer is to their sum. This was used by the Greeks and was given especial honour by the Pythagoreans. *Renaissance artists and geometers took great interest in it, venerating it as a natural principle revealed to mankind. The late 19th century saw renewed attention to this irrational but perfect proportional means, and in 1912 a group of French painters used the term for the group's name and for an exhibition shown in Paris that year. It was in the context of this exhibition that *Apollinaire announced the birth of *Orphism.

Segal, Arthur (1875–1944) Romanian-German-British painter who studied art in Berlin, Munich (partly with *Hölzel), Paris and Italy. He settled in Berlin in 1904, joined the *Secession there and helped

found the New Secession in 1910. During 1914–20 he was in Switzerland, in touch with the *Dada circle. Back in Berlin in 1920, he directed the *Novembergruppe and worked prominently for social justice. From a lively kind of *Fauvism he turned to making paintings in a slightly *Cubist manner, more concerned with constructing a living composition than with any pretence at analysing appearances, which he named Equivalence. In the 1930s he returned to more direct, energetic transcriptions of the visual world. In 1933 he emigrated to Spain and in 1936 to London. He had in Germany initiated a scheme for public lending galleries to enable ordinary people to make contact with modern art. He promoted this in England too but also ran an art school for amateurs and professionals, in London and also temporarily in Oxford, which was highly regarded for its therapeutic role and had Sigmund Freud's support. A commemorative exhibition was shown in London in 1945 and a full retrospective toured European centres and Israel in 1988.

Segal, George (1924–) American sculptor whose first exhibited works were *naturalistic paintings (1956, New York) but who then turned to making highly naturalistic sculptures by means of plaster casts taken from posed models to create generalized *genre scenes: a couple in bed, a man fixing letters to the board outside a cinema, a petrol station, etc. It was easy to associate such slice-of-life images with the *Pop movement of the 1960s but Segal's usually unpainted figures seem curiously ghostlike in their *realistic settings and lack all communication or relatedness, so that one can see his work as a statement about isolation, not unlike that of *Hopper.

Segantini, Giovanni (1858–99) Italian-Swiss painter, born in the Trento and trained in Milan. His first works were *naturalistic and factual, but he became a *Symbolist painter – in touch with the writings of the time while living in relative isolation – and in the 1890s painted a sequence of allegorical pictures in which Alpine scenery and brilliant light are the

setting for visionary events, all made intensely real by means of his version of *divisionism, a dense texture of packed lines of bright paint. A Segantini Museum has been formed in Sankt Moritz, but some of his most powerful paintings are to be seen in Milan (G of Mod. A) and Zurich (Kunsthaus).

Seghers, Daniel (1590–1661) One of the most illustrious Flemish flower painters. Converted to Catholicism through the influence of his teacher, Jan 'Velvet' *Brueghel, Seghers became a Jesuit lay brother. He specialized in garlands or bouquets of flowers surrounding fictive reliefs in *grisaille of religious images, usually executed by other artists. Some of the greatest collectors of the age came to call on Seghers, and sent magnificent offerings in return for his flower pieces. Examples of his work can be seen in Dulwich, Gallery; Oxford, Ashmolean.

Seghers, Gerhard (1591–1651) Flemish painter, like *Rombouts probably a pupil of *Janssens. He travelled in Italy and possibly in Spain, and in his youth painted Caravaggesque works (*see under* Caravaggio) in the manner of *Manfredi. In about 1628 he changed to a rather dry style derived from *Rubens (*Assumption of the Virgin*, 1629, Grenoble, Musée; *Adoration of the Magi*, 1630, Bruges, Onze Lieve Vrouwekerk).

Seg[h]ers, Hercules (*c.*1589/90–after 1635) Dutch painter and etcher (*see under* intaglio) of landscapes, mainly imaginary, often fantastical or romantic in mood. A pupil of *Coninxloo, indebted also to *Elsheimer and *Savery, he had a profound influence on the landscape art of *Rembrandt, who owned eight of his paintings and one of his etched plates, which he reworked (*Tobias and the Angel*, altered into a *Flight into Egypt*). Only about 15 paintings can be attributed to him today (Amsterdam, Rijksmuseum; Berlin, Staatliche; Florence, Uffizi; Rotterdam, Boijmans Van Beuningen). Seghers experimented with making colour prints from single etched plates, either by printing on coloured paper or linen or by touching up the print

with oils or watercolours. The etchings are almost as rare as the paintings: there are only about 165 impressions of some 50 prints, of which almost one third are in the Print Room of the Rijksmuseum, Amsterdam.

Séguin, Armand (1869?–1903) French painter of Breton peasant origin who studied at the Académie Julian in Paris and became a convinced disciple of *Gauguin through seeing the Café Volpini exhibition of the *Synthetists in 1889. He worked mainly in Brittany as part of the *Pont-Aven school.

Seisenegger, Jakob (1505–67) Court painter to the *Habsburg emperor Ferdinand I; he journeyed with the court to Bologna, Madrid and the Netherlands, but was active mainly in Vienna. His best-known work is the portrait of *Charles V with his dog* (Vienna, Kunsthistorisches), a drawing of which served as a model to *Titian; it is one of his many official Habsburg portraits adopting the formula of the life-size full-length likeness evolved by Lucas *Cranach the Elder. There are works by him also in The Hague, Mauritshuis, and Innsbruck, Ferdinandeum.

Seiter, Daniel *See under* Loth, Johann Carl.

Seiwert, Franz Wilhelm (1894–1933) German artist, born and active in Cologne. He was briefly associated with Cologne's *Dada movement but in 1920 joined in founding an Association of Progressive artists. In 1929 he founded the journal *a–z* which ended in 1933. A convinced Communist, he made his art a vehicle for simplified and monumentalized images of ordinary life, delicate as well as strict in its emphasis on geometrical forms.

Sequeira, Domingos António de (1768–1836) Successful Portuguese painter, draftsman and designer for metalwork. He produced portraits and history paintings (Lisbon, Museu) in a *Neoclassical style learned in Rome, working in Lisbon and Paris (where he was influenced by current

*Romantic trends) before returning to end his career in Rome.

Séraphine (1864–1934) French *naïve painter; in domestic service, she began to paint in middle age and was discovered by the critic Wilhelm Uhde who in 1928 included her work in an exhibition of naïve painting alongside pictures by Henri *Rousseau, *Bombois and others. Her patiently painted, compact still lifes convey her piety and innocence.

Sergel, Johan Tobias (1740–1814) Pioneer *Neoclassical sculptor, the son of a German saddler and embroiderer who had settled in Stockholm. His greatest works – mythological groups and statues – were executed during the eleven years, 1767–78, he spent in Rome as a pensionary of the Swedish government (mainly Stockholm, National; also Helsinki, Museum). After his enforced return to Sweden on the order of King Gustavus III, he became principally a portrait sculptor. The pupil and assistant of a French sculptor at the court of Sweden, Sergel worked at the French *Academy in Rome, where he knew *Houdon and was a close friend of *Clodion. Although he declared on his arrival in Italy that he must abandon his earlier 'abominable French manner', like these French sculptors he tempered the influence of the antique, and of *Michelangelo, *Raphael and the *Carracci, with study from the living figure (for example in the fencing halls of Rome). His *realism is especially noticeable in drawings and terracotta models (e.g. Norrköping, Museum). He left a huge collection of drawings and *caricatures of his daily life, family and friends, including the artists *Abildgaard and *Fuseli; another friend, Gavin *Hamilton, obtained an important commission for him from the English collector Thomas Mansell Talbot (now Stockholm, National).

Serpotta, Giacomo (1656–1732) The greatest Sicilian sculptor, working in the traditional local material of *stucco, although he also modelled in plaster for casting in bronze (equestrian monument of Charles II, German Emperor and King of Spain and Sicily, Palermo, 1682, destroyed 1848; a small cast survives in Trapani, Museo). He is celebrated for his decoration of Palermo churches, and although conversant with the Roman *Baroque sculpture of *Bernini, lent his graceful statues and their decorative context – creeper-like festoons, lively *putti – a *Rococo playfulness. In his later work he clothed even *allegorical figures in contemporary dress; the most famous is the ravishing *Fortitude* (Oratorio del Rosario, S. Domenico, 1714–17), the bodice of whose fashionable dress is a vestigial cuirass. There are other decorations in numerous Palermo churches. His brother **Giuseppe** (1653–1719) and his son **Procopio** (1679–1755) were also stuccoists.

Serra, Richard (1939–) American sculptor whose work is a maximal form of *Minimalism in that he erects weighty, sometimes enormous, steel or lead plates in apparently precarious positions and relationships. The formal element of this work is given by factory production; his concern is with situation and with minimal intervention. His work and principles came under dramatic scrutiny with the installation of his large, curved, single-piece sculpture *Tilted Arc* in Federal Plaza, New York in 1981. It had been commissioned in 1980 by a committee that had scrutinized Serra's project with care, and had accepted that the work was conceived for that site and none other. This became crucial when there were protests against the sculpture as ugly and unsafe. A public hearing was followed by a decision to relocate the work. Serra's law suit against this failed, as did an appeal. In 1989 the work was destroyed.

Sérusier, Paul (1863–1927) French painter who first studied philosophy, then worked at the Académie Julien, and in 1888 was profoundly influenced by the example of *Gauguin and the ideas of *Bernard, whom he met together at Pont Aven. He was one of the founders of the *Nabi group and within it promoted the ideas and methods he had learned at Pont Aven. He was associated with the artists at the Benedictine monastery of Beuron. His book, *ABC of Painting* (1921) was widely read.

Servaes, Albert (1883–1966) Belgian
painter, from 1905 a member of the
*Laethem-Saint-Martin community, devel-
oping a solemn, earthy manner which was
seen as a local form of *Expressionism. He
moved to Switzerland in 1945.

Servranckx, Victor (1897–1965)
Belgian painter, most prominent among
the *abstract painters of that country. He
exhibited abstract paintings from 1917 and
in the 1920s developed an idiom rich in
mechanistic references that echoed the
aesthetics of *Purism. His later work is
less geometrical and patterning, and hints
at cosmic experiences. A commemorative
exhibition was shown in 1965 at the Musée
d'Ixelles, Brussels.

Settignano, Desiderio da *See*
Desiderio da Settignano.

Seurat, Georges (1859–91) French
painter, one of the major *Post-
Impressionists and inventor of *Neo-
Impressionism. A Parisian, he studied
briefly in the Ecole des Beaux-Arts under
Henri Lehmann, a pupil of *Ingres, and
always retained a *classical sense of formal
design. But he was also drawn by
*Delacroix's exploration of colour and,
though shocked by his first sight of
*Impressionism in 1879, responded to the
use of separate colours and the broken, all-
over texture of individual touches. Yet he
was also drawn to the art of *Couture and of
*Puvis, and chose to immerse himself in
colour theory and in the psychology of per-
ception. His first known paintings are small
studies of landscapes in oils on wood, fresh
in colour and light, and neat in design.
At the same time he invented a mode of
drawing in black crayon on grainy paper that
enabled him both to simplify forms and to
realise them in fine variations of tone.
 His first major painting, *Bathers at
Asnières* (1883–4; London, National), is of
working-class men and boys at a suburban
bathing place. It shows the influence of
*Puvis in its studied design and a softened
form of Impressionist technique in the
dabs of paint that make up most of its
surface; in using the size and interior scale
of a *History painting for a *genre subject,

Seurat was following *Courbet's challeng-
ing example. Refused by the *Salon, it was
shown in 1884 at the Salon des Indépen-
dants relegated there to the refreshment
room. A second large work to partner it
followed at once: *A Sunday on the Grande
Jatte* (1884–6; Chicago, Art Institute). Here
mostly middle-class people and their pets
are at leisure on an island in the Seine, their
forms much abstracted and the colour and
light now set down using *divisionism
and *pointillism. This was shown at the
Impressionist exhibition of 1886 next to
work using similar methods by *Signac,
*Pissarro and others, demonstrating what
Pissarro called 'scientific Impressionism'. It
was seen again, together with six Seurat
landscapes, in Brussels the following year at
the annual exhibition of the *avant-garde
association, Les *Vingt.
 Seurat painted land and seascapes on the
Normandy coast during the summer from
1885 on; in the winters he developed studio
paintings, mostly of urban and indoor
subjects, such as *Les Poseuses* (1886–8;
Merion, Barnes) but including *The Bridge
at Courbevoie* (1886–7; London, Cour-
tauld). His contributions to the Salons des
Indépendants brought together his summer
and winter work. His concern with the
emotional promptings of forms as well as
colours grew, and here too he sought and
found guidance in science. *La Parade*
(1887–8; New York, Metropolitan), show-
ing performers advertising their skills
outside a circus, shows him concerned with
proportional division of the composition;
in *Le Chahut* (1889–90; Otterlo, Kröller-
Müller), of music-hall dancers in action,
and *Le Cirque* (1890–1; Paris, Orsay) the
system is complete: movement and expres-
sion are frozen in a complex of linear and
colour harmonies, and popular subject
matter is given monumental celebration.
Admiring critics and fellow artists saw in
these developments pointers to art's future.
In fact, *Fauvism, *Cubism, *Futurism
and many individual painters, *Mondrian
among them, derived in part from his work.
 He died aged 31, probably of diphtheria.
One wonders how he would have con-
tinued. 1892 saw memorial shows of his
work in Paris and Brussels but wider recog-
nition of its importance was slow in

coming. In 1900 his major paintings could still be acquired at knock-down prizes and it was only in 1957 (Paris) and 1958 (Chicago and New York) that major retrospectives were dedicated to him. An almost complete Seurat exhibition was shown in Paris (Grand Palais) and New York (Metropolitan) in 1991–2.

Severini, Gino (1883–1966) Italian painter who worked with *Balla and *Boccioni in Rome and in 1906 settled in Paris. There he worked in an *Impressionist idiom refined by the example of *Seurat ('whom I adopted as my teacher for always'), before striving to reconcile the example of *Cubism and the aspirations of *Futurism. He knew *Apollinaire and *Picasso and, having co-signed the Futurist painting manifesto of 1910, persuaded his Italian colleagues to make first-hand contact with Paris before launching their work on the international art world. His painting *The Boulevard* (1910–11; London, pc) is a partly *Symbolist, partly Cubist image of benign urban existence; his *Hieroglyphic of the Bal Tabarin* (1912; New York, MoMA) is an outstandingly successful Cubo-Futurist work delivering the multiple experiences of Paris nightlife through fragmented representations and through symbols.

During the war years his Futurism became somewhat more naturalistic, and then he painted still lifes only slightly tempered by Cubism, in which the objects themselves (e.g. a packet of porridge oats) become prominent and take on an almost *Pop role. Cubism remained a basic influence and in the 1950s led him back into *abstraction. He wrote intelligently and influentially, thinking beyond the principles of groups and movements.

Sforza Italian family of professional soldiers, who seized power in Milan in 1450 from the Visconti, to whom they were related by marriage. Like their predecessors, the Sforza gained possession of nearby territories and threatened Florentine dominion in Central Italy. Having invited the 1494 incursion of the French King Charles VIII into Italy to conquer

Naples, **Lodovico Maria Sforza** (1452–1508), called 'il Moro', 'the Moor', found himself deposed when the next king of France, Louis XII, invaded Milan itself in 1499. The family continued the vainglorious patronage of the Visconti in Milan and Pavia, where the Charterhouse (*see also under* Amadeo, Giovanni Antonio) housed the elaborate posthumous tomb of Gian Galeazzo Visconti (*d.*1402) erected in 1493–7 by Gian Cristoforo Romano (*see under* Isaia da Pisa) and Benedetto *Briosco. The best-known artists associated with the Sforza court in Milan were *Filarete, who worked for the first Sforza duke, Francesco (*d.*1466), the great architect Bramante and *Leonardo da Vinci, who – along with more minor artists such as *Foppa, the de'*Predis brothers, Bramante's pupil *Bramantino, *Bergognone – were employed by Lodovico il Moro.

sfumato (Italian, 'vanished gradually', from the word *fumo*, smoke.) Used in painting to mean the gradual transition from one hue or tone to another (*see* colour); shadowy, rather than hard, contours. *Leonardo da Vinci advocated *sfumato*, using it to soften the transitions from darkest shadow to brightest highlight, and counteract the danger of harshness inherent in his *chiaroscuro. But it was left to others influenced by him (notably *Giorgione and *Correggio), to perfect *sfumato* from one hue to another, sometimes within a narrow tonal range. By enabling artists to build up through layers of translucent glazes (that is, suspensions of pigment in a drying medium) like veils of colour, painting in *oils is supremely suited to achieving these effects.

sgraffito *See* graffito.

Shaftesbury, Anthony Ashley Cooper, 3rd Earl of (1671–1713) English essayist and art patron, a pupil of the philosopher John Locke. He advocated the 'Grand Manner' in art (*see* entries on *genres, *esp.* history painting; *Reynolds; *idealization) decrying the 'merely natural' of Dutch genre painting and prophetically anticipating the reaction of *Neoclassicism against the *Rococo. His writings were

collected in *Characteristicks of Men, Manners, Opinions, Times*, 1714.

Shahn, Ben (1898–1969) American painter and graphic artist, born in Lithuania, brought to the USA at the age of 8, and from 1906 until 1930 working for a lithographer. He studied art and design in New York, and travelled in Africa and Europe. He worked as a photographer during the Depression of the 1930s but also devoted his art to highlighting such instances of political injustice as that occasioned by the Sacco and Vanzetti trials in 1931. He assisted *Rivera on his Rockefeller murals in 1933 and himself gave priority to mural work. After the Second World War he gave more time to producing smaller works, still with a pronounced social content, and he gave the Charles Eliot Norton lectures at Harvard University in 1967–8 under the title *The Shape of Content* (published in book form). His work was exhibited from 1930 on and was chosen to represent the USA at the biennial shows of São Paulo in 1953 and Venice in 1954.

Sheeler, Charles (1883–1965) American painter, trained in design and then in art in his native Philadelphia. He spent 1907–12 in Europe and when he returned to the USA practised photography as well as painting. He exhibited from 1910 on and was included in the *Armory Show. With Morton Schamberg and with *Demuth, he created an American echo of *Cubism subsequently known as *Precisionism, characterized by clear tones and colours and by motifs trimmed to their basic geometrical forms. Photography often served as the raw material for his paintings: his work as a commercial photographer was outstandingly successful in the 1920s. His first one-man show of paintings was held in New York in 1920 and consisted primarily of urban subjects, especially skyscrapers. Later he turned to rural scenes and was associated with American *Regionalism. Later still, from the 1940s on, he gave his attention primarily to urban and industrial subjects. His first retrospective was shown at MoMA in New York in 1939.

shell gold Powdered gold used as a paint, so-called because traditionally it was contained in a mussel or similar shell. It was much used by illuminators of manuscripts and in early panel painting for fine details too small to be gilded with gold leaf.

Sher-Gil, Amrita (1913–41) Indian painter of aristocratic family, born in Budapest, trained in Paris and working, from 1934 on, almost exclusively in India. She shunned modern western tendencies but employed some of the methods of western illustrators in conjunction with Indian traditions to monumentalize the unglamorous life of the ordinary Indian family.

Sherman, Cindy (1954–) American artist, trained in art at the State University of New York in Buffalo during 1972–76. By the time she graduated she had found the speciality that has made her known internationally while its specific character and methods have developed. Using photography as process, film and art imagery as material to be appropriated and transformed, and herself as primary object and performer, Sherman has created long sequences of elaborately constructed pictures, each exploring the implications of familiar picture types. In 1977 she embarked on her series of 'untitled film stills', photographs that look like film stills but present herself in a succession of film-like characters and situations, inviting the viewer's imaginary input of a before-and-after narrative but also refuting it by making us accept her picture as an isolated fabricated moment. She is clearly testing the density and purpose of our mental store of images and the motivation shaping that store. In the 1980s she went on to portray mythical beings of, usually, a ghastly sort, setting up *Bosch- and *Grünewald-like scenes of filth and evil. This led, from 1990 on, to her presenting herself in a series of portraits re-enacting well-known *Renaissance and *Baroque paintings. In many ways Sherman's work is adjacent to the sophisticated but popular visual culture of current film and advertising photography; it is readily accessible as well as rich in moral implications that surface less

immediately. Her first solo exhibition was in 1976, since when her work has been seen many times in the USA and abroad.

Siberechts, Jan (1627–1700/03) Landscape painter from Antwerp. He may have spent some years in Italy, returning home by 1648/9. His earliest-known paintings, 1653, are close to the Italianate Dutch artists *Both, *Dujardin and especially *Pijnacker, whose bluish tints he emulated (e.g. Berlin, Staatliche). Around 1660 Siberechts evolved a type of majestic landscape in which the representation of roads and trees justified the use of converging *perspective, and that of water allowed the use of a strong blue throughout the painting (e.g. London, National). A few *genre paintings by him are known (e.g. Copenhagen, Museum). In 1672/4 he settled in England, where he was active until his death. Among his landscape paintings are a group of bird's-eye views of aristocratic country houses – Longleat, Wollaton Hall, etc. – 'country house portraits', of which he seems to have been the first specialist.

Sickert, Walter Richard (1860–1947) British painter born in Munich into a Danish-German family who moved to England in 1868 and became British. He worked first as an actor, then studied painting at the Slade School, London. He was *Whistler's assistant for a while and then worked with *Degas in Paris: both were to be his models, stressing the transformatory role of art in an age of *naturalism. He brought a controlled form of *Impressionism into English painting and with *Steer presented the exhibition 'London Impressionists' at the Goupil Gallery, London, in 1889. He lived for some years in Dieppe but in 1905 returned to London where he stood out for his intimate knowledge of the best art of Paris. Younger artists gathered round him and a loose circle known as the *Camden Town Group formed and took note of his vivid paintings of life in Camden Town, often gloomy or at least ambiguous scenes that were both Impressionist in technique and *realistic in emphasis. He spent some years in the town of Bath and settled there in 1938. The work of his last years shows some decline where

mood and the representation of real scenes under normal conditions of light were concerned but included some pioneering transcriptions from media photographs. An impressive personality, articulate and witty as well as opinionated, Sickert impressed many with his views on the virtues and vices of modern art.

Siegen, Ludwig von *See under* Rupert of the Rhine, Prince.

Signac, Paul (1863–1935) French painter who inherited *Seurat's mantle as leader of *Neo-Impressionism. He was self-taught, painting landscape in vivid colours. He came to know Seurat in 1884, adopted his *divisionism and *pointillism and pressed them on his acquaintances, including Van *Gogh. His paintings of the 1880s included domestic scenes, severely designed and executed, that influenced the gentler work of the *Nabis. Then his colours became lighter and his technique more openly poetic, as is shown in his series of French harbour paintings. He continued to promote the cause of the movement after Seurat's death, writing articles, some of which became the book *From Delacroix to Neo-Impressionism* (1899), and taking an interest in the work of young artists in the hope of enrolling them in it. His brushwork became more linear and broad, aiming at luminosity and harmony more than at capturing nature's light by analysis. The Rijksmuseum Kröller-Müller at Otterlo has the best collection of his paintings.

significant form Term first used by the critic Clive Bell in his book *Art* (1914). Developing the thought of his friend Roger *Fry, Bell indicated with this phrase the communicative power of form, colour, texture, scale, etc., independent of their representational or symbolic values and more direct and universal. Fry and Bell emphasized this insight to counter the habitual emphasis, especially in Victorian art criticism, on subjects and objects, not to deny that such things can be artistic but to give sensory impact its proper primacy. Bell wrote that significant form, of its nature, 'distinguishes works of art from all other classes of objects'; it is clear, however, that

art shares this with music and that the emphasis, among progressive painters from *Delacroix on what he called 'the musical in painting', prepared the ground for Bell's argument.

Signorelli, Luca (*c*.1450–1523) Painter from Cortona, a much older relative of *Vasari. His vigorous style is marked by clear outlines, bold relief and, in figure drawing, a stress on movement and daring musculature, often in *foreshortening – possibly the consequence of a period of study in the *Pollaiuolo workshop in Florence after his presumed training under *Piero della Francesca. His best-known work, the *frescos of the chapel of S. Brizio, Orvieto cathedral, 1499–1502, on the theme of the end of the world as predicted in the Apocalypse and the Epistles of St John, influenced the *Last Judgement* of *Michelangelo. They complete a decoration begun by Fra *Angelico.

A peripatetic artist, Signorelli is documented in Cortona in 1470 and in Arezzo in 1472. Around 1480 he executed the vault and mural decoration of the sacristy, Loreto, Basilica of the Holy House; in 1481 he may have contributed a design for one of the wall paintings in the Sistine Chapel in Rome (*see also* *Perugino; *Ghirlandaio; *Botticelli; Cosimo *Rosselli). In 1484 he was working on the high altarpiece for Perugia cathedral (now Museo Capitolare). For executing a processional standard, he was made honorary citizen of Città di Castello, 1488, the date also of his remarkable mythological fantasy of *Pan enthroned*, formerly Berlin, Kaiser Friedrich Museum (destroyed, World War Two). In Volterra 1491, Urbino 1494, he executed, 1497–8, nine vividly detailed frescos from the *Life of St Benedict* in the cloister of the abbey of Monteoliveto; the cycle was later completed – albeit with chronologically earlier episodes in the saint's life – by *Sodoma. In Cortona in 1502, he worked in Siena on a design for the pavement of the cathedral in 1506; *c*.1509 he collaborated with *Pintoricchio on the decoration of a room in the Sienese Palazzo del Magnifico, now dispersed between London, National, and Siena, Pinacoteca. In 1508 and 1513 he was in Rome, but his linear and hard

15th-century style was now eclipsed by Michelangelo and *Raphael, and he retired to Cortona, continuing to work for Umbrian churches.

Signorini, Telemaco (1835–1901) Italian painter, prominent among the *Macchiaioli. He had experimented with landscapes done in a broad, patchy technique before going to Paris in 1861 and seeing the work of *Corot and the *Barbizon school. He kept in touch with Paris thereafter and, though his main product was vivid landscape paintings, also embodied socialist ideas in contempoary *genre scenes.

Siloe, Gil de (active *c*.1480–*c*.1505) and his son **Diego** (*c*.1495–1563) Spanish sculptors; Diego was also an architect. Gil de Siloe, who may have come from Orléans, was an outstanding Late *Gothic artist active at Burgos; here he executed grandiose tomb monuments commissioned by Queen Isabella the Catholic, and collaborated as a wood carver on *retables (respectively Burgos, Cortuja de Miraflores, Museo, cathedral). Diego de Siloe, one of the two founders of Spanish *Renaissance sculpture (*see also* Bartolomé Ordóñez) was active principally in Burgos cathedral (1519, monument to Bishop Acuña; 1519–23 Escalera Dorada, 'Golden Staircase'; 1523–6, Chapel of the Constable, high altar) and in Granada from 1528 until his death. He left many pupils in both cities and his Italianate style in sculpture and architecture persisted in Granada until the 17th century.

Diego served his apprenticeship in Florence, perhaps under Andrea *Sansovino; his early work in Naples (*c*.1514–15, S. Giovanni a Carbonara, Caraccioli altar, with Ordóñez; Cathedral, Tocco Chapel, relief of *Virgin and Child*) demonstrates his understanding of *Donatello and the Florentine works of *Michelangelo. In Granada he evolved a style of architectural sculpture which combined clear, monumental Michelangelesque figures with elaborate insertions of exuberant *grotesque surface decoration (1530s, stone portals, cathedral; *see also* Plateresque). His work as a sculptor ranges across most

media: stone, alabaster, *polychrome wood and polished oak (choir stalls, 1528, Valladolid, Museum; 1528–30, Granada, S. Jeronimo) and monuments in marble (c.1528, Mercado monument, Guipúzcoa, Oñate, S. Miguel). *See also* Vigarny, Felipe.

Silvestre, Israël (1621–1691) French draftsman and etcher (*see under* intaglio), influenced by *Callot. His topographical views, as well as being valuable historical records of the architecture and ceremonies of 17th-century France, Rome and Florence, are among the most sensitive landscape prints of the time. He worked for Louis XIII of France and was drawing master to the young Louis XIV.

Simone Martini *See* Martini, Simone.

simultanism Robert *Delaunay considered *simultanéisme* an important aim of his work of about 1911–14. He derived the word from Chevreuil's book on colour in which 'simultaneous contrast' is used to describe retinal actions set off by vivid colours in juxtaposition. But Delaunay meant something wider: not only the mutual heightening of colours but also a sense of mobility resulting from this if the colours are interlocked in certain ways, and the way in which this can be experienced, over time, as the general appearance and content of a painting are assimilated. The *Futurists claimed the word for their presentations of complex present and past experiences, signalling their acceptance of psychic duration as described by the French philosopher Bergson.

sinopia, sinopie *See under* fresco.

Siqueiros, David (1896–1974) Mexican painter who after art studies fought in the revolutionary army and collaborated with Dr Atl on cultural polemics. In 1919 he was sent to Europe as a cultural diplomat and met *Rivera in Paris. Back in Mexico in 1922 he joined the Communist Party and published a manifesto setting out the aims of a revolutionary art and calling for murals as the means of addressing the public. He began to paint murals in 1923

but for political reasons withdrew from that and devoted himself to trades union work and to travels. In 1930–1 he was under house arrest and was visited by the Russian film director Sergei Eisenstein whose ideas on montage and camera angles led him to develop more complex ideas of pictorial composition. In 1932 he was in the USA, painting murals which made their mark on American artists, especially those engaged in *Federal Art Project works. In 1933 he was in Uruguay and Argentina. In 1935–6 he worked in New York and in 1937 fought in Spain as a colonel in the republican army. He lived for a time in Chile, then back in Mexico produced many dramatic murals in Mexico City, including a vast *March of Humanity* in the Parque de la Lama. A powerful personality, forcefully embodying the revolutionary struggle, he spoke and wrote with conviction and in 1951 produced an influential book, *How to Paint a Mural*. A political activist first, a painter second, his career in art was shaped as well as interrupted by periods in prison and in exile.

Sironi, Mario (1885–1961) Italian painter, born in Sardinia, who lived in Rome and Milan. He studied engineering before turning to art, which he studied partly with *Balla. After the First World War he turned away from *Futurist ideas to devote his art to solemn, at times gloomy, but always powerful images of urban life and landscape. He worked for the fascists in the 1930s but his reputation has been retrieved since the Second World War and in the year of his death the city of Milan awarded him a major painting prize.

Sisley, Alfred (1839–99) Anglo-French painter of British family, born in Paris. Sent to London in 1857 to enter the business world, Sisley was drawn to the museums and especially to the work of *Constable, *Turner and *Bonington. In 1862 he entered *Gleyre's studio in Paris, meeting there *Monet, *Bazille and *Renoir. By 1863 he was painting landscapes in the forest of Fontainebleau, often alongside his friends. The Franco-Prussian War of 1870–1 ruined his father's business and forced Sisley into greater production. He contributed to the first *Impressionist

exhibition in 1874 and later that year in London painted the first pictures in which his characteristic freshness and lightness are apparent. He was now in financial difficulties, failing almost totally to sell, yet continued to work with a stylistic consistency not otherwise known among the leading Impressionists. He found urban, landscape and garden subjects in the Ile de France and around Fontainebleau, often returning to the same scene in different seasons. In 1897 he failed to attain French citizenship for lack of documents. The Musée du Petit-Palais in Paris has the best collection of Sisleys.

Sittow, Michel *See under* Juan de Flandes.

Škréta, Karel (1610–74) Bohemian painter born in Prague, where he may have known Wenzel *Hollar. He worked in Italy from around 1630 until 1635; *Sandrart says he spent some years in Venice, and he is documented in the *Schildersbent* in Rome around 1634. In 1635 he went to Saxony, returning to Prague in 1638, to spend the rest of his active and successful career there as a portraitist and a painter of religious imagery (Prague, National). He is regarded as the father of Bohemian *Baroque painting.

Situation Name of an exhibition of British *Abstract Painting presented in 1960 by a number of young painters in a hired London exhibition space, and thus, by association, a label for those included in it. Keenly aware of *Abstract Expressionism, which they admired for its professionalism, and of, in Britain, the St Ives School, which they condemned for its fusion of natural phenomena and effects with decorative abstraction and individual poetry, they presented paintings that were, mostly, large enough to read like murals and either architectonic in character (tending to clear design and sometimes symmetry). These paintings were essentially 'self-referential', as the catalogue essay asserted, detached from nature and not concerned to express individual states. Bernard *Cohen, William *Turnbull, Robyn *Denny and Richard *Smith were among the eighteen

artist shown. In 1961 a second Situation show was presented by Marlborough Fine Art at its New London Gallery: this included a steel sculpture by Anthony *Caro, the first of his abstract works to be exhibited in the UK. In 1962–3 the Arts Council of Great Britain toured a Situation exhibition around the country. The general effect of these shows, plus of course the further careers of the artists included in them, was to assert the status of fully abstract art and to question the dominance, in Britain, of the St Ives School. During 1961–2, however, the British *Pop art movement emerged as a more immediately attractive and entertaining subject for the media and for public attention.

size or **glue-size** Animal-skin glue; the finest was made from parchment clippings. It was used to prime panels or canvases and to bind *gesso grounds. Mixed with *pigments, it was also employed for painting on *canvas, the colours becoming to some extent incorporated into the fibres of the fabric (*see*, e.g., *Bouts). Because size remains permanently soluble in water, such paintings are especially vulnerable to damp.

Slevogt, Max (1868–1932) German painter, a leading figure in its *Impressionist movement. Trained at the Munich *Academy, he worked first in a *naturalistic manner and in the 1890s adopted some of *Art Nouveau's anti-naturalism, but some months in Paris during 1889–90 converted him to the breezy Impressionism of *Manet. It was primarily this that he represented back in Germany, in Munich and then, from 1901, in Berlin. Some of his most admired paintings were of stage performances, his manner benefiting from stage lighting and bravura action. There was also a sombre side to his production and this came to dominate after he had experience of front-line fighting in 1914.

Sloan, John (1871–1951) American painter who grew up in Philadelphia and worked for a long time as graphic artist for the press while also attending drawing and painting clases. He met Robert *Henri and showed paintings in a New York exhibition

Henri arranged in 1901. He moved to New York in 1904, showed in the 1908 exhibition of The *Eight and in the 1913 *Armory Show, among others. He specialized in New York scenes, interiors and streets, making etchings as well as paintings. In 1910 he joined the Socialist Party, became an active politician and was art editor of the socialist periodical *The Masses* from 1912 to 1916. His painting widened after 1913 to include landscapes and nudes, and for many years between 1916 and 1937 he taught at the Art Students' League. Wilmington, Delaware, has a John Sloan Trust and a strong collection of his work.

Slodtz, René-Michel (called **Michel-Ange**) (1705–64) French sculptor, resident in Rome 1728–46 and the most distinguished practitioner of the French neo-*Baroque style derived from *Bernini (*see also* the Adam brothers). One of the five sons of the Flemish-born sculptor **Sébastien Slodtz** (1655–1726), and a pupil of *Girardon, Michel-Ange was to produce his finest works in Italy, although his masterpiece, the *Montmorin tomb*, 1740–4, was executed in Rome for Vienne cathedral in France. Of the works for Roman churches, the best-known is the *expressive St Bruno, 1744, for St Peter's. After his return to Paris, Slodtz was to receive only one further important commission, the *Longuet de Gergy monument*, 1753, St Sulpice, the last allegorical-narrative funerary monument to be produced in 18th-century France. He was the teacher of Simon-Louis *Boizot.

Sluter, Claus or **Klaas** (recorded from 1379–1405/06) Dutch-born sculptor working for Philip the Bold, Duke of Burgundy; the first great master of monumental stone sculpture in northern Europe. His work, in its dramatic force, can be compared favourably with the early sculpture of *Donatello.

First recorded in Brussels in 1379, Sluter joined the workshop of the Flemish sculptor Jean de Merville, in the service of Duke Philip in 1385. After Jean's death in 1389 Sluter was put in charge. In this capacity he designed and carved his great works for the Carthusian monastery founded

by the Duke at Champmol near Dijon: the sculptural decoration of the church portal (completed 1397); the monumental *Calvary* in the cloisters, usually called the *Moses Fountain* (1395–1403; carved base, Champmol, other fragments Dijon, Musée Archéologique *see also* Malouel, Jean; Broederlam, Melchior); a funerary monument of the Duke, commissioned from Jean de Merville in 1384 and completed after Sluter's death by his nephew and successor Claus de Werve (dispersed and partly destroyed; autograph fragments Paris, Cluny; Dijon, Musée).

Sluter's style, albeit founded in late 14th-century monumental sculpture in the southern Netherlands, is characterized by a new attitude to the relationship between architecture and sculpture. Sculpted figures project from their architectural setting with great emphasis on their three-dimensionality. This new *realism of form is further emphasized by realism of portrayal. Not only the actual portraits of the donors on the portal at Champmol, but also the prophets on the Moses Fountain, are fully individualized. The ample draperies suggest the body underneath and also accentuate the dramatic power of pose and gesture. Perhaps the best-known example is the hooded monk from the mourning cortège of Philip the Bold's funerary monument (Dijon, Musée). Restoration has brought to light remnants of *polychromy on the figures of the Moses Fountain.

Sluter's influence on later stone sculpture in Burgundy, France, the Netherlands and Germany is incalculable.

Smet, Gustave de (1877–1943) Belgian painter seen as one of the country's *Expressionists. In 1901 he settled at *Laethem-Saint-Martin and painted rural life in a weighty, earthy manner. This became more vehement when he was in his fifties. There were retrospective shows of his work in Brussels, 1936 and 1950, and at Antwerp in 1961.

Smibert, John (1688–1751) Edinburgh painter, he studied in Rome 1717–20 before establishing himself in London as a portraitist. In 1728 he joined Dean, later Bishop, Berkeley on an expedition to

Bermuda to found a university in the New World; Smibert was to teach drawing, painting and architecture. In the event, the party was stranded in Rhode Island; rather than return to Britain with the others, Smibert settled in Boston (1729), the first fully-trained painter in colonial America. A public showing of his works, including the influential *Bermuda Group* (1729; New Haven, Yale University) was the first recorded art exhibition in America. Smibert's collection of engravings (*see under* intaglio prints), copies after the Old Masters, and plaster casts of antique statuary, in effect provided colonial artists with their first *academic training. Through his partnership with the engraver Peter *Pelham, who reproduced for sale his portraits of public figures, Smibert had a direct influence on the greatest of the New England painters, Pelham's step-son and pupil, John Singleton *Copley.

Smith, David (1906–65) American sculptor who studied art in several places including New York (Art Students' League) but also gained fruitful experience when working for the Studebaker car company in 1925, as well as later, around 1945, as a welder on defence work. He had given priority to painting but produced his first welded sculptures in 1933, influenced as much by *Cubism and the paintings of *Kandinsky as by the sculpture of *González. His first exhibition was in 1938 in New York. His best sculpture in the years that followed was like hieroglyphs set into space but in the later 1950s he began to produce the more massive and monumental *abstract compositions, some in ground and shining steel, others painted in colours, with which he became known internationally. Some of these echo the figure in their dispositions, some suggest still lifes, some landscapes. He worked often in series focusing on a particular formal and technical theme. He divided his time between New York and his farm at Bolton Landing, NY, from 1933 on, and liked to place his sculpture into the landscape space available to him there. In 1962 he spent some months in Italy, rapidly producing some large sculptures which were exhibited at Spoleto. His life ended in

a car crash. Already in the 1940s the critic *Greenberg insisted on Smith's eminence among modern sculptors and this judgement was gradually echoed by many others as Smith's work became better, and better known around the world through many exhibitions.

Smith, Jack (1928–) British painter, much discussed in the 1950s as one of a group of *realistic painters portraying the life of ordinary people in domestic and other scenes which seemed dramatic and even harsh but can now be valued for their formal strength and subtle colour harmonies. In 1957 he won first prize at the John Moores Liverpool Exhibition. He became more and more interested in light and shadows in still-life subjects and in his thirties became an *abstract painter, making compositions out of what appear to be signs and fragments of signs in a calm and spacious manner that suggests pure music. These developments restricted his public but he had major exhibitions in London in 1977 (Serpentine Gallery) and solo exhibitions from 1990 on (Flowers East).

Smith, Joseph (*c.*1675–1770) Englishman resident in Venice from the early 1700s; he was made British Consul in 1744, and is often referred to as Consul Smith. A merchant and sometime publisher, he became an extremely active collector, patron of the arts and art dealer, in close contact with nearly all the leading painters of Venice. He is particularly associated with Sebastiano and Marco *Ricci, Rosalba *Carriera, *Zuccarelli, and, above all, *Canaletto, whose agent he became, especially for commissions from English visitors. In 1761 he sold the bulk of his library and most of his pictures and gems to King George III.

Smith, Matthew (1879–1959) British painter, trained at the Slade School in London and briefly at *Matisse's school in Paris. He returned to London in 1913 where his work became increasingly strong in design and colour, echoing the colour contrasts sometimes found in *Fauvism. The First World War interrupted his work

and brought a period of depression, but from the early 1920s on Smith developed and confirmed a personal style which was a much more fluent, less structured version of his pre-war work, with bright colours and rhythmical brushwork and with the female nude his favourite subject, followed by flowers and other still life subjects. There was a major retrospective at the Tate Gallery, London, in 1953. He was knighted the year after.

Smith, Richard (1931–) British painter, resident since the 1970s in the USA. He was exceptional among the *Pop painters who emerged in the early 1960s for the painterly richness and boldness of his compositions, some of them three-dimensional in emulation of advertising's acute manipulation of pictorial presence. His interest was always in visual subtleties and from about 1964 he used a variety of three-dimensionally shaped canvases, developing particular formats as series of *abstract images. His later paintings were unstretched canvases hung singly or in groups like sails or gathered kites, forming independent and highly decorative objects. There was a large exhibition at the Tate Gallery, London, in 1975, presented as a reconstruction of his previous one-man shows. Since then he has worked principally in Los Angeles and subsequently in New York and London.

Smith, Thomas, Captain (recorded 1680) Colonial American sea captain and portrait painter or *limner, the earliest known by name. He is mentioned in an account book of Harvard College, and a number of rugged male portraits have been attributed to him on the basis of a *Self Portrait* signed with his initials (*c.*1690, Worcester, MA, Museum).

Smith, Tony (1912–80) American painter and sculptor. He studied at the Art Students' League and at the New *Bauhaus in Chicago. He worked for Frank Lloyd Wright and practised as an architect during the 1940s and 50s, during which time he also painted and was in close touch with the leading painters of the New York School, *Rothko, *Newman, *Still etc. His paint-

ings became known in the 1960s as a contribution to *Minimalism, and from 1964 on he also showed large steel sculptures, normally clear, geometrical units and combinations that seem self-explanatory yet, thanks to their scale and disposition, hold some mystery.

Smithson, Robert (1938–1973) American artist, known for his *Earthworks and probably the most poetic and philosophical of artists associated with that movement. He was trained in New York (Art Students' League and Brooklyn Museum), and has additionally concerned himself with the long history of man-made adjustments of the natural environment, from burial mounds and modern nuclear plants to pyramids, architecture and the negative architecture of quarries. His best-known work is the *Spiral Jetty*, 1500 feet long, which he formed in the Great Salt Lake, Utah, in 1970. Consisting of mud, salt crystals and rocks in the red water, its form echoes the growth pattern of the crystals as well as mankind's and nature's many other spirals, but it is in-turned, not a spiral growing to occupy more space, and it is gradually sinking in the water. Other land works by him have included the *Amarillo Ramp* in Tecovas Lake, close to the Amarillo nuclear warhead assembly plant: a mound of earth and rocks which in its manmade timelessness confronts the temporary modernity of a potentially mankind-destroying military industry. Smithson died in an air crash near Amarillo. His writings and interviews, collected by his wife, the artist Nancy Holt, were published in 1978.

Snow, Michael (1929–) Canadian painter, also filmmaker, photographer and musician who studied art in Ontario and spent some time in Europe in 1953–4. Attempting to assert and achieve *realism in his productions, in the sense of escaping from illusionism or, failing that, to comment on our acceptance of contradictory representations as valid versions of reality, he has painted *abstract pictures and created steel sculptures of figures, and also made and displayed photographs of a figure so as to force the viewer into a similar

pose and thus predicament. Since 1970 he has given priority to music, playing in jazz bands and making records. In 1970 Ontario Art Gallery presented a survey of his work, accompanied by a photographic biography. A major retrospective show toured Paris, Lucerne, Bonn, Munich, Montreal and Vancouver in 1978.

Snyders or **Snijders, Frans** (1579–1657) First and greatest Flemish specialist of large-scale *still-life and animal and hunt pictures; sometime collaborator of *Rubens (e.g. Philadelphia, Museum; St Petersburg, Hermitage; Malines, Notre-Dame au delà de la Dyle; Rennes, Musée). He was a pupil of Pieter *Bruegel the Younger and of Hendrick van Balen, the teacher of *Van Dyck. Some time after matriculating in the painters' guild in Antwerp in 1602, he travelled to Italy; in 1608 Jan Brueghel recommended him to his patron, Cardinal Federigo Borromeo, in Milan. He returned to Antwerp in 1609; in 1611 he married the sister of Cornelis and Paul de *Vos.

Snyders's early pictures reflect the manner of *Aertsen and Beuckelaer (e.g. 1603, Brussels, Willems; Karlsruhe, Kunsthalle). Around 1615 he imposed a greater coherence on his large compositions of fruit, vegetables, game or fish, perhaps under the influence of the *classicist Abraham *Janssens, with whom he worked. A good example of his painting at this time is the series of four markets, 1615–20, now in St Petersburg, Hermitage, in which the picture surface is divided into rectangular compartments. Later, under the influence of Rubens, he was to use a characteristically *Baroque scheme of diagonal construction; he also widened the space of his hunting scenes into broad landscapes (e.g. Poznań, Muzeum). His work is robust, colourful, yet stately. His most important pupil was Jan *Fyt.

Socialist Realism, Social Realism The first of these is programmed to celebrate life in a socialist state and was officially adopted in Soviet Russia in 1934 as the only permissible tendency in the arts. Ideology here determines validity, calling truth what is often wishful thinking or adjusted history. Attempts were made in East European countries under Soviet influence to impose the same programme, with varying success. The second refers to art dealing with significant social issues in an illustrational manner. This often means an art of protest, as when poverty, injustice etc. provide themes; the aim here is to press for reform through media too often devoted to escape from the realities of life.

Sodoma; Giovanni Antonio Bazzi, called (1477–1549) Eclectic and prolific painter, mainly active in Siena, but also Rome (1508; c.1516–18). He came from Piedmont, and by the time of his arrival in Siena before 1503 had become acquainted with the works of *Leonardo da Vinci in Milan, from which he retained, throughout his career, superficial characteristics, notably the famous 'Leonardesque smile'.

In Siena Sodoma was influenced by *Pintoricchio, who from 1503–8 was at work on the Piccolomini library. His first major commission, 1505–8, was to complete the cycle of 31 frescos on the *Life of St Benedict* begun in 1497 by *Signorelli at the monastery of Monteoliveto. Called to Rome by the Sienese papal banker Agostino Chigi, Sodoma was lent to Pope Julius II to begin work on the ceiling of the Stanza della Segnatura – but was soon displaced by *Raphael. His major Roman works, the decoration of Chigi's bedroom in the Farnesina (*Marriage of Alexander and Roxane*, 1516–17; *Alexander and the Family of Darius*, 1518) demonstrate his superficial assimilation of Raphael's High *Renaissance style. After c.1518 he worked almost wholly in Siena, where with *Beccafumi he became the leading painter of the third and fourth decades of the 16th century.

Other works by Sodoma are found in various museums, including London, National; Florence, Pitti; Paris, Louvre. His art is a curious amalgam of the provincial and the metropolitan. All his influences remain visible and ill-digested in his work, which nevertheless exercises a good deal of charm through a certain vernacular copiousness and vigour.

Soffici, Ardengo (1876–1964) Italian critic and painter who had studied art at

the Florence Academy and spent 1900–7 in Paris. In 1911 he wrote an article on *Picasso and *Braque which was the first Italian account of *Cubism. He attacked the *Futurists' aims and works but in 1913 was converted to them and wrote in their support in his journal *Lacerba*. His paintings at the same time moved from Cubism into Futurism. In 1914 his views and art reverted again and he resumed his criticism of the Futurists, subsequently also attacking Cubism in order to back an Italian traditionalism associated with the later work of *Carrà.

Sogliani, Giovanni Antonio *See* under Lorenzo di *Credi.

Solari or **Solario, Cristoforo**; called **Il Gobbo**, 'the hunchback' (recorded from 1489–1527) and his brother **Andrea** (1450–*c*.1520) Cristoforo was the best-known member of a large dynasty of Lombard architects and sculptors active in Milan and Pavia from *c*.1428 (but *see also* Pietro Solari, called Lombardo). His earliest known work was in Venice (S. Maria della Carita, *c*.1489, destroyed; S. Panteleon). In 1495 he was recalled to Lombardy to work on the façade of the Charterhouse of Pavia (*see also* Amadeo), but in 1497 the untimely death of the Duchess Beatrice d'Este caused him to be commissioned with the effigies of Beatrice and her husband Lodovico 'il Moro' *Sforza for Milan, S. Maria delle Grazie (now Pavia, Charterhouse). These effigies are characterized by extreme *realism and polished detail, and remain Il Gobbo's best-known works. During 1501–6 he was employed both as architect and sculptor on Milan cathedral, where his statues of *Adam* and *Eve* (1502) and *Christ at the Column* reflect an entirely different, softened *classicism influenced by *Leonardo da Vinci, court painter at Milan until 1499. His last years were spent mainly as an architect, although sculptural commissions for Ferrara and Mantua, *c*.1516, now lost, demonstrate that his reputation extended beyond Lombardy. He is known to have visited Rome *c*.1514, and was popularly supposed to have been the author of *Michelangelo's *Pietà* at St Peter's when it was first exhibited.

Andrea Solari, apparently trained by Cristoforo, was a painter. Accompanying his brother to Venice, he was deeply influenced by *Antonello da Messina and Giovanni *Bellini (*Holy Family with St Jerome*, 1495, Milan, Brera). In 1507–10, he worked in France at the Château de Gaillon; his *frescos there have been destroyed. On his return to Milan, he, too, reshaped his style to that of Leonardo; he was one of the very few Milanese painters to understand its underlying principles (*Virgin with the Green Cushion*, 1510–15, Paris, Louvre). Other works Nantes, Musée; Brescia, Pinacoteca; Rome, Borghese; London, National; etc.

Solario, Antonio de, called **Lo Zingaro**, 'the Gypsy' (active 1502–18) Venetian painter, influenced by Giovanni *Bellini. He is recorded working in the Marches in 1502 and appears to have painted *frescos in Naples. His finest surviving work is the Withypoll triptych, which includes a *donor portrait of the English merchant Paul Withypoll (d.1547) (centre panel, signed and dated 1514, Bristol, City Art Gallery; wings on loan from London, National).

Solimena, Francesco (1657–1747) Trained in the provincial southern Italian workshop of his father Angelo, Solimena was heir-apparent to Luca *Giordano as head of the Neapolitan school. He acquired an international reputation as a painter of altarpieces and grand *fresco decorations, his *Academy becoming the centre of Neapolitan artistic life. Among his pupils was Allan *Ramsay, who nonetheless went on to practise solely as a portrait painter. Solimena combined *Baroque exuberance with *classicizing elements borrowed from, e.g. *Raphael. This academic tendency was reinforced by direct contact with *Maratta in 1700. There are easel paintings in Naples and in many collections, and frescos in Naples, Salerno, Nocera, etc. *See also* Corrado Giaquinto, Sebastiano Conca.

Somer, Paul van (*c*.1577/8–1621/2) Antwerp-born painter, he is recorded working in Amsterdam with his elder brother, **Bernard** (1604), in Leyden (1612, 1614), at The Hague (1615) and in Brussels

(1616). By December 1616 he had settled in London, where he died. From the beginning of his stay in England he was employed at court. A precursor of *Van Dyck, he modified the schematic English 'Costume Piece' to a grander, more life-like portrait-type closer to Continental portraits of the period (*Queen Anne of Denmark*, Coll. HM the Queen).

Sonderborg (1923–) Danish painter whose proper name is Kurt Hoffmann and who studied art and worked primarily in Germany. His work is characterized by calligraphic streaks and scratches, often in black on a white canvas. He was seen as an especially forceful contributor to European *Abstract Expressionism in the 1950s and 60s.

Sonderbund Name, meaning 'special association', of a society of artists and art lovers, including dealers, critics and curators, formed in Germany's Rhineland in 1909 to present exhibitions of modern art. The first three exhibitions were in Düsseldorf (1909–11); the fourth was in held Cologne from May to September 1912 and was the most important and remarkable. Its theme was to offer a historical survey of what was called 'Expressionism', meaning avant-garde reactions against *Impressionism rather than the mainly German movement subsequently referred to as *Expressionism. The leading members of this contemporary movement were included, but so were Van *Gogh with more than a hundred paintings, *Cézanne, *Gauguin, *Munch, and *Picasso: all these had their own rooms. El *Greco was included as a proto-Expressionist. Other rooms surveyed modern art in national groups and included a wide range of French and German painters, as well as a selection of Hungarians, Norwegians etc. Russia was represented in small groups of work by *Kandinsky, *Yavlensky and Vladimir Bechtejeff (Bekhteev), then working in Munich. *Lehmbruck and *Minne were well displayed; generally sculpture was not prominent. One room was treated as a chapel, with specially commissioned stained glass windows by *Thorn-Prikker and mural paintings by

*Heckel and *Kirchner. This display of over 600 works of art (there was a separate crafts section, exclusively of work by the West-German Association for Applied Art) amounted to by far the most informative and impressive modern art exhibition to date, and was the impulse for the 1913 *Armory Show. That year saw also a spectacular display of international contemporary art in the 'Herbstsalon' (autumn show) of the *Sturm Gallery in Berlin.

Soto, Jesús Rafael de (1923–) Venezuelan artist who studied in Caracas and has worked in Paris and in Venezuela since 1950. Already interested in *abstract painting and in *Constructive art before arriving in Paris, he invented there various ways of floating geometrical elements in real and in perceptual space, sometimes as mobile constituents, more frequently rendered mobile by offering shifting readings for the viewers as they move before the work. He contributed to an exhibition of *kinetic art at the Denise René Gallery, Paris, in 1955 and had a one-man show there the following year. From this time on he was seen as one of the most interesting of the artists working on three-dimensional *Op; some of his most compelling were the walk-in environments he called *Penetrables* (1967+). He received commissions for Venezuela and Europe and received major prizes at international exhibitions in the late 1950s and 60s. His native town of Ciudad Bolivar created a Soto Museum of Modern Art in 1973.

sotto in su or **di sotto in su** *See under* foreshortening.

Soulages, Pierre (1919–) French painter who, after war service, turned from farming to painting, was more or less self-taught and had a quick success as a leading *abstract artist. He earned this with dramatic paintings in which broad beams of paint lie over light grounds, black over white, but then also browns and hints of blue, but always back-lit, with the beams done as though imposed in one stroke. The message appeared to be one of survival, of primitive heroic action. His later paintings have been black all over, with texture

still indicating powerful brushstrokes, or divided into broad areas of black and white with brushstrokes making signs akin to Oriental characters over the white.

Soutine, Chaim (1894–1943) Russian-born French painter who was sent to Paris by a patron after running away from his family and studying art in Vilna. In Paris he shared a studio with *Modigliani and was close to *Chagall, but his impetus and manner of painting were different from either's. His painting was tied to reality in that it took subjects from the visible world (portraits, still lifes, landscapes, beef carcases hanging in a butcher's shop inspired by the example of *Rembrandt) but at the same time also intensely visionary in his presentation of it in heavy, swinging brushstrokes and fierce colours, resulting in extreme distortion. His work is essentially *Expressionist in being intensely personal; it is quite without the element of protest occasionally found in German Expressionist work and often referred to. He worked at Ceret in the south of France during 1919–22, and after a few months in Cagnes returned to Paris via the Netherlands where he studied Rembrandt especially. He was unwilling to go to the USA during the Second World War but was able to go on working during the German occupation of France, possibly because of the apparent madness of his work. All his life he suffered from bouts of depression as well as a general lack of confidence. He exhibited the first time in 1927 and frequently from 1935 on, in New York and London as well as Paris, but his fame has been largely posthumous.

Souza, F.N. (1934–) Indian painter, born in Goa, who studied painting in Bombay, came to England in 1949 and subsequently divided his time between New York and India. His vivid figurative images, harshly painted and with distortions that convey his perception of the world, can be classed with the figurative aspect of *Art informel (cf. *Appel) and has been exhibited frequently from 1951 on. He also sees himself as a philosopher and prophet and issues statements offering solutions to the world's problems.

Spadaro, Micco; Domenico Gargiulo, called (1609/10–75) Neapolitan painter; the nickname Spadaro came from the trade of his father, who was a swordsmith. He was a pupil of *Falcone at the same time as *Andrea di Lione and Salvator *Rosa; he was also much influenced by the prints of *Callot. Under Rosa's influence he began to paint landscapes and coastal scenes; the small figures in these have much in common with those of the Roman *Bamboccianti* (*see under* Laer, Pieter van). He often executed the figures in the architectural views of Viviano *Codazzi. From 1638 through the 1640s Spadaro painted biblical scenes and Carthusian legends in *frescos at the Charterhouse of S. Martino, Naples; in the second half of the 1650s he painted a series of *easel pictures chronicling episodes from Neapolitan history teeming with crowds and set in recognizable locations (Naples, Museo di S. Martino).

Spagnoletto *See* Crespi, Giuseppe Maria; Ribera, Juseppe or José de.

Spazialismo, Spatialism A short-lived movement launched in Milan in 1947 by Lucio *Fontana and, in spite of briefly involving a few other Italian painters, identified almost entirely with his personal ideas and processes. In 1946 Fontana, while in Buenos Aires, had issued a White Manifesto announcing that real space, not the illusory space suggested by marks on surfaces, would be art's concern in the post-war world. That year and subsequently Fontana made 'spatial environments': installations of a *Minimalist sort (but long before the movement) using light or the absence of light. His series of punctured or slashed canvases is entitled *Concetti Spaziali* (spatial concepts). Additional Spatialist Manifestos were issued until 1952. The Realist Manifesto issued by *Gabo and *Pevsner in Moscow in 1920 announced art's embrace of time and space by structural means adopted from engineering; Fontana's project, however, was entirely aesthetic and pursued for its sensory and psychological impact on the viewer. It has nothing to do with *Constructivism or Constructive art, but

his 'environments' have everything to do with the *Installation art that emerged during the 1970s.

Spencer, Stanley (1891–1959) British painter, born in the village of Cookham in Berkshire and brought up amid Christian and musical practices. His first art lessons were taken privately in Cookham; in 1908–12 he studied at the Slade School in London and was successful in gaining prizes. Roger *Fry included him in the second *Post-Impressionist exhibition in 1912, but the First World War interrupted this progress. Spencer served as a medical orderly and then as infantryman: his experiences added subject matter and motifs to an art otherwise deeply rooted in Cookham and his family. His work on war themes culminated in 19 canvases painted for a war memorial chapel at Burghclere, Hampshire (1927–31). These pay distant homage to the great religious mural schemes of the Florentine *Renaissance, and this appears more directly in a series of New Testament themes he pictured as events occurring in the streets of Cookham and other Berkshire locations in modern times. He lived in Cookham and in Hampstead, also staying with friends at various times and generally living a colourful social life, passionate and somewhat eccentric.

In the Burghclere chapel he achieved what he often sought: to work in series or in several canvases to be grouped together, preferably in a gallery he titled Church House, to be erected for the purpose. During the Second World War, for instance, he worked in Glasgow on a series of paintings representing shipbuilding work on the nearby Clyde – monumental compositions which should certainly be seen together as planned; at the same time he used a Glasgow location for a group of paintings of the *Resurrection of the Dead*. Narrative subjects, frequently taken from the Bible, dominated his output, but he also painted piercing portraits, landscapes and domestic scenes as well as subjects of his own invention, as in the series *The Beatitudes of Love* (1937–8), seven paintings intended to join the more openly religious works in Church House and lead visitors to

'meditate on the sanctity and beauty of sex'. Here as elsewhere he filled his pictorial stage with figures drawn from his own world: we see their clothes and hair styles but they are also expressively and often humorously distorted in ways that hint at his awareness of Post-Impressionism and some subsequent developments in modern art. Thus Spencer gave an unmistakable 20th-century character to an art that stems from the early Renaissance and echoes the assertive voice and purposes of the *Pre-Raphaelite Brotherhood.

Spencer was a fine draftsman and did many drawings both for their own sake and as preparatory work for his painted compositions. He had his first one-man show in 1927 and examples of his work were shown in Vienna in 1927, at the Venice Biennales of 1932 and 38 and in Pittsburgh, USA, in 1933. None the less it remains little known outside the UK, where Spencer is now seen as a great *realist narrative painter in the tradition of *Hogarth and of Charles Dickens. In 1932 he was elected as associate of the Royal *Academy, but he resigned when two of his paintings, intended for Church House, were rejected from the 1935 Summer Exhibition there. He became a full Royal Academician in 1950 and was knighted in 1958. There was a retrospective at the Tate Gallery in London in 1955, and a more complete exhibition of his paintings and selected drawings at the Royal Academy in 1980. Cookham has a Spencer Gallery but several of his major works are in public London collections, the Tate Gallery and the Imperial War Museum.

Spinario Graeco-Roman bronze statue of a young boy drawing a thorn (*spina*) from his foot, first recorded in Rome in 1165/7 and one of the first ancient statues to have been copied by Early *Renaissance artists. Like the *Belvedere Torso*, it was removed to France in 1798, after Napoleon's successful Italian campaign, and returned to the Palazzo dei Conservatori (Museo Capitolino) in Rome in 1816.

Spinello Aretino (recorded 1373–1411) Painter from Arezzo, working throughout Tuscany, with artistic connections both

with the Sienese followers of *Duccio and the Florentine followers of *Giotto. In his major surviving works, the frescos of the sacristy of S. Miniato al Monte, Florence (1387), he looks back beyond his immediate predecessors to the paintings of Giotto himself, thus anticipating their reinterpretation by *Masaccio. His son **Parri Spinelli** (1387–1453) assisted him in the vigorous frescos of the *Life of Alexander III*, 1408, in a room in Siena town hall.

Spitzweg, Carl (1808–85) German painter and illustrator, associated with Munich but an ardent traveller. He was trained first in pharmacology and was self-taught as a painter, shunning all contact with the *academies. His earlier paintings are anecdotal and charming: see, for instance, *The Poor Poet* (1839; Munich, Bayerische Staatsgemäldesammlungen). A visit to Paris and London in 1849 made him aware of English landscape painting and subsequently he studied the work of the *Barbizon painters, so that his later work is less narrative and more concerned with the use of paint to capture appearances and mood.

Spoerri, Daniel (1930–) Swiss artist, born Daniel Feinstein in Romania, adopted by an uncle in Switzerland in 1942. Self-taught as artist, he studied and practised dance and mime, becoming principal male dancer at the Berne Opera in 1953. Since the late 1950s he has worked as artist in several European centres and in several art forms and media though France has been his base. He has been concerned with *kinetic art, *happenings, concrete poetry, and 'eat-art' events where food is offered in bizarre forms and consumed riotously. He has enjoyed collaborating with other like-minded artists, such as *Roth and *Tinguely, and has generally sought to act outside the boundaries of even the most supposedly *avant-garde doings. His best known personal art productions are the *assemblages he calls *tableaux pièges* (pitfall pictures): tabletops complete with the detritus of a common or garden meal (dirty plates, etc., full ashtrays, empty bottles, just as they were left) hung like pictures. He has exhibited many times in Europe and the USA since 1961.

Spranger, Bartolomeus (1546–1611) Antwerp-born painter, one of the most influential practitioners of international *Mannerism. In 1565 he went to Italy, working for some time in Parma, where the example of *Correggio and *Parmigianino taught him *sfumato* and a particularly supple and elegant mode of figure drawing. In 1570 he was appointed painter to Pope Pius V in Rome. On the recommendation of his compatriot, Giovanni *Bologna, Spranger entered the service of the *Habsburg emperor, Maximilian II, in Vienna (1575). When Maximilian died only a few months after his arrival, Spranger was taken into the employ of his successor, Rudolph II, and moved (1581) with the imperial court to Prague (*see also* Savery; Aachen, Hans von; Arcimboldo). Rudolph was one of the great collectors of curiosities and rarities in the arts and in the natural and occult sciences. He patronized an overwhelmingly secular, refined and often erotic art, favouring representations of the female nude. Thus Spranger's *œuvre*, little of which is to be found outside what were formerly the imperial collections, consists largely of mythological or *allegorical images, some of them imperial panegyrics showing Rudolph bringing the arts to Bohemia, all or nearly all of them featuring female nudes in ever-more complex poses and from suggestive viewpoints (mainly Vienna, Kunsthistorisches).

While in Rome, Spranger had made the acquaintance of his countryman, Karel van *Mander. In 1577 Spranger invited Van Mander to Vienna to assist him in preparing decorations for Rudolph's investiture; in thanks, he gave Van Mander drawings, which the latter took with him when he emigrated in 1583 to Haarlem. There, Van Mander showed the drawings to his new friend and associate *Goltzius, whom they influenced profoundly. Goltzius's engravings after Spranger's designs are the fountainhead not only of Haarlem Mannerism (*see also* Cornelis Cornelisz. van Haarlem) but of an international vogue, influencing artists throughout northern Europe, Italy and the Iberian peninsula.

Squarcione, Francesco *See under* Mantegna, Andrea.

Staël, Nicolas de (1914–55) Russian-French painter, born an aristocrat in St Petersburg, brought west, to Poland and then Brussels in 1919 and 22. He studied art in the Brussels academy, then worked in the Netherlands and travelled widely before settling in Paris in 1938. He returned to Paris in 1943 after a period in the Foreign Legion, and soon was one of the most admired painters of the *Art informel movement. Rich colour in thick layers that left some hint of lower strata visible characterized his paintings which could appear to be wholly *abstract though they tended to be based on specific motifs in the visible world, such as landscapes or a group of musicians. He committed suicide and was memorialized in a major exhibition in Paris in 1956.

staffage A pseudo-French word, pronounced as in French, introduced into English from German. It is formed by the addition of the French suffix *-age* to the root of the German verb *staffiren*: to garnish. Staffage denotes that which is accessory, not integral to the main theme of a work of art. The term is normally but not exclusively employed for the anonymous human figures introduced into landscape pictures to provide colouristic accents and clues to scale, distance and mood. In the 17th century, many northern European landscape and *vedute* specialists collaborated with figure painters who furnished the staffage of their landscapes.

Stamos, Theodoros (1922–97) American painter. He studied sculpture in New York but turned to painting and had his first one-man show in 1940. By the late 40s he was seen as one of the leading (though one of the youngest) *Abstract Expressionists and as such included in international exhibitions while showing frequently by himself in the USA. He is an outstanding colourist, and the power of his colour and brushwork has remained constant while his compositional concerns have varied over the years. Retrospectives were shown at the Corcoran Gallery in Washington in 1958 and at the State University of New York at New Paltz in 1980.

Stankiewicz, Richard (1922–) American sculptor who first studied engineering and turned to art in 1948 after service in the US Navy. He studied painting in New York under *Hofmann and sculpture in Paris under *Zadkine. His first exhibition (1953) consisted of found pieces of metal, including parts of machinery etc., welded together to make impressive, sometimes suggestive, forms. His work was widely exhibited in the USA and abroad, and there were major shows of it at the Jewish Museum in New York in 1964 and at the State University of New York at Albany in 1979.

Stantons of Holborn; Thomas Stanton (1610–1674), his nephew **William** (1639–1705) and William's son **Edward** (1681–1734) Dynasty of English mason sculptors with a large workshop in Holborn, London; their funerary monuments for members of the lesser aristocracy and the professional classes are widespread in England.

stanze (Italian, rooms.) The suite of rooms in the Vatican palace decorated by *Raphael for Pope Julius II and his successor Leo X.

Stanzione, Massimo (1585?–1656) Leading, if extremely eclectic, Neapolitan painter; he was influenced both by Annibale *Carracci and the followers of *Caravaggio during a stay in Rome in 1617–18; later, around 1640, by *Reni, *Domenichino, *Ribera; lastly mainly by Artemisia *Gentileschi and finally *Van Dyck. He was in Rome again from 1625 to 1630, after which he worked almost uninterruptedly for the most important Neapolitan churches (Certosa di S. Martino; SS. Marcellino e Festo; Gesù Nuovo; S. Paolo Maggiore; works also in Capodimonte; De Vito Coll.; Madrid, Prado). His masterpiece has always been considered to be the *classicizing but expressive *Pietà* in the Certosa di S. Martino. Stanzione is supposed to have begun his career as a portraitist. There is a

splendid *Portrait of a Woman in Popular Costume* in San Francisco, Fine Arts, and a *Portrait of Jerome Banks* at Kingston Lacy, Dorset usually dated around 1655.

Starnina, Gherardo (*c*.1354–*c*.1413) Florentine painter, documented in Spain in 1395, 98, and 1401; his work there is lost. He may have been a pupil of Agnolo *Gaddi, and it is believed that he assisted the latter in the *frescos of the Castellani Chapel in S. Croce, Florence. There are fragments of frescos by him in S. Maria del Carmine, and the Uffizi has a lively panel attributed to him illustrating *The Thebaid*, an account of Early Christian hermit monks in the Egyptian desert around Thebes, represented as a rocky landscape with miniature incidents decoratively scattered throughout it. Panels in London, National and Chicago, Art Institute, may have been part of the *predella of an altarpiece in Würzburg, Martin-von-Wagner. Starnina is now generally identified with the so-called Master of the Bambino Vispo ('Lively Infant'), a name coined in 1904 for the painter of panels of the Virgin with an unusually lively Christ Child, now in Pisa, Pinacoteca; Lucca, Museo, and other collections.

State Any of the versions of a print for which the artist has altered the design on the plate (*see* especially intaglio). The first print made from the plate is the 'first state'; if no alterations are made on the plate, subsequent impressions remain the 'only state'. *Rembrandt is known for radically revising the design of his etchings and dry points. Because of differences in inking, in the *paper or other *support, or simply because of the wearing of the plate, it is not always easy to see whether apparently different impressions of a print in fact constitute different states; at times only a unique impression of a state exists.

Stażewski, Hendryk (1894–1987) Polish artist, trained at the Warsaw Academy, who became the leading *Constructivist artist in his country. He visited Paris in 1930 and was a member of *Cercle et Carré and *Abstraction-Création. Much of his work was in the form of reliefs in

which flat forms, shaped (like television screens) to combine rectangularity with curved sides and corners, float in front of a contrasting ground. He was one of the founders of the chief progressive art groups of Poland, Blok, Praesens and a.r. (1923, 1926 and 1929 editor of *Blok* magazine). He was awarded Poland's Golden Cross of Merit in 1955 and other such honours and exhibited frequently in Poland, especially from 1955, and abroad.

Steen, Jan (1625/6–79) Prolific Dutch painter of genre, history pictures (*see under* genres), and some portraits. After a stay at the University of Leiden, he studied painting in Utrecht, then with Adriaen van *Ostade in Haarlem, finally with Jan van *Goyen, whose daughter he married in 1649, at The Hague. He is documented as an independent painter in all three towns; his father, a brewer, leased a brewery for him in Delft, but there is no evidence of his having settled there for any length of time. In 1672 he received a licence to operate a tavern in Leiden.

Steen was as eclectic as he was peripatetic. He is the most spirited of all Dutch painters, and his wit, which cuts across social class and economic condition, is charged with proverbial, aphoristic, emblematic and literary content, as well as demonstrating his close connections with the theatre. But above all it relies on the copiousness of visual detail: the variety of vessels used to collect and distribute the life-giving waters in *Moses striking the Rock* (*c*.1671, Philadelphia, Museum), the varieties of human expressions in nearly all his paintings (e.g. *The Schoolmaster*, Dublin, National; *The Feast of St Nicholas*, *c*.1667, Amsterdam, Rijksmuseum). His repeated use of stock characters and costumes from the Italian *commedia dell'arte*, sometimes ironically (*The Doctor's Visit*, London, Apsley House; *Self-Portrait*, Madrid, Thyssen), later poetically (*Two Men and a Young Woman Making Music on a Terrace*, London, National; *Nocturnal Serenade*, Prague, Gallery) anticipates *Rococo art. A Catholic, Steen painted over 60 biblical narratives. Most embody comic or burlesque elements. Those which do not, reveal an original and tender vision of

Divine grace and human frailty (*Adoration of the Shepherds; Christ at Emmaus*, Amsterdam, Rijksmuseum). An uneven painter, at his best Steen achieves a sparkle which is pictorial as well as intellectual, and has not often been equalled.

Steenwijck, Harmen (1612–after 1664) The leading exponent of the Dutch *vanitas* *still life, a speciality of Leiden. Objects are depicted as symbols of transience and the vanity of earthly life, and motifs such as skulls are introduced to make the intended meaning plain (e.g. London, National). His younger brother **Pieter** (*c*.1615–after 1654) also specialized in this genre. Both brothers studied with David *Bailly, often credited with the invention of this type of painting.

Steenwyck or **Steenwijck, Hendrik van the Elder** (d. 1603?) and his son, **Hendrick van Steenwyck the Younger** (*c*.1580–1649) Netherlandish painters of architectural motifs. The Dutch-born Steenwijck the Elder probably trained with Hans *Vredeman de Vries, and lived in Antwerp in the 1570s and 1580s. He painted some urban scenes, such as the *Market Place at Aachen* of 1598 (Brunswick, Herzog Anton Ulrich), but is particularly remembered for having originated the depiction of observed church interiors in his representations of Antwerp cathedral, which determined the treatment of the subject for the next fifty years (e.g. Budapest, Szépmüvészeti). The works of Steenwyck the Younger, born in Antwerp, are subtler and more detailed than his father's; they are often executed on copper. A Catholic, he depicted the interiors of actual or imaginary Flemish Gothic churches hung with images, which contrast tellingly with *Saenredam's white-washed Gothic Dutch churches; various collaborators, among them Jan *Brueghel, sometimes painted the figures taking part in Catholic ceremonies (e.g. London, National). Steenwyck the Younger also specialized in nocturnal church interiors, particularly appreciated by Charles I and members of his court, for whom the artist worked in London between 1617 and 1637 (*The Liberation of Saint Peter*, 1619, Coll.

H. M. the Queen, is one of several variations on this theme). These church interiors in turn contrast with his imaginary palace views, combining interior and exterior in the manner of Vredeman de Vries, some perhaps with mythological scenes (e.g. Paris, Louvre; London, National). By 1645, he was back in Holland; his widow is documented in Leiden in 1649.

The purely Flemish interpretation of the church interior was taken up and carried on by the Neefs family, and in particular by **Peter Neefs the Elder** (*c*.1578–1656/61), perhaps a student of Steenwyck the Younger, and **Peter Neefs the Younger** (1620–after 1675), whose pictures cannot always be told apart (e.g. Dresden, Gemäldegalerie). In their work the exuberant *Mannerist fantasy of architectural painting subsided into a dry study of linear *perspective.

Steer, Philip Wilson (1860–1942) Son of a portrait painter, Steer studied in Paris after years at Gloucester School of Art, was influenced by *Whistler and *Manet and then also by the *Impressionists. He thus became one of the leaders of Impressionism in Britain, which fitted his natural talent for capturing light and space and his lively, sometimes almost *Expressionistic brushwork. He did not imitate the sometimes quite systematic methods of *Monet or *Pissarro, but worked more instinctively and with some awareness of *Gainsborough and *Constable as his forerunners. In 1886 he was one of the founders of the *New English Art Club.

Stefano da Verona or **da Zevio** (1374/75–after 1438) Italian painter active in Verona; a pupil of *Altichiero, but working in an insubstantial style influenced by International *Gothic art (Verona, Castelvecchio; Mantua, S. Francesco; Milan, Brera).

Stefano di Giovanni *See* Sassetta, Stefano di Giovanni.

Stella, Francis (Frank) (1936–) American artist who, as a history student at Princeton University worked in William

Seitz's open painting studio and turned to painting when he graduated in 1958. His first independent paintings were *Abstract Expressionist, but that same year he saw Jasper *Johns's flags and targets and started to paint what became known as his 'Black Paintings', the first of which were seen in two New York group shows in 1959 (Tibor de Nagy Gallery and MoMA). Plotted on graph paper, they consisted of 6.5 cm straight and parallel bands of black paint divided by narrow bands of bare canvas, together making an at first bi-axially symmetrical pattern on rectangular canvases. By 1960 he was using vertically symmetrical canvases on deep stretchers, the shaped canvas and painted structure being identical and commensurate. From black and dark grey he moved into muted colours and metallic paints giving lustre to the bands and into patterns that were no longer symmetrical, e.g. bands zig-zagging horizontally though still congruous to the total shape. By 1964 he was using bright colours, fluorescent paints and bands of alternating colours. These paintings were seen as giving dramatically new emphasis on 'objecthood', man-made things that are merely themselves, as empty of illusion as marks on a surface can be and totally non-referential. He was having frequent solo shows from 1960 on, in New York and soon in Los Angeles, Paris and London. His paintings were inspiring early examples of the *Minimalism that became a movement in 1966. 'What you see is what you see', Stella was quoted as saying that year. Stella, however, moved on to using shaped canvas accommodating asymmetrical designs in which broader bands are combined with flat areas of colour, designs of almost typographical character that present themselves as asserting flatness yet accepting a degree of illusion in the way the shapes of the design interact. Colours multiplied on banded circles and semi-circles and, by 1968, bands that appear to weave over and under each other. By the 1970s his paintings were assembled wall objects, deeper and no longer one surface. The structures have become more and more three-dimensional, the patterns painted on to them more and more exuberant and independent of each other, the

works themselves, ambiguously paintings or sculptures, joyous, even hyperactive, fairground encounters. In effect, Stella's art moved from a chaste *Neoclassicism to all-out *Baroque dramatics, from compositions in which the parts are carefully interrelated to speak with one voice to a dynamic, ungraspable thicket of hard forms (mostly on aluminium), painted in a graffiti-like manner to bring out their dissonance. In 1983–4 he gave the Charles Eliot Norton Lectures at Harvard University, *Working Space* (published in 1986) in which he presented contemporary abstract painting as part of a continuity of pictorial investigations going back to the *Renaissance. A major retrospective was shown in New York (MoMA) in 1987.

Stella, Jacques (1596–1657) French painter and engraver (*see under* intaglio) from Lyon. In 1619 he began his career in Florence as an engraver, and in 1623 settled in Rome, where he became a close friend of *Poussin, whom he had probably first met in Lyons. After Stella's return to Paris in 1634, the two corresponded regularly; Poussin's letters to Stella give important insights into his – Poussin's – artistic intentions. Stella's early prints are in the Florentine manner of *Callot; his later work is dominated by Poussin (e.g. *The Adoration of the Shepherds*, Barnard Castle, Bowes).

Stella, Joseph (1877–1946) American painter, born in Italy, who settled in New York in 1913. He had already studied in New York: medicine for a short time, then art (Art Students' League and NY School of Art), and he spent 1911–13 in Paris, in touch with the *avant-garde there and divided his time between Paris, New York and Italy during 1926–34. Aware of the aspirations of the Italian *Futurists, he drew and painted the structures and silhouettes of New York in kaleidoscopic and dramatic canvases. Like *Dove (and *Schwitters, of whom he cannot have known) he also made *abstract collages out of urban litter, as well as more *naturalistic portaits and landscapes. There were many one-man shows during his lifetime and they have continued since.

Stenberg, Vladimir (1899–1982) and Georgii (1900–33) Swedish-born Russian artists, trained in Moscow. After the Revolution they worked on propaganda posters and decorations for public festivals. In 1919 they shared in founding the Obmokhu group of young artists and contributed to its four exhibitions during 1919–23. In 1922 they and *Medunetski exhibited together under the title *Constructivists, showing paintings and constructions, the latter, of metal and glass, appearing to be engineering configurations invented as solutions to as yet unposed problems involving light structures for reaching out into and covering space. They were associated with *Rodchenko in *INKhUK and in 1922 gave a paper, with Medunetski, on the bases of Constructivism. They worked for the theatre and for industrial exhibitions and became prominent in the later 1920s for their cinema posters, at once stylistically adventurous and popular.

Stepanova, Varvara (1894–1958) Russian artist, trained as a painter in Kazan where she met *Rodchenko; they married later and much of their work, organizational as well as creative, was done in collaboration. Thus after the Revolution they worked together in the museums section of the Commissariat for Enlightenment, joined *INKhUK where they led the First Working Group of *Constructivists. She was one of the five artists exhibiting in the '5 × 5 = 25' exhibitions in Moscow in 1921, and in 1922 she lectured on Constructivism and made remarkable stage props and costumes for *Tarelkin's Death*, produced by Meyerhold. Like her friend *Popova, she was particularly active in the early 1920s in making designs for printed textiles and for dresses and sports clothes, also teaching design in the VKhUTEMAS. She worked for magazines, including *Lef* and became increasingly prominent as a graphic designer in the 1930s. Her personal work ranged from geometrically abstracted figures to totally abstract paintings and prints and lively collages. Some of her work is signed with the pseudonym Agrarykh or the acronym Varst.

Stern, Irma (1894–1966) South-African painter, who studied painting and worked in Germany during 1913–20 and then returned to South Africa where she represented and promoted modern art styles and methods.

Stevens, Alfred (1817–75) British sculptor who, after years in Italy where he immersed himself in the High *Renaissance art of, especially, *Michelangelo and *Raphael, returned to England to become known as a multifarious artist of great artistic force. He was an outstanding draftsman, he painted some fine portraits and he sometimes sent sculpture to the Royal *Academy exhibitions, but he worked chiefly on interiors for such mansions as Dorchester House (see the fireplace now in the V&A, London) and on monuments such as that to the Duke of Wellington in St Paul's Cathedral, London, begun in 1856 and not finished until long after his death. These works demonstrate an energetic and ambitious vision, and a firm grasp of style, rare in Victorian art.

stiacciato *See rilievo schiacciato.*

Stieglitz, Alfred (1864–1946) American photographer whose Photo-Secession Gallery at 291 Fifth Avenue, New York, enlarged its activities to bring new art from Europe to the USA from 1907 on and became known as 291 Gallery. His was the first *Brancusi show in the world, and he gave the first USA showing to *Matisse, *Picasso and other leaders in the *avant garde of Paris as well as to key American artists such as *Hartley, *Dove and *O'Keeffe. The journal he edited, *Camera Work* (1903–17), similarly embraced modern art; another, *291* (1915–16), spoke for *Dada in New York. The 291 Gallery closed in 1917 and was succeeded by his Intimate Gallery and An American Place (1925–46).

Stijl, De Name of a Dutch art, design and aesthetics journal, meaning 'style', edited by Van *Doesburg and published from 1917 to 1932, the last issue being prepared by the artist's widow; also the name of the movement associated with it,

which numbered *Mondrian among its most important adherents and Van der *Leck among its earliest. Van Doesburg held that it was the modern artist's duty both to create a new art consonant with the philosophical, psychological and technological understanding of the new century and to persuade the lay public of that art's rightness and importance for the future of mankind. His, as also Mondrian's, thinking was rooted in mystical ideas as much as in scientific interests, and it is no accident that their offer of a pure, unemotional, universal rather than subjective art was made during the worst phase of the First World War by a country close to the battlefields though not directly involved. They associated that internecine madness with the negative values of nostalgia and sentimentality they saw in 19th-century art and with too close an attachment to the variety and organic life of nature, rejecting both *Impressionism and *Expressionism as articulations of weakness. Instead they proposed an elemental language for art and design that would echo and represent mankind's rational and constructive role: verticals and horizontals, primary colours, black, grey and white, rectangular relationships and, in two-dimensional work, the avoidance of all illusions of space. Mondrian held to this language until his last years; Van Doesburg, more worldly and restless, varied it from the first and in one basic respect abandoned it in 1924 when he substituted diagonals for verticals and horizontals in search of greater dynamism.

From the first he had sought the interest and participation of architects and other designers in the movement and the journal; he funded as well as edited it and was by nature outgoing and proselytizing. He involved J.J.P. Oud and, from 1918 on, the designer Rietveld. He himself worked as a decorative designer, publishing the results in his journal, and collaborated with the architect Van Eesteren. In the Leonce Rosenberg Gallery's De Stijl exhibition, Paris 1923, architectural design was more prominent than painting. He was also intent on widening the circle of artists connected with the movement. In 1921 he redesigned the magazine and from that date

on invited contributions from artists who cannot be said to have shared his principles or vision except in a very general sense, such as *Brancusi.

A De Stijl exhibition was shown at the Stedelijk Museum in Amsterdam in 1951; a much more comprehensive one in that museum and in the Rijksmuseum Kröller-Müller, Otterlo, in 1978. A facsimile edition of De Stijl was published in 1968.

Still, Clyfford (1904–80) American painter, prominent among the first generation of *Abstract Expressionists. He studied art at Spokane University and Washington State College. In the 1950s he lived in New York; thereafter at Westminster, Maryland. His immediate springboard into Abstract Expressionism was *Surrealism but his mature paintings, characterized by great variegated planes of heavy colour, apparently overlapping each other, soft-edged and torn, suggest cataclysmic or at least dramatic experiences and thus echo some of *Romanticism's more powerful productions, e.g. the late paintings of *Turner. He was one of the originators, with *Rothko, *Motherwell and others, of the Subjects of the Artist school. His first one-man show was in 1943 at the San Francisco Museum of Art but his debut as an Abstract Expressionist was in 1946 at Art of this Century (New York), from which time on he exhibited frequently and widely. In 1966 the Albright-Knox Gallery in Buffalo showed 33 paintings he had given to the museum.

still life (See also genres) The representation, usually in painting, of objects such as flowers, fruit, foodstuffs and kitchen and table implements, etc., as the main focus of interest. Live animals may be included, as in hunting-trophy pictures or in market and kitchen pieces, where human figures may also be portrayed. The revival of still life in European painting around the beginning of the 17th century was certainly influenced by the translation at this time into various modern languages of *Pliny the Elder's 1st century Latin text, Natural History, containing the only surviving history of ancient Graeco-Roman art. Pliny recounts the success of *trompe l'œil

pictures of foodstuffs and flowers, including a famous anecdote of birds coming to peck at grapes painted by Zeuxis (*see also* Labrador). The phrase 'still life' derives from the Dutch *stilleven*, in use from *c*.1650; before that each type of still life was categorized separately, and to this day Dutch still lifes may be termed 'breakfast pieces', 'banquets', 'flowerpieces', etc. Spanish also preserves the early distinction between *bodegón* (from *bodega*, cellar or low-life eating-place) and *florero*, flowerpiece. We speak of the *bodegónes*, of e.g. *Velázquez, in which equal attention is focused on kitchen implements and human figures. The *vanitas* still life is a particular type evolved in the Dutch city of Leiden in the 17th century. Overtly symbolic of the transience of life, it includes emblematic objects such as skulls, snuffed candles, watches, to remind the viewer of mortality and the passage of time. The name is derived from the passage in Ecclesiastes (12:8): 'Vanitas vanitatum . . .' 'Vanity of vanities, saith the preacher, all is vanity' (*see*, e.g. Harmen Steenwijck).

With the *academies now willing to countenance the lower genres, still-life painting flourished in the 19th century, and major painters made a remarkable contribution, using still life as a means of exploring a new *naturalism combined with new pictorial structures. In the 20th century still life became an unexpectedly fruitful field for exploration. There were movements and individuals for whom it was central, as in *Braque's *Cubism, which originated in *Cézanne's landscapes, or in Picasso's Cubism where still life became a motif for sculpture. *Pop art took themes and idioms from the world of advertising and *Conceptual art invited quasi-philosophical displays. Today still life in *installations can also function as an ultimate *realism.

Stimmer, Tobias (1539–84) Versatile German artist – portrait painter (e.g. Basel, Kunstmuseum); decorative painter of *frescos on the façades of houses (Schaffhausen, Haus zum Ritter, 1568–70, now Schaffhausen Museum) and of ceiling paintings on canvas in the Venetian manner (Baden-Baden, castle, 1578–9); designer and decorator of clocks (Strasbourg,

minster, 1571–4) and of small-scale stained-glass panels. Stimmer's fame, however, rests above all on his enormous output of reproductive and illustrative prints (reproductions of portraits of famous men from the humanist Paolo Giovio's Museum at Como, 1575, drawn while visiting Italy; illustrations of Bible stories; illustrations of the ancient historians Livy and Flavius Josephus; the *Ages of Man* and *Woman*, etc.). At a time when engraving (*see* intaglio) was the preferred medium for illustration, Stimmer, inspired by *Dürer, revived woodcut (*see* relief prints) as a serious vehicle for artistic expression.

Stone, Nicholas (*c*.1587–1647) Leading English sculptor. He was taken on as a journeyman by the Dutch sculptor and architect Hendrik de *Keyser (1606–13). After his return to England he built up a large practice in tomb sculpture. Charles I's purchase of the Mantuan collection, 1628/9, had a considerable impact on his style, by introducing him to *Classical sculpture; the outstanding example of his new manner is the wall-monument to John and Thomas Lyttelton (1634; Oxford, Magdalen College). In the late 1630s he also made a number of classicizing statues, the first by a native English sculptor (Northamptonshire, Kirby Hall; Norfolk, Blickling Hall). His son **Nicholas** (1618–47), also a sculptor, was sent with his brother Henry, a painter, for a four-year tour abroad; he is the first English artist to have kept a detailed travel diary, which includes an account of his meeting with *Bernini.

Stoss, Veit (Polish: Wyt Stwosz) (*c*.1450?–1533) With *Riemenschneider, the most fully documented German pre-Reformation sculptor; a distinctive artist, famous especially for the monochrome wood sculpture of his later years (e.g. *St Andrew*, *c*.1510–20, Nuremberg, St Sebalduskirche; *St Roch*, *c*.1510–20, Florence, SS. Annunziata; *Raphael and Tobias*, 1516, Nuremberg, Museum). Earlier in his career he carved also in marble and sandstone and executed monuments in *polychromed wood. Despite the documentation, neither his birthdate nor

birthplace is known. He is first recorded in 1477 giving up his citizenship in Nuremberg to move to the then-capital of Poland, Cracow. There, 1477–96, he was employed both by the resident German merchants and the Polish crown, his main sculptural commissions being the polychrome wood *retable for the high altar of St Mary's, 1477–89, and the red marble tomb of King Casimir IV Jagiello in Wawel cathedral. Much of the exaggerated *foreshortening and contorted *expressiveness of the altarpiece is explained by difficult viewing conditions for which Stoss tried to compensate. The style is indebted to that of *Gerhaert, as is that of the effigy of King Casimir. Stoss may also have practised as an architect, an engraver and a designer for goldsmiths and bronze casters. He almost certainly speculated in commercial ventures.

In 1496 Stoss returned to Nuremberg a rich man. Cheated out of a large sum of money, he forged a document to recoup his losses. During 1503–6 he was tried, convicted, branded on the face and confined to the city, whence he fled. Not until 1507, after an audience with the Emperor, was Stoss able again to take up residence legally in Nuremberg. Stylistically, this period forms a transitional phase between the Cracow exuberance and the mature Nuremberg pieces; the key surviving work is the Volckamer monument of 1499, with monochrome oak figures and sandstone reliefs, (Nuremberg, St Sebalduskirche). From 1507, Stoss worked in a seemingly more simplified mode, but with distinctive, daringly carved drapery. Deeply excavated lozenge and arc shapes, stressing the linear edge of the folds, constitute a virtual signature. In addition to the works mentioned, there are examples of his sculpture in Langenzenn, Pfarrkirche; Bamberg, cathedral; Nuremberg, St Lorenz; London, V&A. Stoss's Cracow *œuvre* influenced much Eastern European sculpture.

strap-work A form of ornamental design resembling leather rolled, folded and cut into fantastic shapes. Although probably first appearing in Italian engravings (*see under* intaglio), and used *c.*1515 by Andrea di Cosimo Feltrini in the decoration of the chapel of Leo X in S. Maria Novella, Florence, it was popularized through the stucco decoration of the Grande Galerie at Fontainebleau, designed by *Rosso *c.*1533–40. The motif, transmitted through prints, was copied all over Europe, becoming an important theme of *Mannerist decoration.

Straub, Johann Baptist (1704–84) German *Rococo sculptor, mainly active in Munich. He trained with his father, the sculptor **Johann Georg Straub**, and was himself the teacher of Ignaz *Günther. From 1728 to about 1730 he was in Vienna (Schwarzpanier Monastery); in 1757 he was appointed Court Sculptor to the Elector of Bavaria. Next to Günther he is the most important sculptor of the 18th century in Munich and throughout Bavaria.

Streeter or **Streater, Robert the Elder** (1624?–1679) English painter. The *allegorical ceiling painting of the Sheldonian Theatre, Oxford, is the most ambitious *Baroque decoration by an English artist before *Thornhill. Other surviving pictures by him include *landscapes (Dulwich, Gallery; Coll. H. M. the Queen) and a portrait of *Sir Francis Prujean* in London, Royal College of Physicians. He was appointed Serjeant Painter to Charles II on the Restoration of the monarchy in 1660; his son Robert (d.1711) followed him in this office.

stretcher *See under* canvas.

Strigel, Bernhard (1460/1–1528) German painter from Memmingen in Swabia; the son of Hans the painter and nephew of Ivo the wood-carver (or vice-versa), in whose workshop he was probably trained. He may also have been a pupil of *Zeitblom. In 1507 he made an official portrait of the Emperor Maximilian (*see under* Habsburg), and afterwards painted him often, although his best-known work is the group portrait of Conrad Rehlinger and his eight children (1517, Munich, Alte Pinakothek). He also painted altarpieces (Schloss Salem; Schloss Donzlof; Nuremberg, Germanisches National).

Strozzi, Bernardo (1581–1644) One of the leading Italian 17th-century painters. Born in Genoa, he settled in Venice in 1631; much of the subsequent development of Venetian painting was influenced by his style, which was formed from the variety of sources available to him during his training in his native city: *Rubens, in Genoa in 1607; *Van Dyck, in 1621; *Barocci, whose huge *Crucifixion* altarpiece had been installed in Genoa cathedral in 1597; the Milanese *Cerano and, in particular, Giulio Cesare *Procaccini, who visited Genoa in 1618. In Venice he looked especially at *Veronese. The modern viewer of his vigorous, painterly and colourful religious and *genre pictures, and his swaggering portraits, may be startled to learn that Strozzi became a Capuchin – that is, a strictly observant Franciscan friar, *c.*1597; he is thus also called 'Il Cappucino' and 'Il Prete Genovese', 'the Genovese priest'.

It is difficult to establish a chronology for Strozzi's easel paintings, which can be found in many collections in Italy and abroad, including London, National; Berlin, Staatliche; Dublin, National.

Struycken, Pieter (1939–) Dutch artist, trained in The Hague, who in 1962 turned from figurative painting to *Constructive art employing systems, sometimes working with computers, lights and film. He has won many prizes and has worked on several architectural and environmental projects.

Strzeminski, Vladislav (1893–1952) Polish painter, born in Minsk (then in Russia). Fighting as a Russian soldier in the First World War, he lost an arm and a leg but in hospital met Katarzyna *Kobro whom he married soon after. He studied art in Moscow and worked beside *Malevich in Vitebsk in 1919–20. In 1922 he moved with Kobro to Warsaw. He helped organize the first Polish modern art exhibition in Vilnius in 1923. It included ten works of his, all of them showing him pressing beyond *Suprematism towards a more consistent and complete kind of total *abstraction; one of his exhibits consisted of four related boards making one plane within a frame, entitled *Plastic Construction (Disruption of the Black Square)* (1923; Warsaw, NM). The following year he joined other Warsaw artists to found the group *Blok and wrote frequently for its magazine. Intent on developing a pictorial object without divisions and oppositions, and the illusionistic effects these produce, but offering a concentrated visual experience, he developed what he called 'Unism' – now seen as a forerunner of *Minimalism – and presented in a treatise of 1928. Unism called for monochrome, or nearly monochrome, surfaces articulated by all-over textures. In 1929, with Kobro, *Stazewski and others, he founded the group a.r. to promote a purified, economical idiom for all architecture, art and graphic work. In 1931 he and Kobro moved to Lodz and founded a school of typography. They also initiated the international collection that in 1937 became the Lodz Art Museum, one of the first modern art museums in the world. In 1931 he was awarded the city's Art Prize, a rare and remarkable instance of an avant-garde artist being publicly honoured in mid-career. During 1945–50 he was professor at the Lodz art school. The Lodz Art Museum has the best collection of his work.

Stuart, Gilbert (1755–1828) American painter, famous for his portraits of George Washington, of which he is said to have executed about 110. Born in Rhode Island, Stuart sailed to London at the very beginning of the American Revolution, and served for five years as chief apprentice in Benjamin *West's studio (*see also* Ralph Earl, John Trumbull, Matthew Pratt), where he developed his sophisticated and cosmopolitan portrait style, reminiscent of *Gainsborough and *Romney. His first great success was *The Skater*, which was exhibited at the Royal *Academy in 1782 (Washington, National). Although he received many lucrative commissions, Stuart accumulated debts. In 1787 he fled with his English wife and two children to Dublin, where he was befriended by the Lord Chancellor, John, Lord Fitzgibbon, whose splendid portrait by Stuart, painted in 1789, is now in the Cleveland Museum. Once again besieged by creditors, he sailed for America in 1792, to find renown as

America's premier portrait painter. His first likeness of George Washington dates from 1795, and although it proved successful and Stuart himself copied it many times, it was only in the third likeness, for which the President sat in 1796, that Stuart achieved the canonical portrait now known to every American schoolchild (Washington, Smithsonian), and whose engraving appears on the dollar bill (*see also* Charles Willson Peale).

Stubbs, George (1724–1806) Classified in his lifetime as a 'sporting painter', Stubbs transcends this category, as he does even those to which he aspired: portraiture and history painting (*see under* genres). Even more than his younger contemporary, *Wright of Derby, he combined a passionate interest in natural science with a poetic, painterly imagination. His pictorial variations on the theme of *Mares and Foals* (nine known, 1760–70; 1773; Grosvenor Estate; Duke of Grafton; Viscountess Ward of Witley; London, Tate; Milton Park; Ascott; USA, Jack R. Dick) have been said to express most intensely Stubbs's identity as a painter: his absorption in anatomical studies of the horse, his profound yet reticent empathy with animals, his fastidious, musical, sense of design.

Born in Liverpool, the son of a currier and leatherseller, Stubbs was an impassioned draftsman, albeit obliged to work at his father's trade until he was 15 or 16. After his father's death in 1741, he was able briefly to assist an artist copying the Earl of Derby's pictures at Knowsley Hall near Liverpool. With his mother's help, he spent the next four years at home teaching himself to paint, and pursuing his earliest and most enduring passion, anatomy, by dissecting horses and dogs.

In 1746 he lectured privately on human anatomy at York Hospital and drew and etched the human embryo for a book on midwifery (publ. 1751). During this time he supported himself by portraiture. In 1754 he visited Italy; claiming to have done so 'to convince himself that Nature is superior to all art', he seems nonetheless to have looked closely at Roman and Hellenistic animal sculpture. Certainly the famous theme of a lion attacking a horse or other animal,

to which he returned several times, which was supposedly inspired by an incident he witnessed in Morocco, is anticipated in the same dramatic form in ancient art. After his return from abroad he retired to Lincolnshire, where, in 1758–9, he prepared the dissections and drawings for his great work, *The Anatomy of the Horse* (publ. 1766). From *c*.1759 he settled in London and practised as a painter of *Conversation Pieces, with or without horses and dogs; of landscapes with figures; of studies of wild animals; and of large horse portraits (London, National, Goodwood House; Manchester, Gallery; New Haven, Yale; etc.). As a 'sporting painter' he was excluded from the Royal *Academy at its foundation, and continued to exhibit at the Society of Arts, along with *Zoffany and Wright of Derby. From the 1770s Stubbs was associated with Wedgwood in the production of paintings in enamel on copper or china plaques (e.g. Barlaston, Museum). Some of these were repeated on canvas. In 1780 he was made Associate of the Royal Academy. In the 1790s he was patronized by the Prince of Wales, for whom he painted some of his most poetic compositions of horses and men (Windsor Castle). From 1802 onwards he was engaged on *A comparative anatomical exposition of the structure of the Human Body with that of a Tiger and Common Fowls*, which was never completed.

stucco Light, malleable plaster made from dehydrated lime (calcium carbonate) mixed with powdered marble and glue and sometimes reinforced with hair. It was used for architectural decoration in ancient Rome, and the technique was revived in the 16th century by *Giovanni da Udine; it came also to be used for sculpture in high relief or in the round. Among other important *Renaissance *stuccatori* were *Primaticcio and *Rosso. *Pietro da Cortona popularized white and gilt stucco decoration in the 17th century. In the 18th century the Sicilian Giacomo *Serpotta was the medium's most virtuoso exponent.

Stuck, Franz von (1863–1928) German painter, associated with *Symbol-

ism and *Art nouveau. He was trained in Munich's applied art school and academy and was drawn to the art of *Böcklin and the Belgian *Symbolists. In 1892 he was one of the founders of the Munich *Secession; later he was its president. Böcklin's influence is evident in the large painting *War* (1894) but Stuck's preference was for mythological subjects, allegories and occasionally *History paintings (*Judith and Holofernes*, 1927; pc) that explore the frontiers of morality and at times celebrate temptation, as in *Sin* (1893). Much of his time and talent went into developing his Munich house, built in 1898, as a brilliant *Gesamtkunstwerk. His exploration of the affective properties of form, in carved frames as well as in the paintings themselves, made him an important teacher. He became a professor at the Munich Academy in 1895; among his students were *Kandinsky and *Klee. His work is best represented in the Bayerische Staatsgemäldesammlungen, Munich.

Sturm, Der German for 'the storm', used by Herwarth Walden for an art newspaper (1910–32) a Gallery (1912–24) and associated actions (e.g. a short-lived art school) in Berlin. Capital of a united Germany since 1871, Berlin was then a particularly energetic cultural centre with clashing values powerfully expressed, with nationalistic academicism hotly supported by the Kaiser, foreign influences welcomed by the *Secession, *Expressionism arriving in 1910–11 and given a nationalistic edge by *Nolde, and a multifaceted, belligerent world of writing, drama and music. Walden (1878–1941) was a writer and composer who became interested in art (the painter Jacoba van Heemskerk was his first wife) and turned to promoting new art through publications, exhibitions and activities. The first issues of *Der Sturm* presented, in words and images, the art of *Kokoschka, Die *Brücke and Der *Blaue Reiter, and published German translations of *Futurist manifestos while his gallery showed the Futurist exhibition seen earlier in Paris. He gave influential solo exhibitions of Parisian and Paris-based artists such as Robert *Delaunay and *Chagall. In the autumn of 1913 he presented the First German Herb-

stsalon (Salon d'Automne), a wide selection of new work by German and foreign artists in which the two Delaunays were prominent. His exhibition programme ranged widely and included a high proportion of artists whom history has seen as outstandingly important in the development of modern art, so that Berlin, thanks primarily to Walden, had better access to *modernist art up to 1914 than anywhere else. The war diminished this programme and occasioned a change of heart in its director. The Walden of the 1920s inclined more to *realism, and the magazine ceased when he departed to Russia, both in order to leave Germany and to live in a Communist society.

Sturmio, Hernando (documented 1537–57) Dutch painter (Ferdinand Sturm) working in Spain at the same time as the Fleming Pedro de *Campaña (Seville, Cathedral). An exquisite draftsman, he influenced Luis de *Morales.

Stwosz, Wyt *See* Stoss, Veit.

Subleyras, Pierre (1699–1749) Born in southern France and educated at Toulouse in the studio of Antoine Rivalz, and at the Royal *Academy in Paris, where in 1727 he gained first prize for painting, he settled in Rome in 1728. Here he specialized in sober, deeply-felt religious pictures and portraits (e.g. Rome, S. Maria degli Angeli, S. Francesca Romana; Accademia di S. Luca), painted in a subtly graduated light tonality with much use of areas of white (*see under* colour). A picture of his own studio (after 1740, Vienna, Akademie) reproduces many of his best-known compositions.

Sublime An aesthetic category, originally formulated in Late Antiquity, refashioned in the 18th century by the Anglo-Irish statesman **Edmund Burke** (1729–1797). 'Longinus', an unknown author of the first century AD, defined the sublime as that which, expressing the grandeur of the Divine Intellect, 'irresistibly uplifts the souls' of all men at all times. Burke's theory, set out in the *Philosophical Enquiry into the Origin of our Ideas*

of the Sublime and the Beautiful (1757), is more grounded in psychology than in metaphysics. While a sense of beauty is aroused by that which attracts, the repellent and disturbing arouse feelings of the Sublime. Infinite extension, excessive size, darkness, are qualities leading to a perception of sublimity; in art, exaggeration and excess. Burke's theory provided a vocabulary for describing such works as the archeological and architectural fantasies of *Piranesi, and influenced the art and art theories of *Romanticism (*see* also Picturesque).

Sugai, Kumi (1919–) Japanese painter, trained in Osaka and resident in Paris since 1952, where he has become prominent as a painter of powerful yet subtle geometrically conceived *abstracts.

Sugerman, George (1912–) American sculptor, trained at New York's City College and at the Zadkine School during his stay in Paris, 1951–6. Using various materials, usually with strong colour, he has sought to explore the spatial and expressive force of usually complex *abstract forms, often to cheering effect and whenever possible for public spaces. He has resided and worked in New York and has exhibited many times since his first one-man show there in 1958.

Sully, Thomas (1783–1872) Prolific American portrait painter, born in Britain but working mainly in Philadelphia. His lively work owes something to the example of *Lawrence.

Superrealism A term that emerged in the late 1960s together with *Photorealism and sometimes thought synonymous with it. But whereas Photorealism indicates the use of photographic source material, Superrealism need not, but implies *naturalism pushed to the point where it becomes strangely compelling, even hypnotic.

support Any surface on which a painting is executed; *see* canvas, panel, paper; fresco.

Suprematism Name chosen by *Malevich for the *abstract painting he developed in 1915 and launched in an exhibition that December, asserting 'the supremacy of sensation' and associated with his vision of cosmic events in infinite space. His *Black Square* (a square of black centred on a white square canvas) hung across the corner of the gallery, *icon-fashion, as the key to and starting point of Suprematism, together with 38 other paintings, most of them more complex compositions involving various colours and geometrical forms. In 1916 he produced a long and passionate manifesto in defence of his new art, which had met with mocking criticism even from the more go-ahead critics. *Popova and other younger painters were associated with Suprematism during 1916–17 and planned a journal, *Supremus*, which never appeared. By about 1920 Malevich's Suprematist paintings had culminated in a series of white-on-white canvases of a clearly transcendental sort. During about 1918–20 it looked as though geometric forms and clear, flat colours, could become the official propaganda style of the Soviet state but many, including Lenin, found it too remote from reality even when it was applied to the design of posters and tramcars. In 1919 a large retrospective exhibition of Malevich's art was put on in Moscow, demonstrating his exceptional status among contemporary artists. During 1919–22 Malevich headed an art-school group in Vitebsk, dedicated to the development of Suprematism as an idiom for applied art as well as for paintings. It was called 'Unovis' (acronym of 'For the New Art'). In 1922 he and it joined the Institute of Artistic Culture in Leningrad where Malevich headed a department until 1926. In 1927 he visited Warsaw and Berlin with an exhibition of Suprematist paintings, and left them with a friend when he returned to Russia. (Most of them entered the collection of the Stedelijk Museum in Amsterdam in 1958.) He subsequently turned to figurative painting. But he lay in state under a *Black Square* painting, hung like an *icon over his head, and his coffin and tombstone bore and bear Suprematist forms. Malevich's Suprematist theory was first published

outside Russia, in summary and selective form, as a *Bauhaus Book in 1927 as *Die gegenstandlose Welt* (The Non-Objective World). Beginning in 1968, a generous selection of his writings have been published in English.

Surrealism A movement in literature and art, named using a term invented by *Apollinaire in 1917 for his own anti-naturalistic, late-Symbolist work, and adopted by *Breton in 1924 for a movement intended to habituate the world to living on the super-real plane of poetic invention and unconscious urges. Like Dada, Surrealism rejected all conventions as repressive. Surrealism was unlike Dada in being less of a timely protest, more an ongoing effort to undo civilization's insistence on self-control as the guiding principle for society. As a movement Surrealism thrived from 1924 through the 1930s, when it became influential internationally, and it has continued since, with work by some of its leading artists, notably *Dalí, becoming highly popular. It has significantly influenced photography and film, directly as when Dalí made films with Buñuel and when Man *Ray or Boiffard made Surrealist photographs, as well as indirectly via the stimulus given by Surrealist paintings, sculpture, assemblages and found objects. Aiming at nothing less than a revolution in awareness and living, Surrealism sought an alliance and hoped it had found this in Communism, to which some of the leading members of the movement belonged for shorter and longer periods. But Communism could not long countenance an art movement so remote from immediate social needs, and their association was marked by dispute and denunciations.

As an art movement Surrealism was both *avant garde and reactionary. Breton overcame his fellow-writers' reluctance to accept the possibility that art could be Surrealist, pointing first to the haunting townscapes of De *Chirico, then importing *Ernst from Cologne and, from 1925 on, pointing to *Picasso as a powerful, instinctive Surrealist. He also asserted the centrality of *automatism as giving access to imagery, and this led to giving renewed priority to marks and signs and to the use of found or random textures, as in the work of *Miró or *Ernst. Detailed accounts of real or invented dreams, as in the mature work of Dalí, tie art back to 19th-century *naturalism. Paradoxical visions, depending on commonsense reading of images in order to experience their unreality as shock, as in the art of *Magritte, serve to undermine the concept of naturalism as truth. At a time when geometric forms, often with reference to modern technology, were prominent in avant-garde art, Surrealism explored the visual and emotional impact of the organic forms of nature, actual (*Arp, Miró) or imagined (*Tanguy, *Matta). The arrival in America during the Second World War of several of the leading Surrealists – including Breton, Ernst and Dalí – greatly heightened Surrealism's influence there, already seeded by exhibitions. The *Abstract Expressionists strove not to appear to be abstract Surrealists, but adopted from them the *Romantic idea that art originates in and acts upon the unconscious as well as automatism as the way to gain access to unconscious material.

Sustermans, Justus (1597–1681) Prolific Flemish-born portraitist of the *Medici court in Florence, where he went *c.*1620 after three years in Paris in the studio of François *Pourbus the Younger. His reputation, dulled by the many poor copies after his originals, has recently been revived as a result of a series of exhibitions in which newly cleaned paintings have revealed his gifts as a draftsman and colourist; he was admired by *Rubens, a life-long friend, and *Van Dyck. At its best, his work bears comparison with their portraits and those of *Velázquez (Florence, Uffizi, Pitti). He also painted some narrative pictures, including the huge canvas of *The Senators of Florence swearing Allegiance to Ferdinand II de'Medici* (1626, Florence, Uffizi; oil sketch, Oxford, Ashmolean), a few *genre scenes and portraits of animals (e.g. Florence, Poggio Imperiale, Uffizi, respectively). The Print Cabinet at the Uffizi has a series of landscape drawings by him, much influenced by those of Florentine artists.

Sustris, Lambert (*c*.1515–after 1568) and his son **Federico** or **Friedrich** (*c*.1540–99) Italo–Netherlandish painters. Lambert, recorded also as 'Alberthus de Olandis', was born in Amsterdam and probably trained in Utrecht under Van *Scorel. By the late 1530s he was in the Veneto, perhaps following a stay in Rome; he worked in Venice in *Titian's studio and independently in Padua. He accompanied Titian to Augsburg in 1548 and 1550, returning alone in 1552; during his visits he executed portraits (Augsburg, Gallery; Munich, Alte Pinakothek; Zeil, castle). On his return to Italy, perhaps through direct contact with *Schiavone, and under the influence of the prints of *Parmigianino, he revised his style to arrive at a personal variant of Venetian *Mannerism, particularly successful in narratives in extensive landscape. There are works by him in Amsterdam, Rijksmuseum; Paris, Louvre; Caen, Musée; Lille, Palais; Madrid, Prado; St Petersburg, Hermitage; Oxford, Christ Church; etc.

Lambert's son and pupil Federico may have been born in Padua. In 1563–7 he worked in Florence with *Vasari, executing cartoons for tapestries for the Palazzo Vecchio, 1564. Summoned to Augsburg to decorate interiors in the Fugger mansion, 1569–73, he was recommended by Hans Fugger to Duke Wilhelm V, for whom he worked at and near Landshut 1573–9. In 1580 he moved to Munich, becoming an architect and supervisor of all artistic projects at court.

Sutherland, Graham (1903–1980) British painter, who studied *etching in London and became known as a printmaker in the pastoral tradition of *Palmer in the 1920s. He took up painting in 1931 and made many visits to Wales in order to paint deeply *Romantic, partly *Expressionist landscapes. His work was included in the London International *Surrealist exhibition of 1936. As an official war artist he presented images of urban destruction in terms that made him part of the *Neo-Romantic tendency in wartime art. After the war he became known for his visionary, quasi-Surrealist picturing of plants and beasts as disturbing presences. In 1944 he had been commissioned to paint a Cruci-fixion for the church of St Matthew in Northampton; this was completed in 1946 and shows him distantly indebted to *Grünewald's Isenheim altarpiece as well as responding to images of concentration-camp victims; his much larger representation of *Christ in Glory in the Tetramorph* in the tapestry he designed for Coventry Cathedral (1952–7) is more in the spirit of French Romanesque sculpture.

In 1947 he had been to the south of France, and from this time on he worked there part of each year, his colours becoming brighter and dramatic. He became known as a portrait painter of literary and other eminent figures, beginning with *Somerset Maugham* (1949; London, Tate), and was commissioned in 1954 to portray Sir Winston Churchill. Completed the same year after many studies, a characteristic Sutherland, it was roundly denounced in Parliament and the press, publicly presented to the sitter in celebration of his 80th birthday, and then quietly destroyed.

In 1952 he had had a major exhibition within the Venice Biennale. In 1953 the Tate Gallery, London, presented a retrospective and in 1960 he was given Britain's highest award, the Order of Merit. By this time he was well-known and highly regarded internationally. His work is widely disseminated, with the Tate Gallery in London owning several major examples. Others were acquired by the National Museum of Wales in Cardiff and in 1976, partly thanks to additional works presented by the artist, a Sutherland Gallery was formed at Picton Castle, Haverfordwest. It closed in 1995. His tense, predominantly graphic style, fitted post-1945 anxieties without being seriously threatening, and this, combined with often decorative colours, made his art accessible and popular.

Swart, Jan (*c*.1500–after 1553) Netherlandish painter, book illustrator and designer of stained-glass windows from Groningen. He worked in Antwerp and Gouda and travelled to Italy early in his career. His paintings combine Italian *Renaissance and Netherlandish elements, and he borrows from greater northern Italianate artists, most especially *Scorel.

Sweerts, Michiel (1618–62/4) Flemish painter, born in Brussels. From *c*.1646–*c*.54 he was resident in Rome, where he was impressed by Pieter van *Laer's pictures of Roman street life, and by *Caravaggio's religious paintings. In 1656 he obtained permission from the city of Brussels to open a drawing *academy. In 1659/60 he was in Amsterdam. A successful portraitist, a grave and lyrical recorder of the life of women and children, of artists' studios and of Roman low-life, he was a profoundly religious man. In 1661, after joining a missionary society, he is recorded as fasting almost daily, taking communion three or four times a day, and giving away his possessions to the poor. His compassionate interest in social problems is recorded in paintings of the *Acts of Mercy* (Amsterdam, Rijksmuseum; New York, Metropolitan). In 1662 he set out with the mission of Bishop François Pallu for Persia, but, 'not the master of his own mind', he was dismissed in Isfahan. He made his own way from Iran to India to join the Portuguese Jesuits, and died in Goa.

Sweerts's clarity of form, purity of colour, and poetic intensity have led to comparisons with the works of *Vermeer's classic period, but his particular synthesis of northern *realism and Italianate eloquence, especially in his paintings of half-length figures, bears comparison with *Rembrandt. There is a self-portrait in Oberlin, Ohio, College; and other works in Hartford, CT, Atheneum; London, Wallace; etc.

Symbolism The use and nature of symbols, but also, with a capital S, the name of a wide movement in the arts, led and given some sort of focus by writers and prominent in the 1880s and 90s though still resonant in the new century, which offered the realities of fantasy, dream and hypersensitivity to experience in place of the straight or idealized *naturalism and *realism that reflected the material world. Contributions to this broad programme could be utterly contradictory. Among the most important artists related to it are *Moreau, *Puvis, *Redon, *Gauguin, *Burne-Jones and *Hodler. What was at issue was neither a style nor a particular

range of subjects but the transmitting of an image of the artist as a poetic visionary through subject-matter and artistic means. As in the work of Symbolism's most eminent poet, Mallarmé, some of these artists sought to purify the means of art by abandoning some of the methods *Renaissance naturalism had introduced, most obviously *perspective and tonal modelling, reverting to pre-Renaissance idioms and at times adapting exotic formulae, e.g. the flat design and colour of Japanese woodcuts, or *primitive idioms, e.g. in the influence of Breton folk art and costume on *Bernard and Gauguin or of Russian folk art and traditional church art on Russian designers and on painters and illustrators such *Vrubel, *Kandinsky, *Bilibin and *Goncharova. The theories and practices of Symbolism, first presented as a movement in Paris, spread rapidly throughout Europe, with England, Belgium, Sweden and Russia as significant contributors and recipients. *Surrealism can be said to have been Symbolism's descendant. Like Surrealism, Symbolism can be presented as a return to the priorities of *Romanticism in that it set the imagination above knowledge and the individual urge to express over any need to inform. Its importance to key developments in *Modernism, notably *Cubism, *Futurism, *Expressionism, *Suprematism and De *Stijl is patent.

Synchromism Term, implying the use of colours together, invented by *Macdonald-Wright and Morgan *Russell as a name for the movement they launched in 1913. Allied to *Orphism, it gave first importance to colour as the source of form and expression in painting. Synchromist exhibitions were shown in Munich and in Paris in 1913, and in New York in 1914, producing something of an American wave of Synchromism during the following two or three years and providing an alternative modernist mode to that offered by *Stieglitz.

Synthetism Term used at the time to designate the new style in painting initiated by *Bernard and *Gauguin about 1888, calling for the simplification of pictorial representation into summary,

often flat forms and unmodulated, often un-*naturalistic colour, within emphatic dark contours that suggest medieval stained-glass windows and *cloisonné* enamels. It is thus one style amid the many serving *Symbolism, but it was aesthetically the most radical on account of its high degree of abstraction and the most important on account of its influence. Gauguin's followers in France took it to extremes he had not envisaged, sometimes with mystical intentions. Maurice *Denis quoted *Sérusier's definition in 1907:

'Synthesis consists in reducing all forms to the small number of forms we are capable of thinking of: straight lines, several angles, arcs of circles and ellipses. Outside of these we are lost in an ocean of varieties', adding 'Here is undoubtedly a mathematical concept of art, not without its own grandeur.' It was as an art of extreme simplification and employing mathematics as a means of representing mystical ideas that Synthetism was understood in Scandinavia and Russia, notably by *Malevich.

T

Tacca, Pietro (1577–1640) Florentine sculptor. Born at Carrara, the site of the great marble quarries of Tuscany, into a family of marble merchants, he disliked marble carving and specialized in bronze. In 1592 he entered the workshop of Giovanni *Bologna, becoming his principal assistant. Before Giovanni Bologna's death in 1608 Tacca carried out the project for the equestrian monument of Ferdinando I de' *Medici (1601–7/8), Florence, Piazza SS. Annunziata), and worked on the early stage of the monuments to Henry IV of France (c.1604–14, formerly Paris, Pont Neuf, destroyed 1792, fragments Louvre) and Philip III of Spain (1606–16, Madrid, Plaza de Oriente). In 1617 Tacca became Giovanni Bologna's successor as grand-ducal sculptor. The major projects carried out in the workshop under him were the four slaves at the base of the monument to Ferdinando I in Livorno (1615–24); two bronze fountains (1627) intended for Leghorn but ultimately installed in Florence, Piazza SS. Annunziata; the bronze boar for Florence, Mercato Nuovo, after an antique marble; the bronze turtles for the bases of the obelisks in Piazza Sta Maria Novella; and the colossal bronze statues for the tombs in the Capella dei Principi, the grand-ducal mausoleum in San Lorenzo. Between 1634 and his death Tacca worked on the great equestrian monument to Philip IV of Spain (Madrid), the first completed monument of a rider on a rearing horse in the history of equestrian statuary, although Tacca had already projected the type in two statuettes, the Louis XIII of France (Florence, Bargello) and Carlo Emmanuele of Savoy (1619–21, Kassel).

Tachism English version of *Tachisme* (from *tâche*, a stain or mark), a term used in France from about 1951 on to indicate a European form of *Abstract Expressionist painting in which paint is applied softly and, it is hoped, sensually, without the attack involved in much American Abstract Expressionism. The writer Michel Tapié gave it currency through his book *Un Art autre*, published in 1952, but it tended to be used indiscriminately as one label among others for expressive abstract art, including Art Autre, *Art Informel, and Abstraction Lyrique.

Taddeo di Bartolo (c.1362/3–1422) Italian painter mainly active in Siena, where he is best known for his *frescos in the Chapel of the Virgin in the Palazzo Pubblico (1406–7) and of the *Civic Virtues* and *Roman Heroes* in that chapel's antechamber (1413–14). He worked also in San Gimignano (fresco of the *Last Judgement*, 1393, Collegiata); in and around Pisa, where he adopted Florentine models for reducing *polyptychs to *triptychs; in Volterra (Pinacoteca), and Perugia (Galleria Nazionale dell'Umbria). Essentially a late *Gothic painter, he shows his awareness of Florentine models not only in the format of altarpieces, but also in experiments with extreme *foreshortening of individual figures within his crowded compositions.

Taeuber-Arp, Sophie (1889–1943) Swiss-French painter, *Arp's partner from 1915 and wife from 1921, and active with him in the Zurich *Dada group. They collaborated on *abstract and semi-abstract work during the war years, and occasionally later, but she personally became known for her abstracted figurative puppets made for drama groups in Switzerland and France, and then also for her abstract paintings and tapestries in clear geometric forms and colours. In 1927–8 she, Arp and Van *Doesburg worked on the rebuilding and development of a café, cinema and dance hall, the Aubette in Strasbourg, each of them designing distinct portions of the interior. (The results were thoroughly unpopular, and soon destroyed.) She designed the Arps' house and studio at Meudon, completed in 1934. From 1925 on the Arps had been located principally in Paris and were seen as part of the Paris artworld and associated with *Surrealism

though Taeuber-Arp's work retained its controlled, geometrical character. They attained French nationality in 1926. In 1942 they made repeated attempts to obtain a visa for the USA, in Paris and then in Switzerland. In 1943 she was killed in her sleep by fumes from a gas stove when staying in Max *Bill's house near Zurich.

Takis (1925–) Working name of the Greek sculptor and *Constructive artist Panayotis Vassiliakis. Self-taught, he worked in Athens from 1945 and soon also in Paris, where he lives, and in London. He brought magnetism and electromagnetism into *kinetic sculpture with his *Signals* (1954 and after) and in subsequent more elaborate works. During 1968–70 he held a fellowship at the Massachusetts Institute of Technology, Cambridge, MA. There was a major retrospective Takis show in Paris in 1972.

Tal-Coat, Pierre (1905–85) Working name of the French painter Pierre Jacob, born in Brittany into a fisherman's family. Mainly self-taught as an artist, he painted a series of *Massacres* in response to the Spanish Civil War and in the later 1940s became a leading figure in *Art informel, producing *abstract images marked by sensations of light and of agitation.

Tamayo, Rufino (1899–1991) Mexican painter, son of Zapotec Indians, trained at the *Academy of San Carlos in Mexico City. In 1921 he was put in charge of the National Museum of Archeology's department of Ethnographic Drawing. His first exhibitions were in 1926, in Mexico City and in New York. He lived in New York during much of 1936–54 but kept in close touch with Mexico and travelled in Europe, exhibiting and painting murals. He turned away from the *Social Realism associated with Mexican mural painting, wishing to give colour and form greater priority and to suggest meaning through symbolism rather than through narrative and description. In 1948 he had a retrospective show in Mexico City and in 1950 showed 16 paintings at the Venice Biennale. He formed a large collection of pre-Columbian Mexican art which he donated to the city of Oaxaca as a museum; his personal collection of modern art became the Rufino Tamayo Museum in Mexico City in 1981.

Tanguy, Yves (1900–1955) French painter, a friend of the poet Prevert. He took up painting in 1923 after seeing a De *Chirico picture and in 1925, together with Prevert, joined the *Surrealist group. He had no formal art training and developed a personal image which he varied and developed over the years: seaside or submarine spaces inhabited by rock and sand formations and little else, echoing some types of dream landscapes and sensations. He emigrated to the USA in 1946 and took American citizenship. He showed frequently with the Surrealists and in 1955 there was a major retrospective in New York (MoMA).

Tanning, Dorothea (1910–) American painter, mostly self-taught, known for her narrative *Surrealist paintings, at once dreamlike and horrific. In 1942 she met Max *Ernst, whose wife she became and with whom she moved to France in 1949.

Tanzio da Varallo (c.1575/80–1635) Lombard painter from a German-speaking community in the Valsesia; he was first known as Antonio d'Enrico. A trip to Rome for the Papal Jubilee, 1600, acquainted him at first hand with the work of *Caravaggio, whom he may have followed to Naples. Caravaggesque influences reinforced local Lombard traditions, notably those derived from Gaudenzio *Ferrari, in Tanzio's best-known work, the *illusionistic and highly *expressive *frescos in the *Sacro Monte at Varallo, painted upon his return to northern Italy, 1616–26. Other works can be found in Varallo, Pinacoteca; Novara, S. Gaudenzio; Milan, Brera.

Tàpies, Antonio (1923–) Spanish painter of middle-class Catalan family, born in Barcelona and deeply affected by the divisions, hunger and bombing occasioned by the Civil War of 1936. He was expected to follow his father in law and became a law student in 1943.

Earlier he had had a serious heart attack and while recuperating, he made his first attempts at painting (copies of *Picasso and Van *Gogh, also independent images), and while he studied law he also went to drawing classes. In 1946 he left his studies and turned wholly to art. His early works were paintings heavy with paint and other materials; he exhibited such works in 1948. After this he came under the influence of *Surrealism, spent a year in Paris and subsequently visited Paris frequently, but by 1962–3 he had returned to his earlier manner and was producing *abstract or near-abstract images.

The characteristic Tàpies is neither abstract nor figurative but a surface (sometimes a three-dimensional *assemblage) of materials bearing signs and symbols of many kinds. The art world has referred to his work as 'matter paintings' because of the pastose materials as well as more three-dimensional stuff of which they are made, but the word tapies suggests 'walls' in Spanish and Catalan and it struck Tàpies that his earliest paintings, in the mid-1940s, 'had turned into walls'. In Tàpies's wall-pictures a door can seem an *icon, a draped cloth a battlefield. We see in them signs that unambiguously speak of Catalonia and must be read as denoting conflict and suffering while indicating humanity's presence by means of marks ranging from footprints to scribbled words. His writings are elegant and enlightening, and he collaborated repeatedly with authors, notably with his friend the poet and playwright Joan Brossa, on books joining images to words.

Tàpies's first solo exhibitions were in Barcelona, from 1950 on. In 1953 he had shows in Chicago and New York (Martha Jackson Gallery), and soon after in France, Germany and Italy. In 1958 he represented Spain at the Venice Biennale and was awarded two major prizes; his first retrospectives were in Germany (Hanover) and New York in 1962. His art, evidently marked by the war experiences of his youth, has qualities of introspection, enhanced by his interest in Eastern thought, which give it a universal character and make it much more than an art of protest and complaint.

Tassi, Agostino See under Guercino; Claude Gelée; Gentileschi.

Tatlin, Vladimir (1885–1953) Russian artist, called the father of *Constructivism though he rejected the role and was regarded in 1920s Western Europe as the man who led art into technology and industrial production. He was essentially poetic, capable of leadership but loved for his quiet ways, his craftsman's skills and his playing and singing of Russian folk music on instruments he made himself. His father was a railway engineer, his mother a poet. Young Tatlin divided his study years between art schools in Penza and Moscow and time as sea as a merchant sailor. Friends described his studio and his life-style as essentially shipshape and his knowledge of rigging and sails shows in his mature work. Little of that, however, remains, the most important productions being a vast tower, shown in drawings and models, his stage production of a poem by Khlebnikov, and models of a flying machine. Even less remains of papers etc. that might give us insight into his thinking but some may be gained from his close friendship with Khlebnikov who combined passionate enquiry into the functioning of mathematics, history, birds and language with speculation into the sort of world the Revolution (which he prophesied) would bring, and wrote about towers and flight and in praise of Tatlin.

He began and ended his career as a painter and stage designer. Some of his training was in painting and restoring *icons and he was later to stress that these had had an important influence on his work, but a major event in his formation was a visit to Paris, in 1914, where he called on *Picasso and saw his current work, including constructed sculptures. For a time such sculpture dominated Tatlin's output: 'pictorial reliefs', 'corner reliefs' hovering in the angle of two walls and 'counter reliefs' slung on ropes or cables at some distance from any wall. These works are often designated *abstract, but the first of them included glass and the image of a bottle and may well have been a visual essay on representation and reality, and others imply meaning in a variety of ways. A

corner relief has a strong iconic quality and echoes Russia's favourite icons of the Mother of God. Few of these constructions, made principally of found bits of wood and metal, survive; those that do seem to have changed in being restored. In 1914–16 they were exhibited in Moscow and Petrograd and attracted the notice of *avant-garde artists, some of whom became his disciples, but little attention from the critics of the day. *Malevich and he found themselves rival leaders in revolutionary art. In 1918 Tatlin was appointed head of the Commissariat for Enlightenment's Moscow art directorate and charged with realizing Lenin's wish to see Moscow (and other cities) equipped with statues to the glory of past revolutionaries. Dissatisfied with the old-fashioned sculptures that resulted, Tatlin conceived a project for a vast monument to the Revolution, an engineering structure of steel and glass, at once sculpture and architecture, to outdo the Eiffel Tower of Paris in size and dynamic form and to house Comintern, the headquarters of international Communist action. It would stand in Petrograd, straddling the river Neva like a Colossus and, pointing to the pole star, would link Earth to the cosmos. Retitled *Monument to the Third International*, it was displayed in large model form in the winter of 1920–1, drew a great deal of attention at home and abroad and was seen as a new form of art, at once visionary and real in its intended use of modern materials and technology. A smaller model was the centrepiece of the Soviet display at the 1925 Exposition of Decorative Arts in Paris.

He taught in the new art institutes of Moscow, Kiev and Petrograd, developing a course in 'the culture of materials'. He and his students made exploratory prototypes for economical and efficient ceramics, clothing and furniture. With government backing he and assistants, with specialist advice from aeronautics and medicine, worked during 1930–3 to fashion a flying machine, to bear and be controlled by one person, from a range of natural and synthetic materials and in organic forms. He intended it to be mass produced, like bicycles, in order to realise mankind's ancient dream of personal flight. Three versions were exhibited in Moscow in 1932. His widow has stated that one was actually flown. In 1931 he had been given the title of Honoured Art Worker of the Soviet Union as an 'artist of great culture, a true master, who is a devoted worker for the proletarian revolution'.

In the 1930s Tatlin returned to figurative painting, mostly as a private pursuit, worked as stage designer and continued to develop his flying machine. Rather than a hothead, eager to end art as an activity beset by bourgeois priorities, he should be seen as a profoundly creative artist as conscious of his inheritance as of the new opportunities and demands created by modern art and the Revolution. There is evidence that he wished to be a modern *Leonardo da Vinci and, like the legendary Daedalus of ancient times, to add to the wonders of the world in the name of the new egalitarian society, through work vivid to the popular mind by being enmeshed in folk and religious traditions.

Tchelitchev, Pavel (1898–1957) Russian-born painter, from 1921 active in several European cities outside Russia, from 1934 on resident in New York and from 1950 in Italy. He had studied art and stage design in Moscow and Kiev and became known principally for his work in the theatre and his portraits, mainly of notable writers and theatre people. Competent in traditional methods of delineation, he added an enticing vein of *Surrealism and elegant stylization to his work which still pleases some educated tastes.

Teerlinc, Levina *See under* Bening.

Telamon *See under* caryatid.

tempera In the history of art, the word is normally used to denote egg tempera, the type of paint favoured for Italian panel paintings until the early 16th century; it consists of pigments ground in water mixed with egg yolk or whole egg. The resulting paint is opaque and eventually dries to a waterproof film with a velvety sheen, the first stage in its drying being the rapid evaporation of the water, followed by the slow and gradual hardening of the egg

proteins. These properties mean that unlike *oil paint tempera can neither be applied in translucent glazes (*see also* under colour) nor thickly applied with textured *impasto, nor blended and worked when wet, because the partially set paint will redissolve and peel away from the surface. The necessary convention of tempera painting is thus to build up the paint film gradually with repeated lightly-touched *hatchings or stipplings, not unlike those of drawing. Once mixed with the egg the paint will begin to dry in its dish or pot; in order to avoid wastage of sometimes expensive materials, the amount of pigment needed had to be assessed accurately before the paint was made. It seems likely therefore that in painting a panel the artist may have moved from colour to colour rather than concentrating on a single figure or scene – that is, painted all the blues, say, at one time across the whole panel. (In workshop practice someone else, with a paint pot of a different colour, could then move in to paint, say, all the vermilion reds.) Tonal modelling of drapery also required the most meticulous planning. Since colours could not be blended and modelled on the surface of the painting, each tone from shadow to highlight had to be mixed and prepared in advance. In practice this meant that the pigment was at its purest and most saturated in the shadows; for the highlights it was mixed with a high proportion of white. A mid-tone was made by mixing equal amounts of the colour prepared for the shadows with that for the highlights; further intermediary tones could then be mixed from these three, and the pre-mixed shades would be systematically applied, beginning with the shadows and working through to the highlights, the initially sharp transitions softened by the intermeshing of the hatched brushstrokes. An alternative method, called *cangiante* (*changeant* in French), used different hues, such as, say, a dark red and a light yellow, for shadows and highlights, imitating the appearance of shot silk woven with yarns of different colour in the warp and weft.

It is easy to see why the laborious methods of tempera panel painting and *fresco, both requiring elaborate planning at an early stage and militating against spontaneous revisions on the surface of the paint, fostered the rise of *disegno* in its practical sense of 'drawing' and its philosophical extensions, so crucial in the evolution of Italian art.

tenebrism, tenebrist (from Italian *tenebroso*, dark, obscure, gloomy) A type of painting which relies for its effects on overall darkness, from which highlights pick out significant details, notably gestures and facial expressions. Generally applied to the later paintings of *Caravaggio and his imitators, the term may also imply emotional gloom, lack of ornamentation, even squalor. *See also* chiaroscuro.

Teniers, David the Younger (1610–90) Prolific Flemish painter, mainly of *genre scenes and landscape; also an etcher (*see under* intaglio), art historian and dealer. He was the pupil of his father, **David Teniers the Elder** (1582–1649), a history painter (*see under* genres) whose *oeuvre* has not been satisfactorily established, although works in Antwerp, Pauluskerk, and Dendermonde, Onze Lieve Vrouwekerk, provide a touchstone. The most obvious influences on Teniers the Younger, however, were his father-in-law, Jan *Brueghel, and Dutch painting, notably works by Jan Davidsz. de *Heem and *Kalf, which inspired the meticulous still lifes in many of his pictures (e.g. Karlsruhe, Kunsthalle; Brussels, Musées; The Hague, Mauritshuis), by Pieter *Codde and Willem *Duyster, whose barrack-room subjects he revived (e.g. St Petersburg, Hermitage), by *Terborch, whose portraits he emulated in his Civil Guards' procession paintings (e.g. St Petersburg, Hermitage) and, most of all, by Adriaen *Brouwer. Teniers imitated Brouwer's peasant scenes, recasting them into his own less vigorous but more refined pictorial idiom (e.g. Kassel, Gemäldegalerie; Leipzig, Museum; London, National, Wallace; Madrid, Prado; Paris, Louvre; Budapest, Museum). Gradually, the earthy subjects inspired by Brouwer gave way to scenes from fashionable life (e.g. London, Edmund de Rothschild). He also depicted apes and cats in human guise; Witches' Sabbaths and other demonic and fantastical subjects in the tradition of

Jan Brueghel and Frans *Francken the Younger.

Shortly after his election as Dean of the Antwerp painters' guild, 1645, Teniers moved to Brussels where he became court artist to the Archduke Leopold Wilhelm and his successor. In Brussels he evolved a version of a Flemish theme traceable back to Jan Brueghel: the depiction of a picture gallery (e.g. Madrid, Prado). Miniature portraits of the artist himself, as custodian and cataloguer of Leopold's treasures, of the Archduke and other visitors, vie in interest with the accurately copied pictures-within-the-picture; the whole providing an invaluable historical record of picture collecting, framing and hanging practice. In addition, Teniers painted small-scale copies of the collection's prime holdings, especially the Venetian pictures, to serve as the basis for engravings, a selection of which was published in 1660 (e.g. London, Courtauld). Teniers's landscapes, related to those by Paul *Bril and Joos de *Momper, also formed the setting for the activities of the court (e.g. Vienna, Kunsthistorisches). After 1662, they often include in the background views of the château of The Three Towers near Perck, bought by Teniers in that year from the second husband of *Rubens's widow, Hélène Fourment (e.g. London, National). Also in 1662 the artist was one of the prime movers in the establishment of the Royal *Academy in Antwerp, finally founded in 1663. In 1680 he obtained a long-sought patent of nobility.

Teniers also practised as an art dealer, travelling to England between 1650–5 to buy paintings for an aristocratic client, and selling pictures to his archducal patron. With the exception of his landscapes the quality of his work deteriorated from c.1650; there are no dated works from 1680–90. His son, **David Teniers III** (1638–85), continued painting in his manner.

Ter Borch or **Terborch, Gerard** (1617–81) Much-travelled Dutch painter based in Deventer after 1654, notable for the pictorial and psychological refinement of his small paintings, mainly *genre scenes with two or three figures in an interior, and portraits. He began his training under his father, **Gerard Ter Borch the Elder** (1584–1662), who had lived in Italy in his youth; his earliest known drawing, made when he was eight years old, represents the rear view of a figure, a motif he was to continue exploring throughout his life, focusing attention on the exquisitely painted sheen of satin stuffs (*The Parental Admonition*, c.1654/5; *The Concert*, c.1675; Berlin, Staatliche). Like de *Hooch, Ter Borch began as a painter of barrack-room scenes (*see also* Duyster, Codde). In the 1640s he added to his repertoire small full-length portraits (*Helena van der Schalke as a Child*, c.1644, Amsterdam, Rijksmuseum). In 1635 Ter Borch was in England; in 1640/41 probably in Rome; he travelled also in France, Spain and throughout the Netherlands. In 1648 he was at Münster, where he painted individual portraits of delegates to the peace negotiations, and his most famous work: *The Swearing of the Oath of Ratification of the Treaty of Münster* (London, National). In this tiny (46 cm × 58 cm) painting on copper, Ter Borch recorded faithfully the interior of the Ratskammer adorned for the ceremony, and portrayed 77 persons attending, including himself. Having demanded the enormous sum of 6,000 guilders for the work, and not received it, the artist kept the picture, and it remained in his family throughout the 18th century. Ter Borch's most important student (c.1655–c.58) was Caspar *Netscher.

Terbrugghen, Henrick (1588–1629) A pupil of *Bloemaert, he is one of a group of painters known as the Dutch Caravaggisti (*see also* Honthorst, Baburen). He is supposed to have spent c.1604–14 in Italy, where he may have met *Caravaggio. Upon his return to Utrecht he began to paint pictures combining deliberate Netherlandish archaicisms – such as motifs derived from Lucas van *Leyden, and grotesque types inspired by Quentin *Metsys – with Caravaggesque elements. After 1620, with the return of other Dutch Caravaggisti from Rome, the Caravaggesque begins to predominate. His dependence on the Italian painter is never slavish, however: he evolved entirely new, shimmering colour

harmonies, a silvery tonality, and a method of painting dark figures against light backgrounds, which anticipates, and may have influenced, the Delft School (*see* Vermeer, Fabritius). There are pictures by him mainly of biblical subjects and *genre, in many major galleries, including Copenhagen, Museum; Kassel, Gemäldgalerie; London, National; New York, Metropolitan; Rome, Nazionale. His masterpiece, *St Sebastian tended by the Holy Women* (1625), is in Oberlin, Ohio, College.

Terracotta (Italian, 'cooked earth') Clay baked to become hard and compact. Associated in English with clay figurines, such as those made in the 3rd and 2nd centuries BC throughout the Greek world. The technique was revived on a larger scale in 15th-century Italy, where even *Donatello employed it for reliefs, busts and figures of angels; *see also* Mazzoni, Niccolò dell'Arca. We think of terracotta as being 'clay' coloured, but it was often painted or gilded, and Luca della *Robbia's decorative terracotta reliefs were, famously, glazed in blue and white.

Testa, Pietro (1612–50) Italian painter and printmaker from Lucca, active mainly in Rome. He was a pupil of *Domenichino, but is mainly known for his philosophically complex but poetical allegorical etchings (*see* allegory; intaglio), comparable to those of *Castiglione. Like *Poussin and *Pietro da Cortona he recorded antique monuments for the 'Paper Museum' of Cassiano del *Pozzo in the 1630s; in his own works, the *classicism of individual figures conflicts with an innate romanticism. Of melancholy disposition, he ended his days by throwing himself into the Tiber.

Theodoric, or **Theodoricus, Master** (recorded between 1348 and 1367) Influential Bohemian painter, first head of the painters' guild founded in Prague in 1348; he is recorded as royal painter to the Emperor Charles IV in Prague and at Karlstejn between 1359 and 1367. He executed the 127 panels of saints, prophets and angels which form part of the decoration of the Chapel of the Holy Cross at Karlstejn

Castle. These abandon the decorative linearity of earlier Bohemian art (*see* Vyssí Brod Master); softened contours and tonal modelling impart an overwhelming sense of volume to the figures, whose faces are executed with a new, portrait-like *naturalism. *See also* Tommaso da Modena.

Theophilus The pseudonym of a 12th-century German author of *De Diversis Artibus*, a treatise detailing the techniques of various crafts such as metalwork, stained-glass painting, manuscript *illumination, wall painting etc. Extant in several manuscripts, it was not generally available until *Lessing produced the first printed edition (posthumously published in 1871), since when it has become our major source of information about the arts in northern Europe in the early Middle Ages. Theophilus is generally identified with the German Benedictine monk and goldsmith Roger of Helmarshausen, documented as the author in 1100 of a portable altar, influenced by *Byzantine art, for Bishop Henry of Werl (Paderborn, Cathedral treasury). (*See also under* Gaddi for Cennino Cennini, author of the *Libro dell'Arte*, the equally important late 14th-century treatise on Italian painters' techniques).

Theotocopulos, Domenico *See* Greco, El.

Thoma, Hans (1839–1924) German painter of peasant origins and great popularity. Trained first as a *lithographer and clock painter, he studied at the Karlsruhe art school but found his own unacademic aims and style during a visit to Paris where he was excited by the work of *Delacroix, the *Barbizon School and, above all, *Courbet. *Realism, an account of the world as he experienced it, was now his priority and shows best in his town and landscapes, panoramic sometimes, at other times intimate and intent on human activity. He worked for a while in Düsseldorf but moved in 1870 to Munich where he was close to *Leibl and to *Böcklin. He returned from a visit to Italy, in 1874, with lighter, airier colours, but continued to paint scenes well known to him and affectionate portraits, mostly of relatives and

friends. From 1876 to 1899 he lived in Frankfurt where his painting took on an unexpected emphasis on anecdote and *allegory, as though he wished to compete with Böcklin as a German *Symbolist. In 1899 he returned to Karlsruhe as professor in the art school and director of the art gallery.

Thoré, Théophile (1807–69) French lawyer who wrote art criticism and art history under the pseudonym 'W. Bürger'. This choice, German for 'citizen', 'commoner', hinted at his inclination. He wanted art for the people, and gave his support to painters such as *Courbet, *Millet and *Manet who ignored or subverted *academic calls for learned subject matter and high rhetoric. He was also a pioneer student of the Dutch School and was the prime discoverer of the work of *Vermeer.

Thornhill, Sir James (1675/6–1734) By far the most successful native painter of *Baroque decoration in Britain. We know little of his early training, which may have been in architecture; of painting, he learned much from *Laguerre, whom he displaced in popularity. He was a vigorous self-publicist and political manoeuvrer, who achieved his pre-eminence not only through considerable ability but also by exploiting xenophobic prejudice to the detriment of his foreign competitors. Xenophobia recurs as a motif in the career of his son-in-law, *Hogarth.

Thornhill's first major commission seems to have been the decoration of the Painted Hall at Greenwich (1708–27), and it remains his greatest achievement. In it he translates episodes of contemporary history into the *idealizing idiom of the Grand Manner (London, British, annotated drawing for *The Landing of George I*). In 1715 Thornhill triumphed over his foreign rivals Laguerre and Sebastiano *Ricci to receive the commission for the decorations of St Paul's (1716–19). These he worked on concurrently with other decorative schemes, not only at Greenwich but also at Blenheim and at Charborough Park. In 1716 he succeeded *Kneller as head of the first, short-lived, *Academy. He was

made 'History Painter to His Majesty' in 1718, and Sergeant Painter in 1720, the year also in which he became Master of the Painter Stainers' Company, and received his knighthood. In 1722 he was elected MP for Melcombe Regis. With the death of his patron, the Earl of Sunderland, and the ascendancy of Lord Burlington, his fortunes began to falter; in 1723 he lost the commission of the decoration of Kensington Palace to William *Kent.

Thornhill practised other *genres as well as grand decoration: there are early portraits by him at Trinity College, Cambridge, and All Souls', Oxford. The sketchbook of his journey to Holland and Belgium in 1711 demonstrates his interest in architecture.

Thorn-Prikker, Jan (1868–1932) Dutch painter, born and trained in The Hague and Holland's outstanding painter of the *Art nouveau phase. He brought to its *abstraction and its taste for sinuous forms a spirit committed to *Symbolism, and in paintings such as *The Bride* (1893) achieved a degree of stylization and an intensity of personal symbolism that link them to *Kandinsky's expressive abstractions of 1910 and after. Like other Art nouveau artists, he worked in several media. In Germany, where he was from 1904 on, he made stained-glass windows and mosaics, adopting a more geometrical idiom. From 1920 to 1923 he was professor at the School of Applied Art in Munich, subsequently teaching at the design schools of Düsseldorf and Cologne. The Rijksmuseum Kröller-Müller in Otterlo has the best collection of his work.

Thorvaldsen, Bertel (1770–1844) Danish sculptor, son of a woodcarver employed in a Copenhagen shipyard. He studied painting at Copenhagen Academy under *Abildgaard from 1781 on and in 1793 won the chief gold medal. This enabled him to go to Rome, where he arrived in 1797. He stayed for 41 years, steeping himself in the *classical past and the *Neoclassical present and developing a career as Europe's chief sculptor after *Canova. Commissions came from Denmark, England, Poland and Russia, and

included that for Pius VII's monument in St Peter's, Rome. He went back to Copenhagen in 1838 but retained his Rome studio and was there again in 1841–2. Copenhagen has a Thorvaldsen Museum, initiated in his lifetime.

Thulden, Theodoor van (1606–69) Flemish painter, designer and maker of *reproductive prints, probably a pupil of *Rubens, with whom he collaborated in 1635 on the decorations for the festival entry into Antwerp of the Cardinal-Infante Ferdinand; he immortalized these temporary decorations in a series of prints, the *Pompa Introitus Ferdinandi*, published in 1642–3. He also executed some of the paintings, based on Rubens's sketches, for Philip IV's hunting lodge, the Torre de la Parada, in 1637. After Rubens's death he continued to work in a sweeter version of his manner on decorative schemes such as that of the Huis ten Bosch outside The Hague (*see also*, e.g. Everdingen, Caesar). Between 1631 and 1633 Van Thulden was in Paris, where he executed his first important graphic work, a print series recording *Primaticcio's now-lost Ulysses cycle at Fontainebleau.

Tibaldi, Pellegrino (1527–96) Precocious *Mannerist painter and architect from Bologna. Following his debut at 15 (*Marriage of St Catherine*, *c.*1542, Bologna, Pinacoteca), he left in 1545/6 for Rome, where he first assisted then succeeded *Perino del Vaga in the *fresco decoration of the Sala Paolina in the Castel Sant'-Angelo (completed 1549). It is here that he evolved the *Michelangelesque idiom of his mature style, and *illusionistic elaborations. He continued to work in Rome (with *Daniele da Volterra *c.*1550, SS. Trinità; S. Luigi dei Francesi; Vatican, Belvedere, S. Andrea; 1549, *Adoration of the Shepherds*, Borghese) moving in 1553 to Loreto (fresco in the Holy House, part-destroyed, part-detached). Sometime during 1553–5 he returned to Bologna, succeeding Nicolò dell'*Abate in the Palazzo Poggi. From 1558–61 he worked mostly in Ancona, in an increasingly ponderous, over-blown style (Palazzo Ferretti, Pinacoteca). During 1586–94/5, he replaced Federico *Zuccaro

at the Escorial in Spain, where his fresco cycles and altar paintings temper *Mannerism with a Counter-Reformatory, *academicizing clarity – a pious *naturalism which was to influence later Spanish artists.

Tiepolo, Giovanni Battista (1676–1770) The towering figure of 18th-century Venetian art, a brilliant virtuoso of vast *fresco schemes and large altarpieces, as well as a draftsman and etcher (*see under* intaglio). The greatest Italian *Rococo painter, he is also the last great master of the Italian Grand Manner founded in the High *Renaissance. While his links to *Veronese are especially close, his works betray knowledge, too, of *Titian, *Raphael, *Michelangelo and the masters of the *Baroque, notably *Rubens. His etchings, produced from *c.*1740, show reminiscences of *Rembrandt, *Castiglione, *Rosa and even *Dürer. Although, until the very last years of his life, his career was meteoric, he never worked in Rome, France or England – the centres of the new *Academic *classicism. His decorative frescos, shimmering with light and air, are superior to his oil paintings – except for sketches and models for larger works (e.g. London, Courtauld, National).

A precocious pupil of the mediocre **Gregorio Lazzarini** (1665–1730) he soon broke away from his master. In view of his later dependence on Veronese, the greatest influence on his earliest work was, surprisingly, not the Veronesque Sebastiano *Ricci but *Piazzetta (e.g. *Sacrifice of Isaac*, *c.*1716, Venice, Ospedaletto; *Madonna del Carmelo*, *c.*1721, Milan, Brera; *Glory of St Teresa*, *c.*1725, Venice, Scalzi).

In 1726 Tiepolo's characteristically light-hued and translucent painting style first appeared in his earliest important fresco cycle outside Venice (Udine, cathedral and archiepiscopal palace). After its completion, he received other commissions in northern Italy outside Venice, followed by the triumphant Venetian decorations: 1737–9, ceiling, Chiesa dei Gesuati; 1740–7, Scuola dei Carmini, Scalzi (destroyed); *c.*1744–5, salon of the Palazzo Labia, for which Girolamo *Mengozzi Colonna painted the architectural

framework. In 1750 he set out for Würzburg, the capital of Franconia, where he was commissioned to decorate the newly built Residenz of the Prince-Bishop (Kaisersaal and Grand Staircase, 1750–3), assisted by his two sons, **Giovanni Domenico** (1727–1804) and the 14-year-old **Lorenzo** (1736–76) (see below). The pedantic programme proposed for this decoration was transformed by Tiepolo into one of his grandest and most imaginative masterpieces. As is usual in his work, historical personages – even in the 12th-century German scenes of the Kaisersaal – are presented in the colourful dress of 16th-century Venice.

On his return, Tiepolo continued his work for Venetian churches (1754–5, Chiesa della Pietà). The family firm also undertook the decoration of several villas in the Veneto; the most outstanding is the Villa Valmarana near Vicenza (1757). Four reception rooms of the main house are each dedicated to one of the great epic poems – two ancient, two modern – Homer's *Iliad*, Virgil's *Aeneid*, Ariosto's *Orlando Furioso* and Tasso's *Gerusalemme Liberata*. All but one of the seven rooms of the guest house, however, were designed and executed by Giovanni Domenico Tiepolo, and here his individual talent was at last given free rein. Less grandly eloquent than his father's, his decorations are, in their very different way, as resonant: of pastoral; of exotic Chinoiserie; of the bourgeois Venetian theatre of Goldoni (a theme to which he would return with even greater vigour and wit in the decorations of the Tiepolos' own villa at Zianigo, 1790s, now Venice, Ca' Rezzonico). Sadly, Giovanni Domenico's talent for lyrical *genre had no other commissioned outlet.

Giovanni Battista's fertile imagination in design and speedy execution are further manifested in two ceilings of the Ca' Rezzonico, Venice, 1758; the fresco of the *Assumption* at Udine, Chiesa della Purità, painted in a single month in 1759; decorations in the Palazzo Canossa, Verona, 1761 and at the Villa Pisani at Stra, 1761–2. In between these commissions Tiepolo was also completing canvases for dispatch to the Russian court and to S. Marco, the Venetian church in Rome.

In the summer of 1762 at the invitation of King Charles III, the Tiepolo firm settled in Madrid. Here Giovanni Battista was to spend the last eight years of his life, electing not to return to Italy after the completion of the original commissions: the huge ceiling *Apotheosis of Spain*, in the throne room of the newly built royal palace, and two lesser ceilings. Yet even in Spain fashion was turning against him. Seven altarpieces, commissioned after some delay for Aranjuez, were soon removed at the instance of the king's confessor to be replaced by works by Anton Raffael *Mengs.

At their father's death Lorenzo and Giovanni Domenico separated, the former to remain in Spain, the latter returning to the Veneto. Although his independent painting output was limited (in addition to the decorations of the Villa Valmarana and his own villa at Zianigo, already mentioned, we can cite his youthful *Stations of the Cross*, 1749, Venice, S. Polo), Giovanni Domenico was a prolific etcher, reproducing his own and his father's works but also originating his own designs. The Punchinelli, which were a half-melancholy, half-satirical Tiepolo print motif, recur in painted form in the Zianigo frescos.

Tietz or **Dietz, Ferdinand** (1708–77) Bohemian-born *Rococo sculptor, active in Southern Germany. Many of his large stone garden sculptures were *polychromed to reproduce the appearance of porcelain figurines (works for Veitshöchheim, begun 1763, now mostly Würzburg, Mainfränkisches).

Tillemans, Peter (*d*.1734) Antwerp painter settled in England in 1708, best remembered as a topographical painter and one of the 'Old Masters' of sporting pictures. (*See also* Wootton; Barlow.)

Tinguely, Jean (1925–91) Swiss sculptor, known principally for his *kinetic constructions, powered to work as busy but functionless machines. He was trained in art and decoration and began to exhibit, mostly in Paris, in 1954. From the 1960s on his partly humorous, sometimes macabre, clanking sculptures were exhibited around

the world, and in 1966 he collaborated with Niki de *Saint-Phalle on a vast woman sculpture shown in Stockholm. Especially newsworthy was the *auto-destructive work, *Homage to New York*, whose brief 1960 life in the garden of the Museum of Modern Art, New York had to be ended by the fire brigade.

Tino di Camaino (active from c.1306–37) Sculptor and architect, son of a master of works at Siena Cathedral, Camaino di Crescentino, and the most gifted follower of Giovanni *Pisano. He was associated with *Giotto at the Angevin court in Naples, where he was summoned in 1323/4, and at his death Pietro *Lorenzetti became guardian to his children. His modern reputation rests on his funerary monuments, of which many are now dismembered and partly destroyed: the *Tomb of the Emperor Henry VIII*, 1315, Pisa, cathedral and Camposanto; the *Petroni monument*, 1318, Siena cathedral; *Della Torre monument*, Florence, S. Croce, and *Orso monument*, Florence cathedral, 1321–3; the Neapolitan tombs of *Mary of Hungary* (St Maria Donna Regina), *Catherine of Austria* (S. Lorenzo), *Charles of Calabria* and *Mary of Valois* (S. Chiara) 1323/4–37. His sculpture is marked by the lyrical interplay between a smoothly flowing incised line and massive block-like forms, but the austere effect today, so evocative of 20th-century experiments, is not the effect intended or indeed achieved in the 14th century, since most of the original *polychromy of many of the statues has been lost. He was the master of Giovanni di *Balduccio.

Tintoretto; Jacopo Robusti, called (1518–94) Prolific and influential Venetian painter, who converted the city's patrons and artists to a belated acceptance of a non-*naturalistic and anti-*classical form of *Mannerism. His nickname derives from his father's occupation of dyer (*tintore*). His virtuoso style, supposedly derived from *Michelangelo's *disegno* and *Titian's colourism, was actually arrived at during a long period of experimentation in the 1540s under the influence of Andrea *Schiavone, *Pordenone, *Lotto and the prints of *Parmigianino. It is characterized by violent energy, arbitrary use of colour and *chiaroscuro, asymmetrical and exaggerated *perspective in which the vanishing point, raised high, creates funnelling effects. His compositions were evidently worked out with the aid of miniature stages on which draped wax figures were disposed and sharply lit.

Tintoretto's reputation was established with the large painting of the *Miracle of St Mark or of the Slave*, 1548 (Venice, Accademia). Three later paintings complete a virtual St Mark cycle (after 1562, Venice, Accademia; Milan, Brera). From 1565 to 87 he worked recurrently on his major project, the pictorial decoration of the Scuola di S. Rocco, the most lavish ensemble of confraternity imagery extant in Venice and the largest to have been designed by a single artist (*see also* Carpaccio, Gentile Bellini). It has been said, justly, that Tintoretto can be fully appreciated only when viewed *in situ* here. The enormous lower hall (*Life of the Virgin*), the upper hall with its sombre painted ceiling compartments framed in heavy carved gilt (*Old Testament* scenes; on the walls, *Life of Christ*) and the adjoining room with its enormous *Crucifixion* (*Passion* scenes) reveal him to be one of the greatest decorative painters of all time. The flickering lights and eccentric foreshortenings which can look melodramatic in a gallery, are shown here to have been supremely effective devices, conveying at one and the same time religious fervour and worldly opulence.

With the aid of his extensive workshop, which included his sons **Domenico** (c.1560–1635) and **Marco** (d.1637) and his daughter **Marietta** (c.1556–c.90), as well as **Andrea Vicentino** (1539–c.1617) and the Greek-born **Antonio Vasilacchi** (1556–1629), Tintoretto worked extensively for the Doge's Palace in Venice. Perhaps the best-known of his vast canvases there is the *Paradiso*, 1588, in the Great Council Hall. A smaller anteroom in the palace contains four of his relatively infrequent mythologies (1578; another, London, National). Earlier in his career he had also been a prolific, if not particularly inventive, portraitist; the most successful portraits seem to be those of old men (e.g. Florence, Pitti, Uffizi; Paris, Louvre). His

best work, and the kind which engaged him most, was religious in content; in addition to the Scuola di S. Rocco, it can be seen to advantage in various Venetian churches, notably S. Giorgio Maggiore, S. Maria dell'Orto, and at the Accademia.

Tischbein Numerous dynasty of German portrait painters; several are identified by nicknames reflecting their places of residence or, in the case of one, most celebrated sitter. The best-known of several painter brothers, **Johann Heinrich the Elder**, 'Kassel' Tischbein (1722–89), a pupil of Carle van *Loo in Paris, 1744–8, and an assistant of *Piazzetta in Venice from 1749–50, produced portraits and mythological and *genre scenes. In 1752 he was appointed court painter by Count Wilhelm VIII of Hessen-Kassel; he later received various academic appointments in Kassel, where he remained for the rest of his life (Kassel, Kunstsammlungen; Berlin, Staatliche). He was the teacher of, among others, his nephews **Johann Friedrich August**, 'Leipzig' Tischbein (1750–1812), and **Johann Heinrich Wilhelm**, 'Goethe' Tischbein (1751–1829). Johann Friedrich August also studied in Paris in 1772–7, Rome and Naples between 1777 and 1780. He came to be considered the most important member of his family, and in 1800 became director of the Leipzig *Academy, a post he held until his death, despite a prolonged visit to Saint Petersburg, 1806–8. He was known particularly for his likenesses of women and children, and the style of all his portraits was influenced by that of the English portraitists, notably *Gainsborough and *Romney (Hamburg, Kunsthalle; Kassel, Kunstsammlungen; Berlin, Staatliche). His cousin Johann Heinrich Wilhelm also studied in Holland, 1771–3, and became a successful court portrait painter in Berlin from 1777 until 1779, when he left for Rome and then Naples, becoming director of the Naples Academy, 1789–99. In 1787 in Rome he had painted his most famous work, a portrait of his friend *Goethe in the Campagna (Frankfurt, Städelsches Kunstinstitut), while in Naples he published etchings (*see under* intaglio) of Greek vase paintings then in Sir William Hamilton's collection. When

Naples fell he returned to Germany, eventually entering the service of the Duke of Oldenburg in Eutin, where he executed designs after Italian scenes and antique decorations. The 44 plates of tapestry designs for the Duke's castle, the *Idylls*, were published with poetic commentaries by Goethe in his magazine, *On Art and Antiquity*.

Tissot, James or **Jacques** (1836–1902) French painter who worked for some time in London and for a while effected close contact between *avant-garde artists in London and Paris. He abandoned *History painting in a medieval mode for picturing modern life and was close to *Degas. He had anglicized his first name in 1859; from 1871 to 1882 he was resident in London, working for the fashionable magazine *Vanity Fair*, enjoying an elegant social life and establishing himself as a portraitist of smartly dressed men and women and of their leisure pursuits. He returned to Paris after the death of his model and mistress; though he visited London again in the 1890s he lost touch with his English friends and lived a relatively withdrawn life in Paris. From 1886 on he made repeated visits to Palestine to make studies towards religious paintings and also a compendious set of drawings for a projected illustrated Old Testament and others, 365 in number, to illustrate the Life of Christ; 270 of these, exhibite in the Louvre in 1894, drew admiration and religious fervour. His style, in his modern subjects, was generally light, combining delight in dress, manners and expressions with hints of social narrative and comment; the religious work is heavier and less engaging. His present popularity is an extension of the popularity of *Impressionism after decades when he was dismissed as little more than a Victorian sentimentalist.

Titian (**Tiziano Vecellio**) (*c.*1480/5–1576) The most celebrated Venetian painter, and the first to acquire a mainly international clientele, despite remaining in Venice for most of his life. A master of local genres, such as the anonymous 'courtesan' portrait (*Flora*, *c.*1520; *Girl in Blue Dress*, 1536, Florence, Uffizi, Pitti respectively),

the recumbent female nude (e.g. *Venus of Urbino*, 1538, Florence, Uffizi) the large narrative *scuola* painting on canvas (*Presentation of the Virgin*, 1534–8, Venice, Accademia; *see also* Gentile Bellini, Carpaccio), he was also prolific and innovatory in all the traditional pictorial categories. His altarpieces revived the venerable form, bringing to it new movement, drama and optical complexity. His portraits established the long-lasting conventions of aristocratic and princely European portraiture. His mythological paintings virtually codified the semblance of pagan antiquity in the European imagination – not by recreating the forms of *classical art, but by seeming to bring the world of ancient myth to life. Albeit not the originator of the most extreme form of Venetian colourism (*see under disegno*; *also* colour) he remains its most famous and influential exponent.

Born in Pieve di Cadore, Titian trained in Venice under the *Bellini, before joining *Giorgione *c.*1507. His first recorded commission, 1508, was the side façade of the Fondaco dei Tedeschi, the German merchants' warehouse whose main façade was assigned to Giorgione (fragments, Venice, Ca' d'Oro). Titian was to complete Giorgione's *Venus* (1510, Dresden, Gemäldegalerie). Their styles were then so close that several works from about this date have been attributed to either artist, although they may be the work of neither (e.g. *Concert Champêtre*, Paris, Louvre). As Titian's own manner becomes distinct from that of Giorgione, however, it can be seen to be more outgoing (e.g. *Gipsy Madonna*, *c.*1510, Vienna, Kunsthistorisches). This is evident even in his most poetic, 'Giorgionesque' secular subjects (*Three Ages of Man*, *c.*1509, Edinburgh, National), and in his works of private devotion (*Noli me tangere*, *c.*1508, London, National), and is confirmed in his first large-scale narrative works, the documented 1511 *frescos for the Scuola di S. Antonio, Padua. It is most striking in his monumental early half-length portraits on the scale of life (*Man with Blue Sleeve*; *Woman called 'La Schiavona'*; both *c.*1511, London, National), which boldly engage the viewer's eye, breaking decisively with the introverted portrait type of Giovanni Bellini and

Giorgione, and perhaps also signalling Titian's interest in the latest developments of central Italian High *Renaissance art, known in Venice through prints and drawings (*see also* his design for a woodcut of the *Triumph of Christ*, 1508, which quotes a figure from *Michelangelo).

Titian's altarpieces were even more revolutionary. The *Assumption and Coronation of the Virgin* (1516–18, Venice, S. Maria Gloriosa dei Frari) was unprecedented in the city in its large scale, dazzling colour, optical *realism, movement and introduction of central Italian *contrapposto. It was followed in 1519–26 with the *Pesaro Madonna* for the same Franciscan church. The brilliant series of altarpieces inaugurated here culminated *c.*1526–30 in the rival Dominican church of SS. Giovanni e Paolo, with the *Death of St Peter Martyr* depicted in an atmospheric, agitated landscape. Although this picture was destroyed by fire in 1867, copies, painted and engraved, attest to its appearance. Perhaps only two of Titian's many later altarpieces rival these in colouristic realism and drama: the nocturnal *Martyrdom of St Lawrence* (*c.*1548–57, Venice, Gesuiti) and its even more extraordinary and powerful variant of 1564–7 in the Escorial, Iglesia Vieja.

In 1513 Titian, after much intrigue against older artists, obtained the sinecure of painting for the Great Council Chamber in the Doge's Palace. Although he continued to draw his salary, Titian only completed one scene, *The Battle of Spoleto* (compl. 1538), a rival of the famous never-finished battle scenes by *Leonardo da Vinci and Michelangelo in an analogous room in Florence. Titian's most elaborate composition, and one of his most influential, it, too, was destroyed by fire (in 1577).

In 1516 Titian began his international career through his association with his first princely patron, Alfonso d'*Este of Ferrara, for whom he painted his first series of large mythological narratives, the genre in which, after the death of *Raphael, he was to have no rivals (*The Worship of Venus*, 1518–19, Madrid, Prado; *Bacchus and Ariadne*, 1520–3, London, National; *The Andrians*, 1523–5, Madrid, Prado). Based

on ancient literary texts, these works have no known visual precedents.

Later in life Titian was to paint another series of mythological narratives, whose principal source was Ovid's *Metamorphoses*, but whose underlying themes were the celebration of the female nude and the power of erotic passion. Painted for Titian's most discerning and appreciative patron, Philip II of Spain, these *poesie* (as Titian called them) demonstrate, as they were intended to, the ability of painting to rival poetry. The choice of subject was left to the artist (*Danaë*, *c*.1549–50; *Venus and Adonis*, 1551–4, both Madrid, Prado; *Perseus and Andromeda*, 1554–6, London, Wallace; *Diana and Actaeon, Diana and Callisto*, both 1556–9, Edinburgh, National; *Rape of Europa*, 1559–62, Boston, MA, Gardner). (The unfinished *Death of Actaeon*, *c*.1555, London, National, was probably begun for the series but was never sent to Spain. *Tarquin and Lucretia*, 1568–71, Cambridge, Fitzwilliam, Titian's last narrative work on an antique theme, was sent to Philip but does not form part of this series.) These works differ from the mythologies for Alfonso d'Este not only in their heightened eroticism but also in style. From the 1540s Titian painted with a more open, looser brushwork, in a complex, time-consuming system of glazes, fluid strokes and even finger smears, intended to give the finished surface the freshness and sparkle of a spontaneous sketch. Although often credited with the invention of this colouristic technique, Titian was almost certainly influenced by the earlier experiments of Andrea *Schiavone and Jacopo *Tintoretto. In the *Diana* paintings he had also changed his figure canon, in response to the *Mannerist engravings of the School of Fontainebleau (*see* Primaticcio).

Titian's lengthy and fruitful relationship with Philip, begun before the latter ascended to the throne of Spain (e.g. *Portrait of Prince Philip of Spain*, 1549, Madrid, Prado) had its origins in his patronage by Philip's father, the *Habsburg Emperor Charles V. Introduced to Charles in 1532, Titian was to execute for him works which virtually created the canon for all later royal portraiture (*Charles V with a dog*, *c*.1532–6, Madrid, Prado, after the painting by Jacob *Seisenegger, and one of the first full-length Italian portraits; *Charles V on Horseback*, 1548, Madrid, Prado; *Charles V Seated*, 1548, Munich, Alte Pinakothek). So many commissions flowed from all the Habsburgs and their courts that from the 1550s Titian hardly executed any pictures for Venetian clients.

In the same years that he was portraying Europe's mightiest secular ruler, however, Titian was also prevailed upon to paint the pope, Paul III *Farnese, in Rome (*Paul III with his grandsons Cardinal Alessandro and Ottaviano Farnese*, 1545–6, Naples, Capodimonte). Left unfinished, this remarkable picture reflects to some extent the schema of Raphael's portrait of Leo X with his nephews – although in other respects Titian's visit to Rome had little impact on the artist, who had assimilated ancient and central Italian influences, through drawings and prints, many years before.

This entry perforce omits perhaps the majority of the works in Titian's enormous *œuvre*, augmented by the output of his studio. His son **Orazio Vecellio** (1525–76) ran the workshop in his father's old age, when few original autograph compositions were produced, except for Philip of Spain. It is still disputed whether Titian's last few years saw the emergence of an even broader and looser painting style, or whether this is an effect produced by the dispersal of unfinished works from the studio after Titian's and Orazio's deaths. Titian's methods of painting in maturity are recorded in the transcript of an eye-witness account by his one-time pupil, *Palma Giovane.

Tobey, Mark (1890–1976) American painter who first became known as an illustrator, working mostly in Chicago and New York. In 1918 he was converted to the Baha'i faith which offers a synthesis of world religions, and about this time he made contact with some of the leading artists of New York and the East coast, including *Duchamp and *Hartley. In 1922 he moved to Seattle where he learned calligraphy from a Chinese student. 1926–9

he was mainly in Paris, though he travelled also to Spain, Greece and Haifa. In 1930, after showing in an exhibition of contemporary American art in New York (MoMA), Tobey moved to England where he taught art, philosophy and other subjects at Dartington Hall until 1937. During those years he also travelled widely in Europe and, with the English potter Bernard Leach, to China and to Japan where he spent some weeks in a Zen monastery. Meanwhile he also made visits to the USA. Back at Dartington Hall, where he came to know the sinologist Arthur Waley, Tobey developed his 'white writing' idiom, painting white, often cursive marks on to dark or tinted canvases or paper. Much of his early work was destroyed in the 1939–45 war. In 1939 he returned to Seattle and worked for the *Federal Arts Projects. He had exhibited in Chicago, New York and Seattle, but from the mid-1940s on showed more regularly in America and Europe. His work was seen at the Venice Biennales of 1948 and 1958, and in 1962 a retrospective toured Paris, London, New York and Chicago. By now he was recognized as a major *Abstract Expressionist, though one standing apart from the New York School in his spirituality and Oriental qualities as well as in his devoted musicianship, playing classical music as well as jazz and blues on the piano. In 1960 he had settled in Basel, but he considered himself a world citizen, travelled frequently and exhibited globally. Major exhibitions celebrated his 80th birthday in Seattle and Basel. In 1974 Washington (National Collection of Fine Art) showed a 'Tribute to Mark Tobey'.

Tobey's art was always distinguished from that of other Abstract Expressionists, even those who in some measure shared his religious feelings, on account of its delicacy and slightness even when individual paintings were of substantial size. Although his 'white writing' style is of especial importance in his development, the marks he made and the colours and scale he used over the years vary astonishingly; what links them is his feeling for silence and significant emptiness and the fusion he achieved of ancient and new cultures and methods.

Tomé, Narciso (*c.* 1690–1742) Spanish sculptor/architect, first recorded with his brothers and their father Antonio working on the University façade at Valladolid in 1715. He is chiefly remembered, however, for the Transparente Chapel in Toledo Cathedral, 1721–32, ingeniously spot-lit by the removal of a Gothic rib-vault, whose conception and execution he proudly claims in an inscription.

Tomlin, Bradley Walker (1899–1953) American painter, born and trained in Syracuse, NY, and also in Paris during 1923–4. He began to have exhibitions in 1923 but his fame dates from the 1940s when, working in New York and close to *Motherwell and others associated with *Abstract Expressionism, he developed a basically *Cubist mode of still-life painting into a vigorous idiom of *abstract painting, characterized by firm brushstrokes and geometrical elements creating between them subtle, not markedly emotional, spatial compositions.

Tommaso da Modena (*c.* 1325–79) Italian painter, active in northern Italy. His chief work is the *fresco decoration of the chapter house of S. Nicolò in Treviso, 1352, with portraits of Dominican friars at their scholarly labours. These lively vignettes, framed by texts, have some kinship with the work of Master *Theodoric in Prague, and there are two panels by Tommaso da Modena in Karlstejn Castle, commissioned by the Emperor Charles IV.

Tondo (Italian, 'round') A circular painting or relief; the most famous must be *Michelangelo's *Doni Tondo* (Florence, Uffizi). *See also* desco da parto.

Toorop, Charley (1891–1955) Dutch painter, taught principally by her father Jan and at first a *Symbolist like him. Subsequently, especially after his death, she attached herself more to the emphatic idiom of Van *Gogh and during the Second World War painted some impressive monumental works, best seen in the Stedelijk Museum, Amsterdam.

Toorop, Jan (1858–1928) Dutch painter, born in Java. He settled in Holland, studied art in Delft, Amsterdam and Brussels where he became a member of the Libre Esthétique group that developed out of Les *Vingt and gave him contact with Belgium's leading *Symbolist artists and writers. In 1886 he was in London, impressed by the *Pre-Raphaelites and by William *Morris. By 1890 he was in touch with the Rosicrucian movement in Paris and its taste for extreme aestheticism and artificiality. About this time he arrived at his particular style and type of subject. The style, even when the work is painted, is primarily graphic, a closely packed surface of sinuous and angular lines delivering figures and natural forms in semi-*abstract, much attenuated forms. His subjects are allegorical inventions, heavy with symbolism largely of his own invention, and explained by him in accompanying texts. Key examples are *Fate*, *The Three Brides* and *Song of Our Time* (all in pencil and chalk on paper, 1893; Otterlo, Kröller-Müller), in which crowded figures, treated as patterns and accompanied by abstract patterns implying sounds, smells and emotions, enact the battle between good and evil, material ties and spiritual aspirations, death and salvation. In date and degree of linear abstraction these works come close to the more directly religious art of his younger contemporary *Prikker, both of them evidence of the hothouse atmosphere offered by Symbolism in the 1890s as well as the influence of *Art Nouveau linearity and patterning. Toorop's work adds to this an intensity which expresses his missionary urgency in terms in Oriental, partly Javanese forms.

Torres-García, Joaquín (1874–1949) Uruguayan painter and sculptor. His family moved to Spain when he was 16, and he grew up in Barcelona where he studied and in 1900 had his first one-man exhibition. The architect Gaudi and others commissioned from him stained-glass windows and murals which he executed in a *classical idiom influenced by *Puvis de Chavannes. He was in New York in 1920–2 but returned to Europe and in 1926 settled in Paris. He became part of the *Elementarist world of Van *Doesburg and *Domela. In 1930 he and *Seuphor founded the short-lived *abstract art association, *Cercle et Carré. In 1932 he moved to Madrid where he tried to establish a school and museum of *Constructive art. In 1934 he returned to his home town of Montevideo. There he gave much time to teaching and writing, forming in 1935 the Association of Constructive Artists and through it propagating his Platonic idealism.

His mature work in two and three dimensions owes much to Elementarism but, just as his thought was eclectic and inclusive, so also his art embraced mythical symbolism and references, American Indian signs and images and aspects of European Bronze Age artefacts, as well as aligning itself with radical abstraction. A typical painting, from the late 1930s on, is divided into several areas containing signs and simplified representations while suggesting tablets at once ancient and modern. The *Cosmic Monument* (1938), carved in granite for a park in Montevideo, is a striking adaptation of this idiom. In 1939 he published an autobiography and in 1944 a major theoretical book, *Constructive Universalism*. Montevideo has a Torres-García Museum.

Torrigiano, Pietro (1472–1528) Florentine sculptor, a pupil of *Bertoldo. He is remembered for having assaulted *Michelangelo and broken his nose, for which he was exiled from Florence (before 1492). After a stay in Rome (*stucco decorations of the Torre Borgia) he served in the armies of Cesare Borgia in the Romagna (after 1498); leaving Italy sometime after 1500, he worked in the Netherlands for the Regent Margaret of Austria (1509–10), and in London from 1511. His main extant work is the marble and gilt bronze tomb of Henry VII and Elizabeth of York (1512–19, London, Westminster Abbey), influenced in form by *Pollaiuolo's tomb of Sixtus IV. He also executed the terracotta monument of Dr John Young (after 1516, now London, Public Records Office) and a bronze relief portrait of Sir Thomas Lovell (*c.*1518, London, Westminster Abbey). Around 1522 Torrigiano

moved to Spain (terracotta statues, now Seville, Museum), where he died at the hands of the Inquisition.

Torriti, Jacopo (active in the 1290s) Italian painter and mosaic designer, famous for two great, signed, mosaics commissioned by Pope Nicholas IV, which decorate the apses of the Roman churches of S. Giovanni in Laterano and Sta Maria Maggiore. While the former has been heavily restored, the latter demonstrates Torriti's brilliant retention, or recapture, of the lively *naturalism of Late Antique plant and animal decoration, and his mastery of the *Byzantine figure style – revealing him as the leading Roman contemporary of *Cavallino. A small group of *frescos in the Upper Church of S. Francesco, Assisi, has been attributed to him.

Toulouse-Lautrec, Henri de (1864– 1901) French painter, born in Albi into an aristocratic family. Of weak constitution, he broke both legs in his teens and they failed to develop as his torso grew. As an adult, a misproportioned dwarf, he stressed his condition through his clothing and in his self-portraits; long immobility had led him into drawing and writing and prevented him from following the family tradition of an army career. His gifts as draftsman showed early; painting he studied in Paris with Princeteau and in Cormon's school where he met *Bernard, Van *Gogh and others. He was attracted to the *realism of *Courbet and *Impressionist *naturalism, and was generally impatient with academic routines. His first paintings are landscapes and portraits of friends and of animals in a fresh manner close to *Degas's. In the later 1880s his incisiveness as draftsman asserted itself in his paintings. He began to work for the music-hall singer Aristide Bruant, decorating a room in his Montmartre dance hall with paintings of young women as symbols of Paris and making illustrations for Bruant's journal. He provided a poster for the opening of the Moulin Rouge in 1890, his first essay in that medium; spread over the walls and fences of Paris, it brought instant fame and further such commissions.

His paintings began to be exhibited and sold when a school friend, Maurice Joyant, was put in charge of the Goupil Gallery in Montmartre. Partly in mockery of *Renoir, whom he admired, he produced paintings of dance-hall and circus scenes that showed not the sweetness but the sleazy gaiety of Paris nightlife: his *Moulin de la Galette* (1889; Chicago, Art Institute) contrasts sharply with Renoir's (1876) though similar in many respects. The chief stylistic difference is in Toulouse-Lautrec's use of thin paint as a graphic medium and his stress on characteristic forms, in faces and movements, coming close to *caricature. His ironic spirit guided his personal life as well as his art: he was as affectionate as harsh in his criticism of the shadowy world he had chosen to inhabit. Eager to live as fully as his physique and figure permitted, he sought experience in nightclubs and brothels, sympathizing both with performance for money and the intimate acts done for love and representing them memorably in paintings and prints marked equally by acuity and courtesy. The life he led damaged his health. A loosening and darkening in his manner of painting is noticeable in the late 1890s. In 1899 he entered a clinic in Neuilly where Joyant encouraged him to work on albums of lithographs, *At the Circus* and *Jockeys*. He spent some months in Le Havre and in Bordeaux. He returned to Paris in 1901.

Of great influence as images of *fin de siècle* Paris, Toulouse-Lautrec's art found many imitators, most of them content to emulate his sharpness. But for some younger artists, *Picasso among them, his work offered a means of making art deal with social deprivation without surrendering to sentimental imagery. Albi has a fine Toulouse-Lautrec museum.

Tournier, Nicolas (1590–1638/9) French painter chiefly active in Toulouse, where he painted religious compositions in a more elegant version of the idiom of *Caravaggio (e.g. Narbonne, Cathedral; Toulouse, Augustins) and *genre works in the manner of *Manfredi (St Louis, City Art). He also executed an enormous *Victory of Constantine* in emulation of *Giulio Romano's murals in the Vatican (Toulouse,

Augustins). He was in Rome from 1619 to 1626.

Tousignant, Claude (1932–) Canadian painter, born and trained in Montreal, who specialized in *abstract colour paintings, aiming at maximal colour experiences through using colour surfaces with only the most minimal divisions or compositions, at times covering them with only one colour and setting them in space like parts of an architectonic sculpture.

Towne, Francis (1739/40–1816) English painter. He was a drawing master in Exeter, but tried unsuccessfully to make a reputation in London with his oil paintings, mainly commissioned portraits of country houses (London, Tate). His best work is now considered to have been the highly individual watercolours he executed during a trip to Switzerland and Italy in 1780–1, which he exhibited in 1785 but very few of which left his hands. They are now mostly in private collections.

Traini, Francesco (active 1321–after 1363) Italian painter active in Pisa. His one signed work is the altarpiece from S. Domenico, Pisa, dated 1345 and now in the city museum, but his reputation rests mainly on his possible, but unproven, authorship of the dramatic *fresco of the *Triumph of Death* executed in the early 1350s in the Camposanto, or cemetery, of Pisa (*see also* Buffalmacco). Some art historians attribute the fresco to an Emilian artist from the circle of *Vitale of Bologna.

Třeboň, Master of (active shortly after 1380) The outstanding Bohemian painter of his time, active in the monastery of Třeboň in Southern Bohemia – Wittingau in German, hence the artist's alternative title of Master of Wittingau. He is known from the panels of a dismembered altarpiece from the monastery (Prague, National). These adopt the *naturalism of Master *Theodoric for the 'plebeian' figures – such as those of the soldiers in the scene of the Resurrection – combining it with *Gothic elegance for the figures of Christ

and the saints painted on the reverse of the panels; the general effect is one of *expressive mysticism which has little counterpart in Western European art, although the Master is sometimes said to have been a pioneer of the International *Gothic style of, e.g. the Limbourg brothers.

Trevisani, Francesco (1656–1746) Neapolitan painter, trained in Venice and working in Rome from 1678/81. Although he also executed altarpieces, he was an internationally popular specialist in *cabinet pictures of the Madonna and Child, painted in a sweet *Rococo style chastened through *Maratta's *classicizing influence (e.g. Rome, Nazionale).

triptych *See under* polyptych.

Tristán, Luis (*c.*1586–1624) The best-known pupil of El *Greco, working in his Toledo studio 1603–8 (*see also* Pedro Orrente, Juan Bautista Mayno). Probably between 1606–13 he went to Italy, returning to settle permanently in Toledo in 1613. He is one of the earliest Spanish artists to evolve a *naturalistic *Caravaggesque style. His works for Seville (Alcazar; cathedral) are thought to have been a decisive influence on *Velázquez. He also executed outstanding portraits (e.g. Madrid, Prado).

Troger, Paul (1698–1762) Austrian decorative painter and printmaker, trained in Italy, where he was particularly influenced by *Solimena. In innumerable *frescos and altarpieces he effected the transition from *Baroque to *Rococo throughout the *Habsburg empire (e.g. Altenburg, church and library). His teaching at the Vienna *Academy was a decisive influence on *Maulbertsch, who emulated his oil sketches.

trompe l'œil *See under* illusionism.

Troost, Cornelis (1696–1750) Amsterdam painter of portraits and *genre, the foremost Dutch portraitist of the 18th century. Working both in *oils and in *pastels, he introduced a note of infor-

mality and wit into the traditions of group and individual portraiture established in the previous century, painting both on the scale of life and in the small format of the *Conversation Piece. A master also of comic genre and theatrical pieces, he has been called a 'Dutch *Hogarth', although he lacks the moralizing bite of his English contemporary (The Hague, Mauritshuis; Amsterdam, Rijksmuseum; Dublin, National).

Troy, Jean-François de (1679–1752) With his rival *Lemoyne, the leading painter in France c.1725; bested by Lemoyne for the post of *Premier Peintre du Roi*, he became Director of the French *Academy in Rome, 1738–52. Trained by his father **François de Troy** (1645–1730), a Toulouse-born painter best known for his portraits in the Flemish tradition of *Van Dyck, Jean-François travelled to Italy 1609–1707, and was received at the Academy in Paris in 1708, the year in which his father became Director (reception piece *Niobe and her Children*, Montpellier, Musée). An able executant of large religious works (e.g. *St Geneviève and the Aldermen of Paris*, 1726, Paris, St Etienne-du-Mont), mythological and history paintings (*see under* genres; e.g. Nancy, Musée; Neuchatel, Musée) and cartoons for Gobelins tapestries (*Story of Esther*, 1738–42, Paris, Louvre; Arts Decoratifs; *Jason and Medea*, 1743–6, museums of Angers; Brest; Clermont-Ferrand; Le Puy; Toulouse; sketch, Birmingham, Barber), he was most prized by connoisseurs for his topical genre pictures (e.g. *The Reading from Molière*, c.1728, coll. Dowager Marchioness of Cholmondeley). In these smaller '*tableaux de mode*', more prosaic than the *fêtes galantes* of *Watteau which may have influenced them, de Troy's gifts for *realistic observation of contemporary fashions of dress, behaviour and setting are most fully displayed.

Troyon, Constant (1810–65) French landscape painter, painting landscapes with animals in a manner he derived from study of *Cuyp and other Dutch painters, and subsequently a member of the

*Barbizon School. *Boudin and the young *Monet admired his rendering of natural light, seen especially in his late marine paintings.

Trübner, Wilhelm (1851–1917) German painter who studied art in Karlsruhe and settled in Munich in 1869. His early work was in the spirit of *Courbet and *Leibl. The later paintings are less factual, freer in the use of paint and to some degree influenced by *Impressionist *naturalism.

Trumbull, John (1756–1843) American painter, son of a governor of Connecticut. He served in the War of Independence and began to study art only in 1777. In 1780 he went to England where he was arrested as a spy. In 1784 he entered the studio of Benjamin *West in London. He remained in London until 1789, doing *History paintings celebrating events in the war in emulation of West and *Copley, and embarking on a project of a pictorial record of the American Revolution. This involved making portrait studies of the politicians and generals who were prominent in it. Back in the USA he worked largely as portraitist. In 1794–1804 he was again in Europe, mainly in London and Paris, on diplomatic and commercial errands as much as artistic, and again was suspected of being a spy. Commissioned to paint murals in the rotunda of the Capitol, Washington, he produced compositions (*The Declaration of Independence* etc., 1817–24) stiffened by crowds of individual portraits. Engravings made them familiar to American citizens. Generally his painting now lacked its earlier energy, and the American *Academy of Fine Arts, which he presided over in 1817, seems to have failed largely through his cold and self-seeking ways. He saw young artists as a threat to himself. He contracted with Yale University in 1831 to supply portraits and miniatures in return for an annuity, and he designed the Trumbull Gallery there. Ready in 1832, it was America's first art museum but was pulled down in 1901. In 1837 he embarked on an autobiography in which he highlights his activities as an agent of his country and

dismisses painting as frivolous and of little social value. Yale University Art Gallery at New Haven has a major collection of his paintings.

Tucker, William (1935–) British-American sculptor, a leading member of the post-*Caro generation. He studied History at Oxford but then turned to art, studying in London at the Central and at St Martin's Schools of Art, and was one of the young artists presented in a milestone exhibition, 'New Generation 1965', at the Whitechapel Gallery. In 1972 his work was included in the British show at the Venice Biennale. In 1973 he had a solo exhibition at the Serpentine Gallery in London. Essays he wrote on modern sculpture were published as *The Language of Sculpture* in 1974 and the following year he presented a major contemporary sculpture show at the Hayward Gallery in London, 'The Condition of Sculpture'. He had been exploring simple, almost *Minimal forms of sculpture during the preceding years, working in a range of materials from plaster, or plaster and steel, to reinforced glass fibres with colour, metal tubes and wood lathes. The work seemed both considered and irrational, strange configurations even when geometrical, and eluding ready understanding. In 1976 he moved to Canada to teach; soon after he moved to the USA and become an American citizen. His work became much larger and more monumental, and in the 1980s Tucker turned to modelling forms, for casting in bronze, that recall the work of *Rodin and hover strangely between being *abstract and *figurative, parts of animals or a human limb or torso, one's reading changing with one's viewing position. These grave and impressive works appear to show him distancing himself from the modern tradition he has written about so intelligently. Some of these new sculptures bear the names of ancient Greek gods and goddesses, and do take on a primeval presence. He has shown in many group exhibitions around the world, and in solo exhibitions in the USA and in Britain.

Tullio Lombardo *See under* Pietro Solari.

Tunnard, John (1900–71) British painter, trained in design at the Royal College of Art and active as commercial artist until 1929, when he turned to painting. In 1933 he had his first solo exhibition (London, Redfern). Soon, influenced by *Klee and Paris *Surrealists, he developed a personal Surrealist idiom involving clear delineation of dream landscapes. In the 1940s his work was seen also on the continent of Europe and in the USA. A major exhibition toured Britain in 1977.

Tura, Cosmè or **Cosimo** (*c.*1430–95) The first important Ferrarese painter, influential on all his successors at the *Este court, where he was employed *c.*1451–86 (*see also* Cossa, Costa). His harsh yet decorative style can be understood as a reworking of the International *Gothic mode in the light of 'modern' researches as mediated through the idioms of *Mantegna, *Piero della Francesca and the Venetian works of *Andrea del Castagno. Major projects by Tura have been destroyed or dismantled. Allegorical figures (now London, National; Berlin, Staatliche) may be all that remain of his decorations for the *studiolo* at Belfiore, 1458–63. The great Roverella *polyptych, *c.*1480, has been dispersed to London, National; Rome, Colonna; Paris, Louvre; San Diego, CA, Museum; New York, Metropolitan; Boston, MA, Gardner and Cambridge, MA, Fogg. Badly damaged organ shutters for Ferrara cathedral, 1469, are now in the Museo del Duomo. Other works Bergamo, Accademia; Florence, Uffizi; etc.

Turnbull, William (1922–) British artist, born in Scotland and, after war service in the Royal Air Force, trained at the Slade School in London during 1946–8. He then spent two years in Paris, close to his fellow student *Paolozzi and meeting some of Paris's leading artists. He showed with Paolozzi in London (Hanover Gallery) in 1950, and from that time has had many solo exhibitions, in London from 1967 on at the Waddington Galleries and also abroad. In 1972 the Tate Gallery, London, presented a retrospective exhibition of his paintings and sculpture. The

sculptor Kim Lim became his wife in 1960. He taught for many years at the Central School in London.

At various times painting seemed to be his dominant concern but an all-over view suggests that sculpture has been his continuing priority. As a sculptor, he worked in two, apparently contradictory directions, as a maker of totemic images, in stone and wood or in bronze, that owe something to *Brancusi's wood sculptures, and as a *Minimalist assembler of industrial steel elements, readymade or specially shaped and constructed, and usually given bright colours. His sculpture has come in three major phases, these two in succession and then, in the 1980s, a return to the totemic and primitivist mode. His painting, of especial strength and significance in the 1960s, also tended to a personal sort of Minimalism well before that movement was recognized and named, and included a number of canvases divided between two colours and others in which one colour seeks to occupy the surface but leaves part of the canvas untouched.

Turner, Joseph Mallord William (1775–1851) English painter, now considered one of the most remarkable of 19th-century artists. Son of a London barber, he drew from childhood and entered the Royal *Academy Schools at 14. At 15 he showed a watercolour in the Academy exhibition and at 16 he began touring around Britain recording buildings and natural scenery in drawings and watercolours. In 1796 he showed an oil painting, *Fishermen at Sea*: a moonlit and stormy scene already marked by his interest in light and in representing man amid nature's drama. He observed, but he also steeped himself in the art of others. He copied J.R. *Cozens's watercolours and took ideas from Dutch painting and from Richard *Wilson and de *Loutherbourg, developing his skills and range of expression. *Loch Awe, with a Rainbow* (about 1801, pc) shows both his *Romantic feeling for special effects of light and atmosphere and a unique delicacy in his use of watercolour and paper.

In 1798, nearly elected an Associate of the Royal Academy, he was found to be younger than the rules allowed; his election

followed in 1799 and full membership in 1802. That year he went on the first of several Continental tours, this time to France and Switzerland. He studied the Louvre's art collection, enriched by Napoleon's looted treasures, and then turned to the Alps. Back home, he worked up sketches into watercolours substantial enough to be exhibited, producing also oil paintings that reflect his enlarged experience. These now included *History subjects: the first was *The Fifth Plague of Egypt* (1800; Indianapolis, MA), a Biblical theme (actually the seventh plague) used as the occasion for a dramatic landscape in the style of *Poussin, apparent also in some of his pure landscapes of the period. *Calais Pier, with French Poissards* . . . (1803) draws on being 'nearly swampt' as his boat attempted to land, and treats a *genre theme as a History subject. Another religious subject, *Holy Family* (1803), involved 'spoiling a fine landscape by very bad figures' and led to the suggestion that he should abandon History painting. Such comments may have spurred him on: in the years that followed he studied and imitated the great landscape and History painters of the past, notably *Claude whose compositions he adapted and whom he challenged directly in his grandiose *Dido building Carthage* (1815; London, National). More impressively, he fused nature and history in *Snow Storm: Hannibal and his Army crossing the Alps* (1812): nature's drama presages the decline and fall of Carthage which Turner associated with France's defeat by Britain and her allies and also with the transience of power; the theme recurs in his *oeuvre*, often borne by vortical compositions. The catalogue entry for this one, at the 1812 Academy show, includes lines from his own epic poem, *Fallacies of Hope*. He used quotations from the same work on later occasions. It reveals both his Romantic spirit, caring more for resonance than precision, and his incomplete education.

His pursuit of nature's riches continued. From 1809 on he repeatedly stayed at Petworth House in Sussex as the guest of Lord Egremont, a great collector of contemporary art. He drew and painted the house and grounds many times, for his

patron and for himself, at times risking incomprehensibility in his attention to effects of light at the expense of form. He went to Belgium, the Rhineland and Holland for the first time in 1817, to Italy for the first time in 1819. Ever greater familiarity with nature's many forms and moods called for experiment and refinement in his picturing of them. Commentators began to divide into those who found his work 'gorgeous' and those who found it unnatural and empty. By the late 1820s Turner was both famous and notorious and when he gave his landscapes History content critics and art-lovers were especially likely to take offence: 'a glaring extravagant daub' and 'colouring run mad' are examples of one sort; 'one of the most beautiful and magnificent landscapes that ever mind conceived or pencil [= brush] drew' (*The Times*, 6 May 1831) can represent those whose response developed with his art. *Ruskin's admiration was forming at this time, stimulated by what he saw as examples of unique truth to nature and interpreted as moral statements for modern times, but he too thought some of Turner's History paintings 'nonsense'.

Turner worked ceaselessly. He never married but had relationships with women whom he kept from sight. His social life was slight; his behaviour was inelegant even when friendly. Fellow artists were in awe of him and reported on his way of transforming exhibited works on the touching-up days allowed by the Academy to associates and members: he heightened colour and light effects, diminishing the impact of others' work nearby and demonstrating art as a virtuoso performance. He did book illustrations and series of views for topographical books, making watercolours which others turned into engravings. His *Liber Studiorum*, 71 engraved images demonstrating his range, was issued in parts during 1807–19 in imitation of *Claude's *Liber Veritatis*; *Sequels*, engraved by himself, were produced later but never published. He exhibited regularly at the Royal Academy and frequently in other galleries; he also had a private gallery as part of, or adjacent to, his successive homes in Central London where his work could

be seen and for some years held annual exhibitions there.

The roles of fancy and fact are not easily distinguished in his art, and there were those who came to think that he was close to madness. Among the paintings he showed in public places in and after 1835 – when he was about 60 years of age and more – are some of his most surprising inventions, their themes pointing to an obsession with apocalyptic extremes and death. *The Burning of the House of Lords and Commons* (two different paintings, 1835; Philadelphia MoA and Cleveland MoA), and *Keelmen heaving in Coals by Night* (1835; Washington National) portray events and activities he witnessed but accord them supernatural force. *Slavers throwing overboard the Dead and Dying* (1840; Boston MFA) combines elements from his seascapes with echoes of such dire visions as the damned in a Last Judgment or the death of Icarus with, as Thackeray wrote, 'a horrible sea of emerald and purple'. 'Is the picture *sublime or ridiculous?' he asked. Ruskin, who owned it, insisted on its sublimity and thought it Turner's masterpiece, yet found it 'too painful to live with' after some years. *Dawn of Christianity* (1841; Belfast, Ulster M), a round image on a square canvas, and *Peace – Burial at Sea* (1842), square, one visionary, the other a memorial to *Wilkie based on witnesses' reports and Turner's intimate knowledge of the sea, were both dismissed as follies, as were two square paintings of 1843, reflecting on a cataclysm in conjunction with colour as images of evil and of hope: *Shade and Darkness – the Evening of the Deluge* and *Light and Colour (*Goethe's Theory) – the Morning after the Deluge*. When he painted *The Angel standing in the Sun* (1846) it was claimed that he had 'taken leave of form altogether' while his use of colour in mighty contrasts was seen as 'consummate'. His paintings of Venice, resulting from visits in 1833 and 1840, drew praise in spite of their pessimistic undertone; the watercolours he made there include some of his most poetic and delicate. In *Norham Castle, Sunrise* (probably after 1835 and perhaps unfinished) he used oils with similar delicacy to

catch the effect of early light seen through mist over water in a place he had painted several times before. Other oils of the period show the same delicate washes; Turner did not exhibit them. Some of them seem to have been removed from his studio, and thus from the bequest, after his death, notably *Landscape with a River* . . . (Paris, Louvre) which went into a Paris collection and was admired by *Pissarro. His late sea paintings, some of them exhibited by him, come close to being *abstract constructions in which the texture of paint, as well as tone and colour and compositional dynamics, together convey experiences whose truth we can only guess at and whose beauty it has taken time to recognize.

Turner's mastery was apparent early, especially to fellow painters. He was elected Professor of *Perspective at the Academy in 1807 and Professor of Painting in 1810. He died a very wealthy man. He had sold well but he had kept pictures he considered key works and had bought others back. He bequeathed his finished paintings to the National Gallery in London, asking that two of them should hang beside two paintings by Claude (as they do today), and that the others – about 100 – should be shown in a Turner Gallery. This has not been done: the many works on paper he left are almost all in the British Museum, a few oils are in the National Gallery and the remainder went to the Tate Gallery where a separate wing, the Clore Gallery, displays many of them (including the paintings here mentioned without location).

Turner was the supreme *Romantic painter, more so than *Delacroix (whom he visited, probably in 1833); he is seen as a forerunner of *Impressionism because of his focus on light; he should perhaps also be seen as an early *Symbolist and, because of the way some of his paintings draw the viewer into compositional vortices, as a pre-urban *Futurist. His range of accomplishment, from the rendering of facts that all could recognize as true and artistic to the picturing of visions full of awe, is unique.

Turrell, James (1943–) American artist, born in Pasadena, son of an aero-

nautical engineer and a doctor. He trained first in experimental psychology and then briefly in art at Irvine, University of California. From the age of 16 a qualified pilot, he worked as an air cartographer and was able to use a plane in searching for apt sites for his work. He works with light and space, making and installing both or adapting natural locations, as in his *Roden Crater Project* in Arizona, involving the transformation of a vast extinct volcano into an observatory. He has described his work as the realization of 'a painter's vision in three dimensions'. Its character is generally sculptural or architectural but its purpose is that of creating an intense, silent environment for seeing space and light. He has been living in Flagstaff, Arizona, and in Ireland where he has been developing a series of *earthworks as his *Irish Sky Garden*. His art involves him in a special awareness of geology and in nature conservation, with the result that his strategic deployments of light and space are accompanied by an unusual sense of time.

Twombly, Cy (1929–) American painter, son of a professional baseball player, who studied art in Boston and New York and then at *Black Mountain College in 1951–2, under *Kline and *Motherwell. He met there *Rauschenberg with whom he travelled during 1952 in Spain, North Africa and Italy. His interest as a painter has centred on graffiti-like images and writing as explored by *Klee, the *Surrealists and some of the *Abstract Expressionists, but also on the ancient art and mythology of the Mediterranean. He settled in Rome in 1957. But for their elegance and delicacy, his paintings can suggest ancient walls and tablets, invoking the antique through cryptic words and slight signs and pictorial short-hand references. Scribbles and hand-writing are his major forms though colour has played important roles, symbolical and decorative, at various times. His 'Blackboard Paintings', from 1966 on, used a dark ground on which he wrote and drew freely in oil paint and in chalk. Denser paint and more elaborate compositions, as in the ten-panel *50 Days at Iliam* (1978),

reflecting on Homer, and the triptych *Hero and Leander* (1981–4), after the poem of Christopher Marlowe.

Tworkov, Jack (1900–82) American painter, born in Poland but living in the USA since 1913. He studied painting in New York. A friend of *De Kooning from the 1930s, he became an *Abstract Expressionist in the mid-1940s and produced paintings remarkable for the fulness of their colour and formal energies. In the 1960s he sought a more prepared, constructed kind of painting, and combined his colour strokes with geometrical matrixes of several sorts. His first solo exhibition was in New York in 1940 and was followed by many others, including a major retrospective at the Guggenheim Museum, New York, in 1982. Outside the USA his work has been in many group exhibitions.

typology A tendentious method of reading the Bible much practised by medieval Christian theologians, which has influenced the *iconography of Christian art. Persons and scenes of the Hebrew bible (types) were understood as prefiguring or symbolizing persons and scenes revealed in the New Testament (antitypes): in this sense the Sacrifice of Isaac in Genesis 22 is the type of Christ's Sacrifice on the Cross in the Gospels. Such scenes might be paired in pictorial decoration, or the 'Old Testament' type might be subordinated to the New Testament antitype. Since many art historians have misunderstood this rather counter-intuitive use of 'type' and 'antitype', and misapplied the terms, it may be helpful to recall that in this context 'anti' does *not* mean 'ante', 'previous or earlier', nor does it mean 'anti' in a hostile sense. The Greek root of the word 'antitype' means 'that which responds to the impression of the die (stamp or type)' and a helpful mnemonic is the analogy with printing: the type is used to produce an impression which is its counterpart or mirror image, the antitype – and it is this antitype which is the 'true semblance', intended from the beginning.

Uccello, Paolo (1397–1475) Florentine painter, a pioneer of studies in linear *perspective (e.g. drawings, Florence, Uffizi). Unlike his younger contemporary *Masaccio, however, he was preoccupied with the ornamental possibilities of this technique. His training under *Ghiberti c.1407–15, and his stay in Venice 1425–30, predisposed him to adopt the linear rhythms and empirical *realism of detail of International *Gothic (*see also* Pisanello; Gentile da Fabriano). His style throughout his working life thus reconciled – albeit imperfectly – two incompatible traditions and attitudes: that of the decorator-artificer with that of the artist-scientist. Where the former devalues *expressivity in favour of elegance, the latter explores the world of appearances and of human emotions. The two extremes of these tendencies in Uccello's art can be observed, on the one hand, in the small *St George and the Dragon*, part of a room decoration (c.1460, London, National) and, on the other, in the *fresco of the *Flood and the Recession of the Flood* (after 1447? transferred to canvas, Florence, S. Maria Novella, Chiostro Verde or Green Cloister).

Much of Uccello's life is ill documented and a number of works are lost, such as the mosaic of *St Peter* set up in 1425 on the façade of S. Marco. His early style upon his return to Florence may be deduced from his first badly damaged frescos on the east wall of the Green Cloister at S. Maria Novella, *The Creation of the Animals and the Creation of Adam, The Creation of Eve and the Fall* (1430–6?, transferred to canvas, *in situ*). Executed largely in the *terra verde*, 'green earth', which gives the cloister its name, these frescos, like their minor Gothic predecessors on the south and west walls, are enlivened by touches of other colours. The design of major figures depends on Ghiberti, that of the many realistic animals on northern Italian sketchbooks. The landscape is conventional and there is as yet no use of linear perspective.

Uccello's next major Florentine commission, however, although also executed in *terra verde*, is very different. His monumental effigy of Sir John Hawkwood (d.1394), English mercenary captain of Florence's armies, replaced an earlier image painted in 1395 by Agnolo *Gaddi in lieu of the originally projected marble monument. Uccello's famous fresco, in the event, was designed to simulate a bronze equestrian monument atop a marble sarcophagus; the effect is now weakened by the loss of the original fictive cast shadow, the addition in the 16th century of a decorative border, and the transferral of the fresco to canvas hung at a different height from the floor. Enough of the original remains, however, to demonstrate Uccello's procedures. The fictive sarcophagus is painted in accurate sharp recession from a low viewpoint, giving even now the illusion of a three-dimensional object on the wall. To avoid distortion, however, neither horse nor rider is foreshortened, although the viewer is not immediately aware of the implied dual viewpoint.

The exact date of the badly damaged *Flood* fresco at S. Maria Novella is not known. From its appearance it is plausible to suppose it was painted c.1447, after Uccello's visit to Padua where he would have seen *Donatello's reliefs for the high altar of S. Antonio. *The Flood* is the work of Uccello's which most nearly complies with *Alberti's prescription for painting an *istoria* (*see under* genres); *Vasari writes that he represented in it '. . . the dead, the tempest, the fury of the winds, the flashes of lightning, the rooting up of trees, and the terror of men . . .'. The vertiginous recession to the vanishing point, however, whilst it adds a surreal grandeur to our sense of scale of Noah's Ark, does not help us see that two separate episodes are here linked in a single visual scheme; even in its original state the fresco could not have been easily read.

Of Uccello's surviving major works, perhaps the one which best exploited his

curious talents is the now-dismembered decoration for a room in the Medici palace in Florence, *The Rout of San Romano* (*c*.1456? three panels now distributed between London, National; Florence, Uffizi; Paris, Louvre). Originally placed with their lower edges seven or more feet from the ground, these large panels display a non-*illusionistic system of perspective, in which the broken lances and bodies of the fallen are arranged to indicate the orthogonals and transversals of the perspective scheme, limited to a fairly narrow strip in the foreground. The background landscape bears no spatial relationship to the foreground, and unity of the three scenes, *Nicolò da Tolentino directing the Battle* (London), *The Unhorsing of Bernardino della Carda* (Florence) and *Micheletto da Cotignola attacking the Sienese rear* (Paris), is imposed by recurrent forms and colours. As *The Flood* explores a range of human actions and emotions, so the *Rout* depicts the fullest range of postures of horses – a theme of great interest in the *Renaissance and one later exploited by *Leonardo da Vinci. The realism of battle, however, is sacrificed to the decorative qualities of costume details (notably the ceremonial head-dress of Nicolò da Tolentino) and other appurtenances, and the patterns created by the lances, crossbows, plumed helmets, men and horses. The glowing oranges on the trees, and the roses on the shrubs against which the episodes of battle unfold, clearly show the relationship of these painted panels to tapestries, and recall that this record of a historical event was intended for a private room rather than a public hall. Part propaganda, part decoration and part exhibition of perspectival skill, the *Rout* remains Uccello's most congenial large-scale work.

In 1465 Uccello was at Urbino, where he painted for the Confraternity of Corpus Domini a narrative *predella in six panels, *The Profanation of the Host*, to an altarpiece of the *Institution of the Eucharist* (later executed by *Joos van Ghent). The romantic little *Hunt* now in Oxford, Ashmolean, was perhaps originally part of a *cassone*. Recession is established through the diminution of tree forms, hunters, stags

and hounds (a repertory of whose poses is furnished analogous to that of horses in the large *Rout*). The tapestry-like flowers of the forest floor and foliage of the tree tops conspire with the bright little figures, seen in profile or from the rear, to lure the viewer into an enchanted world, where even the arduous study of perspective is reduced to dreamlike playfulness.

Udaltsova, Nadezhda (1886–1961) Russian painter, trained in Moscow and making contact with *Cubism in Paris in 1911–12. Back in Moscow, she worked in *Tatlin's studio alongside *Popova and *Vesnin. In 1916, like Popova, she associated with *Malevich and produced *Suprematist paintings and designs for dresses and accessories. Engaged by the Ministry of Education she was prominent among those working on the decoration of the city for the May Day 1918 celebrations. She taught in the new art workshops and was a member of *INKhUK, from which she resigned in 1921, together with her husband, the painter Aleksandr Drevin in protest against the prominence of *Constructivism. She continued to teach and to paint, demanding and demonstrating a return to *figuration.

Uden, Lucas van (1595–1672) Flemish *landscape painter, much influenced by *Rubens's panoramic views and free brushwork. His pictures are often enlivened by little figures added by *Teniers the Younger (Dublin, National; other works in Munich, Bayerische; Frankfurt, Städelsches; Cambridge, Fitzwilliam; Barnard Castle, Bowes). His best works were painted between 1630 and 1650. He was also an excellent etcher (*see* intaglio) and produced *reproductive prints after *Titian and other Venetian artists.

Udine, Giovanni da *See* Giovanni da Udine.

Uecker, Günther (1930–) German artist, a founder of the group *Zero, using nails fixed to static or *kinetic planes, usually painted white, to catch light and create shadows. He also metamorphosed chairs and other objects by covering them with nails and white paint,

and in the 1960s made neon tube sculptures. He exhibited many times with the group and 1980 saw a retrospective show of his work in St Gallen, Switzerland, on which occasion a collection of his writings, including poems, was published.

Uglow, Euan (1932–) British painter, trained at the Slade School of Art in London where he also taught. Starting from the methods of *Coldstream, rooted in keen observation and optical measurement, Uglow developed a particularly disciplined process in which measurement is related to geometry, drawing is scrupulously exact and colour and tone are simplified to establish clear relationships between the planes of the object. Discipline does not exclude humour, so that a method that could seem concerned only with visual truth is in fact charged with intelligence and humanity.

Ugo da Carpi (*d*.1532) Italian pioneer of the chiaroscuro woodcut (*see under* relief prints). In Venice, where he collaborated as a cutter with *Titian among others, he obtained in 1516 a copyright from the state for his 'invention' (although the process had already been used in Germany, he may have discovered the technique independently). By 1518 he had moved to Rome and obtained a further copyright from Pope Leo X for a *chiaroscuro print after *Raphael. However accomplished and technically original a printmaker, Ugo seems never to have himself invented a composition, and mainly relied on copying the prints of others.

Ugolino di Nerio, Ugolino da Siena (active 1317 to 1327) Italian painter, a close follower or pupil of *Duccio and documented at Siena in 1325 and 1327; his work is securely known only from the dismembered high altarpiece of Santa Croce, Florence, 1324–5, which once bore the inscription 'Ugolino da Siena painted me' (majority of fragments London, National; others in New York, Metropolitan; Berlin, Gemäldegalerie; Los Angeles, County; Philadelphia, Johnson Coll.); other works have been attributed to him through stylistic and technical comparison (*polyp-

tychs, Williamstown, MA, Stirling and Francine Clark Art Inst.; Cleveland, Ohio, Museum). Although Ugolino was working in Florence in the 1320s, his dependence on Duccio's delicately *expressive style seems not to have been affected by the more 'modern' manner of *Giotto.

Uhde, Fritz von (1848–1911) German painter. His well-to-do parents encouraged his wish to be a painter but he failed to enter the studios of the established artists he hoped to study with, so he opted for a military career and painted when he could. In 1878 he resigned his commission and went to Paris to work with *Munkácsy, imitating his dark style. In 1880, after another visit to Paris, he settled in Munich where he met *Liebermann whose example transformed Uhde's art. He now studied Dutch masters and painted Dutch subjects in Liebermann's manner, adopting the cool, light and open brushwork Liebermann had learned from *Manet. The most controversial of his new paintings were religious scenes in which Christ is seen among present-day peasants and workers, in a *realistic idiom which many found offensive. He was a founder of the Munich *Secession and was elected president in 1899. In 1907 a large exhibition of his work was presented by the Secession and brought him great acclaim.

Underwood, Leon (1890–1975) British artist, known primarily as a sculptor but active in several media (including writing poetry and a novel, as well as about art) and teaching. He was born in London and studied there at the Regent Street Polytechnic, the Royal College of Art and, after war service, at the Slade School of Art. Henry *Moore was one of his pupils when Underwood taught at the RCA; he also ran a private art school during the 1920s and 30s. In 1931 he published four numbers of a periodical he called *The Island* to which other artists, among them Moore and Eileen *Agar contributed. Its theme was the primacy of the imagination and the essentially priestly function of artists. Mahatma Gandhi wrote a statement for the fourth issue, supporting this emphasis.

Underwood was part of the modern movement but considered himself at odds with it. *Abstract art seemed to him to be an evasion and he regretted its prominence: the point of art was to carry messages important to humanity. He found support of this in *primitive and prehistoric art. In 1923 he visited Iceland on an award that should have taken him to Rome. In 1925 he rushed to see the newly discovered cave paintings at Altamira. In 1928 he explored Mexico in search of Aztec and Mayan art. He bought African carvings when he could and must have read *Fry's essay on African art. There are hints of *Epstein and *Vorticism in his early work, and something of early *Renaissance *frescos in paintings he did around 1920 and of Augustus *John's romantic pastorals about his portraits and figure subjects of the early 1920s. By 1930 there were hints of *Surrealism in some of his paintings while his sculpture was inventive in ways that owed more to non-European art forms than to modern movements. *The Cathedral* (1930–2) fuses the upper torso of a Mayan goddess with the form of a vaulted hall. Carved in poplar, this is a massive work. Other sculptures, often in bronze, are lithe and linear rather than massive, and can be of musicians or dancers, as in *Negro Rhythm* and *Herald of New Day* (London, Tate; both 1934). Such sculptures continued into his last years, becoming ever wilder in their motion. His use of bronze became ever freer and lighter, with Underwood casting open, shell-like forms from the 1950s on. In 1944 he travelled in west Africa at the British Council's invitation, lecturing and drawing, but also enlarging his understanding and collection of African art. In 1947 and 48 he published little books on African sculpture, and in 1960 one on *Colossal Bronze Sculpture of Assyria*. Underwood did not exhibit often but could sometimes be persuaded to lend to mixed exhibitions and, more rarely, to have a solo show. For one in 1961, at the Kaplan Gallery in London, Eric Newton wrote a catalogue essay discussing the similarities between Underwood's and

Moore's early carvings. In 1969 a retrospective exhibition was shown in Colchester, drawing renewed attention to an artist then relatively forgotten.

Unit One Name of a short-lived but significant group of eleven artists and architects formed by Paul *Nash in London in 1933, announced in a letter to *The Times*. In 1934 they held an exhibition at the Mayor Gallery, London, and published a book with statements and photographs representing the work of each of them, edited and introduced by Herbert *Read; a smaller version of the exhibition toured to six other British centres. They were not united by a style or programme so much as by a sense of moving British art forward contemporaneously; they also wished to prove a unity of purpose between painting, sculpture and architecture. The group included the most prominent of British avant-garde artists and designers of the day: Ben *Nicholson, *Moore, *Hepworth, *Burra and the architects Colin Lucas and Wells Coates. The critical response was largely negative.

'Ut pictura poesis' ('poetry is like painting') A famous line from the Roman poet Horace's *Art of Poetry*, influential in art as a misquotation, 'painting is like poetry' – *see also under* Philostratus.

Utrillo, Maurice (1883–1955) French painter, son of Suzanne *Valadon who urged him to take up painting, in part to counteract his addiction to alcohol. His main subject was townscapes, which he portrayed in a simplified, partly naïve style whose quality depended on his sensitivity to tonal relationships. He first showed work in 1909 and had a solo exhibition in 1913. In the 1920s his reputation and prices stood so high that fake Utrillos began to appear on the market. He represented France at the 1950 Venice Biennale.

Uytewael, Joachim *See* Wtewael, Joachim.

V

Vaga, Perino del *See* Perino del Vaga.

Valadon, Suzanne (1865–1938) French painter, first a circus performer, then a model, encouraged by *Degas and others to try her hand at drawing and painting. She exhibited drawings in 1894 and paintings from 1909 on, and her work is valued for its firm, confident treatment of nudes and still lifes, usually in strong colours. She was the mother of *Utrillo.

Valckenborch, Lucas van (1540–97) and his brother **Maerten** (1533–1612) The most important of a Flemish dynasty of *landscape painters, influenced by Pieter *Bruegel the Elder, whose motifs and compositions they continued to imitate in Germany, where they escaped the Spanish invasions of 1566 along with Maerten's sons, the painters **Frederick** and **Gillis van Valckenborch** (Munich, Alte Pinakothek; Vienna, Kunsthistorisches; etc.).

Valdés Leal, Juan de (1622–90) After *Murillo, to whose artistic temperament and ideals he was diametrically opposed, the leading Sevillan painter of the second half of the 17th century. He is best remembered for the two gruesomely *expressive – yet *realistic in detail – *vanitas *still-life *allegories painted to complement Murillo's cycle in the church of the Caridad: *Finis Gloriae Mundi* and *Triumph of Death* (*In Ictu Oculi*) (1672; *in situ*). Smaller, but similar in their use of still-life elements for religious instruction are the now-separated pair, *A Jesuit Conversion* – an illustration of Christian repentence – and *Vanitas* (1660; now York, Gallery and Hartford, CT, Atheneum, respectively).

The son of a Portuguese father, Valdés Leal was born in Seville but educated in the studio of Antonio del *Castello, Cordoba, where he worked until *c.*1654 (e.g. S. Francisco). By 1656 he had settled in Seville, where he became one of the founders, with Murillo and Francisco *Herrera the Younger, of the Seville *Academy, and

served as its president, 1664–6. In addition to the works already mentioned he executed cycles for various convents (now Seville, Museo; Mairena, Bonsor Coll.; Madrid, Prado; Barnard Castle, Bowes; Dresden, Gemäldegalerie; Grenoble, Musée; Le Mans, Musée). Other works now in London, National; New York, Hispanic Society, Kress Foundation; etc.

Valenciennes, Pierre-Henri de (1750–1818) French *landscape painter and writer on art; while his contemporaries admired his finished paintings composed in the *classical tradition of *Poussin and *Claude (e.g. *Cicero discovering the body of Archimedes*, 1787, Toulouse, Augustins; *Mercury and Argus*, 1793?, Barnard Castle, Bowes), modern critics see him, through his sketches from nature which were little known while he was alive, as a precursor to *Corot (Paris, Louvre; Bibliothèque Nationale). He travelled to Italy twice, in 1769 and 1777, and extensively in England, Germany and Spain, and was received in the *Academy in Paris in 1787. In 1775 he published a book on drawing after nature, and in 1799/1800 wrote the influential *Elements of practical perspective . . .* describing various sites in Italy useful for the painter who wishes to reconcile tradition and observation.

Valentin (1594–1632) Also called **Valentin de Boulogne** or **Le Valentin**; his first name is not known. Roman painter born in France of an Italian father, settled in Rome *c.*1612. He was an imitator of *Caravaggio; most of his known work dates from after 1620 and he followed Caravaggio's *tenebrist manner longer than any artist in Rome (but *see* e.g. Honthorst and Terbrugghen in Utrecht). Although his paintings have sometimes been confused with *Manfredi's, he was a more disciplined artist with a wider emotional range. A neighbour of *Poussin's in the latter's early years in Rome, he competed with him in painting the *Martyrdom of SS. Processus and*

Martinianus (1628–30; Vatican, Pinacoteca) as a pendant to Poussin's *Martyrdom of St Erasmus*. There are works attributed to him in Cambridge, Fitzwilliam; London, National; Rome, Nazionale; Vienna, Kunsthistorisches etc.

Vallayer-Coster, Anne (1744–1818) One of the most accomplished French *still-life specialists of the 18th century. Her subjects were influenced by *Chardin, but her colours are brighter and more vivid than his and her *illusionistic detail more insistent (e.g. Cleveland, Ohio, Museum; Toledo, Ohio, Museum).

Valotton, Félix (1865–1925) Swiss-French painter, of French nationality from 1900 on, resident in Paris from 1882 when he came to study at the *Académie Julian. In the 1890s he became prominent as a maker of woodcuts characterized by his dramatic use of broad areas of black and white to deliver domestic or public scenes. He was associated with the *Nabis in the 1890s, and became known also for his paintings, some of them of a sharply simplified sort. His illustrated autobiographical novel *La Vie meurtrière* (The Deadly Life) was published in 1930.

Van Cleef, Joos *See* Cleve, Joos van.

Van Dyck, Sir Anthony (1599–1641) Supreme portraitist of the Stuart court of Charles I, Van Dyck was born in Antwerp, the seventh child of a rich textile merchant. A precocious talent, he was apprenticed at 10 to **Hendrik van Balen** (1575–1632), a painter of elegant small-scale mythological scenes for middle-class collectors, of whose manner little is discernible even in Van Dyck's earliest-known works. He was an independent master before the age of 19. Drawn into the orbit of *Rubens, it was as an assistant in the latter's studio that he came to the notice of England's premier connoisseur, the Earl of *Arundel (portrait, 1620/1, USA, Logan Coll.; *Arundel with his grandson Thomas*, c.1635–6; with *Aletheia, Countess of Arundel*, c.1639, both Arundel Castle; drawing for never-completed family group portrait, c.1643, London, British). At the Earl's instigation

Van Dyck came to London in 1620. He entered the service of James I in 1621, and also painted pictures for the principal collectors at Court (e.g. *Continence of Scipio*, Oxford, Christ Church), studying in their collections works by Venetian *Renaissance painters already influential on him in Antwerp. Thus the influence of Rubens was diluted by that of *Veronese and, above all, *Titian, with a corresponding loosening of brushwork, an increased emphasis on the paint surface deployed on canvas rather than panel, and a certain devaluation of spatial and volumetric definition. In 1621 he received leave to study in Italy, but returned first to Antwerp, then, absconding from the King's service, remained in Italy until 1627; in 1628 he had re-established his studio in Antwerp, and did not return to London until 1632, to the court of Charles I and Queen Henrietta Maria.

In Italy, Van Dyck, quite lacking Rubens's intellectual and archeological interests, sketched mainly pictures he admired; among these works by Titian predominate. He travelled everywhere, cutting an aristocratic figure. Although his altarpiece for Palermo (*Madonna of the Rosary*, 1624–7, Palermo, Madonna del Rosario) had an influence on the Neapolitan school, his main impact was in Genoa. There he executed a brilliant series of aristocratic portraits, which were indebted to Rubens's Genoese portraits of nearly two decades before, but which also developed the full range of Van Dyck's later portrait repertory: equestrian portraits (e.g. *Anton Giulio Brignole Sale*, Genoa, Palazzo Rosso), a monumental family group (*The Lomellini Family*, Edinburgh, National), full-length seated and standing single figures (e.g. *Cardinal Bentivoglio*, Florence, Pitti; *Marchesa Doria*, Paris, Louvre), and standing figures accompanied by children or attendants (*Marchesa Brignole Sale and her Son*, Washington, National).

Back in Antwerp, Van Dyck embarked on a period of intense activity (1628–32) which saw his finest achievements as a painter of large altarpieces (e.g. *Vision of St Augustine*, 1628, Antwerp, Augustijnenkerk; *Crucifixion*, Lille, Musée), smaller works for private devotion (e.g. *Rest on the Flight to Egypt*, Munich, Alte Pinakothek),

mythological or poetic subjects (*Rinaldo and Armida*, Baltimore, Museum), as well as portraits. He also became court painter to the Regent of the Netherlands, Archduchess Isabella. Despite a wealth of commissions and great success, however, Van Dyck responded to solicitations from the English court; in 1632 he began the *œuvre* for which he is best known today, and which transformed, and cast a lasting influence over, the British school. Perhaps a desire to emulate or outshine Rubens had a part in this decision; but it must be said that Van Dyck's removal to London, where he was knighted in 1632, virtually put a stop to his development as a painter of narrative and religious subjects in the greatest tradition of European art, and robbed that tradition of one of its most sensitive exponents. This is not to deprecate his achievements in England, where his finest royal portraits in particular outdo Titian in the poetic and imaginative conflation of the public and the intimate, and the depiction of social status with the illusion of natural nobility (*Le roi à la chasse*, Paris, Louvre). The great equestrian portrait of *Charles I with M. de St Antoine* (1633; Coll. HM the Queen) brilliantly combines the imagery of imperial tradition with a lyricism entirely Van Dyck's own. It is this lyrical gift which transfigures even the most arrogant aristocratic icon (*Lord John Stuart with his brother Lord Bernard Stuart*, *c*.1639, London, National) into a romantic ideal. Not all the innumerable English portraits are autograph throughout, and quality varies; sure touchstones are the earlier portraits of the royal children (1635, Turin, Galleria; 1637, Coll. HM the Queen) and the multiple views of the King (1635) and Queen (1638, both Coll. HM the Queen) furnished to the sculptor *Bernini.

Never intending to settle permanently in London, Van Dyck returned twice to the Netherlands (1633–5; 1640). The first period resulted in some of his finest compositions (e.g. *The Abbé Scaglia*, Viscount Camrose; *The Abbé Scaglia Adoring the Virgin and Child*, London, National; *Equestrian portrait of Prince Thomas of Savoy*, Turin, Galleria; *Lamentation*, Munich, Alte Pinakothek; etc.). On the second occasion he travelled to Paris, in the hope of receiv-

ing the commission for the Grande Galerie of the Louvre which went to *Poussin. Nor was he able to conclude a grand decorative scheme for Whitehall, of which the sketch of the *Garter Procession* (*c*.1638; Belvoir Castle) is the only remaining visual evidence. He died in London; a marvellous late self-portrait (Earl of Jersey) records the appearance, disquieted and worn, of the artist who won the highest distinctions but never fulfilled his ambitions.

Vanderbank, John (1694–1739)
English painter, son of a Huguenot tapestry weaver. He founded the second London painting *academy (1720) in which *Hogarth trained, and was himself a vivid portraitist in the painterly style associated with Hogarth. His masterpiece, the portrait of *Queen Caroline*, 1736, is at Goodwood. He is now best known, however, for 20 small scenes illustrating *Don Quixote* (1731–6), which are among the earliest examples in England of paintings based on a literary text.

Vanderlyn, John (1775–1852) American painter who worked in Paris for many years and was part of the *Neoclassical movement. *The Death of Jane McCrea* (1804; Hartford, Wadsworth Atheneum) is a major example of a modern subject being given the *history painting treatment, with the additional twist of this one – Indians murdering a white woman – not involving a great national event or an eminent individual. This drew attenton to his work in Paris, as did his refined treatment of the mythical subject of *Ariadne asleep on Naxos* (1814; Philadelphia, Pennsylvania Academy of Fine Art). His American public employed him primarily as a portraitist.

Vanitas *See under* still life, Steenwyck, Harmen and Pereda, Antonio del.

Vanloo *See* Loo, van.

Vantongerloo, Georges (1886–1965)
Belgian artist, trained in painting and sculpture. Interned in the Netherlands during the First World War, he was an early member of the De *Stijl group. After the

war he moved to Menton (France) and from 1927 lived in Paris, a prominent member of *Abstraction-Création. In the 1920s he produced paintings and made constructions in wood that echoed *Neo-Plasticism in their use of rectilinear elements set in rectangular relations but also involved giving visible and tangible form to mathematical formulae. The same basis led him in the 1930s to paintings and sculptures dependent on curved lines and surfaces, and subsequently into making complex objects in transparent plastics as well as architectural projects of a visionary sort. His early essays were published in Antwerp as *L'art et son avenir* in 1924 and in New York in 1948 as *Painting, Sculpture, Reflections*, with an introduction by Max *Bill.

Vanvitelli, Gaspare *See* Wittel, Gaspar van.

Varallo, Tanzio da *See* Tanzio da Varallo.

Vargas, Luis de (1506–68) Spanish painter, active in Seville, where he returned after 28 years in Italy and introduced not only an Italianate *Mannerist style but also the technique of painting in *fresco. His best-known work is an altarpiece of the *Adoration of the Shepherds*, with an *Adoration of the Magi* depicted in the *predella, of 1555 in Seville Cathedral.

Varin, Quentin *See under* Poussin, Nicolas.

Varley, John (1778–1843) British landscape painter in watercolours. Important as a teacher – his pupils included David *Cox, *Linnell, William Henry *Hunt and *Palmer – he wrote about landscape painting and himself painted landscapes of a dramatic and *Romantic sort.

Varnish A hard-drying, normally transparent solution applied over a finished painting in order to protect the surface, and to give to the colours a gloss, saturation and unified clarity which they may have lost on drying. There is disagreement over whether tinted varnishes were used in antiquity; such varnishes have certainly been applied in the 18th and 19th centuries to 'mellow' pictures artificially. Early *tempera paintings may have been varnished with egg white (glair), or semi-hard resins boiled in linseed oil. Spirit varnishes, in which soft resins are dissolved in volatile solvents, only evolved in the 16th century; they are still in use today, as well as synthetic varnishes. *Impressionist painters, relying on vivid contrasts and subtle colour interactions, and preferring a matt and textured finish, did not varnish their paintings; most have been varnished since they were executed. Varnishes discolour and darken with age and dirt, and must be removed to restore the intended colour and tonal balance. In most cases, this is a straightforward procedure, for, contrary to received opinion, varnishes are not normally used as a paint *medium. Technically inexpert but experimental artists like *Reynolds and *Turner are, however, known to have done so. Their pictures are consequently difficult or even impossible to clean, since surface varnish cannot be removed without damage to the paint layers.

Varotari, Alessandro *See* Padovanino, Il.

Vasarely, Victor (1908–97) Hungarian-French painter, trained in Budapest and influenced by *Constructivist ideas. He moved to Paris in 1930 and in the late 1940s evolved his characteristic idiom and method. In *abstract paintings he explored ambiguities of form and space and sensations of movement through patterns of black and white and contrasting colours, becoming known as a leading *Op painter in the 1960s. He had a great number of exhibitions from the 1950s; the 60s saw his greatest international success: in 1965, for example, he won the first prize at the São Paulo Bienal. He produced colour-printed plastic tiles as modules with which, if mass-produced, we should all be able to make our own Vasarely pictures and murals, but their success was limited on account of price. He created a Vasarely Museum in Gordes in 1970 and in 1976 formed a Vasarely Foundation near Aix-en-

Provence, itself a demonstration of the application of his tiles. Another Vasarely Museum is in his Hungarian birthplace, Pecs, and New York has a Vasarely Center.

Vasari, Giorgio (1511–74) Painter, architect and art impresario, born in Arezzo but Florentine by adoption, he was the most important contemporary writer on the art of the Italian *Renaissance and *Mannerism. His *Vite de' più eccellenti Architetti, Pittori et Scultori Italiani* (*Lives of the Most Excellant Italian Architects Painters, and Sculptors*, 1st. ed. 1550, 2nd revised ed. 1568) with their prefatory 'Introduction to the Three Arts of Design (*disegno*): Architecture, Sculpture and Painting'; the *Ragionamenti sopra le invenzioni da lui dipinte in Firenze nel palazzo di loro altezze serenissime . . .* (*Dialogues on the Inventions painted by himself in Florence in the Palazzo Vecchio*, 1557, 1563), his *Descrizione dell' Apparato fatto in Firenze per le nozze . . . di Don Francesco de'Medici . . .* (*Description of the Festival decorations for the Wedding of Francesco de'Medici*, 1566) and his letters are unparalleled sources for the biographies of Italian artists, the techniques of art, and modes of thinking by artists about art, in the mid-16th century. In addition, the *Lives* are our primary source of knowledge about earlier Tuscan artists from *Cimabue onwards. Unlike the older Cennino Cennini (*see under* Gaddi) and *Ghiberti, and later *Cellini, whose more limited writings are also important for an understanding of techniques and artistic ideals, Vasari undertook extensive research throughout Italy and adopted for the *Lives* a historical framework whose influence is still enshrined in most scholarly accounts of art. For Vasari, his fellow Tuscan *Michelangelo stands at the apex of an organic evolution of post-antique art, accomplished in three periods corresponding to infancy, youth and maturity.

Vasari's practice of art has until recently been eclipsed by his work as a writer. It was, however, both extensive and important, especially his decorative *fresco cycles (*see below*) and the works of architecture undertaken during Vasari's tenure, from 1555, as Cosimo I de'*Medici's art impre-

sario. It was also in his capacity as Cosimo's artistic adviser that in 1562 Vasari inaugurated the first modern art *academy.

Vasari's intellectual predilections, fostered through his humanist education alongside the young Medici heirs and his artistic training under *Bandinelli, manifest themselves in the complex *iconography and dry abstracting handling of his portraits and altarpieces (e.g. *Duke Alessandro de'Medici*, 1534, Florence, Museo Medici; Camaldoli, Arcicenobio; Florence, SS. Apostoli; Rimini, S. Fortunato; Ravenna, Accademia; Rome, S. Pietro in Montorio). These qualities are a greater asset in his large decorative ensembles, where the execution is in any case largely the work of assistants. The first such commission is the great salone in Rome, Palazzo della Cancelleria (*Sala dei Cento Giorni*, 1546; extensively restored in 1943 after damage by fire). Most striking is Vasari's use here of Michelangelo's designs for the staircase of the vestibule to the Laurentian Library in Florence. From 1556 Vasari designed and oversaw the refurbishment and decoration of the Palazzo Vecchio in Florence, the most extensive *Mannerist decoration in the city expounded in the *Ragionamenti*, which includes the tiny *studiolo* of Francesco I de'Medici, the most perfect Italian example of a *Kunstkammer*.

Vasnetsov, Viktor (1848–1926) Russian painter and designer, a key figure in the great revival of Old Russian themes and methods. He studied with *Kramskoy in St Petersburg and then (1868–74) at the Academy there. From 1874 he exhibited with the *Wanderers and joined the society in 1878. He settled in Moscow in 1878. His best known paintings are powerful accounts of warlike scenes of Russian history, but his later pictures include gentle, decorative treatments of folk legends. He was prominent among those who worked for Mamontov, a rich railway tycoon who patronized archeological research on his estate at Abramtsevo, outside Moscow, where Vasnetsov designed furniture and a revivalist church (1885) and controlled its decoration, while in Moscow he had a private opera house for which Vasnetsov

made stage designs, with folk and religious traditions in mind. Vasnetsov designed the façade of the Tretyakov Gallery in Moscow (1902) in a historicist style, painted murals in Kiev Cathedral and in 1899–1901 made mosaics for the Russian church newly built in Darmstadt. The first issue of the *World of Art journal was dedicated to his work, and he exhibited with the group in 1900.

Vaughan, Keith (1912–77) British painter, self-taught but an admired teacher in London art schools and a thoughtful artist with high ambitions. These centred on continuing *Cézanne's *classical visions of figures in landscape. Some of Vaughan's paintings use religious subjects (e.g. *The Martyrdom of St Sebastian*), but his basic theme, of man in harmony with nature and dignified by simplified representation, goes back to the Greeks. He exhibited many times from 1944 on. His *Journal and Drawings 1939–65* was published in 1966; a more complete edition of his diaries appeared in 1989.

Vautier, Ben (1935–) Swiss artist, self-trained but widely and variously educated. He has lived and worked as an artist in Nice since the mid-1950s, known professionally as Ben and presenting *performances and a wide variety of arte-facts whose general tendency is to dethrone art and mock our myths of creativity. He has exhibited internationally since the early 60s and has been associated with the *Fluxus movement.

Vázquez, Juan Bautista *See* Montañés, Juan Martínez.

Vecchietta; Lorenzo di Pietro, called (1410–80) Sienese painter and sculptor, active also as an architect and metal-worker. His paintings in *fresco and on panel in the hospital and church of S. Maria della Scala are some of the most important produced in Siena in the 15th century. (*See also* Domenico di Bartolo.) Along with *Matteo di Giovanni, *Giovanni di Paolo and *Sano di Pietro he was called by Pope Pius II to paint altar-pieces in the cathedral of Pienza. He carved

in wood throughout his career (Florence, Bargello; Horne Museum) and worked also in marble, but it is for his bronze sculpture, produced after contact with *Donatello's Sienese studio, that he is best known (*Foscari effigy*, 1463–4, Rome, S. Maria del Popolo; *Sozzini effigy*, 1467, Florence, Bargello; tabernacle, 1467–72, Siena, cathedral; New York, Frick). Vecchietta was the teacher of the painter **Benvenuto di Giovanni** (1436–*c*.1518), best remembered for the *frescos of the *Miracles of St Anthony of Padua* in Siena Baptistery; some panel paintings also survive (e.g. London, National). His son **Gerolamo** followed his style closely.

Vecchio, Palma *See* Palma Vecchio.

Vecellio, Tiziano and Orazio *See* Titian.

Vedova, Emilio (1919–) Italian painter, largely self-taught, who was involved in anti-fascist art groups and, after the Second World War, became a leading practitioner of *Art informel in a particular explosive mode associated with anti-authoritarian protest.

Veduta (pl. *vedute*) Topographical view, a type of painting which became important in the second half of the 17th century. It combined landscape elements with the work of the architectural designer and the *quadraturista*, or scene painter. The *veduta esatta* was a precise rendering of a topographical situation; the *veduta ideata*, or *di fantasia*, an imaginary view. Gian Paolo *Panini was the great master of *vedute* of Rome; his *vedute ideate* showed scenic arrangements of antique ruins, and influenced, among others, *Piranesi. *Canaletto specialized in Venetian *vedute*, and his nephew *Bellotto migrated north of the Alps, practising *vedute* painting in Dresden, Vienna, Munich and Warsaw. *See also capriccio*. A *vedutista* is a painter of *vedute*.

Veen, Otto van (also known as **Octavius Vaenius**) (1556–1629) Distinguished Italianate Flemish painter and humanist, teacher of *Rubens. Of patrician birth in

Leiden, Holland, he first studied with **Isaac Nicolai van Swanenburgh**; by 1572 he was in Antwerp and Liège in the southern Netherlands, continuing his training in the eclectic Italianate style of Frans *Floris. In 1575–80 he studied in Rome under the *Mannerist painter Federico *Zuccaro. He worked also in Cologne. In 1585 he entered the service of Alessandro *Farnese in Brussels. Finally, c.1590, he settled at Antwerp, although preserving his connections with the court in Brussels. Rubens was in his studio from c.1596–8, and continued to work with him until he left for Italy in 1600, and perhaps even later.

Van Veen's work immediately after his return to the Netherlands in 1585 reflects his schooling under Zuccaro and his enthusiasm for the school of Parma (*Correggio, *Parmigianino) (Brussels, Musées; Potsdam, Sanssouci; Berne, Museum). But his style began to change in the late 1590s (Antwerp, Openbare Onderstand, Andreaskerk) and by 1610 he had abandoned Mannerist complexities for a clear, rational *Classicism. In this style he executed a number of religious works of Counter-Reformatory propaganda (Munich, Gemäldesammlungen; Ghent, St Bavo).

Van Veen knew Latin and was part of the intellectual life of Antwerp. His importance to the visual arts is not exhausted by his own painted œuvre and his tutelage of Rubens: he was also the author and designer of important *emblem books, both secular and religious, which sparked off the vogue for emblematic literature throughout the Netherlands.

Velázquez, Diego Rodríguez de Silva

(1599–1660) The greatest Spanish painter and one of the greatest figures in European art – recognized as such in his own lifetime and again since the 19th century, despite the loss of many of his works and the fact that none can be seen in its original context. His early *realistic and tightly painted portrait manner inspired by *Caravaggio, decried as 'melancholy and severe' by an Italian contemporary but praised by *Rubens for its '*modestia*', was gradually transformed under the latter's influence and that of *Titian's works in the

Spanish Royal Collections into the more colourful, airier 'distant blobs' with which, said an admirer, Velázquez achieved 'truth rather than likeness'. It is this supremely optical mode which characterizes his great masterpieces: the monumental *genre and mythology painting of *The Fable of Arachne* (*Las Hilanderas*) with its streaking afterimage of a spinning wheel, and *The Maids of Honour* (*Las Meninas*), the sublime court group and self-portrait, with its dim mirror reflection of the King and Queen of Spain seemingly standing beside the viewer (c.1656–8, 1656 respectively, both Madrid, Prado).

He was born in Seville; his paternal grandparents had come from Portugal and were said to have been of noble birth – a fact which was crucial to the artist's strivings, successful in 1659, to be received into the military order of Santiago. Possibly after a brief period with Francisco de *Herrera the Elder, he was apprenticed to Francisco *Pacheco, whose daughter he would marry in 1618, a year after matriculating as master. Like all Sevillan painters of his time, including his fellow-pupil *Zurbarán, he was trained as a painter of religious subjects (*Adoration of the Magi*, 1619, Madrid, Prado; *Immaculate Conception* and *St John the Evangelist on Patmos*, 1617–18, London, National). The artist's treatment of these owes more to the *polychrome sculpture of Juan Martínez *Montañés than to his master Pacheco, and the former's influence is still discernible in the *Christ on the Cross* of c.1631–2 (Prado). More exceptional were Velázquez's *bodegónes* (*see under* still life), of which he was an early exponent in Spain and remains the most celebrated. These paintings were singled out for praise by his early biographers, Pacheco and *Palomino. His earliest surviving dated works are among the finest in this genre, combining 'low-life' figures and kitchen still lifes: *Old Woman Cooking Eggs* (1618; Edinburgh, National) and *Christ in the House of Martha and Mary* (1618; London, National). Of about the same date is one of the first paintings by him seen at court in Madrid, *The Water Seller of Seville*, as well as the *Two Young Men at Table* (both London, Apsley House). Pacheco's claim that Velázquez

studied from the life is confirmed by the reappearance in these and other *bodegónes* of the same models and the same kitchen utensils. Of these works only two include religious themes: the *Christ in the House of Martha and Mary* already cited, and *Tavern Scene with Christ at Emmaus* (Blessington, Beit Coll.). These compositions, in which the religious scene is relegated to the background, derive from the works of Pieter *Aertsen and Joachim Beuckelaer, which Velázquez could have known from engravings. The *bodegónes* in general reflect an interest in Caravaggio and his Spanish follower in Naples, *Ribera – although the precise transmission of these models to Seville before 1620 is not clear.

In 1622 Velázquez undertook his first journey to Madrid (portrait of the poet *Luis de Góngora*, Boston, MFA), being summoned again in the following year to paint the King, Philip IV; in 1623 he was appointed the 18-year-old Philip's painter. From that time he would undertake many additional official duties in the palace, rising to onerous posts which curtailed his production as a painter and incurred the envy of others. His relationship with Philip was close and genuinely friendly – perhaps unique in the history of royal patrons and artists. To it we owe a series of the most intimate state portraits ever painted, in which artist and sitter mature together (e.g. Madrid, Prado; London, National; New York, Frick). Velázquez's portraits of the royal children by Philip's first wife, Isabel of Bourbon, and his second, his niece Mariana of Austria, are probably the subtlest children's likenesses in European art, playing off the grace and vulnerability of childhood against the formality of court apparel and official pose (mainly Madrid, Prado and Vienna, Kunsthistorisches). Equally perceptive and moving are the famous portraits of court dwarfs and buffoons of the 1630s and 1640s (Madrid, Prado).

Accused by rivals of being able to paint 'only faces', Velázquez was commissioned in 1626 to execute his first *history picture, *The Expulsion of the Moriscos* (destroyed 1734), in competition against Vincencio *Carducho and two other artists; Juan Bautista *Mayno was one of the judges

who awarded him the prize. The visit at the Spanish court in 1628–9 of the great narrative painter Rubens not only influenced Velázquez's technique (*see above*) but also inspired the commission and execution of his first mythological subject, *Bacchus and his Companions* (*Los Borrachos, The Drinkers, c.*1628, Madrid, Prado). Rubens, and their joint study of the Venetian works in the royal collection, revived the Spanish artist's desire to go to Italy; he finally received permission in 1629, returning in 1631. The success at court of two narrative works executed in Italy, *Apollo in the Forge of Vulcan* (Prado) and *Joseph's Blood-Stained Coat Brought to Jacob* (Escorial) resulted in further commissions for narrative pictures, of which the most important is *The Surrender of Breda* (1634–5, Madrid, Prado), one of the works commemorating Spanish victories and decorating the Hall of Realms in the Buen Retiro palace (*see also* Zurbarán; Mayno; Carducho). Velázquez was also to contribute a series of royal equestrian portraits to this important ensemble (now Madrid, Prado). *The Christian Soul Contemplating Christ after the Flagellation* (London, National) was probably painted shortly after his return from Italy. Two very different altarpieces, *Sts Anthony Abbot and Paul the Hermit*, with an extensive landscape, and the sumptuous *Coronation of the Virgin* for the Queen's oratory (both Madrid, Prado), date from *c.*1633 and *c.*1640 respectively.

In addition to royal portraits in hunting dress (Prado), other works were also commissioned from the artist for the hunting lodge, the Torre de la Parada, for which Rubens's workshop was painting mythological scenes: the large landscape *Philip IV Hunting Wild Boar* (*c.*1635–7, London, National), *Mars at Rest*; *Menippus* and *Aesop* (all *c.*1636–40, Madrid, Prado). The only surviving female nude by Velázquez, the *Toilet of Venus*, also called the *Rokeby Venus* (1649–51, London, National) was, however, not a royal commission – albeit influenced by Venetian mythologies in the royal collection – but executed for a young nobleman. Like other works of these years the composition was influenced by

Velázquez's study of ancient sculpture during his Italian trip.

In 1649–51 Velázquez was allowed to revisit Italy. Two small but exceptional paintings resulted from this second trip: his only known autograph pure *landscapes, in which the artist anticipates the *plein air effects of 19th-century painting (*Villa Medici Gardens, Rome, Pavilion of Cleopatra* and *Grotto-Loggia Façade*, both Madrid, Prado). More publicly renowned were the two portraits executed in Rome: that of *Pope Innocent X* (1649–50, Rome, Doria), which earned Velázquez admission to the *Academy of St Luke and was described by *Reynolds as 'one of the first portraits in the world', and the 'preparatory' likeness of Velázquez's mulatto servant, *Juan de Pareja* (New York, Metropolitan).

Upon his return to Spain Velázquez designed and supervised the decoration of rooms in the Alcazar palace which were to house the paintings, sculptures, casts and *objets d'art* he had purchased in Italy on the king's behalf, notably the Hall of Mirrors for which *Mitelli and Colonna executed the ornate *quadratura ceiling. The ensemble was destroyed by fire in 1734, and with it three of the four paintings of mythological subjects by Velázquez which were hung between the windows; only the *Mercury and Argus* survives (c.1659, Madrid, Prado). In the airy, impressionistic technique of his late maturity, the artist here returns to the low-life, picaresque mode of his early works. Similarly, the genre character of the foreground of *The Fable of Arachne* (c.1656–8, Madrid, Prado) served to obscure this great work's mythological subject; recognized in Velázquez's own time, it became known merely as *Las Hilanderas, The Spinners*, until its recent re-identification. Formally and in the allusive mode of reference to the 'higher' subject in the background, this work resembles the early religious *bodegónes*.

Velázquez's last great royal commission resulted in his most illustrious work. *Las Meninas* is a group portrait on the scale of life, unprecedented in conception and unequalled in execution. Ten figures, including the five-year-old Infanta Margarita and her maids of honour, dwarfs and

dog, pose as if captured in a single moment of time in a vast airy room hung with pictures – Velázquez's studio in the royal palace. Among this cast of characters drawn from virtually the whole of the artist's portrait repertory, Velázquez has included his only secure self-likeness, in the act of painting. Only the back of his enormous canvas is visible to the viewer, but the subject of this painting-within-the-painting can be deduced from the 'reflections' in a mirror on the back wall of the room: the King and Queen of Spain are posing for their portrait. The spatial scheme makes it evident that they must be standing among us, the viewers of *Las Meninas*; to put it another way, we the viewers have been invited into the artist's spacious studio. Through the magic of this mysterious composition – perhaps inspired by Van *Eyck's *Arnolfini Marriage*, then in the Spanish royal collection – we are enabled to enter the world of Velázquez's art, the very heart of the art of painting. Not surprisingly, *Las Meninas* has proved an abiding inspiration to later painters.

Chief of the artists inspired by Velázquez in his own lifetime, however, is his son-in-law and successor at court, **Juan Bautista Martínez del Mazo** (1612/16–67). His best-known work, a free improvisation on the theme of *Las Meninas*, is *The Artist's Family* (c.1664–5, Vienna, Kunsthistorisches).

Velde, Bram van (1895–1981) Dutch painter trained in Worpswede (Germany) and Paris, and mostly resident in Paris during 1925–65 when he moved to Geneva where the Art Museum has a major collection of his work. His early *Expressionism was moderated in Paris by an emphasis on colour and imprecise forms, and this interest flowered after 1945 into a poetic form of *Art informel.

Velde, Esaias van de (c.1591–1630) Oldest member of a family of distinguished Dutch artists. Draftsman, etcher (*see under* intaglio) (Amsterdam, Rijksprentenkabinet) and painter, he is best known as a pioneer of the *realistic Dutch *landscape, which he began to paint especially after settling in The Hague in

1618 (*The Cattle Ferry*, 1622, Amsterdam, Rijksmuseum; *Winter Landscape*, 1629, Kassel, Kunstsammlungen; Oberlin, Ohio, college). Some of his earlier paintings, notably his scenes of outdoor banquets, show the influence of the Flemish émigré *Vinckboons, who is believed to have been his teacher in his native Amsterdam (Amsterdam, Rijksmuseum). In 1610–18 he worked in Haarlem, where in 1617 he taught Jan van *Goyen. His cousin, **Jan van de Velde II** (1593–1641), a distinguished Haarlem engraver, imitated his landscape prints. The latter's son, **Jan Jansz. van de Velde** (*c*.1619–63 or after), although born and probably trained in Haarlem, is considered primarily as an Amsterdam painter of *still life (Amsterdam, Rijksmuseum).

Velde, Henry van de (1863–1957) Belgian painter and designer. He was one of the pioneers of Belgian *Neo-Impressionist painting and *Art Nouveau graphics and design. Impatient with current domestic design and fashion, he became a designer himself. Made director of the Weimar *Academy, he introduced an Applied Art department there, the basis of Gropius's *Bauhaus. He also became known as a leading architect, and in 1926 was appointed professor of architectural history at Ghent University. His *Towards the New Style* (1955) and *Story of My Life* (1962) demonstrate his deep belief in design's association with craft.

Velde, Willem van de, the Elder (1611–93) and **Willem van de, the Younger** (1633–1707) Marine painters born in Leiden. From 1652, Willem the Elder was the official Dutch war artist, recording the sea fights between the Dutch and English navies. He evolved a *grisaille painting technique which enabled him to render these engagements in more permanent form than drawing but with maximum speed and historical fidelity. He also painted shipping pieces in oil. In 1673, to escape the effects of the French invasion and a tumultuous marriage, he changed sides and settled in England with his son, Willem the Younger. In 1674 they were

officially appointed naval war artists under the English Crown, with a studio in the Queen's House at Greenwich. Willem the Younger, who was also taught by the marine artist Simon de *Vlieger, painted not only portraits of sea battles and individual ships but also atmospheric seascapes. He is the originator of the English tradition of marine painting (*see* Peter Monamy; Robert Woodcock; Samuel Scott; Charles Brooking). There is a large collection of works by both van de Veldes in the Maritime Museum, Greenwich, and also in London (National, Wallace, Kenwood, Ham House; Coll. HM the Queen). Willem the Younger's famous and monumental *The Cannon Shot*, *c*.1660, is in the Rijksmuseum, Amsterdam.

Veneziano, Domenico *See* Domenico Veneziano.

Veneziano, Lorenzo *See* Lorenzo Veneziano.

Veneziano, Paolo *See* Paolo Veneziano.

Veneziano, Sebastiano *See* Sebastiano Veneziano or del Piombo.

Venne, Adriaen van de (1589–1662) Versatile Dutch painter and poet, born in Delft to Flemish parents. Trained in Leiden and The Hague, he worked in Middelburg from *c*.1614 to 1625, becoming the city's most important painter of *landscapes, *allegory, and *genre; his work at this time was much influenced by Pieter *Bruegel and Jan Brueghel (Amsterdam, Rijksmuseum; Paris, Louvre; Worcester, MA, Museum). He also executed portraits of members of the court, and in 1625 he moved to The Hague, where he continued to depict the ruling family (Amsterdam, Rijksmuseum). At the same time, however, he turned to biblical themes (Stockholm, National) and moralizing subjects on the life of the poor, executed in *grisaille (Rotterdam, Boijmans Van Beuningen) and possibly connected with his activity as an illustrator of *emblem books of which his brother was a publisher.

Verhaecht or Verhaeght, Tobias *See under* Rubens, Peter Paul.

Verhaeghen, Pieter Jozef (1728–1811) The only distinguished Flemish painter of altarpieces in the 18th century, active in Louvain. Like Andreas Cornelis *Lens, he was a student of Balthazar Beschey, but took as his models the robust paintings of *Jordaens, eschewing both the tired imitation of *Rubens's heroic, or *Van Dyck's elegant, manners and the growing *Neoclassicism of the period (despite a journey to Italy, 1771–3). There are altarpieces by him in Aarschot, Onze Lieve Vrouwekerk; the Abbey of the Parc and the church at Averbode.

Verhulst, Marie *See under* Bruegel.

Verhulst, Rombout (1624/5–96) Flemish sculptor, active mainly in Holland. Albeit not a formal innovator, he is notable for the delicacy of his modelling, and the sensitivity of his portraits, and has been called 'the aristocrat of Flemish sculptors'. From *c.*1647 he was employed on the Amsterdam Town Hall (now Royal Palace) in the workshop of Artus I *Quellin; the figure of *Venus* (1650/7) and two *allegorical reliefs in the galleries are signed by him. After leaving the workshop long before the completion of the town hall, Verhulst executed a whole series of funerary monuments in churches throughout the United Provinces – in Amsterdam, Delft, Leiden, Katwijk, Utrecht, and in remote villages of Groningen and Zeeland – beginning with monuments in the Nieuwe Kerk at Amsterdam and the Oude Kerk in Delft in 1654 and ending with the elaborate monument to Admiral de Ruyter in the Nieuwe Kerk, Amsterdam, in 1681.

verism Term implying extreme *realism. Its Italian form, *verismo*, came in with Mascagni's opera *Cavalleria Rusticana* (1890) on an everyday, ordinary life theme. Here, and often in art considered realistic or veristic, social criticism is intended, but at times the term is used loosely to indicate a degree of *naturalism as when *Surrealism of the *Dalí sort is labelled 'Veristic Surrealism'.

Vermeer, Jan or **Johannes** (1632–75) The greatest painter of the third, and last, generation of the Golden Age of Dutch art. He was born and lived in Delft, where he is recorded as the worthy successor of Carel *Fabritius, killed in 1654. He is unlikely, however, to have been Fabritius's pupil, although he owned three of the latter's paintings, possibly in his capacity as an art dealer (*see also* Leonard Bramer).

Vermeer's total output was small, totalling some 40-odd pictures. The earliest of these, *c.*1654–*c.*56, are large-scale figure compositions influenced by the Utrecht *Caravaggisti (*see* Terbrugghen, Honthorst, Baburen). They include his only extant religious and mythological narratives: *Diana and her Companions* (The Hague, Mauritshuis) and *Christ in the House of Martha and Mary* (Edinburgh, National) and his first known essay in *genre, *The Procuress* (1656, Dresden, Gemäldegalerie), one of only two dated pictures. In the late 1650s Vermeer changed direction, perhaps under the influence of his Delft contemporary, Pieter de *Hooch: now one, two or three figures, usually in contemporary dress, pursue their tranquil occupations in harmoniously composed Dutch interiors. The interest in anecdote, still conspicuous in the *Soldier and Laughing Girl* (*c.*1657, New York, Frick) wanes as the spatial clarity increases, and cool colour harmony replaces the earlier *chiaroscuro. Yet even a typical example of Vermeer's middle period, the *Woman Weighing Pearls* (*c.*1665, Washington, National) conveys a narrative or *allegorical significance: the contrast between wordly treasures being weighed, and the weighing of souls in the painting of the Last Judgement depicted on the wall behind the woman. Like Fabritius, Vermeer came increasingly to silhouette a darker figure against a light ground, and, also like Fabritius, he used a *camera obscura*, approximating in paint the blurred edges of forms projected in this apparatus. To this end he made use of thick dots of bright paint as highlights over a dark area. Two cityscapes by him are known: *Street in Delft* ('Straatje', *c.*1660, Amsterdam, Rijksmuseum) and the slightly later, larger, *View of Delft* (The Hague, Mauritshuis), one of the most accomplished studies of

atmospheric and light effects in European painting.

In his late works Vermeer abandoned some of the simplicity of the middle period. Around 1670, the contrasts in illumination increase, *perspectival effects become more laboured, accessories more opulent – in line with general developments in Dutch art of this period – and the paint finish harder and more enamel-like (e.g. *The Letter*, Amsterdam, Rijksmuseum; *A Girl with a Guitar*, London, Kenwood; *Young Woman Standing at a Virginal, Young Woman Seated at a Virginal*, London, National). To this same period belong two openly allegorical works: *Allegory of the Art of Painting* (Vienna, Kunsthistorisches) and the *Allegory of the Catholic Faith* (New York, Metropolitan).

Vermeer was elected an official of the Guild at Delft four times. Despite his fellow painters' esteem, however, and the high prices his pictures fetched, he was in constant debt. His slow rate of production, his 11 children, the effects of the war with France, must all have played their share in this.

His reputation remained purely local, until the French art critic, *Thoré-Bürger, published the articles in 1866 which earned Vermeer his present international renown.

Vernet, Claude-Joseph (1714–89) The leading French 18th-century *landscape – and especially seascape – painter; his works, based on studies after nature, were seen as the *naturalistic alternative to the more artificial *Rococo landscapes of *Boucher. He achieved an international reputation for his atmospheric coastal pictures, sometimes calm and sometimes stormy, depicted at various times of day or night. Being able to combine the *picturesque with topographical exactitude, he was commissioned by the crown in the 1750s to paint the ports of France (Paris, Musée de la Marine).

Born in Avignon, he was sent in 1734 by a local patron to Rome, where he settled and married an English wife; many of his clients were English Grand Tourists. Recalled to France in 1751, he did not make Paris his home until the 1760s. The main

influences on his art were *Claude, Gaspard *Dughet, Salvator *Rosa and their 18th-century followers in Rome; his lively figure style, examples of which are in Paris, Louvre; St Petersburg, Hermitage; London, National; and many private collections, was influenced by *Panini. Amongst his many followers and imitators were his probable pupil **Charles de Lacroix** (*d.*1782) and **Pierre-Jacques de Volaire** (1729–1802), who after working with Vernet at Toulon on the *Ports of France* commission went to Rome in 1764 and settled in Naples in 1769, where he specialized in painting eruptions of Vesuvius (e.g. Nantes, Musée). But Vernet's influence was also felt by non-French artists, notably *Wright of Derby and *Wilson. His son **Carle Vernet** (1758–1836) and the latter's son **Horace Vernet** (1789–1863) also became painters, specializing in horse and battle scenes.

Veronese, Paolo Caliari, called (1528–88) Born in Verona and trained by the mediocre Veronese painter **Antonio Badile** (*c.*1518–1560), he became one of the most prolific and successful painters in Venice where he moved *c.*1550. Master of *fresco mural decoration (e.g. façades, now lost; Venice, S. Sebastiano, 1558; Maser, Villa Barbaro, 1560); of altarpieces; of ceiling paintings (Doge's Palace, 1553, before 1585; S. Sebastiano, 1556; Marciana Library, 1556–7); of enormous feast-scenes on canvas for refectories (e.g. Paris, Louvre, 1562–3; Vicenza, Monte Berico, 1572; Venice, Accademia, 1573); and portraits, he also evolved a modern variant of the old Venetian *telero* or *scuola* pictures (*see* e.g. Carpaccio). As in the brilliant *The Family of Darius before Alexander* (late 1550s, London, National) the mood of these and Veronese's other paintings through the 1550s and early 1560s is characteristically grand, dignified and elegant but not tragic or even overtly emotional. These sumptuous parades were revived – even to particulars of costume and physiognomy – some two centuries later by *Tiepolo.

Veronese, at first drawn to *Mannerism, developed a personal style ultimately counter to it: adapting *Titian's colourism (*see under disegno*) to central Italian monumentality and plasticity. One or more trips

to Rome are probable in 1555, 1560 or 1566. His luminous and brilliant colours do not fuse forms – as in Titian's late manner – but serve to pick them out, to enhance *illusionism and a kind of *classicizing *realism. Around 1565, under the influence of *Tintoretto, Veronese began to introduce a darker tonality and *chiaroscuro; the temper of his paintings also became graver and increasingly full of pathos (e.g. *Pietà*, *c*.1565, St Petersburg, Hermitage; *Crucifixion*, *c*.1571, Paris, Louvre; *Agony in the Garden*, *c*.1580, Milan, Brera; *Lucretia*, 1580–5, Vienna, Kunsthistorisches; *Dead Christ appearing to Sts Mark, James and Jerome*, by 1584, Venice, S. Giuliano; *S. Pantaleone Healing a Child*, 1587, Venice, S. Pantaleon).

Through the later 1560s–84 Veronese painted mythological pictures for an international clientele as well as for Venetian clients (now New York, Frick, Metropolitan; Cambridge, Fitzwilliam; London, National; Augsburg, Maximilianmuseum). Two mythologies painted in or just before 1584 were bought for the Spanish Royal Collection by *Velázquez on his trip to Italy in 1650 (*Venus and Adonis*; *Cephalus and Procris*; now Madrid, Prado and Strasbourg, Musée respectively).

In 1573 there occurred in Veronese's life an incident of great art- and socio-historical interest. He was called to appear before the tribunal of the Inquisition to answer charges of having introduced unseemly secular elements into a painting (now in the Accademia) for the refectory of the convent of SS. Giovanni e Paolo: *The Last Supper in the House of Simon* (sic; the confusion is Veronese's own as recorded by the tribunal). Veronese pleaded artistic licence – such as that accorded to 'poets and jesters' – and custom to introduce 'ornament', 'enrich spare space', and 'decorate the picture'. In the event, although decreeing that Veronese should 'improve and change' the painting, the Inquisitors were satisfied with a change in title to *The Feast in the House of Levi*.

Veronese ran a large workshop, which continued to produce works 'by the heirs of Veronese' after his death. It included his brother **Benedetto** (1538–98) and his sons **Gabriele** (1568–1631) and **Carletto**

(1570–96), the latter apprenticed to Jacopo *Bassano, as well as his nephew **Alvise Benfatto**, called **del Frisco** (*c*.1544–1609). The painter **Giovanni Battista Zelotti** (1526–81) shared early decorative commissions with Veronese, and continued to work in his manner in fresco in great country houses in the Veneto and on façades in Vicenza.

Verrio, Antonio (*c*.1639–1707) Mediocre Neapolitan painter, whose mythological and emblematic *fresco decorations gained him enormous wealth and reputation at the English court. Admitted as a member of the Paris *Academy in 1671, after some years' residence in Toulouse, Verrio arrived in England in 1671/2. From 1676 to the Revolution of 1688, he was in continuous employment for the crown, succeeding *Lely as the King's Painter in 1684. He refused to work for William III, and from 1688–99 he mainly painted at Chatsworth and at Burghley House, covering enormous ceiling and wall spaces with his characteristically ill-drawn, ill-coloured, pretentious confections. During 1699–1702 he worked once more under royal patronage, largely at Hampton Court.

Verrocchio, Andrea del (1435–1488) The leading Florentine artist of the 1470s. As an executant he specialized in sculpture, in *bronze, *marble and *terracotta; he was, however, also the head of an active and innovative studio designing and supervising the production of works in other media, including *panel painting (see e.g. the *Ruskin Madonna*, *c*.1470–3, Edinburgh, National; *Baptism of Christ*, *c*.1476, Florence, Uffizi; also Pistoia, cathedral; London, National; Berlin, Staatliche). His workshop included, among others, *Perugino and *Leonardo da Vinci. It is Verrocchio's historical position as a 'hyphen' between *Donatello and Leonardo which has unfairly obscured his originality and achievements. Many of the abiding themes of Leonardo's art originated in Verrocchio's studio and found their first expression in his work.

Trained originally as a goldsmith, Verocchio may have spent some time in the

studio of Antonio *Rossellino, as is suggested by the style of his earliest marble sculpture, the highly ornamental lavabo in the Old Sacristy of San Lorenzo, Florence (*c*.1465–6). Better-known are the bronze works in which the sculptor measured himself against Donatello: the *David* executed for the Medici *c*.1471–3 (Florence, Bargello); the *Christ and St Thomas*, for a niche designed by Donatello and which originally contained Donatello's *St Louis of Toulouse* (1465–83, Florence, Or San Michele), which brilliantly resolves the problem of staging an interaction between two figures in a space intended for one; and the *Putto with a Fish*, a free-standing fountain figure originally for Lorenzo de'*Medici's villa at Carreggi (*c*.1470), later moved to Florence, Palazzo della Signoria, which is the source of the *figura serpentinata* of 16th-century sculpture (*see* e.g. Michelangelo, Giovanni Bologna). Finally, Verrocchio's equestrian *Colleoni monument* (1480–96, Venice, Campo SS. Giovanni e Paolo; *see also* Leopardi) explicitly competes with Donatello's *Gattamelata* in Padua, increasing the figures' *contrapposto* and sense of unstable motion. Clothed, unlike the *Gattamelata*, in purely contemporary armour, Verrocchio's *Colleoni* divorces the equestrian monument from its *Classical origins and prefigures its *Baroque descendants.

A mature marble work, the *Lady Holding Primroses* (*c*.1475–*c*.80) is the first bust in which the sitter's hands are shown, and is thought to be the source for Leonardo's portrait of Ginevra dei Benci and thus, ultimately, the *Mona Lisa*. The marble *Forteguerri Monument* (begun 1476) in Pistoia cathedral was, like the *Colleoni*, left unfinished at the sculptor's death and was further modified in the 18th century. A terracotta model for the monument (London, V&A) suggests that it would have been 'the most richly figurated monument of the whole century', in contrast to Verrocchio's only other tomb, the *Monument to Piero and Giovanni de'Medici* in S. Lorenzo, Florence (1469). This superb work in bronze, marble and red and green porphyry relies for its effect on an inventive use of the decorative vocabulary of the Rossellino workshop and on matchless

craftsmanship. Verrocchio's engineering skill and the craftsmanship of his studio are, finally, demonstrated in the enormous copper orb placed on top of the lantern of *Brunelleschi's dome for Florence cathedral (1467–71; destroyed 1600).

Verschaffelt, Pieter Antoon (1710–93) Flemish-born sculptor. He worked in Paris with *Bouchardon; then spent some 10 years in Rome, where he executed a portrait bust of *Pope Benedict XIV* (1749, Rome, Pinacoteca Capitolina) and the *bronze statue of the *Archangel Michael* atop the Castel Sant'Angelo, the fortress of Rome (1753), replacing an earlier *marble sculpture by Raffaele da Montelupo. He then became court sculptor to the Elector Charles Theodore at Mannheim, in Germany, although returning to his native city, Ghent, to erect the *Monument to Bishop van der Noot* in the cathedral (1778).

Verspronck, Cornelis Engelsz. (active from 1593–before 1666) Dutch painter active in Haarlem. Influenced by *Cornelis Cornelisz. van Haarlem, he specialized in group portraits of civic notables, although far outstripped by his great contemporary Frans *Hals (Haarlem, Frans Hals).

Verspronck, Johannes (1597–1662) Dutch portraitist active in Haarlem and much indebted to Frans *Hals, although he lacked the latter's spontaneity and technical daring. Characteristic of his style is the application of a greyish glaze (*see under* colour, oil paint) to the shaded side of the face, with blue-grey touches to highlight the nose and lips. He combined great refinement with animation, and he acquired a high reputation and increasingly better commissions (Haarlem, Frans Hals; Budapest, Szépmüveszéti).

Vertue, George (1683–1756) English engraver (*see under* intaglio) and antiquary; from about 1713 until his death he collected notes about contemporary art in Britain, with a view to writing its history. This he never did, but his forty-some notebooks (London, British) were bought from his widow in 1758 by Horace Walpole (1717–97), who used them as a basis for his

Anecdotes of Painting in England, begun in 1760 and published 1762–80. This was the first systematic account of British art and, like the notebooks themselves (published between 1930 and 1955), an important source for later scholars.

Veshch/Gegenstand/Objet Journal in Russian, German and French, edited and mostly written by *Lissitzky and Ilya Ehrenburg and published by them in Berlin in three issues in 1922. Through it they promoted the ideas of *Constructivism both as art and as art's input into functional design.

Vesnin, Aleksandr (1883–1959) Russian painter and architect, youngest of three architect brothers. As a painter Vesnin was associated with *Tatlin and *Exter, and especially with *Popova with whom he taught in Moscow and designed the setting for a mass spectacle to be produced by Meyerhold in 1921. He was one of the five exhibitors in the exhibition '5 × 5 = 25' in 1921 and made stage designs for Tairov that explored the *Constructivist idiom and method, most notably the set for a stage version of Chesterton's *The Man Who Was Thursday*, 1922–3. (A model of the set was shown in Paris in 1923.)

Vien, Joseph-Marie (1715–1809) Like that of his younger contemporary the sculptor *Pajou, this French painter's career spanned successfully the most extreme political changes. Head of the royal school of Elèves Protégés; Director of the French *Academy in Rome 1775–81; the last *Premier Peintre du Roi*, 1789, he survived the French Revolution to be made a senator, and finally a Count of the Empire by Napoleon.

Born at Montpellier, he became a pupil of *Natoire in Paris; in 1744–50 he was at the French Academy in Rome, where he was drawn to the Early *Baroque *Classicism of the *Carracci, *Reni and *Guercino. These were the models which he was later to hold up to his pupil *David, with far more dramatic results than those observable in Vien's own paintings (e.g. cycle of the *Life of St Martha*, 1746–7, Tarascon, Collégiale de Ste Marthe). In the

1760s he played a part in the revival of large-scale religious painting in Paris (Paris, St Roch). Encouraged by fashionable antiquarian interest sparked off by the discovery of Herculaneum in 1719 and Pompeii in 1748, and the wall paintings uncovered there, he evolved a rather limp, sentimental form of decorative *Neoclassicism. His work in this style was preferred by Mme du Barry for her lodge at Louveciennes over the far superior, but still *Rococo, panels by *Fragonard (Vien's panels now Paris, Louvre; other paintings in this chastely erotic *manière grecque*, Ponce, Museum; Montpellier, Musée).

Vieira da Silva, Maria Elena (1908–82) Portuguese-French painter who worked in France from 1928 on and became a French citizen. In 1940–7 she lived in Brazil with her painter husband Arpad Szènes. Having studied under *Bissière and others, she developed a delicate linear idiom suggesting landscape and interior spaces that brought her an international reputation in the years of *Art informel.

Vigarny, Felipe (*c.*1470–1543) Also called Bigarny. His real name was Philippe Biguerny. Burgundian-born Spanish sculptor; his style evolved from the Late *Gothic of his first reliefs in Burgos (cathedral, 1498, enclosure of high altar) through a harsh version of Italianate *Renaissance (Madrid University, 1518) to *Mannerism (Granada, Royal Chapel, high altar, 1521). Vigarny gained a more than local reputation when in 1519 he signed a partnership with *Berruguete in Saragossa; in 1525–6 he collaborated with Diego de *Siloe in the Chapel of the Constable at Burgos. His last works were the choir stalls and marble reliefs at Toledo Cathedral, 1539–43.

Vigée-Lebrun, Marie-Louise-Elizabeth (1755–1842) French portraitist, an attractive and charming woman specializing in the attractive and charming depiction of women and children. She was particularly associated with Queen Marie-Antoinette, whose portrait she painted several times from 1779 (Versailles). After her flight from France during the

Revolution she became an international success in most of the capitals of Europe. She returned to France after the Restoration in 1814.

There is an element of paradox in comparing Vigée-Lebrun with her rival Mme *Labille-Guiard, who was received in to the French *Academy on the same day in 1783. The latter, a Republican sympathizer, is best remembered for official court portraiture in a style which harks back to *Nattier. Vigée-Lebrun, a socialite who under the *ancien régime* gave famous parties *à la grecque*, that is, in simplified dress harking back to the ancient Greeks, introduced this type of costume into her portraits. Influenced by *Greuze and *reproductive prints after English painters, she strove for graceful spontaneity in her work. Thus it was she, and not her Revolutionary rival, who first introduced into French portraiture a *Neoclassical simplicity anticipating that of *David's portraits. The naturalness and intimacy of her best work – tending towards archness or sentimentality in her lesser paintings – also anticipate *Romanticism. Late in life she wrote her *Memoirs* (1835). There are paintings by her in Paris, Louvre; St Petersburg, Hermitage; London, National, Wallace, Coll. HM the Queen; Geneva, Musée; Toledo, Ohio, Museum; etc.

Vigeland, Gustav (1869–1943) Famous Norwegian sculptor who studied in Paris and Italy and worked at first in a *naturalistic manner, but in 1900 undertook restoration work on Trondheim Cathedral. This involved him in studying medieval sculpture, and his commission to make a fountain for Frogner Park in Oslo, in the same year, led him into an ever-growing project and the creation, with assistants, of 36 allegorical groups in the park in bronze and in granite, and a tall totemic column of 121 compacted bodies. The scheme was completed in 1944 and is both criticized and popular. The art historian G. H. Hamilton called it 'sculptural Wagnerism'; it is best understood as an ambitious piece of *Symbolist art.

Vignon, Claude the Elder (1593–1670) French painter and picture dealer, much influenced by the work of *Elsheimer, which he could have seen in Rome during his stay there in 1616–24, and by the latter's followers, especially *Lastman. Some of his paintings resemble those of the youthful *Rembrandt, with whom he was acquainted and some of whose pictures he sold in Paris (Paris, Louvre; Nantes, Musée; Stockholm, National). His son, **Claude Vignon the Younger**, was a decorative painter who between 1671 and 1681 worked on the royal apartments at Versailles under the direction of *Lebrun.

Villate, Pierre *See under* Quarton, Enguerrand.

Villers, Marie-Denise *See under* Lemoine, Marie Victoire.

Villon, Jacques (1875–1963) Pseudonym of Gaston Duchamp, older brother of Marcel *Duchamp and Raymond *Duchamp-Villon. Like his brothers, Villon was an artist. He was a founder member of the *Salon d'Automne, was influenced by *Cubism and became the central figure in a Cubist group meeting at Puteaux, on the outskirts of Paris; it included, besides his brothers, *Gleizes, *Metzinger, *Gris and *Léger. He was included in the *Armory Show in 1913. After 1945 his work became wholly *abstract and it was in this late period that he met with success, receiving various prizes and honours, and having a large retrospective show in Paris (Md'AM) in 1951 and an exhibition of his graphic work in New York (MoMA) in 1952.

Vinci, Leonardo da *See* Leonardo da Vinci.

Vinck[e]boons, David (1576–1632/3) Flemish-born, he emigrated with his family to Amsterdam, becoming one of the most prolific and popular painters and print designers in Holland. Himself influenced by Pieter *Bruegel the Elder, he helped to forge the new *realistic style of Dutch *genre and *landscape painting. There are pictures by him in Dresden, Gemäldegalerie; Vienna, Akademie, as well as in Dutch collections.

Vingt, Les or **Groupe des XX** Brussels association of artists, formed in 1883 and internationally without a binding programme or principle. Its secretary, Octave Maus, a lawyer, became very influential, partly through the group's journal, *L'Art moderne*, which he edited. Its exhibitions presented new Belgian art alongside important new work from abroad, notably from Paris and England. They also included the applied arts, and presented lectures and concerts, until 1893–4 when the group's functions were taken over by a new, less controversial organization, La Libre esthétique, directed by Maus.

Viola, Bill (1951–) American artist, born in New York, trained at the College of Visual and Performing Arts of Syracuse University and during the 1970s collaborating with musicians on the production of audio-visual events and tapes. Since about 1975 his work has been acknowledged and exhibited as art and has become known and admired internationally in the form of videos with sound. Some of these have explored particular landscapes and their effect; others with scenes from everyday life, as in his *Nantes Triptych* (1992) which records, on the left, a woman giving birth to a baby in the arms of a man and, on the right, an old woman's death while, in the centre, a dreamlike image of a man moving in/being moved by water suggests our helpless existence between these ineluctable coordinates. His technology becomes more complex, and thus also his communication. The image in his recent video piece, *The Tree of Knowledge* (1997), is partly determined by the movements of the spectator in front of it. In 1995 his work was featured in the American pavilion at the Venice Biennale.

Virgo inter Virgines, Master of the (active *c.*1470–1500) Netherlandish painter and designer of woodcuts for book illustrations (*see under* relief prints) active in Delft and probably also in Gouda and Antwerp. He is named after a panel now in Amsterdam, Rijksmuseum, depicting the Virgin Mary surrounded by Saints Catherine, Cecilia, Barbara, and Ursula –

the *Virgin among Virgins*. Some twenty paintings have now been grouped around this work; all are characterized by warm and intense colour, *expressive distortions, and fanciful costumes perhaps inspired by *Joos van Ghent (first recorded in Antwerp); the first signs of what was to become Netherlandish *Mannerism. There are outstanding works by him in Liverpool, Walker; Barnard Castle, Bowes; Berlin, Staatliche; Rotterdam, Boijmans Van Beuningen.

Vischer, Peter the Elder (*c.*1460–1529), **Hermann the Younger** (before 1486–1517) and **Peter the Younger** (1487–1528) Nuremberg *bronze founders and sculptors. Peter the Elder inherited his father Hermann Vischer's bronze foundry and made it famous throughout Germany. He was assisted by his two sons, one of whom certainly, and both of whom probably, visited Italy. Their work combines *Gothic forms and motifs with features inspired by Italian *Renaissance art and perhaps also by antique pieces in the collection of Peter the Elder. The firm produced many funerary monuments, their last important works being the statues of *Theodoric* and *Arthur* for the *Monument of Emperor Maximilian* (Innsbruck, Hofkirche, 1513). But their most ambitious production was the tomb and shrine of *St Sebald* (Nuremberg, St Sebald, 1507–19; first design, 1488), a large free-standing *bronze structure combining reliefs, statuettes, architectural forms and ornaments, and reflecting Italianate humanist subject matter.

Visconti family *See under* Sforza.

Vitale da Bologna (active 1334–61) The only important Bolognese painter of his day outside the field of manuscript *illumination; he worked also in other centres in northern Italy, such as Udine (cathedral, frescos) and Pomposa (abbey church, frescos, 1351 onwards). Virtually all his paintings on panel and in *fresco are distinguished by brilliant colour and spatial disconnection that add both to their emotional charge and to their highly decorative appearance. There are altarpieces and fragments in the Vatican, Pinacoteca;

Bologna, Pinacoteca, Davia-Bargellini, S. Salvatore; Edinburgh, National.

Viti, Timoteo *See under* Raphael.

Vitruvius Roman architect and engineer flourishing in the 1st century BC, the author of an influential treatise on architecture, whose pages on the mural decoration of Roman villas and town houses were also important for *Renaissance art theoreticians, such as *Alberti, and on patrons and artists.

Vittoria, Alessandro (1525–1608) Unequal but versatile and innovative sculptor from Trent, active mainly in Venice, where he settled in 1543. Having joined the workshop of Jacopo *Sansovino, he fell out with him over his preference for the *expressive sculpture of *Michelangelo above the *classicizing style Sansovino owed to *Raphael. He adapted motifs from Michelangelo – which he knew only from reproductions – in monuments and statues for Venice, the Doge's Palace and various churches. More accomplished as a modeller than a carver in *marble, he executed highly effective *stucco statues. From 1553, he worked also as a medallist, and from *c.*1560 he was the dominant Venetian portrait sculptor; there are *bronze, marble and *terracotta portrait busts by him in Venice and elsewhere. As a maker of small bronze statues, he executed at least one major work, the *Neptune* (*c.*1580–5, London, V&A), which in its dynamic sweep anticipates the *Baroque style of *Bernini.

Vivarini, Antonio (before 1430–after 1476), his brother **Bartolomeo** (*c.*1430– after 1491) and Antonio's son **Alvise** (1446/53–1505) Dynasty of Venetian painters second in importance only to the *Bellini. From *c.*1450–*c.*70 Antonio and Bartolomeo together held a near-monopoly of providing *altarpieces to the provincial churches in the Venetian empire. This market had been opened up by Antonio; except for a brief period *c.*1450–8 the two brothers ran separate workshops, working together, however, on major commissions. After *c.*1470, when Antonio ceased to paint, to 1482, Bartolomeo became the more

dominant figure, executing many altarpieces in Venice itself. From 1488 Alvise became the only artist to work on equal terms with Giovanni Bellini on the decoration of the Great Council hall in the Doge's Palace (*see also* Carpaccio; Titian). His three canvases, never finished, were destroyed with the rest in the fire of 1577, but the prestigious commission earned him other major Venetian work in the 1490s (e.g. altarpieces for S. Giovanni in Bragora; S. Maria Gloriosa dei Frari; Il Redentore). After 1500 his capacity for work was impaired by illness; the Frari altarpiece was completed by his assistant *Basaiti.

Antonio and Bartolomeo Vivarini came from a family of Paduan glass painters established in Murano in the 14th century; Antonio signed himself Antonio da Murano. We do not know the facts of his training; he certainly looked closely at the work of *Gentile da Fabriano and of the Tuscan artists who worked in the Veneto at various times between 1424 and 42: *Masolino; *Ghiberti; Paolo *Uccello; *Donatello; *Michelozzo; Filippo *Lippi; *Andrea del Castagno. His first known work is dated 1440 (Parenzo, Basilica Eufrasina). From the early 1440s until 1450 he often worked in collaboration with his brother-in-law, the German-born **Giovanni d'Alemagna** (*d.*1450), who may have been responsible for the more *Gothic features of their altarpieces and *fresco decorations (e.g. *Ancona of S. Sabina*, 1443, Venice, S. Zaccaria; *Madonna with Saints*, 1446, Accademia; vault, Padua, Eremitani chapel, destroyed in World War Two). Antonio's style hardly evolved, and a good example is the 1446 altarpiece, an early instance in Venice of a *triptych composition pictured within a single spatial construction – a device later to be employed by *Mantegna for the S. Zeno altar in Verona (but *see also* Domenico Veneziano in Florence). Other works by Antonio can be found in Venice, S. Pantaleon; Ca'd'Oro; Houston, Texas, Museum; London, National; Prague, Narodni; Rome, Vatican Pinacoteca; etc.

In 1450 Antonio collaborated with Bartolomeo, who had joined him in Padua, on an altarpiece now in Bologna, Pinacoteca. The brothers' firm was dissolved

after 1458, although they continued informal collaboration. Bartolomeo's style is in some respects more advanced than his brother's, marked by a greater, albeit superficial, dependence on Giovanni Bellini's treatment of light. This was coupled, however, with an exaggerated linearity and hardness of surface acquired in the workshop of the Paduan Squarcione (*see under* Mantegna). Bartolomeo further developed the theme of the *sacra conversazione*, often uniting it with a motif developed by Giovanni Bellini but which the Vivarini brothers made their own: the adoration by the Madonna of the sleeping Christ Child prefiguring the dead adult Christ (e.g. Naples, Capodimonte). Other works, Paris, Louvre; Venice, S. Maria Gloriosa dei Frari and other churches, Accademia; London, National, Westminster Abbey; Padua, Museo; etc.

Alvise, probably trained in his uncle's studio, acquired a better understanding of *Antonello da Messina and Giovanni Bellini's use of light as a record of actual optical experience and a unifying element in pictorial composition. He softened the colours of his paintings, perhaps also under the influence of *Perugino, who was in Venice between 1494–6. In addition to altarpieces in the family tradition, his work in the Doge's Palace also brought him a few portrait commissions, derived from Flemish prototypes through the agency of Antonello (1497, London, National; Washington, National; Philadelphia, Johnson Coll.; Padua, Museo). More vigorous and dramatic in movement than the late work of Bellini, his religious compositions attracted the interest of the young *Giorgione and Titian and influenced *Lotto and Paris *Bordone. His last completed work (1500, Amiens, Musée de Picardie) was once attributed to Basaiti.

VKhUTEMAS Acronym of Russian words meaning Higher Technical-Artistic Studios, name given to the workshops set up in Moscow in 1918 to replace the Moscow Institute of Painting, Sculpture and Architecture and the Stroganov School of Art. Its programme was determined by the Institute of Artistic Culture (INKhUK), several of whose members

taught in the VKhUTEMAS. Although *abstract and *Constructivist ideas and practice thrived there in the early twenties, more *realistic art, especially *Socialist Realism became dominant from about 1925 on, when the name was changed to VKhUTEIN (Higher Technical Institute).

Vlaminck, Maurice de (1876–1958) French painter of Flemish family, born in Paris and self-taught. He was an anarchist and a racing cyclist and worked as a mechanic and as a café violinist. His amateur enthusiasm for painting hardened when he met *Derain in 1900 and shared his studio, painting gloomy but feverish portraits and still lifes. In 1901 he visited a Van *Gogh exhibition where Derain introduced him to *Matisse. He was probably the first artist to collect African tribal sculptures and it seems to have been through him that Derain, Matisse and *Picasso became interested in them. Vlaminck adopted Van Gogh's bright colours and, like his friends, painted now with separate, open brushstrokes echoing both Van Gogh and *Impressionism. His new work, mostly landscapes, proves him the jauntiest of the *Fauves. His focus then shifted to the work of *Cézanne and he adopted some of his methods as well as a much more limited and darker colour range. Later, by about 1920, he turned to a more *realistic mode of painting, still relying on vigour to hold his pictures together. He proclaimed his distance from any professional instruction and tradition and his reliance on instinct in biographical writings, beginning with *Dangerous Corner* (1929).

Vlieger, Simon de (1601–53) One of the most prized Dutch painters of seascapes. Born in Rotterdam, he worked in Delft from 1633/4–8, and in Amsterdam thereafter. A versatile artist, he made cartoons for tapestries (*see under* fresco), painted the doors of the organ in the Grote Kerk in Rotterdam and designed stained-glass windows for the Nieuwe Kerk in Amsterdam. He also made etchings (*see under* intaglio) of landscape and animal studies. But his greatest contribution is to marine painting. Beginning in a style close to that of the Early *Realist *Vroom, he

soon came to be primarily interested (perhaps under the influence of *Porcellis) in the atmospheric depiction of sea, sky and clouds. There are works by De Vlieger in most major galleries, including The Hague, Mauritshuis; Prague, Narodni; Greenwich, Maritime; Budapest, Museum.

Volaire, Pierre-Jacques de *See under* Vernet, Claude-Joseph.

Volterrano, Il *See* Franceschini, Baldassare.

Vorsterman, Lucas *See under* Bolswert, Schelte à.

Vorticism A radical English art movement, led by Wyndham *Lewis and named by the poet Ezra Pound in 1914. Lewis, *Wadsworth, *Gaudier-Brzeska and others exhibited together in Brighton in 1913, presenting their work as and in 'The Cubist Room'. In 1914 they published their first polemical year-book, *BLAST*, and in 1915 they showed in London the Vorticist Exhibition which included several large paintings that are now lost. Essentially urban in its taste for hard, clear forms, Vorticism expressed great impatience with all Victorianism and all revivalism and sought to out-do the *Post-Impressionist and *Fauve modernism propagated by Roger *Fry and his friends. Lewis met his associates when working in Fry's *Omega Workshops; leaving with them after a disagreement with Fry, he adopted the vehemence and rhetoric of the Futurists in his onslaughts on Fry and made the Futurists' attempt to embrace industrial dynamism as the central concern of their art the concern also of Vorticism. *Nevinson joined the group in 1913 but was the only one to call himself a Futurist. *Epstein and *Bomberg exhibited with them but did not become Vorticists. Though the war seemed an apt echo for their initially openly aggressive style and rhetoric – the subjects they used were neither necessarily aggressive nor even modern, though they shunned the French tendency to nudes, still lifes, domestic interiors and landscapes, preferring actions, even if the sources were classical antiquity

or the Bible, rendered in varying degrees of *abstraction – only Nevinson used his Vorticist art to make powerful images of it. The war and its aftermath also broke the group up and found alternative pursuits for its members. There is no exact end date for the movement. The June 1915 Vorticist Exhibition was the only one they put on, and the second and last *BLAST* came out in July 1915. That, in effect, was the end of Vorticist group activity.

Vos, Cornelis de (1584–1651) Antwerp portraitist and *history painter, influenced by *Rubens and the young *Van Dyck. He is perhaps the earliest exponent in Flanders of the group *portrait historié*, hitherto a Dutch genre. There are works by him in Antwerp, Museum, St Paulskerk; Brunswick, Anton-Ulrich; Vienna, Kunsthistorisches; Graz, Landesmuseum. His brother **Paul de Vos** (1596–1678) specialized in hunting and animal scenes (e.g. Madrid, Prado), much influenced by Frans *Snyders, the husband of Cornelis's and Paul's sister Margaretha.

Vos, Maerten de (1532–1603) Italianate Flemish painter, who was a pupil of Frans *Floris. He was directly influenced also by *Tintoretto, whose studio assistant he became during his Italian sojourn, from the early 1550s until 1558. Upon his return to Antwerp, De Vos became one of the leading artists of the city, inheriting Floris's primacy upon the latter's death in 1570. He combined Floris's eclecticism of design with Venetian colourism (*see under disegno*), evolving a highly decorative manner which anticipates the Flemish *Baroque of the 17th century. Many altarpieces and mythological paintings by him are known (Antwerp, cathedral, Museum; Brussels, Musées; Florence, Uffizi; Seville, Museum; etc.). He was the teacher of Hendrick de *Clerck.

Vos, Simon de (1603–76) Flemish painter, a pupil and probably a relation of Cornelis de *Vos in Antwerp. He painted portraits (Barnard Castle, Bowes), biblical subjects in the tradition of *Rubens and *Van Dyck, but his best-known works are

his lively *genre scenes in the manner of Frans *Francken the Younger and *Vranx (Antwerp Museum).

Vostell, Wolf (1932–) German artist, inventor of *décollages*, meaning in some sense the opposite of constructed *collages, using fragments of posters and other found ephemera, often with paint. In the late 1950s he was one of the pioneers of *happenings in Germany.

Vouet, Simon (1590–1649) French painter, born in Paris, who spent 15 years in Italy (1612–27), mainly in Rome, where he emerged as leader of the French colony; he was elected head of the *Academy of St Luke in 1624. On his return to France he gained a virtual monopoly in the production of altarpieces for Parisian churches and of decorative schemes (some carried out in conjunction with the sculptor Jacques *Sarrazin) for great houses and royal palaces. This monopoly was threatened with the arrival of *Poussin in 1640, but with the latter's return to Rome in 1642 Vouet once again regained ascendancy.

During his first years in Rome Vouet copied the style of *Caravaggio, but by the time he returned to Paris he had adopted a 'compromise' manner, a *Baroque style tempered by *classicism. His decorative French commissions are indebted to Venetian painting, especially *Veronese, whose work he studied during his visits to Venice at various times between 1612 and 27. There are paintings by Vouet in churches in Paris, Rome, Naples, Genoa, and in Paris, Louvre; Naples, Capodimonte; Chatsworth; London, National. His pupil, **Claude François (Frère Luc)** (1614–85), became a member of the Recollect Order and painted for their churches in France and Canada. **Aubin Vouet** (1595–1641), Simon's brother, was also a painter.

Vranx, Sebastiaen (1573–1647) Flemish painter and designer of prints, active mainly in his native Antwerp; he travelled to Italy *c.*1593. He was a highly regarded specialist in battle-scenes with horses, *landscapes and domestic interiors, who occasionally collaborated with others but refused to employ studio assistants or

copyists to meet the demand for his pictures. His early work was dependent on Pieter *Bruegel the Elder and influenced by Italian *Mannerism, but soon after 1610 he evolved a more individual and modern style (Kassel, Staatliche).

Vredeman de Vries, Hans (1527–*c.*1606) and his son **Paul** (1567–*c.*1630) Hans Vredeman was a Dutch architect, painter and draftsman active throughout the Netherlands and in Germany. A pupil of Cornelis *Floris, he was the first Dutch artist to specialize in pictures of imaginary architecture (e.g. Amsterdam, Rijksmuseum; Vienna, Kunsthistorisches). His multilingual treatise on *Perspective, that is, the Celebrated Art* . . . (1604) was of great importance to Dutch artists, whilst engravings (*see under* intaglio) after his architectural designs influenced buildings and the design of *retables, etc. throughout the Netherlands, Germany, Scandinavia, England, Spain and Latin America.

Born in Antwerp, Paul Vredeman de Vries followed his father in painting fantasy pictures of churches, palaces and interiors; the figures in these paintings were often done by other artists, e.g. Frans *Francken (Vienna, Kunsthistorisches). Sometime after 1604 he departed for Prague, where he worked at the court of the Emperor Rudolf II.

Vrel, Jacobus (active from 1654 to 1662) Enigmatic and rare Dutch painter of domestic *genre and tranquil town views. Nothing is known of his life, but since pictures by him were once attributed to *Vermeer, whose work they resemble superficially in spirit, it is usually said he probably worked in Delft. The type of architecture he painted in his street scenes suggests, however, that he lived in a more southerly area of the Netherlands (Hartford, CT, Wadsworth Atheneum; Los Angeles, Getty).

Vries (rightly Fries), **Adrian** or **Adriaen de** (*c.*1545–1626) Dutch-born *Mannerist sculptor trained under Giovanni *Bologna. He was a friend of Hubert *Gerhard, and his two monumental fountains in Augsburg, the *Mercury* (1596–9)

and the *Hercules* (compl. 1602), form a series with Gerhard's *Augustus Fountain.* Although he received the commissions on a trip to Germany in 1596, De Vries made the models, which were cast locally by others, in Rome, where he had already executed two monumental multiple-figure groups, indebted to Giovanni Bologna, for the Emperor Rudolf II (1592; now Stockholm, Nationalmuseum; Paris, Louvre). In 1601 De Vries was appointed sculptor to the Emperor in Prague (busts of *Rudolf II* 1603, 1607, Vienna, Kunsthistorisches; of *Elector Christian II of Saxony,* 1603, Dresden, Albertinum; and *allegorical reliefs of *Rudolf II,* 1609, Windsor Castle; Vienna, Kunsthistorisches). After Rudolf's death in 1612 De Vries was employed by Count Ernst of Schaumberg (Bückeburg, parish church, font, 1616; Stadthagen mausoleum sculpture, 1618–20) and Christian IV of Denmark (*Neptune Fountain,* 1617–23, now in Drottningholm, Sweden). From *c.*1622, he worked again in Prague, in the palace of Duke Albrecht of Wallenstein (figures now in Drottningholm). In time, his style departed from the vigorous precision of Giovanni Bologna towards an increasingly more intricate and restless modelling.

Vroom, Hendrick Cornelisz. (1566–1640) The first European artist to specialize in marine painting. After extensive travels as a painter on pottery, Vroom returned to his native Haarlem *c.*1590, to paint large detailed pictures of ships, fleets and sea battles, usually celebrating Dutch marine power (Amsterdam, Rijksmuseum; Haarlem, Hals; etc.). He also designed tapestries, his most famous being a set of 10, *Defeat of the Spanish Armada by the English fleet,* which hung in the House of Lords, Westminster, until destroyed by the fire of 1834. His son, Cornelis Hendricksz. Vroom (*c.*1590/1–1661), was a landscapist best known for his forest views, which anticipate later works by Jacob van *Ruisdael (London, National; Rotterdam, Boijmans Van Beuningen) and were themselves influenced by *Elsheimer.

Vrubel, Mikhail (1856–1910) Russian *Symbolist painter and designer,

who studied law and then art in St Petersburg, including some years at the Academy (1880–4), and soon after participated in the restoration of frescos in St Cyril, Kiev. In 1887 he designed murals for Kiev Cathedral, including *Resurrection* and *Pietà* for which he painted three poignant versions; these were too stark to be accepted. Soon after this he showed signs of insanity, which surfaced again in 1902 and came to dominate his art until blindness, in 1906, made him cease work. In Moscow and at Abramtsevo he worked for Mamontov (*see* Vasnetsov), making stage designs for opera and designing furniture and ceramic sculpture. He also worked on ceramics for Princess Tenisheva at Talashkino, using fairy-tale subjects and a semi-folkloristic style. In 1890–1 he made illustrations for Lermontov's poem 'The Demon' and was for some time obsessed with this subject, making several paintings of this victim-hero and a painted plaster sculpture of him in 1894. He painted panels for Mamontov's Moscow villa, including *The Flight of Faust and Mephistopheles* (1896). He exhibited with the *World of Art during 1900–6. Vrubel's vision and way of painting varied over the years and according to his subjects. His portraits can be vividly *naturalistic and painted in a sketchy, free manner suggesting *Impressionism, while other paintings suggest a *Post-Impressionist feeling for a full and compacted surface; a taste for faceting the surface, as in *The Demon seated* (1890) has led some commentators to call him a forerunner of *Cubism. A highly educated, deeply thinking and restless man – 'For the first time in Russia a painter found himself ahead of his literary counterparts, confident of his own gifts and independent of all theories' (Dmitri V. Sarabianov, 1990) – Vrubel's path as artist did not follow the developmental sequence proposed by western art and he did not commit himself to the dominant tendencies in Russian art of his time. As a Symbolist, he was as much a creator as an adherent of the Russian movement.

Vuillard, Edouard (1868–1940) French painter, one of the founders of the *Nabis. Deeply attached to his widowed

mother and at home amid her couture work (he never married,but formed attachments to society ladies who were also his patrons), Vuillard developed a subtle art of patterns and interacting colours that can 'embody the way we live now, that can legitimize our given, everyday world, however tawdry, as the material of art' (Timothy Hyman). He studied at the Ecole des Beaux-Arts and then in the Académie Julian in Paris. In the early 1890s he produced large decorative panels for the apartments of well-to-do friends and was involved, with them, in the exhibitions and the journal, initiated in 1891, *La Revue Blanche*, for which he also produced posters. Those panels were mostly outdoor scenes; his typical paintings are small and domestic: keenly observed, rigorously designed interiors, noted in soft touches of *oil, *tempera and/or *pastel to form a visual tapestry in which people coexist visually with furnishings and other objects. For a time he accepted many commissions for portraits, adopting some of the methods of *Impressionism, but his finest and most intense works are those in which he realized, on canvas or card, a motif or scene that mattered to him personally in terms of colour and flat design,

from (for example) *In Bed* (1891; Paris, Pompidou) to himself seen in a mirror, *The Artist with Spectacles* (1932). He began to exhibit in 1891 with the Nabis; in 1938 a comprehensive retrospective was organized with his help and shown at the Musée des Arts Décoratifs in Paris. He was known internationally from around 1900 for his lithographs and etchings, some of them done for magazines and thus widely disseminated. His recognition as one of the masters of modern painting is much more recent.

Vyšší Brod, Master of (active *c.*1350) Bohemian painter, named after an altarpiece from the monastery of Vyšší Brod (Hohenfurth in German, giving the artist his alternative title of Master of Hohenfurth), now in Prague, National. Both French and Italian traits are evident in this work, in which *Gothic linear rhythms control the forms. Background details, however, such as the birds perching in the trees of the Garden of Gethsemane, anticipate the *realism of International Gothic painters such as the *Limbourg Brothers. Another important painting from his shop is in Boston, MFA.

W

Wadsworth, Edward (1889–1949) British painter, son of a wealthy Yorkshire industrialist. Sent to Munich to study engineering, Wadsworth was drawn to art and attended the Slade School in London in 1908–12. From 1913 on he was associated with *Vorticism and was stylistically close to Wyndham *Lewis. He translated passages from *Kandinsky for the first issue of *BLAST*; the second has his woodcut cover and illustrations of his work. Few of his paintings of that time now exist: some were close to *Futurism, others wholly *abstract, using geometrical elements in jagged clusters suggestive of urban life; he also made numerous woodcuts some of whose titles refer to towns while only one of them includes figures. He used this experience when dazzle-camouflaging ships in 1918. He made prints of such subjects as well as one powerful oil painting, *Dazzle-Ships in Drydock in Liverpool* (1919; Ontario, National). In 1922 he started using tempera and maritime subjects, including close-ups of grouped objects associated with the seaside and with ships against a vast sea and sky backdrop. His painstaking observation and technique, together with contrasts of scale, give his pictures a *Surrealist quality. Wadsworth was the least insular of artists of his generation, travelling on the Continent and involved in Paris art circles, but also active in the London art world while living in Sussex. In 1933 he was a member of *Unit One. In 1938 he painted two large decorations for the liner *Queen Mary*, to which his preferred subject matter and his ability to work on an epic scale suited him. He also did drawings and prints for publications, notably the engravings for his own book, *Sailing Ships and Barges of the Western Adriatic and the Mediterranean* (1926).

Waldmüller, Ferdinand Georg (1793–1865) Austrian painter who, after travelling in Italy, was professor at the Vienna Academy from 1830 on and soon found himself at odds with its principles. He attacked these in writings from 1846 on but his work and his teaching were clear from the start: he was a convinced *naturalist and he condemned all plagiarism and *idealization, anything that interfered with the accurate rendering of appearances. His subjects were landscapes, still lifes, portraits and occasional *genre scenes; his method was intense observation and detailed, finely modulated painting of every object and of nature's light. He chose his subjects for their ordinary beauty, not for their *sublimity – he was a *Romantic only in his submission to nature – nor for any lessons they might carry about the harsh realities of life – he was not a *realist. His *naturalism, polemical only in itself, is matter-of-fact and undramatic, and he is seen as the leading painter of the style known as *Biedermeier. His influence was extensive, especially upon his students, but none of them could match the relaxed charm of his art.

Walker, Robert (1605/10–after 1656) English portrait painter, possibly a pupil of *Van Dyck; he may also have studied in Italy (the diarist John Evelyn sat to him in 1648 for an eccentrically Italianate likeness, on loan to Oxford, Christ Church). He has been called a 'much inferior counterpart to the Royalist *Dobson on the Parliamentary side' and depicted Cromwell and other leading personalities of the Protectorate (London, National Portrait; Milton Park; Leeds, Walker). A witty self portrait in Oxford, Ashmolean, parodies Van Dyck's famous self portrait pointing to the sunflower of royal favour: in the identical pose, Walker points to a statue of Mercury, patron of vagabonds and thieves.

Wallis, Alfred (1855–1942) British *naïve painter living in St Ives, a seaman and then ship's chandler who took up painting at the age of 70 when his wife died. Ben *Nicholson and Christopher *Wood glimpsed his pictures through his open door in 1928 and began to collect Wallis's

work and help him with paints. He painted on boards and parts of cardboard boxes and used ships' paints, black, white and green, to give what he considered accurate accounts of his town and other ports in Cornwall, and the ships, sea, lighthouses, bridges, etc. that articulate the seafarer's life. This particularity lacked all interference from *perspective, modelling or light and shade, so that his paintings, making deft use of the oddly shaped surfaces on which he worked, had the flatness of child art as well as its unselfconscious narrative intensity. In the 1930s friends of Nicholson began to collect Wallises and he is now seen as Britain's finest naïve painter, entirely untutored and unwavering in his production of strong pictures of the things and sights he knew better than anyone else.

Walpole, Horace *See under* Vertue, George.

Wals, Goffredo *See under* Claude Gelée.

Wanderers Name of an association of Russian painters. In 1863 fourteen students left the St Petersburg *Academy in protest against its traditional system of teaching and assessment and the art it was intended to produce. *Kramskoy was their leader, and in 1870 most of them joined in forming a group dedicated to painting everyday Russian life and Russian scenery, as well as portraits of peasants and of people, often writers as well as painters, dedicated to developing Russian awareness of life outside the great cities, its hardships as well as its strengths, also of great moments in Russian history, notably those that relate to great anti-establishment moments. The Wanderers would paint such subjects and send exhibitions of their work travelling or wandering around the country, stopping at many towns and reaching a much wider public. The Russian term is at times also translated as 'itinerants'. Other painters lent work to these exhibitions, and many became members of the group. The art and music critic Vladimir Stasov promoted their art and programme. The collector Pavel Tretyakov bought many of the best of the Wanderers' paintings, and these became

the basis of the municipal, later national, Tretyakov Gallery in Moscow, open to the public from 1892. By this time leading figures among the Wanderers, such as *Repin, were being sought as professors for the Academy and other art schools. The work of the Wanderers was honoured by a number of Russian writers, and from 1892 on was also used as a basis for political instruction by revolutionaries such as Lenin, his wife Kruskaya and by others who later were leading Bolsheviks. In 1923 the Wanderers' group was replaced by a new society of *realist and *naturalistic painters, the Association of Artists of Revolutionary Russia, which attracted painters dismayed by the avant-garde work of the *Futurists and the *abstract and *Constructivist work of the time, and thus also, with their emphasis on Revolutionary Russia, laid the foundations for the orthodox and official *Socialist Realism of the later 1920s and thereafter.

Wanderjahre (German, travelling years) In the guild statutes governing the professional activities of artists in most German (and other northern European) cities in the Middle Ages and the *Renaissance, the years of compulsory educational travel outside one's own city between the completion of formal apprenticeship and entry into the guild as a master. During this time the young painter or sculptor would work as a *journeyman. The *Wanderjahre* were also, in effect, a 'bachelor's journey' before marriage. *See* e.g. Dürer, Cranach, Breu.

Ward, James (1769–1859) British painter, mostly of landscapes and animal subjects, admired by *Géricault and *Delacroix for the *Romantic warmth of dramatic but also *naturalistic scenes. His most famous picture is the large and dramatic piece of scenery, *Gordale Scar, Yorkshire* (1811–15; London, Tate), portrayed without sweetness of detail or of light as a *sublime encounter.

Warhol, Andy (1928–1987) American painter and film-maker, prominent in the *Pop art movement of the 1960s. Before that he had worked in advertising. In 1962

he exhibited paintings of dollar bills, Coca-Cola bottles and Campbell's soup cans, repeated, almost identical images arranged like sheets of postage stamps and made by stencilling on to canvas and adding colours, not necessarily the correct colours. Soon after, he was producing similar images of film stars and other eminent personages – Marilyn Monroe, Elizabeth Taylor, Elvis Presley, Mrs Kennedy as widow, the Queen of Great Britain, Chairman Mao – by the same method, repeating the stencilled image but varying the added colours in the manner of cosmetics. Which Marilyn do you want? Is any of them the real one? He seized on scenes of horror and disasters – an electric chair, car crashes etc. – as well as eminent individuals at the other end of the social scale, such as the *Most Wanted Men* taken from police photographs. He produced imitation *Brillo Boxes* as objects to be stacked for exhibition, and lighter-than-air silver cushions that could float around his studio and his shows, but from 1963 on he gave an increasing amount of his time to making films such as the several-hours-long, actionless *Sleep* (1963) and the split-screen *Chelsea Girls* (1966). He ran a night club and the rock band, Velvet Underground. He organized his ever larger studios as The Factory, employing many friends as assistants and courtiers while he, fascinated by stardom, became a cultural super-star. In 1968 he was shot and seriously injured by an associate, Valerie Solanis. In the years that followed he became a society portrait painter in his own manner, and also enlarged his subject matter to include, for instance, flowers or cows. His challenging all sorts of frontiers and issues, from originality and authenticity, to significance and monotony, combined with the relentless energy with which he lived his apparently indolent life – very few people ever saw him at work – made him a hero and a major influence on art and art thinking from the 1960s on. He was often interviewed and key quotations are still passed around the art and media worlds. He also contributed *The Philosophy of Andy Warhol* (1975) and helped others write books about him. His exhibitions have been innumerable and have continued after his death, as has interest in him. There are many who consider him and his art worthless; there are countless others who find exhibitions of his work powerful and persuasive and who see his undermining of even modern artistic priorities as important as well as refreshing.

Wassenhove, Joos van *See* Joos van Ghent.

Watercolour A type of paint in which the pigment is bound in a water-soluble *medium such as gum, and that retains transparency, letting the white support – usually paper – show through (compare with body colour, gouache). *Dürer may be the earliest artist to have exploited the spontaneous, poetic effects of watercolour in his travel sketches, but the development of watercolour is above all associated with 18th- and 19th-century English topographical and landscape painters, especially John Robert *Cozens, *Girtin and *Turner.

Waterhouse, John William (1849–1917) English painter, trained at the Royal *Academy Schools. He worked first in a manner close to *Alma-Tadema's, producing ancient *genre scenes, but then came under the influence of *Pre-Raphaelitism and painted some outstanding examples of dreamy, sensual subjects, such as *The Lady of Shalott* (1888; London, National) and *Hylas and the Nymphs* (1896; Manchester City Art). He was elected an associate of the Royal Academy in 1885 and a full member ten years later.

Watson, Homer Ransford (1858–1936) Canadian painter, famous in his time for landscapes and for scenes of rustic life. Oscar Wilde named him 'the Canadian *Constable' because of the personal intensity of his *naturalistic pictures.

Watteau, Jean-Antoine (1684–1721) French painter, born in the formerly Flemish town of Valenciennes. One of the originators of the *Rococo style, he remains its most individualistic exponent. A wilful, independent spirit, his caustic, restless and melancholic temperament was no doubt accentuated by the tuberculosis which killed him. He sought no

commissions and was most at ease painting *cabinet pictures for a small circle of friends, mainly dealers, antiquaries and enlightened collectors. His last two works, however, the enigmatic *Gilles* (c.1719; Paris, Louvre) and *Gersaint's Shopsign* (1721; Berlin Staatliche), indicate that he was taking a new direction, grander in scale and more monumental, yet at the same time, at least in the latter painting, more *realist. Watteau's independence – and his outstanding talent – were recognized by the French *Academy, which allowed him, exceptionally, to choose the subject of his reception piece (*Pilgrimage to the Isle of Cythera*, 1717, Paris, Louvre) and enrolled him in a category of his own invention, the *fête galante*. Two factors raise Watteau above his predecessors and imitators: his constant reference to nature, specifically human nature, through the medium of drawing, in which he built up a large stock of poses and expressions studied from the life (on which he relied in composing his paintings), and the underlying seriousness of his exploration of human psychology. Unusually in the history of art, albeit not in the context of the social history of 18th-century Paris, Watteau does not seek empathy mainly from the male spectator, depicting men and women as equally active partners in subtle emotional transactions.

Arriving in Paris c.1702, steeped in the Flemish–Dutch tradition of small-scale rustic fairground and military scenes (*see especially* Brouwer, Teniers the Younger, Dou) Watteau first found work as a copyist in a sort of picture factory, then entered the studio of Claude Gillot (1673–1722). Originally a decorative painter, now known primarily as an etcher (*see under* intaglio) and book designer, Gillot revived the subject of the *commedia dell'arte* or Italian comedy, with its stock characters of Harlequin, Pierrot or Gilles, Columbine, Pantaloon, etc., which was first introduced in French painting in the late 16th century – a theme of which Watteau was the first to realize the full pictorial and emotional potential (e.g. Washington, National; New York, Metropolitan, Frick; London, Wallace; *see also Gilles*, above). Probably by 1708 Watteau had quarrelled with Gillot and moved to the workshop of Claude III

Audran (1658–1734), who was mainly employed as a decorator and designer and, crucially for Watteau, Keeper of the Luxembourg palace. Audran may have introduced Watteau to the arabesque curve and decoration in the newly fashionable 'Chinese' style (a few decorative panels by Watteau are known, and others engraved). More importantly, however, he allowed the young painter entry to the Luxembourg to study the *Marie de'Medicis* cycle by *Rubens, whose painterly technique was fully assimilated by Watteau (*see also under disegno*). Rubens's example also inspired Watteau to study Italian, and specifically Venetian, art. With this in mind he presented himself to the Academy in 1709 and again in 1712, hoping to win a bursary to the French Academy in Rome. Although unsuccessful, he was later able to study works by *Veronese and *Titian in the collection of Crozat, and to meet Sebastiano *Ricci and Rosalba *Carriera on their visits to Paris; a romantic, nostalgic view of Italy, akin to that associated with *Giorgione, permeates many of his works.

From c.1709 Watteau emerges as an independent artist, first achieving sales with military scenes, then in a wider range of subjects. The *fête galante*, as we have seen, is identified with him, and was to be continued, in more trivial form, by Lancret (1690–1743) and Watteau's only pupil, Pater (1695–1736). In 1720 Watteau visited London, perhaps to consult the collector and famous physician, Dr Mead. He died *en route* to his native Valenciennes, convinced that he would be cured there.

Watteau's influence was enormous, both during his lifetime, when he achieved international fame despite seeking no official commissions, courtly patronage or even great commercial success, and largely after his death, when his total *œuvre* was engraved on the initiative of his friend, the collector Jean de Julienne. The young *Boucher was one of the engravers at work on the four volumes; Gian Domenico *Tiepolo owned at least some of the prints, and *Gainsborough a copy of the whole collection. In England Watteau's influence was also mediated through *Mercier, and is perceptible in such artists as *Hogarth and

*Hayman (*see also* Conversation Piece). In France, perhaps the artist who best assimilated his spirit was *Fragonard, who, like Watteau, cultivated personal and artistic freedom.

Watts, George Frederick (1817–1904) English painter, born into a poor family and largely self-taught. His ambition to shine as a *History painter was encouraged by the first prize he won in 1843 with a cartoon sent in to the competition for painting the new Houses of Parliament in London. He went to Italy that year to study *fresco painting at its best and returned in 1847 to win first prize in a second Parliament competition. No commission ensued, and in 1852 his offer to do frescos for Euston Station without fee was rejected. The following year he began a fresco in the New Hall, Lincoln's Inn (finished 1859), but he had become known as a portrait painter and it was only in the 1880s that his allegorical paintings became known, principally through a solo exhibition in London in 1881–2. In 1884–5 he had an exhibition at the Metropolitan Museum, New York. His fame rose steadily but his ambition outreached it. He saw himself as a modern fusion of *Michelangelo and *Titian, and from 1867 on worked also at sculpture, leaving his most grandiose work, the monumental equestrian *allegory *Physical Energy* unfinished at his death (Kensington Gardens, London). Somewhat isolated among British painters, he can now be seen as part of the European *Symbolist tendency as well as of a campaign to bring grandiose mural painting back for public buildings. He lacked the depth of culture that should protect the pictorial poet against banalities ('My instincts cause me to strive after things that are hardly within the province of art', he wrote to *Ruskin), but he worked benevolently, hoping to enrich the world of ordinary people with his visions of themes of life and death. In 1864 he married Ellen Terry, later a famous actress, then aged 16; they separated in 1865. In 1886 he married again. His wife, an artist herself, created the Watts Gallery near Guildford, England, where many of his best paintings, drawings and sculptures can be seen; Bristol City Art Gallery and the Tate Gallery, London, hold other major works.

Weber, Max (1881–1961) American painter, born in Russia and living in the USA from the age of ten. He travelled widely in Europe, looking at *Post-Impressionist art and making personal contact with *Picasso and *Matisse. He was an important link between avant-garde Paris and the New York art world, where he exhibited at *Stieglitz's gallery '291'. His best paintings are in a *Cubist style incorporating elements of *Futurism, as in *Rush Hour, New York* (1915; Washington, National) and *Chinese Restaurant* (1915; New York, Whitney). He also made sculpture which was *Cubist but displayed ideas he derived from African objects he studied and on occasion acquired in Paris: e.g *Figure in Rotation* (1915; New Rochelle, p.c.). After 1920 Weber abandoned *Modernism for a more descriptive idiom in which to present Jewish themes. See, for example, his *Talmudists* (1934; New York, Jewish).

Weenix, Jan Baptist or **Giovanni Battista** (1621–60/1) Italianate Dutch painter, best known for his *genre-like views of the Roman Campagna and exotic harbour scenes (Detroit, Institute; London, Wallace; etc.). He also painted portraits, indoor genre scenes, and *still lifes with dead game, influenced by the Flemish painter *Snyders (Amsterdam, Rijksmuseum). In 1642/3 he was in Rome; probably after his return from Italy to Holland, 1646/7, he came to know *Berchem, whom he influenced, and whose influence is also occasionally visible in his work (Cleveland, Ohio, Coll. Millikin). His son, **Jan Weenix** (1640–1710), specialized in pictures of hunting trophies, some designed to decorate entire walls (Bensberg, Gemäldesammlungen).

Werefkin, Marianne von (1870–1938) Russian painter who studied under *Repin. In 1891 she met *Yavlensky, a fellow-student. They became partners, moving to Munich in 1896. They were founder-members of the Neue Künstlervereinigung there in 1909, and moved to Ascona in

Switzerland in 1914, where she remained when he moved to Wiesbaden (Germany) in 1921. She did much to encourage her artist friends' spiritual expression, and worked herself in a gently *Expressionist manner charged with *Symbolist aspirations.

Werff, Adriaen van der (1659–1722) Dutch painter and architect resident mainly in Rotterdam, even after becoming painter to the Elector Palatine, Johann Wilhelm, at Düsseldorf from 1696. (See also Godfried Schalcken, Rachel Ruysch.) Van der Werff obtained a hereditary knighthood in 1703 and must be reckoned one of the most successful Dutch artists of all time, although few would now agree with those of his contemporaries who considered him the greatest of all Dutch painters. This judgement must be understood in the light of the *academic theories then fashionable not only in the Dutch Republic but throughout Europe, largely under French influence (see also Gerard de Lairesse).

Van der Werff trained mainly under Eglon van der Neer (see Arnout van der Neer). He perfected the technique of 'fine painting', fijnschilder, evolved in Leiden (see Gerrit Dou). But his international reputation was acquired when, c.1685, he abandoned the *genre subjects of the Leiden school, to produce elegant *classicizing pictures on religious and mythological themes. These *cabinet pictures were most prized for their adherence to academic doctrine, but they appealed also through their covert or overt sensuality and occasional sentimentality. His religious pictures for the Elector (including a series of 15 Mysteries of the Rosary, 1703–16) were compared, to their advantage, with the Passion series by *Rembrandt, then in the electoral gallery. After the Elector's death in 1716, Van der Werff continued to be patronized by princely and wealthy collectors in Russia, France, Germany and England. There are works by him in the major national collections in these countries. A few elegant portraits by Van der Werff are also known, including a Self-Portrait Painting his Wife and Child (1699, Amsterdam, Rijksmuseum). He decorated

his house in Rotterdam with large panels of pastoral scenes, partly preserved in Kassel, Gemäldegalerie. His brother, Pieter van der Werff (1661–1722), was his only pupil and collaborator, and an extant notebook records their precise contributions to various paintings.

Wesselmann, Tom (1931–) American *Pop artist who adopted advertising imagery and idioms to make his bold, colourful, elegantly designed still lifes, and interiors, both often combined with much simplified, flat, but wholly appealing female nudes. In 1961 he began a long series he titled 'Great American Nude' and distinguished by number only. They included small paintings and assembled works large enough to count as *installations, with real objects, such as *iron radiators and other such fixtures, adjacent to painted figures and other portions.

West, Benjamin (1738–1820) Pennsylvania-born painter of Quaker parentage, who set up a studio in London after a study trip to Italy 1760–3. He enjoyed a long association with the British crown from 1769, beginning with the commission for The Final Departure of Regulus from Rome (London, Kensington Palace), pioneered modern-dress *history painting (Death of General Wolfe, 1771, Ottawa, National; five other versions), and having been a founder member of the Royal *Academy, succeeded *Reynolds as President, 1792.

In Rome West had become a protégé of *Mengs and friend of Gavin *Hamilton, and was confirmed in his ambition to relinquish portraiture for *Classical subjects (Agrippina Landing at Brundisium with the Ashes of Germanicus, 1768, New Haven, Yale). Over the years he executed some 75 paintings and designs of paintings for the crown. The most grandiose of the royal schemes was for a series of 36 huge paintings on the theme of Revealed Religion to decorate a new chapel in Windsor Castle. Only seven were completed before George III's madness forced the abandonment of the project; they were returned to West (now Brooklyn; Greenville, South Carolina, Bob Jones University; Philadelphia).

They are composed in what has been called West's 'Dread Manner': a proto-*Romantic reworking of *Baroque principles. Despite this innovatory late style, West is mainly remembered for his modern-day, modern-dress subjects in the Grand Manner; the chief, in addition to the *Death of Wolfe*, being *Penn's Treaty with the Indians* (1771; Philadelphia, Academy) and *The Battle of La Hogue* (1779; Washington, National). As early as 1773, as a companion to the *Death of Wolfe*, West also treated a 'medieval' subject, the *Death of Bayard*, in a 'medievalizing' mode actually copied from Salvator *Rosa, anticipating the 'troubadour' style of the 19th century. West was the teacher of Matthew *Pratt, Ralph Earl, Gilbert *Stuart and John *Trumbull.

Westmacott, Richard (1775–1856) English sculptor, more successful son of a well-known sculptor also named Richard. He was a pupil of *Canova in Rome and in 1795 was made a member of Florence *Academy and awarded a major prize. He returned to London in 1797, busy at once on a wealth of commissions for statues, portrait busts, church monuments and occasionally *History groups and reliefs. Among his major works are the Waterloo Vase in Buckingham Palace Gardens, two reliefs of scenes from modern history over the entrance to Buckingham Palace (but intended for the Marble Arch), and the group of symbolic figures in the pediment of the British Museum, all in London. For the last he followed the new fashion of using colour: he tinted the ground of the tympanum blue and gilded ornamental elements. His son, yet another Richard (1799–1872), was also a successful sculptor though not thought the equal of his father. Both men were elected associates and then members of the Royal Academy.

Weyden, Rogier van der (*c*.1399–1464) Netherlandish painter, one of the most influential artists of the 15th century, internationally famed for the *naturalism of detail and the *expressive pathos and piety which characterize his work. He created a range of pictorial types – for religious subjects such as the *Descent from the Cross* or the **Pietà*, and for portraits –

which entered the repertory of Netherlandish art, and affected artists throughout northern Europe, the Iberian peninsula, and even Italy. These compositions were repeated in quantities in his own prolific workshop, remaining in use in Brussels and Antwerp until the mid-16th century in the workshops of his son Pieter, his grandson Gossen and his great-grandson Rogier.

Born at Tournai, Roger de la Pasture, as he then was, was apprenticed, along with Jacques *Daret, to Robert *Campin, who was to prove the strongest influence on his work. He moved to Flemish-speaking Brussels by 1435, when his name was translated into Flemish. It is thus as Rogier van der Weyden that he became official painter to the city of Brussels, also receiving commissions from Philip the Good, Duke of Burgundy, and members of his court, from foreign princes, and from church authorities. He probably went on pilgrimage to Rome in the jubilee year of 1450, accepting Italian commissions *en route* or on his return (*Entombment*, formerly in the collection of Lionello d'*Este, Marquess of Ferrara, now Florence, Uffizi; *Madonna with Four Saints*, formerly in the *Medici collection, Florence, now Frankfurt, Städel).

Rogier's *oeuvre* is poorly documented and has been reconstructed by comparison with a handful of paintings recorded in his lifetime and in the 16th century. A celebrated secular work, 1439–before 1450, was destroyed in the bombardment of Brussels in 1695. It consisted of four large panels, representing *The Justice of the Roman Emperor Trajan* and *The Justice of Herkinbald*, a legendary Duke of Brabant, for the courtroom of Brussels Town Hall. The only extant work attributed to him in a contemporary source is in fact a workshop replica; *The Altar of the Virgin* (before 1445, Berlin, Staatliche). But the original altarpiece by Rogier exists as separate fragments (*Holy Family* and *Pietà*, Granada, Capilla Real; *Christ Appearing to the Virgin*, New York, Metropolitan). Two further paintings are ascribed to him in 16th-century sources: *The Descent from the Cross* (before 1443, Madrid, Prado) and *The Crucifixion* (1454–60, Escorial).

These works from early and late in Rogier's career reveal that, unlike Robert Campin, he increasingly came to sacrifice both realism and decorative values to the demands of expressivity, albeit of a particular kind. More or less ignoring the logic of scale and of spatial recession, he confined himself to a selective naturalism of detail, and made little or no attempt to differentiate between the emotional reactions of his painted figures, imposing on them a restrained and generalized air of piety or grief. The expressivity which is such a hallmark of his later work comes instead from the powerful tension produced through more abstract pictorial means. Campin's sinuous and decorative line becomes more angular and broken; limbs and features are elongated, poses subtly distorted; seemingly stable compositions are built up of individually unstable figures. By contrast with Jan van *Eyck, some of whose compositions he adapted, Rogier treats the painting as a flat surface upon which he inscribes abstracting contours.

With the exception of the more outgoing *Portrait of a Young Woman* in Berlin, Staatliche, the five independent portraits attributed to Rogier share these abstracting tendencies (Madrid, Thyssen; Brussels, Musées; New York, Metropolitan; Washington, National). Other, equally austere and aristocratic portraits have been identified as the donor half of devotional diptychs (*see* polyptych).

In addition to the paintings mentioned above, works attributed to Rogier can be found in London, National; Madrid, Prado; Boston, MFA; Vienna, Kunsthistorisches; Antwerp, Museum; Beaune, Hôtel-Dieu; Paris, Louvre; Munich, Alte Pinakothek.

The ablest of Rogier's immediate followers was the German-born painter Hans *Memlinc, who was probably his pupil.

Wheatley, Francis (1747–1801) Possibly a pupil of *Zoffany, he began his career with small-scale portraits and *Conversation Pieces, but with a broader and more sensitive touch, especially for landscape. From 1779–83/4 he worked in Dublin (*The Irish House of Commons*, 1780, Coll. A. D. F. Gasgoigne). Some years after

his return to London he took up the sentimental bourgeois *genre made popular by the French painter *Greuze (*Mr Howard offering Relief to Prisoners*, 1787, Sandon) and he is best remembered for his pictures in this vein, and of country life and the rural side of city life (*Cries of London*, 1792/3, Upton House; engraved 1795).

Whistler, James McNeill (1834–1903) American-British painter, born in Lowell, Massachusetts, trained in Paris, active mainly in London. His family stemmed from Scotland. He grew up partly in St Petersburg where he attended drawing classes and visited the imperial collections. In 1851 he entered West Point military academy, but failed tests there and turned to cartography, making his first engraving in 1854. In 1855 he came to Paris, entered the studio of *Gleyre but allied himself to *Courbet and *realism while taking from *Baudelaire the suggestion that 'Painting is an evocation, a magical operation . . .' At first he gave priority to etching (*see* intaglio), producing a series known as the 'French Set', indebted to Dutch painting and to *Millet, published in 1858. Partly thanks to this work he became friends with *Fantin-Latour. His first major painting, *At the Piano* (1858–9; Cincinnati, Taft) is close to Fantin's suave tonal art but exhibits also Whistler's own taste for strong verticals and horizontals and for prominent blacks and whites. Courbet admired it but the 1859 Salon rejected it, and Whistler moved to London.

For a time he worked mainly by the Thames, at Wapping and Rotherhithe, a confused and dangerous dockland world seemingly at odds with his refined taste. His 'Thames Set' (1860) of etchings shows fine control of tone and texture, as does the painting *The Thames in Ice* (1860; Washington, Freer), almost monochrome and done in assertive brushstrokes. These busy outdoor scenes were partnered by suave indoor compositions to which he gave musical titles. *Symphony in White No.1: The White Girl* (1862; Washington, National) is a tall image, the girl dressed in white standing against a white background; *Symphony in White No.2: The Little White Girl* (1864; London, Tate) is a smaller

work with a similar emphasis on white, and with a fan and other objects signalling his passion for Japanese art. *Arrangement in Grey and Black No.1: The Artist's Mother* (1871; Paris, Louvre) seems a demure answer to these elegant studies but has its own remarkable life and dignity; *No.2: Thomas Carlyle* (1873; Glasgow City AG) presents the famous author with almost equal economy. *Harmony in Grey and Green: Miss Cicely Alexander* (1874; London, Tate) brings subtleties of tone, design and complementary areas of visual interest amid plain surfaces to the portrait of a young girl.

Whistler was in pursuit of pure visual poetry. Outdoors his subjects were now twilight and night scenes, inviting dramatic simplification. He called them 'nocturnes'. *Ruskin, reviewing an exhibition at the Grosvenor Gallery in 1877, called *Nocturne in Black and Gold: The Falling Rocket* (c.1874; Detroit, Institute of Arts) the work of an impudent coxcomb. There followed a famous law suit; Whistler won his case that Ruskin's words were libellous, but the damages awarded were derisory. In 1879 he was declared bankrupt and he had to sell his house in Chelsea. At the same time he lost a major client over his efforts to improve a dining room recently designed by an architect in the client's London house. Whistler altered the interior thoroughly, advertised its availability to visitors and demanded a substantial fee for the uncommissioned work. 'The Peacock Room', as left by him, has been reconstructed in the Freer Gallery of Art, Washington. He cheered himself with a visit to Venice in 1879–80; his Venice set of etchings, published in 1880, shows a new, light touch and a variety of engraving techniques to represent unglamorous parts of the city.

Back in London, he gave new energies to painting portraits, at once elegant and impressive, of notables and friends, and found his reputation rising with fellow artists and critics. In 1885 he gave his *Ten o'Clock Lecture*, summarizing his purist views on the duties of the artist and his disdain for much contemporary art. He spent more time in Paris where he became a close friend of the poet Mallarmé and briefly taught in an Académie Whistler.

In 1890 he published *The Gentle Art of Making Enemies*, a collection of writings dedicated to trouncing his critics and instructing artists; it included the text of his lecture and was designed by him with characteristic economy. A one-man show at the Goupil Gallery in London in 1892 finally convinced the public of his qualities and generally the 1890s brought international recognition. He was deeply dismayed at the death of his wife in 1896. His own health deteriorated sharply in his last years, limiting his activity, though he was an effective president of the International Society of Sculptors, Painters and Gravers from 1898 on.

*Sickert wrote of his art as 'a plant without roots and bearing no fruit'. It was indeed a fine plant, at once delicate and vital, but its fruits are both his own work – paintings, decorative schemes, drawings, prints and writings – and the influence his insistence on refinement of tone and on clear construction exercised on several contemporaries and younger artists, Sickert himself among them. The Tate Gallery in London, the Freer Gallery of Art in the Smithsonian Institute, Washington, and the Hunterian Art Gallery, University of Glasgow, have important collections of Whistler's art.

Whiteread, Rachel (1963–)

British sculptor, born and working in London. She studied painting at Brighton Polytechnic and sculpture at the Slade School in London. In 1990 she made casts of a kitchen sink, *Untitled (Square Sink)*, and the room-sized cast of a room, *Ghost*. Both present what we call 'empty space' as a solid: the space under and around the sink, the internal space of the room, articulated by such things as its old-fashioned fireplace and all the details, the mouldings, projections and recesses, the vestigial door-furniture and light-switch, that would make the space habitable and particular, all in plaster blocks. In 1993 she similarly made *House*, a cast of an entire East London house, large, ghostly and a comment on unrealized dreams of progress. It helped her win the 1993 Turner Prize but this did not prevent its being pulled down by the local council the following year, to wide protests.

In 1995 she won a competition for a Holocaust Memorial for the Judenplatz in Vienna with a proposal for a library of un-openable books. Hostile publicity appears to have ended that project but Whiteread has made smaller, very intense works on the theme of averted, dead books. She has been having solo exhibition in Britain since 1988 and abroad since 1992, and has been included in many group shows since 1987. In 1997 *Ghost* and *Untitled (100 Spaces)* (1995) were included in the Royal Academy's 1997 show of Young British Artists, entitled Sensation, but easily overlooked owing to the succinct, reticent character of her art and the fairground hubbub of most of the rest.

Wiertz, Antoine (1806–65) Belgian painter who painted portraits but considered his *history and *allegorical paintings his gift to humanity and his country. These large works, drawing on *Michelangelo and *Rubens for heroic figures and on his own macabre imagination for content, are outstandingly violent and apocalyptic, even among his contemporaries in Belgian late-*Romantic melodramatic art, such as Louis Gaillat and Emile Wauters. Brussels has a Musée Wiertz where can be seen such marvels as *The Revolt of Hell against Heaven* (c.1840). 'His wild eyed hysteria is a mere caricature of real passion' (Fritz Novotny, 1960).

Wijnants, Jan (1620/5–84) Prolific Dutch *landscape painter, active in his native Haarlem and from about 1658 in Amsterdam. In the late 1650s he came to specialize in views of sand dunes, and, under the influence of Italianate-Dutch painters such as Jan *Both, introduced a more southern light and atmosphere into this purely Dutch landscape type; he also painted some specifically Italianate scenes. All but the tiniest figures in his pictures were painted by others, among them *Wouwerman. There are works by him in many collections, including London, National; Kassel, Staatliche; Cleveland, Ohio, Museum; etc.

Wildens, Jan (1586–1653) Flemish *landscape painter. His early work was indebted to Pieter *Bruegel the Elder and his imitators. Between c.1614 and 1618 he worked in Italy, where he was influenced by Paul *Bril; on his return to his native Antwerp he collaborated with *Rubens, and began to paint more monumental scenes such as his *Winter Landscape with Hunter* of 1624 (Dresden, Gemäldegalerie; other works, Antwerp, Museum; Budapest, Szépmüveszéti).

Wilkie, David (1785–1841) British painter, born and first trained in Scotland but from 1805 in London where he studied further at the *Academy Schools. By 1809 he was an Associate of the Royal Academy; in 1811 he was elected a full member. He was greatly admired as a *genre painter, basing himself on Dutch narrative art of the 17th century and gradually achieving greater authority in his painting of figures and more interest in colour and atmosphere and thus achieving something of the presence traditionally associated with *history painting. The message of his pictures tended to be reassuring and without political thrust, meeting the preferences of a new middle-class public. His *Chelsea Pensioners reading the Gazette of the Battle of Waterloo* (1822; London, Apsley House), commissioned by the Duke of Wellington, was a great popular success when exhibited. He also painted portraits; when these were of royalty he used a larger canvas and aimed at a more exalted style. He travelled on the Continent during 1825–8, returning with ideas derived from Italian and Spanish painting. *Géricault and other French painters had been impressed by his work; he, in return, tried to assimilate some of the *Romantic qualities of *Delacroix. In 1840–1 he was in the Holy Land to prepare a series of biblical pictures; his death *en route* became the subject of one of *Turner's most expressive paintings.

Willmann, Michael Lucas Leopold (1630–1706) German painter born in Prussia and active also in Bohemia, where he is considered the most important painter of his time after Karel *Škréta. After studies in the Netherlands he became court painter to the Elector of Brandenburg in 1655–6. In 1660 he entered the Cistercian

monastery of Leubus in Silesia, remaining there until his death, painting mural cycles for the abbey and church and for ecclesiastical and monastic foundations elsewhere, as well as altarpieces, portraits and mythological pictures for both clergy and aristocracy.

Wilson, Richard (1713–82) Welsh-born painter, the first British artist to specialize in *landscape in the *classical tradition, neither topographical record nor simple decoration, but an intellectually rigorous work evocative both of a love of nature and nostalgia for the classical past. His application of this tradition to British – especially Welsh – scenes is his most innovative contribution to landscape painting (*see* e.g. *Snowdon*, Liverpool, Walker). He produced also poetic views of the Roman Campagna (e.g. *Ego fui in Arcadia*, Abbots Worth), dramatic mythological narratives set in landscape and *picturesque or romantic versions of the country-house portrait (e.g. five *Views of Wilton*, Wilton). Although esteemed by some of his fellow artists, being a founder member of the Royal *Academy and its Librarian from 1776, Wilson gained little general recognition in his lifetime and retired to Wales, embittered and impoverished, a year before his death.

The well-educated son of a clergyman, Wilson was apprenticed to a portrait painter in London and in the 1740s produced portraits of some distinction (London, NPG, Tate; Greenwich, Maritime). Temperamentally unsuited to fashionable portraiture, however, he was already drawn to landscape painting (London, Foundling Hospital, roundels; *View of Dover*, engraved 1747; possible country-house portraits). In 1750 he left for Venice, where in 1751 he met *Zuccarelli, who probably influenced him to specialize in landscape, a decision finally settled by meeting *Vernet in Rome in 1752; from 1753 Wilson painted only in this genre. His major influences were *Claude, Gaspard *Dughet, and the Italianate Dutch artist *Cuyp, but his best works show an unmistakable originality; his deep feeling for mountain scenery has been compared with Wordsworth's. Perhaps ironically, this

sharply outspoken man, no respecter of social forms, brought the commissioned country house portrait to its finest perfection, establishing the models which his successors followed (*see* e.g. Turner). There are works by him in private collections throughout England and in most English galleries, as well as in American museums, but the largest collection is in the National Museum of Wales, Cardiff.

Wilton, Joseph (1722–1803) English sculptor. He trained in Flanders and with *Pigalle in France, and spent several years in Italy, returning to England in 1755. He was appointed sculptor to King George III, whose coronation stage coach he had carved. There are monuments by him in several London churches, including that of Sir Hans Sloane in the churchyard of All Saints, Chelsea and of General Wolfe in Westminster Abbey; he also executed portrait busts and reliefs, such as the medallions on the façade of Somerset House.

Winckelmann, Johann Joachim (1717–68) German writer on art and archaeology, a celebrated champion of the *classical ideal (*see also* Bellori, an unacknowledged influence). Winckelmann's emphasis on emotional experience and on the quasi-religious effect of art on the viewer, however, and his insistence on the need to transcend *decorum and disregard academic rules (*see* Academy) made him as significant a founder of *Romanticism as of *Neo-classicism. His passionate advocacy of Greek art, which he hardly knew, seems to have been rooted in a homoerotic fascination with the male nude, as his much-quoted descriptions of classical statues, the *Apollo Belvedere* above all, suggest. But his works were all the more widely disseminated, and their effect all the more profound, for displaying fiery enthusiasm rather than sober scholarship, and their true intention was not, like *Reynolds's in his *Discourses*, to reform art through classicizing precepts but to reshape culture and society. The book which made Winckelmann famous was his *Reflections on the Imitation of Greek Art in Painting and Sculpture*, published in German in 1755 to great acclaim despite its doubtful expertise

– the author had not yet seen any notable examples of ancient art, which he knew only from books, engravings and a few casts. This was followed by the *History of Ancient Art* in 1764 (when Angelica *Kaufmann made her international reputation by painting Winckelmann's portrait). The book's influence on European thought can hardly be overestimated: there were no precedents for such a lucid chronological account of art, based on the analysis of successive stylistic phases and relating them to geographical, political and religious circumstances. With the exception of the great poetic passages on individual works – the *Laocoön* and the *Belvedere Torso* as well as the *Apollo Belvedere* – Winckelmann's critical method is based on the systematic scrutiny of separate parts of individual works, an approach evolved in collaboration with his friend, the German-born painter *Mengs.

Born in a small town in northern Germany, the intelligent, ambitious and energetic son of a penniless cobbler, Winckelmann won a university scholarship, studying classics and literature. In his thirties, after many years' struggle to earn his living, he settled in Dresden, where he first saw great paintings of the past (most importantly *Raphael's *Sistine Madonna*) and moved in a congenial circle of artists and scholars. On the publication of his *Reflections*, converted to Roman Catholicism and with a stipend from the King of Saxony, he realized his dream of settling in Rome, quickly finding sponsors – notably the collector and scholar Cardinal Albani – and remunerative work as an antiquarian, guide, lecturer and mentor to Grand Tourists and art-pilgrims from all over Europe. Wishing to revisit his homeland after an absence of twelve years, he travelled as far north as Vienna, where he was honoured by the Emperor. Assailed by depression, however, he decided to return by the quickest route to Rome, and was killed, ostensibly by a petty thief but possibly in a homosexual encounter, in Trieste while waiting for a boat to Venice. His tragic and sordid death deeply shocked all of Europe, and enhanced his own legend and that of the fatal lure of the Mediterranean world.

Wink, Thomas Christian (1738–97) Important German painter of *frescos and altarpieces, in palaces and churches throughout Upper Bavaria. He was also an etcher (*see* intaglio) and worked as a designer of stage scenery and for the Electoral tapestry works in Munich, where he settled around 1759/60. Appointed Court Painter in 1769, he founded a school of drawing from which the later Munich *Academy developed.

Winterhalter, Franz Xaver (1805–73) German painter, a farmer's son, born at Menzenschwand (Black Forest) and trained in Freiburg and Munich. A small pension awarded him in 1825 by the Grand Duke of Baden decided his career: he would be a court portraitist. In 1832–3 he was in Rome. Appointed court painter in Karlsruhe in 1834, he moved to Paris and was soon painting portraits of French and Belgian royalty, and received several state honours. In 1842 he painted Queen Victoria and Prince Albert for the first time, and from then on worked in France, briefly in Brussels (1848) and England, though he travelled on the Continent most years. Occasionally he also painted *genre subjects and mythological scenes. His enjoyment of the informality of 18th-century portraits shows at times but his usual manner is formal, his painting smoothly naturalistic, his gift that of catching a good likeness and improving it to signal the standing and quality of the sitter. The main collection of his work is held by the British monarch; others include the Château of Versailles, Karlsruhe Kunsthalle and Warsaw's National Museum. A major exhibition of his work was shown at the National Portrait Gallery in London in 1988.

Wissing, Willem, later **William** (1656–87) Dutch-born portrait painter; he may have spent some time in France before arriving in England in 1676, to become the most important of *Lely's later pupils and assistants (his trip to France may date from the latter's death in 1680). Perhaps because of his predilection for 'frenchified' accessories, he became a favoured portraitist of the royal family

(London, St James's Palace, etc.) but his chief patrons during his last years, from 1685, were a group of allied families in Lincolnshire and the surrounding counties (Belton House; Grimsthorpe Castle). His finest work is the elegant portrait of the young Lord Burghley (c.1686, Burghley House).

Wit, Jacob de (1695–1754) Leading Dutch decorative painter, best known for his *illusionistic ceilings (e.g. Heemstede, Huis Boschbeek) and *grisaille imitations of marble reliefs (e.g. Amsterdam, former town hall, now royal palace). He was also, however, the first artist since the 16th century to receive commissions for religious pictures in Dutch Catholic places of worship.

Withoos, Matthias (1627–1703) Dutch flower painter; while in Italy he fell under the spell of Otto *Marseus van Schrieck, and devoted the rest of his career to 'forest floor' pictures, mainly of *vanitas symbolism. Unlike those by Marseus, they generally include an Italianate landscape in the background (Petrodvorets, Hermitage Pavilion).

Witte, Emanuel de (1616/18–92) Born in Alkmaar, active in Rotterdam, c.1639–40, Delft, c.1641–51, and Amsterdam by 1652. He was recognized in his own time and since as the greatest architectural painter of the Netherlands, famous especially for his real and imaginary views of the interiors of churches, always the scene of human action and probably intended to arouse solemn meditations on the significance of human life (Edinburgh, National; London, National; Rotterdam, Boijmans Van Beuningen; etc.). He turned to architectural subjects only c.1650; domestic interiors, harbour and marine views by him are also known, and after 1660 he specialized as well in market scenes, some with portraits (London: Rotterdam, as above). He ended his life by suicide, c.1660, after attempting to solve his financial problems by indenturing himself to a notary. Although his teacher is not known, he may have been in contact with Carel *Fabritius in Delft.

Wittel, Gaspar van (1653–1736) called in Italian Vanvitelli. Dutch topographical painter from Utrecht, who settled in Italy in 1672. He worked mainly in Naples and Rome – where he died – specializing in small, rather dry factual views (*see also veduta*) earlier than *Panini's, but by the end of Van Wittel's career influenced by them. His son **Luigi Vanvitelli** (1700–73), born in Naples, although trained as a painter by his father became a distinguished *Baroque architect; his greatest project, the residence at Caserta of the King of Naples, was completed by his son, Carlo Vanvitelli.

Wittingau, Master of *See* Třeboň, Master of.

Witz, Konrad (c.1410–before or in 1446) Outstanding Swiss painter, a native of the German town of Rottweil who settled in Basel in 1434. His innovative art is related to that of the Burgundian school (*see* Robert Campin). His last known work, the signed and dated *Altarpiece of St Peter* (1444, central panel lost, wings only in Geneva, Musée) included his now most famous painting, the *Miraculous Draft of Fishes*. Not only does the landscape realistically represent part of Lake Geneva, but Witz has portrayed the different effects of reflected and refracted light in depicting the half-submerged rocky foreground – perhaps the first artist to do so. Equally, the *Freeing of St Peter* in the other wing of the altarpiece uses cast shadows to represent one of the earliest night scenes in northern European art.

Witz's earliest known work is the dismembered *Heilspiegel Altarpiece* (Basel, Kunstmuseum; Dijon, Musée; Berlin, Staatliche). As in the *Altar of St Peter*, the central panel has been lost. Surviving panels from another destroyed altar are now in Basel, as above; Strasbourg, Musée de l'Oeuvre Notre-Dame; Nuremberg, Museum.

Wolf, Caspar (1735–83) Swiss painter, the first artist to specialize in Alpine views. His cycle of topographical views of the most *picturesque and *sublime lakes, peaks, glaciers (Winterthur,

Oskar Reinhart Foundation) was painted for *engraving between 1773 and 1779, on the commission of an enterprising Berne publisher. Wolf had previously (1769–71) worked in Paris as an assistant to Philippe de *Loutherbourg, and was inspired also by the landscapes of Claude-Joseph *Vernet.

Wolff, Johann Andreas (1652–1716) Prolific German Court Painter to the Elector of Bavaria in Munich and to the Bishop of Freiburg. He produced numerous altarpieces for churches in Bavaria, Franconia and Upper Austria, and ceilings of mythological and historical subjects for the Munich Residenz. In his youth he came under Italianate influence through the works of Johann Heinrich *Schönfeld and later of Johann Carl *Loth.

Wolgemut, Michael (1434–1519) The major artist and art entrepreneur in Nuremberg before *Dürer, whose teacher he was. He worked on the *Zwickau Altarpiece* (1479, Zwickau, Marienkirche) but his importance rests less on his activities as a painter than on his running a workshop of quasi-independent groups of artists, on whose behalf he imported the latest Italian and German prints – notably the engravings (*see under* intaglio) of Martin *Schongauer – to serve as models. Most significantly, he designed and published books illustrated with woodcuts (*Schatzbehalter*, 1491; *Nuremberg Chronicle*, 1493), hitherto the province of publishers and their craftsmen employees. His elevation of the *relief print into an artistic medium and his underwriting of publications were imitated by Dürer, who improved on Wolgemut's example by himself publishing the woodcut *Apocalypse* in 1498.

Wols (1913–51) German painter, born Alfred Otto Wolfgang Schulze, who studied art briefly at the *Bauhaus in 1932 but moved to Paris that year, and worked as a photographer until he turned to painting after spending some months of 1939–40 in French internment camps. The first exhibition of his characteristic drawings, *aquatints and *watercolours was in 1945. These, like his book illustrations, are small

and delicately worked but grim, even ghastly, in their implications of a human being and artist at the end of his tether. His mostly *abstract images, improvised but growing out of the same patch of imaginative soil, look back to *Surrealism but are also seen as key works in early *Art informel.

Wood, Christopher (1901–30) British painter who studied painting in Paris where he was part of the circle of *Picasso, Diaghilev and Cocteau. In 1926 he became a close friend of Ben and Winifred *Nicholson and exhibited with Ben in London (1927) and in Paris (1930). In 1928 he and Ben discovered the art of Alfred *Wallis in St Ives, which confirmed in both of them a taste for a simple, folkish vision. He did his best work in Cornwall and Brittany in his last years. Their subjects are the life and scenes he saw there, painted energetically but also with a note of bitterness that reflects his temperament. He died by suicide, driven, it is thought, by drug addiction.

Wood, Grant (1892–1942) American painter who was born and worked mainly in Iowa. He was self-taught but his style changed after a visit to Munich in 1928, becoming firmly *naturalistic in a manner that suggests both *naïve painting and *Neue Sachlichkeit. His best-known painting is *American Gothic* (1930; Chicago Art Institute), an *iconic portrait of a farmer and his wife that typifies an aspect of American society in a gently satirical manner.

Woodcock, Robert (c.1691–1728) English marine painter. He was an accomplished musician who in 1723 began to paint copies of pictures by Willem van de *Velde the Younger (*see also* Monamy, Peter; Scott, Samuel, and Brooking, Charles).

Woodcut *See under* relief prints.

Woolner, Thomas (1825–92) British sculptor, one of the original *Pre-Raphaelites and the only sculptor among them. He made free-standing figures and

reliefs of literary and historical figures as well as portraits, but, failing to make his career in England, left for Australia in 1852 (Ford Madox *Brown based his *The Last of England*, 1852–5; Birmingham M & AG, on this event). Woolner soon returned to England to work on portraits, including a bust of the poet Tennyson (1857, Cambridge, Trinity College).

Wootton, John (*d*.1756) Best known as one of the originators of English sporting painting, but even more important as a *landscape artist. He was a pupil of Jan Wyck (1652–1700), with whom he collaborated on some battle-pieces. In the 1720s the Duke of Beaufort paid for him to travel to Rome, where he discovered Gaspard *Dughet and *Claude; on his return, Wootton introduced *classicizing Gaspardesque landscape to British painting, sometimes including it as a backdrop in his sporting pictures and horse portraits. There are works by him at Welbeck; Longleat; Althorp, and London, Tate.

World of Art A Russian association of artists and others wishing to distance themselves both from *academicism and from the insistent Russian-ness of the *Wanderers' art and to demonstrate their cosmopolitan interests. Formed in 1892, it included *Benois, *Serov and *Vrubel among the artists; Diaghilev was a leading figure among the non-artists in it as an organizer of exhibitions and subsequently the creator of the Russian Ballet which brought Russian themes, music and design to the West from 1909 on. The journal *World of Art* (1899–1904) brought together essays and illustrations of contemporary western and Russian art, Russian archaeological findings and unfamiliar aspects of Russian architectural and art history in a lavish production.

Wotruba, Fritz (1907–75) Austrian sculptor, trained at the Vienna School of Fine Arts. During 1938–48 he lived in Switzerland, but otherwise he worked in Austria and became an admired figure in the world of post-Second-World-War sculpture and a prominent teacher. Characteristic Wotrubas were relief and free-standing figures treated as assembled blocks, at once semi-*abstract and close to *primitivism.

Wouwermans, Philips (1619–68) A specialist in small-scale *genre scenes and landscapes with horses, he is esteemed as the most, perhaps the only, successful Dutch painter of horseflesh. In the 18th century no princely collection was without examples of his work (the Hermitage, St Petersburg, owns more than 50; Dresden Gallery, over 60). He lived and worked in Haarlem, where he may have studied with Frans *Hals, but was decisively influenced by Pieter van *Laer.

Wright, Joseph (called **Wright of Derby**) (1734–97) The first professional painter to share and depict the scientific interests of the Industrial Revolution; two of his principal patrons were Wedgwood and Arkwright, and he was in contact with Erasmus Darwin and the Lunar Society. Trained as a portraitist under *Hudson (1751–3; 1756–7) he practised portraiture, mainly in his native Derby, while developing an absorbing interest in *chiaroscuro effects, possibly stimulated by having seen works of the Utrecht Caravaggisti (*see* Caravaggio; Baburen; Honthorst; Terbrugghen). During his 'candlelight period' before 1769 he produced three masterpieces: *Three Persons viewing 'The Gladiator' by Candlelight* (1765, pc); *The Orrery* (1766, Derby, Gallery) and *An Experiment on a Bird in the Air Pump* (1768, London, National). In addition to portraying – on a large scale and without either the comedy of genre or the bombast of *history painting – the preoccupations of a newly emergent educated class, and the effects of artificial light, the pictures depict a range of sympathetically observed, 'natural' emotional responses.

In 1772 Wright exhibited his first literary narrative, *Miravan Opening the Tomb of his Ancestors* (Derby), a genre which he was to exploit more fully after his return from a study tour of Italy, 1773–5. This trip also influenced him to paint landscape in the mode of *Vernet, and to a study of nocturnal light effects: moonlight, Vesuvius erupting, a fireworks display at

Castel S. Angelo, the glow of an iron forge (Derby; St Petersburg, Hermitage; etc.). After his return to England, he hoped to establish himself as a fashionable portraitist in Bath, which *Gainsborough had left in 1774; failing, he returned for good to Derby. His best portraits date from *c.*1781 (*Sir Brooke Boothby*, 1781; London, Tate). Some of the narrative pictures of the 1780s demonstrate his allegiance to international *Neoclassicism: e.g. *The Maid of Corinth*, 1782–4; Mellon Coll. He has been compared, to his advantage, with the French painter *Greuze, and his interests and sensibilities with those of the French Encyclopedists.

Wright, Michael or **John Michael** (1617–99/1700) British portrait painter of distinction, a serious rival to *Lely albeit never as successful, perhaps because more sensitive to nuances of character and not as flattering in his portraits of women; antiquary and scholar. Probably born in London, he was converted to Roman Catholicism, and apprenticed to George *Jamesone in Edinburgh in 1636. By 1647 he was in Rome, the only British painter to be enrolled in the *Academy of St Luke in the 17th century; there he acquired a somewhat superficial *Baroque style. He then went to Flanders, where he is recorded as Antiquary to the Archduke Leopold William, Governor of the Netherlands. Upon the latter's resignation in 1656, Wright returned to England, where he was patronized, although not exclusively, by Catholic families (*Arundel Castle). Throughout the 1660s he produced a series of portraits in the style of *Dobson (London, Ham House), but received court patronage only sporadically (Buckingham Palace; Belvoir; ceiling for Whitehall, now Nottingham, Castle). After a possible stay in Scotland, 1662–5 (Edinburgh, Scottish National Portrait), Wright returned to London, where he executed a series of portraits of officials who had adjudicated in the cases resulting from the Great Fire. Of these 22 full-length likenesses, his most famous works in the eyes of his contemporaries, only two remain (London, Guildhall). His works of the 1670s are marked by French influence (Hampton Court); he

probably visited Ireland (Malahide Castle), to return to London by 1683. In 1685–7 he accompanied, as Steward of the Household, the Earl of Castlemaine on an embassy from James II to Pope Innocent XI, writing an account of it in Italian which he translated and had published in English in 1688. This absence, during which he seems to have done no painting, proved fatal to his portrait practice, for it was during these years that *Kneller consolidated his position as Lely's successor. *Vertue records that Wright was forced to sell his books in 1694, and his collections too were sold to pay his debts.

Wt[t]ewael, or **Uytewael, Joachim** (1566–1638) Dutch painter, one of the so-called Utrecht *Mannerists. The main components of his sophisticated and artificial style were formed during his voyages to Italy, 1586–8, and France, 1588–90, where he encountered the elegant French version of Italian Mannerism evolved at Fontainebleau (*see* Primaticcio). Known chiefly for his bright, precious small-scale collectors' pictures, mainly of mythological and *allegorical subjects (e.g. London, National; Paris, Louvre), he also painted portraits and kitchen scenes. A staunch Dutch Calvinist and patriot, he designed the stained-glass window of Gouda cathedral, depicting *Holland's Chariot of Freedom of Conscience Victorious over Spain and Idolatry* (1595). A series of drawings, never engraved and now dispersed (six in Vienna, Albertina), portray in allegorical form his political ideals for the Netherlands. His son Peter was also a painter.

Wyck, Jan *See under* Wootton, John.

Wyeth, Andrew (1917–) American painter, son of an illustrator, himself an exceptionally popular painter of Pennsylvania scenes and of the coast of Maine, often in *tempera which enhances their severe, joyless but also nostalgic quality. His pictures are sometimes portraits, including a series of paintings of a mistress that have only recently become known, but more often without figures. *Christina's World*, his most famous picture, showing a crippled girl looking back across a meadow and up

to a house (1945; New York, MoMA), is untypical in its spaciousness and the invitation it offers to invent a narrative for it. More typical are the outsides of wooden houses, marked by weather and time, and deserted rooms, with details that are redolent of a severe lifestyle. Though Wyeth is often presented as an outstanding *realist, his work reveals his very incomplete powers of observation. Affecting when seen one or two at a time, in quantity they reveal themselves to be routine creations.

Wynants, Jan *See* Wijnants, Jan.

Yakulov, Georgi (1882–1928)
Russian artist, trained at the Moscow Institute of Painting, Sculpture and Architecture. Some months in Manchuria in 1904–5 bred a special interest in light which he developed in his paintings and found echoed, when he was in Paris in 1913, by the theories of Robert *Delaunay. In 1917 he collaborated with *Rodchenko and others on the decoration of the Café Pittoresque in Moscow. Generally he was active mainly as stage designer. In 1924 he designed a monument dedicated to 26 Baku Commissars which included a spiral tower (cf. *Tatlin). In 1925 he was in Paris, working for Diaghilev, returning to Moscow later that year.

Yáñez de la Almedina, Fernando (recorded in Spain from 1506–31) Foremost Spanish painter of the High *Renaissance, trained, with his collaborator Fernando de los Llanos, in Florence under *Leonardo da Vinci. One of them must have been the 'Fernando spagnolo' who assisted Leonardo in 1505 on the *Battle of Anghiari*. Yáñez's extant works are distinguished by their forceful illusion of space and monumental figures (Valencia, cathedral; Madrid, Prado).

Yavlensky (Jawlensky), Alexei von (1864–1941) Russian painter of aristocratic origins. At 35 he turned from a military career to art and studied at the Petersburg Academy and then, leaving Russia with *Werefkin, in Munich. He travelled in France and was especially influenced by the work of *Gauguin and *Matisse, developing a calm, meditative sort of *Expressionism marked by resonant colours and strong, simple forms, often with religious connotations. In 1909 he was a founder member of the Neue Künstlervereinigung. In 1914 he moved to Switzerland where, from 1917 on, he produced a series of *abstracted, *iconic heads charged with symbolic meaning. From 1924 he lived in Wiesbaden.

Yeames, William Frederick (1835–1918) British painter who had his training in London and Italy and became an admired painter, portraying affecting moments in English history, usually of the Elizabethan period or the Cromwellian interregnum. The most famous of these, then as now, is *'And When did You Last See your Father?'* (1878; Liverpool, Walker). The question is put by one of Cromwell's inquisitors, accompanied by soldiers, to an aristocratic and therefore Royalist boy in his home and before his sister and servants; he stands there, proud and unintimidated. Presented like a stage drama, it is a well-managed piece of pictorial narrative that touches many an English sentimental nerve and foreshadows Hollywood.

Yeats, Jack Butler (1871–1957) Irish painter, brother of the poet W. B. Yeats; their father, **John Butler Yeats** (1839–1922), was a painter and writer. Jack Yeats studied art in London. His early work was drawings of contemporary life. He took up oil painting around 1905 and developed a semi-*Impressionist style that called for luminous, moist-looking touches of thick paint laid on with the palette knife; the effect can be mistaken for *Expressionism, but it was liveliness he was after, not vehemence or deep disclosures. From 1910 on he lived in Dublin. His subjects, again, were primarily the life around him but included stories from Celtic mythology. In either case, they were welcomed as speaking for Irish nationalism and self-regard. He produced a great number of pictures and they can be seen in all the major Irish museums, notably those of Sligo, where he grew up, and of Dublin. He also wrote poetry, plays and novels, and a book about Sligo (1930).

Yoshihara, Jiro (1905–72) Japanese painter, mainly self-taught and supported by his wealth as an industrialist. He was one of Japan's first *abstract painters and in

1954 founded the Gutai Group of avant-garde artists of which he remained the leader and financial support. They worked as *Performance artists as well as experimenting with new painting methods. Yoshihara's own work is characterized by a minimalism in which Japanese calligraphy and Zen ideals meet dramatic qualities derived from *Abstract Expressionism.

Youngerman, Jack (1926–)
American artist who studied in Paris in 1947–8 and made his first reputation there. In the 1950s he became known on both sides of the Atlantic for *hard-edge *abstract paintings and subsequently also experimented with sculpture.

Ysenbrandt or **Isenbrant, Adrian**
See under David, Gerard.

Yvaral, Jean-Pierre (1934–)
French artist, professional name of the son of *Vasarely. He was a founding member of the *Groupe de Recherche d'Art Visuel, and investigated especially the effects of moiré patterns in black and white productions.

Z

Zadkine, Ossip (1890–1967) Russian sculptor who studied art in London and worked mainly in Paris where he moved in 1910. He brought *Cubist qualities into his early sculpture but then, in the 1920s, developed a more fluent, open style with which he was able to make dramatic symbolical figures, such as his monumental image of suffering humanity *The Destroyed City* set up in Rotterdam in 1953.

Zanetti, Anton Maria, called **the Elder** (1679/80–1767) Internationally celebrated Venetian draftsman and *caricaturist, printmaker, collector, connoisseur, writer on art and art dealer, agent between his Venetian artist-friends and important European collectors; he corresponded with *Mariette, and visited Paris, London and Vienna. In his *Diversarum Iconum*, a collection of prints in one volume published in the late 1720s, he revived the technique of the *chiaroscuro* woodcut (*see under* relief prints) favoured by *Parmigianino. In collaboration with his second cousin and namesake, **Anton Maria Zanetti the Younger**, he published his *Raccolta Delle Antiche Statue...* (1740–3), and in 1750 illustrated his collection of antique gems in the *Dactyliotheca Zanettiana*.

Zao Wou-Ki (1921–) Chinese-French painter, who grew up in the Shanghai area and attended Hangchow Art School. He taught there and had solo exhibitions in the 1940s which demonstrated his keen interest in modern western art. In 1948 he settled in Paris, intent on further art studies as well as developing his own response. His work caught the attention of Henri *Michaux who brought a Paris dealer to Zao's studio. A contract and regular exhibitions ensued, as well as a collaborative work in which Zao provided images for Michaux's poems. A brilliant technician, Zao found much in western art that invited a kind of dialogue with his own cultural inheritance. The often delicate art of Paul *Klee, especially, attracted him, then also

the more openly anguished images of *Wols and, with the growing dominance of *Abstract Expressionism and *Art informel, a full engagement with the expressive, sometimes explosive *abstract art of the 1950s. A visit to the USA and personal knowledge of some of the leading New York painters deepened his roots in what was becoming a global art form, and he contributed to this enlargement through his own sometimes lyrical, sometimes epic paintings of *abstract, often apparently random forms and colours on large canvases. His 1981 retrospective at the Grand Palais in Paris travelled to Japanese museums and to Hong Kong and Singapore before returning for further French showings in 1983. Much of Zao's work was done for specific buildings, notably those designed by his friend I. M. Pei. Zao has received many honours, in France and abroad. In 1985 he returned to Hangchou Art School for a spell of teaching.

Zauffaly, Johannes *See* Zoffany, Johann.

Zeitblom, Bartholomäus (1455/60–1520/22) German painter. From *c.*1482 he ran a large workshop in Ulm, producing mainly altarpieces and portraits. *Strigel was probably one of his pupils, and is recorded as a collaborator on his best-known commission, the painted wings of the high altarpiece of the monastery at Blaubeuren near Ulm, 1494, carved by Michel *Erhart.

Zelotti, Giovanni Battista *See under* Veronese.

Zero Name of a group formed by the Düsseldorf artists *Mack, *Piene and *Uecker in the late 1950s. They published their programme in a journal of the same name in 1958 and 1961. It implied the reduction of processes and image and the reliance on pure colour and light in space. Their heritage was that of *Mondrian and

*Malevich (who used the word 'zero' to mark the onset of his *Suprematist art); more recent impulses came from *Fontana and perhaps *Klein. They also exhibited under the group names of Nul (German for nought; 1962) and Dynamo (1963).

Zeuxis *See under* still life.

Zick, Johann (1702–1762) and his son, pupil and assistant **Januarius** (1730–1797) South German painters, specializing in church *frescos; Johann was discarded in favour of *Tiepolo in the Würzburg Rezidenz. After peripatetic years during which he was, *inter alia*, in Paris (1756), the younger Zick settled near Koblenz in 1762, in the service of the Electoral court at Trier and Koblenz. He mainly painted altarpieces and ceiling frescos for churches in Upper Swabia, in which he tried to reconcile the traditions of illusionistic ceiling painting (*see also* illusionism) with the new demands of *Neoclassicism, but also produced some *genre scenes and portraits in the manner of *Rembrandt.

Ziem, Félix (1821–1911) French landscape painter in oils and watercolour whose lively and luminous work is frequently of Venice and other sea-framed places. He exhibited at the *Salon from 1849 and examples of his paintings can be found in many French museums. They tend to be small and are easily overlooked because they are not *Impressionist. They are, however, excellent examples of pre-Impressionist French *naturalism. Van *Gogh admired them greatly.

Zimmermann, Johann Baptist (1680–1758) and his brother **Dominikus** (1685–1766) German *fresco painters and sculptors in *stucco, key figures in the creation of the South German *Rococo style of church and palace decoration (various churches in Bavaria and Swabia, most significantly the pilgrimage churches of Steinhausen, 1728–33, and Die Wies, 1746–54; Amalienburg, Nymphenburg Palace, Munich, 1734–39).

Zoffany (born **Zauffaly** or **Zauffelij, Johann(es) (Josephus))** (1733–1810)

Painter mainly remembered for his minutely detailed, richly coloured, English *Conversation Pieces and theatre pictures. He was in fact a cultured, complex and versatile artist, the full range of whose accomplishments and interests has only recently come to be appreciated. Born near Frankfurt, the son of a court cabinet maker and architect, Zoffany also painted religious and mythological works, and large-scale *fresco and oil decorations in the German *Rococo style (1758–60; Regensburg, Alte Kapelle, Museum; Würzburg, Museum; Koblenz, Museum; Bordeaux, Musée; Manchester, Gallery). Decorations in palaces in Koblenz and Trier destroyed; preparatory drawings, London, British; Coll. HM the Queen). In Florence and Parma (1770s) he painted *Baroque court portraits on the scale of life for the Grand Duke of Tuscany (Vienna, Kunsthistorisches), one of which earned him the title of Baron of the Holy Empire. In the same years, for his own pleasure, he painted highly finished *genre pictures of Italian low-life and peasant festivals (Parma, Galleria; London, Tate). During his first visit to Rome after his apprenticeship in Regensburg, 1750, he had been a protégé of the *Neoclassical painter *Mengs and befriended by *Piranesi. His interest in *classical sculpture can be gauged by the picture he painted of, and for, his friend Townley: *Charles Towneley's Library in Park Street* (1781–3; Burnley, Gallery). In 1794, after a lifetime of tolerant scepticism, in reaction to the massacres of 1792 he painted savage satires on the horrors of the French Revolution. His stay in India (1783–9) produced not only portraits and Conversation Pieces of Anglo-Indian and Indian society (London, India Office; Calcutta, Victoria Hall), but also drawings reflecting his serious interest in Hindu customs (New Haven, Yale; London, British, Courtauld; Oxford, Ashmolean). He became a member of the scholarly Asiatic society, as he was a member of several Italian academies and of the Royal *Academy in London (*The Academicians of the Royal Academy*, 1771–2, Coll. HM the Queen). A series of self-portraits, notably those painted at a difficult personal time in the 1770s (Florence, Uffizi), testify to a

reflective, conflicted nature as much as to his knowledge of the 17th-century emblematic tradition.

Zoffany came to England in 1760. Speaking no English, he was employed in hack work, until rescued by his earliest major English patron, the actor-manager David Garrick. His English reputation was made first through Conversation Pieces of Garrick and his familiars (Coll. Lord Lambton; Lord Egremont) and theatrical pictures of Garrick in various roles (London, NPG, etc.). Introduced to Queen Charlotte, he painted for her two works which inaugurate the informal royal Conversation Piece as a genre (1764; Coll. HM the Queen). In 1772 he was commissioned by the Queen to go to Florence to paint *The Tribuna of the Uffizi* (1772–7/8; Coll. HM the Queen); it was at this time that he worked at the Grand Ducal court (*see above*). But the years after his return to England (1779–83) were disappointing; he had lost his following as a fashionable portraitist, and the *Tribuna*, possibly the most famous picture of a gallery of works of art, was adversely criticized; it was at this time that he decided to go to India, where he repaired his fortunes, but lost his health. He seems to have stopped painting after 1800.

Zoppo, Marco (1432–78) Italian painter of *polyptychs, single-field altarpieces and small devotional works. Born in Cento near Bologna, he was apprenticed to *Squarcione in Padua in about 1453, moved to Venice in 1455 and to Bologna in 1461–2; he died in Venice. His work resembles the hard, linear style of Squarcione's greatest pupil, *Mantegna (London, National; Washington, National; Oxford, Ashmolean; Baltimore, Maryland, Walters).

Zorn, Anders (1860–1920) Swedish painter. At the age of 15 he entered the Stockholm *Academy. In 1881 he went to Paris where he lived until 1896 except when on his travels, to Spain and Portugal, to England (1882–5 in London; 1887–8 in St Ives), also to Hungary, Greece and Turkey. An impressive presence, he also showed great adroitness in his work and achieved international fame with portraits and with

paintings that at first dealt with *realistic themes of Scandinavian life and then increasingly pictured naked girls as bathers and spoke of pleasure both in their bodies and in landscape and seaside settings. Similar subjects appear in the etchings which rapidly made his work known around the globe. From 1896 on he lived in Mora, Sweden, where he started a museum which is now named after him. His work is seen most plentifully there and in Stockholm, Nationalmuseum.

Zuccarelli, Francesco (1702–88) Florentine-born painter of Italianate *Rococo *landscapes, active mainly in Venice and England, where he worked between 1752–62 and 1765–72. In 1751 he met Richard *Wilson in Venice and may have influenced him to take up landscape painting. Zuccarelli was enormously successful in England, enjoying royal patronage, which Wilson never did, and becoming a founder member of the Royal *Academy. From the mid-19th century his work has been denigrated as vapid and artificial, but it should be remembered that his pictures were never intended as serious studies of nature, but merely to embellish a room, as decorative features set into a wall or over a fireplace. There are innumerable works in the royal collection, in private collections, and in public galleries throughout Britain.

Zuccaro, Taddeo (1529–66) and his brother **Federico** (1542/3–1609) Important Roman painters born near Urbino, working in a chastened *Mannerist idiom. Taddeo, the more naturally gifted of the two, came to Rome at the age of 14. Virtually self-taught through the study mainly of *Raphael and his school, he first made his reputation *c.1548 as a painter of façades, none of which survives (*see also* Polidoro da Caravaggio). Virtually all of his major commissions were finished after his death by Federico (S. Marcello al Corso, Cappella Frangipane, the *Conversion of St Paul*, *c.*1563; Caprarola, Farnese palace, begun 1559; *Dead Christ supported by Angels*, 1564–5, Urbino, Galleria; Vatican, Sala Regia). Taddeo's style is tempered both by a retrospective *classicism and

by *realism; at times he anticipates the 'reforming' mode of Annibale *Carracci.

He is nonetheless one of the most formally inventive decorative artists of his day, mingling – as for example in the Sala dei Fasti Farnesiani at Caprarola – *illusionism of various types in a sophisticated but thematically apt and visually clear way.

Federico, trained by his brother, began to paint on his own account before the age of 20 (Casino of Pope Pius IV, partly destroyed). He was a widely travelled artist and was in Venice in 1563–4 (S. Francesco della Vigna, Grimani chapel), Florence in 1565 (ceremonial entry for Giovanna d'Austria) and Orvieto in 1570 (cathedral). In 1574 he went abroad, to Lorraine, Holland and also England, where Elizabeth I gave him a sitting for a portrait (drawing only, London, British). Returning to Italy in the same year, he spent the next five years in Florence completing the *frescos of the cathedral dome left unfinished by *Vasari. On his return to Rome in 1579 he was assigned to complete the decoration of *Michelangelo's Cappella Paolina in the Vatican (finished 1583–4). The task was interrupted by temporary banishment from the city, 1581–3, resulting from the public exhibition of a satirical *allegorical painting, the Porta Virtutis (Gate of Virtue), in which Federico caricatured the detractors of his altarpiece for the church of S. Maria del Barracano in Bologna (painting lost, preparatory drawing Frankfurt, Städel). During his exile he worked for the Duke of Urbino (S. Maria di Loreto, 1582–3) and again in Venice, where he received the prestigious commission for one of the large historical canvases in the Great Council Chamber of the Doge's Palace (see also Giovanni Bellini; Alvise Vivarini; Carpaccio; Titian). In all these schemes Federico attempted to 'correct' local traditions towards greater classicism as this was understood in Rome; in Venice, his particular animus was directed at *Tintoretto, whom he was to pillory in his treatise Lamento della Pittura, published in Milan in 1605. From 1586–8 he worked for King Philip II of Spain, where his work was much disliked. In the early 1590s he was largely involved in founding in Rome the

*Academy of St Luke, which was meant to implement the principles of the Florentine Accademia del *Disegno. He was to publish his theoretical writings in 1607 in Turin, while working mainly in Lombardy and Piedmont; the Idea de'scultori, pittori et architetti is one of the most systematic expositions in Italian of the tenets of late *Mannerism and academic doctrine. Some of his notions are expressed pictorially in the allegorical decoration of his own house in Rome, where he held meetings of the Academy.

Federico's late works approach the counter-Mannerist *naturalism of e.g. *Santi di Tito (e.g. Adoration of the Magi, 1594, Lucca, cathedral), although he continued to deploy Mannerist conceits in decorative contexts. His tendency to academic schemata made him an easy model, and he became widely imitated among contemporaries and even by older artists.

Zucchi, Antonio See under Kauffmann, Angelica.

Zucchi, Jacopo (1541–90) Florentine *Mannerist painter, a pupil and assistant of *Vasari, whom he assisted on *frescos of the Palazzo Vecchio in Florence and in chapels in the Vatican. In 1572 he settled in Rome as an independent artist, continuing to receive fresco commissions (Palazzo di Firenze; Santo Spirito in Sassia; Palazzo Rucellai). His last work was again in Florence (Uffizi, Sala delle Carte Geografiche). Unlike these large mural paintings, his smaller easel works show the influence of Flemish *realism in *still-life details (Rome, Borghese).

Zugno, Francesco (1709–87) Venetian painter, a pupil and collaborator of Giovanni Battista *Tiepolo; some independent canvases are attributed to him (Munich, Alte Pinakothek; London, National).

Zuloaga y Zabaleta, Ignacio (1870–1945) Spanish painter, trained in Paris where was in touch with *Gauguin, *Degas and *Rodin, but, working in Madrid, a devoted disciple of the Spanish

tradition of *Velázquez and *Goya as well as a painter specializing in scenes and subjects celebrating his country. He produced a great quantity of work, and much of it is in the Zuloaga Museum in Madrid.

Zumbo, Gaetano Giulio (1656–1701) Italian wax modeller born in Sicily but active mainly in Florence. He was a pioneer of wax anatomical models (Florence, Zoological) and is best known for macabre *allegorical tableaux admonishing viewers to recall their own mortality (London, V&A).

Zurbarán, Francisco de (1598–1664) One of the greatest Spanish painters, despite a somewhat limited technique, and the one most closely identified with *tenebrist *naturalism and unquestioning piety of Spanish devotional art; rediscovered by the French in the 19th century.

Born in a small town in Estramadura, he was apprenticed in Seville to an obscure painter of religious images, returning to his native region in 1617 to work in Llerena, where in 1626 he received a decisive commission: 21 paintings for the newly built Dominican friary of San Pablo el Real in Seville (five extant). In 1627 he completed the *Christ on the Cross* for the sacristy of San Pablo (now Chicago, Art Institute) and this painting seems to have been instrumental in Zurbarán being invited to settle in Seville without first being examined for membership of the *Academy of St Luke. Throughout the late 1620s and 1630s Zurbarán was almost exclusively employed painting cycles, series and altarpieces for Sevillan monastic patrons: the Trinitarians, Hieronymites, Mercedarians, Franciscans, Carthusians. These ensembles, on which his reputation is founded, have been largely dispersed and partly lost, individual canvases finding their way to various galleries and collections (e.g. Cádiz, Museo; Seville, Museo; Madrid, Prado, Academy; New York, Metropolitan, Hispanic Society; Paris, Louvre; Grenoble, Musée; London,

National; Dublin, National; Strasbourg, Musée). While his altarpieces abound in rich colour and decorative detail, as do some of his single figures of female saints, the majority of the narratives of the lives of monastic saints and the single figures of such saints show the qualities most closely identified with the artist: the graduated depiction of brown, black, grey and especially white habits; monumentality and a dramatic stillness. The narratives, often based on Flemish and other prints and frequently clumsy in their representation of action, are constructed with geometrical simplicity in shallow box-like spaces, almost like sculpted high reliefs. Indeed, his figures show a debt to the work of Sevillan *polychrome-wood sculptors, notably *Montañés.

In 1634, possibly at the instance of his acquaintance *Velázquez, Zurbarán participated in the decoration of the Hall of Realms in the Buen Retiro palace, executing, with assistants, 10 emblematic *Labours of Hercules* and two battle scenes, of which only the *Defence of Cádiz* survives (all Madrid, Prado; *see also* Mayno).

By the 1640s Zurbarán's severe and static style fell out of favour, displaced by the more animated and suave manner of *Murillo. Although he attempted to adapt to the new fashion (e.g. 1658; Madrid, S. Francisco el Grande, Prado) Zurbarán never regained his former domestic market and began to paint large numbers of pictures on speculation to be sold in the Spanish colonies in the Americas. He moved to Madrid in 1658.

Despite the fact that all the faces in Zurbarán's religious paintings are individualized, he painted only a few independent portraits. While still-life accessories in all his works are depicted with almost surreal concreteness, only one documented *still life is known (now Los Angeles, Norton Simon Foundation). On the basis of this others have been attributed to him (Florence, Contini-Bonacossi; Madrid, Prado). His son, **Juan de Zurbarán**, became a still-life specialist.